The Print in the Western World

Linda C. Hults

The University of Wisconsin Press

The Print

An Introductory History

IN THE WESTERN WORLD

The University of Wisconsin Press
1930 Monroe Street
Madison, Wisconsin 53711

3 Henrietta Street
London WC2E 8LU, England

Printed in the United States of America

Library of Congress Cataloging-in-Publication Data

Hults, Linda C.

 The print in the western world: an introductory history / Linda C. Hults

 968 pp. cm.

 Includes bibliographical references and index.

 ISBN 0-299-13700-7

 1. Prints—History. I. Title.

NE400.H79 1996

769.9—dc20 95–7231

Publication of this book was assisted by
grants from the Publications Program of
the National Endowment for the Humanities,
an independent federal agency;
the College of Wooster; and
the Warren G. Moon Fund.

In memory of my father,

CLIFFORD M. HULTS,

whose pride in his own work

inspired me in this project

and in my life

Contents

Preface

I wrote this book to introduce art historians, students, and general readers to the history of western prints, and to provide a workable framework for teaching this subject at the college level. When I was first assigned to teach a course on the history of prints to junior and senior college students, I realized that both I and my students were hampered by the lack of a scholarly, chronological introduction. Printmaking was lost within a general art-historical emphasis on sculpture, architecture, and, above all, painting, and the available material on prints was fragmented into books on separate artists, media or groups of media, and art-historical periods. More comprehensive books devoted to many media or periods within printmaking do exist, but most of these lack a chronological arrangement or are written from the standpoints of printmakers giving instruction or connoisseurs or curators recounting their own experience and appreciation of prints. This book does not replace such studies, but provides a chronological frame of reference from which the reader can move on to more intensive investigation. Above all, I have sought to make the history of prints in the West accessible and stimulating for art historians and students, and teachable for instructors. To this end, I have avoided the amount of technical detail with which a printmaker might write about prints, although the introductions to printmaking techniques found at various points in the text and in the Glossary will provide the necessary technical foundation for understanding the works of art themselves. Perhaps the most significant difference between this book and many other studies of prints is the balance I have sought to achieve between connoisseurship and historical context. Although modern print historians are rapidly changing traditional approaches, subject matter, meaning, and the ways in which prints have functioned within western culture have been much neglected issues.

The "spine" of the chronological body of the book is formed by five artists: Albrecht Dürer, Rembrandt van Rijn, Francisco Goya, Pablo Picasso, and Jasper Johns. They represent such distinct peaks in the development of printmaking that I felt no compunction about discussing them thoroughly even in an introductory book. In different ways, they have all taken printmaking to new aesthetic heights and produced graphic oeuvres of compelling content and expressive power. Other printmakers, scarcely less important—William Hogarth, Honoré Daumier, Käthe Kollwitz, Henri de Toulouse-Lautrec, Edvard Munch, and Robert Rauschenberg, for example—have been given only slightly less attention. It is merely because of considerations of length, and the tremendous variety of contemporary printmaking, that I end my history ca. 1980. I hope that this book, by providing a historical foundation, will encourage readers to appreciate contemporary prints as well.

The basic divisions in the text are mostly due to pragmatic considerations. I wanted to find manageable units within which a relative coherence is present, and frame these within a basically chronological structure. These thirteen units, plus the Introduction, are also geared to fit the format of a fourteen- to fifteen-week semester. The units cohere for different reasons. In some cases the major artists mentioned above formed a natural center for a unit of material. In other instances, a unit was formed around the stylistic and technical development of a particular medium, such as early Italian engraving, lithography in the nineteenth century, or etching in the seventeenth. Chapter 5, on reproductive printmaking and the elaboration of

linear and tonal techniques that developed in conjunction with it, describes a continuous tradition from the late sixteenth through the early nineteenth century. This tradition is set off against the original prints of the Renaissance at one end and against photography and the modern idea of the original print at the other. The chapter on the German Expressionists and related artists, while dominated by no single personality or medium, is based on a unity of purpose and a feeling for the preeminence of graphic art among these artists. This movement seemed to demand separate treatment in a history of prints, whereas, from the standpoint of the history of art in general, it could just as easily have been treated with other twentieth-century "isms." Similarly, Hogarth and Goya are grouped together because they epitomize the role of the printmaker as social reformer as well as the Enlightenment's emphasis on reason as a central principle in human behavior and government. The linkage of these two artists provided a number of natural cross-references (at times they dealt with identical issues) and also a foundation for the development of social and political criticism in modern prints (e.g., in German Expressionism or American prints of the Depression era).

The divisions of the book also reflect various approaches to understanding prints. In one place, I emphasize how styles change and are affected and partly determined by the technical concerns and limitations of printmaking; in another, how prints reflect and affect their context; in yet another, how a print can be appreciated as an aesthetic experience or as the expression of an individual personality. The reader should regard no particular treatment in this book as full and complete, but see each as subject to the exigencies of space and to a consideration of how much a student can absorb during the course of a semester. The suggestions for further reading that may be gleaned from the Notes and References following each chapter will help overcome some of the omissions of the text. Moreover, I have included a Bibliography listing the standard print reference catalogs, which I have not cited routinely in the text itself.

The history of prints is a topic with particularly unclear boundaries because the print, as "the only form of fine art that can be both an artistic and a commercial mode of expression,"[1] has so often participated in divergent aspects of culture and society. The print tends to be linked "horizontally" to popular or functional art forms such as advertising, political cartooning, reproduction of other works of art, or illustration, rather than to dissociate itself from these forms "vertically," as paintings have done (at least in traditional art-historical scholarship). This presented me with some problems. From the purist's point of view, for example, it would have been justifiable to restrict the book to what Adam Bartsch called the *peintre-graveurs,* or "painter-engravers": those artists who produced original as opposed to reproductive prints. The latter duplicate, not just borrow from, works in other media, especially painting, and have usually been made by professional reproductive printmakers. We say that the professionals are working "after" the artists and that dependence already taints the reproductive print in some eyes. But, as Theodore Donson points out, the fact that the works produced by painter-engravers like Dürer or Rembrandt dazzle us does not mean that reproductive prints lack merit. Of the vast numbers that have been produced, many may lack aesthetic interest (although they may well be of historical and cultural interest). However, many reproductive prints are interpretive translations with their own aesthetic value.[2]

The omission of reproductive prints would not only have capitulated to the narrow modern notion of "originality," but would have falsified this history considerably. It was in the reproductive realm that some of the most important printmaking techniques, like aquatint, were generated, and it is against the background of reproductive prints in the eighteenth and

nineteenth centuries that the original printmaking of that period defined itself. Moreover, the distinction between reproductive and original is not as clear-cut as it might seem, for some painters took it upon themselves to make prints after their own works, sometimes using techniques that were native to the reproductive enterprise, like mezzotint, but sometimes not. Serving primarily, but not only, to convey information about other works, reproductive prints exemplify printmaking's "horizontal" tendencies as well as exhibit the extraordinary level of *craft* printmaking often demands.

All artistic media involve craft, but the requirements of technical skill and knowledge weigh particularly heavily on the printmaker and on the development of his or her art. Indeed, printmaking arose in the context of two late medieval crafts: woodcarving and goldsmithing. In general, printmaking has not been something that artists trained in other media could take up quickly or casually. As we shall see, sometimes the social custom of separating designer and printmaker absolutely prohibited painters from making prints; sometimes the science of printmaking (as in the chemistry of lithography) made the collaboration of the artist and the printer essential. But beyond such situations, creative spontaneity is often tempered in printmaking: the artist's initial conception is likely to be subject to numerous transformations dictated by the frequently complex procedures themselves. The clash of original creative impulses—as are often present, for example, in drawings—with materials and procedures is therefore particularly acute in printmaking. In the case of Picasso, the fundamental antagonism of an impatient creative will and stubborn, time-consuming technical procedures is the basis for stunning innovations that profoundly affected the nature of printmaking in the twentieth century.

The extraordinarily painterly or pictorial effects of seventeenth- and eighteenth-century reproductive prints epitomize the sheer craft and technical complexity of printmaking. For this reason, they are crucial for understanding the evolution of printmaking as a whole, even though, from a purist's standpoint, these effects are not fully "graphic" (the prominent print scholar Arthur M. Hind flatly labeled this development in the history of prints a "decay").[3] And, paradoxically, printmaking had sought such effects almost from its beginning. The colorism of painting was always something toward which printmaking might strive, as if its inherent linear or purely tonal qualities were incomplete. It is only against this background of printmaking's quest for painterly effects that Goya's quintessentially graphic etchings—also beautifully crafted, but in a way that rejected the intricate systems of lines and marks associated with reproductive printmaking—can be understood.

Ultimately, the question of whether to include reproductive prints was less problematic for me than *how* to include them. The foundation for reproductive printmaking as an organized enterprise was laid by Marcantonio Raimondi in the sixteenth century, and this development can be comfortably explicated within the context of the Italian Renaissance print. But the subsequent growth of this enterprise is phenomenal, and geographically far-flung. One possibility was to treat the reproductive enterprise country by country, century by century. However, that would have eroded the continuity of the reproductive tradition from the late sixteenth through the nineteenth century (before photography usurped its primary function). Equally important is the crucial role this whole tradition played in the formation of modern attitudes toward the print. Therefore, I chose to stretch the basically chronological structure of the book to treat reproductive printmaking as a unit. Chapter 5 is subdivided, however, into late sixteenth-, seventeenth-, and eighteenth–early nineteenth-century sections, which could alternatively be assigned after Chapters 3, 4, and 6.

Just as the print has often served as a kind of handmaiden to painting, it has frequently accompanied texts or simply conveyed information. A. Hyatt Mayor's wonderful, rambling *Prints and People* gives an excellent sense of the illustrative aspects of printmaking, moving from these with ease to the aesthetic pinnacles of the history of prints. William M. Ivins's brilliant study, *Prints and Visual Communication,* focuses on the important role of prints as vehicles for information, supplementing or supplanting the written word. In this book, I basically consider a print to be a loose, hand-held object (albeit often pasted into albums, bound into volumes, or framed and hung on the wall), but I occasionally broach the subject of book illustration insofar as it sheds light upon the development of printmaking as a whole (as, for example, in describing the state of the art of woodcutting before Dürer). To consider book illustration with any degree of thoroughness would seriously compromise the utility of this book as a scholarly introduction to the history of prints, and especially as a text for a one-semester course, and yet book illustration, too, is another important "horizontal" dimension of printmaking.

Historically, printmaking has also had strong connections with political, religious, or social satire, caricature, and propaganda. There are books that focus solely on this aspect of prints: Frank and Dorothy Getlein's *The Bite of the Print,* Ralph Shikes's *The Indignant Eye,* and David Kunzle's *The Early Comic Strip* are three prominent examples. I touch upon this aspect of printmaking, primarily by emphasizing some outstanding images: Daumier's pointed caricatures, Hogarth's witty narratives, Goya's unforgettable exposures of human stupidity and cruelty. (These images are often in series, ultimately indebted to the graphic cycles on the Passion of Christ or the Life of Mary that we find right from the beginning of printmaking, which has a natural affinity for narrative or serial imagery.) The political prints I discuss in this text can stand up in other times and places as broad statements about the human social condition. But I also try to make the reader aware that artists like Hogarth, Goya, and Daumier are only the most prominent examples of a vast tradition of social and political satire within western printmaking.

By touching upon some of the ways in which prints have distinguished themselves from other art forms in western culture—as sources of information about other artworks, as illustrations, or as a medium for social and political commentary, for example—I have tried resolutely to write a history of prints rather than a history of art. But, necessarily, the history of prints is bound up with the history of art in general. The reader will be introduced to elementary art-historical terms and concepts in this book—Mannerism, Romanticism, Cubism, and so on—but only introduced. It is my hope that the reader will pursue these concepts using my bibliographic suggestions and other resources.

Some comments are in order regarding both the content and the form of the notes and reference lists following each chapter. They are not intended to give a comprehensive account of scholarship on the history of prints (indeed, they could not, given the quantity of this material). Rather, their content reflects the way I have assimilated print scholarship in my own thinking and teaching. Because my primary audience in teaching has been American undergraduates, I have tended to favor English-language sources that are accessible in American college and university libraries. Particular authors or journals that have proven consistently useful to me and to my students are also cited frequently in this text. Beyond these "biases," which prevent me from claiming comprehensiveness, I have made a conscious effort to include a variety of points of view about scholarly issues. If the reader or student will pursue the

bibliographic leads I offer, he or she should be equipped to begin to deal with these issues in a critical manner.

The form I have chosen for my notes and reference lists is a hybrid of the author/date system and a more traditional form of citation used in the humanities. Putting the date of each article or book immediately after the author's name enabled me to use a quick citation in the notes that corresponds to a full reference in the chapter bibliography. In a book with so many references to works by the same authors, this method of citation proved to be most utilitarian. It also has the advantage of making readers more aware of the date of any scholarship—an especially important factor for students to consider in their own research. Other decisions about the form of my citations were also pedagogically motivated. For example, I wanted to make the significance of exhibition-related scholarship on prints very clear, and so I have specified exhibition catalogs, and catalog numbers as well as pages where both exist. Unless the title pages of exhibition catalogs absolutely suggested otherwise, I have listed these works by their primary curators and contributing scholars rather than by institution. Many of the works I cite herein, especially the exhibition catalogs, have several authors. I cite essays within such books separately when I have tended to use them individually. In cases where I have used a multi-author work as a unit (e.g., the 1981 overview of the history of prints by Michel Melot, Antony Griffiths, and Richard S. Field), I have cited it as such.

The legends for the illustrations also require some cautionary comments. In listing medium, I have tried to be as precise as possible about the *dominant* technique used, and in cases of differing interpretations, to arrive at a compromise description. Readers should be aware that techniques for very early prints are often uncertain and that there are often conflicting opinions about graphic media, especially in cases where many have been combined (as, for example, in Kollwitz's intaglio series). Also, a technique such as etching often routinely includes details achieved with other intaglio means like drypoint and engraving. I have not included states in captions unless pertinent to the date or to my discussion in the text. For problematic dates, I have done my best to find a date that represents a reasonable compromise among existing possibilities rather than use "undated." When an extraordinary range of possible dates has been generated by the scholarship (as in the morass of conflicting opinions about prints by Mantegna and his "school"), or when one convincing date comes into conflict with traditional dating (as in the dating of the last section of Goya's *Disasters of War* to 1820–23), I have qualified the date in some way.

For problematic titles, I have based my choices on what seemed to be general usage in the literature on the one hand, and utility for the reader on the other. For example, for Piranesi's prints from the *Vedute di Roma*, it seemed reasonable to use titles that describe the structures depicted rather than titles construed from Piranesi's inscriptions, and since one frequently encounters the Italian titles for Piranesi's various series in the literature, I chose to use *Vedute di Roma* and *Carceri* rather than *Views of Rome* and *Prisons*. Indeed, there are many places in this text where usage seems to sanction retaining foreign-language titles. In addition, of course, for many prints, particularly early ones, there are a number of alternative titles; I have included the most familiar of these in the legends but have only occasionally referred to them in the text.

The approximate dimensions of the prints are given in millimeters, height before width. I have not measured these prints myself (with the exception of those supplied by the College of Wooster Art Museum) but have relied on print reference catalogs, oeuvre catalogs, exhibition catalogs, and museum data. For intaglio prints, the measurements are those of either the

platemark, the borderline, or the image area. For other graphic media, the measurements indicate the image area. Whenever I could ascertain that the measurement is that of the sheet of paper, I have indicated that parenthetically. The reader should be aware that establishing the dimensions of prints is not an exact science because paper shrinks and expands, and blocks or plates are often unevenly cut. I reiterate my initial description of these dimensions as "approximate."

Ernst Gombrich began his basic textbook *The Story of Art* with the statement "There really is no such thing as Art. There are only artists."[4] Those who sympathize with new directions in the discipline of art history, including myself, might take issue with this statement, since it seems to glorify the uniqueness of the artist at the expense of understanding how works of art function in society, and their relationships to other kinds of visual and verbal discourse. But Gombrich's opening pronouncement still offers a useful caveat for anyone undertaking a large-scale study such as this book. Historical context is an especially compelling concern that can swallow up the individuality of a work of art. Another art-historical trap is the tendency to see causal relationships, influences, developments, beginnings, culminations, and the like, so that one loses sight of the individual trees in order to draw a map of the forest. But each work of art still deserves to be treated as a creative achievement, not merely as a piece in the jigsaw puzzle of society or as a stepping-stone to something else in an art-historical sequence. I hope that the reader carries away from this study a fundamental respect and love for prints as works of art and as parts of history—as well as a "map" that is not too illusory. Since prints are a form of art that still lies within the economic means of the average person, it is even more important to make their history broadly accessible.

Wooster, Ohio
October, 1992

LINDA C. HULTS

NOTES

1. Donson 1977, p. 12.
2. Ibid., pp. 19–21.
3. Hind [1923] 1963, p. 197.
4. Gombrich 1951, p. 5.

REFERENCES

Donson, Theodore B. 1977. *Prints and the Print Market: A Handbook for Buyers, Collectors and Connoisseurs.* New York.

Getlein, Frank, and Dorothy Getlein. 1963. *The Bite of the Print.* New York.

Gombrich, Ernst. 1951. *The Story of Art.* New York.

Hind, Arthur M. [1923] 1963. *A History of Engraving and Etching.* Reprint. New York.

Ivins, William M. [1953] 1969. *Prints and Visual Communication.* Reprint. Cambridge, Mass.

Kunzle, David. 1973. *The Early Comic Strip: Narrative Strips and Picture Stories in the European Broadsheet from c. 1450 to 1825.* Berkeley, Calif.

Mayor, A. Hyatt. 1971. *Prints and People.* Princeton, N.J.

Melot, Michel, Antony Griffiths, and Richard S. Field. 1981. *Prints: History of an Art.* New York.

Shikes, Ralph. 1969. *The Indignant Eye: The Artist as Social Critic in Prints and Drawings from the Fifteenth Century to Picasso.* Boston.

Acknowledgments

Since this book is a synthesis of the existing scholarship on prints, the greatest debt I owe is to the scholars cited herein, especially those who have consistently addressed prints in their work and those who teach the history of prints. There are many people who have been especially helpful, both in critiquing the manuscript, and in lending the moral support necessary for such an extensive undertaking.

At the beginning of my work, Walter L. Strauss, a tireless champion of the study of prints, was my most enthusiastic supporter. His ebullient optimism offset my pessimism and caution, and often gave me the boost I needed to continue the project in its early stages. Since Walter's death in 1988, I have missed his advice and encouragement. Larry Silver has consistently bolstered my effort by willingly writing letters to editors and by being the book's most constructive critic, reading nearly half the manuscript, pointing out my blind spots, and helping to shape its content. The debt I owe to Larry is not easy to repay, but I hope that this acknowledgment will convey my deep gratitude. Also important for constructive criticism of the manuscript, and support in the form of letters and personal encouragement, are Jane Hutchison and Jane Peters, scholars of German prints. Tom Bruhn has also been a resource for me, both for the conversations we've had about teaching this material, and for his work on American prints.

My friends and colleagues at the University of Tulsa and at the College of Wooster have sustained me in many ways as I worked on the manuscript. Ceramist Tom Manhart's patience and skill as a teacher helped me learn word processing many years ago. Dear friends and fellow art historians Marty Rosenberg and Maureen Ryan offered extremely useful critiques of large parts of the manuscript, as well as being continuing sounding boards for my expressions of frustrations in getting this book written and published. I also thank my friend and former colleague Nancy Friese, a painter and printmaker whose love of the prints of Thomas and Mary Nimmo Moran broadened my own interest in prints, which began, after all, with German Renaissance material. Over the years, I have been very grateful for Nancy's warm and generous friendship, as well as for her enthusiasm for all kinds of prints and her intelligent perception of them. At the College of Wooster, all my colleagues have offered professional and personal sustenance, and Beth Lewis, in particular, graciously read my chapter on German Expressionist prints, which was much improved after her comments. Susan Hansen contributed publicity photos. Administrative assistant Donna Warner helped with the voluminous correspondence regarding photographs, and curator Kitty Zurko helped with the photographs from the John Taylor Arms print collection of the College of Wooster. Beyond these immediate Art Department colleagues, Chester Andrews aided me with serious word processing problems when I first came to Wooster, and professor of physics Don Jacobs converted my manuscript from IBM to MacIntosh at a particularly crucial and frustrating juncture.

Both the University of Tulsa, in the early stages of this project, and the College of Wooster, more recently, have offered financial backing for research, writing, word processing, correspondence and photo-acquisition. The College of Wooster not only waived permission fees for photographs of works from its collection, but also gave a generous grant toward the illustrations in this book: President Henry Copeland must be singled out for this invaluable aid, which certainly helped me find a publisher willing to take on such a heavily illustrated text. A

paid semester's leave from the College enabled me to develop and circulate the prospectus which was eventually accepted by the University of Wisconsin Press. The Sophomore Research Program directed by Cameron Maneese granted me Jane Erickson, who worked assiduously on the index and saved me many hours of work. The Henry Luce III Fund for distinguished scholarship made the completion of the index possible, since it provided the fees for Jeff Pinkham, whose professionalism is evident in the finished product.

Funding to support production was also provided by the Publications Program of the National Endowment for the Humanities.

Although the difficulties of researching and writing such an expansive manuscript are numerous, they pale when compared to locating and acquiring the photographs to illustrate it. In this four-year effort, I have not always known how to proceed, and a variety of curators, registrars, and reproduction rights personnel have led me through this labyrinth. The staffs of all the institutions where large photographic orders were placed deserve special thanks for going out of their way to give assistance. Among the staffs at those large institutions, I would especially like to thank the personnel at the Art Institute of Chicago, the Boston Museum of Fine Arts, the British Museum, the Cleveland Museum of Art, The Library of Congress, the Metropolitan Museum of Art, the Museum of Modern Art, the National Gallery of Art, the New York Public Library, and the Philadelphia Museum of Art. There are far too many smaller institutions to mention by name, but I am no less grateful for the patience and help of their staffs.

At the University of Wisconsin Press, editorial assistants Ruth Semmerling, Sara DeHaan, and, especially, Susan Spruell, have facilitated the photo-research and acquisition process. Susan's calm manner, unfailing humor and thorough, systematic approach to the acquisition of illustrations have minimized my photographic anxiety attacks. James Watrous, whose book on American printmaking published by the University of Wisconsin Press is one of my inspirations, helped me by donating photographs in his possession. Similar thanks for donated photos should go to R. S. Johnson Fine Art in Chicago, Robert N. Essick, Lawrence Saphire, Pace Gallery, Hirshl and Adler Modern, and Tyler Graphics.

I owe acquisitions editor Barbara Hanrahan and assistant director Elizabeth Steinberg many thanks for their help and encouragement, and Betty additionally for her many editorial contributions to this project. The text itself owes much to copy editor Jane Barry, whose meticulous reading caught contradictions, frequently clarified my meaning, and made my prose far more graceful than it would be in its "natural" state.

Finally, I would like to thank my family, especially my husband, Bill Munger, for his unwavering and uncomplaining support throughout this long project and during my academic career in general.

The Print in the Western World

Introduction

THE FOUR BASIC TYPES OF PRINTMAKING

Defined most simply, a print is a work of art on paper, produced in multiple impressions, each of which is pulled from an inked surface. The transfer of image from surface to paper is definitive: the former thus serves as a modular source for the impressions on paper taken from it. The physical character of the printing surface, the method used by the artist to produce the image upon it, the manner in which it holds the printing ink, and the mechanical process of transferral determine the nature of the resulting print. A brief overview of the four main categories of printmaking will explain this.

The *relief* method is the oldest and, conceptually, the simplest printmaking method: the printing surface is usually a plank of wood, although linoleum and other materials have also been employed, carved with knives, gouges, chisels, or other instruments. A thick ink is rolled on top of the block, leaving the carved-out areas clean. Relief prints are thus conceived negatively: that is, the artist, or someone working after his or her design, carves *around* what is to be printed. Woodcuts may be printed by a press with a perpendicular motion or by hand, by pressing the paper against the block or the block against the paper.

A metal plate, traditionally copper, serves as the printing surface for *intaglio* prints. Conceptually, this second-oldest process reverses the relief method: the ink is held in the excavated parts of the printing surface. The artist incises or scratches an image on the plate manually (*engraving* or *drypoint*) or chemically, by means of acid (*etching*). In this last process, he or she draws the image through an acid-resistant coating called a "ground" to expose the metal underneath. When the plate is immersed in an acid bath, the lines are "bitten." In the various types of intaglio printmaking, what the artist takes away from the plate is the design itself.

Whereas woodcutting involves the removal of excess material from the block, thereby allowing for the employment of a carver to "uncover" the artistic image, intaglio printmaking demands that the artist work directly on the plate. In the case of engravings or drypoints, the width and depth of line are controlled by the pressure of the artist's hand on the burin or stylus; in the case of etchings, by the length of time the acid is allowed to bite the plate.

Since the ink is transferred to the paper from carved incisions or etched crevices in the intaglio plate, its upper surface must be relatively free of ink. The artist accomplishes this by wiping the plate, working the ink down while simultaneously cleaning it off the top. Intaglio plates are customarily printed by a roller press with great pressure that forces the paper into the crevices to pick up the ink. Simultaneously, this produces the characteristic platemark, where the beveled edge of the metal plate has been pressed into the paper.

Relief and intaglio printmaking require an actual carving-out of the plate or block, but lithography, invented in the late eighteenth century, employs chemistry to fix the image on a perfectly flat printing surface, usually a slab of fine-grained Bavarian limestone, although more portable zinc or aluminum plates may be treated to substitute for the heavy stone. Lithography is therefore a *planographic* (flat-surfaced) process, whose operative principle is the antagonism of grease and water. After the image is drawn or painted with a greasy medium, the stone is treated with nitric acid and gum arabic, which "set" the image and prevent the stone from absorbing superfluous grease. Before inking, the stone is wetted down, so that the oily ink will adhere to the marked areas only and be repelled from the wet areas. Lithographs are printed on a press with a bar that scrapes across the back of the paper, which is placed face down on the stone.

Silkscreen (alternatively called *serigraphy* or *screenprinting*) also involves a flat-printing surface—a screen of silk or other material—without incisions. In this process, however, ink is squeegeed *through* the printing surface, parts of which have been blocked out by a variety of methods, rather than lifted *from* it as in the other three major printmaking categories. The old and very simple idea of the stencil is the basis for silkscreen, which has become an increasingly important technique since the 1950s.

This introduction to the mechanics of printmaking is deliberately skeletal. It does not include all possible techniques, not does it take into account the many hybrid methods (for example, the use of a metal plate in a relief process). But we will flesh out the skeleton later; for now, it provides us with a working foundation from which we can begin to apprehend some of the distinctive aesthetic properties of prints.

DISTINCTIVE CHARACTERISTICS OF PRINTS AS WORKS OF ART

Paper has made prints considerably easier to handle and transport than most other art forms and has also limited their size. This is the first distinctive characteristic of the print as a work of art. Extremely large prints are, for the most part, a recent development dependent upon the manufacture of large papers and presses. (Major exceptions to this are the composite multiblock or multiplate prints such as Titian's *Submersion of Pharaoh's Army in the Red Sea* [see fig. 3.43] or the *Triumphal Arch of Maximillian* [see fig. 2.22] designed by Albrecht Dürer.) Traditionally, the print is a hand-held work that can and indeed must be closely viewed. This situation has conditioned the way artists have conceived printmaking within their oeuvres.

Only rarely in the history of western art is an artist known exclusively for prints (as Jacques Callot and Charles Meryon, for example, are). Printmaking frequently functions as an outlet for more personal and/or imaginative explorations of form and subject matter than can be achieved in the more monumental modes of painting or sculpture. In cases in which an artist treats the same theme in both a print and a painting, the print will often lack a degree of formality and grandeur, but possess a freshness that is reinforced by the more intimate way we view and perhaps even handle it.

In our throw-away culture, we take paper for granted. It is the manufactured stuff of containers, newspapers, and magazines. We write on it, read from it—it is readily discarded and ignored. Of course, a print can be produced on common, inexpensive paper, but traditionally the image so carefully incised, carved, painted, or drawn on the printing surface is entrusted only to a worthy receptacle: a fine paper that is as much a part of the aesthetic conception of the print as composition or ink color.[1]

Before 1800 European paper was made from cotton and linen rags that were broken down and mashed with water into a pulp, which the papermaker molded into sheets by drawing a wire tray through it. The layer of pulp was pressed flat and dried between felt blankets, and sized with glue or gelatine to make it ready for printing. The character of the wire tray determined the basic type of paper: *laid* paper bore the marks of the vertical wires and horizontal connecting "chains" of the mold; *wove* paper, invented in the mid-eighteenth century, was quite smooth because of the fineness and close spacing of the wires. In either case, an identifying *watermark* might be embedded in the pulp by incorporating a wire emblem into the tray itself. This reads as a shadowy mark when the paper is held up to the light, and can be important in determining the origins and date of an otherwise unidentifiable print. It can also help to authenticate a print or identify a facsimile or restrike (an impression taken after the artist's death or after the printing surface has lain unused for quite some time).

In addition to those produced in Europe, oriental papers were employed as trade with the Far East increased. Particularly notable are Japan paper, made of mulberry fibers, and thin China paper, which may be laid down on another sheet of paper for backing (in so-called *chine-collé* prints). Prints have also been made on fabrics such as linen, cotton, or silk, on vellum, a calfskin also used by medieval manuscript illuminators, and on synthetic surfaces such as Mylar.

Although paper manufactured from wood pulp has become predominant in general usage, the hand-made variety is still sought by printmakers for its durability and beauty. As we shall see, the wide range of colors, textures, and absorbencies of traditional papers is among the principal means of varying the impressions from a single printing surface. Recently, the interest in hand-made papers has escalated, producing an art form that is neither print nor collage nor molded sculpture but is related to all three: objects or images may be embedded in the paper pulp itself.[2]

To achieve a particular aesthetic effect, the artist must consider how paper works with ink. Most inks used in western prints are combinations of oily varnishes and carbon pigments such as lampblack, made from soot, or vine black. (The latter is made from grape vines, providing an interesting link between the early flourishing of printmaking in the Rhineland and that region's outstanding wine production.) The character of the ink depends on the type and proportion of ingredients—that is, the amount of pigment in relation to varnish—and choices made during processing, like how long to "cook" and thicken the oil. The type of printmaking

will determine the kind of ink needed. Lithography, for example, requires a greasy ink in order to work, while the ink in silkscreen can be many kinds of fluid pigment. Relief printmaking demands a more viscous ink than intaglio, in which ink must penetrate the fine crevices of an incised copperplate. Moreover, with each method of printmaking, the character of inks may vary widely. One of the most striking differences between early German and early Italian engravings is the "color" of the ink: the silvery Italian grays contrast with the dense blacks of the north. This fundamental difference was caused by varying the proportions of varnish and pigment and, within the pigment component, varying the proportions of vine black and lampblack.[3]

The *transfer* of image from surface to paper is the second factor important to our aesthetic understanding of the print. It means that the physical properties, not only of the paper and ink, but also of the plate, stone, block, or screen itself, intervene between the artist's initial conception and the final realization. Of course, materials always impose limitations on, as well as lend possibilities to, artistic conceptions, but in printmaking the artist must be able to anticipate how the mark in the original surface will translate onto the paper when inked and printed. In most kinds of printmaking, reversal of the design is inherent, and this is only the most obvious problem the artist must cope with. In addition to the paper's texture, that of the printing surface will impose itself on the image—indeed, we will see the best printmakers exploiting these extra textures to great advantage. Paul Gauguin and Edvard Munch, for example, incorporated the grain of wood into the formal conception of their woodcuts.

Moreover, the various surfaces used in printmaking demand their own sets of tools and, hence, distinct muscular actions. A burin mark translates differently than an etched line because the latter has been produced by the acid's corrosion of the metal wherever it has been exposed by *scratching* through a ground, whereas the former is the result of *pushing* the burin through the metal. This action reads on the print as a swelling and tapering of the line that reflects the gradual application and lifting of pressure by the artist's hand. Although the plate employed in intaglio printmaking is malleable and smooth, the wooden plank that is the basis for woodcut is hard, grained, and recalcitrant. Closely spaced, fluid lines are nearly impossible to achieve here, especially since the lines are arrived at by a subtractive process. In lithography, on the other hand, the action of the artist's hand meets little resistance from the finely textured stone. Even more than etching, lithography has an *autographic* quality (that is, it reflects the artist's touch with great immediacy) that makes it particularly appealing to artists who dislike the intervention of the complex technical procedures usually associated with printmaking. For this reason, the early name for lithography, *polyautography*, implied the multiplication of a drawing. And, as we shall see, lithography has historically involved the close collaboration of artists and master printers, who took care of the more technical aspects of inking and printing the stones.

Of all the basic printmaking techniques, silkscreen is perhaps the farthest removed from the autographic immediacy possible in lithography. The squeegeeing of ink through a screen tends to produce flat, unmodulated color areas akin to those of commercial design or advertising. The artist must derive complexity of composition or nuances of color by the superimposition (*registration*) of more than one screen on the paper or by the subtlety with which the screen or screens are blocked out. Although this might be regarded as a serious limitation, it has made silkscreen very important for recent movements in American art in which the abolition of the autographic quality and the exploration of American mass culture have been the

objectives. The incorporation of photography into silkscreen as well as lithography (two media that had traditionally been very far apart, as we have noted) has pushed both techniques closer to the imagery of mass media. On the other hand, Robert Rauschenberg's printed collages of photographs have a personal, mysterious quality by virtue of his selection, juxtaposition, and overlapping of images.

Another aspect of transferring an image from printing surface to paper that the print-maker must keep in mind is the pressure and motion of the press (or the hand, if a press is not employed). These factors will combine with the consistency of the ink and the absorbency of the paper to determine whether the image sits flat on the paper, sinks into it, or is pulled up from it, as in intaglio lines that have been molded by high pressure. Printed ink may have a variety of actual textures, ranging from an impasto-like painterly surface to the raised linear relief just mentioned. However, the texture of ink on the printing surface may translate to the paper as the *illusion* of texture. In lithography, such illusionistic effects may often be provocatively combined with the sense of the grain of the stone, as it is revealed by the artist's mark upon it, and the actual texture of the paper.

A third basic condition of printmaking that profoundly affects our aesthetic appreciation of its products is *multiplicity*. It is only in the most basic sense that each impression taken from a plate, block, or stone can substitute for another, with the printing surface itself serving as the key. Although these surfaces are often very beautiful themselves (Gauguin's woodcut blocks that are like independent relief sculptures come immediately to mind), they are not what we normally view. We are concerned with the translation of image to paper, and it is precisely those unique or non-interchangeable aspects of each translation that fascinate us the most.

The most obvious of these aspects—quality of impression—depends largely on the condition of the printing surface when the image was transferred from it. The relief and especially the intaglio processes cause damage and wear to the block or plate. Wood can warp, crack, and wear smoother with printing, and, because of the great pressure of an intaglio press, the incisions or crevices in a metal plate are bound to deteriorate. The "burr" of a drypoint line, a fringe of displaced metal that holds ink and yields a characteristic softness, begins to break down almost immediately. Aquatint etching—basically a pitting of the plate to achieve non-linear areas of tone—will also wear rather quickly, so that an early edition of Francisco Goya's *Caprichos* is incomparably more beautiful than one made posthumously, when the aquatint areas had flattened, losing their integrity as tones and their contrast with the paper that Goya knew how to exploit so well.

Beyond the physical deterioration that might occur from impression to impression, the printing surface may be subject to changes imposed by the artist. Any impression that shows an artist's further work on the plate, block, or stone is called a *state*. Variety may also be achieved, without a state change, by altering inks and papers or the method of applying the ink (or, in intaglio printmaking, by wiping the plate). Indeed, the printed image itself can be quite radically changed. Although the Crucifixion is still a recognizable motif in both the third and the fourth states of Rembrandt's *Three Crosses* (see figs. 4.54, 4.55), it is so profoundly reworked that, in effect, these states are different works of art.

Of course, the opportunities for variety are greatly enhanced in color printing involving a number of plates, blocks, or stones that are differently inked and registered on one sheet of paper. Some artists have also chosen to hand-color impressions—a practice that seemingly subverts the whole purpose of printmaking but that has nevertheless yielded some spectacular

results (e.g., works by Hercules Seghers and William Blake). The ultimate individuality of impressions is achieved in the *monotype* process, a planographic method in which a unique print is taken from a painted surface. This surface may be printed again to yield a *cognate* impression. Because it is an image transferred to paper, the monotype paradoxically qualifies as a print, although it is not a multiple work of art.

SOME QUESTIONS OF VALUE AND ORIGINALITY

The number of impressions taken from a given surface is generally not unlimited. As long as artists worked with printmaking techniques in which the surfaces were subject to wear, this limitation was inherent. Of course, it was possible to rework a worn plate or block and print it anyway, but this disregard for quality showed, and the conscientious printmaker would be careful to avoid it. Efforts might legitimately be directed, however, toward extending the life of the printing surface without a concomitant loss of quality. The capacity for multiplicity, after all, was the chief advantage of printmaking over painting.

When the printing surface does not wear excessively (as lithographic limestone) or can be artificially strengthened (as in the steel-facing of an intaglio plate), then the limitation of multiplicity becomes a more complex issue. The modern concept of the *edition*—that is, a predetermined number of impressions taken from any printing surface—artificially imposes a *cancellation* of the plate, block, or stone, augmenting the rarity and hence the value of each impression. A modern buyer is able to tell how large an edition is and where a particular print stands within it by a fractional notation under the image—for example, *15/25*. Whereas the denominator has equal relevance for a print in any medium because it tells us about its relative rarity, and thus its market value, the numerator has substantive meaning only in cases where deterioration of the printing surface occurs; otherwise, it is a rather superfluous notation. In an edition of drypoints, for example, *1/25* would clearly be more desirable than *24/25*, whereas the distinction between the first and twenty-fourth lithograph in an edition of twenty-five is not nearly so important. Prints might also be made outside the edition proper—for example, the "artist's proof." In the early period of printmaking, *proofs* were trial impressions pulled before the printing surface was complete, either in terms of the image itself or in terms of the *address* (lettering beneath the image that specifies the publisher and other details of a print's production). Theoretically, this is still the case, although sometimes the notation "artist's proof," referring to impressions that the artist reserves for himself or herself without specific limitation, has been used to circumvent the official limitation of the edition. This practice is regarded by some as unscrupulous; others might argue that the whole notion of the limited edition with its attendant notation system is a kind of affectation within an art form whose very purpose is the multiplication of images.

Before the modern era, as Theodore Donson has noted, it was generally quite clear when a print was made by one artist or made after an artist, because the collaborators—artist, engraver, printer—were explicitly listed in the "address."[4] But what is the modern print buyer to make of a lithograph or etching made expertly after a design by Picasso, perhaps one that was never intended to be translated into graphic form, that is presented as an "original" Picasso? The confusion is multiplied when the artist is free with his signature, as Picasso was. It is especially the technology of photographic reproduction of works of art that has obfuscated the

concepts of the original print and the edition. Some artists or their heirs have signed and numbered "editions" of photographic reproductions of their works in other media (e.g., drawings, watercolors). In this case, neither the numerator nor the denominator of the edition notation makes much sense, for the ultimate source of the image is not the printing surface, but another work, of which the surface is only a facsimile. Moreover, photographic reproduction can be carried on indefinitely with no change in quality and no variation from one "impression" to another.

The editioning of photographic reproductions and other questionable practices, entertainingly discussed by Donson,[5] led to a backlash in the form of strict rules governing the definition of an original print. In 1961, for example, the Print Council of America published these guidelines, which paralleled similar efforts in Europe:

> An *original print* is a work of art, the general requirements of which are:
> 1. The artist alone has created the master image in or upon the plate, stone, woodblock or other material, for the purpose of creating the print.
> 2. The print is made from the said materials, by the artist or pursuant to his direction.
> 3. The finished print is approved by the artist.[6]

The emphasis here is on the artist's manual contact with the printing surface, and it is interesting to note that this is exactly how the Victorian critic John Ruskin defended the reproductive print against the reproductive photograph in the nineteenth century.[7] For him, the virtuous investment of hard work on the plate stood in contrast to the easier newfangled method. But, as Donson notes, printmaking has historically embraced new technologies, and the sheer love of manual labor for its own sake has never been a driving force.[8] The earliest etchers were looking, in part, for an easier way to get a line on a plate than using a burin. The guidelines of the Print Council not only were unenforceable in the marketplace, but also, for reasons that will become apparent when we consider recent American printmaking in Chapter 13, proved unacceptable to many artists, and rightly so. For in the final analysis, it is not the technical means employed or the artist's collaboration that should concern us, but the artist's intention (after all, fifteenth-century woodcut designers had left the execution of blocks to form-cutters, and master printers had helped nineteenth-century artists to realize their lithographs). If the intention was merely to print a facsimile of a work of art in another medium, then clearly we are not dealing with an original print. But printed works that offer originality in formal conception and intellectual content should not be denied the title merely because they incorporate photomechanical means of reproduction.

Ambiguities in the definition of an original print did not spring up with the invention of photographic reproduction—they were, in fact, longstanding. Consider the case of transfer lithography, in which an autograph drawing is fixed on stone. The artist works in a greasy medium on a special paper that gives up the image to the stone, a process that eliminates the problem of reversal. The purist connoisseur of lithography will find the transfer print to be a poor cousin to the lithograph proper, because the artist does not draw directly on the stone, and some of the image is inevitably lost in the transfer. A close observer might be able to detect the texture of the transfer paper superimposed on those of the stone and of the paper on which the print is made. Is the transfer lithograph to be understood primarily as a reproduction of the drawing or as an original print? What is the source here, the "lost" drawing or the stone?

The answer is not an easy one, especially since the artistic intention may have been merely to circumvent one of the awkward aspects of lithography—the heaviness of the stone—and, through the portability of the transfer paper, to achieve greater flexibility and spontaneity. These are fairly innocuous ends by any standards, but by the standards of the *plein-air* landscape painters of the nineteenth century, for example, they are downright laudable. When the purist etcher Walter Sickert lambasted Joseph Pennell for his transfer lithographs in 1897, Pennell sued, enlisted James McNeill Whistler as a witness, and won the case.[9]

It is understandable that there are areas of confusion in our concept of the original print because it developed in simpler circumstances, in contradistinction to the *reproductive* print. The latter disseminated information about its model, usually a painting, to a larger audience than the original work would ever reach. Until the advent of photography, the most widespread function of printmaking was reproductive; the original printmaker was distinguished from his or her reproductive counterpart by the French term *peintre-graveur* (literally, "painter-engraver"). Once photography began to be employed to reproduce works of art, the concept of the original print came to be opposed to photomechanical reproduction, whereas before it had been set off against a background of graphic facsimiles of paintings. Today, in the light of modern technology, the reproductive print—formerly looked upon with some disdain—has begun to take on an aura of originality, having relied on human skill, often pedestrian but sometimes truly extraordinary, rather than photomechanical means. The reproductive printmaker seems closer to the painter-engraver than to the impersonal technology of photographic reproduction.[10] Evidently, definitions are not written in stone for eternity, but are the products of changing historical context.

The accidents of history would provide a merely superficial reason to include reproductive printmaking in this book (Chapters 3 and 5). In fact, it maintained a more vital connection to original printmaking than its supposed opposition would imply. The skills necessary to make a good graphic reproduction of a painting have long been, paradoxically, an integral aspect of the history of printmaking as a whole. Almost from the inception, engravers sought to vary and modify burin lines in quest of more painterly prints in which the fundamental linear element would be obscured if not eliminated. Woodcut, perhaps the most stubbornly linear of all print media, was rather quickly modified to include broad areas of tone, with or without linear accompaniments (the *chiaroscuro* or *clair-obscur* technique). This quest culminated in the eighteenth century—the great age of the reproductive print—with the discovery or rediscovery of nonlinear means of obtaining tones, such as mezzotint (scoring the intaglio plate with a rocker so that it would print completely black if not scraped and burnished smooth), and the aforementioned aquatint (etching a plate covered with granules of acid-resistant resin to produce a grainy surface that will print as a tone). If aquatint was initially conceived in imitation of the ink wash, this does not mean that—in the hands of Goya, for example—it is a second-class technique. In no sense can the *Caprichos* be understood as reproductions of his preparatory wash drawings, even when these compositions are quite close to the final prints. For the drawings, while impressive, are means to an end; in the prints, the aquatint technique is not an imitation of something else, but becomes its own grainy, richly textured self—sometimes rough and coarse, sometimes fine and delicate. Goya's stopping-out (painting varnish over parts of the aquatinted plate to prevent the action of the acid) and scraping and burnishing of the plate to achieve highlights yield very different effects than the dilution of ink

or the leaving clean of parts of paper in the drawings. The key to this difference lies in the transfer and translation of the image from plate to paper that is unique to printmaking.

THE HISTORY OF PRINTS AND THE HISTORY OF ART

Thus far, we have outlined some of the basic technical and aesthetic conditions of prints and some of the ambiguities surrounding the definition of an original print. Before we embark on our study of the print in the western world, some introductory historical remarks are also in order. Although readers of this book are likely to be familiar with basic art history, they might not be as well-prepared for the study of prints.

Introductory textbooks in art history focus on painting and, to a much lesser extent, sculpture and architecture.[11] Viewed from the standpoint of printmaking, however, the complex, composite picture of western art history looks considerably different. The comparison between the social roles of prints and paintings that we touched upon in the Preface (and will further elaborate as we proceed) reveals many instructive incongruities also evident in patterns of print consumption and collection. From the earliest devotional woodcuts to the chromolithographs of the nineteenth century, some prints have always been cheap enough to be "consumed" by a broad populace. But prints have also been "collected" by more elite members of society—at first, in the sixteenth century, mostly for their informational value within encyclopedic collections embracing all kinds of objects, and then, gradually, for their aesthetic qualities. By 1700, a tradition of print connoisseurship, with its concern for quality of impression and variety of states, was developing, and this continued into the modern era. One interesting phenomenon that patterns of collection will show us is that the connoisseurs' reverence for the autographic qualities of the print grew when the "consumer print" was at a height: when the reproductive-print industry reached its technical peak in the eighteenth and early nineteenth centuries, and when late nineteenth-century technologies like steel-engraving and chromolithography flooded society with cheap prints. In other words, as some prints become more common, others are esteemed more in the manner of paintings.

An understanding of the history of prints as opposed to paintings also forces us to re-evaluate our notions of stylistic innovation, national preeminence, and the relative importance of the different categories of subject matter in western art. The history of prints has its own "revivals" and "declines" distinct from those of painting. Our whole concept of the Renaissance, for example, is based largely on developments in Italian painting, beginning with Giotto in the early fourteenth century and culminating in the sixteenth with Raphael and Michelangelo. Although this evolution encompassed very individualistic talents, it sought common goals—harmony, monumentality, spaciousness, and an idealistic treatment of the human figure that expressed an elevated view of human moral, spiritual, and intellectual capacity. This achievement, which is surely one of the high points of western culture, is not really paralleled in original printmaking. Engraving, etching, and even woodcut had been channeled in a reproductive direction very early in Italy, and this meant that the finest Italian artists were not drawn to it as a vehicle of individual expression. With the possible exception of Mantegna, whose superlative prints are not numerous (and whose authorship has even been called into question), there is no Italian printmaker to approach the accomplishment of the best painters. Antonio

del Pollaiuolo's *Battle of the Nudes* (see fig. 3.7), the most important fifteenth-century Italian engraving, is the only print he produced!

In northern Europe, where prints were born, the situation was quite different. With the major exception of the early Netherlandish school, from Robert Campin and Jan van Eyck to Gerard David, printmaking often played a significant role. Dürer would be known as a fine painter had he never picked up a burin, but it is his prints that establish him as an artist of universal importance. Not only did he institute new standards of complexity in the technique and content of prints (especially of engravings), but, inspired by the examples of Martin Schongauer and others before him, he brought the print's capacity for narrative and serial imagery to an early fruition. As relatively small works made in multiples on paper, prints provided a natural format for telling a sacred story in episodes and, later, for treating aspects of a single moralizing theme (as in the work of Hogarth and Goya).

Dürer's elevation of the status of the print is witnessed by the way his prints were eagerly collected and in the way his style was reprised by Hendrik Goltzius, the virtuoso Dutch engraver of the late sixteenth century. As we shall see, Goltzius' career marks a critical reception of northern engraving that set it on a par with Italian painting. Considering the delicate beauty of Italian Renaissance prints, it is regrettable that such scant attention is given them in basic texts on this period,[12] but their neglect does not really lessen our appreciation of this artistic epoch. To omit German or Netherlandish prints from a study of the northern Renaissance is, however, to cripple our understanding.[13] Is it any wonder, with the general failure of art history to encompass printmaking, that our notions of what the Renaissance is about have been based largely on the study of Italian painting?

The grandiose style developed in Italy in the early seventeenth century is also best manifested in painting, closely paralleled by sculpture and architecture, as in the Renaissance. When outstanding original prints do appear, as in the work of Annibale Carracci or Salvator Rosa, they are often distinguished from the Baroque mainstream by their informality and even their eccentricity. Meanwhile, in northern Europe, Dutch etching blossomed into a prolific, diverse, and exciting phenomenon, with Rembrandt as its most skilled, inventive, and profound exemplar. His epic religious prints, such as *The Hundred Guilder Print* (see fig. 4.50) or *The Three Crosses* (see figs. 4.54, 4.55), are exceptional, even within the rich context of Dutch Baroque etching. Like Dürer, Rembrandt cannot be fully understood if separated from his graphic oeuvre, and the appreciation and collection of his prints around the beginning of the eighteenth century mark the origin of print connoisseurship as we now know it. In France, Jacques Callot became the first major artist to be known entirely for his prints. Although he is usually given very brief treatment in general books on Baroque art,[14] he is a pivotal figure in the history of his medium. His etching technique represented a final rapprochement between etching and the look of engraving. His innovations in subject matter, particularly his theatrical prints and his *Miseries and Misfortunes of War* (see figs. 4.15–4.17), would prove highly influential.

In general, original printmaking in the seventeenth century excelled in its treatment of subject areas such as genre, portraiture, and landscape that were lower in the hierarchy conceived by academic Baroque classicism, whose finest proponent was Nicolas Poussin. There is no graphic counterpart of equivalent power and quality to his majestic "history paintings" (multifigured religious, historical, or mythological works), which were to become important models for so many eighteenth-century painters.

At no time was the discrepancy between innovation in painting and in printmaking more

apparent than in the eighteenth century, when reproductive etching and engraving reached their peaks. However, just when displays of pure technical skill were the rule, the exceptions proved to be the most individualistic approaches to the print media since Seghers and Rembrandt. Giovanni Battista Piranesi and, later in the century, Blake and Goya all had remarkable visions of the potential of prints. It is no accident that these artists—one an architectural printmaker; the second an odd combination of printmaker, poet, and manuscript illuminator; the third a painter-engraver of the stature of Dürer and Rembrandt—are regarded as early champions of the Romantic movement that was to encroach upon the academic establishment in the nineteenth century. For some of the basic assumptions of Romanticism, such as its acceptance of the fantastic and the grotesque and its emphasis on purely emotional and/or imaginative expression, had always been more at home in prints. There is no question that, for Goya, etching provided an outlet for his idiosyncracies that painting could not. His private mind was keenly tuned to the darker side of human nature, which came into conflict with the tenets of the Enlightenment in which he believed. Even as he expressed the former, he did not relinquish the latter, so that the hope of communicating and thereby reforming societal evils underlies even his bitterest commentaries. This hope, along with the fantastic imagery in which it is couched, is very much a part of the history of printmaking in the West.

It contributed much to both the prints *and* the paintings of William Hogarth, another extraordinary eighteenth-century painter-engraver. The graphic satirical tradition informs Hogarth's works as much as French Rococo paintings or seventeenth-century Dutch genre scenes or contemporary English literature does, and helps to distinguish them from the more polished, elegant paintings of Joshua Reynolds or Thomas Gainsborough. Considering Hogarth's importance for English art, it might well be noted that his paintings met with a general lack of success compared with his prints. From the standpoint of the history of printmaking, his entrepreneurship looks more like the natural proclivity of a printmaker for communication on a broad scale, for the expression of personal opinion with a view to societal reform. The profuse narrative and allegorical detail that seems to burden Hogarth's paintings is more natural in prints, where it forms an analogy to literary prose—the descriptions of settings and the building of a sense of character through an account of human actions and decisions.

In the modern period, the role of the print as contrasted with that of the painting is less easy to evaluate because of the greater diversity of both. As the very integrity and value system of European society, let alone the forms and meanings appropriate for art, began to be questioned, all artistic media became more exploratory, and art, as a whole, more chaotic, less easy to fix into categories. Most general art-historical accounts of the beginnings of modern art have focused on the upset of formal conventions—broadly stated, the conception of the canvas as a window with space and recognizable figures and objects on the other side—by French painters of the nineteenth century, usually beginning with Edouard Manet and the contemporary Impressionist movement. Prints fit into this analysis as well and, as we shall see, are sometimes even more assertive about the autonomy of the pictorial surface as an abstract (non-mimetic) creation than are their painted counterparts. In the hands of Henri de Toulouse-Lautrec and others, color lithography, in particular, lent itself to some of the most strident modes of late nineteenth-century abstraction. And Gauguin's woodcuts are decidedly bolder than his paintings.

Despite the frequent sharing of common formal goals by nineteenth-century prints and paintings, our analysis of the former is more likely to be bound up with subject matter. Tradi-

tionally, prints had functioned as non-esoteric communicators of ideas and information; only rarely were they concerned with purely formal issues. An "art for art's sake" mentality was less readily sustained in printmaking, even when photography pushed it further in the direction of fine art by usurping many of its informational and reproductive tasks. The print's historical role as communicator is nowhere more evident than in the prolific lithographic output of Honoré Daumier, without question the most expert caricaturist Europe had ever seen, but with an ability to lift the cartoon to the level of art. To study the full range of nineteenth-century etchings, lithographs, and wood engravings is to modify even further than art history has already done the understanding of modern art as primarily an ongoing struggle to achieve formal abstraction. Partly because printmaking had never been subject to the restrictions of form or content imposed upon painting, the severing of past connections is tempered by a strong continuity. Whistler's outstanding etchings of Venice or lithographs of the Thames River are part of the tradition of printed city views; Manet's lithographs of the uprising of the Paris Commune are linked to Daumier and Goya; Lautrec's posters are at once an affirmation of avant-garde formal goals and of the old commercialism of prints.

The preeminence of the French avant-garde of the late nineteenth and early twentieth centuries in establishing what we understand as the major goals of modern art might be modified by a fuller consideration of the revival of printmaking in Germany and Scandinavia with Edvard Munch. Whereas the various forms of Expressionism offered a formal revolution as thorough as that of the French, art maintained a vital and more overt political and social involvement, as well as conspicuous links to the past. It is not surprising that, for artists like Munch, Ernst Ludwig Kirchner, and Käthe Kollwitz, printmaking became an important aspect of their careers, replete with its old connotations of craftsmanship and communication to a mass audience. Paradoxically, these artists retained these goals even when craft was obscured under a deliberate rawness of color and form, and even when the masses were indifferent to their prints. If Expressionism may be treated in a general history of art as another "ism" that follows in the wake of a French artistic revolution, in a history of printmaking it is an absolutely pivotal movement.

The most provocative modernist painter is also the most provocative modernist print-maker. Picasso's graphic oeuvre is extensive and intriguing, even though his volatile mentality and the declarative assurance of his formal innovations would not seem to lend themselves readily to the smaller format and painstaking technical procedures of printmaking. Neverthe-less, the various modes of his art—the attenuated, melancholy expressionism of the Blue Pe-riod, his analytic and synthetic cubism, his abstract, expressionistic surrealism, and his nostal-gic, monumental classicism—are all represented in his graphic work. A study of his prints adds dimension to his importance for twentieth-century art. His technical audacity is especially apparent here, where it is often inspired by an impatient urge to realize a creative vision within time-consuming processes.

Picasso's graphic oeuvre also shows, perhaps even better than his paintings, his keen awareness of the artistic past. His *Minotauromachy* (see fig. 11.37) is as detailed and epic an etching as any of Rembrandt's. Picasso also produced some major graphic series, including his *Vollard Suite* (see figs. 11.30; 11.32–11.36), a virtual cornucopia of his key iconographic motifs. There he shows his understanding of the importance of repetition, variation, escalation, con-trast, and surprise for the graphic series. Although the visual language is very different at first glance, these works and others owe a great debt to Goya, Picasso's fellow Spaniard, not only

thematically but also formally. Picasso assimilated Goya's meaningful distortion and sense of caricature, his rich combination of lines with aquatinted areas of tone, his depictions of furious movement and passions, and his precise poising of forms against broadly treated backgrounds.

Before the late nineteenth century, printmaking in America was relatively sporadic and marked not by graphic masterpieces but by commercial prints, such as the hand-colored lithographs of Currier and Ives or the mechanically colored "chromolithographs" of Louis Prang and others. The founding of the New York Etching Club in 1877 brought American artists into the revival of that technique that had begun in Europe and that inspired outstanding landscape prints by Thomas Moran and his wife, Mary Nimmo Moran, James David Smillie, Robert Swain Gifford, and others. At the same time, a school of technically accomplished wood-engraving arose, again with landscape as its typical subject, although numerous artists, such as Winslow Homer, had employed it for journalistic illustration. During these decades American printmaking established a foundation for its remarkable future growth, based on the imagery of the native environment, both human and natural.

The Armory Show of 1913, a major exhibition of European modernists as well as American artists, helped to awaken the latter to their provincialism: their conservative approach to style and their retention of subject matters, particularly the genre works and landscapes, that have been so much a part of the American artistic tradition. Made aware of it, they were forced to reexamine their heritage, to reject it wholly or partly, or to embrace it with renewed vigor. The first decision was to yield a strong native current of abstract and non-objective art that, by the 1950s, would supplant French modernism as the leader of avant-garde developments. The second, less dramatic decision was to expand upon the longstanding predilection for the "American Scene" and the insistence on art's communication of basic American values or concerns. This last objective had been strengthened by the Works Progress Administration's employment of a variety of American artists during the Depression to produce works (many for public buildings), thereby easing their poverty.

Although prints figured in both the avant-garde and the "American Scene" developments, their role has been much more crucial in the latter, at least until the 1960s. The WPA sponsored thousands of prints that recorded the hardships of the times as well as American hopes for the future. Once again, the social function of the print was given enormous impetus, as it had been by the Reformation or the French Revolution. The outstanding American printmakers up through the 1940s were most often concerned with the depiction of both the positive and the negative aspects of their immediate environments.

It was painting that best expressed the goals of the Abstract Expressionists and the bevy of "post-painterly abstractionists" who challenged their conclusions. Even so, the establishment of important printmaking workshops by June Wayne (Tamarind) and Tatyana Grosman (Universal Limited Art Editions) around 1960 encouraged the best American avant-garde painters, especially the Abstract Expressionists, to try their hand, particularly at lithography, with the help of master printers. For most of these artists, however, printmaking was subordinated to painting.

In 1960 Grosman gave some stones to Jasper Johns, and new possibilities for the American print emerged. As a painter and a printmaker, Johns combined beautifully drawn lines and the painterly strokes associated with Abstract Expressionism with a "return to the object." His objects, though—targets, United States flags, or maps—were simultaneously banal and provocative. How could the artist's brushstroke or mark, so revered by Abstract Expressionism,

mean the same thing on the surface of an ale can or an American flag? Johns's prints added extra dimensions to the subtlety of his thought. Not only were his autographic marks framed by sign-like images and extra-personal meanings, but they were transformed by the *illusionistic* impasto characteristic of lithographs made with tusche (a liquid lithographic medium). Moreover, the multiplicity of the printed image categorically denied the soul-baring uniqueness of the gesture in Abstract Expressionism.

A similar complexity marks the prints of Johns's contemporary, Robert Rauschenberg. The objects to which he returned, however, were photographs, the common language of the mass media and, in a sense, an expanded "American Scene." Along with autographic marks, provocative juxtapositions, overlapping of images, and the incorporation of chance elements (in *Accident,* the breaking of the lithographic stone; see fig. 13.45) enrich his prints. Other American Pop artists such as Andy Warhol, Roy Lichtenstein, and Jim Dine, and the British artist Richard Hamilton, further questioned the meaning of personal gesture in art and required the viewer to lend significance to and make connections among the common photographic, commercial, and artistic images that surround contemporary human beings in such bewildering abundance.

With the silkscreen and the silkscreen-like lithograph, Pop Art freed American printmaking from its preoccupation with "cuisine," the heavily worked, virtuoso surface handling that so often unsuccessfully attempts to compensate for vapid content.[15] Most important, it fused the two currents of American art that we have been discussing into one quintessentially American and decidedly avant-garde phenomenon that insisted upon depicting the most ubiquitous aspects of our environment while raising questions about this environment and the nature of art in general.

Currently, the print media are thriving in both Europe and America, and undergoing tremendous changes—so much so that these remarks about the present can only scratch its surface. The variety of processes, diversity of styles, and wide range of content in today's prints will be more easily apprehended once the history of this art form, as distinct from the history of art in general, is better understood. Clearly the most complex printed images of the present are still linked to the rudimentary woodcuts of the early fifteenth century, not only by virtue of their multiplicity and their transferral from an inked surface, but most of all by the idea of bringing art to the widest possible audience.

NOTES

1. On the history and techniques of papermaking, see Long and Levering, eds., 1979. Helpful introductions to the importance of paper in printmaking are Robison 1977 and Webb 1982.

2. In the 1970s and early 1980s, paper was the focus of some exhibitions. See Flint 1976, Institute of Contemporary Arts 1977, Rubin 1977, and Gilmour and Willsford 1982.

3. See Manick 1989.

4. Donson 1977, p. 23.

5. Ibid., pp. 3–10.

6. Print Council of America [1961] 1967, pp. 5–7. For some of the problems leading to the Print Council's reforms, see Ashton 1955. Such regulations were developed internationally by various Print Councils. See Lambert 1987, p. 32.

7. Quoted in Lambert 1987, pp. 108–9.

8. Donson 1977, p. 27.

9. Ibid., p. 29. Also see Lochnan 1981.

10. Lambert 1987 also addresses some of these issues.

11. For a good discussion of the failure of art history to incorporate prints, see Wechsler 1983.

12. Hartt 1987, pp. 314–15, discusses only one print—Pollaiuolo's *Battle of the Nudes.*

13. See the extensive discussions of prints in Cuttler 1968, pp. 293–316 and passim, and Snyder 1985, pp. 266–92 and passim.

14. Held and Posner 1979, p. 146, discuss one print from Callot's *Miseries and Misfortunes of War.*

15. See Field 1981 in Melot, Griffiths, and Field 1981, pp. 188–89.

REFERENCES

Ashton, Dore. 1955. The Situation in Printmaking: 1955. *Arts Magazine,* vol. 30, no. 1, pp. 15–17, 60.

Cuttler, Charles D. 1968. *Northern Painting from Pucelle to Bruegel.* New York. (Reissued with enlarged bibliography and revisions in 1991.)

Donson, Theodore B. 1977. *Prints and the Print Market: A Handbook for Buyers, Collectors and Connoisseurs.* New York.

Flint, Janet. 1976. *New Ways with Paper.* Exhibition catalog. National Collection of Fine Arts, Washington, D.C.

Gilmour, Pat, and Anne Willsford. 1982. *Paperwork.* Exhibition catalog. Australian National Gallery, Canberra.

Hartt, Frederick. 1987. *History of Italian Renaissance Art.* 3rd ed. New York.

Held, Julius S., and Donald Posner. 1979. *17th and 18th Century Art.* New York.

Institute of Contemporary Arts. 1977. *The Handmade Paper Object.* Exhibition catalog. Boston.

Lambert, Susan. 1987. *The Image Multiplied.* New York.

Lochnan, Katharine. 1981. Whistler and the Transfer Lithograph: A Lithograph with a Verdict. *Print Collector's Newsletter,* vol. 12, no. 5, pp. 133–37.

Long, Paulette, and Robert Levering, eds. 1979.

Paper: Art and Technology: The History and Methods of Fine Papermaking and a Gallery of Contemporary Paper Art. San Francisco.

Manick, Annette. 1989. A Note on Printing Inks. In Reed and Wallace 1989, pp. xliv–xlvii.

Melot, Michel, Antony Griffiths, and Richard S. Field. 1981. *Prints: History of an Art.* New York.

Print Council of America. [1961] 1967. *What Is an Original Print?* 3rd ed. New York.

Reed, Sue Welsh, and Richard Wallace. 1989. *Italian Etchers of the Renaissance and Baroque.* Exhibition catalog with contributions by David Acton, David P. Becker, Elizabeth Lunning, and Annette Manick. Museum of Fine Arts, Boston.

Robison, Andrew. 1977. *Paper in Prints.* Exhibition catalog. National Gallery of Art, Washington, D.C.

Rubin, David S. 1977. *Paper Art.* Exhibition catalog. Galleries of the Claremont Colleges, Claremont, Calif.

Snyder, James. 1985. *Northern Renaissance Art: Painting, Sculpture and the Graphic Arts from 1350 to 1575.* New York.

Webb, Sheila. 1982. *Paper: The Continuous Thread.* Exhibition catalog. Cleveland Museum of Art.

Wechsler, Jeffrey. 1983. Print Issues. *Print Review 18,* pp. 29–36.

If you cannot read, then take one of those paper images

on which the meeting of Mary and Elizabeth is

painted. You can buy one for a penny. Look at it, and

think of how happy they were and full of hope, and

come to know that in your faith! Then show your

extreme reverence for them; kiss the picture on the piece

of paper, bow down before it, kneel in front of it! Call

upon the Virgin, give alms to a poor person for her

sake!—Geiler von Kayserberg

1

Early Relief and Intaglio Techniques

Northern Printmakers before Dürer

ORIGINS AND TECHNIQUES OF WOODCUT

When paper became widely available in Europe about 1400, the western tradition of printmaking began in the contexts of two crafts: woodcarving, which spawned the woodcut, and goldsmithing, which gave rise to engraving. As we shall see, these origins shaped the form and content of these graphic media throughout their histories.

Woodcut was the first born, although exactly how, when, and where it arose is a matter of debate. Woodcuts from about 1400 are thought to have originated in France, Bohemia, and, especially, upper Bavaria and Austria.[1] Although it has been assumed that woodblocks were used extensively to print textiles in medieval Europe, and that the printing of designs from woodblocks on paper must have followed suit, Donald King's research suggests otherwise. He found many extant textiles from the Rhineland to be nineteenth-century forgeries, and concluded that textile printing was not nearly as common as we thought.[2] Perhaps the woodcut process of the early fifteenth century paralleled rather than followed the development of textile printing.[3] That there is some strong link between the two enterprises is suggested by the stylistic and expressive affinity between early woodcuts and printed textiles.

A large fragmentary block, the *Bois Protat* (the "Protat woodblock," named after its own-
ers; fig. 1.1) bears part of the crowd beneath the cross in a *Crucifixion* on its better-preserved
side, and an angel from an *Annunciation* on its other, badly damaged side. Our illustration is a
modern impression on paper from the *Crucifixion* side. The *Bois Protat* may have been used
for printing on cloth, to produce a decoration for an altar, for example, or on paper. In the
latter case, however, the sheets would have been glued together, since a complete design for a
Crucifixion or an Annunciation would have been too large for any contemporary sheet.[4] The
style and costumes of the images on the *Bois Protat* suggest a Burgundian origin and a date
about 1380–1400.

One of the few surviving printed textiles of the Middle Ages is part of a cloth intended to
be hung over a lectern (fig. 1.2). It seems to depict the Marriage at Cana, when Christ changed
water into wine (its other half, showing the raising of Lazarus, is now lost). Like the *Bois Protat*,
it dates from around the turn of the fifteenth century, but its provenance is Austrian.[5] Six
different blocks were used to print the image—one for the miracle itself, one for the decorative
border, and two each for the grapevines that symbolize the Eucharist and the powerful busts
of the saints or prophets below. It is possible that the blocks that printed the narrative scenes
on this cloth were also employed to make prints on paper, but no examples survive.

As stated more generally in the Introduction, woodcut is the primary *relief* process: the positive design is raised on the printing surface and inked. Carving the design is therefore largely a subtractive activity. Knives, gouges, and chisels are used *with* the grain (as opposed to wood-engraving done on an end-block or blocks) to yield a black-on-white image. In the so-called white-line woodcut, this process is reversed and the amount of cutting on the block is considerably reduced: the artist does not carve around the lines, but creates the lines themselves.

The ink rolled on the block by the woodcut artist is thicker than that used in intaglio printing in order to avoid encroachment into the carved-out areas. The simplest (and earliest) way to print a woodcut was to press the inked block against the paper. Alternatively, the paper could be placed face down on the block and rubbed. A printing press with a perpendicular motion, such as that employed by Johann Gutenberg along with movable type to make the first printed books in the 1450s, can also print woodcuts. Therefore, they were suitable as illustrations for the many printed books that superseded the precious illuminated manuscripts of the Middle Ages and the tediously cut blockbooks and thus profoundly altered the course of western civilization.[6]

Many unanswered questions plague our understanding of the production of early wood-cuts.[7] The division of labor in textile workshops may also have applied to relief printmaking. This traditional division required separate artisans to make the design (the *Reisser*), transfer it to the block (an unnamed artisan),[8] cut the block (the *Formschneider*), and print it (the *Drucker* or *Aufdrucker*). Hand-coloring—a practice that continued well into the sixteenth century with the *Briefmaler,* or sheet-colorers, who helped manufacture broadsheets for popular consumption—may have involved yet another artisan (the *verwere* or *tinctor*). However, Hans Körner has emphasized the ambiguity of many of these terms as used in contemporary documents,[9] and it is unlikely that this system would be strictly followed everywhere, especially in provincial areas, where itinerant artisans may have produced woodcuts on a free-lance basis. Adding to the confusion are the monastic origins of many early woodcuts—for example, a *Crucifixion* from about 1420 to 1440 bearing the coat of arms of the Tegernsee monastery of upper Bavaria.[10] Monks (and nuns?) conceivably expanded their duties as scribes and illuminators of manuscripts to include the production of woodcuts, especially when such prints served as pilgrim souvenirs—mementos and devotional sheets sold at the many shrines of late medieval Christendom, often located in monastic settings. The coloring of early woodcuts was perhaps meant to resemble, however distantly, the color of manuscript paintings.

Indeed, the woodcut's potential as a cheap substitute for manuscript illumination may have been an important impetus for its early development and dispersal. And early woodcuts also seem to have echoed or served as substitutes for the small private altars made by painters in urban workshops for a bourgeois clientele.[11] Unlike the itinerant craftsman or the monk, urban artisans belonged to guilds, organizations that bound them together in defense of their economic interests and regulated the cost and quality of goods and services, and the training of new members. The first urban woodcutters we know of generally belonged to the form-cutters' or the carpenters' guild. But what about the painters? Might they also have played a part in the early production of prints from woodblocks?

The question of the painters' involvement in designing and producing woodcuts through the middle of the fifteenth century is particularly intriguing, especially since, in the later part

of the century, painters such as Michael Wolgemut and Albrecht Dürer are known to have provided designs for woodblocks, and some think that Dürer may have cut at least some of his own blocks. The expressive power of many of the early woodcuts has indicated to some the probability of painters' involvement: form-cutters, although skilled technicians, did not have much training in the visual arts, and they might not have possessed the expressive sensitivity of master painters. On the other hand, Körner has rightly cautioned against applying our own valuation of artistic originality—and the modern concept of the original print—to the late Middle Ages.[12]

Our many questions about early relief prints are likely to remain unanswered because extant woodcuts, our main evidence, are few and far between. Their very abundance worked against their preservation. Easily purchased at fairs and shrines from itinerant peddlars, they never received the care given to intaglio prints. Some have survived pasted in boxes or books or sewn into clothing. Despite the efforts of scholars to date and to assign them to specific workshops or geographic areas by means of technical or stylistic comparison and examination of provenance,[13] early woodcuts still speak most eloquently as general cultural documents, anonymous voices informing us of the concerns of the fifteenth century. In order to focus more on the thematic content of the prints and their function within society, our discussion of early woodcuts will move rather freely among the four phases of fifteenth-century woodcut technique as first outlined by pioneering scholars such as Arthur M. Hind. An outline of the development of woodcutting, therefore, will be helpful.

In roughly the first quarter of the century, no efforts to shade or model forms with hatching are apparent. Cutting is simple, with lines ending in curves or hairpin-shaped loops. Parallel hatching begins to appear in the second phase (ca. 1420s–1460), and lines become thinner and more angular in contrast to the early looped curves. In the third phase, about 1460–90, powerfully unified, monumental designs appear, as do a wider repertory of figures and gestures and (in the 1480s) cross-hatching. A greater pictorial complexity and sureness of cutting characterize this phase. Not surprisingly, these stylistic and technical changes occur alongside an expansion of woodcutting for book illustration, either in blockbooks or in books printed with movable type. Late in the century this complexity and sureness become even more apparent, until, in the woodcuts of Dürer and his immediate predecessors, the woodcut line begins to approach engraving in its capacity to depict modeled forms in space.

EARLY DEVOTIONAL WOODCUTS IN THE NORTH

The function of fifteenth-century woodcuts throughout these developmental phases was overwhelmingly religious, although they were also used as playing cards, as illustrations for secular books, and as political broadsheets. The mentality behind early woodcuts is vividly illustrated by the quotation that opens this chapter, even though it was spoken by a popular Strasbourg preacher in the early sixteenth century.[14] Such prints inspired the faithful, instructed them on how best to achieve salvation, offered protection from the plague that frequently ravaged Europe during this period, and granted indulgence—that is, remission of the need for penitence—when their blessed subjects were invoked. They made the religious subjects of devotional altars more accessible, and the religious experience derived from "higher"

art forms more intimate, even while they reinforced the collective consciousness of late medieval Europe.[15]

Two of the earliest and most charming woodcut pictures are *St. Dorothy* (fig. 1.3) and the so-called *Rest on the Flight into Egypt* (fig. 1.4, color plate, p. 461). Both show the gracefulness of the late Gothic International Style and the "loop" technique of cutting characteristic of woodcut's first phase, with its hooked, rounded drapery folds. St. Dorothy, the virgin martyr of fourth-century Asia Minor, helper against poverty and false accusation, is depicted on her way to be burned at the stake. A scribe, Theophilus, had mocked her with her own descriptions of the Garden of Paradise and asked that she send him apples and roses from there. The heavenly messenger, a little child clothed in royal purple who presents Dorothy and later Theophilus with a basket of roses and apples, was interpreted as the Christ child. The bittersweet pathos of this story is expressed in the tender glance and gesture of the saint as she takes the hand of her tiny visitor, who smiles up in support, holding his basket of apples. A rose bush blooms extravagantly, filling up the space around the figures.

A similar naive charm and a gentle humor characterize the delicately hand-colored *Rest on the Flight into Egypt*. Mary, Joseph, and the Christ child, having fled from the jealous wrath of Herod, have apparently paused—Mary to nurse her son (a motif that emphasized her function for the devout as nurturer and intercessor) and a humble Joseph to cook something (perhaps eggs). It has been recently suggested that, rather than an episode during the Flight, this image may be an early version of a type of "Holy Family" that the Housebook Master and Dürer were to echo around the turn of the century (see figs. 1.48, 2.6).[16] The Virgin is crowned and enthroned, and an angel regards the Queen of Heaven with hands clasped in veneration. Whatever the print's precise subject is, iconic formality and intimacy are remarkably combined.

The second stage of woodcut development is ushered in by a famous *St. Christopher* (fig. 1.5), dated 1423 in the inscription. This print was preserved in the binding of a manuscript that once belonged to a parish priest in Memmingen in southern Germany, was passed on to the neighboring Carthusian monastery at Buxheim, and later found its way to England. The lines are thinner; the pervasive looping curves have given way to greater angularity and variety of line. The parallel lines on the saint's drapery and the river bank contain the seed of the later use of hatching for shading. Like Dorothy, the giant Christopher (literally, "Christ-bearer") was a very popular saint in the fifteenth century. His legend, along with those of many other saints, was told in *The Golden Legend* by Jacobus da Voragine (ca. 1275). In service to Christ, Christopher carried people over a treacherous river. One night a child appeared for ferrying, but in midstream he became an almost unbearable burden—as heavy as if, in Christopher's words, the whole world were on his shoulders (note that the child holds an orb). To reveal his true identity, the Christ child caused Christopher's staff to sprout like a date palm, the Tree of

FIGURE 1.6

Unknown Austrian or South German artist? Christ as the Man of Sorrows. *Ca. 1430–40. Hand-colored woodcut. 197 × 137 mm. National Gallery of Art, Washington, D.C.*

Life. The rather grumpy disconcertion of the saint and the total disregard for scale (being a giant, Christopher is naturally larger than what surrounds him, but the fish in the water is the size of a small whale!) are typical of the ingenuous directness of early woodcuts. Undoubtedly the owners of this print were reassured by the notion that whoever looked upon Christopher's image would gain the saint's protection against sudden death on that particular day.

Christ as the Man of Sorrows (fig. 1.6) dates perhaps a decade later than *St. Christopher* and is superbly preserved. It condenses into schematic form Christ's suffering or Passion—the events from the Entry into Jerusalem to the Crucifixion and sometimes beyond. These events formed narrative cycles that were among the most important subjects in fifteenth- and sixteenth-century prints, both relief and intaglio. At the upper left, the coins received by Judas hang over a representation of his kiss of betrayal. Surrounding Christ are the Instruments of the Passion—the crown of thorns hanging on the left arm of the cross; the rods, scourge, and column of the Flagellation on the right; the auger and tongs used at the Crucifixion on the left; the lance that pierced Christ's side, and the bucket for the vinegar that was given him instead of water. The nails are still on the cross. On the right, the cock and sword refer to Peter's betrayal (echoing Judas' on the left) and his violent attack on Malchus. Despite all this symbolism, the woodcut is not cluttered but well organized, dominated by the suffering Christ, who kneels in his own tomb, his discarded robe draped over its back edge. The designer emphasized Christ's ribs, breastbone, and sunken stomach, as if to add hunger to his tribulations. He holds the cat-o'-nine-tails with bloodied hands and points sadly to the wound in his side. All this reminded the viewer poignantly of Christ's sacrifice on behalf of men and women, and of human betrayal and brutality.

FIGURE 1.7

Unknown South German artist? The Wounds of Christ with the Symbols of the Passion. *Ca. 1490. Hand-colored woodcut. 121 × 83 mm. National Gallery of Art, Washington, D.C.*

The repentance induced by such meditations of course played a part in the viewer's own salvation. As pared-down and direct as this woodcut is, a south German(?) cut dating from about 1490 is even more so (fig. 1.7). Its cutting is as simple as that of earlier prints, undoubtedly in part because of its iconically presented subject. The pierced hands and feet, Veronica's veil (or *sudarium*) bearing the image of Christ's head crowned with thorns, and the huge wound in his side are disposed to form a kind of *homunculus* (little man). Inside the wound is Christ's heart pierced with nails, symbolizing not only the physical pain of the Crucifixion but also the emotional pain of betrayal. The inscription, whose basic sense might well be applied to figure 1.6 as well, reads (at the right), "Whoever kisses it [the cross in Christ's wound] with devotion shall be protected from sudden death or misfortune," and (at the left), This is the length and width of Christ's wound which was pierced in his side on the Cross. Whoever kisses this wound with remorse and sorrow, also with devotion, will have as often as he does this, seven years indulgence from Pope Innocent [VIII]."[17] Sixten Ringbom noted that such "indulgenced images" in printed form are especially good examples of the intensification of private piety toward the end of the fifteenth century. Because they were so cheap, anyone could own an image on which to focus prayers for his or her salvation.[18] However, the escalating abuse of indulgences—the spurious claims to remove thousands of years from one's time in Purgatory, the misunderstanding of the indulgence as a means toward direct remission of sin rather than a form of penitence, and the use of profits from the sale of indulgences to augment the material wealth of the Church (e.g., to construct the new basilica of St. Peter's in Rome)—would spark Luther's Reformation in 1517.

While Christ's sorrowful aspect persuaded mankind to repent through pity, his triumphant aspect did so through fear. An impressive *Last Judgment with the Apostles* (ca. 1460;

FIGURE 1.8

Unknown Swabian artist? The Last Judgment with the Apostles. *Ca. 1460. Hand-colored woodcut. 380 × 270 mm. National Gallery of Art, Washington, D.C.*

fig. 1.8) shows the Saviour, wounds prominently displayed, as king and judge at the end of time. This print comes from the third phase of woodcut development and aptly illustrates the new unity and monumentality of design and precision of cutting that occur during this period. Its subject derives from apocalyptic thought, which became increasingly prevalent toward the end of the fifteenth century, when it combined with social unrest and dissatisfaction over the abuses of the Church (note that those forced into hell by the demon include the clergy and rulers). At the same time, this print honors the old schematic arrangement of the Last Judgment as exemplified sculpturally in numerous medieval church facades and in paintings. As angels trumpet, Christ on the orb and rainbow (a symbol of the covenant between God and man that Christ fulfills) hovers above a landscape where the dead rise from their graves. On the left, Mary and apostles float above an image of St. Peter conducting the saved into heaven; on the right, Paul, grouped with other apostles and holding a sword, presides over the induction of the damned into hell. Lily and sword issue from Christ's mouth. A softening note appears within this harsh picture in the figures of the Virgin and St. John the Baptist, who act as

FIGURE 1.9

Unknown Swabian or Franconian artist. Madonna in a Closed Garden. *Ca. 1450–70. Hand-colored woodcut. 189 × 130 mm. National Gallery of Art, Washington, D.C.*

FIGURE 1.10

Unknown Augsburg artist. Madonna in a Wreath of Roses. *Ca. 1490–1500. Hand-colored woodcut. Diameter: 175 mm. National Gallery of Art, Washington, D.C.*

intercessors, pleading for Christ's mercy on behalf of sinful humanity. Christ even deviates from his usual iconic imperturbability in this context to glance at Mary. He cannot deny his humanity to his beloved mother, nor refuse her an audience. The principle of intercession by Mary and the saints reached its height in the waning Middle Ages and early Renaissance and would become another major point of contention in the Reformation.

Mary was extremely important as an object of devotion during this period; her veneration would be sharply curtailed in Protestantism, for, from this point of view, it detracted from the centrality of Christ. But the huge body of Marian iconography as well as the principles she embodied—sympathy, gentleness, a feminine beauty and maternal softness—could not readily be discarded. *Madonna in a Closed Garden* (ca. 1450–70; fig. 1.9) and *Madonna in a Wreath of Roses* (ca. 1490–1500; fig. 1.10) both express those principles.

Although the former shows some angularity, especially in the faces, the curvilinear drapery folds, vestiges of the first woodcut phase, may indicate its origins in an earlier conception: Field has suggested that it is perhaps a copy of a lost prototype, possibly a painting (another woodcut version of this image, in the reverse direction, exists in the Landesmuseum, Stuttgart).[19] Mary appears, seated as a Madonna of Humility,[20] in a garden dominated by a rose bower and surrounded by a low wattle fence. This enclosure refers to Mary's virginity and derives ultimately from the Song of Solomon, which was, despite its eroticism, applied to Mary: "A garden locked is my sister, my bride, a garden locked, a fountain sealed" (4:12). Another common symbol of her virginity is the vase of white lilies at the right. While one angel plays a harp, another gathers roses and hands them to Mary. She, in turn, offers a rose to the Christ child. Mary herself was designated a "rose without thorns" because of her freedom from original sin. However, the real rose does have thorns that allude to the crown of thorns worn by Christ; thus, the tender gift of the flower harbors a sad prophecy. Similarly, the goldfinch with which

Christ plays symbolizes, because of its predilection for thorns and thistles, Christ's Passion, and accordingly appears within this paradisical setting.[21]

Madonna in a Closed Garden illustrates the difficulty of dating many early woodcuts, but *Madonna in a Wreath of Roses* (fig. 1.10) stands within the late phase of the evolution of woodcut technique in the fifteenth century. The cutting shows an abundant use of hatching for shading and modeling form. This can be seen especially in the Virgin's drapery, which reveals her solid contrapposto pose underneath. The surroundings are far more spatial and complex than anything we have seen so far; the lines are thinner and closer together.

Madonna in a Wreath of Roses is also a fascinating example of Marian iconography during this period. The early scholar of woodcuts, Wilhelm Schreiber, suggested that this print may have been intended for the lid of an apothecary's jar containing medicine against the plague,[22] and the three arrows held by God have been thought to denote protection for the woodcut's owner against famine, war, and pestilence.[23] Elements of the landscape—the tower and the seaport—allude to Mary. Two of her liturgical epithets are "Star of the Sea" and "Port of Salvation," whereas the tower symbolizes her chastity.[24] The crown marks the Virgin as the Queen of Heaven.

The rose-garland border of this print stands for the rite of the rosary, allegedly instituted by St. Dominic (1170–1221), confirmed by papal edict in 1470, and promulgated by Jakob Sprenger's founding of the Confraternity of the Rosary in 1474. The rosary's sequence of larger and smaller beads on a string guides the pious to a corresponding order of prayers, alternating between the Our Father, the Hail Mary, and others. But also implicit in this devotion was the idea of the Christian Community, bound together, like the beads of the rosary or the flowers in a garland, by faith.[25] In our woodcut, a king, queen, pope, bishop, and cardinal, as well as ordinary folk, gather under Mary's cloak. To satisfy the needs of the new cult, the designer has borrowed from the older iconography of the Madonna of Mercy (*Madonna della Misericordia*)—a motif, found frequently in sculpture, that focused on the Virgin as a source of succor and protection.[26]

Not only Mary but also the vast population of saints functioned as a shelter in time of need or a shield against harm. In *The Martyrdom of St. Sebastian* (fig. 1.11), an extraordinarily fine woodcut probably dating from mid-century (the latter part of the second phase—note the angularity of many of the lines), a long Latin inscription implores the saint to "intercede for us with the Lord Jesus Christ that we may be delivered from pestilence or epidemic," and "from all evil to come as well as from all dangers to the body and spirit, and from sudden unexpected death and from all enemies visible and invisible every day, hour, and moment through Christ the Lord."[27] Thus, the world is perceived as a minefield in which the aid of the saint must be enlisted at every step.

Sebastian was a commander in the Praetorian guard under the Roman emperor Diocletian in the third century. His Christianity provoked the emperor's anger, and he was sentenced to be shot to death by arrows. Left for dead, he was nursed back to health by St. Irene, a Roman woman who aided him secretly at night. Because of the ancient association of disease with the arrows of Apollo, Sebastian's miraculous first recovery, and the cessation of an epidemic in the seventh century when he was invoked, he became, along with St. Roch, the principal protector against the plague in the Middle Ages. Both his physical torment and his inner beatitude are expressed here in the bent body and large, drooping head with its serene countenance. The stodgy figure of Diocletian at the far right, the very image of inflexibility and opacity, and the

FIGURE 1.11

crudely aggressive bodies of the bowmen act as perfect foils for Sebastian's elastic and moving form. The sensitivity and plasticity with which Sebastian's nude body is treated are suggestive of Italian influence.[28]

To the modern observer, the prayer in this image might seem to express a pathetically misguided hope of protection against the dangers that made life then especially fragile. It was a time when "the plague, or just a scratch on the nose, might at any moment eject anybody from this life to the next."[29] However, taken together, these early religious woodcuts present a remarkably coherent world, permeated with meaning and purpose. The disparate, distressing aspects of human history and present experience were made apprehensible for many by the expansive, commonly understood language of late medieval Christianity "written" in these prints. In the syntax of this language, everything and everyone, past and present, great and small, had an assigned place. To the attentive and devout, help and guidance were implicitly available.

FIGURE 1.12

Unknown Netherlandish artist? The Hand as the Mirror of Salvation. *1466. Hand-colored woodcut. 385 × 265 mm. National Gallery of Art, Washington, D.C.*

For example, whoever owned *The Hand as the Mirror of Salvation* (1466; fig. 1.12), a rare dated print, possibly Netherlandish,[30] need have looked no farther than his or her (note the emphasis on female saints) own constantly available hand for spiritual instruction. "Mapped" according to our woodcut, a hand was full of meaning: the thumb signified God's will; the forefinger self-examination; the middle finger repentance; the ring finger confession; the "ear" (little) finger satisfaction. At the left, the Christian is exhorted, "When thou knowest the will of the Lord, then own [admit] the faults in order to avoid them. When thou hast done evil then repent of it. When thou verily repentest, then confess it. When thou hast confessed then do penance." Aiding the Christian in this process are quotations from the gospels at the top of the print. Luke 9:25 perhaps summarizes best the emphasis on self-scrutiny: "For what does it profit a man if he gains the whole world and loses or forfeits himself?" Like the rosary, the hand provides a framework for prayer and meditation; Mary Martha at the right, accompanied by the dragon she conquered with holy water, exemplifies prayer, while Mary Magdalene at the left epitomizes self-knowledge and contrition.[31]

The Way of Salvation (ca. 1490; fig. 1.13), perhaps from the same Augsburg workshop as *Madonna in a Wreath of Roses* (fig. 1.10; compare the narrow mouths, small heads and eyes, and pointed noses),[32] also contains considerable moral bolstering and instruction, now within an allegorical format of a rocky, mountainous landscape riddled with thorns and thistles. The short banderoles lead us, like the rungs of Jacob's ladder, to God. Each step along the way is a virtue to be acquired (from bottom to top: faith, charity, modesty, steadfastness, justice, strength, determination, temperance, patience, obedience, humility, and love of God—this last illustrated by the pierced heart). The long banderoles contain exhortations to triumph over sin and tread over thorn and thistle. Two of the Instruments of the Passion, the whip and the

FIGURE 1.13

Unknown Augsburg artist. The Way of Salvation. *Ca. 1490. Hand-colored woodcut. 262 × 181 mm. National Gallery of Art, Washington, D.C.*

scourge, lie at the base of this mountain of virtue as reminders of Christ's suffering, which made redemption possible. The kneeling nun suggests that this print has to do with the cloistered life in particular, although the virtues could equally apply to the layperson.[33]

BLOCKBOOKS AND SECULAR WOODCUTS

Figures 1.12 and 1.13 are closely related to the religious didacticism of woodcut blockbooks such as the *Ars Moriendi* (*Art of Dying;* see fig. 1.15), the *Speculum Humanae Salvationis* (*Mirror of Human Salvation*), the *Ars Memorandi* (an aid for memorizing the scripture), and the *Biblia Pauperum* (*Bible of the Poor;* see fig. 1.14), among others. An important lay devotional organization, the Brethren of the Common Life, one manifestation of the widespread intensification

of lay piety in the fifteenth century, was particularly active in promoting the use of such texts. Clergy could use the blockbooks as guides for composing sermons and instructing their flock—the pictures were explicitly understood as directed toward the religious enlightenment of the general populace.

The individual sheets of the blockbooks were printed from single blocks endowed with both text and image. The block might cover one page or two pages when the sheet was folded. Generally, only one side of the page was printed (front or back, depending on the method of printing and binding).[34] It was once thought that blockbooks were the ancestors of books printed with movable type, a technology that developed in the 1450s. However, most of the blockbooks still extant seem to have been printed as late as the 1460s, primarily in the Netherlands. Thus, blockbooks have an uncertain relationship to movable-type printing: perhaps they were parallel phenomena.[35]

Robert Koch has suggested that the images of the first edition of the forty-page *Biblia Pauperum,* one of the most important Netherlandish blockbooks, served as models for the miniatures in an Utrecht Book of Hours, and that both books date from about 1460, thus affirming the close links between the blockbooks and works in other media.[36] The text of the *Biblia Pauperum* was an anonymous mid-twelfth-century typological treatise; that is, it interpreted the Jewish scripture in terms of prefigurations of Christian events. In a characteristic page from it (fig. 1.14), the Annunciation to Mary is flanked by scenes of Eve tempted by the serpent and Gideon visited by an angel of the Lord. On the ground in front of Gideon is the fleece of wool on which God caused dew to appear, and then not to appear, as a sign of his intervention against the Midianites on Israel's behalf (Judg. 6:36–40). Whereas the Annunciation of Christ's birth is an antidote to Eve's sin and Mary the antithesis of Eve, the "annunciation" to Gideon is construed as a foreshadowing of the New Testament event. Gideon, like Mary, was the recipient of a heavenly message and an instrument of salvation for God's chosen people. The architectural structure does more than organize clearly the narrative scenes and the prophets: it gives the sense of history as an edifice growing by human action and divine intervention and acquiring meaning as correspondences and antitheses are grasped.

The popular *Art of Dying,* composed anonymously in the early fifteenth century, told the tale of a dying man tempted to despair, impatience, lust, pride, and greed by demons and finally won over by angels and saints. The theme was analogous to that of St. Michael weighing souls at the Last Judgment, with angels and demons trying to tip the scales; even in the end, salvation hangs "in the balance," and medieval sculpture and painting expressed this with their succinct literalism. Here, like an unruly child, the demon of impatience overturns the night table of the sick man, who kicks his physician in the back (fig. 1.15). This same image was also engraved by Master E.S., perhaps from a common manuscript model.[37] But the profound meaning this treatise held for its readers may be best illustrated by Hieronymus Bosch's *Death of the Miser* (ca. 1490?; fig. 1.16) in which the simplistic composition and moral of the *Art of Dying* are expanded into a painting of great subtlety and complexity (even this early, popular prints had begun to be absorbed into the "higher" media of painting and sculpture). Although the soul in the *Art of Dying* is saved (and in the illustration depicting his temptation to greed, the demon is pathetically outnumbered by the forces of good), Bosch does not make the outcome of the contest so clear. Even as Death steps in the door, the dying man impulsively reaches for a bag of gold. In the foreground, Bosch has summarized the man's past devotion to wealth and position (note the discarded robe and armor). None of this helps him now; not

even the sealed paper held by the demon beneath the chest, probably an indulgence, will help
the unrepentant.[38]

The Revelation of St. John, known also as the Apocalypse, that final, most problematic
book of the New Testament, was the subject for some of the earliest blockbooks, as it had been
for sculpture and illuminated manuscripts throughout the Middle Ages. Thus, when Dürer
issued his epoch-making version in 1498, he was following in the footsteps of others. An image
of *The Four Horsemen of the Apocalypse* (fig. 1.17)—famine, pestilence, war, and death—from
a blockbook is typically direct, two-dimensional, and unembellished. The urgency with which

FIGURE 1.15
*Unknown Netherlandish
artist. Page from the first
Netherlandish edition
of the* Ars Moriendi
with The Dying Man
Tempted to Impatience.
*1460s. Blockbook. 220 ×
160 mm. British Library,
London.*

FIGURE 1.16
Hieronymus Bosch.
Death of the Miser.
*Ca. 1490? Oil on panel.
930 × 310 mm. National
Gallery of Art, Wash-
ington, D.C.*

Dürer will invest this image, largely by the close proximity of hooves and crowd, is not yet present (see fig. 2.3). Our comparison here is more than a little unfair, however, for Dürer's woodcut was intended as a visual counterpart of the rich, poetic imagery of the text and, in a sense, has primacy over it, a matter of considerable significance for the history of prints.

Although religion dominates the subject matter of early woodcuts, secular concerns did appear in single-sheet and blockbook form. A very early political cartoon is the *Allegory of the Meeting of Pope Paul II and Emperor Frederick III* (Ulm; ca. 1470; fig. 1.18), probably based on a Venetian engraving.[39] In terms of a specific controversy over who would determine the crown of Bohemia, it reflects the age-old struggle between papacy and imperium. In 1468 Frederick III traveled to Rome for a conference with Paul II, who is shown here in control of the "ship of state." Beneath the rulers, both ludicrously stripped down to their underwear, the various parts of the ship are labeled with the names of the pope's supporters. In his right hand, he holds a configuration that further represents his political adherents. The emperor, on the other hand, holds the broken scepter of Bohemia while standing on a diminutive Hapsburg lion. A comet, probably the one sighted in 1468, looms in the upper right as an ominous portent, for the emperor at least. (Later, in a woodcut from the *Liber Chronicarum*—usually known as the *Nuremberg Chronicle*—imperium, personified by the same emperor, coexists peacefully with Pope Pius II.) The political satire evident in this print will play an increasingly important role in our history.

Images depicting the influence of the planets, whether in drawings, single-sheet prints, or blockbook form,[40] were also very popular in this astrologically gullible age and provide an excellent source for iconographic interpretation of a wide variety of prints and paintings that

FIGURE 1.19

*Unknown German artist.
The Children of Mer-
cury from a series of The
Seven Planets. 1460s?
Woodcuts pasted in a
manuscript. Upper image:
85 × 125 mm. Lower
image: 125 × 125 mm.
Zentralbibliothek,
Zürich.*

incorporated such lore. One lively image depicts various artisans working under the influence of Mercury (fig. 1.19). The painter is included here, although by Dürer's time it was the dark, unpredictable influence of Saturn that determined his genius; the cheerful assiduousness of the artisan, represented in Dürer's *Melencolia I* (1514; see fig. 2.16) by the little putto and in our woodcut by everybody, had been outgrown.

THE LATE FIFTEENTH CENTURY: BOOK ILLUSTRATION AND METALCUTS

When books printed with movable type began to take hold after the 1460s, blockbooks went out of fashion, but pictures printed from sturdy, economical wooden blocks readily assumed an illustrative role in the new enterprise. There was an enormous increase in the number of form-cutters available toward the end of the century, and woodcut centers such as Ulm and Augsburg became more important. As we have already noted, the design and technique of woodcuts became more complex, with a larger repertory of formal devices—most importantly, cross-hatching—for suggesting space and mass, and an increased vocabulary of poses and gestures for figures. A title page from the *Missale Pataviense* (fig. 1.20), printed in 1494 by the Augsburg printer Erhard Ratdolt, illustrates this heightened sophistication, as well as a new level of technical sophistication in the way color is achieved. Like Mary in *Madonna in a Wreath of Roses* (fig. 1.10), the three patron saints of Passau—Valentine, Stephen, and Maximilian—appear solid, an illusion produced by the placement and shading of drapery folds. In

Hans Burgkmair? Saints Valentine, Stephen, and Maximilian. *Title page from the* Missale Pataviense. *Augsburg: Erhard Ratdolt, 1494. Woodcut with stencil or block-printed color. 261 ×166 mm. National Gallery of Art, Washington, D.C.*

contrast to the hand painting of so many of our examples, however, the color here may derive from a second block or stencil; the realization of obtaining color by a printing method is significant either way. The design of this woodcut has been attributed to the young Hans Burgkmair of Augsburg.[41]

It was in Nuremberg that the new book printing industry reached its height in the fifteenth century in the firm of Anton Koberger, Dürer's godfather. Begun in 1470, it expanded rapidly from one to twenty-four presses and employed a hundred editors, proofreaders, and typesetters.[42] The most elaborate and delightful book produced by Koberger was the *Nuremberg Chronicle* (*Liber Chronicarum,* 1493) by Hartmann Schedel, a history of the world with lessons in religion and geography, and a little of Ripley's Believe-It-Or-Not tossed in for good measure. The *Chronicle* followed on the heels of a similarly ambitious book, Bernhard von Breydenbach's *Sanctae Peregrinationes* (*Holy Pilgrimages*), published by the artist-printer Erhard Reuwich at Mainz in 1486. The 645 woodblocks for the *Chronicle* (some serving as illustrations more than once) were prepared in Wolgemut's shop while Dürer was apprenticed there.

Koberger published the *Nuremberg Chronicle* in both German and Latin (a practice Dürer would later follow with his *Apocalypse*), and the Latin edition was more carefully laid out and printed, since it appealed to a more elite audience. Fifteen hundred Latin and a thousand German copies were printed, and they sold very well: by 1509, 509 Latin and 49 German copies remained. The cost of the book, unbound and without hand-coloring of the illustrations, was two gulden, one-sixteenth of the annual salary of a printer (thirty-two gulden) and one-fiftieth of a physician's (a hundred gulden).[43] Although not cheap, the *Chronicle* was within the means

FIGURE 1.21

Michael Wolgemut Shop. Page with the Drunkenness of Noah *from the* Liber Chronicarum *by Hartmann Schedel. Nuremberg: Anton Koberger, 1493. Image of* Drunkenness of Noah: *140 × 225 mm. Library of Congress, Washington, D.C.*

of a variety of people, and its sales figures give us some sense of the revolutionary implications of the shift from illuminated manuscript to printed book effected in the fifteenth century.

Figure 1.21 shows the layout of one of the *Chronicle*'s pages. Texts and pictures were variously combined; here, the family tree of Noah's eldest son Shem meanders from the left to the right of the page as the text accommodates it. Above the narrative scene, however, the words expand to the full width of the page to explain the *Drunkenness of Noah*, entertainingly rendered below. As the old man slumbers, unconsciously revealing his private parts, his good sons Shem and Japeth turn their heads away. Ham, meanwhile, disrespectfully looks upon the patriarch's nakedness. For this error, Ham's son (Noah's grandson) Canaan was condemned to servitude (Gen. 9:20–26).

The same liveliness pervades the illustrations of this book, even the numerous busts of emperors and saints, the multiple-limbed, acephalic or otherwise malformed beings, the panoramas of great cities (such as Venice, shown here; fig. 1.22)—sometimes fairly accurate, sometimes not—and the grinning skeletons who leap from their graves at the end of time (fig. 1.23). In the masterful frontispiece of the book, *God the Father Blessing* (fig. 1.24), the majesty of the Creator is accompanied by delightful putti romping through vines and hairy wild men bearing coats of arms (the strength of these superhuman, mythical creatures was thereby lent to the

FIGURE 1.22

Michael Wolgemut Shop.
Panorama of Venice
from the Liber Chroni-
carum *by Hartmann*
Schedel. Nuremberg:
Anton Koberger, 1493.
Woodcut. 190 × 505 mm.
Library of Congress,
Washington, D.C.

owner of the escutcheon). Empty escutcheons at the bottom of the page could be filled in with the heraldic devices of the book's owner. Wolgemut's (?) preparatory drawing for the frontis-piece, dated 1490 (fig. 1.25), survives in the British Museum.[44] Although the woodcut is an extraordinary printed equivalent of the drawing, following it virtually line for line, it also shows how some sublety and delicacy were inevitably lost in the translation.

A comparison of the woodcut with our *Last Judgment* of about thirty years earlier con-cisely elucidates how technical refinements in the medium accelerated toward the century's close, however. The solid figure of God with his expressive head and gesture formed, along with the many other illustrations from Koberger's books, an important part of Dürer's early training. Although his actual participation in the designing of woodcuts in Wolgemut's shop is a thorny problem, we know that Dürer tried his hand at designing book illustrations on his journeyman travels between 1492 and 1494.[45] The landscapes and urban views of the *Nuremberg Chronicle* were also expanded and complicated in the young Nuremberger's prints. But perhaps most significant for Dürer was the general vitality of Koberger's pictures and their relative importance with respect to the written word. These qualities Dürer brought with him to his *Apocalypse* in 1497–98 (see figs. 2.2–2.5).

Koberger was a highly prolific publisher, and his books were generously illustrated. For example, the 1491 edition of Stefan Fridolin's devotional work the *Schatzbehalter* (*Treasure Chest of the True Riches of Salvation*) contained ninety-six full-page pictures from ninety-one blocks: images every bit as engaging as those of the larger *Chronicle*. In 1483 he published a Bible with woodcuts that had been used previously in the so-called Quentell Bible (Cologne, 1480). Com-pared with our blockbook rendition of *The Four Horsemen of the Apocalypse* (fig. 1.17), the Quentell-Koberger image (fig. 1.26) is far more descriptive: the members of the crowd are differentiated, as are the riders, and the setting has expanded to include a rudimentary land-scape and a mouth of hell that is stuffed with the aid of a demon wielding a cat-o'-nine-tails. Although it is doubtful whether Dürer was familiar with any blockbooks, we can be sure he knew these Bible illustrations. He restates aspects of this exact picture in his *Four Horsemen* (see fig. 2.3), reorganizing the basic components more meaningfully into a direct, antagonistic relation and increasing the sense of immediacy and urgency.

FIGURE 1.23
Michael Wolgemut Shop.
The Resurrection of
the Dead *from the*
Liber Chronicarum *by*
Hartmann Schedel.
Nuremberg: Anton
Koberger, 1493. Woodcut.
195 × 224 mm. Library
of Congress, Washington,
D.C.

Before we leave early relief prints, we need to note briefly their production from metal plates—a kind of hybrid of the relief concept and intaglio materials. Metalcuts (sometimes known as "dotted" prints because of the use of goldsmiths' punches and other tools to "dot" the plate) are considerably rarer than woodcuts or engravings. They were produced almost exclusively in the Rhine valley in the second half of the fifteenth century. Presumably, the artisans who made them were goldsmiths or armorers.

Since metalcuts are printed, like woodcuts, from a raised inked surface rather than inked incisions, the designer must think negatively, for what is *not* to be printed must be cut away. Compared with woodcuts, however, considerably less printing surface is eliminated. The resulting white-on-black effect and the use of various tools for patterning give metalcuts their distinctive, decorative fullness. This *Crucifixion* (ca. 1460; fig. 1.27) reveals a *horror vacui;* virtually every area, except for the bodies of Christ and the thieves, is broken up into ornamental patterns, as in a tapestry. Despite this, the bodies have considerable plasticity, especially the figure seen from behind in the lower right, which is reminiscent of similar space-creating figures in Giotto's frescoes.[46] The combination of spatiality and sculptural solidity with flat, abstract design gives this print a tension that heightens its religious meaning: the Crucifixion is both a real, historical event and a sacrament taking place in an eternal, symbolic realm. Later, in the eighteenth and nineteenth centuries, William Blake would again combine intaglio materials with the basic concept of the relief print in his hand-colored relief etchings.

FIGURE 1.24

Michael Wolgemut Shop.
God the Father Blessing
from the Liber Chroni-
carum *by Hartmann
Schedel. Nuremberg:
Anton Koberger, 1493.
Woodcut. 375 × 235 mm.
Library of Congress,
Washington, D.C.*

EARLY INTAGLIO METHODS: ENGRAVING AND DRYPOINT

The early history of intaglio printmaking is not as obscure as that of woodcuts. In most cases, early intaglio prints can be assigned to specific ateliers or artists, although many are known only by their initials. The first intaglio technique, engraving, emerged from goldsmiths' practice of incising designs on metal and then inking those designs and impressing them on paper to check their accuracy or preserve them for later reference. It did not take long for goldsmiths to realize the potential for producing images on paper from flat plates. Scholars believe this happened in southern Germany in the 1430s.[47] The earliest dated engraving is *The*

FIGURE 1.28

Master of 1446. The
Flagellation of Christ.
*1446. Engraving. 102 ×
79 mm. Staatliche Mu-
seen, Berlin.*

Flagellation of Christ (1446; fig. 1.28), a modest print known in a unique impression in Berlin. The technique of the "Master of 1446" is characterized by short, choppy flicks of the burin for interior modeling and strong ornamental contour lines; it probably implies about a decade of engraving. The emphatic contours readily reveal their ancestry in the chasing of designs on metal objects, while the softer interior modeling shows the influence of engraving's first major artistic personality: the Master of the Playing Cards, possibly a painter.

Goldsmiths dominated engraving until the later fifteenth century, when painters such as Martin Schongauer and Master LCz took it up (it should be noted, however, that Schongauer, like Dürer after him, had a goldsmith father). It was especially Schongauer and Dürer who saw the potential of the medium as a fine art independent of metal design and as a vehicle for innovation in subject matter and expression. With a higher status than woodcut but with fewer constraints and conventions than painting, engraving would become Dürer's primary medium when presenting complex intellectual content in a new way was his goal.

In contrast to the artisans who made the earliest woodcuts, goldsmiths were highly skilled and knowledgeable. To use our own hierarchy of artistic creativity, their status was between that of an artisan and that of a fine artist. The separation between the designer and those who executed and printed the design that we saw in early relief printmaking did not apply to the intaglio processes, except much later, as we shall see, when they were used reproductively. The designer was often a major painter. These basic differences conditioned the form of intaglio prints, which were far more intricate than their woodcut counterparts, as well as their cost, availability, audience, and content. Whereas early woodcuts mostly reflect a direct, popular religiosity, and later ones continue this directness in other subject areas, engravings were more restrained and refined right from the beginning, and aimed at a more discriminating, wealthier audience. We know from Dürer's records that despite his close approximation of engraving in some of his woodcuts, the latter still sold for considerably less money.[48]

Besides engraving, early intaglio methods included drypoint and etching (see Chapter 2). The decisive trait of all these is the containment of ink *in* incisions rather than *on* a carved surface. In engraving, the design is carved on a metal plate, usually copper, with a *burin,* an instrument with a wedge-shaped tip that produces a sharp, clean-edged line. The displaced metal, or *burr,* appears on the sides and at the end of the line and is normally scraped away. The varying pressure applied to drive the burin through the metal gives the engraved line a distinctive swell, depth, and taper that can only be achieved by the artist. No form-cutter can be interposed in this process.

After the design is engraved, the plate is inked—a process that is much more complicated than it sounds. The ink must be worked into the crevices while simultaneously being cleaned off the plate's surface. To accomplish this, a series of progressively less inky cheesecloths or muslin *tarlatans* is employed to wipe the plate. Many variations can occur in wiping, and artists learn to exploit them for formal effects (Rembrandt, and printmakers of the nineteenth-century "etching revival," are known for this). Although some early engravings, especially Italian, seem to have been hand-printed, normally the plate and dampened paper are run through a roller press at great pressure, so that the paper is literally molded by the inked crevices. Viewed in a raking light, an intaglio print reveals a shallow relief of raised lines. Intaglio prints always have a *platemark* where the plate's beveled edge has been pressed into the paper.

An obvious alternative to carving the plate with a burin is simply scratching it more or less deeply with a metal stylus. This is the *drypoint* technique. The burr that is scraped away in engraving is the best part of drypoint, for it builds up on the sides of the scratch and holds ink, producing an exquisite, velvety line when printed. Unfortunately, this burr wears down very quickly, so that drypoint is not a lucrative technique. This is probably why Dürer, always alert to economic advantage, abandoned it quickly. But for some artists drypoint's aesthetic effects outweighed its problems. We know the delightful personality of the Housebook Master almost entirely from drypoints and drawings, and Rembrandt grew increasingly enamoured of this method as he grew older.

EARLY INTAGLIO PRINTMAKERS IN THE NORTH: THE MASTER OF THE PLAYING CARDS AND MASTER E.S.

Despite the domination of early engraving by the honed precision of metalworking, our first major personality in intaglio printmaking was very likely a painter from the upper Rhine valley called the Master of the Playing Cards.[49] He was named for his set of about sixty cards in five suits (gambling provided a major format for early relief and intaglio printmaking alike). *The King of the Wild Men* (ca. 1435–40; fig. 1.29) reveals this master's interest in textures and light. The soft fur of the wild man is rendered with repeated irregular flicks that contrast with the long, curled strokes of the hair and beard.

Wild people were an important aspect of medieval folklore.[50] They appeared on playing cards, coats of arms (where they served to protect and lend strength to the family, as we have seen in the *Nuremberg Chronicle* frontispiece, fig. 1.24), candlesticks, tavern signs, stove tiles, and in the border illuminations of manuscripts. Superhumanly strong, covered with fur or foliage, and wielding clubs, they reputedly lived in the depths of forests. Although they were generally reclusive, some tales held that they attacked villages and even ate children. As urban-

FIGURE 1.29

Master of the Playing Cards. The King of the Wild Men. *Ca. 1435–40. Engraved playing card. 133 × 90 mm (sheet). Staatliche Museen, Berlin.*

ization increased during the fifteenth century, they came to be viewed nostalgically, as exemplars of an uninhibited life at one with nature.

The Martyrdom of St. Sebastian from mid-century (fig. 1.30) shows a sensitivity for composition and expression that far outstrips that of the Master of 1446. The saint's gently modeled body is a tender target for the arrows of the executioners, who are arranged into a wedge-shaped group and variously posed. Their angular costumes and vicious weapons are contrasted with Sebastian's softness, emphasized by his flowing hair and the pillow of leaves that surrounds his head. The expressive restraint of this print may be compared with the intensity of our contemporary woodcut of this subject (see fig. 1.11); this basic difference is typical and will persist through much of our history.

The first printmaker to sign his works with a monogram was Master E.S., possibly a Swiss or south German goldsmith active between 1450 and 1470. Numerous attempts to associate his initials with a name have been made, but all have failed. Master E.S. was a prolific artist, with a body of perhaps five hundred or more engravings that appealed primarily to a middle-class audience in the cities of the upper Rhineland. He was also well-versed in art and, in turn, influential: his works show many connections with Netherlandish painting and with contemporary German sculpture and painting. He carried engraving technique forward by leaps and bounds with his development of cross-hatching and other systematic groupings of burin marks. The short, hyphen-like strokes in the 1446 *Flagellation of Christ* (fig. 1.28) or in works by the Master of the Playing Cards, or even in the early works by Master E.S. himself, become more varied. Lengthened, or shortened almost into stippling, they effectively model form, define contours, and combine into parallel formations and networks to suggest tonality.[51]

FIGURE 1.30

Master of the Playing Cards. The Martyrdom of St. Sebastian. *Ca. 1440–55. Engraving. 142 × 209 mm (sheet). Metropolitan Museum of Art, New York.*

In his *Adoration of the Magi* (fig. 1.31), for example, Master E.S. employed various burin marks to depict wood, brick, grass, fur, hair, and cloth. Cross-hatching appears in the deep shadows. The softness of the Master of the Playing Cards' style yields to a precise severity and a more rigorous definition of form. Despite the untenability of the spatial construction of the shed, Master E.S. has attempted a more extensive and detailed space than we have yet seen.

It is possible to see in Master E.S.'s oeuvre a general division between what might be termed a goldsmith's method and a painter's method of working the plate: the latter characterized by soft, short strokes and emphasizing tonal effects; the former by stronger contours and longer strokes. But it is not clear how we should interpret this division: does it reflect a chronological development in his work, as recently reaffirmed by Fritz Koreny, or perhaps different preferences among his clientele for each "manner"? Holm Bevers has proposed that the variety of techniques in Master E.S.'s prints might mean that he functioned as a print publisher, supervising a number of engravers in a large workshop.[52]

Expressively, Master E.S.'s prints do show unity. His works have an unmistakable, irresistible sprightliness. Lacking Schongauer's gravity and monumentality, he looked upon his subjects with a good-natured humor—much like that of his courtly counterpart, the House-book Master—and a superb feeling for gestures and facial expressions. In his *Adoration,* the smiling Magus in the right foreground presses forward eagerly, his left foot turned outward and his left arm jerked back and up to raise the lid of his gift for the sturdy, puffy-cheeked Christ child. The angel announcing Christ's birth to the shepherds in the distance is not exquisitely clothed, but is curiously covered with feathers; he flies in from the right, guiding the Christmas star.

Master E.S.'s *Madonna of Einsiedeln* (1466; fig. 1.32) is a large, impressive work in which the awkwardness of the *Adoration* is gone. The Benedictine monastery at Einsiedeln in northeastern Switzerland commissioned three engravings from Master E.S. to be sold as souvenirs to pilgrims who attended a ceremony commemorating the five-hundredth anniversary of a papal bull promoting pilgrimage to a certain chapel dedicated to the Virgin. The souvenir function was common for early woodcuts; here, this purpose was extended to engraving. This

chapel had been built by St. Meinrad, founder of the monastery, in the ninth century. In the
mid-tenth century, Conrad of Constance had witnessed a miraculous consecration of the
chapel by Christ and a host of angels. This vision was repeated a number of times and resulted
in the papal bull of 966.[53]

This is the largest of Master E.S.'s three engravings. It depicts St. Meinrad's chapel as a
freestanding structure, without the abbey church that had been built around it later. Christ,
God the Father, and a host of angels appear above to consecrate the chapel with holy water,
while the Virgin and Child on the altar below are adored by a saint, probably Benedict,[54] and
pilgrims, kneeling or removing their hats in reverence. The inscription on the arch of the
chapel reads: "This is the angelic consecration of our blessed Lady of Einsiedeln; hail, full of
grace." Masons' "signatures" mark the stones. The statue of Mary and Christ that occupied
the altar had been given to St. Meinrad by Hildegard, the abbess of Zurich, whereas Master
E.S. fashioned his own Madonna according to the prevailing late Gothic taste. Holding her
lily and her engaging infant, she is indeed "full of grace." Although the print is highly orna-
mental and full of detail, the space inside the chapel, defined by the canopy above, is convinc-
ing. Master E.S. rendered the miraculous consecration of the past *and* the experience of the
present pilgrim as vividly as possible.

In an apparent effort to imitate a drawing on tinted paper, highlighted with white ink,
Master E.S. produced *Madonna and Child with a Bird* (ca. 1465–67; fig. 1.33), the only known
white-line engraving of the fifteenth century. Although the early scholar of prints Max Lehrs
thought that this print was produced by normal intaglio means, using white ink on black-
tinted paper, Alan Shestack has suggested that a relief process was employed, with the black
being printed from the inked surfaces between the empty lines. He has also conjectured that

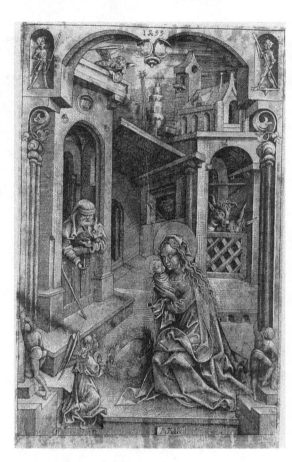

Master E.S. further pursued the effect of a drawing on tinted paper by pulling a *counterproof* (an impression taken from another, freshly pulled impression), thus making the black less intense and the lines less distinct.[55] This latter print was also highlighted with pen and ink.

In pose and expression, the Virgin and Child are closely related to the Einsiedeln example, but the printing technique makes them more delicate and ephemeral. The method thus reinforces the poignancy of the subject: the bird is probably a goldfinch, symbol of Christ's Passion, weighing upon the tenderness of his infancy. Mary is seated on the grass as a sign of her humility, and the vase on the bench may contain violets, small, humble flowers that grow close to the ground.[56] The Virgin's majesty is retained in the crown that floats above her.

Some thirty years later, Nicolas Mair von Landshut made a similar attempt to emulate heightened pen drawings on colored paper in the print medium. A *Nativity* (1499; fig. 1.34) on blue-green paper epitomizes Mair's style. The brushed-on white and yellow highlights create the effect of a moonlit night. A fanciful jumble of architectural forms—note the acrobatic figures at the bases of the piers at the right and left and the curious pendant dividing the arch—shelters the Holy Family. Mair may have intended one of the elaborate stone edifices to represent the Jewish temple,[57] replaced in Christian thought by Christ's body, raised up in three days even though destroyed (John 2:19). In a continuation of this architectural metaphor, Christ's body is also the stone, rejected by the builders, which now has become "the head of the corner" and will crush evil at the end of time (Matt. 21:42–44; Luke 20:17–18). In Mair's engraving, Mary lifts her child from a basket-like cradle to caress him, as Joseph, holding a candle that stands for the presence of divinity, and a kneeling angel look on. Another angel

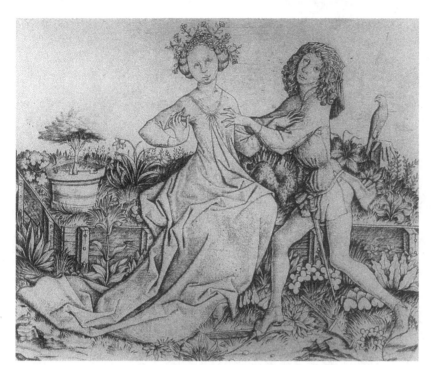

FIGURE 1.35

Master E.S. Lovers on a
Grassy Beach. *Ca. 1450.*
Engraving. 134 × 164 mm
(sheet). British Museum,
London.

glances offhandedly at the Holy Family from a balustrade above. Architecture, lighting, and the down-to-earth figures lend this print a charm that compensates for Mair's rather pedestrian handling of the burin.

Like Israhel van Meckenem, and in contrast to Schongauer, Master E.S. was attracted by secular subjects such as the delightful lovers of a print of about 1450 (fig. 1.35). Being less dependent on religious commissions than was painting, printmaking was an important vehicle for genre (scenes from everyday life, often with allegorical or moralizing meaning), mythological or classical subjects, and, somewhat later, landscape. Here, the woman seated on the grassy bench reacts in mock surprise to the male's approach, as her little lap dog echoes her weak attempt to keep her suitor at bay. The youth's aristocracy is revealed by the falcon and glove behind him, which have now lost his attention. The profuse foliage and flowers of the bench and the woman's headdress create the ambiance of a garden in spring, a favorite location for amorous encounters. Indeed, Master E.S. engraved a number of love gardens in which he brought out the sexual reality underlying the chivalric ideal of courtly love.[58] In the same spirit, the suitor's gesture here is surprisingly direct.

One of the most curious series in early prints is the so-called *Fantastic Alphabet* engraved by Master E.S. about 1466–67. Its closest prototype is Giovannino de' Grassi's alphabet dating shortly before 1400, drawn on parchment and painted. Master E.S. sometimes copied de' Grassi, sometimes paraphrased him; and sometimes departed completely from his model. The Italian series may go back to an earlier prototype. We simply do not know much about the origins and function of these alphabets, except that they relate to marginal designs in medieval manuscripts and the columns of intertwined animals in Romanesque architecture.[59]

Master E.S.'s letters are composed from a wide variety of intertwined, bent animals and figures, including wild men. Often the letters are merely whimsical, but sometimes, as in the *Letter G* (fig. 1.36), Master E.S.'s intent was clearly satirical. The concupiscence of the clergy is

FIGURE 1.36

Master E.S. Letter G *from the* Fantastic Alphabet. *Ca. 1466–67. Engraving. 151 × 143 mm (sheet). Staatliche Museen, Berlin.*

the real subject of the letter: its "spine" comprises a monk with a nun riding his shoulders. On her arm perches an owl, a nocturnal bird generally associated with reprehensible activities of the night and a harbinger of evil. As a flourish at the upper right, another monk's bare bottom makes a kind of visual pun on his tonsured head. The left side of the letter and its "tail" are formed by monkeys—common symbols of the lower passions—and a dog greedily chewing on a bone. In his engraved series of scenes from everyday life, Israhel van Meckenem pictured a monk and nun eyeing each other while a dog in the lower right scratches himself. The message, of course, is that dogs and people will scratch "itches." Such anticlerical humor became increasingly abundant in northern Europe before the Reformation, and the abuses of monastic life would become one of Luther's main targets.

SCHONGAUER

Perhaps the most skilled engraver of the fifteenth century was Martin Schongauer. His prints so impressed the young Dürer that, during his travels as a journeyman artist (his *Wanderjahre*), he went to Schongauer's workshop in Colmar, but the master had unfortunately died. Unlike many of the printmakers discussed in this chapter, Schongauer's life is fairly well documented, perhaps because he was first and foremost an important painter.[60] Whereas few of his paintings have survived, his 116 known engravings are extant in considerable numbers.

Schongauer matriculated at the University of Leipzig in 1465, but returned home after a year, maybe because he preferred artistic training. He was probably apprenticed to Caspar Isenmann, the city painter of Colmar, in 1466. Whoever taught Schongauer exposed him to the stylistic influences of the fifteenth-century masters, among them Rogier van der Weyden and Hugo van der Goes. On his journeyman travels he went to the Netherlands, and his subsequent work shows his assimilation of the Flemish panel paintings he saw.[61]

One of Schongauer's most influential prints is his early *Temptation of St. Anthony* (ca. 1470–75; fig. 1.37), more accurately titled *The Tribulations of St. Anthony,* since evil offers no seduction here but, offended by the saint's goodness, abuses him with club and claw. Anthony was a third-century Egyptian hermit who established the monastic ideal of seclusion and meditation in Christianity. During his retreat to the Egyptian desert, he was subjected to torments in the forms of assaults by demons and erotic visions. At one point, the demonic attack took place in the sky, where the saint was carried "out of himself"—the literal meaning of the word "ecstasy." In Schongauer's imaginative print, Anthony is suspended in mid-air to withstand the formidable demons (for the air is the realm of bad spirits) who try to prevent his ascent.[62]

The life of St. Anthony was told elaborately in two medieval texts—the already-mentioned *Golden Legend* and the *Lives of the Church Fathers.* With his heroic discipline, he epitomized the Christian's struggle to resist the temptations of this world. His constant piety was a model for the monastic life. Bosch, in his bizarre, magnificent triptych in Lisbon (ca. 1500–1505) elevated Anthony almost to the status of Christ (indeed, Christ's own Temptation is painted in grisaille on the exterior of the triptych) by repeatedly depicting him as an oasis of purity in the sprawling, fetid panorama that represented Bosch's view of the world.[63] Like St. Sebastian, Anthony was frequently invoked to prevent the plague and other illness. He was particularly associated with "St. Anthony's fire," or ergotism, a painful putrefaction of the limbs, accompanied by hallucinations, that was caused by consuming rye (in bread) poisoned by a fungus. Because of this connection and his reputation as a pious hermit, he plays a central role in Matthias Grünewald's *Isenheim Altarpiece* (1510–15), a huge, complex, folding polyptych, one of the great masterpieces of northern European painting, that was kept in the chapel of an Antonite monastery hospital very close to Colmar.[64] Grünewald's panel devoted to a demonic assault on the saint (on the ground, however) is strongly indebted to Schongauer's engraving. The print itself may also have been associated with the Isenheim Antonites and may have afforded a sense of protection against illness to anyone who owned it.[65]

Although the tightness of contours and details in this print betrays the artist's inexperience, his inventiveness is undeniable. It emerges especially in the fantastic demons, composed of reptilian, mammalian, and fish- and bird-like parts. The expansion of the repertory of textures from Master E.S.'s prints is remarkable, and left a long legacy. The beast to the left of St. Anthony's head and about to club it is an ancestor of the snout-nosed devil in Dürer's *Knight, Death, and the Devil* (1513; see fig. 2.14). But, in more general terms, the descendants of Schongauer's demons populate such prints as Master LCz's *Temptation of Christ* (see fig. 1.42) and even Jacques Callot's *Temptation of St. Anthony* (1635). Anthony responds to their flapping, scaly clamor, violent blows, and tugs at his hair and clothing with utter stoicism. Since his true home is not the evil world but heaven, they cannot puncture his buoyancy.

The Death of the Virgin (fig. 1.38) is another early print, made before 1481, the probable date of Hugo van der Goes's related painting in the Groeningemuseum in Bruges. Dürer borrowed aspects of Schongauer's print when he conceived the scene of Mary's demise in his *Life*

of the Virgin (1510). In apocryphal literature and in *The Golden Legend,* the apostles were present at Mary's death. Here, St. John supports the lighted candle that she can no longer hold herself, while the other apostles, whose faces are sharply distinguished, look on in sorrow and concern. One reads the scripture with the aid of magnifying glasses and one holds an asperge for sprinkling the holy water brought in a pail by another. Their slightly unkempt appearance—note the bare feet—and their crowding around Mary's bed lend the image urgency: Christ's mother is drawing her last breath.

The complex, close-knit calligraphy that Schongauer could achieve with his burin contributes to this intensity. Note, for example, the area around the taper held by John and Mary where a number of curves interact: in the Virgin's hair, her hand, and the hands of the apostles, and especially in the folds and edges of the drapery. A broad white line circles St. John's wrist, sweeps elegantly up and over his shoulder and returns to his other arm. The candlestick at the lower right testifies to Schongauer's familiarity with metalworking, which he knew from his goldsmith father. It impressed Dürer, and he multiplied it in simplified woodcut form for his magisterial *Vision of the Seven Candlesticks* (see fig. 2.2) in his *Apocalypse.* At the base of Schongauer's object romp infinitesimal nude figures, one holding a lute, and lions hold sheep under their paws. The lighted tapers stand for divine light, whereas the candlestick base was the traditional domain of spiritual darkness and bondage to the world.[66]

A similar excitement and overabundance of linear detail characterize *The Bearing of the Cross* (fig. 1.39), Schongauer's largest engraving, dated about 1475 and based on a painting by Jan van Eyck, known only by a copy in Budapest.[67] The vertical format employed by Schongauer himself in his engraved Passion series (ca. 1480), and, as we will see, by Dürer in the early sixteenth century in his closely related engraved and woodcut *Passions,* condensed the narrative detail into episodes with a quickly apprehended, concentrated emotional impact that gathered momentum as the series was viewed as a whole. But the panoramic spreading out of the violent, uncaring crowd around Christ encourages a cumulative approach within one image; in scanning the scene, the viewer has time to contemplate the evil of the world. As James Marrow has shown, an affective narrative approach to the suffering of Christ, which proliferated the brutal details of his arrest, trial, and execution, was characteristic of late fifteenth-century Passion literature as well as art.[68] Both the vertical Passion series, in which the viewer experiences this brutality episodically, and Schongauer's large, horizontal print with its panoramic effect, attest to these changing attitudes. Our woodcuts of *Christ as the Man of Sorrows* (fig. 1.6) and *The Wounds of Christ* (fig. 1.7), on the other hand, epitomize an older, more iconic approach to Christ's suffering, even though the latter image dates from 1490.

In Schongauer's print, a variety of realistic and grotesque types torment Christ or go along with the spectacle: note the little boy in the lower left, for example, and the dogs that trot along with the crowd. Dark clouds gather over Golgotha, where the execution of Christ and the two thieves will occur. A small group of Christ's family and followers appears immediately to the right of the hill. Within the crowd itself, the only good people are Simon of Cyrene, who tries to help Christ carry his burden, and St. Veronica, who waits ahead, wearing the veil on which the likeness of Christ's face will be miraculously impressed when she wipes away his blood and sweat.

In Schongauer's later works, his burin lines became more sure and controlled, their beautiful swelling and tapering more concisely defined underlying volumes, and his compositions were simplified and clarified. He accomplished more with less, as in his *St. Sebastian* of about

FIGURE 1.37

Martin Schongauer. The Temptation of St. Anthony. Ca. 1470–75. Engraving. 312 × 230 mm. Cleveland Museum of Art.

FIGURE 1.38

Martin Schongauer. The
Death of the Virgin.
*Before 1481. Engraving.
255 × 169 mm. Cleveland
Museum of Art.*

1480–90 (fig. 1.40). In contrast to our other two examples (see figs. 1.11, 1.30) this engraving is not narrative but depicts the saint iconically, as a stark emblem of faith and martyrdom. The nude here is rendered with a success rare for its time. One need only compare its anatomical detail with the figure by the Master of the Playing Cards to understand the increasing interest in observed reality toward the end of the fifteenth century. Nevertheless, Schongauer's saint is also gothically graceful, arranged in a prolonged S-curve that, along with his crossed feet, is weight-denying. And the plasticity of the body is combined with a crisp, metallic linearity in the tree branches and the intricate folds and contours of the billowing loincloth.

Schongauer also imparted the painter's understanding of space and mass and a sensitivity for the metallic character of his medium (and subject here) to his *Censer* (ca. 1480–90; fig. 1.41), a tour de force of engraving skill and religious expression. Although Lehrs thought that Schongauer's engravings of liturgical objects functioned as models for goldsmiths,[69] *The Censer* surely transcends this pragmatic purpose. It is powerfully three-dimensional despite its surface intricacy. Its tiny angelic occupants have an uncanny vitality. Across its main facets, the play of light and shade lends unity to the incredible minutiae. Schongauer set off the dominant verticality of the object perfectly by the casual crumpling of chains and the curling filigree. More than just an impeccable rendering of a magnificent object, *The Censer* possesses an artistic and religious authority that seems to demand the solemnity appropriate to a High Mass. The vine-like character of much of its ornament suggests the grapes made into the Eucharistic wine.

FIGURE 1.39

Martin Schongauer. The Bearing of the Cross. *Ca. 1475. Engraving. 288 × 434 mm. Cleveland Museum of Art.*

MASTER LCz AND ISRAHEL VAN MECKENEM

Master LCz, almost certainly identifiable as the painter Lorenz Katzheimer of Bamberg,[70] was strongly influenced by Schongauer in his early development. Affinities between LCz's style and those of Wolgemut and Hans Pleydenwurff of Nuremberg also lead us to believe that he may have been trained in Wolgemut's shop, where Dürer also received his early artistic education.

As he developed his engraving skill, Katzheimer began to handle the burin in a manner quite different from Schongauer's, building up dense groupings of marks and strokes more spontaneously to produce rich, painterly effects. The drypoints of the Housebook Master and the "curly" woodcut style of the Wolgemut shop were amalgamated in Katzheimer's approach.[71] His *Temptation of Christ* (ca. 1500; fig. 1.42), one of the masterpieces of early engraving, exemplifies this pictorial sensibility.

The drama of Christ's Temptation (Matt. 4:1–11; Mark 1:12–13; Luke 4:1–13) unfolds in a dense landscape. At the end of forty days of fasting in the wilderness after his baptism, Christ encounters the Devil, who tempts him to use his powers as the Son of God for an empty trick—turning stones into loaves of bread. In the foreground, Katzheimer's Devil—an imaginative creation surely made with Schongauer's *Temptation of St. Anthony* (fig. 1.37) in mind—stands in front of a forbidding rocky outcropping. A goat, symbol of unbelief, stands on a ledge behind him.[72] Satan points to some rocks on the ground as Christ gestures authoritatively, replying, "Man shall not live by bread alone, but by every word that proceeds from the mouth of God" (Matt. 4:4). Although he and the Devil stand head to head, the erectness of Christ's stance and the impression of solidity derived from his substantial drapery clearly

FIGURE 1.41

Martin Schongauer. The Censer. *Ca. 1480– 90. Engraving. 263 × 210 mm (sheet). Cleveland Museum of Art.*

lend him a moral strength that the Devil, with his equivocal standing-walking pose and bent posture, not to mention his grotesque, ambiguous anatomy, cannot upset. Dürer adapted this slinking attitude in his *Knight, Death, and the Devil* (1513; see fig. 2.14). Master LCz borrowed the lizard near Christ's feet from Schongauer's *Flight into Egypt* (ca. 1470–75).[73] Like most animal symbols, it can be variously interpreted, but it probably functions here as a symbol of death, decay, and evil. In Dürer's engraving, the Knight's canine companion jumps over a similar creature.

FIGURE 1.42

*Master LCz (Lorenz
Katzheimer).* The Temp-
tation of Christ. *Ca.
1500. Engraving. 227 ×
165 mm (sheet). National
Gallery of Art,
Washington, D.C.*

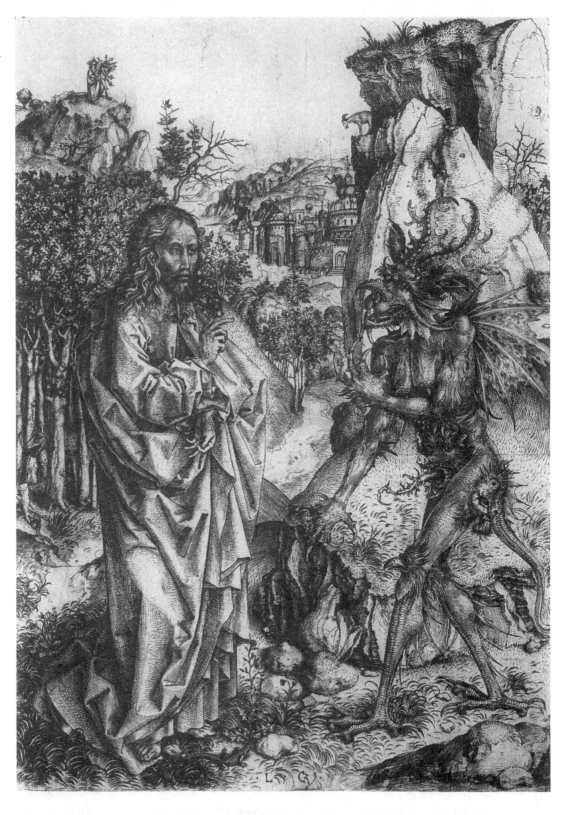

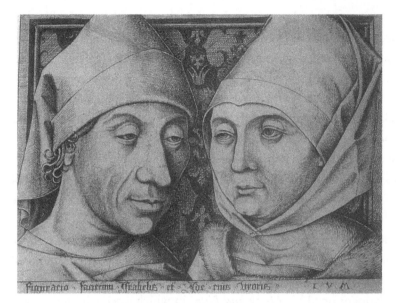

FIGURE 1.43

Israhel van Meckenem.
Double Portrait of
Israhel van Meckenem
and His Wife Ida.
Ca. 1490. Engraving.
130 × 175 mm (sheet
trimmed at platemark).
National Gallery of Art,
Washington, D.C.

In a further effort to tempt Christ to misuse his power, the Devil carries him to the top of the temple of Jerusalem, seen in the background, and urges him to throw himself down: surely angels would come to hold him up if he were the Son of God. But Christ remains resolute and reproaches the Devil for tempting him. As a last resort, the Devil then shows Christ a view from a high mountain (at the left) of all the kingdoms of the world that he could possess if he would forsake God and serve him. Echoing Exodus 20:2–3 ("I am the Lord your God. . . . You shall have no other gods before me"), Christ commands Satan, finally, to be gone.

Although he stands victorious above the lizard and against a backdrop of oak trees, traditional symbols of fortitude in faith (oak leaves ornament the horse in Dürer's engraving), Christ does not undergo the Temptation easily. His face is tense, and veins bulge from his hands. Shestack cites a woodcut model for his strangely positioned left hand,[74] but might this also be explained by the traditional notion of the left hand's vulnerability to evil? If so, not only Christ's triumphant divinity is shown here, but also his human weakness.

Israhel van Meckenem of Bocholt (near the border of Germany and the Netherlands) was even more prolific than, if not so original as, Master E.S. His father is thought to be the Master of the Berlin Passion, thus also a goldsmith-engraver.[75] Meckenem portrayed himself and his wife and business-partner Ida in this first engraved portrait in the history of prints (fig. 1.43). He appears in everyday working attire, looking somewhat lethargic despite his huge oeuvre. Of his more than six hundred prints, only about one-fourth are original designs. Meckenem copied Master E.S., Schongauer, the Housebook Master, Hans Holbein the Elder, and the young Dürer. He also owned and reworked worn plates by Master E.S., Master F.V.B., and the Master W with the Key. In the fifteenth century, the ownership of printed designs was no more sacrosanct than that of painted or sculpted ones. Early prints might appropriate motifs or whole compositions from any source, a practice distinct from the explicit reproduction of a specific work in another medium. As we shall see, the struggle for the establishment of enforceable copyrights was lengthy.

But Meckenem was no mere copycat. He also made original prints, like the double portrait above, which were especially innovative. Most important are the twelve engravings of his so-called *Alltagsleben* (*Everyday Life*) series (ca. 1495–1503), each of which depicts a couple. Despite the general title, Meckenem was concerned specifically with a moralistic interpretation of love and marriage, subjects that Hogarth and Goya would take up much later. Six of the prints have nondescript backgrounds, except for oddly empty banderoles, perhaps to be filled in by purchasers, floating above the figures (in one of these six, the banderole is replaced by a demon). The other six have domestic interiors or settings that suggest taverns or inns: Meckenem apparently intended to combine more contemporary mates with medieval stereotypes of ideal or mismatched lovers—hence the genre-like realism of six of the prints as opposed to the more formulaic character of the other half.[76]

Whereas some of Meckenem's pairings depict true love, in the chivalric tradition of the Middle Ages (*Knight and Lady*), or in the more contemporary terms of the blissful harmony of a married couple (*The Organ Player and His Wife*), some are satires of matches motivated by lust or greed. We have already mentioned his *Monk and Nun*, in which a scratching dog provides a commentary on the lustful glances of the people. In a foreshadowing of Hogarth's *Marriage à la Mode*, Meckenem also depicted two mismatched couples in which one partner marries another one for financial gain; in Meckenem's conception, the matches are also complicated by age disparity. In *The Angry Wife* (fig. 1.44), the most vehemently satirical and antifeminist of the prints, a couple is engaged in a fierce battle over who will "wear the pants in the family," in this case the tights in the lower right. The woman clearly has the upper hand as she beats her spouse gleefully with her distaff and spindles. Inspiring her is the demon of anger. In another beautifully composed print (fig. 1.45), an apparently unmarried couple in an inn or tavern play a musical duet, an activity that will be depicted frequently in seventeenth-century Dutch genre paintings, usually with the same underlying meaning—the "duet" is both musical and erotic. The lute in particular is a common attribute of amorous couples.[77] Despite Meckenem's heavy handling of the burin, graceless when compared with Schongauer's, this composition has a striking clarity of line and of tonal contrast.

Meckenem's interest in secular subjects also emerges in *The Dance at the Court of Herod* (ca. 1500; fig. 1.46). The biblical subject—the beheading of John the Baptist—is relegated to the background, while the foreground is occupied by the splendidly dressed lords and ladies of Herod's court. Some glance tenderly at each other, oblivious to the grisly events, particularly Salome's presentation of the severed head, behind them. The dogs, one humorously following the dance and two mocking the tête-à-têtes of the people, add a down-to-earth note. The inversion of the relationship between subject matter proper (the beheading of the Baptist) and incidental detail (the splendor of the dance) anticipates late sixteenth-century Mannerist art, in which such inversions are typical.[78] Here, Meckenem's emphasis on the worldly pleasures in the foreground serves to reinforce the world-denying asceticism for which John the Baptist was known.

With the exception of a few early prints by Dürer, Meckenem's *Death of Lucretia* (ca. 1500–1503; fig. 1.47) is unprecedented in its depiction of a classical subject; in the fifteenth century in the north, the world of antiquity was given less attention by printmakers and their audience. Lucretia's tragic story, told in Livy's *History of Rome* 1:57–60, would become very popular after the turn of the century, when a statue thought to represent the ancient heroine was unearthed in Rome. The tale provided a context for both the female nude and the presen-

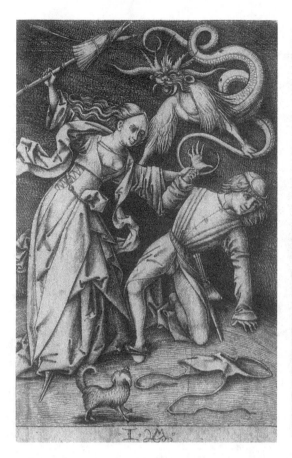 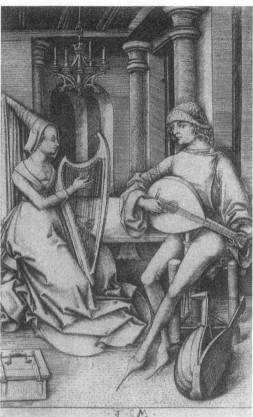

tation of a classical incident.[79] Often, the sado-erotic implications of a nude woman stabbing herself in shame after having been raped would overcome the kernel of positive meaning in the story—that is, the heroic courage of a Roman noblewoman who exemplified marital fidelity and feminine virtue, an antidote to the antifeminist satire that proliferated in late medieval and Renaissance art. Here, however, Lucretia is fully, albeit splendidly, clothed, so the stress is more on her deed than on her pulchritude.

She is nude as she is raped by the Etruscan prince in the bedroom at the left, however. In the middle distance, Lucretia confesses her "dishonor." In the foreground, assisted by her maids, Lucretia falls on a sword as her kinsmen look on, vowing the revenge that will lead to the fall of the Etruscan monarchy and the rise of the Roman Republic. The Latin inscription reads: "Through Lucretia's example, modesty is woman's ornament / To what end does the wicked ravish for such small gain" (i.e., Lucretia was had, but Rome was lost). The didactic value of Lucretia's suicide is made clear by the inscription's exhortation toward female modesty, but, beyond that, her extreme act illustrated the importance of marital fidelity; her last wish was that no unchaste woman be spared death because of her example.

THE HOUSEBOOK MASTER AND MASTER I.A.M. OF ZWOLLE

One of the most engaging personalities in the history of prints is the Housebook Master (in earlier literature, he is called the Master of the Amsterdam Cabinet because of the large

FIGURE 1.46
Israhel van Meckenem. The Dance at the Court of Herod. Ca. 1500. Engraving. 215 × 317 mm. Cleveland Museum of Art.

collection of his works in the print room of the Rijksmuseum). The "Housebook" for which he is named, currently in the collection of the Castle of Waldburg-Waldegg, comprises about sixty pages of texts and drawings with varied subjects—battle, hunt, and genre scenes, coats of arms, and planetary allegories—by the Master himself, and other, unknown artists. Numerous theories, reflections of European politics and the rise and fall of art-historical methodologies, have failed to provide the Housebook Master with a name and place of origin. Research to date suggests that he painted miniatures and panels as well as making prints and drawings and was active in western Germany, notably in Heidelberg and Mainz, in the last three decades of the fifteenth century. His patronage came from aristocratic and humanistic circles. His interest in chivalric themes and landscape and his awareness of current philosophical and religious issues connect him to such renowned figures as Conrad Celtes, poet laureate to Friedrich III, and Rudolf Agricola, a humanist on the faculty of the University of Heidelberg.[80]

Unfortunately, few prints by this distinctive artist have come down to us. He used tin or lead plates and the drypoint technique, which, especially when applied to soft metal, does not permit numerous impressions. It has been suggested that he did not always intend his prints for wide dispersal but only for his workshop and colleagues.[81] The sketchy, velvety quality of the Housebook Master's line lends itself perfectly, however, to the freshness and intimacy of his approach. Although he was a contemporary of Schongauer, no artist could provide a more thoroughgoing contrast to the somber painter-engraver of Colmar.

FIGURE 1.47

Israhel van Meckenem.
The Death of Lucretia.
Ca. 1500–1503. Engraving. 270 × 186 mm (sheet trimmed at platemark). National Gallery of Art, Washington, D.C.

The Holy Family (fig. 1.48), perhaps made about 1490, shows the Housebook Master's willingness to treat even a religious theme with a charming humor—something which we could never imagine in the context of Schongauer's monumental, serious, and meticulously detailed engravings, but which bears comparison to an early woodcut such as *Rest on the Flight into Egypt* (fig. 1.4, color plate, p. 461; possibly a Holy Family). The Housebook Master's sketchiness extends even to Mary's crooked halo. Joseph peeks from behind a grassy bench and rolls apples toward the Christ child as if he were teaching him to play soccer. The chubby infant clearly enjoys the game, and Mary looks on contentedly. The conventional symbolism with which we are by now familiar is there: the tower, the seaport, the rose bush, and the apple, which, of course, stands for the original sin that Christ will conquer. No doubt these meanings were as profoundly felt by the Housebook Master as by others, but what he depicts is almost a genre scene of a family at play. Dürer would echo the warmth of this print in a number of his early Madonnas, particularly *The Holy Family with the Butterfly* (engraving, ca. 1495; see fig. 2.6).[82]

FIGURE 1.48

The Housebook Master.
The Holy Family.
Ca. 1490. Drypoint.
142 × 115 mm (sheet).
Rijksmuseum-Stichting,
Amsterdam.

Aristotle and Phyllis (ca. 1485; pendant to the *Idolatry of Solomon*) is an earlier print with a stiffer drypoint style (fig. 1.49). The aged philosopher wears a bit and bridle as Alexander the Great's courtesan reduces him to animal status. Aristotle had tried to persuade his pupil to end his affair, and Phyllis, in revenge, aroused the philosopher's passion, demanding that she be allowed to ride his back as proof of his ardor. The Housebook Master augmented the inherent humor of the situation by Phyllis' sly glance and the awkward position of one of history's greatest thinkers. We recognize another expression of the power of women, but Jane Hutchison has hypothesized that the print may also be a satire of the Neo-Thomist philosophy that revived

FIGURE 1.49

The Housebook Master.
Aristotle and Phyllis.
*Ca. 1485. Drypoint.
Diameter: 158 mm
(sheet). Rijksmuseum-
Stichting, Amsterdam.*

FIGURE 1.50

The Housebook Master.
Death and the Youth.
*Ca. 1485–90. Drypoint.
141 × 87 mm (sheet).
Rijksmuseum-Stichting.
Amsterdam.*

the scholastic thought of St. Thomas Aquinas, of which Aristotle was the primary source. The Neo-Thomist movement, the *via antiqua,* was vociferously opposed by the *via moderna,* which stressed natural philosophy and Stoic ethics. In Heidelberg, where the Housebook Master apparently worked for Philip the Sincere, the modernist movement revolved around Rudolf Agricola.[83]

The Housebook Master dealt with serious subjects as well. *Death and the Youth* (ca. 1485–90; fig. 1.50) was known by Dürer; its elegiac sentiment recurs in his engraved *Promenade* (1497). The young man's foppish concern with his appearance is shown by his impractically long-toed shoes and his carefully groomed, curly hair. Implicit in the pairing of fop and corpse and in their similar size and bearing is that the former will eventually become the latter.[84] Although the corruption of Death is indicated by the frog and the snake at his feet, his approach to the young man is gentlemanly, and his emaciated form is not truly horrific (compare, for example, the risen dead from the *Nuremberg Chronicle,* fig. 1.23). The Housebook Master's basically positive outlook lent itself to sunnier subjects, even though he treated the theme of Death more dramatically in *The Meeting of Three Living and Three Dead Kings* (ca. 1485–90).

His *Bearing of the Cross* (ca. 1480; fig. 1.51), however, is an intense rendition of Christ on the road to Calvary amidst the brutality of the world. His supporters are relegated to the far left; the center of the print is dominated by the fallen Christ and a huge cross that bears down on his neck and shoulders (Dürer would employ the same sense of physical weight upon Christ in his *Small Passion* woodcut; see fig. 2.12). Like Schongauer, the Housebook Master employed the horizontal, narrative format, but he relied less on the proliferation of incidental detail than

on the isolation of the downtrodden Christ and the exaggerated bestiality of his torturers (see fig. 1.39). As Jesus falls under the burden of the cross, we can vividly picture the prophecies of Isaiah (53:7) and Jeremiah (11:19) that the Messiah will be led like a lamb to the slaughter.

One of the most brutal prints of the fifteenth century is *The Betrayal of Christ* (ca. 1485; fig. 1.52), part of an unfinished series of Passion images by Master I.A.M. of Zwolle. Active toward the end of the century, this inventive Dutch goldsmith and engraver provides, along with the Housebook Master, a fitting conclusion to our study of early intaglio prints. He drew from the styles of the renowned Dutch painters Geertgen tot sint Jans, Albert van Ouwater, and perhaps the Master of the Virgin among Virgins. In turn, some of his engravings may have been intended as models for wood sculptors.[85]

The crowding of figures to the surface in the *Betrayal* and their strong sculptural quality could indeed be readily adapted to relief carving, but the chiaroscuro of the print is more closely allied to painting: note especially the lantern in the foreground that sheds delicately rendered rays of light. The range of light and darks in this engraving points toward Dürer's development of a "graphic middle tone" that largely replaced the white of the paper with a gray, medium darkness from which forms projected into light or receded into shadow.

Although vertical in format, as befits an image in a Passion cycle, and indebted to Schongauer's series of twelve Passion scenes of about 1480, this print is filled with the narrative detail of horizontal images like Schongauer's or the Housebook Master's images of Christ carrying

FIGURE 1.52

Master I.A.M. of Zwolle.
The Betrayal of Christ.
Ca. 1485. Engraving.
325 × 237 mm (sheet).
National Gallery of Art,
Washington, D.C.

the cross. The closest analogy to the intensified, up-close violence of this image is found in paintings by Bosch (especially *The Bearing of the Cross* in Ghent, ca. 1515). Like the demons in Schongauer's *Temptation of St. Anthony* (fig. 1.37), which Master I.A.M. probably knew, the soldiers and onlookers kick and beat and pull the hair of their victim, who is being led away by the neck. As if the arrest were not violent enough, Master I.A.M. includes at the far left the episode of Peter cutting off the ear of Malchus, who recoils in pain and horror in the center of this turgid scene. With tied hands, Christ catches the severed ear and is about to heal it, glancing reproachfully at Peter all the while.

Direct enough to reflect the heightened religiosity of the late fifteenth century yet subtle in its composition and chiaroscuro, innovative in its treatment of subject matter as only a print could be yet related to painting and sculpture as both a recipient and a source of influence, *The Betrayal of Christ* exemplifies the unique position of printmaking within the various art forms of the rapidly waning Middle Ages. Originating in craft, the print had quickly turned into art, but art of a different kind—more open to new ideas or new treatments of old ideas than

painting and, because of its multiplicity, an artistic Grand Central Station in which influences from and to all media were interchanged. Far more accessible than paintings, prints drew closer to a commonly understood symbolic and expressive language, while at the same time they offered each viewer a uniquely intimate relationship with subject matter. Prints formed, along with the printed book, the currency of the international exchange of information, ideas, and images whose growth accelerated so rapidly in the sixteenth century. Along with this proliferation—not least attributable to their being relatively inexpensive—prints were also drawing nearer to paintings in formal and intellectual complexity. Thus the contradictory aspects of the print—the preciousness that made it desirable to elite collectors and connoisseurs and its tenacious grasp on commonness—arose very early. We will observe the persistence of this contradiction.

As we consider Schongauer's *Censer* (fig. 1.41), with its connection to the pragmatic models for goldsmiths' reference and its devotional expression as profound as any painting's, or Bosch's *Death of the Miser* (fig. 1.16), with its dependence upon the *Ars Moriendi* woodcuts (see fig. 1.15), we may well ask whether paintings are coming "down" to prints or prints coming "up" to paintings. The answer is, probably, a little of both. As painters came to assimilate some of the compositions and subjects, as well as the directness and intimacy, of prints, printmakers strove to appeal to the affluent or middle classes by approximating the illusionism and refinement of painting. The late fifteenth-century print's linking of pure technical skill and intellectual depth, of multiple, circulating manifestations with the unique conception they represent, is precisely at the heart of Dürer's prophetic comprehension of the potential of the print, the main subject of the following chapter.

NOTES

1. Hind [1935] 1963, vol. 1, pp. 114–27.

2. King 1962.

3. Körner 1979, pp. 26–27.

4. Bouchot 1902; Hind [1935] 1963, vol. 1, pp. 70–72.

5. Field 1965, no. 1 (not paginated).

6. For studies of the enormous cultural significance of printing, see Ivins [1953] 1969; Eisenstein 1979.

7. Stewart 1980 provides a concise statement of these problems.

8. The means of transferral is problematic. It may have been accomplished by glueing the paper on the block and cutting through it, or by pricking the sheet of paper, laying it against the block, and *pouncing* it (dusting it with charcoal). A number of extant uncut blocks of the fifteenth and sixteenth centuries show drawing directly on the surface. See Hind [1935] 1963, vol. 1, p. 17; Stewart 1980, p. 190. Also see n. 45 below.

9. Körner 1979, pp. 28–29.

10. Hind [1935] 1963, vol. 1, pp. 108–9 (fig. 45); Körner 1979, p. 29; Stewart 1980, p. 189.

11. Körner 1979, pp. 34–36.

12. Ibid., p. 31.

13. The fundamental literature on early woodcuts is very extensive. See the bibliography in Field 1965.

14. Quoted in Schoch 1986, p. 95.

15. Körner 1979 sees a major change in the attitude toward religious images fostered by the printmaking processes. Also see the discussion in the introduction to Field 1977 (not paginated). On indulgenced images, see Ringbom 1965, pp. 23–30.

16. Körner 1979, pp. 56–58.

17. Field 1965, no. 260 (not paginated).

18. Ringbom 1965, p. 29.

19. Field 1965, no. 167 (not paginated).

20. For a discussion of the Madonna of Humility, see Meiss 1936.

21. Hall 1974, pp. 327–30. Hall summarizes the vast body of Marian iconography on pp. 323–35.

22. Schreiber 1926, vol. 2, no. 1012a, pp. 106–7.

23. Field 1965, no. 156 (not paginated).

24. Hall 1974, pp. 327, 330.

25. For a discussion of the rosary in connection with Dürer's *Feast of the Rose Garlands,* see Panofsky [1955] 1971, pp. 110–13.

26. Baxandall 1980, pp. 165–72, discusses sculptor Michael Erhart's *Virgin of Mercy* and its relationship to prints.

27. Field 1965, no. 244 (not paginated).

28. Ibid. and Mongan 1941, no. 9, p. 21.

29. Mayor 1971, above fig. 23.

30. There are two other versions of the Speculum Hand. See Field 1965, no. 269 (not paginated).

31. Ibid.

32. Ibid., nos. 156, 270.

33. Field speculates on the woodcut's association with the Augustinian order, ibid., no. 270.

34. See Hind [1935] 1963, vol. 1, pp. 214–15, for a discussion of the various ways blockbooks were bound.

35. By photographing watermarks with beta rays and comparing them, Allan Stevenson 1966 concluded that none of the extant blockbooks predates the 1460s. His conclusions are disputed by Koch 1977, p. 285, n. 12.

36. Koch 1977. For links of blockbook images to works in other media, see Koch 1950; Gibson 1965.

37. For summaries of the various arguments about the priority of the engraved or woodcut versions of the *Ars Moriendi,* see Shestack 1967b, no. 15 (not paginated); Bevers 1986, no. 90, pp. 64–76.

38. Cuttler 1968, p. 202.

39. Hind [1938–48] 1970, vol. 1, pp. 251–54.

40. Hind [1935] 1963, vol. 1, pp. 252–55.

41. Field 1965, no. 248 (not paginated).

42. Strauss 1980, p. 8.

43. Wilson 1976, pp. 43, 229–41.

44. On the attribution of this drawing, see Wilson 1976, pp. 78, 193, 195, and 200; Stewart 1980, p. 192; Rowlands 1988, no. 33, p. 57.

45. See Strauss 1980, nos. 1–21, pp. 13–103, for Dürer's possible authorship of the designs of book illustrations before and during his *Wander-jahre.* Also see Strauss 1974, vol. 1, no. 1492/4, pp. 70–77, on *Terence Writing,* a beautiful drawing by Dürer on a whitened woodblock, intended to be cut for an illustration for an unpublished edition of the *Comedies of Terence.* Compare the drawing with the woodcuts intended for this book, Strauss 1980, no. 11 a–m, pp. 41–49.

46. Field 1965, no. 342 (not paginated).

47. Shestack 1967a, introduction (not paginated).

48. Talbot, ed., 1971, p. 15.

49. Shestack 1967a, no. 1 (not paginated).

50. Bernheimer 1952.

51. Shestack 1967b, introduction (not paginated); Bevers 1986, pp. 7–20.

52. See Bevers 1986, pp. 12–17, and Koreny 1987, p. 308.

53. For a history of the Einsiedeln commission, see Hoffmann 1961.

54. Ibid., p. 233.

55. Shestack 1967b, no. 66 (not paginated).

56. Koch 1964, p. 77.

57. Compare the ruined structures in some fifteenth-century Nativities: Snyder 1985, colorplates 22, 27, 28, and figs. 129, 147.

58. On the love garden in early prints, see Bliss 1928. Keith Moxey (1980; 1985, pp. 69–70) discusses Master E.S.'s satirical/moralizing approach to this subject.

59. On these alphabets, see Shestack 1967b, nos. 72–75 (bibliography is in n. 1); Bevers 1986, nos. 110–32, pp. 87–94.

60. For a discussion of Schongauer's paintings, see Minott 1971b, pp. 17–32.

61. For a biography of Schongauer, see ibid., pp. 11–15; Shestack 1969, pp. v–xvi.

62. For a thorough discussion of the iconography of this print, see Massing 1984.

63. The most complete discussion of the Lisbon triptych is Bax 1979.

64. For detailed discussions of the *Isenheim Altarpiece,* see Scheja 1969; Hayum 1990.

65. Massing 1984, p. 222.

66. Shestack 1967a, no. 41 (not paginated).

67. Koch 1955.

68. For background on the evil elements surrounding Christ in the devotional literature and

art of the late fifteenth century, see Marrow 1977; Marrow 1979.

69. Lehrs 1908–34, vol. 5, no. 106, pp. 359–61.

70. On Master LCz's identity, see Shestack 1971, pp. 15–16.

71. Shestack 1967a, no. 125 (not paginated).

72. Minott 1971a, p. 17; Shestack 1971, p. 31.

73. Shestack 1971, pp. 26–29; on the lizards in the Schongauer print, Koch 1976.

74. Shestack 1971, p. 31.

75. On the Master of the Berlin Passion, see Shestack 1967a, nos. 20–22 (not paginated).

76. Scillia 1989.

77. Hall 1974, pp. 196–97.

78. Compare Snyder 1985, colorplate 71, and fig. 534.

79. For a selection of Renaissance images of Lucretia, see Stechow 1951; Donaldson 1982.

80. Hutchison 1985 provides a fascinating summary of the debate over the Housebook Master's identity and summarizes what can be concluded about him. Also see her monograph on the Housebook Master (1972).

81. Filedt Kok, comp., 1985, pp. 35–36.

82. The date of the Housebook Master's *Holy Family* and, hence, its influence on Dürer, are problematic. See Filedt Kok, comp., 1985, p. 32, and no. 28, pp. 121–22.

83. Hutchison 1985, p. 60.

84. Filedt Kok, comp., 1985, no. 58, pp. 154–56.

85. Shestack 1967a, nos. 134–37.

REFERENCES

Bax, Dirk. 1979. *Hieronymus Bosch: His Picture-Writing Deciphered.* Trans. M. A. Bax-Botha. Rotterdam.

Baxandall, Michael. 1980. *The Limewood Sculptors of Renaissance Germany.* New Haven, Conn.

Bernheimer, Richard. 1952. *Wild Men in the Middle Ages.* Cambridge, Mass.

Bevers, Holm, 1986. *Meister E.S.: Ein Oberrheinischer Kupfersticher der Spätgotik.* Exhibition catalog. Staatliche Graphische Sammlung, Munich.

Bliss, Douglas P. 1928. Love Gardens in Early German Engravings and Woodcuts. *Print Collector's Quarterly,* vol. 15, no. 2 (April), pp. 91–109.

Bouchot, Henri. 1902. Le Bois Protat. *Gazette des Beaux-Arts,* 3rd ser., vol. 27 (May), pp. 395–97.

Cuttler, Charles D. 1968. *Northern Painting from Pucelle to Bruegel.* New York. (Reissued with enlarged bibliography and revisions in 1991.)

Donaldson, Ian. 1982. *The Rapes of Lucretia: A Myth and Its Transformations.* Oxford and New York.

DuBruck, Edelgard E., ed. 1989. *New Images of Medieval Women: Essays toward a Cultural Anthropology.* Lewiston, N.Y.

Eisenstein, Elizabeth, L. 1979. *The Printing Press as an Agent of Change.* New York.

Field, Richard S. 1965. *Fifteenth-Century Woodcuts and Metalcuts from the National Gallery of Art.* Exhibition catalog. National Gallery of Art, Washington, D.C.

Field, Richard S. 1977. *Fifteenth-Century Woodcuts.* Exhibition catalog. Metropolitan Museum of Art, New York.

Filedt Kok, J. P., comp. 1985. *The Master of the Amsterdam Cabinet, or The Housebook Master, ca. 1470–1500.* Exhibition catalog with contributions by K. G. Boon, J. P. Filedt Kok, M. D. Haga, Jane Campbell Hutchison, M. J. H. Madou, Peter Moraw, and Keith P. F. Moxey. Rijksmuseum, Amsterdam.

Gibson, Walter S. 1965. A New Identification for a Panel by the St. Barbara Master. *Art Bulletin,* vol. 47, no. 4 (December), pp. 504–6.

Hall, James. 1974. *Dictionary of Subjects and Symbols in Art.* New York.

Hayum, Andrée. 1990. *The Isenheim Altarpiece: God's Medicine and the Painter's Vision.* Princeton, N.J.

Hind, Arthur M. [1935] 1963. *An Introduction to the History of Woodcut.* 2 vols. Reprint. New York.

Hind, Arthur M. [1938–48] 1970. *Early Italian Engraving.* 7 vols. Reprint. Nendeln, Liechtenstein.

Hoffman, Edith W. 1961. Some Engravings Executed by the Master E.S. for the Benedictine Monastery at Einsiedeln. *Art Bulletin*, vol. 43, no. 3 (September), pp. 231–37.

Hutchison, Jane Campbell. 1972. *The Master of the Housebook*. New York.

Hutchison, Jane Campbell. 1985. EX UNGUE LEONUM: The History of the "Hausbuchmeisterfrage." In Filedt Kok, comp., 1985, pp. 41–64.

Ivins, William M. [1953] 1969. *Prints and Visual Communication*. Reprint. Cambridge, Mass.

King, Donald. 1962. Textiles and the Origins of Printing in Europe. *Pantheon: Internationale Zeitschrift für Kunst*, vol. 20, no. 1 (January–February), pp. 23–30.

Koch, Robert A. 1950. The Sculptures of the Church of St-Maurice at Vienna, the *Biblia Pauperum* and the *Speculum Humanae Salvationis*. *Art Bulletin*, vol. 32, no. 2 (June), pp. 151–55.

Koch, Robert A. 1955. Martin Schongauer's "Christ Bearing the Cross." *Record of the Art Museum, Princeton University*, vol. 14, no. 2, pp. 22–30.

Koch, Robert A. 1964. The Flower Symbolism in the Portinari Altar. *Art Bulletin*, vol. 46, no. 1 (March), pp. 70–77.

Koch, Robert A. 1976. Martin Schongauer's Dragon Tree. In *Print Review Number Five: Tribute to Wolfgang Stechow* (Spring), pp. 114–19.

Koch, Robert A. 1977. New Criteria for Dating the Netherlandish *Biblia Pauperum* Blockbook. In Lavin and Plummer, eds., 1977, vol. 1, pp. 283–89.

Koreny, Fritz. 1987. Review of Bevers 1986. *Print Quarterly*, vol. 4, no. 3 (September), pp. 304–8.

Körner, Hans. 1979. *Der früheste deutsche Einblattholzschnitt*. Mittenwald.

Lavin, Irving, and John Plummer, eds. 1977. *Studies in Late Medieval and Renaissance Painting in Honor of Millard Meiss*. New York.

Lehrs, Max. 1908–34. *Geschichte und kritischer Katalog des deutschen, niederländischen und französischen Kupferstich im XV. Jahrhundert*. 9 vols. Vienna.

Marrow, James. 1977. *Circumdederunt me canes multi: Christ's Tormentors in Northern European Art of the Late Middle Ages and Early Renaissance*. *Art Bulletin*, vol. 59, no. 2 (June), pp. 167–81.

Marrow, James. 1979. *Passion Iconography in Northern European Art of the Late Middle Ages and Early Renaissance: The Transformation of Sacred Metaphor into Descriptive Narrative*. Kortrijk, Belgium.

Massing, Jean Michel. 1984. Schongauer's *Tribulations of St. Anthony:* Its Iconography and Influence on German Art. *Print Quarterly*, vol. 1, no. 4 (December), pp. 221–36.

Mayor, A. Hyatt. 1971. *Prints and People*. New York.

Meiss, Millard. 1936. The Madonna of Humility. *Art Bulletin*, vol. 18, no. 4 (December), pp. 434–64.

Metropolitan Museum of Art and Germanisches Nationalmuseum. 1986. *Gothic and Renaissance Art in Nuremberg, 1300–1550*. Exhibition catalog with contributions by Alfred Wenderhorst, Rainer Kahsnitz, Rainer Schoch, et al. New York and Munich.

Minott, Charles Ilsley. 1971a. Albrecht Dürer: The Early Graphic Works. *Record of the Art Museum, Princeton University*, vol. 30, no. 2, pp. 7–27.

Minott, Charles Ilsley. 1971b. *Martin Schongauer*. New York.

Mongan, Elizabeth, J. 1941. *The First Century of Printmaking 1400–1500*. Exhibition catalog. Art Institute of Chicago.

Moxey, Keith P. F. 1980. Master E.S. and the Folly of Love. *Simiolus*, vol. 11, nos. 3–4, pp. 125–48.

Moxey, Keith P. F. 1985. Chivalry and the Housebook Master. In Filedt Kok, comp., 1985, pp. 65–78.

Panofsky, Erwin. [1955] 1971. *The Life and Art of Albrecht Dürer*. One volume paperback edition, without handlist. Princeton, N.J.

Ringbom, Sixten. 1965. *Icon to Narrative: The Rise of the Dramatic Close-Up in Fifteenth-Century Devotional Painting*. Åbo, Finland.

Rowlands, John. 1988. *The Age of Dürer and Holbein: German Drawings 1400–1550*. Exhibition catalog. British Museum, London.

Scheja, Georg. 1969. *The Isenheim Altarpiece.* Trans. R. Wolf. New York.

Schoch, Rainer. 1986. A Century of Nuremberg Printmaking. In Metropolitan Museum of Art pp. 93–99.

Schreiber, Wilhelm Ludwig. 1926–30. *Handbuch der Holz- und Metallschnitte des XV Jahrhunderts.* 8 vols. Leipzig.

Scillia, Diane G. 1989. Israhel van Meckenem's Marriage à la Mode: The *Alltagsleben.* In DuBruck, ed., 1989, pp. 207–39.

Shestack, Alan. 1967a. *Fifteenth-Century Engravings of Northern Europe from the National Gallery of Art.* Exhibition catalog. National Gallery of Art, Washington, D.C.

Shestack, Alan. 1967b. *Master E.S: Five Hundredth Anniversary Exhibition.* Exhibition catalog. Philadelphia Museum of Art, Philadelphia.

Shestack, Alan. 1969. *The Complete Engravings of Martin Schongauer.* New York.

Shestack, Alan. 1971. *Master LCz and Master WB.* New York.

Snyder, James. 1985. *Northern Renaissance Art: Painting, Sculpture and the Graphic Arts from 1350 to 1575.* New York.

Stechow, Wolfgang. 1951. Lucretiae Statua. In *Essays in Honor of Georg Swarzenski,* pp. 114–24. Chicago.

Stevenson, Allan. 1966. The Quincentennial of Netherlandish Blockbooks. *British Museum Quarterly,* vol. 31 (1966–67), pp. 83–87.

Stewart, Alison. 1980. Early Woodcut Workshops. *Art Journal,* vol. 39, no. 3 (Spring), pp. 189–94.

Strauss, Walter L. 1974. *The Complete Drawings of Albrecht Dürer.* 6 vols. New York.

Strauss, Walter L. 1980. *The Woodcuts and Woodblocks of Albrecht Dürer.* New York.

Talbot, Charles W., ed. 1971. *Dürer in America: His Graphic Work.* Exhibition catalog with notes by Gaillard F. Ravanel and Jay A. Levenson. National Gallery of Art, Washington, D.C.

Wilson, Adrian. 1976. *The Making of the Nuremberg Chronicle.* Amsterdam.

2

Dürer and Other Sixteenth-Century

Northern Artists

DÜRER

Perhaps no other single artist had as lasting an impact on the history of printmaking as Albrecht Dürer. Born in Nuremberg in 1471, the son of a goldsmith and the godson of the publisher Anton Koberger, Dürer was to revolutionize the techniques and content of both relief and intaglio prints, leading printmaking away from its lingering association with the metalworking and woodcarving trades—a direction Schongauer and others had already initiated. At the same time, Dürer's mature prints represent this late medieval tradition of craftsmanship at its most refined.

The relative latitude of printmaking with respect to content, and the novelty of its techniques, dovetailed with Dürer's personal goals as an artist. Thoroughly self-aware and deliberate in his actions, Dürer consistently used prints to proclaim his abilities within a Renaissance framework of values: his prints reveal his skill in constructing the proportioned nude and using linear perspective, his consummate technical facility in handling the burin or designing for the woodcutter's knife, and, most important, his innovative approach to subject matter and composition. Dürer's preference for printmaking over painting is documented by a passage from his sometimes petulant letters to Jacob Heller, for whom he was laboriously completing an altarpiece. In one of these the artist laments that he would have been far richer had he spent the time making prints.[1] But the importance of Dürer's graphics, apart from these finan-

FIGURE 2.1

Albrecht Dürer. The
Stargazer Fool. *Woodcut
illustration for Sebastian
Brant's* Ship of Fools
*(Basel, 1494). 117 ×
86 mm. Germanisches
National museum,
Nuremberg.*

cial considerations, is that they reveal vividly and intimately the mind and spirit of this remark-
able man.

In 1490, perhaps in the safe company of one of Koberger's book-delivery convoys, Dürer
set out from Nuremberg on his travels as a journeyman artist. This carefully planned journey
mainly took him to important artistic and publishing centers throughout the Rhineland, prob-
ably as far downstream as Cologne.[2] One of his goals was to visit Colmar, home of Schongauer,
who unfortunately died before Dürer arrived. For the young Nuremberger, Schongauer epito-
mized the intaglio printmaker, and he had, like Dürer himself, come to printmaking from a
background in painting and an inherited appreciation of goldsmithing. Among the works of
this period that must be attributed to Dürer, however, are *relief* prints—some terse, lively
woodcut illustrations for the original edition of Sebastian Brant's *Ship of Fools,* a widely read
satirical book (Basel, 1494). In *The Stargazer Fool* (fig. 2.1), a young man is drawn into astrology
by a fool, illustrating Brant's assertion that the "stars' prediction" is "every fool's addiction."[3]
The setting here contains the germ of the landscape backgrounds and turgid skies of the *Apoca-
lypse* cuts (especially the *Seven Trumpets* and the *Opening of the Fifth and Sixth Seals*). Although
the landscape is only minimally articulated and the hatching rudimentary, the poses are fluid,
the gestures well calculated, and the figures convincing forms in space.

Despite their expressive clarity, the *Ship of Fools* illustrations retain much of the stiffness
and abrupt angularity of early relief prints. In the fifteen woodcuts of Dürer's *Apocalypse* (pub-
lished in 1498), however, the lines have assimilated some of the flexibility and descriptive ca-
pacity of engraved lines—swelling, breaking, and tapering over masses and grouping together
to create light and shadow. That Dürer was able to transform the woodcut line like this while
still maintaining its aggressive expressiveness insures the *Apocalypse* its position in the history
of prints as a revolutionary work. It took the best aspects of early woodcutting, especially as

exemplified in Koberger's books (Dürer even used the same typeface and format as the *Nuremberg Chronicle*), yet opened up formal and technical possibilities undreamed of by his predecessors. Indeed, the technical accomplishment of the *Apocalypse* is so extraordinary that some scholars have speculated that Dürer himself cut some of the blocks, despite the traditional separation of designing and cutting that we observed in Chapter 1. The monogram in the *Apocalypse* occurs in two variations, indicating two hands, one of which might have been Dürer's. On the other hand, the task of the form-cutter required much training that Dürer may not have had, and we know from surviving early uncut blocks that his designs were either glued on blocks or drawn directly on a white ground in preparation for cutting. Still, he was a highly dexterous artist, and it is difficult to imagine that even a form-cutter trained in Wolgemut's shop could translate Dürer's intention without considerable guidance and perhaps some actual finishing touches by Dürer himself. William Ivins observed a liveliness in the *Apocalypse* prints that he felt was absent from Dürer's mature woodcuts and precluded the intervention of a form-cutter.[4]

In terms of its salability and the publicity it lent its creator, the *Apocalypse* (Greek for "unveiling" or "revelation") was an extremely canny, sophisticated enterprise. It was the first book conceived, designed, and published by an artist (Dürer was inspired by Erhard Reuwich of Mainz, who illustrated and published Bernhard von Breydenbach's *Sanctae Peregrinationes* in 1486), and it advertised Dürer's technical virtuosity and pictorial inventiveness. The woodcuts appear without regard for the content of the particular section of text they accompany: they dominate rather than illustrate the continuous text printed (except for the final image) on their versos. The subject matter, drawn from the Revelation of St. John the Divine, with its arcane, visionary imagery, offered boundless artistic challenge, thereby augmenting Dürer's accomplishment. Moreover, John's Revelation was a fundamental part of the religious consciousness of Dürer's contemporaries. Paradoxically, these far from naive prints capitalized on the traditional, popular role of woodcuts in the religious life of Europe. Dürer published the *Apocalypse* in both German and Latin in 1498 in an attempt to bridge the gap between humanists and ecclesiastics and the public who read only vernacular German. The second edition of 1511, however, was in Latin alone. Does this indicate that Dürer's message—and we are by no means in agreement as to what it is—held more appeal for his humanist colleagues than for the general populace?

Although a full-page image of John's torture and, in the 1511 edition, a frontispiece of John adoring the Apocalyptic Woman (Mary) introduce the series, Dürer's rendering of the biblical narrative per se begins with the magisterial *Vision of the Seven Candlesticks* (fig. 2.2). It preserves the iconic impact of medieval depictions in illuminated manuscripts, which Dürer may not have seen, while asserting woodcut's capacity for representing three-dimensional, detailed form. The stark frontality of the Son of Man with his flaming face, seven stars, hovering sword, and rainbow is coupled with a convincing sense of volume in the arrangement of the candlesticks, and of weight in the figure of St. John, turned at an angle into space. Parallel hatching begins to establish an overall medium gray, which Erwin Panofsky dubbed the "graphic middle tone" and which would later become a dominant note in Dürer's prints.[5] It would eventually replace the white of the paper, moving the print toward pictorial illusionism and away from the nearly exclusive linearity of early woodcuts. Dürer's respectful rivalry with Schongauer and his determination to draw woodcut closer to engraving is exhibited in the superbly rendered candlesticks—each a separate invention—which suggest the goldsmith's art and the detail that

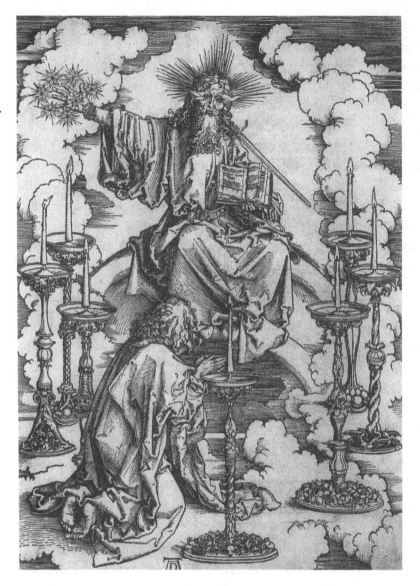

could be achieved with the burin. This sheet is considered one of the last of the series to be conceived. It exhibits a judicious balance of detail and broadly treated volumes and masses, as well as Dürer's maturing sense of simplicity and monumentality.

Unlike many of the other prints in the series (*St. Michael Fighting the Dragon,* for example), in which the visionary realm is shown above a landscape or separated from it by a fringe of clouds, *Seven Candlesticks* immerses us, and the seer, in the heavenly sphere. With his bare feet curled together and projecting toward us, John becomes the intermediary between us and the Son of Man. A careful comparison of the biblical text (Rev. 1:12–16) and the image only reinforces Dürer's accomplishment: its rich and coloristic verse is rendered in black and white with no loss of symbolic or imaginative power.

In *The Four Horsemen* (fig. 2.3), the most famous print from Dürer's series, suffering is inflicted on mankind in the forms of war, pestilence, and famine (the scales imply a scarcity of grain): these compete with Death himself, who appears on a pale, emaciated horse (Rev. 6: 1–8). The flickering lights and darks and the agitated lines convey the terror of an imminent crisis. The hooves of the horses are about to descend on a pathetic humanity. A bishop or king

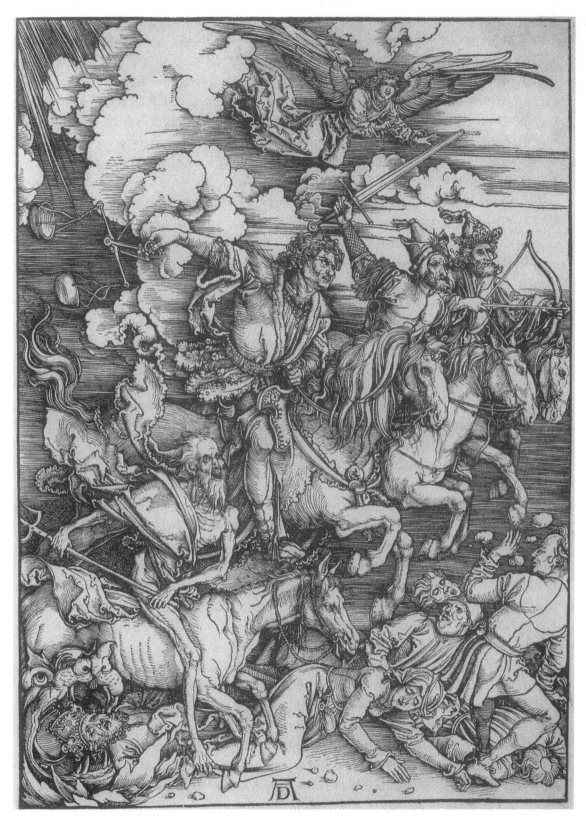

FIGURE 2.3

Albrecht Dürer. The
Four Horsemen *from the*
Apocalypse. *1497–98.
Woodcut. 390 × 281 mm.
Cleveland Museum of
Art.*

is devoured by the mouth of hell.[6] Here, Dürer exploited the implications of social upheaval that could be derived so readily from apocalyptic thought: during the final days, the last shall be first and vice versa.

Which elements of society did Dürer regard as last and first? The degree to which the artist's interpretation reflects contemporary religious and political meaning, and therefore announces the Reformation, is debatable. For Rudolf Chadabra, greatly expanding on Max Dvořák's interpretation, the *Apocalypse* is, among other things, a hymn to the emperor Maximilian, on whom the German lower and middle classes and humanists had mistakenly pinned their hopes for a united Germany, free from the domination of the Roman Church and the divisiveness of the nobility. If this was Dürer's main purpose, then the four riders would act as a force for social betterment: Chadabra sees the central horseman as Maximilian, carrying the scales of justice.[7] On the other hand, the pale rider may be understood more conventionally as the great leveler who lays waste to all accomplishments, wealth, and class distinctions and whose sudden appearance reminds us all of the transience of life.

Alternately praised and criticized,[8] the climactic and central *St. John Devouring the Book* (fig. 2.4) reveals a curious blend of literalism and illusionism, as well as Dürer's outstanding editorial gift. He sifted through the overwhelming detail of the text and drastically reduced the number of images that were usually employed to illustrate it. In some cases he combined crucial narrative incidents into single images, but in others (as here) he isolated events that were particularly symbolic. The angel with the flaming face, a rainbow around his head and legs like pillars of fire, who stands on the land and the sea (Rev. 10:1–2), is represented faithfully, and yet the incongruity of his form is softened by merging it with the clouds behind. This blurring of the distinction between the angel's abstract form and the nature surrounding him, like his straddling of land and sea, is part of the print's meaning. The angel mediates between earth and water, and his "body" encompasses the other two elements: air and fire. Dürer may have intended him as a universal absolute in which opposites are reconciled, as in the philosophy of Nicolas of Cusa, who, according to Franz Juraschek, was the major influence on Dürer's series.[9] Cusa, a strong advocate of ecclesiastical and social reform (in these realms also, opposites should be reconciled), was one of the eminent thinkers of the fifteenth century. Dürer may have been drawn to his thought through the influence of Caritas Pirckheimer, Mistress of the Novices at the Franciscan convent of the Poor Clares, sister of Dürer's best friend Willibald, and, like her more famous brother, a brilliant scholar.[10]

Since the angel mediates between God and man, he is also Christ—in Cusa's thought, the great Mediator, Technician, and Artist underlying all creation, both human and divine. Moreover, Dürer lent the angel a distinctly Apollonian quality: he is a solar god and, like Apollo, he is Lord of Light, Wisdom, Prophecy, Truth, and Justice. Such merging of pagan and Christian mythologies was typical of the humanistic mind and permeated Neoplatonism, an eclectic strain of philosophical thought that influenced a number of Renaissance artists, including Dürer. As the qualities of the solar diety have so often been attached to temporal rulers, so Chadabra sees the angel as Maximilian too—John assimilates the prophecy in both its religious and its contemporary political interpretations.[11]

Faced with the prospect of depicting John eating the "scroll" (Rev. 10:10), a lesser artist of naturalistic inclination might have despaired, but Dürer, recognizing that eating was the only metaphor direct enough to express the assimilation of prophetic knowledge, accentuated its physicality. The passing of revealed truth from God to John through the intermediary of

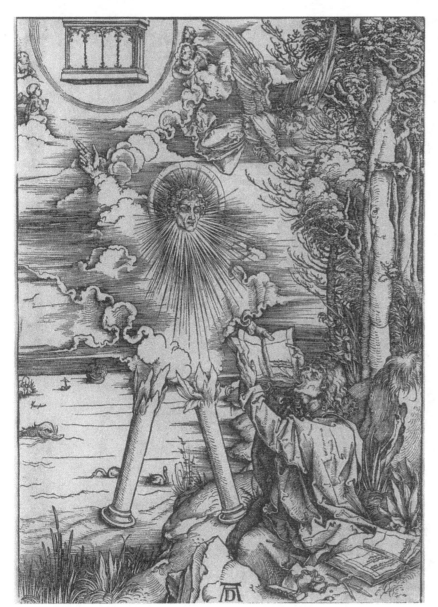

FIGURE 2.4
Albrecht Dürer. St. John
Devouring the Book
from the Apocalypse.
1497–98. Woodcut.
391 × 284 mm. Cleve-
land Museum of Art.

the angel is clearly expressed in a single diagonal axis that moves from upper left to lower right (common in the *Apocalypse* compositions), where pen, ink, and paper wait to give form to the prophecy. One cannot help observing that these writing tools might very well be replaced by woodblock, gouges, and knives.

In a remarkable image (fig. 2.5) based unabashedly on Schongauer's *Temptation of St. Anthony* (fig. 1.37), the battle between the forces of good and evil reaches a peak: the archangel Michael (also Maximilian?),[12] accompanied by three angels, forcefully vanquishes the scaly, leather-winged Devil and demons that are conscious echoes of Schongauer's monsters, yet done in woodcut, a fact that must have elicited surprised admiration from Dürer's audience. The crowded battle is poised against a dark gray, again composed of parallel lines, and above a peaceful landscape reminiscent of those of the *Nuremberg Chronicle* (see fig. 1.22). In the last image, Michael incarcerates Satan under the earth in preparation for the millennium (Rev. 20: 1–6)—a period of a thousand years in which peace and good reign before the final unleashing

FIGURE 2.5

Albrecht Dürer. St.
Michael Fighting the
Dragon *from the*
Apocalypse. *1497–
98. Woodcut. 394 ×
283 mm. Germanisches
Nationalmuseum,
Nuremberg.*

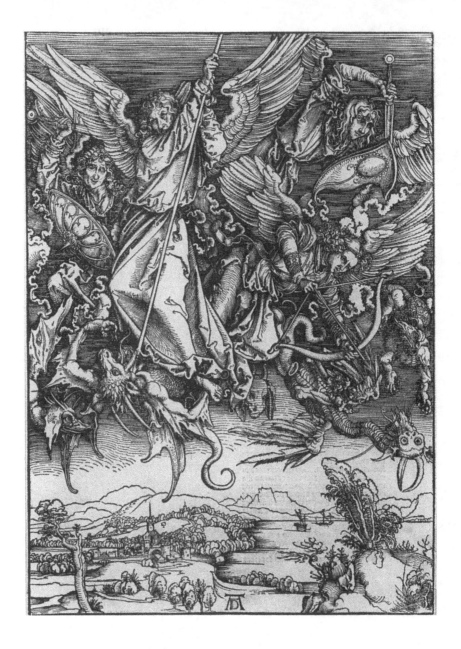

of evil once again and the ultimate victory of Christ and the blessed at the Last Judgment (Rev. 20:7–15). These last events of the apocalyptic narrative are curiously curtailed in the Bible, but Dürer collapsed them even further. He left out the Last Judgment, skipping from Michael's imprisonment of Satan to his revelation of the New Jerusalem, depicted as a decidedly earthly German city in the distance, to a weary John (chaps. 21 and 22). It seems likely that this is a deliberate omission important to Dürer's intention. Was he trying to suggest, contrary to a literal interpretation of the text, that utopia will not descend from the sky at the end of time but is possible *on earth* if the forces of evil are conquered by just rule within the ecclesiastical and the temporal realms? The year 1500, the expected date of the struggle initiating the millennium—some predicted great upheaval and even the end of the world—came and went. As the sixteenth century wore on, bringing with it the death of Maximilian and the Reformation and its accompanying violence, Dürer must have been deeply saddened by the loss of his dream.

The modest early woodcut illustrations of fifteenth-century books often served as models for Dürer's *Apocalypse* compositions. These he surpassed, both technically and expressively.[13]

FIGURE 2.6

Albrecht Dürer. The
Holy Family with the
Butterfly. *Ca. 1495.
Engraving. 237 ×
185 mm. Cleveland
Museum of Art.*

And, although the woodcuts Wolgemut's workshop designed for Koberger's publications pro-
vide some mediation between the ingenuous simplicity of fifteenth-century relief prints and
Dürer's accomplishment, they are still worlds apart. In intaglio printmaking, however, Dürer
faced a greater challenge from artists who preceded him, such as Schongauer and the House-
book Master. Dürer's early engraved *Holy Family with the Butterfly* (ca. 1495; fig. 2.6) captures
some of the homey humor of the Housebook Master's slightly earlier *Holy Family* (fig. 1.48),[14]
and approaches Schongauer's skilled burin work. However, the irregular cross-hatching in the
drapery and the awkward combination of long strokes with flicks there and in the landscape
background reveal an unpracticed hand. He had not yet caught up to these older masters. As a
naturalist, too, Dürer (a few years later the author of such brilliant morphological studies as
The Hare and *The Great Piece of Turf*) leaves something to be desired at this point: the insect
in the lower right has been variously identified as a butterfly, dragonfly, praying mantis, or
locust, its symbolic meaning changing accordingly.[15]

In order to assimilate the secrets of art that Dürer felt were jealously guarded by Italian

FIGURE 2.7

Albrecht Dürer. The Four
Witches (Four Naked
Women). *1497. Engrav-
ing. 194 × 136 mm.
Museum of Fine Arts,
Boston.*

artists, he ventured twice across the Alps between 1494 and 1495 and 1505 and 1507. "Here, I
am a gentleman," he wrote to Willibald Pirckheimer in 1506, "at home, a parasite."[16] His
comment reflects the higher economic and social status of the artist in Italy. It was this view of
the artist, as much as the knowledge of proportion and perspective, that Dürer fostered in
Germany with his prints. In *The Four Witches,* also known as *Four Naked Women* (1497;
fig. 2.7), the female nude is programmatically displayed from different views. Curving and
sometimes crossed burin lines define the figures insistently and awkwardly (note the curious,
bulging back of the figure at the far left). These nudes are strongly related to those of Jacopo
de' Barbari's engravings, such as his undated *Victory and Fame* (see fig. 3.22). In addition, their
circular arrangement recalls mythological motifs such as the Three Graces. This has led some
scholars to postulate a mythological subject for the print as well, along with a variety of com-
plex allegorical meanings that would have appealed to a humanistic audience.[17]

However, such attempts have not been entirely convincing. Dürer lent his group of women a threatening, conspiratorial quality, as if a mere gathering of nude females were dangerous (a thoroughgoing misogyny was just as typical of Dürer's age as an intense veneration of the Virgin Mary and female saints). Moreover, the devil lurking in the doorway, the skull and bone at the women's feet, and the globe-like mandrake fruit with its stubbornly enigmatic "O.G.H." place the print firmly in the context of witchcraft lore, although the specific ceremony being performed eludes us.[18] Panofsky suggested a magical abortion as described in the *Malleus Maleficarum* (*Hammer of Witches*), a virulently misogynistic, widely distributed witch-hunting treatise written by Heinrich Institoris and Jakob Sprenger, founder of the Confraternity of the Rosary. The *Malleus* was first published in 1486, with editions by Koberger in 1494 and 1496.[19] Although not an exact solution, the figures may be engaged in the kind of infanticidal rite attributed to witches. Perhaps Dürer did not intend to tell a specific story but, like Hans Baldung Grien in his *Bewitched Groom* (see fig. 2.20), to provide a general sense of evil and the discrepant parts of a story that the viewer could piece together. Both these artists provocatively concealed the actions and relationships of their protagonists. At any rate it is significant that Dürer couched this early attempt at the Italianate nude in terms of a subject as yet infrequently illustrated and so topical in northern Europe.

The *Fall of Man*, also called *Adam and Eve* (1504; fig. 2.8), is a virtuoso example of burin technique, with none of the awkwardness of *The Four Witches*. It also has a complex, erudite iconography that proclaims that the artist is learned as well as skilled. The burin is used here with even more versatility than Schongauer's—now moving wavelike across a thigh; now suggesting, in choppy, varied strokes, peeling birch bark, scaly serpent's skin, and fur. The primordial identity of human beings, soon to be shattered by the disobedience of the first couple, is conveyed by the mathematical proportions of the figures. The balanced natures of Adam and Eve are soon to be divided by this alienation from their creator into contentious temperaments, each governed by an imbalance of bodily fluids, or humors, and planetary influences. These temperaments are represented by animals—the elk for the melancholic, the ox for the phlegmatic, the cat for the choleric, and the rabbit for the sanguine. To express the imminent expulsion of mankind from the ideal realm of Eden into the present, imperfect reality, Dürer opposed the predatory cat to the vulnerable mouse in the foreground. In the background, the goat, symbol of unbelief, teeters on the edge of a cliff.[20]

Despite the ultimate ancestry of Dürer's Adam in the antique *Apollo Belvedere* and of Eve in the *Medici Venus,* they remain northern figures, viewed against the dark forest, tense unions of the specific and the ideal. Dürer's assimilation of Italian idealism into his own heritage, concerned most of all with the vitality of individual organisms, is perhaps best exemplified by his *Nemesis* (1501–2; fig. 2.9), also known as *The Large Fortune.* Spread beneath her less than ideal body is a precisely observed Tirolean town; the sweep of this engraved landscape reflects Dürer's unprecedented watercolor studies of the countryside he traversed on his first trip to Italy. Fortune's body is an exercise in both generalizing mathematical proportions, gleaned from the ancient Roman author Vitruvius, and gross specificity.[21] Thus, she functions as an abstract, universal principle (Fate or Fortune) and as a specter encountered, as in a dream, with a scary verisimilitude. She does not glance at the anthill-like community beneath, or at us. Instead, she looks straight ahead, dispassionately dispensing reward, represented by the cup, and retribution (or temperance), signified by the bridle. The leather of the bridle, the shiny surface of the metal cup, and, above all, the meticulously detailed feathers of her wings (com-

FIGURE 2.9

Albrecht Dürer. Nemesis (The Large Fortune). *1501–2. Engraving. 333 × 230 mm. Cleveland Museum of Art.*

parable to his breathtaking watercolor study of the wing of a blue roller) testify to Dürer's command of the recalicitrant burin.

Between 1511 and 1513, Dürer published no fewer than five religious books: the second edition of the *Apocalypse,* the *Large Passion,* and the *Small Passion,* both in woodcut, the *Engraved Passion,* and the woodcut *Life of the Virgin.* In these publications, he exploited printmaking's capacity for serial imagery, already recognized in the fifteenth century, as well as its capacity to reach a varied audience. All the books reveal a deep piety that is variously expressed according to medium, format, and, of course, price. In the three versions of Christ Carrying the Cross, for example, Dürer conceived Jesus as a dignified man who still maintains control despite the evil surrounding him (fig. 2.10; *Engraved Passion*), as a half-kneeling but still calm and noble figure, engulfed by a seething, hostile world (fig. 2.11; *Large Passion*), and as a cowering victim (fig. 2.12; *Small Passion*), much as the Housebook Master had envisioned him in

FIGURE 2.8

Albrecht Dürer. The Fall of Man (Adam and Eve). *1504. Engraving. 250 × 193 mm. Cleveland Museum of Art.*

FIGURE 2.10
Albrecht Dürer. The
Bearing of the Cross.
1512. From the Engraved
Passion, *published 1512.
117 × 74 mm. Cleveland
Museum of Art.*

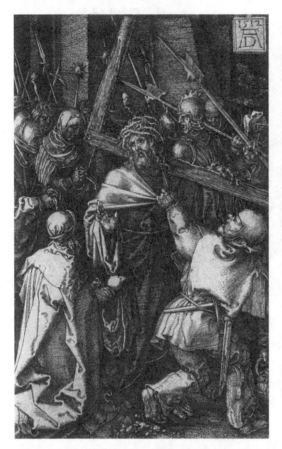

FIGURE 2.11
Albrecht Dürer. The
Bearing of the Cross.
*1498–99. Woodcut from
the* Large Passion, *pub-
lished 1511. 390 × 284 mm.
Cleveland Museum of
Art.*

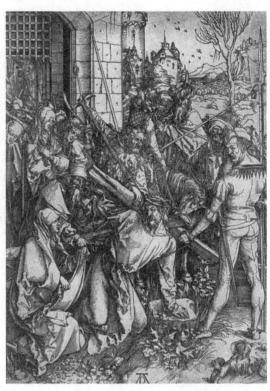

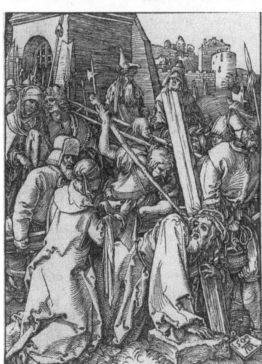

FIGURE 2.12
Albrecht Dürer. The
Bearing of the Cross.
1509. Woodcut from the
Small Passion, *pub-
lished 1511. 127 × 97 mm.
Cleveland Museum of
Art.*

his famous drypoint. The more violent pathos of the *Small Passion* image is also conveyed by an unrefined, abrupt woodcut line.

In his *Life of the Virgin*, published in 1511 but composed in part and executed from as early as 1502, Dürer capitalized on the great importance of Mary in Christian devotion during the late Middle Ages and before the Reformation and drew on a number of sources outside the accepted scriptures.[22] Unlike the *Apocalypse*, the *Life of the Virgin* offers a close correspondence between text—nineteen Latin poems in classical meter by Benedictus Chelidonius, a Benedictine monk and scholar at the monastery of St. Aegidius in Nuremberg—and images. But Dürer's wording of the long title (*Excerpts from the Story of the Holy Virgin Mary Presented in Pictures by Albrecht Dürer with Verses by Chelidonius*) makes it very clear that the woodcuts are not mere illustrations but dominate the text. Dürer dedicated his book to Caritas Pirckheimer, whose cloistered life, like that of all nuns, was ultimately modeled on Marian virtues.

Whereas in the *Apocalypse* and the Passion series mentioned above, Dürer developed an intensely visionary and emotional style, the images in the *Life of the Virgin* are conceived in more rambling, narrative terms. Figurative and architectural details, extraneous to the story itself but lending it an informal touch and a down-to-earth, middle-class realism, are greatly expanded. The complex architectural settings in these woodcuts, often containing Italianate details, were an important demonstration of Dürer's skill in the use of linear perspective. The series' innovative nature manifests itself particularly in his varying of the viewer's spatial position and in his placing of the figural groups with respect to the architectural frameworks. Dürer was certainly conscious of this inventiveness: at the end of the bound editions of the *Apocalypse* and the *Life of the Virgin* in 1511, he warned "secret begrudgers and thieves of the labor and invention of others" of a ban on copying that extended throughout Maximilian's territories.[23] However, Marcantonio Raimondi had already copied the cuts in engravings, complete with Dürer's monogram. During Dürer's second trip to Italy in 1506, he complained about the pirated designs to the Venetian Senate, one of the earliest recorded instances of a printmaker's attempt to protect his creations. According to the second edition of Giorgio Vasari's *Lives of the Artists* (1568), the first book on the history of art, the Senate responded by ordering Raimondi to cease using Dürer's monogram. He complied to this extent, but went on to issue engraved copies of the *Life of the Virgin* woodcuts that Dürer subsequently completed.[24]

The Birth of the Virgin (ca. 1503–4; fig. 2.13) is set in a homey interior filled with women; the three on the left form an exact isosceles triangle. They offer Anna, Mary's mother, food and drink, eat and drink themselves, talk, sleep, play with a toddler (lower left), and care for the newborn (lower right). The framing arch has expanded outside our field of vision to bring us closer to the activity. Above this perfectly common setting, an angel appears, swinging a censer. This visionary element, distinguished from the earthly realm by Dürer's characteristic fringe of clouds (compare *Nemesis*), and the slightly raised point of view let us know that, despite the worldly details, this is not just any birth. Rembrandt later adapted Dürer's composition and the abrupt intrusion of the divine into the ordinary in his *Death of the Virgin* (1639; see fig. 4.40).

Dürer's so-called Master Engravings of 1513–14, *Knight, Death, and the Devil* (fig. 2.14), *St. Jerome in His Study* (fig. 2.15), and *Melencolia I* (fig. 2.16), represent the apogee of burin technique in the early sixteenth century. Although their sizes vary slightly and Dürer's Netherlands diary does not indicate that he distributed them together,[25] the three prints have been considered as a trilogy in terms of meaning and form. They are essays on three kinds of vir-

FIGURE 2.13

Albrecht Dürer. The
Birth of the Virgin.
*1503–4. Woodcut from
the* Life of the Virgin,
*published 1511. 293 ×
207 mm. Cleveland
Museum of Art.*

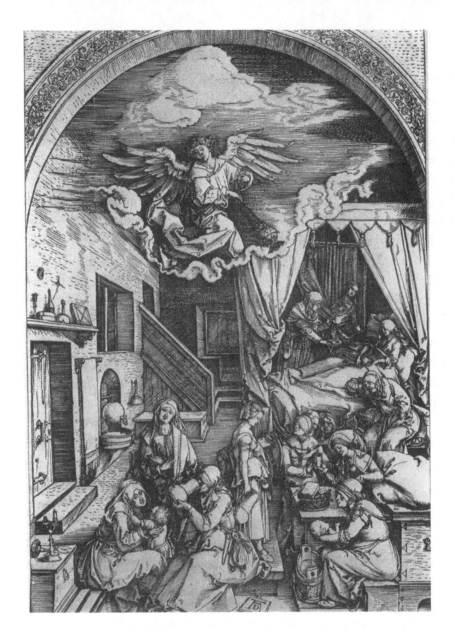

tue—theological (*St. Jerome*), moral (*Knight*), and intellectual (*Melencolia*)—and the two for-
mer engravings contrast the contemplative and active Christian lives.[26] *Melencolia I* deals with
the limits of secular intellectual inquiry, especially as practiced by the artist, and contrasts it to
Jerome's application of the mind in the service of God.

Knight, Death, and the Devil (1513; fig. 2.14) depicts a dauntless knight riding through a
rocky and tangled landscape on a magnificent horse that exemplifies ideal equine proportions.[27]
Death in the form of a rotting cadaver confronts the knight with an hourglass, symbolic of the
passage of time, as the Devil, composed of various faithfully rendered animal parts, slinks
alongside. So far, this scenario reads like a Dance of Death with its typical message: pay atten-
tion to spiritual values, for life is short; do not fall into the trap of sin.[28] Is the knight a repre-
hensible character who needs to heed this warning and change his ways? Some scholars, Sten
Karling and Ursula Meyer in particular, have elaborated on the negative moral and political
connotations of knighthood in Dürer's time, going so far as to suggest that Death and the
Devil are attributes, not antagonists, of the knight.[29]

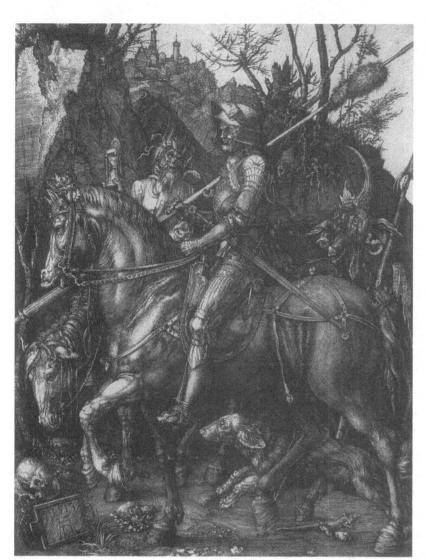

FIGURE 2.14
Albrecht Dürer. Knight, Death, and the Devil. *1513. Engraving. 245 × 189 mm. Cleveland Museum of Art.*

However, knighthood could also be viewed nostalgically and idealistically (as by the chivalrous Maximilian, whose adoption of the persona of the knight is surely important for Dürer's engraving), and the knight's armor here may be read as a moral one, enabling him to "ride by" sin and death. This picture of aggressive moral strength may also be augmented by the old conceit of the "Christian Knight," especially as developed by Erasmus in his essay *Enchiridion Militis Christiani* (*Handbook of the Christian Soldier*), first published in 1503. And later, in his famous response in his Netherlands diary to Luther's disappearance, Dürer would dub Erasmus himself a "Knight of Christ."[30] But we need not postulate Erasmus' essay as Dürer's source, for St. Paul used military metaphors to express the idea of unwavering faith and virtue: for example (Eph. 6:11): "Put on the whole armor of God, that you may be able to stand against the wiles of the devil."[31] If our knight is specifically a soldier of Christ, then the fortress is the faith in God that sustains him. The dog, too, in contrast to the sleeping, emaciated creature of *Melencolia I,* is the very image of fidelity and strength. He shares the virtue of fidelity with Jerome's smaller, quieter canine companion. The oak leaves adorning the horse, like the oak grove

behind Christ in Master LCz's *Temptation of Christ* (fig. 1.42), stand for fortitude in faith, while the lizard, also an inhabitant of LCz's print, may be associated with sin. The foxtail, symbol of deceit, would be something that the knight has conquered (note that it is draped over his lance).[32] Heinrich Theissing has broadened the meaning of the print beyond Christianity. For him, the knight is the transcendent human spirit in its most positive, thoroughly Renaissance manifestation.[33]

Despite its detractors, the interpretation of the knight as a soldier of Christ, standard since its adoption by Panofsky in his monograph on Dürer, has the virtue of making the Master Engravings intelligible as related, though not rigidly interdependent, statements about life's possibilities as Dürer viewed them in 1513–14. Perhaps more important, an understanding of *Knight, Death, and the Devil* as an allegory of active, moral striving has a universality and profundity that are commensurate with the technical brilliance, formal elaboration, and size of the print.

In contrast to the active, militant *Knight,* the other two Master Engravings, possibly distributed by Dürer as a pair,[34] describe the life of the mind. Dürer depicted St. Jerome (fig. 2.15) deeply engaged in scholarly work in a cozy room that contrasts with the gloomy outdoor setting of *Melencolia I* (fig. 2.16). His task is the Latin translation of the Bible. Peter Parshall has explained the prominent gourd suspended from the ceiling as a reference to an esoteric philological controversy about the translation of the Hebrew word *kikayon* in Jonah 4:6.[35] Although it means "gourd," Jerome had translated it into Latin as "ivy." Dürer's inclusion of the fruit, more recognizable as an attribute of Jerome than a sprig of ivy would have been, calls attention not only to the saint's scholarship, but also to the divine favor under which Jerome worked. For the biblical story concerns a plant that the Lord caused to spring up to shelter Jonah from the sun, as Jerome is protected here. His animal companions rest contentedly at his doorstep, and he has forgotten the symbols of death and transience (the skull and hourglass, and possibly the gourd itself, for the plant sent to Jonah "perished in a night") in the fulfillment of work done for the glory of God. Although Ivins elaborated on irrationalities in the perspective of the room,[36] the overall effect is at once powerfully spatial and harmonious (contrast Baldung's *Bewitched Groom;* see fig. 2.20), particularly since Dürer bathed the setting in what is surely the warmest light ever achieved in an engraving.

Melencolia I (fig. 2.16) is neither warm nor harmonious. It is Dürer's most personal and complex work and, as such, has elicited a wealth of interpretations ranging from the mystical doctrines of alchemy to Dürer's despair over the death of his mother.[37] The most profound and convincing analysis is still that of Panofsky, Fritz Saxl, and Raymond Klibansky, who uncovered the ancestry of Dürer's female figure in medieval illustrations of the vice of *acedia* (sloth) and the temperament of melancholy, and in the "Typus Geometriae" from Gregor Reisch's early encyclopedia, *Margarita Philosophica* (Strasbourg, 1504). Dürer, however, under the influence of Neoplatonic philosophy, transformed these concepts into a complicated image of artistic creativity.[38]

The Florentine Neoplatonist Marsilio Ficino had discussed the melancholy temperament and the influence of the planet Saturn upon it in his treatise on medicine and astrology, *De Vita Triplici,* published first in 1489 and in German (by Koberger) in 1505. Ficino applied Plato's concept of divine madness (*furor divinus*) to this temperament, which Aristotle had already associated with intellectuals but which the Middle Ages had seen as entirely negative. Interpreting Ficino in *De Occulta Philosophia,* apparently known to Dürer in manuscript form,

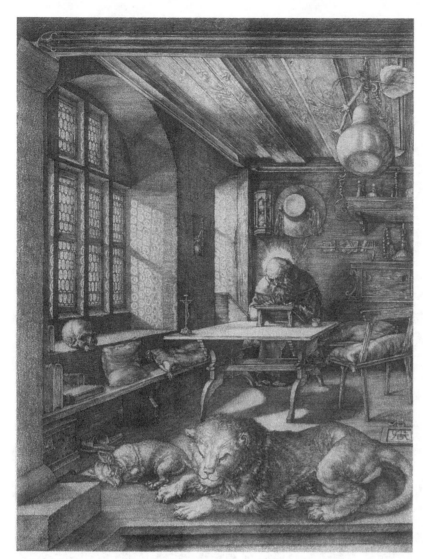

FIGURE 2.15
Albrecht Dürer. St.
Jerome in His Study.
*1514. Engraving. 245 ×
186 mm. Cleveland
Museum of Art.*

the German physician and humanist Agrippa of Nettesheim distinguished three levels of melancholy: the upper level was that of theologians; the middle, that of scholars and statesmen; the lowest, that of artists. This is the state of Dürer's figure—the first level of melancholy (hence the title—*Melencolia I*).

But this frustrated, dark-visaged figure, sitting inertly amid scattered talismans of her temperament and tools of her profession, in a landscape flooded by Saturn's influence and presided over by the nocturnal bat, personifies not only Melancholy but also Art and Geometry. Few artists today would place Geometry at the heart of their creativity, but for the Renaissance artist, it was not merely a technical resource but a science containing the very secrets of harmony and proportion, and therefore beauty, and reflecting the divine order of the universe itself. Moreover, Dürer imbued his tools and objects of measurement with a hierarchical order. Some are carpenters' and stonecutters' utensils (tongs, plane, molding curve, hammer, ladder, crucible, ruler, and nails), while some—the sphere and polyhedron—are objects created by more sophisticated means like the compass that Melancholy holds. The hourglass, bell, scale, and magic square (whose rows of numbers all add up to thirty-four) reflect number and measurement in a purely abstract form.

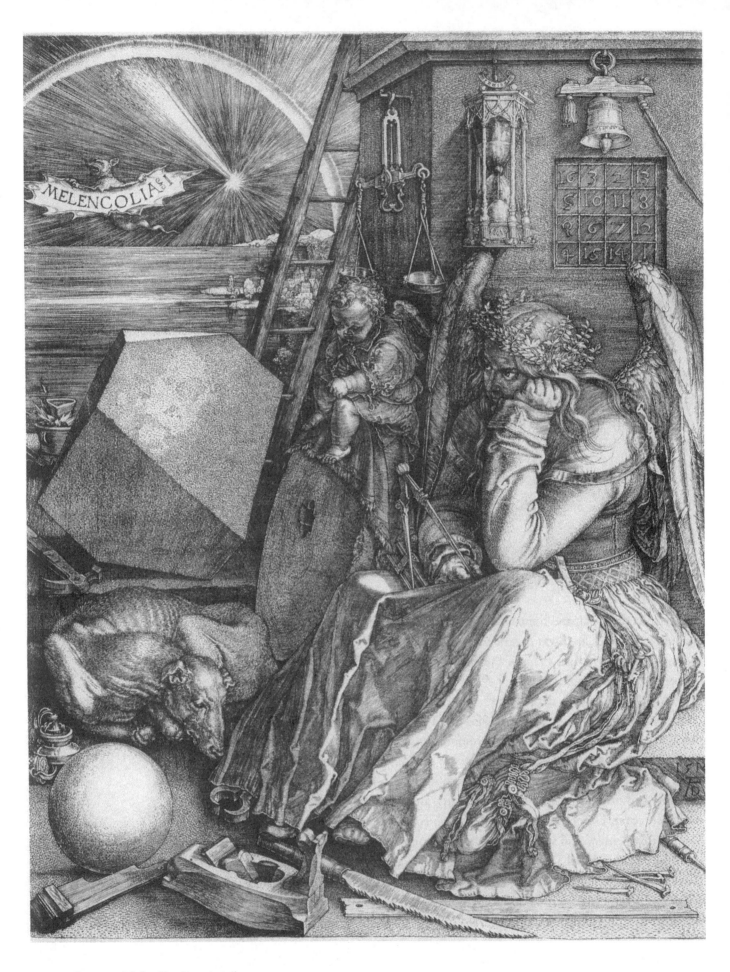

MELENCOLIA §I

The busy little putto and Melancholy herself extend this contrast between skill and Art. In the former figure, Dürer embodied the uninspired but contented activity of the artisan; in the latter, the struggle that accompanies the true creativity of the great artist. The melancholic artist, both cursed and blessed with a wider range of knowledge and a glimpse into the realm of metaphysical insight, is painfully aware of the discrepancy between the necessarily physical concerns of art and the higher metaphysical understanding that is desired. If *Melencolia I* is not, as Panofsky thought, a direct reflection of Dürer's own concept of his psychological make-up, then it certainly expresses Dürer's understanding of the position of the contemporary German artist, poised between the Middle Ages and the Renaissance. In his outline of a manual for young artists, Dürer warned of their special vulnerability to melancholy.[39]

The elaborate iconography of the Master Engravings testifies not only to the profundity of Dürer's thought but also to the greatly expanded potential of prints to convey intellectually complex ideas—a capacity that his works fostered. Although scholars will argue for some time to come about iconographic "solutions" for the puzzle presented by the Master Engravings (the literature on *Melencolia I* is voluminous and promises to keep growing), no one will dispute the brilliance of Dürer's technique in these prints. In *St. Jerome* he made visible, out of metal, ink, and paper, the effect of sunlight filtered through little round panes of glass and settling warmly onto a stone wall, a human skull, or a wooden ceiling. In contrast, the dark chiaroscuro of *Melencolia I* conveys the surreptitious flash of a comet, revealing simultaneously the surface of a cut-stone polyhedron, the scrubby fur of an emaciated dog, and the bilious face of Melancholy. But Dürer's genius should not blind us to the many other talented northern artists who produced prints and explored new possibilities for graphic media in this fruitful period.

DÜRER'S PUPILS AND CONTEMPORARIES

At about the same time Dürer began work on the *Small Passion,* with its starkly linear images (see fig. 2.12), another, more pictorial direction was being followed by his contemporaries. *Clair-obscur* or *chiaroscuro* woodcut (from the French and Italian words for light and shade) is closely related to a type of drawing, favored by Swiss and German artists, that employs dark and white inks or chalks on tinted paper.[40] In the woodcut process, a line block is combined with one or more tone blocks, gouged out in places, that print, respectively, black lines and tonal areas or white highlights. In early Italian chiaroscuro woodcuts, best represented by the works of Ugo da Carpi, the line block is subordinated to the tone blocks, thus producing a more painterly effect. Da Carpi, who used the technique primarily to achieve the effect of wash drawings, claimed in 1516 to have invented it, despite the earlier experiments of German artists: for example, Hans Burgkmair's *St. George on Horseback* (1508), at first printed partially in metallic inks suggestive of medieval manuscripts. Perhaps with the help of cutter Jost de Negker, Burgkmair next omitted the metallic highlights and combined the black line block with a tone block that echoed colored paper (fig. 2.17). Paired with an equestrian portrait of the emperor, *St. George* emphasized Maximilian's identification with the Christian knight.[41] Lucas Cranach the Elder's *St. Christopher* (ca. 1509; fig. 2.18) is a vigorous restatement of an old motif (compare the Buxheim *St. Christopher,* fig. 1.5) that gained greater significance as the association between spirituality and the landscape grew during the sixteenth century.[42] In one

FIGURE 2.16
Albrecht Dürer. Melen-colia I. 1514. Engraving. 241 × 189 mm. Cleveland Museum of Art.

FIGURE 2.17
Hans Burgkmair. St.
George on Horseback.
*1508. Chiaroscuro wood-
cut. 320 × 231 mm.
Graphische Sammlung
Albertina, Vienna.*

FIGURE 2.18
*Lucas Cranach the
Elder.* St. Christopher.
*Ca. 1509. Chiaroscuro
woodcut. 281 × 199 mm.
Cleveland Museum of
Art.*

sense, the technique has been employed in both of these prints as a shortcut to achieve effects native to drawing. But the chiaroscuro woodcut had aesthetic possibilities all its own, allowing German printmakers to combine the nervous linearity they loved with a new sculptural plasticity created by broad tones. It must have been regarded as a significant discovery, because Cranach apparently back-dated *St. Christopher* to appear to have precedence over Burgkmair.

The vigor of chiaroscuro woodcut is especially evident in Hans Baldung Grien's *Witches' Sabbath* (1510; fig. 2.19), perhaps the masterpiece of German examples of the technique. It was printed with either an orange or a gray tone block. Like Cranach's *St. Christopher,* this woodcut has an extraordinary energy, but unlike the former, Baldung's print presents a relatively new subject matter with an unprecedented intensity and completeness.

Despite its traditional title, it probably does not represent the large, orgiastic homage to the Devil called the witches' *sabbat* or sabbath, but the magical preparations, including the rubbing of the witches themselves and their forked sticks with the drug-laden "flying unguent"

FIGURE 2.19

Hans Baldung Grien.
Witches' Sabbath
(Witches Preparing for
the Sabbath Flight).
*1510. Chiaroscuro wood-
cut. 379 × 260 mm.
Museum of Fine Arts,
Boston.*

in the central jar, for levitating *to* this gathering. Although Dürer's art and personality had enormous impact on his pupil and lifelong friend, Baldung's work took a decidedly individual direction, even from their earliest association. Here, the wildly gesticulating, naked witches cook their repulsive brew amid a clutter of bones, sticks, and other paraphernalia. Along with Dürer's *Four Witches* (fig. 2.7), this print introduces us to the disturbing world of witchcraft belief that was soon to escalate into the genocidal witch-hunts of the late sixteenth and early seventeenth centuries. The fact that this subject now appears in *prints* is one indication of its growing appeal. Baldung's attitude toward these women was partly satirical,[43] but he also revealed his penchant for observing the dark side of human nature that the far more idealistic and spiritual Dürer tended to suppress or control.

Baldung also stands out as an exceptional woodcut artist when working with pure line. He directed the line-woodcut away from Dürer's approximation of engraving toward a more direct, raw vigor, while retaining its capacity to define powerful volumes and masses. His best-

FIGURE 2.20

Hans Baldung Grien.
The Bewitched Groom.
1544. Woodcut. 338 ×
198 mm. Cleveland
Museum of Art.

known woodcut, *The Bewitched Groom* (1544; fig. 2.20), portrays a man rendered helpless or dead by a witch and a malevolent horse. It remains enigmatic despite many attempts to explain it in narrative or allegorical terms. The presence of the artist's coat of arms on the stable wall suggests that the horse and the witch are personal demons to which he has succumbed or which, at the very least, dominate his artistic imagination. Both the witch and the horse function in Baldung's art as representatives of irrepressible appetites that come into conflict with Christian morality and reason.[44]

FIGURE 2.21

Urs Graf. The Standard
Bearer of the Canton
of Unterwalden. *1521.*
White-line woodcut.
198 × 108 mm. Ville de
Genève, Geneva.

The eerie effect of the image depends not only on the ambiguous situation it depicts but also on its sheer boldness of form. The pronounced massiveness of the horse and groom, both sharply foreshortened, seems too much for the room to contain. The spatial recession pulls us back quickly, while the projecting glance and huge rear end of the horse (ironically taken from Dürer's gentle *Large Horse,* an engraving of 1505) propel us back to the picture plane, where the fascinating woodcut lines—now architectonic, now wildly curling—exist in and for themselves. We become aware that the forms on the base of the pier to the left are nearly repeated in the capital and that there is a disturbing similarity among the coursing lines in the witch's torch, the horse's mane and tail, the hay, and the rumpled sleeves of the groom. *The Bewitched Groom* proclaims an imaginative freedom, and yet (if we can indeed take the groom as the artist's alter ego) warns of its dangers. Baldung has clearly left Dürer's more balanced world for an eccentricity more akin to later sixteenth-century Mannerist art.

The robust, arabesque linearism of the Swiss artist Urs Graf bears much in common with Baldung's style. An exact contemporary of the Strasbourg artist, Graf also plunged headlong into the sensual aspects of life with even less faith in restraint and rationality than Baldung seems to have had. His quirky individualism emerges in his drawings and prints, such as this white-line woodcut, *The Standard Bearer of the Canton of Unterwalden* (1521; fig. 2.21). In this technique of woodcutting, the positive design is carved out of the block, leaving a much greater portion of it to be inked. Here, the white lines flash against the black ground to express the flamboyance of the uniform with its split sleeves, feathered cap, tight leggings, and prominent codpiece. When not in jail for his unruliness and intractability, Graf spent much of his time

with the Swiss mercenaries who fought against the French for control of the Duchy of Milan. His drawings show that he knew not only the pageantry of war, revealed in our woodcut, but also its horror; one depicts the gore of a battlefield, another an armless woman with a wooden leg, a camp-follower apparently wounded in crossfire.[45] When understood in the context of all his works, the rooster-like arrogance of the soldier is conditioned by Graf's awareness of the precariousness of life.

The emperor Maximilian sponsored a number of printed projects that utilized the talents of many artists and took printmaking into realms formerly reserved for the arts of architecture and pageantry.[46] Within his far-flung empire, Maximilian realized, prints could serve important political purposes. Dürer functioned as the chief designer for the *Triumphal Arch* (fig. 2.22), a paper tribute to the emperor comprising 192 woodcuts, which, when assembled, would measure about 11 by 9.5 feet (3.4 by 2.9 meters). He collaborated with Johannes Stabius, Maximilian's poet, astronomer, and historiographer, who devised the program, the architect Jörg Kölderer, the woodcutting firm of Hieronymus Andrae, and his friend Willibald Pirckheimer, who helped with the work's iconography. The *Arch* was completed in 1517 and was to be supplemented by an equally remarkable *Triumphal Procession*, a long frieze composed of individual woodcuts (fig. 2.23). The completion of the *Procession* was cut short by Maximilian's death in 1519, but Dürer published the imperial chariot—formed from eight woodcuts of his own design—in 1522. About half of the remaining woodcuts of the *Procession* were designed by Hans Burgkmair the Elder of Augsburg. Other artists who worked on the project were Albrecht Altdorfer, Wolf Huber, Hans Springinklee, Hans Schäuffelein, and Leonhard Beck. The woodcuts by these artists were published in 1528–29, without Dürer's, by order of Ferdinand, king of Bohemia.

The affable if bombastic and imperious spirit of Maximilian, the "last knight," reigned over these graphic projects. ("We do not like it and are displeased," he wrote of the *Arch* to Stabius in 1517.)[47] In one of the illustrations for his autobiographical novel, *Der Weisskunig* (the title plays on *weiss*, "white," and *weise*, "wise"), he benevolently oversees the artist in the latter's studio (fig. 2.24). Although the artist here is painting, it was printmaking in which Maximilian's patronage had the most impact. *Der Weisskunig* was illustrated with more than two hundred woodcuts by Beck and Burgkmair. The relationship between artist and monarch revealed in Burgkmair's print speaks as much for the status of the artist's profession as it does for the erudition of the monarch.

The assimilation of Italian motifs and style that had been so important to Dürer accelerated in his wake. The so-called *Kleinmeister* (Little Masters)—Barthel Beham, Hans Sebald Beham, and Georg Pencz of Nuremberg, and the Westphalian artist Heinrich Aldegrever, among others—utilized Italian models with a greater facility made possible by his example.[48] Their small, jewel-like prints reveal a broad command of the nude and of classical ornament. An educated elite enjoyed the Italianate references and appreciated the small format and fine detail of the prints, which could be easily mounted in books or placed among the other precious objects in the *Kunstkammer* (collector's cabinet).[49]

Barthel Beham, the most talented of the group, studied in Rome with Marcantonio Raimondi, as he had with Dürer in his native city. His *Virgin and Child at the Window* (ca. 1529; fig. 2.25) is freely adapted from an engraving of Helena's vision of the cross from the circle of Raimondi,[50] who had calmed Dürer's technique and made it more rigid. A simplicity and monumentality that are thoroughly Italian in feeling pervade Beham's print. However, the

FIGURE 2.22
Albrecht Dürer and others. Triumphal Arch of Maximilian. *1515–17. 192 woodcuts, measuring 3409 × 2922 mm when assembled. Österreichische Nationalbibliothek, Vienna.*

FIGURE 2.23
Hans Burgkmair. Masked Standard Bearer and Footmen *from the* Triumphal Procession of Maximilian. *Ca. 1516–18. Woodcut. 380 × 370 mm. College of Wooster Art Museum, Wooster, Ohio.*

FIGURE 2.24
Hans Burgkmair. Emperor Maximilian Instructs the Artist *from* Der Weisskunig. *1514–16. Woodcut. 200 × 195 mm. Metropolitan Museum of Art, New York.*

FIGURE 2.25

subtle, warm light that reveals a variety of textures recalls Dürer's *St. Jerome in His Study*
(fig. 2.15).[51] So unobtrusive are the symbols of the Virgin Birth (the vase of lilies, the tower,
and the glass carafe) and so serene is the halo-less Mary that the engraving seems at first to be
a simple image of motherhood. Only a hint of Mary's sorrowful meditation on her son's future
Passion qualifies the down-to-earth character of the image.

 All three of the Nuremberg *Kleinmeister* were expelled from the city in 1525 for their
spiritualistic religious views.[52] The repudiation of the basic tenets of Christianity by the three
"godless painters," as they were called, was one of the many extreme responses to the religious
revolution launched by the Reformation. Dürer, however, after long thought and struggle,
embraced an emerging Protestant world-view that apparently enabled him to mend the rift
between art and piety implied in the contrast between *Melencolia I* and *St. Jerome in His Study*
(see figs. 2.15, 2.16).

The Reformation changed the course of European history and the role of art within it, and prints were not exempt from these sweeping changes.[53] We have seen how early prints functioned satirically, but their polemical, propagandistic capacity received its first great impetus from the Reformation. The *Formschneider* and *Briefmaler* enjoyed a booming business producing broadsheets dealing with Reformation issues, and the Protestant banner was taken up by a number of prominent artists as well. Hans Holbein the Younger's *Hercules Germanicus* (fig. 2.26), a hand-colored woodcut dating from about 1520, represents Luther as a northern Hercules, vigorously clubbing the papists, scholastic theologians, and indulgence-sellers. Around his neck dangles a "lion's skin" made of a flayed pope. In a dynamic woodcut portrait of Luther by Baldung (1521; fig. 2.27), used as frontispiece for a pamphlet, Luther appears with a halo, the dove of the Holy Spirit, and a Bible.

Here, Baldung summarized the widespread feeling, echoed by Dürer in his letters and diaries, that Luther had not only made the Bible accessible to the broad masses by his German translation, but had also interpreted scripture with a revelatory force and clarity. The likeness of Luther in Baldung's print is in turn based on an engraving by Lucas Cranach the Elder (1520; fig. 2.28), who emphasized his sturdy "peasant's" face. Cranach was, in fact, Luther's close friend, and his workshop was to provide the illustrations for Luther's Bible of 1522. It supported the religious controversy with numerous polemical prints, exemplified by Lucas Cranach the Younger's *Two Kinds of Worship* (ca. 1550; fig. 2.29), which explains, from the Protestant viewpoint, the differences between Protestant and Catholic services. The latter are depicted as incontrovertibly materialistic and shallow; the Protestant as serenely pious. In contrast to the flurry of seemingly aimless activity on the right, only two sacraments—baptism and communion in which the laity receive both bread and wine—occupy the Protestants. Luther himself preaches the gospel while the Elector of Saxony cranes his head to glance at us from the attentive audience. Equally strident prints spoke out for the Catholic side. In one anonymous engraving of the early 1500s (fig. 2.30), Luther pretends piety while sporting a wolf's tail and listening to a demon (just as the monk in Cranach the Younger's woodcut is diabolically inspired!). At times, the polemics sank to salacious mud-slinging: an anonymous trick woodcut with folding flaps (ca. 1535; fig. 2.31) showed Luther and a nun exposing themselves. (The woman may represent Luther's wife, the former nun Katharina von Bora.) Along with the other exhibitionists featured in the print, a doctor holding a uroscopy flask (for viewing urine) and a mendicant friar, Luther and Katharina are characterized as lewd. The Protestant opposition to clerical celibacy is motivated, we are to conclude, by the same base instincts that drive physicians and priests, both frequent targets of social satire.[54]

We might better understand the vehemence of these prints by looking at works, such as Dürer's *Sudarium Held by One Angel* (1516; fig. 2.32), that reveal the depth of spiritual unease before the onset of the Reformation in 1517. In this surprising image, Dürer employed the recently developed technique of etching to achieve an agitated expressiveness that he usually kept under a modicum of control. In other contemporary etchings—*Agony in the Garden, Abduction on a Unicorn,* and especially the strange and disorderly *Desperate Man,* probably his first, "practice" attempt at the process—Dürer hinted at a religious crisis of his own. Before

FIGURE 2.26

Hans Holbein the
Younger. Hercules Ger-
manicus. *Ca. 1520. Hand-
colored woodcut. 345 ×
226 mm. Zentralbib-
liothek, Zürich.*

we examine the *Sudarium*'s meaning, however, we need to digress briefly into the etching technique itself.

If engraving emerged from the goldsmith's art, etching originated in the armorer's craft. When armor was decorated with paint, it rusted, and so fifteenth-century armorers developed a way of coating the metal with a layer of protective wax and allowing a mixture of vinegar, sal ammoniac, and vitriol to "bite" the design into the metal slowly, over a periods of days. About 1500, the Augsburg armorer Daniel Hopfer and his two sons etched flat plates to be printed like engravings. If accurately dated, Graf's flamboyant *Girl Bathing Her Feet,* preserved in only one grainy impression in Basel, would be our earliest known etching (1513). The woman, with her feathered hat, revealing bodice, and raised skirt, is one of the prostitutes who populate Graf's oeuvre along with his fellow mercenary soldiers.[55]

The first etching plates, including Dürer's, were iron; they produced a coarse line and had to be kept oiled to prevent rusting. About 1520 Lucas van Leyden substituted copper for iron: the problem of rust was eliminated and a much finer line could be obtained. Gradually, more sophisticated *grounds* (mixtures of waxes, gums, and resins) and faster *mordants* (dilute nitric acid, perchloride of iron, or diluted hydrochloric acid with chlorate of potash—the so-called Dutch bath) were devised, and by the seventeenth century, etching had become a highly efficient and popular process.

As we shall see, the great advantage of etching is its potential for speed and spontaneity of execution. The lines are produced not by carving into metal, but by scratching through the ground—the acid does the physical work of incising the plate. The ground is spread on by

FIGURE 2.31
Unknown German artist. Hand-colored trick woodcut with Martin Luther and a Nun (Katharina von Bora?) Exposing Themselves. *Ca. 1535. Woodcut. Germanisches Nationalmuseum, Nuremberg.*

dabbing, rolling, melting (when the plate is heated), or pouring (when the waxy mixture is dissolved in chloroform). By holding the plate against burning candles, the ground can be smoked so that the artist can see the shiny copper against a dark surface. After the image is drawn, the plate is immersed in an acid bath (early in the history of etching, printmakers probably built wax walls to contain the acid on the plate). The etcher must be skilled enough to calculate the length of the bath. A longer exposure will mean deeper lines, which hold more ink and print darker. Too long a bath will cause an encroachment of acid *under* the ground

FIGURE 2.32

Albrecht Dürer. The Sudarium Held by One Angel. *1516. Etching. 185 × 134 mm. Cleveland Museum of Art.*

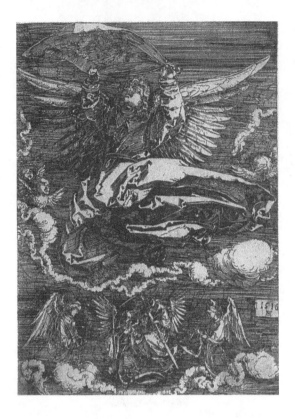

and *between* the desired lines (two distinct lines, so bitten, merge). Similarly, any misapplication or breakdown of the ground during immersion will cause such *foul-biting,* unwanted crevices or pits that hold ink. One can complicate and lengthen the etching process by multiplying the number of baths. An artist who wants to make particular areas of the image darker can do so by varnishing or *stopping-out* the parts that he or she wants to remain as they are and then re-etching the plate. Rembrandt and Callot would both exploit this potential, with completely different effects. Since etched plates are wiped and printed like engraved plates, the etcher can achieve many variations here as well, leaving *surface tone* (a light film of ink) or more concentrated areas of ink, as in *retroussage,* a process of drawing the ink up from the lines with the tarlatan.

Close-up, the etched line is entirely different from the engraved line. In cross-section, it looks like a pit—a broad ∪ rather than a ∨. It neither swells and tapers like a burin line nor prints as crisply. Burr is absent. Like the drypoint line, the etched line is looser and freer than one made with a burin, and as close to a drawn line as is possible in printmaking, at least until the invention of lithography in the late eighteenth century.

In Dürer's *Sudarium* etching, Veronica's veil, in Panofsky's words, "billows like the sail of a ship on a stormy night. . . . Space seems to have dissolved into a darkness pervaded by a long wail of lament, and nothing seems to be left but the accusing symbols of the Passion floating 'upon the face of the deep.'"[56] To compare this etching with an engraving of a few years earlier (fig. 2.33), in which the sudarium retains its iconic appearance—Dürer "standardized" Christ's countenance—and is securely held by two angels, is to understand something about Dürer's spiritual malaise. For a devout artist, for whom the making of the image of Christ was of vital importance, the near loss of the sudarium in the etching might function as a metaphor for the undermining of his *raison d'être,* an erosion of earlier confident assumptions about the role of

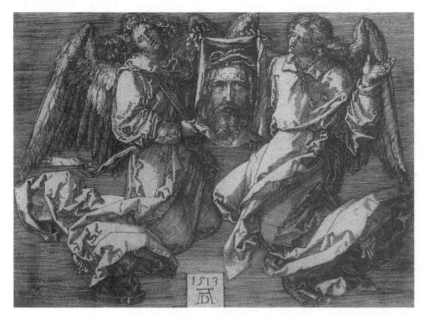

FIGURE 2.33

Albrecht Dürer. The
Sudarium Held by Two
Angels. *1513. Engraving.
100 × 139 mm. Cleveland
Museum of Art.*

the Christian artist. Moreover, images of Veronica's veil were the first to be indulgenced (by Pope Innocent III in the early thirteenth century), and they had proliferated since then.[57] Does this etching reflect Dürer's questioning of this practice?

Similarly but more provocatively, Baldung's *Christ Carried to Heaven by Angels* (woodcut, 1515–17; fig. 2.34) seems to show the Christian Trinity broken apart, its components off-axis and separated. Are we to read this as merely another example of Baldung's insistent and often bizarre inventiveness, or does the print reveal a genuine doubt about one of the fundamental tenets of Christianity? It is only with considerable effort that the viewer can resolve the paradox expressed here. In contrast to the still unified, still comforting image of the Trinity in Dürer's only slightly earlier woodcut, *The Holy Trinity* (fig. 2.35), in which Christ's elegant and eloquent body is held lovingly by God the Father, Baldung's awkwardly overturned Christ is pushed upward to a distant God by fat, puffing angels. His arrival seems dubious. Baldung's woodcut technique, with its strident wave-like and angular lines, is as wrenching as his unorthodox treatment of the subject matter.[58] Dürer, on the other hand, had pushed woodcut as far as it could go toward complete tonality. *The Holy Trinity* is astonishingly like his engravings of the same period in which the "graphic middle tone" is fully realized.

One of the many givens of Renaissance Christianity that was called into question during the Reformation was the role of art in worship. The age-old prohibition of idolatry fueled iconoclastic riots over northern Europe, and artists who had made their livings producing altarpieces and other devotional objects were thrown out of work. Dürer's basically unshakable piety and his intellectual determination allowed him to conceive, in his famous painting *The Four Apostles* (1526), or in an engraving like *The Madonna with the Swaddled Child* (1520; fig. 2.36), a formal and iconographic austerity that would permit art to function in a Protestant context. His Madonna is not a heavenly queen but the earthly mother of Christ. The iconography of the print is restricted to the suggestion of Christ's death and sacrifice conveyed by the somber tonalities and the swaddled, sleeping child. The more florid aspects of Dürer's style are severely curtailed. But such clear efforts to move toward what we might call a "Protestant

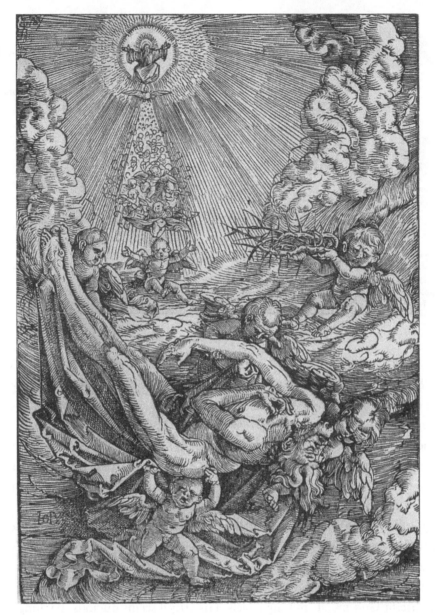

aesthetic" were not typical. Altdorfer's *Beautiful Virgin of Regensburg* (color woodcut, 1519–20; fig. 2.37, color plate, p. 461) harks back to the more primitive devotional imagery we encountered at the beginning of our study. Despite its technical sophistication (Altdorfer used a line block and five color blocks), the woodcut probably functioned as a pilgrim souvenir, sold at the shrine of the "Schöne Maria" of Regensburg—a thirteenth-century Italo-Byzantine icon that Altdorfer had copied in paint. Although Dürer had castigated the ecstatic veneration of Mary at this shrine (he wrote his remarks on a souvenir woodcut by Michael Ostendorfer),[59] Altdorfer in this print seems to have participated without hesitation in the "unreformed" mentality represented by the shrine. There could be no greater contrast to the strict Christo-centrism of Dürer's contemporary engraving, and no clearer evidence of the variety of religious attitudes that coexisted in the Reformation. Later, in 1533, Altdorfer would vote as a city councillor to replace the Catholic services in Regensburg with Protestant worship.

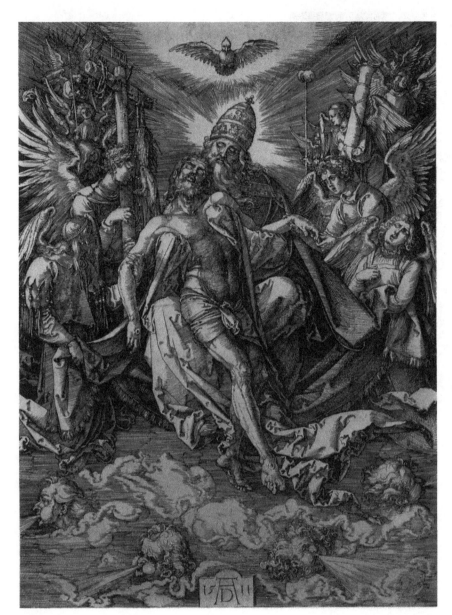

FIGURE 2.35

Albrecht Dürer. The
Holy Trinity. *1511. Wood-
cut. 391 × 282 mm. Cleve-
land Museum of Art.*

Riding on the coat-tails of the Reformation were a number of social, economic, and
political issues that had little to do with Christianity per se. In 1550 the shoemaker-poet Hans
Sachs of Nuremberg added a verse to a bizarre and grisly hand-colored woodcut of rabbits
catching hunters and their dogs by Georg Pencz (1534–35; fig. 2.38). Although the print is
blandly titled *Everyone Should Bear His Yoke at This Time and Overcome His Misfortune with
Patience,* the implications of the image and of Sachs's verse are more pointedly political. The
normally passive hares have taken over the domain of the hunters and hounds, busily trapping
them, sentencing them to death, executing them, and cooking them. The final lines of Sachs's
poem read:

> It is true, as Seneca says,
> That whatever man practices great
> Tyranny, levies high taxes and

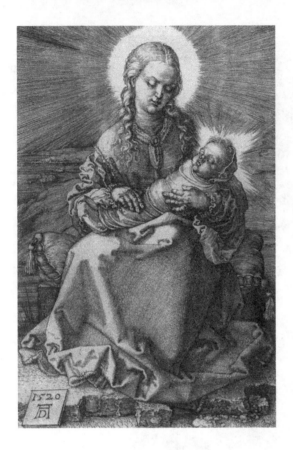

Exploits his people,
Thinking to oppress his subjects
So that they fear and respect his person,
Must himself fear many of them.
And if he should overdo it
His actions will perhaps be rewarded
With violence.[60]

Any utopian dream for a united Germany (such as Dürer perhaps expressed in his *Apocalypse*)
was completely shattered by the violence of Protestant-Catholic conflict itself, the contentious-
ness of the wide-ranging Protestant factions, and the deep-rooted class conflicts that began to
bubble to the surface more frequently in early modern Europe. In the Peasant War of 1525, to
which our woodcut may obliquely refer, a revolt of the lower classes was brutally suppressed by
the German nobility, with whom Luther sided. Like the hares in this print, the peasants banded
together to reverse the order of things. Subsequently, they were satirized as morally inferior in
graphic art by the Behams and others,[61] and kept down by taxation and repression, whose
excessiveness Sachs warns against here.

In the face of the tenuous position of religious art within Protestantism, many artists
turned more frequently to ostensibly secular subjects such as portraiture, classical themes,
genre, and landscapes. As Jeffrey Chipps Smith has stated about Nuremberg artists, "If
Albrecht Dürer and the early humanists had paved the way for artists to understand the lesson
of Italian art and culture, the Reformation pushed local artists fully into the Renaissance."[62]
Another example is Hans Holbein of Augsburg, who left the continent for long periods to

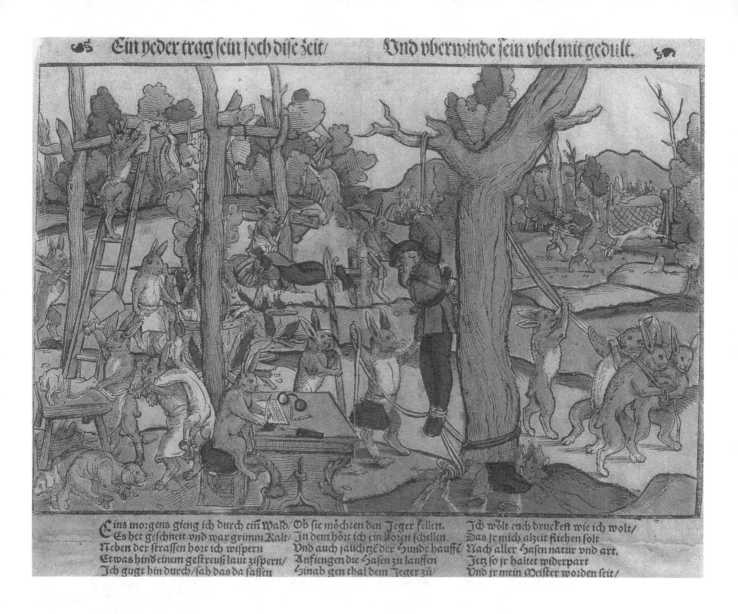

Eins morgens gieng ich durch ein Wald/ Ob fie möchten den Jeger fellen. Ich wölt euch druckeft wie ich wolt/
Es het gefchneit vnd war grimm Kalt/ In dem hört ich ein Horen fchellen. Das jr mich alzeit fliehen folt
Neben der ftraffen hort ich wifpern Vnd auch jauchtze der Hunde hauffe/ Nach aller Hafen natur vnd art.
Etwas hind einem geftreuß laut zifpern/ Anfiengen die Hafen zu lauffen Jetz fo jr haltet widerpart
Ich gugt hin durch/fah das da faffen Hinab gen thal dem Jeger zu/ Vnd jr mein Meifter worden feit/

work as a court portraitist for Henry VIII of England. Perhaps paradoxically then, much as it provided a forum for political and social issues, the spiritual upheaval of the Reformation fostered art's concern for the worldly aspects of life. These aspects, however, were often treated with a spiritual underpinning, such as an ironic sense of how the ephemeral world fails us. The diminutive woodcuts of Holbein's *Dance of Death* (designed 1523–26; published 1538), for example, put all worldly concerns into their proper perspective. A nimble Death appears in all kinds of social contexts—as a thief stealing gold from a horrified miser, as a member of the papal entourage, as a companion to a handsome young man who distracts a flighty nun from her devotions, or to a farmer as he plows (see figs. 2.39–2.42). Cutter Hans Lützelburger preserved all the humor and vigor of Holbein's designs. No one escapes Death's lively dance, and his mischievous glee as he approaches his victims effectively warns us against our pretensions and castigates our moral weaknesses.

FIGURE 2.38

Georg Pencz. Everyone Should Bear His Yoke at This Time and Overcome His Misfortune with Patience (The Hunters Caught by the Hares). *1534–35 (verse by Hans Sachs added 1550). Hand-colored woodcut. 254 × 393 mm (image without inscription). Museum of Fine Arts, Boston.*

FIGURE 2.39

Hans Holbein the Younger (cut by Hans Lützelburger). The Miser *from* The Dance of Death. *1523–26; published in 1538. Woodcut. 64 × 47 mm. Cleveland Museum of Art.*

FIGURE 2.40

Hans Holbein the Younger (cut by Hans Lützelburger). The Pope *from* The Dance of Death. *1523–26; published in 1538. Woodcut. 64 × 48 mm. Cleveland Museum of Art.*

FIGURE 2.41

Hans Holbein the Younger (cut by Hans Lützelburger). The Nun *from* The Dance of Death. *1523–26; published in 1538. Woodcut. 65 × 48 mm. Cleveland Museum of Art.*

FIGURE 2.42

Hans Holbein the Younger (cut by Hans Lützelburger). The Ploughman (Death and Everyman) *from* The Dance of Death. *1523–26; published in 1538. Woodcut. 66 × 50 mm. Cleveland Museum of Art.*

FIGURE 2.43

Lucas van Leyden. The Milkmaid. *1510. Engraving. 115 × 155 mm. Cleveland Museum of Art.*

VAN LEYDEN, THE DANUBE SCHOOL, BRUEGEL

Despite their moralization and the omnipresence of Death, Holbein's prints sparkle with the delight he took in the little vignettes of daily life. As a category of subject matter, genre had been gaining in importance in the fifteenth and sixteenth centuries. Lucas van Leyden's *Milkmaid* (engraved in 1510; fig. 2.43) foreshadows the poetry of the ordinary that characterizes the genre scenes favored by his seventeenth-century countrymen. And, like many such seventeenth-century scenes, *The Milkmaid* has provoked speculation about possible meanings. Are the shepherd and milkmaid related to each other erotically? Largely on the basis of a pun in sixteenth-century Dutch (*melkan*, "to milk," and *lokken*, "to lure"), Leo Wuyt has seen the print as an allegory of lust and free will.[63] So, despite the homely details and the dominating presence of the cows, looking much like the monumental bovine subjects of Aelbert Cuyp's paintings a century later, Lucas may have been inviting his audience to contemplate sin. Such an interpretation makes the rather coy pose and glance of the milkmaid more understandable—the bumbling shepherd is the prey who will fall victim to her sexual power (a common theme in fifteenth- and sixteenth-century art). In the center of Lucas' architectonic composition is the head of a cow, who stares out at us and draws us into the suspenseful exchange of glances by the drama's protagonists.

Lucas was apparently a youthful prodigy (although we do not know how youthful; debate regarding his exact birthdate continues), who emerged about 1508 with the distinctive style exhibited in *The Milkmaid*. Printing imperfections, such as interrupted lines, blotches caused

by movement of the paper in the press, and small dots resulting from flaws in the copperplate, suggest that Lucas was something of a pioneer in engraving in Leiden, working without benefit of a strong graphic tradition or proper materials. His dry, non-oily inks contributed to the silvery tonalities of his prints.[64]

A silvery light dominates Lucas' *Ecce Homo* (1510; fig. 2.44), an epic engraving that was to inspire Rembrandt's drypoint *Christ Presented to the People* (see figs. 4.52, 4.53). In both prints (at least until Rembrandt altered his conception in the fifth state), the genre elements—the rabble that called for the release of Barabbas—take over the foreground. A stone parapet and a vast spiritual distance separate the crowd, and us, from Christ. But our slightly elevated position gives us an edge in distinguishing the spiritual from the worldly, which is magnificently embodied in the print by a busy, urban setting, drawn with impeccable perspective. In fact, this setting is based on the actual town square of Leiden.[65] Both the large size of this engraving—it is as big as Schongauer's *The Bearing of the Cross* (fig. 1.39)—and its detail reveal Lucas' intention to rival the greatest graphic artists he knew: Schongauer before him and Dürer, a close contemporary with whom he was to exchange prints in 1521.[66]

It was not only ordinary human activities and environments that gained importance during this period, but also nature itself, apart from other subject matter or as a setting for it. In both German and Netherlandish art of the sixteenth century, landscape became an independent subject. The relatively new medium of etching, exercised much like pen drawing, found one of its most enduring theaters.

FIGURE 2.45
Albrecht Altdorfer.
Landscape with a Large
Pine. *Ca. 1520–23.*
Etching. 225 × 170 mm.
Fitzwilliam Museum,
Cambridge University.

Albrecht Altdorfer's *Landscape with a Large Pine* (etching, ca. 1520–23; fig. 2.45) is one of the many studies of the Danube valley produced by artists of the Danube School.[67] In 1494–95 Dürer had painted watercolor landscapes, but autonomous *printed* landscapes are doubly remarkable, for they imply a substantial audience, created by the nationalistic and spiritual significance the German landscape had acquired. The dense German forests were pictured as

FIGURE 2.46

Augustin Hirschvogel.
Landscape with a Village
Church. *1545. Etching.
155 × 188 mm. National
Gallery of Art, Wash-
ington, D.C.*

FIGURE 2.47

Hanns Lautensack. Land-
scape with a Castle and
Radiating Sun. *1553.
Etching. 164 × 111 mm.
National Gallery of Art,
Washington, D.C.*

proving grounds for the trials and meditations of saints or for ancient national virtues.[68] In-
deed, topographical or invented landscapes continued to carry such meanings for various na-
tionalities, providing one of the major themes for prints in the centuries to come.

In Altdorfer's etching, the sweep of space is convincing, not only back toward the horizon
but up toward the mountaintops and the sky. The large tree is instrumental in both cases: first,
it acts as staffage against which distance can be measured, and, second, it draws the eye upward
and beyond the picture's edge. Typically for the Danube school, the viewer's spatial position is
in mid-air. Altdorfer's terse, curving lines, isolated or grouped into little explosive bunches,
swell, flow, and droop as direct expressions of nature's vital forces. Humanity and its petty or
futile endeavors are dwarfed or engulfed.

The second generation of Danube school artists carried on Altdorfer's vision of nature,
but in their hands it became further removed from observed reality. Among the various occu-
pations of the Nuremberg artist Augustin Hirschvogel was cartography—he developed the
modern trigonometric system of surveying. The objectivity necessary for this activity is absent
from his poetic *Landscape with a Village Church* (etching, 1545; fig. 2.46) in which Altdorfer's
linear vocabulary is forcefully exaggerated and condensed (compare the drooping moss).
Although equally mannered in his adaptation of Altdorfer's style, Hanns Lautensack, per-
haps trained as a goldsmith in Nuremberg, moved in the opposite direction, creating con-
voluted filigrees that are almost reducible to individual leaves, pebbles, and dewdrops. His
etching of a landscape at sunrise (1553; fig. 2.47) is less about nature than about a feeling nature
generates—the ecstatic sense of renewal is a human emotion metaphorically embodied in the
rising sun.

In Flanders, Pieter Bruegel the Elder also helped landscape attain autonomy as an art form. He was above all a great painter (his 1565 series, *The Months,* constitutes a landmark in landscape painting), but he tried his hand at etching once to produce the *Rabbit Hunters* (1560). As we shall see in the course of our history, etching frequently appealed to painters. In its simplest form it was a relatively easy technique to master, whereas engraving was completely unconquerable without considerable training. Moreover, in etching Bruegel was able to convey the atmosphere and soft details of his drawn landscapes, characteristics that tended to get lost in engravings after his designs.[69] In *Rabbit Hunters* (fig. 2.48), Bruegel suggested the corruption of human society by showing the hunter himself being stalked, perhaps by a game warden intent on catching a poacher, or by evoking Erasmus' saying, "He who hunts two hares catches neither."[70] But it is primarily through the contrast of the scattered evidence of human habitation—the figures, buildings, and boats—with the flow of space, as vast and convincing as that of Altdorfer's *Large Pine* (fig. 2.45), that humanity is criticized and nature is glorified. As Altdorfer did, Bruegel suggested circular, ovoid, or elliptical movements for the eye to follow, establishing a sense of nature's coherence, or the continuity and interrelatedness of life forms. Like other lowlanders before and after him, Bruegel was permanently impressed by the high terrain on a trip to Italy about 1552–53. Indeed, his many sensitive pen drawings of Alpine views are reflected in this print. But as important as Bruegel's personal experience of the Alps was his contact with landscapes in Venetian woodcuts by Domenico Campagnola (see fig. 3.47), Titian, and Girolamo Muziano: once again, prints served as the chief currency for stylistic interchange between the north and the south.[71]

Bruegel's work for the print publisher Hieronymus Cock in Antwerp was primarily in the form of pen drawings to be engraved by others. Cock's company, "The Four Winds," based on his experience of Italian reproductive engraving, was extremely important for the growth of this enterprise in the north, as we shall see in Chapter 5. The freshness of Bruegel's *Rabbit Hunters* suggests what is lost when the final print is detached from the original artist. Nevertheless, engravings after Bruegel's designs do furnish us with insights into his intellectual attitude, a cynical vision of the foibles and follies of human society. In the repressive political climate of the Spanish-dominated Netherlands, the criticism implicit in many of Bruegel's engravings must have seemed very thinly veiled indeed. His series *The Virtues* (1559), however, is problematic. *Justice* (fig. 2.49) gives a terrifyingly accurate account of contemporary punishments: chopping off the hand for thievery, burning at the stake, breaking on the wheel (wheels also litter the horizons in Bruegel's paintings). Although the Latin inscription reads, "The law aims to correct him whom it punishes, or to improve others by example, or to eliminate the wicked so that others shall live more securely," the image itself is a panorama of inhumanity, and this may have been the comment Bruegel intended to make, however laconically. The French essayist Michel de Montaigne would deplore the infliction of pain for the sake of justice in 1580.[72] We face a similar interpretive problem with Jacques Callot's etching *The Punishments* (before 1630), strongly influenced by Bruegel's print, and with the scenes of military justice in Callot's *Miseries and Misfortunes of War* (see figs. 4.15–4.17).

Sometimes hybrid forms excerpted and recombined from the weird menageries of Hieronymus Bosch appear in Bruegel's engravings. But the forms are divested of their religious significance; they are less concrete embodiments of evil opposing God (as in Bosch's near dualism) than the forces of unreason. Both the illness and the remedy are more human. In *The Temptation of St. Anthony* (fig. 2.50), related to Bosch's epic paintings of the saint's suffering at

FIGURE 2.48
Pieter Bruegel the Elder.
Rabbit Hunters. *1560.*
Etching. 223 × 292 mm.
Metropolitan Museum of
Art, New York.

the hands of his demonic torturers, Anthony turns away from the rotting "ship" of the Church, threatened by the Turkish hordes from without (note the turban sailing in from the distance) and by corruption from within. Only nature, a spectacular, precisely tuned organism, is perfect. All that is human, in Bruegel's view, is bound to be something less.

THE LATE SIXTEENTH CENTURY: PRINT COLLECTING AND INTERNATIONAL MANNERISM

Despite his visit to Italy, Bruegel's style remained obstinately northern. But, for the most part, late sixteenth-century northern artists were profoundly affected by (some might say drowned in) the tide of Italianate figures and motifs that came across the Alps, largely in the form of prints, such as the often reproductive engravings of Raimondi, Giorgio Ghisi, Domenico del Barbiere, and others. This interest in things Italian was not new, but its intensity certainly was. It was reinforced by increasing contact between the north and the south. Ghisi, for example, visited Antwerp in 1550, where he trained engravers for Cock, who published several of his plates. And at Fontainebleau, Francis I hired Italian artists as decorators. The

FIGURE 2.49

Probably Philipp Galle after Pieter Bruegel the Elder. Justice *from* The Virtues. *1559. Engraving. 225 × 295 mm. National Gallery of Art, Washington, D.C.*

fantastic, complex designs of Rosso Fiorentino and Primaticcio were engraved and etched by numerous printmakers, both French and Italian.[73] Their prints helped to spread the artistic sensibility of Italian Mannerism throughout northern Europe.

Extravagantly praised by painter-writer Carel van Mander in his crucial treatise on northern artists, *Het Schilderboek* (*Book on Picturing,* Alkmaar 1604), Hendrik Goltzius was the consummate Netherlandish Mannerist in printmaking.[74] He achieved superlative technical skill, both as a reproductive engraver (see Chapter 5) and as an original graphic artist, in spite of burns sustained as a child that stiffened his right hand. Goltzius' fame was significantly based on a predominantly *graphic* oeuvre, and it coincided with an escalation of appreciation for prints that built on the reputations of earlier virtuoso printmakers like Dürer and Lucas van Leyden and signaled an even greater status for prints in the seventeenth century.

From the second half of the sixteenth century, we begin to find evidence of prints functioning as integral parts of the wide-ranging private museums or *Kunstkammern* of wealthy collectors, as we noted in our discussion of the *Kleinmeister*. This evidence surely reflects an earlier tradition of collecting: Dürer and Lucas must have aimed many of their superb prints at a preexisting elite market. Moreover, the increasing technical finesse and complexity of content of prints since the late fifteenth century presuppose the existence of an audience conscious of these qualities. Even earlier than that, prints might be pasted into books in an attempt to better preserve them—a rudimentary form of collecting.

The earliest known formulation of the ideal print collection occurs in a treatise (1565) by Samuel van Quicchelberg, a Flemish bibliophile who helped reorganize the ducal collection of

Albrecht V of Bavaria. During the same period, Archduke Ferdinand of Tyrol was amassing a vast print collection in his own *Kunstkammer* at Schloss Ambras. Although late sixteenth-century collectors seem to have valued prints primarily for their subject matter, as additions to collections incorporating all sorts of natural and manufactured objects, we can also perceive an increase in the aesthetic appreciation of individual graphic masters, as well as a historical consciousness about prints that recognized these masters as part of a developing graphic canon. Ferdinand's collection, for example, included a volume of 224 Dürer prints and drawings. As we shall see in Chapter 4, this interest in unique graphic talents would culminate in a new way of arranging collections in the seventeenth century—by artist, rather than by subject—and in a vogue for acquiring impressions by the most individualistic printmakers like Hercules Seghers and Rembrandt.[75]

Just as Goltzius' career coincides with this new stage in the aesthetic appreciation of the original print, it also bears witness to the increased importance of reproductive prints, both as "records" of works in other media and as aesthetic creations in their own right. Trained by Dirck Volkertsz. Coornhert and influenced by another of Cock's pupils, Cornelis Cort, Goltzius in turn trained a generation of fine reproductive engravers: Jan Muller, his own stepson Jacob Matham, and Jan Saenredam, whose collective influence extended to the printmakers working under Rubens.

Goltzius' skilled use of the burin can perhaps best be observed in his famous *Standard Bearer* (1587; fig. 2.51), which derives from an old tradition of depicting the flamboyant pageantry of military uniforms (compare Graf's *Standard Bearer*, fig. 2.21). Behind the elegantly

Signifer ingentes animos, et corda ministro,
Me stat stante phalanx, me fugiente fugit.

dressed and posed figure is a military encampment and view of Haarlem. The year 1587 saw many reversals in the struggle of the northern Netherlands against the Spanish. Goltzius' proud engraving confirms his faith in the eventual victory of his hometown and his country. Indeed, the Latin inscription beneath the print, by emphasizing the leadership of the standard bearer, may refer indirectly to Haarlem, a staunch supporter of the revolt: "When the standard bearer advances, the troops advance; when he flees, they die." On the other hand, it has been suggested that the dandified quality of this figure subtly implies the superficiality of his courage.[76]

The influence of Goltzius' print on subsequent military imagery is due not only to its patriotic meaning but also to its formal beauty. Goltzius extended the delicate tonalities of Lucas' engravings into a pictorial system in which individual swelling lines of his invention are so varied or so fine and closely spaced that their separate existence is almost totally obscured in favor of broad areas of light and shade. A careful look at the splendid, silken, wind-rustled banner in this print will tell why Rubens sought Goltzius' pupils as reproductive printmakers—the Flemish master's extremely painterly style required a graphic equivalent in which line was minimized insofar as possible.

The Judgment of Midas (engraving, 1590; fig. 2.52) is an exemplary work of Mannerism; indeed, the Mannerist painter Bartholomeus Spranger (whose designs Goltzius also engraved) used this print as a basis for one of his painted compositions.[77] Sophisticated, erudite, and flawlessly polished in conception and execution, this engraving deals directly with the divine basis of great art, an idea that had appeared in the Neoplatonic philosophy of the Renaissance, but that began to be further explored in the newly theoretical and academic context of late sixteenth-century art. The story concerns the ever thick-headed King Midas, who has dared to prefer the pipes of Pan over the refinements of Apollo's playing and has been punished for his stupidity by growing donkey's ears. Judging the contest is King Timolus; flanking Apollo to the left are the Muses, while satyrs, of course, accompany Pan. The elongated figures and elegant, artificial poses are part of the repertory of international Mannerism, which was to become less concerned with nature and easily communicable ideas and more concerned with abstruse visual and intellectual conceits. This was, in a sense, a natural outgrowth of the quest for artistic autonomy that we have been tracing in this chapter. As we shall see, the convoluted path of Mannerism was to be cut short by the naturalism and directness of the Baroque style.

Goltzius' biography figured in the construction of a new history of art, expanded from Vasari's earlier and narrower version, in which Carel van Mander juxtaposed northern engraving—with Goltzius as its apogee—to Italian painting. And although it might seem odd to us today, Van Mander's praise of Goltzius centered on his chameleon-like ability to assimilate his own virtuoso handling of the burin to the manners of other artists. One anecdote in particular illustrates this: Goltzius' deception of artists and collectors alike with his *Circumcision* (fig. 2.53) in the manner of Dürer, part of his series of six scenes from the life of the Virgin (1594), each in the style of a northern engraver or an Italian painter. Not only did Goltzius approximate Dürer's handling of the burin in this print, but his understanding of the latter's figural groups and architectural settings in the woodcut *Life of the Virgin* (especially the corresponding scene of the Circumcision) is remarkable. Van Mander tells us that Goltzius went so far as to remove his monogram from the plate and darken an impression with smoke to age it, thereby convincing his audience that a long-lost Dürer print had been discovered. The name of Goltzius' series, the *Meesterstukje* (*Master Engravings*), also expresses the engraver's homage to and rivalry with Dürer, whose art began to be canonized toward the end of the century, especially in the Bavar-

FIGURE 2.52

Hendrik Goltzius.
The Judgment of
Midas. *1590. Engraving.*
409 × 669 mm. New
York Public Library.

FIGURE 2.53

Hendrik Goltzius. The
Circumcision *in the*
manner of Dürer. From
the Meesterstukje.
1594. Engraving. 465 ×
351 mm. Art Institute of
Chicago.

FIGURE 2.54

Hendrik Goltzius. Pietà
(Lamentation of the
Virgin) *in the manner
of Dürer. 1596. Engrav-
ing. 188 × 129 mm.
R. S. Johnson Fine Art,
Chicago.*

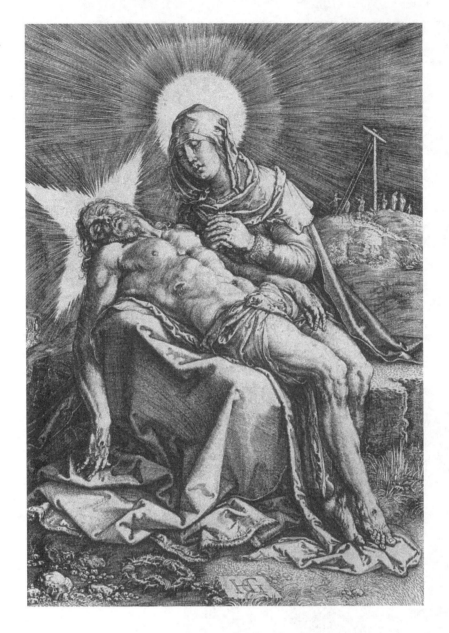

ian court. Goltzius dedicated his *Meesterstukje* to Wilhelm V of Bavaria, who awarded the artist
a gold chain for his efforts.[78]

Goltzius' *Pietà* (1596; fig. 2.54) is even more astonishingly like Dürer's engravings in style
and expressiveness (compare especially *The Madonna with the Swaddled Child,* fig. 2.36). The
dark, flickering chiaroscuro, the streaming rays of light, and the lingering concentration on
surfaces—note Mary's glistening tears—are pictorial devices that Dürer probably would have
used had he made an engraving of this theme. But the most important source for the poses of
Mary and Christ is Michelangelo's Vatican *Pietà* (1489/99–1500), which Goltzius must have
seen while he was in Rome. His interpretation differs greatly from Annibale Carracci's exquisite
contemporary etching of this theme, which we will encounter in Chapter 4 (see fig. 4.2).
Goltzius' *Meesterstukje* and his *Pietà* are especially good examples of both the historical aware-
ness and the consciousness of stylistic alternatives that mark the Mannerist sensibility.

It is one of the many paradoxes of Mannerism that it was, on the one hand, perfectly
suited to the stilted environment of late sixteenth-century courts and yet, on the other, lent

FIGURE 2.55

Juste de Juste? Pyramid of Six Men. *Ca. 1543. Etching. 255 × 203 mm. Los Angeles County Museum of Art.*

itself to extraordinary flights of personal eccentricity (we have been introduced to such idiosyncrasy in the works of Hans Baldung Grien). An unknown artist, perhaps one "Juste de Juste," attached to the court at Fontainebleau, etched curious figural pyramids that defy description or analysis (fig. 2.55). A close comparison is to Stefano della Bella's etchings of the Italian tumblers who performed in a tournament held by the d'Este court in Modena.[79] But Juste de Juste's naked acrobats are at once the culmination of the Renaissance's preoccupation with the figure and a mocking of this tradition. Despite their striking modernity, they recall Master E.S.'s *Fantastic Alphabet,* with its whimsical combinations of figures to make up letters (see fig. 1.36).

It is in the realm of religious art that the almost impenetrable eccentricity of some Mannerist artists is most evident. A *Pietà* (ca. 1615; fig. 2.56) by the great etcher Jacques Bellange of Lorraine gains its heightened intensity by means of an exaggerated affectation and artificiality characteristic of the extremely late stages of Mannerism.[80] Contrasted with Goltzius' Düreresque version of the theme as well as Annibale's etching, it seems extraordinarily peculiar (see figs. 2.54, 4.2). An impossibly proportioned Mary throws back her swan-like neck in anguish. The gesture of her right hand, with its long, splayed fingers, is meaningful only as a spasmodic expression of grief. Across her lap, her son's arms stretch as if they were made of rubber. His

FIGURE 2.56

Jacques Bellange. Pietà. *Ca. 1615. Etching. 320 × 200 mm. Metropolitan Museum of Art, New York.*

head and neck sink deeply between his pulled-out shoulder sockets. Despite this suggestion of Christ's suffering and the basket containing some of the Instruments of the Passion in the lower left, Bellange lingered over the melting sensuality of his body, which is pressed between Mary's legs as a graphic visualization of her role as mother and bride of the Saviour. A flame-like quality characterizes the group as a whole and its individual parts. What emerges is a morbidly pious sensibility that combines eroticism and devotion, pain and beauty.

The most remarkable of French Mannerist printmakers, strongly influenced by the Fontainebleau etchers and engravers, was Jean Duvet of Langres. His masterpieces are the twenty-three engraved plates of his *Apocalypse,* completed in 1555 when the artist was seventy. The heir of Dürer's epoch-making woodcuts of 1497–98, Duvet's *Apocalypse* provides a fitting conclusion to this chapter on printmaking in northern Europe in the sixteenth century.

FIGURE 2.57

Jean Duvet. Duvet as
St. John the Evangelist
(Duvet Studying the
Apocalypse) *from*
The Apocalypse. *1555.
Engraving. 301 ×
226 mm. Cleveland
Museum of Art.*

The frontispiece of the series, *Duvet as St. John the Evangelist* (sometimes entitled *Duvet Studying the Apocalypse;* fig. 2.57) is replete with the abstruse symbolism typical of Mannerism. It is as convoluted and personal in its meaning as Dürer's *Four Horsemen* (fig. 2.3) is forceful and social, yet Dürer himself had contributed mightily to the artistic freedom that made Duvet's series possible. The French artist took aspects of his iconography, such as the hourglass, the emaciated dog, and the other symbols of the four temperaments, from Dürer's famous engravings. The conventional representation of the melancholy temperament determines the pose of the artist/evangelist. His brooding, muscular form is also reminiscent of Michelangelo's Sistine ceiling prophets (Michelangelo, of course, epitomized the melancholic artist). The winged genius and the Platonic *daemon* with bellows spur the artist on to a final burst of creativity, as the swan, Duvet's personal emblem and also a symbol of death, breaks the chain

of life and presents the artist/evangelist with Apollo's arrows of death. A boat carrying the Three Fates, who cut the thread of life, floats incongruously through the air toward the artist. This engraving is Duvet's "swan song," his triumph over approaching death.[81]

Despite its allegorical fullness and humanistic allusions, Duvet's *Apocalypse* is an almost hermetic creation. The unstable energy, visionary intensity, and formal intricacy of its engravings, however, are traits held in common with Dürer's woodcuts discussed at the beginning of this chapter. Sixteenth-century northern prints introduce a multileveled complexity—a new expressive, technical, and aesthetic range—into our history. In the next century, northern Europe would produce printmakers, such as Rembrandt and Seghers, who also held complicated, personal, and intense visions of the potential of their media. The prints of the Italian Renaissance, to which we now turn, are part of a very different tradition. They possess a classical beauty and clear, southern light that lend them an irresistible appeal of their own.

NOTES

1. Cited in Strauss 1974, vol. 2, p. 1074. For an interpretation of the Heller letters, see Hutchison 1990, pp. 97–105. Dürer's complete written remains (in German) are collected in Rupprich, ed., 1965–69. For English translations of these, see Conway 1889; Conway 1958. Also see Hutchison 1990 for interpretations of Dürer's writings in the context of his biography, and an account of how his letters and diaries fit into the Renaissance understanding of these literary forms. The bibliography on Dürer is vast, and my references here are highly selective. For bibliography before 1971, see Mende 1971. Anzelewsky [1980] 1981 and Strieder [1981] 1982 are two recent monographs with substantial bibliographies. Despite its age, the standard work on Dürer is still Panofsky [1955] 1971.

2. See Hutchison 1990, pp. 27–39, on Dürer's "bachelor journey."

3. Strauss 1980, no. 13j, p. 72.

4. Ivins 1929.

5. Panofsky [1955] 1971, pp. 134–35.

6. Waetzoldt [1935] 1955, p. 35; Chadabra 1964, p. 47.

7. Chadabra 1964, pp. 98–99.

8. Strauss 1980, no. 53, pp. 195–96.

9. Juraschek 1955.

10. Hutchison 1990, p. 61.

11. Chadabra 1964, pp. 62–77.

12. Ibid., pp. 89–90.

13. See Panofsky [1955] 1971, pp. 51–59.

14. Ibid., pp. 22–23; Hutchison 1972, p. 35; and Filedt Kok, comp., 1985, p. 38, and no. 28, pp. 121–22.

15. For the various identifications of the insect, see Strauss [1976] 1981, no. 4, pp. 28–29. On Dürer's studies of plants and animals, see Koreny 1988.

16. Cited in Strauss 1974, vol. 2, p. 906. Also see Hutchison 1990, p. 96.

17. Poesch 1964 interprets the print in terms of the Three Graces and the Judgment of Paris. Dwyer 1971 interprets the engraving as representing Discord and the Three Fates, but allows for many different, layered meanings, witchcraft included. Perhaps the most complex interpretation in allegorical terms is Anzelewsky 1983, pp. 29–44.

18. See Strauss [1976] 1981, no. 19, pp. 62–64, for a summary of additional theories about Dürer's *Four Witches*. For an introduction to the tensions and contradictions in the representation of women in prints of the Renaissance and Baroque periods, see Russell 1990.

19. Panofsky [1955] 1971, p. 71; Anzelewsky 1983, p. 104.

20. This motif may or may not have been taken from the Master LCz's *Temptation of Christ:* see Shestack 1967, no. 125 (not paginated); Minott 1971, p. 17.

21. For a summary of the arguments about the proportions of Dürer's *Nemesis,* see Talbot, ed., 1971, no. 25, p. 129, n. 5.

22. See Strauss 1980, no. 94, p. 312 and p. 449;

Metropolitan Museum of Art and Germanisches Nationalmuseum 1986, no. 127, p. 302.

23. Strauss 1980, no. 156, p. 450.

24. Vasari [1568] 1851, vol. 3, pp. 492–93.

25. Conway 1958, pp. 100, 103–5, 108–9, 113, and 116. Also see Strauss [1976] 1981, no. 71, p. 196, no. 77, p. 212, and no. 79, p. 218. Grigg 1986 questions whether the diary entries can tell us which prints Dürer intended to go together. For the complete Netherlands diary along with sketches and paintings made during the trip, see Goris and Marlier [1970] 1971.

26. Panofsky [1955] 1971, pp. 151–55.

27. Ibid., pp. 152–53.

28. Gombrich 1969.

29. Karling 1970; Meyer 1978.

30. Panofsky [1955] 1971, pp. 151–55. For Dürer's Netherlands diary entry on Luther's disappearance, see Strauss 1974, vol. 4, pp. 1993–94; Hutchison, 1990, pp. 157–69.

31. Panofsky [1955] 1971, p. 152.

32. Theissing 1978 offers a thorough discussion of the symbolism of the print. For Dürer's use of dogs as symbols in the Master Engravings, see Reuterswärd 1981.

33. Theissing 1978, esp. pp. 131–38.

34. The two prints often appeared as part of larger groups. Grigg 1986 questions whether we can conclude that they were paired.

35. Parshall 1971.

36. Ivins 1948, p. 42.

37. For useful summaries of some of the interpretations, see Strauss [1976] 1981, no. 79, pp. 218–24; Metropolitan Museum of Art and Germanisches Nationalmuseum 1986, p. 312. The notes in Sohm 1980 (a reevaluation of the Klibansky, Saxl, and Panofsky theory of 1964) are also helpful.

38. Klibansky, Saxl, and Panofsky 1964.

39. Hutchison 1990, pp. 116–18, questions Panofsky's idea that *Melencolia I* is a spiritual self-portrait.

40. See Strauss 1973 on the chiaroscuro woodcut in the north.

41. Silver 1983, pp. 22–23.

42. Ibid., pp. 28–29.

43. Hults 1982; Hults 1987.

44. Hults 1984 (the notes provide earlier bibliography on *The Bewitched Groom*).

45. On Graf's war imagery, see Andersson 1978, pp. 27–46. See Hale 1986 on war imagery in Swiss and German art of this period.

46. See Silver 1985 for an overview of Maximilian's patronage of the graphic arts.

47. Strauss 1980, no. 175, pp. 500–501 (quotation on p. 500).

48. See Emison 1988.

49. See Goddard 1988.

50. Goddard, ed., 1988, no. 33, p. 133.

51. See Smith 1983, no. 98, p. 199.

52. See Moxey 1989, pp. 30–33, for a discussion of various proposed reasons for the Behams' expulsion.

53. On some of the ways in which religious themes were transformed during the Reformation, see Harbison 1969. Christensen 1979 is a general study of the impact of the Reformation on art in Germany and the position of art in Protestant thought. For a discussion of the impact of the Reformation on religious art in Nuremberg, see Smith 1983, pp. 23–38. Andersson 1985 is a study of Nuremberg polemical prints of the Reformation; Moxey 1989, pp. 24–29, discusses the effect of the Reformation on Nuremberg broadsheets of the sixteenth century.

54. Andersson 1985, pp. 52–54, discusses this and other trick woodcuts.

55. See Andersson 1978, pp. 61–66, on Graf's imagery of women.

56. Panofsky [1955] 1971, p. 197.

57. Ringbom 1965, pp. 23–24.

58. Hults 1981 is a discussion of the impact of the Reformation on Hans Baldung Grien. Baldung's unique approach to subject matter has been discussed by Kaufmann 1985; Koerner 1985; Marrow 1986.

59. See Christensen 1979, pp. 22–23, and p. 111, fig. 1.

60. Translated in Smith 1983, no. 106, p. 208.

61. See Moxey 1989, pp. 35–66, for a study of this satire.

62. Smith 1983, p. 36.

63. Wuyt 1974–75.

64. Jacobowitz and Stepanek 1983, p. 20.

65. See ibid., no. 30, p. 97, n. 4, for bibliography.

66. Dürer's Netherlands diary (Antwerp, June 8–July 3, 1521) mentions Lucas twice:

"Master Lucas who engraves in copper asked me as his guest. He is a little man, born at Leyden in Holland; he was at Antwerp." Also, "I gave him 8 fl. worth of my prints for a whole set of Lucas' engravings." (This latter passage gives interesting insight into the esteem in which Dürer's prints were held, even when compared with prints by one of the greatest artists of the Netherlands. See Conway 1958, pp. 122–23).

67. For a survey of the prints of the Danube school artists, see Talbot and Shestack, eds., 1969.

68. Silver 1983 discusses the various cultural factors that contributed to the Danube school landscapes.

69. A excellent discussion of Bruegel's painted, drawn, and printed landscapes is Gibson 1989, pp. 60–75. On *Rabbit Hunters,* see White 1979.

70. Brown 1986, no. 7, p. 97.

71. Ibid., pp. 16–17.

72. See Klein 1963 for translations of the Latin inscriptions on Bruegel's prints; Kunzle 1973, pp. 162–63, for interpretive issues surrounding *Justice.*

73. On the prints of the Fontainebleau artists, see Zerner 1969.

74. Van Mander [1604] 1936, pp. 355–73. On Goltzius' prints, see Strauss 1977.

75. On print collecting in northern Europe in the sixteenth and seventeenth centuries, see especially Hajós 1958; Robinson 1981; Parshall 1982. Many further references may be found in the notes of these sources.

76. Stone-Ferrier 1983, no. 58, pp. 201–2. Also see Emison 1986, no. 52, pp. 94–96.

77. Strauss 1977, vol. 2, no. 285, pp. 504–5.

78. Van Mander [1604] 1936, pp. 365–66. Also see Strauss 1977, no. 322, pp. 586–87, and especially Melion 1990. This last article is a thoughtful discussion of Van Mander, Goltzius, and the status of printmaking—especially reproductive printmaking—in the late sixteenth century.

79. Massar 1971, p. 25.

80. On Bellange's prints, see Worthen and Reed 1975.

81. Eisler 1979, no. 65, pp. 301–2.

REFERENCES

Ackley, Clifford. 1981. *Printmaking in the Age of Rembrandt.* Exhibition catalog with an essay by William W. Robinson. Museum of Fine Arts, Boston.

Andersson, Christiane. 1978. *Dirner-Krieger-Narren: Ausgewählte Zeichnungen von Urs Graf.* Basel.

Andersson, Christiane. 1985. Polemical Prints in Reformation Nuremberg. In Smith, ed., 1985, pp. 41–62.

Anzelewsky, Fedja. [1980] 1981. *Dürer: His Art and Life.* Trans. Heide Grieve. New York.

Anzelewsky, Fedja. 1983. *Dürer-Studien.* Berlin.

Brown, Christopher. 1986. *Dutch Landscape: The Early Years, Haarlem and Amsterdam, 1590–1650.* Exhibition catalog with contributions by David Bomford, E. K. J. Reznicek, Margarita Russell, M. A. Schenkeveld–van der Dussen, and Jan de Vries. National Gallery, London.

Chadabra, Rudolf. 1964. *Dürers Apokalypse: Eine ikonologische Deutung.* Prague.

Christensen, Carl C. 1979. *Art and the Reformation in Germany.* Athens, Ohio, and Detroit.

Conway, William Martin. 1889. *Literary Remains of Albrecht Dürer.* Cambridge, England.

Conway, William Martin. 1958. *The Writings of Albrecht Dürer.* New York.

Dvořák, Max. 1924. Dürers Apokalypse. In *Kunstgeschichte als Geistesgeschichte: Studien zur abendländischen Kunstentwicklung,* pp. 193–202. Munich.

Dwyer, Eugene. 1971. The Subject of Dürer's *Four Witches. Art Quarterly,* vol. 34, no. 4 (Winter), pp. 456–73.

Eisler, Colin. 1979. *The Master of the Unicorn: The Life and Times of Jean Duvet.* New York.

Emison, Patricia A. 1986. *The Art of Teaching: Sixteenth-Century Allegorical Prints and Drawings.* Exhibition catalog. Yale University Art Gallery, New Haven, Conn.

Emison, Patricia A. 1988. The Little Masters,

Italy and Rome. In Goddard, ed., 1988, pp. 30–39.

Filedt Kok, J. P., comp. 1985. *The Master of the Amsterdam Cabinet, or The Housebook Master, ca. 1470–1500.* Exhibition catalog with contributions by K. G. Boon, M. D. Haga, Jane Campbell Hutchison, M. J. H. Madou, Peter Moraw, and Keith P. F. Moxey. Rijksmuseum, Amsterdam.

Freedberg, David. 1989. *The Prints of Pieter Bruegel the Elder.* Exhibition catalog with contributions by David Freedberg, Keith Moxey, Jacques Van Lennep, Lisa Vergara and Jan Van der Stock. The Bridgestone Museum of Art, Tokyo.

Gibson, Walter S. 1989. *"Mirror of the Earth": The World Landscape in Sixteenth-Century Flemish Painting.* Princeton, N.J.

Goddard, Stephen H. 1988. The Origin, Use and Heritage of the Small Engraving in Renaissance Germany. In Goddard, ed., 1988, pp. 13–29.

Goddard, Stephen H., ed. 1988. *The World in Miniature: Engravings by the German Little Masters, 1500–1550.* Exhibition catalog with essays by Patricia A. Emison, Stephen H. Goddard, and Janey L. Levy. Spencer Museum of Art, University of Kansas, Lawrence.

Gombrich, Ernst. 1969. The Evidence of Images. In *Interpretation: Theory and Practice,* ed. Charles Singleton, pp. 97–103. Baltimore.

Goris, Jan Albert, and Georges Marlier. [1970] 1971. *Albrecht Dürer: Diary of His Journey to the Netherlands.* English edition. Greenwich, Conn.

Grigg, Robert. 1986. Studies on Dürer's Diary of His Journey to the Netherlands: The Distribution of the *Melencolia I. Zeitschrift für Kunstgeschichte,* vol. 49, no. 3, pp. 398–409.

Hajós, Elisabeth M. 1958. The Concept of an Engravings Collection in the Year 1565: Quicchelberg, *Inscriptiones vel Tituli Theatri Amplissimi. Art Bulletin,* vol. 40, no. 2 (June), pp. 151–56.

Hale, John R. 1986. The Soldier in Germanic Graphic Art of the Renaissance. *Journal of Interdisciplinary History,* vol. 17, no. 1 (Summer), pp. 85–114.

Harbison, Craig. 1969. *Symbols in Transformation: Iconographic Themes at the Time of the Reformation.* Exhibition catalog. Art Museum, Princeton University, Princeton, N.J.

Hults, Linda C. 1981. Baldung and the Reformation. In Marrow and Shestack, eds., 1981, pp. 38–59.

Hults, Linda C. 1982. Hans Baldung Grien's *Weather Witches* in Frankfurt. *Pantheon,* vol. 40, no. 2 (April–June), pp. 124–30.

Hults, Linda C. 1984. Baldung's *Bewitched Groom* Revisited: Artistic Temperament, Fantasy and the "Dream of Reason." *Sixteenth Century Journal,* vol. 15, no. 3 (Fall), pp. 259–79.

Hults, Linda C. 1987. Baldung and the Witches of Freiburg: The Evidence of Images. *Journal of Interdisciplinary History,* vol. 18, no. 2 (Autumn), pp. 249–76.

Hutchison, Jane Campbell. 1972. *The Master of the Housebook.* New York.

Hutchison, Jane Campbell. 1990. *Albrecht Dürer: A Biography.* Princeton, N.J.

Ivins, William M. 1929. Notes on Three Dürer Woodblocks. *Metropolitan Museum Studies,* vol. 2, pp. 102–11.

Ivins, William M. 1948. On the Rationalization of Sight. *Metropolitan Museum of Art Papers,* no. 8.

Jacobowitz, Ellen S., and Stephanie Loeb Stepanek. 1983. *The Prints of Lucas van Leyden and His Contemporaries.* Exhibition catalog. National Gallery of Art, Washington, D.C.

Juraschek, Franz. 1955. *Das Rätsel in Dürers Gottesschau: Die Holzschnittapocalypse und Nikolaus von Cues.* Salzburg.

Karling, Sten. 1970. Riddaren, döden och djävulen. *Konsthistorisk Tidskrift,* vol. 39, nos. 1–2, pp. 1–13.

Kaufmann, Thomas DaCosta. 1985. Hermeneutics in the History of Art: Remarks on the Reception of Dürer in the Sixteenth and Early Seventeenth Centuries. In Smith, ed., 1985, pp. 23–39.

Klein, H. Arthur. 1963. *Graphic Worlds of Peter Bruegel the Elder.* New York.

Klibansky, Raymond, Fritz Saxl, and Erwin Panofsky. 1964. *Saturn and Melancholy.* London.

Koerner, Joseph Leo. 1985. The Mortification of the Image: Death as a Hermeneutic in Hans Baldung Grien. *Representations,* vol. 10 (Spring), pp. 52–101.

Koreny, Fritz. [1985] 1988. *Albrecht Dürer and the Animal and Plant Studies of the Renaissance.* English trans. Published in conjunction with an exhibition at the Graphische Sammlung Albertina, Vienna.

Kunzle, David. 1973. *The Early Comic Strip: Narrative Strips and Picture Stories in the European Broadsheet from c. 1450 to 1825.* Berkeley, Calif.

Marrow, James. 1986. Symbol and Meaning in Northern European Art of the Late Middle Ages and the Early Renaissance. *Simiolus,* vol. 16, nos. 2–3, pp. 150–69.

Marrow, James, and Alan Shestack, eds. 1981. *Hans Baldung Grien: Prints and Drawings.* Exhibition catalog with essays by Alan Shestack, Charles W. Talbot, and Linda C. Hults. National Gallery of Art, Washington, D.C., and Yale University Art Gallery, New Haven, Conn.

Massar, Phyllis. 1971. *Presenting Stefano della Bella: Seventeenth-Century Printmaker.* New York.

Melion, Walter. 1990. Hendrick Goltzius's Project of Reproductive Engraving. *Art History,* vol. 13, no. 4 (December), pp. 458–87.

Mende, Matthias. 1971. *Dürer-Bibliographie.* Wiesbaden.

Metropolitan Museum of Art and Germanisches Nationalmuseum. 1986. *Gothic and Renaissance Art in Nuremberg, 1300–1550.* Exhibition catalog with contributions by Alfred Wenderhorst, Rainer Kahsnitz, Rainer Schoch, et al. New York and Munich.

Meyer, Ursula. 1978. Political Implications of Dürer's "Knight, Death and the Devil." *Print Collector's Newsletter,* vol. 9, pp. 35–39.

Minott, Charles Ilsley. 1971. Albrecht Dürer: The Early Graphic Work. *Record of the Art Museum, Princeton University,* vol. 30, no. 2, pp. 7–27.

Moxey, Keith P. F. 1989. *Peasants, Warriors and Wives: Popular Imagery in the Reformation.* Chicago.

Panofsky, Erwin. [1955] 1971. *The Life and Art of Albrecht Dürer.* One-volume paperback edition, without handlist. Princeton, N.J.

Parshall, Peter W. 1971. Albrecht Dürer's *St. Jerome in His Study:* A Philological Reference. *Art Bulletin,* vol. 53, no. 3 (September), pp. 303–5.

Parshall, Peter W. 1982. The Print Collection of Ferdinand Archduke of Tyrol. *Jahrbuch der Kunsthistorischen Sammlungen in Wien,* vol. 78, pp. 139–84.

Poesch, Jesse. 1964. Sources for Two Dürer Enigmas. *Art Bulletin,* vol. 46, no. 1 (March), pp. 78–86.

Reuterswärd, Patrik. 1981. The Dog in the Humanist's Study. *Konsthistorisk Tidskrift,* vol. 50, no. 2, pp. 53–69.

Ringbom, Sixten. 1965. *Icon to Narrative: The Rise of the Dramatic Close-Up in Fifteenth Century Devotional Painting.* Åbo, Finland.

Robinson, William W. 1981. "This Passion for Prints": Collecting and Connoisseurship in Northern Europe during the Seventeenth Century. In Ackley 1981, pp. xxvii–xlviii.

Rupprich, Hans, ed. 1965–69. *Dürer: Schriftlicher Nachlass.* 3 vols. Berlin.

Russell, H. Diane. 1990. *Eva/Ave: Woman in Renaissance and Baroque Prints.* Exhibition catalog with contribution by Bernadine Barnes. National Gallery of Art, Washington, D.C.

Shestack, Alan. 1967. *Fifteenth Century Engravings from the National Gallery of Art.* Exhibition catalog. National Gallery of Art, Washington, D.C.

Silver, Larry. 1983. Forest Primeval: Albrecht Altdorfer and the German Wilderness Landscape. *Simiolus,* vol. 13, no. 1, pp. 4–43.

Silver, Larry. 1985. Prints for a Prince: Maximilian, Nuremberg and the Woodcut. In Smith, ed., 1985, pp. 7–21.

Smith, Jeffrey Chipps. 1983. *Nuremberg: A Renaissance City, 1500–1618.* Exhibition catalog. Archer M. Huntington Art Gallery, University of Texas, Austin.

Smith, Jeffrey Chipps, ed. 1985. *New Perspectives on the Art of Renaissance Nuremberg: Five Essays.* Austin, Tex.

Sohm, Philip L. 1980. Dürer's *Melencolia I:* The Limits of Knowledge. *Studies in the History of Art,* vol. 9, pp. 13–32.

Stone-Ferrier, Linda A. 1983. *Dutch Prints of Daily Life: Mirrors of Life or Masks of Morals?* Exhibition catalog. Spencer Museum of Art, University of Kansas, Lawrence.

Strauss, Walter L. 1973. *Chiaroscuro: The Clair-Obscur Woodcuts by the German and Netherlandish Masters of the 16th and 17th Centuries.* Greenwich, Conn.

Strauss, Walter L. 1974. *The Complete Drawings of Albrecht Dürer.* 6 vols. New York.

Strauss, Walter L. 1977. *Hendrik Goltzius 1558–1627: The Complete Engravings and Woodcuts.* 2 vols. New York.

Strauss, Walter L. 1980. *Woodcuts and Woodblocks of Albrecht Dürer.* New York.

Strauss, Walter L. [1976] 1981. *The Intaglio Prints of Albrecht Dürer.* 3rd rev. ed. New York.

Strieder, Peter. [1981] 1982. *Albrecht Dürer: Paintings, Prints, Drawings.* Trans. Nancy M. Gordon and Walter L. Strauss. New York.

Talbot, Charles W., ed. 1971. *Dürer in America: His Graphic Work.* Exhibition catalog with notes by Gaillard F. Ravanel and Jay A. Levenson. National Gallery of Art, Washington, D.C.

Talbot, Charles W., and Alan Shestack, eds. 1969. *Prints and Drawings of the Danube School.* Exhibition catalog. Yale University Art Gallery, New Haven, Conn.

Theissing, Heinrich. 1978. *Dürer's Ritter, Tod und Teufel: Bildsinn und Sinnbild.* Berlin.

Van Mander, Carel. [1604] 1936. *Dutch and Flemish Painters.* Trans. Constant van de Wall. New York.

Vasari, Giorgio. [1568] 1850–52. *Lives of the Most Eminent Painters, Sculptors and Architects.* 5 vols. Trans. Mrs. Jonathan Foster. London.

Waetzoldt, Wilhelm. [1935] 1955. *Dürer and His Times.* Trans. R. H. Boothroyd. Enlarged ed. London.

White, John E. C. T. 1979. The "Rabbit Hunters" by Pieter Bruegel the Elder. In *Pieter Bruegel und Seine Welt,* ed. Otto von Simpson and Matthias Winner. Berlin.

Worthen, Amy N., and Sue Welsh Reed. 1975. *The Etchings of Jacques Bellange.* Exhibition catalog. Des Moines Art Center, Des Moines, Iowa.

Wuyt, Leo. 1974–75. Lucas van Leyden's "Melkmeid," Een Proeve tot Ikonologische Interpretatie. *De Gulden Passer,* vols. 52–53, pp. 441–53.

Zerner, Henri. 1969. *The School of Fontainebleau: Etchings and Engravings.* New York.

Italian Renaissance Prints

Konrad Oberhuber, one of the foremost scholars of Italian Renaissance prints, has aptly contrasted them with their northern counterparts. The rich black inks of the north give way to soft grays in Italy; linear brilliance yields to subtle tonal contrasts. And, since these prints were the primary emissaries of the coveted discoveries of Italian Renaissance artists, they do not often come down to us in good condition. Retouched with the pen, torn, folded, or printed from reworked plates, extant impressions of Italian prints may be only faded reminders of their original pristine appearance.[1] But despite such difficulties, the study of Italian prints is extremely rewarding, not only because of their individual beauty and content, but because they show us what the Italian Renaissance meant to the rest of Europe. We know that many northern artists, Dürer and Rembrandt in particular, absorbed Italian art largely through prints, and Italian prints were eagerly collected by non-artists as well. One of Koberger's printers, Johannes Amerbach, brought twenty-nine Italian woodcuts and eighty-one engravings back from Venice in 1482. His heirs would compile one of the biggest print collections of the sixteenth century.[2]

Like northern Europe, Italy saw a gradual evolution of the print during the fifteenth and sixteenth centuries: from the simplicity of the earliest devotional woodcuts to the complexity of engravings, produced first by skilled artisans like goldsmiths, and then by prominent painters. As in the north, we can perceive a growing appreciation of individual graphic masters on the part of elite collectors by the latter half of the sixteenth century, as well as a developing awareness of the history of printmaking. The collection of Cardinal Scipione Gonzaga, organized in the 1560s, contained volumes of prints by Dürer, Lucas, Cornelis Cort, and, most

FIGURE 3.1
Maso Finiguerra. Cor-onation of the Virgin. 1452. Engraved silver and niello Pax. 130 × 88 mm. Museo Nazionale del Bargello, Florence.

FIGURE 3.2
Impression from Maso Finiguerra's niello Pax (fig. 3.1). Bibliothèque Nationale, Paris.

likely, Marcantonio Raimondi, alongside the volumes of prints organized by subject. And in 1568, when Vasari (who, as an artist, was probably a print collector himself) published the second edition of his *Lives of the Artists,* he added a chapter on Raimondi's life. That chapter gives an account of major engravers—a significant inclusion of printmaking in the history of art—although, as David Landau notes, Vasari's opinion of printmaking within the hierarchy of media was relatively low.[3]

Despite Vasari's belief that engraving was invented in Italy, we know now that it appeared over a decade later here than in the north, arising in Florence in the 1440s.[4] A candidate for the father of engraving in Italy is Maso Finiguerra, a Florentine goldsmith and niellist whose oeuvre is difficult to reconstruct. A fairly certain attribution is a niello Pax—an object that was passed around during the mass and kissed by the congregation after the blessing of peace ("Pax Domini sit semper vobiscum")—depicting the *Coronation of the Virgin* (1452; fig. 3.1).[5]

A niello is a piece of gold or silver with an engraved design, the crevices of which have been filled with *nigellum,* a powdered amalgam of copper, silver, lead, and sulphur that is allowed to melt on the heated plate. When the plate is burnished, the design appears black on a shiny ground. Sulphur casts were made of nielli, and impressions on paper could be taken from the unfilled plate or from the casts. Both prints and casts probably helped to guide the artist or preserved the design for future reference.

The style of this Pax and the impression from it (fig. 3.2) reveals the mentality of a metalsmith: full surface and intricate linear detail. In this sense, it resembles Master E.S.'s *Madonna of Einsiedeln* (fig. 1.32), but the character of the figures is entirely different. Finiguerra's are massive and solidly modeled, lacking the graceful S-curve poses but gaining monumentality

FIGURE 3.3

Baccio Baldini. The
Libyan Sibyl *from a*
series of prophets and
sibyls. Ca. 1470–80.
Engraving. 178 × 108 mm
(sheet, trimmed close to
platemark). National
Gallery of Art, Washing-
ton, D.C.

and solemnity. They appeal to us less by their charm than by their imposing spatial presence.

The relationship between niello prints and the origins of engraving proper in Italy is problematic.[6] Finiguerra does not seem to have made engravings, although his designs were engraved by Francesco Rosselli and Baccio Baldini. Although it may not be possible to connect Finiguerra firmly with the initiation of Italian engraving, major early Florentine engravers were associated with his shop—and Italian engraving, like the Renaissance itself, was cradled in Florence.

The Florentine "fine" and "broad" manners, so named for the relative thickness of modeling lines, represent the two basic stylistic trends in Italian engravings produced about 1460–90. Baldini, a pupil of Finiguerra, appears to have been the major exponent of the fine manner, which is characterized by thin, delicate hatching for interior shading and stronger contours.[7] Paul Kristeller observed that this technique imitated pen and ink wash drawings, with the fine cross-hatching suggesting the tonal areas of wash and the gouged lines echoing the pen marks.[8] Indeed, engravings in Italy seem to have been especially prized by collectors as early as the fifteenth century as reflections of drawing styles; the prints of Andrea Mantegna and his school are most often based on drawings.[9]

Baldini's *Libyan Sibyl* (fig. 3.3) is one of the twelve engravings of the legendary female seers of antiquity that accompanied twenty-four engraved Old Testament prophets to form a series (ca. 1470–80). For Christianity, the sibyls' prophecies represented an affirmation of the coming of Christ by the pagan (Gentile) world, just as the pronouncements of the Old Testament prophets were understood as preparing the way for Christ among the Jews. A *Nativity*

from two plates, represented in only two impressions, probably formed the climax of this extensive series, which contained thirty-seven images.[10] The Incarnation of Christ, the central mystery expressed in Nativity scenes, is the focus of the predictions of the prophets and sibyls and was linked to the latter in contemporary mystery plays.[11] The inscriptions on this print concern the birth of Christ and his Second Coming: The upper one reads: "Behold the day is coming, and the Queen of Nations will hold in her lap him who will open hidden things." The lower reads: "The day shall come in which the eternal Lord / Will give light to all hidden things / And break the ties of error. / He shall give light to the synagogues / And will loosen the lips of the sinners. / He will weigh everything with his scales. In the lap of the Queen of Nations this holy living king will sit."[12]

In the composition of the sibyl's drapery, her pose, and the delicate flicks of the burin that model her form, the Italian artist has been influenced by Master E.S., particularly his *St. John* (ca. 1460–65).[13] The decorative finesse of the fine manner is best manifested in the embroidered cloak and the transparent veil (borrowed from E.S.'s *Woman with an Escutcheon*) that falls over the sibyl's left shoulder. Youthful yet solemn, she turns the pages of her book ceremonially.

Baldini's *Judgment Hall of Pilate* (ca. 1465–75; fig. 3.4), perhaps engraved after a design by Botticelli,[14] is unfortunately known only in late, reworked state. Nevertheless, it summarizes many of the qualities that made Italian prints so appealing to artists of other nations. The composition is an exercise in one-point linear perspective and the imaginative reconstruction of the architecture of Roman antiquity. Two distinct episodes are encompassed by the imposing hall with its barrel vault and composite columns. At the right, Christ appears before the Roman governor of Judaea, who washes his hands; the Flagellation of Christ is at the left. The combination of accusing, hostile, or indifferent figures and the architecture of the judgment hall expresses the weightiness of the legal system that condemns Christ. Lucas van Leyden and Rembrandt were to use a similar conceit in their prints *Ecce Homo* and *Christ Presented to the People* (see figs. 2.44, 4.52, 4.53).

The two halves of an anonymous fine-manner *Triumph of Bacchus and Ariadne* (1485; fig. 3.5) reflect Finiguerra's approach to engraving and the stylistic influence of Botticelli. The latter combined Christian references with the iconography of pagan antiquity in exquisite mythological paintings associated with the Medici court of the 1470s and 1480s, which was steeped in the Neoplatonism that also inspired the young Michelangelo. Here, the sylph-like women at the left, engraved counterparts of the Three Graces from Botticelli's *Primavera* (ca. 1482), prepare the way for the chariot of the god of wine and regeneration, Bacchus, and his consort, Ariadne. The whole composition is based on the reliefs on Roman sarcophagi, where the figures occupy the foreground plane. Throughout, a grapevine, heavy with its intoxicating produce, provides continuity. The more grisly aspects of Bacchic ritual are suggested by the maenad, a frenzied female devotee of the god, who lifts up a mutilated dog as an offering. In their drunken ecstasy, maenads were known to tear apart animals (and possibly people as well). Who is to say whether the pagan cult is understood here in terms of its Christian allusions—Ariadne and Bacchus representing the union of human and divine through love, and the grapevine having a Eucharistic significance—or appreciated in and for itself? Whatever the answer, these lovely prints illustrate the broader range of subject matter of early Italian engravings compared with their northern counterparts. Mythological subjects were long in coming to the north, where Christian subjects were overwhelmingly predominant.

FIGURE 3.4

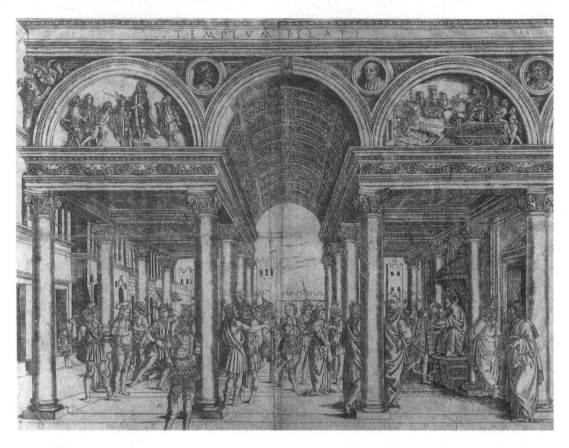

Baccio Baldini. The
Judgment Hall of Pilate.
*Ca. 1465–75. Engraving.
435 × 581 mm. Museum
of Fine Arts, Boston.*

In broad-manner engravings, linear fineness is subordinated to larger pictorial effects of
massiveness and spatiality. With decisive parallel hatchings for shading and stronger contours,
the creators of these prints mimicked Italian pen drawings. In one of six illustrations for Pe-
trarch's *Triumphs, The Triumph of Love* (1470s), attributed to Francesco Rosselli, whose oeuvre
as a miniaturist and printmaker is difficult to reconstruct,[15] the gracefulness of the Botticelli-
inspired figures is tempered by solidity and restraint in the use of curving lines and ornament
(fig. 3.6). The spatial distance is emphasized not only by the lightening of the lines in the
background but also by the flaming pedestal on which Cupid stands. Firmly modeled, it acts
as a spatial reference (staffage). The horses pulling Love's chariot, which reflects the elaborate
floats of the street pageants given by the Medici, are convincingly massive; in their bodies, the
capacity of the broad manner to express the Italian Renaissance sense of form is best revealed.

POLLAIUOLO AND ROBETTA

The Battle of the Nudes (fig. 3.7) by the Florentine artist Antonio del Pollaiuolo is un-
doubtedly the most influential Italian engraving of the fifteenth century, and the first one to
bear the artist's complete signature. In our time, the *Battle* is rare: all surviving impressions
show vertical folds, and most show horizontal ones, as well as considerable wear. Among these
impressions, there is also an unusual amount of restoration with pen and ink. The popularity
of the print is also attested to by the fact that the plate was reengraved by another artist after it

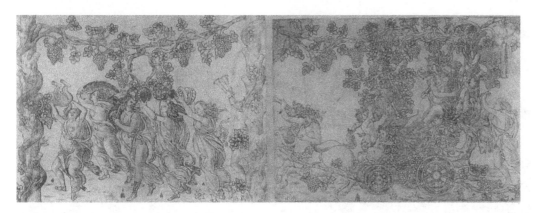

FIGURE 3.5

Unknown fine-manner engraver. The Triumph of Bacchus and Ariadne. *1480s. Engraving from two plates. Right half: 192 × 276 mm; left half: 205 × 276 mm. British Museum, London.*

FIGURE 3.6

Attributed to Francesco Rosselli. The Triumph of Love *from the* Tri- umphs of Petrarch. *1470s. Engraving in the broad manner. 261 × 173 mm. British Museum, London.*

wore down: the impression in the Cleveland Museum, with its play between delicate modeling lines and strong contours, reflects the plate's first state. Although Pollaiuolo's print is often interpreted as the first masterpiece of the broad manner, it is the reworked lines of the later state that primarily support this judgment. On the basis of the Cleveland impression, it seems that Pollaiuolo synthesized the delicate fine manner with the bolder broad manner.[16] Ulti- mately, the place of this print within the evolution of Italian engraving depends on when it was made.

The date of the *Battle* is much debated; on stylistic grounds, it seems to fall between 1460, when Pollaiuolo executed his Hercules paintings (lost, but echoed in smaller versions in the

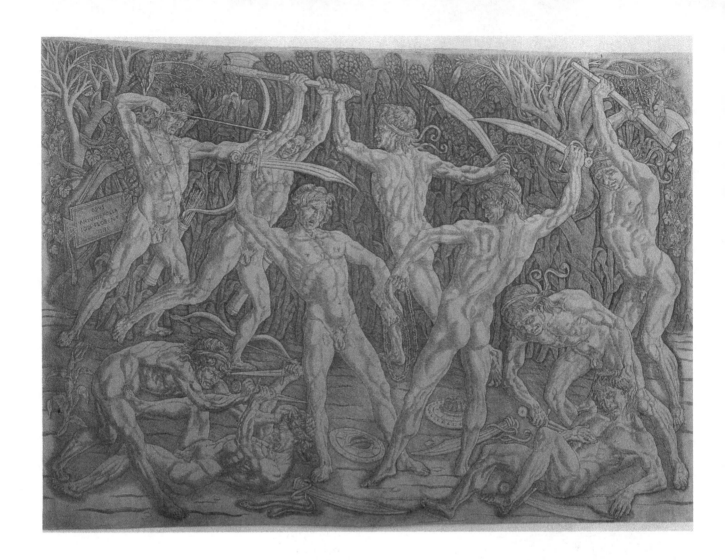

FIGURE 3.7

*Antonio del Pollaiuolo.
The Battle of the Nudes,
first state. Commonly
dated ca. 1470. En-
graving. 398 × 594 mm.
Cleveland Museum of
Art.*

Uffizi) for the Medici, and 1475, the date of the *Martyrdom of St. Sebastian* in the National
Gallery in London, an extremely important painting for the development of the figure and
compositional modes in the High Renaissance. However, a date as late as 1489 has recently
been proposed.[17] The date of the print would also determine the origin of the so-called return
stroke, a thinner diagonal between parallel hatchings that creates zigzag patterns across a mod-
eled area. This stroke, borrowed from pen drawing, is found in the *Battle,* but also in late works
by Rosselli and in Mantegna's engravings. Pollaiuolo's return strokes are exceedingly smooth,
indicating that, unlike Mantegna, he may not have used a burin for them, but a goldsmith's
tool similar to a drypoint stylus (he would have had to polish off the burr).[18]

In comparison with the earliest Italian engravings, the lines of the *Battle* are more varied,
flexible, and descriptive. The appeal of the print, however, lay not so much in its technical
brilliance but in its treatment of the male nude: it was recognized during its time as the last
word on the subject. We now understand its importance as an transitional work linking the
stiffer quattrocento conception of the figure to the perfect facility with which the human body
was rendered by such High Renaissance masters as Leonardo, Michelangelo, and Raphael.

Despite his multifaceted talent—he painted, sculpted, and did goldsmith work—
Pollaiuolo made only this one engraving (as far as we know). A print of *Hercules and the Giants,*

however, might reflect an original by Pollaiuolo similar to *The Battle of the Nudes*.[19] Both images convey a fascination with the physical human being as a part of the animal kingdom. Pollaiuolo's deterministic vision of nature's energy, akin to Leonardo's, is beautifully expressed in the *Battle*'s composition, in which ten moving anatomical "manikins" are engaged in a fierce struggle for survival. With the possible exceptions of the figures to the far right and left, all are mortally threatened.

Even more than the date, the subject of the print is problematic. Panofsky believed that this work, a drawing in the British Museum, and *Hercules and the Giants* illustrated episodes from a Roman legend. But his theory rested on the unproven attribution of the Hercules engraving to Pollaiuolo and a tenuous relationship between all three images and the story he cited. Similarly, John Phillips' connection of the *Battle* to an aspect of the story of Jason and the Golden Fleece is unconvincing. Perhaps a more general interpretation, not tied to a particular text, such as that proposed by Kristeller and Adam Bartsch, is in order: both saw the image as depicting a gladitorial combat. Colin Eisler has amplified this approach by citing an ancient funerary custom in which the deceased was commemorated by a blood sacrifice provided by the deaths of the gladiators. The coarse corn or *saggina* behind the figures formed the gladiator's diet, together with wine and olive oil. More profoundly, the cycle of nature is represented here: the vegetation that nurtures the warriors will in turn be nurtured by the spilled gore of their battle. Thus, nature regenerates itself, unconcerned for the individual human lives in its midst. Patricia Emison's recent interpretation of the *Battle* also assumes the basic independence of the print from textual sources, and the basic legibility of its allegorical significance in terms of the transitoriness of human life: in her view the chain held by the two warriors in the center is the interpretive key to the engraving. The suggestive echo of the Latin *vinco, vincire* (to fetter or chain) and *vinco, vincere* (to conquer) expands to encompass the meaning of the whole image, in which the violent, grimacing nudes are bound to the flesh and the world, conquerable only through death, which releases the soul from its bondage. Perhaps the most important aspect of Emison's interpretation for our purposes is her assertion that engraving was the major medium in the late fifteenth century for images that could be independent from texts but sustain a text-like authority. This is something we have already observed in Dürer's early engravings, for which Pollaiuolo's *Battle* is a precedent.[20]

So preeminent is Pollaiuolo's interest in human anatomy here that some writers have deemphasized the quest for a subject and seen the print primarily as a vehicle for the depiction of the nude.[21] Although this would go against the passionate interest in ancient literature and history we generally associate with the Renaissance, we must admit that Pollaiuolo's meticulous analysis of the musculature and the programmatic display of the figure from many angles (note the exact and near mirror images) seem to exceed the requirements of any subject. As a guide to this celebration of the human musculature, Pollaiuolo may have employed ancient sculpture or, perhaps, a lost original work by the Niobid Painter, whose paintings on ceramic vessels reflected the monumental frescoes, long since disappeared, of the ancient Greek artists Polygnotos and Mikon.[22] Pollaiuolo may also have observed dissections, but it remained for Leonardo to put the analysis of separate muscles together into a coherent, moving whole. As the ancient Greeks learned, and as the later Renaissance would learn, it is not the depiction of discrete muscles that makes for completely naturalistic movement, but the suggestion of the reciprocity and continuity of muscular action. We cannot sense the movements that

FIGURE 3.8

Cristofano Robetta.
Adam and Eve with the
Infants Cain and Abel.
*After 1498. Engraving.
257 × 178 mm. Museum
of Fine Arts, Boston.*

immediately precede and follow these poses, and muscular tension is not balanced with relaxation—hence the deadlocked quality in the individual figures as well as the composition as a whole. Still, Pollaiuolo's importance in the advancement of the understanding of anatomy in the Renaissance is unquestionable. Vasari emphasized the modern nature of his nudes, and his correct placement of their muscles.[23]

Toward the end of the century, northern printmaking made an increasingly strong impact on its southern counterpart. The work of the Florentine goldsmith and engraver Cristofano Robetta clearly exemplifies this influence. Robetta was neither an inventive genius nor a slavish copyist; he was, rather, a skilled orchestrator of motifs pulled from many sources: Pollaiuolo, Filippino Lippi, Schongauer, and Dürer. Despite their derivativeness, his prints often possess great charm. *Adam and Eve with the Infants Cain and Abel* (fig. 3.8), probably a late work (as is true of many Italian printmakers, Robetta's chronology is problematic),[24] is perhaps the most appealing. Cast out of Eden, the "first family" sits in a landscape lifted directly from Dürer's *Madonna and Child with the Monkey* (ca. 1498). And Eve sits on a rock in much the same manner as the nude maiden in Dürer's *Penance of St. John Chrysostom* (ca. 1497). Her head, however, has all the grace of the female types of Botticelli or Filippino Lippi.

Robetta seems to have been fascinated with the story of Adam and Eve, for episodes from it occur frequently in his work. Some of the disastrous consequences of the Fall of Man are suggested here. The hoe held by Adam shows that he must now till the soil for his food, while Eve's burden was the painful childbirth that resulted in her sons Cain and Abel. The loss of paradise is reflected in her downcast, melancholy glance. Adam, meanwhile, seems to stew in bitterness. Although in technique this print cannot stand up to comparison with Dürer's contemporary burin work, Robetta revealed a clear awareness of some of the virtues of the German

artist's method: the combination of flecks and stipples with line and the use of curving parallel hatching to render the masses of the landscape and figures.

NORTH ITALY: TAROCCHI CARDS, MANTEGNA, BARBARI

Outside Florence, especially in northern Italy, other important centers of engraving developed. The school of Ferrara about 1465–70 is represented by two versions of a deck of engraved cards, erroneously dubbed the "Tarocchi Cards of Mantegna." Both versions of these sets, called the *E-* and *S-Series Tarocchi* (the *S-Series* is apparently a copy of the *E-Series*), have fifty cards divided into five groups of ten. In addition to letters designating the groups, each card bears a number that indicates its place within the whole set. In the *E-Series,* the first group of ten images is marked with the letter *E;* in the *S-Series,* inexplicably, this same group bears the letter *S.* The fifty cards do not form a Tarocchi (tarot) deck, and indeed, it is not clear that they were ever used in a game.[25] However, they do bear a relationship to the *attuti* (instructional) cards appended to the suits in Venetian tarot decks or in their Florentine counterpart, the *Minchiate.* Sometimes these instructional cards were also called *Tarocchi,* obfuscating their distinction from the tarot suits as a whole.

The subjects of the five sets of ten images may be outlined as follows:

E (S) Cards 1–10—Conditions of Humanity
D Cards 11–20—Apollo and the Muses
C Cards 21–30—Liberal Arts
B Cards 31–40—Cosmic Principles
A Cards 41–50—Firmaments of the Universe

The cards thus describe a "great chain of being" linking God in the heavens to mankind on earth,[26] and as such they offered philosophical and cosmological instruction. This lofty purpose is borne out in their superb compositional surety and, particularly, in the technical finesse of the *E-Series,* which is not only engraved with great precision but printed with a clarity rare in Italian printmaking. *Luna* (no. 41 in group A; fig. 3.9), the personification of the moon, is carried across the heavens in a chariot drawn by two small horses; her path is traced by a single, isolated, curving line. She holds the lunar crescent, equally isolated against an unworked background. Although the image is generally static, her hair trails slightly behind and her garment clings to her legs as if pressed there by rushing air. In the landscape beneath, as above, the artist has made a virtue of understatement, with the simple combination of hills, water, and shoreline serving to suggest the vastness of the earth over which the sun, moon, and planets seem to move. An instructive comparison may be made with Dürer's more elaborate *Nemesis* (fig. 2.9), in which both the personification and the landscape beneath are rendered with the utmost complexity and specificity.

The ninth and final material sphere before the First Cause (God, the *Prima Causa*) is the Prime Mover, or *Primum Mobile* (fig. 3.10), who sets all the lower spheres in motion. Although conceived of by philosophers as crystalline and invisible, the Prime Mover is personified here by an angelic figure, beautifully draped and precisely balanced in a dance-like pose that at once conveys energy and its resolution. One is reminded of Hindu images of Siva's cosmic dance of creation and destruction in which all the polarities of existence are resolved into the unchang-

ing oneness of the Godhead, of which Siva, like the Prime Mover, is but a manifestation, and the circle (with no beginning and no end) is but a symbol.

Despite his probable oeuvre of only seven plates,[27] Andrea Mantegna is the most impressive Italian engraver of the fifteenth century. Dürer sought him out on his first trip to Venice, but Mantegna had died too soon, like Schongauer, Dürer's other artistic mentor. In Mantegna's prints, Dürer recognized a powerful expression of the Italian sense of harmony, clarity, and monumentality. Most of all, that coveted connection to classical antiquity was manifestly present in the engravings of Mantegna.

Since none are signed or dated, an exact chronology of these engravings is impossible to establish.[28] Stylistic parallels between Mantegna's engraved designs and dated paintings (an essential aspect of the method used to establish a chronology in the 1973 National Gallery catalog of early Italian engravings, the source followed here) are not always reliable guides, because the plates may have been engraved long after the designs were conceived. *The Entombment* (fig. 3.11) for example, bears many similarities to the *Crucifixion* on the predella of the *St. Zeno Altarpiece* (ca. 1457–59), and is perhaps close to it in date. The relationship of Mantegna's technique here to the Florentine fine manner may also suggest a placement of this print at the beginning of his engraving career, perhaps between 1465 and 1470.[29]

FIGURE 3.11

Andrea Mantegna. The
Entombment. *Ca. 1465–
70? Engraving. 337 ×
452 mm (sheet).
Cleveland Museum of
Art.*

The closely spaced lines and fine patterns in *The Entombment* lend it a surface intricacy that Mantegna would sometimes subordinate to the plasticity of masses and compositional simplicity, characteristics perhaps indicative of a stylistic evolution. Although the setting is extensive, the figures are disposed in two basic planes in the foreground, much as in ancient Roman relief sculpture, especially on sarcophagi, with which Mantegna was certainly familiar. The rhythmic curves of the landscape provide a natural analogy to the swell of grief expressed by the figures. Such a humanized approach to nature is typically north Italian; it emerges with special clarity in the paintings of Giovanni Bellini, Mantegna's brother-in-law. From Bellini, this poetic feeling for nature was passed on to Giorgione and Titian.

Although it has some precedent in Florentine painting,[30] Mantegna's conception of the theme is innovative. Nicodemus (the member of the Sanhedrin who came to question Christ at night in John 3), and Joseph of Arimathea, the wealthy man who dedicated his own tomb to Christ, carry Jesus in his winding sheet as if it were a hammock. This emphasizes the heaviness of the body and hence Christ's physical death. It is an unusual motif and was reiterated, along with the unconscious Virgin, by Raphael in his *Entombment* (1507) in the Borghese Gallery in Rome. All the figures at the right are normally found at the foot of the cross in images of the Crucifixion; in essence, Mantegna conflated aspects of the Crucifixion and Entombment into a new and moving scene. Dürer was particularly impressed by the solid figure of St. John at the far right, for he included it in his *Crucifixion* (1508) from the *Engraved Passion*.

The Risen Christ between SS. Andrew and Longinus (ca. 1472?; fig. 3.12) is closely related to *The Entombment* in its delicate technique. Mantegna poses the figures on a raised ledge, so that they are visible from below. St. Andrew's right foot protrudes over the edge, and Christ raises his hand in benediction while looking down at the viewer. Thus, spatial immediacy is paradoxically combined with the basically iconic stiffness of the image: the resurrected Christ is venerated by two saints who hold their attributes—a cross, instrument of Andrew's martyrdom, and the spear with which Longinus pierced Christ's side. No environment is depicted. Only the open sarcophagus, Christ's wounds, and his strained countenance suggest his suffer-

FIGURE 3.12

Andrea Mantegna.
The Risen Christ be-
tween SS. Andrew and
Longinus. *Ca. 1472?*
Engraving. 304 ×
271 mm (sheet).
Cleveland Museum
of Art.

ing. For the most part he is a robust, triumphant figure whose musculature, although emphati-
cally modeled, is more coherent than that of Pollaiuolo's embattled nudes. An ambivalently
related image is a fresco for the facade of the Church of Sant' Andrea in Mantua, dated 1488,
sometimes mentioned as the prototype for this engraving, but possibly by a follower of Man-
tegna who was inspired by the print.[31]

A knowledge of Pollaiuolo's *Battle* (depending, of course, on its highly controversial date)
may have intervened between the *Risen Christ* and the two pendant *Bacchanals* that Mantegna
perhaps engraved between 1475 and 1480. The figures now occupy more of the pictorial space.
The contours defining them are stronger, and the lines of their interior modeling more broadly
spaced and vigorous. A trace of the static, composite quality evident in *The Entombment* still
persists in the *Bacchanal with a Wine Vat* (fig. 3.13); it may predate slightly the *Bacchanal with*
Silenus (fig. 3.14), which is a more fluid, active composition, with further unity provided by
the powerful, even lighting. At the left in what is probably the earlier print stands Bacchus
himself, a magnificently structured figure supporting a cornucopia of grapes as he receives a
crown. To his right, the effects of his vintage are apparent in his followers, who gather around
the vat. In what is probably the later print, a drunken procession is stumbling forward and to
the right. Its star is the obese Silenus, companion of the god, who is also crowned with a wreath.
Both of these engravings were extremely influential. Leonardo, Dürer, and Peter Paul Rubens,
among others, drew studies from them.

Although the two *Bacchanals* are closely related, they do not depend on each other to
make sense. *The Battle of the Sea Gods* (fig. 3.15), however, is in two parts (Dürer copied the
right half in a beautiful drawing of 1494). How closely these prints are related to the *Bacchanals*

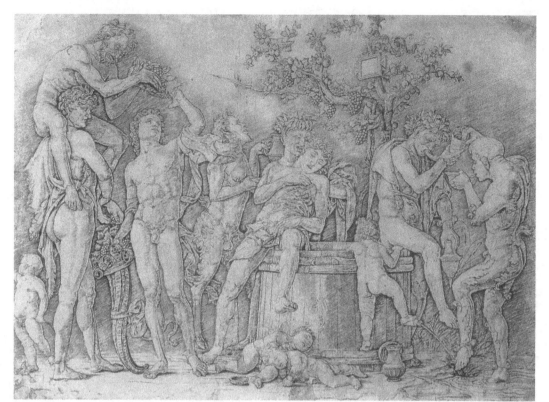

FIGURE 3.13

Andrea Mantegna.
Bacchanal with a Wine
Vat. *Ca. 1475? Engraving. 301 × 438 mm
(sheet). Cleveland
Museum of Art.*

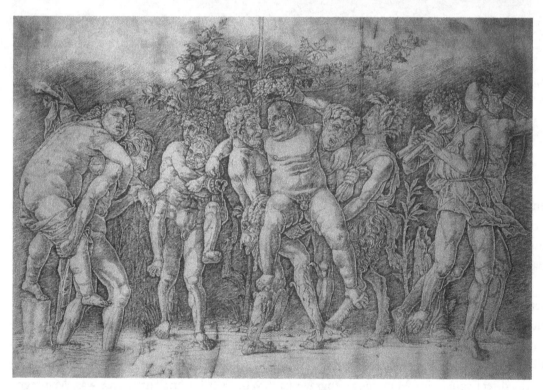

FIGURE 3.14

Andrea Mantegna.
Bacchanal with Silenus.
*Ca. 1475–80? Engraving. 283 × 404 mm
(sheet). Cleveland
Museum of Art.*

and, hence, when all should be dated are matters of debate: Levenson, Oberhuber, and Sheehan have suggested a date of 1485–88 for the *Battle* and an earlier one, 1475–80, for the *Bacchanals,* but many scholars would date all the prints close together.[32] Michael Vickers has even attempted to relate all of the engravings—interpreted as reflections of never-executed paintings—compositionally and iconographically to a painted *Triumph of Caesar.* Both sets of

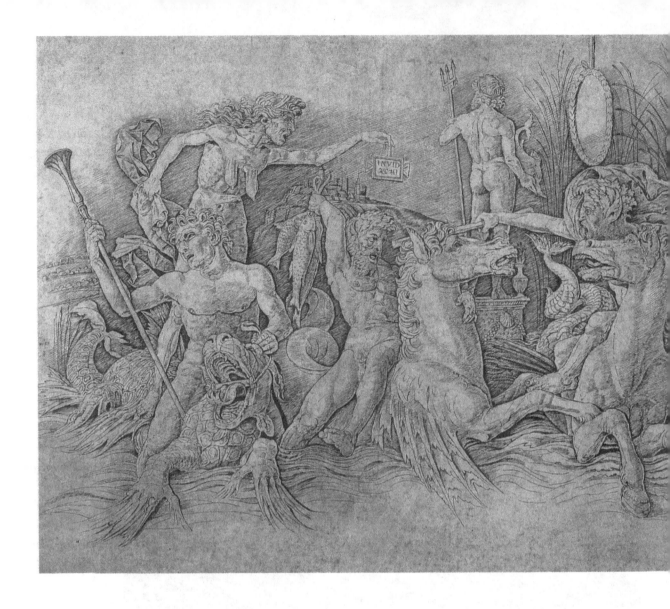

FIGURE 3.15

Andrea Mantegna. The Battle of the Sea Gods. Ca. 1485–88? (sometimes dated in second half of the 1470s). Engraving from two plates. 330 × 431 mm (left half); 268 × 393 mm (right half). (Differently trimmed sheets.) Cleveland Museum of Art.

engravings would indeed lend themselves to mural compositions, even though the figures are not, like those of *The Triumph of Caesar*, seen from below. Vickers' theory is questionable and indeed illustrates a certain reluctance to see Italian prints as works of art independent of paintings.[33]

Like Pollaiuolo in his *Battle of the Nudes*, Mantegna, an avid antiquarian, probably referred to ancient sources in his compositions. Vickers has also proposed that examples of antique sculpture, possibly housed in the Palazzo Santacroce in Rome, served as the chief source for both the *Battle* and the *Bacchanals* (as well as the painted *Triumph of Caesar*), whereas Phyllis Pray Bober has suggested a fragment of an ancient Roman relief in the Villa Medici as the direct source for Mantegna's engravings.[34] Whatever his ancient source was, Mantegna did not copy it directly but absorbed its rhythms and powerful figures to invent his own conception.

The emaciated hag at the left is Envy (*Invidia* in Latin), who instigates the conflict: Mantegna perhaps synthesized her from Giotto's imagery of Virtue and Vice and from two of Reuwich's woodcuts, illustrating a baboon and an Ethiopian(!), in von Breydenbach's tale of travels in the Holy Land, published in Mainz in 1486.[35] Compared to Pollaiuolo's *Battle*, a

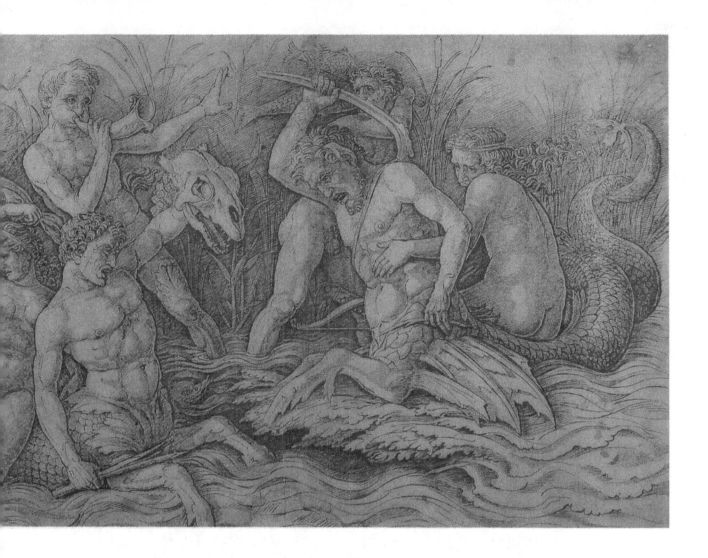

mortal struggle, Mantegna's seems like a frenetic, rather empty display, which Ronald Lightbown has aptly described as a "mock tourney." Bones, sticks, and even fish are bandied about ineffectually. The artist may have intended the *Battle* to ridicule the jealous pretenders to his artistic throne (of which more will be said below), for the particular sea-monsters here might be the Telchines, legendary and notoriously spiteful Rhodian sculptors mentioned in Strabo's *Geography,* who are here literally "bogged down" by their rivalries. This explanation, proposed by Michael Jacobsen, has much to recommend it, including, possibly, the inscription beneath "Invidia" on the plaque held by that figure, which has been associated with, among other things, the astrological sign for the melancholic temperament, traditionally associated with artists.[36] Perhaps this particular meaning added to the print's appeal for Dürer.

On strictly stylistic grounds, however, it is easy to see why the northerner drew the *Battle* so lovingly. Mantegna's command of the figure, space, and composition, already impressive in his *Bacchanals,* is even more so in this print. Bold foreshortening gives greater visual impact to the figures and their mounts. The artist has achieved variety in the poses and even in the views of the faces (profile and three-quarter views from above and below). A more subtle shading interweaves the figures with surrounding space more effectively. Although all the combatants

FIGURE 3.16

Andrea Mantegna.
Madonna and Child,
*first state. Ca. 1485–91?
(sometimes dated as an
early work in the 1460s).
Engraving with drypoint.
337 × 261 mm (sheet).
Graphische Sammlung
Albertina, Vienna.*

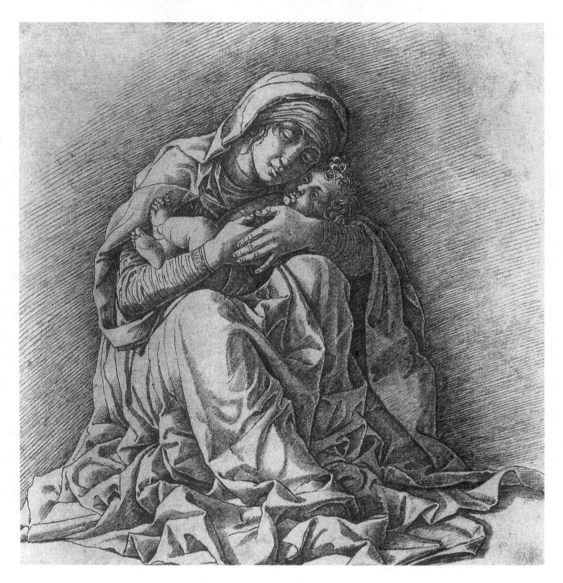

flow together in a continuous serpentine movement, they also fall clearly into subgroups. In the middle of the composition, a V-shape separates the two halves, while, at the edges, curving forms close the composition and lead the eye back into the midst of the fray.

Thus far, we have seen nothing to suggest that Mantegna was capable of expressing tenderness, but he does just that in one of the most beautiful engravings of the fifteenth century—his *Madonna and Child* (ca. 1485–91?; fig. 3.16). A sculptural model, Donatello's *Shaw Madonna* (1425–28), a relief now in the Museum of Fine Arts in Boston, supplied the inspiration for this print. Like others before him, Mantegna combines the Madonna of Humility type (Mary seated on the floor or ground) with an ancient Byzantine type, the *Glykophilusa* ("sweetly loving" Mary). The result is an utterly simple motif with an immediate emotional appeal testifying to the intensification of Marian devotion in the fifteenth century that we have already noted. Rembrandt reiterated Mantegna's conception, retaining its touching naivete while giving it a homey environment, in his etched *Virgin and Child* (see fig. 4.49) of 1654.

FIGURE 3.17

Second state of Mantegna's Madonna and Child *(fig. 3.16).* Engraving. *251 × 244 mm (sheet). Cleveland Museum of Art.*

Although it has been dated early in Mantegna's oeuvre by some critics, including Arthur Hind, Paul Kristeller, and Mark Zucker in *The Illustrated Bartsch,* this print may very well be a late work by virtue of its subtle chiaroscuro and emphatic, sculptural plasticity and monumentality—an effect that would have been augmented without the severe cropping within the platemark suffered by so many of Mantegna's prints.[37] The modeling lines vary in width and direction. By the second state (fig. 3.17), identifiable by a halo around Mary's head, the plate was much worn. The first state, known regrettably in only three impressions, gives a much better idea of Mantegna's intentions. The cascade of drapery around the Virgin's legs exhibits a delicacy of modeling that is intricate but never loses the sense of a broad, pyramidal mass. The lines of the hatching are beautifully soft and crumbly. Though numerous engravings were made after Mantegna's designs, none possesses the sensitivity exhibited in the best impressions from the seven plates believed to be by his hand.

Two engravings of the Flagellation of Christ, one with and one without pavement, illus-

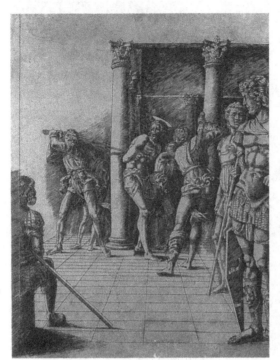
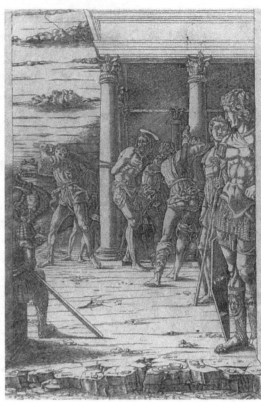

trate this point (figs. 3.18, 3.19). The unfinished version (with the pavement) may be by the best engraver working for Mantegna.[38] And yet the parallel hatchings—so brittle and granular in Mantegna's prints—petrify, as do the contours. The engraver has failed to understand the vortex of figures whose central axis is the column to which Christ is tied. The basic geometric volume is there, but the foreshortening and movement of the individual bodies lack the spatial conviction and dynamism that Mantegna's original conception, whether drawn or painted, would undoubtedly have possessed. What a remarkable spatial entity the scourger closest to us would have been! Projecting forward and back, he was intended to link the middleground to Christ, while the torsion of his upper body propelled the circular motion around Christ. The engraver grasped the immediacy of Mantegna's basic spatial construction, however, enhanced here by the lines of the pavement and the proximity of the foreground figures to us.

By pushing these same figures back, allowing a rock ledge to intervene between them and the viewer, and by stressing the individual horizontal lines on the ground, the engraver of the *Flagellation of Christ* without the pavement (a finished composition) considerably diminished the Mantegnesque spatiality of the scene. This artisan had an even harder, more mechanical touch. Because we do not know the nature of Mantegna's original *Flagellation* (that is, whether it was a painting or a drawing), we cannot speak to his intentions for the environment of the figures, but one this fussy is not likely to have pleased him. A. Hyatt Mayor described Mantegna's sensitivity for empty areas: "Where professionals [that is, artisans who made prints after others' designs] worked the entire copper surface, Mantegna reserved ample blanks of air to absorb the energy that compressed into the center."[39] This effect, as we have seen, is often damaged by cropping; in the *Flagellation* without the pavement, this energy is diffused by the engraver's *horror vacui.*

An intriguing document, a petition dated about 1475, suggests that Mantegna's designs were sometimes engraved without his permission.[40] The painter and engraver Simone di Ardizone had come to Mantua and been offered work by Mantegna, who was apparently eager to take advantage of the then rare skills of an engraver. Simone lent his services instead to his painter friend Zoan Andrea—thought by some scholars to be the same "Z.A." who signed engravings after Mantegna—who had recently been robbed of a number of medals, drawings, prints, and plates. Presumably, part of Simone's assistance to his friend involved reengraving the images of lost plates. Despite warnings from Mantegna, Simone continued this work until one night he and Andrea were beaten and left for dead, apparently by thugs hired by the painter. When Simone recovered, he continued engraving. As a new tactic, Mantegna brought charges of sodomy against him. Simone then fled to Verona, where he petitioned the Marquis for justice so that he and his family would not have to undertake a vendetta. He received safe conduct back to Mantua, and the matter seems to have died.

Were the drawings being engraved by or after Mantegna or was Mantegna's rage provoked by the defection of Simone into the service of a rival painter? Both explanations are quite possible. A difficult question remains, however, regarding the absence of signatures on Mantegna's plates. Was his style alone enough to mark his work, so that a signature or monogram was superfluous? If so, then the concern for protecting his designs from plagiarism apparently came too late. The possibility has also been raised that Mantegna engraved nothing—that even the seven plates thought to be by his hand are really by an engraver or engravers working after his designs.[41] Could Vasari have meant, when he listed seven engravings by Mantegna (not exactly the same seven that modern criticism has established),[42] that these were from Mantegna's *shop?* The Italians did not always distinguish sharply between an autograph work and a workshop production—witness Raphael's well-known gift of a workshop drawing to Dürer in 1515. In 1520, when Raphael died, Dürer noted on the sheet, "Raphael of Urbino, who was so highly esteemed by the Pope, has made these nudes and has sent them to Nuremberg, to Albrecht Dürer, in order to show him his hand."[43] Dürer's assumption that the drawing was by Raphael himself must be contrasted with Raphael's assumption that it was enough to give a good representation of his *style.* Despite its detractors, however, the attribution of the seven plates to Mantegna himself persists because of their undeniably superior quality in both conception and execution. All in all, it is difficult to imagine any other master producing these prints.

An even more enigmatic northern Italian printmaker was Jacopo de' Barbari, whose prints, mostly signed with a caduceus, were also important for Dürer. A Venetian, Barbari has the distinction of being the only fifteenth-century Italian printmaker to travel extensively in the north (hence his name, "Jacopo of the barbarians"). After 1503 he worked for Frederick the Wise of Saxony and for Count Phillip of Burgundy and his grandniece, Archduchess Margaret, regent of the Netherlands, from whom Dürer tried unsuccessfully to buy a sketchbook by Barbari in 1521. In 1500, however, he had established residence in Nuremberg as a portraitist and miniaturist for Maximilian I, and this is perhaps when Dürer met him.[44] A passage from a draft of Dürer's intended treatise on human proportions describes an encounter between himself and his Italian colleague:

> For I myself would prefer to hear and read a well-learned man, famous in this art [human proportions], than to write about it as a novice. However, I find no one who has written

anything about how to make a canon of human proportions except for a man named Jacobus, born in Venice and a charming painter. He showed me a man and a woman which he had made according to measure, so that I would now rather see what he meant than behold a new kingdom; and if I had it, I would want to put it into print in his honor, for the use of all. But I was still young at that time and had never heard of such a thing. And the art was very dear to me, so I considered how such a thing might be done. For this aforesaid Jacobus did not want to show his principles to me clearly, that I saw well. But I set out to work on my own and read Vitruvius [whose writing preserves aspects of the proportion theories of antiquity] who writes a bit about the human figure. Thus from, or out of, the two above-mentioned men did I take my start, and thereafter, from day to day, I have carried on the search according to my own design.[45]

Barbari undoubtedly felt that his canon of proportions was a shop secret that he could not rightfully divulge to Dürer. Despite his reticence, the impact of his prints on Dürer's was enormous, and vice versa. Two engravings of Apollo and Diana illustrate this problematic interchange.

The chronology of Barbari's prints is very difficult to establish, but Panofsky argued that his *Apollo and Diana* (fig. 3.20) was the direct prototype for Dürer's engraving of about 1504–5 (fig. 3.21).[46] This places the former work at about 1503–4. A drawing in the British Museum of a male nude, closely related to the late classical *Apollo Belvedere,* seen from the front and a nude woman seen from the back (ca. 1501–3) was apparently altered by Dürer under the influence of Barbari's print—the empty, radiant solar disk held by the male figure was inscribed "APOLO," and long hair was added, thus clarifying the figure's iconographic identity. This drawing, however, never came to fruition in an engraving of the sun god and moon goddess; rather, Dürer adapted the Apollo figure for his Adam in the 1504 *Fall of Man* (fig. 2.8).[47] He began another composition of Apollo and Diana, again utilizing Barbari's print. This time Apollo holds the bow and arrow and has had his flowing locks from the beginning. Dürer turned Diana around to face the viewer and brought the couple down from the crystalline spheres of the heavens, depicted in Barbari's engraving by graceful, curving lines reminiscent of the Ferrarese *tarocchi* cards.

Dürer's nudes are more successfully rendered than Barbari's, with more varied, livelier interior modeling and contour lines (this is true even of the female nude, never Dürer's forte). He changed the untenable pose of Apollo—which Barbari had in turn derived from one of the bowmen in Pollaiuolo's *Battle* (fig. 3.7)—into a vigorous stance: the forceful pulling of the bow can now be felt, not just intellectually understood. In comparing these two prints, we might be moved to think that Dürer was being uncharacteristically modest when he wrote matter-of-factly that he "carried on the search according to my own design." It appears instead that he picked up the search where another artist dropped it.

In another of Barbari's undated prints, *Victory and Fame* (fig. 3.22), however, the influence may have flowed from north to south. Did Dürer utilize these nudes in the conception of his *Four Witches* (1497; fig. 2.7), or was it Barbari who borrowed the contrast of back and front views of the female nude for his print, with the back view, especially, revealing some of the same awkwardness? Do the plank of wood and tuft of grass at the lower left of Barbari's print derive from Dürer's *Holy Family with the Butterfly* (ca. 1495; fig. 2.6) or from some earlier work by Schongauer? (Or, art historians notwithstanding, are they merely a plank of wood and a tuft of grass that anyone could observe?) Is the forward-facing Fame a descendant or prototype

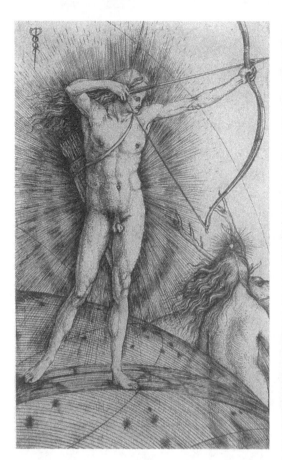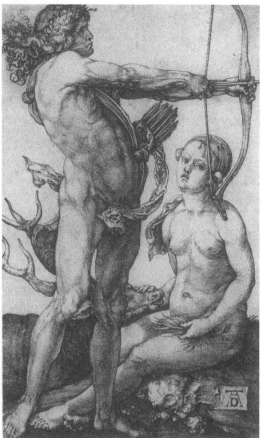

FIGURE 3.20

Jacopo de' Barbari. Apollo and Diana. *1503–4? Engraving. 160 × 98 mm (sheet, trimmed at plate-mark). National Gallery of Art, Washington, D.C.*

FIGURE 3.21

Albrecht Dürer. Apollo and Diana. *Ca. 1504–5? Engraving. 115 × 72 mm. National Gallery of Art, Washington, D.C.*

of the female nude in Dürer's *Dream of the Doctor* (ca. 1498–99)?[48] The questions about precedence provoked by these comparisons are less important than the fact of the interchange of artistic motifs that they establish. It is clear that, in *Victory and Fame*, Barbari is just beginning his synthesis of northern engraving technique (in which the deeper cutting considerably increased the longevity of the plate) with his Italian heritage. He retains the parallel hatching of Mantegna but begins, like Dürer, to bend this hatching pronouncedly around the masses of the bodies.

Perhaps Barbari's finest intaglio print is *St. Sebastian* (fig. 3.23), dated late in his career, probably between 1509 and 1516, when he died. Its silvery tonality compares to the engravings of Lucas van Leyden, with which he may have been familiar by 1509.[49] This print is also outstanding for its understatement and simplicity, especially when we compare it with the examples of Sebastian's martyrdom we viewed in Chapter 1 (see figs. 1.11, 1.30, 1.40). The saint is tied to a huge tree trunk, which acts as a dark foil for his nude body, now rendered by Barbari with far greater surety. The textural contrast between his skin and the rough bark of the tree is convincing and visually arresting; so is the play between the bulk of the tree and the delicacy of the vine at the lower left and the folds of Sebastian's loincloth. Although it has been suggested that Barbari's "characteristic lack of concern for iconographic clarity" was responsible for the absence of arrows,[50] it may be that the representation of the saint *before* martyrdom was intended to enhance the affective quality of the image and thus its function as a devotional print. This is Sebastian about to be shot, with the viewer occupying the spatial position of one of the executioners.

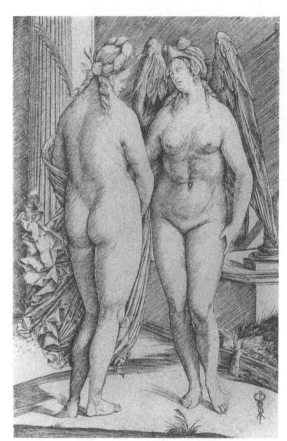

WOODCUT

Barbari did not restrict himself to intaglio printmaking, but ventured into woodcut as well. In Italy, engraving seems to have been an even more privileged medium that it was in the north. Few Italian collectors concerned themselves much with woodcuts from their native land, except for the chiaroscuro woodcuts after Raphael and other masters, which were seen (as were their northern counterparts) as reflections of ink-wash drawings.[51] Nevertheless, Italy made distinctive contributions to the development of woodcut.

In fifteenth-century Italy as in the north, woodcut was channeled in two directions: into devotional prints, of which directness and simplicity are the hallmarks, and into book illustrations. One of the earliest Italian woodcuts is the *Madonna of the Fire* (fig. 3.24). We know that it dates before 1428 because it figured in a miraculous occurrence that year. Nailed to the wall of a schoolhouse in Forlì, it survived a fire, emerging from the flames and drifting down to the amazed crowd surrounding the building. They carried the print to the cathedral, where a chapel was built around its shrine in 1626. Each year a gilt-bronze cover over the print was raised for devotional purposes.[52] The magical properties often associated with early woodcuts are exemplified by this charming story, just as the popular religious sentiments they embodied are well expressed in the woodcut's portrayal of Mary, Jesus, and related saints and narrative events. An ample, solemn Virgin holds her sturdy son, surrounded by tiers of saints and sur-

FIGURE 3.24

Unknown Italian artist. Madonna of the Fire. *Before 1428. Woodcut. 268 × 227 mm. Cathedral of Forlì, Italy.*

mounted by a Crucifixion and an Annunciation. Thus, Mary's special place above the saints and her role as the bearer of God's son and savior of mankind are made clear. A graceful balance and order, reinforced by the division of the composition into distinct areas, pervade the image.

A similar serenity is found in an *Annunciation* (ca. 1490–1500; fig. 3.25) associated with a Carmelite monastery in Bergamo (see the inscription). The cutting is less complex than that of contemporary northern woodcuts (compare the illustrations to the *Nuremberg Chronicle,* for example, figs. 1.21–1.24), with the modeling lines of the figures spaced fairly widely, continuing

FIGURE 3.25

Unknown Italian artist. The Annunciation. *Ca. 1490–1500. Woodcut. 266 × 178 mm. Ashmolean Museum, Oxford.*

the clarity of the linear design of the classically inspired arch. The ineffectual perspective of Mary's lectern is counteracted by the sureness with which the figures and the dramatic moment are depicted. They incline slightly toward each other, the dove of the Holy Spirit between them and God the Father and angels above. Mary responds to Gabriel's salutation and outstretched hand with a gesture of humble acceptance and modestly lowered eyes. Both their heads—one with long, flowing locks and the other with a delicate veil—are lovely.

Woodcut book illustration thrived in fifteenth-century Italy, with outstanding examples of both secular and religious texts.[53] We can only touch upon this vast area here by looking at two images, from one of the finest of these books, notable equally for its superb woodcut pictures and its innovative typography. The *Hypnerotomachia Poliphili* (*Strife of Love in a Dream*) was written by Francesco Colonna and published by Aldus Manutius of Venice in 1499. It concerned the lover (Poliphilus) of an ancient city (Polia), who wanders with his "sweetheart" through ancient ruins, ardently and elaborately described by the author. One of the most beautiful cuts, however, shows the lovesick Poliphilus strolling distractedly through a wood alone (fig. 3.26). The image is dominated by the undulating rhythm of the tree trunks, punctuated by the bunches of leaves. The strength of the *Hypnerotomachia*'s illustrations lies in both their cutting and their design, which are extremely different from those of the roughly contemporary *Nuremberg Chronicle*. In figure 3.27, the precision of the standing architecture (however improbably compiled) is played against the jumble of broken entablatures, column parts, and masonry blocks below. Although the allegorical conceit of the book strikes us as absurd today, it expressed perfectly the fanatic devotion of many Renaissance humanists to

antiquity. For them, "she" was not merely a mass of dry ruins and an echo of dead languages but a living tradition to be embraced, explored, and venerated.

Barbari's sweeping *View of Venice* (fig. 3.28) represents a high point in Italian Renaissance woodcutting. Published in 1500, it was printed from six blocks and measured almost three meters in length. It probably functioned as an economical, graphic mural decoration, rife with patriotic connotations that the Republic of Venice was quick to recognize: it granted Anton Kolb, the Nuremberg merchant who published the print, a four-year copyright and license to sell the work throughout Venetian territory for three ducats, free of taxation. Thus, Kolb was rewarded for his substantial investment of money and time (it had taken three years to have the blocks prepared from Jacopo's drawings) because he and Barbari contributed to "the fame of this most excellent city."[54]

Neither a devotional print nor a book illustration, the *View of Venice,* along with *The Triumph of Men over Satyrs,* printed from three blocks, showed that woodcut had a purely aesthetic dimension.[55] In an exhaustive analysis of the place of *Venice* within the tradition of cartography, understood both as an informational enterprise and as a carrier of abstract religious or political meanings, Juergen Schulz concludes that Barbari did not rely on known surveying techniques but composed the print like a mosaic, from drawings done from different vantage points within the city. *Venice,* then, was truly a work of art—as opposed to a map for getting one from here to there—and although it was vastly more detailed and accurate than earlier city-views such as those of the *Nuremberg Chronicle* (see fig. 1.22), these aspects were less important than its glorification of Venice.[56] Beneficently keeping watch over the city are the sea deity Neptune and Mercury, god of commerce. Together they represent the reason for Venice's wealth and fame: its leadership in maritime trade. The fruits of Barbari's labor were reaped later by Titian, whose magisterial *Submersion of Pharaoh's Army in the Red Sea* (see fig. 3.43)—apart from Dürer's *Triumphal Arch of Maximilian* (fig. 2.22) the most ambitious woodcut ever conceived—would not have been possible without the *View of Venice.* In both

FIGURE 3.26

Unknown Venetian artist. Poliphilus in a Wood *from* Hypnerotomachia Poliphili *by Francesco Colonna. Venice: Aldus Manutius, 1499. Woodcut. 104 × 130 mm. Library of Congress, Washington, D.C.*

FIGURE 3.27

Unknown Venetian artist. Poliphilus and Polia Wandering Among Ruins *from* Hypnerotomachia Poliphili *by Francesco Colonna. Venice: Aldus Manutius, 1499. Woodcut. 160 × 130 mm. Library of Congress, Washington, D.C.*

relief and intaglio printmaking, Barbari provided a foundation for the print's vigorous development in the High Renaissance.

MARCANTONIO AND HIS PUPILS

With Jacopo de' Barbari, we leave the north of Italy to turn again to its midsection. There the center of artistic gravity was shifting from Florence to Rome, largely under the impetus of the papacy of Julius II. In 1506 the young Marcantonio Raimondi, born near Bologna between 1475 and 1480, and trained by the Bolognese painter-goldsmith Francesco Francia, visited Venice, where a vital printmaking tradition was forming under the influence of Giulio Campagnola. According to Vasari, Marcantonio spent all his money on Dürer's woodcuts of the *Life of the Virgin,* which he found on sale in the Piazza di San Marco, and set about industriously engraving the designs, complete with Dürer's monogram! (Goltzius would use his own monogram in his *Meesterstukje,* although he burnished it out of the *Circumcision* in his effort to create a long-lost Dürer.) When Dürer brought his protest to the Venetian Senate in 1506, Marcantonio was forbidden to use the "AD" monogram, a stipulation with which he subsequently complied.[57]

Marcantonio had already copied Dürer while he was still in Bologna. His *Offer of Love* (ca. 1505; fig. 3.29) meticulously plagiarizes the German prototype (ca. 1495; fig. 3.30). Such attentiveness to a model so obviously northern in everything from the facial types to the awkward bodies to the detailed, meandering landscape must have required extraordinary self-effacement and concentration for one schooled in the Italian tradition. Indeed, selfless submersion in compositions by others was to prove Marcantonio's long suit. Whatever fame and profit he gained from his imitation of the famous German's work accompanied great advances

FIGURE 3.29
Marcantonio Raimondi after Dürer. The Offer of Love. *Ca. 1505. Engraving. 147 × 137 mm. Art Institute of Chicago.*

FIGURE 3.30
Albrecht Dürer. The Offer of Love (The Ill-Assorted Couple). *Ca. 1495. Engraving. 150 × 139 mm. Cleveland Museum of Art.*

in his own technical skill, for, in imitating, Marcantonio learned precisely what Dürer was doing and that he could not do this himself. He applied himself instead to translating the untranslatable into a systematic technique. Lost is all the intricacy, idiosyncracy, and flexibility of Dürer's line. The hatchings are unrelentingly even in their spacing and graceless in their terminations. The contours are overly insistent: what emerges is an efficient and bloodless image. Although we can be sure that Dürer was not happy with this pirated print, in one sense it is a sincere form of flattery. No comparison could better illustrate the difficulty of imitating a particular way of handling the burin. Marcantonio fares well, not as a translator of any artist's unique touch, as Goltzius would later become, but as a translator of an overall style or compositional principles. Eisler has described Marcantonio's work, perhaps too ungenerously, as a "mechanical, soulless, heartless oeuvre," which is often more important for understanding the history of artistic influence than the originals themselves. "Ticking little paper time bombs," Marcantonio's prints "robbed their magnificent source of reality and actuality, of volume and color, or warmth and breadth" and transmitted it, in this dessicated form, to subsequent generations.[58] His early plagiarisms, and then his collaborations with Raphael, set the stage for the enterprise of reproductive engraving. Consider the huge number of Marcantonio's less gifted pupils and artistic heirs, some of whom we will discuss in Chapter 5, and you will begin to have some sense of the import of this enterprise for the history of western art. With Marcantonio, we find a decisive shift in the way engraving was conceived. It began to adapt itself more flexibly in order to "reproduce," for better or worse, painted and sculpted works, and even other prints. It became the single most important means of circulating information about art—a kind of traveling museum on paper.

A Venetian work, the so-called *Dream of Raphael* (ca. 1507–8; fig. 3.31), perhaps preserves the design of a lost painting by Giorgione, described briefly in an eighteenth-century inventory as a "fire, with various figures."[59] The present title does nothing to elucidate the meaning of this curious image, which, like Giorgione's *Tempest,* one of the best-known paintings of the Venetian High Renaissance, still eludes cogent interpretation. Gustav F. Hartlaub explained

FIGURE 3.31

Marcantonio Raimondi
after Giorgione? The
Dream of Raphael.
Ca. 1507–8. Engrav-
ing. 238 × 335 mm.
Metropolitan Museum
of Art, New York.

the dream as that of Hecuba, mother of Paris, who envisioned him in her sleep as a torch being born from her womb and setting fire to the city of Troy. According to Hartlaub, the second woman is Hecuba again, seeing herself as she dreams.[60] Perhaps Giorgione's main intention was not to illustrate a particular story but to poetically evoke the sense of a nightmare. To the right of the sleeping women are a Bosch-like inferno and hybrid monsters. The tense poses and facial expressions of the figures suggest their troubled sleep.

In this print, Marcantonio achieved a remarkably successful graphic equivalent for the luministic, nocturnal atmosphere that must have been a part of the original painting by Giorgione (if, indeed, there was one). As in *The Tempest,* lights flash in a stormy sky and the fleshy bodies are modeled more in terms of light falling across their soft surfaces than in ana-lytical terms—that is, the structural approach often taken by central Italian artists, wherein each muscle is made manifest on the surface of the body. The reflections of the burning city in the water particularly reveal Marcantonio's relatively "painterly" approach, as do the flecks and stipples utilized, along with the now more sensitive lines, to create shadow in the landscape and on the figures. Marcantonio has learned from the prints of Giulio Campagnola (to be discussed below), who first began to express the concerns of the Venetian High Renaissance with the burin. Still, he is unwilling to relinquish the carefully defined, sculptural plasticity that would make his engraving style so adaptable to the Roman school, with its perennial emphasis on *disegno* (drawing or design) as opposed to *colore* (color).

From Venice, Marcantonio traveled south to Rome via Florence, where he engraved fig-ures from Michelangelo's *Battle of Cascina* cartoon, which was on display at the Palazzo della Signoria. In Rome he was to fill a great vacancy, becoming the engraver whose prints carried

the designs of Raphael and his pupils throughout Europe. The extraordinary importance of Raphael's artistic achievement dovetailed with Marcantonio's innovations in engraving technique, which established the direction that the reproductive enterprise would take for centuries to come. He steered it away from achieving the appearance of pen drawings toward the creation of a graphic equivalent for painted, and sometimes sculpted, works. (This remains true even when the prototype for his print was a drawing; he filled in the drawing so that the finished reproductive image *looks* as if it were made from a painting.) As Innis Shoemaker states, Marcantonio's particular skill lay in his development of a *system* of marks—dense cross-hatchings, widely spaced parallel hatchings, flecks, and dots—that, at its best, echoes the chiaroscuro of a painting. As a system it could be taught to others, but even Marcantonio's closest followers were hard-pressed to equal the versatility he lent it.[61]

The precise business arrangements between Raphael's workshop and Marcantonio's, and the procedures by which the latter produced engravings after the master's designs, remain frustrating enigmas. The nature and degree of Raphael's participation is, of course, the crucial issue. Vasari tells us only that Raphael hired Marcantonio to make prints after his drawings and that one Baviero di Carrocci of Bologna, known as Baviera, handled the printing and marketing of the images. This statement is intriguing when considered along with the assertion that Baviera was affluent after the disastrous Sack of Rome in 1527 because he possessed Raphael's engravings (he may have meant plates), but that Marcantonio was reduced to pauperhood and left Rome for his native Bologna, where he died. (In 1524 the luckless engraver had been arrested and incarcerated for a series of licentious engravings called *I Modi*, "the ways" of performing sexual intercourse, while Giulio Romano, Raphael's star pupil who had designed the prints, had left the papal jurisdiction and went unpunished.)[62]

Shoemaker stresses the diversity, "rife inconsistency," and "lack of documentation" in the operation of Marcantonio's Roman workshop.[63] Its chief goal was high production, and to this end it may not have followed any particular system of obtaining drawings and producing prints. The market for these engravings must have been substantial. A growing number of literate, middle-class patrons, who could not afford the real thing but satisfied their interest in art and antiquity through the more affordable medium of the print, augmented the market already created by upper-class patrons.

An early work from Marcantonio's Roman period is *The Suicide of Lucretia* (ca. 1511–12; fig. 3.32), a print in which many fundamental concerns of the Renaissance flowed together and were, in turn, transmitted to contemporary artists and posterity. In Rome, about 1500, an ancient statue was excavated and interpreted by the future Pope Leo X, then Cardinal Giovanni de' Medici, as representing the heroic Roman matron Lucretia (we have already encountered her story, as told by Livy, in our discussion of Israhel van Meckenem's *Death of Lucretia;* fig. 1.47). Marcantonio's print, which is mentioned by Vasari as the work that persuaded Raphael to hire the engraver on a more permanent basis, reflects an exquisite sepia drawing by the painter, possibly based on this fragmentary statue.[64] The dynamic torsion and amplitude of Lucretia's form also echo the figures from Raphael's frescoes in the Stanza della Segnatura in the Vatican, the first major statement of his balanced vision of High Renaissance style.

Lucretia's landscape background is taken from Lucas van Leyden's *Susanna and the Elders*. Lucas, in turn, was to use Marcantonio's figure for his Eve in the *Lamentation over the Body of Abel* of 1529.[65] It is, however, the classical architecture that predominates and sets the mood for this story of stoic resolve and virtue. The sarcophagus on which Lucretia rests her foot is

FIGURE 3.32

*Marcantonio Raimondi
after Raphael.* The
Suicide of Lucretia.
*Ca. 1511–12. Engraving.
212 × 130 mm. Museum
of Fine Arts, Boston.*

inscribed (oddly, in Greek rather than Latin): "Better to die than to live in dishonor." Except for the modest exposure of a breast, Raphael avoided the eroticism into which sixteenth-century depictions of this theme so often lapsed. Lucretia is a heroine, not a seductress. She stands as a model of courage and marital fidelity, and, most of all, of the ethos of the Roman Republic, so admired by Renaissance Italy.

Marcantonio's technique here is much improved over his slightly earlier *Dido,* which Vasari may have confused with *Lucretia* as the first print prompting Raphael's employment of the engraver.[66] Stippling and hatching are more concentrated into well-defined tonal areas. Marcantonio's systematic approach becomes clear in the floor, for example, where lines at the back change into shorter lines, then into stippling, which grows less dense toward the foreground. In the column, long and short curved, parallel hatchings flank a stippled highlight. The emphatic yet fluid and eloquent contours of the figure and the trace of woodenness in the arm gestures are the result of the translation of a passionate, subtle drawing into a graphic system. Marcantonio's most damaging change was to put Lucretia's face in profile; in the original drawing, Raphael gave it a three-quarter view and a softly angelic, upward glance that conveyed the pathos of the moment much more effectively. It is important to remember that it was engravings like this, and countless ones that were far less accomplished, that transmitted the knowledge of the Italian High Renaissance to subsequent artists and the public in general. One is reminded of Marshall McLuhan's dictum, "The medium is the message," in part inspired by Ivins' study of the transmission of information in graphic form.[67]

In supplying an environment for Lucretia, Marcantonio acted as a kind of *pasticheur.* Albeit with more guidance, he functioned identically in *The Massacre of the Innocents* (fig. 3.33),

known in two versions—with and without a fir tree in the upper right corner—and probably designed about 1511–12 *solely* for engraving. Six extant Raphael, or Raphael-shop, drawings guided the printmaker(s). The most complete preparatory drawing is in Budapest (fig. 3.34). Although there may have been more studies, now lost, that dealt with the background, Raphael's primary concern, as revealed in the works that remain, was the figures. The background was taken from a copy of an image in a sketchbook by a follower of the late fifteenth-century Florentine painter Domenico Ghirlandaio.[68] Although we cannot document the point at which the figures and background were compiled, the careful way in which the architecture functions compositionally points to Raphael's close supervision.

Each of the two main versions of the print has its champions and detractors: was Marcantonio responsible for the *Massacre* with the fir tree, without the fir tree, or both? Emison has reviewed the connoisseurship of these two prints to conclude that the Marcantonio version lacked the fir tree. One of the salient points in her argument concerns the unfocused glance of the central woman in the version with the fir tree; in what Emison deems the true Marcantonio version, this woman looks directly and more sensibly at the attackers to her right. Who was responsible for the second version? Emison suggests Agostino Veneziano, a more heavy-handed engraver whose coarser touch shows up in the handling of the hatching and dotting in the version with the fir tree.[69] This observation of course raises the question of Raphael's precise relationship to Marcantonio and other engravers. Why was a second version made at all? Did it undercut the first in the print market?

Wendy Sheard has stressed the importance of Roman relief sculpture in Raphael's conception of the image.[70] As we have already suggested, it provided inspiration for Mantegna as well. A more contemporary source was Michelangelo's *Battle of Cascina* cartoon, which Marcantonio had already utilized for prints. In this work, during the chaos of a surprise attack, the Florentine army was made to exhibit all manner of complex poses and muscular exertion. *Cascina* stood as a virtuoso piece, an example of Michelangelo's matchless rendering of the human form. Here, Raphael quite consciously recalls his Florentine rival while balancing the latter's obsession with the human body with a concern for spatiality and figural interaction. Raphael aimed, Vasari wrote, for an overall, synthetic excellence rather than succumbing to a hopeless attempt to match the inimitable.[71]

Raphael's own inimitability was rooted in his gift for composition, which nourished so many subsequent artists from Poussin to an unlikely Rembrandt to Ingres. The *Massacre* is an especially brilliant example of this gift. From the central axis, occupied by the figure of a terrified, trapped mother holding her child, the drama of Herod's preemptive attack on the Christ child (Matt. 2:16) unfolds in two diagonals, united at the top by the bridge and at the bottom by the figure of a slaughtered infant. Vertical elements, as in most classical compositions, neatly close off the sides. Although the terror of the moment and the physical intensity of the struggle are far better conveyed in the drawings, Raphael's compositional means are abstracted and made more apparent in the print.

Marcantonio's finest accomplishment in Rome, however, was his *Judgment of Paris* (ca. 1517–20; fig. 3.35) after Raphael himself or a member of his school. Preparatory drawings are unfortunately lost, although Erika Tietze-Conrat published a sheet of sketches in a New York collection that she believed to represent Raphael's preliminary ideas for the design.[72] The subject is a divine beauty contest, inspired by the jealousy of Eris, goddess of strife. The hapless judge of the contest was Paris, son of Hecuba (the proposed protagonist of *The Dream of*

FIGURE 3.35

Marcantonio Raimondi after Raphael. The Judgment of Paris. *Ca. 1517–20. Engraving. 292 × 433 mm. Art Institute of Chicago.*

Raphael; see fig. 3.31). Paris was forced to choose among Juno, shown here with her peacock, Minerva, who has laid her armor aside for the moment, and Venus, who wins by virtue of her bribe: an offer to deliver to Paris any mortal woman he desires. This mortal was Helen, wife of the king of Sparta, whose abduction by Paris started the Trojan war.

Raphael has assembled a number of antique deities: Mercury, Apollo, Jupiter, Diana, and the group of river gods on the right, later translated by Edouard Manet into a scandalous gathering of contemporary Parisians in his *Déjeuner sur l'Herbe* (1863). Once again, ancient sculpture has been consulted in the composing of the image. But more important, Shoemaker argues, is Raphael's subtle transformation of these sources for his own purposes.[73]

Marcantonio's now highly developed technique both conveys the sculptural plasticity of the figures and lends atmosphere to the environment in which they exist. To achieve a unifying tone, he apparently scored the plate all over with a rough, pumice-like stone before he began engraving.[74] The highlights are therefore softened, and the hatching lines blended more in the shadows. We may well see in this not only Marcantonio's growing technical skill but also his effort to comply with the augmented colorism and chiaroscuro of Raphael's style as it developed from the Stanza d'Eliodoro (1511) to the *Transfiguration of Christ* (1518).

It is difficult to say at what point the central Italian High Renaissance's erudite references to antique sources and to its own masterpieces, its complex, eminently knowledgeable treatment of figures in motion, and its sense of composition as an organic whole comprising moving, interrelated parts developed into the problematic style of Mannerism.[75] At what point did Raphael's facility (his apparent ease in handling difficult figural and spatial problems—for Vasari, one of the highest qualities to which an artist could aspire) lose its profound connection to nature and become a body of artistic motifs arbitrarily manipulated, not struggled for, by Mannerist artists like Vasari himself? Sometime in the 1520s, *facilità* became the self-conscious application of the Renaissance artistic vocabulary of form, and Michelangelo's *terribilità* (the disturbing spirituality of his style) lost its connection to his awesome vision of human dignity and purpose. The political and religious foundation of the Roman papacy of the early sixteenth century, which had supported the High Renaissance, was faltering. The Reformation took its toll, and the Sack of Rome in 1527 by the troops of Charles V, many of whom were inflamed

FIGURE 3.36

Marcantonio Raimondi after Baccio Bandinelli. The Martyrdom of St. Lawrence. 1525. Engraving. 437 × 575 mm (sheet). British Museum, London.

by the ravenous antipapism of northern Europe, dealt a devastating blow.[76] Michelangelo, as always unconstrained by art-historical categories, persisted on his own path. He died at a ripe old age in 1564, having nourished the High Renaissance and Mannerism equally well and, moreover, having left a legacy for Baroque artists.

The techniques developed by Marcantonio and the engravers under his tutelage (Agostino Veneziano, Marco Dente da Ravenna, and Jacopo Caraglio, for example) fitted certain aspects of Mannerism well, as did the newer medium of etching. Marcantonio's own *Martyrdom of St. Lawrence* (1525; fig. 3.36) was engraved after a drawing by the Florentine sculptor Baccio Bandinelli, who arranged for Marcantonio to be let out of jail, where he was being punished for *I Modi,* for this task. The print is a vivid illustration of the "marriage" of Marcantonio's style and Mannerism. The balance achieved easily in Raphael's *Massacre of the Innocents* design (see fig. 3.33) has a preordained, insistent quality here: an ovoid shape rigidly governs the grouping of the figures flanking the saint and on the central, receding ledge, and the positioning of the dark arches that Rembrandt seems to have contemplated as he reworked *Christ Presented to the People* (see figs. 4.52, 4.53).[77] A frozen symmetry and a sense of mirror-like, answering poses pervade the whole. In Pollaiuolo's *Battle,* such devices seemed a way of understanding human anatomy and exhibiting it to the fullest; here, with anatomical understanding and figural variety achieved, they become affectations imposing an aura of unreality on the horrible event.

Even so, it is usually unfair to accuse Mannerism of a loss of feeling, especially religious feeling, for Mannerism coincided with the post-Reformation era in which Christian issues were foremost in the minds of both Catholics and Protestants. It is less physical necessity that impels

Bandinelli's figures than inner turmoil. Some turn violently away from the sight; others seem frozen. The executioners go about their task with an oddly urgent determination, while the roasting saint strikes a curiously elegant pose (Lawrence is purported to have joked with his executioners, informing them that they could turn him over because he was done on one side). The whole effect is undoubtedly artificial but also haunting.[78] Like much Mannerist art, it leaves us with a particularly poignant sense of what is ephemeral and senseless about the human condition; the divine purpose so obvious in Michelangelo's concept of humanity seems to have eroded, and it is left to the viewer to rediscover that purpose in the process of meditating on the image. Here, the massive building with its emphatic jutting in and out only serves to emphasize the insubstantial quality of the figures, and of human accomplishment as a whole.

One of Marcantonio's pupils, Marco Dente da Ravenna, apparently perished in the Sack of Rome. He left behind one of the most famous engravings of the Renaissance, the *Laocoön* (1520–25; fig. 3.37), after the Hellenistic statue that had been excavated in 1506 in Rome as Michelangelo watched. The statue depicted the divinely ordained death of the Trojan priest Laocoön and his two sons from the venom of serpents, brilliantly described by the Latin poet Virgil in his *Aeneid* (II:199–233). (The work has since been associated with Pliny's description of a Laocoön group by the Rhodian sculptors Hagesandrus, Polidorus, and Athenodorus that decorated the palace of the Roman emperor Titus.) Marco Dente recorded the fragmentary form of the *Laocoön*—the missing limbs and serpent segments—with relative accuracy, and placed it on a pedestal. The statue itself would be put in the new Belvedere Court as part of the papal collection, and artists from Michelangelo to Rubens and beyond would draw inspiration from it. Yet it was the numerous engravings after this work that spread its fame as the quintessence of antique art. Marco Dente's print, especially, does justice to the work's sculptural plasticity and emotional power.[79]

The Sack of Rome also scattered Marcantonio and his workshop. Jacopo Caraglio, for example, went as far as Poland. But the reproductive enterprise was well established. As we noted in Chapter 2, Cock visited Rome in 1546 and took reproductive printmaking back to Antwerp, where he established "The Four Winds." And, in Marcantonio's wake, Roman print publishers flourished, supplying Europe with reproductions of Italian Renaissance works and the sculpture and architecture of antiquity. Antonio Salamanca took over Baviera's position, and later entered into partnership with a French immigrant, Antonio Lafréry. Lafréry's stocklist of 1572 reveals a vast range of prints, especially works illustrating Roman monuments that could be assembled, as the purchaser desired, into a volume for which Lafréry provided the frontispiece: *Speculum Romanae Magnificentiae*. This assemblage of Roman monuments is the ancestor of various later series of topographical prints of Rome, including Giovanni Battista Piranesi's in the eighteenth century.[80]

SIXTEENTH-CENTURY VENICE

In Venice, the High Renaissance gave way to no real Mannerism, only isolated examples of mannered figures and spatial constructions, as in the works of Tintoretto. Instead, the style that evolved in sixteenth-century Venice would contribute immeasurably to the formation of the high Baroque style. Color, fluid diagonal movements, an atmospheric light that melded figures and space together, and evocative, sensual moods were the basic concerns of Bellini,

FIGURE 3.37

Marco Dente da Ravenna. Laocoön *(as found in 1506). 1520– 25. Engraving. 472 × 324 mm (sheet). British Museum, London.*

Giorgione, and the young Titian. This last artist's life probably spanned over seventy years of the late fifteenth and sixteenth centuries. Corresponding to the golden age of Venetian painting that centered on him was an extraordinary development in printmaking, unfortunately fraught with all manner of knotty problems and unanswered questions.

Jacopo de' Barbari's example had provided a base on which sixteenth-century Venetian printmakers could build. But, in contrast to Barbari's experience, their involvement with and in some cases dependence upon painters went very deep. Although the early phase of Giulio Campagnola's career reflects early prints by Dürer and Mantegna's engravings, the later phase seems to spring from a close collaboration or at least a close contact between the engraver and painters. The greatest confusion arises over the attribution of drawings that appear to be preparatory studies for Giulio's prints. Although we cannot investigate this complex problem here, we can state its crux: how original was Giulio Campagnola? Did he, as Ulrich Mitteldorf

FIGURE 3.38

Giulio Campagnola.
The Old Shepherd.
Ca. 1509. Engraving.
79 × 133 mm. British
Museum, London.

maintained, design most of his engravings himself?[81] Or is an evaluation of his graphic oeuvre largely dependent upon an understanding of other authors of the designs: Giorgione, Titian, or Sebastiano del Piombo? Scarcely a less difficult problem, thoroughly bound up with the first one, is the chronology of his prints. Kristeller and, more tentatively, Hind established a chronology based on what they thought was a clear-cut technical evolution from line-engraving to stippling. But this view has been strongly challenged by Oberhuber, who believes that Giulio may have combined line and stipple in his later engravings, and returned entirely to line at the end.[82] One plate left unfinished on Giulio's death, *Shepherds in a Landscape,* was a line-engraving completed by his adopted son, Domenico.

The Old Shepherd (fig. 3.38) is similar in style and technique to Giulio's only dated print, *The Astrologer* (1509). Line predominates in the form of parallel hatching, but dots obtained with the point of the burin soften the shading. Although the poetic mood of Giorgione's interpretation of nature is evident, Giulio's understanding of space and the coherence of separate forms is not so well developed—the figure and animals are not embedded in a landscape but remain before it, and the distance from the front hillocks to the background houses is difficult to read. Despite the sense of atmosphere Giulio has created with his shading, he has not overcome the additive character of the original conception.

Christ and the Samaritan Woman (ca. 1515; fig. 3.39), on the other hand, also a combination of line and stipple, is conceived completely differently. The middleground here, barely articulated except with sparse lines, effectively separates a darkened, stippled foreground from the serene water of the distance. This is linked to the sky and horizon by repeated, horizontal lines. The well is a polygonal volume that helps establish the foreground plane as well as push us back to the space occupied by the ample figure of the Samaritan woman. The dramatic interchange in which Christ perceives her secret sin and forgives it is conveyed by her startled expression and twisted head. The compositional and figural relationship between this print and Titian's *Sacred and Profane Love* (ca. 1515) in the Borghese Gallery in Rome, and its distinct contrast to Giulio's *Shepherd,* bring up the question of the authorship of the design: it was very likely the young Titian.[83]

Similarly, Giorgione's creative spirit seems to lie directly behind this *Reclining Venus* (ca. 1508–9; fig. 3.40), which Giulio executed entirely in the stippling technique. The figure is reminiscent of the nude seen from the back in Marcantonio's *Dream of Raphael* (fig. 3.31), also

FIGURE 3.39

Giulio Campagnola after Titian? Christ and the Samaritan Woman. *Ca. 1515. Engraving. 135 × 184 mm. Graphische Sammlung Albertina, Vienna.*

possibly after a design by Giorgione, and corresponds in general terms to the beautiful "gypsy" in Giorgione's *Tempest*—fleshy, soft, and completely at home in the lush, slightly wild landscape. The buildings at the right are somewhat obscured in an atmospheric distance, because of the delicacy of Giulio's technique, while the foliage in the foreground is an exercise in the potential of stippling.

Giulio's adopted son, Domenico, was probably born of German parents in Venice. The influence of Titian pervades Domenico's prints; indeed, his drawings have often been confused with Titian's, although careful analysis reveals irreconcilable differences between their approaches.[84] Domenico's engraved oeuvre consists of thirteen prints, all executed about 1517–18.

His *Battle of Nude Men* (fig. 3.41) recalls, of course, Pollaiuolo's famous example (see fig. 3.7), as well as two particularly canonical prototypes from the central Italian Renaissance—Michelangelo's *Battle of Cascina* and Leonardo's *Battle of Anghiari,* both intended for the Palazzo della Signoria in Florence. Neither was completed, but so many artists drew from the cartoons that were exhibited in the Palazzo that both conceptions were very well known. In 1513 the challenge of depicting the fury of military action was taken up by Titian himself in his *Battle of Cadore,* destroyed in a fire in 1577. Domenico's print may reflect that painting as well. However, a comparison of his engraving with Titian's *Submersion of Pharaoh's Army in the Red Sea* (see fig. 3.43) makes apparent the distinction between a major artist working with a skilled cutter, and a secondary master. Domenico's odd manner of handling the burin to carve wave-like parallel hatchings and areas of cross-hatching that bear little relationship to underlying volumes does lend an urgency to his conception, but it remains a confusing jumble of figures and horses. The print is the closest Venetian art of the sixteenth century ever comes to Mannerism.[85] Figures are distorted, yes, but individual movement and overall fluidity are unimpaired. Very different are the deadlocked compositions of many Florentine and Roman Mannerists. And what Domenico does here with his figures seems less a deliberate artifice than a function of his burin stroke (compare Marcantonio's engraving after Bandinelli, fig. 3.36). In his woodcut landscapes (see fig. 3.47), the eccentricity evident here is missing; what emerges is a calm if slightly rambling style profoundly influenced by Titian.

FIGURE 3.40
*Giulio Campagnola after
Giorgione?* Reclining
Venus. *Ca. 1508–9.
Stipple engraving. 119 ×
183 mm. Cleveland
Museum of Art.*

Under the latter's direction, the woodcut in Italy reached a new height. *The Triumph of
Caesar,* an engraving by the Mantegna school, served as inspiration for Titian's *Triumph of
Christ* (ca. 1510–11; fig. 3.42), a procession printed originally from ten blocks but published
repeatedly in different versions. True to the original spirit of the woodcut, this work reflects
popular pageants on Christian feast days such as that of Corpus Christi. Christ in a chariot
pulled by the symbols of the four evangelists divides the procession in half, separating the eras
before and after grace. Beyond its Christian meaning, the *Triumph* draws together numerous
artistic references: Michelangelo's *Battle of Cascina* figures, Marcantonio's *Standard Bearer,*
Mantegna's *Parnassus* figures, and the *Laocoön* from antiquity.[86] Titian's design has a controlled
rhythm and an inexorable forward impetus. It achieves continuity without becoming redun-
dant, because of the artist's command of the human figure and its variety of action. Although
known as the subtlest colorist of the Italian Renaissance, Titian was also an extraordinary
draughtsman whose irregular, fluid drawing technique must have been the bane of his wood-
cutters. What was Titian's procedure for having prints made after his designs? How deeply was
his control imposed on the craftsmen transferring his drawings to the block and cutting it?

There have been various answers to these questions. Hans Tietze and Erika Teitze-Conrat,
pioneering scholars of prints and drawings, especially Italian, minimized Titian's responsibility
for his prints, believing that he prepared compositions for his printmakers almost offhandedly,
when he found the time.[87] This assumption allowed them to separate print from initial con-
ception—often by many years—and, as David Rosand and Michelangelo Muraro point out,
it "actually undervalues the graphic medium." By contrast, these later scholars assert the mas-
ter's "personal involvement" and "commitment to woodcut design," in which he sought "a
kind of refined graphic eloquence that might respond to Dürer's controlled pictorialism."[88]

FIGURE 3.41

Domenico Campagnola.
Battle of Nude Men.
*1517. Engraving. 222 ×
230 mm. Los Angeles
County Museum of Art.*

FIGURE 3.42

Titian. Detail from The
Triumph of Christ, *1517
edition. Woodcut from
five blocks, measuring
390 × 2642 mm when
assembled. New York
Public Library.*

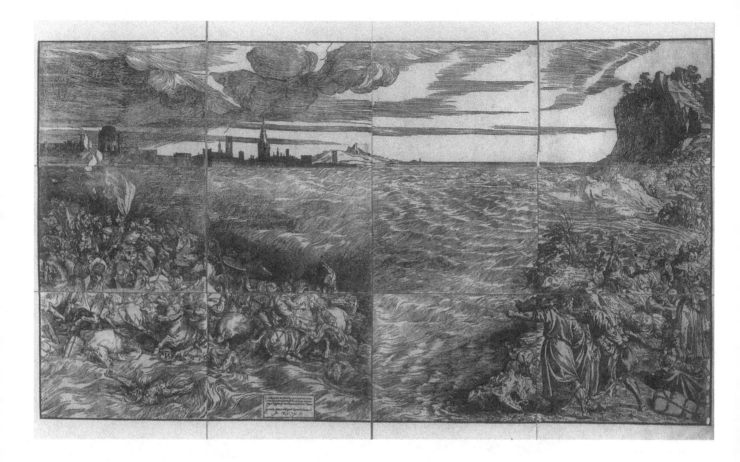

Titian's *Submersion of Pharaoh's Army in the Red Sea* (ca. 1514–15; fig. 3.43), scholars gen-
erally agree, was cut from a drawing done directly on the whitened block. Rosand and Muraro's
opinion quoted above, however, is based partly on their understanding of some drawings
closely related to Titian's prints: "Several of these drawings bear traces of their mechanical
transfer by means of counterproof [in this context, pressing the drawing against the block] or
even of pricking along the contours, and this affords specific evidence of the care with which
these woodcuts were developed; the designs were fully and precisely elaborated, sometimes in
a series of preparatory models, before they were finally given to the cutter for transference to
the woodblock."[89]

But, in a fascinating study, Peter Dreyer has reevaluated the same drawings and come to
a different conclusion: Titian drew directly on the blocks. Through a careful examination of
the drawings in question, he has come to believe that they were forged from the wood-
cuts—true counterproofs, retouched with the pen.[90]

Perhaps the most outstanding drawing that Dreyer examined is a study of trees (fig. 3.44;
now in the Metropolitan Museum), printed, according to him, from two of the blocks making
up *The Sacrifice of Abraham* (ca. 1514–15; fig. 3.45). If one looks at the upper right corner of the
lower right block and the upper left corner of the upper right block, the main components of
the drawing can be seen, reversed. Dreyer noted caesuras (breaks) in the sheet that correspond
to the borders of the blocks—one vertical line is visible even in reproduction. The individual
forging the drawing (Landau suggests Domenico Campagnola as the "culprit")[91] filled in the
intervening areas with the pen. Whereas these marks are not duplicated by anything in the
woodcut, Dreyer found an exact correspondence between the other lines and those of the print.

FIGURE 3.43

Titian. Submersion of
Pharaoh's Army in the
Red Sea. *Ca. 1514–15.
Woodcut from twelve
blocks, measuring 1225 ×
2215 mm when assembled.
Museo Correr, Venice.*

FIGURE 3.44

Titian or unknown artist? Study of Trees, *preparatory drawing for Titian's* Sacrifice of Abraham *or counter-proof from this woodcut retouched with ink? After 1514–15. 218 × 319 mm. Metropolitan Museum of Art, New York.*

FIGURE 3.45

Ugo da Carpi after Titian. The Sacrifice of Abraham, *first state. Ca. 1514–15. Woodcut from four blocks, measuring 800 × 1065 mm when assembled. Staatliche Museen, Berlin.*

Although Rosand cogently argues against Dreyer's disattribution of the Metropolitan study in particular, he admits that Dreyer's assertions have enormous ramifications of the connoisseurship of Titian's drawings.[92]

The additive quality of *The Sacrifice of Abraham* makes it one of the least successful prints after Titian's design (even though the cutter here was Ugo da Carpi, an excellent technician). The *Red Sea*, however, is a highly innovative and unified conception, despite its printing from twelve blocks: it was truly a mural print. Such an ambitious woodcut required the backing of

FIGURE 3.46

Nicolò Boldrini (?) after Titian. The Stigmatization of St. Francis (The Vision of St. Francis). *Ca. 1530. Woodcut. 293 × 433 mm. Museum of Fine Arts, Boston.*

a publisher, and Bernardino Benalio functioned as Anton Kolb had for the production of Barbari's *View of Venice* (Benalio had also published *The Sacrifice of Abraham*). Unfortunately, we do not know the cutter(s) of the blocks.[93]

The *Red Sea* reflects Titian's early studies for *The Battle of Cadore,* mentioned earlier. Commissioned in 1513, it was not finished until 1538 and was Titian's first major public commission. Although he was certainly aware of the battles of Cascina and Anghiari, he centered his design for the woodcut, not on the human figure or horses, but on the stormy sea. This was, of course, altogether appropriate for a print whose intended audience was the proud citizenry of a maritime republic, engaged at the time in a war with the League of Cambrai. The Egyptians in Titian's woodcut stood for the invading northerners. As the defecating dog on the Israelite's shore expressed contempt for the pharaoh's army, so the citizens of Valsugana had bared their bottoms to retreating German soldiers.[94] Titian's indecorous inclusion is thus a patriotic reference.

One of the most talented cutters working for Titian was Nicolò Boldrini, who was probably responsible for a superb *Stigmatization of St. Francis* (fig. 3.46) after the master's design (ca. 1530). The augmentation of religious ecstasy by an expressive natural setting was as appealing to the Venetians as it was to Altdorfer's German audience. The vision of the cross that impresses the mystical wounds of Christ on the saint is carved with radiating parallel hatchings that obliterate or cut through the contours of the trees at the right. The difficulty of rendering the explosive light associated with visions had been encountered before by Dürer in his *Apocalypse* images and solved with equal finesse (see figs. 2.2–2.5). Cross-hatchings deepen the shadows under the foliage and on Francis' foreshortened left arm. But the skill in execution does not explain the powerful expressiveness of this print, which is largely due to the boldness of conception. The poses of Francis and Brother Leo are calculated not only to express astonishment but also to draw the viewer into the richly articulated and varied middleground, while the foreground and middleground act as a unit played against the illuminated distance. The sweep of space, the surging curves of the tree trunks, and the figures combine to convey a visionary excitement. This woodcut makes it obvious why Titian was so significant for Baroque

FIGURE 3.47

Domenico Campagnola. Landscape with a Wandering Family. *Ca. 1535–40. Woodcut. 330 × 444 mm. Metropolitan Museum of Art, New York.*

artists. It bears much in common with the woodcut that provides our only evidence of his famous lost altarpiece of St. Peter Martyr (1526–30), drawn upon by so many seventeenth-century masters.

Titian left an important legacy to the subsequent practice of woodcut. In particular, the excellent prints after Rubens by Christoffel Jegher (see fig. 5.20) are part of Rubens' reprisal of Titian in his late period, although they also owe a debt to the woodcuts of Goltzius. (In fact, Rubens' understanding of printmaking as a whole stems partly from Titian and partly from the strong northern tradition of Goltzius and his pupils.) In the 1560s an aged Titian lost interest in the woodcut and turned completely to engraving, used as a reproductive medium. The arrival in Venice of the skilled Netherlandish printmaker Cornelis Cort in 1565 signaled a short, fruitful collaboration that we will treat in Chapter 5.

One of those artists reaping the benefits of Titian's approach to woodcut was Domenico Campagnola, whom we have already encountered as an engraver. His *Landscape with a Wandering Family* (ca. 1535–40; fig. 3.47), signed in the lower right, evokes the ancient world with the ruins of a Roman arena in the center above the watermill. Medieval architecture and contemporary life—a shepherd and shepherdess in the valley at the left and a vagabond (refugee?) family in the foreground—coexist to give the sense of the land sustaining its human inhabitants throughout the centuries. Made up of innumerable little hillocks, ridges, and ravines, Campagnola's landscape structure permits no climax, not even in the tallest mountain to the right of center. Rather, it invites perusal by a meandering eye.

THE CHIAROSCURO WOODCUT AND THE LINE WOODCUT

During his employment by Titian, Ugo da Carpi introduced the chiaroscuro woodcut to Italy. In his petition to the Venetian Senate for a copyright on the process in 1516, he claimed to have discovered it, despite earlier German examples; it was, the petition states, "something

quite new and never before done; and it is a beautiful thing, especially useful to all those who appreciate drawing."[95] We can perhaps forgive Ugo his chauvinism, because the Italian version of the technique did evolve into something "quite new."

St. Jerome (ca. 1516; fig. 3.48) is probably Ugo's first attempt at the process. The designer's name, Ticianus, is conspicuous; the cutter's name is somewhat more modestly placed in the lower right. Printed with a gray-green tone block with carved-out highlights over a black line block, this print is identical to German chiaroscuro cuts, save for, of course, the recognizably Italian figure-type and style. But in Ugo's *Diogenes* (1524–27)[96] after Francesco Mazzola of Parma, called Parmigianino, four blocks were employed to print tones and highlights only, in imitation of ink-wash drawings (fig. 3.49, color plate, p. 462). Most chiaroscuro woodcuts after Parmigianino, such as those by Antonio da Trento, show tones over lines and cross-hatching, so *Diogenes* is unusual, and apparently the only print ever done by Ugo for this painter. Their collaboration—if it indeed was that and not the woodcutter's pilfering of the design, perhaps from a much inferior engraving by Caraglio—was too short-lived, considering the results it yielded.[97] Arguably the most beautiful Italian example of the technique, *Diogenes* is a large, impressive print in ochres, browns, and black, or shades of sea green.

Parmigianino gave the fourth-century Cynic philosopher a spiraling, typically Mannerist torsion, ultimately going back to Michelangelo's *ignudi* on the Sistine ceiling. The torso turns in the opposite direction to the head and legs, and the whole movement is augmented by swirling drapery, hair, and beard. Thus, Parmigianino let the body express the probing mind and austere spirit of this man who lived nearly naked in a tub and roamed the streets with his lantern searching for an honest man. Diogenes' resolutely uncomplimentary estimate of the human condition is metaphorically expressed by the plucked rooster in the background, a visual expression of Plato's definition of the human being as a featherless biped.

Parmigianino's choice of Antonio da Trento to produce chiaroscuro woodcuts after his designs was an unfortunate one, according to Vasari, for the printmaker stole the painter's copperplates, woodblocks, and drawings one morning while he slept.[98] *The Martyrdom of SS. Peter and Paul* (more accurately, the martyrdom of Paul, with Peter being led away to his own execution; fig. 3.50) had been engraved by Caraglio in Rome, and when Parmigianino gave the design to Antonio in Bologna, he made detailed drawings for the areas in which adaptations for the new medium would be made.[99] The composition is closely related to Raphael's frescoes in the later Vatican Stanze and, especially, to his cartoons for the tapestries, depicting scenes from the Acts of the Apostles, that would be woven in Flanders and hung on the walls of the Sistine Chapel (1515). The decisive gesturing of Raphael's characters became more explosive in Parmigianino's hands: Nero, who seems to be ordering Peter's crucifixion, points emphatically forward while looking directly back, and the soldier who responds to his command does so with equally aggressive, bodily enthusiasm. In front, the executioner wielding his sword against Paul is a strong spatial device similar to Mantegna's scourger in the *Flagellation* (fig. 3.18); he forms the fulcrum of the composition, completing the diagonal movements from the right and left and, with his jutting elbow, almost intruding into the viewer's space. Antonio employed a tan tone block over black lines that were probably cut from the painter's drawing on the whitened block. No complete drawings exist for the woodcuts attributed by Vasari to Antonio da Trento, and yet these prints give a credible sense of the style of Parmigianino's more finished drawings.[100]

FIGURE 3.50

FIGURE 3.50

*Antonio da Trento
after Parmigianino.* The
Martyrdom of SS. Peter
and Paul. *Late 1520s?
Chiaroscuro woodcut.
296 × 481 mm. Metro-
politan Museum of Art,
New York.*

FIGURE 3.48

*Ugo da Carpi after
Titian.* St. Jerome.
*Ca. 1516. Chiaroscuro
woodcut. 156 × 96 mm.
British Museum, London.*

The Florentine Mannerist Domenico Beccafumi (ca. 1486–1551) may have cut his own
blocks for chiaroscuro prints. This figure, identified only as "apostle," is printed in purplish-
gray inks and betrays an exceptional sensitivity for the texture of the wood (fig. 3.51). The artist
has gone so far as to carve an artificial grain in the background. The figure is muscle-bound
and elongated, posed in a serpentine curve reinforced by the strong division of shadow and
highlight. The arbitrariness of the Mannerist figure is particularly evident in his arms, which
would reach to his knees if unbent. The right one balances a huge book uncomfortably on his
hip, while the left arm and hand, descended from Michelangelo's *David* (1501–3), seem to hold
a stone, instrument of the apostle Stephen's martyrdom, or an attribute of Jerome, one of the
four Latin Church Fathers. The head, with its intense glance, recalls Michelangelo's *Moses* (ca.
1515) from the ill-fated tomb of Julius II. Thus, Mannerism quotes the recent artistic past as it
profoundly challenges its underlying assumptions.

The unusual talent of the painter-printmaker Giuseppe Scolari closes our study of Italian
Renaissance woodcuts. Practically nothing is known about his life. He is recorded as a member
of the painters' guild of Venice between 1592 and 1607, and he also worked in Vicenza and
probably Verona. Although Scolari certainly profited by Titian's example in woodcut, he cut
his own blocks as well as designing them, and his approach to the medium is wholly unusual.[101]
Unlike the ruggedly irregular lines in Titian's *Red Sea*, those of this *Man of Sorrows* (ca. 1580;
fig. 3.52) are sustained and sharply hewn. The effect is white on black, reversing the normal
appearance of woodcut. Only Urs Graf had attempted something akin to Scolari's approach.
In addition, Scolari sometimes created his woodcuts in states by inserting plugs of wood and

FIGURE 3.52
*Giuseppe Scolari.
The Man of Sorrows.
Ca. 1580. Woodcut.
527 × 373 mm. Metro-
politan Museum of Art,
New York.*

FIGURE 3.51
*Domenico Beccafumi
(1486–1551).* Standing
Apostle. *Chiaroscuro
woodcut. 414 × 208 mm.
British Museum, London.*

recarving them to alter the compositions substantially.[102] (Generally, wooden plugs were used only to make small corrections or repair damaged blocks.)

The Man of Sorrows is related to Titian's paintings of Christ, seen in half-length, wearing the crown of thorns and robe, and carrying the "scepter" given him by the Roman soldiers after the Flagellation.[103] Such close-up images of the suffering Christ have intense emotional appeal, which Scolari heightens by his strident line and contrasts of light and dark. This print is at once a reaffirmation of the simple religiosity of the earliest woodcuts and a foreshadowing of the immediacy of Baroque devotional imagery.

ETCHING

As engraving became more standardized in the course of the sixteenth century, the newer intaglio process—etching—extended its inherent appeal as a freer, more spontaneous way of working. Having lost his engraver Caraglio after the Sack of Rome, Parmigianino apparently

began to etch as well as experiment with the chiaroscuro woodcut. He probably etched no more than sixteen plates, but in those works he greatly expanded etching's potential in this direction and established an Italian approach to the medium that would carry through to the Tiepolos in the eighteenth century. Moreover, his prints were copied frequently and often inspired pastiched variations. It was through Parmigianino's prints rather than his relatively few paintings that his enormous influence on International Mannerism was transmitted.[104]

The Entombment is his best-known print, extant in two versions drawn in opposite directions; here we show the later, more detailed image (fig. 3.53).[105] It betrays his training under Correggio and a rivalry with Raphael, who had painted this subject in 1507. In contrast to this earlier work, full of the physical struggle of heaving the body of Christ into the tomb and the dramatic expression of grief, the etching takes a more symbolic approach. Christ's body is displayed on the tomb slab as the sacrifice it constitutes. The mourning figures do not touch him for the most part, but withdraw into their separate meditations on the meaning of his death. Their narrow heads and distended bodies are typical of Parmigianino's adaptation of the melting sensuality of Correggio's style. An agitated, individualistic despair replaces the unified, mostly ecstatic emotionalism of the latter's religious works. Parmigianino's nervous handling of the etching needle is ideally suited to the mood of the subject. It simulates his rapid pen sketches with widely spaced parallel and cross-hatchings. The plate is lightly bitten, preserving this spontaneous, autographic character. A painter's etching *par excellence, The Entombment* was widely copied.

Certainly the most prolific Italian etcher of this period was Antonio Tempesta, who worked primarily in Rome. Among his vast graphic output are illustrations for Ovid's *Metamorphoses,* Tasso's *Jerusalem Delivered,* grisly visualizations of the torture of saints for Antonio Galloneo's 1591 treatise on their martyrdoms, numerous hunt and battle scenes, animal prints, biblical and historical scenes, and landscapes. In other words, Tempesta's graphic oeuvre constitutes a kind of encyclopedia of late Renaissance imagery, and we can be sure that these technically unassuming prints served exactly this purpose for seventeenth-century artists.[106] Altogether typical of his style is *Alexander Battling the Persians* (fig. 3.54), from a life of Alexander the Great that Tempesta dedicated to the Duke of Croy (1608). Dominating the teeming scene is Alexander on his magnificent rearing horse, Bucephalus, but all sorts of equine poses show Tempesta's skillful approach to this very important Renaissance problem. In the lower right, for example, a horse lies on its side, its back legs and torso in a foreshortened view. The crowding of the composition and ornamental touches such as the horses' curling manes and tails place this image in the context of late Cinquecento Mannerism, but its energy and fluidity of movement would have appealed to a Peter Paul Rubens or Pietro da Cortona.

The best of Italian etching at the end of the century is represented by Federico Barocci's four prints, three of which are reproductive and one of which, *St. Francis Receiving the Stigmata* (ca. 1581; fig. 3.55), is closely related to painted prototypes.[107] Barocci had had two paintings, a *Rest on the Return from Egypt* and a *Madonna with the Cat,* engraved by Cort, who had, we recall, come to Italy from Cock's Antwerp print-publishing firm and worked for no less a painter than Titian. The success of Cort's two engravings after Barocci's paintings, their brilliant tonal richness and clear detail, and Cort's untimely death in 1578 may have inspired the painter to produce his own reproductive prints, but in the newer medium of etching, more amenable to a painter's sensibility.

Barocci's choice signals a general shift from virtuoso engraving to etching on the eve of

the seventeenth century. In the hands of such skilled practitioners as Cort and Goltzius, engraving reached a sort of impasse by the late sixteenth century. Henceforth, the elaborate variety of burin lines and marks developed by these engravers would be expanded upon, embellished, systematized, and refined by reproductive engravers of the seventeenth and eighteenth centuries, but the primary arena for innovation, especially in original printmaking, would be etching.

In *St. Francis Receiving the Stigmata,* burin work·is combined with the etched lines, bitten in two immersions. Later etchers such as Callot would strive to smooth out the tonal differences between the bites, as the process of multiple acid baths was refined and elaborated in the seventeenth century. In 1581, Barocci's approach was new; it envelops the background in an atmospheric, space-creating haze and emphasizes the ecstatic saint. Now more isolated against the surrounding woods than in Titian's and Boldrini's woodcut, tilted forward and open to the viewer, with buckled legs lost in drapery, St. Francis' pose concisely expresses his ecstatic assimilation of Christ's suffering in the form of the stigmata. Like Scolari, Barocci anticipated the directness and intensity of seventeenth-century religiosity. The print retains the character of a pen sketch, despite the tonal contrast caused by the double biting. In his two most elaborate reproductive prints, Barocci combined this spontaneous, pen-like treatment with a rich colorism derived from Cort's reproductive engravings.

Although the quest for a graphic analogy to the color of paintings was to seduce the bulk of Italian printmakers in the seventeenth and eighteenth centuries, and the reproductive function of the print was to dominate, at least in sheer numbers of prints produced, the Italian market, some of the most outstanding contributions to original printmaking in these centuries would come from Italian artists, especially those building on the heritage of Parmigianino's and Barocci's etchings. Indeed, our study of the great age of original etching begins with Italian examples.

FIGURE 3.55

Federico Barocci.
St. Francis Receiving
the Stigmata. *Ca. 1581.*
Etching and engraving
with burin used in lower
part of print to yield
burr. 231 × 152 mm.
Metropolitan Museum
of Art, New York.

NOTES

While the book was in press, *The Renaissance Print* by David Landau and Peter Parshall was published (see Bibliographical Note, p. 863). Although I was not able to incorporate their extensive scholarship in my text here or in Chapter 5, I was able to make some small adjustments in response to their clarification of the notoriously vague term, "reproductive."

1. In Levenson, Oberhuber, and Sheehan 1973, pp. xxv–xxvi. This source provides a good bibliography on Italian prints up to 1973; for later sources, see Karpinski 1987.

2. See Clark 1966 for a classic study of Rembrandt's use of Italian Renaissance prints. Goddard 1988, pp. 14–15, 21–22, discusses the Amerbach collection.

3. See Bury 1985, especially pp. 16, 26, on the Gonzaga collection, and Landau 1983b on Vasari and prints.

4. See Levenson, Oberhuber, and Sheehan 1973, pp. xiii–xviii, for the origins of Italian engraving.

5. Ibid., pp. 2–3.

6. Ibid., pp. xvi–xvii; Hind [1923] 1963, pp. 42–44.

7. Phillips 1955, pp. 56–59; Levenson, Oberhuber, and Sheehan 1973, pp. 13–21.

8. Kristeller [1905] 1921, p. 176.

9. Landau 1983b, p. 4; Bury 1985, pp. 21–24.

10. Hind [1938–48] 1970, vol. 1, p. 183, and plate 257 in vol. 3.

11. Mâle 1906.

12. Levenson, Oberhuber, and Sheehan 1973, no. 2, p. 27.

13. Ibid., p. 26.

14. Phillips 1955, p. 63.

15. Phillips 1955, pp. 68–75; Levi d'Ancona 1965; Levenson, Oberhuber, and Sheehan 1973, pp. 47–59.

16. Richards 1968.

17. Hind [1938–48] 1970, vol. 1, p. 191 (dated after 1470); Phillips 1955, pp. 45–46 (dated 1460–62); Levenson, Oberhuber, and Sheehan 1973, no. 13, pp. 72–75 (dated 1470–75). On the basis of a comparison to an ancient marble group excavated in 1488, Fusco 1984 dates this print to 1489.

18. On the origins of the return stroke and Pollaiuolo's possible tools, see Levenson, Oberhuber, and Sheehan 1973, pp. xviii–xviiii.

19. For a discussion of the possible relationship between *The Battle of the Nudes* and *Hercules and the Giants,* see Anderson 1968.

20. The arguments regarding subject matter are summarized in Levenson, Oberhuber, and Sheehan 1973, no. 13, pp. 66–71, and in Emison 1990.

21. For example, Barr 1926, p. 77; Clark 1956, p. 352; Richards 1968.

22. On Pollaiuolo's use of ancient art, see Shapley 1919; Vickers 1977a; Fusco 1979; Fusco 1984. On ancient statuary in prints in general, see Shepherd 1969; Haskell and Penny 1981, passim.

23. Vasari [1568] 1851, vol. 2, p. 227.

24. Levenson, Oberhuber, and Sheehan 1973, p. 291.

25. Brockhaus 1933, pp. 398–400, offers the most elaborate thesis asserting that the cards were used in a game.

26. Seznec 1953, p. 139.

27. According to Kristeller 1902, Mantegna engraved only seven plates: the *Madonna and Child, The Entombment,* the two *Bacchanals,* the two for *The Battle of the Sea Gods,* and *The Risen Christ between SS. Andrew and Longinus.* All are on Vasari's list except the *Madonna and Child.* Vasari added a *Descent from the Cross* to make up seven plates, and, in his second edition, he listed *The Triumph of Caesar* as Mantegna's. Bartsch 1803–21 catalogued twenty-three plates by Mantegna, while Portheim 1886 reduced this to fourteen. Hind [1938–48] 1970 basically followed Kristeller, with the reservation that an absolute division between Mantegna and the Mantegna school was too dogmatic. See Levenson, Oberhuber, and Sheehan, p. 168 and n. 25; Lightbown 1986, pp. 237–38.

28. See Levenson, Oberhuber, and Sheehan 1973, nos. 70–77, pp. 170–95, for varying opinions on the dating of all of Mantegna's prints. Also see Zucker 1984, nos. .001–.007, pp. 79–98; Lightbown 1986, nos. 205–11, pp. 489–91.

29. Levenson, Oberhuber, and Sheehan 1973, pp. 167–68, 170, on the date of the beginning of Mantegna's engraving activity. For a discussion of the date of *The Entombment,* see Zucker 1984, no. .001, pp. 79–85; Lightbown 1986, no. 205, p. 489. Lightbown himself argues for a date of 1488–90.

30. E.g., an *Entombment* attributed to Fra Angelico or Fra Filippo Lippi in the National Gallery in London.

31. Levenson, Oberhuber, and Sheehan 1973, no. 72, pp. 178–80. Also see Lightbown 1986, p. 239, and no. 206, p. 489.

32. On the dating of the *Bacchanals* and *The Battle of the Sea Gods,* see Levenson, Oberhuber, and Sheehan 1973, no. 73, p. 182, n. 3, and p. 188; Vickers 1976, p. 834; Zucker 1984, nos. .004 and .007, pp. 90–98; Lightbown 1986, nos. 208–11, pp. 490–91.

33. Vickers 1978. For objections to Vickers' theory, see Hope and MacGrath 1978; Martindale 1978.

34. Bober 1964, pp. 43–48; Vickers 1976.

35. Vickers 1977.

36. Lightbown 1986, pp. 240–41; Jacobsen

1982 (on the inscription and its association with melancholy, see p. 624, n. 3).

37. For arguments against an early date, see Levenson, Oberhuber, and Sheehan 1973, no. 77, p. 194. Arguments for an early date are presented by Zucker 1984, no. .003, pp. 88–9. For a summary of opinions, see Lightbown 1986, no. 207, pp. 489–90.

38. Levenson, Oberhuber, and Sheehan, no. 78, p. 205.

39. Mayor 1971, under fig. 191.

40. Kristeller 1902, p. 402, p. 530, doc. 55.

41. Tietze-Conrat 1943.

42. The *Descent from the Cross* and the *Triumph of Caesar* mentioned by Vasari are now thought to be school pieces (see n. 27 above).

43. Panofsky [1955] 1971, p. 284.

44. For a summary of and bibliography for the problems involved in determining Barbari's biography, see Levenson, Oberhuber, and Sheehan 1973, pp. 341–44. Some scholars think that Dürer may have met Barbari earlier, in 1494–95. This is suggested vaguely by a passage from one of Dürer's letters, written to Pirckheimer from Venice in 1506, and quoted on p. 344 in Levenson, Oberhuber, and Sheehan.

45. Quoted in Levenson, Oberhuber, and Sheehan, pp. 344–45.

46. Panofsky 1920.

47. Talbot, ed., 1971, nos. 7 and 12, pp. 39–40, 50–51.

48. Levenson, Oberhuber, and Sheehan 1973, p. 347.

49. Ibid., no. 147, p. 380.

50. Ibid.

51. Bury 1985, pp. 21–24.

52. Mayor 1971, under fig. 10.

53. See Hind [1935] 1963, vol. 2, for a treatment of Italian woodcut book illustration.

54. Rosand and Muraro 1976, p. 11.

55. See Landau 1983a, p. 304.

56. Schulz 1978.

57. Vasari [1568] 1851, vol. 3, pp. 492–93; Shoemaker and Broun 1982, p. xiv (Vasari mistook the *Life of the Virgin*, however, for the *Small Passion*).

58. Eisler 1982, pp. 80, 94 (quotation on p. 84).

59. Shoemaker and Broun 1982, no. 12, p. 74.

60. Hartlaub 1960, p. 79.

61. In Shoemaker and Broun 1982, p. 3.

62. Vasari [1568] 1851, vol. 3, p. 504.

63. In Shoemaker and Broun 1982, pp. 10–11 (quotation on p. 10).

64. See Stechow 1951; Sheard 1978, no. 102 (not paginated). Raphael's drawing has been published by Stock 1984.

65. Sheard 1978, no. 102 (not paginated); Jacobowitz and Stepanek 1983, no. 15, p. 68, and n. 2 on p. 68.

66. Sheard 1978, no. 102 (not paginated).

67. Ivins [1953] 1969.

68. See Shearman 1977.

69. Emison 1984.

70. Sheard 1978, no. 45 (not paginated).

71. Raphael's synthetic ability is stressed throughout his biography: Vasari [1568] 1851, vol. 2, pp. 1–65.

72. Tietze-Conrat 1953. A lack of coherence in the upper part of the final composition has suggested to some scholars that Raphael's ideas were synthesized by a pupil rather than the master himself. See Emison 1986, cat. no. 13, p. 36.

73. In Shoemaker and Broun 1982, no. 43, p. 146. Also see Sheard 1978, no. 90 (not paginated).

74. Shoemaker and Broun, no. 43, p. 146.

75. See Freedberg [1961] 1972, vol. 1, chaps. 5, 6, and 7, for a subtle discussion of the development of Mannerism from High Renaissance classicism.

76. For a social interpretation of Mannerism, see Hauser 1965.

77. Davis 1988, no. 38, pp. 114–15.

78. Davidson 1961, pp. 3–4, offers an especially positive interpretation of the print's religious expression.

79. Sheard 1978, no. 60 (not paginated).

80. Lowry 1952.

81. Mitteldorf 1958.

82. See Levenson, Oberhuber, and Sheehan 1973, pp. 390–401, for a discussion of issues of chronology in Giulio's oeuvre.

83. Ibid., p. 395.

84. Ibid., pp. 414–16.

85. See ibid., p. 417, for the opposite opinion regarding Domenico and Mannerism.

86. Rosand and Muraro 1976, nos. 1 and 2, p. 43.

87. Tietze and Tietze-Conrat 1938.

88. Rosand and Muraro 1976, p. 21.

89. Ibid.

90. Dreyer 1979.

91. Landau 1983a, p. 305.

92. Rosand 1981, pp. 303–6.

93. Rosand and Muraro 1976, no. 4, p. 73, argue against Ugo da Carpi as the cutter; Karpinski 1976 argues for Andrea Schiavone.

94. Rosand and Muraro 1976, no. 4, pp. 72–73.

95. Ibid., p. 20.

96. Goldfarb 1981, p. 313, thinks that the print might predate Parmigianino's flight from Rome in 1527.

97. See ibid. for the opinion that Ugo may have printed *Diogenes* without Parmigianino's permission. Also see Popham 1971, vol. 1, p. 13; Davis 1988, cat. no. 19, pp. 74–75.

98. Vasari [1568] 1851, vol. 3, p. 365.

99. Popham 1971, vol. 1, p. 13, no. 191, p. 93, and no. 407, p. 144. Also see O.R. nos. 115 and 116, p. 259 (these latter two entries concern old reproductions of lost drawings).

100. Popham 1971, p. 13.

101. Rosand and Muraro 1976, pp. 296–97.

102. Ibid., nos. 97A and 97B, pp. 302–3, and nos. 104A and 104B, pp. 312–13.

103. Wethey 1969–75, vol. 1, nos. 32, 33, 34.

104. On Parmigianino's etchings, see Oberhuber 1963; Popham 1971, vol. 1, pp. 13–17; Reed and Wallace 1989, p. xxiv.

105. Reed and Wallace 1989, no. 9, pp. 13–14.

106. For example, Govaert Flinck utilized one of Tempesta's images from Otto van Veen's book on the Bavarian rebellion: see Carroll 1986, p. 17, and plates 30 and 31.

107. Pillsbury and Richards 1978, no. 72, p. 102.

REFERENCES

Anderson, Lilian Armstrong. 1968. Copies of Pollaiuolo's *Battling Nudes. Art Quarterly*, vol. 31, no. 2 (Summer), pp. 154–67.

Barr, Alfred H. Jr. 1926. A drawing by Antonio Pollaiuolo. *Art Studies*, vol. 4, pp. 73–78.

Bartsch, Adam. 1803–21. *Le peintre-graveur.* 21 vols. Vienna.

Bober, Phyllis Pray. 1964. An Antique Sea-Thiasos in the Renaissance. In *Essays in Memory of Karl Lehmann*, pp. 43–48. New York.

Brockhaus, Heinrich. 1933. Ein edles Geduld spiel: Die Leitung der Welt oder die Himmelsleiter, die sogenannten Taroks Mantegnas vom Jahre 1459–60. In *Miscellanea di Storia dell'Arte in Onore di I.B. Supino*, pp. 398–400. Florence.

Bury, Michael. 1985. The Taste for Prints in Italy to c. 1600. *Print Quarterly*, vol. 2, no. 1 (March), pp. 12–26.

Carroll, Margaret Deutsch. 1986. Civic Ideology and Its Subversion: Rembrandt's *Oath of Claudius Civilis. Art History*, vol. 9, no. 1 (March), pp. 12–35.

Clark, Kenneth. 1956. *The Nude: A Study in Ideal Form.* London.

Clark, Kenneth. 1966. *Rembrandt and the Italian Renaissance.* New York.

Davidson, Bernice Frances. 1961. Marcantonio's Martyrdom of S. Lorenzo. *Bulletin of the Rhode Island School of Design*, vol. 47, no. 3 (March), pp. 1–6.

Davis, Bruce. 1988. *Mannerist Prints: International Style in the Sixteenth Century.* Exhibition catalog. Los Angeles County Museum of Art, Los Angeles.

Dreyer, Peter. 1979. Tizianfälschungen des sechzehnten Jahrhunderts. *Pantheon*, vol. 37, no. 4 (October–December), pp. 365–75.

Eisler, Colin. 1982. Marcantonio: The Reproductive Print as Paradox. *Print Collector's Newsletter*, vol. 13 (July–August), pp. 80–84,

Emison, Patricia. 1984. Marcantonio's *Massacre of the Innocents. Print Quarterly*, vol. 1, no. 4 (December), pp. 257–67.

Emison, Patricia. 1986. *The Art of Teaching: Sixteenth-Century Allegorical Prints and Drawings.* Exhibition catalog. Yale University Art Gallery, New Haven, Conn.

Emison, Patricia. 1990. The Word Made Naked in Pollaiuolo's *Battle of the Nudes. Art History,* vol. 13, no. 3 (September), pp. 261–75.

Freedberg, Sydney J. [1961] 1972. *Painting of the High Renaissance in Rome and Florence.* 2 vols. Reprint. New York.

Fusco, Laurie. 1979. Antonio Pollaiuolo's Use of the Antique. *Journal of the Warburg and Courtauld Institutes,* vol. 42, pp. 257–63.

Fusco, Laurie. 1984. Pollaiuollo's Battle of the Nudes: A Suggestion for an Ancient Source and a New Dating. In *Scritti di Storia dell'Arte in Onore di Federico Zeri.* vol. 1, pp. 196–98. Milan.

Goddard, Stephen H. 1988. The Origin, Use, and Heritage of the Small Engraving in Renaissance Germany. In Goddard, ed., 1988, pp. 13–29.

Goddard, Stephen H., ed. 1988. *The World in Miniature: Engravings by the German Little Masters 1500–1550.* Exhibition catalog with essays by Patricia A. Emison, Stephen H. Goddard, and Janey L. Levy. Spencer Museum of Art, University of Kansas, Lawrence.

Goldfarb, Hilliard T. 1981. Chiaroscuro Woodcut Technique and Andrea Andreani. *Bulletin of the Cleveland Museum of Art,* vol. 67, pp. 307–28.

Hartlaub, Gustav Friedrich. 1960. Giorgione im graphischen Nachbild. *Pantheon,* vol. 18, no. 2 (March), pp. 76–85.

Haskell, Francis, and Nicholas Penny. 1981. *Taste and the Antique.* New Haven, Conn.

Hauser, Arnold. 1965. *Mannerism.* 2 vols. New York.

Hind, Arthur M. [1923] 1963. *A History of Engraving and Etching.* Reprint. New York.

Hind, Arthur M. [1938–48] 1970. *Early Italian Engraving.* 7 vols. Reprint. Nendeln, Liechtenstein.

Hind, Arthur M. [1935] 1963. *An Introduction to the History of Woodcut.* 2 vols. New York.

Hope, Charles, and Elizabeth McGrath. 1978. A Setting for Mantegna. *Burlington Magazine,* vol. 120, no. 906 (September), pp. 603–4.

Ivins, William. [1953] 1969. *Prints and Visual Communication.* Reprint. Cambridge, Mass.

Jacobowitz, Ellen S., and Stephanie Loeb Stepa-

nek. 1983. *The Prints of Lucas van Leyden and His Contemporaries.* Exhibition catalog. National Gallery of Art, Washington, D.C.

Jacobsen, Michael A. 1982. The Meaning of Mantegna's *Battle of Sea Monsters. Art Bulletin,* vol. 64, no. 4 (December), pp. 623–29.

Karpinski, Caroline. 1976. Some Woodcuts after Early Designs of Titian. *Zeitschrift für Kunstgeschichte,* vol. 39, no. 4, pp. 258–74.

Karpinski, Caroline. 1987. *Italian Printmaking: Fifteenth and Sixteenth Centuries: An Annotated Bibliography.* Boston.

Kristeller, Paul. 1902. *Andrea Mantegna.* Berlin and Leipzig.

Kristeller, Paul. [1905] 1921. *Kupferstich und Holzschnitt in vier Jahrhunderten.* Berlin.

Landau, David. 1983a. Printmaking in Venice and the Veneto. In Martineau and Hope, eds., 1983, pp. 303–5.

Landau, David. 1983b. Vasari, Prints and Prejudice. *Oxford Art Journal,* vol. 6, pp. 3–10.

Levenson, Jay A., Konrad Oberhuber, and Jacquelyn L. Sheehan. 1973. *Early Italian Engravings from the National Gallery of Art.* Exhibition catalog. National Gallery of Art, Washington, D.C.

Levi d'Ancona, Mirella. 1965. Francesco Rosselli. *Commentari,* vol. 16, nos. 1–2, pp. 56–75.

Lightbown, Ronald. 1986. *Mantegna: With a Complete Catalogue of the Paintings, Drawings and Prints.* Berkeley, Calif.

Lowry, Bates. 1952. Notes on the Speculum Romanae Magnificentiae and Related Publications. *Art Bulletin,* vol. 34, no. 1 (March), pp. 46–50.

Mâle, Emile. 1906. Une influence des mystères sur l'art italien du XV siècle. *Gazette des Beaux-Arts,* 3rd ser., vol. 35, pp. 89–94.

Martindale, Andrew. 1978. A Setting for Mantegna. *Burlington Magazine,* vol. 120, no. 907 (October), p. 675.

Martineau, Jane, and Charles Hope, eds. 1983. *The Genius of Venice 1500–1600.* Exhibition catalog with contributions by J. R. Hale, Howard Burns, Francis Haskell, David Landau, et al. Royal Academy of Arts, London.

Mayor, A. Hyatt. 1971. *Prints and People.* New York.

Mitteldorf, Ulrich. 1958. Eine Zeichnung von Giulio Campagnola. *Festschrift Martin Wackernagel,* pp. 141–52. Cologne–Graz.

Oberhuber, Konrad. 1963. Parmigianino als Radierer. *Alte und Moderne Kunst,* vol. 8 (May–June), pp. 33–36.

Panofsky, Erwin. 1920. Dürers Darstellungen des Apollo und ihr Verhaltnis zu Barbari. *Jahrbuch des Preussischen Kunstsammlungen,* vol. 41, pp. 371–73.

Panofsky, Erwin. [1955] 1971. *The Life and Art of Albrecht Dürer.* One-volume paperback edition, without handlist. Princeton, N.J.

Phillips, John Goldsmith. 1955. *Early Florentine Designers and Engravers.* New York.

Pillsbury, Edmund P., and Louise S. Richards. 1978. *The Graphic Art of Federico Barocci: Selected Drawings and Prints.* Exhibition catalog. Cleveland Museum of Art, Cleveland, Ohio.

Popham, Arthur Ewart. 1971. *Catalogue of the Drawings of Parmigianino.* 3 vols. New Haven and London.

Portheim, Fritz. 1886. Mantegna als Kupferstecher. *Jahrbuch des Preussischen Kunstsammlungen,* vol. 7, pp. 214–26.

Reed, Sue Welsh, and Richard Wallace. 1989. *Italian Etchers of the Renaissance and Baroque.* Exhibition catalog with contributions by David Acton, David P. Becker, Elizabeth Lunning, and Annette Manick. Museum of Fine Arts, Boston.

Richards, Louise S. 1968. Antonio Pollaiuolo: *Battle of Naked Men. Bulletin of the Cleveland Museum of Art,* vol. 55, pp. 61–70.

Rosand, David. 1981. Titian Drawings: A Crisis of Connoisseurship. *Master Drawings,* vol. 19, no. 3 (Autumn), pp. 300–308.

Rosand, David, and Michelangelo Muraro. 1976. *Titian and the Venetian Woodcut.* Exhibition catalog. National Gallery of Art, Washington, D.C.

Schulz, Juergen. 1978. Jacopo de' Barbari's View of Venice: Map Making, City Views, and Moralized Geography before the Year 1500. *Art Bulletin,* vol. 60, no. 3 (September), pp. 425–74.

Seznec, Jean. 1953. *The Survival of the Pagan Gods.* New York.

Shapley, Fern Rusk. 1919. A Student of Ancient Ceramics, Antonio Pollaiuolo. *Art Bulletin,* vol. 2, pp. 78–86.

Sheard, Wendy Stedman. 1978. *Antiquity in the Renaissance.* Exhibition catalog. Smith College Museum of Art, Northhampton, Mass.

Shearman, John. 1977. Raphael, Rome and the Codex Escurialensis. *Master Drawings,* vol. 15, no. 2, pp. 107–46.

Shepard, Katharine. 1969. Antique Sculpture in Prints. *Hesperia,* vol. 38, pp. 223–30.

Shoemaker, Innis H., and Elizabeth Broun. 1982. *The Engravings of Marcantonio Raimondi.* Exhibition catalog. Ackland Art Museum, University of North Carolina, Chapel Hill, N.C., and Spencer Museum of Art, University of Kansas, Lawrence, Kansas.

Stechow, Wolfgang. 1951. Lucretiae Statua. In *Essays in Honor of Georg Swarzenski,* pp. 114–24. Chicago.

Stock, Julian. 1984. A Drawing by Raphael of "Lucretia." *Burlington Magazine,* vol. 126, no. 976 (July), pp. 423–24.

Talbot, Charles W., ed. 1971. *Dürer in America: His Graphic Work.* Exhibition catalog with notes by Gaillard F. Ravanel and Jay A. Levenson. National Gallery of Art, Washington, D.C.

Tietze, Hans, and Erika Tietze-Conrat. 1938. Titian's Woodcuts. *Print Collector's Quarterly,* vol. 25, nos. 3–4, pp. 332–60, 464–77.

Tietze-Conrat, Erika. 1943. Was Mantegna an Engraver? *Gazette des Beaux-Arts,* 6th ser., vol. 24 (December), pp. 375–81.

Tietze-Conrat, Erika. 1953. A Sheet of Raphael Drawings for the *Judgment of Paris. Art Bulletin,* vol. 35, no. 4 (December), pp. 300–302.

Vasari, Giorgio. [1568] 1850–52. *Lives of the Most Eminent Painters, Sculptors and Architects.* 5 vols. Trans. Mrs. Jonathan Foster. London.

Vickers, Michael. 1976. The "Palazzo Santacroce Sketchbook": A New Source for Andrea Mantegna's "Triumph of Caesar," "Bacchanals" and "Battle of the Sea Gods." *Burlington Magazine,* vol. 118, no. 885 (December), pp. 824–35.

Vickers, Michael. 1977a. A Greek Source for Antonio Pollaiuolo's *Battle of the Nudes* and

Hercules and the Twelve Giants. Art Bulletin, vol. 59, no. 2 (June), pp. 182–87.

Vickers, Michael. 1977b. The Sources of Invidia in Mantegna's *Battle of the Sea Gods. Apollo,* vol. 106, no. 188 (October), pp. 270–73.

Vickers, Michael. 1978. The Intended Setting of Mantegna's "Triumph of Caesar," "Battle of the Sea Gods" and "Bacchanals." *Burlington Magazine,* vol. 120, no. 903 (June), pp. 365–71.

Wethey, Harold E. 1969–75. *The Paintings of Titian.* 3 vols. London.

Zucker, Mark J. 1984. vol. 25 of *The Illustrated Bartsch* (see Bibliography of Print Reference Catalogs, p. 860).

4

Etching in the Seventeenth Century

Etching, as we have seen, was invented in the early sixteenth century as a means of putting designs on armor. During the course of the century, improvements in the methods and materials of etching (for example, the use of copper rather than iron plates that were vulnerable to rust) made etching a staple printmaking technique. Whereas the sculptural and classical character of High Renaissance art was well suited for translation into engraving, the Mannerist aesthetic, with its emphasis on inventiveness and its challenge to High Renaissance art, provided a major impetus for seventeenth-century etching.[1] And, at the end of the sixteenth century, Barocci's few etchings revealed a loose but richly tonal approach that would appeal greatly to subsequent Italian artists. Etching's continuing viability, however, was not due to a single interpretation of the technique but to its adaptability. Like lithography, etching can create the appearance of a spontaneous sketch or a laborious study. It can produce effects roughly similar to engraving (at least until one inspects the line closely) or be combined with engraving or drypoint. Or etching can deviate entirely from its older intaglio sibling to seek its own path, where sketchiness, movement, and atmosphere are more readily achieved.

Despite etching's steadfastness, and its primacy in the late nineteenth-century "etching revival," its apogee can justifiably be placed in the seventeenth century. Except for the major development of aquatint in the eighteenth century, the seventeenth century's use of etching ran the full gamut from the purest linearity and immediacy to complex permutations and tonality in which the various states of a print might differ substantially from each other. Both these extremes are found in the work of Rembrandt, who was to etching what Dürer was to

engraving—an example impossible to surpass yet always inspiring to subsequent artists, an artistic sensibility perfectly matched to a medium. Whistler, one of the printmakers who was to revitalize etching in the late nineteenth century, could look back to a print like *The Gold-weigher's Field*, or *View of Saxenburg*, (see fig. 4.46) to find an extraordinary freshness and economy of means; Picasso to a print like *The Three Crosses* (see figs. 4.54, 4.55), whose separate states constitute different dramatic moments, to find a lengthy metamorphosis that capitalizes on the possibilities for change inherent in the graphic processes with no concomitant loss of immediacy.

In the seventeenth century, etchings took their place alongside masterpieces of original and reproductive engraving in collectors' cabinets. For example, Rembrandt's extensive print collection, partly gleaned from the estate sale of the Amsterdam painter Jan Basse in 1637, contained etchings by Jusepe de Ribera, Jan Lievens, Guido Reni, Ferdinand Bol, and himself, alongside the albums of engravings by masters like Dürer and Lucas, some of which, as we shall see, served as inspirations for Rembrandt's etchings or drypoints. Rembrandt's prints were only part of his encyclopedic collection of objects, but they were organized primarily by *artist*, in keeping with the shift in classification patterns at the end of the Renaissance mentioned earlier.[2] This shift stems from the same aesthetic sensibility that valued the *autographic* quality of etching: that is, its capacity to reveal the artist's unique touch more directly than engraving.

ITALY

Engraving seems to have impressed the Italians as a technique that was suited primarily to tightly controlled reproductive prints, exemplified by the work of Marcantonio or Cort. Etching, on the other hand, while also used reproductively in Italy, was handled more loosely. Parmigianino's light touch found echoes in Italian etchers like Giovanni Benedetto Castiglione and the Tiepolos. In his *St. Francis Receiving the Stigmata* (fig. 3.55), and in more strictly reproductive etchings after his own paintings (see Chapter 5), Barocci went beyond Parmigianino's tonal range, striving for a coloristic richness through a more varied use of hatching and stipple. In its expressive intensity and incipient looseness of handling, Barocci's work was an important source for the Italian Baroque style. This style emerged out of late Mannerism in the 1590s, particularly in the works of Annibale Carracci and Michelangelo Merisi da Caravaggio. Although the latter's brief, innovative, and troubled career left only one etching,[3] all the artist members of the Carracci family—the brothers Annibale and Agostino and their cousin Ludovico—made prints. Agostino was printmaker by trade and, as we shall see, one of the most important and skilled reproductive engravers of the seventeenth century. Ludovico produced only four prints. Annibale's graphic oeuvre is substantial but not huge: Diane DeGrazia (formerly Bohlin) catalogs twenty-two examples.[4] As in painting, his was the most original talent of the Carracci family. Prints seemed to function as a "private means of expression" for this painter of monumental altarpieces and fresco cycles.[5]

Although Agostino etched only two plates, and even then treated the process as if it were engraving, Annibale seems to have preferred etching to engraving and often combined the two media, as Lucas van Leyden had first done in his portrait of Maximilian of 1520.[6] *The Holy Family with St. John the Baptist* (1590; fig. 4.1) has deep burin lines combined with the most delicate strokes of the etching needle. Annibale looked at Barocci's broken contour lines and

FIGURE 4.1

Annibale Carracci.
The Holy Family with
St. John the Baptist.
1590. Etching and en-
graving. 164 × 219 mm.
New York Public Library.

used this technique to produce the sunlight-suffused atmosphere that softens the forms. Note, for example, the Madonna's left sleeve, which nearly merges with the background landscape. The monumental simplicity of this composition and the powerful, massive figures are hallmarks of Annibale's style, which harked back to the artists of the High Renaissance (Michelangelo and Raphael in particular) to seek a way out of the complexity of late Mannerism. The mood of this print is intimate and tender. Mary gently restrains the infant Christ while glancing toward a pensive Joseph, who is reading a scripture with ominously darkened pages, presumably the prophecies of his foster son's mission.[7] The young John the Baptist, whose shaded face almost disappears, embraces the Christ child, perhaps in a prophetic apprehension of their future suffering. Rembrandt was impressed by this print and used aspects of it in an early etching of *The Holy Family*.[8]

Of a melancholy disposition himself, Annibale was drawn to themes marked with much pathos, such as the Pietà. In his *Pietà* (1597; fig. 4.2), a remarkable, shimmering light surrounds the mourners. This is produced by Annibale's rather nervous use of the etching needle, his occasional use of the drypoint, and the fortuitous, rippling lines in the sky (such marks are usually caused by a breakdown of the etching ground during biting).[9] Along with the poignant gestures and facial expressions, it is the light that gives this print its emotional impact. Its compositional simplicity and the beautiful classicism of Christ's body are typical of Annibale; its expressive directness might be directly contrasted with the Mannerist approach to religious themes (compare Bellange's *Pietà*, fig. 2.56).

FIGURE 4.2

Annibale Carracci. Pietà. *1597. Etching, engraving and drypoint. 125 × 164 mm (sheet). Library of Congress, Washington, D.C.*

Guido Reni dominated the Bolognese school after his arrival there in 1614. He synthesized what he had learned from the Carracci in Bologna and from his experience in Rome into a fluid, graceful style. Not only were Reni's paintings frequently reproduced in prints, but he and his followers, such as Simone Cantarini and Elisabeta Sirani, an unusual example of a woman painter-printmaker, produced numerous etchings.[10] Reni's free technique, founded on Parmigianino's fluid use of the needle and Barocci's broken lines, is evident in this *Holy Family* (fig. 4.3), which clearly goes back to Annibale's example in its expression of tender pathos. The Virgin's elegant, twisting pose as she turns toward the Christ child, however, reflects a lingering Mannerism in Reni's style that is not present in Annibale's image. And although both etchings stand within the Italian tradition of emphasizing the etched line, Annibale used cross-hatching to build substantial, clear masses, while Reni was more interested in broken form and flickering light.

One of the finest etchers of the early Italian Baroque period was a native Spaniard, Jusepe de Ribera ("lo Spagnoletto"), who studied under Caravaggio in Rome and worked in Naples, where he was patronized by Spanish viceroys and the religious orders. Ribera's style carried Caravaggio's naturalism a step further into a coarser, more textural realism. The abandonment of the Italian idealism underlying Caravaggio's style, despite its apparent naturalism, is characteristic of the Dutch and Spanish Caravaggisti. In Ribera's paintings, his faithful rendering of surfaces, achieved partly by the dragging of coarse brushes over wet paint, is dazzlingly apparent. Something of that tangibility emerges in his etchings as well.[11] In *Silenus Drinking* (1628;

fig. 4.4), based on a painting which reprises the Bacchic theme of Mantegna's pendant engravings (see figs. 3.13, 3.14) as well as Caravaggio's early paintings, one can sense the various surface textures: the wooden wine cask, the fur of the satyr's leg, the silken skin of Silenus' distended belly. Such bravura handling of the etching needle would not have been lost on Rembrandt (compare the shiny sleeve of his *Self-Portrait* of 1639, fig. 4.41). The braying donkey at the right introduces a humorous, down-to-earth note into the mythological context. Genre-like treatment of mythological themes is characteristic of the international Caravaggesque movement: for example, Velasquez's famous painting *The Drinkers* (1628–29) in the Prado, Madrid, which is related to Ribera's conception.

Born near Naples, Salvator Rosa worked mainly in Florence and Rome. He had studied under Ribera, and was an actor, poet, and musician as well as an artist. Rosa is best known for wild, Romantic landscapes that contrast profoundly with the classicizing landscape tradition represented by Claude Lorrain. The sinister mood of Rosa's landscapes is also evident in his choice of bandits, soldiers (notorious as ruffians in Rosa's time), sorcerers, alchemists, and witches as subjects. His etchings parallel the nervous, vibrant touch that characterizes his paintings, but, in contrast, the prints approach the blond tonality produced by a sparse and delicate use of line that we will find again in Giambattista and Domenico Tiepolo. *Democritus in Meditation* (1661–62, etching with some drypoint; fig. 4.5) might be compared to the elder Tiepolo's *Capricci* or *Scherzi di Fantasia* etchings, in respect to both composition along major diagonals, answered by secondary diagonals, and an exemplary lightness of touch (see Chapter 6).

FIGURE 4.4

Jusepe de Ribera. Silenus
Drinking. *1628. Etching.
270 × 351 mm. Phila-
delphia Museum of Art.*

Democritus is companion piece to another etching, *Diogenes Casting Away His Bowl,* and
both prints are based on large paintings of 1650–52. Richard Wallace has analyzed Rosa's con-
ception of Democritus, the "laughing philosopher," in great detail.[12] Although Democritus is
supposed to have laughed at the vices and follies of humanity, Rosa transformed him into a
"weeping Heraclitus," his philosophical opposite. The message of the print is pessimistic; its
symbolic detail redundantly asserts that all of human life—even knowledge and art—is tran-
sient vanity. The Latin inscription reads: "Democritus, the mocker of all things, is here stopped
by the ending of all things." Thus, *Democritus* continues the pictorial and iconographic tradi-
tion of *Melencolia I* (fig. 2.16; compare the poses of the two main figures) and demonstrates
the dark note sounding throughout Rosa's work. The *memento mori,* or reminder of death, is
represented by funerary monuments, a fallen obelisk, various animal and vegetable symbols of
decay, and especially the piles of brittle bones, for which Rosa made some raggedly etched
studies.

The other major etcher working in Rome in the early seventeenth century was Pietro
Testa. Among Testa's patrons was Cassiano dal Pozzo, a remarkable scholar and antiquarian
whose *Museo Cartaceo* (*Paper Museum*) was an attempt to catalog existing Roman antiquities
with an entirely new precision, by means of bound albums of drawings, some of which were
produced by Testa.[13] Discouraged about the reception of his paintings, Testa ultimately turned
to etching and experimented with multiple biting, etched plate tone, and the use of trial
proofs.[14] Testa's rough, vigorous, and broad-lined style is displayed admirably in one of his
earliest prints, *The Martyrdom of St. Erasmus* (1630–31; fig. 4.6), closely related to his friend

FIGURE 4.5

Salvator Rosa. Democ-
ritus in Meditation.
*1661–62. Etching. 456 ×
276 mm. Museum of Art,
Rhode Island School of
Design, Providence.*

FIGURE 4.6

Pietro Testa. The
Martyrdom of St. Eras-
mus, *second state.
Ca. 1630–31. Etching.
275 × 185 mm (sheet).
Pinacoteca Nazionale,
Bologna.*

Poussin's famous painting of the same name (1628–29). Testa had originally come into contact with Poussin during his training in the Roman studio of Domenichino.

The martyrdoms of the early saints had always been important subjects in Christian art, but during the Catholic revival of the seventeenth century they were, like the ecstasies of later saints, more frequently and realistically depicted, often to the point of a gory brutality difficult for us to apprehend. Its purpose was to shore up unity, reaffirm the divine ordination of the Roman church, and promote, by shock treatment, devotional fervor among its members. As multiple images, of course, prints were important tools in this effort. Erasmus' martyrdom was surely one of the most hideous: his intestines were wound around a windlass, an instrument that made him the patron saint of sailors. Testa spread the body of the saint, with its gaping wound, across the picture at eye level. All around, figures move and gesticulate wildly, while angels waft down with the crown and palms of martyrdom. The pagan idol that Erasmus

refused to venerate sits glowering in the background. The enterprising Testa dedicated his print to the "noble spirit of my benefactor, Cardinal Stefano Garbesi," a inscription probably added after Garbesi had seen and approved a trial proof. The dedication of copperplates was financially risky because any monetary reward depended upon the hoped-for benefactor's decision to pay for the honor with a fee.[15]

Claude Lorrain, born Claude Gelée in Lorraine, was a thoroughly Italianized Frenchman whose landscapes of the Roman *campagna* epitomize a glowing, arcadian harmony and establish him as one of the foremost artists of the classical landscape tradition. Claude's approach was more sensual than Poussin's, and appealed to a different set of patrons: the aristocracy, high ecclesiastics, royalty.[16] Claude brought his sensitivity for light and atmosphere to his etchings as well as his paintings. Whether populated by characters from Greek mythology or by peasants, as in *The Village Dance* (1630s; fig. 4.7), which reproduces in reverse a painting in the Uffizi, Claude's nature, bathed in light and imbued with an unobtrusive order, nostalgically evokes a golden age when humanity was at its best. Like the painted landscapes they often reproduce (Claude, like Barocci, promoted his paintings in prints etched by his own hand), his etchings are usually conceived *contre-jour* (against the light), so that the magnificent trees with their tangled foliage and the more awkward figures stand out against a luminous background. To achieve this luminosity here, Claude brushed acid directly on the plate in the foreground, hill, and sky. The resultant tone, however, wore quickly and is best visible in early impressions.[17]

A more monumental print is his vision of a harbor at sunrise (1634; fig. 4.8), reproducing in reverse a painting in the Hermitage, which conjures up the grandeur of past civilizations, poignantly recalled through their ruins. *The Rising Sun* also looks ahead to Turner's romantic harbor views in the nineteenth century. The tonal gradations, from the dark shadows cast by the figures and boats in the foreground to the ghostly grays of the ships in the distance, reveal a fine sensitivity for the luministic possibilities of etching. Moreover, Claude enhanced the tonal richness of this print by an ink film left on the plate.[18] Despite imperfections in biting and printing, Claude's relatively small output of etchings (he made between forty and fifty) is important for its realization of the potential of the medium. As his painted landscapes escaped the academic relegation of landscape to a low point in the hierarchy of subjects, his etched landscapes have a monumentality that transcends the informality of many seventeenth-century examples.

The most technically innovative etcher of the Italian Baroque period was Giovanni Benedetto Castiglione of Genoa. As we shall see in Chapter 9, he is credited with the invention of monotype and soft-ground etching.[19] Like Hercules Seghers in the north, Castiglione tirelessly explored the painterly capacity of printmaking, and both inventions are related to this pursuit.

The interest in nocturnal lighting, displayed sporadically in the Renaissance but more widely and intensely pursued by Baroque artists such as the Dutch Caravaggisti, the German painter Adam Elsheimer, and Rembrandt, underlies Castiglione's *The Bodies of SS. Peter and Paul Hidden in the Catacombs* (fig. 4.9) in both its etched and its monotype versions from the late 1640s. The subject is unusual, perhaps explained by a contemporary revival of the old association of Peter and Paul in Christian thought as the two pillars of the early Roman church, and by legends surrounding their death and interment. Moreover, a wall painting of this subject had been reproduced in Antonio Bosio's book on Roman burial places, *Roma Sotteranea*,

FIGURE 4.7

Claude Lorrain. The Village Dance (Land-scape with Country Dance), *first state. 1630s. Etching. 195 × 255 mm. British Museum, London.*

FIGURE 4.8

Claude Lorrain. The Rising Sun (Harbor View with Rising Sun). *1634. Etching. 127 × 196 mm. British Museum, London.*

FIGURE 4.9

*Giovanni Benedetto
Castiglione.* The Bodies
of SS. Peter and Paul
Hidden in the Cata-
combs. *Late 1640s.
Etching and drypoint.
295 × 203 mm. R. S.
Johnson Fine Art,
Chicago.*

first published in 1632.[20] Peter, the more distant figure, identifiable by the key, was crucified upside down at his own request, to avoid comparison to Christ, and Paul was decapitated. Their executions took place on the same day but on different hills in Rome. In Castiglione's etching, their bodies are discovered by a close-knit band of Christians who press forward through the cavernous setting by shimmering torchlight. This light, the movement of the figures, and Castiglione's rapid strokes lend the image a dramatic urgency. The Catholic mind of the seventeenth century perceived the early church as intensely faithful and unified in spirit. It drew an allusion to itself, recovering from the divisive blow of the Reformation with a renewed sense of purpose.

Although Castiglione's etching has an exceptionally rich tonal range, its fluid, pen-like character stands fully within the basic Italian sense of the medium. The complexities of numerous bitings and stoppings-out were largely left to the Dutch etchers Seghers and Rembrandt, or to the Frenchman Callot. The straightforward use of etching as a kind of drawing on the plate was also frequent in the north, however, and was employed most skillfully by Anthony van Dyck in his *Iconography*, a series of portraits of dignitaries, including artists.[21] Portrait prints were eagerly collected in the seventeenth century, as by the famous diarist and Secretary of the British Admiralty Samuel Pepys. Pepys's portrait prints were arranged in albums, one of which was devoted to "paynters, gravers, statuarys, architects."[22]

Van Dyck's scheme for a collection of contemporary graphic portraits evolved gradually, but the basic idea and most of the plates probably date from the period after 1626, when he left Italy and returned to Antwerp, but before he left for England (1631–32). It is difficult to assess his exact role in the production of the plates. For many of the portraits, he provided chalk and grisaille studies to the reproductive printmakers, just as his teacher Rubens would have. But he also appears to have done some of the preliminary etching of faces and torsos. After his death, fifteen plates of the second edition (1645) showed up with his signature. All but five of these autograph plates were given the elaborate engraved backgrounds and retouchings that made such prints more salable in the seventeenth century. This finishing by professional engravers now seems regrettable, for the impressions from the unfinished plates are extraordinarily vivid and fresh, satisfying our predilection for the spontaneous.

The likeness of Rubens' most talented reproductive engraver, Lucas Vorsterman, seen here in the first state before the engraved background was added (fig. 4.10), conveys his troubled personality, and helps explain the one recorded instance of outright hostility toward the much-beloved Rubens—apparently an attempted assassination.[23] Perhaps the compulsiveness and paranoia suggested in Van Dyck's portrait actually helped Vorsterman to achieve such exacting results, as in his *Descent from the Cross* after one of Rubens' Antwerp altarpieces (see fig. 5.18). The cool elegance and psychological distance that appropriately characterize Van Dyck's painted court portraits are absent from his portrait etchings. Instead, vigorous lines and an imposing massiveness lend the sitters an immediate presence. The unfinished *Iconography* prints suffice to establish Van Dyck as a major exemplar of the type of etching that is basically a drawing on a plate, even though he picked up the needle only infrequently.

Another, much less influential, direction for etching was established by Jacques Callot. He did not paint—his considerable reputation, in his own century as well as later, was based solely on a superb graphic oeuvre. Born in 1592 in Nancy in Lorraine, where his father worked as a designer of court pageants, Callot rebelled against his family's pressure to enroll him in the clergy and twice ran away to Italy, once with a band of gypsies. On both occasions, he was brought or sent home, but he had made his point: his family sent him to study art in Rome with the pupils of Cornelis Cort in 1608–9. He worked for the Grand Duke of Tuscany until 1621, when the death of his patron prompted Callot to return to Nancy, where he remained until his own death in 1635.[24]

Callot's etchings frankly imitate engravings. After all, etching had always been perceived as a faster way of getting a line on a plate than laborious carving with a burin. He invented a

FIGURE 4.10

Anthony van Dyck.
Lucas Vorsterman *(first state) from* The Iconography. *Ca. 1626–36.*
Etching. 245 × 156 mm.
National Gallery of Art, Washington, D.C.

new kind of etching needle, the *échoppe,* which had a sharp edge along the circumference of its flat, oval end. By twisting this end, Callot could vary the thickness of the lines he drew through the ground. In addition to this new instrument, Callot used a harder-than-normal ground borrowed from the lutemaker's varnish. The combined result was a sharp, deeply bitten line that wore well and curved and tapered like one cut with a burin.

Lest we interpret Callot as an artist who merely took the easy way out, we need to consider his extensive and expert use of multiple biting and stopping-out, which produced a tonal range not usually evident in etchings. In effect, Callot employed multiple biting to achieve what virtuoso engravers like Dürer and Goltzius had achieved by manipulating the burin to control depth, width, and type of cut. Numerous, detailed preparatory drawings allowed Callot, when his plates were worn, to copy his images on new ones as if they were freshly conceived.

Technically and visually, then, Callot's prints are some of the most stunning of his century. Expressively, they are less easy for the twentieth-century viewer to appreciate. Callot's reticence regarding his subject matter and the ostentatious elegance and flamboyant pantomime in which he clothed it combine to express a subtly ironic view of the world, where splendor and horror, humor and pathos, comingle on a day-to-day basis. In this sense, his oeuvre has much in common with that of Jacques Bellange, also from Lorraine. But Callot's vision captured the monumental contradictions of his century more powerfully.

Within *The Fair at Impruneta* (first conceived in 1620, with a second version produced after Callot's return to Nancy), for example, the elegant coexists with the coarse and gruesome. This spectacular *grande machine* of an etching (fig. 4.11) contains (by one count) 1,138 figures, 45 horses, 67 donkeys, and 137 dogs![25] Its magnificent, sweeping space gives us a bird's eye view of the ant-like people. As we move among them, we begin to see details like a crippled beggar on a cart, two copulating dogs exactly in the center of the print, and someone suffering on the strappado, a torture device in which the victim was lifted on a rope and dropped abruptly to just above the ground. The result was extreme pain, dislocation of the weighted limbs, and often death. Callot's figures are perfectly realized despite their diminutive size, but they cannot be separated from their collective existence, and do not seem to amount to much, even in this. The artist has brought to this subject, done for the Grand Duke of Tuscany, the northerner's cynical approach to human behavior.

The prints of Callot's *Balli di Sfessania* (ca. 1621), produced in Nancy from sketches made in Italy, have long been interpreted as representations of Commedia dell'Arte actors and actresses, stock characters acting out partly impromptu comic scenarios on outdoor stages. But Donald Posner has shown that although the names of Commedia characters appear, drawn from the broad realm of popular entertainments, the prints really represent dances—in particular, a Neapolitan variant of the morris dance called the *sfessania*. Callot then embellished the scenes of dance with a few that seem to involve dialog and settings suggesting public fairs, including in one print a transient stage like those employed by the Commedia.[26]

The morris dance originated in the late Middle Ages and pantomimed the battles between Moors and Christians with violent movement and extravagant costumes. The *sfessania* morris dance merged with another local dance and song, "Lucia Camazza," in which a "dead" girl is brought to life by erotic overtures and by the dance itself. Thus Callot's figures are sometimes lasciviously posed and sometimes engaged in exaggerated, aggressive confrontation, as in figure 4.12, in which one dancer threatens another with a clyster (enema) pipe. Goya surely knew this figure and transformed it into a haranguing cleric in *Swallow It, Dog* (see fig. 7.31) from his *Caprichos*.

The *Balli di Sfessania* are more than costume plates—although the seventeenth-century fascination with costume must have contributed to their appeal—or "records" of contemporary theater. One senses that Callot was struck by the perennial Italian flair for the expressive use of the human body and, back in Lorraine, nostalgically recalled it along with the atmosphere of Italian popular festivals. The grace with which the pairs of figures pirouette in complementary poses would be the envy of any ballet dancer or mime.

Artists' interest in performers often hinges upon the dichotomy between real life and external display. In Jean-Antoine Watteau's paintings of the Commedia dell'Arte characters in the early eighteenth century, this dichotomy is worked into a gentle pathos; Lautrec and Picasso

FIGURE 4.11

Jacques Callot. The
Fair at Impruneta. *1620.
Etching. 430 × 675 mm.
Cleveland Museum of
Art.*

FIGURE 4.12

Jacques Callot. Captain
Cardoni and Maramao
from Balli di Sfessania.
*Ca. 1621. Etching. 71 ×
91.5 mm. National
Gallery of Art, Wash-
ington, D.C.*

in the nineteenth and twentieth centuries seem to have seen their circus or cabaret performers as emblems of a modern alienation from bourgeois culture; Edgar Degas liked to exploit the difference between the seemingly effortless glamor of performance and the decidedly unglamorous life backstage, with its grueling labor and mundane tasks like tying one's shoe. Can a coolly ironic meditation on the whole world as a stage (to borrow from Shakespeare) underlie Callot's studies of dancers? The theme itself implies some satiric import, for the comic figures mock human pretense and folly. Posner emphasizes the importance of Callot's choice of subjects that reveal the aggressive and foolish aspects of human behavior, clothed ironically in artifice and elegance.[27]

The meaning of Callot's *Balli,* although subtle, is at least apprehensible for the modern viewer. We are less receptive to, and even offended by, the *Gobbi* (ca. 1622; fig. 4.13), a series of calligraphic designs based on the deformities of performing dwarves and hunchbacks, and *The Beggars* (ca. 1622; fig. 4.14), in which impoverished and deformed figures are elegantly and coldly treated. We prefer the approach of Velasquez, who painted sensitive portraits of the dwarves who were collected, like prize horses, by the Spanish court, to Callot's impersonal flourish and cynical view of the human condition. Similarly, Rembrandt's warm light and raggedy line appear more sympathetic and suitable for the beggar than Callot's fluid, crisp treatment, which seems to mock the desperate condition of his subject (see fig. 4.39). It surprises us to learn that Rembrandt was apparently deeply impressed by Callot's beggars, and that similarities can be found between them and Rembrandt's most spontaneous-looking studies.[28] Did the Dutch artist perceive something that we miss in Callot, or did he totally transform this source as he did so many others?

FIGURE 4.13

Jacques Callot. The Drinker, *front view, from* Gobbi (Grotesque Dwarfs). *Ca. 1622. Etching. 61 × 86 mm. Huntington Library, San Marino, California.*

FIGURE 4.14

Jacques Callot. Seated Beggar with Bowl *from* The Beggars. *Ca. 1622. Etching. 137 × 86 mm. Metropolitan Museum of Art, New York.*

FIGURE 4.15

Jacques Callot. The
Pillage: *Plate 5 from the
large* Miseries and Mis-
fortunes of War. *1633.
Etching. 82 × 187 mm.
Elvehjem Museum of Art,
University of Wisconsin–
Madison.*

The real power of Callot's irony emerges only in his *Miseries and Misfortunes of War* (1633), the first of many series of this kind in western prints. Callot's native Lorraine, like much of Europe during the seventeenth century, was immersed in war. When the French monarchy under Louis XIII and Cardinal Richelieu besieged Lorraine in an attempt to annex it, Callot depicted the conflict in two series of etchings, one smaller (about two by two inches) and one larger (about three by seven). The small etchings were published posthumously and were perhaps intended as studies for the large. We are brought abruptly out of our appreciation of the beauty of these prints by the realization of their subject matter—executions, burnings, lootings, rapes, the lines of maimed and wounded filing into hospitals.

The large *Miseries* begins with the enrollment of troops. Their handsome uniforms, neatly displayed weapons, and the gentlemanly politeness with which the whole business is conducted provide no preparation for Callot's next plate, which shows a turbulent battle in which all order and elegance are abandoned. In a subsequent plate, the copious interior of a farmhouse reveals rape, pillage, and murder committed by soldiers (fig. 4.15). One of the occupants is burned alive while another is forced to watch. As difficult as it is for us to imagine the methodical incineration of a human being, it was not uncommon in Callot's time as a punishment for crimes regarded as especially heinous, such as heresy. The soldiers here repeat the cruelty that existed on an institutional level.

The soldiers' atrocities are soon answered by the peasants' revenge and by military justice itself. Callot depicted execution by hanging, burning at the stake, breaking on the wheel, and firing squad. *Death by Hanging* (fig. 4.16) is the most unforgettable image from the *Miseries.* The corpses dangle gracefully from the tree, like so many ripe apples. Priests are busy receiving the confessions of the condemned—one scurries up the ladder after his penitent (did Callot at this point recall his family's desire that he enter the church?). It has been suggested that the men throwing dice under the tree and the pile of garments represent an ironic reenactment of the Roman soldiers gambling for Christ's robe.[29] A more quietly moving image is *The Hospital,* in which the maimed and wounded hobble or drag themselves toward succor. At the end of the series, Callot placed another scene of order and pageantry that forms a companion to *The Enrollment of Troops* at the beginning: *The Distribution of Honors* (fig. 4.17).

A la fin ces Voleurs infames et perdus , Monstrent bien que le crime (horrible et noire engeance) Et que cest le Destin des hommes vicieux
Comme fruicts malheureux a cet arbre pendus Est luy mesme instrument de honte et de vengeance , D'esprouuer tost ou tard la iustice des Cieux , 11

Cet exemple d'un Chef plein de recognoissance , Doit picquer les soldats d'un aiguillon d'honneur , Et qu'ordinairement ils reçoiuent du Vice
Qui punit les méchans et les bons recompence , Puis que de la vertu, depend tout leur bon heur , La honte, le mespris, et le dernier supplice . 18

FIGURE 4.16

Jacques Callot. Death by Hanging: *Plate 11 from the large* Miseries and Misfortunes of War. *1633. Etching. 82 × 187 mm. Elvehjem Museum of Art, University of Wisconsin–Madison.*

FIGURE 4.17

Jacques Callot. The Distribution of Honors: *Plate 18 from the large* Miseries and Misfortunes of War. *1633. Etching. 82 × 187 mm. Elvehjem Museum of Art, University of Wisconsin–Madison.*

This final image helps us focus on the problems of interpreting Callot's series as a whole. Is it simply a record of one aspect of the soldier's life: the reward for good military behavior? Some have viewed the *Miseries* as a collection of such records.[30] Or is it related to what comes before by irony, as if to ask how honor can be possible in the context of the horrors of war? Or is it a sincere recommendation that exemplary actions be praised, just as the reprehensible deeds of the marauding soldiers are punished? Particularly when we consider the straightforward inscriptions of these prints, we are faced with precisely the same problems we encountered in interpreting Bruegel's *Justice* (see fig. 2.49; Callot also etched a panoramic display of contemporary punishments for which Bruegel's engraving is the direct model).

To date, the most detailed interpretation of *The Miseries and Misfortunes of War* is that of Diane Wolfthal. She relates the prints carefully to contemporary writings about military procedure and just and unjust conduct in war. Callot, she believes, condemns unjust behavior and supports the punishment of the offending soldiers.[31] Yet despite this eminently logical conclusion, there will be those who cannot relinquish the sense of a greater irony in Callot's adroit

juxtaposition of horrific and honorific images. His intentions perhaps transcend contemporary military theory and practice. The numerous artists (Goya, Daumier, Rouault, Dix, Kollwitz, Bellows) who have drawn inspiration from Callot's *Miseries and Misfortunes of War* may have held this latter opinion.

Callot had no equals in his particular type of etching, but for a time he had followers, such as Abraham Bosse, who wrote the earliest treatise on engraving and etching, published in 1645. In it, Bosse asserted that the aim of etching is to imitate engraving. In Italy and France, the prolific Florentine Stefano della Bella followed in Callot's footsteps as an employee of the Medici, producing charming little vignettes of everyday life, landscapes, *grandes machines* à la Callot's *Fair at Impruneta* (fig. 4.11), and an impressive series of oval etchings of Death repeating his ancient dance.[32] Della Bella dealt with Death on the battlefield, of course, but also with mortality of a less discriminating kind—the plague. In *Death Carrying a Child to the Right* (fig. 4.18), two skeletons carry children to the Cemetery of the Innocents in Paris. For centuries this place had been the major burial site in the city; as soon as the bodies rotted, they were placed in cribs above the walls to make room for new occupants. The linear elegance of Della Bella's etching technique, now freer than Callot's, interacts ironically with the gruesome subject. Note especially the fluttering drapery, looser but related to that of Goltzius' *Standard Bearer* (fig. 2.51).

The checkered existence of Wenceslaus (Wenzel) Hollar, another prolific etcher whose manner is based partly on Callot's, demonstrates the political turbulence of the seventeenth century. Driven from his native Bohemia by religious strife and later, temporarily, from his adopted England by civil war, the assiduous, quiet Hollar adapted to a variety of circumstances and patrons—from the Earl of Arundel, to whose retinue he became attached in Germany while the earl was on a diplomatic mission, to the gentry of Cromwellian England in the 1650s, to Charles II, the restored Stuart king, who hired Hollar as Royal Scenographer. Hollar's work illustrates the overlap between art and craft that we often find in the history of printmaking. He made original landscapes and portrait prints, costume plates, maps, topographical or architectural views, and book illustrations. He seems to have regarded himself primarily as a recorder of what was around him, for his etchings are marked by a meticulous detail, methodical objectivity, and attention to textural realism that Hind condescendingly described as "more properly that of the graver."[33] It is probably the static, cartographic quality of Hollar's style that made Van Dyck object to him as a copyist of his elegant, volatile portraits.[34] Yet the very qualities Van Dyck disliked give Hollar's prints their straightforward charm. At his simplest and most typical, as in *View of Cologne* (1643–44; fig. 4.19), Hollar presents an economy of means that bears comparison with Dutch landscapes of the early seventeenth century, such as Esaias van de Velde's *Landscape with Gallows* (see fig. 4.24). Hollar's work is, however, less atmospheric, less fluid, and more severely architectonic—qualities that were to appeal to his English patrons, such as Sir William Dugdale, who commissioned Hollar to illustrate many of his books. The plates of Dugdale's *History of St. Paul's* (1658), for example, preserve the old church's form before the disastrous fire of London in 1666, whose results Hollar recorded in detailed "before and after" city views that earned him the position of Royal Scenographer. In this sense of benefiting from catastrophe, Hollar resembled Sir Christopher Wren, the great architect who was to design so many buildings, including the new St. Paul's, after the fire.

Before the fire, the preservation of St. Paul's had been a political and religious issue (the two were rarely separate in the seventeenth century). Changes and repairs (classical elements

FIGURE 4.18
Stefano della Bella.
Death Carrying a Child
to the Right *from* The
Five Deaths. *Ca. 1648?*
Etching. 177 × 144 mm.
National Gallery of Art,
Washington, D.C.

Chez M.ᵉ Vincent procbe S.ᵗ Benoit, ruě S.ᵗ Jacques. à Paris

added to the façade by the English Palladian architect Inigo Jones, for example) had been made under James I and Charles I. The building was a living symbol of the old religious values. England's early churches had not escaped damage under the Cromwells, and beneath one of Hollar's interior views (fig. 4.20), the inscription (in Latin) reads: "Wenceslaus Hollar of Bohemia, sketcher and former admirer of this church (whose fall we daily await), has thus preserved its memory."[35] The absence of human figures and the unrelenting movement toward the altar traced by Hollar's perspective lend the print a hushed reverence that suggests a nostal-

FIGURE 4.19
Wenceslaus Hollar.
View of Cologne *from*
Amoenissimi aliquot
Locorum in diversis
Provincijs iacetium
Prospectus. *1643–44.*
Etching. 95 × 175 mm.
Folger Shakespeare
Library, Washington,
D.C.

FIGURE 4.20
Wenceslaus Hollar. The
Choir of St. Paul's *from*
The History of St. Paul's
Cathedral in London
from its Foundations
until these Times *by*
Sir William Dugdale.
London, 1658. Etching.
318 × 223 mm. British
Library, London.

gia on the artist's part for the old religious ways, or at least the mystery and splendor of religious edifices of which Protestantism is suspicious. Hollar's own religious affiliation remains shadowy. It may have been the persecution of Protestants in Bohemia that drove him westward, but we find him arrested along with about thirty others for attending Mass on the Feast of the Epiphany in 1656.[36] Was Hollar's presence merely accidental? His attitude toward religious issues may have been as detached as his approach to his artistic subject matter.

The capacity of etching to ape the textural fidelity of engraving is epitomized by Hollar's *Muff with a Band of Brocade* (1647; fig. 4.21), in which the etcher's needle was used in combination with the drypoint stylus and burin. Extravagant costume was one of the passions of the seventeenth century; Hollar made prints of English costumes in the early 1640s. But here, isolated from the whole ensemble, the muff becomes a marvelous curiosity, like the shells and butterflies intermingled with the works of art in the Earl of Arundel's collection. Hollar's notebooks on this collection provided him with material for prints and serve as a record of many items: for example, lost drawings by Dürer. After he left the earl's service, the collection was broken up and sold.

FIGURE 4.21

Wenceslaus Hollar. Muff
with a Band of Brocade.
*1647. Etching with burin
and drypoint.* 84 ×
*112 mm. British Mu-
seum, London.*

THE DUTCH REPUBLIC: LANDSCAPE AND GENRE ETCHINGS

Despite the appeal of Callot's approach, it was not to be the main direction of etching in the future. That lay in the freedom of touch and the responsiveness to the potential for change within the etching process that are so clearly represented in the works of Dutch etchers, particularly Rembrandt. So spellbinding are his prints (mainly pure etchings or combinations of etching with drypoint and burin) that it is easy to underestimate other Dutch printmakers.[37]

The seventeenth-century Dutch landscape tradition, to which Rembrandt was a major contributor, was perhaps the most original of this small nation's many gifts to European art.[38] For our purposes it is important to note that the roots of the Dutch vision of nature in the seventeenth century, with its unprecedented freshness, its sense of being created from life (*naer het leven*), its atmospheric specificity and subtle, unobtrusive sense of pictorial structure, are found in drawing and printmaking, not in painting.[39] Thus, even though Dutch Baroque landscapes, both painted and printed, were likely to be composed in studios from observed elements, a naturalistic approach to native terrain dominated the Dutch sensibility. This sensibility was shaped by the growing importance of topographical prints, such as the village views by the Master of the Small Landscapes published in Antwerp by Hieronymus Cock in 1559 and 1561 or Claes Jansz. Visscher's *Pleasant Spots,* realistic views of the Dutch countryside published in 1607–8. Viewing such prints echoed the experience of walking through the same Dutch countryside that was currently being praised in contemporary literature; both graphic and literary traditions had to do with the increasing pride Dutch citizens took in their nation.[40]

Haarlem was the birthplace of the earliest deviations from the reigning Mannerist approach to landscape,[41] which we might illustrate with the engraving by Nicolas de Bruyn after Gillis van Coninxloo's *Hunters in a Mountain Landscape* (1600; fig. 4.22). Echoes of the imposing mountains (nowhere to be found in the low countries) and the layered, disjunctive space of Joachim Patinir, an important early contributor to the independence of landscape, appear here. Each leaf or rock is separately conceived, and curving, gnarled forms are insistently emphasized. This is basically an imagined, not an experienced, landscape. By comparison, Willem Buytewech's *Landscape with Bare Trees and a Man Gathering Wood* (ca. 1616; fig. 4.23), part of a series of nine small etched landscapes, tempers ornamental qualities with a sense of being on the scene, feeling the breeze and the humidity of the Dutch air. Buytewech accentuated the tentacle-like limbs and trunks of the trees so that their curving movements are counterpoised

to the cursive flight of birds in the sky. But the right side of the composition is open; space is fluid and unified. Our point of view is not elevated, but near the ground, and therefore a large portion of the pictorial surface is occupied by the sky, which does, indeed, dominate one's attention in the Netherlands.

Esaias van de Velde, Buytewech's contemporary, also produced a series of etched landscapes, apparently taken from the environs of Haarlem, around 1615–16. *Landscape with Gallows* (fig. 4.24) capitalizes on the oblong format to emphasize the lateral extension and openness of space so characteristic of the Dutch terrain. This type of panoramic view, with no decisive vertical elements to stop the eye at the sides, was to be further developed by Seghers, Rembrandt, Philips Koninck, and others. At the right are only the wheel and gallows, fairly common sights in the seventeenth century, which penetrate the sky slightly. The problem of "underlying" meanings in Dutch landscapes, still lifes, and genre scenes is a difficult and controversial one.[42] Here, it may be that Van de Velde juxtaposed the executions and the traveler on the wayside to remind his contemporaries of the literal and moral perils of life and its transience.[43] Another of the etchings in this series juxtaposes the peaceful occupation of fishing with fortifications, stressing the need to defend the land and the virtue of the industrious cultivation of nature. The ability of the Dutch to win and sustain independence from Spain depended upon these factors, as well as on the maritime trade that produced a strong economy. In a very important sense, then, every Dutch landscape and seascape of the seventeenth century has to do with national pride in the reclamation, cultivation, and holding of the land, and many Dutch landscapes bear the signs of contemporary changes reshaping the land itself.[44]

In a further development, Pieter Molijn's works are more atmospheric and painterly, corresponding to the tonal phase of Dutch landscape, described by Wolfgang Stechow and best exemplified by the paintings of Jan van Goyen. Only four etchings can be attributed with certainty to Molijn's hand, all landscapes around Haarlem. *Landscape with a Hut on the Left* (1620s; fig. 4.25), however, was etched by another artist after Molijn's drawing (note the abbreviation for the term *invenit* at the upper right). The lightly etched forms on the horizon are played here against the heavier blacks of the right foreground to create a swift spatial recession. The rich linear articulation of the hut, trees and wedge of ground at the left contrasts with the empty sky on the right, interrupted briefly by the silhouettes of two figures.

The greatest master of the so-called structural or monumental phase of Dutch landscape painting—marked by voluminous forms, strong tonal contrasts, and the playing of verticals against horizontals—was Jacob van Ruisdael. He had known the heavily wooded country of northern Germany and incorporated into his works its dense thickets with their mottled patterns of light and shade. *The Large Oak* (1651–55; fig. 4.26) heroizes a huge, gnarled tree that clings to a bank of land. Its bent trunk, exposed roots, and partly dead limbs tell us that it—perhaps as a moral example to human beings—has withstood many rigors. It is witness to the violent clash of elemental forces that underlies Ruisdael's conception of nature. The two tiny travelers and the cottage barely visible through the branches at the right seem frail and transient by comparison; once again, this may be a part of the print's spiritual meaning.

The most important etcher of marine views in seventeenth-century Holland was Reinier Nooms, called "Zeeman." Seascapes, of course, were of vital interest to a nation whose independence and prosperity depended so much on naval superiority and maritime trade.[45] As his eponym suggests, Nooms was almost certainly a sailor for part of his life. His series of twelve etched views of ships in harbors (mid-1650s) was preceded by Hollar's etchings of Dutch ships,

FIGURE 4.22
Nicolas de Bruyn after Gillis van Coninxloo. Hunters in a Mountain Landscape. *1600. Engraving. 448 × 628 mm. Rijksmuseum-Stichting, Amsterdam.*

FIGURE 4.23
Willem Buytewech. Landscape with Bare Trees and a Man Gathering Wood. *Ca. 1616. Etching. 87 × 123 mm. Rijksmuseum-Stichting. Amsterdam.*

published in Amsterdam in 1647 (Hollar had left England for the continent because of civil war). We might expect Nooms's mariner background to inspire accuracy in the depiction of the ships and the crews' activities—like the cleaning and caulking of hulls that occurs here (fig. 4.27)—but his accuracy does not override his sense of atmosphere and mood. His ships are less linear and insistently detailed than Hollar's. Their dark, monumental sails against the sky and the smooth surface of the water suggest the paintings of Jan van de Capelle, one of the chief representatives of the structural phase in Dutch marine painting.

Italianate landscape paintings, such as those by Claude Lorrain, were also produced by Dutch artists, and they seem to have been more highly valued among Dutch patricians than landscapes composed from the native terrain. Thus classical Italianate landscapes are virtually the only type that appear in the inventories of the residences of the *Stadholder,* the aristocrat who executed the decisions of the States General, chief governing body of the Dutch Republic.[46] *Prints* of Italianate scenery, of course, would have given the middle class the opportunity to indulge in these courtly tastes.

The Utrecht painter Jan Both etched about fifteen plates, including a series based on views of the Roman *campagna,* from which *Landscape with Ruins and Two Cows at the Waterside* (late 1640s; fig. 4.28) is taken. Both was in Rome in the late 1630s and early 1640s, living

FIGURE 4.24

Esaias van de Velde.
Landscape with Gal-
lows. *Ca. 1615–16.*
Etching. 88 × 173 mm.
Museum of Fine Arts,
Boston.

FIGURE 4.25

After Pieter Molijn.
Landscape with a Hut
on the Left. *1620s.*
Etching. 127 × 157 mm.
Rijksmuseum-Stichting,
Amsterdam.

with his brother Andries, who painted genre scenes and was also an etcher. Jan had worked
with Claude on a series of landscapes with religious subjects for the palace of Philip IV of
Spain. After Andries drowned in a Venetian canal in 1641, Jan went home, only there devel-
oping his Italianate style to maturity. The ruins in this print, which also appear in a painting
by Both in Edinburgh, remind us of the glory of a past civilization that now provides a grazing
place for cattle and support for vegetation. Both's loosely grouped parallel lines are translucent
enough to suggest the golden light of Italy that was pursued by so many northern artists.

The audience for Hercules Seghers' extremely unusual prints must have been fairly exclu-
sive, but we know that it included Rembrandt, because he owned Seghers' plate for *Tobias and
the Angel* and altered it to make *The Flight into Egypt*. He also repainted a *Mountain Landscape*
by Seghers, which he owned. Such reworking of an older artist's conceptions is a curious form

FIGURE 4.26
Jacob Ruisdael. The
Large Oak. *1651–55.*
Etching. 183 × 279 mm.
College of Wooster Art
Museum, Wooster, Ohio.

FIGURE 4.27
Reinier Nooms (Zeeman).
Harbor View with Ships
Careened *from a series*
of twelve marine views.
Mid-1650s. Etching.
204 × 302 mm. New
York Public Library.

of homage, but Rembrandt seems to have been genuinely impressed with Seghers' understanding of nature. No other landscape artist had a more lasting impact on him.

Only a minimum of factual evidence about Seghers' life remains. Born in Haarlem in 1589 or 1590, the son of a Mennonite who was probably a religious refugee from Flanders, Seghers was trained by Gillis van Coninxloo and eventually settled in the metropolis of Amsterdam, where he apparently enjoyed some success as a painter. In an interesting parallel to Rembrandt's life, his career was marred by financial problems. He is recorded as a picture dealer in Utrecht, and perhaps died in the Hague, where a document places him in 1633. The only

seventeenth-century writer to devote much attention to Seghers was Samuel van Hoogstraeten. His account of the artist's life in his *Introduction to the High School of Painting* (1678) is entitled, "How the Artist Should Behave in the Face of Adverse Fortune." Hoogstraeten paints a depressing picture of a struggling artist who fell down a flight of stairs to his death in a fit of drunken despair. This account is colored by the stereotype of the melancholy artist and by the fact that Hoogstraeten was primarily familiar with Seghers' prints as opposed to his more successful paintings.[47] But it is true that melancholy tinges Seghers' conception of nature; his works often have a brooding mood that moved Rembrandt. Many of Seghers' landscapes are not naturalistic but fantastic, and develop the artificial, imaginary tradition of Mannerist landscape into an operatic type that Rembrandt perpetuated.

It is almost impossible to reconstruct the processes by which Seghers made his prints, or to arrange them chronologically.[48] He frequently cut up his plates, printed on colored papers, or hand-colored his impressions and used counterproofs (Hoogstraeten used the fortuitous term *drukte schildery*, "printed paintings," to describe these works). Seghers apparently developed a new technique in which a drawing is made on the plate with ink and sugar. When covered with the ground or a stop-out varnish and submersed in water, the sugar swells and lifts off, leaving the plate exposed. Then the plate is aquatinted and bitten as usual. The sugar-lift technique (also called lift-ground) was revitalized in the eighteenth century by Alexander Cozens and Thomas Gainsborough, and resurrected again in the modern period—by Picasso, for example.

Seghers' *Mossy Tree* (fig. 4.29, color plate, p. 463) was perhaps executed in sugar-lift. He printed this unique impression in green and greenish-black ink on pink-painted paper, with the addition of blue and blue-gray color at the top and bottom. The effect is so unusual as to seem at first entirely outside the western tradition. Indeed, *The Mossy Tree* seems close to the trees whose gracefully gnarled, drooping branches are silhouetted against misty backgrounds in Chinese paintings. But Seghers was probably influenced by the etchings of Danube school artists such as Altdorfer and Hirschvogel and their expressive, moss-laden trees. It is Seghers' technique of biting the plate that creates the very different effect of disembodied silhouette.

Figures 4.30 and 4.31 (color plates, pp. 463, 464) show Seghers' use of the same plate, cut down from a much larger plate with a ship and a landscape, to create totally different effects. In addition, Seghers trimmed the prints differently—the first at the sides and bottom, the second at the left and right. Figure 4.30 is a counterproof taken from the first state of this etched plate. Indeed, the first state is known only by this counterproof. It is printed in black ink on cotton (Seghers also used linen occasionally) that has been painted yellow-brown. He reworked the landscape and sky with yellow and grayish-white paint that has since oxidized to black in places. This overpaint covers up the fragments of the ship's rigging that lie over the landscape on the plate. Despite the windmill visible in the lower right, the scene seems more lunar than terrestrial.

The ship's rigging is allowed to appear in figure 4.31. Here, Seghers used blue ink on pink-painted paper, with the further addition of blue color and drypoint. The warm, almost arid quality of the terrain in figure 4.30 was thus transformed into a cold, perhaps rainy view, seen as if from on board a ship pulling into a rocky coast. Although Rembrandt's etchings do not resemble Seghers' stylistically, this willingness to radically alter the plate contributed much to Rembrandt's approach to the medium.

Haarlem was also the most important city for the early development of the seventeenth-century Dutch genre tradition, and Willem Buytewech again stands at the starting line. Although *Lucelle and Ascagnes* (1616; fig. 4.32) was etched for the title page of Gerbrand Adriaensz. Bredero's Dutch edition of Louis le Jar's play *Lucelle* (1563), its meaning and form are related to the "merry company," a type of genre scene in which young women and cavaliers eat, drink, and flirt.[49] The moral point of such scenes is the participants' obvious disregard for spiritual values and their own mortality. Since the lovers in the play meet a tragic end, Buytewech's blending of illustration and moralizing genre is not inappropriate. Both print and play satirically censure amorousness and indulgence in sensual pleasure, while utilizing these as artistic premises. Such a paradoxical combination greatly appealed to the Calvinist Dutch. Buytewech perfectly balanced the ornamental elegance of the costumes and setting with the casual naturalism of the poses. As this naturalism increases in seventeenth-century genre scenes, satirical meaning becomes even more difficult for us to perceive.

The Pancake Woman (ca. 1626; fig. 4.33) by Jan van de Velde II, cousin of Esaias, continues the sixteenth-century tradition of Carnival imagery. Pancakes and waffles were rich foods associated with the gluttony and riotous celebration of Shrovetide. In Bruegel's famous painting *The Battle between Carnival and Lent* (1559; Kunsthistorisches Museum, Vienna), for example, the old pancake-maker appears behind the overfed forces of Carnival, which combat the lean "troops" led by Lent. But it is difficult to measure the extent to which Van de Velde's print echoes the satire of Bruegel's image. Although the witch-like traits of the old woman and the grins of the children evoke the mood of Carnival, *The Pancake Woman* is more of a general street scene than an explicit image of the religious festival.[50] The inscription, in Van de Velde's beautiful calligraphic hand, has nothing to do with Carnival but is a Latin quotation from the Roman author Martial about the baker's activities signaling the approach of morning. This may have given the print more appeal to educated viewers.[51]

Van de Velde's work is an excellent example of the so-called black prints that were eagerly collected by seventeenth-century patrons.[52] It was primarily through these engravings and the paintings of the Dutch followers of Caravaggio that the Italian master's *tenebroso* lighting, which plunged some forms into darkness while revealing others in sharp, raking areas of light,

FIGURE 4.32

Willem Buytewech.
Lucelle and Ascagnes,
*title page from Gerbrand
Adriaensz. Bredero's
translation of* Lucelle *by
Louis Le Jars (1563). 1616.
Etching. 206 × 164 mm.
Rijksmuseum-Stichting,
Amsterdam.*

was carried to northern countries. Very important for the "black print" tradition was Hendrik Goudt, to be discussed in the next chapter, who made prints after the paintings of Adam Elsheimer, a specialist in nocturnal effects who worked painstakingly slowly. Like Van de Velde, Goudt created his deep shadows with regular networks of engraved lines, against which the white of the paper stood out brilliantly. Rembrandt's nocturnal effects, deriving from the same Dutch Caravaggesque tradition, are very differently executed with ink left on the plate and unsystematic combinations of etching, engraving, and drypoint.

The Pancake Woman is one example of how seventeenth-century artists reformulated Bruegel's peasant imagery, a pictorial tradition also carried on by Bruegel's own sons, by the Fleming Adriaen Brouwer, who emigrated to the Dutch Republic, and by Adriaen van Ostade, one of the most acclaimed Dutch etchers. Ostade seems to have produced fifty prints. *The Family* (1647; fig. 4.34) is especially interesting because of its treatment of the peasant. Although Ostade's subjects are clearly poor, they are dignified and exist in pleasant domestic harmony. It is difficult to view them as exemplars of folly or vice. Linda Stone-Ferrier has noted that by mid-century, the economic lot of Dutch peasants was improving. Inventories show that they possessed copper, tin, and iron implements and, after mid-century, amenities such as carpets, clocks, oak chests, books, and even paintings. Could Ostade's print have found its audience among this new peasant class, which viewed the poverty depicted in the etching as part of their past, or would the etching have appealed to middle- and upper-class patrons who saw it as evidence of their own superior economic status?[53]

REMBRANDT VAN RIJN

Like Seghers, Rembrandt had an experimental attitude toward the etching process.[54] Although he did not print in color, he constantly varied inks, wiping techniques, and papers—from ordinary white paper, to gray-flecked "oatmeal" paper that softened tonal contrast,

FIGURE 4.33

Jan van de Velde II.
The Pancake Woman.
Ca. 1626. Engraving.
185 × 128 mm. Museum
of Fine Arts, Boston.

to the warm, absorbent Japan paper that first reached Holland through the Dutch port of Batavia (now Djakarta) on the island of Java in the 1640s. Rembrandt was apparently the first western printmaker to use Japan paper. He also employed vellum, a kind of parchment made from calf-, kid-, or lambskin, especially for prints with extensive drypoint (nine impressions of the first state of *The Three Crosses,* for example, are on vellum). Vellum is even warmer and more absorbent than Japan paper. To etch his plates, Rembrandt used a very slow-biting mordant for extra fineness and control. He utilized stopping-out to greater advantage than any predecessor. Rembrandt's multiple biting and stopping-out is so subtle that it is often impossible to determine how many times his plates have been immersed in the acid. He frequently combined etching with burin and drypoint, the latter becoming increasingly important for him. As he grew more skilled at working directly on the plate, drypoint tended to replace the slower process of multiple biting; he would etch his late plates only once, then work them heavily with the drypoint stylus, a decision predicated on the willingness to sacrifice a long-wearing plate for the beautiful effects drypoint produced. No image was sacrosanct for Rembrandt; any could be radically altered by scraping and burnishing the plate. To this end, he often used exceptionally thin copper: anything thicker would have increased the physical labor necessary to hammer and smooth the plate from behind after so much reworking.

Rembrandt was introduced to etching by a commission from a Haarlem publisher who also employed Jan Lievens, the artist who shared Rembrandt's first studio in Leiden. This and other early etchings show a very tentative beginning: a gradual mastery of the etching needle, an ability to handle it with increasing freedom, as he would handle a pen or chalk. Shortly after his move to Amsterdam, Rembrandt produced *The Raising of Lazarus* (ca. 1632; fig. 4.35), a large, elaborate, and highly dramatic print that served to announce his arrival as a major printmaker, just as his contemporary painting, *The Anatomy Lesson of Dr. Tulp,* was his calling card as the up-and-coming virtuoso portraitist of Amsterdam. *The Raising of Lazarus* has its draw-

backs, in both conception and execution; Rembrandt's sole authorship has even been questioned, although the plate is signed.[55] All in all, however, the extravagant drama, Caravaggesque lighting, and exaggerated gestures, and the insistent presence of details such as the sword, bow, arrow, and quiver of the deceased, accord well with other works of Rembrandt's early years.[56] He has not yet developed his matchless capacity for understatement. If isolated areas of this print suggest the sensitivity we associate with Rembrandt's etchings, the plate as a whole is overworked and tight. Still, there is something unforgettable in Christ's commanding gesture, a superhuman grandeur that Rembrandt contrasted to the frailty of Lazarus, almost reluctantly coming to life below. The cavernous setting with its strongly lighted opening already hints at Rembrandt's skill in the expressive use of space.

The Raising of Lazarus (fig. 4.36) by Jan Lievens, Rembrandt's early colleague, bears a problematic relationship both to Lievens' painting of the same subject in Brighton and to a drawing by Rembrandt in the British Museum, begun as a Raising of Lazarus but changed to an Entombment. However one assesses the knotty problems of precedence and influence, the close relationship between the two artists as they shared a studio in Leiden is obvious. Lievens' etching seems to conflate the moment when Christ raises Lazarus with the moment of giving thanks to God immediately before the resurrection.[57] As Jesus pauses to communicate with his Father, Lazarus' hands are already beginning to reach up tenuously from the sarcophagus, as if to emphasize the preordained nature of the miracle. Unlike the Christ of Rembrandt's print, who is a powerful, almost sorcerer-like figure, Lievens' Christ is more an instrument, a conduit for the power of God. Despite the difference in conception, both artists approached etching similarly. A strong, theatrical chiaroscuro is established by fine webs of lines that build together into deep shadows. Lievens' plate was reworked with the burin for publication by Frans van den Wyngaerde in Amsterdam: its first state is fairly rare.

Rembrandt briefly ventured into reproductive printmaking in his huge (530 by 410 mm) *Descent from the Cross* (1633; fig. 4.37), after a painting he had done as part of a Passion series commissioned by Prince Frederick Henry, the Stadholder of Holland. Here, Rembrandt seems to have had in mind Barocci's etchings after his own paintings, as well as Rubens' practice of publishing with a government privilege (copyright). The print itself was commissioned by an Amsterdam dealer, Hendrik van Uylenburgh, whose address appears in the plate and whose cousin, Saskia, Rembrandt would marry. Rembrandt's inspiration for both painting and reproductive etching was Rubens' *Descent from the Cross* and Vorsterman's engraving after it, which we will encounter again in Chapter 5 (see fig. 5.18).

A comparison between the two prints is instructive. First, it shows how Rembrandt assimilated and often totally transformed the influences that came to him, largely in the form of the prints he collected on a vast scale. The basic composition, the pose of Christ, the actions of the mourners struggling to lower him from the cross, and the white cloth that defines his body visually and symbolically as sacrificial offering are related to Rubens' work, but Rembrandt's is introspective and unidealized. The keys to understanding the basic differences between these two quintessentially Baroque artists are the two figures of Christ—one classically conceived and dominating the central space by his size and arresting beauty; the other painfully small, awkward, and dominant only because he is so mercilessly exposed and made vulnerable by the light. At the same time, this light functions as an intangible symbol of his transcendence of death.

Conceptually and expressively, both prints are complex and moving, but if we were to

FIGURE 4.34

*Adriaen van Ostade.
The Family. 1647. Etch-
ing. 179 × 159 mm. R. S.
Johnson Fine Art,
Chicago.*

judge them solely as reproductions of paintings, Vorsterman's clearly excels. His outstanding burin work has some chance of echoing the wealth of sense impressions, irresistible movement and swelling forms offered by Rubens' painting, but the painted prototype for Rembrandt's etching seems violated by its graphic translation. At this point Rembrandt was apparently reluctant to submerge the mourners in the blackness of some of his later etchings. The white-gold light of the painting, which picks out the crumpled body of Christ, is not quite as dominant in the print. The details of clothing and facial expressions are overstated. Even though Christopher White concludes that "Rembrandt must have regretted his almost exclusive absorption in the main theme,"[58] a certain technical timidity and conventionality in the print might also be postulated.

About twenty of Rembrandt's early etchings are genre scenes involving beggars and other street types. Although there are prototypes for these subjects in printmaking (Callot's series of beggars, for example), Rembrandt's images give a vivid sense of observed reality. *The Pancake Woman* (1635; fig. 4.38) depicts an Amsterdam street vendor who fries her wares in silence, unimpressed by the hubbub that surrounds her. The similarity to Van de Velde's black print is obvious (see fig. 4.33), but Rembrandt has removed the image even further from the realm of moralizing genre, lending the scene a delightful sense of spontaneity.[59] The unabashed delight of the children as they eat or anticipate their pancakes is matched by the ferocious determination of the foreground youngster to protect his pancake from a greedy dog. Rough, scratchy

FIGURE 4.35

Rembrandt van Rijn.
The Raising of Lazarus.
Ca. 1632. Etching and
burin. 366 × 258 mm.
British Museum, London.

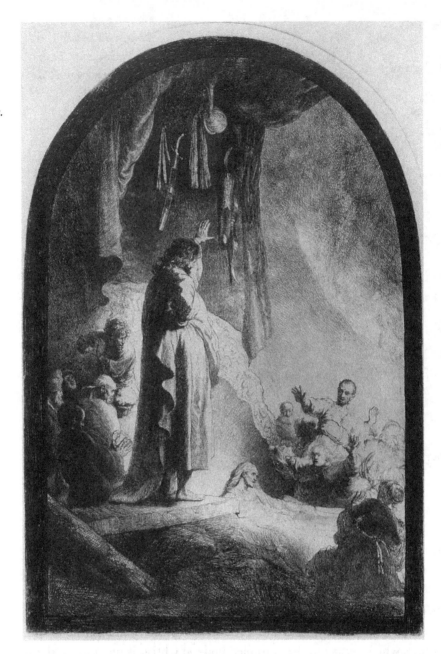

lines are chosen to express precisely the rowdy ambiance that the artist observed in Amsterdam's streets. An obscure image of a grimacing face in the right background is difficult to interpret; Franklin Robinson has suggested that it embodies the fears and fantasies of little children.[60] Perhaps it makes a bemused comment on the aggressive confrontation of child and dog. Whatever its meaning, the passage illustrates Rembrandt's practice of contrasting deeply bitten with lightly etched areas.[61]

Rembrandt often sketched directly on the plate. One sheet (fig. 4.39), dating between 1639 and 1642, combines depictions of Saskia in bed with beggars and lepers (note the clappers the figures in the upper left hold to signal their coming). The ragged lines with which the beggars are rendered—especially those with slightly grotesque features at the lower left—differ entirely from the extremely delicate marks that describe the artist's sick wife. Until her

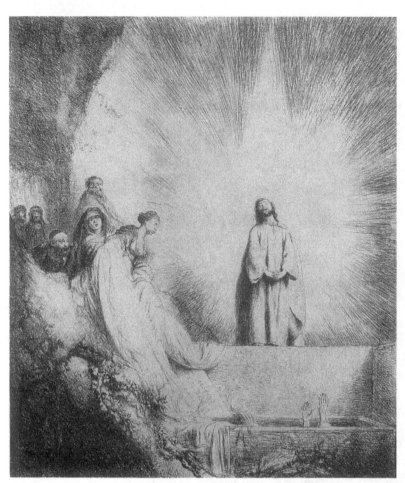

FIGURE 4.36

Jan Lievens. The Raising
of Lazarus. *1630–31. Etch-
ing. 360 × 312 mm
(sheet). Davison Art
Center, Wesleyan Uni-
versity, Middletown,
Connecticut.*

death in 1642, Saskia was frequently ill from childbirth; she bore four children to Rembrandt, of whom only a son, Titus, lived to adulthood. Uniting this plate's disparate images is a tragic mood.

In sixteenth-century northern works, such as prints by Lucas van Leyden, beggars were depicted satirically as exemplars of idleness.[62] Fortified by literature such as Sebastian Brant's *Ship of Fools* (1494) and Luther's preface to the *Liber Vagatorum,* a treatise vilifying mendicants published in 1509, the middle class came to view the increasing numbers of indigents with suspicion. As Suzanne Stratton has pointed out, however, more sympathetic and charitable attitudes toward beggars developed within Dutch Protestantism in the second half of the seventeenth century. She understands Rembrandt's etchings of beggars done after the 1630s as harbingers of this new attitude.[63] Perhaps our sketch, which combines slightly grotesque elements with the plaintive outward glance of the beggar woman at the left, represents a transitional state in Rembrandt's attitude.

The high point of Rembrandt's early etchings is his *Death of the Virgin* (1639; fig. 4.40). Here he achieved an exhilarating sense of light-filled space, a freedom and variety of line and tonal contrast. In White's words, the work is "pictorial without aping the finish of a picture [contrast *The Descent from the Cross;* fig. 4.37], and at the same time has the linear precision of a drawing without losing sight of the fact that etched and drawn lines are very different in character."[64] In 1638, at the estate auction of Gommer Spranger, Rembrandt had purchased a number of prints by Dürer, including numerous sets of the woodcut series *Life of the Virgin*

FIGURE 4.37

Rembrandt van Rijn.
The Descent from the
Cross. *1633. Etching and*
burin. 530 × 410 mm.
British Museum, London.

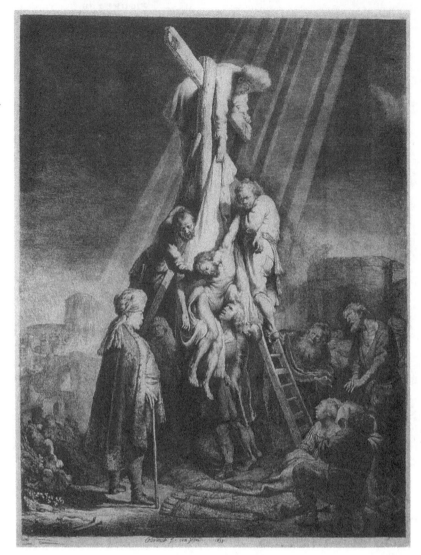

(published in 1511).[65] From Dürer's scene of Mary's death, Rembrandt borrowed merely a figure holding a staff surmounted by a cross (at the far left of the etching). But from Dürer's *Birth of the Virgin* (fig. 2.13), he adapted the feeling of a tall, ample space into which the visionary abruptly intrudes in the form of a censer-swinging angel surrounded by clouds. Rembrandt added barely traced cherubim. Mary's soul, in the form of a tiny child, is received into heaven: an archaic symbolic motif that Rembrandt easily adapted to his fluid composition. Beneath the heavenly irruption, a wide array of people attend Mary. Despite the miraculous event above them, which only the Magdalen seems to see, they are troubled by the loss of a much-loved woman. The simple humanity of their facial expressions and gestures is no less moving than the small form of Mary, propped up against a pillow by an aging apostle, her pulse now taken by a physician: a new, naturalistic note.[66] Undoubtedly, Rembrandt had seen Saskia propped up like this many times during the course of her illness. The image of Mary bears much in common with Rembrandt's sketches of his sick wife. Few artists absorbed their lives into their art as thoroughly as Rembrandt.

This point can be made most strongly with Rembrandt's numerous self-portraits, which reflect his stylistic and personal evolution more vividly than those of any other artist.[67] In 1639

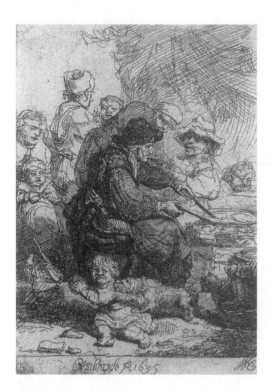

FIGURE 4.38
Rembrandt van Rijn.
The Pancake Woman.
*1635. Etching. 108 ×
78 mm. Museum of Fine
Arts, Boston.*

FIGURE 4.39
Rembrandt van Rijn.
Sheet of Studies with
Saskia in Bed, and
Beggars and Lepers.
*1639–42. Etching. 138 ×
150 mm. Harvard Uni-
versity Art Museums,
Cambridge.*

Rembrandt was a successful painter, primarily of portraits of wealthy patrons, in Amsterdam. *Self-Portrait Leaning on a Stone Sill* (fig. 4.41) reflects his self-confidence. He displays his rich clothing and seems to challenge the viewer to appraise him. This etching is a masterpiece of textural suggestion put together from two sources—Raphael's portrait of Baldassare Casti-glione, a quintessential Renaissance aristocratic portrait that indirectly put Rembrandt in touch with Leonardo's *Mona Lisa,* and Titian's portrait of an unknown man, sometimes thought to be the poet Ariosto, also a great example of Renaissance portraiture. By assimilating these two prototypes, Rembrandt portrayed himself as both a gentleman, with the easy, unaffected grace of Castiglione, and a creative genius like Ariosto. Moreover, he put himself in the same league with two near-legendary Renaissance artists: Raphael and Titian. Both *Ariosto* and *Castiglione* had appeared on the Amsterdam art market in 1639 and had been purchased for the king of France by Alfonso Lopez, a Spanish Jew living in the city. On the hasty sketch he made after Raphael's work during the auction, Rembrandt noted that it sold for 3,500 guilders, consider-ably more than he had been paid for his most recent paintings. (The underbidder for the work, at 3,400 guilders, had been the painter-printmaker Joachim von Sandrart.)[68] In the sketch, Rembrandt had already begun to assimilate Castiglione's features into his own. The snub nose and rakish angle of the cap appear as deviations from the painting, as does an accentuation of the contrast between head and body directions. From the Titian, he took the parapet and the

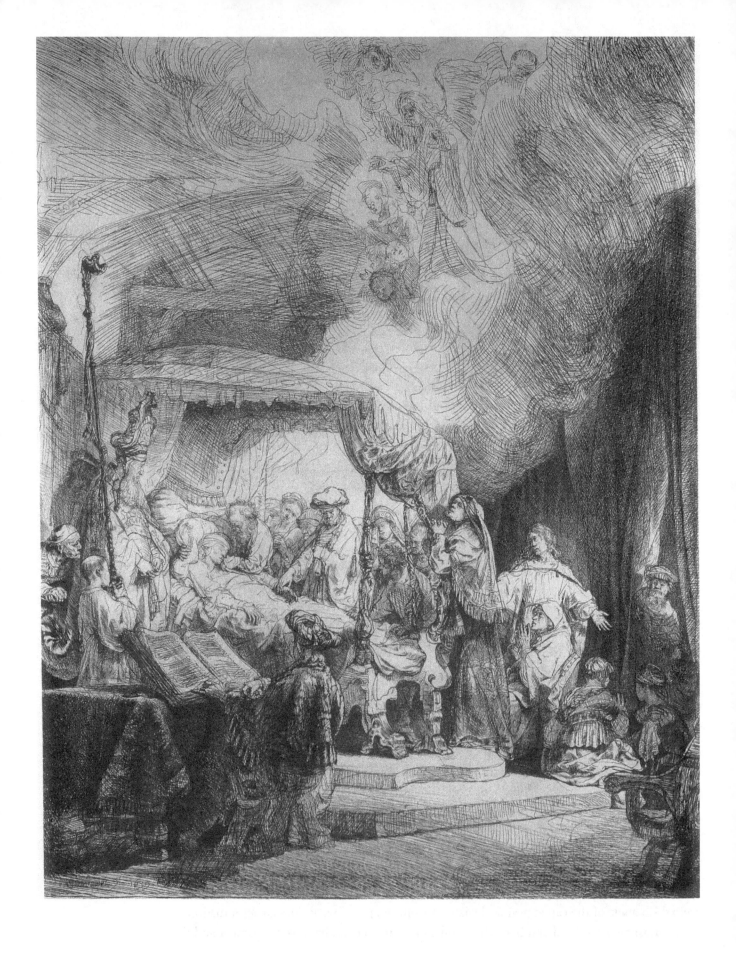

splendid sleeve, an exquisite, silken blue in the painting, and the greater brashness of the sitter.[69]

The year 1648 found him a different, more introspective man. He had lost three children in infancy, and his mother had died in 1640. His beloved Saskia had died in 1642. The nurse he had hired for Titus and with whom he evidently became sexually involved, Geertge Dircx, would soon leave his home under unpleasant and controversial circumstances in which Rembrandt revealed himself at his worst.[70] Hendrickje Stoffels, who was to become his common-law wife, had perhaps just entered his household, coexisting for a time with Dircx in what must have been an uncomfortable relationship. His financial situation, not yet desperate, was worsening. Now, Rembrandt depicted himself in severe black garb as he drew from a mirror image. Gone are the suggestions of the gentleman-artist; Rembrandt portrayed himself unpretentiously at work.[71] The first state of this etching (fig. 4.42), used as a working proof, shows us his process: over the etched network of dense hatching composed of variously bitten lines, he worked with a drypoint and burin to "sculpt" and broadly define the masses of the lower body, table, and drawing pad (the face had already been modeled thoroughly with fine, etched lines; to this he added only a few touches of drypoint). In the second state (fig. 4.43), this process of biting then reworking with drypoint and burin was continued on a more refined level, so that a delicate veil of tone smooths out the boundaries between the previously established tonal areas, without, however, disturbing the luminosity of the white areas. The result is one of the most penetrating self-portraits in the history of prints, and one wonders what the commercial appeal of such a sober image would have been. Portrait prints of the famous were collected as a way of understanding history and envisioning personal traits worthy of emulation.[72] Perhaps the etched self-portraits, *Leaning on a Stone Sill* and *Drawing at a Window,* illustrated different aspects of the artist's persona: the social grace (not, in fact, Rembrandt's forte) and learning that facilitated dealings with elite patrons, and the skill and industriousness necessary for the practice of art.

A year earlier, Rembrandt had etched his first portrait of Jan Six (also portrayed in a stunning painting in Amsterdam, done in 1654), with whom he apparently developed a friendship, despite differences in station and temperament. Six was a wealthy businessman and sometime burgomaster of Amsterdam, with a strong interest in the arts, especially poetry. Whereas the famous painting of 1654 depicts Six putting on gloves as he prepares to go out, poised psychologically on the threshold between his private and public selves, the etching depicts him engrossed in a book in a study setting (fig. 4.44). His public self is suggested only by the attributes of the room. As David Smith has noted, this print evokes a new sense of privacy and inwardness, suggested not only by Six's pose, but also by the deep shadows of the room, contrasted with the outside world implied by the luminous window. Six's face and easy stance convey an unstudied humility and gentility, the very essence of the ideal gentleman as defined by Castiglione in his *Book of the Courtier.*[73] The blacks of this print are so rich as to suggest comparison with mezzotint, one of the primary "tonal" (non-linear) intaglio techniques to be discussed in the next chapter, but Rembrandt has achieved them by fine layers of etched, drypoint, and burin lines. The few highlights are therefore especially scintillating. The sunlight passes through Six's thin, light hair to disperse itself sparingly around the dark room. The man who planned to sell Rembrandt a house in 1655 was aware of this etching's superb quality. He was willing to accept payment in both money and art: "the forenamed Rijn shall etch [a portrait of the seller] from the life, to be of the quality of the portrait of Heer van Six."[74]

FIGURE 4.40
Rembrandt van Rijn. The Death of the Virgin. *1639. Etching and drypoint. 409 × 315 mm. Staatliche Museen, Berlin.*

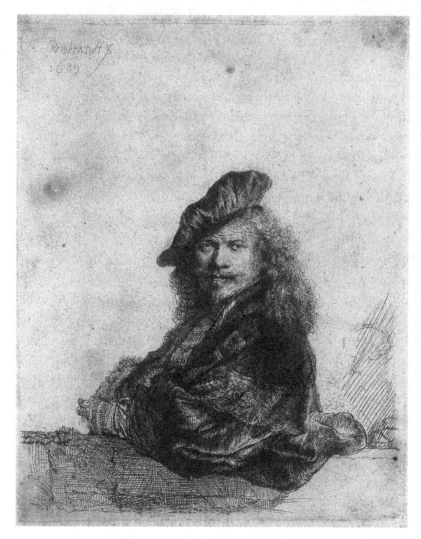

Rembrandt began to make landscape etchings only around 1640; they are confined within his oeuvre to the forties and early fifties. His landscape paintings, on the other hand, belong predominantly to the 1630s and 1640s and are often indebted to the Mannerist tradition and to Seghers' fantastic, mountainous views.[75] But in his prints, the landscape is the familiar area around Amsterdam, not copied with topographic accuracy by any means, but studied and absorbed through experience. *The Three Trees* (1643; fig. 4.45) is based on sketches made in the environs of the city, although it contains echoes of Seghers' drama. Rembrandt must have had the experience, familiar to those who live on flat land, of noticing a striking configuration of trees against the illuminated horizon. Their scale and their dark, vertical shapes sharpen our sense of the expanse and flatness of the terrain. The utter simplicity of the motif cannot explain the uncanny grandeur of this print, in which human activity and meteorological turbulence combine. Rain clouds loom at the left while the sun still shines bright on the right. The land is striped with sun and shadow as a result of the clouds' rapid movement. Here and there we gradually discover the human inhabitants: barely visible lovers in the foliage in the right corner, a fisherman and his wife at the left, a cartful of peasants and an artist sketching, seen against the sky at the right, and dwellings, cattle, and more people stretching out toward the horizon at the left.

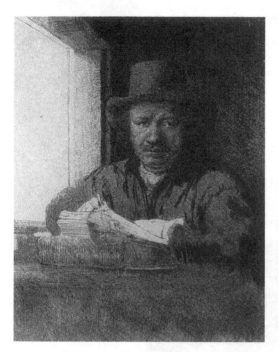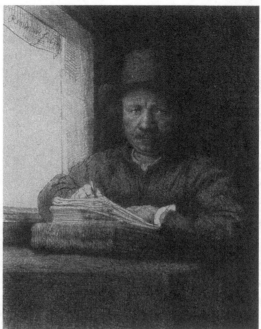

FIGURE 4.42
Rembrandt van Rijn.
Self-Portrait Drawing at
a Window, *first state.*
1648. Etching, drypoint,
and burin. 160 × 130 mm.
British Museum, London.

FIGURE 4.43
Rembrandt van Rijn.
Self-Portrait Drawing at
a Window, *second state.*
1648. Etching, drypoint,
and burin. 160 × 130 mm.
Pierpont Morgan Library,
New York.

The activities depicted suggest that Rembrandt had a particular meaning in mind: the pleasures and virtues of the simple country life, sought out by residents of the city (the primary audience for Dutch landscape)—a theme also treated in contemporary Dutch literature. The distant city in the print, the starting point of the artist's sketching excursion, reminds us of cares left behind. The cottages on the dike beyond the trees might be part of a country estate, built by a city-dweller to escape from his urban world. The large trees themselves have been interpreted in terms of Dutch moralizing emblems relating the strong tree that withstands storms to the virtuous person.[76] It may also be significant that the trees are oaks, symbols of fortitude in faith, as we have seen in Dürer's *Knight, Death, and the Devil* (fig. 2.14), and that their arrangement is reminiscent of the three crosses on Golgotha.[77] Within this rendering of his native countryside, then, Rembrandt conveyed a spiritual message: return to the simple, pastoral life to recover moral strength and inner spiritual peace. Because of his extensive use of drypoint, we can conclude that the audience for the print was relatively small. It undoubtedly provided psychological refreshment to Rembrandt's Amsterdam patrons.

The Three Trees exists in only one state, albeit in various inkings, so we cannot retrace with accuracy Rembrandt's procedure. Etching, drypoint, and burin work are thoroughly mingled in the lower right, for example, where the detail of the lovers is nearly lost. The richness of Rembrandt's line is best observed in the landscape at the left of the print, where the sense of space depends almost entirely on subtle variations in the thickness of line, and in the sky, where ephemeral and decisive strokes combine with surface tone to suggest the moisture-laden clouds and rain falling in sheets across part of the land. A graininess of uncertain origin also appears here and in the pastures beneath—did Rembrandt apply a sulphur tint (a technique in which sulphur is used like aquatint) or were the marks made manually on the plate?[78]

The most panoramic of all seventeenth-century Dutch landscapes, at least in print, is an etching-drypoint by Rembrandt of 1651 (fig. 4.46), known in only one state, although the burr varies in different impressions. In contrast to *The Three Trees,* this print shows a preference for

FIGURE 4.44

Rembrandt van Rijn.
Jan Six. 1647. Etching,
drypoint, and burin.
245 × 193 mm. Cleve-
land Museum of Art.

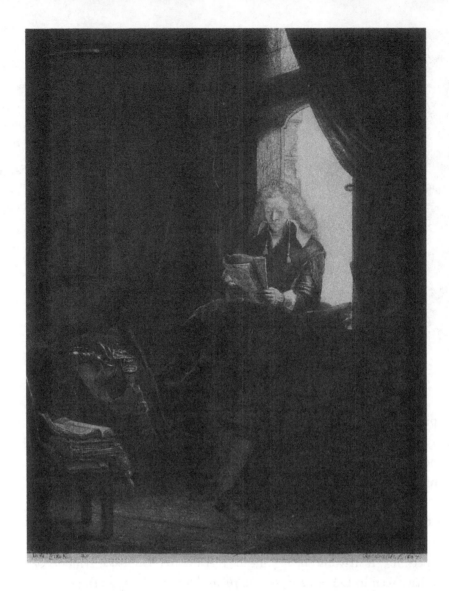

unworked, open areas and less detail that is typical of Rembrandt's etched landscapes of the 1650s.[79] It is traditionally known as *The Goldweigher's Field* because it was thought to represent the estate of a tax receiver, Jan Uytenbogaert, whom Rembrandt depicted as a goldweigher in an etching of 1639. The locale, however, seen in reverse, has been identified as Saxenburg, the estate of Christoffel Thijsz. near Haarlem (the church of St. Bavo is in the left distance).[80] At the time Rembrandt made the print, he owed Thijsz. money for a home he had purchased in Amsterdam. It is possible, Stone-Ferrier has suggested, that Thijsz. commissioned the "portrait" of his estate from Rembrandt. The linen-bleaching fields in the right middleground may suggest Thijsz.'s connection to the textile industry of Haarlem or simply his pride in both the natural and the human attributes of the area around his estate.[81]

Rembrandt's use of curving lines to the right and left created a bowl-shaped composition that gives a sense of space expanding radially from an invisible central axis. Even though the geometric center of the horizon bears no special visual distinction, we are pulled to it as if by magnetic force, and compelled to traverse the intervening fields and wooded areas. This rapid movement is augmented by the rich drypoint burr (in early impressions) in the foreground, which is likened to the natural, optical blurring of close objects whenever we focus on distant

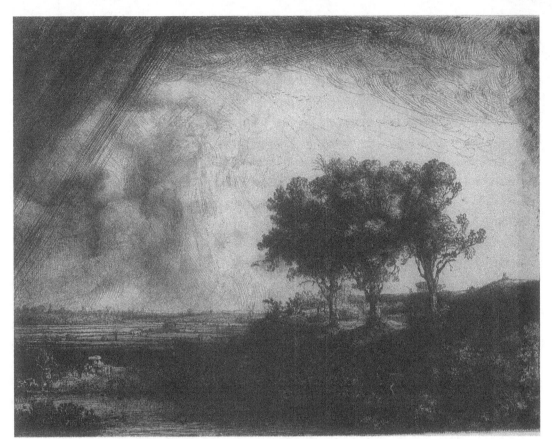

FIGURE 4.45
Rembrandt van Rijn.
The Three Trees. *1643.*
Etching, drypoint, and
burin (with sulphur
tint?). 213 × 282 mm.
Cleveland Museum of
Art.

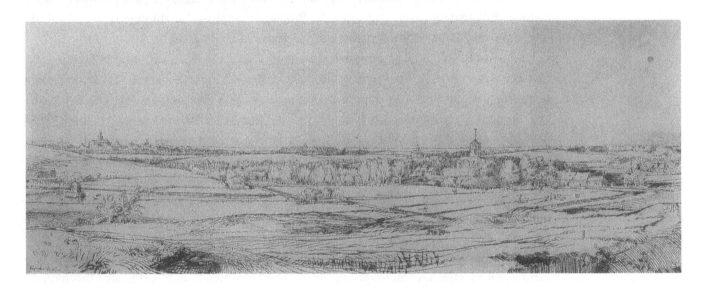

FIGURE 4.46
Rembrandt van Rijn.
The Goldweigher's Field
(View of Saxenburg).
1651. Etching and dry-
point. 120 × 317 mm.
National Gallery of Art,
Washington, D.C.

ones. The print is one of the foremost examples of that Baroque compulsion to seduce into and carry the viewer through pictorial space.

Dutch Protestantism's emphasis on the Bible surely contributed to Rembrandt's constant probing of the Old and New Testaments, and to the market for his biblical prints.[82] We cannot ascertain Rembrandt's true religious affiliation. Although he appears to have been officially connected to the Dutch Reformed or Calvinist Church, Gary Schwartz has recently stressed his connections to the anti-Calvinist, or pro-Remonstrant, faction in Dutch society and politics.[83] Rembrandt knew people of varied religious persuasions: Catholics, Jews, Mennonites, and members of Protestant sectarian groups. Most likely he was as independent in spiritual matters as in everything else. Clearly, however, his works plumb the central issues of Protestant thought. As no other artist before or after him, he explored the nooks and crannies of Bible stories, his understanding deepening as his life went on, and he produced different versions of the same narrative in prints, drawings, and paintings.

His fascination with certain biblical themes was often directly related to events in his own life.[84] In two superb etchings done ten years apart (figs. 4.47, 4.48), Rembrandt treated different aspects of the story of Abraham and Isaac (Gen. 22:1–19), in which God, testing the patriarch's faith, commands him to substitute his son for the ram about to be sacrificed. Judging from the frequent appearance of contemporary and biblical domestic motifs in his works (especially in drawings), Rembrandt must have found great joy in family life with Saskia, and then Hendrickje, and his two children (Titus by Saskia and Cornelia by Hendrickje). He had also experienced the loss of children, and so the story of Abraham's excruciating choice must have impressed him as particularly poignant. Not only was Abraham's pain personally meaningful to Rembrandt; it also embodied the Protestant emphasis on absolute faith in God, the covenant between God and mankind, and the power of God's grace.[85]

In contrast to Ugo da Carpi's woodcut after Titian (see fig. 3.45), both of Rembrandt's etchings focus clearly on Abraham's choice. The earlier etching (1645) stresses the father's moral agony. He beckons his son to approach with a gesture that also points to the reason for what he is about to do. His other hand, clutching his breast, is no less expressive. His body bends from the weight of his decision. Isaac, holding the wood for the holocaust, is utterly trusting, dependent, and fearless; he stands upright, concerned and inquisitive about his father's obvious distress. This is a simple scene, but a wealth of emotion charges the small space between the two protagonists. As in *The Death of the Virgin* (fig. 4.40), Rembrandt's lines (and hence textures) are richly varied. Etching and burin work combine with his wiping of the plate (note the heavy, drypoint-like blotches of ink) to produce a scintillating surface.

In the etching with drypoint of 1655, more emphasis is lent to the overtly dramatic moment when an angel approaches to stay Abraham's hand. Rembrandt had treated this moment before in two thoroughly baroque early paintings, one in Leningrad and one in Munich. Now, Abraham shields Isaac's eyes with his large, comforting hand. His son still does not believe that any harm could come to him and submits docilely to his father's will. Ultimately, his trust is not misguided, for a rugged angel appears out of nowhere to stop the sacrifice. His embrace of the patriarch is controlling yet protective and loving, much like Abraham's grasp on Isaac. For Rembrandt, love between people and love between God and mankind were analogous, and mystery was readily found in ordinary life and human relationships.

Conversely, the divine takes on the garb of the ordinary in Rembrandt's works, only to have its true nature revealed through unpretentious pictorial means. *The Virgin and Child*

FIGURE 4.47
Rembrandt van Rijn.
Abraham and Isaac.
1645. Etching and burin.
158 × 131 mm. Cleve-
land Museum of Art.

FIGURE 4.48
Rembrandt van Rijn.
Abraham's Sacrifice.
1655. Etching and dry-
point. 156 × 131 mm.
R. S. Johnson Fine Art,
Chicago.

(fig. 4.49), a charming etching of 1654, part of an informal series on the Infancy of Christ, takes its cue from an engraving by Mantegna in which Mary is seated on the ground as a Madonna of Humility embracing her child (see figs. 3.16, 3.17). For all the room's homey detail (a cat, a chair, an open box of mending), we note that it is elevated—an old symbolic motif denoting Mary's virginity. An oval pane of glass suggests a halo. From under her skirts crawls the serpent on which she treads: through the immaculate birth and sacrifice of Christ, original sin is defeated. The naturalism of this image seems to belong to Rembrandt's sensibility alone, yet it is really a fulfillment of the northern tradition of "disguised" symbolism—somewhat misnamed by Panofsky, since to a contemporary audience the meanings would not seem to be hidden—whereby religious significance inhabits the objects of the everyday world.[86]

Rembrandt developed the theme of Christ preaching in an intimate and an epic mode. Both express the Protestant stress on preaching the gospel—as St. Paul had written: "So faith comes from what is heard, and what is heard comes by the preaching of Christ" (Rom. 10:17). The so-called *Hundred Guilder Print* (completed in 1649; fig. 4.50), named after its price as recorded in eighteenth-century sources, recounts the nineteenth chapter of the Gospel of Matthew. It is Rembrandt's most ambitious religious composition, unprecedented in the scope of its thematic treatment and very large in scale. We know of only two states of this print, and these differ merely in a small addition to the neck of a donkey on the right. But a large number of preparatory drawings, and *pentimenti* (changes) on the plate show the care Rembrandt took with the individual figures—the position of Christ's hand and eyes, for example—and figure groups.

Rembrandt studied the aspects of Christ's ministry described in this passage of scripture carefully, not just for literal accuracy, but for deeper meaning. Matthew speaks of the multitudes of poor and sick who flock to Christ when he arrives in Judaea. These people, each sensitively portrayed, walk, or are carried on litters and carts, from the right. Also present are mothers wanting Christ to bless their children: "The disciples rebuked the people; but Jesus said, 'Let the children come to me, and do not hinder them, for to such belongs the kingdom

FIGURE 4.49

Rembrandt van Rijn.
The Virgin and Child
(with Cat and Snake).
1654. Etching. 95 ×
145 mm. British Mu-
seum, London.

of heaven.'" Rembrandt depicted a child urging its mother and infant sibling toward Christ, who has already been approached by another mother with her baby. Peter is admonished for his attempt to stop them with the firm gesture of Christ's right arm, which also welcomes the supplicants.

Matthew also recounts an attempt by the Pharisees to entangle Christ in a debate on divorce (a test of whether his thought violated the Jewish law). They appear at the upper left, engaged in vigorous discussion. The juxtaposition of Pharisees and Christ illustrates the dichotomy between the law and the gospel, with Christ insisting upon the spirit and not the letter of the law. Beneath and to the right of the Pharisees is a pensive young man sketched in drypoint. He is the wealthy youth of verses 16–24 who asks Christ how he might obtain eternal life. Christ answers that he must first give up his riches and follow him. Confused and disturbed, the young man departs, whereupon Christ remarks that "it is easier for a camel to go through the eye of a needle than for a rich man to enter the kingdom of God." The camel passing through the narrow arch at the right recalls these words. Thus, in a totally convincing, natural manner, a great many scriptural references are combined.

These separate references are united, however, by the emphasis on the kingdom: who shall enter it, and how one may enter it. It is not those who dominate the current world (the chapter ends, "But many that are first will be last, and the last first"). It is not through obedience to the law or good works, but through faith, such as that exhibited by those who have come to be healed. It requires the innocent trust and openness of a child and precludes the profound involvement with the material world that riches entail. It requires the unconditional love of other people that Christ exemplifies.

Rembrandt's print is thus a visual homily on the nature of faith and salvation, understood particularly from the Protestant perspective. Christ blessing the children, the contrast between the law and the gospel, and the totally transforming nature of faith are all stressed in Protestant thought.[87] We have already noted the changing attitude toward the indigent in seventeenth-century Holland. However, Rembrandt wanted to do more here than evoke sympathy. As Robert Baldwin has recently shown in detail, Dutch Protestantism understood the poor and

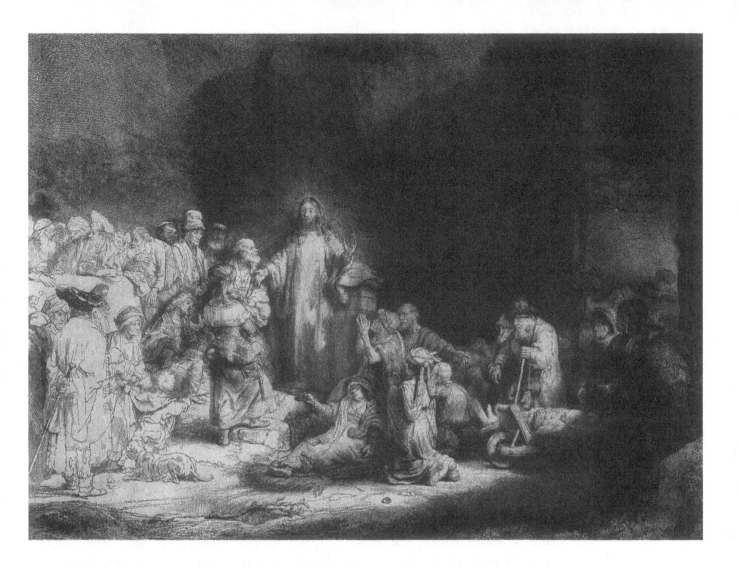

the diseased as embodiments of the lowly existence and mortality that Christ assumed and the wretched spiritual condition of sinful mankind.[88] Moreover, as Baldwin has further noted, this understanding made Rembrandt's print—itself an expensive, highly collectible item—a poignant reminder for the increasingly prosperous Dutch of what was spiritually important.[89] But the Christianity of the print is even more basic. Rembrandt made Christ its absolute, commanding center, yet at the same time kept him fully human. His gesture is authoritative but not forbidding; his physique is nothing special. Yet the crowd is drawn inexorably toward him, and his elevated placement against a dark, arch-shaped background affirms his centrality. It is primarily Rembrandt's light that establishes the relationship between Jesus and humanity. It illuminates the suffering of the multitudes, isolates Christ against an impenetrable darkness, inevitably suggesting the death that he overcomes, and ties the multitudes and Christ together. His radiance falls on them, and their shadow, in the form of a woman's hands raised in prayer, is cast upon him.[90]

In the next decade Rembrandt produced *Christ Preaching* (fig. 4.51), a smaller print based partly on an engraving after a drawing by Maerten de Vos in which St. Peter, not Christ, preaches. In comparison to *The Hundred Guilder Print,* the later composition is less complex and we are brought closer to the scene. As is usually the case with Rembrandt's religious works, the later interpretations of a theme focus more on inner reality than external narrative. Here,

FIGURE 4.50

Rembrandt van Rijn. The Hundred Guilder Print (Christ Healing the Sick). *Ca. 1639–49. Etching, drypoint and burin. 281 × 393 mm. Cleveland Museum of Art.*

FIGURE 4.51

Rembrandt van Rijn.
Christ Preaching. *Ca.*
1652. Etching, drypoint,
and burin. 156 × 208 mm.
Cleveland Museum of
Art.

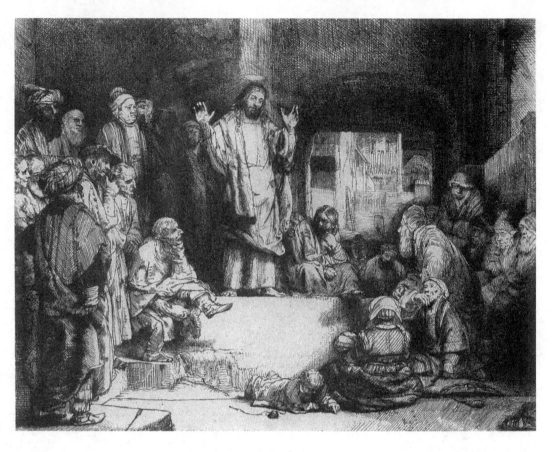

Christ heals souls, not physical illness. He speaks; the crowd listens. The basic message of *The Hundred Guilder Print*—the centrality of faith—is thus embodied here in every figure who ponders Christ's words. The old man in the lower right with his chin on his hand is especially moving. Entirely rapt, he seems to have lost awareness of his body as he absorbs Christ's message. With his arms slightly outstretched in an open-palmed gesture that suggests his sacrifice on the cross, Christ is emphasized by a vertical pillar behind him and the luminous area in front.

As he speaks, Christ contemplates a woman with two young children. One plays in the dirt, his top set aside. Top-spinning, like many other children's games, put together in one famous painting by Bruegel (1560; Kunsthistorisches Museum, Vienna), functioned as a metaphor for folly,[91] and Rembrandt may have recalled that meaning here. More generally, however, the infants express the Protestant emphasis on our child-like nature. William Halewood has noted that even the adults in this print have child-like proportions and gestures: to Christ we are all like children, forgivable despite our weakness and imperfection.[92] Perhaps it is significant that the little boy has put aside his top, and scribbles in the dirt as Christ himself did in the episode of the adulteress (John 8:1–11). As that writing suggested a tacit communication between Christ and God the Father, we know here that the child, despite his inattention to the sermon, is bound to Christ through love.

This plate was bitten once, then heavily reworked with burin and drypoint. The latter medium is particularly appropriate for this image, in which Christ's benevolent warmth and

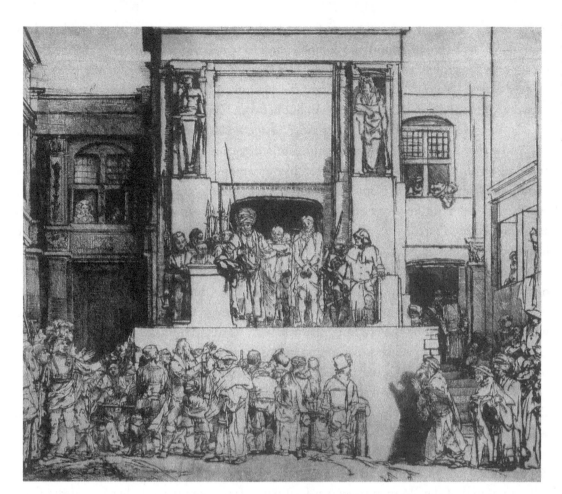

FIGURE 4.52
Rembrandt van Rijn.
Christ Presented to the
People, *first state. 1655.*
Drypoint. 383 × 455 mm.
*Metropolitan Museum of
Art, New York.*

the crowd's hushed receptiveness are the keynotes. The intimate mood is also augmented by the use of Japan paper in some impressions: the drypoint burr is enriched and differentiated more thoroughly from the fluid hatching of etched lines.

Two prints of Rembrandt's late period are done entirely in drypoint and burin: *Christ Presented to the People* (sometimes incorrectly titled *Ecce Homo*) and *The Three Crosses.* Both of these prints illustrate Rembrandt's willingness to transform his plates for the sake of uncovering new possibilities of meaning in religious themes. The first state of *Christ Presented* (fig. 4.52) is closely related to Lucas van Leyden's century-earlier *Ecce Homo* (fig. 2.44), an engraving that reflects in turn a long tradition of Netherlandish images of the mocked and beaten Christ shown to the crowd that chose Barabbas' freedom rather than his. Pilate says to them, "Behold the man"—*ecce homo* in Latin (John 19:5). Like Lucas, Rembrandt referred in his print to the contemporary practice of sentencing prisoners in public squares,[93] but shows a different moment in the story. Christ has not been beaten and wears no crown of thorns. This is the very moment when the crowd chooses between Christ and Barabbas. Margaret Carroll emphasizes this moment of choice as the key to Rembrandt's meaning. We are forced to focus less on Christ's suffering than on our own role as choosers and, hence, on the ultimate fallibility of human justice.[94]

In subsequent states, Rembrandt cut down the plate at the top, primarily so that it would fit on a piece of Japan paper, but also probably because the architecture was in danger of overwhelming the figures. He added details and definition to the remaining architecture and

to figures in the crowd and on the platform. At the fifth state, when much of the burr had worn down, he began to rethink the composition as a whole. He scraped and burnished until most of the foreground crowd was obliterated. (A major exception is the old man at the right whose prayer is projected in shadow upon the platform.) Now, the main drama occurs not between Christ and the foreground crowd, but between Christ and the viewer.

In the seventh state (fig. 4.53), a strange image replaces the crowd: a canal-like chasm, framed by two arches suggesting the opening of a dungeon or sewer and guarded by an emaciated old man holding an urn, who looks like an antique river god and has been variously identified (White called him Neptune).[95] Carroll notes his infernal character and identifies him as Acheron, god of the first river of the underworld, who greeted souls at the entrance of Hades and who had been interpreted as an embodiment of the torments of a guilty conscience. The introduction of this figure is accompanied by changes in Christ: he is more weary, and his gaze is lowered toward us. He thus approaches the mocked and beaten Christ (the Man of Sorrows) of the traditional Ecce Homo representations. This is the Christ whose sacrifice at the hands of a miscarried justice frees us from sin, death, and bondage to the law, the imperfections of which are symbolized by the cracking platform with its denizen of hell and the abyss below. Christ represents grace, which is contrasted in this print and in Protestant thought in general to the law: faith above works; the spirit of the law above the letter.[96]

The seventh state is signed and dated 1655, as if Rembrandt considered the plate complete. But he took only three impressions from it that we know of, and produced an eighth state in which the old man is largely burnished away. According to White's analysis, Rembrandt recognized the obtrusiveness of "that unsuitable intruder from another, more watery, world."[97] While acknowledging Rembrandt's effort to erase the figure, Carroll notes that the phantom-like appearance of the old man (now urn-less) reminds us more powerfully of the death from which we might be saved. At the same time his "disembodiment" brings us spatially closer to the platform and spiritually closer to the choice we must make.[98] Neptune or Acheron, the old man and the pit he guards must have represented for Rembrandt the dark emptiness that turning away from Christ implied. Thus, as we look from the platform to the frightening, enigmatic image below, we are engaged in choosing, no longer able to slough this decision onto a crowd.

The changes between the third and fourth states of *The Three Crosses* (figs. 4.54, 4.55) are just as remarkable as the waxing and waning of our old river god, but more intelligible, since they are based on a change in Rembrandt's scriptural sources. The first three states were apparently all executed in 1653 and are based on Luke's narrative of the Crucifixion (23:44–48):

> It was now about the sixth hour, and there was darkness over the whole land until the ninth hour, while the sun's light failed; and the curtain of the temple was torn in two. Then Jesus, crying with a loud voice, said, "Father, into thy hands I commit my spirit!" And having said this he breathed his last. Now when the centurion saw what had taken place, he praised God, and said, "Certainly this man was innocent!" And all the multitudes who assembled to see the sight, when they saw what had taken place, returned home beating their breasts.

Rembrandt's basic fidelity to this text is clear. Figures "return home" in the foreground (the exhausted Simon of Cyrene, who helped Christ carry the cross, is supported by companions as he leaves toward the left, while Joseph of Arimathea and Nicodemus hurry off to prepare

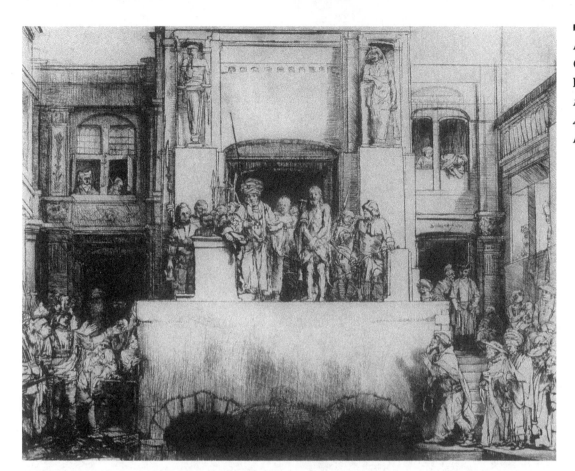

FIGURE 4.53

Rembrandt van Rijn.
Christ Presented to the
People, *seventh state.*
1655. Drypoint. 358 ×
455 mm. British Museum,
London.

Christ's grave toward the right). Kneeling at the left of the cross is the converted centurion, borrowed from an engraving by the Master of the Die (1532). Halewood, however, points out Rembrandt's preference for Matthew's version of the centurion's words, "Truly this was the Son of God!" (27:54), for the stance of this figure shows that he is overwhelmed.[99]

The good and bad thieves, distinguished uniquely in the Lukan text, are differentiated by light and shadow and placed to the right and left of the cross respectively. The traditional placement of the good thief on Christ's right was, of course, reversed in printing; apparently this detail did not disturb Rembrandt at this point.[100] Christ has expired while darkness moves over the earth, save for the powerful cone of light that falls over Christ, the good thief, and the core of mourners under the cross. Rembrandt utilized the first two states to establish this cone of light more firmly, by subordinating much of the rich detail of the crowd at the left, balancing this area with pitch blackness of the grave at the lower right. He signed this state and dated it 1653.

Although, like *The Hundred Guilder Print* (fig. 4.50), the third state of *The Three Crosses* contains a wealth of detail, its focus is more on a single moment of spiritual revelation, so that its title could more narrowly be "The Conversion of the Centurion." Amid the hysteria of the mourners and the clattering efficiency of the Roman soldiers, a single kneeling man grasps the transcendent meaning of Christ's ignoble death. The light, like an opening into heaven, stands for his sudden understanding.

It was probably around 1660 that Rembrandt reworked this plate, and the resulting print (fig. 4.55) was to be one of his last and greatest essays in the graphic media (painting dominated

FIGURE 4.54

Rembrandt van Rijn.
The Three Crosses,
third state. 1653. Dry-
point and burin. 385 ×
450 mm. British Museum,
London.

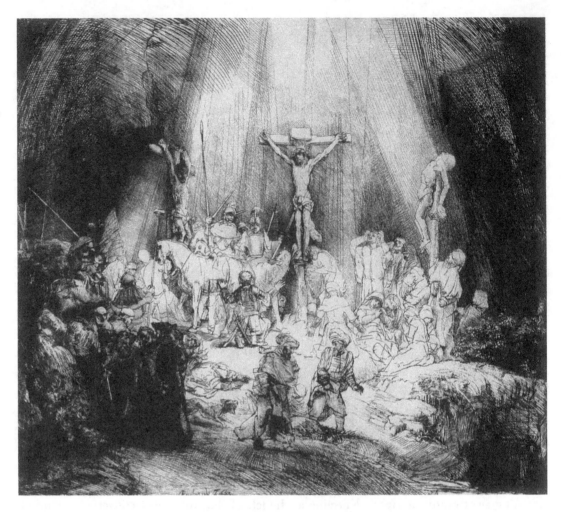

his last years). A mere reworking of the lines in this already densely carved plate would have produced a flat image with little linear variation, so Rembrandt set out to laboriously scrape, burnish, and polish extensive areas. We can tell more about what he did from a maculature (an impression taken from a plate that has already been run through the press to clean out the ink) that is preserved in the British Museum.[101] The left of the plate is more radically altered than the right. A rearing horse restrained by a man—taken from an ancient sculpture of the Dios- curi, the twin sons of Zeus and Leda—becomes the dominant form at the far left. This agitated animal augments the sense of terror and panic in the print, but Rembrandt may have intended something more by the Dioscuri motif. For the brothers were taken to refer to the dual nature of Christ, the human half of which is manifested brutally in the Crucifixion.[102]

Replacing the figures who were under the former bad thief is a single helmeted figure and another mounted man wearing a huge hat. The latter is taken from a medal of Gianfrancesco Gonzaga by Pisanello, and is interpreted by Clark as a detached figure, unaware of the momen- tousness of the event he witnesses.[103] But the figure might also be a new version of Longinus, the centurion. If this is so, how are we to understand his attitude? Baldwin describes it as "an intense inwardness, a nonclassical transcending of the self before an awesome and over- whelming Christian mystery that precludes free action and good works."[104] In other words, Rembrandt changed the centurion figure to emphasize the inner nature of his conversion. In

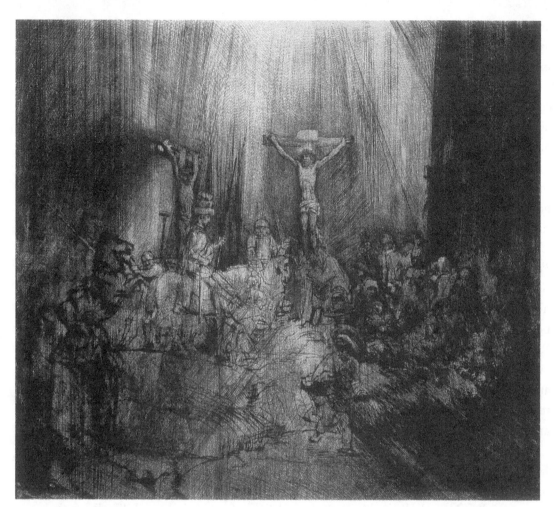

FIGURE 4.55
Rembrandt van Rijn.
The Three Crosses,
*fourth state. Ca. 1660.
Drypoint and burin.
376 × 442 mm (sheet
trimmed inside plate-
mark). Cleveland
Museum of Art.*

keeping with the general movement in Rembrandt's art from the gestural to the spiritual, the centurion no longer has to kneel and spread his arms before Christ; rather, he remains utterly still and silent.

On the right a curtain of darkness falls over what were once the good thief and the grave and obscures the once distinct figures in the crowd of mourners. Even considering the tremendous variations in inking and wiping among the different impressions of the various states of *The Three Crosses*, the fourth state is markedly darker than the earlier ones. The light is no longer conical, but falls in a rectangle over Christ, the former bad thief, and the two mounted men. This is not an image of hopeful revelation like the third state. Instead, it is the lowest point in Christ's life, when his cry of anguish is heard and his divinity, veiled in a "mist of torment," as Rembrandt's contemporary Jeremias de Decker described it,[105] does not seem apparent. Rembrandt's scriptural source is Mark or Matthew: "Now from the sixth hour there was darkness over the land until the ninth hour. And about the ninth hour Jesus cried with a loud voice . . . "My God, my God, why hast thou forsaken me?" (Matt. 27:45–46).

Christ is now alive, and drypoint marks make his suffering even more apparent. His followers beneath the cross and we, the viewers, share in his suffering. The running figure to the right of center flees from this terrible moment, as we are tempted to flee. Christ is now more completely isolated from everyone by the darkness that blocks off the side of the com-

position. Thus, Rembrandt has focused more relentlessly on human weakness and on the crisis of faith that Christ's death provokes. The fourth state of *The Three Crosses* is a more demanding, uncompromising image.

In *Christ Presented to the People* and *The Three Crosses,* Rembrandt turned away from etching and the mastery of the needle, and multiple biting and stopping-out, toward a more direct "attack" on the plate. Why? Like Michelangelo, Rembrandt seems in his late years to have become increasingly frustrated by his materials and the conventional ways of handling them. The desire for a revelatory clarity and depth of expression demanded a directness that the inherently circuitous art of printmaking (especially the kind of etching that Rembrandt had developed), like the necessarily slow and careful process of carving marble, could not supply. The physically difficult hammering, scraping, burnishing, and recarving of *The Three Crosses* plate, like Michelangelo's hacking away of the stone in his late Florence and Rondanini *Pietàs,* represent the stubborn will of the aged artist to force the materials to do his bidding. And that bidding was a conception of a theme so profoundly personal that it stood outside normal iconographic traditions, and certainly outside the stylistic expectations of their contemporaries. The terror of the running figure in the fourth state of *The Three Crosses,* one feels, is Rembrandt's own. Some have even suggested that this figure is a self-portrait, although this is impossible to ascertain.[106] The appeal of this dark print, with its awkward divisions into rectangles and trapezoids of tone and its chunky, minimally articulated figures, lies not only in the technical finessse it exhibits, but in the documentation it provides of the spiritual life of a great artist.

Rembrandt was a gifted teacher, and some of his pupils, most notably Ferdinand Bol and Jan Joris van Vliet, were skilled etchers. But beyond this immediate impact, his prints set new technical, expressive, and aesthetic standards. His own fascination for varied states and impressions proved to be both the harbinger and the delight of a dawning sensibility. By 1700, a new consciousness about states and quality of impression began to manifest itself in collections such as that of the Amsterdam art dealer, Jan Pietersz. Zomer (or Zoomer), assembled from about 1670 to 1720. Zomer described his collection of 428 Rembrandts as "complete, including every state, excellent impressions, and such that neither he, nor anyone else could collect their likes."[107] In 1751, Rembrandt's prints were the first to be cataloged by a dealer (Edme-François Gersaint), an indication that prints could take their place along with paintings in any full understanding of an artist's oeuvre.[108]

In contemporary England, the demand for Rembrandt's prints reached a peak, even while, as Ellen D'Oench notes, his paintings were criticized for their lack of idealization. Both the print's lower status in the artistic hierarchy of media and the development of print-connoisseurship contributed to the English craze for Rembrandt's prints, roundly censured by the critic William Gilpin in his *Essay upon Prints* (written in 1753 and published in 1768). As English mezzotinters, enamored with Rembrandt's chiaroscuro, produced reproductions of his paintings and prints or original works in the manner of Rembrandt, a more dubious homage occurred as the Rembrandt copyist Captain William Baillie, having purchased the plate of *The Hundred Guilder Print,* issued a notorious restrike (posthumous impression) in 1776, and then actually cut the plate into four sections and printed from those. In doing so, of course, he destroyed Rembrandt's brilliant gathering into one image of the full spectrum of humanity touched by Christ—a quality that had been praised by Jonathan Richardson in his second edition of the *Essay on the Theory of Painting* (1725).[109]

For the nineteenth and twentieth centuries, Rembrandt's prints continued to represent the highest standards of autographic work on an intaglio plate. For the so-called etching revival of the late nineteenth century, for example, his simpler etched landscapes epitomized freshness for numerous professional and amateur etchers. But what was most enviable about Rembrandt as a printmaker was essentially inimitable, because it depended upon a unique vision of all that could be done with a metal plate wedded to a compelling view of humanity and nature. His most personal graphic expressions—his complex, combined intaglio prints like *The Three Trees, The Hundred Guilder Print,* and *The Three Crosses*—defy the flattery of imitation.

The Baroque tradition of original etching was carried on by a few outstanding printmakers in the eighteenth century and would flourish again, more vigorously, in the nineteenth. There was a counterpoint to this tradition, however: the growth of reproductive printmaking, which fostered a highly systematic use of the burin or combination of the burin with the etching needle, and the invention of various non-linear intaglio processes. It is to these developments—Marcantonio Raimondi's legacy—that we now turn.

NOTES

1. Reed and Wallace 1989, p. xx.

2. Robinson 1981, p. xxxiv. Also see Strauss and Van der Meulen 1979, pp. 140–43.

3. Reed and Wallace, no. 72, pp. 149–50, and p. xxvii.

4. Bohlin 1979.

5. Ibid., p. 40.

6. Jacobowitz and Stepanek 1983, nos. 74 and 75, pp. 199–201.

7. Reed and Wallace 1989, no. 49, pp. 106–7.

8. White 1969, vol. 1, p. 33, and fig. 19 in vol. 2.

9. Bohlin 1979, no. 18, pp. 452–53.

10. Reed and Wallace 1989, nos. 62–64, pp. 128–31. On Reni's reproductive prints, see Birke 1988.

11. On Ribera's etchings, see Brown 1973.

12. Wallace 1979, no. 104, p. 261, and pp. 60–69.

13. On Cassiano dal Pozzo, see Haskell [1963] 1980, pp. 98–114. On Testa's involvement with the "Paper Museum," see Solinas and Nicolò 1988.

14. A recent study of Testa's graphic oeuvre is Cropper 1988.

15. See Consagra 1988, p. xc. On *The Martyrdom of St. Erasmus,* see Cropper 1988, nos. 5 and 6, pp. 9–13.

16. Lagerlöf 1990, pp. 74–76.

17. Russell 1982, no. 20, pp. 332–33.

18. Ibid., no. 23, p. 341.

19. Blunt 1971; Metropolitan Museum of Art 1980, no. 5, pp. 68–69 (on Castiglione's earliest known monotype).

20. Percy 1971, no. E 21, pp. 144–45.

21. The fundamental study of Van Dyck's *Iconography* is Hind 1915.

22. On Pepys's collection, see Van de Waals 1984.

23. Held 1969.

24. On Callot's life and works, see Bechtel 1955.

25. Mayor 1971, remarks under fig. 456.

26. Posner 1977.

27. Ibid., p. 216.

28. White 1969, vol. 1, pp. 153–54 and, in vol. 2, figs. 214, 217.

29. See Brown University and Rhode Island School of Design 1970, no. 51.

30. See Russell 1975, p. 211.

31. Wolfthal 1977, p. 225.

32. On Della Bella's prints, see Massar 1971.

33. Hind [1923] 1963, p. 161.

34. Van Eerde 1970, p. 20.

35. Ibid., p. 55.

36. Ibid., p. 57.

37. For a more detailed introduction to Dutch etching of this period, see Ackley 1981.

38. The classic study of Dutch seventeenth-century landscape painting is Stechow [1968]

1981. The essays in Sutton 1987b provide a good revision and updating of Stechow's study.

39. See Groot 1979, introduction (not paginated).

40. For a thorough discussion of the cultural background of Dutch landscape etching, see Freedberg 1980; Schama 1987; Sutton 1987a.

41. Brown 1986 is a study of this early phase of Dutch landscape.

42. See Alpers 1983, especially pp. 229–33. This book challenges the interpretation of Dutch art in symbolic or emblematic terms. Contrast Alpers' approach to that of Kahr 1978, in her general textbook on Dutch seventeenth-century painting. This problem is also addressed throughout Sutton 1987b, especially in Schama's essay.

43. Ackley 1981, no. 40, pp. 66–68. On religious meaning in Dutch landscapes, see Bruyn 1987.

44. See De Vries 1986.

45. For a thorough study of Dutch marine paintings and prints, see Keyes 1990.

46. Sutton 1987a, p. 4. For a more detailed analysis of which segments of Dutch society patronized which types of landscapes, see Chong 1987.

47. Rowlands 1979, pp. 13–14.

48. On Seghers' chronology, see Haverkamp-Begemann 1973, pp. 53–55. This book also contains the most detailed descriptions of Seghers' techniques.

49. On Buytewech's etchings, see Van Gelder 1931; Haverkamp-Begemann 1959, pp. 24–25; Haverkamp-Begemann 1962.

50. Stone-Ferrier 1983, no. 25, pp. 110–12.

51. Ackley 1981, no. 61, pp. 102–3.

52. See ibid., pp. xxiii–xxv.

53. Stone-Ferrier 1983, no. 9, pp. 65–67.

54. White 1969 emphasizes Rembrandt's experimental approach to etching. Also see Boston Museum of Fine Arts and Pierpont Morgan Library 1969.

55. Melot, Griffiths, and Field 1981, pp. 67–68.

56. Since Rembrandt directly juxtaposes these objects with the hand of Christ, it may be that he intended them to represent the worldly con- cerns to which Lazarus has died—he is reborn literally but also into the life of the spirit.

57. See Ackley 1981, no. 82, p. 131.

58. White 1969, vol. 1, p. 35.

59. Stone-Ferrier 1983, no. 26, pp. 112–14.

60. Robinson 1980, p. 166.

61. On some iconographic implications of Rembrandt's use of two manners—one very sketchy, the other more complete—see Dickey 1986.

62. See Silver 1976.

63. Stratton 1986. On Rembrandt and beggars, also see Baldwin 1985.

64. White 1969, vol. 1, p. 43.

65. Strauss and Van der Meulen 1979, p. 150.

66. Perlove, ed., 1989, no. 5, pp. 50–51.

67. On Rembrandt's self-portraits, see Chapman 1990.

68. Strauss and Van der Meulen 1979, p. 177.

69. On these influences on Rembrandt's etching, see Clark 1966, pp. 123–27; Chapman 1990, pp. 69–78.

70. In the course of Rembrandt's involvement with Dircx, he rashly gave her some of Saskia's jewelry, which he attempted to keep in the family by influencing her to will it to Titus. Dircx pawned the jewelry, apparently because of financial difficulties. She also charged Rembrandt with breach of promise, claiming that he had promised to marry her. Although the Chamber of Marital Affairs reserved judgment about the truth of her accusation, Rembrandt was compelled to pay an unusual sum for her support. In 1650, Dircx was confined to a correctional institution, evidently at Rembrandt's instigation. In 1655, when a friend facilitated her release, Rembrandt vehemently insisted on her confinement. See Strauss and Van der Meulen 1979, pp. 267–76, 340–42.

71. Chapman 1990, pp. 81–87.

72. Robinson 1981, p. xl.

73. Smith 1988.

74. Quoted in White 1969, vol. 1, p. 131.

75. Schneider 1990, pp. 1–2, 71–73, for comparisons of Rembrandt's and Seghers' approaches to landscape. Rembrandt may have abandoned landscape paintings in part because they were harder to sell (ibid., p. 60).

76. Stone-Ferrier 1983, no. 46, pp. 169–72.

77. The resemblance to the motif of the three crosses is noted in Brown 1986, no. 112, p. 226.

78. Hollstein 1949—, vol. 18, p. 103.

79. Schneider 1990, pp. 58–59.

80. Van Regteren Altena 1954.

81. Stone-Ferrier 1985, pp. 429–36.

82. For studies of Rembrandt's approach to biblical subjects, see Visser t'Hooft 1957; Rosenberg [1964] 1980, pp. 169–234; Halewood 1982; Perlove, ed., 1989.

83. Schwartz 1985.

84. Rembrandt's interest in the story of David and Bathsheba, for example, was strengthened by his own relationship with Hendrickje, whom he could not legally marry because of the terms of Saskia's will. Thus, their daughter Cornelia was illegitimate. Hendrickje was called before the council of the Dutch Reformed Church in 1654, the year of Cornelia's birth, and admonished. That year Rembrandt painted *Bathsheba with King David's Letter* (Louvre) with Hendrickje as his model. See Strauss and Van der Meulen 1979, pp. 318–20.

85. On Rembrandt and the story of Abraham, see Smith 1985; Perlove 1989.

86. On the principle of disguised symbolism, see Panofsky [1953] 1971, vol. 1, pp. 131–48.

87. See Christensen 1979, pp. 42–65, on Luther's theology and art, and pp. 124–30, 134–36, on the Law and the Gospel and Christ Blessing the Children as motifs in Protestant art.

88. Baldwin 1985.

89. Baldwin 1989, pp. 30–31.

90. See Rotermund 1952 on the motif of radiance in Rembrandt's drawings.

91. See Hindman 1981.

92. Halewood 1982, p. 75.

93. Lindenborg 1976 suggests that Rembrandt referred in this print to the public execution of Charles I of England, who had many Dutch sympathizers.

94. Carroll 1981, pp. 592–96.

95. White 1969, vol. 1, p. 90.

96. Carroll 1981, pp. 597–600.

97. White 1969, vol. 1, p. 91.

98. Carroll 1981, p. 603.

99. Halewood 1982, p. 147, n. 7.

100. Stechow 1950, p. 254, suggests that his error prompted the revisions in the fourth state.

101. White 1969, vol. 2, fig. 94.

102. Baldwin 1984.

103. Clark 1966, pp. 170–71.

104. Baldwin 1984, p. 27.

105. Quoted ibid., pp. 26–27.

106. Carroll 1981, p. 608, n. 111.

107. Robinson 1981, pp. xl–xli.

108. Melot, Griffiths, and Field 1981, pp. 64–65.

109. On the taste for Rembrandt's prints in eighteenth-century England, see D'Oench 1983, especially pp. 70–71 on Gilpin's criticism, and p. 75 on the Baillie restrike. Also see Alexander 1983 on Rembrandt and the English reproductive print.

REFERENCES

Ackley, Clifford S. 1981. *Printmaking in the Age of Rembrandt.* Exhibition catalog with an essay by William W. Robinson. Museum of Fine Arts, Boston.

Alexander, David. 1983. Rembrandt and the Reproductive Print in Eighteenth Century England. In Yale Center for British Art 1983, pp. 47–54.

Alpers, Svetlana. 1983. *The Art of Describing: Dutch Art in the Seventeenth Century.* Chicago.

Baldwin, Robert W. 1984. Rembrandt's Visual Sources from Italy and Antiquity. *Source,* vol. 4, no. 1 (Fall), pp. 22–29.

Baldwin, Robert W. 1985. "On Earth We Are Beggars, as Christ Himself Was": The Protestant Background of Rembrandt's Imagery of Poverty, Disability, and Begging. *Konsthistorisk Tidskrift,* vol. 54, no. 3, pp. 122–35.

Baldwin, Robert W. 1989. Rembrandt's New Testament Prints: Artistic Genius, Social Anxiety and the Calvinist Marketed Image. In Perlove, ed., 1989, pp. 24–34.

Bechtel, Edward De T. 1955. *Jacques Callot.* New York.

Birke, Veronika. 1988. *Guido Reni und der Repro-duktionsstich.* Exhibition catalog. Graphische Sammlung Albertina, Vienna.

Blunt, Anthony. 1971. The Inventor of Soft-Ground Etching: Giovanni Benedetto Castiglione. *Burlington Magazine,* vol. 113 (August), pp. 474–75.

Bohlin, Diane DeGrazia. 1979. *Prints and Related Drawings by the Carracci Family.* Exhibiton catalog. National Gallery of Art, Washington, D.C.

Boston Museum of Fine Arts, and Pierpont Morgan Library. 1969. *Rembrandt, Experimental Etcher.* Exhibition catalog. Museum of Fine Arts, Boston and Pierpont Morgan Library, New York.

Brown, Christopher. 1986. *Dutch Landscape: The Early Years, Haarlem and Amsterdam 1590–1650.* Exhibition catalog with contributions by David Bomford, E. K. J. Reznicek, Margarita Russell, M. A. Schenkeveld–van der Dussen, and Jan de Vries. National Gallery, London.

Brown, Jonathan. 1973. *Jusepe de Ribera: Prints and Drawings.* Exhibition catalog. Princeton University Art Gallery, Princeton, N.J., and Fogg Art Museum, Harvard University, Cambridge, Mass.

Brown University and Rhode Island School of Design. 1970. *Jacques Callot, 1592–1635.* Exhibition catalog. Museum of Art, Rhode Island School of Design, Providence, R.I.

Bruyn, Josua. 1987. Toward a Scriptural Reading of Seventeenth-Century Dutch Landscape Paintings. In Sutton 1987b, pp. 84–103.

Carroll, Margaret D. 1981. Rembrandt as Meditational Printmaker. *Art Bulletin,* vol. 63, no. 4 (December), pp. 585–610.

Chapman, H. Perry. 1990. *Rembrandt's Self-Portraits: A Study in Seventeenth-Century Identity.* Princeton, N.J.

Chong, Alan. 1987. The Market for Landscape Painting in Seventeenth-Century Holland. In Sutton 1987b, pp. 104–20.

Christensen, Carl. 1979. *Art and the Reformation in Germany.* Athens, Ohio, and Detroit.

Clark, Kenneth. 1966. *Rembrandt and the Italian Renaissance.* New York.

Consagra, Francesca. 1988. The Marketing of Pietro Testa's "Poetic Inventions." In Cropper 1988, pp. lxxxvii–civ.

Cropper, Elizabeth. 1988. *Pietro Testa 1612–1650: Prints and Drawings.* Exhibition catalog with contributions by Charles Dempsey, Francesco Solinas, Anna Nicolò, and Francesca Consagra. Philadelphia Museum of Art, Philadelphia.

De Vries, Jan. 1986. The Dutch Rural Economy and the Landscape. In Brown 1986, pp. 79–86.

Dickey, Stephanie S. 1986. "Judicious Negligence": Rembrandt Transforms an Emblematic Convention. *Art Bulletin,* vol. 68, no. 2 (June), pp. 253–62.

D'Oench, Ellen G. 1983. "A Madness to Have His Prints": Rembrandt and Georgian Taste, 1720–1800. In Yale Center for British Art 1983, pp. 63–81.

Freedberg, David. 1980. *Dutch Landscape Prints of the Seventeenth Century.* London.

Groot, Irene de. 1979. *Landscape Etchings by the Dutch Masters of the Seventeenth Century.* London.

Halewood, William. 1982. *Six Subjects of Reformation Art: A Preface to Rembrandt.* Toronto.

Haskell, Francis. [1963] 1980. *Patrons and Painters.* Rev. ed. New Haven, Conn.

Haverkamp-Begemann, Egbert. 1959. *Willem Buytewech.* Amsterdam.

Haverkamp-Begemann, Egbert. 1962. The Etchings of Willem Buytewech. In Zigrosser, ed., 1962, pp. 55–81.

Haverkamp-Begemann, Egbert. 1973. *Hercules Seghers: The Complete Etchings.* Amsterdam and the Hague.

Held, Julius S. 1969. Rubens and Vorsterman. *Art Quarterly,* vol. 32, no. 2 (Summer), pp. 111–29.

Hind, Arthur Magyar. 1915. Van Dyck, His Original Etchings and His Iconography. *Print Collector's Quarterly,* vol. 5, pp. 3–37, 221–53.

Hindman, Sandra. 1981. Pieter Bruegel's *Children's Games,* Folly, and Chance. *Art Bulletin,* vol. 63, no. 3 (September), pp. 447–75.

Hollstein, F. W. H. 1949–. *Dutch and Flemish Etchings, Engravings and Woodcuts, ca.*

1450–1700. Continuing series. Amsterdam.

Jacobowitz, Ellen S., and Stephanie Loeb Stepanek. 1983. *The Prints of Lucas van Leyden and His Contemporaries.* Exhibition catalog. National Gallery of Art, Washington, D.C.

Kahr, Madlyn Millner. 1978. *Dutch Painting in the Seventeenth Century.* New York.

Keyes, George S. 1990. *Mirror of Empire: Dutch Marine Art of the Seventeenth Century.* Exhibition catalog with essays by George S. Keyes, Dirk de Vries, James A. Welu, and Charles K. Wilson. Minneapolis Institute of Arts, Minneapolis.

Lagerlöf, Margaretha. 1990. *Ideal Landscape: Annibale Carracci, Nicolas Poussin and Claude Lorrain.* New Haven, Conn.

Lindenborg, Ida. 1976. Did the Execution of Charles the First Influence Rembrandt's Ecce Homo? *Print Review 6,* pp. 19–26.

Mayor, A. Hyatt. 1971. *Prints and People.* New York.

Melot, Michel, Antony Griffiths, and Richard S. Field. 1981. *Prints: History of an Art.* New York.

Metropolitan Museum of Art. 1980. *The Painterly Print: Monotypes from the Seventeenth to the Twentieth Century.* Exhibition catalog with contributions by Sue Welsh Reed, Eugenia Parry Janis, Barbara Stern Shapiro, David W. Kiehl, Colta Ives, and Michael Mazur. New York.

Panofsky, Erwin. [1953] 1971. *Early Netherlandish Painting.* 2 vols. Reprint. New York.

Percy, Ann. 1971. *Castiglione: Master Draughtsman of the Italian Baroque.* Exhibition catalog. Philadelphia Museum of Art, Philadelphia.

Perlove, Shelley Karen. 1989. Visual Exegesis: The Calvinist Context for Rembrandt's Etchings of the Life of Abraham. In Perlove, ed., 1989, pp. 11–23.

Perlove, Shelley Karen, ed. 1989. *Impressions of Faith: Rembrandt's Biblical Etchings.* Exhibition catalog with essays by Shelley K. Perlove and Robert W. Baldwin. Mardigan Library, University of Michigan, Dearborn.

Posner, Donald. 1977. Jacques Callot and the Dances Called *Sfessania. Art Bulletin,* vol. 59, no. 2 (June), pp. 203–16.

Reed, Sue Welsh, and Richard Wallace. 1989. *Italian Etchers of the Renaissance and Baroque.* Exhibition catalog with contributions by David Acton, David P. Becker, Elizabeth Lunning, and Annette Manick. Museum of Fine Arts, Boston.

Robinson, Franklin W. 1980. Puns and Plays in Rembrandt's Etchings. *Print Collector's Newsletter,* vol. 11, no. 5 (November–December), pp. 165–68.

Robinson, William W. 1981. "This Passion for Prints": Collecting and Connoisseurship in Northern Europe during the Seventeenth Century. In Ackley 1981, pp. xxvii–xlviii.

Rosenberg, Jakob. [1964] 1980. *Rembrandt: Life and Work.* Reprint of rev. ed. Ithaca, N.Y.

Rotermund, Hans Martin. 1952. The Motif of Radiance in Rembrandt's Biblical Drawings. *Journal of the Warburg and Courtauld Instiatutes,* vol. 15, pp. 101–201.

Rowlands, John. 1979. *Hercules Segers.* New York.

Russell, H. Diane. 1975. *Jacques Callot: Prints and Related Drawings.* Exhibition catalog with contributions by Jeffry Blanchard and John Krell. National Gallery of Art, Washington, D.C.

Russell, H. Diane. 1982. *Claude Lorrain 1600–1682.* Exhibition catalog. National Gallery of Art, Washington, D.C.

Schama, Simon. 1987. Dutch Landscapes: Culture as Foreground. In Sutton 1987b, pp. 64–83.

Schneider, Cynthia P. 1990. *Rembrandt's Landscapes.* New Haven, Conn.

Schwartz, Gary. 1985. *Rembrandt: His Life, His Paintings.* New York.

Silver, Lawrence. 1976. Of Beggars—Lucas van Leyden and Sebastian Brant. *Journal of the Warburg and Courtauld Institutes,* vol. 39, pp. 253–57.

Smith, David R. 1985. Towards a Protestant Aesthetics: Rembrandt's 1655 *Sacrifice of Isaac. Art History,* vol. 8, no. 3 (September), pp. 290–302.

Smith, David R. 1988. "I Janus": Privacy and the Gentlemanly Ideal in Rembrandt's Portraits of Jan Six. *Art History,* vol. 11, no. 1 (March), pp. 42–63.

Solinas, Francesco, and Anna Nicolò. 1988. Cassiano dal Pozzo and Pietro Testa: New Documents Concerning the *Museo cartaceo*. In Cropper 1988, pp. lxvi–lxxxvi.

Stechow, Wolfgang. 1950. Review of J. Rosenberg's *Rembrandt: Life and Work. Art Bulletin*, vol. 32, no. 3 (September), pp. 252–55.

Stechow, Wolfgang. [1968] 1981. *Dutch Landscape Painting of the Seventeenth Century*. Reprint ed. Ithaca, N.Y.

Stone-Ferrier, Linda A. 1983. *Dutch Prints of Daily Life: Mirrors of Life or Masks of Morals?* Exhibition catalog. Spencer Museum of Art, University of Kansas, Lawrence.

Stone-Ferrier, Linda A. 1985. Views of Haarlem: A Reconsideration of Ruisdael and Rembrandt. *Art Bulletin*, vol. 67, no. 3 (September), pp. 417–36.

Stratton, Suzanne. 1986. Rembrandt's Beggars: Satire and Sympathy. *Print Collector's Newsletter*, vol. 17, no. 3 (July–August), pp. 77–82.

Strauss, Walter L., and Marjon van der Meulen. 1979. *The Rembrandt Documents*. New York.

Sutton, Peter C. 1987a. Introduction. In Sutton 1987b, pp. 1–63.

Sutton, Peter C. 1987b. *Masters of 17th-Century Dutch Landscape Painting*. Exhibition catalog with contributions by Albert Blankert, Josua Bruyn, C. J. de Bruyn Kops, Alan Chong, Jeroen Giltay, Simon Schama, and Marjorie Elizabeth Wieseman. Rijksmuseum, Amsterdam, Museum of Fine Arts, Boston, and Philadelphia Museum of Art, Philadelphia.

Van Eerde, Katherine S. 1970. *Wenceslaus Hollar: Delineator of His Time*. Charlottesville, Va.

Van de Waals, Jan. 1984. The Print Collection of Samuel Pepys. *Print Quarterly*, vol. 1, pp. 236–57.

Van Gelder, J. G. 1931. De etsen van Willem Buytewech. *Oud-Holland*, vol. 68, pp. 49–72.

Van Regteren Altena, J. Q. 1954. Le champ du peseur d'or. *Oud-Holland*, vol. 69, pp. 1–17.

Visser t'Hooft, Willem Adolf. 1957. *Rembrandt and the Gospel*. London.

Wallace, Richard. 1979. *The Etchings of Salvator Rosa*. Princeton, N.J.

White, Christopher. 1969. *Rembrandt as an Etcher: A Study of the Artist at Work*. 2 vols. University Park, Pa.

Wolfthal, Diane. 1977. Jacques Callot's *Miseries of War. Art Bulletin*, vol. 59, no. 2 (June), pp. 222–33.

Yale Center for British Art. 1983. *Rembrandt in Eighteenth Century England*. Exhibition catalog with essays by Christopher White, David Alexander, and Ellen D'Oench. New Haven, Conn.

Zigrosser, Carl, ed. 1962. *Prints: Thirteen Illustrated Essays on the Art of the Print Selected for the Print Council of America by Carl Zigrosser*. New York.

One thing the god [of taste] loves . . . is a collection of

prints after the great masters, an enterprise most useful

to the human race, which multiplies at little cost the

merits of the best painters, which bestows immortality,

in all the private collections of Europe, on beauties

which would perish without the help of engraving, and

which can introduce all the schools of painting to a man

who has never seen a picture.—Voltaire

Reproductive Printmaking and Related Developments from the Later Sixteenth through the Eighteenth Century

MARCANTONIO'S LEGACY: SOME ISSUES RAISED BY REPRODUCTIVE PRINTS

Fifteenth-century printmakers' appropriation of designs (e.g. Wenzel von Olmütz or Meckenem), or their collaboration with painters to produce independent prints (Mantegna), provided the conceptual basis for Marcantonio's activity. But Marcantonio's work and that of his pupils, especially Agostino Veneziano, Marco Dente da Ravenna, and Jacopo Caraglio, proved the viability of engraving as a medium for reproducing paintings, drawings, and even sculpture. Henceforth, this function—with its attendant collaboration between designer, engraver, and publisher—would dominate the oldest intaglio technique. Very soon, etching and even woodcut were brought more frequently and successfully into service.

Beginning in the second half of the sixteenth century, print publication firms thrived. Many of Marcantonio's plates were bought by Antonio Salamanca of Milan, who specialized in prints of classical monuments, and in 1553 Salamanca merged with Antonio Lafréry. Hieronymus Cock set up his Antwerp firm, *Aux Quatre Vents* (At the Sign of the Four Winds), when he returned from Rome in 1548. We have already encountered Cock's enterprise in connection with Pieter Bruegel the Elder, who supplied drawings for engravings. One of Cock's engravers, Philipp Galle, started his own company. In the late sixteenth century, Netherlandish dynasties of reproductive engravers—the Wierixes, fraternal *Wunderkinder,* as well as the Sadelers and the Van de Passes—worked throughout Europe. Business was booming and would continue to do so through the seventeenth and eighteenth centuries. In the absence of illustrated art books as we know them today, the demand for reproductive prints would be quelled only by the invention of photography, and even then, as we shall see, printmaking continued to provide an alternative to photographic reproduction.[1]

Was the growth of the reproductive print detrimental to printmaking as a creative medium? Perhaps. The manufacture of a print by the successive efforts of designer, artisan, and printer is a far cry from Dürer's patient incising or Rembrandt's burnishing, scraping, and reworking of a copperplate. The former necessitates a division of labor, severing the link between idea and execution, and there can be no doubt that the institutionalization of this division discouraged some of the most inventive painters from exploring original printmaking. The process of reproducing a painting, drawing, or sculpture in print also implies the servitude of one medium to another: engraving, an inherently linear technique, was forced to retreat from linearity in an effort to suggest the tonality and eventually the coloristic qualities of painting. Giulio Campagnola's stippling, born from the interaction of printmaker and Venetian painters, was more than a retreat—it was an out-and-out surrender. The servitude of prints to other media, most especially painting, moved the prominent but puristic scholar of prints Arthur M. Hind to label the eighteenth century (the great age of the reproductive print and tonal processes) as the era of engraving's "decay" and the period we consider first in this chapter—the later sixteenth century when reproductive engraving was in the ascendant—as an age of "decline."[2]

There are many other ways to understand the development of reproductive printmaking, however, than as a regrettable capitulation of the print to painting or, less significantly, to drawing or sculpture. In the first place, the basic motivations underlying this evolution did not arrive with Marcantonio, but were of long standing, and it was inevitable that they should find overt expression. As a multiple image, the print inherently denied the uniqueness of a composition and affirmed the value of its circulation and advertisement. Reproductive printmaking merely applied these values to paintings or works in other media; in this sense, it assimilated these media to itself rather than the other way around. The simultaneous growth of printmaking and the Renaissance concept of creativity as conceptual invention, with execution understood as an important but mechanical adjunct, insured that prints would be used to promulgate knowledge of an artist's work.

Second, many of the formal concerns of the Renaissance—textural and anatomical naturalism, spatiality and massiveness, fluidity of movement, clarity and persuasiveness of gestures—made it impossible for the print to withdraw into its own linearity. From the very beginning, printmakers strove to make their images more convincingly naturalistic, to suggest space and mass, and to render figures and settings vividly, precisely because these were the

highest artistic values of the times. And these goals were best achieved not through the abstract purity of line, but by the tone and color possible in painting. Even Dürer, early champion of the print and of the stark directness of black and white, aspired toward increasingly complex tonality. Without relinquishing the line, he did endeavor to obscure it and brought to his prints the kind of visual complexity and richness heretofore achieved only in paintings. Thus, what we might call the pictorial print is not the invention of the skilled reproductive engravers of the seventeenth and eighteenth centuries. It was always a part of printmaking, not something imposed from the outside.

Moreover, the separation of designer from executor of the design in reproductive printmaking had its base in the production of woodcuts, where a division of labor was the normal procedure. The reproductive print was born when this procedure began to be applied to engraving, which had previously demanded that the designer incise the plate. When Parmigianino and Titian employed woodcutters to duplicate their designs, they were simply continuing an old way of making woodcuts. But a conceptual shift was necessary when etching came to be used reproductively because that process especially implied unity of design and execution. Perhaps for this reason, Barocci etched his own reproductive prints after Cort died. He preserved his own touch on the plate, although the compositions originated in paintings. Like Goltzius' curious original designs in the manner of Dürer or Lucas, prints made by an artist after his own paintings have a niche somewhere between the categories of reproductive and original. It is difficult to know where to place these works, but I have considered factors such as technique (does the artist's method align itself with that of professional reproductive printmakers?), and degree of duplication (how close is the work to the painted composition it reproduces?). Nevertheless, many works are not easily pigeonholed, and readers may well disagree with my placement.

Just as woodcut, in spite of Dürer, initially tended to be "lower" than engraving, closer to craft than to fine art by virtue of the separation of design and execution, its cheaper materials, and its innately coarser visual effects, so the reproductive print must be understood as an art form very different from the original print. This difference involves a fine yet significant distinction in intention. What was uppermost in the mind of the print's creator(s)? Was it to promote, comment upon, or give information about a work in another medium, or to create an autonomous work in print? Most original prints are in fact "reproductive" of preparatory drawings, but we generally reserve this epithet for prints after unique originals in other media, and use it only exceptionally for prints after drawings. As we shall see, however, the growing popularity of drawings in the eighteenth century created a market for prints reproducing them. Artists even made drawings explicitly to be etched. However, such drawings differed from the usual preparatory drawing an artist might make for a print because they were conceived not in terms of the translation of the image into print, but in terms of the qualities of drawing.

The two approaches to printmaking—original and reproductive—are inextricably related. The considerable skills required for reproductive work had their origins in, and in turn contributed to, original printmaking. We will have occasion to consider prints which are not literally reproductive but which adopt the same technical principles. And we will also find that reproductive printmaking, especially engraving, acted as a foil against which original printmakers from the seventeenth through the nineteenth centuries defined their works.

Against increasingly complex tonality, technical virtuosity, and colorism, original printmakers asserted the ragged line on the white of the paper (Tiepolo), the mutability of the image

on the plate (Rembrandt), or the bitten graininess of the aquatint, no longer understood as the graphic equivalent of the ink wash (Goya). To some extent, the great esteem for these prints is due to the preeminence of the reproductive print in these centuries. As one became more common and informational, the other became rarer, closer to painting without mimicking it. Seventeenth- and eighteenth-century original prints paralleled the uniqueness of paintings or drawings by variations in inking, wiping, and papers, and appealed to elite collectors as objects of connoisseurship.

Although etching was never deeply embedded in reproduction and so became the principal means for original expression in these centuries, engraving's involvement was too profound; its techniques were so systematized and made so sophisticated for purposes of reproduction that it never really found its way back to its initial power as a means of original printmaking. So the distinction we draw between the two functions of the print in the seventeenth and eighteenth centuries—to serve as a creative vehicle or to advertise an artist's painted works—is, by and large, the distinction between etching and engraving. In the nineteenth century, as technologies expanded (e.g., chromolithography, the steel-engraving and steel-facing of copperplates, or the electrotyping of wood-engraving blocks) and reproductive prints became so widely available as to seem ubiquitous, etching's distinctiveness as an original medium was heightened. In the late nineteenth-century etching revival, painter-engravers, amateur etchers, and collectors alike celebrated state changes, variable wiping of the plate, artist's signatures, *remarques* (etched vignettes outside the margin of an image)—anything that foregrounded etching's autographic character.

In the context of her work on the Carracci, Diane DeGrazia (formerly Bohlin) discusses the importance of reproductive engraving as a fulfillment of art-theoretical premises, especially the Neoplatonic *idea*. This disembodied model of the work of art might exist *a priori*, be abstracted from nature by the artist, or arise in his mind as a gift from God. But, in any case, the *idea* was independent of the work of art, which, like the reproductive print, was merely its reflection. Both the painter and the reproductive engraver sought to imitate the *idea*. From this point of view, originality was less crucial. Although DeGrazia's remarks perhaps overemphasize the creative aspects of reproductive printmaking at the expense of its craft dimension, they illuminate the endeavor considerably and show the need for incorporating it into a general history of western art, where it has been even more roundly ignored than original printmaking.[3]

Studies of print collecting from the sixteenth through the eighteenth centuries bear out DeGrazia's point: that the unique physical object was less important than the creative concept that object represented. Reproductive prints were highly valued as skilled interpretations of artistic conceptions, and the best examples were understood as beautiful prints in their own right. They existed alongside original prints, without the condescending judgments of the "cult of originality" that still affects our ability to appreciate reproductive prints today. The classification by subject that appears to have dominated sixteenth-century print collecting, of course, favored a leveling of reproductive and original prints within subject-categories. The motivation behind Cardinal Scipione Gonzaga's print collecting, which began in the 1560s, was to assemble the best examples of engravings and woodcuts, and to illustrate the history of the graphic arts, whether the prints were reproductive or not.[4] As we have seen, albums of prints after Raphael and Bruegel coexisted in Rembrandt's collection with albums of works by Dürer, Lucas, and himself. In the vast collection of the Abbé de Marolles, assembled between 1644

and 1666, many prints were classified by subject, and those organized by artist were subdivided according to quality. Reproductive prints after the Italian Renaissance masters, and after Baroque masters such as Rubens and the Carracci, were placed in the first category (masters "whose works are esteemed above all others"), along with superb original prints.[5]

The rational and didactic spirit of the Enlightenment did much to encourage the flourishing of reproductive printmaking, as Voltaire's remarks suggest.[6] Already in Florent Le Comte's "Idea of a Fine Library of Prints" (1699), prints performed an educational and aesthetic role that Samuel van Quicchelberg could scarcely have envisioned when he wrote about the ideal "universal theater" in 1565. Le Comte's ideal print cabinet consisted of 151 albums arranged in four sections, the first of which was to do no less than review western history from Genesis to the reign of Louis XIV. The history of art, from the glory of antiquity to the "decadence" of the Middle Ages to the resurgence of the arts in the Renaissance and continuing up to Le Comte's own time, was the subject of the second section, which was mostly organized by artist. The educational character of the collection was also evident in the proposed section on moral subjects, and even in the final section on miscellaneous subjects, which included prints of famous and infamous women, from virtuous heroines to the "violent and debauched."[7] The scope of Le Comte's ambitions for the function of prints fostered both reproductive and original graphic art. Clearly, modern attitudes do not tell us much about the way in which prints were perceived in earlier periods.

THE HIGH RENAISSANCE AND THE ENGRAVERS OF "THE FOUR WINDS"

By the middle of the sixteenth century, the works of the High Renaissance masters, Raphael and Michelangelo, assumed a status as artistic sources equal to nature and antiquity. This esteem underlay the tremendous demand for prints after those artists. In 1552 Vincenzo Borghini of Florence wrote to Vasari asking ardently for "all those [engravings] printed from Michelangelo, because I want to have all those I can near to me."[8]

Vasari's description of the unveiling of Michelangelo's *Last Judgment* (1536–42) in the Sistine Chapel in the Vatican exceeds even his normal tendency toward hyperbole: the painting left viewers awestruck with both the terror of the Judgment and the inimitable power of Michelangelo's art.[9] Small wonder that this majestic, perennially moving fresco should have been engraved a number of times, often in sections. Even the engravings were reproduced. Understandably, these prints showed varying degrees of fidelity.[10] One scholar of *The Last Judgment*, Leo Steinberg, has pointed out how the engravers editorialized on the content of Michelangelo's fresco, reinforcing what he believes to be a mistakenly harsh interpretation of the subject.[11]

Domenico del Barbiere was a sculptor himself, and so was attuned to Michelangelo's feeling for the plasticity of the human form. He engraved the section immediately to the right of Christ in the fresco (reversed in the print) containing the powerful figures of St. Peter, holding two huge keys, and St. Bartholomew with his attribute, the flaying knife, and his detached skin (fig. 5.1). On the latter grisly detail, Michelangelo painted his own self-portrait, distorted, as if to imply an analogy between his own long-suffering devotion to God and the saint's martyrdom. Both saint and artist are suspended in anticipation of the last moment, when Christ will determine the fate of everyone. Domenico's burin focused on the bulging

FIGURE 5.1

Domenico del Barbiere.
Group of Saints *after a
section of Michelangelo's*
Last Judgment. *1544.
Engraving. 364 ×
220 mm. Bibliothèque
Nationale, Paris.*

musculature and titanic (even for Michelangelo) scale of the figures, but their apprehension and helplessness before the power of Christ, who is not included in the engraving, is also conveyed. The fact that even a section of the fresco was a suitable subject for a print testifies to Michelangelo's extraordinary importance for the later Cinquecento, when his every figure was patiently drawn and studied by other artists. Our engraving was probably made after such a drawing, perhaps Primaticcio's.[12] The print reflects the painting before the Counter-Reformation demanded the concealment of the genitals of the figures, naked before God in Michelangelo's original conception.

Raphael's works, too, were perennial objects of reproductive prints. At Hieronymus Cock's request, Giorgio Ghisi, foremost of the Mantuan school of engravers and author of one of the most popular versions of *The Last Judgment,* came to Antwerp in 1550 to train engravers and to make prints.[13] The guiding light of this school had been Giulio Romano, Raphael's pupil, who had been brought north by the commission for the Palazzo del Tè, a consummate example of Mannerist painting and architecture. Giulio's style was sculptural, dark, and polished, and was translated into engravings with close-set parallel hatchings and dots between the lines to produce deep shadows, emphatic rendering of the sculptural masses, and firm contours.

One of Ghisi's first works in Antwerp was the large *School of Athens* (1550; fig. 5.2), made from two plates after Raphael's famous fresco in the Stanza della Segnatura in the Vatican (1509–11). The painting filled a semicircular area of wall, but Ghisi extended the architecture at the upper right and left. At the same time, the vaults, reflecting Donato Bramante's designs

for the new basilica of St. Peter's, were lowered, altering the lofty space of the original work. Ghisi's omission of the coffering of the arches and the squares on the pavement also serves to increase the heaviness of the architectural setting.

Moreover, Ghisi modified the relationship of figures to space by enlarging them: they are far closer to the Michelangelesque ideal in bulk, strain, and torsion than to Raphael's graceful conception of the body, which owes so much to Leonardo. Although the fresco's muted colors and light-suffused space clearly subordinate some details (like the statues in the niches) to the whole, the engraving has an all-over emphasis; Plato and Aristotle do not command the scene so imperiously. But the brooding Michelangelo, posed in the melancholic attitude alongside his marble block in the foreground, looms larger in the print. The typically Mantuan intensity of light and dark contrasts is very different from the restrained, even lighting of Raphael's work. Giulio's Mannerist sensibility has intruded upon Ghisi's interpretation of a High Renaissance masterpiece.

Clearly, Ghisi did not copy his model faithfully. He interpolated intervening influences to make the image a more eclectic representation of the Italian High Renaissance (including Raphael *and* Michelangelo) and to bring it up to date with a Mannerist veneer of sharply defined lighting, discrete details, and contours. Ghisi's systematic handling of the burin— variations in the spacing of the parallel hatchings provide most tones, with cross-hatching employed in the darkest areas and stippling for the modeling of the flesh—yields a bold, sculptural plasticity, devoid of atmosphere, that is quite alien to his model.

These changes from Raphael's fresco illustrate how reproductive engravings could function not only as mere copies but as interpretations of their models. The alterations occurred despite the probability that Ghisi worked from a drawing by Cock after the original work.[14] Even more remarkable than the stylistic differences is the fact that the subject matter has been misunderstood. The inscription at the left identifies the scene as Paul preaching in Athens, a confusion that affected the criticism and scholarship on Raphael's work for years, since commentators often looked at engravings rather than the less accessible frescoes.[15]

Dirck Volkertsz. Coornhert, a Dutch freedom fighter, theologian, and poet as well as engraver, worked for Cock while Ghisi was in his employ. His *Balaam and the Angel* (1554; fig. 5.3) after Marten van Heemskerck could be appended to a landscape print that extended the composition to the right.[16] In contrast to Ghisi, Coornhert used subtle, flickering lights: a surface scintillation that conditions the sense of massive form. Contours, too, are not rigid and unyielding, so that forms are more compatible with surrounding space. Here the mandorla surrounding the avenging angel is particularly impressive, set off against the deep shadows of the architecture. The angel's appearance to the evil prophet Balaam, enemy of the Jews, fore-shadowed Gabriel's appearance to Mary, both incidents illustrating the intervention of God in the course of human life. (Rembrandt surely knew Coornhert's print when he conceived his painting of the same subject in 1626.)

Undoubtedly some of the shimmering quality of the print is due to Heemskerck's original pen drawing. He had studied in Rome for several years, sketching architectural monuments—including the few parts of St. Peter's that Bramante had finished before his death in 1519—enveloping them in an atmosphere created by delicate pen strokes. The setting of the encounter between Balaam and the heavenly messenger is an architectural fantasyland, a dream for a lover of ruins, like Poliphilus in the *Hypnerotomachia Poliphili* (1499; see figs. 3.26, 3.27). A groin vault with an unlikely oculus at its apex stands incongruously alone in the center.

FIGURE 5.2

*Giorgio Ghisi after
Raphael.* School of
Athens. *1550. Engraving
from 2 plates. 526 ×
824 mm. Rijksmuseum-
Stichting, Amsterdam.*

Foliage creeps over it and the ruined pillar at the left. In the background, stacked arches suggest
what is left of an aqueduct or perhaps a façade like that of the Colosseum. All this recalls
imperial Rome, grafted anachronistically onto the world of the Old Testament. Although Pi-
ranesi's huge etchings would imbue Roman ruins with a more blatantly romantic, moody
grandeur, the spirit of these prints seems already present in Heemskerck and Coornhert's
image.

IHERONYMVS COCK PICTOR EXCVDEBAT.1550. CVM GRATIA ET PRIVILEGIO P.AN .I.

Philipp Galle, the last of Cock's major engravers, struck a middle course between the very different approaches of Coornhert and Cornelis Cort. *Lot and His Daughters* (1558; fig. 5.4) after the Flemish painter Frans Floris may be compared with Cort's engraving of the same subject (fig. 5.5), also after Floris. The varied textures of the setting—tree bark, foliage, skin, clothing, stone—are more important to Galle than to Cort, who stressed volume and used a uniform burin stroke for every surface. Whereas Cort's leaves are separate entities suspended in

FIGURE 5.3

*Dirck Volkertsz.
Coornhert after Marten
van Heemskerck.* Balaam
and the Angel. *1554.
Etching and engrav-
ing. 297 × 428 mm.
Graphische Sammlung
Albertina, Vienna.*

an airless space, Galle's merge into bunches mottled by light and shade. The burning cities of Sodom and Gomorrah flash in the distance, and the flickering luminosity there is carried through the relatively sketchy landscape at the left, which in Cort's work is a single, swelling volume. Lot's unfortunately curious wife, now a pillar of salt, stands backlighted in Galle's print, which links her to the darker forms of the foreground. In Cort's engraving, she is clearly relegated to the distance of the strictly bileveled space.

CORT IN ITALY, GOLTZIUS, AGOSTINO CARRACCI

Galle left the Four Winds establishment to form his own publishing company when Cornelis Cort, with whom he had been closely associated, left Antwerp for Italy in 1565. Cort's technique in Cock's shop was bold, highly sculptural, and regular: he had absorbed much from Ghisi and would depart decisively from this training only under the direction of Titian in Venice. But even in his earlier works, such as *Auditus* (*Hearing;* fig. 5.6) from a series of the Five Senses designed by Floris (1561), Cort began to suggest the edges of forms by the terminations of the hatchings rather than by contour lines (note the background landscape).

Such modifications of Ghisi's regular, mechanical burin work with its insistent contours and volumes increased when Cort went to Italy and was faced with reproducing the highly atmospheric, luministic works of the north Italian painters, especially Titian. Cort learned to vary the size and type of stroke and to combine these varied marks in new ways. Ingeniously, he juxtaposed multidirectional hatchings, more open than Raimondi's or Ghisi's, and learned to exploit the swelling and tapering of the burin line to great advantage in his description of

FIGURE 5.4

*Philipp Galle after
Frans Floris.* Lot and
His Daughters. *1558.
Engraving. 270 × 391 mm.
Rijksmuseum-Stichting,
Amsterdam.*

LOTH EX VNO PERICVLO AB ANGELIS EDVCTVS, INSIDIIS FILIARVM SVARVM IN ALTERVM INDVCITVR. GEN. XIX.

FIGURE 5.5

*Cornelis Cort after
Frans Floris.* Lot and
His Daughters. *1550s.
Engraving. 257 × 336 mm.
Rijksmuseum-Stichting,
Amsterdam.*

LOTH EX VNO PERICVLO AB ANGELIS EDVCTS, INSIDIIS FILIARVM SVARVM IN ALTERVM INDVCITVR GEN XIX

Reproductive Printmaking and Related Developments **263**

FIGURE 5.6

*Cornelis Cort after
Frans Floris.* Auditus
(Hearing) *from a series
of the Five Senses.
1561. Engraving. 202 ×
267 mm. Staatliche
Kunstsammlungen,
Dresden.*

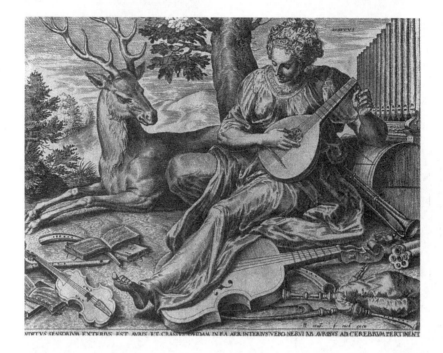

volumes. His use of a thicker burin line in foreground areas and a thinner one in backgrounds made it easier to suggest depth (this method is analogous to multiple biting in etching). Although, like Marcantonio, Cort developed a graphic system for reproducing paintings, his was a more complex, flexible vocabulary in which the continuous line yielded to more variations and many other kinds of strokes. Cort's Italian-nurtured system was transmitted to the north by Hendrik Goltzius, who had been trained under Coornhert and had assimilated Cort's approach to engraving in Rome as it proliferated throughout Italy under the influence of Domenico Tibaldi and, most important, Agostino Carracci.

One of Cort's greatest admirers was Domenicus Lampsonius, privy secretary to the Prince-Bishop of Liège and author of a number of important books on northern art. Walter Melion has analyzed Lampsonius' valorization of northern reproductive engraving in letters to Vasari, Titian, and Giulio Clovio written in 1565, 1567, and 1570. Focusing especially on Cort's work for Titian, Lampsonius viewed the reproductive print as a dialectical interaction of the artistic skill and creativity of *both* the painter and the engraver, and held that the latter's work, especially his fluid, brilliantly descriptive line, should enable the viewer to imagine the one element missing from the print: the color of the original painting. It is clear that Lampsonius valued not only the particular genius with which the engraver manipulated the burin, but also the ability to evoke the original painting. Both artist and engraver, then, are glorified by the process of translating the image from canvas to paper.[17]

Titian's two versions of the *Martyrdom of St. Lawrence*—one done between 1548 and 1559 for the Chiesa dei Crociferi in Venice and the other in 1567, commissioned by Philip II of Spain, now in the Escorial—were combined in Cort's engraving, authorized by Titian and dedicated to Philip in 1571 (fig. 5.7).[18] The lower figures in the engraving correspond more closely to those of the earlier painting, whereas the upper part of the composition, including the angels and clouds, derives from the Escorial version. The architectural backdrop found (in different forms) in both paintings is omitted from the prints. Only a statue of the goddess Vesta holding a victory figure remains to suggest the environment of ancient Rome (compare

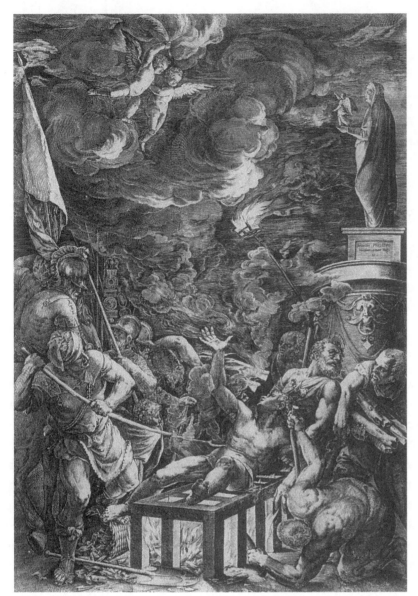

FIGURE 5.7

Cornelis Cort after Titian. The Martyrdom of St. Lawrence. *1571. Engraving. 497 × 349 mm. Graphische Sammlung Albertina, Vienna.*

the elaborate setting in Marcantonio's engraving of the same subject after Baccio Bandinelli, fig. 3.36).

Cort's closely spaced burin lines create a deep gray from which pronounced highlights, like those which flash against the profound darkness of both of Titian's paintings, stand out. The figures and the billowing smoke are more sharply defined in the print. The chiaroscuro accentuates the already strident drama of Lawrence's grisly death; the executioner is in the process of turning him over with a forked stick, while a henchman brings in more wood at the right. The presence of angels, carrying the palm of martyrdom, changes the character of the saint's gesture; in the Crociferi work, he was evidently addressing the robed judge on the steps of the building, asking sarcastically to be turned over, since he was done on one side.[19] But in Cort's print, as in the Escorial painting, Lawrence's attention is diverted from his agonizing death to the victory that awaits him in paradise. Panofsky suggested that the statue of Vesta symbolizes that victory; surrounded by light, she represents the transition from paganism to Christianity.[20]

FIGURE 5.8

Trained under Coornhert at an early age, Hendrik Goltzius became one of the most brilliant original printmakers of the late Renaissance. Some of his most esteemed prints, as we have seen, mimicked the styles of other master engravers with such astonishing precision that they seem "reproductive" but are nevertheless original. But Goltzius also worked reproductively and collaboratively. In the 1580s, he engraved and published wash drawings by Bartholomeus Spranger, transmitted to him by Van Mander in Haarlem. Spranger, an extravagantly Mannerist painter, hailed from Antwerp but traveled extensively, eventually becoming court painter to Rudolph II of Prague. *Judith with the Head of Holofernes* (ca. 1585; fig. 5.8) shows Spranger's elegant, courtly style and Goltzius' technically superlative means of expressing it graphically. The building blocks of Goltzius' system are areas of curved cross-hatching, often circular or nearly so, in which the individual lines swell in the middle, only to taper to a graceful termination or, occasionally (e.g., Judith's left thigh), fade into stippling. Although successful in rendering emphatic volumes, such as the heroine's spherical breasts, this technique is essentially linear. In some places it produces a moiré-like iridescence quite apart from the forms it describes. Indeed, Melion sees a decisive change in Goltzius' approach as he moved from his prints after Spranger to later works such as the *Meesterstukje,* in which even the independent flourish of Goltzius' line is suppressed in favor of the virtuoso mimicking of another engraver's hand.[21]

Spranger's conception of the theme—the Jewish heroine beheading the licentious Assyrian commander as he reclines, intoxicated, in his tent—might be compared with Rubens' treatment, engraved by Cornelis Galle (see fig. 5.17). The Baroque artist delighted in depicting the moment of decapitation with all its gory physicality, whereas the Mannerist artist focused on Judith's nearly nude, elongated body, posed sinuously and displaying all the contrasts of direction possible. Holofernes' head is already detached and held up like a trophy for Judith, with her deeply sunken eyes and pouty, open mouth, to gaze upon. The basic independence and ornamentality of Goltzius' characteristic swelling lines are well suited to Spranger's determined artificiality of style.

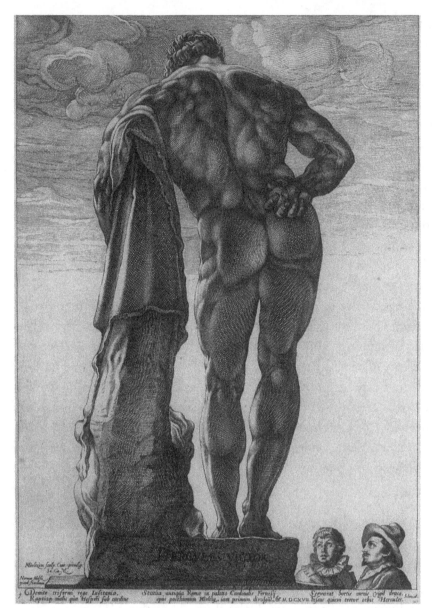

FIGURE 5.9

Hendrik Goltzius after
The Farnese Hercules.
Ca. 1592. Engraving.
405 × 294 mm. Museum
of Fine Arts, Boston.

One of Goltzius' reproductive masterpieces was after a Roman work made by the sculptor Glycon in the third century A.D. for the Baths of Caracalla in Rome: *The Farnese Hercules* (fig. 5.9). Although there are many problems in extrapolating the appearance of Greek originals from Roman copies, scholars believe Glycon's figure to have been based on an original by Lysippos of the fourth century B.C.[22]

During the sixteenth century, an era with a voracious appetite for antiquity, prints became the principal vehicle for transmitting knowledge of ancient works. Engravers very often added imaginative settings or filled in the missing parts of their models.[23] Goltzius' adaptation of this sculpture into print is particularly ingenious. Although Ghisi and others had engraved the exhausted, muscle-bound hero from the front and in a niche,[24] Goltzius chose the back view and placed the work in the open air (its actual location at the time of Ghisi's and Goltzius' engravings is uncertain). The titanic quality of the sculpture is doubly emphasized by this setting and the dwarfing of two spectators (Goltzius' friends), who glance upward.[25] Clutched

in the hero's hand are the golden apples of the Hesperides that were the goal of his last labor: the content of the myth was thus suggested from either the front or the back view. But the principal advantage of the back view was that it gave Goltzius the opportunity to produce a stunning study of the musculature of Hercules' back, shoulders, and buttocks, with the whole figure densely worked with Goltzius' characteristic curved hatchings. The lighting of the figure from behind not only is more dramatic but also gives full play to the engraver's own style.

In Italy, Cort's style passed on to Agostino Carracci at Bologna. Of the three Carracci, he was the first to embark on printmaking, and the only one to make it his main vocation. He began by emulating the Marcantonio school. It was his apprenticeship under Domenico Tibaldi that encouraged him to make his lines swell and taper, to use differently curved hatchings, and to vary the length and spacing of his strokes to achieve greater richness of chiaroscuro and texture. In his engraving after Paolo Veronese's *Mystic Marriage of St. Catherine* of 1582 (fig. 5.10), Agostino attempted to capture the sumptuous, painterly surface of this Venetian artist's work. By and large, especially in the beautiful figure of the saint herself as she becomes a "bride of Christ," he succeeds. But in the overall sharp definition of forms (for example, in the clouds and rays of light above the Virgin and Child), Agostino betrayed his model. The quintessentially Venetian composition with one major and two minor diagonals is made too heavy by the pervasive clarity of details that, in the painting, are softened or obscured by light and shadow. The print is in the same direction as its prototype; presumably Agostino worked after a lost drawing by Veronese for the painting, which may even have been transferred to the plate.[26] When compared with Cort's *Martyrdom of St. Lawrence* (fig. 5.7), Agostino's print reads like a homage to the earlier engraver, whose entire vocabulary he has utilized: the dramatic, spiraling clouds, rich chiaroscuro, and strong definition of volumes by cross and parallel hatching.

ETCHING AND COMBINED ETCHING AND ENGRAVING: FONTAINEBLEAU AND BAROCCI

In the 1540s, Rosso Fiorentino, Primaticcio, Lucca Penni, and other Mannerist painters came from Italy to France to establish an important artistic center at the Chateau of Fontainebleau, which they decorated for the French king, Francis I. The "School of Fontainebleau" served as a conduit for Italian Mannerism into the north, and as disseminators of specific Italian compositions or general stylistic assumptions, the prints related to this group were especially effective. They also help us reconstruct the Fontainebleau style despite the loss or damaging of many of the Chateau's frescoes.[27]

A. Hyatt Mayor describes the Fontainebleau etchings as "slapdash."[28] Although descending from the free technique of Parmigianino's *Entombment* (fig. 3.53), the style of the Fontainebleau etchers lacks that artist's delicacy and sensitive draughtsmanship. The printmakers were apparently motivated by a wish to preserve the figural and compositional *invenzione* of the painters, who seem to have supplied drawings liberally, rather than by any desire for technical finesse.

The *Assembly of Sea Gods* (also entitled *Saturn Asleep*; fig. 5.11) was etched by Antonio Fantuzzi (possibly the same as Antonio da Trento) after a drawing by Primaticcio (1544),

FIGURE 5.10

*Agostino Carracci
after Paolo Veronese,*
The Mystic Marriage
of St. Catherine. *1582.
Engraving. 505 × 344 mm.
Library of Congress,
Washington, D.C.*

FIGURE 5.11

Antonio Fantuzzi after
Primaticcio. Assembly
of Sea Gods (Saturn
Asleep). *1544. Etching.*
242 × 359 mm. British
Museum, London.

invented in Bologna, as the print's inscription tells us, and preserved in the Louvre. The composition was also painted on the vault of the vestibule of the Porte Dorée in the Chateau.[29] The figural group conforms to the oval format and presents a decorative pattern of intertwined curves and rippling volumes. At Fontainebleau, the human figure would lose the Herculean vigor it had in the High Renaissance and become an object of ornament. Though Michelangelo painted walls, we would hardly call the images "decorative"; here, the label fits perfectly.

For example, two female nudes, almost merging with the fruits, vegetables, putti, shields, and other ornamentation surrounding them, flank a blank cartouche in one of two prints signed by Jean Mignon (1544; fig. 5.12), a more talented etcher than Fantuzzi who imbued his forms with a scintillating light that truly derives from Parmigianino. The design for this work is adapted from a painting in the Chambre de Madame d'Étampes by Primaticcio.[30] Mignon apparently worked from a drawing, now in the Louvre. The painter's ideal of feminine beauty is typical of Fontainebleau: long-legged and small-headed, the female body served as an elegant, readily repeatable decorative motif. Here the figures are nearly mirror-images of each other, except for their differently crossed legs. The combination of elements revolves around the abundance of nature, represented not only by the produce spilling over the cartouche, but by the goats' heads and trotters, the herms of Pan, and, indeed, the female nude itself.

The Mannerist passion for fantastic ornament comprising vines, foliage, urns, fruit, vegetables, shields, bucrania, and more was nowhere more evident than at Fontainebleau. One of the major sources of this passion was the excavation of the Golden House of Nero in Rome while Raphael was Director of Antiquities. This *Nymph* (fig. 5.13), engraved after Rosso by Pierre Milan and finished by René Boyvin about 1553, is framed like a panel painting hanging on the wall or ceiling, and surrounded by a delightful, varied array of antique ornament. At some point, a figure of Danaë designed by Primaticcio was substituted for the nymph, and the oval plus its surrounding decoration was painted in the Galerie de Francis I.[31] (The inscription on the print refers to a sculpture, as if the design was originally intended for a bas-relief.) Perhaps in the early 1540s, Primaticcio's figure was engraved by the Monogrammist L.D. (prob-

FIGURE 5.12

Jean Mignon after Primaticcio. Ornamental design for Fontainebleau. 1544. Etching. 244 × 236 mm. Bibliothèque Nationale, Paris.

ably Léon Davent) after a drawing now in Chantilly, and it was in printed form (fig. 5.14) that Titian perhaps encountered the figure and adapted it into one of his most breathtaking paintings, the *Danaë* of 1554–55, although the ultimate source for all of these reclining figures is *Night* from Michelangelo's Medici tombs. The crisp complexity of the Fontainebleau style is perhaps better captured in L.D.'s and Milan's works than in the etchings. Engraving was better suited to express the intricacy and artificiality of the Fontainebleau decorations: the fairly simple approach of the etchers (involving only line and rudimentary cross-hatching) seems to pit sketchiness of technique against the polished elegance of the images themselves, at least in their final painted form. Although the loose, shimmering etched lines have their own appeal, it would be the finesse of engraving that appealed to most seventeenth-century French tastes.

If the etchings of the Fontainebleau printmakers show little or no attempt to capture the rich tonality of paintings, Federico Barocci's certainly do. We have already discussed his *St. Francis Receiving the Stigmata* (fig. 3.55) as a major achievement in Italian etching after Parmigianino. Barocci also etched three more elaborate prints after his own paintings, combining the fluidity and freedom of touch of Parmigianino's *Entombment* (fig. 3.53) with the richer, more complex graphic style he learned from Cort's engravings. (Cort had engraved the earliest print after Barocci—a *Rest on the Return from Egypt*—in 1575.) Why so gifted an etcher should produce only four plates remains an enigma, but in those plates technical innovations with important consequences are found. As Edmund Pillsbury and Louise Richards have remarked, Barocci expanded the technical range of etching by incorporating multiple biting, some en-

FIGURE 5.13

*Pierre Milan and
René Boyvin after Rosso
Fiorentino,* Nymph
and Ornament *for Fon-
tainebleau. Ca. 1553.
Engraving. 305 ×
515 mm. Art Institute of
Chicago.*

FIGURE 5.14

*Monogrammist L.D.
(Léon Davent?) after
Primaticcio.* Danaë.
*Ca. early 1540s. En-
graving. 215 × 290 mm.
Bibliothèque Nationale,
Paris.*

graving and drypoint, and the Venetian clustered dots for modeling. He also employed the
open hatchings and uneven parallel strokes of Parmigianino and oblique cross-hatching with
dots, as well as the evenly spaced parallel lines favored by reproductive engravers. In short, he
drew from the rich tonal repertory of reproductive engraving while retaining the kinds of marks
that lent etching its apparent spontaneity.[32]

 The Annunciation (1584–88; fig. 5.15) reproduces Barocci's altarpiece (1582–84), commis-
sioned by Francesco Maria II della Rovere for the ducal chapel of the basilica of Loreto. Etched
and engraved lines are combined with dark drypoint accents (e.g., above the angel's feet).
Gabriel's shimmering garment is etched with curved cross- and parallel hatchings reminiscent

FIGURE 5.15
Frederico Barocci. The
Annunciation. *1584–88.*
Etching with engraving
and drypoint. 438 ×
311 mm. British Museum,
London.

of Cort's engravings, whereas dots, intermingled with engraved parallel hatching, figure heavily in the Virgin's robe. The divine presence is suggested above by a burst of light, set off against deep shadows, with the whole upper configuration comprising numerous layers of hatching. The direct, ingenuous expression of this print, as in the original painting it is based upon, belies the Mannerist elongation of the bodies and the elegance of the heads. Italian etchers, however, did not generally follow Barocci in this complex, painterly mode. Rather, his heir was Rembrandt, who owned an album of etchings by Francesco Vanni and Barocci.[33]

THE SEVENTEENTH CENTURY IN THE NETHERLANDS: GOUDT AND THE RUBENS SCHOOL

We have observed the development in seventeenth-century Holland of an outstanding tradition of original etching that included the so-called black prints by such artists as Jan van de Velde and Rembrandt. Both were influenced by a reproductive printmaker: Hendrik Goudt of The Hague, who made only seven prints to our knowledge, all after the German painter Adam Elsheimer. Goudt studied in Rome, perhaps with Elsheimer, and settled eventually in Utrecht, where he died in 1648—made feeble-minded, according to a colorful story repeated by Joachim von Sandrart, when a woman living in his house gave him a love potion in order to gain control of his property.[34]

The largest of Goudt's seven prints, *The Flight into Egypt* (1613; fig. 5.16) reproduces, in reverse, a small painting on copper by Elsheimer, now in the Alte Pinakothek in Munich. The calligraphic inscription, however, does not identify Elsheimer as the designer: Goudt dropped

FIGURE 5.16

Hendrik Goudt after Adam Elsheimer. The Flight into Egypt. *1613. Etching and engraving. 361 × 409 mm. Museum of Fine Arts, Boston.*

the practice of acknowledging the painter when he left Italy. Unlike his other engraved reproductions, this print combines engraving with etching to achieve its rich, deep darks, particularly in the trees and sky. The light sources, defined by the more precise marks of the burin, are numerous: a fire, the moon and stars, and Joseph's torch all reinforce the understanding of Christ as the "Light of the World," which is being protected in darkness from the jealousy of Herod.[35] Elsheimer's oeuvre was one of the crucial links between the Caravaggesque lighting of early Baroque Italy and the north. His paintings were not numerous (he worked slowly and meticulously), and it was largely Goudt's reproductive prints that transmitted this influence to his Dutch colleagues.

In printmaking as in painting, seventeenth-century Flanders was dominated by Peter Paul Rubens. Among his many tasks in Antwerp were superb designs for book illustrations and title pages for the Plantin Press, then headed by Balthasar Moretus, grandson of Christopher Plantin. Rubens, of course, was well aware of the strong tradition of reproductive printmaking in the Netherlands, and in particular the legacy of Cock in Antwerp and of Goltzius in Haarlem. And a major part of the Italian tradition that Rubens assimilated was an appreciation of Titian's high standards for prints after his paintings and drawings, epitomized by Cort's *Martyrdom of St. Lawrence* (fig. 5.7). Rubens asked his printmakers to emulate these standards, and he was difficult to satisfy in this respect. His painterly style depended upon light reflected from thickly

built-up areas of juicy oil paint and thin, translucent layers in the shadows. Despite his broad knowledge and deep understanding of Italian art, Rubens' Flemish heritage made textures and luministic effects as important for him as volumes and masses.[36]

Rubens' first collaboration with a printmaker was the impressive *Judith and Holofernes* (fig. 5.17), traditionally dated about 1610.[37] The engraver was Cornelis Galle, son of Philipp Galle, Cock's student and head of a dynasty of Antwerp engravers. The cool, calculated decapitation of the drunken Assyrian commander by the print's heroine signaled a triumph of the Jews over their archenemies. Filled with the Lord's power, even a woman could defeat a brutal opponent, or so goes the message of the Book of Judith. But Rubens' sturdy heroine seems physically capable of handling Holofernes; she holds her own visually as well against the imposing male nude, based on the *Laocoön,* which Rubens, like many other artists, had sketched in Rome. Galle's rendering of the muscle-bound torso and hoary head, however, has more in common with Marco Dente da Ravenna's engraving after the statue (see fig. 3.37) than with Rubens' drawings, which, typically, invest the stone model with quivering vitality. The reference to the antique masterpiece in this print not only advertises Rubens' knowledge but is also narratively appropriate, for both Laocoön and Holofernes were enemies of a chosen people (the Greeks in one case, the Jews in the other) who were punished by divine wrath.

In the inscription, Rubens dedicated the *Judith* to his friend, the scholar Jan Woverius (who was, like Rubens' brother Philip, a pupil of the Neo-Stoic philosopher Justus Lipsius), and stated that he had promised Woverius the print during his stay in Verona. This means that Rubens was thinking about reproductive prints as early as 1602. Also in the inscription, Rubens described the print as "auspicious," although his subsequent actions make it clear that he was not entirely satisfied with what Cornelis had produced.[38]

Despite its undeniable vigor and the fact that it reproduces a relatively early painting by Rubens, Galle's systematic, professional technique imposes a stony, overly defined quality on Rubens' conception. Judith's silky garment, reminiscent of the banner in Goltzius' *Standard Bearer* (fig. 2.51), and the convincing massiveness of the figures, show Cornelis' mastery of a state-of-the art graphic vocabulary. But without Rubens' color and chiaroscuro, the jets of blood, fluttering wings, and beams of light are overbearing.

Rubens looked next toward Haarlem engravers who based their technique on Goltzius, and still he was dissatisfied. Pieter Soutman tried etching, but his prints after Rubens, even the successful hunt scenes, did not adequately capture the textures and light of the paintings. This was left to Lucas Vorsterman, whose portrait, as we have seen (fig. 4.10), is one of the most compelling images in Van Dyck's *Iconography.* Like Soutman, Vorsterman was trained by Rubens, but his innate gifts gave the master's style its finest graphic translation. *The Descent from the Cross* (fig. 5.18), engraved after the central panel of one of Rubens' altarpieces in Antwerp Cathedral, is one of the masterpieces of reproductive printmaking.

The Descent from the Cross was commissioned by the Guild of Harquebusiers (a harquebus is a kind of musket) for their altar in the transept of Antwerp Cathedral in 1611. It followed on the heels of a commission for a larger altarpiece—*The Raising of the Cross*—by the authorities of the Church of St. Walburga in 1609, immediately after Rubens' return from Italy at the age of thirty-one. Today, both altarpieces are in the cathedral. They represent the dynamic and quiet extremes of Rubens' style as well as his synthesis and reinterpretation of the various influences of his eight-year stay in Italy. The paintings also reveal two different expressions of the sacrifice and suffering of Christ.[39]

FIGURE 5.17

Cornelis Galle after Peter
Paul Rubens. Judith and
Holofernes. *Ca. 1610.*
Engraving. 550 × 380 mm.
National Gallery of Art,
Washington, D.C.

Cedite Romani ductores, cedite Graii: Vestra fint magnà victoria parta virum vi, Barbarus vnius dextrà cadit Induperator,
Obstruxit vestris femina luminibus. Et cessit laudis pars bona militibus; Defendit patriæ perniciem vna manus.
Clariss⁰ et amicissimo viro D. IOANNI WOVERIO paginam hanc auspiculem primumque suorum operum
typis æneis expressam PETRUS PAVLVS RVBENIVS promisit, voti sua tum Virtute a se facti memor DAT DICAT.

Against the physical turbulence of *The Raising of the Cross,* the *Descent* offers a more stable but no less intense image of the suffering of Christ and his mourning followers. Christ's slack body forms the center of a more or less radial pattern of shapes and lines, many of which are arms and legs reaching for him—the theme of Christ-bearing (physically but also in the heart) united all three panels of the triptych.[40] The composition is also determined by a sweeping diagonal from the upper right to the lower left. The body falls inexorably from its white winding sheet to the embrace of the female mourners at the lower left (these directions are reversed in Vorsterman's print).

In *The Descent from the Cross,* Rubens not only took into account the long Flemish tradition for this subject but also incorporated his knowledge of the heroic ideal of the figure from antique and sixteenth-century Italian art. The answering diagonals of Venetian compositions, the imperious women of Veronese and Titian, and the muscular male ideal of the Roman High Renaissance all found a place in Rubens' conception. The figure of Christ is closely related, once again, to the *Laocoön.* Minus his physical agony and struggle for life, the Trojan priest

FIGURE 5.18

Lucas Vorsterman after
Peter Paul Rubens. The
Descent from the Cross.
1620. Engraving. 569 ×
430 mm. British Mu-
seum, London.

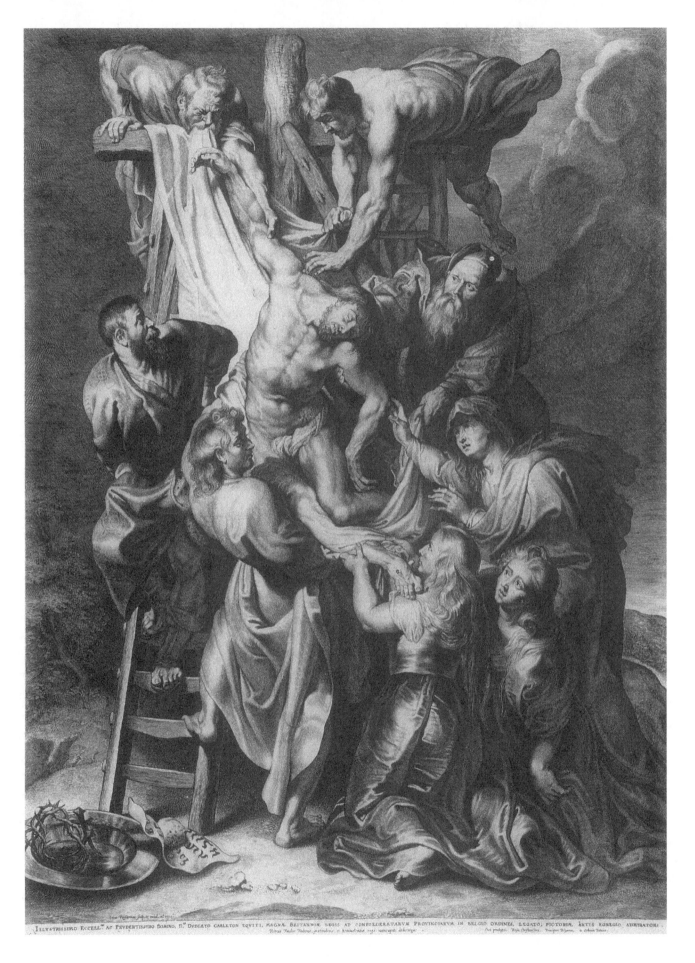

ILLVSTRISSIMO. ECCELL.^{mo} AC PRVDENTISSIMO DOMINO, D.^{no} DVDLEIO CARLETON EQVITI, MAGNÆ BRITANNIÆ REGIS AD CONFOEDERATARVM PROVINCIARVM IN BELGIO ORDINES, LEGATO, PICTORIÆ, ARTIS EGREGIO ADMIRATORI:
Petrus Paulus Rubens, præstantiæ et benivolentiæ ergo nuncupat, dicatque.

served as a model for the basic pose and proportions of the dead Christ. At the same time, the pose of Nicodemus on the ladder recalls that of Laocoön's elder son to his right.

Vorsterman's translation of the rich color and shimmering textures of the painting is truly remarkable. In the figure of Magdalene, seen from behind and kneeling, we can particularly appreciate his artistry. For the first time, an engraver has done justice to Rubens' painterly treatment of his subject. Contours are avoided. Rather, it is the juxtaposition of elaborately varied hatchings and other burin marks that establishes edges, shadows, highlights, and textures. Vorsterman managed to convey saturation (intensity) of color rather than directly transcribing its tonality (lightness or darkness) with the burin. What is darkest in the painting is not necessarily darkest in the print (e.g., John's robe). Instead, the printmaker has subtly allowed tone to do in the print what tone *and* color do in the painting—bring forms forward or back, and establish primary and secondary centers of interest.[41]

Rubens was pleased with Vorsterman's work. In a letter of 1619, he expressed his preference for a young man who is malleable and not too set in his ways, as opposed to a well-seasoned engraver.[42] Tragically, however, Vorsterman suffered a nervous breakdown and apparently assaulted Rubens in 1622. For a time, Europe was shaken by rumors of the painter's assassination, for he was not only an acclaimed artist but an important diplomat as well. We wish we knew more about Vorsterman's illness. The assault is all the more mysterious because Rubens seems to have been universally beloved. His diplomatic efforts were marked by a forthrightness that stands apart from the hornets' nest of seventeenth-century politics. Vorsterman himself seems to have emulated him early in their association. How much Rubens' exacting standards contributed to the episode, coupled with Vorsterman's own perfectionism and the inherent difficulty of the task, we will never know. The vocation of engraving may have had an innate appeal for compulsive or obsessive types.[43]

Vorsterman's derangement and eventual departure for England in 1624 prevented Rubens from having him engrave *The Raising of the Cross*. Toward the end of his life, the painter entrusted this task to a lesser talent, Jan Witdoeck. The large print (fig. 5.19) is made from three plates (the joints are visible in the reproduction) and considerably alters the composition of the triptych, which is divided among center panel and narrow wings. The figures that are compactly grouped together in the elongated wing panels are spread out in the print, the foreground is augmented, and more landscape intervenes between the side and central panels. The scene of the cross being heaved into place is substantially based on a painting by Tintoretto in the Scuola di San Rocco in Venice.[44] The effect of the changes is to attenuate the compact, zig-zag movement across all three panels and to alleviate the abrupt physical and spatial power of the Tintoretto-inspired center. In the print, the event is recounted in epic, narrative terms—one "reads" it. Once again, we are reminded that the function of reproductive prints was not always *simply* to copy.

Like Titian's, Rubens' style was surprisingly well suited for reproduction in woodcut, despite its colorism and textural richness. In the latter's late period, when the sensuous color and golden light of Titian became increasingly important for his paintings, Rubens also reprised the vigorous linearity of woodcuts after the Venetian master. But Rubens' late woodcuts also continued the northern tradition of woodcut, especially as exemplified in pastoral landscapes and figurative works by Goltzius.

Like Titian and Goltzius, Rubens knew the limitations of the technique and did not attempt to obtain the qualities he sought in reproductive engravings. It was especially Chris-

FIGURE 5.19

*Jan Witdoeck after
Peter Paul Rubens.* The
Raising of the Cross.
*1638. Engraving from 3
plates. 660 × 1254 mm.
British Museum, London.*

toffel Jegher whose gouge and knife captured the surging energy and bold plasticity of the
Flemish painter's works. His *Garden of Love* (fig. 5.20) after Rubens' late painting of about
1632–34 is perhaps his greatest woodcut. So different from the painting and true to its medium
is this woodcut that it stretches the limits of the term "reproductive."

Although its ancestry lies in the fifteenth- and sixteenth-century love gardens of northern
prints, and a number of allegorical interpretations have been proposed for this painting, its real
inspiration, as Elise Goodman has asserted, came from contemporary social gatherings of the
fashionable, well-educated elite, among whom the painter himself moved. Moreover, the dig-
nity and beauty of contemporary women were central to the social ideal that Rubens expressed
here.[45] His own second wife, Hélène Fourment, whom he married in 1630 when she was not
yet seventeen years old, resembled the glowing, rotund beauties of his *Garden of Love.* His
second marriage underlies this vision of male-female relationships, which was later to be ex-
panded upon and lent a melancholy air by Watteau. The architectural background, reminiscent
of the gate of the courtyard of Rubens' Antwerp house, is considerably modified in the print,
as are the figure groups. Jegher worked from two drawings, now in the Metropolitan Museum,
that formed the left and right halves of a frieze-like composition. Unlike the painting, which is
exquisitely atmospheric, anticipating Watteau's *Embarkation for Cythera* (ca. 1718), the print is
robust, giving full force to the single woodcut line, despite areas of dense cross- and parallel
hatching. No artist since Dürer, Baldung, or Titian and his interpreters had understood the
woodcut line as well as Jegher. Curved diagonal hatchings form a rhythmic surface pattern
superimposed on the powerful volumes, and everywhere the active contours interpret the joy-
ous superfluity of feminine form and amorous feeling with a purely linear energy. The little
putti who prod the slightly shy beauties into love are as charming as the couples themselves,
who derive from preparatory sketches that, once again, foreshadow Watteau in their ephemeral
delicacy.

Only one print—an etching—can be directly attributed to Rubens, and even in this case
we might bear in mind the possibility of a pupil's authorship (as we have seen, Rubens' pupil
Van Dyck was one of the best etchers of the seventeenth century). *St. Catherine in the Clouds*
(ca. 1620–21; fig. 5.21) basically copied a figure in a now-destroyed painting by Rubens on the

FIGURE 5.20

Christoffel Jegher after Peter Paul Rubens. Garden of Love. 1632– 36. Woodcut from two blocks. 464 × 603 mm (left); 469 × 536 mm (right, trimmed sheet). Metropolitan Museum of Art, New York.

ceiling of the Jesuit church in Antwerp, but in appearance and intent it is not truly reproductive. It may even have been produced after Rubens' sketch for the painting rather than from the painting itself. To correct the first state of the plate, Rubens drew with a pen on a counterproof (an impression pulled from another impression that enables the artist to see the image in the same direction in which it is drawn on the plate). In this charming etching he made no attempt to obtain the textural fidelity and colorism he expected from his engravers. Rather, the line is exceptionally vigorous. Much as in Jegher's woodcuts, Rubens sought an analogy for his painting, not an imitation of it. By the second state, signed "P. Paul. Rubens fecit," the plate seems to have been reworked by another hand, perhaps without Rubens' knowledge.

Schelte à Bolswert's superb engravings after Rubens' landscapes seem to have been engraved after the painter's death in 1640.[46] *Landscape with Philemon and Baucis* (fig. 5.22) reproduces, in reverse, a painting in Vienna dating from the 1620s. The lush chiaroscuro of both the

painting and the print expresses the sacred significance of the story from Ovid's *Metamorphoses,*
in which a humble old couple extend kindness to two travelers, only to discover that they are
the gods Jupiter and Mercury. The couple are rewarded for their goodness by being saved from
a flood, which ravages the countryside below the hill where the old man and woman kneel
before the deities. As a rendering of a stormy landscape, and as a statement about the discovery
of spiritual significance in unexpected places, Bolswert's interpretation of Rubens bears com-
parison with Rembrandt's *Three Trees* (fig. 4.45). Both convey the grandeur of nature as God's
creation, but the Dutch etcher chose the flat land of Holland rather than the ornamental
mountains of the Flemish Mannerist tradition, reinterpreted here in dynamic seventeenth-
century terms. No deities are found in Rembrandt's nature; only Dutch citizens going about
their business, and while every inch of Bolswert's print is covered with the evidence of his
highly professional burin, Rembrandt's unpredictable lines stand out against an almost pal-
pably humid atmosphere. In this contrast and the contrast of Rubens' *St. Catherine* (fig. 5.21)
to Vorsterman's *Descent from the Cross* (fig. 5.18), original etching defines itself against the splen-
did foil of its reproductive counterpart.

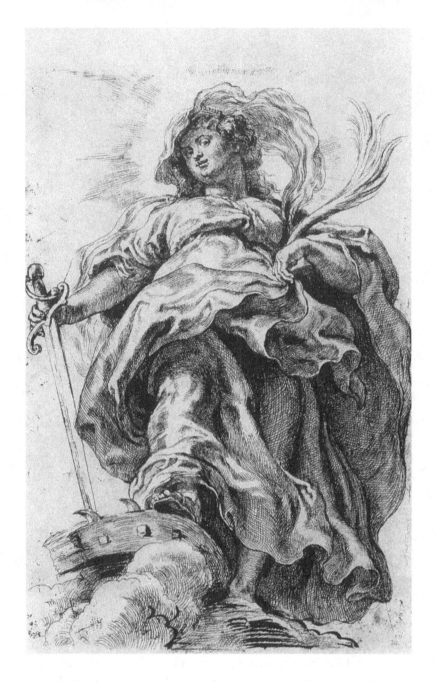

BAROQUE FRANCE

Except for Jacques Bellange and Jacques Callot of the Duchy of Lorraine (annexed by the French Crown in 1634), printmaking in French-speaking territories in the early seventeenth century was relatively undistinguished compared with the innovative developments in Holland and Italy that we surveyed in Chapter 4. As it had been for the Mannerist printmakers at Fontainebleau in the sixteenth century, Italian influence remained paramount for early seventeenth-century French printmakers. Barocci, Reni, and the Carracci were especially important for the printmakers in the school of Simon Vouet, whose slickly decorative style dominated Parisian painting in the first half of the century.[47] But toward the middle of the century, the center of printmaking shifted from the low countries to a politically ascendant France. A French tradition of eloquent prints after paintings and drawings and technically superb en-

FIGURE 5.22

*Schelte à Bolswert after
Peter Paul Rubens.* Land-
scape with Philemon
and Baucis. *1640s.
Engraving. 468 ×
639 mm. National Gal-
lery of Art, Washington,
D.C.*

graved portraiture—whether after painted works or done from drawings made explicitly to be engraved—was about to begin.[48]

Claude Mellan had probably been taught by Francesco Villemena in Rome, where he also engraved works by Vouet, who was then absorbing Caravaggio's style and other Roman influences. By his return to Paris in 1636, Mellan had developed his distinctive manner of engraving, which avoided cross-hatching. His best-known work is his *Sudarium of St. Veronica* (1649; fig. 5.23). The subject is an old one that Schongauer and Dürer had engraved (see figs. 2.32, 2.33), but conceived by Mellan with a new "gimmick": Christ's face is entirely rendered with one spiraling line that begins at the tip of the nose. The swelling and thinning of the line—a logical but spectacular extension of Goltzius' spiraling strokes—gives the print an ephemeral, shimmering quality that evokes the miracle of the *vera icon.*

Mellan's engraved portraits of illustrious people best reveal his sensitivity. His *Portrait of Nicolas Fouquet* (1660; fig. 5.24) is seen in three-quarter view against a subtly worked sky; Mellan again relied wholly on parallel hatchings, varied in spacing and thickness. Although as precise and restrained as we would expect a French portrait of the king's superintendent of finances to be, it gives a vivid sense of a lively intelligence and wit. There is also a hint of vulnerability in the inquisitive eyes and slight smile.

The demand for printed portraits (chiefly of the aristocracy and intellectuals, including artists) grew until, by 1704, engravers who wanted to be admitted to the French Academy submitted two portraits by which to be judged.[49] As we have seen, portrait prints were collected and studied as aids to understanding history, and as depictions of the qualities required for greatness. Commissioning an engraved portrait was a costly enterprise, even more expensive than the painted portrait, but worth it to those who wanted to spread their fame as far as it

FIGURE 5.24

Claude Mellan. Portrait
of Nicolas Fouquet.
*1660. Engraving. 327 ×
229 mm. Bibliothèque
Nationale, Paris.*

FIGURE 5.23

Claude Mellan. The
Sudarium of St. Veron-
ica (The Holy Face).
*1649. Engraving. 430 ×
320 mm. National Gal-
lery of Art, Washington,
D.C.*

could go. Michel Melot has described these engraved portraits as bids for recognition in which no attribute, no gesture, is without a political meaning. The details of portrait engravings, he argues, had a resonance with the public difficult for us to comprehend today.[50] Despite his reluctance to find an analogy to the engraved portrait in today's world, however, we might consider the concern for the televisibility of politicians, whose images must adapt well to the "tube."

Jean Morin's etching of the printer Antoine Vitré after Philippe de Champaigne's portrait of 1655 has an overall dark tonality from which the right hand and serious head stand out (fig. 5.25). One senses that the perfect triangle to which the body conforms is merely an expression of the meticulous professionalism of the sitter. Titian's portrait of an unknown man (the so-called *Ariosto*), which turned a huge, silken sleeve resting on a balustrade into an effective space-creating and eye-catching device, must have appealed as much to de Champaigne as it did to Rembrandt, for both artists followed Titian's lead (see fig. 4.41). The accomplished rendering of textures in Vitré's portrait lends immediacy to his physical and psychic presence.

FIGURE 5.25

Jean Morin after Philippe de Champaigne. Portrait of the Printer Antoine Vitré. *Ca. 1655. Etching. 312 × 211 mm. Bibliothèque Nationale, Paris.*

The etcher has worked from darks to lights, an approach to tonality that anticipates later mezzotint portraits and testifies to the absorption of Caravaggesque *tenebroso* lighting by seventeenth-century French painters like de Champaigne.

The most renowned French portrait engraver was Robert Nanteuil, who usually worked after his own drawings, explicitly made to be engraved. Although such prints are not reproductive, Nanteuil used a linear vocabulary that was extremely important to subsequent reproductive printmakers. His more systematic use of line, polished sculptural forms, and cool interpretation of personality contrasted with Morin's rougher, more spontaneous approach.[51] Nanteuil's image of Louis XIV, the "Sun King" (1672; fig. 5.26), descends from the tradition of state portraiture developed by Titian, Velasquez, Rubens, Van Dyck, and others, in which the point was to convey role, status, and power. An imperious Louis is cleverly framed by a lion's skin, the attribute of Hercules, a demigod and symbol of strength traditionally associated with the French monarchy. The sovereign's abundant hair even suggests the mane of the king of beasts. The lion's paws are emblazoned with *fleurs-de-lis,* the French royal insignia, connected to a third *fleur-de-lis* at the bottom by an oval of olive branches, symbolizing peace and wisdom. At the lower left, an emblem likens the king to a mirror whose brilliance reflects that of the sun to ignite a bundle of arrows. Louis's vision of the grandeur and unassailability of the French monarchy found its architectural fruition in the palace of Versailles, whose magnificent opulence came to represent everything opposed by the French Revolution.

Nanteuil was a superb technician who learned from Mellan's works, from the engravers employed by Van Dyck, and from Abraham Bosse, Callot's pupil, who wrote the first treatise on engraving and etching in 1645. Louis's face is modeled with minute short strokes placed

FIGURE 5.26

Robert Nanteuil. Portrait
of Louis XIV. *1672. En-*
graving. 680 × 592 mm.
National Gallery of Art,
Washington, D.C.

close together, so that the flesh is distinguished from the hair and clothing, rendered with
thicker lines. The portrait as a whole is set apart from its emblematic frame, which is modeled
with even more emphatic burin lines. The effect is analogous to a softly painted portrait,
framed by sculpted elements. Considering Nanteuil's illusionistic skill and his vitality of inter-
pretation, small wonder that Louis yielded to the engraver's petition to elevate his vocation
from an Industrial to a Liberal Art in the 1659 Edict of St. Jean de Luz. Louis and his court
were avid patrons of printmaking, in part because of its tremendous potential for political
propaganda. In 1667, during Louis's reign, the huge print collection of the Abbé de Marolles
was purchased for the French Crown.[52]

Louis's decree tells us much about the status of printmaking in the seventeenth century.
Although it was clearly an important enterprise, the king still had to plead for its recognition
as a liberal *art* by undermining its *craft*. The edict argued that etchings and engravings "de-
pended upon the imagination of their authors and cannot be subject to any laws other than
those of their genius; this art has nothing in common with the crafts and manufactures." In
order to separate printmaking further from craft, the decree also championed the individuality
of each engraver's style. This elevated perception of printmaking, reminiscent of the efforts of
such advocates as Lampsonius and Van Mander, would become untenable under the aegis
of the strict neoclassical aesthetic of the late eighteenth century, when the lush pictorial style

of French engravers following in Nanteuil's footsteps (like Pierre-Imbert Drevet, discussed below) would give way to the cold linearity of Charles-Clément Bervic, or even the pure outline style of engravings after the English sculptor and designer John Flaxman. In 1791 one of neo-classicism's leading thinkers, Antoine Quatremère de Quincy, remarked that "printmaking is not, and could never be an art form."[53]

Beginning with Simon Vouet, French Baroque artists made extensive use of professional printmakers to promulgate their painted compositions. The significance of reproductive print-making in French seventeenth- and eighteenth-century culture can readily be gauged by pondering the sheer numbers—some three to four hundred—of images after the important French painter Nicolas Poussin. As we have already noted, prints after paintings often altered their models substantially or, at the very least, promoted some artistic values over others. In effect, reproductive prints were a form of art criticism. The seemingly unavoidable hardening and systematization we have observed in the translation of a painting into a print (to some extent true even of the most painterly reproductive prints) conditioned the understanding of contemporary or Renaissance masters and the works of antiquity. Precisely rendered sculptural volume and the architectonic aspects of design were stressed above all. Clarity, sometimes turning into rigidity, of contour, expression, and composition were fostered, while the more ephemeral qualities of light and color—indeed, any form of ambiguity—fell by the wayside. Poussin himself stated that "nothing has been engraved of my work, with which I am not very angry."[54] Although the implications of reproductive prints for western art history tend to be studied on a case by case basis (as when a print after a painting influences a painter), Poussin's remark suggests that their effect on our perception of artistic intention warrants much deeper investigation.

Vouet employed his sons-in-law as reproductive printmakers. Although one of these, Michel Dorigny, etched nearly ninety works after his father-in-law, he also issued original prints.[55] His *Penitent Magdalene* (1651; fig. 5.27) is based on one of Vouet's many versions of this popular seventeenth-century devotional subject.[56] Mary Magdalene, having turned away from her life of prostitution to follow Christ and later, after his death and Resurrection, to meditate in the desert, offered an opportunity to combine the representation of religious ecstasy, beloved by the Catholic Revival, and feminine beauty. Here, she holds a cloak to her breast, but it is evident that, underneath, her hair has grown to its legendary length, covering her naked body. Her upturned head and weak grasp of the cross convey her ecstatic swoon. The skull is a symbol of transience alluding to the brevity of human life on earth, from which her thoughts turn to dwell upon the spiritual life represented by the cross. In this etching, the print returns to its original simply (indeed starkly) devotional purpose.

Dorigny was one of the many artists who made prints after Poussin, one of the most reproduced artists (along with Raphael).[57] Despite the fact that he lived most of his life in Italy, Poussin epitomized the skills of the "history painter" for seventeenth- and eighteenth-century French artists. History painting (i.e., multifigured compositions with mythological, religious, or historical subjects) provided the utmost challenge for the artist of a classical bent: it was necessary to organize a large number of figures and focus on a significant moment while paying heed to harmony, balance, and spatial and gestural clarity—all the ideals of the classical style, for which Raphael and "the ancients" provided the best guidance. In and around the late seventeenth-century French Academy, Poussin and Raphael were established as classical paradigms: Roland Fréart de Chambray, for example, used Marcantonio's engravings after Raphael

FIGURE 5.27

*Michel Dorigny after
Simon Vouet.* The
Penitent Magdalene
(Magdalene in the
Desert). *1651. Etch-
ing. 236 × 206 mm.
Bibliothèque Nationale,
Paris.*

to illustrate his *Idée de la Perfection de la Peinture* (*Idea of the Perfection of Painting*, 1662). But even more important than achieving a stylistic ideal was providing uplifting moral, spiritual, or intellectual instruction for his audience—a didactic function enhanced by the numerous prints after his paintings.

The Death of Germanicus (1626–30), for example, engraved in 1663 by Guillaume Chasteau (fig. 5.28), recounted a story from the *Annals* of Tacitus in which a great Roman military hero (the nephew of the emperor Tiberius) expires nobly while his wife, Agrippina, grieves at his bedside and his loyal officers swear an oath of vengeance. Germanicus, so named because of his campaigns against the Germanic tribes, had met the same fate as, perhaps, many members of the Julio-Claudian clan: death by poisoning. Thus, Poussin's work expressed the pathos of a good man's death by intrigue, the virtues of loyalty and service to the state, and a stoic attitude toward death itself. The painting is composed like an ancient relief (as on a sarcophagus), with the figures disposed in a shallow foreground space, their heads mostly on the same level (isocephalism). Attention is concentrated on the dying hero by the V-shape formed by the gesturing officer and the seated Agrippina; the dark cloth behind the bed also accentuates Germanicus' pale head and torso. The architecture provides an austere setting for this grim subject and a framework for the composition. A strong vertical leads the eye to the oath-swearing officer, and pilasters at the far left and right close off the composition at its edges. Space is well defined but limited, a stage for the human drama taking place in the foreground. The close-knit arrangement of lines, shapes, and volumes is further structured by the formality of Chasteau's engraving technique.

In two later pendant paintings (1648), done for the businessman and banker Paul Cérisier, Poussin depicted Plutarch's story of the wrongful death of another general, Phocion of Athens, so rigorously dedicated to the truth that he was condemned for treason. In the first of Poussin's paintings, Phocion's body is carried outside the city walls, having been refused burial within. In the second composition, shown here as engraved by Etienne Baudet in 1684 (fig. 5.29), Phocion's widow collects his ashes, which will be properly honored under the new regime.

FIGURE 5.28

Guillaume Chasteau after Nicolas Poussin. The Death of Germanicus. *1663. Engraving. 405 × 500 mm. Bibliothèque Nationale, Paris.*

If *The Death of Germanicus* seems highly structured, *The Widow of Phocion Collecting His Ashes* (fig. 5.29) is even more so. The moral austerity of the hero, much venerated in Stoic philosophy, in which Poussin and his patrons were profoundly interested, is echoed by the order of nature. Poussin's concern for landscape increased from the late 1640s until his death in 1655, and he provided western art with the most thoroughly civilized vision of nature that could be imagined. The classical architecture, the figures, and the roads are inseparable from the rigidly geometric, rarified structure of the landscape itself, in which trees, clouds, and mountains obey an unequaled pictorial logic born out of Poussin's Stoic faith in the enduring *logos* of nature. This logic, Margaretha Lagerlöf has suggested, also appealed to Poussin and his middle-class patrons, like Cérisier, as an analog for a social, economic, and political order that could be threatened by monarchical power on the one hand and by the unrest of the masses on the other.[58] Later, in the nineteenth century, Poussin's ordered vision of nature would inspire *plein-air* painter Paul Cézanne, who wrestled with the problematic relationship of this vision to the fluctuation of human perception.

Poussin had an overwhelming influence on the course of French art in the late seventeenth and eighteenth centuries. Among those affected by his style was Charles Le Brun, a highly competent artist who was the arbiter of French official painting. He was the creative force behind the decorative schemes of Louis XIV's palace at Versailles, that monument to monarchical pomp and splendor. In five huge paintings of the *Triumphs of Alexander* (1661–68), Le Brun likened the Sun King to the greatest empire-builder of antiquity and illustrated the virtues of a good king.[59]

FIGURE 5.29

*Etienne Baudet after
Nicolas Poussin.* The
Widow of Phocion
Collecting His Ashes.
*1684. Engraving. 570 ×
750 mm. Bibliothèque
Nationale, Paris.*

Epitomes of conformity to academic rules, these paintings eclectically recall venerable artistic prototypes—Leonardo's *Battle of Anghiari* and Raphael's and Giulio Romano's battle scenes in the Vatican Stanze—in an effort to express a culturally sanctioned, normative vision that reproductive engravings had helped to establish and continued to promote. The inventory of Le Brun's possessions after his death revealed well over a hundred prints after his *Alexander* compositions. *The Battle of Arbela,* engraved by Gérard Audran on four plates (1674; fig. 5.30), was composed with Pietro da Cortona's painting of the same subject in mind, and as a criticism of it. Whereas the latter (done in the 1630s) is a fully baroque, furious depiction of the confrontation of the Hellenistic monarch and Darius, the Persian emperor, Le Brun's work might seem, to modern eyes, overdetermined by the principles of classical composition. A basic symmetry, clarity of contour, and a posed quality in the figures—all accentuated, of course, in the engraving—compromise the spontaneity of action that would be characteristic of such an event. In the art-theoretical debates of the period, Le Brun's style exemplified a refined "baroque classicism" that was contrasted to the supposed extravagance of the high baroque style of Gianlorenzo Bernini in sculpture and Cortona in painting.

THE EIGHTEENTH CENTURY: THE CONTINUING TRADITION OF PORTRAITURE AND THE ROCOCO STYLE IN REPRODUCTIVE PRINTS

The French tradition of portraiture was continued in the eighteenth century, perhaps most spectacularly by the engraving dynasty of the Drevets, who were especially known for

their textural realism, accomplished solely with the burin (no etching was admitted).[60] Pierre-Imbert Drevet's *Portrait of Cardinal DuBois* after Hyacinthe Rigaud (1724; fig. 5.31) is a superb example of the *portrait d'apparat* (*apparat* meaning "pomp"), in which accoutrements and clothing take on nearly as much importance as the sitter.[61] It would have astonished earlier virtuosi of engraving (Dürer, Cort, Goltzius) to see the machine-like precision and textural range that the engraver's art attains here. The lace sleeves, the fur cape, the puff ornamenting the hat, the flesh, hair, and stunning drapery are all discrete textures, each conveyed by a different system of burin marks. And yet, despite the overblown grandeur typical of Rigaud and the virtuosity of the technique, considerable vitality is transferred from sitter to painter to engraver.

Against the weightiness of both the form and the subject matter of French academic classicism as represented by Le Brun, Jean-Antoine Watteau's exquisitely delicate Rococo style feels like a fresh breeze.[62] Influenced by the late style of Rubens, its frothy, pastel colorism and glowing light gave form to the *fête galante,* a new category of subject matter introduced into the academic scheme to accommodate Watteau. It was basically an elegant gathering, often out-of-doors, of amorous couples, the perfect format for showing off elaborate eighteenth-century costume and the pursuit of pleasure in general. With Watteau's followers, the *fête galante* amounted to little more than that. Watteau himself, however, was able to imbue the theme with a sense of unfulfilled longing and even melancholy that none of his followers recaptured. Born on the Franco-Flemish border, Watteau was to live a scant thirty-seven years, succumbing to tuberculosis in 1721. The painter of ephemeral love and happiness lived a fleeting life himself.

Watteau was probably introduced to etching by his first teacher, Claude Gillot, who made prints of decorative or fantastic subjects, such as bacchic and demonic themes. As we will see, the younger artist etched two prints of his own—a scene of troops on the march and one of the Italian comedy (see fig. 6.24). He also produced a series of fashion plates, the *Figures de Mode* (see fig. 6.23), which are outstanding for their lightness of touch.[63] But Watteau made his greatest impact on the history of prints as a model for reproductive engravers.

One of the most ambitious print projects we shall encounter is the *Recueil Jullienne* (1735), more than two hundred prints bound in two volumes (single-leaf prints were also sold to help finance the enterprise), which duplicated Watteau's painted compositions. These were complemented by 351 prints after Watteau's drawings (the *Figures de Différents Caractères* of 1726–28). There had been earlier large-scale reproductive projects, but they had recorded collections in prints. An early example was *Le Théâtre des Peintures* (1658), based on the collection of Archduke Leopold of the Netherlands. Masterminded by the important Flemish painter, David Teniers, Keeper of the Royal Collection in Brussels, *Le Théâtre* was criticized for the poor quality of the prints. In 1721, the year of Watteau's death, the collectors Pierre Crozat (called "le pauvre" to distinguish him from his even wealthier brother), Pierre-Jean Mariette, and the Comte de Caylus initiated the *Cabinet de Crozat,* an engraved record of Italian works in French collections. Particular attention was given to drawings, which were reproduced in actual size. Crozat's project was supposed to be an art book for an elite audience, with a text by Mariette. Crozat had four presses installed in his home so that engravers could work from originals in his own collection and the collections of the king and the Duc d'Orléans. The best French engravers were employed in this project, much as they were for the *Recueil Jullienne*.[64] But the latter had a different focus: the oeuvre of a single artist.

LA VERTV EST DIGNE DE L'EMPIRE DV MONDE.

Alexandre apres plusieurs Victoires deffit Darius dans la bataille qu'il donna pres d'Arbelle, et ce dernier ayant acheué de renverser le throsne des Perses tout l'Orient fut soumis a la puissance des Macedoniens

FIGURE 5.30

Gérard Audran after Charles Le Brun. The Battle of Arbela. *1674. Engraving from 4 plates. 713 × 1590 mm. Bibliothèque Nationale, Paris.*

DIGNA ORBIS IMPERIO VIRTVS.

FIGURE 5.31

*Pierre-Imbert Drevet
after Hyacinthe Rigaud.*
Portrait of Cardinal
DuBois. *1724. Engrav-
ing. 487 × 359 mm.
Cleveland Museum of
Art.*

The man behind the *Recueil* was Jean le Jullienne, director of the Gobelins tapestry works
and a devotee of the painter. Jullienne financed the undertaking himself, refused to sell the
prints by subscription, and made no profit. However, commercial motivations cannot be ruled
out entirely. Marianne Roland Michel has noted that although Jullienne clearly wanted to
further recognition of his friend's genius, he had also observed that the *Figures de Différents
Caractères* had enhanced the market for Watteau's drawings. The patron knew that the prints
after Watteau's paintings were likely to help place those paintings, many of which Jullienne
owned, in the best collections at good prices.[65]

Jullienne's ambitious tribute to a single artist foreshadowed the modern "catalogue rai-
sonné," which attempts to bring together an individual's complete works in one volume. The
Recueil Jullienne often included information normally found in sales catalogs: the dimensions
of the original work and its provenance. Omissions from the *Recueil* might be explained, Ro-
land Michel suggests, as works (such as the Louvre *Cythera,* discussed below) which were not
available for sale or which had already been placed in important collections. Thus, the repro-
ductive prints sponsored by Jullienne became certificates of authenticity within an advertising

L'EMBARQUEMENT POUR CYTHERE. AD CYTHERA CONSCENSIO.

process. They have also provided information for subsequent scholars seeking to understand Watteau.[66]

Jullienne employed just about every major French printmaker, including Nicolas Cochin *père,* the young François Boucher, and Jean Audran, a nephew of Gérard. The combination of etching and engraving developed in Gérard's shop was adapted to Watteau. The preparatory etching provided a freedom of line, pose, and gesture, while the engraving—a synthesis of the various systems perfected by the early eighteenth century—captured the broken lights and shadows of the drapery surfaces for which Watteau was known. The print after Watteau's ultimate *fête galante,* the *Embarkation for Cythera* (ca. 1718; Schloss Charlottenburg, Berlin), engraved by Nicolas-Henri Tardieu (fig. 5.32), exemplifies the success of this approach.

Cythera was a legendary island of love that had figured in Florent Dancourt's romantic comedy of 1700, *Les Trois Cousines* (*The Three Cousins*). The Charlottenburg painting from which Tardieu worked was a version, probably made for Jullienne, of Watteau's reception piece for the Academy, now in the Louvre. In 1712, the subject of this work-to-be was described as a "Pèlerinage à l'isle de Cythère," which, in keeping with the explicit Latin and French inscrip-

tions on Tardieu's engraving, had generally been interpreted as "Pilgrimage to Cythera" until 1961. At that point Michael Levey suggested that the Louvre painting represented, not a departure for, but a departure *from* the island, and what Watteau's figures expressed was not joyous anticipation of what was to come, but melancholy reverie about the amorous pleasure that had passed. The ambiguity of the Louvre version has not only been confirmed by the continued scholarly debate sparked by Levey's suggestion,[67] but is also reflected in the Academy's response to the picture in 1717 (when Watteau finally and quickly executed it): "Le Pélerinage à l'isle de Cythère" was crossed out and replaced by the general title, "une feste galante." Clearly, Watteau's contemporaries were confused by what the artist may have meant as a *double-entendre:* the island not as a place but as a state of mind that one enters and leaves.[68] The answer is probably that the Louvre work represents a pilgrimage to Cythera, while the symbolically more explicit Berlin work (note the prominence of the statue of Venus and her attributes) represents—Tardieu's title notwithstanding—a taking leave of the island.[69]

Thus, the reproductive engraving does not necessarily help us solve this knotty iconographic problem. It is, however, the masterpiece of the *Recueil Jullienne,* and, insofar as possible, a faithful record of the expression of Watteau's painting. Tardieu began with a preliminary etching that reversed the composition of the painting but preserved the delicacy of Watteau's forms. The burin was not used simply to fill in etched outlines. Rather, it followed the etched lines to add volume, clarity of detail, and emphasis, without destroying the spontaneity of the etched beginnings.[70]

REPRODUCTIVE PRINTS AND DRAWING: NEW TONAL PROCESSES, THE CRAYON AND PASTEL MANNERS

Watteau's magnificent, gauzy drawings have always been treasured. The *Study of a Woman's Head* from the *Figures de Différents Caractères* (fig. 5.33) was etched by Boucher after a sketch by Watteau in black and red chalk. Although Boucher employed the etching needle deftly, skimming over the surface of the plate, and modeled the face with a sprinkling of stipple, the image is still clearly etched and pursues its own crisp expression, very different from that of its model. Actually, no print could truly capture a drawing by Watteau, but it remained for Louis-Marin Bonnet and Gilles Demarteau to develop a closer printed facsimile of chalk (*crayon* in French).

Boucher's prints after Watteau's drawings anticipated the veritable craze for prints after his own works in chalk. The collecting and connoisseurship of drawings was an eighteenth-century passion, well exemplified by the astute critical eye of Mariette. The capacity of drawings to reveal an artist's sensibility with a unique clarity and immediacy was recognized. Wealthy men like Crozat amassed huge collections with a large proportion of works by modern masters (from the Renaissance on), among whom Boucher, an exceptional draughtsman who worked with legendary speed, figured prominently. The interest in drawing was transmitted to the middle class, for whom the less expensive reproductive print served in the place of the autograph work.[71]

Boucher's facility was well matched to his precarious financial condition, and he turned out large numbers of drawings for a variety of purposes—including reproduction in the *crayon manner,* a new tonal (that is, non-linear) process invented in the mid-1750s in France by Jean-

FIGURE 5.33

François Boucher after Antoine Watteau. Study of a Woman's Head *from* Figures de Différents Caractères. *1726–28. Etching. 226 × 169 mm. Metropolitan Museum of Art, New York.*

Charles François, a mediocre talent. François's pupil, Louis-Marin Bonnet, adapted it for printing in color (in which case it is sometimes called the *pastel manner*) and transmitted it to Demarteau. When François died, Demarteau bought his plates and published them with the inscription *Demarteau perfecit.* After François's death, Demarteau was considered the inventor of the technique, as well as its "perfector."[72]

The crayon manner is really a mechanized stippling by which the effect of chalk on coarse paper was duplicated. The principal instrument was the *roulette,* which came in a variety of forms and had, as its name suggests, a revolving head covered with irregular points. When applied to an etching ground, the points dug through it, producing a stippled line. Another tool was the *mattoir* or mace-head, a blunt-ended, irregularly spiked object that yielded tonal areas when pressed against the grounded plate. The ungrounded plate could be touched up, of course, with a variety of intaglio tools.

Boucher's *Two Nereids and a Triton* in red, white, and black chalk (fig. 5.34) was reproduced by Demarteau in the crayon manner, but using only red ink (fig. 5.35). The print is faithful to the spirit of the drawing, except for a certain flatness and the absence of Boucher's sprightliness. Two heads have been sketchily added in the background, drawing attention away from the dimpled buttocks (Boucher's forte) of the reclining nereid. Printmakers like Demarteau and Bonnet, who also made numerous prints after Boucher, often made preparatory studies from the originals in which they altered some details. These drawings, called *dessins destinés à être gravés* (drawings meant to be engraved) were exhibited by the printmakers to show their skill. Such sheets coexist with originals, as well as counterproofs from originals retouched by the printmakers, creating problems in connoisseurship.[73]

FIGURE 5.34

François Boucher. Two
Nereids and a Triton,
study for The Rising of
the Sun. *Early 1750s. Red
and black chalk on brown
paper heightened with
white. 291 × 469 mm.
Musée du Louvre, Paris.*

FIGURE 5.35

*Gilles Demarteau after
fig. 5.34. After 1761.
Crayon-manner etch-
ing. 384 × 530 mm
(including inscription).
Musée du Louvre, Paris.*

FIGURE 5.36

Nicolas De Launay after Jean-Honoré Fragonard. The Swing (The Swing's Lucky Chances). *1782. Etching and engraving. 515 × 425 mm. R. S. Johnson Fine Art, Chicago.*

THE *ESTAMPE GALANTE*

In the 1760s, 1770s, and 1780s, French printmakers popularized the *estampe galante,* a highly finished print of an amorous subject by one of the Rococo masters, such as Jean-Honoré Fragonard, Boucher's pupil and also an important original etcher. Fragonard's *The Swing* (1761), etched and engraved by Nicolas De Launay (fig. 5.36), epitomizes the coy frivolity of late Rococo painting. A frothy harmony of silvery pastel colors, the painting depicts a minor incident in the world of love—a stolen glimpse of a young woman's ankles, petticoats, and perhaps more by an enamoured suitor, whose ruse is helped along by a companion. The young lady is perfectly aware of what she is revealing; this is clear from her sly smile and her flirtatious discarding of a tiny, pointed shoe.[74] A lush, wooded garden surrounds the doll-like figures, who are as insubstantial as the feathery foliage above them.

Framed and hung, prints such as De Launay's complemented the intricate curves and intimate scale of Rococo interiors (the symbiosis with interior decor was even stronger in the case of color prints). Producing such refined works was usually a team effort that combined preliminary etching with finished burin work, as the artists of the *Recueil Jullienne* had done. Although the etched beginnings often appeal more to our tastes, such proofs are rare. The aesthetic sense of the eighteenth century favored the finished product. The framing elements and the "address" (the lettering below the image) often involved another hand. Collectors preferred the state *avant la lettre*—before the address.

De Launay produced prints after other painters specializing in *galante* subjects, which are often more titillating than romantic. One such artist was Boucher's son-in-law, Pierre-Antoine Baudouin, whose visions of the erotic escapades of the French aristocracy in this prerevolution-ary period were engraved in the 1770s, even though he had died in 1769. The Swede Nicolas Lafrenson, called Lavreince in France, where he stayed between 1774 and 1791, began as a commercial engraver in Baudouin's shop, and continued the latter's series of amorous prints, albeit with a heavier touch. *The Happy Moment* (1777; fig. 5.37), again engraved by De Launay, depicts a declaration of love (note the cupid in the oval painting above). Judging from the couple's impetuous embrace, the viewer had best turn discreetly away, lest he or she change from viewer to voyeur. On the other hand, it is the hint or actuality of voyeurship that is the life of such works. The print was issued as part of a series only loosely linked by subject matter. Sean Taylor has suggested that De Launay conceived of this open-ended series of reproductive images surrounded by similar framing motifs as a means of increasing sales. Additions were easy to make, and the frames provided some continuity.[75]

A sensitive interpreter of the age of Louis XVI and Marie Antoinette was Jean-Michel Moreau, called Moreau *le jeune,* the brother of Louis Moreau, a landscape artist. Illustrator of the works of Jean-Jacques Rousseau, Moreau *le jeune* also designed some images of the *Monu-ment du Costume* (1776) that brought a new liveliness to the fashion plate, popular since the sixteenth century. Sponsored by a Strasbourg banker, the *Monument* sought to promulgate "the code of fashion and etiquette." Moreau followed the progress of a highly placed man and woman as they pursued the activities associated with the aristocracy. The woman's ambitions are fulfilled when she becomes lady-in-waiting to the queen. Moreau's design, resplendent with the courtiers' enormous, intricate dress, powdered wigs, and plumes, and the decor of the room itself, was beautifully engraved by Pietro Antonio Martini from Parma (fig. 5.38). The grace-fulness of Moreau's style is evident not only in the heroine herself, but also in the figures of the little pages to the left. In one plate Moreau contrasted the "true happiness" of a farmer's family to the lives of his aristocrats. And in the later edition of the *Monument,* an apology is offered for the attention to the wealthy class: "France . . . is full of virtuous people and respectable families . . . but the monotony of a decent, peaceful household would have no interest for our readers."[76] The public's persistent fascination with the lives and mores of the extravagantly rich is not, it seems, restricted to our own time.

CHARDIN AND GREUZE

Earlier in the century, the painter Jean-Baptiste-Simeon Chardin had endeavored to de-pict the "monotony of a decent, peaceful household" in dignified, exquisitely composed and

FIGURE 5.37

Nicolas De Launay after Nicolas Lavreince. The Happy Moment. *1777. Etching and engraving. 352 × 252 mm. Bibliothèque Nationale, Paris.*

FIGURE 5.38

Pietro Antonio Martini after Jean-Michel Moreau le jeune. The Queen's Lady in Waiting *from the* Monument du costume. *1776. Etching and engraving. 268 × 218 mm. Bibliothèque Nationale, Paris.*

lighted genre scenes worthy of Jan Vermeer or Gerard ter Borch, who painted their seventeenth-century Dutch "ancestors." These pictures were engraved between 1723 and 1757 by artisans like François-Bernard Lépicié. *The Busy Mother* (1740; fig. 5.39) exhibits the qualities that made and still make Chardin so appealing: his inimitable understatement and his ability to imbue the most banal subject with a sense of transcendent moral purpose and human worth. The virtues of diligence and maternal love underlie this quiet scene, in keeping with a new concern in Enlightenment thought for the importance of family life, centering on the contented mother, as Carol Duncan has shown. Following the lead of English thinkers, the French *philosophes* emphasized the value of positive childhood experiences in the formation of adults, and disparaged the harsh treatment and neglect of children.[77] In his scene of mother and child working in mutual respect and contentment, Chardin epitomized these new ideals while drawing on the many equally intimate Dutch scenes of maternal care.

Chardin did not force these values on his audience, mostly made up of elite connoisseurs. Rather, he revealed his meaning through light and compositional harmony, which are visual analogies for the simple but efficient order of the middle-class household and the tender relationship of mother and daughter. The *prints* after these paintings, as Thomas Crow points out, "pulled Chardin into another receptive space. . . . The reticence so carefully built into the images is there overruled by the very compulsion to moralize that Chardin had so artfully spared his primary clients."[78]

Mariette regretted the success of these prints, for they represented to his mind the waning of the "grand manner" he so loved: "The engravings after M. Chardin's paintings . . . have now become very fashionable, together with those after [David] Teniers [the younger], Vauvermans [Philips Wouverman] and [Nicolas] Lancret, they have succeeded in dealing the final blow to

LA MERE LABORIEUSE

serious prints after Le Brun, Poussin, Le Sueur, and even [Noel] Coypel. The general public takes pleasure in seeing again actions which take place daily under its very eyes in its own home, and unhesitatingly gives them preference over more elevated subjects which require, however, a slight effort to understand."[79]

In contrast to Chardin's works, the genre paintings of Jean-Baptiste Greuze may seem, to the modern viewer, painfully mawkish. If we are to derive anything from such images, we must remember the longstanding concern for the clarity, indeed the rationalization, of the "passions" in seventeenth- and eighteenth-century art as well as art's didactic function, which was taken for granted by Greuze and extolled by Denis Diderot and other Enlightenment thinkers. As he endeavored to imbue genre subjects with the elevated aims of history painting, Greuze appealed to both the crowd and the intellectuals, in Crow's terms, by "deploy[ing] all the narrative resources of academic art without seeming to." The formal and expressive devices fostered by the French Academy were made to appear natural, as if they resulted "from a wholehearted and unselfconscious immersion in the drama before him."[80]

This capacity for moral enrichment and instruction was greatly augmented by the print, which circulated to a wide public. Indeed, William Hogarth's moralizing prints, a major influ-

FIGURE 5.40

Jean-Michel Moreau le jeune and Pierre-Charles Ingouf after Jean-Baptiste Greuze. The Happy Household. *1766–67. Etching and engraving. Metropolitan Museum of Art, New York.*

ence on Greuze to be discussed in Chapter 7, had already exploited that capacity in England. Greuze's interpretation of the contented household, engraved by Pierre-Charles Ingouf over preliminary etching by Moreau *le jeune* (1766–67; fig. 5.40), is a more emphatic assertion of the Enlightenment's interest in a happy family life than Chardin's *Busy Mother*. It fairly drips with the father's protective concern for his little brood and the wife's devotion to her spouse. Like Chardin, Greuze supervised the production of prints after his paintings rather than entrust this enterprise to one of the large printmaking firms, such as those of Le Bas or Wille. Madame Greuze handled the business end, and is notorious for her ingenious money-making schemes (printing more sheets than an edition called for and duping collectors by selling spurious "rare" states). Such practices sparked criticism even in the eighteenth century, when we might not expect standards to be as codified as they are today.

De Launay, Martini, Ingouf, and Lépicié represent the best of French professional print-making in the eighteenth century, but they were among a great many skilled individuals who took up this trade. Collecting prints was at a peak, and large studios thrived, such as those of Jean-Georges Wille and Jacques-Phillippe Le Bas (who was especially important in the production of those prints after Dutch masters that Mariette so disliked). "The professional engraver," states Adhémar, ". . . spent his life making reproductions of pictures brought to him by private customers, publishers and print dealers. He engraved them with meticulous care, taking great pride in their perfection, giving them a finish and brilliance which was much appreciated. The publisher and the engraver were regarded as benefactors of the human race because they made known to the general public works which, before the creation of museums, would without their help have remained unknown and hidden in private collections."[81]

Wille was a German who spent most of his life in Paris as one of the heirs of the Drevet tradition. His major contribution to the history of engraving was its further systematization, especially in the form of the "dot and lozenge" technique, which is best seen in the works of his pupil, Charles-Clément Bervic. This artist worked with such painstaking slowness that he did not produce many plates. The dot and lozenge system superimposed stippling and curved cross-hatching regularly, so that within each roughly trapezoidal lozenge was a single dot or a very short burin stroke. This technique became standard, imposing a virtually flawless but lifeless surface on the works it reproduced. It survives intact today in our paper currency, and the relentless regularity of its syntax finds an echo in the half-tone screen of photographic reproduction.

Bervic applied his system to his 1809 engraving of the *Laocoön* (fig. 5.41), which had served as the model for innumerable copies, casts, and prints, and as an inspiration for artists composing scenes of anguish, since its excavation in 1506. As Marco Dente's engraving (1520–25; fig. 3.37) showed, the right arm of the Trojan priest and the right hands of his sons were missing when the statue was excavated, and the *Laocoön* was restored numerous times in marble and terra cotta.[82] The major differences between Bervic's engraving and Marco Dente's print are due to physical differences in the restored models.

But even when we ignore these differences, the gulf separating the two engravers' conceptions is wide. The Italian gave more bulk to the torso of the Trojan priest and emphasized the muscular divisions of all the figures more. By comparison, the French *Laocoön* is refined and elegant. The brutal anguish of the original work, still reflected in the Italian engraving, is now only pantomimed—the statue becomes a *sign* for anguish, triggering in the viewer the appropriate responses to the artistic expression of emotion and to the glory of ancient art. Although Bervic's system can be understood in the context of neoclassicism, which shunned the textural effects of engravings like Drevet's *Cardinal DuBois* (fig. 5.31), preferring the rigor of the regularized line, this rigor overwhelms the print's subject. It was the varied linear syntaxes of the many prints after this most famous work of antiquity that led Ivins to discuss the impact of different "nets of rationality" upon perceptions of the same work of art. It is indeed hard to believe that "so dissimilar pictures were supposed to tell the truth about the one identical thing."[83]

It was largely in response to the increasing demand for reproductive prints that various

FIGURE 5.41

Charles-Clément Bervic after the Laocoön. *1809. Engraving. 426 × 315 mm. Metropolitan Museum of Art, New York.*

tonal processes were developed in the eighteenth century. We have already discussed the *crayon manner,* which could produce tone as well as line in imitation of chalk drawings, and the *pastel manner,* its multicolored counterpart. Other eighteenth-century tonal methods completely obliterated the line, which, as we have seen, had long been under attack. *Stipple engraving,* which Campagnola discovered in the sixteenth century, was more broadly employed in this period. *Mezzotint* and *aquatint,* both more recent inventions, also enjoyed a flowering. All these methods came to be used with color, thereby producing reproductions of paintings and drawings that were closer than ever to the originals. Two basic approaches were taken: the inking of one plate in different colors (*à la poupée*), which had the advantage of minimizing plate wear, and the superimposition of a number of plates each bearing a single color, which required a system of exact registration.

A German soldier, Ludwig von Siegen, anticipated eighteenth-century mezzotint about 1642 when he used a fine roulette for tonal areas on an intaglio plate (not different, in principle, from the crayon manner). Although his work was based on a limited use of the roulette and on a tonal progression from light to dark, as in most other intaglio techniques, there is some evidence that he did use a tool resembling subsequent mezzotint *rockers.* In the 1650s Prince Rupert of the Rhine, exiled from England when his uncle, King Charles I, was overthrown by

Cromwell, developed true mezzotint by working the plate from dark to light. He probably worked in conjunction with Wallerant Vaillant, a French portrait painter and etcher.[84]

The initial rich black tone was laid on the mezzotint plate with a *rocker,* a spiked instrument much like the mace-head, or *mattoir,* that was moved back and forth across the plate to score it thoroughly with an even burr. The image was then created by scraping and burnishing this burr from black to higher values. Mezzotint was often combined with other intaglio methods, although the greater longevity of etched or engraved lines caused the quick wearing of mezzotint burr to be all the more obvious as impressions were printed.

Mezzotint first took hold in England as a means of reproducing portraits, and so it is often called "the English manner," or *la manière anglaise.* Although Britain boasted virtuoso engraver-etchers such as Sir Robert Strange, William Sharp, and William Woollett, it did not have as highly developed a tradition of conservative portrait engraving as France, and so the growth of mezzotint portraiture was not impeded. It also had a strong middle class that valued portraiture.[85] Sir Joshua Reynolds, who set the standards for the fashionable likeness in the eighteenth century, had an enormous impact on the popularity of mezzotint in England, for he was acutely aware of the value of keeping his name before the public by means of reproductive prints. His sleek, vivacious portraits were reproduced by an array of skilled Irish and English mezzotinters with much greater frequency than those of his rivals, Thomas Gainsborough and George Romney.[86] John Jones's *Portrait of Lady Caroline Price* (1788; fig. 5.42) after Reynolds exemplifies the suitability of mezzotint for these portraits. The vivid highlights of the face, hair, and costume are set off against deep blacks, and Reynolds' relatively loose and eloquently descriptive brushstrokes are imitated better by the scraper and burnisher than they ever could be by a linear process, no matter how complex. The elegance and variety of Reynolds' portraits depended precisely on those qualities that the mezzotint was best able to capture.

In *The Drop Forge* (1773; fig. 5.43) after Joseph Wright of Derby's painting of 1772, Richard Earlom employed the scraper and burnisher more tightly to yield a finer, more detailed surface and a meticulous rendering of Wright's chiaroscuro. The painter's interest in naturalistic light effects in a darkened setting is part of a tradition going back to the Renaissance, when the contexts for nocturnal lighting would have been the Nativity, with the miraculous radiance of the Christ child providing the illumination, or the despair of Christ in the Garden of Gethsemane, or some other religious narrative. Here, however, we are clearly in the modern age. In keeping with Enlightenment thought, Wright heartily celebrated the early Industrial Revolution (as he often did the scientific revolution) in this reverential and meticulously accurate depiction of an early forge for changing pig iron into wrought iron. There is no hint of pollution, child labor, poverty, or even danger. The worker and his family are portrayed as healthy and content. It is a far cry from the criticism of industry and of the social order in general in which printmaking would soon become engaged as the less than idyllic implications of the Industrial Revolution became apparent.

The most distinguished exemplar of the English genre of "sporting art" (focusing on prize horses, hunting dogs, and their owners) was George Stubbs, who made his own technically innovative, mixed intaglio prints, basing them, often rather loosely, on his paintings, or on details of his paintings. These extraordinary prints are discussed in Chapter 6. However, Stubbs's paintings were also reproduced by professional engravers like William Woollett and mezzotinters like Robert Laurie. For *Lion Attacking a Horse* (1791; fig. 5.44), Laurie worked not after an original oil (apparently the original is now lost, although a relatively close version is in

FIGURE 5.42

John Jones after Sir Joshua Reynolds. Portrait of Lady Caroline Price. *1788. Mezzotint. 378 × 277 mm. Yale Center for British Art, New Haven.*

the Yale University Art Gallery), but after another mezzotint by Stubbs's son, George Townley Stubbs. The melodrama of the subject was accentuated by its translation into the mezzotint, where the flashing highlights and dark shadows of the wild landscape are intensified. Stubbs was preoccupied by the horse and lion theme from the 1760s through the 1790s. In numerous images of a horse being stalked or devoured by a lion, he combined his superb knowledge of equine anatomy, about which he had written a book in 1766, with his interest in themes of awesome violence and terror, which corresponded to the contemporary idea of the sublime as expounded by the philosopher Edmund Burke. Such images foreshadowed Eugène Delacroix's scenes of animal violence in the nineteenth century (see fig. 8.10), and were very different from the magnificent portraits of pedigree horses for which Stubbs was primarily known. This theme was elevated above the "sporting genre" not only by its grandeur but also by having an antique source, a statue in the Conservatori Palace in Rome, much admired since the Renaissance, which Stubbs had undoubtedly seen on a trip in 1794.[87]

Crowning the English mezzotint tradition are landscapes that take us into the next century: the spectacular prints done by John Martin after his own works and by David Lucas after

FIGURE 5.45

John Martin. The Deluge. *1828. Mezzotint with etching. 473 × 715 mm. Yale Center for British Art, New Haven.*

John Constable. Like Stubbs, Martin became deeply involved in printmaking to promote his art, refusing to rely totally on professional printmakers, and he handled mezzotint sensitively, using inks of various densities that he blended in the wiping. *The Deluge* (1828; fig. 5.45) was based on a now-lost oil painting of 1826; indeed, the print is the only record of Martin's original conception, and it served as the basis for an even more stupendous oil painting of 1834. Martin dedicated the print to the tsar of Russia, who had visited his studio and given him a diamond ring and a gold medal. An eight-page descriptive pamphlet (including a quotation from Lord Byron's *Heaven and Earth*), published after the print, asserted that it contained improvements that made it more than a mere copy. Martin's mezzotint thereby deflected apparently baseless rumors that he had plagiarized his conception of the Flood from the painter Francis Danby.[88]

As Lynn Matteson has demonstrated, Martin's image owed much not only to the idea of the sublime, but to current debates between scientists and religionists over the biblical account of history. The geologist James Hutton had argued in 1795 that the six thousand years biblical apologists gave as the age of the earth was not long enough for the slow changes in the earth's crust that Hutton envisioned. Baron Georges Cuvier, however, argued in his *Essay on the Theory of the Earth* (1813) that the world took shape through great catastrophes, like floods and earthquakes, and that the Flood of Noah was ultimately responsible for the current status of humankind, which was based on an evolution dating back only that far—that is, about six thousand years. Cuvier thus reconciled the Bible and science in a clever compromise that gave

Martin's "catastrophic" painting and print much topical resonance. In addition, Matteson argues that Martin's conception of the Deluge, which includes a comet along with the sun and moon in the sky, echoed William Whiston's theory (1696) that the gravitational pull of a comet generated the Genesis flood. The minuscule details, compelling space, and vigorous tonality of Martin's mezzotint swept viewers into a vortex of rain, water, and lightning to persuade them that faith and science could be harmonized.[89]

Less rhetorical but just as technically superb are the mezzotints after Constable by Lucas. Remarkable as they seem today, they lost money for both painter and printmaker. They were "glimpses of fresh weather" (note the dazzling display of meteorological energy in the sky) that were upstaged, Mayor suggests, by early photography.[90] Like Martin, Lucas worked on the newly introduced steel plates, which had greater longevity than the traditional copper ones, although the burr produced was less rich. He worked from numerous proofs that Constable corrected in black and white paint to insure the perfect results of the final editions. *Summer Afternoon—After a Shower* (fig. 5.46), published in 1831 as part of a series of twenty-two prints with appended text, entitled *Various Subjects of Landscape, Characteristic of English Scenery, from Pictures Painted by John Constable, R.A.* (London, 1830–32), is representative of Lucas' skill and Constable's painstaking supervision. The atmospheric chiaroscuro of the sky, evidence of Constable's study of clouds, and as dramatic as that of Rembrandt's *Three Trees* (fig. 4.45), is particularly rich and multilayered. An echo of Rembrandt and Seghers certainly exists in the windmill and church tower that reach above the horizon, but the relentlessly flat Dutch panorama gives way to the more variegated rural countryside of England, here celebrated just as urbanization, industrialization, and the process of enclosing more and more land for cultivation had begun to alter its appearance forever. In Ann Bermingham's discussion of Constable's landscapes, she suggests that the Lucas mezzotints were such virtuoso examples of the reproductive engraver's skill that they subverted Constable's stated aim for his publication, which was to give "'to one brief moment caught from fleeting time', a lasting and sober existence, and to render permanent many of those splendid but evanescent Exhibitions, which are ever occurring in the changes of external Nature."[91] And indeed Constable's late brushwork, as reflected here in the mezzotint, affirmed change and evanescence rather than any "lasting and sober," Poussinesque order. The rapid, flicked-on highlights of Constable's late paintings signaled the gradual loosening and refreshing of landscape painting that would culminate in Impressionism in the late nineteenth century.

One of the most important tonal methods for nineteenth- and twentieth-century artists is aquatint, whose origins were in eighteenth-century France and England.[92] In France, aquatint was called *gravure au lavis* (engraving in washes), a title that expresses its initial purpose: the replication of ink-wash drawings. Jean-Baptiste le Prince claimed its invention in 1768, but slightly earlier experiments had been done by François-Phillippe Charpentier and the Swedish engraver Per Gustaf Floding. Seghers also appears to have anticipated the modern technique of sugar-lift aquatint, and Rembrandt corroded his plates with sulphur particles. But grains of acid-resistant resin, sifted onto a heated plate or brushed on in an alcohol solution, form the basis for true aquatint etching: in biting *around* the grains, the acid produces tonal areas whose value (lightness or darkness) depends upon the length of immersion in the bath. Aquatint tone is "peppery" and readily distinguishable (at very close range, that is) from pure acid *lavis* (direct brushing of acid onto the plate), which will usually display bubble-like rings and "tide" or rippling marks at the edges of its application. Goya apparently employed this latter technique

FIGURE 5.46

David Lucas after John Constable. Summer Afternoon—After a Shower (Windmill at Redhill) *(1831) from* Various Subjects of Landscape, Characteristic of English Scenery, from Pictures Painted by John Constable, R.A., *first edition, 1830–1832. Mezzotint. 178 × 220 mm. Metropolitan Museum of Art, New York.*

only when he lacked aquatint supplies (as in *The Disasters of War*), for it is very difficult to control. But aquatint itself also demands a high degree of precision and watchfulness from the printmaker: the coarseness of the grains, the evenness of their sifting, and the length of the acid bath are adjustable factors, and one may utilize stopping-out and multiple immersions as in regular line-etching, which is often combined with aquatint tone.

A major disadvantage of aquatint is its tendency to wear quickly, especially in the more shallowly bitten areas, resulting in a difference in quality between early and late impressions. Another is the fact that the artist must think negatively: that is, what are applied to the plate directly with the brush are the stopped-out areas (white or higher values), not the aquatint itself. The sugar-lift method corrects this problem by allowing the artist to paint the design directly on the plate with a sugary syrup, over which an etching ground or varnish is laid. When the plate is immersed in water, the sugar swells, lifting up the ground and exposing the plate in areas where the aquatint is then applied. When Seghers created his famous *Mossy Tree* (fig. 4.29, color plate, p. 463) in the early seventeenth century, he used a process of this sort, but he apparently drew with a pen instead of a brush (the French call this etching *à la plume*).

Some of the finest early examples of aquatint are by the English landscape and portrait artist Thomas Gainsborough. *Wooded Landscape with Cows at a Watering Place* (mid-1780s; fig. 5.47), printed in brown ink, is known in only one impression, in Minneapolis. It is a typically "sylvan" and "decidedly anti-urban" landscape (to borrow Bermingham's words) of Gainsborough's native East Suffolk, made even more intimate by the original medium: the artist's inscription explicitly describes the print as imitating a drawing.[93] Although he probably learned

FIGURE 5.47

Thomas Gainsborough.
Wooded Landscape with
Cows at a Watering
Place. *Mid-1780s. Aqua-
tint. 181 × 240 mm.*
*Minneapolis Institute of
Arts.*

the aquatint process from one of its early English exponents, Peter Burdett or Paul Sandby, Gainsborough's approach was much more spontaneous and painterly. The sugar-lift solution has been brushed on freely, and the white of the paper, preserved by the stopping-out varnish, creates an intense luminosity coming from the horizon, reflected in the pond's surface, and framed by washes of shadows at the left and right. Gainsborough worked the foreground with the *roulette* as well, to add a textural quality to those deep shadows that push the pond and its bovine occupants back in space.

In his landscape prints, Gainsborough also employed a newly rediscovered technique—soft-ground etching—either alone or in combination with aquatint. Castiglione had invented the method in the seventeenth century, but no one continued it. It was probably in the context of François's experiments in the crayon manner that it was resuscitated as a way of making facsimiles of chalk drawings. As such, it enjoyed early success in the hands of Gainsborough, John Sell Cotman, Sawrey Gilpin, and others until it was superseded by the chalk (or crayon) lithograph, which yielded equally good facsimiles more cheaply and without the deterioration of the printing surface implicit in any intaglio process. Later on in the modern period, soft-ground etching would be reexplored through the use of literal textures (cloth and the like) impressed into the ground and thereby etched into plates.

In soft-ground etching, the acid-resistant substance that covers the plate is made more malleable by the addition of tallow. The artist draws on a sheet of paper placed over the grounded plate, so that the impression of the drawing (and of the paper itself) is left in the ground. When the plate is bitten, cleaned, inked, wiped, and printed (as in any other etching procedure), the drawing is reproduced quite faithfully. Soft-ground etching yields results very similar to the crayon manner, but the lines of the latter generally betray the regularity of the mechanical *roulette* or *mattoir*. Both crayon-manner prints and soft-ground etchings have plate marks, of course, which distinguish them from lithographs made with crayon.

The famous English satirist-printmaker Thomas Rowlandson produced a series of reproductions of drawings about 1788 entitled *Imitations of Modern Drawings.* In it he included five

FIGURE 5.48

*Thomas Rowlandson after
Thomas Gainsborough.*
Landscape with Cottage
from Imitations of Mod-
ern Drawings. *1789.
Aquatint and soft-ground
etching. 229 × 324 mm.
Yale Center for British
Art, New Haven.*

works after Gainsborough. In our example (fig. 5.48), aquatint (in imitation of ink wash) estab-
lishes some of the shadows, whereas the soft-ground etching (mimicking chalk) delineates
contours and reinforces the shadows. Gainsborough himself was more apt to employ the soft
ground to add a textural dimension to deeper, yet still translucent, shadows, and to blend the
latter with contour for a more atmospheric effect. The thicker edges and sketchier description
of forms by Rowlandson betray the parodic approach of a caricaturist.[94]

COLOR AND REPRODUCTIVE PRINTS

The incorporation of color into the tonal processes (as well as lithography) in the eigh-
teenth and nineteenth centuries represented the culmination of reproductive printmaking.
Marcantonio could scarcely have hoped for a more thorough approximation of the painted
model.[95] The elaborate color prints of the late eighteenth and early nineteenth centuries might
even be varnished and hung on walls like paintings. The talented original printmaker Philibert-
Louis Debucourt, discussed in Chapter 6, utilized the techniques of reproductive printmaking
ingeniously in his works; in effect, these techniques become almost a way of painting. By the
end of the century, photographic methods of color reproduction would make the more labo-
rious and expensive printmaking methods obsolete for purposes of imitating works of art in
other media. At the same time, new reproductive technologies contributed to a renewed ap-
preciation of the original print.

In Francesco Bartolozzi's *Portrait of Lady Smyth and Her Children* (1789; fig. 5.49, color
plate, p. 465), after the elegant, animated portrait by Sir Joshua Reynolds, the old, if rarely
employed, technique of stipple engraving—resuscitated as an alternative to mezzotint in
eighteenth-century English portraiture—provided a wide range of tone as a foundation.[96]
Color was then applied to the plate *à la poupée* (that is, with dabbers made of rag stumps or
cloth-covered cotton fleece). The inking and wiping of the plate—every time it is printed—

thus becomes an even more demanding endeavor than usual, and admits considerable variation from impression to impression.

Sir Isaac Newton's discovery that all colors derive from the three primary hues (red, yellow, and blue) so fascinated Jakob Christoph Le Blon that he published a treatise on the subject entitled *Coloritto, or Harmony of Color Painting* (London, 1725) and set out to prove Newton's theory in a variety of color mezzotints. His hope was to print three plates inked with the primary colors and registered on the same sheet of paper to arrive at a totally coloristic image in imitation of painting. As he developed the process, however, he was forced to add plates in black, browns, and other hues to achieve the desired results. Le Blon's best known print, extant in only four impressions, is his portrait of Louis XV after Nicholas Blakey (1739; fig. 5.50, color plate, p. 466), printed in red, blue, light and dark brown, and black. White ink has also been added to the surface by hand. The muddiness that is apt to occur in color mezzotint (especially as the plates wear) is visible even in this excellent impression from the National Gallery in Washington D.C.[97]

As an imitation of color in painting, Le Blon's superimposition of hues was too simplistic. Our perception of color in painting is the result of numerous factors, for the hue, saturation (intensity), and value of any color are perceived in relation to other colors within the work. It is not likely that any mechanical system of printmaking can arrive at the complexity and richness of color achievable in painting, since the latter depends not only upon blending, but also upon juxtaposition and mutual interaction. Moreover, the print will always lack the texture inherent in painting. The future of color printmaking, therefore, could not lie in an imitation of painting, but in a *graphic* clarity and separation of color (as, for example, in the work of Toulouse-Lautrec and Munch).

Nevertheless, eighteenth-century reproductive printmaking in color represented an impressive technical achievement, whose apogee was the oeuvre of Jean-François Janinet. He abandoned his career as a painter to become an exacting reproductive printmaker, working after major Rococo masters—Lavreince, Fragonard, Boucher, and the architectural painters Hubert Robert, C. L. Clérisseau, and Giovanni Pannini. *Colonnade and Gardens of the Medici Palace* (ca. 1776; fig. 5.51), after Robert, was part of a series of prints of Roman ruins and villas. Like Piranesi, to be discussed in the next chapter, Robert used space to augment the grandeur of the architecture. By placing us low in front, in the company of the sketching artists, he impresses us with the height of the colonnade. Color makes clear the richness of the building materials, and is therefore crucial for Janinet's print. Although his method for duplicating watercolor or ink washes is often described as *lavis* or aquatint, close inspection reveals that he achieved his color primarily through the roulettes and *mattoirs* associated with the crayon and pastel manners. The minute abrasions in the plate held thin films of ink that can easily be mistaken for areas of aquatint or *lavis*. In this print, the delicate blending of hues is accomplished with four plates overprinted in yellow, blue, red, and black (Le Blon's method).[98]

EPILOG: THE NINETEENTH-CENTURY REPRODUCTIVE PRINT AND PHOTOGRAPHY

The invention of early photographic techniques, such as Louis-Jacques-Mandé Daguerre's direct-positive *daguerreotype* (1839) and William Fox Talbot's less time-consuming, albeit less

FIGURE 5.51
Jean-François Janinet
after Hubert Robert.
Colonnade and Gardens
of the Medici Palace.
Ca. 1776. Etching and
lavis-manner engraving
(with crayon-manner
tools) printed in black,
red, yellow and blue
from four plates. 395 ×
300 mm (sheet). Cincin-
nati Art Museum.

exquisite, negative-positive *calotype* (1841), did not immediately displace the reproductive print, as one might imagine. Photography would require a number of improvements before it would be viable as a means of reproducing paintings or sculptures. Problems like lighting conditions surrounding works of art, the photograph's incompatibility with the printing press, and the impermanence of photographic papers kept printmaking a strong contender for control of the reproductive enterprise. Moreover, nineteenth-century technology greatly expanded the number of images that could be printed from plates or blocks. We have already mentioned intaglio plates made of steel. By 1839 woodblocks or metal plates could be duplicated by an electrolysis process called electrotyping, vastly extending the life of an image, and by 1857 copperplates

FIGURE 5.52

*Frederick Hollyer after
Sir Edwin Landseer.* The
Old Shepherd's Chief
Mourner. *1869. Mixed
mezzotint. 655 × 730 mm.
Victoria & Albert
Museum, London.*

could be faced with a thin coat of steel by electrolysis for the same purpose. Chromolithography, the American development of which we will encounter in Chapter 12, could achieve good reproductive results with numerous impressions. It was above all the photograph's inability to produce reliable color, which did not begin to be overcome until the 1880s, that held it back as a reproductive medium.[99]

And despite photography's steady evolution, reproductive prints with an old-fashioned, hand-crafted appearance still had wide appeal as works of art that were accessible to the middle class. Mid-nineteenth-century "art unions" gave away reproductive prints as bonuses to subscribers, who participated in art lotteries to win paintings or small statues—a practice that failed to elevate either public morals or aesthetic tastes, or so critics argued.[100] And popular prints like Frederick Hollyer's mixed mezzotint (1869; fig. 5.52) after Sir Edwin Landseer's painting *The Old Shepherd's Chief Mourner* (1837; Victoria and Albert Museum) capitalized on the sentimental tastes of the Victorian public. Influenced by Stubbs and capable of depicting animals realistically in the wild, Landseer nevertheless anthropomorphized this dog blatantly. The painting was effusively praised by the critic John Ruskin, and one can imagine that the print was framed and hung in many a parlor. Landseer, whose father and brother were engravers, understood the value of reproductive prints as a way to publicize his art and achieve a steady income.[101]

FIGURE 5.53

Ferdinand Gaillard after Jan van Eyck. Man with a Pink. *1869. Engraving published in the* Gazette des Beaux-Arts. *230 × 190 mm. Cleveland Museum of Art.*

Even late in the nineteenth century, printmaking still had much to recommend it as a way of capturing the essential qualities of a painting. Ferdinand Gaillard's *Man with a Pink* (1869; fig. 5.53) after Jan van Eyck is part of a last-ditch movement to assert the value of reproductive engraving. It was paralleled by similar efforts on behalf of etching.[102] Gaillard's print follows in the grand tradition of French engraving, with its extraordinary textural fidelity. This black and white print offers a superb graphic equivalent for the superabundance of detail that Van Eyck achieved in oil paint; the engraver's syntax is beautifully suited to his model. But despite the appeal of Gaillard's solution to the problem of reproduction, photography would outgrow its initial shortcomings and triumph over printmaking to create what André Malraux termed the "museum without walls."[103] Photographic reproduction would lead, in the twentieth century, to a revolution in the study of art history and a "democratization" of the work of art that surpassed that made possible by nineteenth-century reproductive printmaking.

It is against the background of technically polished reproductive prints discussed in this chapter that the works of original printmakers of the eighteenth and early nineteenth centuries must be seen. For although this period saw the fulfillment of Marcantonio Raimondi's legacy (in the sense of the subordination of printmaking to painting and the printmaker's personality to what he was reproducing), it also saw some of the most extravagant examples of graphic idiosyncrasy—William Blake's works, for example—and the most brilliant expressions of

creativity in traditional linear techniques. The rugged vigor of Piranesi's etchings contrasts with the rococo delicacy of Robert's work, reproduced by Janinet, even though both artists treated their architectural subjects with the same loving fascination. Goya turned a tonal method—aquatint—into something that could no longer be regarded as an imitation of ink wash. It is to the original printmakers of this period that we turn in the next two chapters.

NOTES

1. On photomechanical means of reproduction, see Lambert 1987, pp. 107–11. On the rivalry of the reproductive print and photography, see Fawcett 1986.

2. Hind [1923] 1963, pp. 118, 197.

3. Bohlin 1979, pp. 54–56.

4. Bury 1985, p. 16.

5. Robinson 1981, pp. xxxvi–xxxix, especially p. xxxvii.

6. Voltaire [1733] 1877, p. 593.

7. Robinson 1981, p. xxxvii.

8. Quoted in Lambert 1987, p. 169.

9. Vasari [1568] 1850–52, vol. 5, pp. 285–90.

10. See Boorsch 1986, no. 9, pp. 56–57, for a partial list of these engravings.

11. Steinberg 1975, p. 61.

12. Zerner 1969, D.B. [Domenico del Barbiere], no. 3 (not paginated).

13. Riggs 1977, pp. 46–47, 77–80.

14. Boorsch 1986, no. 11, p. 63, n. 3.

15. Ibid., p. 61, for translation of inscription. Also see Wood 1988.

16. Riggs 1977, pp. 337–38, nos. 108–9, fig. 129.

17. Melion 1990, pp. 467–74.

18. Bierens de Haan 1948, pp. 144–46.

19. Gaston 1974 discusses Titian's iconography in detail.

20. Panofsky 1969, pp. 53–57.

21. Melion 1990. On this image, also see Strauss 1977, vol. 1, no. 218, pp. 358–59.

22. See Haskell and Penny 1981, no. 46, pp. 229–32.

23. Ibid., pp. 17–22.

24. On Ghisi's *Farnese Hercules*, see Boorsch 1986, no. 58, pp. 189–91.

25. Strauss 1977, vol. 2, no. 312, pp. 562–63.

26. Bohlin 1979, no. 104, pp. 202–3.

27. For an in-depth discussion of Fontainebleau prints, see Zerner 1969.

28. Mayor 1971, fig. 355.

29. Zerner 1969, A.F. [Antonio Fantuzzi], no. 72 (not paginated).

30. Ibid., J.M. [Jean Mignon], no. 7.

31. Ibid., P.M. [Pierre Milan], no. 7; L.D. [Monogrammist L.D.], no. 8.

32. Pillsbury and Richards 1978, p. 99.

33. Strauss and Van der Meulen 1979, p. 369.

34. Sandrart [1675] 1925, p. 180.

35. Ackley 1981, no. 44, pp. 73–75.

36. See Judson and Van de Velde 1977 for a thorough treatment of Rubens' book illustrations and title pages. Basic studies of Rubens' reproductive prints are Renger 1974, Renger 1975, and De Pauw-De Veen 1977. On Jegher's woodcuts after Rubens, see Myers 1966.

37. Pohlen 1985, pp. 41–42, and no. 10, pp. 199–200, favors a later date of 1617–18.

38. Quoted in De Pauw-De Veen 1977, p. 244.

39. For a thorough discussion of the style and iconography of these altarpieces, see Martin 1969, pp. 37–52.

40. Ibid., p. 44.

41. De Pauw-De Veen 1977, pp. 246–47.

42. Magurn 1955, letter no. 36, pp. 69, 443.

43. See Adhémar 1964, p. 9. On Rubens and Vosterman, see Held 1969.

44. Martin 1969, p. 39.

45. Goodman 1982.

46. De Pauw-De Veen 1977, p. 249.

47. Clark 1987, pp. 16–17.

48. For a discussion of French engraved portraiture in the seventeenth century, see Harris 1987, pp. 64–75.

49. Melot, Griffiths, and Field 1981, pp. 77–78. On the eighteenth-century engraved portrait, see Campbell 1985. Also see Johnson 1982.

50. In Melot, Griffiths, and Field 1981, p. 79.

51. Clark 1987, p. 54.

52. Robinson 1981, p. xxxix.

53. On Nanteuil and the Edict of St. Jean de Luz, see Hind [1923] 1963, p. 146, and also Harris 1987, pp. 67–72. On the print and neoclassicism, see Levitine 1985, pp. 19–20.

54. Quoted in Lambert 1987, p. 149.

55. Bréjon de Lavergnée 1981, pp. 445–55.

56. Dargent 1959, pp. 31–40.

57. See Wildenstein 1955; Davies and Blunt 1962, on prints after Poussin. On Poussin's paintings, see Blunt 1967.

58. Lagerlöf 1990, pp. 68–69.

59. Posner 1959.

60. On the Drevet school of engravers, see Harris 1987, pp. 110–16.

61. On the *portrait d'apparat,* see Campbell 1985, pp. 30–31.

62. Grasselli and Rosenberg 1984, Posner 1984, and Roland Michel 1984 celebrate Watteau's three-hundredth birthday.

63. Watteau's original etchings are discussed by Parmentier 1984.

64. On Crozat, see Crow 1985, pp. 39–44; Haskell 1987.

65. Roland Michel 1984, p. 267.

66. Ibid., pp. 269–70.

67. Levey 1961; see Grasselli and Rosenberg 1984, no. 61, pp. 400–401 for further discussion and bibliography.

68. Grasselli and Rosenberg 1984, no. 61, pp. 400–401.

69. Ferraton 1976.

70. See Carlson and Ittmann 1985, no. 15, pp. 79–81.

71. Lambert 1987, pp. 121–25.

72. Adhémar 1964, pp. 133–35.

73. See Slatkin 1972.

74. See Posner 1982.

75. Taylor 1987, pp. 518–22.

76. Quoted in Adhémar 1964, p. 164.

77. Duncan 1982.

78. Crow 1985, p. 137.

79. Mariette 1851–53, p. 359. Also cited in Adhémar 1964, p. 122.

80. Crow 1985, p. 147.

81. Adhémar 1964, p. 120.

82. Haskell and Penny 1981, no. 52, pp. 246–47, discuss the various restoration attempts.

83. Ivins [1953] 1982, pp. 89–90, and figs. 73a–77b.

84. Wax 1990, pp. 13–20.

85. Ibid., pp. 36–39.

86. On the tradition of English mezzotint portraits after Reynolds, see Griffiths 1978, pp. 32–24; Harris 1987, pp. 124–34.

87. Wax 1990, p. 83. On Stubbs's lion and horse paintings, see Taylor 1965.

88. Wees 1986, pp. 29–30.

89. Matteson 1981. For further discussion of Martin's *Deluge,* see Feaver 1975, pp. 92–95.

90. Mayor 1971, fig. 515.

91. Bermingham 1986, pp. 151–52.

92. See Griffiths 1987 for a discussion of the early development of aquatint.

93. Bermingham 1986, p. 40. On Gainsborough's landscape prints, see Hayes 1971.

94. Hayes 1971, p. 29.

95. For an introduction to eighteenth-century color printmaking, see Ittmann 1985, pp. 22–24.

96. Harris 1987, pp. 134–36.

97. See Fine 1982, no. 59, pp. 174–75; Carlson and Ittmann 1985, no. 24, pp. 2, 100–101. Also see Lilien 1985 on Le Blon.

98. See Carlson and Ittmann 1985, no. 90, pp. 258–59.

99. Fawcett 1986.

100. On art unions, see Smith 1986.

101. On Landseer's prints, see Dyson 1984. Ruskin's response to the painting is quoted in Ormond 1981, p. 111. On Victorian popular prints in general, see Dix 1983, pp. 55–65.

102. Fawcett 1986, p. 203.

103. Malraux [1953] 1978, pp. 13–16.

REFERENCES

Ackley, Clifford. 1981. *Printmaking in the Age of Rembrandt.* Exhibition catalog with an essay by William W. Robinson. Museum of Fine Arts, Boston.

Adhémar, Jean. 1964. *Graphic Art of the Eighteenth Century.* New York.

Bermingham, Ann. 1986. *Landscape and Ideology: The English Rustic Tradition, 1740–1860.* Berkeley, Calif.

Bierens de Haan, J.C.J. 1948. *L'oeuvre gravé de Cornelis Cort: Graveur hollandais 1533–1578.* The Hague.

Blunt, Anthony. 1967. *Nicolas Poussin.* 2 vols. New York.

Bohlin, Diane DeGrazia. 1979. *Prints and Related Drawings by the Carracci Family.* Exhibition catalog. National Gallery of Art, Washington, D.C.

Boorsch, Suzanne. 1986. *The Engravings of Giorgio Ghisi.* Exhibition catalog with catalogue raisonné by Michal Lewis and R.E. Lewis. Metropolitan Museum of Art, New York.

Bréjon de Lavergnée, Barbara. 1981. New Light on Michel Dorigny. *Master Drawings,* vol. 19, no. 4, pp. 445–55.

Broude, Norma, and Mary D. Garrard, eds. 1982. *Feminism and Art History: Questioning the Litany.* New York.

Bury, Michael. 1985. The Taste for Prints in Italy to c. 1600. *Print Quarterly,* vol. 2, no. 1 (March), pp. 12–26.

Campbell, Richard. 1985. The Portrait Print: Traditions and Transformations. In Carlson and Ittmann 1985, pp. 28–35.

Carlson, Victor I., and John W. Ittmann. 1985. *Regency to Empire: French Printmaking 1715–1814.* Exhibition catalog with contributions by Victor I. Carlson, John W. Ittmann, David P. Becker, Richard Campbell, Jay McKean Fisher, George Levitine, and Mary L. Myers. Baltimore Museum of Art, Baltimore, and Minneapolis Institute of Arts, Minneapolis.

Clark, Alvin, L., Jr. 1987. *From Mannerism to Classicism: Printmaking in France, 1600–1660.* Exhibition catalog. Yale University Art Gallery, New Haven, Conn.

Clifford, Timothy, Antony Griffiths, and Martin Royalton-Kisch. 1978. *Gainsborough and Reynolds in the British Museum.* Exhibition catalog. British Museum, London.

Crow, Thomas E. 1985. *Painters and Public Life in Eighteenth-Century Paris.* New Haven, Conn.

Dargent, Georgette. 1959. La Madeleine dans l'oeuvre de Simon Vouet. *Bulletin de la Société de l'Histoire de l'Art Français,* pp. 31–40.

Davies, Martin, and Anthony Blunt. 1962. Some Corrections and Additions to M. Wildenstein's "Graveurs de Poussin au XVII siècle." *Gazette des Beaux Arts,* 6th ser., vol. 60, pp. 205–22.

De Pauw-De Veen, Lydia. 1977. Rubens and the Graphic Arts. *Connoisseur,* vol. 195, pp. 243–51.

Dix, Brenda R. 1983. *Pictures for the Parlour: The English Reproductive Print from 1775 to 1900.* Exhibition catalog. Art Gallery of Ontario, Toronto.

Duncan, Carol. 1982. Happy Mothers and Other New Ideas in Eighteenth-Century French Art. In Broude and Garrard, eds., 1982, pp. 202–19.

Dyson, Anthony. 1984. Images Interpreted: Landseer and the Engraving Trade. *Print Quarterly,* vol. 1, no. 1 (March), pp. 29–43.

Fawcett, Trevor. 1986. Graphic Versus Photographic in the Nineteenth-Century Reproduction. *Art History,* vol. 9, no. 2 (June), pp. 185–212.

Feaver, William. 1975. *The Art of John Martin.* Oxford.

Ferraton, Claude. 1976. "L'embarquement pour Cythère" de Watteau. *Jardin des Arts,* vol. 149 (July–August), pp. 81–91.

Fine, Ruth E. 1982. *Lessing J. Rosenwald: Tribute to a Collector.* Exhibition catalog. National Gallery of Art, Washington, D.C.

Gaston, Robert W. 1974. Vesta and the Martyrdom of St. Lawrence in the Sixteenth Century. *Journal of the Warburg and Courtauld Institutes,* vol. 37, pp. 358–62.

Goodman, Elise. 1982. Rubens's *Conversatie à la Mode:* Garden of Leisure, Fashion, and Gallantry. *Art Bulletin,* vol. 64, no. 2 (June), pp. 247–59.

Grasselli, Margaret Morgan, and Pierre Rosenberg. 1984. *Watteau: 1684–1721.* Exhibition catalog with contributions by Nicole Parmantier, Ségolène Bergeon, Lola Faillant-Dumas, and Sarah L. Fisher. National Gallery of Art, Washington, D.C.

Griffiths, Antony. 1978. *Prints after Reynolds and Gainsborough.* In Clifford, Griffiths, and Royalton-Kisch 1978, pp. 29–42.

Griffiths, Antony. 1987. Notes on Early Aquatint in England and France. *Print Quarterly,* vol. 4, no. 3. (September), pp. 255–70.

Harris, Constance. 1987. *Portraiture in Prints.* London.

Haskell, Francis. 1987. *The Painful Birth of the Art Book.* London.

Haskell, Francis, and Nicholas Penny. 1981. *Taste and the Antique.* New Haven, Conn.

Hayes, John. 1971. *Gainsborough as a Printmaker.* New Haven, Conn.

Held, Julius S. 1969. Rubens and Vorsterman. *Art Quarterly,* vol. 22, no. 2, pp. 111–29.

Hind, Arthur M. [1923] 1963. *A History of Engraving and Etching.* Reprint ed. New York.

Ittmann, John W. 1985. The Triumph of Color: Technical Innovations in Printmaking. In Carlson and Ittmann 1985, pp. 22–27.

Ivins, William M. [1953] 1982. *Prints and Visual Communication.* Reprint ed. New York.

Johnson, W. McAllister. 1982. *French Royal Academy of Painting and Sculpture Engraved Reception Pieces: 1672–1789.* Kingston, Canada.

Johnson, W. McAllister. 1986. Paintings, Provenance and Price: Speculations on the Eighteenth-Century Connoisseurship Apparatus in France. *Gazette des Beaux-arts,* 6th ser., vol. 107 (May–June), pp. 191–99.

Judson, J. Richard, and Carl van de Velde. 1977. *Book Illustrations and Title-Pages (Corpus Rubenianum Ludwig Burchard).* 2 vols. Brussels.

Lagerlöf, Margaretha Rossholm. 1990. *Ideal Landscape: Annibale Carracci, Nicolas Poussin and Claude Lorrain.* New Haven, Conn.

Lambert, Susan. 1987. *The Image Multiplied.* New York.

Levey, Michael. 1961. The Real Theme of Watteau's "Embarkation for Cythera." *Burlington Magazine,* vol. 103, no. 698 (May), pp. 180–85.

Levitine, Georges. 1985. French Eighteenth-Century Printmaking in Search of Cultural Assertion. In Carlson and Ittmann 1985, pp. 10–21.

Lilien, Otto M. 1985. *Jacob Christoph Le Blon 1667–1741: Inventor of Three- and Four-Colour Printing.* Stuttgart.

Magurn, Ruth. 1955. *The Letters of Peter Paul Rubens.* Cambridge, Mass.

Malraux, André. [1953] 1978. *The Voices of Silence.* Reprint ed. Princeton, N.J.

Mariette, Pierre-Jean. 1851–53. *Abecedario de P.J. Mariette et autres notes inédites de cette amateur sur les arts et les artistes,* vol. 1. Annotated by Ph. de Chennevieres and A. de Montaiglon. Paris.

Martin, John Rupert. 1969. *Rubens: The Antwerp Altarpieces.* New York.

Matteson, Lynn R. 1981. John Martin's "The Deluge": A Study in Romantic Catastrophe. *Pantheon,* vol. 39, pp. 220–28.

Mayor, A. Hyatt. 1971. *Prints and People.* New York.

Melion, Walter. 1990. Hendrick Goltzius's Project of Reproductive Engraving. *Art History,* vol. 13, no. 4 (December), pp. 458–87.

Melot, Michel, Antony Griffiths, and Richard S. Field. 1981. *Prints: History of an Art.* New York.

Myers, Mary L. 1966. Rubens and the Woodcuts of Christoffel Jegher. *Metropolitan Museum Bulletin,* vol. 25, no. 1 (Summer), pp. 7–23.

Ormond, Richard. 1981. *Sir Edwin Landseer.* New York.

Panofsky, Erwin. 1969. *Problems in Titian: Mostly Iconographic.* New York.

Parmantier, Nicole. 1984. The Etchings. In Grasselli and Rosenberg 1984, pp. 227–39.

Pillsbury, Edmund P., and Louise S. Richards. 1978. *The Graphic Art of Federico Barocci: Selected Drawings and Prints.* Exhibition catalog. Cleveland Museum of Art, Cleveland.

Pohlen, Ingeborg. 1985. *Untersuchung zur Repro-duktionsgraphik der Rubenswerkstatt.* Munich.

Posner, Donald. 1959. Charles Le Brun's *Triumphs of Alexander. Art Bulletin,* vol. 41, no. 3 (September), pp. 237–48.

Posner, Donald. 1982. The Swinging Women of Watteau and Fragonard. *Art Bulletin,* vol. 64, no. 1 (March), pp. 75–88.

Posner, Donald. 1984. *Antoine Watteau.* London and Ithaca, N.Y.

Renger, Konrad. 1974. Rubens Dedit Dedicavitque: Rubens' Beschäftigung mit der Reproduktionsgrafik, I Teil: Der Kupferstich. *Jahrbuch der Berliner Museen,* vol. 16, pp. 122–75.

Renger, Konrad. 1975. Rubens Dedit Dedicavitque: Rubens' Beschäftigung mit der Reproduktionsgrafik, II Teil: Radierung und Holzschnitt—Die Widmungen. *Jahrbuch der Berliner Museen,* vol. 17, pp. 166–213.

Riggs, Timothy A. 1977. *Hieronymus Cock: Printmaker and Publisher.* New York.

Robinson, William W. 1981. "This Passion for Prints": Collecting and Connoisseurship in Northern Europe during the Seventeenth Century. In Ackley 1981, pp. xxvii–xlviii.

Roland Michel, Marianne. 1984. *Watteau: An Artist of the Eighteenth Century.* New York.

Sandrart, Joachim von. [1675] 1925. *Academie der Bau- und Bild- und Mahlery-Künste von 1675.* Commentary by A. R. Pelzer. Munich.

Slatkin, Regina Shoolman. 1972. Some Boucher Drawings and Related Prints. *Master Drawings,* vol. 10, no. 3 (Autumn), pp. 264–83.

Smith, Roger. 1986. The Rise and Fall of the Art Union Print. *Print Quarterly,* vol. 3, no. 2 (June), pp. 95–108.

Steinberg, Leo. 1975. Michelangelo's "Last Judg-ment" as Merciful Heresy. *Art in America,* vol. 63 (November–December), pp. 48–63.

Strauss, Walter L. 1977. *Hendrik Goltzius 1558–1617: The Complete Engravings and Woodcuts.* 2 vols. New York.

Strauss, Walter L., and Marjon van der Meulen. 1979. *The Rembrandt Documents.* New York.

Taylor, Basil. 1965. George Stubbs: "The Lion and Horse" Theme. *Burlington Magazine,* vol. 107, pp. 81–86.

Taylor, Sean J. 1987. Pendants and Commercial Ploys: Formal and Informal Relationships in the Work of Nicolas Delaunay. *Zeitschrift für Kunstgeschichte,* vol. 50, no. 4, pp. 509–38.

Vasari, Giorgio. [1568] 1850–52. *Lives of the Most Eminent Painters, Sculptors, Architects.* 5 vols. Trans. Mrs. Jonathan Foster. London.

Voltaire, François. [1733] 1877. Variantes du Temple du goût. In *Oeuvres complètes de Voltaire,* vol. 8, Paris.

Wax, Carol. 1990. *The Mezzotint: History and Technique.* New York.

Wees, J. Dustin. 1986. *"Darkness Visible": The Prints of John Martin.* Exhibition catalog. Sterling and Francine Clark Institute, Williamstown, Mass.

Wildenstein, Georges. 1955. Les graveurs de Poussin au XVII siècle. *Gazette des Beaux Arts,* 6th ser., vol. 46, pp. 77–371.

Wood, Jeremy. 1988. Cannibalized Prints and Early Art History: Vasari, Bellori, and Fréart de Chambray on Raphael. *Journal of the Warburg and Courtauld Institutes,* vol. 51, pp. 210–20.

Zerner, Henri. 1969. *The School of Fontainebleau: Etchings and Engravings,* New York.

6

Original Etching and Engraving

in the Eighteenth and

Early Nineteenth Centuries

ITALY: *VEDUTE, CAPRICCI,* CANALETTO

The eighteenth and early nineteenth centuries were not only the great era of the highly refined reproductive print, but also the period in which the appreciation and connoisseurship of original prints was developed. This pivotal epoch is marked at one end by a collector like Jan Pietersz. Zomer (1641–1724), whom we encountered in Chapter 4, with his pioneering concern for states and quality of impressions, and at the other end by the monumental twenty-one-volume catalog of the *peintre-graveurs* (painter-printmakers) compiled between 1803 and 1821 by Adam Bartsch (1757–1821), Director of the Imperial Print Collection in Vienna. The reproductive print was definitively demoted.

The autographic qualities of the original print were epitomized in Italy by Canaletto, the Tiepolos (Giambattista and his son Domenico), and especially Piranesi. These artists perfected the Italian approach to etching, which was dominated by a basic simplicity and respect for the innate character of the etched line. Piranesi, however, modified this approach by intensifying the range of biting and, hence, tonal contrasts. Along with this powerful chiaroscuro, their impressive scale and the unflagging grandeur with which they are composed make Piranesi's

works a high point in the history of etching. That they are principally architectural views does not diminish their capacity to move us, for Piranesi's architecture is moody, drenched in the human history that produced and inhabited it. It is also "capricious," even when real, and expresses the considerable imaginative powers of the artist.

Piranesi's works have their roots in the tradition of the printed *veduta* (actual view) and the architectural *capriccio* or fantasy. Ruins were important for both categories, but especially for the *capriccio*. As vestiges of the magnificence of bygone civilizations, particularly ancient Rome, ruins had long fascinated artists and their audience (think of the *Hypnerotomachia Poliphili;* figs. 3.26, 3.27). At once sad and awesome, foliage-covered, crumbling ruins expressed the inexorable passage of time and corresponded therefore to the themes of *vanitas* or *memento mori* so popular in Renaissance and Baroque art. But they also spoke of past human achievements, of the history of civilization and its outward manifestation: architecture. Literally and figuratively monumental, the *capriccio* blended the elements of antiquity together in ways that were more expressive than real ruins generally were, for the accidents of history seldom gave consideration to aesthetic effects. Closely related to the architectural *capriccio* was the art of stage design, which also flourished during the eighteenth century. It too brought together architectural drawing, the knowledge of antiquity, the romance of ruins, and the artist's power of invention.

Marco Ricci's *Experimenta* was published in 1730, one year after his death. Born in Belluno, Ricci participated in the flowering of art in early eighteenth-century Venice. One print from his publication centers on a huge groin vault, the darkened underside of which frames a sunlit middleground (fig. 6.1). There, a round Ionic temple and an equestrian figure—one thinks immediately of the *Marcus Aurelius* on the Capitoline Hill in Rome and its Renaissance descendants—recall the religion as well as the politics of the Roman Empire. In the foreground, figures climb on the remains of a massive entablature, the sculpted capital, and the cracked, detached shaft of a column. Above at the left, a decapitated figure reclines on a sarcophagus, a *memento mori* poignantly juxtaposed to a living figure who casually leans against its pedestal. The small child held by the woman at the right reminds us that life goes on. Characteristically Venetian is this work's hazy luminosity and richness of texture.

The best known of the view painters was Giovanni Antonio Canal, called Canaletto. In a series of thirty-one stunning etchings executed in Venice between 1740 and 1743, Canaletto perfected the printed topographical view. In his title, however, he indicated that some of the prints were not actual views of the city—"vedute presa i luoghi," taken on the spot—but were "vedute ideate," imaginary views. Canaletto's project was dedicated to his patron, the British consul in Venice, Joseph Smith, who, significantly, bound the prints in leather albums along with Canaletto's *drawings*. As Francis Haskell has noted, the etchings represent a "deeply felt, informal, often poignant vision" that differed markedly from the paintings Canaletto produced for Smith.[1]

The Piazzetta or *La Piera del Bando* (fig. 6.2) depicts a scene on the "little piazza" near the larger Piazza of San Marco. Canaletto featured not only the façade of the doge's palace, with its arcades of pointed arches and centered balcony, but also the fragment of the huge porphyry column that served as a speaker's platform (*la piera del bando*). The crowd shuffles about as a decree is read, lending the scene an air of busy, day-to-day reality. On the other hand, *Arch with a Lantern* (fig. 6.3) is an imaginary, lonely view with only several figures to give a sense of scale and life to the ancient, or dilapidated contemporary, buildings. A temple

FIGURE 6.1

Marco Ricci. Land-
scape with Figures and
Ruins (Capriccio)
from Experimenta. *1730.
Etching. 426 × 315 mm.
Museo Correr, Venice.*

and triumphal arch coexist with common dwellings. Whereas the *Piazzetta*'s foreground is sunlit, that of *Arch with a Lantern* is in shadow, thus framing the luminous, beckoning central horizon, with its silhouetted ships. The darkened lantern hanging from the arch also sets off the clear, open sky. Canaletto's etching technique is a model of simplicity, even though he employed double biting. There is no cross-hatching, just quivering lines, long or short, layered or etched more deeply for darkness. The result is a magical translucency: the very opposite of the linear precision and dense detail of many of the engraved and even etched *vedute*.

In response to the market for printed views of the city created by Venetian tourism, the more prosaic Michele Marieschi published his *Magnificentiores Selectioresque Urbis Venetiarum Prospectus,* a book of "magnificent and selected" views of Venice, in 1741. In contrast to Canaletto, he chose straightforward or otherwise unimaginative spatial perspectives and gave his prints a more uniform lighting. Few details of architectural landmarks or even ordinary structures, such as those on the Grand Canal, are overlooked (fig. 6.4). To the left is the restrained Church of SS. Simeone e Giuda, designed by Giovanni Scalfarotto, an older colleague of Piranesi's architect uncle, Matteo Lucchesi, and the master of Piranesi himself. Since *vedute* were born out of tourism, the need to depict a scene in all its detail was inherent: it took an exceptional artist like Canaletto or Piranesi to overcome the commercial requirements of this genre.

THE TIEPOLOS

The most prominent painter of eighteenth-century Venice was Giovanni Battista (Giam-
battista) Tiepolo. Busy with extensive fresco commissions (from the king of Spain and the
prince-bishop of Wurzburg, for example), he had little time for printmaking. But his small
oeuvre of thirty-five etchings is nevertheless outstanding. Only his *Adoration of the Magi* is

FIGURE 6.4

Michele Marieschi.
View of the Grand
Canal, Venice *from*
Magnificentiores
Selectioresque Urbis
Venetiarum Prospectus.
1741. Etching. 315 ×
466 mm. New York
Public Library.

based on a painting, now lost. The remainder of his graphic oeuvre consists of the ten prints of the *Capricci*, the twenty-three of the *Scherzi di Fantasia* (literally, "jokes of fantasy"), and a *Joseph Holding the Infant Christ*, which may have been intended as part of the latter series, along with the *Adoration*.

The *Capricci* and the *Scherzi* are absorbing and still unsolved puzzles. The former prints are horizontal in format; all but two of the latter are vertical. The greater sketchiness and freedom of the *Capricci* have suggested to some scholars an earlier date (ca. 1740?) than the more detailed *Scherzi* (late 1740s or 1750s?). However, the same visual evidence has led some to the opposite conclusion.[2] In terms of visual motifs and meaning, the two series are closely related. In both, motley groups of figures—magicians, satyrs, philosophers, gypsies, soldiers— gather with owls, dogs, monkeys, horses, and serpents in ramshackle settings of altars, piled ruins, skulls, urns, weapons, and other assorted objects. In contrast to the more purely architectural *capriccio*, these prints deal with human "flotsam and jetsam" as well: characters, sometimes from the fringes of civilization, who come together for unspecified and perhaps sinister purposes.

The only readily decipherable print from the *Capricci* is *Death Giving Audience* (fig. 6.5). The reader will recognize the familiar confrontation of the living with the skeletal personification of mortality, who looks through a large book, presumably containing the names of imminent victims. The crowd that anxiously awaits his word is varied. The prominent, peering figure leaning against the block is perhaps marked as a magician by his exotic headdress. Farther back, a soldier holds a lance and shield. The etching technique betrays a gifted draughtsman trying out a new drawing tool: the etching needle skims lightly and a little hesitantly over the surface of the plate, digging in here and there to produce scratchy areas of shadow. Tiepolo's compositions are an airy version of the Venetian Baroque, ultimately derived from the diagonal figure groupings and free movement of the paintings of Titian, Veronese, and Tintoretto.

In another one of the *Capricci,* a soldier tries to control a rebellious horse: again, an intelligible motif expressing the need to subdue the baser passions so long represented by this animal (think back to Baldung's *Bewitched Groom,* fig. 2.20). Yet most of the prints are, to our eyes at least, obscure. Here, in figure 6.6, a calm, pastoral mood seems to contradict the scene

Giovanni Battista Tiepolo. Death Giving Audience *from the* Capricci. *Ca. 1740?* Etching. 140 × 176 mm. National Gallery of Art, Washington, D.C.

Giovanni Battista Tiepolo. Nymph and Satyr Child *from the* Capricci. *Ca. 1740?* Etching. 140 × 174 mm. National Gallery of Art, Washington, D.C.

with the Grim Reaper just discussed. The landscape is luminous, and a lovely woman holds a goat-legged satyr child and a tambourine. She looks wistfully toward a city in the distance, as if she were forever cut off from the companionship afforded by civilization. When we consider the various negative connotations of the goat—at best an uncanny, scavenging animal; at worst, a familiar of witches or the embodiment of Satan—we realize that this is indeed a wild group.

The piling up of objects in Tiepolo's two series is much like the paraphernalia of witch-craft imagery (compare Baldung's famous woodcut, fig. 2.19). It also recalls Castiglione's *Diogenes,* in which the philosopher searches for an honest man amid ruins while a horse's skull,

FIGURE 6.7

*Giovanni Battista
Tiepolo. Title page from
the* Scherzi di Fantasia.
*Late 1740s–50s? Etching.
226 × 180 mm. National
Gallery of Art, Wash-
ington, D.C.*

a monkey, an owl, and a herm of Pan (related to satyrs) appear on the right. Another precedent
might be Rosa's *Democritus* (fig. 4.5), with its brooding philosopher surrounded by the relics
of civilization, and life itself, in total disarray.

The picturesque, often slightly scary, heaps of creatures and objects are more impressive
in the *Scherzi,* whose beautiful title page (fig. 6.7) is populated by menacing owls, nocturnal
harbingers of evil. One can imagine Goya's delight when he saw the line of staring birds
perched atop the huge stone, for Tiepolo's series was to serve the Spaniard well. Its twenty-one
vertical prints have roughly the same proportions as Goya's *Caprichos,* and he frequently recalls
Tiepolo's diagonal compositions. Is there any relationship in meaning? This is more difficult
to determine than the obvious formal resemblance between the two sets of "caprices."

Goya's series is more profound and far-ranging, but among its many aims is the dispelling
of superstition. Most of Tiepolo's *Scherzi* contain magicians or sorcerers as their main charac-
ters. The followers who gather around focus their attention on an object, such as an altar where
bones, or in one case a head with the flesh still on it, are being consumed by the flames. In one
print the bent shoulders and surly, lined face of the old magician are mimicked by a fat urn on
top of the remains of a stone pedestal (fig. 6.8). In another, the crowd anxiously regards a large,
coiling snake; in another, an effigy of Punchinello (from the Commedia dell'Arte); in yet
another, the grotesque character himself (fig. 6.9). Throughout the series, there is a sense of

FIGURE 6.8

Giovanni Battista Tiepolo. Magician Pointing Out a Burning Head to Two Youths *from the* Scherzi di Fantasia. *Late 1740s–50s? Etching. 225 × 175 mm. National Gallery of Art, Washington, D.C.*

surreptitious gatherings of wandering people, perennially in flight and looking for magical knowledge of the universe (a recurring globe suggests this). The books, possibly *grimoires* or books of magic, urns (containers for magical substances?), mirrors (instruments of divination), musical instruments, goats, and satyrs all betray a nomadic existence and a kind of pagan wisdom that, from the standpoint of Christianity, is not wisdom at all because it remains unenlightened by Christ. The characters of Tiepolo's *Scherzi* are locked in ignorance because they reject or do not yet know of the true source of wisdom.

Herein lies the probable significance of Domenico Tiepolo's inclusion with the *Scherzi* of *Joseph Holding the Infant Christ* and the *Adoration of the Magi*.[3] Beyond this general contrast of true and false wisdom, it is perhaps a mistake to overanalyze either of Tiepolo's series,[4] because it is clear that he regarded neither as a major enterprise. Indeed, he lacked the time to correct the plates technically: foul-biting recurs in the *Scherzi*. We know that Domenico sent four of the prints to their publisher, Antonio Maria Zanetti, with the suggestion that Pierre-Jean Mariette, the important French connoisseur and collector who was to be the recipient, touch up the impressions by hand himself.[5]

Zanetti, a remarkable combination of print publisher, printmaker, and print-collector,

FIGURE 6.9

Giovanni Battista Tiepolo. Punchinello Talking to Two Magicians *from the* Scherzi di Fantasia. *Late 1740s–50s? Etching, reworked with pen and brown ink. 223 × 184 mm. National Gallery of Art, Washington, D.C.*

served as a link between the Venetian art world and the rest of Europe. Not only did he correspond with Mariette, but he was a close friend of Mariette's friend, Pierre Crozat, whose *Cabinet de Crozat* we discussed in Chapter 5. Zanetti was especially proud of his print collection's comprehensiveness, describing it as exceeding "anything that might be expected of a private citizen." However, he most savored the autographic qualities of etchings by Rembrandt and Castiglione, and the mannerist and picturesque elements of da Carpi's chiaroscuro woodcuts and Callot's etchings. Zanetti's cousin, Antonio Maria the Younger, distinguished two kinds of people who appreciated prints: the general public, who preferred "carefully finished prints, and especially those with strong contrasts of light and shade," and artists and connoisseurs, "who like prints engraved with great speed and liveliness and with broad strokes." Of course, Zanetti the Elder was the latter kind of print-lover, and Tiepolo's luminous, sketchy etchings corresponded exactly to his tastes.[6]

The younger Tiepolo carried on his father's approach, but was a more prolific and in some ways a more skilled etcher. He produced two major series, the *Via Crucis* (*Way of the Cross*) in 1749, and the *Flight into Egypt* in 1753. The former depicts the episodes between Christ's condemnation and Entombment that were more or less codified at the end of the

FIGURE 6.10

Giovanni Domenico Tiepolo. Jesus Condemned to Death *from the* Via Crucis. *1749. Etching. 210 × 183 mm. National Gallery of Art, Washington, D.C.*

seventeenth century into the Stations of the Cross.[7] In terms of the history of prints, Domenico's series of fourteen images, plus a frontispiece featuring the Instruments of the Passion with Golgotha in the distance, bears much in common with Passion series of the past, like Dürer's, but has a narrower focus: the bearing of, and death upon, the cross itself.

The first print is *Jesus Condemned to Death* (fig. 6.10). Here Domenico drew upon Rembrandt's *Christ Presented to the People* (figs. 4.52, 4.53) but interpreted his graphic precedent in his own way, abruptly contrasting foreground and background and emphasizing the view from below. Unlike Rembrandt's print, this is a true Ecce Homo, with Christ already beaten and mocked and wearing the Crown of Thorns. His placement atop a Roman arch, flanked by a large Corinthian column and with a winged female personification in its spandrel, is indicative of his eventual triumph over paganism. To the right, a muscular figure holds the cross that Christ is to carry. Mostly in shadow, these elements are ominous portents of what is to come.

The younger Tiepolo's etching skill is amply revealed in the light effects of this print. Strong tonal contrasts separate the foreground crowd from Christ both spatially and symbolically. The whole is pervaded by the bright sunlight, made more emphatic by a cloudless sky, that also characterizes the Tiepolos' paintings.

The Flight into Egypt (Matt. 2:1–12) protected the Christ child from the wrath of Herod, who was threatened by predictions of a triumphant king who would supplant him. The journey of the Holy Family was elaborated upon in the apocryphal scriptures and other writings as

FIGURE 6.11

Giovanni Domenico Tiepolo. Joseph, Standing, Adores the Child *from the* Flight into Egypt. *1753. Etching. 187 × 243 mm. National Gallery of Art, Washington, D.C.*

well as in art.[8] Domenico's images are conceived with a freshness and warmth that transcend the traditionalism of the theme. Published in 1753 and dedicated to the prince-bishop of Wurzburg, for whom the Tiepolos were working at the time, the *Flight* was presumably composed partly in Venice and partly in Wurzburg.

Joseph, Standing, Adores the Child (fig. 6.11) epitomizes the spontaneous charm of the *Flight* etchings. Joseph turns impetuously to look at the infant as a coterie of angels hovers protectively behind them. Here, Joseph is conceived as a vigorous, patriarchal figure. He is also rendered younger, and then older and weaker, in the series. This perhaps reflects various theological views. Although Domenico depicted him as the heroic protector of Mary and Jesus, fully cognizant of Christ's purpose, Christian art did not always view Joseph in such a positive light. There is a tradition for seeing him as a bumbling and unenlightened fool.[9] The general mood springing from the love of those surrounding the infant Christ also pervades the peaceful landscape and dappled lighting. Even the patient, scruffy donkey is appealing. The piling up of forms to one side and their placement against an open, light-filled distance is typically Tiepolesque.

PIRANESI: "THESE SPEAKING RUINS . . ."

In contrast to the Tiepolos, Giovanni Battista (Giambattista) Piranesi was not a painter. Since his numerous etchings are almost all architectural, we might say that he fulfilled on paper his early training as an architect. Only one of the structures he designed, S. Maria del Priorato

in Rome, was ever built.[10] The combination of architect and printmaker resulted in an architectural polemicist: a man with strong aesthetic ideas and the means to circulate them. Piranesi, who loved a good argument, was drawn into the eighteenth-century debate regarding the comparative virtues of Greek and Roman aesthetics. He vehemently defended the ancient Romans against an increasing idolization of the Greeks. But these theoretical ideas developed gradually. It is best to begin with Piranesi's background in Venetian art and his lengthy involvement with Roman ruins.

Considering that Piranesi and Rome are so inextricably linked, it is perhaps surprising to realize the great importance of Venice, near which he was born, for his development. Not only was the best original etching in the eighteenth century done in Venice by Ricci, the Tiepolos, and Canaletto, but, as we have seen, the *veduta* and *capriccio* traditions were well established there. Both were crucial for Piranesi. His uncle's employment as an engineer with the Venetian waterworks that maintained the city's hydraulic system, and his apprenticeship to the architect Scalfarotto, who also worked with the waterworks, must have given the young man knowledge of and respect for engineering, at which the ancient Romans excelled. Almost equally important for him was stage design, exemplified in Venice by the Bibiena family. Ferdinando Bibiena's *L'Architettura Civile* (*Civic Architecture*) of 1711 provided designs in which complex and divergent architectural perspectives replaced the more traditional single-point view. There is much that is theatrical about Piranesi's etchings. He learned to use spatial sensations and light as stage designers and lighting directors do—to create mood.[11]

In 1740 Piranesi was appointed to the retinue of the Venetian ambassador to Pope Benedict XIV as a draughtsman. The wealth of architectural experience available in the Eternal City, where ancient Roman, early Christian, medieval, Renaissance, and Baroque structures coexisted as nowhere else, stimulated the young man's imagination. His brother, a Carthusian monk, had already imbued him with a fascination for the Latin past, and it was indeed the ruins of ancient Rome that captivated Piranesi most thoroughly. But the importance for Piranesi of the contrast of old and new, and of the incongruous juxtaposition of buildings of different epochs, of decaying ruins with living people, and of dismembered parts with whole structures, should not be forgotten. By themselves, ruins lack the drama that he was to give them by exploiting such contrasts. Coming from a Venetian background, he also knew how to utilize textures, light, and spatial effects so that travelers schooled in his etchings were often disappointed by the real thing when visiting Rome.[12]

Piranesi's first independent publication in Rome was based not on existing ruins, but on a poetic vision of the past. The *Prima Parte di Architetture e Prospettive* (1743–49)—first part of a book on architecture and perspective—was inspired by Giuseppe Bibiena's *Architetture, e Prospettive*, published in 1740. The second part never appeared, but in 1750 Piranesi reissued the plates of the *Prima Parte* and several more under the title *Opere Varie*—"various works." Both Bibiena's and Piranesi's works demonstrated their authors' virtuoso handling of perspective and an imaginative approach to architectural design based on the recombination of classical elements and the invention of fantastic ones—an approach traceable to Michelangelo and other Mannerist architects of the sixteenth century.[13] Compared with Bibiena's, however, Piranesi's plates are more passionately conceived. The prints are not just a display of skill but a vigorous championing of the greatness of antiquity, particularly Roman antiquity. We read in Piranesi's preface:

These speaking ruins have filled my spirit with images that accurate drawings . . . could never have succeeded in conveying, though I always kept them before my eyes. Therefore, having the idea of presenting to the world some of these images, but not hoping for an architect of these times who could effectively execute some of them . . . there seems to be no recourse than for me or some other modern architect to explain his ideas through his drawings, and so to take away from sculpture and painting the advantage . . . they now have here over architecture.[14]

This brief passage is a particularly rich source for understanding Piranesi's thought. A certain frustration born of the inability to realize his architectural vision combines with a hypersensitivity to the ruins of the past. They "speak," and their true essence cannot be conveyed by "accurate" drawings. This implies a necessary wedding of the topographical view and the "caprice" when dealing with ruins. We are on the verge of Romanticism, with its celebration of imagination and of the exotic past. At the same time, Piranesi's approach may be classified as Neo-Mannerist, rooted in sixteenth-century, especially Michelangelesque, conceptions about architecture. Far from being governed by rules, architecture should delight, surprise, even confound us.

One of the most spectacular prints of the *Prima Parte* is *The Ancient Mausoleum* (fig. 6.12). It is a modern challenge to one of the most ambitious tombs of antiquity: Hadrian's mausoleum, whose form was barely discernible under the Castel Sant'Angelo, used as a fortress and prison since the early Middle Ages. Although the undulating exterior and dome of Piranesi's structure recall Francesco Borromini's S. Ivo della Sapienza, designed in the 1640s, its scale and detail are Piranesi's own. From a rusticated pedestal, the building rises in tiers. The first is a loggia and portico of Ionic columns, carrying an entablature ornamented with garlands and a segmental pediment. The second is a wall, articulated with windows topped by alternating segmental and triangular pediments, and a large triangular pediment capping a relief above the portico. The third comprises a drum and dome, both more delicately ornamented than the lower stories. Above the portico, the stacking of forms continues with the remains of a wall from which trees sprout. In niches on the pedestal of the building are urns much larger than people. Bizarre obelisks rise dramatically to the side of the mausoleum proper, where steps lead to no visible entrance. Incommensurability is the quality Piranesi sought and achieved. Not only are we unsure of the structure's extent at the back, but the portico we have been describing does not seem to be an entrance. Rather, the rusticated base of the mausoleum continues to the left, where it supports another structure (or is this a continuation of the mausoleum?). Light is employed to enhance the building's fantastic appearance. It dramatically silhouettes the obelisks against the mausoleum itself. At the top, the dome (characteristically cut off) exists in a haze. The sense of distance is reinforced by the dark, foliage-covered wall in the right foreground, which acts to push the rest of the architecture back in space.

Out of many possibilities, one comparison must suffice to elucidate Piranesi's revolutionary approach to real monuments. The oeuvre of Giuseppe Vasi fulfilled typical expectations for the *veduta*. His etching featuring the pyramid of Cestius (1747; fig. 6.13) from his *Delle Magnificenze di Roma Antica e Moderna*, a compilation of 250 etchings in ten volumes published between 1747 and 1761, is highly detailed, with equal attention paid to all major structures. An uninspiring view down a centered road dominates the print, with the pyramid placed matter-

FIGURE 6.12

Giovanni Battista Piranesi. The Ancient Mausoleum *from the* Prima Parte di Architetture e Prospettive. *1743–49. Etching, engraving and drypoint. 364 × 257 mm (without inscription). National Gallery of Art, Washington, D.C.*

of-factly to the left. Light is used chiefly to clarify structure. Piranesi's etching (fig. 6.14) of the same monument, part of *Varie Vedute di Roma Antica e Moderna* (1745), is conceived quite differently. The importance of the pyramid itself is amplified by its central spatial position and proximity to the observer. Piranesi did not concern himself with adjacent structures except for parts of the Porta S. Paolo and two tall columns, which, along with the figures, contribute to our sense of scale. The turreted tops of one of the round towers, so prominent in Vasi's etching, hover discreetly in the left distance. Instead of a relatively smooth surface, Piranesi lent the monument the texture of age, and echoed this quality in a gnarled tree to the right. Its irregular form sets off the precise geometry of the pyramid's mass. Piranesi even dared to cut off the pyramid's apex, but this does not violate the monument. Rather, it enhances its looming quality.

Despite its success, *The Pyramid of Cestius* is humble when compared with Piranesi's later Roman *vedute,* in which ruins take on an awesome grandeur through the artist's expert handling of space and light. The 135 views in his large *Vedute di Roma,* produced over about thirty years (ca. 1748 to 1778), gave new life to the familiar monuments of the ancient city.

The Basilica of Maxentius and Constantine (called the "Temple of Peace" in Piranesi's time) was a fourth-century structure, built on the superhuman scale of the late Roman Empire. In its apse sat the huge image of Constantine, now in pieces, with its stark posture and somber, staring eyes. Its central, groin-vaulted hall was flanked by three giant barrel vaults, the only part of the elevation that remained intact. By positioning the viewer nearly under the first arch at the far left, and expanding its bulk beyond the limits of the image, Piranesi established a sweeping perspective to the right that gives full expression to the lateral extension of these three vaults (fig. 6.15). More recent dwellings to the far left, not to mention the people who scuttle about below, are completely dwarfed by the sheer volume of space they encompass.

The Colosseum, or Flavian Amphitheater, built about A.D. 80, presented a challenge to the artist. How could its colossal scale be conveyed without losing a sense of its complexity: its internal structure of barrel-vaulted corridors and rows of seating, and its tiered façade? Piranesi depicted this quintessential symbol of imperial Rome a number of times, but in what is perhaps the most magnificent image from his series, he combined all these aspects (fig. 6.16). Had the subterranean corridors been excavated, he undoubtedly would have portrayed those as well. People move like ants through the tunnels of a fabulous anthill. The "speaking ruin" gives us imaginary access to the bloody spectacles that distracted the Roman populace from its many troubles—the sea battles staged on the arena's flooded floor, or the slaughter of animals and people accompanied by a tremendous din, locked in by canvas awnings rolled out on a system of ropes and pulleys and manned by a permanent detachment of a hundred Roman sailors. Whatever visual refinement was applied to architecture by the ancient Greeks, they had nothing to equal the awesome technology, formal invention, and scale of Roman civic structures. With his *vedute* of Roman ruins, Piranesi engaged himself in a battle against "Grecophilia" as promulgated by Julien-David LeRoy, the Comte de Caylus, Marc-Antoine Laugier, Johann Winckelmann, and others. Later, in his *Della Magnificenza ed Architettura de' Romani* (1761) and other publications, he would make his architectural arguments in verbal terms that, while polemical, were never as strident as his visual expression.[15]

The *Vedute di Roma* included not only antiquities but more modern buildings, piazzas, and other sites, such as the Piazza Navona with Bernini's *Four Rivers* fountain and Borromini's Church of S. Agnese, the Capitoline Hill with Michelangelo's palaces, or the Piazza of St.

FIGURE 6.13

Giuseppe Vasi. View of the Porta S. Paolo and the Pyramid of Cestius: *Plate 11 in Book 1 of* Delle Magnificenze di Roma Antica e Moderna. *1747–61. Etching. 200 × 300 mm. Library of Congress, Washington, D.C.*

FIGURE 6.14

Giovanni Battista Piranesi. The Pyramid of Cestius *from the* Varie Vedute di Roma Antica e Moderna. *1748 edition (first published 1745). Etching. 115 × 194 mm. National Gallery of Art, Washington, D.C.*

Peter's, with Maderno's façade and Bernini's colonnade. Beautiful, atmospheric, and spacious as these prints are, they lack the mystery of the images of ruins. In *Le Antichità Romane*, published in 1756, Piranesi was more of an archaeologist. In this vast enterprise, he attempted to investigate the ancient structures of Rome as thoroughly as possible, combining the conventional exterior views with reconstructions of plans, sections, interior elevations, and construction techniques. Despite its ambitiousness, Piranesi thought of the *Antiquità* as only a first step toward a complete understanding of ancient Roman architecture.

His scholarly approach did not prohibit Piranesi from lending these images his gift for imaginative overstatement. This is made apparent in the frontispiece for the second volume (fig. 6.17), where fragmentary sculptures and tombs litter the forks of a road, paved with large

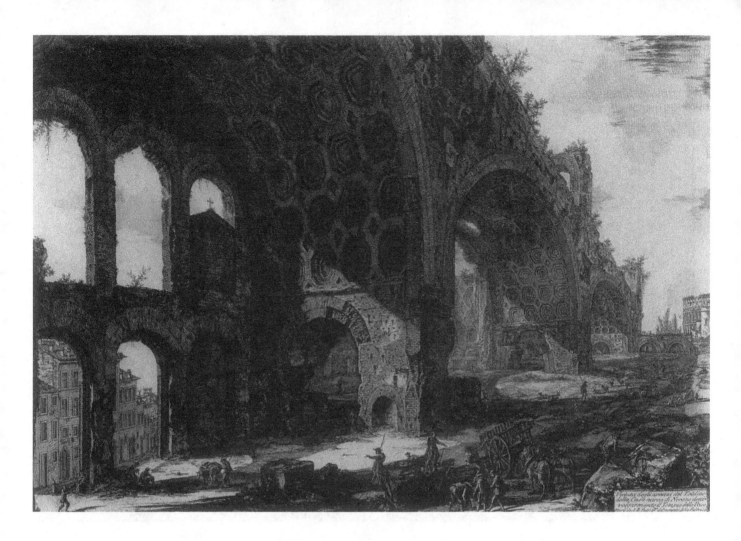

FIGURE 6.15

Giovanni Battista
Piranesi. The Basilica
of Constantine *(1774)*
from the Vedute di Roma.
Ca. 1748–78. Etching
and engraving. 491 ×
717 mm. Elvehjem
Museum of Art, Uni-
versity of Wisconsin–
Madison.

stones like those of the Appian Way. In contrast to the bewildering diversity of this print, however, *The Foundations of Hadrian's Mausoleum* (the Castel Sant'Angelo) depends primarily on the visual impact of the chunky stones (fig. 6.18). Stripped of ornamental detail or facing, Roman architecture reveals its raw, concise, structural brilliance. The cyclopean proportions of the foundations are emphasized by the presence of a few tiny figures. The viewer is positioned so that the masonry abutments loom above; one almost expects to see the tragic heroine of Puccini's opera *Tosca* plunging to her death from the upper walls of the building. In the foreground, the remains of an entablature push their way into our space.

Piranesi is best known today, not for his *vedute* of Rome or his archaeological contributions, but for a remarkable, enigmatic series of fourteen etchings of imaginary prisons: *Invenzioni Capric di Carceri* (1749–60). It first appeared without any indication of his authorship on its frontispiece and sold rather cheaply—each image (see fig. 6.19) went for less than half the cost of a print in the *Vedute di Roma.* John Wilton-Ely observes that both facts may reflect the private nature of the prison series and Piranesi's timidity in offering them for sale.[16] The series was republished with the original plates reworked (see figs. 6.20, 6.21), two additional images (see fig. 6.22), and a more informative frontispiece. After the second edition, retitled *Carceri d'Invenzione* (1761–78), the series began to receive the appreciation it deserves.

The rapid, scratchy technique of the *Carceri,* especially the more vibrant, reetched second states, contributed to an interpretation in terms of the artist's febrile visions. In *Confessions of*

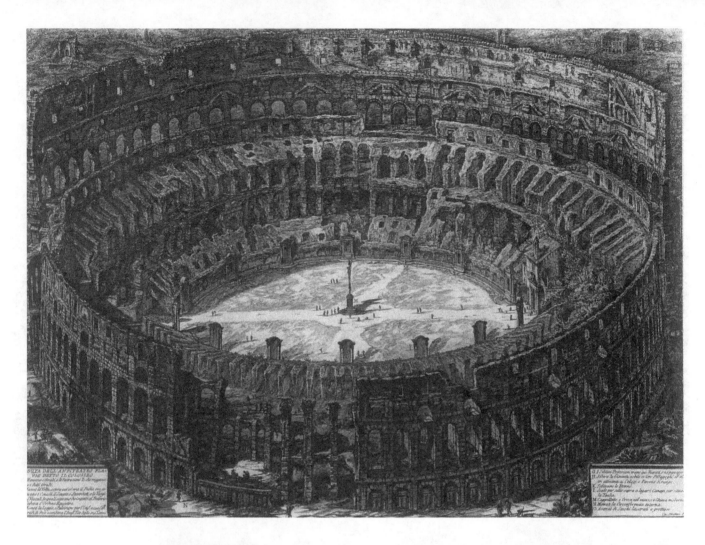

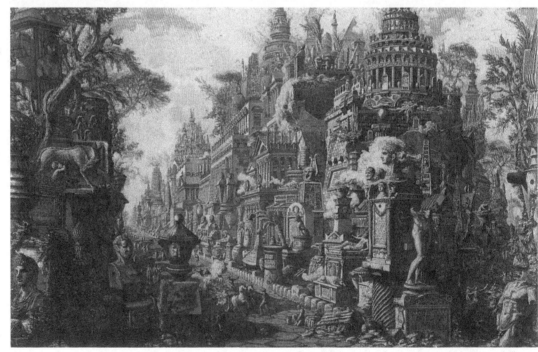

FIGURE 6.16

Giovanni Battista Piranesi. The Colosseum (Bird's Eye View; *1776*) *from the* Vedute di Roma. *Ca. 1748–78. Etching and engraving. 495 × 705 mm. Elvehjem Museum of Art, University of Wisconsin–Madison.*

FIGURE 6.17

Giovanni Battista Piranesi. Frontispiece for the second volume of Le Antichità Romane. *1756. Etching and engraving. 395 × 640 mm. National Gallery of Art, Washington, D.C.*

340 *Original Etching and Engraving*

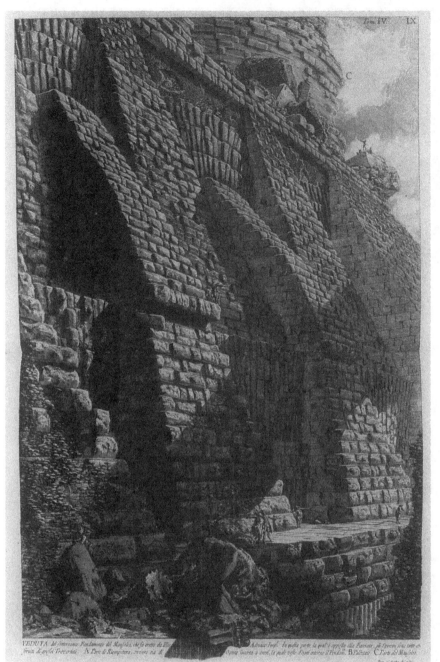

FIGURE 6.18
*Giovanni Battista
Piranesi.* The Foun-
dations of Hadrian's
Mausoleum (Castel
Sant' Angelo) *from* Le
Antichità Romane. *1756.
Etching and engrav-
ing. 875 × 450 mm.
Ashmolean Museum,
Oxford.*

an English Opium Eater (1822), Thomas De Quincey paraphrased an oral description of the
Carceri by the English poet Samuel Coleridge. In this account, one of the tiny figures is inter-
preted as "poor Piranesi" himself, who labors to climb an endless staircase poised precariously
above an abysmal space.[17] And in the epic poem *Clarel* (1876), by the American Herman Mel-
ville, the etchings ("those touches bitten in the steel") are mysterious visions to be contem-
plated in the night:

> In Piranezi's rarer prints,
> Interiors measurelessly strange,
> Where the distrustful thought may range
> Misgiving still—what mean the hints?

FIGURE 6.19

Giovanni Battista Piranesi. The Draw-bridge, *first state: Plate VII from the* Invenzione Capric di Carceri. *First edition issued between 1749 and 1760. Etching and engraving. 548 × 409 mm. Cleveland Museum of Art.*

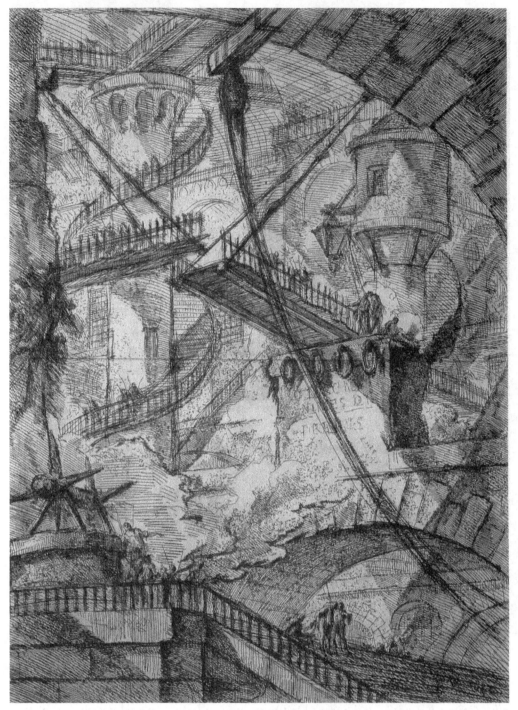

Stairs upon stairs which dim ascend
In series from plunged Bastiles drear—
Pit under pit; long tier on tier
Of shadowed galleries which impend
Over cloisters, cloisters without end;
The height, the depth—the far, the near.[18]

 In 1949 the British novelist Aldous Huxley published an essay on the *Carceri* in conjunction with critical notes on the prints by the art historian Jean Adhémar. Here, the etchings are

FIGURE 6.20

Giovanni Battista Piranesi. The Drawbridge: *Plate VII from the* Carceri d'Invenzione. *Second edition issued between 1761 and 1778. Etching and engraving. R. S. Johnson Fine Art, Chicago.*

interpreted less as feverish dreams than as an expression of the fundamental confusion and angst of the human condition:

> Beyond the real, historical prisons of too much tidiness and those where anarchy engenders the hell of physical and moral chaos there lie yet other prisons, no less terrible for

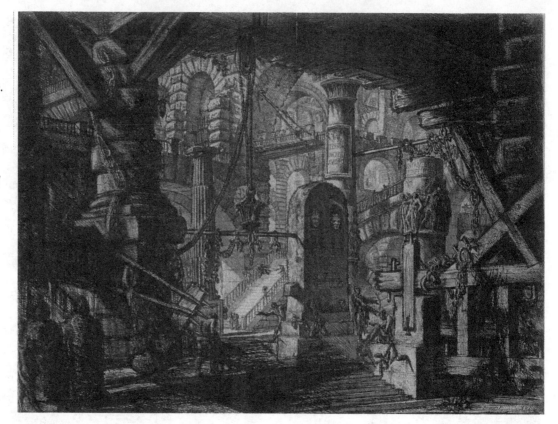

being fantastic and unembodied—the *metaphysical prisons,* whose seat is within the mind, whose walls are made of nightmare and incomprehension, whose chains are anxiety and their racks a sense of personal and even generic guilt.[19]

In Huxley's analysis, it is not the power of the imagination that is celebrated in the *Carceri;* rather, the condition of humanity, particularly modern humanity, is lamented. There is even a suggestion of the alienation of individuals from their environment in the industrial world. "Today," states Huxley, "every efficient office, every up-to-date factory is a panoptical prison, in which the worker suffers . . . from the consciousness of being inside a machine."[20] In this light, Piranesi's prisons are much like the incomprehensible, stifling situations and environments of Franz Kafka's novels, in which human beings are powerless to act effectively or to understand their world. Coherence and meaning are forever beyond their reach.

Like all great works of art, Piranesi's series has resonated against its various audiences, and never lost its power to move them, for different reasons. But how do we get back to the mid-eighteenth century from De Quincey, Melville, and Huxley?

The first step is a consideration of the series' immediate context and sources. The relationship of these images to stage design has long been noted: about 1705, Pietro Albani made an etching after a design for a prison stage set by Ferdinando Bibiena, and Piranesi himself included a similar prison scene in the *Prima Parte.*[21] In part, the *Carceri* must be understood as exercises in a kind of theatrical perspective—virtuoso displays of the architectural imagination. A related aspect that we have already noted concerns Piranesi's architectural aesthetic. In the continuing dialog between classicistic or purist architects and those who prized *invenzione* above all, Piranesi clearly stood on the side of the latter.

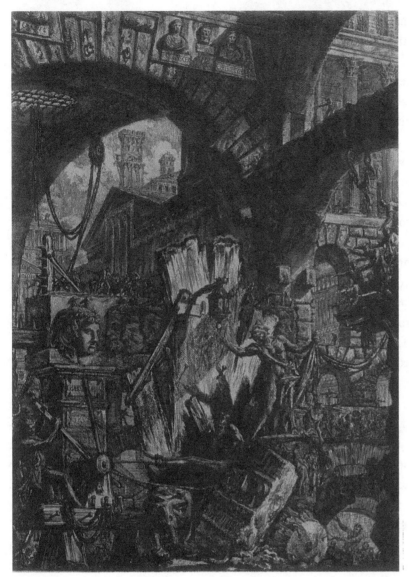

FIGURE 6.22

Giovanni Battista Pi-
ranesi. The Man on the
Rack: *Plate II from the*
Carceri d'Invenzione.
Second edition issued
between 1761 and 1778.
Etching and engraving.
571 × 420 mm. R. S.
Johnson Fine Art,
Chicago.

Even his technique and style depart from eighteenth-century norms—exaggeratedly scratchy (beyond Tiepolo or Fragonard), laden with startling contrasts and a carefully cultivated ambiguity.[22] There is none of the meticulous attention to detail associated with architectural prints. The parallel lines within the areas of shadow assert themselves almost violently. The various ropes, cables, and grilles are rendered with essentially the same aggressive lines. Elsewhere, the hatching thins out to mere scratches against the white of the paper. Contours like the corners of walls or the edges of an arch are hastily and imprecisely drawn. Shadows and ephemeral puffs of smoke appear out of nowhere, often obscuring crucial areas of architecture that would help make sense of "this shadow-world of perpetual flux," as Wilton-Ely aptly describes it.[23]

When the series was reissued in the 1760s with two additional plates, having attracted little attention its first time out, these technical and stylistic effects were much augmented. Tonal contrasts became more extreme, and any traces of delicacy were eclipsed by the overall harshness of the rebitten plates. The structural imponderability and vastness of the prisons were made more explicit. A variety of chains, ropes, and instruments of torture were inserted

into the old compositions, and figures were added. Piranesi now had more control over the inking and printing of the *Carceri,* and he continued to experiment with the plates on an individual basis into the 1770s.[24]

Thus the *Carceri* are triumphs of artistic invention. They bring a barely explored subject to expressive heights, establish a new approach to etching, and, while illustrating their author's skill in imaginative architectural draughtsmanship, present an experience of total ambiguity that would have impressed the best sixteenth-century Mannerist architects, and still impresses modern viewers familiar with Cubism. But the two additional plates of the 1760s edition make clear another purpose: to champion the stern justice of early Rome, before it was "contaminated" by Greek influence. Piranesi's turning again to the *Carceri* plates reflects his continuing involvement in the Greco-Roman controversy, this time on a moral plane.

Three plates, interpreted in detail by Andrew Robison, exemplify these concerns best: the two additions (Plates II and V), and the one reworked as Plate XVI.[25] This last image, *The Pier with Chains* (fig. 6.21), contains inscriptions referring more or less directly to incidents from Livy's account of early Roman history. On the palm-leaf column, "AD TERROREM INCRESCENTIS AUDACIAE" states the purpose of the Mamertine (or Mammertine) Prison, erected in the Forum by the just king Ancus Marcius: "To terrify the growing audacity." The "infamous wickedness" ("INFAME SCEIUSS [Scelus]") above the right-hand relief was perhaps committed by the daughter of another good king, Servius Tullius. She conspired against her father and spattered herself with his blood when she had her chariot driven over his dead body. Also on the right-hand relief, "RI INFELICE SUSPE," is a quotation from a law regarding the harsh punishment of traitors, cited by Livy in his account of the trial of one of the Horatii. Robison finds no source for the inscription on the monument closest to us, but the two heads in the niches must refer to the traitorous sons of Lucius Junius Brutus, who presided stoically over their public stripping, flogging, and decapitation. With these references, then, Piranesi expressed his admiration for the awesome severity of early Roman justice.

By contrast, Plate II, *The Man on the Rack* (fig. 6.22), condemns the unjust punishment of his enemies by the corrupt emperor Nero, who was enamoured of all things Greek. The names of Nero's victims, as mentioned in the *Annals* of Tacitus, are recorded beneath the portrait reliefs at the top and, in a fragmentary manner, on the pillar at the left. Robison speculates that the sculpted figure on the rack—the torture scene is ancient statuary; the tiny figures are its eighteenth-century audience—is the freedman of one of these victims, Minucius Thermus. Because his freedman had leveled criminal charges against one of Nero's henchmen, Minucius Thermus was killed and his freedman put to the rack. Finally, in Plate V, *The Lion Bas-Reliefs,* a huge relief sculpture of captives and captors underscores Piranesi's condemnation of injustice under a tyrant.[26]

Robison's analysis of the *Carceri* is painstaking and convincing. As we have seen, however, these extraordinary etchings transcend a single, time-bound interpretation. They epitomize the incommensurate, the ambiguous, and the terrifying, and for this reason they will be meaningful to viewers of many times and places. Piranesi's prisons are an extreme statement of that aspect of the Italian architectural genius that departs from harmonious classicism. On paper at least, Piranesi followed in the footsteps of Michelangelo and Borromini.

The strength of reproductive printmaking in eighteenth-century France has as its corollary the weakness of the concept of the original print. Not that the distinction did not exist, or that original prints were not produced, but while legions of diligent artisans labored to produce prints that were credible interpretations of paintings or drawings, very few artists were willing to take up the technical complexities of printmaking, even for short periods of time. A limited audience for etchings by *peintre-graveurs* (or *eaux-fortes libres,* as these prints were called) developed in the latter half of the century among certain print-dealers and critics.[27] The greatest original French prints of the eighteenth century are, in a sense, flukes: products of economic necessity or the sporadic experimentation of a painter. Their rarity adds to their already considerable charm. A quality of fragility and evanescence accompanies a characteristically French stylistic refinement.

The *Recueil Jullienne* after Watteau's paintings, for example, was a far more significant enterprise, in terms of its influence and magnitude, than the tiny body of images etched by the painter himself. These include the seven plates of the *Figures de Mode* (*Figures of Fashion,* ca. 1710), possibly the frontispiece to his series *Les Habits Sont Italiens* (*The Clothes Are Italian,* 1715–16), and *Recrue Allant Joindre le Régiment* (*Troops Joining the Regiment,* ca. 1716).[28]

Figures de Mode is part of the tradition of costume illustration that developed in the sixteenth and seventeenth centuries. In France, such prints were produced by the Bonnart family (Nicolas, Henri, Robert, and Jean-Baptiste) and other artists such as Bernard Picart and Claude Simpol. In contrast to the works by these men, Watteau's etchings (see fig. 6.23) show an extremely light touch and suppression of details in deference to general poses, gestures, and the atmosphere of serene landscape settings. Watteau realized this, and handed the etched plates over to a professional engraver, Henri-Simon Thomassin *fils,* for finishing with the burin. Thomassin defined landscape backgrounds, removed traces of foul-biting and other defects on the plates, and emphasized the exquisite fabrics and cut of the clothing, but basically retained the unpretentious freshness of Watteau's originals.

In *Les Habits Sont Italiens* (fig. 6.24), Watteau returned to a subject that often preoccupied him: the theater, particularly the Commedia dell'Arte. The woman in the center of this more ambitious print is Columbine, the female counterpart of Harlequin, who stands behind her. At the right is a mournful Pierrot. The figure pulling the curtain aside at the right gives the impression that the performance is over, and the actors and actresses are taking a bow. As with *Figures de Mode,* Watteau had the etched plate retouched with the burin, this time by Charles Simmoneau the Elder, a surprising choice given his conservative approach. Simmoneau completely altered Watteau's hesitant touch with his cold professionalism. The first, autograph state of the print is extremely rare.[29]

Watteau's etching is similar to several extant paintings, none of which are certainly by Watteau himself. The design was transferred to the plate from a preparatory drawing now in Berlin. In addition to later states of the plate with engraved additions, François Boucher also prepared an etching after this drawing. All this testifies to the appeal of Watteau's original conception, with its sense of the transitory moment in which the gaiety of the performance changes to a more somber mood offstage. Columbine moves gracefully forward, looking wistfully at the viewer, while Pierrot is more obviously melancholy, and stands with his arms drooping at his side, much as in Watteau's famous painting of him in the Louvre (1718–19).

FIGURE 6.23

Jean-Antoine Watteau.
Seated Woman *from the*
Figures de Mode, *second*
state. Ca. 1710. Etching
with engraving. III ×
71 mm. Bibliothèque
Nationale, Paris.

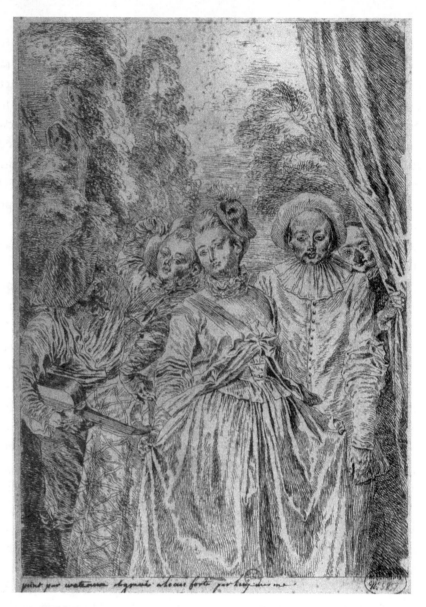

FIGURE 6.24

Jean-Antoine Watteau.
Les Habits Sont Italiens,
first state. 1715–16. Etch-
ing and engraving. 275 ×
190 mm. Bibliothèque
Nationale, Paris.

Watteau's teacher was Claude Gillot, known for his ornamental designs for tapestries, furniture, and wallpaper. He also etched bacchic and theatrical scenes. Like *Les Habits Sont Italiens,* his *Mischievous Harlequin* (fig. 6.25) deals with the Commedia dell'Arte, this time using an actual scene from a play of the same name, albeit rendered with a large measure of artistic license. Harlequin, armed with a torch at the right, has just set fire to a paté on the table. The other characters (more than participated in the actual scene)—Scaramuccia, Mez-

FIGURE 6.25

Claude Gillot. Mischievous Harlequin. After 1716. Etching with burnishing. 169 × 223 mm. Bibliothèque Royale Albert, Brussels.

ARLEQUIN ESPRIT FOLET.

Dans ce magique endroit, pauvre troupe affamée,
Vous ne vous plaindrez pas d'une indigestion,
Le Lutin qui vous sert cette colation ;
Paris chez Vanhock

Ne donnant que des mets de flame et de fumée ?
Le sort aussi malin ne vous offre souvent
Que des biens très flateurs et qui n'ont que du vent.
M. Maraire

zotino, and Punchinello—express astonishment when their seats rise from the floor. The burlesque of the moment is tempered by the refined elegance of the interior setting, perhaps inspired by Gillot's work as a decorative artist. In the play itself, the incident occurred in a modest inn. The etching was part of a series of four prints of Commedia subjects, each of which may also have been painted. Both a drawing and a painting corresponding to one of the etchings exist, and an inscription on a later state of *Mischievous Harlequin* reads "gillot pinx. et sculpt.," implying a painted original. The series dates from the return of the Commedia to France in the early part of the Regency. In 1697 the troupe had been banished from France for their jibes about Louis XIV and his mistress, Madame de Maintenon, to whom he was secretly married.

The painter François Boucher was also one of the most talented printmakers working in France. Himself an admirer of Watteau, Boucher was one of those who worked the more than six hundred prints of the *Recueil Jullienne:* his contribution amounted to something over one hundred prints. The experience of translating Watteau's draughtmanship into prints was immensely important for the young Boucher, who was himself endowed with a superb facility for drawing. The frontispiece for the first volume of the *Recueil* (fig. 6.26), once thought to be a self-portrait, was reattributed to Boucher in 1970.[30] The younger artist perhaps worked after a lost original by Watteau, however. The large head, set off against an empty background, peering intently and leaning forward and to the left, has a remarkable presence, while the execution

FIGURE 6.26

François Boucher (after Watteau?). Portrait of Watteau, *frontispiece from the first volume of the* Recueil Jullienne. *Ca. 1727. Etching. 351 × 245 mm. Cleveland Museum of Art.*

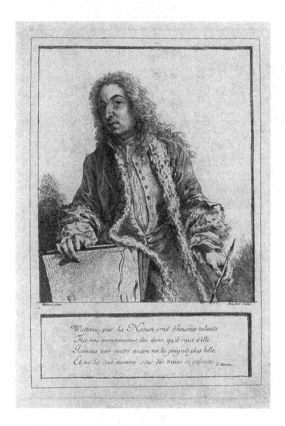

of the figure as a whole is accomplished by sure, rapid strokes of the needle that reinforce the directness of the facial expression.

One of Boucher's most ambitious plates is *The Laundress* (1756; fig. 6.27). From the lovely laundress and charming child to the picturesquely ramshackle shed and fence, this print exudes a sense of untroubled joy in a rural existence that Boucher euphemistically drained of arduous labor and poverty. Utilizing delicate, varied strokes, he rendered the sunlight filtering through the trees and reflecting off the water. The print's·ebullient mood and airy composition, based on diagonals suspended in ample, light-filled spaces, is typical of the French Rococo style that would be carried on by Fragonard, who made his first etching after a drawing by Boucher.

Boucher was one of the greatest illustrators in a century notable for achievements in this realm. The sensitivity for small-scale design and ornament that characterizes so much of eighteenth-century French art combined symbiotically with the fashion for reading and collecting books. Vignettists like Charles Eisen and Charles-Nicolas Cochin *fils* drew small scenes to be etched and engraved by professional printmakers and placed at the head or foot of a text. The production of these and other kinds of book illustrations was an elaborate enterprise involving many different stages.[31]

As a frontispiece for Corneille's play *Rodogune* (1759; fig. 6.28), Boucher etched this climactic scene of the Parthian princess accusing the jealous Queen of Syria of killing one of her own sons and plotting to kill another because of their love for Rodogune. Although Boucher himself was responsible for the shimmering, original etching, he gallantly attributed it to Madame de Pompadour, one of his most important patrons, in an inscription on the second state of the print, which had been finished by the addition of engraving by Nicolas Cochin *fils*.[32] Pompadour was one of the most famous amateur etchers of the century. After her fall from the position of Louis XV's mistress to that of a favored friend, she took up etching to fill her time.

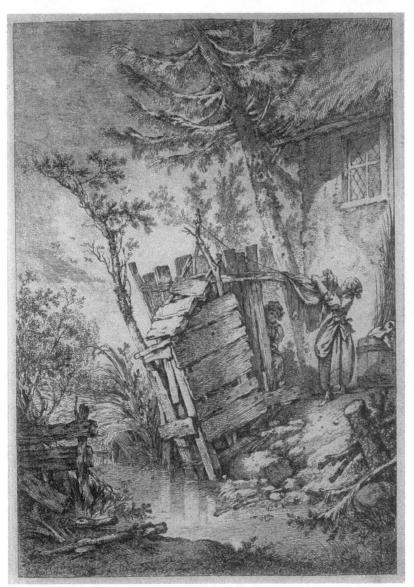

FIGURE 6.27

François Boucher. The
Laundress. *1756. Etch-
ing. 296 × 215 mm.
Metropolitan Museum of
Art, New York.*

A press was installed in her apartments at Versailles. Since etching was the one printmaking
method that could be undertaken without much technical knowledge, it was not uncommon
for the educated elite to dabble in it. It provided a diversion not unlike the pseudo-scientific
experiments in amateur *laboratoires de physique.*[33]

Despite a relatively small oeuvre of original prints (his paintings, like Watteau's were
reproduced, and he, like Boucher, made etchings after paintings and drawings by others),
Fragonard was one of the century's most naturally gifted etchers. In 1752 he won the coveted
Prix de Rome and spent three years studying in Italy, and between 1755 and 1761 he traveled
through that country with his friends Hubert Robert, one of the best painters of ruins in the
eighteenth century, and Jean-Claude Richard, the Abbé de Saint Non, who was also an etcher.
It was perhaps shortly after his return to France in 1761 that Fragonard etched the lovely *Petit
Parc* (*The Little Park;* fig. 6.29) as a souvenir of Italy—and, in particular, of his visit to the
gardens of the Villa d'Este in Tivoli near Rome. Similar compositions are found in a painting
in the Wallace Collection in London and in three drawings, but in the diminutive copperplate

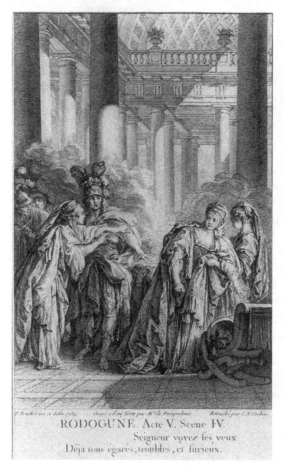

FIGURE 6.28

François Boucher, and Charles-Nicolas Cochin fils. Frontispiece (1759) for Rodogune, princesse des Parthes *by Pierre Corneille. Versailles, 1760. Etching with engraving. 222 × 133 mm. Library of Congress, Washington, D.C.*

Fragonard exercised the greatest spontaneity and sketchiness. The foliage is rendered with transparent layers of scratchy lines. A large part of the romantic, picturesque appeal of the print is the overgrown, tangled, and half-wild vegetation that threatens to gently engulf the figures, architecture, and remains of sculptures. Two dark statues are silhouetted against the bright oval of light that opens between two large trees, pushing the hazy distance even farther back.

Other reminiscences of Italy were Fragonard's four *Bacchanales* (1763), based on ancient reliefs. Compared with the *Petit Parc,* which represents his early venture into etching, these prints reveal more skill: the lines are more varied and descriptive of solid forms, without, however, any loss of the delicacy and spontaneity so evident in the earlier print. Figure 6.30 reproduces a now lost marble bas-relief in the Villa Mattei. Fragonard made a preparatory drawing in black chalk in the same direction as the relief, while the etching, of course, reverses the relief's composition. The Abbé de Saint Non made his own print after this drawing and published it in his *Recueil de Griffonis* (ca. 1765–76).

The oval relief showed a nymph frolicking with two satyrs. Fragonard accentuated the pagan nature of the subject by propping the relief amidst thick vegetation, thereby suggesting a wild, pastoral existence (compare Tiepolo's *Scherzi,* where ruins of ancient reliefs exist alongside real satyrs in distinctly uncivilized settings; figs. 6.7–6.9). Despite its basis in an actual piece of ancient sculpture, Fragonard's etching is hardly conceived with archaeology as the foremost concern. Rather, it was the bacchic indulgence in the passions that appealed to this Rococo painter. The satyrs leer as the plump, naked nymph steps playfully across their joined arms.

FIGURE 6.29

*Jean-Honoré Fragonard.
The Little Park* (Le Petit
Parc). *Ca. 1763. Etching.
III × 165 mm. National
Gallery of Art, Washington, D.C.*

Although it is conceived in the moralizing spirit of the eighteenth century—a bit overblown and obvious for our taste—Fragonard's largest etching, *L'Armoire* (*The Cupboard*, 1778; fig. 6.31), does not abandon the titillation so basic to the French Rococo. Its subject is an interrupted sexual encounter. A shamefaced young man is discovered by angry parents in a closet as his lover, their daughter, sobs at the left. In an earlier wash drawing of this composition, the young man's hat is held at his chest. In the print, however, the hat covers his state of sexual arousal, the reason for his embarrassment.[34] The drama of this subject is accentuated by Fragonard's intense tonal contrasts and scintillating surfaces.

The Saint-Aubin brothers, sons of an embroiderer, were all printmakers. Charles-Germain was chiefly a designer of embroidery but produced nearly thirty etchings. Augustin was a vignettist and portrait-engraver, and Gabriel-Jacques de Saint-Aubin, the most talented member of the family, depicted scenes of Parisian life in about fifty etchings. These prints challenged the dominant taste for highly finished prints and revealed an "intense commitment to the present."[35]

Gabriel-Jacques's continued failures to win the Prix de Rome persuaded him to turn from painting to drawing and printmaking. But his etchings, like Fragonard's, reveal a painter's sensibility—light and atmosphere are emphasized, rather than the detail and finish of much eighteenth-century printmaking. The paired prints *The Watering-Cart* and *The Chairs* (1760–63; figs. 6.32, 6.33), when cut apart and placed side by side, form the panorama of *Scenes in the Tuileries*. The Paris Garden, famous for its tulip trees, was such a popular gathering place that, in order to accommodate the crowds, chairs were made available for renting. The dust stirred up by strollers was kept down by dampening the unpaved paths with water. The subject provided an opportunity for the interpretation of figural groups and landscape—the whole bathed in light and atmosphere, but lacking the artificiality typical of the Rococo. Richard Field notes the "undercurrent of Callot" in the bustle of the numerous tiny figures (compare *The Fair at Impruneta*, fig. 4.11).[36] In 1762 and 1763 Saint-Aubin reworked the etching with drypoint for an even bolder, more direct effect. Manet was surely aware of these prints when he conceived his robust lithograph of the Tuileries a century later.

FIGURE 6.30

Jean-Honoré Fragonard.
Nymph and Two Satyrs
from the Bacchanales.
*1763. Etching. 147 ×
213 mm. National Gallery
of Art, Washington, D.C.*

FIGURE 6.31

Jean-Honoré Fragonard.
L'Armoire. *1778. Etch-
ing. 420 × 513 mm.
Museum of Fine Arts,
Boston.*

354 *Original Etching and Engraving*

FIGURE 6.32

Gabriel-Jacques de Saint-Aubin. The Watering-Cart (*right half of* Scenes in the Tuileries). *1760–63. Etching and drypoint. 204 × 193 mm (whole sheet). National Gallery of Art, Washington, D.C.*

FIGURE 6.33

Gabriel-Jacques de Saint-Aubin. The Chairs (*left half of* Scenes in the Tuileries). *1760–63. Etching and drypoint. 204 × 193 mm (whole sheet). National Gallery of Art, Washington, D.C.*

FIGURE 6.34

Charles-Germain de Saint-Aubin. La Toilette *from* Papilloneries Humaines. *After 1756. Etching. 332 × 237 mm. Metropolitan Museum of Art, New York.*

By contrast, Charles-Germain's *Ideas for Butterflies Masquerading as Humans,* or *Papilloneries Humaines* (after 1756), are frothy, humorous, thoroughly Rococo caprices in which insects take on the pretensions of human beings. There are two *Papilloneries* series, one in a vertical and one in a horizontal format, each consisting of six prints. *La Toilette* (fig. 6.34) exhibits Charles-Germain's background in fabric design as well as his humor. Delicate, shell-like curves, for which the Rococo style is named, and a flower garland form a canopy over a scene of butterfly vanity. One helps another with a coiffure, while another, cross-legged, keeps them company by reading aloud. Although the design as a whole is purely ornamental (no part overwhelms any other, and the composition, with its cartouche-shape, would be perfectly at home on a piece of wallpaper), Saint-Aubin's gentle wit is irresistible. The tiny insects, with their pointed toes, elegant gestures, curving antennae, and magnificent wings parody the eighteenth-century preoccupation with elaborate wigs, costumes, and manners.

Another printmaking family was the Cochins. Charles-Nicolas Cochin *père* was one of the best reproductive engravers of the eighteenth century, working on the *Recueil Jullienne* after Watteau as well as engraving paintings by Chardin, Boucher, and others. His career has been largely overshadowed by that of Charles-Nicolas Cochin *fils,* whose etchings (over a thousand) are mostly book illustrations. But he also etched portraits and court ceremonies, such as the elaborate *Decoration for a Masked Ball Given by the King* (1746; fig. 6.35) in the Galerie des Glaces (Hall of Mirrors) in the palace of Versailles. This event was the climax of the festivities associated with the marriage of the Dauphin to Princess Maria Theresa of Spain.

The Galerie des Glaces was the most spectacular room in Versailles. Designed by Charles Le Brun and Jules-Hardouin Mansart, it was lined with mirrors that reflected and augmented not only the rest of the decoration but also the gardens of André le Notre, visible through the arched windows opening onto the rear of the palace. On the night of the ball, the hall and the

FIGURE 6.35

Charles-Nicholas Cochin fils. Decoration for a Masked Ball Given by the King. *1746. Etching with engraving. 478 × 778 mm. Philadelphia Museum of Art.*

palace exterior alike were ablaze with lights and crowded with costumed guests. King Louis XV is one of the clipped yew trees coming in from the right, while the royal newlyweds appear unmasked in the center, dressed as a shepherd and shepherdess. According to tradition, the shepherdess in the straw hat, seen from the rear in the center front, is Madame d'Etoiles, the future Marquise de Pompadour (this was her first encounter with Louis XV). As in Gabriel de Saint-Aubin's *Tuileries,* the figures, although carefully observed and rendered, are small in proportion to the elaborate setting; Cochin *fils* has created not only a souvenir of an event but a tribute to the architecture of Versailles.

One of the most innovative of the French printmakers was the painter Philibert-Louis Debucourt. He began learning intaglio methods in 1781, and by 1785 he was practicing multiple-plate color printing like Jean-François Janinet and Charles-Melchior Descourtis.[37] His masterpiece, and one of the most important examples of eighteenth-century color printing, is *La Promenade Publique* (*The Public Promenade,* 1792; fig. 6.36, color plate, p. 466). In 1787 Debucourt had published the *Promenade de la Gallerie du Palais Royal* (*The Promenade of the Palais Royal Gallery*), a notorious depiction of pleasure-seekers influenced by Thomas Rowlandson's equally notorious *Vauxhall Gardens* of 1785 (see fig. 7.13, color plate, p. 468). *La Promenade Publique* returns to the same basic satirical idea as these two prints. Along with the well-to-do gentry, Debucourt boldly portrayed the Duc d'Aumont dressed in pink and reclining across three chairs, and the future Louis XVIII raising himself foppishly on tiptoe to blow a kiss to someone. Such satirizing of well-known individuals led Debucourt to publish the print without any announcement and without his own address (he does include that of the

printseller Depeuille). But even in the anonymous figures, such as the group at the table in the right foreground, eagerly discussing the rapidly changing political scene (the French Revolution had begun in 1789), the affectation of gesture and costume is emphasized. *La Promenade Publique* is a panorama of frivolity, the last gasp of the *ancien régime*, which was shortly to crumble completely with the guillotining of Louis XVI and Marie Antoinette in 1793.

ENGLAND: BARRY, STUBBS, AND BLAKE

The situation of original printmaking in England was much the same as that in France. Except for the vital British tradition of satirical prints, which we will examine in Chapter 7, reproductive etching and engraving were dominant, with printmakers like William Sharp and William Woollett developing the polished systems of lines and marks that imitated the textures and chiaroscuro of paintings. Mezzotint, in which line is abolished, was especially strong in England, as we have seen. Only a few painters, such as James Barry and his friend Georges Stubbs, designed and executed prints.

Although Stubbs's prints were based on his paintings, they were not reproductive in the usual sense, and his approach differed entirely from that of reproductive engravers. He reworked compositions or extracted details from them, transforming these sources by an extraordinarily subtle combination of intaglio methods into prints of an incomparable delicacy.[38]

Stubbs was introduced to etching and engraving by illustrating books: first John Burton's treatise on midwifery (1751), and second his own treatise on the anatomy of the horse (1766). In the late 1770s, Stubbs began making prints after his own paintings. *A Horse Attacked by a Lion* (1788; fig. 6.37) is close to a few painted versions of this theme: for example, the oil in the Yale Center for British Art (1762?). In translating the image into print, Stubbs reversed the composition, of course, and altered the landscape setting extensively. The expression of the print is more natural, less dramatic: the animals are placed against dark shadows in the painting but surrounded by atmospheric space in the print; the lion's tail, the horse's neck, and its wind-whipped mane are less exaggerated. In contrast to the strong chiaroscuro of the painting (or even of Robert Laurie's mezzotint after a different Stubbs conception of this theme; see fig. 5.44), the tonality of Stubbs's print is soft and subtle, derived from a seamless blending of mezzotint and stipple. Even more remarkable for their vibrancy and their atmospheric qualities are the three tiny prints of foxhounds (1788), after details from a painting of 1759, *The Third Duke of Richmond with the Charleton Hunt* (Goodwood Collection, Chichester). The marvelously alive *Foxhound on the Scent* (fig. 6.38) is perhaps the most appealing of the set because of the outward glance of the dog, its attention momentarily divided between the viewer and the scent it detects on the ground.

James Barry's encouragement contributed to Stubbs's decision to take up printmaking, but Barry's own extremely large and bold prints, which also defied the expectations of a public familiar with the polished products of professional engravers, could not be more different from his friend's. *Job Reproved by His Friends* (etching and aquatint, 1777; fig. 6.39), which influenced Blake's engraving of the same subject (see fig. 6.45), exemplifies Barry's massive forms and almost raw techniques. It was dedicated to the philosopher and statesman Edmund Burke, who frequently used the Book of Job to illustrate the sublimity of God's power. But the print's primary significance is political. It is a comment on the suffering British nation, symbolized by

FIGURE 6.37

George Stubbs. A Horse
Attacked by a Lion.
*1788. Mixed intaglio.
248 × 348 mm. British
Museum, London.*

FIGURE 6.38

George Stubbs. A Fox-
hound on the Scent.
*1788. Mixed intaglio.
100 × 115 mm. Yale
Center for British Art,
New Haven.*

Job himself, led by the king into a war against the rebellious American colonies. Burke himself may be depicted as the most prominent of Job's counsellors, gesticulating in the left foreground. Job's wife resembles Prime Minister William Pitt, who opposed the war. Thus, the biblical story of Job and, in a pendant print of the following year, a story from Roman history were transformed into topical political statements.[39]

Barry's political ideals were couched in forms that, while vigorous, were essentially traditional, derived from the time-honored iconographic and stylistic language of academic history painting. William Blake's vision of the revolutionary spirit of the age was far more idiosyncratic. England's most outstanding original printmaker of the late eighteenth century emerged from the context of reproductive etching and engraving, and his early training under the professional engraver James Basire must be constantly kept in mind if we are to understand the persistently unconventional means of Blake's prints. His humble origins—he was the son of a hosier—kept him from aspiring to the status of a painter. But in the end it did not matter, because he created, out of his unique world-view, his artistic imagination, and his reaction to the boredom of his primary livelihood, a compelling, if difficult, graphic oeuvre whose technical creativity is rivaled only by that of Seghers.

Blake was also one of the finest English poets of the period, and voluminous literary criticism has perhaps diverted our attention from his artistic accomplishment. For one of Blake's most significant achievements, in his own prophetic books and in his illustrations for the Book of Job and Dante's *Inferno*, was a return to the total unity of image and text encountered in medieval illuminated manuscripts. In order to comprehend the visual/verbal language that Blake developed in these books, his symbolic world, with its cast of characters personifying universal principles, *and* his graphic techniques must be considered equally.[40]

The former aspect of Blake's work is especially bewildering for the student first approaching it. The basic components of his philosophy, however, can be stated concisely.[41] For Blake, the current world was steeped in error and opacity rooted in reason, which assumed the character of a force of darkness and evil, diametrically opposed to that of light and goodness, to which humanity can aspire only through imagination and faith. Thus, Blake assumed a dualism in which the spirit is forever opposed to matter, and struggling to free itself of its chains. His chief villain was Urizen (from the same root as "horizon," meaning "limits"), who looks like the Old Testament God, Jehovah, as visualized by Michelangelo: a white-bearded, commanding patriarch. For Blake, however, this God was a false one. He led humanity to rationalism and moral legalism. The Fall in Blake's thought is man's estrangement from his own imagination. In Urizen, Blake embodied not only the Jewish law, interpreted by the artist as a hindrance to true, Christian faith, but also eighteenth-century deism with its impersonal God and mechanistic universe.

Los, the spirit of creative imagination and prophetic poetry, also personified the artist, enslaved by Urizen but striving to break free. The child of Los by Enitharmon, who personified the female principle that uses comfort and pleasure to seduce the artist from his struggles, is Orc. Blake conceived the fiery and energetic Orc as a kind of Satan, in the original biblical sense of a rebellious angel. He also viewed Orc as the spirit of political revolution, pursuing the throne of Urizen but possessing a Christ-like side as well. Like the French Revolution, Orc's quest for power was in danger of ending in a new form of tyranny supplanting the old. What is the remedy for this situation, according to Blake? This we find in the spiritual odyssey of the giant Albion, the archetypal man and a personification of the British nation, who pro-

FIGURE 6.39

James Barry. Job Reproved by His Friends. *1777. Etching and aquatint. 568 × 757 mm. Yale Center for British Art, New Haven.*

gresses backward, in Blake's epic poem *Jerusalem,* to the primordial, pre-Fall unity of human nature through faith in Christ. Unlike some of the giants who populate late eighteenth- and early nineteenth-century imagery, Albion had the potential for spiritual awakening.[42]

Such an arcane and personal mythology would not seem capable of effecting broad social and political change, and, indeed, Blake's audience was never large during his lifetime. However, he was no recluse, nor was he out of step with his rapidly changing times. Albert Boime has emphasized his connections to the members of the Lunar Society, so called because it met on Mondays closest to the full moon, which facilitated members' journeys home. It included the poet and physician Erasmus Darwin (father of Charles), the iron and steel magnate Matthew Boulton, and Josiah Wedgwood, pioneer in the ceramic industry and in factory organization. These people, like Blake himself, held liberal political ideals, such as supporting the French and American revolutions and abolishing slavery, but were also pragmatists in business and industry. Perhaps such associations help to clarify some apparent dichotomies in Blake. In books that harked back to the precious illuminated manuscripts of the Middle Ages, he championed a revolution of the human spirit, which was grounded in a long tradition of apocalyptic and mystical literature and echoed the thought of theologians such as Jakob Boehme and Emanuel Swedenborg. At the same time, Blake's relief etching techniques combined image and letterpress in order to make his books cheaper and more accessible to the public.[43] And although the Blakean cosmos just described seems to be the product of a hermit-philosopher or mystic, he never shrank from what he described in the first chapter of *Jerusalem* (Plate 5) as his "great task": "To open the Eternal Worlds," and "immortal Eyes" of human imagination.

Original Etching and Engraving **361**

The image of the single figure joyously leaping up, recalling Renaissance drawings of the ideally proportioned man, occurs twice in Blake's single-sheet prints: a color print with pen and watercolor additions, dated about 1793 (fig. 6.40, color plate, p. 467), and a line engraving (fig. 6.41).[44] Although Blake inscribed the plate *Albion Rose,* the image is also known as *The Dance of Albion* and *Glad Day.* The engraving in fact formed the basis of the color print. The engraved lines are visible underneath the thinly printed second impression, probably a maculature, of the color version in the Huntington Library. About 1804 the plate began to be printed in line only, but with the probable addition of the bat-winged moth and the more certain additions of the worm and the inscription.[45] The figure itself must have been conceived in 1780, as witnessed by the inscription on the plate.

For the color print, Blake painted directly on the copper so that when it was run through the press, the ink came off in mottled patches. Thus, he aligned himself with experiments in monotype (or a hybrid monotype that incorporates intaglio lines) by Castiglione and Seghers. The ebullient, radiant figure springs from this murky color and seems almost to detach himself from the ground. If the image of Vitruvian man inscribed in a circle expresses the notion of the human microcosm linked to the perfection of the macrocosm, then Blake's figure finds his kernel of divinity here, not through any geometrical order echoing that of the universe itself but through a sheer joy and creative energy that have been squelched by a corrupt civilization. In the line engraving, Blake couched this image of freedom in more explicit and personal terms:

> Albion rose from where he labourd at the Mill with Slaves
> Giving himself for the Nations he danc'd the dance of Eternal Death

The contrast of Albion with the worm represents the contrary capacities of human beings, as Blake explained in the third chapter of *Jerusalem* (Plate 55): "At will Contracting into Worms or Expanding into Gods." The bat-winged moth, a creature of darkness, symbolizes the opposite of the spiritual illumination represented by Albion.[46] According to Robert Essick, however, Blake also achieved his meaning in his second version of the plate by a deliberate contrast between the expansive figure and the constrained, cross-hatched background, emblematic of Blake's profession of reproductive engraver. It is the artist himself as well as the human imagination that "labourd at the Mill with Slaves," but will break free. Blake's development of techniques—particularly relief etching—that radically depart from graphic conventions is summarized in the relation of this figure to its *graphic* surroundings.[47]

Blake had learned reproductive techniques well, as evidenced by his impressive undated print after Henry Fuseli's *Head of a Damned Soul* (ca. 1789?; fig. 6.42). Etching and engraving are combined in the characteristic eighteenth-century fashion, and the dot and lozenge pattern, the epitome of systematic printmaking, is exhibited overall. At the opposite pole, Blake engraved the linear pen and ink drawings of the sculptor John Flaxman, including an illustration from an edition of the poems of Hesiod (1817; fig. 6.43). The influence of Flaxman's illustrations of Hesiod, Homer, Aeschylus, and Dante was far-ranging: even Goya, who seems at first glance to have nothing in common with Flaxman, knew them well.[48] They were also one of the most important manifestations of the appreciation of Greek art within the neoclassical movement of the late eighteenth century. Based largely on the study of Greek vase painting, Flaxman's drawings did away with chiaroscuro to arrive at a stately linear classicism, and for his

FIGURE 6.41

William Blake. Albion
Rose (The Dance of
Albion, *or* Glad Day),
*second state. Ca. 1804.
Line engraving. 265* ×
*188 mm. National Gal-
lery of Art, Washington,
D.C.*

contemporaries pure line held a significance that is difficult for us to appreciate. Blake's friend,
the engraver-writer George Cumberland in his *Thoughts on Outline* (1796), for which Blake
did some illustrations, championed the "inestimable value of chaste outline," which could
show "grace, action, expression, character and proportion," and, for Cumberland, was no less
than a symbol of the supremacy of British commerce, industry, and art. Cumberland even
criticized Flaxman's outlines for their fluctuating thickness, which he thought deviated from
the purity of the Greek vases.[49]

Blake, then, adapted his burin to the complex linear repertory of reproductive engraving
or the outlines of Flaxman's drawings—both highly systematic approaches. Adaptability and a
painstaking diligence in mastering linear systems were the greatest virtues of the professional
engraver. In his heart, Blake valued creative freedom above all. But when he tried something
totally his own in the context of a commission, it was often received with hostility. In 1805, for
example, the publisher Robert Cromek had him design the illustrations for Robert Blair's poem
The Grave (1743). The only image etched by Blake himself is a curious white-line etching with
added wash, *Death's Door* (fig. 6.44). Like white-line woodcut (recall Urs Graf's *Standard
Bearer,* fig. 2.21), this type of etching is essentially a relief process in which the lines bitten in

William Blake after Henry Fuseli. Head of a Damned Soul *in Dante's* Inferno. *Ca. 1789? Etching and engraving. 350 × 265 mm. British Museum, London.*

the plate do not hold ink. In addition, Blake could use a burin to reinforce or create new white lines in the dark (unbitten) areas. *Death's Door* was so far removed from conventions and so displeased Cromek (to whom Blake later referred as "Screwmuch") that he hired a more conventional printmaker, Luigi Schiavonetti, pupil of the stipple engraver Bartolozzi. Blake regarded this as utter treachery.

Clearly there was no remedy but for Blake to work on his own, separating his own creativity from the workaday world of the reproductive engraver. His highly original style, combining aspects of weightless, Gothic sculpture with the ponderous yet spiritually motivated figures of Michelangelo, is evident very early, as in the beautiful paired engravings *Job* and *Ezekiel*, designed about 1793–94 but reworked, especially with burnishing, sometime after 1800, possibly even after 1804 (figs. 6.45, 6.46).[50]

The two characters embody contrasting spiritual attitudes. Indeed, their bulky, big-handed, and megalocephalic bodies, and their bearded, large-eyed faces, are the same; the two men are but different aspects of the soul. (Later, in his illustrations for the Book of Job, Blake would use Job himself to express the evolution of one state into the other.) Here, Job, con-

William Blake after John Flaxman. Pandora Attired: *Plate 4 from* Compositions from the Works [and] Days and Theogony of Hesiod. *1817. 172 × 244 mm. (image). British Museum, London.*

William Blake. Death's Door, *illustration for Robert Blair's* The Grave. *1805. White-line relief etching. 175 × 114 mm. Collection of Robert N. Essick.*

JOB

What is Man That thou shouldest Try him Every Moment. fc.

fronted by his wife and accusing friends as in Barry's etching (fig. 6.39), confronts God in turn in a paraphrase of Job 7:17–18: "What is Man That thou shouldest Try him Every Moment?" With tears streaming down his face, Job is the rationalist who seeks a reason for suffering. His health and well-being, threatened now by disaster after disaster, prevent him from rising above the material world to a pure acceptance of divine providence. Job's agony is reinforced by the dark tonality of the print, against which (in the reworked state) burnished highlights, such as the flashes of lightning in the distance, stand out brilliantly. The overall effect is not unlike that of Dürer's *Melencolia I* (fig. 2.16), which Blake greatly admired.

In contrast, Ezekiel exists on an advanced spiritual plane, conveyed generally by the radiant quality of light in the print. As God had commanded (Ezek. 24:16), he does not mourn his dead wife but resigns himself to divine will. In the second state of the print, Blake burnished exquisite highlights, particularly for the halos surrounding the heads of Ezekiel and his wife. Whereas he has achieved peace while alive, hers is the serenity of death—a total transcendence of the material world, to be not feared but accepted. Blake was, after all, a thoroughgoing Platonist. When he was thirty, he had been deeply moved by his vision of the "ascension" of

EZEKIEL

his younger brother Robert into heaven, clapping his hands joyously as he rose through the ceiling.

The relief etching method, already described in its purely linear manifestation for *Death's Door*, was utilized most effectively by Blake in books of his own authorship and design dating from 1788 to 1795. He moved now from white lines on black backgrounds to large, flat areas that may be enhanced with lines. He could even establish black, worm-like squiggles within the white, etched areas by employing a square-ended graver that raised a double burr—his etching was so shallow that the burrs printed black.[51]

In Blake's illuminated books, the universal drama envisioned by the poet plays itself out. *Songs of Innocence* (1789) and *Songs of Experience* (1794) describe, with deceptively simple poetry and images, the progressive corruption of the free human spirit by society and by involvement in the material world. *Infant Joy* (fig. 6.47) describes the pristine state of the child before the spirit is stifled by training and education:

FIGURE 6.46
William Blake. Ezekiel,
*second state. After 1804?
Engraving. 353 ×
480 mm. British Mu-
seum, London.*

FIGURE 6.47

William Blake. Infant
Joy *from* Songs of
Innocence. *1789. Relief
etching with watercolor.
181 × 127 mm (page).
Yale Center for British
Art, New Haven.*

I have no name,
I am but two days old.—
What shall I call thee?
I happy am
Joy is my name,—
Sweet joy befall thee!

Pretty joy!
Sweet joy but two days old.
Sweet joy I call thee:
Thou dost smile.
I sing all the while
Sweet joy befall thee.

Blake's working methods have been debated, but the letters of the verse were probably
made by brushing stopping-out varnish on the plate—backward, of course, an extraordinary
feat of skill.[52] At the top of the page, a young mother and an angelic, butterfly-winged girl
greet the new life, sheltered in a blossom. To express the sense of budding life, Blake sur-
rounded his verses with a vine-like ornament not unlike the marginal decorations found in
medieval manuscripts. The hand-coloring reinforces this similarity and, in a sense, defeats the
purpose of printmaking, or at least moves it closer to painting. On the other hand, Blake's
Songs of Innocence is related to the popular moralizing children's books of John Newbury, re-
vealing the artist's desire for a wide audience, and the use of relief etching for both image and

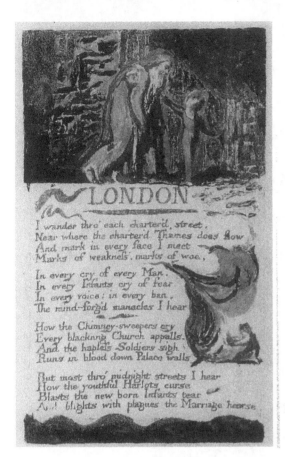

FIGURE 6.48

William Blake. London *from* Songs of Experience. *1794. Relief etching with watercolor. 184 × 121 mm (page). Yale Center for British Art, New Haven.*

text replaced the collaboration of artist and publisher and the division of labor in letterpress printing, allowing the artist to produce a cheap "luxury edition" on his own.[53] As so often in Blake, the entrepreneur and the poet coexisted: a preciousness of form and thought combined with the hope of reaching a broad audience through printmaking.

In *Songs of Experience,* Blake traced the suppression of the child's spirit. In *London* (fig. 6.48), he viewed it in terms of the urban environment:

> I wander thro' each charter'd street,
> Near where the charter'd Thames does flow.
> And mark in every face I meet,
> Marks of weakness, marks of woe.

Here, Blake expressed a specific social concern. But *Experience,* like *Innocence,* is also metaphysical, addressing what Blake seems to have understood as an inevitable downfall of human potential, implicit in the very giving of life, and the irreconcilable conflict of eternal spirit and mortal flesh:

> O Rose thou art sick.
> The invisible worm,
> That flies in the night
> In the howling storm:
>
> Has found out thy Bed
> Of crimson joy:

William Blake. The Sick Rose *from* Songs of Experience. *1794. Relief etching with watercolor. 197 × 133 mm (page). Yale Center for British Art, New Haven.*

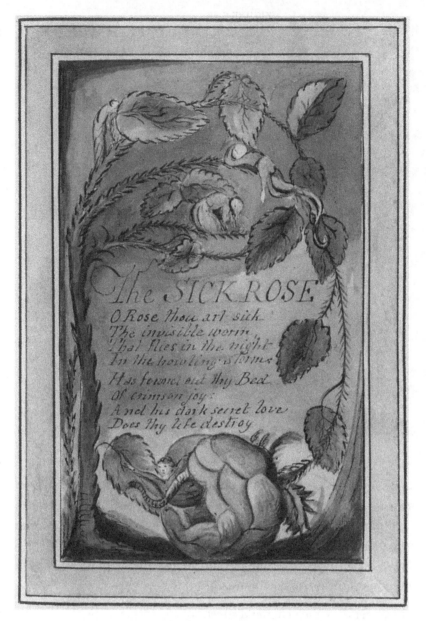

And his dark secret love
Does thy life destroy.

As a metaphor for this insidious decay, Blake's hand-coloring suppresses the natural green of the leaves and the blushing pink of the rose with grayish-blue, acid yellow, and brown (fig. 6.49). Instead of rising triumphantly from the top of the plant, the heavy flower sinks down; its leaves are outnumbered by thorns, and caterpillars and defeated figures crawl through its petals and branches. In the most famous poem of this book, *The Tyger,* Blake dealt with the mystery and seductive beauty ("thy fearful symmetry") of evil as he understood it: Does it derive from the same God who made what is good? ("Did he who made the Lamb make thee?")

Blake's so-called Lambeth Books, named for the neighborhood on the south bank of the Thames where he and his wife, Catherine, moved after his mother's death in 1790, represent the most powerful expression of his personal philosophy, except for *Jerusalem* and *Milton,*

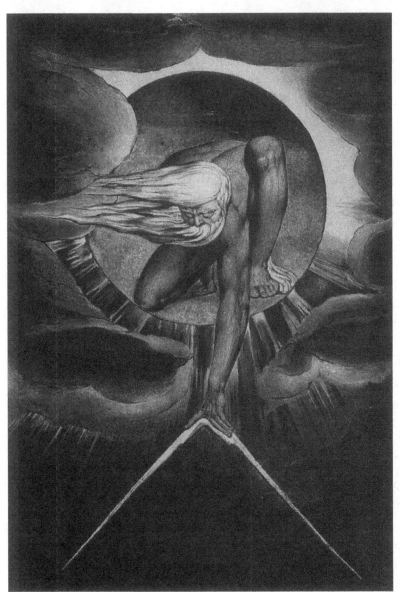

FIGURE 6.50

William Blake. The
Ancient of Days *from*
Europe: A Prophecy.
*1794. Color-printed relief
and white-line etching
with watercolor. 233 ×
168 mm. Whitworth Art
Gallery, University of
Manchester.*

which followed the seven years at Lambeth. In the color-printed and hand-colored relief etch-ings of *America: A Prophecy, Europe: A Prophecy, Visions of the Daughters of Albion, The Song of Los, The Book of Ahania, The Book of Urizen,* and other works completed during this period, Blake as an artist is often at his most compelling. As a thinker, he is at his most arcane.

In *The Ancient of Days,* the frontispiece to *Europe* (1794; fig. 6.50), also published as a separate print, Blake's links to medieval art are immediately evident, for the image of God the Father creating the universe with a compass is found in medieval manuscripts.[54] Blake's inter-pretation, however, is totally negative: the demiurge, a Jehovah-Urizen figure, emerges out of a dark, blue-violet and red sky, created out of the mottled, reticulated textures inherent in Blake's application of opaque colors to the plates and, according to Essick, symbolic of the fallen, material universe.[55] Anxious, with head bowed and body in a cramped position, the demiurge struggles to impose order on a vigorous, rebellious life. Thus, Blake set up the prem-ise for the political allegory of the text: a turgid account of the history of Europe before the revolutions of the late eighteenth century. The Ancient of Days is the God of the Enlighten-

ment who forces humanity, in the words of Anthony Blunt, to "live the bounded and restrained life of reason as opposed to the free life of the imagination. The compasses, which the colossal figure holds down onto the black emptiness below him, symbolise for Blake not the imposition of order on chaos, but the reduction of the infinite to the finite."[56]

The compasses recur in *Newton* (ca. 1805; fig. 6.51, color plate, p. 467), one of Blake's large, separate color prints taken from painted millboards or from the backs of copperplates.[57] These works constitute important early experiments in monotype, which Castiglione seems to have invented in the seventeenth century and which would come into its own in the late nineteenth century with Degas. Blunt has noted the similarity of Newton's pose to that of a figure in one of Michelangelo's Sistine ceiling lunettes, engraved by Ghisi and in turn copied by Blake in a watercolor drawing.[58] Both artists used the pose to express a spiritual misdirection: Michelangelo to convey the weary wandering of the Old Testament peoples, Blake to convey a concentrated, active effort to impose a rational order on the world. Isaac Newton was Blake's definitive scientist, a pure product of the Enlightenment and an enemy of the human spirit.[59] He sits in an underwater environment (water symbolizing, for Blake, the material world), formed of the murky blue and gold patches of pigment pulled up from the printing surface.

The twenty-two illustrations for the Book of Job were commissioned in 1821 by a young artist-friend, John Linnell, who had been impressed by the Job watercolors Blake did for his major patron, the military official and financier Thomas Butts. In these illustrations, Blake returned to pure engraving. In many ways these marvelous prints, whose compositions he had been working on since 1805, crown his artistic career. In them, Blake's interest in the northern Renaissance tradition of engraving, with its well-defined forms and careful detail, and his knowledge of the principles of design in medieval illuminated manuscripts are blended with his personal interpretation of the Book of Job.

One of the greatest essays on the religious and philosophical problem of suffering, this biblical book asserted the necessity of absolute trust in God in the face of the apparent meaninglessness of unwarranted misfortune. Job, the archetypal righteous man, lived by the letter of the law but lacked the complete surrender to the will of God that, in Judaeo-Christian thought, must be faith's ultimate response to the existence of evil in the world. Job's spiritual odyssey takes him through a quest for the reasons behind the catastrophes that befall him to a realization that divine providence lies beyond human reasoning and questioning. For Blake, the story confirmed his view of the victory of the irrational spirit over reason. Job's final acceptance of God's will becomes the discovery of the divinity Blake felt was within each person. Visually, Job's form is assimilated to that of God as this discovery is made.

Thus Did Job Continually (Plate I; fig. 6.52) describes the hero's self-satisfied complacency before his travails. With prayerbook open, he sits beneath a sheltering tree with his family and flocks. The opening words of the Lord's Prayer, from the sixth chapter of Matthew or the eleventh chapter of Luke, are engraved above, to indicate Job's dependence on the repetitive forms of devotion. As Jenijoy La Belle has shown, Blake used the engraved biblical quotations ingeniously, drawing from other parts of the Bible as well as the Book of Job and sometimes creatively altering the wording to his own purposes.[60] Below, two rams' heads on the altar refer to the burnt offerings that Job made "continually" on behalf of sons who may "have sinned, and cursed God in their hearts" (Job 1:5). But the blissful peace Job thinks he has established for himself and his family, conveyed by the symmetry of the main composition and the har-

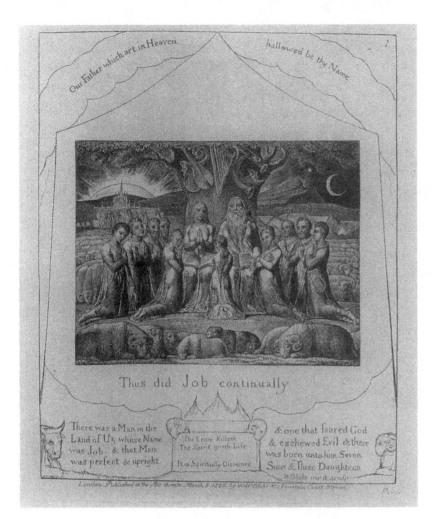

FIGURE 6.52

William Blake. Thus
Did Job Continually:
Plate I from Illustrations
for the Book of Job. *1805–
25. Engraving. 184 ×
150 mm. Pierpont Morgan
Library, New York.*

monious simplicity of the border, is precarious. A sun sets on a Gothic church in the distance.
The musical instruments, which might be used to "make a joyful noise to God" (Psalm 66:1),
hang silent on the tree. Job performs the outward signs of devotion, but is without the inner
spirit of true worship. On the altar, Blake inscribed a quotation from Paul's first letter to the
Corinthians (3:6): "The Letter [of the law] Killeth, [but] the Spirit giveth Life."

The various physical and mental trials that test Job's faith evoked some of Blake's most
powerful creations. Plate XI (fig. 6.53), whose central text, "With Dreams upon my bed thou
scarest me and affrightest me with Visions," derives from Job's reply to the rebuke of Eliphaz
(Job 7:13–14), who accused him of putting himself above the Lord. With eyes open, Job has a
vision of a vengeful God, head ablaze and body entwined with a serpent, who points to the
tablets of the law and to the pit of flames beneath Job's bed. Like St. Lawrence on his grill, Job
reclines in agony, licked by the flames. Demons reach up to chain him. In the midst of his
terror, Job affirms his faith in the reward that he will glean in the end for his righteousness:
"For I know that my Redeemer liveth and shall stand in the latter days upon the earth. . . .
destroy thou this body, yet in my flesh shall I see God." (Job 19:22–27). Blake thus conveyed
the hero's self-righteous entrapment in the law. The just must be rewarded, if only later; yet
even the just are haunted by fear of God's terrible wrath. By placing the two similar bodies
close together, Blake suggested that Job's vision is of his own creation; indeed, it seems but an
aspect of himself.

FIGURE 6.53

William Blake. With
Dreams upon My Bed:
Plate XI from Illustra-
tions for the Book of
Job. *1805–25. Engrav-
ing. 197 × 152 mm.
Philadelphia Museum
of Art.*

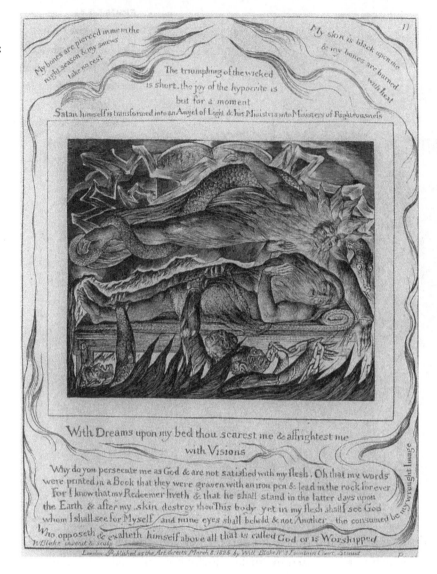

In Plate XIV (fig. 6.54), Job, accompanied by his wife and friends, has another vision, this time of the Creation by an omnipotent God, who finally puts an end to Job's speculations with a resounding account of his majesty (Job 38, beginning with the decisive words, "Then the Lord answered Job out of the whirlwind"). As he had done all through these illustrations, Blake blended phrases from the Book of Job with other scriptures, this time from Genesis. But the key phrase is Job 38:7, "When the morning Stars sang together, and all the Sons of God shouted for joy." God the Father appears in the center, and with a commanding gesture sends out the chariots of the sun and moon. As in his image of God speaking to Job out of the whirlwind (Plate XIII), Blake has been influenced here by the striking figure of Jupiter Pluvius on the Column of Marcus Aurelius.[61] Above, the morning stars, conceived by Blake as a row of angelic figures, stretch out their arms in praise. Their singing replaces the silent musical instruments of the first plate. Job, virtually identical in appearance to God (in Blakean terms, he has understood that God must be one with every individual soul), worships—not complacently, in anticipation of reward, but with love and awe. The organization of this page, with its oval encapsulations of the stages of Creation at the sides and its opposition of the serpent in

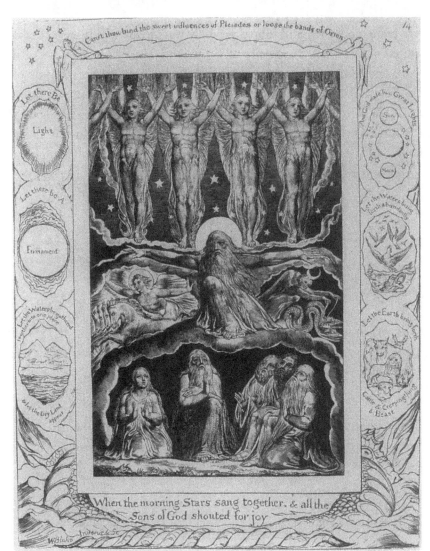

FIGURE 6.54

William Blake. When the Morning Stars Sang Together: *Plate XIV from* Illustrations for the Book of Job. *1805– 25. Engraving. 193 × 151 mm. Philadelphia Museum of Art.*

water below and the heavens above, is an inspired translation of medieval book design, and the division of the central image by fringes of clouds recalls Dürer's *Apocalypse* (see Chapter 2). Like the German artist, albeit more idiosyncratically, Blake used the Bible for his own artistic purposes. But it would be unfair to say that he distorted the meaning of the text. Rather, he adapted his message to a new age and to his own terms, which remain as deeply mystical as the Book of Job itself.[62]

Both as a poet and as a printmaker, Blake was a curious and grand anomaly. For poetry was as natural a means of expression for the mystic in him as printmaking was for the social reformer, and these media and motivations were not easily blended. In order to do so, Blake molded his poetry in the shape of his personal yet mythic vision of a new world, and conceived printmaking not only in terms of the accessibility it offered but also in terms analogous to painting or manuscript illumination. Although Blake's religio-philosophical ideas fell short of being broadly applicable to the political and social revolutions of his time, we can appreciate his questioning of the status quo. Like Francisco Goya, one of the main subjects of the next chapter, Blake never ceased to hope for and apply his art toward social and political change.

Although they were contemporaries, and sometimes they were ideologically close, Blake and Goya produced printed oeuvres that are visually very different. The printmakers we turn to in the next chapter participated in and greatly expanded a longstanding graphic tradition of moralizing satire. As pungent and communicative as Blake's works are idealized and at times hermetic, these prints will tell us more about the momentous social and political changes of the eighteenth and early nineteenth centuries. For the print played a vital role in this era of Enlightenment and, finally, of Revolution, when Reason—the Enlightenment's triumphant principle—would be mortally tested.

NOTES

1. See Haskell [1963] 1980, pp. 304–8, especially p. 308. On Canaletto's etched oeuvre, see Bromberg 1974.

2. Russell 1972, pp. 16–22. Also see Rizzi 1971, pp. 14–16; Robison 1974, pp. 296–97, for some of the issues surrounding the dating of the *Scherzi* and the *Capricci*.

3. Russell 1972, p. 27.

4. A fairly detailed analysis appears in Metcalfe 1920–21. Also see Rizzi 1971, pp. 11–14, for a summary of various interpretations.

5. Russell 1972, p. 34.

6. Haskell [1963] 1980, pp. 341–45, provides a general account of Zanetti's activities. The Zanettis are quoted on pp. 342–43.

7. Russell 1972, p. 85 and n. 3 on p. 85. Also see Hall [1974] 1979, pp. 289–90.

8. The story of the Flight is elaborated upon in the apocryphal gospels of Thomas and Pseudo-Matthew and the Arabic Gospel of the Infancy. See Hall [1974] 1979, pp. 124–35; Russell 1972, p. 95, n. 4.

9. Panofsky 1953, vol. 1, pp. 164–65.

10. Wittkower 1975a.

11. On Piranesi's Venetian background, see Wilton-Ely 1978, pp. 9–11.

12. For example, Johann Wolfgang von Goethe. See ibid., p. 44.

13. See Wittkower 1975b on Piranesi's architectural theory.

14. Quoted in Wilton-Ely 1978, p. 12.

15. For good summaries of Piranesi's contribution to the Greco-Roman controversy, see ibid., pp. 65–80; Scott 1975, pp. 149–62.

16. Wilton-Ely 1978, p. 81.

17. De Quincey [1822] 1949, pp. 849–50.

18. Melville [1876] 1960, pp. 260–61.

19. Huxley and Adhémar 1949, p. 16.

20. Ibid., p. 15.

21. Robison 1986, no. 3, pp. 71–72.

22. See the analysis in Sekler 1962.

23. Wilton-Ely 1978, p. 85.

24. Robison 1986, pp. 51–53.

25. Ibid., pp. 49–50. Robison's analysis here builds on Calvesi 1967, pp. xvii–xviii, and Gavuzzo-Stewart 1971. Arguments in these Italian sources are summarized by Wilton-Ely 1978, pp. 88–89; Robison 1986, p. 57, n. 81.

26. Wilton-Ely, p. 89; Robison 1986, p. 49.

27. See Levitine 1985.

28. On Watteau's original etchings, see Parmantier 1984.

29. Ibid., no. 8, pp. 238–39.

30. Carlson and Ittmann 1985, no. 13, p. 74.

31. On eighteenth-century French book design, see Furstenberg 1975; Ray 1982.

32. Grigaut 1948.

33. Levitine 1985, p. 10. On Madame de Pompadour as a patron, see Posner 1990.

34. See Posner 1982, p. 85.

35. Field 1975, p. 15.

36. Ibid., p. 20.

37. For an introduction to color printing in the late eighteenth century, see Ittmann 1985.

38. On Stubbs's prints, see Taylor 1969; Godfrey 1982.

39. For a survey of Barry's prints, see Pressly 1983, nos. 21–27, pp. 72–78, and nos. 62–77, pp. 118–35. For *Job Reproved* and its companion piece, see nos. 24 and 26, pp. 76–78.

40. This approach is taken most consistently by Essick 1980. Blake's poetry and prose works

are collected in Erdman, ed., 1965, which serves as the reference for Blake's writings cited in my text.

41. See the lucid introduction to Blake's thought in Bindman 1982, pp. 10–48. Raine 1970 is a good introductory book on Blake.

42. Chan 1984, pp. 83–84.

43. Boime 1985, pp. 112–13.

44. On this work, see Blunt 1938.

45. Essick 1980, pp. 182–83; Essick 1983, no. VII, pp. 24–29.

46. Essick 1983, no. VII, p. 29.

47. Essick, ed., 1973; Essick 1980, pp. 145, 182–83.

48. On Flaxman's illustrations, see Irwin 1979, pp. 67–122; on their influence, Symmons 1984.

49. Irwin 1979, pp. 83–84; Boime 1985, p. 111.

50. Essick 1980, pp. 178 and 186; Essick 1983, nos. V and VI, pp. 17–23.

51. Essick 1980, p. 109 and fig. 107.

52. Some have suggested that Blake must have written his texts in acid-resistant varnish on paper, which he then pressed onto the plates. For convincing arguments against this, see ibid., pp. 89–92.

53. Boime 1985, p. 112. Blake's affinity for popular publications is also discussed by Bindman 1986.

54. See Blunt 1959, p. 35 and plate 24b.

55. Essick 1980, pp. 148–49.

56. Blunt 1959, p. 57.

57. Bindman 1982, pp. 110, 115. Also see Butlin 1990, no. 29, pp. 92–94, on the dating of *Newton* to about 1805 on the basis of watermark.

58. Blunt 1959, p. 35 and plates 30a and 30b.

59. On Blake and Newton, see Ault 1974.

60. La Belle 1973.

61. Flaxman also utilized this sculpture for one of his illustrations to Dante. See Blunt 1959, plates 25c and 25d.

62. See Wright 1972, introduction, pp. xv–xxi.

REFERENCES

Ault, Donald. 1974. *Visionary Physics: Blake's Response to Newton.* Chicago.

Bindman, David. 1982. *William Blake: His Art and Times.* Exhibition catalog. Yale Center for British Art, New Haven, Conn.

Bindman, David. 1986. William Blake and Popular Religious Imagery. *Burlington Magazine,* vol. 128, no. 1003 (October), pp. 712–17.

Blunt, Anthony. 1938. Blake's "Glad Day." *Journal of the Warburg and Courtauld Institutes,* vol. 2, pp. 65–68.

Blunt, Anthony. 1959. *The Art of William Blake.* New York.

Boime, Albert. 1985. William Blake's Graphic Imagery and the Industrial Revolution. *Arts Magazine,* vol. 59, no. 10 (June), pp. 107–19.

Bromberg, Ruth. 1974. *Canaletto's Etchings.* London.

Butlin, Martin. 1990. *William Blake, 1757–1827.* London.

Calvesi, Maurizio. 1967. Introduction to the Italian edition of Henri Focillon's *Giovanni Battista Piranesi.* Bologna.

Carlson, Victor, Ellen D'Oench, and Richard S. Field. 1975. *Prints and Drawings by Gabriel de Saint-Aubin 1724–1780.* Exhibition catalog. Davison Art Center, Wesleyan University, Middletown, Conn., and Baltimore Museum of Art, Baltimore.

Carlson, Victor I., and John W. Ittmann. 1985. *Regency to Empire: French Printmaking 1715–1814.* Exhibition catalog with contributions by Victor I. Carlson, John W. Ittmann, David P. Becker, Richard Campbell, Jay McKean Fisher, George Levitine, and Mary L. Myers. Baltimore Museum of Art, Baltimore, and Minneapolis Institute of Arts, Minneapolis.

Chan, Victor. 1984. Rebellion, Retribution, Resistance, and Redemption: Genesis and Metamorphosis of a Romantic Giant Enigma. *Arts Magazine,* vol. 58, no. 10 (Summer), pp. 80–95.

De Quincey, Thomas. [1822] 1949. *Confessions of an English Opium Eater.* In *Selected Writings of Thomas De Quincey,* ed. Philip van Doren Stern, pp. 625–862. New York.

Erdman, David V., ed. 1965. *The Poetry and Prose*

of William Blake. With commentary by Harold Bloom. Garden City, N.Y.

Essick, Robert N. 1973. Blake and the Traditions of Reproductive Engraving. In Essick, ed. 1973, pp. 493–525.

Essick, Robert N. 1980. *William Blake: Printmaker.* Princeton, N.J.

Essick, Robert N. 1983. *The Separate Plates of William Blake: A Catalogue.* Princeton, N.J.

Essick, Robert N., ed. 1973. *The Visionary Hand: Essays for the Study of William Blake's Art and Aesthetics.* Los Angeles.

Field, Richard S. 1975. Gabriel de Saint-Aubin as Etcher. In Carlson, D'Oench, and Field 1975, pp. 15–26.

Furstenberg, Jean. 1975. *La gravure originale dans l'illustration du livre français au dixhuitième siècle.* Hamburg. (Text in French and German.)

Gavuzzo-Stewart, Silvea. 1971. Nota sulle Carceri Piranesiane. *L'Arte,* vols. 15–16, pp. 57–74.

Godfrey, Richard T. 1982. George Stubbs as a Printmaker. *Print Collector's Newsletter,* vol. 13, no. 4 (September–October), pp. 113–16.

Grasselli, Margaret Morgan, and Pierre Rosenberg. 1984. *Watteau, 1684–1721.* Exhibition catalog. National Gallery of Art, Washington, D.C.

Grigaut, Paul LeRoy. 1948. Madame de Pompadour and the *Rodogune* Frontispiece. *Art Quarterly,* vol. 11, no. 3 (Summer), pp. 262–67, 269.

Hall, James. [1974] 1979. *Dictionary of Subjects and Symbols in Art.* New York.

Haskell, Francis. [1963] 1980. *Patrons and Painters: A Study in the Relations between Italian Art and Society in the Age of the Baroque.* Second ed. New York.

Huxley, Aldous, and Jean Adhémar. 1949. *Prisons.* London.

Irwin, Davis. 1979. *John Flaxman 1755–1826: Sculptor, Illustrator, Designer.* New York.

Ittmann, John W. 1985. The Triumph of Color: Technical Innovations in Printmaking. In Carlson and Ittman 1985, pp. 22–27.

La Belle, Jenijoy. 1973. Words Graven with an Iron Pen: The Marginal Texts in Blake's *Job.* In Essick, ed., 1973, pp. 527–50.

Levitine, George. 1985. French Eighteenth-Century Printmaking in Search of Cultural Assertion. In Carlson and Ittmann 1985, pp. 10–21.

Melville, Herman [1876] 1960. *Clarel: A Poem and Pilgrimage in the Holy Land.* Ed. Walter E. Bezanson. New York.

Metcalfe, Louis. 1920–21. Etchings of Giovanni Battista Tiepolo. *Print Connoisseur,* vol. 1, pp. 354–76.

Panofsky, Erwin [1953] 1970. *Early Netherlandish Painting.* 2 vols. Reprint. New York.

Parmantier, Nicole. 1984. The Etchings. In Grasselli and Rosenberg 1984, pp. 227–39.

Posner, Donald. 1982. The Swinging Women of Watteau and Fragonard. *Art Bulletin,* vol. 64, no. 1 (March), pp. 75–88.

Posner, Donald. 1990. Mme. de Pompadour as a Patron of the Visual Arts. *Art Bulletin,* vol. 72, no. 1 (March), pp. 74–105.

Pressly, William L. 1983. *James Barry: The Artist as Hero.* Exhibition catalog. Tate Gallery, London.

Raine, Kathleen J. 1970. *William Blake.* London.

Ray, Gordon N. 1982. *The Art of the French Illustrated Book 1700–1914.* 2 vols. Exhibition catalog. Pierpont Morgan Library, New York.

Rizzi, Aldo. 1971. *The Etchings of the Tiepolos: Complete Edition.* Trans. Lucia Wildt. New York.

Robison, Andrew. 1974. Review of Aldo Rizzi's *Etchings of the Tiepolos.* (1971). *Art Bulletin,* vol. 56, no. 2 (June), pp. 295–96.

Robison, Andrew. 1986. *Piranesi: Early Architectural Fantasies: A Catalogue Raisonné of the Etchings.* Washington, D.C.

Russell, H. Diane. 1972. *Rare Etchings by Giovanni Battista and Giovanni Domenico Tiepolo.* Exhibition catalog. National Gallery of Art, Washington, D.C.

Scott, Jonathan. 1975. *Piranesi.* New York.

Sekler, Patricia May. 1962. Giovanni Battista Piranesi's *Carceri* Etchings and Related Drawings. *Art Quarterly,* vol. 25, no. 4, pp. 331–65.

Symmons, Sarah. 1984. *Flaxman and Europe: The Outline Illustrations and Their Influence.* New York.

Taylor, Basil. 1969. *The Prints of George Stubbs.* London.

Wilton-Ely, John. 1978. *The Mind and Art of Giovanni Battista Piranesi.* London.

Wittkower, Rudolf. 1975a. Piranesi as Architect. In *Studies in the Italian Baroque,* pp. 247–58. Boulder, Colo.

Wittkower, Rudolf. 1975b. Piranesi's Architectural Creed. In *Studies in the Italian Baroque,* pp. 235–46. Boulder, Colo.

Wright, Andrew. 1972. *Blake's Job: A Commentary.* Oxford.

7

The Print and Socio-Political Reform:

Hogarth and His Heirs and Goya

HOGARTH

The time-honored function of prints as the conscience of European society is nowhere better exemplified than in the graphic works of William Hogarth and Francisco Goya. Both artists epitomize one of the chief assumptions of the eighteenth-century intellectual movement called the Enlightenment: that human society could be improved through reason and education. It was art's task to contribute to this. Both Hogarth and Goya were unconventional artists who were nevertheless eager to succeed in conventional, academic art circles. Both married relatives of prominent academic painters: Hogarth eloped with Sir James Thornhill's daughter, and Goya married the sister of Francisco Bayeu. Of course, painting, not printmaking, was the path to success in either country, yet both Hogarth and Goya, dissatisfied with current painting styles and discouraged by the response to their paintings, gravitated toward printmaking. Both were gifted with an ability to uncover the motives behind human behavior, and prints provided the best showcase for their incisive commentary.

Although Hogarth and Goya often aimed their satire at similar targets (arranged marriage, prostitution, drunkenness, lust, hypocrisy, arrogance, greed, political corruption), they were very different artists. Hogarth was a member of one of the freest societies in Europe, where political and social satire, in both visual and verbal form, could thrive.[1] Goya's Spain was the most repressive. As a result, Hogarth's prints were commercial successes, sold by subscription

to guard against the theft of his designs, whereas much of Goya's graphic oeuvre either circulated among a small group of liberals or was published posthumously. Hogarth questioned his own technical ability,[2] but Goya was a born printmaker to whom the aquatint resin and etcher's stylus were natural tools. A brilliant innovator, Goya couched his comments in compositions that are often prophetically abstract. And despite ongoing iconographic research, some of Goya's prints seem ultimately impervious to intellectual analysis or verbal explanation. Fred Licht argues that despite his Enlightenment context, Goya expressed "that indissoluble residuum of darkness which persists in even the most enlightened souls." That "steadfast center that upholds an essentially rational universe" and the equilibrium of transgressions and punishments that pervade Hogarth's art were shaken in Goya's.[3]

Hogarth's dense prints, steeped in detail like contemporary novels, lend themselves to a lingering "reading." Their superabundance of witty detail is drawn from contemporary events, literature, and the very streets of London. Indeed, David Bindman has analyzed Hogarth's "Progresses" as odysseys through the neighborhoods of London as well as spiritual journeys.[4] The frankly didactic, topical, and narrative character of Hogarth's prints seems worlds apart from Goya's laconic, penetrating imagery, but ultimately both artists used the satirical image to illuminate tragic aspects of the human condition. In Hogarth and Goya, the print found artists capable of developing its potential as a shaper of social and political attitudes to the fullest, with no loss of aesthetic quality or expressive power.

Hogarth's success was largely based on his "novels" in paint or print (for the same compositions would be produced in both media), the "Progresses." Only the engravings survive for *A Harlot's Progress* (1732), whereas both prints and paintings exist for *A Rake's Progress* (1735) and *Marriage à la Mode* (1745). Much to Hogarth's dismay, he was known more for his graphic art than for his painting.

A Harlot's Progress was partially inspired by Richard Steele's essay of 1711, "A Consideration of Poor and Publick Whores."[5] Despite the narrative effectiveness of the series, Hogarth may have initially intended only two images (Plates 2 and 3) of a harlot as pendant scenes; the rest of the story may have developed gradually.[6] The tale begins with the arrival in London of a naive country girl, M. Hackabout (fig. 7.1). A hack is a taxi for hire, and *Kate* Hackabout was a notorious prostitute in Hogarth's time, "a very Termagant [shrew] and a terror," who lived in Drury Lane.[7] Although Hogarth gave his protagonist no first name, we will call her "Moll," since she recalls Moll Flanders in Daniel Defoe's *Fortunes and Misfortunes of the Famous Moll Flanders* (1722), a character whose driving ambition is to become a gentlewoman.

Moll's fate is prophesied by the pile of buckets knocked over by the horse of a country clergyman, preoccupied with a letter to the Bishop of London. Details like this abound in Hogarth's prints, underlining the fatal importance of moments of heedlessness or weak will. Waiting to meet Moll are two infamous real-life people, Colonel Charteris, in the doorway, and Mother Needham. Charteris was a lascivious predator upon young girls who had been saved from hanging only by his wealthy connections, and Mother Needham was a procuress known for her pretensions of piety. Henry Fielding also castigated her in his play, *The Covent Garden Tragedy* (1732), as had Alexander Pope in *The Dunciad* (1729).[8]

After this inauspicious welcome to the city, Moll quickly loses her innocence, ultimately becoming a victimizer as well as a victim (Goya, too, as we shall see, emphasizes the double nature of the prostitute in his *Caprichos*). In Plate 3 (fig. 7.2), she is shown in squalid surroundings, having lost her wealthy Jewish lover: Hogarth was not above anti-Semitism. Sir John

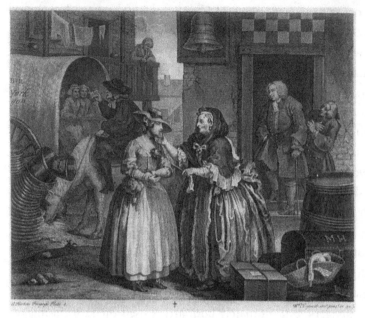

William Hogarth. She Arrives in London: Plate 1 of A Harlot's Progress. 1732. Engraving and etching. 317 × 392 mm. Elvehjem Museum of Art, University of Wisconsin–Madison.

Gonson, notorious arrester of harlots, pauses to eye her before taking her to Bridewell Prison, where she will serve her sentence beating hemp used in the manufacture of rope. Littering Moll's room is the evidence of her degradation. The wig box of a dashing highwayman, James Dalton, sits atop her bed, and pictures of dubious heroes hang on her wall. A pointed "witch's" cap and scourge suggest her penchant for masquerades or perhaps mark her as one of the Quakers, who were maligned as lecherous.[9] From one of her customers, she has stolen a watch that might also double as a symbol of the passage of time, or as a parodic allusion to a traditional emblem of Temperance, the pendulum, for Moll, of course, embodies Temperance's exact opposite.[10] Medicine bottles betray the venereal disease that will eventually kill her. Her coarse but loyal servant has wrapped Moll's butter in an obviously ineffective pastoral letter from the bishop of London.

Moll expires in Plate 5 (fig. 7.3), one of Hogarth's deftest blends of comedy and tragedy. Only her servant, futilely trying to silence two squabbling doctors, really cares. Moll's pathetic child worries about some meat roasting on the fire, and another woman sorts out clothes from a chest, trying to find something suitable for burial. Having been loosened by treatment with mercury, a common remedy for the "secret disease," Moll's teeth lie on top of the coal bin at the far right. The two doctors are modeled after Richard Rock and Jean Misaubin, both of whom had invented spurious cures for Moll's illness.

Plagiarism of Hogarth's designs followed *A Harlot's Progress*, although he had tried to forestall the copyists by offering subscriptions to the prints while he was still engraving the plates. In 1733 he announced subscriptions to *A Rake's Progress*, but he delayed publication of that series until 1735, when the law that he had championed protecting the copyright of engravers went into effect.[11] The prints of *A Rake's Progress* were copyrighted for fourteen years.

Printmakers had faced the problem of copyists for centuries. Dürer, as we saw, had complained to the Venetian Senate about Marcantonio's pirating of his woodcut designs, and subsequent Renaissance and Baroque artists sought privileges from rulers (to whom specific prints might be diplomatically dedicated), which would protect designs from piracy for a certain

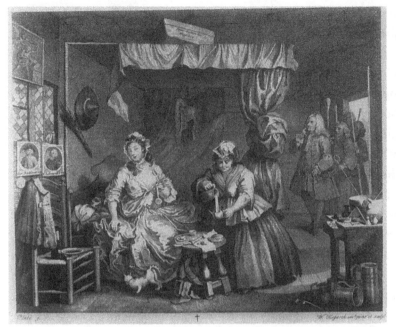

FIGURE 7.2

William Hogarth. She Is Arrested: *Plate 3 of A Harlot's Progress. 1732. Engraving and etching. 320 × 389 mm. Elvehjem Museum of Art, University of Wisconsin–Madison.*

FIGURE 7.3

William Hogarth. She Expires While Doctors Dispute: *Plate 5 of A Harlot's Progress. 1732. Engraving and etching. 321 × 392 mm. Elvehjem Museum of Art, University of Wisconsin–Madison.*

number of years. Rubens lobbied for privileges for his reproductive prints in his native Flanders and France as well as in Holland, which was more difficult. To win over the Dutch government, he engaged the lawyer Pieter van Veen, the brother of his teacher Otto van Veen, and Sir Dudley Carleton, British ambassador to The Hague, to whom Vorsterman's *Descent from the Cross* (fig. 5.18) was dedicated. In a letter to Van Veen, Rubens revealed his awareness that touchy religious and political issues could affect his attainment of a privilege in the Dutch Republic: "As to the subjects [of the prints], no difficulties will rise, because they have nothing to do with the state in any way, and they are without ambiguity nor mystic sense."[12]

Hogarth's Copyright Act of 1735 meant that an engraver could work independently, without the protection of a publisher or patron, and without having to censor his subject matter in order to insure that his designs were protected. He and his artistic heirs could lampoon any class or person, even the Crown. Very different was the contemporary situation in France, where, as we have seen, the artistic status of engravers had been elevated (relative to their English counterparts) by the Edict of St. Jean de Luz in 1659, but the state kept strict control over the content of prints and required a certain number of impressions to be deposited with the government. Rubens' prints are, in fact, the first known examples of this "dépôt légal."[13]

In *A Rake's Progress*, Hogarth's target was an overly self-indulgent member of the wealthy middle class. The protagonist of the series, Tom Rakewell, is, like Moll, gullible and pretentious. Driven to spend the fortune accumulated by his miserly father, he descends, like the Prodigal Son, from a fashionable West End house into the debauched world of London taverns and gambling houses. At the same time, his pretensions to aristocracy surround him with a motley assortment of greedy hangers-on. *The Rake's Levée* (fig. 7.4) shows poor Tom bewildered and besieged by a jockey, a fencing instructor, foreign musicians, and, in the foyer, still more of the cultural elite who clamor for his company. On his wall are the foreign (mostly Italian) "dark pictures" so detested by Hogarth as detrimental to the native English school. The Rake has made the very human error of trying to live above his station.

All this culture, plus gambling and carousing, lead to Tom's financial and moral ruin. *The Tavern* (fig. 7.5), in a setting based on the Rose Tavern in Covent Garden, is reminiscent of seventeenth-century Dutch pictures of the Prodigal Son's dissipation. Bawdy women spit gin and verbal abuse across a table, while a serving maid sets fire to a map of the world. The Roman emperors have all lost their heads, except for Nero, the most depraved. In the right foreground, a "posture woman" begins undressing. She will dance obscenely on the tabletop platter being brought by a waiter modeled after "Leather Coat," who worked at the Rose Tavern and, for a sufficient quantity of beer, would allow a carriage to drive over him. Hogarth's moral disgust is encapsulated in a small detail at the far right, where a chamberpot spills over a roast chicken.

The Rake is temporarily saved from the debtors' prison by marrying an ugly old woman, but his gambling debts finally put him there and, eventually, in Bedlam—the insane asylum (fig. 7.6). There, he finishes out his days raving mindlessly, accompanied, as he had been throughout his moral journey, by his pregnant, jilted girlfriend, Sarah Young. Jane Kromm has traced Hogarth's image back to the theatrical staging of asylum scenes and to book illustrations, such as one from Jonathan Swift's *A Tale of A Tub* (1710). Hogarth juxtaposed some known characters to a supercilious, wealthy young woman who has come to Bedlam for an afternoon's entertainment. As Kromm points out, Hogarth understood insanity not so much in humanitarian as in moralistic terms—as retribution for a life of excess and poor judgment. Although a tragic figure, in Hogarth's view Tom received his just reward.[14]

Another eight years went by before Hogarth published *Marriage à la Mode,* which he regarded as a more refined production than either of his earlier Progresses, and one requiring the skills of French engravers, recruited in Paris.[15] Also in contrast to his earlier Progresses, Hogarth avoided topical and local references and sought to present the theme on a more universal level. Again, the story involves greed, social pretensions, and moral dissolution. A hopelessly mismatched couple are victimized by an arranged marriage that connected a financially depleted aristocratic family, aptly named the Squanderfields, with the economic resources of their bourgeois in-laws.

FIGURE 7.4
William Hogarth. The
Rake's Levée: *Plate 2 of*
A Rake's Progress. *1735.*
Engraving and etching.
356 × 410 mm. Elvehjem
Museum of Art, Uni-
versity of Wisconsin–
Madison.

The Tête à Tête, often called *The Breakfast Scene* (fig. 7.7), shows the sad boredom of the couple as they sit, weary from last night's separate excesses, amid their eclectic bric-a-brac.[16] A dog sniffs at a woman's cap tucked in young Lord Squanderfield's pocket. The couple's taste is epitomized by a ludicrous Rococo clock comprising a tree, a fish, and a fat oriental figure, and by a poorly restored (note the nose) antique bust. They have also acquired a liking for "dark pictures," one of which is so scandalous that it requires a cover. Morally upright servants (one has a religious pamphlet in his pocket) approach the disarray with amusing disgust.[17] But the comedy of this marriage is woven with tragedy, for the separate ways of the couple lead to disease, suicide, and to the husband's being killed in a duel with the wife's lover, the lawyer Silvertongue, who had arranged the marriage. Goya, too, would deal with unhappy marriage, infidelity, venereal disease, and dueling in the *Caprichos,* where one caption reads, "Is There No One to Untie Us?" (see fig. 7.25) and another, more simply, "Love and Death."

The effectiveness of Hogarth's print as satire depends in part upon a denial of our expectations. His style in *The Tête à Tête,* for example, is related to the Rococo depictions of elegant interiors and flirtatious couples engaged in intimate conversations. We expect to find a playful and pleasant subject and to take hedonistic delight in the ornamentation of the room and the curvaceous elegance of the artist's use of line and shape. But elegance here is a sham covering for pretense and hypocrisy. The purpose of the Rococo style has been turned on its head.

Hogarth's paired prints, *Gin Lane* and *Beer Street* (etching and engraving, 1751), contributed to the passage of the Gin Act of 1751, which sought to limit the drinking of cheap imported gin by the London poor. Whereas the healthy consumption of domestic beer in *Beer Street* is accompanied by prosperity and good will, only the pawnbroker prospers in *Gin Lane* (fig. 7.8), where starvation, poverty, suicide, child abuse, and murder—note the impaled baby in the middle distance—occur at every turn. Similarly, in *The Four Stages of Cruelty* (also a combination of etching and engraving, 1751), Hogarth reacted to the rampant abuse of animals that could be observed in the streets of London. The main character, aptly named Tom Nero,

O Vanity of youthfull Blood, / So by Misuse to poison good: / Woman, permit her Social Love, / Fairest gift of Powers above. — Fountain of every Houshold Blessing, / All Charms in Divestion possessing / But turnd to Vice, all Plagues above, / Foe to thy Being, Foe to Love: — Guest Divine to outward Viewing, / Abler Minister of Ruin: / And Thou, no less of Gift divine, / Sweet Poison of Misused Wine — With Freedom led to every Part, / And secret chamber of y Heart, / Lest thou thy friendly Host betray, / And shew thy riotous Gang y Way. — To enter in with sweet Treason, / O'erthrow the drowsy Guard of Reason, / To ransack the abandond Place, / And revel there with wild Excess.

Invented Painted Engrav'd & Publish'd by W^m Hogarth June y^e 25 1735. according to Act of Parliament.

FIGURE 7.5
William Hogarth. The Tavern: Plate 3 of A Rake's Progress. 1735. Engraving and etching. 356 × 406 mm. Elvehjem Museum of Art, University of Wisconsin–Madison.

progresses from cruelty to animals to cruelty to people, until he is finally abused himself as a hanged criminal dissected by surgeons in public (fig. 7.9). A dog innocently licks his heart. The lines in these prints are deliberately coarse and simplified, akin to woodcut lines, so that their cheaper price would make them available to the populace that Hogarth hoped to educate. They might be contrasted with *The Tête à Tête* from *Marriage à la Mode*, engraved by French printmakers who used their intricate cross-hatchings and elegant swelling incisions (*tailles*) to correspond to the more elegant, Rococo style of that series.

SOCIAL AND POLITICAL PRINTS IN THE WAKE OF HOGARTH

Hogarth's influence extended as far as Daniel Chodowiecki of Berlin, a prolific illustrator and vignettist whose style was also shaped by eighteenth-century French prints, particularly those after Greuze. Chodowiecki had gained his reputation with his engraving after his own

FIGURE 7.6

William Hogarth. The
Rake in Bedlam: *Plate 8
of* A Rake's Progress.
*1735. Engraving and
etching. 356 × 406 mm.
Elvehjem Museum of Art,
University of Wisconsin–
Madison.*

painting, *Calas' Last Farewell* (1767), which depicted the execution in 1762 of a Protestant merchant in Toulouse unjustly accused of murdering his Catholic son. However, Chodowiecki's more typical prints were tiny etched illustrations for books or for the almanac, or *Kalendar*, a peculiarly German literary form that gave pragmatic advice and, in the eighteenth century, developed into a pictorially interesting phenomenon. In the twelve etchings of *The Life of an Ill-Educated* Girl (1780), published in the Berlin *Almanac*, Chodowiecki demonstrated his familiarity with Hogarth's *A Rake's Progress* (of which *The Ill-Educated Girl* is a female version), his less vindictive wit, and his ability to achieve convincing characterization on a very small scale. Plate 5 of Chodowiecki's series (fig. 7.10), related to the tavern scene in Hogarth's, shows the main character, a victim of her parents' failure to teach her solid values, at a gambling table at a masquerade. Although Chodowiecki satirizes her vanity through her huge coiffure, popular at that time, he preserves her prettiness and dignity. He does so up until the end, when she is imprisoned for debt after the death of her husband (she had married him for his money, which she, of course, squandered). Chodowiecki's settings are much simpler than Hogarth's, so that the focus is on the characters' skillfully rendered gestures and expressions rather than on literary and symbolic allusions.[18]

Of course, Hogarth's greatest influence was in his own country. There his artistic heirs— Thomas Rowlandson, James Gillray, and George Cruikshank, to name the best—continued to make graphic contributions to the lively, contentious world of English satire, but without Hogarth's subtle wit, sense of irony, or abundance of detail.[19] And Hogarth's harsh moralism was sometimes undermined, as it was by Chodowiecki. For example, the six stipple engravings of John Raphael Smith's *Laetitia* (1789) offer the possibility of redemption for whores. As Ellen D'Oench has shown, this more charitable attitude was also reflected in numerous literary works and attempts at reform, such as the Magdalen Hospital in London, founded in 1758 for the care of repentant prostitutes. Like Hogarth's protagonist, Laetitia starts out as an easily seduced country bumpkin. Unlike M. Hackabout, however, she does not die in the end but is embraced

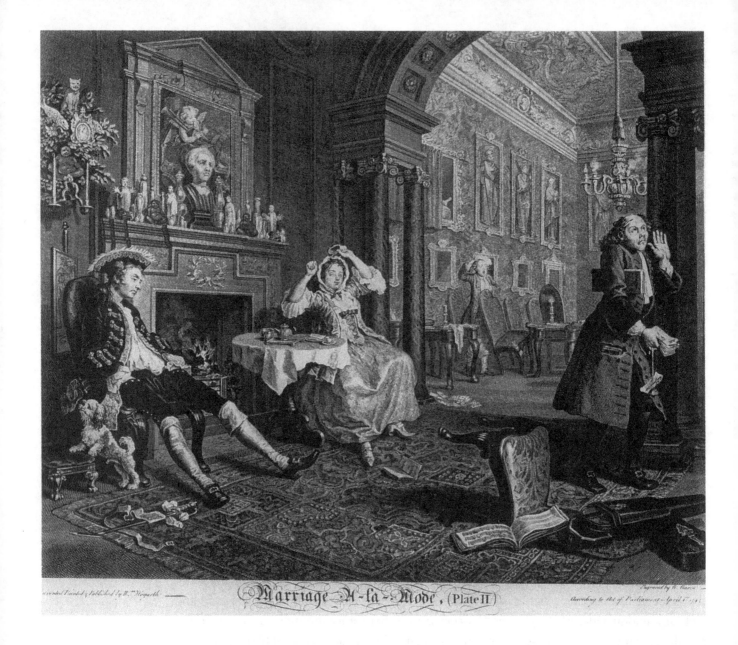

FIGURE 7.7

William Hogarth. The Tête à Tête (The Breakfast Scene): *Plate II of* Marriage à la Mode. *1745. Engraving and etching. 383 × 465 mm. Elvehjem Museum of Art, University of Wisconsin–Madison.*

and transformed by parental love, having "collapsed with neo-classical decorum," as David Kunzle puts it, at the door of her childhood home (fig. 7.11). It is interesting to note that although *Laetitia* was in all likelihood Smith's invention, he persuaded his friend, the popular painter George Morland, to paint canvases as the "models" for the prints, thus insuring the series' popularity.[20]

Underlying Hogarth's prints and his personal character were a fundamental puritanism and a thoroughly English sense of propriety. Thomas Rowlandson ("Rowly"), on the other hand, lived a bawdy, wild life, gambling away an inheritance like Hogarth's rake. Whereas the impact of Hogarth's prints depends upon comic situations that are nevertheless grounded in tragedy, Rowlandson's prints are unabashedly, extravagantly, and coarsely funny. His flowing etched lines and broad, generalized treatments of environments make his prints less literary than Hogarth's; they are not read, but have an immediate satiric impact.[21] His technique usually involved deep line etching, done by himself, with tones produced by aquatint laid by

FIGURE 7.8

William Hogarth. Gin
Lane. *1751. Engraving
and etching. 389 ×
322 mm. Elvehjem
Museum of Art, Uni-
versity of Wisconsin–
Madison.*

FIGURE 7.9

William Hogarth, The
Reward of Cruelty: *Plate
4 of* The Four Stages of
Cruelty. *1751. Engrav-
ing and etching. 386 ×
319 mm. Elvehjem Mu-
seum of Art, University
of Wisconsin–Madison.*

FIGURE 7.10

Daniel Chodowiecki.
Innocent Amusement:
Plate 5 from The Life of
an Ill-Educated Girl.
*1780. Etching. 82 ×
48 mm. Staatliche
Museen, Berlin.*

FIGURE 7.11

*John Raphael Smith
after George Morland.*
The Fair Penitent: *Plate
6 from* Laetitia. *1789.
Stipple engraving. 336 ×
273 mm. British Museum,
London.*

artisans, and watercolor added later by artisans in accordance with a painted proof that Rowlandson supplied as a guide. *The Exhibition Starecase* (ca. 1811; fig. 7.12) depicts the stairs of the Somerset House, in which the Royal Academy, where Rowlandson himself had been trained as a landscape artist, held its exhibitions. The art-loving public here is composed of fools who scratch their vacant heads in confusion or argue vehemently with each other, and lechers who catch glimpses of abundant female derrières during a fleshy avalanche triggered by an unfortunate dog on the steps. A Venus in the frieze above looks down on this catastrophe, while a famous Hellenistic statue—the *Callipygian Venus* ("Venus of the Beautiful Buttocks")—cranes her head to watch the spectacle from her niche.

Rowlandson was not alone in his irreverence toward this particular monument of antiquity, which had been criticized in the eighteenth century for its drapery and proportions and more recently for its moral deficiency. Although it supposedly represented Venus, it was also associated with an ancient legend about two peasant girls who, unable to decide who possessed the shapelier buttocks, enlisted the aid of a passerby as judge, offering the reward of marriage to the girl of his choice.[22] Even beyond the silliness of the statue and this story, Rowlandson invested his scene with a wonderfully comic momentum by his use of the spiraling architectural forms and the exaggerated change in the scale of the figures from the top of the stairs to the bottom. The positions of many of the fallen figures suggest a succumbing to the licentious drives that motivate Rowlandson's humanity, and here constitute, to borrow Ronald Paulson's phrase, "nature's revenge against culture."[23]

Rowlandson's most notorious print is *Vauxhall Gardens,* published in 1785 (fig. 7.13, color plate, p. 468), which depicts a London amusement spot for the wealthy and distinguished and those ordinary citizens who wanted to ogle them.[24] George IV, then the Prince of Wales, is featured at the right, whispering into the ear of a lady who walks arm-in-arm with her ugly, misshapen husband. The two prominent women under the balcony are the Duchess of Devonshire and her sister, Lady Duncannon, who are observed by a peg-legged seaman, a fop, and a bespectacled old man, clasping his hands in delight and peeking out from behind a tree. At the table at the left are seated Dr. Johnson, Oliver Goldsmith, Boswell, and Mrs. Thrale, a "bluestocking"—that is, a member of a literary group whose article of dress would become synonymous with intellectual affectation and whose pretensions would be satirized by Daumier as well, as we shall see. All were well-known contemporary figures. Like Hogarth, Rowlandson has made the London of his own time his subject, but the broader implications are for human society in general: its hypocrisy and pretentiousness are castigated. This print, as we have seen, inspired Debucourt in his *Promenade Publique* (fig. 6.36, color plate, p. 466), which, because of its scandalous subject, was published without Debucourt's address.

Along with following Hogarth's practical advice in *The Analysis of Beauty* regarding the types of lines that suggest ugliness or its opposite, Rowlandson was acquainted with Johann Caspar Lavater's treatise on physiognomy, first published in Geneva in the late 1770s. Lavater's ideas in turn derive from René Descartes's and Charles Le Brun's treatises on the expressions of the passions of the soul; all had to do with the seventeenth and eighteenth centuries' love for categorization and rationalization. The basic assumption of Lavater's book, like that of the theory of the four temperaments, is that the moral man reveals himself through his exterior:

> The moral life of man discovers itself principally in the face,—in the various changes and
> transitions, or what is called the play, of the features. . . . Beauty and ugliness have a strict

FIGURE 7.12

Thomas Rowlandson.
The Exhibition Stare-
case. *Ca. 1811. Hand-
colored aquatint and
etching. 448 × 290 mm.
British Museum, London.*

connection with the moral constitution of the Man. In proportion as he is morally good, he is handsome: and ugly, in proportion as he is morally bad.[25]

The implications of this for art, particularly for satirical art, are enormous. Goya, too, was familiar with Lavater's work. James Gillray, Rowlandson's friend and contemporary, extended the correlation between distortion and moral corruption even farther than Rowlandson, and primarily in the context of political satire. His prolific graphic production provides a chronicle of political issues in late eighteenth-century England. No one in the government was immune to Gillray's satirical barbs, not even the Crown. In *Temperance Enjoying a Frugal Meal* (hand-colored etching, 1792; fig. 7.14, color plate, p. 468), King George III and Queen Sophia Charlotte feast on sauerkraut and boiled eggs—peasant fare appropriate for a Hanoverian monarch

of German descent—in a cold room with unlit fireplace, surrounded by their treasures. In the tradition of Hogarth, the painting on the wall, depicting the Israelites busily gathering manna from heaven, provides a commentary on the scene. This image of the parsimonious, gobbling monarchs, with their oversized lips and heads craned eagerly forward, deflates the notion of noblesse oblige.

France, of course, had been engaged in a bloody struggle over the sovereignty of the king since the fall of the Bastille prison on July 14, 1789. The rapidly escalating violence of the French Revolution culminated in the decapitation of Louis XVI and Marie Antoinette by guillotine in 1793, events that shocked and divided the Francophilic Spanish liberals (Goya's primary audience) and the English, even though the latter had beheaded their own Charles I in 1649. Along with the development of a parliamentary government in England and the American Revolution, the events in France were the prelude to the painful birth of the modern democratic state. The French Revolution was a monumental and dramatic upheaval that, like the Reformation in the sixteenth century, had enormous implications for prints. Faced with rapidly evolving events of unprecedented significance, printmakers responded with forceful, often grotesque, visual commentary.

Klaus Herding emphasizes the awkward, hybrid character of French revolutionary prints, which combined figures, texts, and allegory with the visual strategies of history painting in new and uneasy ways. The prints of the French Revolution literally taught the public about its new-found power and constantly undermined the governing classes.[26] As in the Reformation, conservative forces responded with equally vehement but ultimately less effective prints: by its ferocious threatening of specific individuals, Claude Langlois argues, counterrevolutionary caricature actually helped to forestall a royalist takeover.[27]

Many revolutionary prints are anonymous, such as an etching of about 1793, *Robespierre Guillotining the Executioner* (fig. 7.15). Maximilien Robespierre, the brilliant lawyer and orator who stridently attacked the monarchy and its supporters and was responsible for numerous executions during the period of the Terror (1792–94), sits on a tomb and wields the rope of the guillotine himself to finish off the executioner. In the background, more guillotines sprout like cornstalks in a field. Brainchild of Dr. Joseph-Ignace Guillotin, this instrument was developed to kill quickly and equitably, in the sense that it was applied equally to ordinary citizens, aristocrats, and even royalty. Robespierre himself, overcome by the numerous enemies he had made, would be guillotined in the following year. Dr. Guillotin's egalitarian and "humane" invention became the universal symbol of the snowballing violence of the French Revolution.

It occupies a central position in Gillray's *Zenith of French Glory* (hand-colored etching, 1793; fig. 7.16). The Revolution provided the English artist with a subject for some of his most vehement anti-French statements, and this particular image conveys with a visceral power the horror felt by many Europeans at the Terror. Beneath a banner marked "Vive l'Egalité" (Long Live Equality), the guillotine continues to operate while Paris burns and a cleric, monks, and a judge are hanged. The grotesque, bare-bottomed figure wearing the Jacobin cap personifies the working-class *sans-culottes,* the most radical group within the Revolution. He sits on a street lamp and fiddles, like a modern-day Nero, while his city is destroyed. Two crossed daggers fixed to his belt are still dripping blood. He rests his dirty foot on the head of one of the hanged men.

Gillray's prints were known to the great French neoclassical painter, Jacques-Louis David, who also produced two political cartoons at the request of the Committee for Public Safety,

FIGURE 7.15

Unknown French artist. Robespierre Guillotining the Executioner. *Ca. 1793. Etching. 140 × 84 mm. Bibliothèque Nationale, Paris.*

formed in 1793 to deal with threats to the revolutionary government from within and without. In *The English Government* (hand-colored etching, 1793–94; fig. 7.17), David relied on Gillray's caricatures of George III, such as the one in *Temperance Enjoying a Frugal Meal* (fig. 7.14, color plate, p. 468), as well as the demon in Callot's *Temptation of St. Anthony* and a Reformation woodcut by Wenzel von Olmütz entitled *The Pope-Ass*, which illustrated a pamphlet of about 1523 by Luther and Melanchthon. The ass-face motif of the woodcut was transformed by David into a crude barb at the English, who boasted a constitutional government but were still oppressed by a monarch. King George III's head, embedded in the anus of the flayed devil, "farts" taxes upon his people. The scatological character of this image would seem very far from David's neoclassical paintings, but Boime has argued for the close psychological relationship between the two modes. While the neoclassical style venerated and idealized authority, the political cartoon uses gross anal imagery in a kind of Oedipal rebellion against the dominant order.[28]

Gillray became insane in his later years and was cared for by Mistress Humphrey, who owned the print shop above which he lived and worked. Upon Gillray's death in 1815, George Cruikshank, one of the sons of the caricaturist Isaac Cruikshank, emerged as the leading satirical printmaker. He was also destined to be a great book illustrator, associated particularly with Charles Dickens' novels. He may have completed some of Gillray's plates, and he produced prints of his own in the manner of the older artist.[29]

While abhorring, as had Gillray, what he perceived as an extremism analogous to the radical forces of the French Revolution, Cruikshank nevertheless supported the economic and

The Zenith of French Glory; — The Pinnacle of Liberty.

political causes of the common man: "John Bull," the "free-born Englishman," who first appeared in English satire in the late eighteenth century.[30] Although England was comparatively open to free speech and expression, suffrage was still very limited and Parliament was still controlled by the landholding interests and the new industrial aristocracy. The conditions of the urban poor, so poignantly described by Dickens, were appalling. As a reaction to disturbances among the impoverished and disenfranchised, the British government passed the Six Acts of 1819, which curtailed freedom of speech, assembly, and the press. In response, Cruikshank produced an etching, *Poor Bull and His Burden—Or, The Political Murraion!!!* (fig. 7.18), which shows John Bull as a bull ridden by a mound of tax collectors, soldiers, bishops, and finally the British Crown, and confronted by Lord Wellington as a butcher. "Murraion," a variant of "murrain," refers to various diseases of cattle.[31] Although this is a brilliantly witty image, it pales beside Goya's *You Who Cannot* (fig. 7.34) as a work of art. It is cluttered and additive—indeed, Cruikshank has used these qualities to advantage to produce a great car-

EXPLICATION.

Nº 1. Gouvernement Anglois. Nº 2. l'Anglois né Libre.

Ce Gouvernement est représenté sous la figure d'un Diable écorché tout vif, occupant le Commerce, et revêtu de toutes les décorations Royal. le Portrait
du Roi se trouve au derrière du Gouvernement, lequel vomit sur son Peuple une multitude d'impôts avec lesquels il le foudroye. Cette prérogative est attachée au Sceptre
et à la Couronne.

toon—whereas Goya's work is visually succinct, and is as powerful aesthetically as it is satirically.

The personal tragedies of poverty and alcoholism are most eloquently depicted in Cruikshank's later series, *The Bottle* (1847), praised by Dickens, and its less popular sequel, *The Drunkard's Children* (1848). Both series reprise the Hogarthian Progress, in which characters are brought to ruin by their moral lapses. Although Cruikshank was careful not to specify the occupation of the alcoholic parents, the better to impress the value of abstinence on the lower and middle classes alike, Kunzle points out that the core of the audience for these prints was composed of middle-class temperance fanatics, whom Cruikshank himself, as a reformed alcoholic, had joined.[32] In Plate 8 of *The Drunkard's Children* (fig. 7.19), an image whose expressive power surpasses the more journalistic character of the other images in the two series, the daughter jumps to her death in a fit of alcoholic despair. As in Hogarth's *Gin Lane* (fig. 7.8), the offending substance is cheap gin, but the girl's small form, isolated against the dark bulk of the bridge that seems to embody the impersonal harshness of the urban environment, conveys a sense of tragic waste that goes beyond the immediate social problem of alcoholism. The bridge is a specific one—Waterloo—known as a site of suicides. Cruikshank's images were reproduced by the inexpensive process of glyphography, in which a raised drawing on a metal plate was duplicated by electrotyping and then converted into a relief surface for printing.[33]

FIGURE 7.17
Jacques-Louis David.
The English Government. *1793–94. Etching with hand-coloring on blue paper. 248 ×
392 mm. British Museum, London.*

FIGURE 7.18

GOYA: THE *CAPRICHOS*

Although these English artists may have influenced their society in small ways with their prints, Goya had no such chance in Spain. The repressive, corrupt monarchy of Charles IV, who followed his enlightened, ascetic father, Charles III, the tremendous social and economic inequalities that reinforced themselves as time went on, and a stubbornly backward, fanatically Catholic, and superstitious populace made up Spanish society in Goya's time. This bleak picture was relieved for Goya by fellowship with his liberal friends and the rare occasions on which

FIGURE 7.19

George Cruikshank.
The Maniac Father and
the Convict Brother Are
Gone—The Poor Girl,
Homeless, Friendless,
Deserted, Destitute and
Gin-Mad Commits Self-
Murder: *Plate 8 of* The
Drunkard's Children.
*1848. Hand-colored
glyphograph. 222 ×
330 mm. Yale Center for
British Art, New Haven.*

repressiveness was eased.[34] The aged Goya finally left Spain for voluntary exile in France—the France he so harshly censured in *The Disasters of War*—but for most of his life, he followed the way of compromise, except in his prints.

In 1799 Goya published his first major graphic cycle in etching and aquatint, the *Caprichos*, the eighty plates of which had been conceived and executed between 1796 and 1798. Before this, Goya had worked within the system of royal and ecclesiastical patronage, producing designs for tapestries to be woven in the Royal Tapestry Works in Madrid, portraits, and religious works in a late baroque style. Janis Tomlinson's careful study of Goya's early career emphasizes the importance of the serial nature of the tapestry cartoons for his later graphic oeuvre, the connections between the moralizing genre themes of the cartoons and those of the *Caprichos,* and, most important, the inventiveness of the cartoons—fueled in part by his extensive knowledge of prints like the engravings of the *Recueil Jullienne*.[35] Nevertheless, the *Caprichos* are still startling examples of the change in Goya's outlook after his serious illness of 1793, which left him profoundly deaf and which would recur later. Although Tomlinson urges us to rethink the romantic notion of an illness-provoked "crisis" in Goya's art, the experience does seem to have catalyzed his impatience with commissioned work and his fascination with increasingly profound and caustic satiric themes.[36]

Like many later prints by Goya, the *Caprichos* developed from ink-wash drawings in which he established very broad areas of tone that would be occupied by aquatint. There are three sets of drawings that apply to the *Caprichos*.[37] The first was made at Sanlúcar in 1796, when Goya reputedly had his ill-fated affair with the beautiful and fiery Duchess of Alba. These drawings are extraordinarily intimate studies of the duchess and other people in her household. The second album of drawings was begun at Sanlúcar and finished when Goya returned to Madrid. In effect, both of these albums constitute an artistic diary—a record of what Goya

observed and thought—but the later album was also the ground in which the *Caprichos* germinated. Goya's satirical talent became more apparent; punning or ironic titles began to appear, and his sense of caricature was sharpened. The third set of drawings, entitled *Sueños* (*Dreams*), is more terse and savage. The drawings of this set, related to Francisco de Quevedo y Villegas' literary *Sueños,* in which the author converses with inhabitants of the underworld,[38] are direct preliminary studies for the *Caprichos.*

The purpose of the *Caprichos* (literally, "caprices," in the sense of extravagant actions) is stated tamely enough in the advertisement Goya wrote, probably with the help of a literary colleague, for the *Diario de Madrid:* the censure of human errors and vices that is the proper domain not only of rhetorics and poetry, but also of art. Goya was also careful to emphasize the universality of his intentions and to deny any reference to specific individuals or groups.[39] But such references were unmistakable. The politically inflammatory nature of these prints, apparently still well-understood and even exaggerated by an early nineteenth-century audience,[40] may be revealed in Goya's choice of a perfume and liqueur shop in which to sell them. Bookstores and print shops were regularly visited by the Inquisition, the organ of the Catholic church that routed heresy, and that was an important agent of political repression in Spain.[41] The *Caprichos* were withdrawn from sale fifteen days after they were advertised, perhaps under Inquisitorial pressure, perhaps after only twenty-seven sets had been sold.[42] Later, Goya traded the plates for a government pension for his son Javier.

Capricho 43, *The Sleep of Reason Produces Monsters* (see fig. 7.27), is a concise visualization of the series' purpose. On the preparatory drawing (*Sueño* 1), Goya wrote, "The author dreaming. His one intention is to banish harmful beliefs commonly held and with this work of *caprichos* to perpetuate the solid testimony of truth."[43] Even without this inscription, we know that the sleeping figure in the print is the artist by the etching tools at his side. Various creatures of the night, of evil and deceit, threaten him, much as the witch and the horse threaten the artist/groom in Baldung's *Bewitched Groom* (fig. 2.20). Their menace is twofold. They are the creatures of fantasy that must be tamed by reason, and they are the evils of society that follow this print and are exposed by the artist.

The *Caprichos* fall into three distinct sections:

Plates 1–36: The follies of society, such as arranged marriage, prostitution, errors in child rearing, superstition, and religious abuse, introduced by a contemptuous self-portrait.[44]

Plates 37–42; Donkeys personifying doctors, aristocrats, teachers—the "leaders" of society.

Plates 43–80: Abstract and fantastic scenes that reiterate the follies of society dealt with in the first part of the series, particularly witchcraft and the abuse of religion. This section is introduced by *The Sleep of Reason,* a spiritual self-portrait corresponding to the literal self-portrait introducing the first part.

With the limited selection of images possible here, it is difficult to give a sense of Goya's masterful use of sequence, repetition, and contrast in this and all of his graphic cycles. As Tomlinson's recent study has established, the published sequence of Goya's series often differs considerably from the order in which the plates were created, and the relationship between the two sequences warrants more intensive study. Departing from the more strictly narrative

FIGURE 7.20

Francisco Goya. All
Will Fall: *Plate 19 of* Los
Caprichos. *1799. Etching
and aquatint. 214 ×
148 mm. Elvehjem
Museum of Art, Uni-
versity of Wisconsin–
Madison.*

Hogarthian Progress, Goya seems to have developed his series in a complex, organic manner, eschewing storytelling to explore the multifaceted implications of particular themes. As he worked, he eventually positioned his images to play off each other, either expressing the same theme from different angles or showing relationships and contrasts between themes.[45]

All Will Fall (Plate 19; fig. 7.20), for example, occurs within a sequence of images dealing with prostitution (15–22). In 1623 Spain's legal, inspected brothels were closed, leading to a proliferation of prostitution and the venereal disease—symbolized by the balding, scrofulous "poultry customers" of Plate 20—it fostered. As in Hogarth's England, venereal disease was a serious concern: the father of Goya's playwright friend, Leandro Fernández de Moratín, had offered practical advice (like where to find condoms) in his *Art of Whores* (1769).[46]

FIGURE 7.21

Francisco Goya. How
They Pluck Her! *Plate
21 of* Los Caprichos.
*1799. Etching and aqua-
tint. 214 × 148 mm.
Elvehjem Museum of Art,
University of Wisconsin–
Madison.*

¡Qual la descañonan!

The young prostitutes of *All Will Fall* disembowel an unfortunate, chicken-like customer while the old procuress hopes for more "poultry" to fall, lured by the flighty prostitutes above. The Tiepolesque grace of the composition (compare the Italian artist's *capricci,* figs. 6.5–6.9) is vitiated by the gleeful viciousness of Goya's humor. On a spherical perch reminiscent of Fortuna's globe, an alluring hen who looks much like the Duchess of Alba entices a chicken who bears a resemblance to the artist. This etching is one of three *Caprichos* (one of which was not published with the series) that allude to Goya's attachment to the duchess and equate her visually with Fortuna by suggesting the goddess's attributes or qualities like flightiness and deceitfulness.[47] On the basis of images like this, one could dismiss Goya as a misogynist embittered by a difficult personal experience. But, as always in Goya, the other side of the issue emerges—in this case in his equally savage treatment of males at various points in the *Caprichos.*[48]

In Plate 21 (fig. 7.21), for example, the prostitutes' victims are avenged as greedy, bestial authorities devour their prey: an anguished *búho* (the word for "owl" and "streetwalker"). The two figures gnawing her wings are a notary (at the left) and a constable (at the right). Whereas Hogarth, in *She Is Arrested* (fig. 7.2), conveyed the predatory nature of the authorities by Gonson's prurient glance, and the whore's victimization by details betraying her poverty, Goya chose an abstract, wrenching image of carnivores feeding on a still-living meal. Moreover, the sanctimonious magistrate presiding over this feast spreads his cloak in a mockery of the Virgin of Mercy.[49] Through utterly different visual means, both artists recognized prostitution and the legal procedures controlling it as a self-perpetuating system in which the whores were both seducers and victims.

In another superb example of meaningful sequencing, two scenes of the cruelty of the Inquisition—*That Dust* (23; fig. 7.22) and *There Was No Remedy* (24)—are followed by *But He Broke the Pitcher* (25; fig. 7.23). This last image depicts the brutal disciplining of a child over a trivial offense. Goya's grotesque characterization of the mother tells us that her brutality is engendered by ignorance and the brutality *she* has endured.[50] Paulson reads this image in terms of its relationship to the preceding scenes of the judgment against prostitutes and of the Inquisition, in which male-controlled legal institutions exercise absolute control. Only in the realms of the boudoir or child rearing, then, can women retaliate by exercising power over their sons and lovers, and an image that seems to interrupt a sequence in fact contributes to it.[51] On a level even more profound than the struggle of the sexes, however, *But He Broke the Pitcher* suggests that the abusiveness we have seen in the adult world of political, social, and religious institutions has its roots, ultimately, in the cruelty experienced, accepted, and finally learned by children.

Goya also tackled the custom of arranged marriage. Here again, he departed from Hogarth, whose *Marriage à la Mode* was the most important essay on this theme. *What a Sacrifice!* (14; fig. 7.24) depicts the beautiful young victim, given away by her relatives to a grotesquely hunchbacked, leering suitor. The man's frog-like appearance, reinforced by the spots on his trousers, betrays lechery, a vice with which frogs were traditionally associated. What is told in Hogarth's series by means of the narrative itself and innumerable, witty details is conveyed by Goya tersely, like a quick punch in the stomach. The ridiculous takes on a demonic quality that it never possesses in Hogarth. This is not to say that, for Goya, evil was inhuman: on the contrary, its roots lie in our unreasoning behavior. Yet in Goya's images, the power of unreason is presented with a new and disturbing force.

Is There No One to Untie Us? (75; fig. 7.25) is even further removed from a narrative context. Whereas *What a Sacrifice!* occurs early in the *Caprichos, Is There No One* comes after *The Sleep of Reason* (43), and is, like most of the etchings that follow this crucial image, more dream-like and abstract. The suffering couple are bound together to a tree, significantly without foliage. They are menaced by the vicious talons of a great owl, not unlike the one who flutters above the sleeping artist in Plate 43. Although sometimes a symbol of wisdom, this bird was frequently associated with the night, with witches and demons, and with evil itself. Here, Goya gave him spectacles, such as might be worn by someone aged and learned, in order to turn the connotation of wisdom on its ear. For the owl represents the pretense of wisdom on the part of those supporting the outmoded custom of arranged marriage. Comparable in meaning to *The Tête à Tête* (fig. 7.7) from Hogarth's series, which blends the ludicrous aspects of the couple's marriage with the unfortunate, Goya's image is overwhelmingly tragic.

Superstition is tentatively introduced in the first part of the *Caprichos* in the fairly realistic Plate 12, *Hunting for Teeth* (in folk belief the teeth of hanged men were thought to be valuable in spells; fig. 7.26). After *The Sleep of Reason* (43; fig. 7.27), however, the scenes of witches and goblins are more unreal and nightmarish. Goya at once satirized these beliefs and demonstrated their powerful appeal to those made vulnerable when reason sleeps. Moreover, as he worked, the witches and goblins with which he began (many of the images of superstition are technically and stylistically conservative, suggesting that they were the first *Caprichos* Goya conceived) became indistinguishable from the human members of Spanish society.[52] Superstition and the abuse of religious belief, for example, became simply two sides of the coin of unreason.

Goya repeatedly tackled absurd beliefs about the flight of witches and their cannibalism

FIGURE 7.22
Francisco Goya. That
Dust: *Plate 23 of* Los
Caprichos. *1799. Etching
and aquatint. 216 ×
149 mm. Elvehjem
Museum of Art, Uni-
versity of Wisconsin–
Madison.*

FIGURE 7.23
Francisco Goya. But He
Broke the Pitcher: *Plate
25 of* Los Caprichos.
*1799. Etching and aqua-
tint. 207 × 151 mm.
Elvehjem Museum of Art,
University of Wisconsin–
Madison.*

of infants: twin pillars of the myth of witchcraft that the Inquisition had earlier helped to build.
In Plate 68, *Linda Maestra!* (*Fine,* or *Beautiful, Teacher;* fig. 7.28) a young witch is initiated into
broom flight by an old hag. The print doubles as a comment on prostitution (note the *búho*),
as the old bawd teaches the young woman to "fly" (*volar* means to have an orgasm).[53] And
bundles of babies, the witches' "harvest," dangle here and there in the series—they are strapped

FIGURE 7.24
Francisco Goya. What a
Sacrifice! *Plate 14 of* Los
Caprichos. *1799. Etching,
aquatint and drypoint.
198 × 149 mm. Elvehjem
Museum of Art, Uni-
versity of Wisconsin–
Madison.*

FIGURE 7.25
Francisco Goya. Is There
No One to Untie
Us? *Plate 75 of* Los
Caprichos. *1799. Etching
and aquatint. 212 ×
151 mm. Elvehjem
Museum of Art, Uni-
versity of Wisconsin–
Madison.*

to a demon's back in *If Day Breaks, We Will Go* (71; see fig. 7.35), for example. At the same time, the witches' consumption of infants provided a gross physical analogy to the parasitic sapping of Spain's energy and resources by the greed and corruption of the upper classes, church, and government.

In *There's a Lot to Suck* (45), Goya merely showed the witches collecting babies in baskets as they enjoy the elegant habit of dipping snuff. But in *Blow* (69; fig. 7.29), their victims will be roasted on a fire fanned by a bellows made of a baby's body (note the witch chewing on an infant's genitals below). While suggesting the witches' horrific practice of roasting children, Goya also indicted pedophilia; *soplar* also means "to fornicate."[54] Moreover, this verb, as in Plate 48, *Blowers,* or *Squealers,* may also express Goya's contempt for those who informed to the Inquisition.[55]

Goya's comparisons between the authorities in the demonic world and the ruling insti-tutions of the real world are devastating. The monkish academics huddled mindlessly in *What*

A caza de dientes.

a *Golden Beak!* (53; fig. 7.30) are not very different from the witches and demons who learn
their evil ways in various images of demonic instruction. One of these, Plate 70, is even entitled
Devout Profession. Here, "bishops" use pincers—instruments for tearing flesh—to "torture"
meaning from their "scripture." Goya's audience could extrapolate from this infernal scene to
the machinations of theologians.[56] And just as a sham bogeyman frightens women and children
(Plates 3 and 52), a cleric harangues a crowd in *Swallow It, Dog* (58; fig. 7.31). His tool for
keeping his listeners attentive is a clyster (enema) pipe, an object that frequently occurs in
eighteenth-century political satire: a visual culture in which Goya was well versed. He may also
have been aware of the mock confrontation between characters, one of whom employs the
clyster pipe, in Callot's *Balli di Sfessania* (see fig. 4.12). In addition, "Tragala Perro" were
the first words of a song held dear by Spanish liberals.[57] They emerge ironically here from the
mouth of a representative of one of the institutions most responsible, in liberals' eyes, for
Spain's backwardness.

The upper classes suffered no less than the clergy from Goya's scrutiny. *The Chinchillas*
(50; fig. 7.32), related to a contemporary comedy whose main character was Lucas de Chin-
chilla, depicts them rendered impotent by straitjackets made of their coats of arms. One chin-
chilla holds a rosary; the other, a sword. Their ears are padlocked, their bulging genitals
highlighted, their eyes closed, and they are spoonfed by a blindfolded, donkey-eared figure.[58]

The whole jackass is the subject of Plates 37–42. In *As Far Back as His Grandfather* (39;
fig. 7.33), he traces his genealogy through a family tree whose every branch is occupied by
another jackass. Like Hogarth's Rake, the jackass also affects an appreciation of learning and

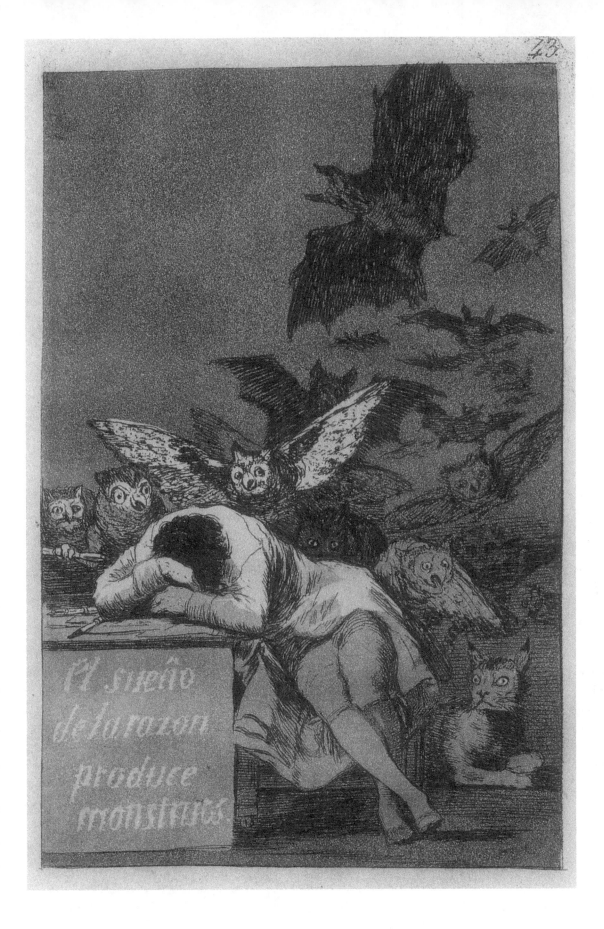

El sueño de la razon produce monstruos

FIGURE 7.32
Francisco Goya. The
Chinchillas: *Plate 50 of*
Los Caprichos. *1799.*
Etching and aquatint.
205 × 151 mm. Elvehjem
Museum of Art, Uni-
versity of Wisconsin–
Madison.

FIGURE 7.33
Francisco Goya. As Far
Back as His Grandfather:
Plate 39 of Los
Caprichos. *1799. Aqua-*
tint. 214 × 152 mm.
Elvehjem Museum of Art,
University of Wisconsin–
Madison.

the arts in the other plates of this section. When Goya made this image, he perhaps had in mind Manuel Godoy, who had risen with dizzying speed to the position of prime minister by virtue of his shrewdness and his status as the queen's favorite (in Plate 56, *Ups and Downs,* a man identified as Godoy in some commentaries rises and falls with his hair aflame and brandishing thunderbolts).[59] One of the more outrageous aspects of Godoy's career was his attempt to prove his noble ancestry. Hence, *As Far Back As His Grandfather* may have a provocative political meaning.

But despite its specific reference to the condition of the Spanish peasantry, *You Who Cannot* (42; fig. 7.34), derived from a Spanish proverb meaning "oppress the feeble who cannot resist," is a timeless statement of political and economic domination, conceptually akin to the Master E. S.'s image of knights riding the backs of peasants from *The Fantastic Alphabet* (see Chapter 1). One of the donkeys here even has spurs to help him control his peasant mount. Goya's print is clearly related to the indictment of the upper class in a report on Spanish

Tu que no puedes.

FIGURE 7.35

Francisco Goya. If Day Breaks, We Will Go: *Plate 71 of* Los Caprichos. *1799. Etching and aquatint. 197 × 149 mm. Elvehjem Museum of Art, University of Wisconsin–Madison.*

agriculture published in 1795 by his friend Gaspar Melchor Jovellanos, the greatest figure of the Spanish Enlightenment.[60] Considering the force of this image, we do not wonder why the sale of *Los Caprichos* was short-lived. This circumstance cannot have surprised Goya, either.

Does the aggressiveness of Goya's attack on the forces hampering Spain's progress indicate hopelessness? José López-Rey, in his still-fundamental study of the *Caprichos,* observed that dawn breaks at the end of the cycle.[61] *If Day Breaks, We Will Go,* the demons muse in Plate 71 (fig. 7.35). They gather beneath an exquisite, star-studded sky, produced by the stopping-out of the aquatinted plate. And go they do in Plate 80, yawning grotesquely as light (reason) advances. In Goya's subsequent series, reason's victory would be less assured.

THE *TAUROMAQUIA* AND *THE DISASTERS OF WAR*

During the final years of the eighteenth century and the early years of the nineteenth, the hatred of the Spanish people for the unholy "Trinity" governing them—Queen Maria Luisa, her favorite Godoy, and the inept and naive King Charles IV—grew ferocious. The people pinned their hopes—without reason, in retrospect—on the crown prince, Ferdinand. Meanwhile, France under Napoleon fixed its gaze on Portugal as a prize to win away from English influence, and invaded Spain. At first, the general belief was the French had come in support of Ferdinand. He summoned the royal family to Bayonne, leading the populace of Madrid to believe that their crown prince had been taken from them. What had really happened was that the Spanish royal family had handed over the crown to Napoleon on a silver platter. They lived out a comfortable exile in France. But the citizens of Madrid turned against the French troops

under Marshall Joachim Murat, and, the troops' response sparked the bloody War of Independence, which was to culminate in 1813 with the withdrawal from Spain of the exhausted French army and Joseph Bonaparte (or "Joe Bottles," as the Spanish called him, after his fondness for wine). In 1814, Ferdinand VII made his triumphal entry into Madrid. Goya's great canvases about the Madrid Rebellion, *The Second of May in the Puerto del Sol* and *The Executions of the Third of May, 1808,* were perhaps designed for triumphal arches made for this event.

As a liberal entranced with the ideas of the French Enlightenment, as the *Caprichos* testify, Goya may have had illusions, in the beginning, of benefits arising from the French occupation. Members of Goya's circle had many links with France. Some aspects of his behavior during this period bear witness to his collaboration with the occupying forces; Joseph Bonaparte must have seemed, in some ways, a better alternative than Ferdinand.[62] But Goya's ultimate horror at the war engendered by the French presence is manifested powerfully in the prints of *The Disasters of War,* on which he worked from 1810 to at least 1820, and possibly as late as 1823. His masterfully etched series on bullfighting, the *Tauromaquia,* published in 1816, may have compensated somewhat for the fact that Ferdinand's harsh repression of liberalism and his desire to obliterate memories of the French occupation made publication of the *Disasters* unthinkable.

The thirty-three prints of the *Tauromaquia,* ostensibly making up a vaguely historical account of this uniquely Spanish sport,[63] may also have functioned, however obliquely, as expressions of the savagery that Goya had witnessed during the war. Man and bull are pitted repeatedly against each other, as implacably as the French army had been pitted against the Spanish people. Is there a possibility that a covert political allegory, suggesting what the *Disasters* were prevented from stating unequivocally, underlies this contest? Although there is evidence of Goya's interest in bullfighting, it has been pointed out that Spanish liberals had spoken out against the barbarism of the sport.[64] A treatise of 1813, *Bread and Bulls,* sometimes attributed to Goya's friend Jovellanos, treated bullfighting in sharply satirical terms: "If the elegant Greeks invented tragedy, to eradicate from the world the ignoble passion of fear and terror, the polished Spaniards have invented the bullfeasts, where deeds are realized more horrid than even the Greeks have feigned."[65]

Unlike *The Disasters of War,* which record the many varieties of brutality in human society, the prints of the *Tauromaquia* focus on the microcosm of the bullring and a concise, sustained struggle between the bull's brute strength and humanity's destructive capacity, more ornamental and clever, but no less savage. Goya's early designs, some on the backs of the plates, were refined into compositions of superb simplicity and tense concentration. *They Loose Dogs on the Bull* (25; fig. 7.36) is based on a single diagonal movement anchored at the lower left by the dark bull silhouetted against the light aquatint ground. The short, muscular bodies of the dogs surround him while, as an ultimate contrast to the fundamental battle taking place, a foppishly costumed figure rides away to the upper right. An even more surprising composition is Plate 21: *The Dreadful Events in the Front Rows of the Ring at Madrid and the Death of the Mayor of Torrejón* (fig. 7.37). The scraggly masses of etched lines describing the bull, the bodies of the victims, and the hysterically fleeing survivors of the mishap coagulate into a triangle wedged in the lower right corner. The light tone of the rest of the print expresses the sunlit atmosphere into which the tragedy has abruptly and incongruously intruded. The bull stands inert, a gored body replacing its head with a macabre absurdity.

The *Tauromaquia* ends with another goring that signals the ultimate victory of the great

FIGURE 7.38

Francisco Goya. A Way
of Flying (known as
Proverbios 13). 1815–16.
Etching. 245 × 350 mm.
Museo Lázaro Galdiano,
Madrid.

black bull who bears down upon the fallen matador, Pepe Illo, grinding its horns into his body as he tries vainly to remove them. Scantily etched figures scramble over the fence, while another in the ring tries uselessly to distract the bull from his victim. In the edition of the *Tauromaquia* that Goya gave his friend Juan Agustin Ceán Bermúdez, who filled out Goya's captions with more information and tried to suggest to the artist a more historically accurate sequencing, a thirty-fourth image was included at the end: the enigmatic *A Way of Flying* (fig. 7.38), which was later altered and added to the edition of *Los Proverbios* published after Goya's death (see below). In what sense might this print contribute to the meaning of Goya's *Tauromaquia*?

Eleanor Sayre, comparing this image to an etching of Jacob Degen's "flying machine," made of varnished wings that could be manipulated by its pilot, concludes, "Just as common men are able to conquer through skill, knowledge, and courage one of nature's most savage creatures, the bull, so will they one day emulate the birds and conquer the air."[66] In contrast, Nigel Glendinning states flatly, "There is no obvious optimism in the flying men of 'Modo de volar.'"[67] If the bullfighter, with all his cleverness, cannot ultimately conquer the bull, then what are we to expect from these ingeniously fashioned, glider-like contraptions that carry their riders aimlessly through the void? Are they bound to fall, like Icarus, with his wings made of wax and feathers by the ingenious Daedalus? Might *A Way of Flying* be a laconic comment on human folly? Like the images of the flight of witches from the *Caprichos,* it suggests the lengths to which people will go to escape the limitations imposed by nature. The ambivalence of the *Tauromaquia,* Paulson suggests, is fundamental to its meaning: "In the *Tauromaquia* Goya takes the simple opposition of light and dark or man and animal inherited from the Enlightenment, which saw light as illumination of darkness, superstition and royal tyranny, and pushes it toward confrontation, reversal, and then undifferentiation."[68]

In the eighty-two etchings of *The Disasters of War,* Goya frequently eschewed the fantastic imagery of the *Caprichos.* As Licht observes, the motto for this series might well be taken from

the caption of Plate 44: *Yo Lo Vi* (*I Saw This*).[69] And there is one specific person depicted in the series—the cannon-firing female patriot, Agustina de Aragón (Plate 7).[70] On the other hand, Tomlinson cautions against overemphasizing the documentary character of the *Disasters,* pointing out that it is partly the development of war photography after 1850 that encouraged such a reading early on. The printers who first published the plates of the *Disasters* in 1863 reinforced comparison to contemporary photographs, such as Matthew Brady's images of the American Civil War, by adding aquatint to many images.[71] Moreover, Goya's familiarity with political prints of other nations also conditioned *The Disasters of War,* and not only the abstract allegorical images at the end. Ernst Gombrich has noted that Goya's moving war scenes may owe something to the anti-Napoleonic atrocity prints of a minor British artist, Sir Robert Kerr Porter.[72]

Certainly, then, the *Disasters* are much more than reportage. They follow upon the heels of Callot's supremely ironic *Miseries and Misfortunes of War,* but they reveal human brutality with a far greater intensity. It is significant that this intensity was protracted over as many as thirteen years (1810–23) as the *Disasters* were composed and executed. To interpret the series as a cathartic scream of despair is, therefore, to misunderstand it. Even though it was not published until twenty-five years after his death, Goya surely anticipated its moral impact on posterity. Some of the harshest indictments of war in twentieth-century art (especially Picasso's *Guernica* and related works) have been nourished by what Goya "saw."

Like the *Caprichos,* the prints of the *Disasters* fall into three basic parts. Plates 2 to 47 are scenes of guerrilla war fought against the occupying Napoleonic troops; Plates 48 to 64 are scenes of the Madrid famine of 1811–12. The *caprichos enfáticos* ("emphatic" or "striking" caprices), Plates 65 to 82, are allegories attacking the reactionary forces that fostered the return of the corrupt Ferdinand VII after the French withdrawal from Spain, and caused the downfall of the short-lived constitutional government (1820–23). Plate 1, *Sad Presentiments of Things to Come,* is a lament introducing the series. It belongs to the *enfáticos* in date and conception.

The *Disasters* vary considerably in style and technique. Goya was clearly working under hardship conditions, using scratched and pitted plates that he tried to correct by scraping and burnishing, and acid washes called *lavis* rather than aquatint in some cases. Both aquatint and *lavis* can help to camouflage defects in the plate, but the latter method, invented by Johann-Adam Schweikard in 1750 and made known by Jean-Baptiste le Prince's *Découverte du Procédé de la Gravure au Lavis* (Paris, 1780), is much cruder. The acid is allowed to etch the plate directly by immersion or brushing onto the surface. *Lavis,* of course, has no grain, but a brush-stroke is often evident, and the bubbles in the acid produce small dots surrounded by dark rings. In addition, Tomás Harris has noted areas in some of the prints (33 and 37, for example) that could not have been produced by *lavis* or aquatint. He suggests that Goya utilized grains of salt or sand in the ground, so that the acid would etch wherever the grains were.[73]

Despite these technical anomalies within the *Disasters,* the series does not suffer as a visual or political statement. A superb control of his means and a compositional monumentality especially mark the later images of war and famine. The *enfáticos,* equally powerful, are most comparable to the *Disparates.* They are similarly abstract and, sometimes, difficult to interpret.

The sequence of images in the 1863 edition of the *Disasters* was based on a volume of proofs belonging to Ceán Bermúdez. The captions, many of which link images sequentially, are likely to be by Goya; at least, this is what Valentín Carderera, one of the earliest connoisseurs of Goya's prints, assumed.[74] If this assumption is true, then Goya used sequence, repeti-

tion, and contrast with more assurance and effectiveness in the *Disasters* than he did in the *Caprichos*.

We are somewhat prepared for repeated violations of the human body by Plate 30, *Ravages of War* (fig. 7.39), with its disorienting jumble of people, hurled about by the collapse of a house in the French bombardment of Saragossa. Goya had visited the ruins of the city "to paint the glorious deeds of her citizens, from which I cannot excuse myself as I am so much interested in the glory of my native land."[75] Following this image are two cruel, makeshift hangings (31 and 32) and the beginnings of a dismemberment (33: *What More Can One Do?*; fig. 7.40). As Licht points out, all compositional forces in this last print are brought to bear on the excruciating point at which the saber touches the victim's groin.[76] In Plates 34, 35, and 36, Goya shows the prisoners mercilessly executed for no real reason: *For Having a Knife, One Can't Tell Why, Tampoco (Not in This Case Either)* (fig. 7.41), the captions read. The victims in Plates 37 (*This Is Worse*), 38 (*Barbarians!*), and 39 (*What Courage against Corpses!*; fig. 7.42) are impaled, tied and shot, and dismembered. Atrocities committed against the individuals in these images (Plate 39 may refer to the murder and mutilation of General Benito San Juan, victim of rampant accusations of treason)[77] are also violations of the nobility that the whole, undefiled body implies in western art, a nobility that can still be sensed, however, in the rugged face of an impaled head or in a muscular torso, tied like St. Sebastian to a tree (39).

Goya magnified this horror by suggesting its repetition and escalation. In *Tampoco* (36), one pathetic hanged civilian, watched cavalierly by a Polish member of Napoleon's army,[78] is echoed by other victims in the distance, much like the victims of the firing squad in *And There Is No Remedy* (15; fig. 7.43). In looking from Plate 34 to Plate 35, we see one garrotted man turn into many. One corpse with missing arms is impaled on a tree in Plate 37; then there is more dismemberment, an impaled head, and figures tied to another tree in *What Courage against Corpses!* (39). Similar escalation and repetition are used in the rape scenes at the beginning of the *Disasters* (Plates 9–11 and 13), Goya's moving tribute to the heroism of Spanish women, where the captions read, *They Don't Want To, Nor Do These, Nor These, Bitter Presence*. And in the etchings treating the typhus epidemic in Saragossa and the famine of Madrid, the image of a pile of bodies—which Goya may have taken from one of Flaxman's illustrations for Dante's *Inferno, The Pit of Disease*[79]—grows until it becomes simply, in Plate 63, *Muertos Recogidos (Dead Bodies Heaped Together)*. In *Bury Them and Be Silent* (18; fig. 7.44) and *Beds of Death* (62; fig. 7.45), the living form vertical accents that punctuate the heaps of corpses like exclamation points. Ghost-like themselves, they lament the dead helplessly or search for loved ones. Käthe Kollwitz was later to reiterate this contrast between physical death and the living death endured by survivors (see fig. 10.45).

Although dated by many scholars from about 1816 to 1820, the *enfáticos* deal with the reactionary forces threatening the fragile return of constitutional government between 1820 and 1823, and they may date from this period.[80] The reactionary forces may appear as animals, related to characters in a contemporary Italian satire of reactionary politics, *The Talking Animals* by Giambattista Casti,[81] or hybrid monsters, recalling images from the *Caprichos* and distinguishing this section of *The Disasters of War* from the scenes of guerrilla warfare and famine. In *May the Rope Break* (77; fig. 7.46), however, the protagonist, a high ecclesiastic balancing precariously on a tightrope, takes totally human form. This image expressed the self-serving complicity of the Church (in Goya's preparatory drawing, the figure is clearly Pope Pius VII, whereas in a much cruder print from the French Revolution, the teetering figure is an

FIGURE 7.39

Francisco Goya. Ravages of War: *Plate 30 of* Los Desastres de la Guerra. *Ca. 1810–14. Etching and lavis (?). 140 × 170 mm. Metropolitan Museum of Art, New York.*

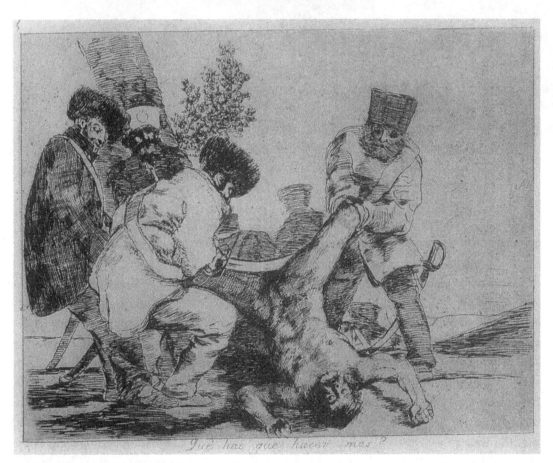

FIGURE 7.40

Francisco Goya. What More Can One Do? *Plate 33 of* Los Desastres de la Guerra. *Ca. 1810–14. Etching and lavis. 155 × 205 mm. Metropolitan Museum of Art, New York.*

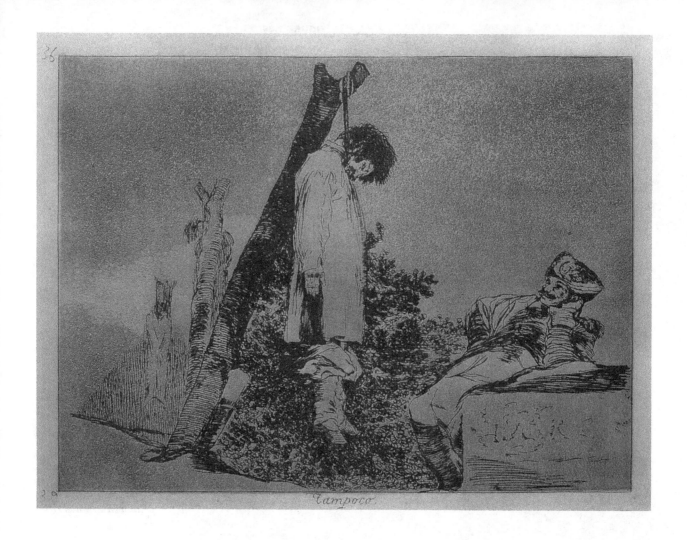

FIGURE 7.41

Francisco Goya. Tampoco (Not in This Case Either): *Plate 36 of* Los Desastres de la Guerra. *Ca. 1810–14. Etching and aquatint. 155 × 205 mm. Metropolitan Museum of Art, New York.*

aristocrat)[82] with such concise brilliance that Picasso adapted it, with many other Goyaisms, for his *Dream and Lie of Franco* (see fig. 11.38).

In Plate 79, a group of monsters destroys Truth, or Constitutional Government. *Will She Rise Again?* (fig. 7.47) asks the caption of the next plate (80). A monkish figure at the right stands ready to club and stone her. The pessimism of this and other *enfáticos* (Plate 69, for example—*Nada [Nothing]: The Event Will Tell*—shows a corpse sinking into its grave) is somewhat mitigated by the last two plates of the series, which were originally misplaced and never issued with the other eighty images. *Cruel Monster* (81) shows a porcine rodent who belches up a gory pile of bodies as he expires. Bearing a striking resemblance to Rembrandt's etched study of a hog, and a generic resemblance to a French print depicting Louis XVI as a pig, this image may refer to Napoleon, regurgitating the Spain he had hoped to digest, or to Ferdinand, temporarily brought down by the rebellion of 1820, or to war itself.[83] Plate 82, *This Is the Truth* (fig. 7.48), is an allegory of abundance in which a radiant Truth leads a peasant to the bounty of a peaceful Spain, which Goya, amazingly, was still able to envision.

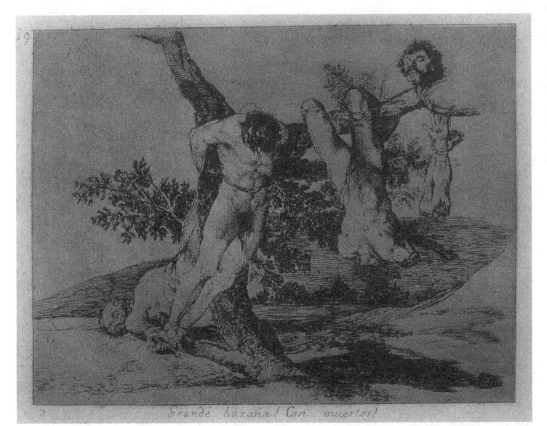

FIGURE 7.42

Francisco Goya. What
Courage against Corpses!
Plate 39 of Los
Desastres de la Guerra.
*Ca. 1810–14. Etching
and lavis. 155 × 205 mm.
Metropolitan Museum of
Art, New York.*

THE *DISPARATES*

It was, however, a futile dream. The constitutional government toppled, and Ferdinand reentered Madrid in triumph. In 1824, as an old man of seventy-nine, Goya left Spain for voluntary exile in France, returning only to obtain his pension in 1826. The mentality of Goya's late period is best exemplified not only by the *caprichos enfáticos,* but also by the remarkable "Black Paintings" with which he "decorated" his house (*La Quinta del Sordo*—the "House of the Deaf Man") near Madrid,[84] and the equally remarkable *Disparates* (*Follies*), twenty-one etchings probably conceived and executed about 1816–17. Their number is often given as twenty-two, because the inclusion of *A Way of Flying* (fig. 7.38) with the set (the plates of the *Tauromaquia* and the *Disparates* have the same basic dimensions). The checkered history of the publication of this series is especially regrettable, for it leaves us with much uncertainty about Goya's original intentions. The series was incomplete when Goya left for France, the copper-plates stored away in chests with his others. When eighteen plates were finally published by the Academy of San Fernando in 1864, it was without the titles and numbers that Goya himself had written on fourteen of the artist's proofs, and under the general title *Los Proverbios* (*Proverbs*). Nine editions of *Los Proverbios* were published between 1864 and 1937. Four of Goya's *Disparates,* however, had become separated from the original set of plates and were not published until 1877, when they appeared in the French periodical *L'Art.* Moreover, there are eight drawings that seem to be preparatory drawings for the *Disparates,* but for which no prints exist.[85]

FIGURE 7.43

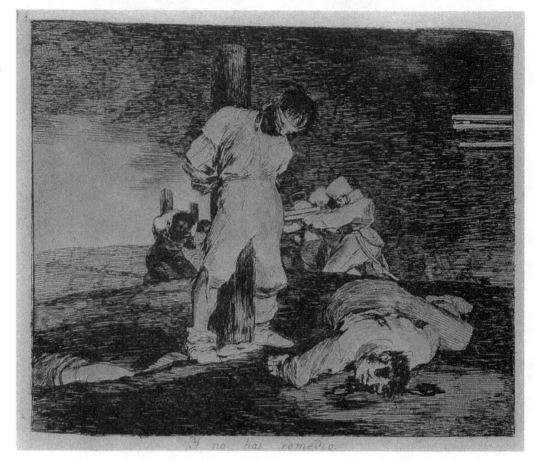

Francisco Goya. And
There Is No Remedy:
Plate 15 of Los Desastres
de la Guerra. *Ca. 1810–
14. Etching. 145 ×
165 mm. Metropolitan
Museum of Art, New
York.*

FIGURE 7.44

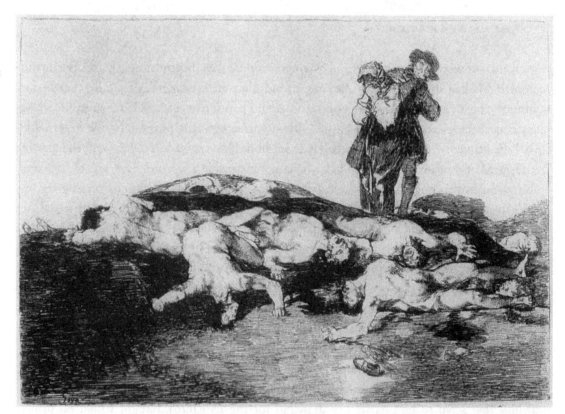

Francisco Goya. Bury
Them and Be Silent:
Plate 18 of Los Desastres
de la Guerra. *Ca. 1810–
14. Etching and lavis.
160 × 235 mm. Metro-
politan Museum of Art,
New York.*

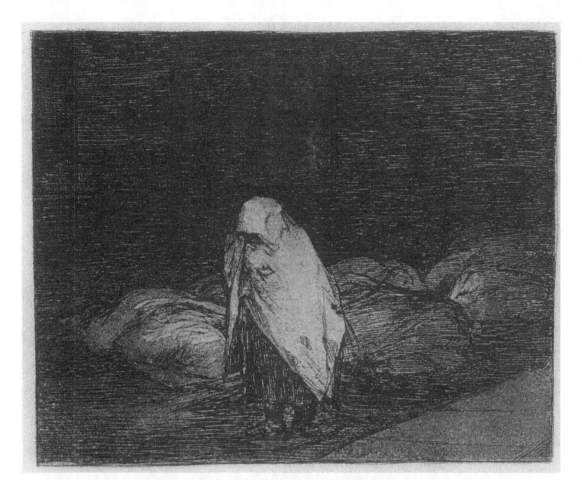

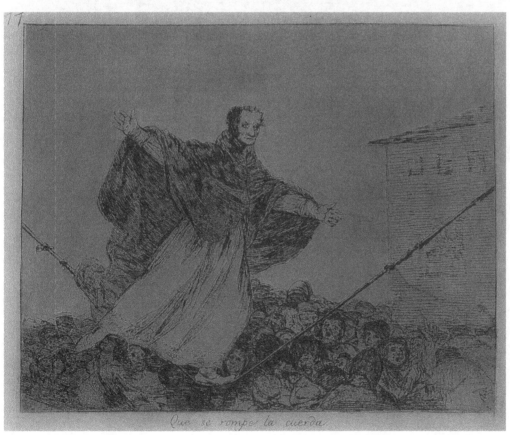

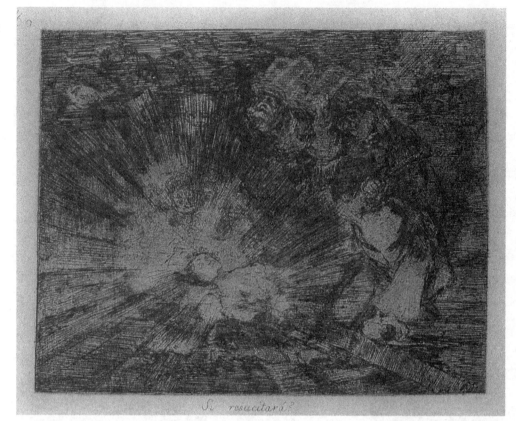

Had Goya been able to complete the series, he would perhaps have provided some written explanation of its purpose, like that provided for the *Caprichos* in the *Diario de Madrid* advertisement. The *Disparates* seem to condense several of the major themes of Goya's graphic art: the follies and misrepresentations of male/female relationships, the abuse of the Spanish people by the Church and clergy, pretensions, fears, and impossible dreams. The Spanish people might be the main theme of these etchings. Ignorant and easily led, like the bulls blown about by the wind in *Fool's Folly,* and taking two steps backward for every step forward, the people are nevertheless strong and, like a bull, dangerous when roused. George Levitine has shown that in the enigmatic *Animal Folly* (fig. 7.49), Goya transformed old moral emblems into a picture of Spain as a great hulking beast, mostly trusting and malleable, approached warily by "wise men," one offering learning in the form of a huge book, the other offering a ludicrous gift of little bells.[86] The turbaned men may well be "Persians," the name by which supporters of the monarchy were known after the publication of the so-called Persian Manifesto, an anti-constitutional document, in 1814.[87] Goya was also partly inspired by Stefano della Bella's lively etching of an elephant.[88] By the glint in the animal's eye, Goya suggested that ultimately it cannot be dominated. It will not be held to the limitations represented by the luminous circus ring outside which it stands. Similarly, the castanet-bearing giant of the image traditionally known as *Simpleton's Folly* is only tenuously controlled by the figure (clearly a cleric in the preparatory drawing) hiding behind a statue of the Virgin.[89]

Although we can find specific meanings for many of the *Disparates,* they evade normal methods of iconographic interpretation. Most emphatically, they transcend interpretations as proverbs, despite the title given to the series in 1864. *Ridiculous Folly* (fig. 7.50), for example, is a timeless statement of the human condition that needs no caption to communicate its message. Huddled inertly on a rotten branch, a group of people sit, receiving instruction from authority. Significantly, those farthest out on the limb seem to take command of the others, who remain silent and uncomprehending. A more specific meaning derives from Goya's antipathy toward certain members of the aristocracy: this could be the dead branch of a family tree supported by nothing. The Spanish expression "to walk along the branches" (to be concerned with what is least important) characterizes the content of the speaker's address.[90]

A comparison of *Feminine Folly* (fig. 7.51), with one of Goya's most beautiful and vaguely disturbing tapestry designs, *The Straw Manikin* (fig. 7.52), shows how far he had come. In the earlier image, lovely, mindless women toss a manikin in a blanket—a charming, eighteenth-century game that illustrates the sexual power of women over men, an old leitmotif in anti-feminist satire.[91] Victor Chan has also discussed Goya's allusion to the broader themes of Fortune and Time, to which all humans are subject.[92] Although the oddly mechanical quality of the activity in *The Straw Manikin* provokes, for this writer at least, some unease (who are the *real* puppets, the women who occupy the seductress role society imposes on them, or the men who succumb to their seduction? Or perhaps everyone is a puppet in this game?), the image in the *Disparates* savagely attacks the game of seduction. The women are drunk with their empty power, while the abject foolishness of the males they attract is embodied more strongly by the jackass in the blanket and the straw manikin flopping above. A similar comparison might be made between *Merry Folly* and its prototypes in eighteenth-century images of Blind Man's Buff. In his tapestry cartoon of this subject,[93] Goya had dealt gingerly with the sexual play sublimated into the game itself, but he couched the print in terms of a relentless determinism of sexual

FIGURE 7.51
Francisco Goya.
Feminine Folly *from* Los
Disparates (*Plate 1 of*
Los Proverbios). *Ca.*
1816–17. Etching and
aquatint. 240 × 350 mm.
National Gallery of Art,
Washington, D.C.

FIGURE 7.52
Francisco Goya. The
Straw Manikin. *1791–92.*
Tapestry cartoon. 267 ×
160 mm. Museo Nacional
del Prado, Madrid.

FIGURE 7.53

Francisco Goya. Funereal
Folly *from* Los Dis-
parates (*Plate 18 of* Los
Proverbios). *Ca. 1816–
17. Etching and aquatint.
245 × 350 mm. National
Gallery of Art, Wash-
ington, D.C.*

attraction that gains a wild momentum in the circular (eternal) dance. In the *Disparates,* Goya
left the world of the Rococo *fête* entirely behind.

The posthumously titled *Funereal Folly* (fig. 7.53) depicts another kind of Blind Man's
Buff that reveals the deeply personal nature of the *Disparates,* beyond their function as social
and political criticism. Sayre has recently suggested that it was to be the frontispiece for the
series.[94] An old man resembling the artist hovers above his own sleeping body (or corpse?), a
winding sheet trailing behind. He is surrounded by monsters who taunt him. It is as if the evil
creatures and tortured victims of Goya's prints have assembled here in an inferno of the mind
(as in *The Sleep of Reason;* fig. 7.27) or, if one sees the body as dead, in the grave itself. It is a
frightening image—Goya had seen many frightening things in his life—but there is something
heroic about the old soul who still has the strength to rise above his body and confront his
memories, with enough innocence left to be amazed and outraged by it all. One is reminded
of Goya's late drawing of an old, white-bearded man, hobbling along on canes.[95] At the top of
the drawing, Goya wrote, "Aun Aprendo" ("I am still learning"). This image captures the
attitude with which Goya approached his exile and which underlay his entire graphic produc-
tion. Despite the vices and atrocities castigated in Goya's prints, and the erosion of his faith in
reason that they trace, these images are ultimately a testimony to the extraordinary resilience
of the human spirit.

As we have seen, the satirical tradition in prints is as old as the graphic media themselves.
Boosted by the Reformation and the political social turmoil in its wake, and then by the
revolutions of the late eighteenth century, this tradition was elevated immeasurably by the
examples of Hogarth and Goya, whose works reached an unprecedented level of intellectual
depth and aesthetic quality. In the 1830s in France, another artist would emerge with equal
satirical talent: Honoré Daumier. Daumier's medium was the new technique of lithography,
the development of which is the subject of our next chapter.

1. For a survey of English political prints during Hogarth's time, see Atherton 1974.

2. See Burke, ed. [1955] 1970, p. 202.

3. Licht 1989, pp. lxxx–lxxxi.

4. Bindman 1981, pp. 73–83.

5. Essay in *The Spectator,* no. 266 (Jan. 4, 1711–12). Quoted in Paulson [1965] 1970, vol. 1, no. 121, p. 143. Also see Paulson 1971 for a discussion of the relationship between Hogarth and contemporary literature.

6. Godby 1987, p. 27.

7. Kate Hackabout was described in the *Grub Street Journal,* August 6, 1730. Cited in Paulson [1965] 1971, vol. 1, no. 121, p. 143.

8. See Paulson [1965] 1970, vol. 1, no. 121, p. 144.

9. Wind 1989.

10. Godby 1987, pp. 29–30.

11. Pirated "copies" of Hogarth's prints were made from memory by copyists visiting Hogarth's shop under the pretense of being prospective customers. The pirates of *A Rake's Progress* produced their versions of Hogarth's designs before the Copyright Act took effect on January 24, 1735. See Paulson [1965] 1970, vol. 1, pp. 158–60.

12. Renger 1974, pp. 124–27. Rubens' letter of January 23, 1619, is quoted in De Pauw-De Veen 1977, p. 250.

13. Renger 1974, p. 126.

14. Kromm 1985.

15. Paulson [1965] 1970, vol. 1, p. 268.

16. For good details of this print, especially of the collectibles, see Wensinger and Coley, 1970, pp. 35–43.

17. For a detailed discussion of this pamphlet and of the iconography of the print as a whole, see Cowley 1983, pp. 57–80.

18. See Adhémar 1964, pp. 143–50; Kunzle 1973, pp. 393–401.

19. For a survey of the tradition of English graphic satire after Hogarth, see George 1967.

20. D'Oench 1990; Kunzle 1973, p. 346.

21. See Paulson 1972, pp. 13–18.

22. See Haskell and Penny 1981, no. 83, pp. 316–18.

23. Paulson 1983, p. 161.

24. On Vauxhall Gardens, see George 1967, p. 77.

25. Lavater quoted in Paulson 1972, p. 66.

26. Herding 1988.

27. Langlois 1988.

28. Boime 1988.

29. Two useful works on Cruikshank are Evans and Evans 1978; Santa Barbara Museum of Art 1978.

30. George 1967, p. 13 and note.

31. Santa Barbara Museum of Art 1978, no. 39, p. 22.

32. On these two series and Cruikshank's own abstinence from alcohol, see Evans and Evans 1978, pp. 124–37; Kunzle 1990, pp. 24–25.

33. Casteras 1982, no. 22, p. 68.

34. For Goya's political and social context, see Klingender [1948] 1968; Williams 1976; Anes 1989. Good discussions of his patrons are Glendinning 1981; Glendinning 1989.

35. Tomlinson 1989a.

36. Ibid., p. 227.

37. On Goya's albums, see Sayre 1964; Gassier 1973; Sayre 1989.

38. Sayre 1989, pp. xcviii–xcix.

39. See Gassier and Wilson 1971, p. 129. On Goya's literary connections in general, see Helman 1959; Helman 1963.

40. Sayre 1989, pp. ci–ciii, lists very early commentaries on the *Caprichos.* Tomlinson 1989b, pp. 12–13, points out that the political atmosphere between 1799 and 1808, characterized by increasing hostility to the monarchy, may have encouraged more specific interpretations of Goya's images than Goya intended.

41. See the discussion in Sayre 1974, pp. 56–58.

42. Tomlinson 1989b, pp. 13–14, questions both of these assumptions: twenty-seven sets seem very few to her, and the Inquisitorial censure, she believes, might postdate Goya's donation of the plates to the government—a gift inspired possibly by the commercial failure of the *Caprichos.*

43. Sayre 1974, no. 73, pp. 98, 103.

44. Pérez Sánchez and Sayre 1989, no. 38, pp. 84–86.

45. Tomlinson 1989b. Also see Paulson 1983, pp. 286–387, for an insightful and provocative essay on Goya's prints that lends much attention to sequence.

46. Pérez Sánchez and Sayre 1989, no. 44, pp. 96–98.

47. See Chan 1981.

48. See Glendinning 1989, p. lxxiv, on Goya and women. Contrast this with the more negative discussion in Glendinning 1978a.

49. Pérez Sánchez and Sayre 1989, no. 45, pp. 98–101.

50. See Licht 1989, p. lxxxii. Goya may have satirized the opposite kind of parental behavior in *Nanny's Boy* (4), in which a moustached adult has been so pampered that he still sports a tumbling cap and rattle, and is still preoccupied with eating and excreting. This etching, with a background in Carnival imagery, primarily served to denigrate the aristocracy. See Sayre 1974, no. 38, pp. 65–66; Pérez Sánchez and Sayre 1989, no. 41, pp. 90–92. On the relationship of this image to the Carnival figure of the man-child, see Márquez 1989, p. xc and fig. 13.

51. Paulson 1983, pp. 310–13.

52. Tomlinson 1989b, pp. 16–23.

53. Pérez Sánchez and Sayre 1989, no. 57, pp. 125–26.

54. Ibid., no. 58, pp. 127–28.

55. López-Rey 1953, pp. 141–42.

56. Pérez Sánchez and Sayre 1989, no. 61, pp. 132–34.

57. Harris 1964, vol. 2, no. 93, p. 133.

58. Pérez Sánchez and Sayre 1989, no. 55, pp. 121–22.

59. Sayre 1974, nos. 81–82, pp. 110–11; Pérez Sánchez and Sayre 1989, no. 56, pp. 123–24.

60. Pérez Sánchez and Sayre 1989, no. 49, pp. 107–9.

61. López-Rey 1953, pp. 158–64. Also see Pérez Sánchez 1989, p. xxiii, on light.

62. Hull 1987, pp. 135–57; Baticle 1989.

63. Sayre 1974, pp. 197–205, gives a thorough discussion of the *Tauromaquia* as Goya's meditation on the history of the bullfight.

64. For interpretations of this series in satirical terms, see Glendinning 1961; Tomlinson 1983, especially pp. 37–40.

65. Quoted in Tomlinson 1983, p. 37.

66. Sayre 1974, nos. 200–202, pp. 248–50 (quotation is on p. 250).

67. Glendinning 1961, p. 126 and n. 32 on same page.

68. Paulson 1983, p. 357.

69. Licht 1979, p. 130.

70. Pérez Sánchez and Sayre 1989, no. 84, pp. 190–92.

71. Tomlinson 1989b, p. 26.

72. Gombrich 1963, pp. 124–26.

73. Harris 1964, vol. 1, pp. 25–26.

74. Tomlinson 1989b, p. 25.

75. Letter of October 2, 1808, quoted in Sayre 1974, p. 126. Paulson 1983, pp. 155–57, fig. 25, discusses a print by Rowlandson, showing the collapse of a floor during an opera, that may have influenced Goya.

76. Licht 1979, p. 145–46.

77. Pérez Sánchez and Sayre 1989, no. 89, pp. 200–201.

78. Ibid., no. 88, pp. 198–99.

79. Symmons 1984, p. 264, and figs. 97 and 98.

80. Pérez Sánchez and Sayre, nos. 154–163, pp. 343–67. On the dating of the *caprichos enfáticos* to 1820–23, see Sayre 1989, pp. cxiii–cxiv.

81. Glendinning 1978b.

82. Pérez Sánchez and Sayre, no. 159, pp. 356–68; Cuno and Burlingham, eds., 1988, no. 59, p. 174.

83. White 1969, vol. 2, plate 242; Cuno and Burlingham, eds., 1988, no. 80, p. 189; Pérez Sánchez and Sayre 1989, no. 163, p. 367, and fig. 3. On this animal as a symbol of war, see Paulson 1983, p. 377.

84. On the Black Paintings, see Muller 1984.

85. For preparatory drawings and related *Disparates* prints, see Gassier and Wilson 1971, nos. 1571–1613, pp. 325–27. Also see Holo 1976.

86. Levitine 1959.

87. Pérez Sánchez and Sayre 1989, no. 143, pp. 319–21.

88. Massar 1971, p. 108.

89. Pérez Sánchez and Sayre 1989, no. 139, pp. 310–12. The varied meanings of Goya's giants, including the patriotic significance, are discussed by Chan 1984, pp. 84–91.

90. Pérez Sánchez and Sayre, no. 138,
pp. 307–10.

91. Tomlinson 1989a, pp. 207–10.

92. Chan 1985.

93. Gassier and Wilson 1971, no. 276, p. 98;
Tomlinson 1989a, pp. 183–84.

94. Pérez Sánchez and Sayre 1989, no. 137,
pp. 304–6.

95. Gassier and Wilson 1971, no. 1758, pp. 354,
366.

REFERENCES

Adhémar, Jean. 1964. *Graphic Art of the Eighteenth Century.* New York.

Anes, Gonzalo. 1989. Freedom in Goya's Age: Ideas and Aspirations. In Pérez Sánchez and Sayre 1989, pp. xxvi–xlix.

Atherton, Herbert M. 1974. *Political Prints in the Age of Hogarth.* Oxford.

Baticle, Jeannine. 1989. Goya and the Link with France at the End of the Old Regime. In Pérez Sánchez and Sayre 1989, pp. l–lxiii.

Bindman, David. 1981. *Hogarth.* New York.

Boime, Albert. 1988. Jacques-Louis David, Scatological Discourse in the French Revolution, and the Art of Caricature. In Cuno and Burlingham, eds., 1988, pp. 67–82.

Burke, Joseph, ed. [1955] 1970. *The Analysis of Beauty.* Oxford.

Casteras, Susan. 1982. *The Substance or the Shadow: Images of Victorian Womanhood.* Exhibition catalog. Yale Center for British Art, New Haven, Conn.

Chan, Victor. 1981. Goya, the Duchess of Alba and Fortuna. *Arts Magazine,* vol. 56, no. 3 (November), pp. 132–38.

Chan, Victor. 1984. Rebellion, Retribution, Resistance, and Redemption: Genesis and Metamorphosis of a Romantic Giant Enigma. *Arts Magazine,* vol. 58, no. 10 (Summer), pp. 80–95.

Chan, Victor. 1985. Goya's Tapestry Cartoon of *The Straw Manikin:* A Life of Games and a Game of Life. *Arts Magazine,* vol. 60, no. 2 (October), pp. 50–58.

Cowley, Robert L. S. 1983. *Hogarth's Marriage à la Mode.* Ithaca, N.Y.

Cuno, James, and Cynthia Burlingham, eds., 1988. *French Caricature and the French Revolution, 1789–1799.* Exhibition catalog. Grunwald Center for the Graphic Arts, Wight Art Gallery, University of California, Los Angeles.

De Pauw-De Veen, Lydia. 1977. Rubens and the Graphic Arts. *Connoisseur,* vol. 195 (August), pp. 243–51.

D'Oench, Ellen G. 1990. Prodigal Sons and Fair Penitents: Transformations in Eighteenth-Century Popular Prints. *Art History,* vol. 13, no. 3 (September), pp. 318–43.

Evans, Hilary, and Mary Evans. 1978. *The Life and Art of George Cruikshank: The Man Who Drew the Drunkard's Daughter.* London.

Gassier, Pierre. 1973. *Francisco Goya: Drawings, the Complete Albums.* New York.

Gassier, Pierre, and Juliet Wilson. 1971. *The Life and Complete Work of Francisco Goya.* New York.

George, M. Dorothy. 1967. *Hogarth to Cruikshank: Social Change in Graphic Satire.* New York.

Glendinning, Nigel. 1961. A New View of Goya's *Tauromaquia. Journal of the Warburg and Courtauld Institutes,* vol. 24, pp. 120–27.

Glendinning, Nigel. 1978a. Goya on Women in the *Caprichos:* In the Case of Castillo's Wife. *Apollo,* vol. 107, no. 192 (February), pp. 131–34.

Glendinning, Nigel. 1978b. A Solution to the Enigma of Goya's 'Emphatic Caprices.' *Apollo,* vol. 107, no. 193 (March), pp. 186–91.

Glendinning, Nigel. 1981. Goya's Patrons. *Apollo,* vol. 114, no. 236 (October), pp. 236–247.

Glendinning, Nigel. 1989. Art and Enlightenment in Goya's Circle. In Pérez Sánchez and Sayre 1989, pp. lxiv–lxxvi.

Godby, Michael. 1987. The First Steps of Hogarth's *Harlot's Progress. Art History,* vol. 10, no. 1 (March), pp. 23–37.

Gombrich, Ernst H. 1963. Imagery and Art in the Romantic Period. In *Meditations on a*

Hobby Horse, and Other Essays on the Theory of Art, pp. 120–26. London.

Harris, Tomás. 1964. *Goya: Engravings and Lithographs*. 2 vols. London.

Haskell, Francis, and Nicholas Penny. 1981. *Taste and the Antique: The Lure of Classical Sculpture 1500–1900*. New Haven, Conn.

Helman, Edith F. 1959. The Younger Moratín and Goya. *Hispanic Review*, vol. 27, no. 1, pp. 103–22.

Helman, Edith F. 1963. *Trasmundo de Goya*. Madrid.

Herding, Klaus. 1988. Visual Codes in the Graphic Art of the French Revolution. In Cuno and Burlingham, eds., 1988, pp. 83–100.

Holo, Selma. 1976. *Goya: Los Disparates*. Exhibition catalog. J. Paul Getty Museum, Malibu, Calif., and Museum of Art, Washington State University, Pullman.

Hull, Anthony. 1987. *Goya: Man among Kings*. New York.

Klingender, Francis D. [1948] 1968. *Goya in the Democratic Tradition*. London.

Kromm, Jane E. 1985. Hogarth's Madmen. *Journal of the Warburg and Courtauld Institutes*, vol. 48, pp. 238–42.

Kunzle, David. 1973. *The Early Comic Strip: Narrative Strips and Picture Stories in the European Broadsheets from c. 1450 to 1825*. Berkeley, Calif.

Kunzle, David. 1990. *The History of the Comic Strip: The Nineteenth Century*. Berkeley, Calif.

Langlois, Claude. 1988. Counterrevolutionary Iconography. In Cuno and Burlingham, eds., 1988, pp. 41–54.

Levitine, George. 1959. Some Emblematic Sources of Goya. *Journal of the Warburg and Courtauld Institutes*, vol. 22, pp. 106–31.

Licht, Fred. 1979. *Goya: The Origins of the Modern Temper in Art*. New York.

Licht, Fred. 1989. Goya and David: Conflicting Paths to Enlightenment Morality. In Pérez Sánchez and Sayre 1989, pp. lxxvii–lxxxiv.

López-Rey, José. 1953. *Goya's Caprichos: Beauty, Reason and Caricature*. 2 vols. Princeton, N.J.

Márquez, Teresa Lorenzo de. 1989. Carnival Traditions in Goya's Iconic Language. In Pérez Sánchez and Sayre 1989, pp. lxxxv–xciv.

Massar, Phyllis. 1971. *Presenting Stefano della Bella, Seventeenth-Century Printmaker*. New York.

Muller, Priscilla. 1984. *Goya's Black Paintings: Truth and Reason in Light and Liberty*. New York.

Paulson, Ronald. [1965] 1970. *Hogarth's Graphic Works*. 2 vols. New Haven, Conn.

Paulson, Ronald. 1971. *Hogarth: His Life, Art and Times*. New Haven, Conn.

Paulson, Ronald. 1972. *Rowlandson: A New Interpretation*. New York.

Paulson, Ronald. 1983. *Representations of Revolution (1789–1820)*. New Haven, Conn.

Pérez Sánchez, Alfonso E. 1989. Introduction. In Pérez Sánchez and Sayre 1989, pp. xvii–xxv.

Pérez Sánchez, Alfonso E., and Eleanor A. Sayre. 1989. *Goya and the Spirit of Enlightenment*. Exhibition catalog. Prado Museum, Madrid, Museum of Fine Arts, Boston, and Metropolitan Museum, New York.

Renger, Konrad. 1974. Rubens Dedit Dedicavitque: Rubens' Beschäftigung mit der Reproduktionsgrafik, I. Teil: Der Kupferstich. *Jahrbuch der Berliner Museen*, vol. 16, pp. 122–75.

Santa Barbara Museum of Art. 1978. *George Cruikshank, Printmaker (1792–1878): Selections from the Richard Volger Collection*. Exhibition catalog. Exhibition organized by Richard Kubiak. Santa Barbara Museum of Art, Santa Barbara, Calif.

Sayre, Eleanor A. 1964. Eight Books of Drawings by Goya—I. *Burlington Magazine*, vol. 106, no. 730 (January), pp. 19–31.

Sayre, Eleanor A. 1974. *The Changing Image: Prints by Francisco Goya*. Exhibition catalog. Museum of Fine Arts, Boston.

Sayre, Eleanor A. 1989. Introduction to the Prints and Drawings Series. In Pérez Sánchez and Sayre 1989, pp. xcv–cxxvii.

Symmons, Sarah. 1984. *Flaxman and Europe: The Outline Illustrations and Their Influence*. New York.

Tomlinson, Janis A. 1983. *The Disasters of War, La Tauromaquia, A Spanish Entertainment and*

Other Prints. Exhibition catalog. Arthur Ross Gallery, University of Pennsylvania, Philadelphia.

Tomlinson, Janis A. 1989a. *Francisco Goya: The Tapestry Cartoons and Early Career at the Court of Madrid.* Cambridge.

Tomlinson, Janis A. 1989b. *Graphic Evolutions: The Print Series of Francisco Goya.* Exhibition catalog. Wallach Art Gallery, Columbia University, New York.

Wensinger, Arthur A., and W. B. Coley, trans. and ed. 1970. *Hogarth on High Life: The Mar-* *riage à la Mode Series from Georg Christoph Lichtenberg's Commentaries.* Middletown, Conn.

White, Christopher. 1969. *Rembrandt as an Etcher.* 2 vols. University Park, Pa.

Williams, Gwyn A. 1976. *Goya and the Impossible Revolution.* London.

Wind, Barry. 1989. Hogarth's Fruitful Invention: Observations on *Harlot's Progress,* Plate III. *Journal of the Warburg and Courtauld Institutes,* vol. 52, pp. 267–69.

8

Lithography in the Nineteenth Century

Nineteenth-century printmaking presents a formidable organizational task. The reproductive print lingered and was even reinforced by technological advances such as chromolithography, while original printmaking, after its sporadic (albeit brilliant) eighteenth-century manifestations, was thriving by mid-century. By the century's end, the appreciation of the immediate, autographic qualities of etching had been bolstered by the etching revival of the 1860s, 1870s, and 1880s, and an ever-broadening base of print collectors sought out rare states, differently inked impressions on fine papers, and artists' proofs. The modern concept of the edition—an artificial limitation on the number of impressions—expressed the concern for rarity. Lithography had found its way from simulating drawings and paintings to its own distinctive formal possibilities, an evolution culminating in the 1890s in France with the eagerly collected color lithographic poster. In the hands of Gauguin and Degas, the monotype developed as a form of printmaking that approximated painting, not only in its stylistic effects, but in its uniqueness. The original print had finally come into its own.

It was not by coincidence that the nineteenth century saw simultaneously the apotheosis of the original print and the downfall of the values of academic art, at least in avant-garde circles. With its high regard for monumental history painting and the classical style, academic art could not readily accommodate the print, except as a reproductive form.[1] The production of the great majority of prints was too bound up in the manual labor mandated by the complex linear systems and tonal methods of the eighteenth century, all linked to the reproductive

430

enterprise, that we discussed in Chapter 5. With the progressive assaults on the academic value system by nineteenth-century Romanticism, Realism, Impressionism, and the movements in its wake, such as Symbolism, the original print—as the artist's autographic response to inner emotions or outer appearances—gradually gained status. As photography began to supplant the reproductive print toward the end of the century, the original print emerged with the strength it had had in northern Europe in the Renaissance and Baroque eras, but into a very different context.

Only fairly limited technical possibilities were available to Dürer, Rembrandt, and Goya, and what they did within those limits earned them the epithet of "old-master" printmakers. But printmakers of the nineteenth century could partake of the bounties of modern technology, from offset lithography to the steel-facing of intaglio plates or the duplication of plates or blocks by stereotyping and electrotyping, from gillotage to photomechanical means of reproduction. The extraordinary array of technical possibilities in the nineteenth century implied a democratization of the print, its broader availability to a middle-class public. The appreciation of the original print—for example, the return to Rembrandtesque etching on the part of the etching revivalists of France, England, and the United States in the mid- to late nineteenth century—and the renewed emphasis on print connoisseurship are curiously wedded to this democratization. The painter-engraver's exclusive reliance on the relatively simple relief and intaglio methods was, however, gone forever. Lithography, with its basis in chemistry and its dependence on the technical knowledge of skilled printers, embodies this change.

One of the most important Expressionist artists of the early twentieth century, Wassily Kandinsky, characterized lithography as the quintessentially modern printmaking medium.[2] The development of Senefelder's invention is so distinctive and significant for modern art that I have chosen to set it apart in this chapter, even though this imposes an artificial division in the oeuvres of artists who worked in lithography as well as intaglio or relief media. We will take our cue from Kandinsky. The evolution of lithography offers an excellent introduction to the extensive changes in art as a whole during this pivotal period.[3]

Also called "polyautography" in early sources, lithography was invented in 1798 by the ingenious German actor and writer Alois Senefelder for the mundane purpose of printing his verses and plays. Lithography would be plagued with this commercial stigma throughout the nineteenth century. The word "lithography" comes from the Greek *lithos,* meaning "stone," and reflects the use of fine-grained Bavarian limestone as a printing surface. However, Senefelder himself developed metal plates (zinc, aluminum, or some alloy) that were specially grained, chemically treated, and worked like slabs of lithographic limestone. The major advantage of metal plates is their portability.

As we noted in the Introduction, lithography is the primary *planographic* process; that is, the image is set down on a level surface without incisions. Therefore, lithographs have no plate marks, although the edge of the stone might leave a trace, and the lines or marks are not raised or set into the paper. The mutual rejection of grease and water is the basic principle behind lithography. The artist draws upon the stone with greasy pencils, chalks, crayons, or paint (*tusche*). The stone is then treated chemically with nitric acid and gum arabic, which set the marked areas into the stone and prevent them from spreading into the unmarked areas. While the marked areas have an affinity for the greasy lithographic ink, the dampening of the stone causes rejection of ink in unmarked areas.

Lithographic limestone is a very sensitive surface, with a receptiveness to the artist's touch that surpasses even a soft etching ground. Early lithographers were warned against making accidental marks on the stone with fingers or falling dandruff. They, in particular, exploited the extraordinary sensitivity of the surface to achieve gradual tonal nuances from deep, tar-like blacks to wispy grays. But because of the variety of materials one can use to work the stone, lithographs, especially toward the end of the nineteenth century, began to exhibit a dazzling range of effects. And color lithography, which generally involves one stone per color and the registration of the separate stones on the same sheet of paper, had gradually detached itself from reproductive printmaking, opening up the medium to many new possibilities.

Linear precision, painterly bravura, bold, flat color areas, and areas resembling ink washes are all possible with lithography. The artist may scrape the stone to bring out high values, much as one would use an eraser with pencil or chalk, or dilute liquid lithographic medium with various solvents, producing washes (*lavis*) that may form fascinating rippling effects as they dry. Later, in the twentieth century, lithography would be combined with photography in many innovative ways, particularly by Robert Rauschenberg, who incorporated newspaper and magazine photographs into his prints in much the same way that he incorporated found objects into his assemblages. This versatility has made lithography a highly significant medium within the evolution of modern art, in which the only constant is the rapidity of change.

There are pragmatic reasons as well for lithography's appeal. Because it is almost entirely a chemical process, the printing surface is subject to less physical wear than the metal plate in intaglio processes or the wooden block in woodcutting. A large number of impressions can be taken from a lithographic stone or plate (subject, of course, to the quality of the printing surface, the delicacy of the marks, and the artist's discretion). And because lithography approximates painting or drawing in that the stone can be worked on directly without cutting, it is one of the most appealing printmaking techniques for painters, especially when their efforts are aided by skilled printers. Lithography accommodated even Picasso's characteristic impetuosity when he decided to draw his children on transfer paper, which releases the image when it is pressed against the stone and moistened, with his fingers dipped in lithographic ink.[4]

Transfer paper was also invented by Senefelder. It eliminates the problem, inherent in intaglio and relief printmaking, of the reversal of the artist's initial conception. Viewed from a historical perspective, transfer lithography simply addressed the old need to reproduce drawings. But because it also avoided direct work on the stone, transfer lithography was considered by some to be a poor substitute for lithography proper, which can yield a greater range of subtle effects. Nevertheless, artists like Odilon Redon liked the transfer process because of its capacity for improvisation, its ability to convey "the most delicate and elusive inflexions of the mind."[5] In the 1890s the debate about the legitimacy of transfer lithography came to a head. Henri Fantin-Latour was severely criticized for his transfer lithographs, exhibited in the Musée de Luxembourg in 1899, and we have already mentioned the controversy between Joseph Pennell and Walter Sickert, into which Whistler was drawn as a witness for Pennell. Central to the debate were the conflicting attitudes of professional lithographers and painter-lithographers: for the former, the technical purity of working on the stone defined the process; for the latter, the process, defined more broadly as the use of the stone as a *printing* surface, was often but a means to an artistic end.

The music publisher Johann Anton André persuaded Senefelder to come to Offenbach-on-Main, establish a press there, and instruct assistants in the process. Johann's brothers,

Frédéric in Paris and Philipp in London, where Senefelder had obtained a patent, were instrumental in promulgating lithography beyond Germany and Austria. From the very beginning, then, the role of those schooled not in art but in the technical aspects of the medium would be crucial in the history of lithography. Karen Beall observes:

> Although there were artist-printers, most artists preferred to let skilled printers take over for them; therefore, the importance of the printers' role must be stressed. Most improvements in the early decades of the development of lithography were made by printers, whose experience in mixing inks, registering prints, and handling other details eliminated countless hours of trial and error for the artist.[6]

EARLY LITHOGRAPHY IN ENGLAND, FRANCE, AND GERMANY

Although France was the country in which nineteenth-century lithography reached its pinnacle, England was more receptive at first. Philipp André published the *Specimens of Polyautography,* the first collection of artists' lithographs, in 1803. He supplied many major artists with the necessary materials and asked them to try out the new process. *The Angel of the Resurrection* (1801; fig. 8.1) by Benjamin West, an American artist living in England, is perhaps the best print included in this early publication. Like the other *Specimens,* it borrows certain qualities from line etching: the fine grain of the stone has not been exploited, and the hatching technique recalls that of some intaglio prints. And, like the simplest etching, it bears a strong resemblance to pen drawing.

After *Specimens of Polyautography,* scattered attempts at lithography were made in the early part of the century in England (by William Blake, for example), France, and Germany. *Twelve Views of Scotland* (1803), a joint effort of Philipp André and Rudolf Ackermann, a publisher of aquatints, helped to establish the viability of lithography as a medium to satisfy the demand for topographical prints. Beginning in 1818, an enormous boost was given to early lithography by the appearance of a number of technical treatises. Such books were extremely important, as Beall points out, not only because they instructed artists in lithographic technique, but also because they attracted a clientele for the prints.[7] Ackermann's translation of Senefelder's book, *A Complete Course in Lithography,* was published in 1819, as was a French treatise by Colonel Antoine Raucourt. In 1822, Godefroy Englemann's *Manuel du Dessinateur Lithographe* was published; and, in 1824, Charles Hullmandel's *Art of Drawing on Stone.* Hullmandel, in particular, was a crucial figure for the development of the artistic potential of lithography, occupying the same position, Michael Twyman argues, that Dürer did in woodcut at the end of the fifteenth century.[8]

It was the French artist Théodore Géricault who produced the first truly great lithographs. In 1820 he was in England with his friend, Nicolas-Toussaint Charlet, who also made lithographs, mostly scenes of the Napoleonic wars, and had instructed Géricault in the process. Small lithographic reproductions of Géricault's painted masterpiece, *The Raft of the Medusa* (1819), were sold to English patrons of its public showing. Twelve lithographs of London scenes, printed by Hullmandel, were published by Géricault in 1821. *The Flemish Farrier* (fig. 8.2) is one of the best. Géricault used the crayon to achieve an extraordinary tonal subtlety, as in the cloud of steam rising from the horse's new shoe. The silhouette of the rugged farrier

against the steam and the contrast of his compact form with the magnificent, dappled bulk of the passive animal create an unsentimental, impressive image of the common working man, similar to that painted by Goya in *The Forge* (1812–16) or by Gustave Courbet in his much later *Stonebreakers* (1849). Many of the lithographs of Géricault's *English Set* dealt with the problems of unemployment and homelessness among the working class in the wake of the Napoleonic wars. In his images of London beggars, Géricault was influenced by the English etcher John Thomas Smith, who in turn reached back to Callot and Rembrandt.[9]

In 1820 Baron Taylor launched his monumental collection of lithographic views, *Voyages Pittoresques et Romantiques dans l'Ancienne France* (*Picturesque and Romantic Voyages through Old France*), an Anglo-French project that was to involve more than one hundred and fifty artists and last fifty-eight years. The *Voyages* glorified the France of the *ancien régime,* before the social and political changes brought by the French Revolution. Not only did this work represent the culmination of topographical printmaking, it also stimulated the blossoming of lithography as an artistic medium.

Richard Parkes Bonington's *Rue du Gros Horloge* (1824; fig. 8.3), one of the most beautiful prints in the *Voyages,* is based, like Géricault's *Flemish Farrier,* on an exquisite tonal finesse analogous to that obtainable in chalk drawing. The great clock for which the street is named is suffused with the sunlight that spreads forward across the aged and intricate façades. Bright, windswept clouds above are balanced by dark accents in the crowd below; the whole print is pervaded by light and atmosphere and Bonington's judicious balance of minutiae with broad shapes and tonal areas.

Equally atmospheric and picturesque are Eugène Isabey's views of the Normandy coast from his *Six Marines,* published in Paris, London, and New York in 1833 (Isabey had also

FIGURE 8.2

Théodore Géricault. The
Flemish Farrier *from*
The English Set. *1821.
Lithograph. 227 ×
315 mm. British Mu-
seum, London.*

worked on the *Voyages Pittoresques*). In *Near Dieppe* (fig. 8.4), he pitted rugged cliffs against a
turbulent sea. The strong chiaroscuro in the landscape elements and the dramatic sky convey
the power of nature, while quaint huts, the irregular pilings of the dock, and small figures
indicate a precarious but persistent human presence. Like Bonington's lithograph, Isabey's il-
lustrates the use of the new medium to satisfy (vicariously) the wanderlust of patrons, some-
thing prints had been doing since the seventeenth century.

Perhaps the most innovative early lithographs were made by the aged Goya, who had left
Spain for France, leaving his unpublished *Disasters of War* and *Disparates* behind. He had
already experimented with the new medium briefly in 1819, but in 1825, under the auspices of
the professional lithographer Cyprien Gaulon of Bordeaux, Goya produced a set of four very
beautiful and rare lithographs, *The Bulls of Bordeaux*. His choice of this quintessentially Span-
ish theme (later explored in graphic art by another great Spaniard, Pablo Picasso) seems to
reflect his meditations on his exile and the conditions that had brought him to this decision.

A Spanish Entertainment (fig. 8.5) depicts the letting loose of bulls in the piazza of a
Spanish village, so that all would-be matadors may try their hand. In the isolation of four center
bulls against the luminous oval of ground, something of the bold, precise balance of masses
and voids in the *Tauromaquia* (see figs. 7.36, 7.37) is retained. But the clarity and economy of
the etched series is relinquished in favor of a painterly richness—Goya's thickly applied crayon,
heavily reworked with scraping, is nevertheless miraculously graphic and "in the paper." He
had hit upon one of the paradoxical possibilities of lithography that would not be further
explored until much later.

Expressively, Goya was no longer dealing with frozen moments of mortal confrontation
between an individual or a few individuals and the bull; here, humanity has expanded (or,

FIGURE 8.3

Richard Parkes Bonington.
Rue du Gros Horloge
from Baron Taylor's Voy-
ages Pittoresques et
Romantique dans
l'Ancienne France. *1824.*
Lithograph. 244 ×
251 mm. Cleveland
Museum of Art.

from another point of view, contracted) into glacier-like mobs that act mindlessly, as if now by sheer magnitude and blind persistence they can overcome the bulls. There seems to be no question any more of human cleverness or heroism. The great beasts have already trampled some of the crowd into raggedy lumps. In one sense the people here are more frightening than the bulls. They represent collectively the human folly that Goya had spent a lifetime observing.

The frequently dark vision of humanity found in Goya's works is one of the many qualities that link him, despite his Enlightenment foundations, to the Romantic movement, of which Delacroix is perhaps the most important French exemplar. Delacroix had seen some of Goya's graphic art and possessed a similarly fresh approach to lithography. He was the first major artist to use the new medium for lively illustrations—for Goethe's *Faust,* Shakespeare's *Macbeth,* and other literary masterpieces. (Lithography, as a planographic process, did not lend itself as readily to combination with letterpress printing as woodcut or wood-engraving did.) Delacroix was perhaps inspired as much by theatrical productions he had seen on his trips to London as by the literature itself.[10] His extensive use of the scraper—expanded beyond that of Charlet or Isabey—to create luminous effects established a new expressive potential for lithography. In *Macbeth Consulting the Witches* (1825; fig. 8.6), Shakespeare's protagonist is sur-

FIGURE 8.4

Eugène Isabey. Near
Dieppe: *No. 1 from* Six
Marines. *1832–33.*
Lithograph. 223 ×
297 mm. Cleveland
Museum of Art.

rounded by the swirling vapors, described entirely by the scraper, from the cauldron of the
three hags, whose ugly faces and bodies glimmer in the sparse firelight. As Claude Roger-Marx
observes, the print is conceived as a mezzotint—from darks to lights.[11] Of the equally vivid
illustrations for Goethe's *Faust* (1828), the poet himself commented, "Delacroix has surpassed
my own imagination in scenes which I created myself; how much more will they come to life
for the average reader and exceed *his* imagination."[12] In one of the plates, Mephistopheles, an
oddly Michelangelesque gargoyle, flies above the city at night (fig. 8.7). Not only does he move
forward, but his wings, misshapen head, and limbs move in all directions, giving a vivid sense
of his shrewdness and energy. Charles Meryon was certainly aware of his predecessor's Meph-
istopheles when he conceived his famous etching, *Le Stryge* (see fig. 9.20).[13]

Delacroix's visualizations of Shakespeare and Goethe were financial disasters, but they
remained a model for later lithographic book illustration.[14] Moreover, the influence of his
scraping technique was considerable. It may be perceived in the prints of Adolf Menzel, a
talented German painter, printmaker, and illustrator, or Charlet's pupil Denis-Auguste Raffet,
who made prints of Napoleonic scenes and was also employed as a political cartoonist by
Charles Philipon. In *The Captives' Journey through a Wood* (1851; fig. 8.8) Menzel employed
crayon and wash for the definition of form and, conversely, for its veiling in atmosphere, but
it is the scraper that depicts the driving rain and lends the illustration a sense of linear excite-
ment, akin to that of Delacroix's *Macbeth Consulting the Witches*. Raffet's *Night Review* (1836;
fig. 8.9) is conceived along similar lines. In this crayon lithograph—a vestige of the Napoleonic
era—the emperor, on a white charger, reviews his ghostly troops at night. The legends of
Napoleon and the triumphs of *La Grande Armée* were exalted in popular lithographs by Baron

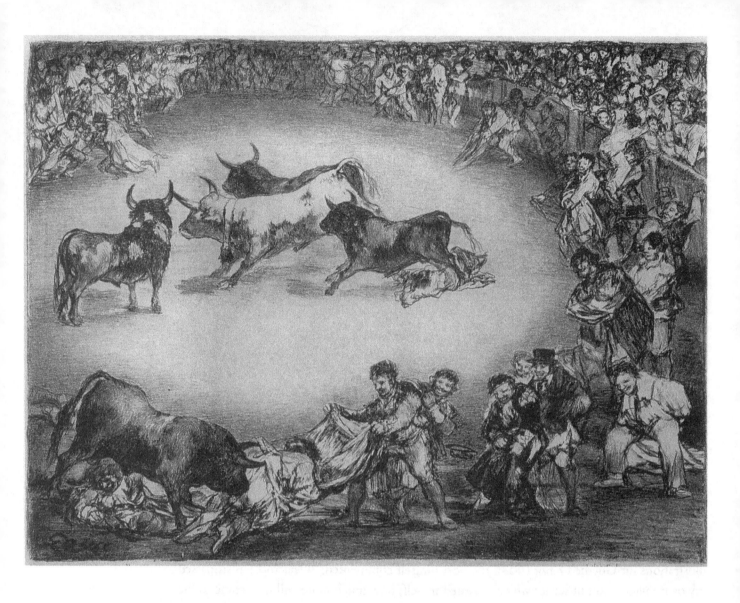

Gros, Charlet, Géricault, Raffet, and others long after Waterloo, and the Napoleonic myth would emerge again in the period of the Second Empire under Napoleon III (1852–70). Raffet's romanticized, nocturnal vision is a particularly poignant reminder that dreams die hard. The scenes of brutality and famine from Goya's *Disasters of War* provide quite another interpretation of the Napoleonic era.

Delacroix's single lithographs of animals were perhaps the best graphic outlet for his imagination. Like Stubbs before him, he reveled in the bloody savagery inherent in a tiger's devouring of a horse (1828; fig. 8.10)—the tiger's paws and claws are oversized, and his body is totally contracted as, with eyes gleaming with ferocity, he bites into his victim's neck. Although no human element is depicted here, Eve Twose Kliman has suggested that Delacroix understood the lion and tiger as analogs for human beings, whose passions equally transcend rationality and morality.[15] Delacroix, like Goya, has used the lithographic crayon very loosely, so that the print has something of the spontaneity of a sketch. A comparison of the print to the preparatory drawing shows, however, that the composition was carefully considered. The two animals form a whirling, swastika-like form centering on the bitten neck.

FIGURE 8.6

Eugène Delacroix. Macbeth Consulting the Witches *from* Macbeth *by William Shakespeare. 1825. Lithograph. 350 × 325 mm. Metropolitan Museum of Art, New York.*

FIGURE 8.7

Eugène Delacroix. Mephistopheles Flying over the City *from* Faust *by Johann Wolfgang Goethe. Paris: C. Motte, 1828. Lithograph. 270 × 238 mm. Metropolitan Museum of Art, New York.*

EARLY EXPERIMENTS WITH COLOR

Almost as soon as lithography was invented, Senefelder himself and others began experimenting with the use of more than one stone to achieve a tint over the initial drawing, much as in chiaroscuro woodcuts. The early tinted lithograph was generally printed with a key slab containing the drawing and a second stone in buff, grayish blue, or some other neutral color that established a slight tint within a basically monochromatic image. In Domenico Quaglio's *Prunn Castle in the Altmuhl Valley, Bavaria* (fig. 8.11), for example, a blush of grayish lavender is superimposed on a subtle, atmospheric drawing in crayon. The color adds to the atmosphere, enhancing the luminous mist that surrounds the precipitously placed castle as well as the contrasting darkness of the forest below, but does not define form.

Early multicolored lithographs generally imitated oil and watercolor painting by superimposing many stones, as in this print after a portrait by Greuze from Englemann's *Album Chromolithographique* (1838; fig. 8.12). Englemann sought an effect akin to Le Blon's color

mezzotint after Blakey's *Portrait of Louis XV* (fig. 5.50, color plate, p. 466). Tonal lithographs might also be overpainted in watercolor. As we shall discuss in the chapter on American printmaking before World War II, the numerous popular lithographs produced by the firm of Currier and Ives in New York were generally finished in this manner. Their rare black and white prints reveal a tonal power and graphic richness obscured by the hand coloring.

Arguably the finest early color lithographs produced before Manet's seven-color *Polichinelle* (dated 1874–76, and probably to be read as a political caricature),[16] and the masterpieces of Toulouse-Lautrec at the end of the century, came from Hullmandel's press in London. The twenty-eight prints in *Picturesque Architecture in Paris, Ghent, Antwerp, Rouen . . .* (1839; fig. 8.13, color plate, p. 469) were done in collaboration with the painter Thomas Shotter Boys, who drew the views "from nature." Boys's indebtedness to the printer is clearly revealed in his dedication of this landmark publication, described as "forming another epoch" and "presenting entirely new capabilities of the Art," to Hullmandel.[17] The latter had coined the term "lithotint" to describe his process of lithography in color washes imitating watercolor. The thinned lithographic medium may be used as a liquid wash. However, since a wash can hold only a small proportion of grease, thereby lessening its attraction to ink, it is often difficult to print. Hullmandel's expertise kept the colors of Boys's prints delicate, clear, and largely independent of each other. The white of the paper retains a brilliant luminosity. It is this approach to color lithography that inspired the French painter-lithographers of the 1880s and 1890s.

FIGURE 8.10

Eugène Delacroix. Wild
Horse Attacked by a
Tiger. *1828. Lithograph.
200 × 276 mm. Biblio-
thèque Nationale, Paris.*

FIGURE 8.11

*Domenico Quaglio
(1787–1837).* Prunn
Castle in the Altmuhl
Valley, Bavaria. *Ca. 1815.
Two-color lithograph.
573 × 445 mm. Verwal-
tung der staatlichen
Schlösser, Gärten und
Seen, Museumsabteilung,
Munich.*

BARBIZON

Although artists of the Barbizon school (named for a hamlet in the forest of Fontaine-bleau, the site that especially inspired them) are most closely associated with the revival of etching (see Chapter 9), some also produced lithographs. Jules Dupré employed the medium for a small number of prints after his own paintings. *Pastures of Limousin* (1835; fig. 8.14) was published in the periodical *L'Artiste*, and reproduced a painting entitled *Villagers in the Forest* of the same year. The image evokes the active skies and monumental trees of Ruisdael, an inspiration to many Barbizon artists. The tallest tree establishes a central vertical that counter-balances the basic horizontality of the composition, rooted in the low-lying land and reclining or peacefully grazing cattle. Spatiality is enhanced by the contrast between the vigorous draw-ing and dark tones of the trees and foliage in the foreground and middleground and the subtle grays of the sky. Dupré evidently saw no difference between his autographic work and prints made after his paintings by reproductive lithographers, for he seems to have quickly abandoned making his own lithographs, or at least signing them.[18]

The pastoral subjects of Barbizon art suggest the conflict between the Industrial Revolu-tion and the way of life it was rapidly supplanting.[19] In the works of Jean-François Millet, rural subjects attained more forceful political meaning. T. J. Clark points out that the Fontainebleau itself, like all the woodlands around Paris, was an area of political turmoil. In the woods was a proletarian class, a population deprived of land and subsisting by gleaning, gathering faggots, and grazing stock at the forest's edge. And even these avenues to survival were gradually re-stricted: gleaning required a certificate of indigence; guards drove stock away from the forests; the gathering of faggots was forbidden. The peasants hung on until they were forced to seek

FIGURE 8.14

Jules Dupré after his own painting, Pastures of Limousin. *1835. Lithograph. 138 × 216 mm. Museum of Art, Rhode Island School of Design, Providence.*

work in quarries and urban factories. It is no coincidence that Millet's paintings and prints focus on mundane activities of the rural forests.[20]

Although it is set in a Normandy landscape, Millet conceived *The Sower* (fig. 8.15) soon after his trip to Barbizon, with the etcher Charles Jacque, in 1849. There are two paintings of the theme, one slightly earlier than that exhibited at the Salon of 1850. Perhaps the lithograph was originally intended for the periodical *L'Artiste* to publicize the Salon canvas.[21] This painting drew criticism for the "savagery" of its technique, although its political implications went largely unnoticed: Millet's works could be viewed in reassuring, pastoral terms that asserted the countryside as calm and unchanging. But the sower's movement and gesture, at first more free and open, was dampened in the 1850 painting and in the lithograph to express Millet's vision of the peasant's lot. Far from imparting a sentimental aura to the peasant and his relationship to the earth, and despite the biblical implications of the theme, *The Sower* sounded a distinctly contemporary and tragic note. "Work, for Millet," states Clark, "is not usually a process which changes or shapes the surrounding world, not a matter of making or assertion. It is a series of actions endlessly repeated, a spell, an incantation, magic which the magician does not expect to work."[22]

DAUMIER AND FRENCH SATIRICAL LITHOGRAPHS

Although lithography's incompatibility with letterpress printing prevented its widespread use for illustration during the first third of the century, it did not hamper a flourishing market for popular prints in single-sheet or album format. Wood-engravings (to be discussed in Chap-

FIGURE 8.15
*Jean-François Millet
after his own painting,*
The Sower. *Ca. 1850.
Lithograph. 191 ×
156 mm. New York Pub-
lic Library.*

ters 9 and 12), relief prints made from durable end-grain blocks, dovetailed with letterpress and were most commonly used to illustrate books and journals in the nineteenth century, despite the enormous labor involved in their production. It was especially after 1830, when steam-driven presses made vast numbers of books and journals possible, that wood-engraved images flooded Europe and America, and this flood was augmented by the ability to duplicate the blocks and to combine wood-engraving with photography later in the century.

In the meantime, lithography had entered the field of journalistic illustration with the publications of Charles Philipon, himself a lithographer and caricaturist, in the 1830s. Wood-engraving and lithography vied for dominance of the popular image market during much of the century.[23] In Chapter 1, we noted the exchange that took place between relatively crude images, such as those of the blockbooks, and "higher" art forms such as painting and sculpture. The same kind of exchange was still taking place at a heightened pace. Nineteenth-century artists could not remain insulated from the abundance of printed images. For example, the English landscape painter Joseph Turner designed steel-engraved illustrations, and his American counterpart Thomas Moran busily helped to fill American journals with wood-engravings. And popular wood-engravings and lithographs, absorbed, reworked, and combined with other influences, contributed to some of the century's most important paintings.[24]

The most renowned artist working for Philipon was Honoré Daumier. In more than four thousand lithographs, Daumier kept a constant watch on French culture and politics.[25] His career spanned some remarkable political changes. He was trained during the Restoration of the Bourbon monarchs (Louis XVIII, whom Debucourt had mocked as a youth in his *Promenade Publique* [fig. 6.36, color plate, p. 466], and Charles X, who came to power after the fall of the Napoleonic Empire), and he began producing lithographs as the constitutional monarch, Louis-Philippe, was brought into power by the Revolution of July 1830. The corpulent Louis-Philippe, "citizen-king" and constitutional monarch in name only, provided Daumier with the richest fodder for satire of the artist's career. However, Bonapartists, lawyers, early feminists, and the French middle class itself were also the focus of Daumier's scrutiny. His work continued through a brief Republican period after the Revolution of 1848, the Second Empire, and into the Third Republic, founded after Napoleon III's defeat in the Franco-Prussian War.

Philipon's business sense and political acumen (he maintained much control over the content of his publications) are crucial to our history. Philipon circumvented the antagonism of lithography and letterpress printing in two ways. The two lithographs per issue of his monthly magazine *La Caricature* were inserted so that they could be detached and framed. For the second journal he founded, *Le Charivari* (literally translated as "cacophany," and referring to a noisy mock ceremony for newlyweds), he used two press runs, one for the lithographs and one for the type. The technique of offsetting the image onto a roller and then onto more stones enabled Philipon to produce enough papers to satisfy a circulation of between one and two thousand.[26] In 1870, long after Philipon's death in 1852, *Le Charivari* went to the gillotage process, by which the zinc lithographs were translated by etching into relief plates—a process not far removed from Blake's relief etching. These plates could be printed along with type, but at great loss to Daumier's sensitive drawing.

Except during the brief period after the Revolution of 1848 and up until 1881, government censorship hampered graphic satire in France, especially after the harsh "September Laws" of 1835, although there were ways of evading the censors' judgments without rendering the political sense of an image unintelligible. Charlet would alter offensive captions.[27] As James Cuno has shown, Philipon too dealt ingeniously, if not often successfully, with government censorship, and he understood that being censored had a certain publicity value. While appearing in court in 1831, for example, Philipon argued that a caricature depicting Louis-Philippe as a mason plastering his unfulfilled promises on a wall referred not to the person of the king but merely to his public role, the resemblance to the king's person being only incidental. By April

1832 Philipon had been arrested three times, sentenced to thirteen months in prison, and fined 4,600 francs. Thereafter, along with establishing *Le Charivari*, less politically inflammatory than *La Caricature*, Philipon founded *l'Association Mensuelle*, an organization devoted to the liberty of the press. Members received a monthly lithographic caricature for a fee that helped offset the publisher's court costs. Although these prints were topical (Daumier's greatest political statements are *l'Association Mensuelle* prints), they were printed on fine paper and, like the prints inserted in *La Caricature*, could be framed. They appealed to a middle-class audience not only angered by the "citizen-king's" betrayal but also increasingly interested in print collecting. When the stamp tax laws of 1834 mandated the stamping of political caricatures on the image itself, Philipon argued for the status of *l'Association Mensuelle* prints as fine art.[28]

Although Philipon employed many writers and artists—Raffet, Grandville (Jean-Ignace-Isidore Gérard), and Paul Gavarni (Guillaume-Sulpice Chevalier), for example—Daumier's prints most often transcended the specific political topics they addressed to become more broadly applicable commentaries on injustice and folly. Raffet's *Les Incurables* (fig. 8.16), done for *La Caricature* in 1831, illustrates his indebtedness to Hogarth, Goya, and Rowlandson as well as lithography's particular suitability for Philipon's purposes. Rapid drawing established the distorted physiognomies and bloated figures of the aristocrats who hobble about, crippled by their own short-sightedness and greed as well as by the Revolution itself. Raffet conveyed their ineptitude through the imagery of physical immobility, as Goya had done in *The Chinchillas* (fig. 7.32) from the *Caprichos* and *People in Sacks* from the *Disparates*, only without Goya's nearly surrealistic condensation of form and meaning.

In its pure, gut-level visual impact, however, Daumier's imagery is often the equal of Goya's. His powerful *Don't Meddle with the Press* (1834; fig. 8.17), for example, embodies the longstanding battle for freedom of thought and expression. Although it contains contemporary figures—its main target, Louis-Philippe, on the left, and the expiring absolutist Charles X, whose repressive measures had helped bring about the Revolution of 1830, on the right—it remains relevant for many societies in our own time. Daumier has subordinated details to the figure of the pressman, whose clenched fists and pose convey his determination to maintain his stand. It is important to remember that taking such a stand meant more than being inconvenienced: Daumier was always in financial trouble and, like Philipon, frequently subject to government reprisals. In 1832 he spent some time in jail for his tasteless cartoon of Louis-Philippe as "Gargantua" eating wealth and defecating it to his followers. He made the most of his stay in the prison of Sainte-Pélagie, complaining of his inkwell running dry, dubbing himself "The Loafer," and basking in "the pleasure of opposition."[29]

Not only did Daumier learn to dispense with the superfluous details that often characterize political satire, he transformed caricature into art. It was he who most brilliantly capitalized on Louis-Philippe's resemblance to a plump pear to create unforgettable images of stupidity, greed, and mediocrity. As Cuno has discussed in great detail, the *poire* called up an amazing number of visual and verbal associations for the French public of the 1830s. The word had the idiomatic connotation of "moron," and, with its phonetic resemblance to *poireau* (leek, a phallic-shaped vegetable) and *poivre* (pepper, slang for syphilis), carried pornographic connotations as well. The image of the pear resembled both Louis-Philippe's face and his derrière, which, when merged, characterized him as an "ass-face," a highly inflammatory image, as we have seen in Jacques-Louis David's *The English Government* (fig. 7.17). It also suggested the phallus, and by association of shape and action, the clyster or enema pipe that Goya and many

FIGURE 8.16

Denis-Auguste Raffet. Les Incurables (*for* La Caricature). *1831. Lithograph. 180 × 263 mm. New York Public Library.*

Les Incurables.
Ceux seuls ont compris la Révolution

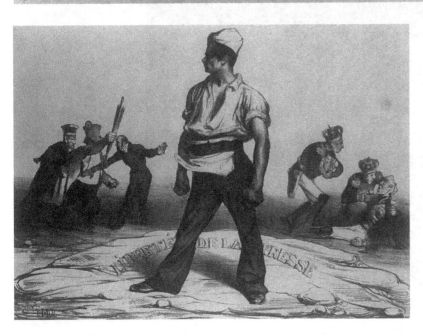

FIGURE 8.17

Honoré Daumier. Don't Meddle with the Press (*for* l'Association Mensuelle). *1834. Lithograph. 307 × 431 mm. National Gallery of Art, Washington, D.C.*

others had employed so well to suggest oppression. Finally, the pear was Louis-Philippe's entire body, his person, his government. Capitalizing on this complex metaphor, *Past, Present, and Future* (1834; fig. 8.18) places on exhibit the incompetent monarch who "buggers" his people with repressive measures while feeding on their wealth. And the resemblance of Louis-Philippe's tripartite, pear-shaped head to a pair of buttocks could not help but suggest that the public administer the clyster pipe right back.[30] More broadly, the image conveys the notion that despite the many shifts in political leadership in France, things never really changed for those most oppressed.

FIGURE 8.18

Honoré Daumier. Past,
Present, and Future (for
La Caricature). 1834.
Lithograph. 214 ×
196 mm. New York
Public Library.

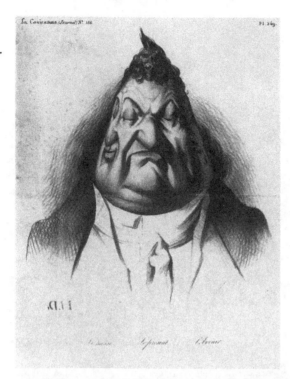

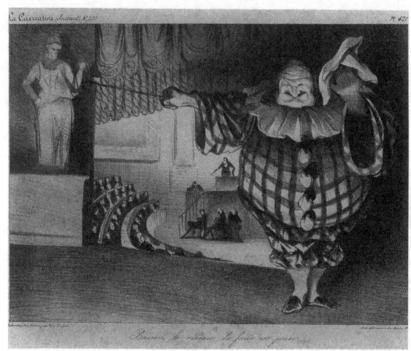

FIGURE 8.19

Honoré Daumier. Bring
Down the Curtain: The
Farce Is Over (for
l'Association Men-
suelle). 1834. Lithograph.
200 × 278 mm. New
York Public Library.

The Revolution of 1830 had proved to be a victory only for the upper bourgeoisie. Louis-Philippe betrayed hopes for true republicanism, and France was in fact ruled, as in the past, by the "haves," leaving the "have-nots" to continue their ancient struggle. In *Bring Down the Curtain: The Farce Is Over* (1834; fig. 8.19), Louis-Philippe, his pear shape enveloped by a preposterous clown suit, brings the curtain down on a subservient legislature. His baton tips the scales of Blind Justice. The passivity of the legislature itself is revealed in *The Legislative*

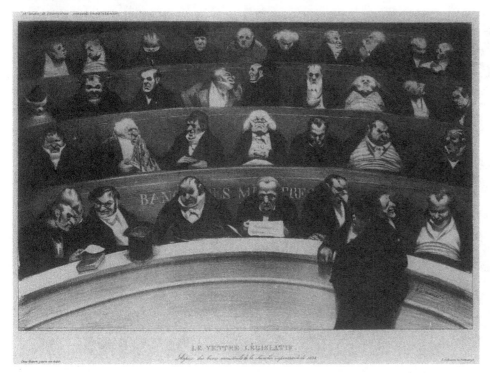

FIGURE 8.20

Honoré Daumier. The Legislative Belly (*for l'Association Mensuelle*). *1834. Lithograph. 280 × 431 mm. National Gallery of Art, Washington, D.C.*

LE VENTRE LÉGISLATIF

FIGURE 8.21

Jean-Ignace-Isidore-Gérard Grandville. Digestion of the Budget, Administrative, Political, and Especially Economic Work (*for La Caricature*). *1832. Lithograph. 168 × 309 mm. Baltimore Museum of Art.*

Digestion du Budget
travail administratif politique, moral et surtout économique

Belly (1834; fig. 8.20), in which the rows of delegates are arranged as if in some great alimentary tract whose sole purpose is to digest the wealth of the nation. Grandville's earlier *Digestion of the Budget, Administrative, Political, and Especially Economic Work* (1832; fig. 8.21) for *La Caricature* hinges upon the same idea, but it is too detailed and unfocused to equal Daumier's statement. Whereas Grandville gave the legislators tubes from which to suck the wealth of society, Daumier transformed them into the intestine itself.

FIGURE 8.22

Honoré Daumier.
Rue Transnonain
(*for* l'Association Men-
suelle). *1834. Lithograph.*
290 × 460 mm. National
Gallery of Art, Washing-
ton, D.C.

Daumier's unquestioned masterpiece is *Rue Transnonain* (1834; fig. 8.22), the last of *l'Association Mensuelle*'s twenty-four prints. An uprising led by the republican Society of the Rights of Man to protest against a law restricting the right of association had been brutally suppressed by the government. When fired upon from a working-class building in Rue Trans-nonain, where barricades had been erected against them, Louis-Philippe's troops entered the house, indiscriminately killing and wounding the occupants. Daumier's print represents an unsuspecting family murdered in the fray. In the main victim, lying in his simple nightshirt amid the disarray of the final moment of panic, Daumier recalled countless dead Christs in their winding sheets, and drew upon centuries of meditative images of Christ as a martyr. But this winding sheet is a bed sheet; the martyr is an anonymous worker, lying atop his own child with its bludgeoned head. Not by coincidence, Daumier's image also recalls the fallen bodies in Goya's *Disasters of War,* the outstretched limbs of a corpse in Géricault's *Raft of the Medusa,* and the latter's trenchant studies of decapitated heads (see the head at the far right of Daumier's print). Daumier's masterful use of light to isolate the fallen father in the gray stillness of the room, and the simple pyramidal composition that culminates in his lifeless head make this an unforgettable image: the lithographic equivalent of Goya's most eloquent *Disasters of War* etchings.

The complicity of lawyers and judges in maintaining the status quo was also savagely attacked by Daumier, who had worked as a bailiff and was thoroughly cynical about the French legal system. He used their costumes to satirical advantage, turning them into black-winged vultures who prey upon the remains of their client-victims. *A Dissatisfied Client* (1846; fig. 8.23), intended for *Le Charivari* but not published, was part of a series of thirty-nine lithographs made between 1845 and 1848, *Les Gens de Justice* (*Men of Justice*). The placement and gestures of the two figures on the stairs succinctly express the social and economic differences between lawyer and client. One suspects that with a wealthier client, the lawyer's disdain might turn

LES GENS DE JUSTICE.

26.

VENT
ETUDE
JUGEMEN
JUGE

Un plaideur peu satisfait.

FIGURE 8.23

Honoré Daumier. A Dissatisfied Client *from* Les Gens de Justice *(intended for* Le Charivari *but not published).* *1846. Lithograph. 234 × 191 mm. National Gallery of Art, Washington, D.C.*

into obsequiousness. The mercenary motives behind the legal process are cleverly suggested by the juxtaposition of placards headed *Vente* ("Sale") and *Jugement* ("Judgment").

In comparison with these images of lawyers, Daumier's prints satirizing bourgeois mores after *La Caricature* closed seem mild. *When One's Portrait Is Exhibited at the Salon* (1845; fig. 8.24) pokes fun at the pretensions of the middle class, but not too harshly. The man and wife are pathetically lost in their surroundings. With *In Front of M. Manet's Canvas* (1865), Daumier captured the utter lack of comprehension with which the middle-class public greeted avant-garde art. These people would be, one expects, fair game for the swindlers and charlatans, epitomized by Daumier's invented characters Robert Macaire and Bertrand, who, in numerous lithographs, capitalized on the get-rich-quick mentality of the times. Through these characters, Daumier satirized his society's misplaced values.

Although they staunchly defended republican values, the rights for which Daumier and his companions fought so hard were still essentially the rights of white males. One of the themes that Philipon and Daumier settled upon in their retreat from the political subjects that incurred fines was that of the "uppity woman," satirized early by Israhel van Meckenem (see fig. 1.44). Indeed, one of the lithographs of Daumier's *Bluestockings* series (1844) reiterated the "battle for the trousers" theme, with a slightly different twist: a bluestocking wife (a woman

FIGURE 8.24

Honoré Daumier.
When One's Portrait Is
Exhibited at the Salon
from Les Beaux Jours de
la Vie (*for* Le
Charivari). *1845.
Lithograph. 245 ×
230 mm. New York Pub-
lic Library.*

who had given herself over to the pursuit of literature, neglecting her true station in life) refuses to mend her husband's trousers, throwing them disdainfully in his face.

The term "bluestockings" was a nickname given to cultivated people who met at the Montague house in London to discuss literary issues. In France the term was gender-specific. It was particularly the novelist George Sand (Amandine-Aurore-Lucie Dupin), Daumier's contemporary, who represented the dangers of intellectual pursuits for women. Her life-style—her habit of cross-dressing, her separation from her husband, and her extramarital af-fairs—scandalized the public. Daumier's caricature of a bluestocking mother busily writing as her baby drowns in the bathwater is captioned: "The mother is in the fire [throes] of compo-sition; the baby is in the bathwater" (fig. 8.25). The mother here is depicted as old (despite the fact that she has a young child) and ugly, like all bluestockings in Daumier's series. In abandon-ing their domestic duties, they have also lost their femininity: an old taunt that is still with us today.

But beyond pursuing literature and scholarship, bluestocking and socialist women held the even more threatening idea of social equality. The economic and political liberation of women did not keep pace with that of men in nineteenth-century France.[31] Françoise Parturier points out that Daumier "really knew nothing about the new [women's] movement, about the

LES BAS-BLEUS.

La mère est dans le feu de la composition l'enfant est dans l'eau de la baignoire !

FIGURE 8.25

Honoré Daumier. The Mother Is in the Throes of Composition, the Baby Is in the Bathwater! *from* Les Bas-Bleus (*for* Le Charivari). *1844. Lithograph. 233 × 190 mm. New York Public Library.*

clubs, women's newspapers, the many declarations concerning women's rights. His knowledge was limited to what he gleaned from a mocking, hostile press, the anecdotes about them and the myths about cigarettes, punch, banquets and hats." Had he known about the denunciations of the wretched conditions of working women in the socialist women's press, Parturier speculates, he could not have failed to be moved. As it was, he simply fell back, in his *Bluestockings* and *Socialist Women* (1849), on time-tested antifeminist motifs.[32]

But to end our discussion of Daumier with these reactionary images would be unfair. In his late work he often recovered the power of his lithographs of 1834. With our contemporary experience of nuclear weapons and of the Cold War, we might well shudder at the prophetic quality of many of Daumier's lithographs warning of war in Europe, which was made inevitable by the growing Prussian state and its rivalry with France. *The Dream of the Inventor of the Needle-Gun* (1866; fig. 8.26) recalls the skeletal personification of death that has often recurred in European art. The numerous corpses and the name "needle-gun" foreshadow the deadly efficiency of modern weapons. And the bayonets that hold up the world so precariously in Daumier's *European Equilibrium* (1866) could be replaced by missiles in the twentieth century. In *Peace: An Idyll* (1871; fig. 8.27), the skeleton Death reappears, wearing a shepherd's hat and gleefully piping a tune across a devastated Europe. With deft strokes of the lithographic crayon,

The Nineteenth Century: Lithography **453**

FIGURE 8.26

Honoré Daumier. The
Dream of the Inventor
of the Needle-Gun
(*for* Le Charivari).
*1866. Lithograph. 233 ×
199 mm. National
Gallery of Art, Wash-
ington, D.C.*

ACTUALITÉS. 213

Le rêve de l'inventeur du fusil à aiguilles,
le jour de la Toussaint.

Daumier gave Death an ironic liveliness, much as Holbein had done in woodcuts four centuries earlier, but with less bitterness (see figs. 2.39–2.42). Daumier would live to see the fall of the Second Empire after the Franco-Prussian War, the doomed Paris Commune, and finally, the establishment of the Third Republic in 1872. He died in 1879 after retiring on a small pension, his production of lithographs curtailed by his failing eyesight.

The work of Daumier and his lesser contemporaries firmly established the political role lithography had played since its early association with Napoleonic imagery. Lithography would continue to play this role into the twentieth century.[33]

STYLISTIC AND TECHNICAL INNOVATION IN LITHOGRAPHY AFTER 1850

The lithographs that we have seen so far rely largely on lithographic crayon handled as chalk would be handled in drawing. With the exception of Daumier's swifter, sketchier images, Goya's painterly bullfights, and the lithotint method of Boys and Hullmandel, lithography had not been explored with an eye for stylistic and technical experiment but had been kept within a fairly limited range of visual effects. In the late nineteenth century, however, the Impressionists, Symbolists, Nabis, and other avant-garde artists tapped lithography's enormous potential

ACTUALITÉS

LA PAIX
Idylle.

FIGURE 8.27

Honoré Daumier. Peace:
an Idyll *from* Actualités
(*for* Le Charivari).
*1871. Lithograph. 235 ×
184 mm. Bibliothèque
Nationale, Paris.*

for visual variety. Along with the traditional techniques of etching and woodcut, lithography
took new and surprising directions.

There can be no question that these new directions in printmaking were closely related
to the acceleration of stylistic change and the break from the whole European artistic tradition
that began in late nineteenth-century painting. The longest strides in printmaking were made
by the most innovative painters, who sometimes had to be persuaded to take up printmaking
by publishers and dealers like Alfred Cadart or Ambroise Vollard. The Impressionist painter
Claude Monet flatly refused to make prints. But those painters who did were usually fascinated;
they persisted in making prints even when there was a lack of financial reward or public re-
sponse. They brought to printmaking two attitudes that have led to superlative graphic art in
the past: the openness toward technical experiment and the refusal to allow their prints merely
to imitate paintings. Thus, although the development of printmaking in the late nineteenth
century runs parallel to the development of painting, it is not, in the last analysis, derivative.
There are times when the prints of these artists seem to be clearer statements of their artistic

goals. Lautrec's superb sense of flat shape and line finds its fulfillment in his lithographic posters. And Manet's elimination of half-tones is even more striking in his lithographs and etchings.[34]

Manet was encouraged to take up lithography by Cadart, who had also contributed to the revival of etching after 1850 that will be the chief subject of the next chapter. When Manet produced *The Balloon* (fig. 8.28) in 1862 from a stone Cadart had sent him, he was already an experienced, innovative etcher, primarily creating prints after his paintings. He adapted readily to the soft lithographic crayon, using its malleability to create a bustling street scene, similar in feeling to his painting *Music at the Tuileries* (ca. 1862), one of his most impressionistic works. Jean Leymarie points out, however, that, true to the more popular role of prints, the crowd in *The Balloon* comprises not genteel concert-goers but a motley group attending a street fair, with puppet shows, boys climbing greasy poles topped with prizes, and the moored hot-air balloon itself.[35]

The exact identification of this street fair, and hence the political meaning of *The Balloon*, have been the subject of much debate. Douglas Druick and Peter Zegers have convincingly argued that Manet represented a specific "Fête de l'Empereur," an event that had come to embody Louis-Napoleon's betrayal of the republican principles of the 1848 Revolution, which ushered in the Second Republic and brought an end to the reign of Louis-Philippe. The balloon launchings that accompanied these festivals were intended to symbolize the ascendancy of the Second Empire and France, but Manet quite obviously juxtaposed his balloon with a crippled boy on a cart—an embodiment of "the people." This juxtaposition, however, is hard to read. Unlike Gavroche, the heroic street urchin of Victor Hugo's *Les Miserables,* Manet's youth is an antihero. In contrast to Hugo's great moralizing book, Manet's print is more skeptical and ironic, an image appropriate for the "painter of modern life," as Manet has been dubbed by twentieth-century scholars. The stylistic similarity of *The Balloon* to Goya's *A Spanish Entertainment* (fig. 8.5), which the critic Charles Baudelaire admired, is not accidental, Druick and Zegers conclude. Borrowing some phrases from Baudelaire's description of Goya's image, Druick and Zegers note that both prints are scenes of "the crowd at play and being played upon," pictures "full of 'rout and rabble,' in which the trivial and the terrible subtly merge," visions "in which passion is balanced by impartiality, in which art 'dominates' and morality is 'intermingled with it and lost sight of.'"[36]

Thus the first lithograph of this complex artist is already an interpretive problem. Debate about meaning in Manet—about his position at the crossroads of modern, avant-garde style and liberal politics—continues.[37] Was Manet's concern in his art primarily formalistic, or was he deeply committed to effecting political change through his works? When directed toward his prints, traditional means of political expression, the question becomes particularly acute.

The sense of detachment and objectivity that Manet's works have elicited (and which persists, albeit in a balanced way, in Druick and Zegers' interpretation of *The Balloon*), has also complicated our understanding of two more overtly political lithographs commemorating the fall of the Paris Commune in 1871: *The Civil War* and *The Barricade* (figs. 8.29, 8.30). Although we do not have Manet's personal written testimony regarding the events of 1871, "the two lithographs," as Anne Coffin Hanson states, "seem to be evidence enough. Propagandistic in both approach and medium they view the real dehumanization of war, perhaps all the more gruesome when seen, like a news report, without idealization or hope."[38]

Manet's sympathies were surely with the Paris Commune, or municipal government,

which had attempted to secede from the French nation after the disastrous Franco-Prussian War dissolved the Second Empire. When France surrendered to the Prussians (a move opposed by Paris), a conservative government based in Versailles attempted to collect back rents that had been suspended during the war and terminated the pay of the National Guard. Paris, dominated by republican and left-wing forces, refused to cooperate and formed the Commune. In March 1871, the Versailles troops besieged the city, executing twenty thousand citizens, the majority during one *Semaine Sanglante* ("Bloody Week") when government troops sought out partisans in streets, alleys, and homes. The Commune became a symbol of resistance to oppression.

Manet left Paris to visit his family when the Prussian troops attacked the city, but he later returned. He seems to have witnessed the executions of Communards, but his impressions were transformed and informed by contemporary photographs and wood-engravings, and certainly by previous artistic sources, including works of his own, and careful preliminary watercolors and drawings.[39] Daumier's *Rue Transnonain* (fig. 8.22) must have figured into his conception. But when compared with Daumier's image, which is itself relatively unrhetorical and

FIGURE 8.28

Edouard Manet. The Balloon. 1862. Lithograph. 403 × 515 mm. Harvard University Art Museums, Cambridge.

FIGURE 8.29

Edouard Manet. The
Civil War. *1871. Litho-
graph. 397 × 508 mm.
Philadelphia Museum
of Art.*

restrained, Manet's *Civil War* verges on journalistic neutrality. The slaughtered Communard,
looking much like Manet's *Dead Toreador* (1864), lies flat on the losing side of the barricade.
Manet scrupulously avoided the overt manipulation and arrangement of forms. The pyramidal
structure and careful chiaroscuro of the nineteenth century's climactic statements of heroism
and political martyrdom, such as Daumier's print, Géricault's *Raft of the Medusa* (1819), and
Delacroix's *Liberty Leading the People* (1830), are all but relinquished here. Why?

In a fascinating article, Jacquelynn Baas has suggested that Manet's "generalizing" of *The
Civil War* was undertaken in the hopes of evading censorship. Like Goya, who tamed the
imagery in his ink-wash drawings in the course of composing the *Caprichos,* Manet deliberately
obfuscated his pro-Communard stance. She points to his use of an agitated graphic stroke,
which takes the place of specificity of detail and heroic composition to express the artist's horror
and indignation. She also notes that beside the dead figure's hand is a crumpled white cloth,
pathetic remnant of an ignored attempt to surrender, which Manet has aggressively marked
over. The publication of *The Civil War* was in fact delayed until 1874.[40]

But Manet's reticence might also derive, in part, from a modern sensibility averse to an
art of ideology or overt commentary. The burgeoning medium of photography had captured
violent death journalistically, without the visual and iconographic filters of the traditional
European artistic vision: "For Manet," comments Hanson, ". . . the photograph offered a blunt
record of nature as the human eye sees it in 'masses' of different values, devoid of imposed
interpretation, mechanical and unfeeling."[41] It is also, in other words, the very banality of such
an incident, increasingly revealed to modern humanity through photography and, later, the

FIGURE 8.30

Edouard Manet. The
Barricade. *1871. Litho-
graph. 465 × 334 mm.
Baltimore Museum
of Art.*

electronic media, that Manet commented upon by choosing to represent it. Underlying Manet's reticence may be not indifference but the sense that, in the face of some realities, commentary is superfluous. Taking Goya's sense of ambivalence and indeterminacy a step further, Manet questioned how art was to function in a world that is replete with images, but where meaning is at best elusive. The literal use of photographic images in American Pop Art prints, especially Andy Warhol's deliberately redundant serigraphs of atom bomb blasts, car wrecks, and electric chairs, while perhaps more conspicuously avant-garde, owes a debt to Manet.

The decisiveness that characterizes Manet's handling of paint also characterizes his use of the lithographic crayon in *The Civil War.* Comparatively speaking, *The Balloon* now looks rather hesitant. The crayon's flat edge is used to summarize the barricade and buildings; the point, to make the slashing marks that describe, without delineating, the crumpled mass of the dead body. In *The Barricade,* the flat edge is used very lightly in the background to push the buildings back spatially and to create the smoke-filled atmosphere of the city. In the fore-

ground, government troops unload their guns into victims obscured by smoke and pressed against the barricade. One raises his head in a final cry that will be extinguished in a fraction of a second. The Communards were reported to cry, "Vive le Commune!" as they fell.[42]

This work, which Manet may have intended to publicize a projected painting, is, like *The Civil War*, an ironic combination of artistic prototypes, venerated and kept distant on museum walls, and the shock of observed, present reality. Like Manet's different versions of *The Execution of Maximilian*, it builds upon Goya's images from the *Disasters of War* and especially his painting *The Third of May, 1808* (1814), and Manet's own versions of *The Execution of Maximilian*. In fact, Juliet Wilson has concluded that Manet traced a photograph of his watercolor made after the central group of soldiers in the lithographic version of *Maximilian*, but reversed, to compose *The Barricade*. The stylistic discrepancy between the soldier-group on the one hand and the victims and setting on the other may be accounted for by Manet's odd use of these existing images.[43]

Compared with Goya in *The Third of May, 1808*, Manet eschewed the sense of heroic martyrdom achieved by a climactic composition and dramatic light focused on a main victim. He played instead on the conflict of heroism—indeed, of meaning itself—with the instantaneity of the artist's vision.[44] He suspended the viewer in the instant before martyrdom is concluded; we must find our own foundation from which to respond to the moment. Manet's works present us with many unanswered questions, not the least of which concerns the role of the artist in manipulating and interpreting reality. This question becomes more acute in the graphic media, where direct communication of meaning had traditionally been crucial.

Manet was drawn to printmaking partially because of its potential to accentuate the bold reduction of modeling that he sought in his paintings. Melot has pointed out the ways in which Manet's attitude was at odds with the glorification of the original print, understood in terms of the artist's autographic work on the plate or stone, independent from painted prototypes, that had been fostered by the etching revival. Despite autonomous prints like the lithographs we have just discussed, much of Manet's graphic oeuvre consists of what Melot calls "autographic reproductions"—that is, Manet's own graphic versions of his painted compositions—a practice we have noted in Barocci and many other "painter-engravers." Moreover, Manet often made use of other printmakers, like Félix Bracquemond and Alphonse Legros, to help him with the more mechanical aspects of printmaking, and he was not averse to processes like gillotage or photomechanical means of reproduction in which the main point is the artist's design, not autographic work on the plate or stone.[45]

Edgar Degas held very different attitudes toward the print, although he too was open to the expanding print technology of the times. He came to printmaking as an incomparable draughtsman whose innate linear sense and insistence on technical perfection were applied to more traditional graphic values: the exploration of tonal gradation and line. He combined this classic approach with technical innovation in lithography, etching, and monotype and a "hands-on" approach to the printing surface. An Impressionist in his choice of subjects if not in the calculated linearity and monumentality of his style, Degas observed contemporary Parisians discreetly. The ballet dancer rehearsing, the laundress ironing, or a woman at her bath are viewed with the eye of the bourgeois "man about town," able to savor aesthetically the labors or private moments of his primarily female subjects. Like many of the greatest graphic artists of the past, such as Blake and Seghers, Degas moved along exasperatingly oblique paths in his relentless pursuit of the results he wanted. One of his procedures in lithography, for example,

FIGURE 1.4
*Unknown Bohemian
artist?* Rest on the
Flight into Egypt (Holy
Family). *Ca. 1410–20?
Hand-colored wood-
cut. 284 × 212 mm.
Graphische Sammlung
Albertina, Vienna.*

FIGURE 2.37
Albrecht Altdorfer. The
Beautiful Virgin of
Regensburg. *1519–20.
Color woodcut. 340 ×
245 mm. National
Gallery of Art, Wash-
ington, D.C.*

462

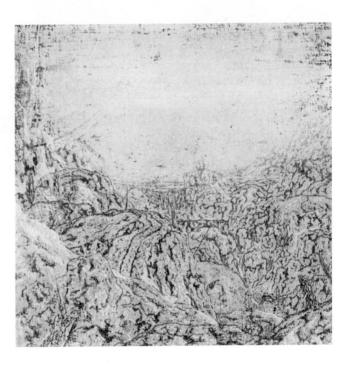

FIGURE 4.31
Hercules Seghers (active ca. 1612–35).
Mountain Gorge Bordered by a Road, Seen through Ship's Rigging. *Etching with* drypoint, printed in blue ink on pink-painted paper with the addition of blue watercolor. 167 × 154 mm (sheet). *Rijksmuseum-Stichting, Amsterdam.*

FIGURE 5.49
(on facing page)
Francesco Bartolozzi after Sir Joshua Reynolds. Portrait of Lady Smyth and Her Children. *1789. Stipple engraving in color. 341 × 250 mm. Cleveland Museum of Art.*

Painted by Sir Joshua Reynolds. Engraved by F. Bartolozzi R.A.

Lady Smyth

Tra l'ensier vaghi, e paurosa Speme,
L'intenerito Cuor or gode or treme.
 VINCENZO da FILICAJA.

465

FIGURE 5.50

*Jakob Christof Le Blon
after Nicholas Blakey.*
Portrait of Louis XV.
*1739. Color mezzotint
with some etching and
added white paint. 599 ×
433 mm. National Gallery
of Art, Washington, D.C.*

FIGURE 6.36
*Philibert-Louis
Debucourt.* La Prom-
enade Publique. *1792.
Etching, engraving, and
aquatint, printed in
yellow, blue, red, and
black inks from four
plates. 373 × 607 mm.
Metropolitan Museum of
Art, New York.*

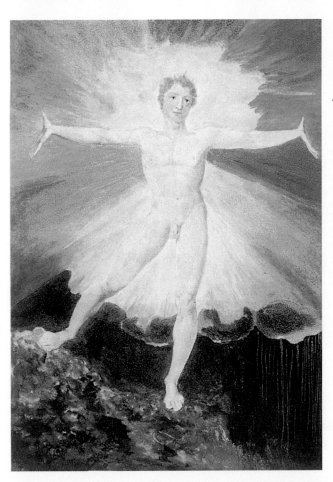

FIGURE 6.40

William Blake. Albion Rose (The Dance of Albion, *or* Glad Day), *first state. Ca. 1794–96. Color print with pen and watercolor additions over line engraving. 271 × 201 mm. British Museum, London.*

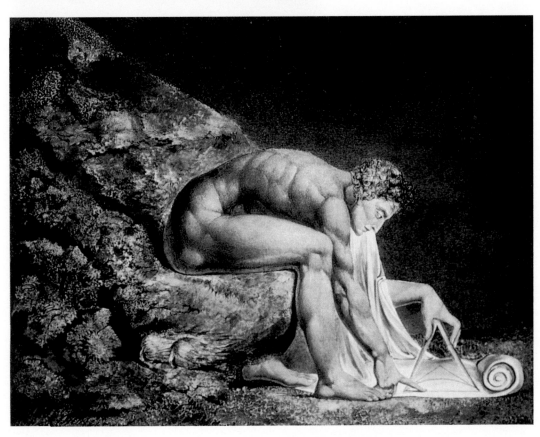

FIGURE 6.51

William Blake. Newton. *Ca. 1805. Color-printed drawing with pen and watercolor. 460 × 600 mm. Tate Gallery, London.*

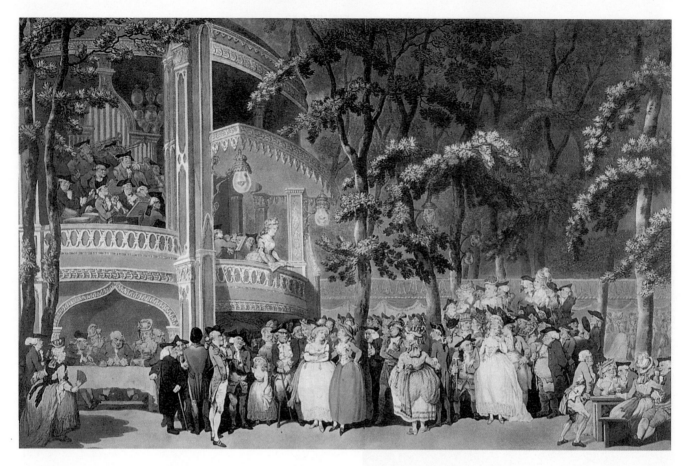

FIGURE 7.13

Thomas Rowlandson.
Vauxhall Gardens. 1785.
Hand-colored aquatint
and etching. 484 ×
745 mm. British Museum,
London.

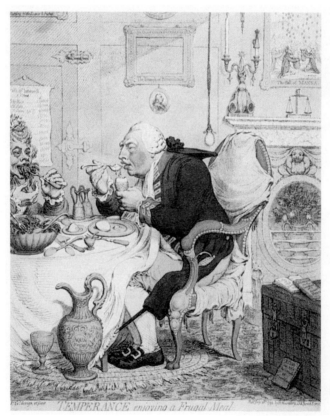

TEMPERANCE enjoying a Frugal Meal.

FIGURE 7.14

James Gillray. Temper-
ance Enjoying a Frugal
Meal. *1792. Hand-colored*
etching. 362 × 295 mm.
New York Public Library.

FIGURE 8.13
Thomas Shotter Boys.
Notre Dame from the
Quai St. Bernard *from*
Picturesque Architecture in Paris, Ghent,
Antwerp, Rouen. . . .
*1839. Color lithograph.
248 × 380 mm. Yale
Center for British Art,
New Haven.*

FIGURE 8.43
Auguste Renoir. The
Pinned Hat. *1897. Color
lithograph. 600 ×
492 mm. National
Gallery of Art, Washington, D.C.*

FIGURE 8.46
Jules Chéret. Loie Fuller
at the Folies-Bergère.
*1893. Color lithographic
poster. 1201 × 822 mm.
Victoria & Albert
Museum, London.*

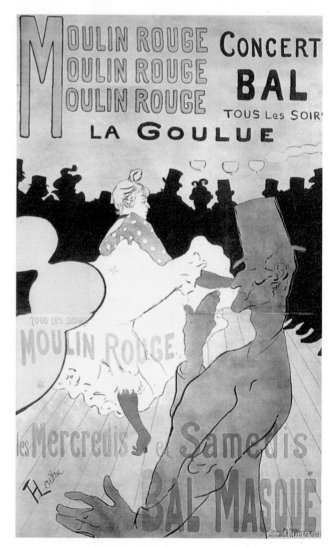

FIGURE 8.47
*Henri de Toulouse-
Lautrec.* Moulin-Rouge:
La Goulue, *second state.
1891. Color lithographic
poster. 1910 × 1170 mm.
Art Institute of Chicago.*

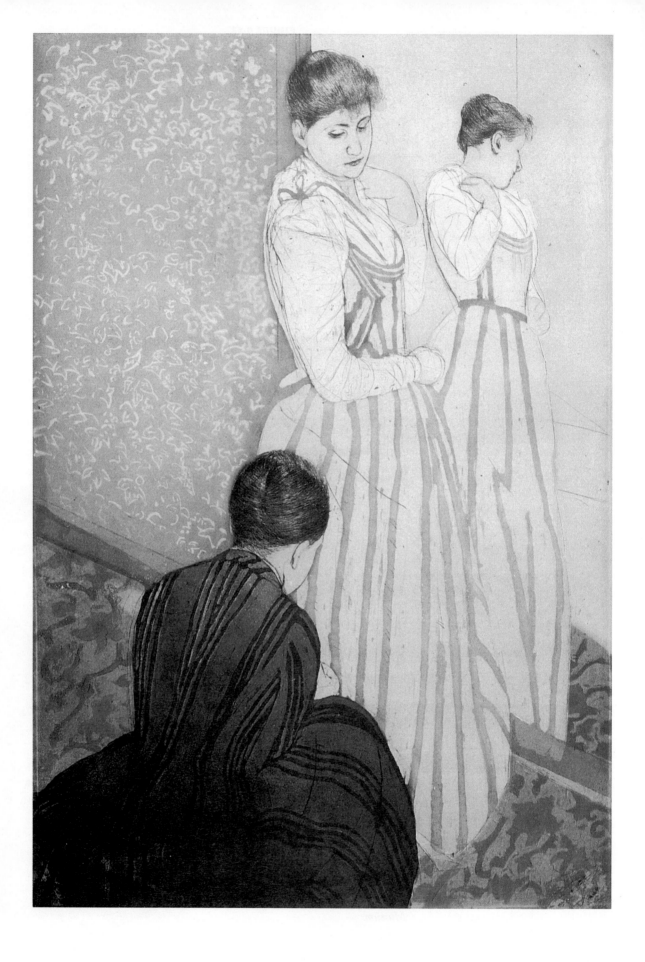

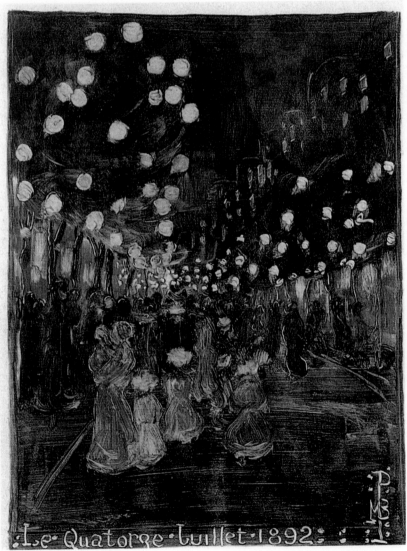

FIGURE 9.60
Maurice Prendergast.
Bastille Day. 1892. Mono-
type in oil colors. 174 ×
131 mm. Cleveland
Museum of Art.

:Le·Quatorge·Luillet·1892:

FIGURE 9.35
(on facing page)
Mary Cassatt. The
Fitting *from a series of*
ten color prints. 1890–91.
Aquatint etching and
drypoint. 377 × 256 mm.
New York Public Library.

473

FIGURE 10.14
Edvard Munch.
Vampire. *Designed in
1895; color lithograph
with woodcut, 1902.
382 × 549 mm. Munch
Museet, Oslo.*

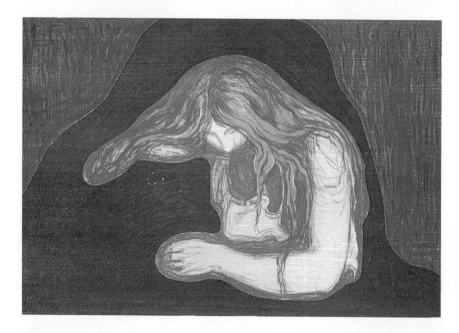

FIGURE 10.21
Ernst Ludwig Kirchner.
Winter Moonlight. *1919.
Color woodcut. 306 ×
295 mm. Museum of
Modern Art, New York.*

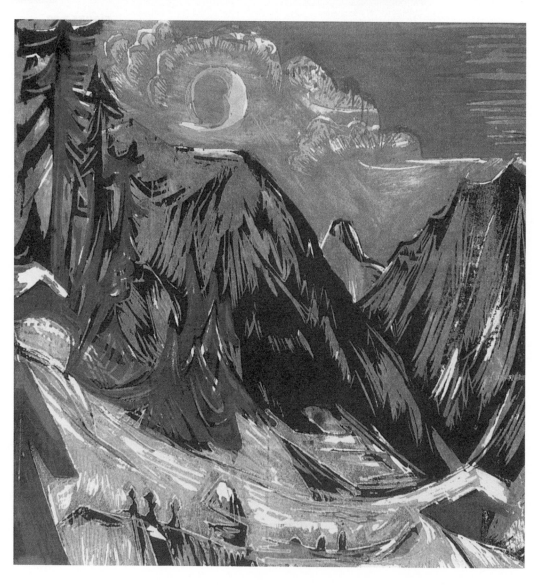

FIGURE 10.22

Emil Nolde. Autumn
Landscape. *1926. Color
lithograph. 600 ×
808 mm. Cleveland
Museum of Art.*

FIGURE 10.30

Wassily Kandinsky.
Lyrical. *1911. Color
woodcut from* Klänge
*(1913). 145 × 216 mm.
Los Angeles County Mu-
seum of Art.*

478

FIGURE 11.52

Marc Chagall. Plate XII
of Four Tales from the
Arabian Nights. *New
York: Pantheon Books,
1948. Color lithograph.
378 × 290 mm. Museum
of Modern Art, New
York.*

FIGURE 11.9

(on facing page)
Henri Matisse. Icarus:
Plate 8 from Jazz. *1944–
47. Color pochoir. 420 ×
327 mm (page). Harvard
University Art Museums,
Cambridge.*

FIGURE 12.3

Paul Revere. The Bloody
Massacre Perpetrated in
King Street Boston on
March 5th. *1770. Hand-
colored engraving. 261 ×
220 mm. Museum of Fine
Arts, Boston.*

FIGURE 12.8

*Louis Prang and
Company after Thomas
Moran.* The Lower
Yellowstone Range. *1875.
Illustration from* The
Yellowstone National
Park and the Mountain
Regions of Portions
of Idaho, Nevada,
Colorado and Utah.
*Boston: Louis Prang
and Company, 1876.
Chromolithograph.
356 × 248 mm (page).
National Museum of
American History,
Smithsonian Institution,
Washington, D.C.*

FIGURE 12.11

Julius Bien and Company after John James Audubon. American Flamingo, Old Male *from* The Birds of America. *New York, 1860. Chromolithograph. 1016 × 685 mm. National Museum of American History, Smithsonian Institution, Washington, D.C.*

FIGURE 12.12

Currier and Ives.
Champions of the
Mississippi: A Race for
the Buckthorns. *1866.*
Hand-colored lithograph,
designed by Fanny
Palmer. 464 × 708 mm.
Metropolitan Museum of
Art, New York.

THE CHAMPIONS OF THE MISSISSIPPI.

FIGURE 12.42

Max Weber. Mother
and Child. *1919–20.*
Color woodcut. 108 ×
50 mm. National Mu-
seum of American Art,
Smithsonian Institution,
Washington, D.C.

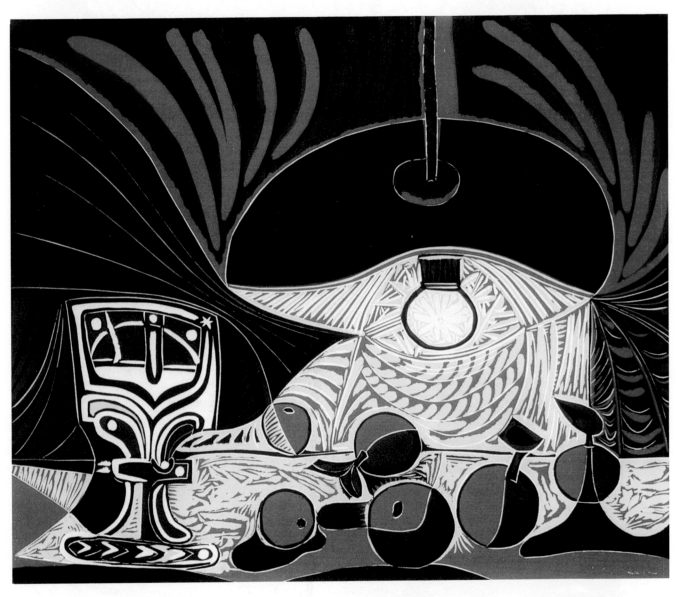

FIGURE 13.5
Pablo Picasso. Still
Life with Glass under
the Lamp. *1962. Color
linocut. 530 × 640 mm.
Museum of Modern Art,
New York.*

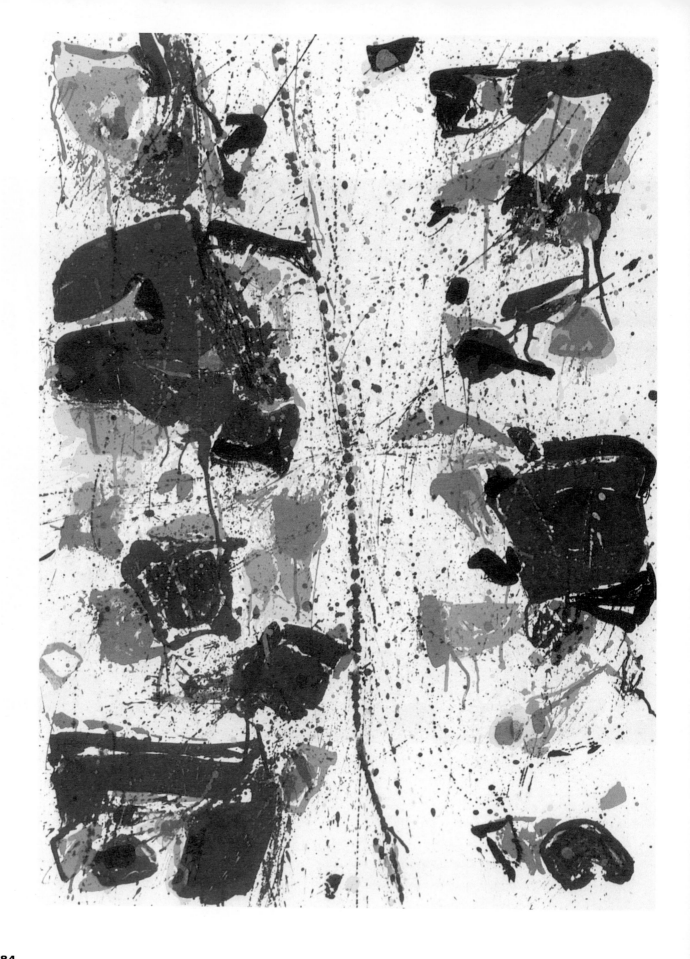

484

FIGURE 13.40

Jasper Johns. Number 7 *from* Color Numerals *series. 1969. Color lithograph. 720 × 550 mm. National Gallery of Art, Washington, D.C.*

FIGURE 13.36

Robert Motherwell. Red 8-11: *Folio 15 from* A la Pintura *by Rafael Alberti. West Islip, New York: Universal Limited Art Editions, 1972. Color lift-ground aquatint and letterpress. 600 × 681 mm. Museum of Modern Art, New York.*

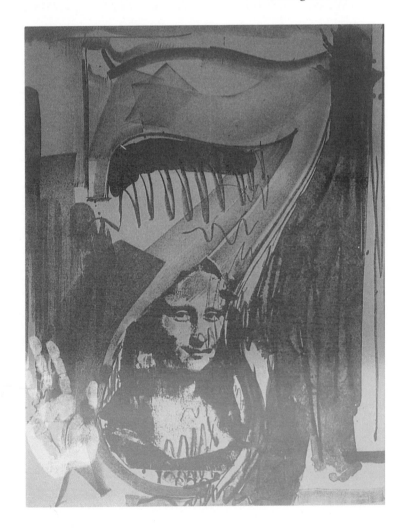

FIGURE 13.35

(on facing page)
Sam Francis. The White Line. *1960. Color lithograph. 907 × 632 mm. Museum of Modern Art, New York.*

FIGURE 13.44

Jasper Johns. Scent.
1975–76. Color litho-
graph, linocut, woodcut.
795 × 1195 mm. Art
Institute of Chicago.

FIGURE 13.50

(on facing page)
Robert Rauschenberg.
Link *from* Pages and
Fuses. *1974. Handmade*
paper, pigment, silkscreen,
tissue and paper pulp.
635 × 508 mm. National
Gallery of Art, Wash-
ington, D.C.

FIGURE 13.53
Andy Warhol. Marilyn
Monroe *from* Ten
Marilyns. *1967. Color
silkscreen. 913 × 913 mm.
Elvehjem Museum of Art,
University of Wisconsin–
Madison.*

FIGURE 13.56

Roy Lichtenstein. POW!
Sweet Dreams, Baby!
1965. From the portfolio
Eleven Pop Artists III.
*1966. Color silkscreen.
908 × 650 mm. Museum of Art, Rhode Island
School of Design, Providence.*

FIGURE 13.57

Roy Lichtenstein. Rouen
Cathedral 4 *from* Cathedrals. *1969. Color lithograph. 1060 × 685 mm.
Elvehjem Museum of Art,
University of Wisconsin–
Madison.*

FIGURE 13.66
Victor Vasarely. Plate 2 from Planetary Folklore. *1964. Color silkscreen. 626 × 601 mm. Museum of Modern Art, New York.*

FIGURE 13.68
Helen Frankenthaler. Savage Breeze. *1974. Color woodcut. 752 × 635 mm. Museum of Modern Art, New York.*

FIGURE 13.75

Richard Estes. Grant's
from Urban Landscapes
I. *1972. Color silkscreen.*
503 × 650 mm. Museum
of Art, Rhode Island
School of Design,
Providence.

was to draw with a brush and ink on a copperplate and transfer this image to transfer paper and then to the stone, which he worked on with crayon, ink and brush, and scraper. With the help of his friend Michel Manzi, a specialist in reproductive prints, he also combined lithography with the latest photographic technology.

The various versions and states of *After the Bath* (1891–92), a luminous study of a woman performing her toilet, have been analyzed in painstaking detail by Sue Welsh Reed and Barbara Stern Shapiro.[46] The three related lithographs have a common ancestor, a lost original drawing, made by Degas in greasy ink on celluloid (a transparent material made from nitrocellulose that can be used as a substitute for photographic film), and transferred photographically to the stones, which he then reworked heavily. The soft, blotchy character of the photographically transferred drawing, however, is still partly visible in the lithographs.

Our example is the fifth state of the second version of *After the Bath* (fig. 8.31). Having reworked the transferred drawing extensively with crayon, Degas realized that the image was being obscured by ink, and in the second state he began to rescue the figure's integrity by scraping. Always a diligent student of human anatomy, Degas dealt expertly with the lateral bend of the woman's body as well as its movement into space. Both the contours and the masses of the body—the complex protrusions and hollows of the back and buttocks, the curve of the left hip, and the crease of the waist at the right—are superbly rendered despite the substantial reworking of the stone. The fifth state is especially notable for Degas's extensive scraping.

Just as Manet removed the filters of European iconographic and formal language in his images of war, Degas stripped away the association of the female nude with ideal beauty, and treated it freshly in an unconventional pose that occurs, unlike the pose of the model in the studio, in the course of an everyday activity. A comparison with Théodore Chassériau's *Venus Anadyomène* (1839; fig. 8.32) should make clear Degas's profound departure from the academic tradition of the nude as well as conventional lithographic technique. But beyond this, Degas's subject matter raises questions about the roles of gender and class (of the artist as well as subjects) and the female nude in modernist art.[47]

Although the combination of subject and technique recalls the French tradition of erotic lithographs (or *lithographes libres*),[48] Druick and Zegers have noted Degas's more realistic approach, slightly tinged, they think, with satire. His bathers are bulky, awkward nudes uncognizant of spectators. "These women of mine," Degas said, are "unconcerned by any other interests than those involved in their physical condition. . . . It is as if you looked through a keyhole."[49] More recently, Eunice Lipton has pressed forward this emphasis on the sheer physicality of Degas's bathers. Judging from their bathing habits, from what we know of the artist's experience, and from contemporary mores, which would not have considered an ordinary middle-class woman at her bath to be a fit subject for art, Degas's bathers must be prostitutes. Although prostitutes would often bathe in front of clients as a part of services rendered, Degas's monumental women do not pander to the viewer's erotic response but are absorbed in their own pleasure.[50]

In the late nineteenth century, the lithographic landscape was increasingly opened up to light, with the individual marks of the crayon becoming more transparent and looser. Isabey's *Near Dieppe* (fig. 8.4) is constructed of dense strokes and worked from a middle gray (the sky at the right) up to white and down to rich, bituminous blacks. In Camille Corot's *Souvenir of Italy* (1871; fig. 8.33), however, the white of the paper is the starting point and the dominant, luminous note that sounds throughout the image. It glows through the tangled net of dark

FIGURE 8.31

Edgar Degas. After the Bath II, *fifth state. 1891–92. Lithograph. 210 × 147 mm. Philadelphia Museum of Art.*

lines and feathery, diffused strokes, which seem to be breathed onto the paper. The change suggested here tonally is analogous to the heightening and brightening of the painter's palette and the abandonment of dark underpainting by French Impressionists, for whom Corot's work (especially his late paintings filled with silvery light and feathery brushstrokes) was so important.

Even when compared with Corot's ephemeral image, James McNeill Whistler's *Early Morning* (1878–79; fig. 8.34) is a masterpiece of the barest suggestion. Whistler was an expatri-

FIGURE 8.32

FIGURE 8.32
Théodore Chassériau.
Venus Anadyomène.
1839. Lithograph. 470 ×
448 mm (sheet). Museum
of Fine Arts, Boston.

FIGURE 8.33
Jean-Baptiste-Camille
Corot. Souvenir of Italy,
first state. *1871. Litho-*
graph. 127 × 178 mm.
National Gallery of Art,
Washington, D.C.

ate American whose work stood at the forefront of the development of European modernism. Like Degas, he was an outstanding printmaker whose work will form a major part of our discussion of nineteenth-century etching, the revival of which he championed. Indeed, Whistler is a crucially important figure for our history, since he fostered the consciousness of the original print as a rare, collectible object, an attitude that was especially significant for lithography, with its persistent commercial associations. Working in collaboration with the printer Thomas Way, Whistler endeavored to elevate lithography in the hierarchy of graphic arts,

FIGURE 8.34

James McNeill Whistler.
Early Morning *from*
Views of the Thames.
1878–79. Wash litho-
graph. 163 × 249 mm.
Library of Congress,
Washington, D.C.

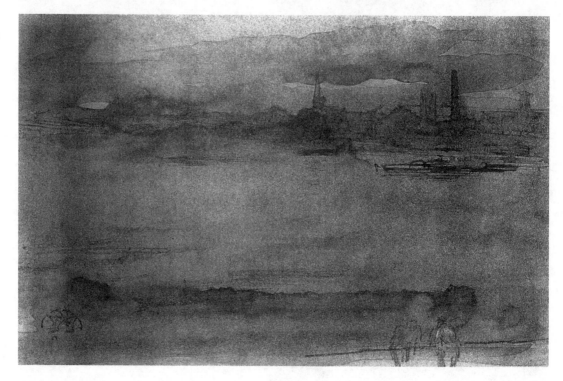

striving for delicacy and autographic effects and printing relatively few impressions on fine papers.[51] *Early Morning* is one of a number of views of the Thames River, executed in a diluted lithographic ink (lithotint), which rival oriental ink-wash landscapes with their floating, ethereal forms that are all but consumed in atmosphere. The bold abstraction of this print, comparable to that of Lautrec's later lithograph of Loie Fuller (see fig. 8.52, color plate, p. 471), is prophetic of one of the major directions lithography would take in the twentieth century.

The Impressionist concern for bright color, ephemeral light effects, and the potential dissolution of solid form, line, and closed compositional structure which that concern implied might seem inimical to printmaking, which, up until the eighteenth century at least, had been primarily linear or tonal by virtue of grouped lines. Indeed, the lack of interest in printmaking on the part of that quintessential Impressionist Monet perhaps reflects this basic antagonism between medium and stylistic goals. Camille Pissarro is the only Impressionist artist for whom printmaking was a major concern—Leymarie describes him as the truest "engraver" of the Impressionists and the truest Impressionist of the "engravers."[52] (French scholars often use *gravure* and its derivatives to refer to all forms of printmaking.) Other Impressionists, such as Auguste Renoir and Alfred Sisley, merely dabbled in printmaking. Manet and Degas, two artists who are closely associated with the Impressionists but whose work eludes categorization within this movement, were, as we have seen, brilliant printmakers.

Pissarro produced over a hundred etchings and sixty lithographs, usually in very small editions. He combined exacting craft, sometimes working his plates many times over, with the utmost freshness of vision, epitomizing the Impressionist aesthetic. *Women Bathing in the Shade of Wooded Banks* (fig. 8.35), a lithograph on a zinc plate, is part of a series of bathing scenes published in 1894. A subtle circular pattern of brief crayon marks ties woods, water, and

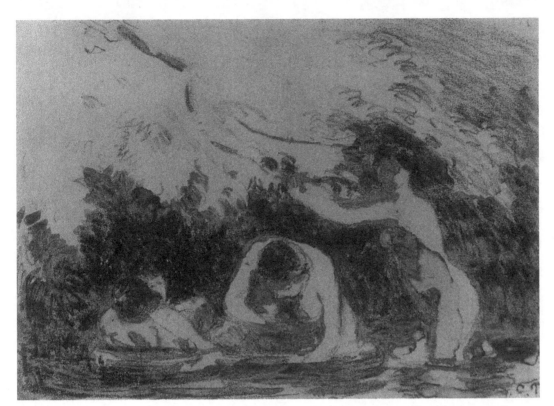

FIGURE 8.35

Camille Pissarro.
Women Bathing in
the Shade of Wooded
Banks. *1894. Lithograph.*
159 × 217 mm. Balti-
more Museum of Art.

figures together. The near absence of contour lines and the delicate, transparent areas of wash create the sense of dappled sunlight and moving forms—playful figures, rippling water, and windblown foliage. This print reveals the profound belief in the serene symbiosis of humanity and nature that underlies Pissarro's art. For much of his life he lived in villages outside Paris, sympathetically depicting peasants at their work.

After 1885 Pissarro and other French artists were drawn more frequently into social radicalism, as the promise of the Third Republic to bring democracy to the masses failed.[53] Pissarro did not allow his anarchist and socialist convictions to dominate the subject matter of his art; rather, he eschewed confrontational images in favor of a visual evocation of a utopian rural ideal.[54] Yet, as Melot has discussed, Pissarro's political convictions complicated his approach to printmaking. Schooled in the writings of Prudhon, Marx, and Kropotkin, Pissarro carried the Barbizon painters' sympathy for the peasant and nostalgia for rural life into an anarchist's distrust of all the institutions of modern industrial society, including the print market. Whereas anarchism's respect for individuality and absolute freedom and its anti-industrialism contributed to Pissarro's sense of the work of art as a finely crafted object, it also fed his distrust of the elitism of the late nineteenth-century aesthetic of the original print. He often refused to sell his prints to avoid participating in a market that stressed preciosity, rarity, and high price. But on the grounds of artistic autonomy—art's position beyond social issues as an expression of individual freedom—Pissarro also avoided what Melot terms art's "massification."[55]

Untypical of Pissarro is a lithograph in an explicitly political context like *The Vagabonds*, (fig. 8.36) which he contributed to Jean Grave's anarchist paper, *Les Temps Nouveaux* (*New Times*), as part of a series of articles on homelessness in 1896. Despite its appearance in a political journal, we need no caption to understand the meaning of the image, and there is

FIGURE 8.36

Camille Pissarro. The
Vagabonds (*for* Les
Temps Nouveaux). *1896.*
Lithograph. 250 ×
304 mm. Baltimore
Museum of Art.

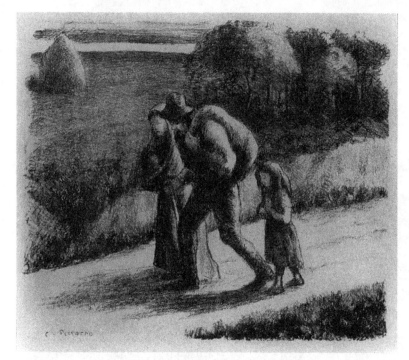

nothing overstated about its pathos. Although Pissarro neither suggested any end to their hardship nor minimized their burdens, the expression of his print depends less on the bearing of the figures than on the contrast of the resolute family with its peaceful surroundings. As John Hutton notes, this contrast places the blame for poverty and homelessness on the socio-economic system, rather than on the natural order.[56]

The artist who best exemplifies the tradition of political lithography late in the nineteenth century, providing numerous lithographs for journals in the tradition of Daumier, is the Swiss-born Théophile-Alexandre Steinlen, although his color posters relate him equally well to Lautrec and the Nabis, whom we shall discuss shortly.[57] In the 1890s the fall of the Paris Commune, which Manet had depicted in his lithographs of 1871, was a symbol for the struggle of the working class, and Steinlen evoked the memory of the slain Communards in *The Shout of the Streets* (1894; fig. 8.37), a cover for the successful and inexpensive socialist periodical *Le Chambard Socialiste (The Socialist Outcry)*. It is an image that is as strident as Pissarro's and Manet's images are understated, and it bears comparison with Käthe Kollwitz's most powerful lithographs for the socialist cause. The workers and children who defended the Commune against the government troops rise up like specters from a still-bloody street, accentuated with stenciled red color, to tell the Third Republic: "Your republic is the daughter of our blood." By 1894 even the gillotage process that was used for Daumier's late lithographs was outdated, and Steinlen's image was reproduced by photomechanical means. However, the printer Edouard Kleinmann also offered *Le Chambard*'s covers as original prints, on fine white paper and on cheaper yellowish paper. Like the lithographs of *La Caricature,* these images appealed to the print-collecting aspirations of the audience, as well as its political convictions.[58]

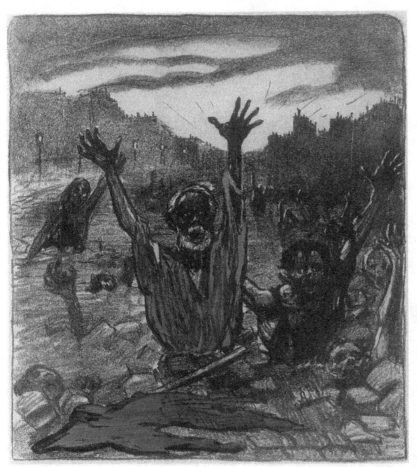

FIGURE 8.37

Théophile-Alexandre Steinlen. The Shout of the Streets (*for* Le Chambard Socialiste). *1894. Lithograph with stenciled color. 325 × 293 mm. Jane Voorhees Zimmerli Art Museum, New Brunswick.*

THE INNER WORLD: SYMBOLIST TRENDS IN LITHOGRAPHY

The various Symbolist and early Expressionist modes that arose in the late nineteenth century rejected the Impressionists' basic naturalism and reticent attitude toward subject matter in favor of subjective approaches in which visual appearances were transformed to express a strong emotional or symbolic content. The imaginative lithographs of Odilon Redon, for example, emerge partly from an unconscious world in which forms are irrationally juxtaposed or metamorphosed. He was introduced to printmaking by the eccentric, impoverished recluse Rodolphe Bresdin, used by Champfleury as a model for his story of bohemian life, "Chien-Caillou."[59] Bresdin's lithographs approached the engravings of Dürer or Duvet in their scintillating detail. Indeed, eight of them were originally intaglio works: newly printed etchings transferred to stones by the printer Joseph Lemercier. Bresdin's *Comedy of Death* (1854; fig. 8.38), not one of these eight certain transfers, was probably conceived after a poem by Théophile Gautier (1838). It recalls traditional images of hermit saints who retreat to the wilderness to fight their spiritual battles with death and demons. Here, the very fabric of the landscape is fraught with innumerable demons and reminders of death. The wildly dancing skeletons seem to emerge from the gnarled tree, while Boschian goblins lurk in the tangled underbrush. In the background, Christ, ignored by the hermits, points to the light in a dramatic, superbly rendered sky.

FIGURE 8.38

*Rodolphe Bresdin. The
Comedy of Death. 1854.
Lithograph. 218 ×
150 mm. Cleveland
Museum of Art.*

Redon followed Bresdin's tradition of spectral imagery. "All my originality, Redon wrote, "consists then of making improbable beings come to life humanly according to the laws of the probable, putting, as far as possible, the visible at the service of the invisible."[60] Despite the otherworldly aura of Redon's lithographs, Ted Gott's recent study emphasizes how they functioned in the artist's efforts to promote himself, particularly in the literary circle within which his primary support was found.[61] Redon's lithographs generally conform to an understanding of the medium in terms of chalk drawing—although with a particular emphasis on beautiful, deep blacks, accentuated by Redon's favorite support of *chine collé,* a thin oriental paper affixed to a heavier backing. Expressively, Redon's prints point forward to Surrealism and certain aspects of Expressionism (the work of Paul Klee, for example) while being rooted in the traditional freedom of graphic art to explore fantastic and visionary realms.

Redon made no fewer than three lithographic series after Gustave Flaubert's *Temptation of St. Anthony* (1874), and Gott is quick to point out the popularity of this text among Redon's audience. The narrative sequence would have been clear to this audience, and so Redon was

FIGURE 8.39

Odilon Redon. Quel est le but de tout cela? *Plate 18 from* The Temptation of St. Anthony *(third series). 1896. Lithograph. 311 × 250 mm. Museum of Modern Art, New York.*

free to choose particular incidents that sparked his artistic imagination.[62] The lush descriptive language of Flaubert's book and its fluid, eclectic symbolism transformed Anthony, the third- and fourth-century anchorite monk, into a nineteenth-century hero whose temptations take him through a labyrinth of philosophical, religious, and hedonistic alternatives. Redon loved Flaubert's use of fantastic and demonic imagery and saw the book as a rich source for his own works.[63] Here, the depth of the saint's torment is expressed in an abyss of rich black that he seems to contemplate (fig. 8.39). At the right, it expands into a leathery bat wing; at the bottom left, into an impervious void. "What is the point of all this?" queries St. Anthony. "There is no point!" answers the devil. Redon's interpretation of spiritual questioning in indefinite terms is as appropriate for his own time as Schongauer's highly concrete imagery (see fig. 1.37), in which sins and doubts take on specific forms that can be battled in specific ways, was for the fifteenth century.

Pegasus Captive (1889; fig. 8.40), with its lush tonalities so typical of Redon's lithographs, is at once compelling and inscrutable. Redon did not disclose the full bulk of the mythical beast that looms toward us, its power all the more frightening because its limits are unknown. The beast nevertheless allows itself to be led, apparently tamed by the golden bridle Athena gave to Bellerophon.[64] Phantom legs and feathers seem to envelop the figure at the bottom. There is a strong eroticism, reminiscent of the myths of Jupiter and Ganymede or Leda and

FIGURE 8.40

Odilon Redon. Pegasus
Captive. *1889. Litho-
graph. 344 × 298 mm.
Philadelphia Museum
of Art.*

the swan, in the clinging together of the beast and the human. But on a more abstract level, this print evokes the sense of supernatural strength tamed by an equally supernatural beauty: a theme that will be explored repeatedly by Picasso.

In the small town of Pont-Aven in Brittany in 1888, Paul Gauguin and Emile Bernard developed a style they called "Synthetism," characterized by flat areas of intense color and heavy, cloisonné-like outlines, and geared, like the broader movement of Symbolism that encompassed it, to evoke mystery, sensuality, and what were posed as elemental human emotions and states of being. The rural society of Brittany, with its strong Catholic traditions and its distinctive costumes, was the source to which Gauguin first turned in his efforts to escape the modern urban condition, as well as his ties to wife, family, and bourgeois responsibilities. Later in Tahiti, as we shall see, Gauguin's "primitivism," a problematic blend of colonialistic, psychological, sexual, and artistic motivations, would lead to some of the most extraordinary woodcuts of modern art.[65]

Albums of lithographs from zinc plates (often called "zincographs" in the Gauguin literature) were presented by Gauguin and Bernard at the Café Volpini, located on the periphery of the Paris Universal Exposition in 1889. These were important statements of the Synthetist aesthetic.[66] Gauguin's eleven prints depicted scenes of Arles, where he had stayed for two months with Vincent Van Gogh, Martinique, which he had visited in 1887, and Brittany. Three of the lithographs, like Manet's "autographic reproductions," were graphic translations of

FIGURE 8.41
Paul Gauguin. The
Dramas of the Sea *from
the* Volpini Suite. *1889.
Lithograph. 175 ×
276 mm. Art Institute of
Chicago.*

painted compositions. *The Dramas of the Sea* (fig. 8.41), however, was not. Conceived in the
fan shape popular with late nineteenth-century avant-garde artists, the print asserts flatness by
its format as well as by the bold lines and shapes Gauguin created with lithographic tusche and
lavis. But, at the same time, there is a dizzying sense of plunging into the maelstrom of water.
Beneath a small vignette of a calm sea and boat, turgid waves threaten to swallow up the figure.
Gauguin's unusual choice of a vibrant canary-yellow paper with broad margins not only recalled
the backgrounds of various Japanese prints, New Year's cards, and book covers, but also created
throbbing optical effects in combination with the blacks and grays of the lithographic ink. A
subtle brownish cast appears sometimes when the grays interact with the brilliant yellow of the
paper.[67]

Mystery and sensuality were essential to Symbolist art, and Eugène Carrière evoked both
by the motif of the human head. His lithographs are as sensitive to tonal values as Redon's, but
conceived from blacks to whites, much like mezzotints. In his portrait of Marguerite Carrière
(1901; fig. 8.42), the simplified but highly plastic facial masses emerge vaguely from undefined
darkness. The tonal layers were achieved by the superimposition of three stones, each carefully
drawn with crayon, inked, and scraped. It is not only the tilt of Marguerite's head and her half-
open eyes and mouth that lend her a provocative sexuality characteristic of the fin de siècle
vision of woman; it is Carrière's technical and formal means. Shrouded in an aura of tone that
seems to be created by floating veils, the subjects of his portraits evade apprehension as physical

FIGURE 8.42

Eugène Carrière.
Marguerite Carrière,
second state. 1901.
Lithograph on chine collé.
432 × 346 mm. High
Museum of Art, Atlanta.

beings but have a powerful spiritual and psychological presence. Later, in the twentieth century, the American printmaker Nathan Oliveira would find inspiration in Carrière's lithographic portraits.

Certainly the most important printmaker of the Symbolists was the Norwegian Edvard Munch. His lithographs and above all his woodcuts were so important for the development of the German Expressionist print that he will be discussed in Chapter 10, along with Gauguin's remarkable *Noa Noa* woodcuts.

NEW HEIGHTS FOR COLOR LITHOGRAPHY: TOULOUSE-LAUTREC AND THE POSTER

Although color lithography had made some hesitant steps toward being recognized as a fine-art medium earlier in the century, it was not until the last decade that color lithography would shake off its commercial associations and rival etching as an artist's medium. The publisher and dealer André Marty's periodical *L'Estampe Originale* (*The Original Print*), which began publication in 1893, and the periodicals that followed in its wake, *L'Epreuve* (*The*

Proof) and *L'Estampe Moderne* (*The Modern Print*), all included original prints and did much to promote the color lithograph as art. But the turning point really came in 1895 when the aggressive champion of printmaking, Ambroise Vollard, decided to commission and publish prints by contemporary artists.[68] Vollard's print albums revealed his intense interest in color, and a view of the print that differed from that of the etching revival. He cared less for the autographic qualities of the original print. For Vollard, the end justified the means, and the means often included the expertise of the printer Auguste Clot.[69]

Clot was as important to the development of lithography after 1870 as Hullmandel was for early nineteenth-century endeavors. He often worked from black and white proofs that were hand-colored by the artist. These *maquettes* then served as Clot's guides for the final color prints, and both the black and white impressions and the hand-colored maquettes were autographic in a way that the final print was not. The involvement of the printer in this process exceeded that of a mere technician, and this disturbed some contemporary critics. André Mellerio, for example, noted the "personnalité cachée" (hidden personality) behind Vollard's print album of 1897.[70]

In the multicolored version of Renoir's *The Pinned Hat* (1898), Clot used this complex method. But the 1897 version (fig. 8.43, color plate, p. 469) is simpler. Both illustrate the extreme dissolution of shape, line, and solid form that could occur in Impressionism. The stylistically varied forms of art in the wake of Impressionism (such as Gauguin's Symbolism) retained its heightened palette and, sometimes, its loose brushstrokes, but asserted firmly constructed pictorial surfaces with emphatic shapes and lines. Artists became progressively less attached to visual appearances as the nineteenth century came to a close, setting the stage for the development of non-objective art in the early twentieth century. Color lithography had a significant role in this development.

In Paul Signac's *Port of Saint-Tropez* (1897–98; fig. 8.44), for example, the Impressionist brushstrokes are regularized into near dots (the style developed by Signac and Georges Seurat is called "divisionism" or "Neo-Impressionism"), and the composition is based upon a static geometry reminiscent of the classicizing landscapes of Corot or Poussin. The scintillating light effects of Impressionism are divested of their fleeting quality. Printed by Clot from six stones for one of Vollard's unpublished print albums, *Saint-Tropez* exemplifies the technical excellence of color lithography toward the end of the century.

Although Paul Cézanne was not very much interested in printmaking, he apparently took great care with the color lithographs Vollard pressed him to publish. *The Large Bathers* (fig. 8.45), ca. 1896–98, is based on Cézanne's famous painting of 1875–76, *Bathers at Rest* (Barnes Foundation, Merion, Pennsylvania), and may have been intended as a graphic vindication of the painting, which had been rejected when it was bequeathed to the state by its owner, the Impressionist painter Gustave Caillebotte.[71] According to Druick, the vibrancy of line in the lithograph indicates that it was done by the transfer process, in contrast to *The Small Bathers,* in which Cézanne drew on the unfamiliar stone surface hesitantly, creating insistent, dry contours.[72]

From Cézanne's colored maquettes, Clot worked on four stones to produce the final print, a graphic statement of Cézanne's style, in which he walked a fine line between sensory perception and intellectual construction, laying a foundation for the later development of Cubism by Picasso and Georges Braque. The flat-topped mountain anchors the image. Its vertical axis is echoed by trees and the figures to the right, and directly opposed to the horizon-

FIGURE 8.44

Paul Signac. Port of
Saint-Tropez. *1897–98.*
Color lithograph. 437 ×
333 mm. Cleveland
Museum of Art.

tal lines within the landscape and the reclining figure to the left. The image hovers between
spatiality and a tightly knit surface organization: in this sense, it is always elusive, never com-
plete. But a comparison with Pissarro's *Women Bathing in the Shade of Wooded Banks* (see fig.
8.35) makes clear Cézanne's fundamental departure from Impressionism.

The most impressive strides in color lithography toward the end of the century were made
in the unexpected realm of the poster. The lithographic poster had been introduced in the late
1860s by Jules Chéret. Possibly influenced by American woodcut posters for circuses, Chéret
developed a system of printing from three stones: one, in black, to establish the drawing; a
second to catch the eye with a strong red; and a third to establish a gradated background of
cool and warm colors from top to bottom (he abandoned this gradated background in later
posters). He also used a technique called *crachis* (from *cracher,* "to spit"), in which a brush
filled with ink is rubbed across a mesh to create a speckled effect that could serve as modeling.
Chéret's and Eugène Grasset's works of the 1880s, along with the use of photomechanical color
illustrations in books and journals and the contemporary interest in Japanese color woodcuts,
sensitized the public to the use of color in prints, and prepared the way for the success of the
color lithographic poster of the 1890s. Also important, Phillip Cate and Sinclair Hitchings

FIGURE 8.45
Paul Cézanne. The
Large Bathers. *Ca. 1896–
98. Color lithograph.
415 × 515 mm. Cleveland
Museum of Art.*

argue, was an 1881 law on freedom of the press that exempted the *afficheurs* (who actually pasted the posters on walls) from having to obtain legal authorization for each poster and show each to the prefect of police. Certain buildings, designated by mayors, were off-limits to posters, and anyone tearing down a poster was subject to a fine, imprisonment, or both. While official notices had to be on white paper, posters were to be on tinted paper—a specification that had considerable aesthetic ramifications.[73]

The American dancer Loie Fuller chose Chéret to design the poster for her appearance at the Folies-Bergère in 1893 (fig. 8.46, color plate, p. 470). Like her colleague Isadora Duncan, Fuller danced in diaphanous, flowing costumes that underlined contemporary notions of the erotic and child-like nature of woman. Fuller's swirling skirts, emphasized in Chéret's poster, also capitalized on the fin de siècle fascination for the biblical character of Salome and her dance of the seven veils.[74] Fuller's particular innovation, however, was her incorporation of electric lighting into her dance. Dubbed the "electric fairy," she combined a new technology with an old eroticism.

It was especially the poster's marriage to the principles of Japanese design and the Post-Impressionist concern for structured compositions that brought it to aesthetic heights during this period.[75] Print dealers like Edmond Sagot added posters to their inventories, posters were eagerly collected (even to the point of violating the 1881 law against tearing them down), and in 1889 the first large exhibition of the French poster was organized at the Paris Universal Exposition.[76] Although a number of contemporary artists, including Chéret and Alphonse

Mucha, produced superb examples, the unquestioned master of the poster during the 1890s was Henri de Toulouse-Lautrec.

Lautrec's large lithographic production consists of book illustrations, programs for the theater, and the series *Elles* (1896)—intimate vignettes from the life of the clown Cha-U-Ka-O and her lesbian companion.[77] But by far his best-known prints are advertisements for the colorful cabaret entertainers of Montmartre, a poor area on the north end of Paris that overlooked the rest of the city. Artists and writers flocked there because of the cheap rents and the carnivalesque atmosphere provided by the *café-concerts,* nightclubs patronized by a broad spectrum of Parisians.[78] Lautrec repeatedly sketched Montmartre performers in their own surroundings, and his works suggest a sympathetic identification with their anomalous world that was perhaps fostered by his own physical deformity, a failure of growth in the bones of his legs. Lautrec's familiarity with and empathy for these entertainers enabled him to capture their eccentric on-stage personalities with economical, energetic lines that immediately caught the attention of cabaret-goers. Freely formed lettering transmitted information as straightforwardly as possible. Despite their directness of appeal and commercial purpose, however, Lautrec's characterizations are not without emotional and psychological depth; the ironic combination of gaiety and melancholy, of extravagance and ennui, that marks fin de siècle Europe has, one feels, taken its toll on these outrageous individuals. Lautrec's posters are described by Richard Thomson as "means to represent a complex, fluctuating scene, chic and seedy, corrupt and commercial, subtle and gross."[79]

A master of drawing in the tradition of Degas, Lautrec combined, as Degas did, a precise and expressive line with traits gleaned from Japanese prints: large, flat color areas, diagonal arrangements, and oblique or unusually high or low points of view. Japanese woodcuts were widely and cheaply available in late nineteenth-century France. But *japonisme,* unlike the eighteenth-century passion for *chinoiseries,* was neither shallow nor piecemeal—it became, rather, a transforming influence on the course of European art. Seeking a way out of the impasse they felt was presented by their own tradition, European artists looked to Japan, as they would to Africa and Oceania, for new and different directions. The subject matter of Japanese prints was also appealing. It offered (to the European eye at least) a startlingly intimate and/or casual glimpse of urban life. Lautrec's re-creation of the *demimonde* of Montmartre bears much in common with the Japanese vision of the "floating world" (*ukiyo*) of courtesans and actors in the *kabuki* theater that is represented in Japanese *ukiyo-e* ("pictures of the floating world").

In *Moulin Rouge: La Goulue* (1891; fig. 8.47, color plate, p. 470), Lautrec used four stones and spattered lithographic ink, a technique he had borrowed from Chéret. In the poster's second state, shown here, conventional red letters not of Lautrec's design obscure the lanky, speckled silhouette of the dancer Valentin le Désossé (the Boneless One). He remains subordinate to the exuberant La Goulue (the Gluttoness), whose pantaloons and underskirts merge into a large, radial white shape, punctuated by dark red stockings, near the center of the poster. This abstraction of La Goulue's pose—arrived at via more naturalistic illustrations in the popular press—epitomizes the salaciousness of the Naturalist Quadrille, or can-can.

A dance with decidedly proletarian overtones, initially intended to shock the bourgeoisie, the can-can and the dance halls in which it was performed became the targets of a moralistic campaign in 1890. But the dance was popularized when the actress Régine danced it in *Ma Cousine* (1891), a comedy by Henri Melhac. The costume of the quadrille dancer ultimately

became fashionable for respectable middle-class ladies: Lautrec's poster took advantage of the fad.[80]

La Goulue was instantly recognizable to Parisians by her yellow topknot and widely flung legs, and the poster was an overnight success. Similarly, Lautrec brought his talent for abstraction to Jane Avril's melancholy face, mop of yellow-orange hair, and graceful, black-stockinged legs in *Jane Avril: Jardin de Paris* (1893; fig. 8.48). Lautrec was unfamiliar with her routine, which played a feigned innocence against the lasciviousness of the quadrille, when he designed the poster, so he worked from a photograph.[81] We can also see the impact of Japanese courtesan prints (see fig. 8.49) on Lautrec's decorative, freeform treatment of Avril's figure and costume. We view the dancer from the orchestra pit, where we are seated behind a musician, a compositional device employed by Daumier, Degas, and others. His form is cut off, recalling Japanese prints once again (for example, the landscape or city views by Hiroshige that we see through a curtailed form in the foreground). The neck of his instrument merges with a greenish border that encircles the dancer: his hand directs our gaze toward her and the lettering above.

In his posters for the satirical singer Aristide Bruant (fig. 8.50), Lautrec used a concise facial expression of extreme disdain to convey his subject's insulting and salacious wit. A huge cape, bright scarf, and walking stick give some sense of his larger-than-life stage presence. The shapes of his clothing are placed so as to accentuate his name and arrogant face. Lautrec had certainly seen Japanese prints of *kabuki* actors that brilliantly combine costume and facial expression into a vivid caricature and striking decorative unity (fig. 8.51). Bruant had Lautrec's poster placed on both sides of the stage at Les Ambassadeurs, where he performed, as well as on Parisian walls.

Although Loie Fuller preferred Chéret as a designer for her 1893 Folies-Bergère poster (fig. 8.46, color plate, p. 470), Lautrec's contemporary lithograph, published by Marty, outstrips Chéret's effort in boldness of technique and design. The impressions of *Miss Loie Fuller* (1893; fig. 8.52, color plate, p. 471) have been interpreted as hand-colored black-and-white prints, although it has also been suggested that the colors, and even the metallic gold, were in fact printed.[82] Although Chéret's image of the dancer is energetic, Lautrec's dissolving of her body in the costume, monolithic in shape but broken by iridescent color, gives a more vivid sense of the swirling, spiraling movements for which she was known. The *crachis* effect is now entirely detached from modeling to enhance the abstract impact of the print. Although the spatial point of view is similar to that taken in *Jane Avril*, the actual setting seems less important; appearance is further subordinated to form. Yet *Loie Fuller* is no less dependent upon Lautrec's understanding of his subject's gestures and the expressive mood of her performance.

Pierre Bonnard and his friend Edouard Vuillard belonged to a group of artists who called themselves the Nabis, after the Hebrew word for prophet. Like Lautrec, these artists rejected the naturalism and spontaneity of Impressionism in favor of two-dimensional designs that were ideally suited for color lithography. Maurice Denis, the spokesman of the Nabis, had proclaimed in 1890 that "a picture before it is a warhorse, a naked woman, or some anecdote, is essentially a flat surface covered with colors arranged in a certain order."[83]

Bonnard's poster for *La Revue Blanche* (1894; fig. 8.53), nearly contemporary with Lautrec's *Loie Fuller,* also achieves a directness of impact and decorative finesse. This periodical, founded in 1891, published a broad selection of contemporary French literature and art, including lithographs in the front of each issue, and epitomized the avant-garde culture of France at the end

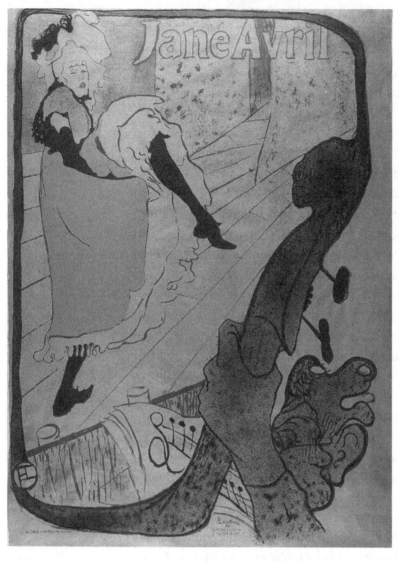

FIGURE 8.48
Henri de Toulouse-
Lautrec. Jane Avril:
Jardin de Paris. *1893.*
Color lithographic poster.
1208 × 885 mm. Art
Institute of Chicago.

FIGURE 8.49
Katsukawa Shunsen.
Courtesan on Parade.
Ca. 1810. Color woodcut.
762 × 253 mm. Victoria
& Albert Museum,
London.

FIGURE 8.50

Henri de Toulouse-Lautrec. Les Ambassa-deurs: Aristide Bruant. *1892. Color lithographic poster. 1345 × 930 mm. Art Institute of Chicago.*

FIGURE 8.51

Shunkosai Hokuei. *Far
right panel from a
pentaptych,* Mist on the
Mirror of Fashion:
Portraits of Actors.
*Ca. 1834–35. Color
woodcut. 367 × 252 mm.
Victoria & Albert
Museum, London.*

of the century. Bonnard echoed Lautrec's posters in his emphatic use of shape and freeform lettering, but a tapestry-like pattern of somber colors (matte gray and beige) emerges in the repetition of the title of the magazine behind the figures. The sultry woman is Misia Natanson, wife of the journal's publisher, Thadée Natanson, Bonnard's friend and biographer.[84] Bonnard's humor is apparent in the gesturing, grimacing boy, in the way "La Revue Blanche" peeks out insistently at every turn, in the treatment of the phrase "en vente partout" (sold everywhere), and in the way the "a" and the "v" of the title suggest Misia's umbrella.

In 1900 Vollard commissioned from Bonnard what must be regarded as the finest group of lithographic book illustrations since Delacroix's *Faust:* the 109 prints in rose crayon that accompany the Symbolist poet Paul Verlaine's collection of erotic verses, *Parallèlement,* written ten years earlier (Bonnard also made nine wood-engravings for this text). Bonnard's formal conception was as innovative as the poetry itself, whose frank sexuality led the *Imprimerie Nationale,* which had printed the edition, to request the return of the copies not yet distributed.[85] Bonnard's choice of rose color evokes Watteau's, Boucher's, and Fragonard's Rococo nudes in red chalk (recall Boucher's *Two Nereids and a Triton,* etched in the crayon manner by

FIGURE 8.53

Pierre Bonnard. La
Revue Blanche. *1894.
Color lithographic poster.
800 × 620 mm. Metro-
politan Museum of Art,
New York.*

Demarteau, fig. 5.34), and his designs play adventurously over, around, and even behind the text. With its languid, animalistic nude, reminiscent of Bonnard's sensual painted studies of his wife, Marthe, *Séguidille* (fig. 8.54)—the *seguidilla* was a Spanish dance whose rapid tempo was analogous to that of the poem—exemplifies the delicate touch and free-flowing line that Bonnard employed to suit the more lyrical aspects of Verlaine's imagery.[86]

Denis's dictum on the autonomy of surface design is best evidenced in Vuillard's refor-mulation of the typical Impressionist street scene in *La Patisserie* (*The Cake Shop;* fig. 8.55, color plate, p. 471), part of an album of twelve color lithographs published in 1899, *Paysages et Interieurs* (*Landscapes and Interiors*). To some extent, Vuillard retained the form-dissolving, sparkling effects of Impressionist light. But, for the most part, the patches of light themselves, along with the stripes of the awnings, the letters of the sign, and the plaid of a woman's blouse, resolve themselves into surface-oriented patterns, tightly knitted together into a coherent design.

Despite the polemical formalist note that later critics and artists might read into Denis's words, the Nabis were not indifferent to subject matter. The prints of Vuillard and Bonnard

FIGURE 8.54

Pierre Bonnard. Séguidille:
Page 27 from Parallèle-
ment *by Paul Verlaine.*
Paris: Ambroise Vollard,
1900. Lithograph in rose.
300 × 240 mm (page);
232 × 203 mm (image).
Museum of Modern Art,
New York.

often express a quietly poetic domesticity reminiscent of seventeenth-century Dutch genre scenes. In Bonnard's *Child in Lamplight* (ca. 1897; fig. 8.56), the child's head emerges abruptly into light from an atmospheric background of indistinct marks. The lamp's glare rakes across his face and forearm and intensifies the contrast between the bright accents of the train cars and the vibrant orange of the table top. Bonnard's print is not only a study of color interaction and the concise shapes created by the light; it also captures a single moment of ineffable charm, as a child props himself up on the table, utterly preoccupied with his tiny toys. Helen Giam-bruni has noted that this lithograph reflects the reality of French family life after dark in the 1890s, centered on a small table lit by an oil or kerosene lamp.[87]

The direction suggested by these and other late nineteenth-century color lithographs would be taken up again by early twentieth-century printmakers such as Braque, Picasso, and Kandinsky. Lithography, which had begun rather humbly as a technique for reproducing script, and had made its way through the nineteenth century frequently as a second cousin to other printmaking media or painting, had found a decisive direction of its own. In the next chapter, we will trace the evolution of etching in this graphically rich century, discover a renewal of interest in the woodcut and monotype, and observe one of the earliest mergers of the print and the photograph—the *cliché-verre.*

FIGURE 8.56

Pierre Bonnard. Child in Lamplight. *Ca. 1897. Color lithograph. 333 × 461 mm. Museum of Modern Art, New York.*

NOTES

1. See Levitine 1985, pp. 19–20.

2. Carey and Griffiths 1984, p. 154.

3. Good, recent general surveys of lithography are Porzio 1983, and especially Gilmour, ed., 1988, notable for its extensive bibliography and scholarly approach. Also see Weber 1966; Man 1970; Twyman 1970.

4. See Mourlot 1970, no. 186, p. 168.

5. Redon quoted in Melot, Griffiths, and Field 1981, pp. 118–19.

6. Beall 1980, p. 201. Also see Gilmour 1988b for a survey of lithographic collaboration.

7. Beall 1980, pp. 198–99.

8. Twyman 1988, p. 58.

9. See Fox 1988.

10. See Mayor 1971, under fig. 618; Rodetis 1986.

11. Roger-Marx 1962, p. 53.

12. Quoted in Beall 1980, p. 200.

13. Holcomb 1971–72, p. 152.

14. See Armingeat 1983 on lithographic book illustration.

15. Kliman 1982.

16. Manet's *Polichinelle* may or may not be a caricature of Marshal MacMahon, who headed the repression of the Paris Commune and became president of the Third Republic two years later. See Farwell, ed., 1977, no. 11, p. 29; Reff 1982, no. 40, pp. 124–25; Brown 1985.

17. Quoted in Beall 1980, p. 200.

18. Melot [1978] 1980, p. 284.

19. See Herbert 1962.

20. Clark 1973, pp. 79–80.

21. Melot [1978] 1980, no. M. 22, p. 291.

22. Clark 1973, pp. 72, 93–96. Contrast Weisberg 1974, pp. 16–17, who interprets Millet's peasant imagery as expressing the timeless bond between peasant and the earth and a concern for rural depopulation. On the biblical significance of the sower, see Sund 1988.

23. For surveys of French satirical lithographs in the nineteenth century, see Farwell 1989. Far-

well, ed., 1977 offers an overview of French popular prints and photographs in the nineteenth century.

24. On the influence of journalistic illustration on Impressionist painters, see Isaacson 1982.

25. On Daumier's life and career, and his work in all media, see Passeron 1981.

26. Farwell 1989, pp. 10–11.

27. Driskel 1987.

28. Cuno 1983; Cuno 1985a (an expanded version of the 1983 work).

29. See Passeron 1981, pp. 62–69; Finlay 1984, pp. 5–6.

30. Cuno 1985b, pp. 193–258. Also see Wechsler 1982, pp. 71–75.

31. Ilan-Alter 1988, a general essay on the position of women in late nineteenth-century France as reflected in art, gives a good sense of how women continued to be oppressed despite the political changes during the course of the century.

32. In Armingeat 1982, pp. 18–19.

33. See Melot 1983b; Farwell 1989, pp. 18–19.

34. On the relationship between Manet's painterly and graphic styles, see Harris 1970, pp. 7–12.

35. Leymarie 1971, p. 17.

36. Druick and Zegers 1983 (quotation on pp. 44–45). For a popular wood-engraving of a balloon launching, see Reff 1982, no. 99, pp. 262–63.

37. See Farwell 1985.

38. Hanson 1977, p. 120.

39. See Wilson 1978, nos. 79 and 80, pp. 78–79; Fisher 1985, nos. 54 and 55, pp. 93–95.

40. Baas 1985. For a contrasting view, see Brown 1983.

41. Hanson 1977, p. 196.

42. Wilson 1978, no. 80, pp. 78–79.

43. Ibid.; Fisher 1985, no. 54, pp. 93–94.

44. For a comparison of Manet's with earlier images, see Nochlin 1971, pp. 73–76.

45. Melot 1983a.

46. Reed and Shapiro 1985, nos. 63, 64, and 65, pp. 231–44.

47. For a history of the interpretation of Degas as a misogynist and arguments against this view, see Broude 1977; Broude 1988.

48. For examples, see Farwell, ed., 1977, pp. 103–21.

49. See Druick and Zegers 1985, pp. lxii–lxv (Degas quoted on p. lxiv).

50. Lipton 1980, pp. 94–97; Lipton 1986, pp. 151–86.

51. On Whistler's lithographs, see Lochnan 1981; MacDonald 1988.

52. Leymarie 1971, p. 120.

53. Weisberg 1974, pp. 31–35. For a thorough study of social radicalism among artists, see Egbert 1970.

54. Thomson 1990.

55. Melot 1979–80; Melot 1986.

56. Hutton 1990, pp. 305–6.

57. On Steinlen, see Cate and Gill 1982.

58. Ibid., pp. 89–96, and no. 23, p. 144.

59. On Bresdin's prints, see Museum of Modern Art and Art Institute of Chicago 1962; Norman MacKenzie Art Gallery 1981.

60. Quoted in Hobbs 1977, p. 20.

61. Gott 1990.

62. Ibid., pp. 23, 80.

63. On Redon's interest in the St. Anthony theme, see Hobbs 1977, pp. 66–67, 100–24.

64. Mellerio [1913] 1968, no. 102, p. 106, refers to the human figure as male, although this seems ambiguous.

65. Basic sources on the phenomenon of primitivism are Goldwater 1967; Rubin, ed., 1984. Leighten 1990 represents an especially significant contribution to the understanding of primitivism as a whole, although it deals primarily with Picasso's art. On Gauguin's primitivism and Tahiti, see Varnedoe 1984; Solomon-Godeau 1989. For Brittany, see Orton and Pollock 1980.

66. On the *Volpini Suite,* see Boyle-Turner 1989, pp. 37–43; Brettell's commentary in Brettell, Cachin, Frèches-Thory, and Stuckey 1988, nos. 66–77, pp. 130–43. Boyle-Turner 1986 provides an overview of the prints of the Pont-Aven school.

67. Boyle-Turner 1989, p. 39.

68. A good study of the renaissance of color lithography in the 1880s and 1890s is Cate and Hitchings 1978. On Vollard's numerous graphic projects, see Johnson 1977.

69. On Clot, see Gilmour 1988a.

70. Mellerio cited in Druick 1972, p. 7.

71. Waldfogel 1965.

72. Druick 1972, p. 12.

73. Cate and Hitchings 1978, pp. 4–9.

74. On Salome in fin de siècle culture, see Dijkstra 1986, pp. 379–401.

75. On posters, see Hutchison 1968; Weill 1983; Weill 1985. On the influence of Japanese prints on western artists, see Ives 1974; Whitford 1977.

76. Cate and Hitchings 1978, p. 12.

77. On Lautrec's entire graphic oeuvre, see Adhémar 1965 and, more recently, Wittrock 1985. Stuckey 1979 provides a good survey of his work in both painting and graphic art.

78. Cate 1988 is a fascinating study of Montmartre and art in the late nineteenth century.

79. Thomson 1985, p. 16.

80. See Murray 1980.

81. Thomson 1985, pp. 23–24 and fig. 10.

82. Fine 1982, nos. 86–87, pp. 232–35.

83. Denis quoted in Holt, ed., 1966, p. 509.

84. Ives 1989, pp. 105–8.

85. Johnson 1977, p. 24, and no. 166, p. 156.

86. On Bonnard and *Parallèlement*, see Newman 1989, pp. 162–72.

87. Giambruni 1989, pp. 83–84.

REFERENCES

Adams, Clinton. 1988. The Nature of Lithography. In Gilmour, ed., 1988, pp. 25–41.

Adhémar, Jean. 1965. *Toulouse-Lautrec: His Complete Lithographs and Drypoints.* New York.

Armingeat, Jacqueline. 1982. *Daumier: Liberated Women (Bluestockings and Socialist Women).* Preface by Françoise Parturier. New York.

Armingeat, Jacqueline. 1983. The Illustrated Book. In Porzio, ed., 1983, pp. 223–39.

Baas, Jacquelynn. 1985. Edouard Manet and "Civil War." *Art Journal,* vol. 45, no. 1 (Spring), pp. 36–42.

Beall, Karen F. 1980. The Interdependence of Printer and Printmaker in Early Nineteenth-Century Lithography. *Art Journal,* vol. 39, no. 3, pp. 195–201.

Boyle-Turner, Caroline. 1986. *The Prints of the Pont-Aven School: Gauguin and His Circle in Brittany.* Exhibition catalog. In collaboration with Samuel Josefowitz, and with a foreword by Douglas Druick. Smithsonian Institution, Washington, D.C.

Boyle-Turner, Caroline. 1989. *Gauguin and the School of Pont-Aven: Prints and Paintings.* In collaboration with Samuel Josefowitz, and with a foreword by Douglas Druick. Exhibition catalog. Royal Academy, London.

Brettell, Richard, Françoise Cachin, Claire Frèches-Thory, and Charles F. Stuckey, with assistance from Peter Zegers. 1988. *The Art of Paul Gauguin.* Exhibition catalog. National Gallery of Art, Washington, D.C., and Art Institute of Chicago, Chicago.

Broude, Norma. 1977. Degas's "Misogyny." *Art Bulletin,* vol. 59, no. 1 (March), pp. 95–107.

Broude, Norma. 1988. Edgar Degas and French Feminism, ca. 1880: 'The Young Spartans,' the Brothel Monotypes, and the Bathers Revisited. *Art Bulletin,* vol. 80, no. 4 (December), pp. 640–59.

Brown, Marilyn R. 1983. Art, the Commune, and Modernism. *Arts Magazine,* vol. 58, no. 4 (December), pp. 101–7.

Brown, Marilyn R. 1985. Manet, Nodier and "Polichinelle." *Art Journal,* vol. 45, no. 1 (Spring), pp. 43–48.

Cachin, Françoise, and Charles S. Moffett. 1983. *Manet 1832–1883.* Exhibition catalog with contributions by Anne Coffin Hanson and Michel Melot, and print entries by Juliet Wilson Bareau. Galeries Nationales du Grand Palais, Paris, and Metropolitan Museum of Art, New York.

Carey, Frances, and Antony Griffiths. 1984. *The Print in Germany 1880–1933.* Exhibition catalog. Department of Prints and Drawings, British Museum, London.

Carlson, Victor I., and John W. Ittmann. 1985. *Regency to Empire: French Printmaking 1715–1814.* Exhibition catalog with contributions by David P. Becker, Richard Campbell, Jay McKean Fisher, George Levitine, and

Mary L. Myers. Baltimore Museum of Art, Baltimore, and Institute of Arts, Minneapolis.

Cate, Phillip Dennis. 1988. Paris Seen through Artists' Eyes. In Cate, ed., 1988, pp. 3–53.

Cate, Phillip Dennis, ed. 1988. *The Graphic Arts and French Society, 1871–1914.* New Brunswick, N.J.

Cate, Phillip Dennis, and Susan Gill. 1982. *Théophile-Alexandre Steinlen.* Salt Lake City, Utah.

Cate, Phillip Dennis, and Sinclair Hamilton Hitchings. 1978. *The Color Revolution: Color Lithography in France 1890–1900.* Exhibition catalog. Rutgers University Art Gallery, New Brunswick, N.J., and Baltimore Museum of Art, Baltimore.

Clark, Timothy J. 1973. *The Absolute Bourgeois: Artists and Politics in France 1848–1851.* Greenwich, Conn.

Cuno, James B. 1983. Charles Philipon, La Maison Aubert, and the Business of Caricature in Paris, 1829–41. *Art Journal,* vol. 43 (Winter), pp. 347–54.

Cuno, James B. 1985a. The Business and Politics of Caricature: Charles Philipon and La Maison Aubert. *Gazette des Beaux-Arts,* 6th ser., vol. 106 (October), pp. 95–112.

Cuno, James B. 1985b. Charles Philipon and La Maison Aubert: The Business, Politics, and Public of Caricature in France. Ph.D. dissertation, Harvard University.

Dijkstra, Bram. 1986. *Idols of Perversity: Fantasies of Feminine Evil in Fin-de-Siècle Culture.* New York.

Driskel, Michael Paul. 1987. Singing "The Marseillaise" in 1840: The Case of Charlet's Censored Prints. *Art Bulletin,* vol. 69, no. 4 (December), pp. 604–25.

Druick, Douglas W. 1972. Cézanne, Vollard, and Lithography: The Ottawa Maquette for the "Large Bathers" Colour Lithograph. *Bulletin of the National Gallery of Canada, Ottawa,* vol. 19, pp. 2–35.

Druick, Douglas W., and Peter Zegers. 1983. Manet's "Balloon": French Diversion, the Fête de l'Empereur 1862. *Print Collector's Newsletter,* vol. 14, no. 2 (May–June), pp. 37–46.

Druick, Douglas W., and Peter Zegers. 1985. Degas and the Printed Image. In Reed and Shapiro 1985, pp. xv–lxxii.

Egbert, Donald Drew. 1970. *Social Radicalism and the Arts: Western Europe.* New York.

Farwell, Beatrice, ed. 1977. *The Cult of Images: Baudelaire and the 19th-Century Media Explosion.* Exhibition catalog. Art Museum, University of California at Santa Barbara.

Farwell, Beatrice. 1985. Editor's Statement: "Manet et Manebit." *Art Journal,* vol. 44, no. 1 (Spring), pp. 7–8.

Farwell, Beatrice. 1989. *The Charged Image: French Lithographic Caricature, 1816–1848.* Exhibition catalog. Santa Barbara Museum of Art, Santa Barbara, Calif.

Fine, Ruth E. 1982. *Lessing J. Rosenwald: Tribute to a Collector.* Exhibition catalog. National Gallery of Art, Washington, D.C.

Finlay, Karen A. 1984. Daumier and 'La Caricature.' Exhibition catalog. Art Gallery of Ontario, Toronto.

Fisher, Jay McKean. 1985. *The Prints of Edouard Manet.* Exhibition catalog. International Exhibitions Foundation, Washington, D.C.

Fisher, Jay McKean. 1988. Manet's Illustrations for "The Raven": Alternatives to Traditional Lithography. In Gilmour, ed., 1988, pp. 91–109.

Fox, Celina. 1988. Géricault's Lithographs of the London Poor. *Print Quarterly,* vol. 5, no. 1 (March), pp. 62–66.

Giambruni, Helen. 1989. Domestic Scenes. In Ives, Giambruni, and Newman 1989, pp. 39–92.

Gilmour, Pat. 1988a. Cher Monsieur Clot . . . : Auguste Clot and His Role as a Colour Lithographer. In Gilmour, ed., 1988, pp. 129–75.

Gilmour, Pat. 1988b. Lithographic Collaboration: The Hand, the Head, the Heart. In Gilmour, ed., 1988, pp. 308–59.

Gilmour, Pat, ed., 1988. *Lasting Impressions: Lithography as Art.* London.

Goldwater, Robert. 1967. *Primitivism in Modern Art.* New York.

Gott, Ted. 1990. *The Enchanted Stone: The Graphic Worlds of Odilon Redon.* Exhibition catalog. National Gallery of Victoria, Melbourne, Australia.

Hanson, Anne Coffin. 1977. *Manet and the Modern Tradition.* New Haven, Conn.

Harris, Jean C. 1970. *Edouard Manet: Graphic Works: A Definitive Catalogue Raisonné.* New York.

Herbert, Robert L. 1962. *Barbizon Revisited.* New York.

Hobbs, Richard, 1977. *Odilon Redon.* Boston.

Holcomb, Adele. 1971–72. Le Stryge de Notre-Dame: Some Aspects of Meryon's Symbolism. *Art Journal,* vol. 31, no. 2 (Winter), pp. 150–57.

Holt, Elizabeth, ed., 1966. *From the Classicists to the Impressionists.* Vol. 3 of *A Documentary History of Art.* New York.

Hutchison, Harold F. 1968. *The Poster: An Illustrated History from 1860.* New York.

Hutton, John. 1990. "Les Prolos Vagabondent": Neo-Impressionism and the Anarchist Image of the *Trimardeur. Art Bulletin,* vol. 72, no. 1 (June), pp. 296–309.

Ilan-Alter, Ann. 1988. Paris as a Mecca of Pleasure: Women in Fin-de-Siècle France. In Cate, ed., 1988, pp. 55–82.

Isaacson, Joel. 1982. Impressionism and Journalistic Illustration. *Arts Magazine,* vol. 56, no. 10 (June), pp. 95–115.

Ives, Colta. 1974. *The Great Wave: The Influence of Japanese Woodcuts on French Prints.* New York.

Ives, Colta. 1989. City Life. In Ives, Giambruni, and Newman, pp. 93–144.

Ives, Colta, Helen Giambruni, and Sasha M. Newman. 1989. *Pierre Bonnard: The Graphic Art.* Exhibition catalog. Metropolitan Museum of Art, New York.

Johnson, Una E. 1977. *Ambroise Vollard, Editeur: Prints, Books, Bronzes.* Exhibition catalog. Museum of Modern Art, New York.

Kadison, Stuart. 1989. The Politics of Censorship. In Farwell 1989, pp. 23–37.

Kliman, Eve Twose. 1982. Delacroix's Lions and Tigers: A Link between Man and Nature. *Art Bulletin,* vol. 64, no. 3 (September) pp. 446–66.

Leighten, Patricia. 1990. The White Peril and *l'Art nègre:* Picasso, Primitivism and Anti-colonialism. *Art Bulletin,* vol. 72, no. 4 (December), pp. 609–30.

Levitine, George. 1985. French Eighteenth-Century Printmaking in Search of Cultural

Assertion. In Carlson and Ittman 1985, pp. 10–21.

Leymarie, Jean. 1971. *The Graphic Works of the Impressionists.* Catalog by Michel Melot. New York.

Lipton, Eunice. 1980. Degas' Bathers: The Case for Realism. *Arts Magazine,* vol. 54 (May), pp. 94–97.

Lipton, Eunice. 1986. *Looking into Degas: Uneasy Images of Women and Modern Life.* Berkeley, Calif.

Lloyd, Christopher, ed. 1986. *Studies on Camille Pissarro.* New York.

Lochnan, Katharine. 1981. Whistler and the Transfer Lithograph: A Lithograph with a Verdict. *Print Collector's Newsletter,* vol. 12, no. 5 (November–December), pp. 133–37.

MacDonald, Margaret F. 1988. Whistler's Lithographs. *Print Quarterly,* vol. 5, no. 1 (March), pp. 20–55.

Man, Felix H. 1970. *Artists' Lithographs: A World History from Senefelder to the Present Day.* New York.

Mayor, A. Hyatt. 1971. *Prints and People.* New York.

Mellerio, André. [1913] 1968. *Odilon Redon.* New York.

Melot, Michel. 1979–80. Camille Pissarro in 1880: An Anarchist Artist in Bourgeois Society. *Marxist Perspectives,* vol. 2 (Winter), pp. 22–54.

Melot, Michel. [1978] 1980. *The Graphic Art of the Pre-Impressionists.* Trans. Robert Erich Wolf. New York.

Melot, Michel. 1983a. Manet and the Print. In Cachin and Moffett 1983, pp. 36–39.

Melot, Michel. 1983b. Social Comment and Criticism. In Porzio 1983, pp. 207–21.

Melot, Michel. 1986. A Rebel's Role: Concerning the Prints of Camille Pissarro. In Lloyd 1986, pp. 117–22.

Melot, Michel, Antony Griffiths, and Richard S. Field. 1981. *Prints: History of an Art.* New York.

Mourlot, Fernand. 1970. *Picasso Lithographs.* Paris.

Murray, Gale B. 1980. The Theme of the Naturalist Quadrille in the Art of Toulouse-Lautrec: Its Origins, Meaning, Evolution and Relationship to Later Realism. *Arts Magazine,*

vol. 55 (December), pp. 68–75.

Museum of Modern Art and Art Institute of Chicago. 1962. *Odilon Redon/Gustave Moreau/ Rodolphe Bresdin.* Exhibition catalog. Museum of Modern Art, New York.

Newman, Sasha M. 1989. Nudes and Landscapes. In Ives, Giambruni, and Newman 1989, pp. 145–91.

Nochlin, Linda. 1971. *Realism.* New York.

Norman MacKenzie Art Gallery. 1981. *Prints by Rodolphe Bresdin.* Exhibition catalog. Norman MacKenzie Art Gallery, Regina, Saskatchewan.

Passeron, Roger. 1981. *Daumier.* New York.

Orton, Fred, and Griselda Pollock. 1980. Les données bretonnantes: La prairie de la représentation. *Art History,* vol. 3, no. 3 (September), pp. 314–45.

Porzio, Domenico, ed. 1983. *Lithography: 200 Years of Art, History and Technique.* With essays by Jean Adhémar, Michel Melot, Jacqueline Armingeat, and others. New York.

Reed, Sue Welsh, and Barbara Stern Shapiro. 1985. *Edgar Degas: The Painter as Printmaker.* Exhibition catalog with contributions by Clifford S. Ackley, Roy L. Perkinson, Douglas W. Druick, and Peter Zegers. Museum of Fine Arts, Boston.

Reff, Theodore. 1982. *Manet and Modern Paris.* Exhibition catalog. National Gallery of Art, Washington, D.C.

Rodetis, George A. 1986. Delacroix and Shakespeare: A Struggle between Form and the Imagination. *Journal of Aesthetic Education,* vol. 20, no. 1 (Spring), pp. 27–39.

Roger-Marx, Claude. 1962. *Graphic Art of the Nineteenth Century.* New York.

Rubin, William, ed., 1984. *"Primitivism" in Twentieth Century Art: Affinity of the Tribal and the Modern.* 2 vols. Exhibition catalog. Museum of Modern Art, New York.

Shapiro, Barbara Stern. 1973. *Camille Pissarro: The Impressionist Printmaker.* Exhibition catalog. Museum of Fine Arts, Boston.

Solomon-Godeau, Abigail. 1989. Going Native. *Art in America,* vol. 77, no. 7 (July), pp. 118–29, 161.

Stuckey, Charles F. 1979. *Toulouse-Lautrec:*

Paintings. Exhibition catalog. Art Institute of Chicago, Chicago.

Sund, Judy. 1988. The Sower and the Sheaf: Biblical Metaphor in the Art of Vincent Van Gogh. *Art Bulletin,* vol. 70, no. 4 (December), pp. 660–76.

Thomson, Richard. 1985. The Imagery of Toulouse-Lautrec's Prints. In Wittrock 1985, pp. 13–34.

Thomson, Richard. 1990. *Camille Pissarro: Impressionism, Landscape and Rural Labour.* Exhibition catalog. City Museum and Art Gallery, Birmingham, England.

Twyman, Michael. 1970. *Lithography 1800–1850: The Techniques of Drawing on Stone in England and France and Their Application in Works of Topography.* London.

Twyman, Michael. 1988. Charles Joseph Hullmandel: Lithographic Printer Extraordinary. In Gilmour, ed., 1988, pp. 42–90.

Varnedoe, Kirk. 1984. Gauguin. In Rubin, ed., 1984, pp. 179–209.

Waldfogel, Melvin. 1965. Caillebotte, Vollard and Cézanne's *Baigneurs au repos. Gazette des Beaux-Arts,* 6th ser., vol. 65 (February), pp. 113–20.

Weber, Wilhelm. 1966. *A History of Lithography.* New York.

Wechsler, Judith. 1982. *A Human Comedy: Physiognomy and Caricature in Nineteenth-Century Paris.* Chicago.

Weill, Alan. 1983. The Poster. In Porzio 1983, pp. 191–206.

Weill, Alan. 1985. *The Poster: A Worldwide Survey and History.* Boston.

Weisberg, Gabriel P. 1974. *Social Concern and the Worker: French Prints from 1830–1910.* Exhibition catalog. Utah Museum of Art, Salt Lake City.

Whitford, Frank. 1977. *Japanese Prints and Western Painters.* New York.

Wilson, Juliet. 1978. *Manet: Dessins, aquarelles, eaux-fortes, lithographies, correspondance.* Exhibition catalog. Huguette Bères, Paris.

Wittrock, Wolfgang. 1985. *Toulouse-Lautrec: The Complete Prints.* With essays by Richard Thomson and Antony Griffiths. 2 vols. London.

The Nineteenth Century

The Etching Revival and New

Technical Approaches

INTAGLIO PRINTMAKING IN THE FIRST HALF
OF THE CENTURY

Our survey of nineteenth-century lithography has provided an overview of the major stylistic changes of the period and introduced us to the heightened appreciation of original printmaking that occurred in the latter half of the century. In this chapter, we shall explore these developments further in the context of traditional and newly invented, or rediscovered, techniques.

Although it is commonplace to speak of an etching revival after mid-century, this medium was never really in danger of expiring. As we have seen, outstanding original etchers persisted even during the great age of reproductive printmaking, and even in France, where reproduction and a highly polished, systematic engraving technique reigned supreme. In the early nineteenth century, Romantic artists carried on the ideals of original etching, passing the torch to the Barbizon landscapists in the 1840s and to Meryon in the 1850s, who in turn transferred it to artists such as Manet, Degas, Pissarro, and Whistler. But the notion of a revival is true in the sense that there was an etching boom in the 1860s, marked at one end by the founding of the

Société des Aquafortistes (Society of Etchers) in 1862, and led by the artists Félix Bracquemond and Alphonse Legros, the publisher Alfred Cadart, and the master printer Auguste Delâtre, who had already supported the Barbizon and other artists in their efforts to make prints. It was this renewed sensitivity toward the medium, characterized by distinct aesthetic assumptions (what good etching was supposed to look like), that was carried by the English etcher Francis Seymour Haden to the United States. There it served to inspire some of the most outstanding American prints of the nineteenth and twentieth centuries.

The implications of Goya's use of etching and aquatint fell on fallow ground at first, except for the prints of Delacroix, a consummate painter associated with the French Romantic movement. *The Jewess of Algiers* (1833; fig. 9.1), for example, whose subject responded to the French public's fascination with an exotic and recently colonized region,[1] recovers the bold scratchiness of Goya's etched lines and his strident light and dark contrasts. Moreover, the appreciation of Goya's use of aquatint, later to be even more thoroughly absorbed by Manet, is especially apparent in Delacroix's *Blacksmith* (1833; fig. 9.2). The worker appears here as a monumental hero, in contrast to Goya's unidealized treatment of smiths in his large painting *The Forge* (1812–16) in the Frick collection. Delacroix's modern Vulcan draws back his hammer with a powerful, Michelangelesque arm, and his open shirt reveals an expansive chest. As in Joseph Wright and Richard Earlom's mezzotint depiction of an iron forge (see fig. 5.43), the smith's physical stature is augmented by a tenebroso lighting derived from the glow of the hot metal. But in place of the calm, commanding facial expression of Wright's iron-worker is a leonine ferocity and glint in the eye.

Paul Huet, a close friend of Delacroix, took a similarly vigorous approach to etching and applied it to landscape. In his quieter, smaller glimpses of nature, such as *The Heron* (etching, 1833; fig. 9.3), however, he anticipated the Barbizon school (Huet visited Barbizon after 1849). Since his early visits to the Ile Séguin, an overgrown island in the Meudon, Huet had been fascinated with the kind of tangled vegetation exhibited here. *The Heron* is a close-up view of nature, similar to the woodland studies of Courbet or the American Hudson River painters, but more picturesquely arranged, with rococo curves dominating the trees and even the configuration of the bank. Although we look directly into a mysterious grotto, any sense of threatening enclosure is modified by the cutting off of foreground and trees so that the image retains a certain distance. The freedom and variety of line as well as the light underlying the tangle, recall Fragonard. The bear lurking at the left, however, gives a sense of the predatory and dangerous forces of nature that are so much a part of the Romantic conception.

Although some of the plates of Joseph Turner's *Liber Studiorum* (1807–19) are related to painted compositions, this series of seventy-one (of a planned 100) landscapes printed in sepia ink is an ingenious blend of original printmaking and processes and techniques more readily associated with the reproductive enterprise. This set of prints was only one among many that Turner would produce in his lifetime, but its title indicates its purpose as Turner's manual of landscape types, and its centrality within his oeuvre as a statement of his philosophy of landscape.[2]

For the *Liber,* Turner generally supplied his engravers with carefully but partially etched guidelines on the plate and drawings specifically intended to be read and translated into mezzotint. Aquatint was employed on a few early plates, but it proved to look too different from mezzotinted tones and was abandoned. He maintained a strict control over the process and asked his engravers to supply him with numerous proofs, which he annotated and corrected.[3]

FIGURE 9.1
Eugène Delacroix. The
Jewess of Algiers. *1833.*

Etching. 208 × 153 mm.
Metropolitan Museum of
Art, New York.

FIGURE 9.2
Eugène Delacroix.
The Blacksmith. *1833.*
Etching and aquatint
on chine collé. 160 ×
95 mm. Elvehjem Mu-
seum of Art, University
of Wisconsin–Madison.

FIGURE 9.3
Paul Huet. The Heron.
1833. Etching. 245 ×
348 mm. Bibliothèque
Nationale, Paris.

In two cases he did the mezzotinting himself and had the preliminary etching done by others.[4] Relations between painter and engravers were not always smooth. In one instance an engraver complained that the etching lines did not correspond exactly to the drawing Turner had given him as a guide, and the latter, much annoyed, was obliged to make another drawing on one of the etched proofs.[5] And Charles Turner (no relation), after engraving the first four parts of the *Liber*, ended his dealings with the painter because of arguments over money.

Joseph Turner's meticulous supervision and his own participation in the completion of the plates was partly a reaction to the famous *Liber Veritatis*, a series of prints after Claude's drawings by Earlom. Claude was long dead, and many felt that the mezzotinter, despite the series' title, which insisted on the truth of the images, violated the painter's intentions outrageously. The drawings for this earlier endeavor had been made only for the purpose of verifying Claude's designs and protecting against forgeries, not as preliminary studies from which an engraver could work.

The prints in the *Liber Studiorum* form a compendium of landscape types: Historical, Mountainous, Pastoral, Elevated—or Elegant or Elegiac—Pastoral (a category distinguished by its Claudian characteristics),[6] Marine, and Architectural. *The Fifth Plague of Egypt* (figs. 9.4, 9.5), from a painting of the same name, falls into the Historical category. Despite the title, the passage from the Bible published by Turner in the exhibition catalog indicated that the event portrayed was the seventh plague: "And Moses [in the lower right] stretched forth his hands toward heaven, and the Lord sent thunder and hail, and the fire ran along the ground" (Ex. 9: 23).[7] It is a powerful and dramatic image, combining natural ferocity with the memory of a past, exotic culture. Turner's preliminary etching (fig. 9.4) might well be admired for its restrained linear purity and its surety of contours and depths of biting or, alternatively, criticized for its lack of spontaneity, but it must be remembered that the etching was always meant to be largely covered by the mezzotint (or aquatint). The final conception (fig. 9.5) tops the stately pyramids and dying humans with a dramatic sky filled with streaks of lightning. The implication is that humanity and its creations will eventually succumb to the ravages of time and nature. Turner's *Liber* was enormously influential, especially for American landscape artists, who by and large preferred his earlier, more Claudian, and more naturalistic works to his later, more abstract compositions.

Mezzotint was the best possible graphic medium for this grandiose and sublime conception of the landscape, which demanded a fully painterly range of tone. Moreover, it echoed Turner's wiping out of light areas from dark in his oils and watercolors.[8] In *The Source of the Arveron* (fig. 9.6), Turner did the mezzotinting himself, but turned the preliminary etching over to one of his hirelings, probably Henry Dawe. The lines of the proofs were, unlike Turner's, uninspired and tentative, whereas the finished print is vigorous and extremely pictorial. The observer overlooks a valley, so that the mountains rise directly in front, their awesome height made even more mysterious by mists and clouds. The partially blasted trees in the foreground convey the hostility of this environment. Mountains were considered the most "elevated" type of landscape in the Romantic repertory because they inspired the full gamut of "sublime" responses—from an awestruck terror at the destructive powers of their various meteorological phenomena (storms and avalanches, for example) to a contemplative loss of self in their vast spaces and mysterious mists. Ruskin, an ardent supporter of Turner, wrote extensively about mountain scenery in his *Modern Painters,* commending it to the "highest powers" of artists.[9]

FIGURE 9.4

Joseph Turner. Pre-liminary etching for The Fifth Plague of Egypt *from the* Liber Studiorum. *1808. 180 × 260 mm. New York Public Library.*

FIGURE 9.5

Charles Turner after Joseph Turner. The Fifth Plague of Egypt *from the* Liber Studiorum. *1808. Mezzotint over Turner's preliminary etching. 180 × 260 mm. New York Public Library.*

The experience of finishing some of the *Liber Studiorum* prints apparently inspired Turner to begin a series of original mezzotints after watercolors in the early 1820s.[10] Although they were not published, the twelve prints of the so-called *Little Liber* are among the most remarkable examples of mezzotint in the history of the medium, ranking with David Lucas' prints after Constable's paintings in their exploration of its full possibilities. *Catania, Sicily* (ca. 1820–25; fig. 9.7), depicts Mount Etna (note the plume of smoke) at the left, partly obscured by a furious rainstorm. The tonal nuances in the dark clouds, the streaks of lightning, the reflections on the water, and the diagonally falling rain are achieved by a subtly controlled

scraping of the mezzotinted background. (Later impressions of the *Little Liber* plates, pulled by Francis Seymour Haden, were done in sepia ink, like the *Liber Studiorum* prints, whereas Turner chose black ink to maximize tonal contrast.) Combining the power of the ocean, always a major concern for Turner, with volcanic and meteorological turbulence in the context of the topographical print, this image is an excellent example of Turner's "topographical sublime."[11]

A more modest approach to the landscape print, suitable therefore for pure line etching, was championed by John Crome and John Sell Cotman, the leading artists of the Norwich school. "Old Crome," as the former was called, greatly admired Jacob Ruisdael and Meindert Hobbema. *Road Scene, Trowse Hall* (1813; fig. 9.8) recalls these artists' rendering of gnarled trees and woodland depths; it might be directly compared to Ruisdael's *The Large Oak* (fig. 4.26). Crome's tree is less overwhelming, however, and invites us toward it for shelter and contemplation of its expansive branches, whose curving horizontal forms echo the meandering fence beneath. The ground, strewn with leaves and twigs, also invites the viewer in and even offers two well-trodden paths around the venerable tree. In a seventeenth-century Dutch context, the nature embodied in the huge tree might still be conceived as something to conquer; for Crome in early nineteenth-century England, it had become more threatened than threatening. The celebration of the rural landscape in English art of this period masked the rapid physical and social transformation of the countryside through industrialization and the accelerated "enclosure" of lands formerly held as "commons" or lying fallow. As small farms were swallowed up by large ones and rural "cottage" industries began to disappear, the nostalgia for the past in painted and printed landscapes gained resonance with the English public.[12]

Cotman, Crome's younger rival, capitalized on this nostalgia in his rendering of the picturesque scenery and architecture of Norfolk and Yorkshire. Like Piranesi, whom he very much

FIGURE 9.7

Joseph Turner. Catania, Sicily, *from the* Little Liber. *Early 1820s. Mezzotint with added graphite and chalk. 193 × 252 mm. Yale Center for British Art, New Haven.*

admired, Cotman excelled in the depiction of ruins. *South Gate, Yarmouth* (fig. 9.9), duplicating a painting in the Tate Gallery, was one of the sixty prints of *The Architectural Antiquities of Norfolk,* published in 1818. Cotman varied his etched lines and marks to create a vivid sense of the textures of the old stone walls, wood surfaces, and roofs. However, the print still satisfied the topographical requirement for accuracy and detail: compared with many of Piranesi's or Turner's works, it is exceedingly tame, allowing the architecture to stand largely on its own without dramatic enhancement, particularly by light. Cotman's print serves as a record of the medieval gate, torn down in 1812 and part of a rapidly disappearing past.

Cotman was one of the earliest and most important artists to make extensive use of soft-ground etching, originally invented by Giovanni Benedetto Castiglione. Inspired by Turner's *Liber Studiorum,* he conceived his own series of the same name in 1824, although it was not published until 1838. Cotman had made pencil copies of Turner's images, but his own *Liber* eschews colorism and sublimity for the intimacy and fluidity of small-scale landscape drawings. In *Postwick Grove, Norfolk* (Plate 19; fig. 9.10), no architecture, save an inconspicuous mill at the upper left, distracts from the landscape elements and figures in the foreground. The real subject of the print is the small grove of trees, reminiscent of Gainsborough's but more sedate and tightly delineated. The charming spontaneity and autographic quality possible with soft-ground etching, and so evident in Cotman's *Liber* plates, was more easily obtainable in lithography, a medium that would supersede Castiglione's invention shortly after its revival in the late eighteenth and early nineteenth centuries.[13]

The Nineteenth Century: Other Techniques

FIGURE 9.8
John Crome. Road
Scene, Trowse Hall.
1813. Etching, re-
touched with pen. 203 ×
274 mm. British Mu-
seum, London.

FIGURE 9.9
John Sell Cotman. South
Gate, Yarmouth *(1812),*
from The Architectural
Antiquities of Norfolk.
1818. Etching. 254 ×
362 mm. Yale Center for
British Art, New Haven.

FIGURE 9.10

John Sell Cotman.
Postwick Grove,
Norfolk: *Plate 19 from
the* Liber Studiorum.
*1824–38. Soft-ground
etching. 79 × 113 mm.
British Museum, London.*

THE BARBIZON ETCHERS, COROT AND
THE *CLICHÉ-VERRE*, PALMER

English landscape works of this period helped to mold contemporary French sensibilities toward this subject, which was to become one of the chief vehicles by which the hierarchy of subject matter and the stylistic assumptions of the French Academy were challenged and eventually broken down. Without entirely rejecting the classical landscape vision of Claude, the artists named for their association with the hamlet of Barbizon, near the forests of Fontainebleau, took their main cues from Dutch seventeenth-century landscapists as well as recent English artists.[14] In the landscapes of the Barbizon artists, indigenous scenery supplanted the foreign and the classical. The distant panorama was rejected for the limited view the artist could take while working from a single position out of doors (*en plein air*); the grandiose ideal gave way to the more intimate and natural, the polished and studied to the more spontaneous, painterly surface. The tradition of the topographical print, which focused on actual views of a particular region, not only fed the Barbizon approach to *painting* nature but also lent greater strength to printmaking within the oeuvres of these artists. Jules Dupré, Charles-François Daubigny, and Charles Jacque were trained as printmakers and worked on topographical illustrations.[15] Grounded etching plates could be carried to a site and summarily sketched upon there, thus offering the artists of Barbizon the freedom of a drawing, at least in the beginning stages of the etching process, with less ephemeral, and multiple, results. Like their English counterparts, the Barbizon landscapists responded to a nostalgia for the rural past that must be understood in tandem with the rapid contemporary transformation of the countryside and the social and economic relationships of its inhabitants. Of course, prints—as multiple, inexpensive art forms—made this nostalgic view of the countryside more widely available.

As a prolific printmaker, Daubigny occupied roughly the same place among the Barbizon painters that Pissarro would later occupy among the Impressionists. For Daubigny, etching was at first primarily a means of maintaining financial solvency, but even when his paintings gained

an audience (after the achievement of a jury-free salon in the context of the Revolution of 1848),[16] he continued making prints in order to expand his public and take advantage of the increasing appreciation of original prints, especially among middle-class patrons, which became even more pronounced after the *Société des Aquafortistes* was launched. The rural subjects of Barbizon prints reminded their bourgeois audience of an increasingly tenuous social order in which work was harmonized with nature, and class hierarchy was "naturalized."[17]

In 1851 Daubigny published his first two etched series, consisting of six prints each and modestly priced at one franc per print, or five francs for the set. The price and the fact that these were not printed in limited editions, observes Melot, show that Daubigny was still thinking of his prints as images that were widely accessible rather than aimed at an audience of connoisseurs—a concept of the print that would soon be fostered by the etching revival.[18] For *Stags by the Waterside (Souvenir of the Islands at Bezons),* he employed a cloth texturing of the grounded plate to establish the basic tonal values (fig. 9.11), which he then reworked with lines (fig. 9.12), thus obscuring the startlingly impressionistic qualities of the early state. Still, the final image is fresh, vigorously drawn, and unpretentious—qualities that mark Daubigny's style as well as that of the Barbizon school as a whole.

Stags by the Waterside reveals Daubigny's preference for river scenery, which he sketched from aboard his *Botin,* a boat converted into a floating studio. His delightful etched series *Voyage en Bateau (The Boat Trip,* 1861–62) presented whimsical, roughly sketched vignettes of his aquatic wanderings. Even though Cadart published the series of fifteen prints in 1862 for twenty francs, it seems largely to have been intended for the amusement of Daubigny's family and artist friends (Corot had been appointed honorary admiral of the *Botin,* but rather than set sail, he preferred to participate in the festivities that accompanied the boat's departures and returns).[19] A more serious purpose may underlie Daubigny's humor: across one of the canvases stacked in the lower right of one etching is written the word "Réalisme," and the individual prints themselves strongly assert the *plein-air* aesthetic. Many of the compositions owe much to Daumier's series of boating prints, *Les Canotiers Parisiens* of 1843. The prominence of the lantern in many of the scenes may identify the artist as a kind of modern-day Diogenes. *The Boat Trip* thus becomes a realist odyssey, lightheartedly recounted, in which the artist, pictured as a good-natured bohemian, searches for the natural.[20] He is accompanied by his cabin boy, who fishes for food and pulls the boat along when the current is inadequate. Together, he and the artist float through dark, silent waters at night, bed down on straw on the deck, or search for an inn. The spirit of these etchings is epitomized by *The Rejoicing of the Fish at the Departure of the Cabin Boy* (fig. 9.13), in which the river's inhabitants leap happily out of the water in the wake of the *Botin's* passing.

Perhaps Daubigny's best-known print is *Tree with Crows* (etching, 1867; fig. 9.14). Not intended to be part of a published series, it may have been done for himself, an indication of a change of attitude toward printmaking.[21] Much as in Rembrandt's *Three Trees* (fig. 4.45), the motif is simple—trees against a horizon—but the artist's subtle treatment lends it excitement. Daubigny exaggerated the analogy between the bare branches and the pointed forms of the crows, and exploited the rushing movement into space by emphasizing the ruts in the road and the long shadows, cast by the trees, that seem to fall down the slope to the road.

Camille Corot was also associated with Barbizon, although the classical aspects of his art and its firm foundation in Poussin and Claude tempered his adoption of the *plein-air* aesthetic and the influence of the Dutch and English landscape traditions. The paintings he exhibited

FIGURE 9.11

*Charles-François
Daubigny.* Stags by the
Waterside (Souvenir of
the Islands at Bezons),
*first state. 1850. Soft-
ground etching with
"cravate" (cloth overlay).
118 × 155 mm (image).
Bibliothèque Nationale,
Paris.*

FIGURE 9.12

*Charles-François
Daubigny. Seventh state
of fig. 9.11, with "cravate"
effect eliminated by line
work. College of Wooster
Art Museum, Wooster,
Ohio.*

FIGURE 9.13

Charles-François Daubigny. The Rejoicing of the Fish at the Departure of the Cabin Boy *from* The Boat Trip. *1861–62. Etching. 100 × 155 mm. College of Wooster Art Museum, Wooster, Ohio.*

FIGURE 9.14

Charles-François Daubigny. Tree with Crows. *1867. Etching. 180 × 275 mm (image). College of Wooster Art Museum, Wooster, Ohio.*

at the Salon generally carried on the classical or Romantic traditions; it was his looser, smaller studies of nature that spoke most clearly to the Impressionists. He treated printmaking off-handedly, to say the least, often not bothering to etch the plates he had drawn. Bracquemond, who frequently played the role of catalyst to reluctant painter-engravers, found one such plate in a box of nails in Corot's house; he proceeded to etch and print it for the old artist.[22] *Italian Landscape* (fig. 9.15) is a quick sketch, epitomizing the spontaneity that came to be so highly valued in etching toward the end of the century. Its lacy charm, even though clearly effortless, is a tribute to Corot's highly tuned sensitivity to landscape. Even though the lines are rapidly drawn, an order is imposed by their generally parallel directions, and one does not perceive tangled vegetation and wildness so much as a cultivated, civilized nature. The deep shadows in the foreground and trees backlighted by a Claudian glow on the horizon betray Corot's clas-

FIGURE 9.15

Jean-Baptiste-Camille Corot. Italian Landscape. *Ca. 1865. Etching. 158 × 237 mm. National Gallery of Art, Washington, D.C.*

sical interests. The domed building in the distance and the figures to the left complete the sense of serene harmony between the human and the natural.

Corot's glass prints, or *clichés-verres,* are the most beautiful early experiments with this new technique, which blended photography and printmaking. The artist worked on a glass plate made opaque by coating it with collodion, printer's ink, or oily pigment. The design might be made by scratching through the coating with a point or metal brush, or by manipulating the malleable pigment with a rag stump called a *tampon,* fingers, or any other kind of tool. To print the plate, it is placed against a light-sensitive paper that receives the image as from an ordinary photographic negative. When the plate's clean side is placed down on the paper, the light is diffused through the glass to produce a blurry, shimmering image. When the coated side is touching the paper, the lines and modeling are more immediately registered, and more faithfully and sharply rendered.

Corot's interest in this medium was sparked by his friend and admirer Constant Dutilleux, a painter and lithographer who was one of a small group experimenting with its possibilities. Corot made glass plates, printed by a variety of people, over twenty-two years from 1853 to 1860 and 1871 to 1874.[23] *Souvenir of the Fortifications at Arras* (1854; fig. 9.16) was "painted," perhaps using a rag, a *tampon,* and a brush-end or stylus for the lines, with an oily medium that could be easily manipulated on the plate. The deep shadows in the foliage and the iridescent light of the cloudy sky, broken by bare branches, give the effect of a moonlit night. By contrast to Corot's point-drawn glass prints, which closely resemble his etchings, this work exhibits qualities that are unique to the *cliché-verre:* the diffused light and an illusionistic impasto similar to that of monotype.

Millet fled the industrialized environment of Paris and settled in Barbizon in 1849. As we have seen in our discussion of his lithograph *The Sower,* his version of pastoral life was sullen, deterministic, and read by some contemporaries as politically dangerous. Although Barbizon art has been interpreted as an effort to hold on to a rural past, an "impassioned outcry," ac-

FIGURE 9.16

Jean-Baptiste Camille Corot. Souvenir of the Fortifications at Arras. *1854. Impasto cliché-verre. 183 × 142 mm. Bibliothèque Nationale, Paris.*

cording to Robert Herbert, against the onslaught of the Industrial Revolution, Millet's emphasis on the dreary, unchanging severity of peasant life was quite contemporary in that it showed a displaced proletariat struggling to survive.[24] *Peasants Going to Work* (1863; fig. 9.17), based on a painting of about 1850, is Millet's most carefully worked out plate, with seven extant preparatory drawings and trial etchings of details.[25] His peasant couple, with facial features shaded and holding ancient attributes of water jug, basket, and pitchfork, move slowly through a field, going to work as they always have. Clark comments upon the combination of delicacy and brutality that Millet achieved in the painting: a precise contrast between the broken, nervous forms of the male and the rounded, closed forms of the female figure—opposites that are bound together into an elemental unit.[26] In the etching, these contrasts are heightened by the greater distance between the figures and the stronger use of line, while the bonding of peasant and land, accomplished in the painting by Millet's subtle interweaving of earth colors, is conveyed in the print by the choppy hatching that moves through figures and field.

Accompanying Millet to Barbizon in 1849 was the prolific printmaker Charles Jacque, trained first as a mapmaker and woodcutter of illustrations. He is best known, however, for his etchings of farmyards and pastures. *The Staircase* (1845; fig. 9.18) typifies Jacque's sense of tex-

FIGURE 9.17

Jean-François Millet.
Peasants Going to
Work. *1863. Etching.
385 × 310 mm. College
of Wooster Art Museum,
Wooster, Ohio.*

tures and his efforts to interpret the rustic environment as ageless and unchanging: one could easily mistake his images for seventeenth-century Dutch rural genre scenes. The woman concentrating on her work and the child concentrating on its play are unaware of observers (as is frequently the case in Dutch genre) and are emphasized no more, no less, than the dilapidated stairs or the pot hanging on the cracked wall. The rich blacks and tangible surfaces of Jacque's etchings, as well as their understated realism, greatly appealed to Whistler and Haden, as well as to American etchers of the late nineteenth century. When he died in 1894, Jacque was the last of the Barbizon artists.

The British painter Samuel Palmer expressed a pastoral mood more poetically than the
Barbizon artists in etchings such as *The Sleeping Shepherd: Early Morning* (1857; fig. 9.19).
Palmer carried on the tradition of landscape prints descending from Crome and Cotman, but
expressed the ideal of a rural life untouched by modern changes with an almost religious inten-
sity.[27] In *Sleeping Shepherd*, Palmer's dense network of lines, established by multiple bitings, is
reminiscent of the white-line effect of his idol Blake's diminutive wood-engravings illustrating
Virgil's poetry or his relief etchings. Palmer never lost the light through these lines, so the print
maintains a lacy sparkle despite his heavy working of the plate with multiple bitings. We are
enclosed in the shaded area of the foreground, sheltered, like the shepherd, by the vine-covered
trellis that also frames the sun's light and a plowman on the distant hillside. It is a comforting,
almost ecstatic, image asserting the harmony between humans and nature, again only fully
understandable in terms of the Industrial Revolution and the transformation of the English
countryside. Published by the London Etching Club, founded in 1838, as part of a portfolio of
prints by a number of artists, *The Sleeping Shepherd* is evidence of the health of original etching
in England, even before the aesthetic of the etching revival, promulgated in England by Whist-
ler and his brother-in-law, Francis Seymour Haden, superseded Palmer's intensely expressive,
densely crafted style.

FIGURE 9.19

Samuel Palmer. The
Sleeping Shepherd:
Early Morning. *1857.*
Etching. 95 × 78 mm.
College of Wooster Art
Museum, Wooster, Ohio.

MERYON AND THE ETCHING REVIVAL

A decade before the etching revival blossomed, then, there were many excellent practitioners, and in France the important printer Delâtre and others championed the medium. Certainly the most outstanding intaglio printmaker of the 1850s was Charles Meryon, the illegitimate son of a British doctor (French-born, but a naturalized citizen of England) and a dancer at the Paris Opera, Narcisse Gentil. Shortly after young Charles matriculated in the naval academy at Brest in 1837, his mother died insane. On his sea voyages, Meryon developed his longstanding interest in art. He took a leave of absence from the navy in 1846 to devote himself to this interest, finally resigning entirely in 1848. In the course of his early artistic career, he discovered that he was color-blind. At the 1848 Salon, where he had exhibited a drawing, Meryon met Eugène Bléry, a minor artist who etched landscapes, and discovered an alternative to the career as a painter that was now closed to him. Throughout the 1850s and early 1860s, Meryon continued to produce magnificent etchings while struggling against his own encroaching mental illness: the critic Philippe Burty reported that he began digging up his yard looking for corpses and that Delâtre came frequently to care for him. He was finally confined for good in Charenton asylum in 1866, and died there two years later, refusing to eat and believing he was Christ taken captive by the Pharisees.[28]

If Rome lay at the core of the imagination of the eighteenth century's greatest etcher, Piranesi, then Paris held that position for Meryon, even though he also etched views of Bourges and a huge plate after a daguerreotype of San Francisco. Seldom before or since has a great city been so passionately interpreted and yet so meticulously studied, and at a time—the Second Empire under Napoleon III (1852–1870)—when massive modernization was changing its face. Under the direction of Baron G. E. Haussmann, much of medieval Paris was being destroyed in order to connect the outlying districts with the center of the city by broad avenues and boulevards. Meryon's etchings preserve the aged Paris beloved by Hugo and Baudelaire, and the medieval architecture celebrated by the restorer Eugène-Emmanuel Viollet-le-Duc. His prints were thus part of the contemporary surge of interest in France's past, which we have already seen operating in Baron Taylor's *Voyages Pittoresques* (see Chapter 8). A more bitter nostalgia underlay Meryon's vehement hatred of Napoleon III. Meryon's familiarity with military draughtsmanship and his interest in photography, then enjoying great popularity in Paris, gave his etchings an exactitude that went beyond most topographical prints. However, their hallucinatory clarity of detail lends them a hyper-real quality that implies not only objective study but a spellbound immersion in the city's aura of history. Something of this aura is conveyed in a passage from the journals of the art-lovers Edmond and Jules Goncourt, written upon their visit to Jules Niel's collection of Meryon's works in 1856:

> It seems as though a hand of the past has held the engraver's needle [*sic*] and that more than the very stonework of old Paris has been brought to these sheets of paper. Indeed, in his images, one could say some of the soul of the old city had been revived. It is as though magical reminiscence of old quarters, foundering oftentimes as in a dream, troubles the mind of a clairvoyant conscious of perspective—the poet-artist—who has Lunacy and wretchedness seated nearby on his bench. . . .
>
> Poor unhappy madman, during the clear moments beyond his lunacy, takes endless walks to capture the picturesque strangeness of shadows in the great cities.[29]

Eaux-Fortes sur Paris (1850–61), dedicated to Reinier Nooms (Zeemann), another sailor-turned-etcher (see Chapter 4), was meant to consist of twelve large views and ten small prints of Meryon's poetry and incidental, emblem-like images. Complete editions, however, were apparently very rare, and the chronology of the issuance of the prints is still uncertain.[30]

Le Stryge (fig. 9.20), first of the twelve large plates of the series, establishes its eerie mood. It offers a close view of the upper parts of the Cathedral of Notre Dame and a panoramic view of the right bank of the Seine beneath. In composing the print, Meryon was influenced by a photograph by Charles Nègre that emphasized the height of the cathedral and the imposing silhouette of the gargoyle recently designed by Viollet-le-Duc, against the sky.[31] The restorer's creation was adopted by Meryon as a symbol of the vices of the city.[32] Its protruding tongue and simian face suggest lechery; the black crows that link it to the Tower of St. Jacques in the middleground are ominous portents of the city's decay. The print's title, changed by Meryon from "La Vigie" (a lookout on a ship's prow), refers to a predatory night bird with humanoid aspects (*striga* in Latin) that, in ancient folk belief, ravaged the towns and countryside, cannibalizing the populace. Meryon partook here of the idea that moral values were inevitably destroyed by urban development. His 1855 etched poem, *La Loi Solaire,* set out the changes he would enact "if he were king or emperor"—mandatory incorporation into the city of "air and sun, the two principal essentials of life," and land.[33]

FIGURE 9.20

Charles Meryon. Le
Stryge, *seventh state (first
state 1853), from* Eaux-
Fortes sur Paris. *1850–61.
Etching with drypoint.
169 × 130 mm. College of
Wooster Art Museum,
Wooster, Ohio.*

More immediately threatened than morality, however, is the sixteenth-century Tower of St. Jacques, in the late, flamboyant Gothic style, which was soon to be razed for a road-building project, part of Napoleon III's and Haussmann's renovation of Paris. The stryge's gaze and the menacing birds foretell its fate. Thus, as Adele Holcomb explains, Meryon expressed his concern and love for the historic city while embodying its decline in the gargoyle: "Evidently, Meryon's idea of the corruption bred by cities was not incompatible with his attachment to Paris; indeed, it would seem that it was his grasp of the city as a complete moral universe with a demonic dimension that made his relation to it so compelling."[34]

In *The Morgue* (fig. 9.21), the same impulses are blended, but a specific situation replaces the abstract conceit of *Le Stryge*. Philippe Burty, well acquainted with the artist, interpreted the print in narrative terms: a corpse has just been pulled from the Seine by the police; a woman and a little girl watch in despair.[35] All three are victims of the modern city, like Max Klinger's family from *Dramas,* or Käthe Kollwitz's impoverished women and children (see Chapter 10).

FIGURE 9.21

Charles Meryon. The
Morgue, *fourth state
(1854), from* Eaux-
Fortes sur Paris. *1850–61.
Etching and drypoint.
232 × 207 mm. Phila-
delphia Museum of Art.*

The rising, sooty smoke, ever-circling crows, and overall sense of grime—even more pro-
nounced in impressions with heavy plate tone and retroussage—combine to present an
unforgettable picture of the crumbling inner city, even without Burty's (and perhaps
Meryon's) little story. Yet the old morgue, one senses, will endure, and beneath its walls, on the
laundry boats, the everyday life of the city continues as usual.

Perhaps the most impressive etching from the series is *L'Abside de Notre-Dame* (fig. 9.22),
which betrays Meryon's most important literary inspiration: Hugo's *Notre Dame de Paris* (1831).
Meryon's print is replete with a sense of age and the artist's warm regard for the great edifice,
which sits like a benevolent giant above the Seine and the surrounding city. Concentrating on
its apse, Meryon was able to render the fan-shaped arrangement of the flying buttresses, as well
as the towers of the façade, seen from behind. The Gothic verticality of the building is rein-
forced by contrast with the emphatic horizontal of the bridge, and the diagonal movement of

FIGURE 9.22
Charles Meryon.
L'Abside de Notre-
Dame, *fourth state*
(1854), from Eaux-Fortes
sur Paris. *1850–61.*
Etching and drypoint.
166 × 300 mm. Phila-
delphia Museum of Art.

bank and river is continued in the sky by the flock of birds, whose presence we can, by now, anticipate.

They also circle above the city and perch on the cathedral in *La Galerie Notre-Dame* (fig. 9.23). Meryon places us in the dark gallery of the building so that we look out on a view of the city: the spatial sensation—from enclosure to an open, aerial view—is rendered more striking by his textural treatment of the gallery walls, almost like engraving in its precision, and his softened, atmospheric vision of the city outside. In a sense we become the crows, alighting in the gallery and soaring above Paris. Like Poe's raven, they are enigmatic presences that, along with the demonic carved heads atop the corner collonettes, express Meryon's convictions about the sorry fate of his beloved city.

In 1862 the tireless champion of printmaking, Alfred Cadart, founded the *Société des Aquafortistes.* Cadart had left his job with the French railroad system in 1859 to become a publisher. He was also an amateur etcher, but his greatest contributions to the etching revival were his organizational skill and his determination to continue with his enterprise even though it was not always a financial success. With Auguste Delâtre, the printer who had already assisted so many of the Barbizon artists, and the artists Félix Bracquemond and Alphonse Legros, Cadart set out to increase the public's awareness of and demand for original prints, particularly etchings.[36] The movement's heroes were Goya and, above all, Rembrandt, whose works were so far removed from "the regular, automatic and uninspired" qualities (see below) of reproductive prints, or even those prints exhibiting the *vocabulary* of reproductive engraving, etching, and lithography. The polarization of "reproductive" and "original" became absolute in an artistic context in which the values of expressive freedom and stylistic innovation were gradually gaining on the values of the academy, which for so long had fostered reproductive engraving. In the interesting case of Léopold Flameng, a reproductive engraver turned bohemian etcher, this polarization led to some fascinating copies of Rembrandt prints and incongruous

FIGURE 9.23

Charles Meryon. La Galerie Notre-Dame, *fourth state (1853), from* Eaux-Fortes sur Paris. *1850–61. Etching and drypoint. 280 × 175 mm. New York Public Library.*

creations of his own in which the figures often take on distinctly academic traits within Rembrandtesque settings.[37]

The *Société* published monthly portfolios of five original prints, each by a different artist. In 1867 these portfolios were replaced by those of *L'Illustration Nouvelle,* which Cadart continued to publish until 1880. The plates, printed by Delâtre, were steel-faced (that is, coated with a thin layer of steel by means of electrolysis) to withstand wear, and proofs printed before address were sold at higher prices. Cadart's efforts were augmented by the writings of Baudelaire, Emile Zola, Philippe Burty, and Théophile Gautier. This last critic summarized the virtues of etching:

In these times, when photography fascinates the vulgar by the mechanical fidelity of its reproductions, it is needful to assert an artistic tendency in favour of free fancy and picturesque mood. The necessity of reacting against the positivism of the mirror-like apparatus has made many a painter take to the etcher's needle; and the gathering of those men of talent, annoyed at seeing the walls crowded with monotonous and soulless pictures, has given birth to the "Société des Aquafortistes." It has been founded to fight photography, lithography, and aquatint and all engravings whose re-crossed hatchings show a dot in the centre [the dot and lozenge system]. In other words, they are against the regular, automatic and uninspired work which deprives an artist's idea of its very nature; and they wish their plates to speak to the public directly at their own risk and peril.[38]

Crucial for the movement were books: the *Treatise on Etching* (1866) by the Barbizon artist Maxime Lalanne and Philip Gilbert Hamerton's *Etching and Etchers* (1868). These widely used texts not only gave practical instruction but promulgated etching as an autographic, freely expressive process. The long history of the medium as one imitating or combined with engraving was conveniently set aside.

Indeed, this period saw a renewed awareness of the history of original printmaking throughout Europe. In *Death in the Pear Tree* (1869–75; fig. 9.24), Legros adapted an archaic subject matter to his own times and to the vigorous, linear etching style championed by the revival. Although the animated interaction between Death and his victim indicates that the artist was certainly aware of Holbein's *Dance of Death* (see figs. 2.39–2.42), and perhaps of Alfred Rethel's 1848 series (see fig. 9.46), this confrontation of the living with the Death skeleton occurs in the context of an old French folk tale of "Le Bonhomme Misère" ("Old Man Misery"). Several versions of this story had been published in Champfleury's *Histoire de l'Imagerie Populaire* (*History of Popular Imagery*, 1869).

Saints Peter and Paul had once come to the old man and, having been kindly treated, offered to grant him a wish. What he wanted above all else was protection for his pear tree, the source of his livelihood. The saints arranged it so that no one who climbed the tree to steal pears would be able to come down without le Bonhomme Misère's permission. One day Death arrived to take the old man away, but was persuaded to climb the tree to fetch one last pear for his victim. Of course, Death could not climb down without the old man's agreement, and so a bargain was struck between them—Misery was to remain on earth until the Last Judgment. Champfleury remarked, "Misère will remain on earth as long as the world exists, but one must not take this outcome as absolutely final, an inflexible axiom which would encourage governments to turn their attention from the sufferings of the masses."[39] Legros may also have intended his etching of the story as an allegory of human suffering in his own time. The raggedy old man does not seem to control his destiny; rather, he looks anxiously at Death, who maliciously dangles a ripe pear, his last, simple request, just beyond his reach. Is Misère a pathetic representative of the lower classes, for whom death and perennial misery are the only alternatives? The millstone at the foot of the tree and the quarry wheel in the background suggest the continuous grind of labor and, more broadly, Time itself. Or is the etching satirical: does the old man's attempt to escape his own mortality represent human foolishness?[40] In either case, Legros capitalized on the significance of the print as a conveyor of social concern or an expression of popular wisdom.

Bracquemond's *The Cock* (1882; fig. 9.25) also shows a historical awareness, for not even Dürer, with his variety of burin marks, could have better captured the textures of this animal's

FIGURE 9.24

Alphonse Legros. Death
in the Pear Tree. *1869–
75. Etching. 223 ×
147 mm. Kresge Art
Museum, Michigan State
University, East Lansing.*

feathers, beak, feet, and crest, or its arrogant, alert stance. (Picasso, in his delightful series of animal prints, would later do this last aspect of the cock equal justice.) However, rather than try to conceal the strong, dark, etched lines, Bracquemond emphasized them, achieving his textures by their sparseness or thick grouping, a linear range that is even more evident before the background was added. Not only is this print a superb illustration of a natural form; it is also a display of the sheer beauty of the printed line: what the original printmaker should value most highly, according to the aesthetic of the etching revival.

The chief vehicle of this aesthetic was landscape. In *The Willows on the Mottiaux* (1868; fig. 9.26) Bracquemond carried on Daubigny's interest in the river view and a love of reflections on rippling water. The clarity of individual forms and details remains intact, however—the pollarded willows at the left, the dense undergrowth on the bank at the right, the moored boats and the ducks on the water. The lightly bitten and cleanly wiped countryside in the back-

FIGURE 9.25

Félix Bracquemond. The
Cock, *first state without
background. 1882.
Etching. 322 × 249 mm.
College of Wooster Art
Museum, Wooster, Ohio.*

ground serves as a foil for the dark shadows of the trees and boats, more deeply etched and richly inked. We are made very aware of the action of the etcher's needle, particularly in the surface of the water. With more than nine hundred works to his credit and his encouragement of artists like Manet and Degas to produce prints, Bracquemond must be regarded as a central figure in the renewed appreciation of etching in the late nineteenth century.

Johan Barthold Jongkind had come to France from Holland in 1846. Despite the preeminence of etching in his native artistic heritage, Jongkind made only twenty-two plates, mostly for Cadart. These works are, however, some of the most surprisingly spontaneous prints of the late nineteenth century. In comparison with Bracquemond's delicate *Willows*, Jongkind's *Setting Sun, Port of Antwerp* (fig. 9.27) published in *L'Illustration Nouvelle* in 1868, is positively crude. Unconcerned with the niceties of the technique, Jongkind allowed foul-biting, pitted plates, and seemingly haphazard slips of the needle to characterize his prints—indeed, this is part of their charm.[41] *Setting Sun* fairly quivers with his active and undisguisedly "etchy" line. Rooted in Dutch seventeenth-century harbor views, with their tall masts and sails forming imposing silhouettes against cloudy skies, it is nevertheless thoroughly modern in its assertion of the aesthetic of the sketch and its concern for light and shade as opposed to solid form.

FIGURE 9.26

*Félix Bracquemond.
The Willows on the
Mottiaux. 1868. Etching.
203 × 295 mm. College of
Wooster Art Museum,
Wooster, Ohio.*

FIGURE 9.27

*Johan Barthold Jongkind.
Setting Sun, Port of
Antwerp. 1868. Etching.
151 × 233 mm. Biblio-
thèque Nationale, Paris.*

The most important painters to be encouraged by Cadart and Bracquemond to make prints were Manet and Degas, whose lithographic work we have already encountered. Manet's inspiration, in etching as in some of his lithographs, was Goya. *Lola de Valence* (ca. 1863; fig. 9.28), a portrait of a voluptuous Spanish dancer who performed at the Hippodrome in Paris, derives directly from Manet's own painting and indirectly from the *majas* of Goya's *Caprichos*. Like his fellow Parisians, Manet was fascinated by all things Spanish. But more than that, Goya's use of aquatint undoubtedly appealed to Manet because it corroborated his interest in flat areas of tone or color and the reduction or omission of the gradual stages of shading that were associated with the academic tradition. In *Lola,* Manet moved from a delicate linear surface to a dense network of lines over coarse aquatint in the published state, shown here. Despite its flat shapes and stark chiaroscuro, however, Manet maintained the extraordinary transparency of Lola's lace mantilla throughout his transformations of the plate. Beneath the etching, Baudelaire's verse carried an erotic *double-entendre* that corresponded to the bold sexuality of both Manet's Lola and Goya's fiery *majas*.[42]

Traced from a preparatory drawing, which was itself traced from a photograph of the original oil, *Lola* is one of many of Manet's etchings that duplicate or rework painted compositions in emphatically graphic terms. It could be argued that the most innovative aspects of Manet's style—his reduction of modeling and spatial layering, his bold shapes and strident tonal contrasts—are accentuated in his etchings, which usually functioned to promote his paintings. One of the two etchings after his most notorious canvas, *Olympia* (1863), illustrated Zola's pamphlet defending Manet's art, published for the latter's one-man show in 1867. Although not one of Manet's most impressive prints, and completed with an uncertain amount of help from Bracquemond, this etching of *Olympia,* with added Spanish curl as if to acknowledge Goya's influence, reiterated the flatness and frankness of the canvas and reasserted its ironic transformation of the ideal Renaissance nude into a bored, waiting courtesan.[43]

Manet's most impressive etching related to a painting is the large *Dead Christ with Angels* (1866–67; 9.29), whose ultimate model was exhibited in the Salon of 1864. From a photograph of that work, Manet prepared a watercolor, with composition reversed. He then used the reversed watercolor, in which the position of Christ's wound is correct, as the immediate reference for his work on the etching, in which the wound is wrongly placed, as in the original oil. (We might recall Rembrandt's apparent lack of concern for the iconographically correct position of the two thieves in the third state of *The Three Crosses;* see figs. 4.54, 4.55). As he worked through the states of the *Dead Christ,* Manet expertly used the aquatint to attain a graphic equivalent for the washes of the watercolor and, especially in the somber third state, for the disturbing realism of his original conception. The *Dead Christ* was never published (it was too big for the usual print portfolios and journals) and remains a rare print.[44]

What Manet intended by this image is, of course, debatable, but perhaps, as Michael Driskel suggests, it is more important to discover the meaning the image would have had within Manet's historical and social context, apart from the artist's intentions, which in Manet's case are particularly elusive.[45] Criticism of the painting was mostly scathing, and focused on the handling of paint as well as the mundane character of Manet's Christ, who looked more like an "unwashed cadaver" than the Son of God.[46] Manet's Jesus is indeed surprising. Although the figure relates closely to Renaissance and Baroque images of the Man of Sorrows

FIGURE 9.28

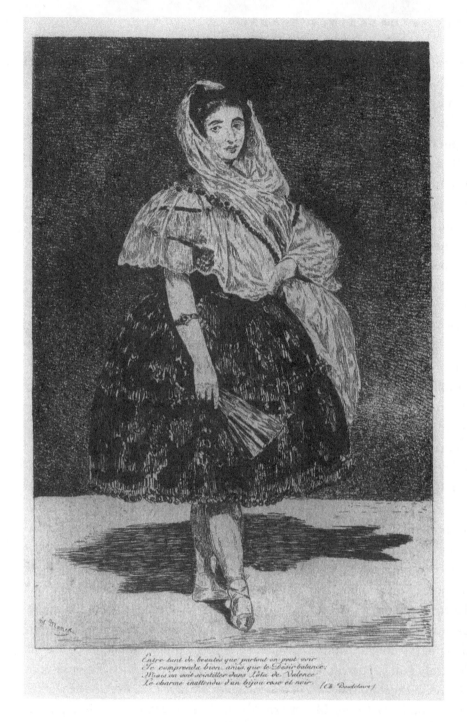

FIGURE 9.29

Edouard Manet. Dead Christ with Angels, *third state. 1866–67. Etching and aquatint. 329 × 280 mm. Cleveland Museum of Art.*

(for example, a painting by the seventeenth-century Spanish Artist Francisco de Ribalta, which Manet would have known through a reproductive engraving), Driskel has detailed its associations with the "Christ-People," a realistically depicted Christ who symbolized the downtrodden proletariat and the hope for the Republic. Driskel makes an especially interesting comparison between Manet's painting and a reproductive lithograph of Antoine Etex's painting *The Deliverance* (1845), which depicted a dead Christ reclining across the foreground and mourned by angels, one of whom held a broken shackle. The lithograph appeared in the radical journal *Le Peuple* (*The People*) in 1848 and was explicitly interpreted as "the Death of the Proletarian."[47] Given the complex political meaning that images of Christ accrued in the nine-

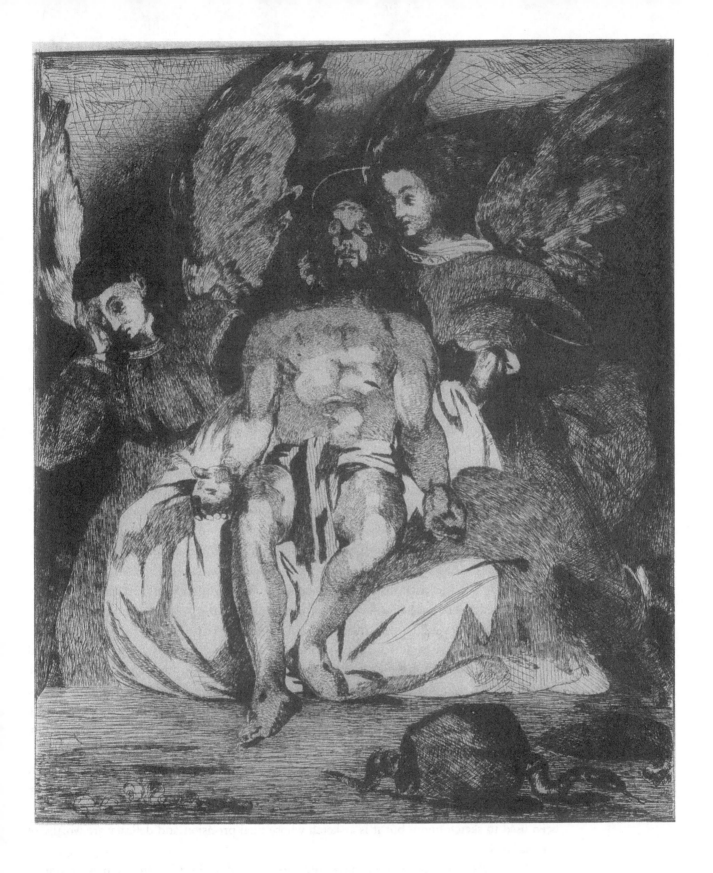

teenth century, and the long tradition of devotional prints of the suffering Christ (one of the earliest woodcuts we discussed was a Man of Sorrows—fig. 1.6), Manet's etching would have suggested, even better than the painting, a devotion to a new icon of social justice: the image of the suffering people.

Edgar Degas, not employed by Cadart, was one of the century's most fascinating print-makers. His first etching, a self-portrait done in 1857 (fig. 9.30) when he was twenty-one years old, already reveals his feeling for the brittleness of the etched line. In the third state, the plate was marred by accidental biting, which Degas cleared away in the fourth state, while strengthening the features with drypoint.[48] Despite the redundancy and tightness of the cross-hatching, built up from numerous bitings, the print is a frank, convincing image focusing on his objective, scrutinizing gaze. Its somberness is akin to Rembrandt's *Self-Portrait* of 1648 (figs. 4.42, 4.43), despite the difference in the subjects' ages. (The plain black hat and coat may even indicate Rembrandt's work as a direct influence on Degas.) Through the years and with a very small audience of artists and friends, he added lithography, etching, and monotype to his exploration of sculpture, pastel, oil, and even photography.

Degas was intensely interested in the subtle transformation of an image throughout the various states of a print. *Mary Cassatt at the Louvre: The Paintings Gallery* (aquatint, etching, and drypoint, 1879–80; figs. 9.31, 9.32) went through twenty states, the first and tenth of which are reproduced here. The striking silhouette of his American friend and colleague, probably accompanied by her sister Lydia, was derived from a Japanese woodcut, one of Hokusai's sketches from *Manga*. In the first state, the basic contours of the two figures are established. Degas did not change them in later states, but concentrated instead on refining the spatial implications of the tonal values, as well as shape and pattern: the states show seven patterns for the door jamb and four different forms for Mary's hat.[49] In the tenth state, the marble-like border on the left reads like a wall around which we are about to step to encounter the painter, absorbed in the paintings, and Lydia, looking up from her guidebook. At the same time, the mottled surface of this strip combines with the herringbone pattern of the floor, the trapezoids of the frames, and the black shape of Mary herself to form a tightly knit surface composition. Equally varied and controlled is the range of textures within the aquatinted areas.

For both Degas and Cassatt, the traditional importance of line and drawing, as well as the impact of the Japanese print, remained undiminished despite their links to Impressionism and the etching revival's emphasis on sketchiness. *Quietude* (ca. 1891; fig. 9.33) depicts Cassatt's favorite subject, a mother caressing her child, in pure drypoint. The flat, profile view of the mother is contrasted to the rotund form of the infant, staring full face at the viewer like some Renaissance Christ child: indeed, the Madonna tradition is never far from Cassatt's conception. Her numerous explorations of the mother and child theme, tender yet never sentimental, reflect the contemporary interest in the domestic and maternal duties of women.[50] Here, Cassatt modeled the mass of the child's body fully, with overlapping lines of subtly altered thicknesses. Around the child's feet and the mother's hands and arm, *pentimenti* are visible; the plate has been used to sketch upon, but it is a sketch whose final precision and delicacy are worthy of Raphael or Ingres.

In Cassatt's series of ten innovative color prints, produced for her first solo exhibition at the Durand-Ruel Gallery in Paris in 1891, the Japanese influence is most pronounced. Her exposure to Kitagawa Utamaro's superb woodcuts, such as *Combing Hair* (fig. 9.34) from a series on female activities (ca. 1800), is especially apparent. Indeed, Nancy Mowll Mathews

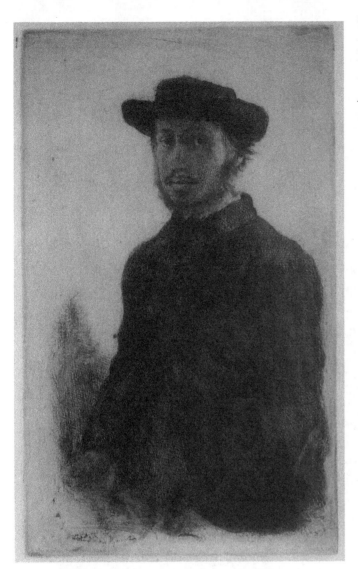

FIGURE 9.30

Edgar Degas. Self-Portrait, *fourth state. 1857. Etching and drypoint. 232 × 144 mm. National Gallery of Art, Washington, D.C.*

points out that it may have been Cassatt's intention to produce an essay on the daily life of western women that echoed such cycles in Japanese prints.[51] In the Durand-Ruel prints, Cassatt's art achieved its greatest range in terms of subject matter, although the private world of women was still her major concern. In *The Fitting* (fig. 9.35, color plate, p. 472), Cassatt's observation of women engaged in an ordinary activity on which they concentrate, unaware of the viewer, is similar to Utamaro's in *Combing Hair*. There is also a like play of pattern against pattern—in the Japanese example, the two kimonos; in Cassatt's, the two striped dresses and the leafy wallpaper—and of flat, unmodulated cheeks and hands against the fine linear treatment of the hair. Both prints have a subtle, neutral color scheme in which mauve and brownish-mauve predominate. The two works are sharply distinguished, however, by the different attitudes toward the women they portray. We revel in the delicate features and colorful garments of Utamaro's gorgeous mannequins; Cassatt observes, without erotic overtones, plain women. Her works reveal a unique insight into the private spaces of women's lives.

The Letter (fig. 9.36), also a part of the 1891 series, is reminiscent of seventeenth-century Dutch images of women reading or writing letters, with the vague suggestion of absent lovers

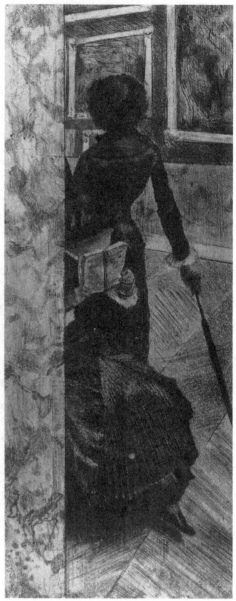

or husbands. The mauve of *The Fitting* reappears in the woman's bodice, played here against a
brilliant turquoise blue. The beige pattern of the dress stands out against this dark blue field;
in the wallpaper, the dark/light relationship is reversed, with green leaves on a pale surface.
Cassatt even gave the woman Japanese features, including the slightly crossed eyes considered
a mark of beauty, as if to underline her debt to Utamaro, Toyokuni, and others. (Likewise, the
faces of the infants in this series are reminiscent of Utamaro's little Kintaro, nourished by his
mountain mother, in a series of thirty charming woodcuts.)[52]

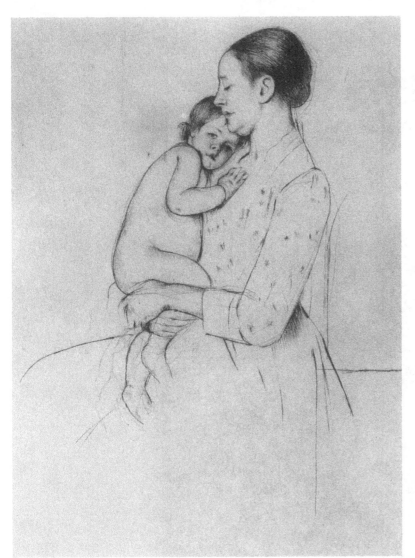

FIGURE 9.33

Mary Cassatt. Quietude. *Ca. 1891. Drypoint. 258 × 174 mm. New York Public Library.*

Cassatt herself described the multiple-plate technique of these magnificent prints in two letters (though unfortunately not very thoroughly), and her methods were also discussed by Pissarro in a letter to his son Lucien. She seems to have made a key, linear plate in drypoint, which was printed last, like the line blocks in the Japanese process. As a guide, the linear design was transferred to one or two additional plates by a soft-ground or other process, and these plates were then aquatinted (*not* soft-grounded, as has been speculated), inked *à la poupée,* and masterfully registered, along with the key plate, to obtain the final image. The extraordinary beauty and delicacy of the Durand-Ruel prints reflect not only the coloristic sensibilities of a fine painter, but also a gift for comprehending the experimental possibilities of intaglio print-making, akin to Rembrandt's and Degas's. Rather than work conventionally through orderly state changes on each plate, Cassatt took a more organic approach to developing the final image: color might appear in the proofs before the linear plate was completed, for example. Undoubtedly Cassatt's innovation was aided by the advice of the expert M. Leroy. The artist acknowledged his collaboration on the prints of the final edition, much as Japanese woodcuts are embellished with the printer's stamp.[53]

FIGURE 9.34

Kitagawa Utamaro.
Combing Hair. *Ca. 1800.*
Color woodcut. 381 ×
245 mm. Elvehjem
Museum of Art, Uni-
versity of Wisconsin–
Madison.

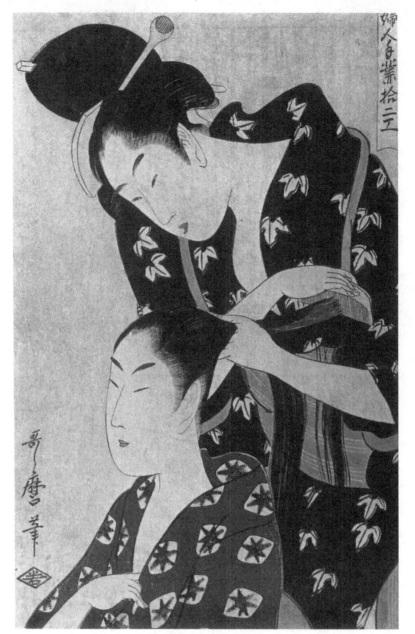

As we noted in Chapter 8, of all the Impressionists, Pissarro was the most dedicated to printmaking. His printing of *Twilight with Haystacks* (etching and aquatint; 1879; fig. 9.37, color plate, p. 473) with variously colored inks is analogous to Monet's famous series of paintings in which he explored the changing effects of light on the masses of hay.[54] And Shapiro has discussed the affinities between Pissarro's experimental approach to etching and Rembrandt's, as well as that of his colleague, Degas.[55] In *Haystacks*, Pissarro minimized lines, so that the aquatinted and stopped-out areas read as the diffused light and the long, iridescent shadows of twilight. The composition is structured solely by these dark/light areas: the crescent-curve of the road divides the landscape, whose horizontality is punctuated by rhythmic verticals—the row of thin trees at the left, followed by squatter trees near the center, the figures and the fat, pointed turban-shapes of the haystacks. This dominant horizontal/vertical structure is subtly

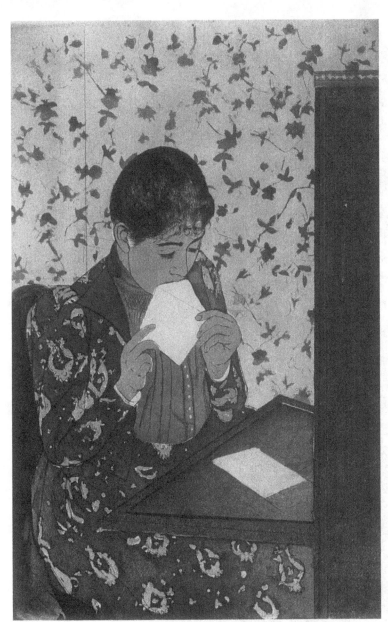

FIGURE 9.36

Mary Cassatt. The Letter *from a series of ten color prints. 1890–91. Aquatint etching and drypoint. 345 × 211 mm. New York Public Library.*

countered by concentric, scraped lines in the sky, which give a sense of light radiating from a point on the horizon: Claude and Turner have not been entirely forgotten.

Nor has the Barbizon school. The influence of Millet is still evident (compare *Peasants Going to Work,* fig. 9.17), but the human being is, in Pissarro, even less heroic, more absorbed into his/her surroundings. *Woman in a Kitchen Garden* (etching, aquatint, begun about 1880; fig. 9.38)—in Europe, small gardens utilize all available space—aggressively asserts this tie to the earth by formally assimilating the rounded masses of the woman's bent form to the cabbages she tends. Both are kept within the lower area of the composition, sharply separated from the upper layers with the wall and large house.

FIGURE 9.38

Camille Pissarro.
Woman in a Kitchen
Garden, *second state*
(first state ca. 1880).
Etching and aquatint.
248 × 169 mm. Biblio-
thèque Nationale, Paris.

WHISTLER AND HADEN

In England, the most prominent exemplars of the etching movement were the expatriate American James McNeill Whistler, and his brother-in-law, the physician-etcher Francis Seymour Haden. Unlike Whistler, the latter maintained strong connections to French champions of the etching revival such as Cadart and Burty, and would play a central role in the proliferation of the movement in America. Haden's *Shere Mill Pond, Surrey* (1860; fig. 9.39), an unassuming slice of nature, reveals his most important debt: to Rembrandt. The ordinariness of the scene is transfigured by freshness and luminosity with which it is interpreted. In his first edition of *Etching and Etchers,* Philip Gilbert Hamerton praised Haden extravagantly for raising public awareness about etching and for adhering to its innate aesthetic properties (as defined by Hamerton) in his own works.[56]

FIGURE 9.39

Francis Seymour Haden.
Shere Mill Pond, Surrey.
1860. Etching with dry-
point. 178 × 333 mm.
Cleveland Museum of
Art.

Haden's irascible relative, however, was a far more interesting artist. His early *French Set* (1858), so named even though it incorporated German scenes, is still heavily indebted to the etchers of Barbizon, particularly Jacque and Millet. *The Unsafe Tenement* (fig. 9.40) might be compared to Jacque's *Staircase* (fig. 9.18). Both prints show a concern for aged, textured surfaces, rendered with complex hatchings, and an unstudied realism reminiscent of Dutch Baroque genre scenes. But a year later, when he etched his famous *Thames Set*, not published until 1871, the new, dynamically linear approach of Meryon and Bracquemond became apparent, and Whistler had clearly established himself as an etcher of the foremost rank and originality.

Two centuries earlier, Hollar had etched sparse, beautifully composed *Views of London before and after the Fire*, a precedent of which Whistler was well aware (see Chapter 4).[57] As in Hollar's series, the Thames River is the central thread running throughout Whistler's. *Black Lion Wharf* (fig. 9.41), with its backdrop of inky, crumbling buildings reminiscent of Meryon's *Morgue* (fig. 9.21) and other views of Paris, has the gritty realism that characterizes all the etchings. Much more prominent in Whistler's prints than in Meryon's are the working-class people; here, one dominates the foreground, which is, like the middleground, more sparsely delineated than the row of buildings on which we focus. Katherine Lochnan has illustrated the relationship of Whistler's etchings to contemporary optical theory and photography: when the eye or camera focuses on one spatial area, details in the others tend to "fall away."[58]

Even the realist in Whistler was captivated by the romantic scenery of Venice, which he visited in 1879 after the humiliating experience of declaring bankruptcy. The popularity of Venice for artists, tourists, and writers insured an audience for any prints Whistler made there. *The Balcony* (1879–80; fig. 9.42), part of a series of twelve etchings commissioned by the Fine Art Society in London, reveals a tremendous change from the etchings of *The Thames Set*. Instead of the strong lines and tonal contrasts reminiscent of Meryon, Whistler worked impressionistically, breaking the continuity of the crumbling surfaces with light and shadows

FIGURE 9.42

*James McNeill Whistler.
1879–80.* The Balcony
from The Venice Set,
*published 1886. Etching
and drypoint. 293 ×
198 mm. Library of
Congress, Washington,
D.C.*

made up of delicate, often interrupted lines. The images hover within the sheets of paper, and vacillate between a two-dimensional, softly patterned flatness—augmented by the reflections on the water's surface—and a sense of layered space (here, from the water in the foreground, to the boat and projecting balcony, to the façade of the building and the door's threshold, and beyond into the darkness of the interior in which the figure stands). The luminous quality that artists had always found in Venice (think back to Canaletto, for example, figs. 6.2, 6.3) is achieved in these prints in terms of a new understanding of the non-mimetic autonomy of the pictorial surface, for which Whistler was an important spokesman.

Woodcut and wood-engraving, too, enjoyed a flowering in the nineteenth century.[59] The former, the earliest print medium, had long been relatively dormant, whereas the latter, more recently invented, became a frequent means for book and journal illustration. Although also classified as relief prints and printed the same way as woodcuts, wood-engravings may differ considerably from their siblings in appearance. A hard wood, usually boxwood, is cut across the grain and carved with a burin very similar to the tool used in intaglio engraving. Often large blocks for wood-engraving are made up of small end-grain blocks bolted together. The usual effect of wood-engraving is white-line on black ground, but this can vary depending upon the amount of the printing surface excavated by the graver. The prints of Alfred Rethel's 1849 series, for example, are traditionally classified as wood-engravings, but they look just like wood-cuts and are sometimes designated as such (fig. 9.46).

Absolutely essential for the extraordinary success of the wood-engraving in the nineteenth century were the smoother wove papers of the eighteenth, without which all its fine detail would have been lost in printing. And, like woodcuts, wood-engravings were compatible with type, and could be used as illustrations much more cheaply and easily than intaglio plates or lithographic plates or stones. But it was the dramatic improvement of printing technology in the nineteenth century that reinforced the inherent compatibility of relief printmaking in the form of wood-engraving with illustration. The development in 1829 of stereotypes—duplicate molds made from combined type and relief images—and of electrotypes a decade later, made it possible to print the same image on several presses at once. Efficiency was also increased by steam-driven presses and machine-made papers.

Professional wood-engravers generally worked from drawings: the traditional separation of designers and artisans in the relief medium was maintained. By the 1860s, however, photographs could be transferred directly to wood blocks. This wedding of wood-engraving and photography would have insured the dominance of the former for illustration had it not been for the invention of the line-block process, descendant of gillotage, whereby an image was photographically transferred to a zinc plate, which was then etched in relief and thus made type-compatible. Reproductive wood-engravers, such as those of the American school whom we will discuss in Chapter 12, tried to prove their superiority by attaining an extraordinary degree of photographic accuracy through manual skill. The revival of the original woodcut in the late nineteenth century, especially by the Symbolist artists Munch and Gauguin, must be understood against the increasingly technological and reproductive character of relief print-making in that period. Woodcuts by these artists formed such an important precedent for German Expressionist woodcuts that they will be discussed in Chapter 10.

Although white-on-black wood-engraving had been used in the late seventeenth century for initial letters in books, its history really begins with Thomas Bewick of Newcastle (1753–1828), who perfected it in charming, delicately carved vignettes and illustrations and his books, the most famous of which were *A General History of Quadrupeds* (1790; see fig. 9.43) and *The History of British Birds* (1797–1804).[60] With the works of his followers, wood-engraving was well on the way to being the most important mode of book and periodical illustration in the nineteenth century.

The seventeen prints Blake made to illustrate *The Pastorals of Virgil with a Course of English Reading, Adapted for Schools . . .* by Robert John Thornton (1821) are certainly the

FIGURE 9.43

Thomas Bewick. The
Cur Fox *from* A General
History of Quadrupeds.
*Newcastle Upon Tyne,
1790. Wood engraving.
51 × 89 mm. Yale Center
for British Art, New
Haven.*

FIGURE 9.44

William Blake. Blasting *London: F. C. and J.*
Winds (Thenot): *Sixth* *Rivingtons, 1821. Wood*
illustration from vol. 1 of *engraving. 35 × 74 mm.*
Robert John Thornton's *Yale Center for British*
The Pastorals of Virgil. *Art, New Haven.*

most remarkable examples in the first half of the century. Neither Thornton nor the publishers liked them—they departed too much from the precisely detailed wood-engravings that had developed from Bewick's example—but the author was persuaded to use them, in an altered form, by some artist admirers of Blake.[61] The prints taken from the recut blocks are much more conventional than Blake's proofs, which show no interest in the precision possible in wood-engraving. Rather, he sought coarse and powerful white-line effects similar to those in his relief etchings. The sixth illustration (fig. 9.44), devoid of human figures, depicts a stormy night with a crescent moon illuminating the field and a huge, gnarled tree. The rhythmic repetition of semicircular curves, not surface precision, dominates Blake's conception, and the white lines and shapes suggest broad areas of light and shadow. This visual language, of course, reasserted Blake's vehement opposition to anything systematized or mechanical in printmaking, and reaffirmed the artist's presence as creator of the images.

Blake's wood-engravings inspired Edward Calvert's seven blocks, which, along with two engravings on copper and two lithographs, make up the tiny graphic oeuvre of this pastoral painter. In *The Ploughman—The Christian Ploughing the Last Furrow of Life* (1827; fig. 9.45), the soul coming to the end of his mortal life is about to emerge into a clearing, where musicians and a shepherd will greet him. At the left, a descending angel slays a serpent. The Christian symbolism of death, eternal life, and redemption is couched in pastoral terms. The mood and simplified figure style recall Blake's *Virgil* illustrations. But the rhythmic, swinging curves of Calvert's landscape, by comparison, are almost rococo in their complexity. The white lines and

FIGURE 9.45

Edward Calvert.
The Ploughman—The
Christian Ploughing the
Last Furrow of Life.
1827. Wood engraving.
82 × 127 mm. Yale
Center for British Art,
New Haven.

stippling that describe the foliage, tree trunks, and horse's coat approach Bewick in their fineness and also recall Renaissance engravings such as Dürer's *Fall of Man* (fig. 2.8). As Essick remarks, the true heirs of Blake's *Virgil* illustrations are Munch and Gauguin, artists who worked *with* the nature of the wood rather than *against* it.[62]

Building upon Holbein's earlier series (see figs. 2.39–2.42), Rethel, in *Auch ein Totentanz* (*Another Dance of Death,* 1849), expanded the settings while preserving the sinister liveliness of the skeletons. Whereas Holbein's skeletons embodied a natural force that attacked all social classes, Rethel's Death is a very particular and political seducer: he is interested in the deception and ultimate ruin of the lower classes. *Auch ein Totentanz,* Peter Paret has recently pointed out, does not condemn all revolutions, only those—like the urban uprisings in Europe in 1848 and 1849—in which the lower classes are incited to attack law and order. As a moderate bourgeois, Rethel supported only some reforms: those leading to a constitutional government with a monarch. He saw the extension of political power to peasants and workers as dangerous.[63] In *Death on the Barricade* (9.46), the fifth print of the series, the skeleton stands squarely atop a mattress, pulling away his coat to reveal his own hollowness. Clark notes the sense of confusion and futility conveyed by Rethel's fragmented design.[64]

Nineteenth-century wood-engravings more often than not imitated intaglio engravings in their fineness of line and detail. The subtle tonal effects of Gustave Doré's illustration for Dante's *Inferno* (1865; fig. 9.47), all derived from closely spaced hatchings, are also reminiscent of old-master engravings. The principle of the graphic middle tone, employed by Dürer, is natural to wood-engraving, since the uncarved surface is inked, with the white lines emerging from the dark background as highlights. Doré and the carver he employed exploited the principle brilliantly, contrasting the fiery chasm with the shaded rocks in the foreground and the grays of the high space above the figures, whose small forms cast long, dark shadows on the walls behind.

In London, the brothers George and Edward Dalziel carved blocks after drawings made on the wood by artists such as John Everett Millais, William Holman Hunt, and Arthur Boyd

Fünftes Blatt.

„Zur Barrikade!" „Pflaster auf!" — —
Da steht der Bau — und oben drauf
Er, den zum Führer sie ernannt,

Die blut'ge Fahn' in fester Hand! —
Kartätschen pfeifen, hei! das kracht,
Sie stürzen rings, Er aber lacht:

„Jetzt lös' ich mein Versprechen Euch!
„Ihr Alle sollt Mir werden gleich!"
Er hebt sein Wamms und wie sie's schaun,

Da faßt ihr Herz ein eisig Grau'n,
Ihr Blut strömt, wie die Fahne roth,
Der sie geführt, — es war der Tod!

FIGURE 9.46

Alfred Rethel. Death on the Barricade: *Plate 5 from* Auch ein Totentanz (Another Dance of Death), *1849. Wood engraving. 270 × 395 mm. New York Public Library.*

Houghton. Although often not very well integrated with type and page design, these illustrations are beautifully drawn and executed prints.[65] Millais's *Return of the Prodigal Son,* from *The Parables of Our Lord and Saviour Jesus Christ,* published in 1864 (fig. 9.48), exhibits the Dalziels' expert technique: fine white lines and stippling define the textures of the father's robe, the grass, and the fur loincloth that is the son's only remaining garment. As the two embrace tenderly, reclining cattle and broad trees on the hillside convey the serenity of homecoming.

In the mid-1880s photomechanically produced blocks and plates put an end to the thriving industry of wood-engraved illustrations and reproductions. The technique was resuscitated toward the end of the century, however, by artists such as Edward Burne-Jones, who designed illustrations for an 1896 edition of Chaucer published by the Kelmscott Press (see fig. 9.49), co-founded by himself and William Morris, leader of the Arts and Crafts movement. Their interest in medieval art, especially book illumination, is reflected in the use of vellum for the pages. Coupled with the border designs and powerful type, set in two columns on each page, the eighty-seven illustrations have a strong, black-on-white impact. Any semblance of the conventions of Victorian wood-engraving has been abandoned in favor of flat, patterned design, reminiscent of the stately compositions in the *Hypnerotomachia Poliphili* of the fifteenth century (see figs. 3.26, 3.27). Similarly, both the Vale Press under the leadership of Charles Shannon and Charles Ricketts and Lucien Pissarro's Eragny Press produced illustrated books

FIGURE 9.47

Gustave Doré. The Punishment of the Evil Counselors *(Canto XXVI, lines 46–49) from* L'Enfer de Dante Alighieri. *Trans. Pier-Angelo Fiorentino. Paris: L. Hachette, 1865 (first edition 1862). Wood engraving. 241 × 191 mm. Library of Congress, Washington, D.C.*

with strikingly flat, "decorative" images. In *Ophelia* (fig. 9.50) by Lucien Pissarro, the numerous patterns of the image itself are framed by a beautiful flower and vine border, reminiscent of those found in the margins of medieval manuscripts.

In contrast to Lucien Pissarro, Félix Vallotton favored the traditional woodcut, carved on the plank-grain. His woodcuts are some of the most unusual prints of the late nineteenth century. Strongly influenced, like many of his contemporaries, by Japanese woodcuts, Vallotton pursued Japanese principles of design in the same medium in which he encountered them, instead of translating them into lithography (Lautrec) or etching (Cassatt). Vallotton's political views dominate his woodcut oeuvre. Like Pissarro, he contributed to the journal *Les Temps Nouveaux* and sympathized with the anarchists' cause. In *The Demonstration* (1893; fig. 9.51), the diagonal movement of the street, filled at the top with the solid black shapes of the dispersing demonstrators, dominates the composition. The rotund, cartoon-like figures are entirely anonymous: members of the masses who are victims of larger political and economic forces. Like Daumier, Vallotton learned to simplify in order to achieve an immediate visual impact.

FIGURE 9.48

George and Edward Dalziel after John Everett Millais. The Return of the Prodigal Son *from* The Parables of Our Lord and Saviour Jesus Christ. *London: Routledge, Warne and Routledge, 1864. Wood engraving. 140 × 108 mm. British Library, London.*

MONOTYPE: ORIGINS AND FLOWERING

Except for occasional efforts such as Blake's color prints, the monotype process, invented in the seventeenth century by Giovanni Benedetto Castiglione, had likewise lain dormant until awakened in the nineteenth century, catalyzed by the etching revival's emphasis on the variable inking and wiping of plates, and the contemporary concept of the fine original print, with all its implications of spontaneity and autographic expression.[66]

The idea of the monotype is akin to the variable inking and wiping of intaglio plates, and to the *à la poupée* inking of any plate, stone, or block. Rembrandt had gone to extraordinary lengths to vary impressions, not only by altering the plate itself, but also by inking and wiping it differently. Perhaps the most dramatic examples of this are the different impressions of his *Entombment* (1654; figs. 9.52, 9.53) in which the quiet mourning figures are crisply illuminated or plunged into varying degrees of a nocturnal gloom that echoes their despair. Nineteenth-century etchers greatly admired Rembrandt for such experiments. The printer Delâtre was particularly well known, and often criticized, for his heavy and varied inking of plates.[67] It

FIGURE 9.49

Edward Coley Burne-
Jones. First illustration for
the Parlement of Foules
from The Works of
Geoffrey Chaucer. *Upper
Mall, Hammersmith,
Middlesex: The Kelmscott
Press, 1896. Wood en-
graving. 390 × 260 mm
(page). British Library,
London.*

FIGURE 9.50

Lucien Pissarro. Ophelia, *frontispiece of* Moralités Legendaires *by Jules Laforgue. London: Hacon and Ricketts, 1897–98. Wood engraving. 186 × 115 mm. British Library, London.*

could too easily become a gimmick that only thinly disguised banal imagery, as in the eighty various views of the Escaut River by Vicomte Ludovic Napoléon Lepic, in which the weather changes from impression to impression, and a windmill catches fire.[68]

In contrast to Lepic, an inspired amateur, Whistler was a practiced artist and experimented with such effects, as Rembrandt had, without falling into gimmickry. A superb example is *Nocturne* (1879–80; figs. 9.54, 9.55), etched in Venice—not in front of the site (the Grand Canal with Palladio's church of San Giorgio Maggiore in the right background), but from memory.[69] No two impressions of this plate are exactly alike. Through selective inking and wiping of the plate, Whistler alternately emphasized the broad, luminous expanse of water,

FIGURE 9.51

Félix Vallotton. The
Demonstration. *1893.
Woodcut. 204 × 319 mm.
National Gallery of Art,
Washington, D.C.*

FIGURE 9.52

Rembrandt van Rijn.
The Entombment, *first
state. 1654. Etching with
drypoint and engraving,
clean-wiped. 211 ×
161 mm. Pierpont
Morgan Library, New
York.*

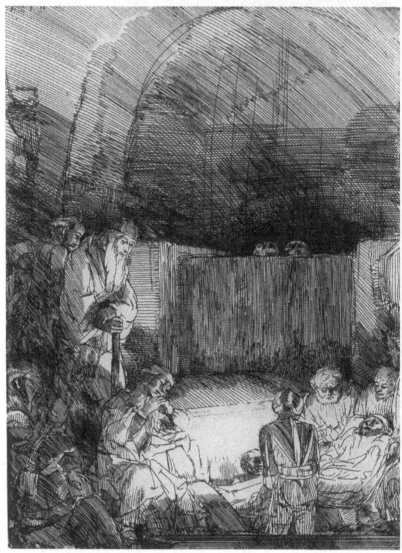

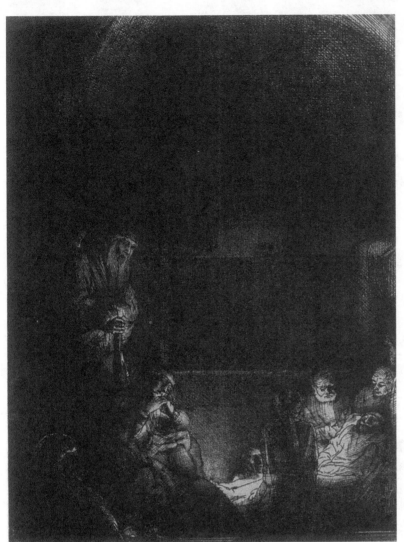

FIGURE 9.53
*Rembrandt van Rijn.
Fourth state of fig. 9.52,
with added drypoint and
printed surface tone.
Pierpont Morgan Library,
New York.*

the Claudian or Turneresque glow of light at the horizon, or, in the darkest impressions, the obliteration of spatiality in a foggy continuum. Whistler entitled his print *Nocturne* to deemphasize topography (the view itself is reversed) and to assert the image as an independent creation, like a musical composition, potentially free of narrative or descriptive content and subject to different interpretations with each "performance" (each inking, wiping, and printing of the plate). It is easy to see how the monotype would appeal to late nineteenth-century printmakers, familiar with the possibilities of variable inking and wiping in etching and steeped in the notion of artistic autonomy.

The monotype qualifies as a print by virtue of its having been taken off a surface such as a painted copperplate. It departs from the basic definition of the print, however, by being unique. It might be thought of as a printed painting, with the added dimension of the paper's absorbency, which causes the impasto effects literally there on the painted plate to be illusionistically present in the final image. Castiglione's *David with the Head of Goliath* (1650–55; figs. 9.56, 9.57) was printed in two pulls from a plate painted with brown oil pigment. In the first impression, the forms are well defined by the brushstroke and the brush-end, which Castiglione has employed to scrape white lines into the areas of pigment. The second, *cognate*

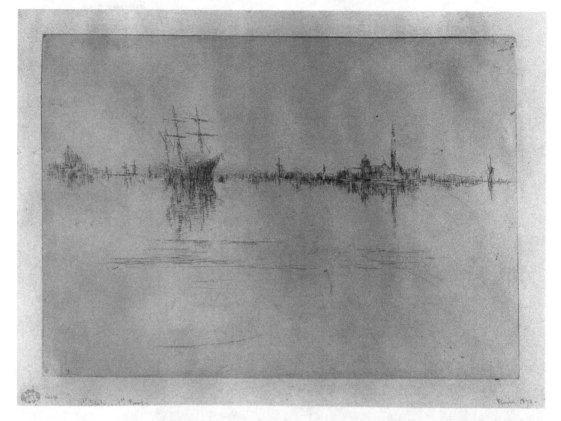

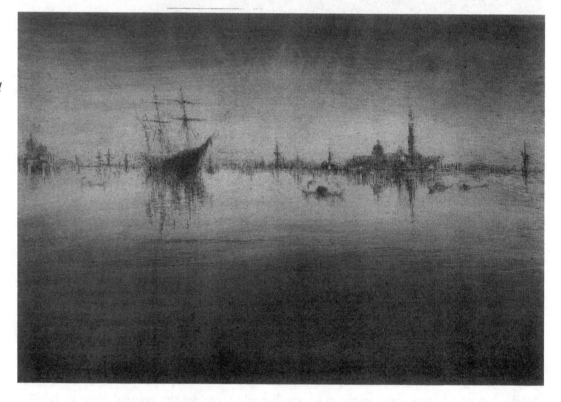

impression is lighter and softer. On both prints, Castiglione added pigment after printing. As we shall see, nineteenth-century monotypes could also be used as bases for further drawing or painting.

Castiglione's initial impression and cognate are called "white-field" monotypes—that is, the image is defined in dark lines and tones against a light ground. Another approach, analogous to the mezzotint or scraped aquatint, is the "dark-field" process, in which the image is established by wiping away ink with the fingers, palm, rags, or other implements. Degas's *The Fireside* (ca. 1877–80; fig. 9.58) is such a print. The plate was covered with black ink, which was manipulated with rags, brushes, a sharp tool for the lines, and the hand itself. Two heavy female nudes are discernible in the murky atmosphere—one is seated at the left with her leg raised above the fireplace; the other stands at the right near a bed and reaches between her legs. The setting is a brothel, and Degas dealt with it most explicitly in this series of monotypes.[70]

Despite the gestures, his treatment is not erotic, for the prostitutes are unaware of our presence and are observed with the same apparent detachment as Degas's ballet dancers or laundresses. Although some scholars see realism and immediacy as Degas's primary motivations in these unusual prints,[71] their expressive purpose is difficult to determine. Eugenia Parry Janis has noted that Degas depicted only old or unattractive women: "ugly creatures, but comic, waiting for or administering to their clients. Even at their most obscene, they are caricatures of obscenity."[72] Hollis Clayson has interpreted the prints in terms of contemporary attitudes toward prostitution. She identifies Degas's brothel setting as a licensed *maison de luxe,* which provided specialized erotic services for the habitual client, and at least a semblance of intimacy. Degas's treatment of the women and of the contact between them and their clients, Clayson argues, denies all this. His prostitutes, through both appearance and attitude, discourage sexual appetite and fantasy. Degas reduced the narrative of prostitution to a mere exchange of money and sex. His approach, Clayson concludes, was neither entirely objective nor wholly misogynistic.[73] In different ways, Eunice Lipton and Norma Broude have attempted to locate Degas's brothel monotypes in the context of rapidly changing gender roles and the ambivalent or uncomfortable responses of men to this situation.[74]

The vibrant indistinctness of the figures in *The Fireside,* as if they were phantoms taking shape out of the ether before our eyes, is one of the qualities Degas and others sought from monotype. He often utilized his monotypes and cognate impressions as a basis for pastel drawings, a process that enabled him to work through the basic conflict in his art between the impressionistic and the linear.[75] But he also employed the monotype technique for its own sake, as a way of establishing an image with the utmost economy and rapidity of means. Stored away in portfolios, these prints seem to have served as a repository of ideas for compositional motifs. In *The River* (ca. 1878–80; fig. 9.59), a small, exquisite landscape in brown ink, Degas used a few sparse wipes of the rag for the sky, plain, and hill. At the horizon line are dark clouds made of his fingerprints.

Like Whistler, Maurice Prendergast was an expatriate American whose work bears much affinity with that of his European colleagues. Prendergast was one of the most important experimenters with the monotype process.[76] *Bastille Day* (1892; fig. 9.60, color plate, p. 473), like the contemporary lithographs of the Nabis, shows the influence of Japanese prints in its spatial construction and flat patterns (e.g., the repeated round shapes of the lanterns). Prendergast developed a Whistlerian sense of floating, insubstantial forms and a harmony of saturated dark blues and greens with his deft manipulation of the oil pigment with the rag stump and brush.

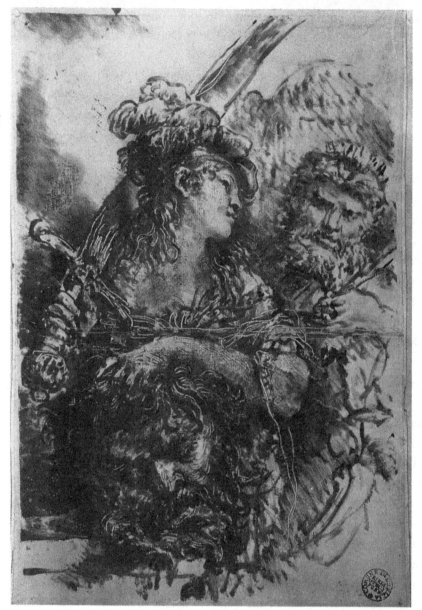

FIGURE 9.56

Giovanni Benedetto Castiglione. David with the Head of Goliath. *1650–55. "White-field" monotype in brown pigment, first pull, retouched with brown. 371 × 254 mm (sheet). Pinacoteca Civica Tosia Martinengo, Brescia.*

Another major artist experimenting with the monotype process in the late nineteenth century was Paul Gauguin. His approach to this medium was as innovative as his understanding of woodcut; indeed, Gauguin's monotypes will form a bridge to the next chapter on German Expressionist prints, for which his woodcuts were so important. Two basic techniques within Gauguin's monotype oeuvre must be distinguished: gouache (or watercolor transfer) and tracing (called "transfer drawing" in the catalog of the 1988 Gauguin exhibition).[77] In both cases the pigment or ink-bearing surface is not a copperplate but another sheet of paper, or perhaps, it has been suggested, a stronger material such as cardboard, or even a pastiche of materials.[78]

The technique of the traced monotype is reminiscent of the procedure for making soft-ground etchings. Instead of being transferred to a waxy ground on a plate, however, the drawing made on one side of a sheet of paper is transferred to the other side by placing it against a second sheet of inked paper while drawing. The image that results when the sheets are pulled

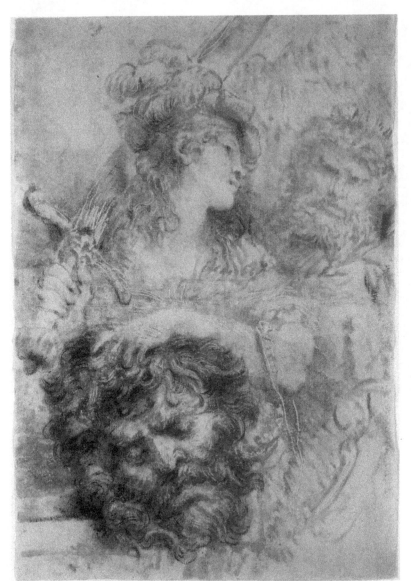

FIGURE 9.57
Giovanni Benedetto
Castiglione. Second pull
(cognate) of fig. 9.56, also
retouched with brown.
348 × 248 mm (sheet).
National Gallery of Art,
Washington, D.C.

apart has a blotched quality. The powerful modeling of *Tahitian Woman with Evil Spirit* (fig. 9.61) is thus modified by the interposing of the paper texture itself—one step removed from the actual touch of the drawing implements—and the process of pressing together and pulling apart the two sheets, which is analogous to the technique of counterproofing. Gauguin employed two "inkings"—one in black and one in brown.

In the conception of this haunting image, part of a group of ten monotypes sent to Vollard in the spring of 1900, Gauguin worked from photographs and an alleged Tahitian "idol," which he may have carved himself.[79] It is more like a gargoyle (compare Meryon's *Le Stryge,* fig. 9.20) than an Oceanic wooden figure. The unselfconscious sexuality of the Tahitian girl, with her emphatic breasts, full lips, and heavy-lidded eyes, is equally a construction—one that fitted in with Gauguin's European stereotypes of the inhabitants of the French colonies. Here the girl's sexuality is combined with an ominous sense of evil as a human hand creeps across the pillow. Is the spirit an externalization of the girl's beliefs? In his book *Noa Noa,* Gauguin claimed to

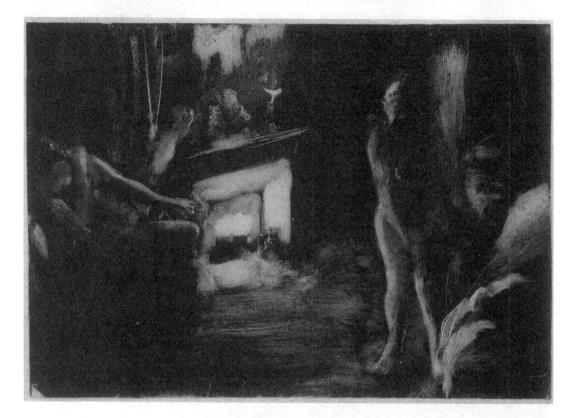

have learned about Polynesian religion from his thirteen-year-old Tahitian mistress, although this account may have been produced to appeal to French art circles. Gauguin's knowledge of traditional Tahitian culture was necessarily inaccurate and limited because of the effects on that culture of the colonization process.[80] Did Gauguin, alternatively, want to make us aware of the conflict (in western culture) of body and spirit by his juxtaposition of lush, innocent sensuality and its apparent opposite? Are the gargoyle-idol and the native girl symbols of the artist's own problematic relationship with the culture of the Pacific islands? As is usual with Gauguin, no single reading seems to encompass this suggestive image.

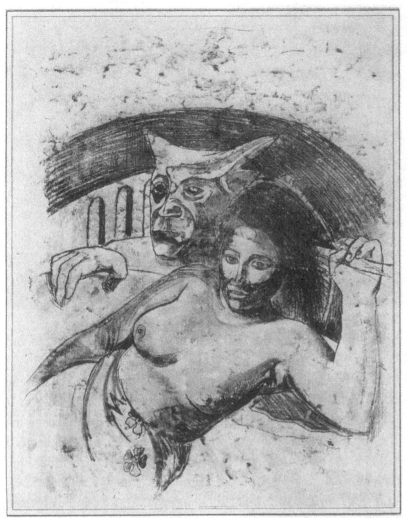

FIGURE 9.61

Paul Gauguin. Tahitian
Woman with Evil Spirit.
*Ca. 1900. Traced mono-
type or transfer drawing,
printed twice, in black
and ocher. 561 × 453 mm
(sheet). Schweizerisches
Institut für Kunstwissen-
schaft, Zürich.*

Gauguin explored the theme of the horse and rider in *The Pony* (ca. 1902; fig. 9.62) and in works in other media, including traced monotype. In this version, opaque gouache colors—blues, purples, ochers, brownish-pink, and white—were transferred in various densities from another sheet of paper by the application of pressure and rubbing, as in counterproofing a print or a drawing. Gauguin also added gum or varnish to the original image, which subsequently resulted in a crackling of the surface of the monotype itself. In a manner similar to Degas and Prendergast in their monotypes, Gauguin used this printing process to achieve a shadowy indefiniteness. In Degas's case, this indefiniteness countered a traditional, classical drawing; in Gauguin's, according to Richard Field, it tempered the decorative qualities that are inherent in the strong outlining of shapes and that Gauguin wanted to avoid. Although they grew out of his woodcuts of 1893–94, the monotypes were a reaction against them. The woodcuts, as printed by Gauguin, were a unique combination of hard and soft surfaces; as printed by Louis Roy, however, they became hardened into shaped color areas. The monotypes reversed this trend and achieved a far greater formal integration. Their color was soft and unshaped, a continuous flow that often penetrated over and under the contours, which in other media had acted as restraining limits. Thus, the process of monotype printing, which yielded this softness, was used to subdue the tyranny of the line in general, and of flat color shapes

FIGURE 9.62

Paul Gauguin. The
Pony. *Ca. 1902. Gouache
monotype with addition
of gum or varnish,
printed in blues, purples,
ochers, flesh and white.
333 × 596 mm (sheet).
National Gallery of Art,
Washington, D.C.*

specifically. By suspending the image in the medium, spatial ambiguities were introduced and illusionism was reduced.[81]

The Pony is a relief-like composition, with both the hooded rider (looking much like the idol in *Spirit of the Dead Watching*) and the horse in absolute profile. The flatness that is established by the profile view, however, is belied by the nebulous spatiality created by the monotype process: the rider and horse float within the mottled washes of color, as ephemeral as Blake's *Newton,* anchored in his blotchy, underwater world, is heavy. Even the contour lines (from the blue *cernes* of Gauguin's paintings) lack precise definition. William Kane has associated the main motif with Dürer's *Knight, Death, and the Devil* (fig. 2.14), a facsimile of which Gauguin pasted on the rear cover of his manuscript of *Avant et Après (Before and After).*[82] Dürer's engraving may well have appealed to Gauguin because it dealt with a spiritual struggle that he could relate to his own efforts to transcend the materialism and positivism of contemporary Europe by his trips to the supposedly "primitive" Brittany and Oceania. Gauguin's syncretistic mentality made such relationships among disparate traditions possible. Nor is it unusual to find that the spirit, which functions elsewhere as a representative of the supernatural realm, is here transformed into a metaphor for the human seeker.

Despite its departure from the mainstream of printmaking, the monotype epitomizes the nineteenth-century concept of the original print. With this technique the print is as unique as a painting or drawing, but unlike those media it incorporates the process of transferral from a printing surface to a sheet of paper. Twentieth-century artists would employ monotype frequently.

By the end of the nineteenth century, original printmaking had firmly reestablished itself as an art form with much to offer the most innovative European and American painters. It had regained whatever ground it may have lost during the eighteenth-century heyday of the reproductive print. Although most modern movements incorporated printmaking, Expressionism, the subject of the next chapter, esteemed it as highly as painting—or more. For the avant-garde German artists of the early twentieth century, Gauguin's woodcuts, as well as his claim to seek spiritual renewal through assimilation of non-industrial, non-European cultures, would be of crucial importance.

1. For a discussion of the stereotype of the Jewess, see Ockman 1991. For a critique of western culture's fascination with "oriental" cultures, see Said 1978.

2. On Turner's prints, see Hermann 1990. Older sources are Rawlinson 1913; Finberg 1924.

3. See Gage 1969, pp. 42–52, Hermann 1990, pp. 247–51, for the aesthetic purposes underlying Turner's instructions to engravers.

4. Finberg 1924, pp. l–li, and nos. 58 and 60.

5. Ibid., p. l.

6. On the "Elevated Pastoral," see Wilton 1980, no. 25, pp. 121–22; Hermann 1990, p. 29.

7. Wilton 1980, no. 43, pp. 133–35.

8. Gage 1969, p. 43.

9. Ruskin [1843–1860] 1888, vol. 3, part 4, pp. 256–57.

10. On the *Little Liber,* see Wilton 1980, no. 74, p. 158; Hermann 1990, pp. 144–52.

11. On Turner and topography, see Wilton 1980, pp. 78–102.

12. See Bermingham 1986.

13. Popham 1922, p. 250.

14. On the Barbizon painters, see Herbert 1962; Bouret 1972; Weisberg 1985.

15. Herbert 1962, p. 17. For the importance of printmaking in Barbizon art, also see Thyssen 1985, a brief but useful study.

16. Herbert 1962, pp. 37–40, gives an account of the Barbizon artists and the 1848 Revolution.

17. Melot [1978] 1980, pp. 275–76; Thyssen 1985, p. 17, 22–23.

18. Melot [1978] 1980, p. 276.

19. Ibid., p. 280.

20. Tien 1983.

21. Melot [1978] 1980, no. D 120, p. 282.

22. Ibid., no. C1, p. 257.

23. Ibid., pp. 22–24.

24. See Herbert 1962, pp. 41–47 (p. 46 for quotation); Weisberg 1974, especially p. 17; Clark 1973, pp. 72–98.

25. Melot [1978] 1980, no. M 19, pp. 290–91.

26. Clark 1973, p. 97.

27. On Palmer's etchings and paintings, see Lister 1969; Lister 1987. Also see Bermingham 1986, pp. 142–43.

28. For biography on Meryon, see Burke 1974. Schneiderman 1990 is a recent catalogue raisonné of Meryon prints.

29. Quoted in Burke 1974, p. 7.

30. Ibid., pp. 27–28.

31. Ibid.

32. Holcomb 1971–72.

33. Burke 1974, no. 111, pp. 110–11. Also see Yarnall 1979 for the relationship of this and other Meryon prints to Rosicrucianism.

34. Holcomb 1971–72, p. 156.

35. Burke 1974, nos. 62–66, p. 69.

36. For a more thorough introduction to the etching renaissance in France, see Weisberg 1971; Shestack 1974. Also see Lang and Lang 1990 for a sociological approach to the etching revival.

37. Samis 1990.

38. Cited in Shestack 1974, p. 20.

39. Cited in Van Voorhis 1985, p. 8.

40. Ibid.

41. See Roger-Marx 1962, p. 99.

42. Baudelaire later modified this. See Reff 1982, no. 34, p. 112. Also see Cachin and Moffett 1983, nos. 50–53, pp. 146–56.

43. On *Olympia,* see Reff 1976; Cachin and Moffett 1983, nos. 64 and 69, pp. 174–83, 186–89; Clark 1985, pp. 79–146. For a feminist interpretation of Manet's images of women in general, see Lipton 1975.

44. Wilson 1978, no. 44, pp. 45–46; Fisher 1985, no. 38, pp. 73–74.

45. Driskel 1985, p. 54.

46. Cachin and Moffett 1983, no. 74, pp. 199–203, and no. 76, pp. 205–7.

47. Driskel 1985, p. 54.

48. Reed and Shapiro 1984, no. 8, pp. 23–30.

49. Ibid., no. 52, pp. 184–97.

50. Buettner 1986–87, pp. 15–17.

51. Mathews 1989.

52. See Breeskin 1979, p. 22.

53. Shapiro 1989, pp. 68–71.

54. Melot, Griffiths, and Field 1981, pp. 36–37.

55. Shapiro 1973, introduction (not paginated); Shapiro 1986.

56. Hamerton 1868, dedication page.

57. Lochnan 1984, pp. 78–80.

58. Ibid., pp. 95–100.

59. See Baas 1984.

60. On Bewick and his pupils, see Dobson 1884 [1968].

61. See Essick 1980, pp. 224–25.

62. Ibid., p. 233.

63. Paret 1986.

64. Clark 1973, pp. 26–27.

65. See Godfrey 1978, p. 101.

66. See Janis 1980.

67. Ibid., pp. 14–17.

68. For more impressions and discussion: ibid., pp. 18–22 and nos. 19–21, pp. 93–95.

69. See Lochnan 1984, pp. 196–99, for discussion and more illustrations.

70. Janis 1968, pp. xix–xxi and nos. 61–118.

71. See, for example, Adhémar and Cachin 1974, pp. 83–84.

72. Janis 1968, p. xx.

73. Clayson 1983.

74. Lipton 1986, pp. 151–86; Broude 1988.

75. See Janis 1967.

76. On Prendergast's monotypes, see Langdale 1979.

77. On Gauguin's methods, see Field 1973, especially pp. 15–22; Brettell's commentary in Brettell, Cachin, Frèches-Thory and Stuckey 1988, nos. 247–51, pp. 447–53.

78. See Metropolitan Museum of Art 1980, no. 41, pp. 132–33.

79. Field 1973, no. 66, p. 91.

80. Solomon-Godeau 1989, p. 126.

81. Field 1973, p. 39.

82. Kane 1966, pp. 361–62.

REFERENCES

Adhémar, Jean, and Françoise Cachin. 1974. *Degas: The Complete Etchings, Lithographs and Monotypes.* Trans. Jane Brenton. London.

Baas, Jacquelynn. 1984. The Artistic Revival of the Woodcut in France. In Baas and Field 1984, pp. 14–21.

Baas, Jacquelynn, and Richard S. Field. 1984. *The Artistic Revival of the Woodcut in France, 1850–1900.* Exhibition catalog. University of Michigan Museum of Art, Ann Arbor.

Bermingham, Ann. 1986. *Landscape and Ideology: The English Rustic Tradition, 1740–1860.* Berkeley, Calif.

Bouret, Jean. 1972. *The Barbizon School and Nineteenth-Century French Landscape Painting.* Greenwich, Conn.

Breeskin, Adelyn Dohme. 1979. *Mary Cassatt: A Catalogue Raisonné of the Graphic Work.* Washington, D.C.

Brettell, Richard, François Cachin, Claire Frèches-Thory, and Charles F. Stuckey, with assistance from Peter Zegers. 1988. *The Art of Paul Gauguin.* Exhibition catalog. National Gallery of Art, Washington, D.C., and Art Institute of Chicago, Chicago.

Broude, Norma. 1988. Edgar Degas and French Feminism, ca. 1880: "The Young Spartans," the Brothel Monotypes, and the Bathers Revisited. *Art Bulletin,* vol. 70, no. 4 (December), pp. 640–59.

Buchloh, Benjamin H. D., Serge Guilbaut, and David Solkin, eds. 1983. *Modernism and Modernity: The Vancouver Conference Papers.* Halifax, Nova Scotia.

Buettner, Stewart. 1986–87. Images of Modern Motherhood in the Art of Morisot, Cassatt, Modersohn-Becker, Kollwitz. *Woman's Art Journal,* vol. 7, no. 2 (Fall 1986/Winter 1987), pp. 14–21.

Burke, James D. 1974. *Charles Meryon: Prints and Drawings.* Exhibition catalog. Yale University Art Gallery, New Haven, Conn.

Cachin, Françoise, and Charles S. Moffett. 1983. *Manet 1832–1883.* Exhibition catalog with contributions by Anne Coffin Hanson and Michel Melot, and print entries by Juliet Wilson Bareau. Galeries Nationale du Grand Palais, Paris, and Metropolitan Museum of Art, New York.

Clark, T. J. 1973. *The Absolute Bourgeois: Artists and Politics in France 1848–1851.* Greenwich, Conn.

Clark, T. J. 1985. *The Painting of Modern Life: Paris in the Art of Manet and His Followers.* New York.

Clayson, Hollis. 1983. *Avant-Garde* and *Pompier*

Images of 19th Century French Prostitution: The Matter of Modernism, Modernity and Social Ideology. In Buchloh, Guilbaut, and Solkin 1983, pp. 43–64.

Dobson, Austin. [1884] 1968. *Thomas Bewick and His Pupils.* Detroit.

Driskel, Michael Paul. 1985. Manet, Naturalism, and the Politics of Christian Art. *Arts Magazine,* vol. 60, no. 3 (November), pp. 44–54.

Essick, Robert N. 1980. *William Blake, Printmaker.* Princeton, N.J.

Field, Richard S. 1973. *Paul Gauguin: Monotypes.* Exhibition catalog. Philadelphia Museum of Art, Philadelphia.

Finberg, Alexander J. 1924. *A History of Turner's Liber Studiorum, with a New Catalogue Raisonné.* London.

Fisher, Jay McKean. 1985. *The Prints of Edouard Manet.* Exhibition catalog. International Exhibitions Foundation, Washington, D.C.

Flescher, Sharon. 1985. More on a Name: Manet's "Olympia" and the Defiant Heroine in Mid-Nineteenth Century France. *Art Journal,* vol. 44, no. 1 (Spring), pp. 27–35.

Gage, John. 1969. *Color in Turner: Poetry and Truth.* New York.

Glassman, Elizabeth. 1980. Cliché-verre in the 19th Century. In Glassman and Symmes, 1980, pp. 27–44.

Glassman, Elizabeth, and Marilyn F. Symmes. 1980. *Cliché-verre: Hand-Drawn, Light-Printed. A Survey of the Medium from 1839 to the Present.* Exhibition catalog. Detroit Institute of Arts, Detroit.

Godfrey, Richard T. 1978. *Printmaking in Britain: A General History from Its Beginnings to the Present Day.* New York.

Hamerton, Philip Gilbert. 1868. *Etching and Etchers.* London.

Herbert, Robert L. 1962. *Barbizon Revisited.* New York.

Hermann, Luke. 1990. *Turner Prints: The Engraved Work of J. M. W. Turner.* New York.

Holcomb, Adele M. 1971–72. Le Stryge de Notre Dame: Some Aspects of Meryon's Symbolism. *Art Journal,* vol. 31, no. 2 (Winter), pp. 150–57.

Janis, Eugenia Parry. 1967. The Role of the Monotype in the Working Method of Degas: Parts I and II. *Burlington Magazine,* vol. 109, nos. 766 and 767 (January–February), pp. 20–27, 71–81.

Janis, Eugenia Parry. 1968. *Degas Monotypes: Essay, Catalogue and Checklist.* Exhibition catalog. Fogg Art Museum, Harvard University, Cambridge, Mass.

Janis, Eugenia Parry. 1980. Setting the Tone—the Revival of Etching, the Importance of Ink. In Metropolitan Museum of Art 1980, pp. 9–28.

Kane, William M. 1966. Gauguin's Le Cheval Blanc: Sources and Syncretic Meanings. *Burlington Magazine,* vol. 108 (July), no. 760, pp. 352–62.

Lang, Gladys Engel, and Kurt Lang. 1990. *Etched in Memory: The Building and Survival of Artistic Reputation.* Chapel Hill, N.C.

Langdale, Cecily. 1979. *The Monotypes of Maurice Prendergast.* Exhibition catalog. Davis and Long, New York.

Lipton, Eunice. 1975. Manet: A Radicalized Female Imagery. *Artforum,* vol. 13, no. 7 (March), pp. 48–53.

Lipton, Eunice. 1986. *Looking into Degas: Uneasy Images of Women and Modern Life.* Berkeley, Calif.

Lister, Raymond A. 1969. *Samuel Palmer and His Etchings.* London.

Lister, Raymond A. 1987. *Samuel Palmer: His Life and Art.* Cambridge, England.

Lloyd, Christopher, ed. 1986. *Studies on Camille Pissarro.* London.

Lochnan, Katharine A. 1984. *The Etchings of James McNeill Whistler.* New Haven, Conn.

Mathews, Nancy Mowll. 1989. The Color Prints in the Context of Mary Cassatt's Art. In Mathews and Shapiro 1989, pp. 19–56.

Mathews, Nancy Mowll, and Barbara Stern Shapiro. 1989. *Mary Cassatt: The Color Prints.* Exhibition catalog. Williams College Museum of Art, Williamstown, Mass.

Melot, Michel. [1978] 1980. *The Graphic Art of the Pre-Impressionists.* Trans. Robert Erich Wolf. New York.

Melot, Michel, Antony Griffiths, and Richard S. Field. 1981. *Prints: History of an Art.* New York.

Metropolitan Museum of Art. 1980. *The Painterly Print: Monotypes from the Seventeenth to the Twentieth Century.* Exhibition catalog with contributions by Sue Welsh Reed, Eugenia Parry Janis, Barbara Stern Shapiro, and others. New York.

Ockman, Carol. 1991. Two Large Eyebrows 'à l'orientale': Ethnic Stereotyping in Ingres' Baronne de Rothschild. *Art History,* vol. 14, no. 4 (December), pp. 521–39.

Paret, Peter. 1986. The German Revolution of 1848 and Rethel's *Dance of Death. Journal of Interdisciplinary History,* vol. 17, no. 1 (Summer), pp. 233–55.

Popham, A. E. 1922. The Etchings of John Sell Cotman. *Print Collector's Quarterly,* vol. 9, no. 3, pp. 236–73.

Rawlinson, William George. 1913. *The Engraved Work of J. M. W. Turner, R.A.* 2 vols. London.

Reed, Sue Welsh, and Barbara Stern Shapiro. 1984. *Edgar Degas: The Painter as Printmaker.* Exhibition catalog with contributions by Clifford S. Ackley, Roy L. Perkinson, Douglas Druick, and Peter Zegers. Museum of Fine Arts, Boston.

Reff, Theodore. 1976. *Manet: Olympia.* New York.

Reff, Theodore. 1982. *Manet and Modern Paris.* Exhibition catalog. National Gallery of Art, Washington, D.C.

Roger-Marx, Claude. 1962. *Graphic Art of the Nineteenth Century.* Trans. E. M. Gwyer. London.

Ruskin, John. [1843–1860] 1888. *Modern Painters.* 5 vols. Sunnyside, Orpington, Kent, England.

Said, Edward W. 1978. *Orientalism.* New York.

Samis, Peter S. 1990. *Aemulatio Rembrandti:* The 19th-Century Printmaker Flameng and His *Prises/Crises de Conscience. Gazette des Beaux-Arts,* 6th ser., vol. 116 (December), pp. 243–60.

Schneiderman, Richard S. 1990. *The Catalogue Raisonné of the Prints of Charles Meryon.* London.

Shapiro, Barbara Stern. 1973. *Camille Pissarro: The Impressionist Printmaker.* Boston.

Shapiro, Barbara Stern. 1986. Camille Pissarro, Rembrandt, and the Use of Tone. In Lloyd 1986, pp. 123–35.

Shapiro, Barbara Stern. 1989. Mary Cassatt's Color Prints and Contemporary French Printmaking. In Mathews and Shapiro 1989, pp. 68–73.

Shestack, Alan. 1974. Some Thoughts on Meryon and French Printmaking in the Nineteenth Century. In Burke 1974, pp. 15–21.

Solomon-Godeau, Abigail. 1989. Going Native. *Art in America,* vol. 77, no. 7 (July), pp. 118–29, 161.

Thyssen, Esther. 1985. *Natural and Pastoral Themes by the Barbizon Printmakers.* Exhibition catalog. Davison Art Center, Wesleyan University, Middletown, Conn.

Tien, Mary L. 1983. Observations on Daubigny's *Voyage en Bateau.* Paper presented to Midwest Art History Society, tenth annual meeting, University of Iowa, Iowa City.

Van Voorhis, Cathy F. 1985. Alphonse Legros's *Death in the Pear Tree. Kresge Art Museum Bulletin,* vol. 1 (new series), pp. 5–13.

Weisberg, Gabriel P. 1971. *The Etching Renaissance in France 1850–1880.* Exhibition catalog. Utah Museum of Fine Arts, Salt Lake City.

Weisberg, Gabriel P. 1974. *Social Concern and the Worker: French Prints from 1830–1910.* Exhibition catalog. Utah Museum of Fine Arts, Salt Lake City.

Weisberg, Gabriel P. 1985. *Millet and His Barbizon Contemporaries.* Exhibition catalog. Art Life Ltd., Tokyo.

Wilson, Juliet. 1978. *Manet: Dessins, aquarelles, eaux-fortes, lithographies, correspondance.* Exhibition catalog. Huguettes Bères, Paris.

Wilton, Andrew. 1980. *Turner and the Sublime.* Exhibition catalog. Art Gallery of Ontario, Toronto.

Yarnall, James Leo. 1979. Meryon's Mystical Transformations. *Art Bulletin,* vol. 61, no. 2 (June), pp. 289–300.

10

The German Expressionists

and Related Artists

PRINTMAKING AND EXPRESSIONISM

Of all the many "isms" of twentieth-century art, Expressionism, a broad term used to encompass distinct groups and individual artists working primarily in Germany in the first quarter of the century, had the strongest impact on printmaking. It is difficult to generalize accurately about the many artists commonly labeled "Expressionist." Indeed, it is important to recognize how the term itself, by conjuring up an image of the tortured artist expressing authentic emotions, may hamper our attempts to understand Expressionist art in its context.[1] Nevertheless, it is useful for our purposes to generalize to some extent in order to suggest reasons why the print played such an important role in the artistic production of Expressionist artists. Their stated aim of communicating elemental ideas and emotions, their often disappointed aspirations for their art as a renewing social and cultural force, as opposed to what they perceived as a more narrow aesthetic experience, led them to printmaking, which traditionally had a more popular base and more frankly communicative ends than painting. A hoped-for bond with the working class, elusive in reality, drew many Expressionist artists to the manual skill required by printmaking, even while they cultivated the growing interest in original prints among middle-class collectors. And although artists of many nationalities contributed to Expressionism and the movement is inconceivable without artists of the Symbolist generation—Van Gogh, a Dutchman; Gauguin, a Frenchman; and Munch, a Norwegian—its heart

was in Germany, the birthplace of printmaking.[2] The prints of German Expressionists were in part an attempt to recover the German cultural heritage. This is particularly true of their woodcuts, in which the original strength of the medium in the fifteenth century was rediscovered. Prints especially supported the assertion that Expressionism was the triumphant and inevitable result of a long artistic evolution.[3]

Although the spiritual and metaphysical concerns voiced by Expressionist artists, not to mention their unconventional if varied aesthetics, sometimes left them vulnerable to charges of political ineffectiveness or escapism, Expressionism was fundamentally inseparable from the political turmoil of early twentieth-century Europe, and especially of Germany.[4] The frequent Expressionist quest for a humanity that was transfigured on both the individual and social levels was inevitably linked, directly or indirectly, to political struggles against the status quo. The waxing of nationalism in the empire of Kaiser Wilhelm after the Franco-Prussian War of 1871, the phenomenal growth of urban industry and the consequent suffering of the working classes, the growth of socialist and communist ideologies, the initial patriotic fervor of World War I, which turned to disillusionment by 1916 as casualties mounted, and the emergence of the Weimar Republic from the disastrous German defeat and the Revolution of 1918–19, all had a direct impact on the imagery, and indeed the lives, of Expressionist artists. As social criticism, pitted against economic injustice, complacency, and corruption, Expressionist prints frequently have the power of Goya's or Daumier's. Indeed, it is largely within the Expressionist perspective that graphic cycles dealing with modern war were created, and not only by German artists like Käthe Kollwitz and Otto Dix, but by the French artist Georges Rouault as well. These took their cue from Goya but revealed an awareness of new terrors introduced in World War I—trench combat, poison gas, and airborne destruction.

German Renaissance artists like Altdorfer, Baldung, and even Dürer had manifested a tendency toward expressive distortion, and German Expressionism drew upon this legacy, as well as upon the various Symbolist and deliberately primitivistic trends of the late nineteenth century, all of which reacted against the materialism and positivism of bourgeois society as well as the basic naturalism of Impressionism. For all its overturning of the artistic heritage of Europe, Impressionism was primarily concerned with finding a contemporary visual language that could represent the new forms of modern life. Expressionism, however, focused on the spiritual realm: it transformed the visible world by inner experience. This experience ranged from the ecstatic to the despairing, expressing, for example, a modern alienation of people from each other and from a surrounding, hostile world, or a Romantic identification of humanity with nature. The roots of this latter experience are in the rural areas of northern Germany or the alpine forests of the south; of the former, in the industrialized metropolises of central and southern Germany, such as Berlin and Munich. Expressionist *style* may vary—the insistence on directness sometimes leading to an overt crudeness and distortion, sometimes to a deliberately child-like lyricism, or to a symphonic monumentality. The different modes of early twentieth-century Expressionism took the lead, along with Cubism, in finalizing modern art's reworking of traditional pictorial and spatial structure. And the print was central in establishing both the thematic and the formal priorities of the various forms of Expressionism.

Expressionism also had a significant impact on print collecting and connoisseurship. The importance of printmaking within the movement generated large numbers of collectors—so many that the contemporary art historian Curt Glaser worried that artistic quality would be lost in the deluge of prints published to capitalize on the renaissance of the graphic media.[5]

But the Expressionist approach to the print implied an even deeper change: a challenge to traditional standards of connoisseurship. These had developed (particularly around etching) since the eighteenth century, with its stress on states and quality of impression, and were reinforced during the etching revival. The unorthodox methods of Expressionist printmakers and the ostensibly crude appearance of their works overturned these values. More significant was the communicative or political aspect of the print, as the art historian Gustav Hartlaub eloquently stated in 1920. His words are a direct repudiation of the concerns of the etching revival:

> [Printmaking] is no longer an art for lovers of minor masters' artistic translations of technical refinements and variations. . . . It imperatively demands a new type of collector, who unhesitatingly aims more at artistic content and less at rarity and every possible collector's value. . . . In the final analysis, print collecting today should no longer be carried on in a cabinet and in a private, capitalistic manner. Printmaking today is public and popular. Today graphic art . . . does not want to be motionlessly preserved in portfolios. The print wants to fly, a broadsheet fluttering down out of the spiritual clouds on a vast populace with hands stretched upward![6]

GAUGUIN AND THE WOODCUT

The attitudes out of which Expressionism developed began to emerge in the late nineteenth century in artists who sought new visual languages to explore the spiritual, emotional, or imaginative aspects of the modern experience, or the myths, rituals, and art forms of tribal or non-industrial European peoples. Two such artists were Vincent van Gogh and Paul Gauguin, who worked together briefly in the south of France. Van Gogh made only ten prints, but the highly charged brushstrokes, strident colors, and hypersensitive approach to nature and people evident in his paintings contributed much to twentieth-century Expressionist paintings *and* prints. Van Gogh's art was exhibited and discussed in Germany early in the century, and to that audience his brushstroke was a record of an always intense response. Early accounts of his troubled personal life facilitated this reading of his art. Van Gogh was promoted in early biographies as an individual forever at odds with his own society: as such, he provided an archetype for rebellious young German artists.[7]

Tenacious and self-absorbed, Gauguin was also viewed as a tragic figure, having died sick and impoverished in the Marquesas Islands in 1903. He voiced a disgust for bourgeois European society that also provided a model for Expressionists. Gauguin's abandonment of his job and family, his efforts to find a greater closeness to nature and an all-encompassing cultural alternative to western modernity in regions like Brittany, Tahiti, and the Marquesas, were read as part of a profound critique of western culture. Gauguin wanted the South Seas to be the place where Europe was "wholly destroyed, truly dead, the old civilization," and he would emerge "reborn; or rather another man, pure and strong."[8]

In fact, what Gauguin found in the South Seas was not a "wholly destroyed" Europe. Rather, he encountered an indigenous culture and society pillaged and transformed by white occupation, and made even less accessible to him because he could not speak the native language. Simply by working as a French artist in a colonized territory and appropriating aspects of Polynesian culture into his paintings, prints, and drawings, where they were constantly

mixed with references to the art and literature of Europe, Gauguin was unwittingly contributing to the decay of the culture he wanted to embrace.[9] But it is equally true that the collision of Gauguin's thoroughly French refinement of form, color, and composition with the images and ideas he encountered in the South Seas produced a body of work of enduring fascination and beauty. For our purposes, it is also a body of work in which the print stands alongside painting and sculpture as a major means of expression.

As we have seen, Gauguin's lithographs from Brittany (Chapter 8) and the monotypes from his late stay in the South Seas (Chapter 9) represent significant steps in the evolution of these media, but in woodcut Gauguin initiated a revolution. He revitalized a medium that had lain dormant since its first flowering in the Renaissance, and consequently altered the nineteenth-century perception of the relief processes as primarily journalistic and illustrative. This reawakening of the woodcut had particular impact on German Expressionism, even though Expressionist artists handled it differently. The significance of the woodcut medium for Gauguin himself is concisely summarized by Field as a bridge between subtle optical surfaces and bold abstract shapes, between painting and sculpture, between what Gauguin understood as the civilized and the primitive. Moreover, as Gauguin developed it, the woodcut technique allowed for the suggestiveness and ambiguity that is at the heart of the Symbolist aesthetic.[10]

Gauguin's undisputed woodcut masterpieces are the ten prints of the *Noa Noa Suite,* probably produced early in 1894 after he returned from his first stay in Tahiti, and originally intended to accompany the manuscript of *Noa Noa* (*Fragrance*), on which Gauguin collaborated with his friend Charles Morice. As Richard Brettell has observed, Gauguin's considerable literary ambitions are perhaps the most underexamined aspect of his career. As an illustrated text, *Noa Noa* was undertaken partly to explicate the Tahitian works Gauguin had exhibited at the Durand-Ruel Gallery in Paris in November of 1893. But it also provided a sensationalistic narrative of the artist's Tahitian journey that bears little resemblance to the more prosaic account in his letters. The manuscript took the form of a travel journal and was influenced by Delacroix's diary, published between 1893 and 1895, and Julien Viaud's autobiographical novel about an affair between a French sailor and a fourteen-year-old Polynesian girl (Gauguin gave thirteen as the age of his mistress, Tehamana or Tehura, a woman whose actual age and fate remain unknown). Although certainly Gauguin was aware of the long tradition of woodcut book illustration, it is clear that the prints for *Noa Noa* took their own path, away from both the manuscript of *Noa Noa* and any conventional understanding of woodcut.[11]

According to Field, the images form a fluid cycle of divine creation, the experiences of human life, sex, death, and rebirth.[12] Gauguin himself printed no more than twelve impressions from any of the blocks, but editions were pulled by the printer Louis Roy and by Gauguin's son Pola. The impressions vary tremendously. Field's careful observations have revealed that, far from seeking raw, flat forms, Gauguin strove for ambiguity and unclarity, using overprintings and off-register printings, blending of inks on the blocks, hand rubbing the paper against the blocks, and inking the *lower* areas of the blocks so that the paper would pick up the soft, wavy marks made by the carpenter's chisel. He utilized unorthodox tools, many of which were commonly present in *lithographic* workshops—needles, sandpapers, razors—to create fine white lines from the hard surface of the boxwood (the material of commercial wood-engraving). "There arises," states Field, "a double effect which was dear to the heart of the Symbolist: the forms are felt as either tangible, glowing volumes or noncrystallized shapes in the process of creating themselves."[13]

These effects, wholly consistent with what we have seen in Gauguin's monotypes and entirely different from what we would expect of the woodcut technique, were not reconcilable with the need for a large edition. Roy's printing, apparently done in collaboration with the artist, was more "correct" by conventional standards, with flat, black areas more akin to the decorative style of Art Nouveau. Clarity replaced ambiguity. In contrast, Pola Gauguin's efforts were geared toward capturing, rather than covering, his father's delicate working of wood surfaces.

Nave Nave Fenua (*Delightful Land;* fig. 10.1), related to one of the best paintings in his 1893 exhibition, is shown here in an impression printed by Gauguin himself. The block is in its fourth state, after Gauguin had redefined the composition's components with the traditional woodcut gouge. The figure is related to the sinuous figures of Hindu relief sculpture.[14] The design on the left border recalls Oceanic wood carvings, although Gauguin, instead of recreating actual works of tribal or oriental art, made his own analogs to the imagery of non-European cultures. Here, the subject draws upon a long European tradition of equating both so-called primitive cultures and the female figure with nature itself. The woman is a Tahitian "Eve," standing in a luxuriant "Eden," the earth's fertility embodied in her heavy abdomen and thighs, and seemingly threatened by a winged lizard above her left shoulder. Whereas Roy's printing tended to emphasize all elements of the composition equally, Gauguin's own printing of the block shows a struggle for dominance among "Eve," the winged lizard, and elements of the landscape setting.[15]

The title of *Manao Tupapau* (*The Spirit of the Dead Thinks of Her,* or *She Thinks of the Spirit of the Dead;* fig. 10.2), is that of the famous painting of 1892, now in the Albright-Knox Gallery in Buffalo, although the painting and the print are very different. In the painting, a woman reclines on a bed, terrified by the spirit of the dead, embodied in the "idol" in profile at her feet. In the woodcut, the woman's body is placed against an amoebic shape that dominates the composition and suggests, by its closed position, the fetus in the womb as well as burial. Birth is explicitly contrasted with and yet linked to death. Later that year Gauguin reprised this conception in another large woodcut, which he hand-colored in pale watercolor hues reminiscent of the earliest European painted woodcuts.[16]

With these printed and painted images, Gauguin may have been alluding to the perception of death in Oceanic society as a dangerous realm: the ancestors, one aspect of native Tahitian belief that remained strong, must be propitiated so that they are not hostile toward the living. The two realms of life and death are not separate, then, but bound together in a vital reciprocal relationship that is embodied in both the girl's terrified perception of the spirit in the painting and the fetal/burial position of the woman in the woodcut versions of *Manao Tupapau.* In his interpretation of the double meaning "Manao Tupapau" in a letter to his wife, Mette, and in his *Cahier pour Aline* (a notebook for his daughter), Gauguin acknowledged the fluid relationship in mythic thought between imaginative experience (for example, a Tahitian woman's nocturnal terror inspired by the *tupapau*) and the real structure of the world, articulated in myth (the spirit thinking of her).[17] Gauguin argued that modern industrial society has made these distinctions and is no longer able to connect the two realms; it therefore needed an art that manifested both mythic structure and mystery, both emotional response and intellectual reflection.

Formally, this print reveals one of the most sensitive treatments of a wood surface in the history of the medium. (Indeed, Gauguin's printing surfaces sometimes became bas-reliefs.)[18]

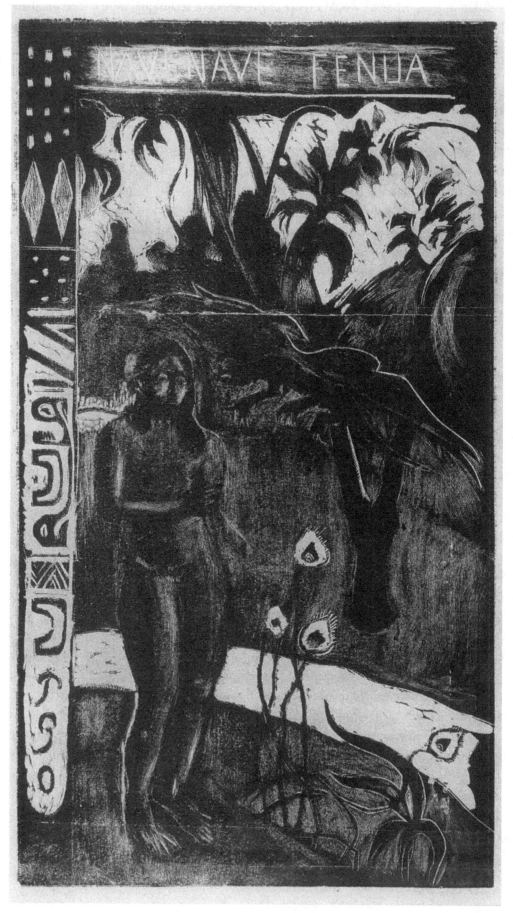

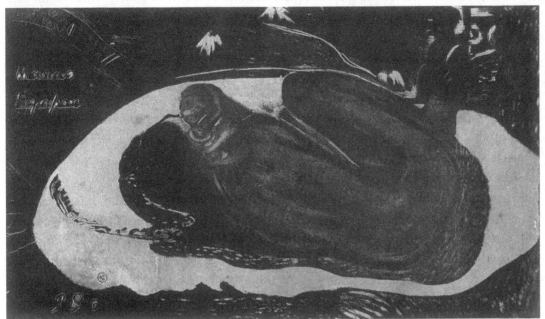

FIGURE 10.2
Paul Gauguin. Manao Tupapau (The Spirit of the Dead Thinks of Her, *or* She Thinks of the Spirit of the Dead) *from the* Noa Noa Suite. *1894. Woodcut. 203 × 356 mm. Art Institute of Chicago.*

Fine scratches and cuts combine with dark shapes to model the muscular undulations of the girl's back and the indentation of the spine. And yet the body, surrounded by an emphatic contour line, is a flat shape as well, the dark "yolk" in the middle of the "egg" in which she seems to lie. The delicacy that dominates Gauguin's woodcuts distinguishes them from those of the early German Expressionists, who sought to convey the physical action of the knife slashing the wood by a raw, violent appearance that disguises consummate craft. However, his celebration of the nature of his material, the chiseled, scratched, and grainy quality of the printing surface that emerges in the final print, leads directly to Expressionist woodcuts. In both cases the artist's processes and means are deliberately blatant. Moreover, Gauguin's claim to focus on elemental human experiences—birth, death, sexuality—and his attempt to unite these with a sophisticated European aesthetic consciousness held much appeal for the Expressionists.

KLINGER AND ENSOR

A foundation for German Expressionism was also, of course, laid in Germany in the late nineteenth century. In contrast to Gauguin, with his deliberate primitivism and radically innovative approach to printmaking techniques, the Berlin artist Max Klinger was a virtuoso in traditional intaglio methods, sometimes ingeniously combined. If he was best known in his own time for his paintings and polychrome sculptures, Klinger's reputation today rests almost entirely on his graphic oeuvre. Indeed, the importance he lent to printmaking went against the more typical indifference of painters.[19] The psychological and social orientation of his content also make him an especially important precursor of Expressionism.

Klinger's most memorable graphic series, and one of the most bizarre works of the late nineteenth century, is *A Glove* (1881). Ten etchings tell the story of a man's fantasies about a beautiful woman's lost glove in terms that foreshadow later Surrealism—in particular, one of the images from Max Ernst's *Une Semaine de Bonté* (*One Week of Kindness;* see fig. 11.46)—and anticipate Freud's studies of sexual psychoses. The series' focus on a single object, itself suggestive of both male (with its phallic fingers) and female (with the dark opening for the hand and the slit in its leather at the back), gives visual form to his fetishistic obsession. The artist/lover picks up the glove in a skating rink, and then we follow the object through his dreams. The glove changes size. Sometimes it is enshrined like an object of worship; sometimes it is threatened by the sea or by frightening animals; sometimes *it* is threatening. Perhaps the most striking plate, *Anxieties* (fig. 10.3), depicts the artist in a fitful sleep, pressed against the wall as various creatures (reminiscent of those created by Goya, to whom Klinger was greatly indebted) and reaching hands float toward him from the left, carried on an impossible wave of water. The glove, monstrously oversized, lurks behind his pillow at the right. The components of this composition and Klinger's tight, detailed technique do not seem to belong together at first, and yet it is this combination which gives the image its uncanny, dream-like quality. It is not surprising that Giorgio de Chirico, the pioneer of modern Surrealism, found Klinger so fascinating.

A Glove is less complex technically than Klinger's later series, in which aquatint, engraving, mezzotint, and even lithography came to be incorporated.[20] *Night* (fig. 10.4), for example, from Part 1 of his cycle on death, first published in 1889, combines a great variety of hatchings with the granular effect of aquatint and delicate, burnished highlights.

The somber meditation of the central figure, meant to suggest the artist, recalls Dürer's *Melencolia I* (fig. 2.16). Both prints deal, in very different ways, with the artist's aspiring transcendence of the material world. In Klinger's print, the path leads toward the peaceful sea and the beckoning, moonlit horizon. The opening in the fence between sea and land is punctuated with a glowing white lily, a symbol of moral purity, but also perhaps an embodiment of the perfect beauty sought by the artist. Such perfection, Klinger seems to say, is found only in death, when the barrier between finite life and eternity, for which the sea is a metaphor, is traversed. The inscription on a plate from the first part of the Death cycle reads: "We flee from the manner of death, not from death itself; for the goal of our highest desires is death."[21]

Still, many of the prints from *On Death: Parts 1 and 2* express its abruptness and unpredictability, much as the Dance of Death did in the Middle Ages and Renaissance. *The Plague* (from Part 2, 1898; fig. 10.5) is such an image. Klinger's couching of violent movement and intense emotion in weirdly static terms is epitomized here: a nun swings her rosary at two crows, harbingers of the corruption of disease and death already visible in the emaciated patients. The crisply etched black birds seem to have arrived on a gust of wind that parts the windows and unfurls the thin white curtains. The frozen moment of panic and realization of mortality is best expressed in the face and upraised hands of the corpse-like man in the foreground bed. Traditional religion, present in the shadow of the cross and in the rosary, provides little comfort in this modern meditation on death.

Many of Klinger's graphic cycles were conceived in the moralizing spirit of Hogarth and Goya. *A Life* (1884) recounted a lower-class woman's unwitting fall into prostitution, while *A Love* (1887) concerned an upper-class woman who, like Tolstoy's Anna Karenina, is ruined by an illicit love affair. *Dramas* (1883) consisted of six scenes of urban tragedies. This aspect of

FIGURE 10.3

Max Klinger. Anxieties: Plate 7 of A Glove. *1881. Etching. 144 × 269 mm. University of Michigan Museum of Art, Ann Arbor.*

FIGURE 10.4

Max Klinger. Night: Plate 1 of On Death, Part 1. *1889. Etching and aquatint. 314 × 317 mm. Staatliche Museen, Berlin.*

Klinger's art, as well as his definition in *Malerei und Zeichnung* (*Painting and Drawing*) of painting as best suited for the rendering of nature, and drawing or printmaking for the rendering of states of the soul or outlooks on the world, deeply influenced the young Kollwitz, who first saw *A Life* in Berlin in 1884. Although Munch's work led her away from Klinger's anecdotal and melodramatic realism, Kollwitz's essentially traditional drawing and her feeling for intaglio printmaking derived, in part, from his example.

A Mother 1 from *Dramas* (fig. 10.6) depicts a scene of domestic violence nearly subsumed by the dirty tenement district in which it takes place. A mother and child huddle against a wall as neighbors try to stop a drunken husband from beating them. By the sweeping spatial view

FIGURE 10.5

Max Klinger. The Plague: *Plate 3 (1903) of* On Death, Part 2. *1898– 1909. Etching and aquatint. 494 × 339 mm. Museum of Modern Art, New York.*

and the smallness of figures in relation to their surroundings, Klinger suggested the commonness of this kind of scene. In the industrial cities of the late nineteenth century, urban poverty exacerbated by overpopulation and economic recession bred despair and family strife, much as it does today. In subsequent plates, the mother, seeing no way out of her situation, attempts to drown herself and her child. She alone is rescued, to stand trial for the murder of her offspring. Kollwitz's work would later provide a stage on which the suffering and desperation of such women were played out with an even greater empathy.

The etchings and drypoints of the Belgian painter James Ensor also have a bearing on later Expressionist prints.[22] The scratchy, deliberately crude character of his technique is perfectly suited to his cynical view of the world, related to the rebelliousness that so many late nineteenth-century artists felt, but rooted as well in Bosch and Bruegel in the sixteenth century. Ensor's style also incorporated fantasy and distortion toward satirical ends. A little print, *My Portrait in the Year 1960: Simple Anticipation* (1888; fig. 10.7), epitomizes Ensor's biting wit, which does not shrink here from self-mockery or from a realistic contemplation of death, and the rough immediacy of his approach to etching. His *Entry of Christ into Brussels* (1898; fig. 10.8), based on his famous painting of the same name, is a kind of modern Ecce Homo in which Christ is nearly engulfed in a motley urban crowd, whose grotesque masks, emblems of hypocrisy, scarcely disguise the corruption underneath. Ensor's quivering lines are a graphic

FIGURE 10.6

Max Klinger. A Mother
1 *from* Dramas. *1883.*
Etching and aquatint.
460 × 320 mm.
Staatliche Museen,
Berlin.

equivalent for the iridescent, nervously applied color of his paintings. In the prints of the German Expressionists and Rouault, we will also observe the renewed relevance of Christian imagery for the modern world.

MUNCH

"I do not believe in an art which is not forced into existence by a human being's desire to open his heart. All art, literature and music must be born in your heart's blood. Art is your heart's blood," declared Edvard Munch.[23] Despite the relevance of the graphic art of Klinger, Gauguin, and Ensor for later Expressionism, Munch was an equally important force in its formation. He was a Norwegian Symbolist artist who worked frequently in Germany. Munch's 1892 exhibition in Berlin caused a scandal and made him a hero of the German avant-garde, and it was in Berlin in 1894 that he took up printmaking. Like Gauguin, Munch celebrated the raw materials with which prints are made, making these integral to his aesthetic conceptions. In *The Kiss* (1902; fig. 10.9), for example, the grain of the wood, printed in a soft gray, is allowed to rain down around and be visible underneath the black ink of the embracing couple, reinforcing their oneness. Two blocks were used for this image—a completely unworked plank of

FIGURE 10.7

James Ensor. My Portrait in the Year 1960: Simple Anticipation. *1888. Etching. 70 × 119 mm. Bibliothèque Royale Albert, Brussels.*

FIGURE 10.8

James Ensor. The Entry of Christ into Brussels. *1898. Etching. 249 × 358 mm. Bibliothèque Royale Albert, Brussels.*

pine printed for the gray, and a sawn-out shape for the black—so that the texture of the figure block is superimposed on that of the uncarved plank. The apparent simplicity of means corresponds to the elemental subject: the power of sexual attraction and the dissolution of individual existence in *eros*. We should not take this in any lightheartedly romantic or titillating sense, as is shown by a description of one of Munch's paintings of this motif, written by his friend, the Polish novelist Stanislaw Przybyszewski:

> We see two human forms whose faces have melted together. Not a single recognizable facial feature remains; we see only the site where they melted together and it looks like a gigantic ear that became deaf in the ecstasy of the blood, it looks like a puddle of liquefied flesh: there is something repulsive in it. Certainly this manner of symbolizing is unusual,

but the entire passion of the kiss, the horrible power of sexuality, painfully yearning longing, the disappearance of the consciousness of the ego, the fusion of two naked individualities—all this is so honestly experienced that we can accept the repulsive-unusual.[24]

Over and over, Munch explored the "ecstasy of the blood" in paintings and prints, experimenting with the position of the figures, the merging of their heads, and their surroundings (or lack of surroundings). There are at least five versions of *The Kiss* (that is, new renderings of the same motif) in woodcut, not to mention the variations in paper, inkings, and combinations of sawn-out blocks with background blocks. As a technical innovator, Munch

FIGURE 10.9

Edvard Munch. The Kiss. *1902. Color woodcut. 470 × 473 mm. Munch Museet, Oslo.*

was unmatched in his time. He combined lithography and woodcut, adapted *à la poupée* inking to these media, and developed entirely new approaches to color woodcut.[25]

Munch's works are as fascinating thematically as they are technically.[26] Many critics have explored the relationship between Munch's subject matter and his unhappy life, marked by failed love affairs, the deaths of his sister and father, the ideological separation from his intensely Christian, bourgeois family, and the frequent hostility of the public to his works. For Reinhold Heller, Munch's art was "not only a means to fame, but also a means of therapeutic self-presentation intended to effect a cure while transmitting to the viewer his subjective soul-state."[27] But the themes Munch treated obsessively echoed the concerns of many others of his generation. Scholars have noted the relationship between Munch's imagery and the thought of Darwin and his German disciple, Ernst Haeckel, in which human beings are determined not only by their physiology but also by their integral relationship to all living and non-living things. Women, Kristie Jayne points out, did not fare as well as men in this monistic and biologically deterministic system of thought. Controlled by their ovaries and uteruses, and exhausted from their predestined tasks of reproduction, women "naturally" lacked the strength, energy, and intellectual capacity of men, who in turn were "naturally" aggressive competitors and achievers.[28] *The Kiss* visually locks men and women into their sexuality as surely as these theories of evolution and cosmic order. Munch's art both "objectifies" his biography—transforming his personal experiences into broader statements about the human condition—and propagates contemporary ideas.

Utilizing only gray and black inks, *The Kiss* is a relatively simple example of Munch's innovative approach to woodcut. He also developed a technique that avoided the problem of registration by sawing one or more blocks into color areas that were then separately inked and assembled for printing. *Evening (Melancholy: On the Beach)* (1896; fig. 10.10), obviously based on Klinger's *Night* (fig. 10.4), provides a more complex instance. Two planks are employed, both sawn into two pieces. The horizontally grained block, which bore most of the drawing, including the figure, was cut along the contours of the landscape above the figure and the diagonal separation of land from sea. The other block, vertically grained, was cut across the horizon line opposite the figure, then over his head and shoulders. Depending on the inking, of which there are numerous variations, one knot in the vertically grained plank can shimmer like a sun through stringy clouds; another can be read as the figure's elbow.[29]

The motif was inspired by Munch's friend Jappe Nilssen, a young journalist who fell in love with Oda Krohg, the wife of the painter Christian Krohg. Love triangles, the pain of jealousy and infidelity, and even the bourgeois institution of marriage complicated the practice of free love envisioned by Munch and his circle. Nilssen's despair is provoked by the sight of two figures on the jetty in the distance (Oda and her husband), but the image goes beyond the anecdotal to become an emblem of loneliness itself, reinforced by the empty sea over which Nilssen gazes: a Romantic metaphor for the soul's yearning. Munch's formal rendering is disarmingly simple, until one considers the rich interweaving of textures and colors he accomplishes with the printing technique (in his paintings, this textural complexity is accomplished by scumbling thin washes and combining them with impasto areas). The basic mood of the initial conception gains different nuances from impression to impression.

Munch's lithographs and intaglio prints are as powerful as his woodcuts, though perhaps not so thoroughly original. *The Scream* (1895; fig. 10.11) is his best-known lithograph. Here, the individual strokes recall the gouge marks in Gauguin's woodcuts or the elongated brushstrokes

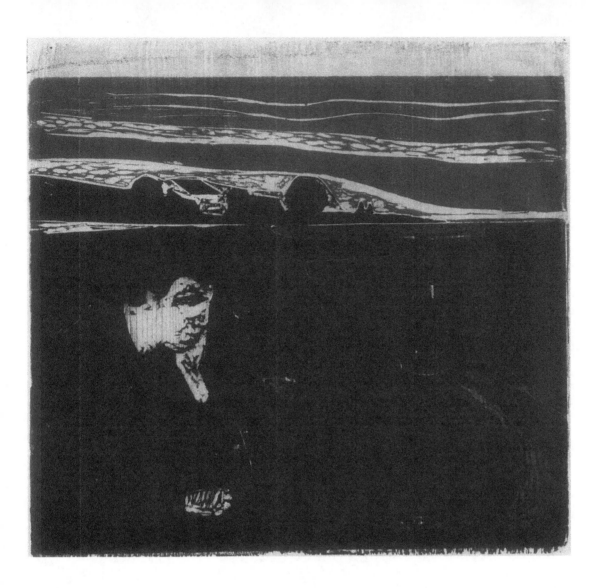

FIGURE 10.10
Edvard Munch. Evening (Melancholy: On the Beach). *1896. Color woodcut. 403 × 457 mm. Museum of Modern Art, New York.*

of Van Gogh's paintings. The experience of nameless dread that led to *The Scream* was described by Munch in terms that will introduce us to the existential anxiety common in Expressionist artists:

> I was walking along the road with two friends. The sun set. The sky became a bloody red. And I felt a touch of melancholy. I stood still, leaned on the railing, dead tired. Over the blue-black fjord and city the sky hung blood and tongues of fire. My friends walked on and I stayed behind, trembling with fright. And I felt a great unending scream passing through nature.[30]

Munch's even emphasis on parallel, linear shapes echoes the morbid heightening of sense perception described in this passage. His steep space sends the central figure careening toward us. Its open mouth and skull-like head not only convey unspecified anxiety but suggest death as well, so that a subjective, momentary state of mind is curiously merged with the object of fear (death) that provokes it.

Munch combined lithography with woodcut in new ways. *Madonna* (1902; fig. 10.12), a stunning lithograph made with tusche and crayon on three stones printed in beige, red, and black, and with a woodblock inked in blue, is another deterministic statement of gender roles.

FIGURE 10.11

Edvard Munch. The
Scream. *1895. Litho-
graph. 352 × 254 mm.
National Gallery of Art,
Washington, D.C.*

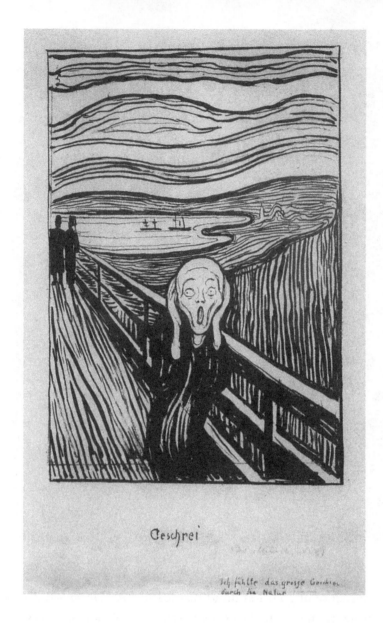

The siren-woman, ecstatic at the moment of conception and seen from the point of view of
the male fertilizing her, swims luxuriantly in her own hair and is surrounded by a remarkable
border comprising spermatozoa and a fetus. With the power to attract and hold the male,
woman was for Munch an ambiguous creature—enticing, fertile, predatory.[31] It is no wonder
that the wraith-like girl in figure 10.13 (etching, 1902) seems to tremble on the brink of this
sexuality that will overwhelm her individual identity. Although Munch depicts the girl with
sensitivity and compassion, this simple etching indirectly suggests the same disturbing oblit-
eration of female individuality in sexuality as the more complex and strident *Madonna*.

 Vampire (1895; fig. 10.14, color plate, p. 474) is another extraordinary mixed-media print
dominated by Munch's joyless view of human sexuality. Here, the woman is entirely dehuman-
ized (as is the man, in a sense) by her fearsome, animalistic domination. Ostensibly, she leans
over to kiss the nape of his neck, but her action is made to seem parasitic rather than loving.
Blood-red hair, which preoccupied Munch through his many painted and printed versions of
this theme, reinforces the menacing character of her gesture. Like *Madonna*, *Vampire* was ini-

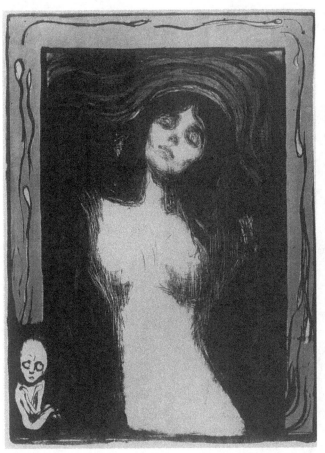

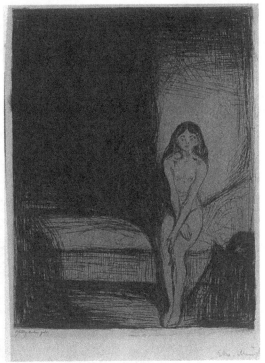

FIGURE 10.12
Edvard Munch.
Madonna. *Designed in
1895; color printing 1902.
Color lithograph and
woodcut. 603 × 442 mm.
Museum of Modern Art,
New York.*

FIGURE 10.13
Edvard Munch. Puberty
(At Night). *1902. Etch-
ing and aquatint. 197 ×
160 mm. Art Institute of
Chicago.*

tially conceived as a lithograph alone, but Munch began experimenting with a red-inked wood-
block for the woman's hair. He abandoned this alternative, preferring to print the red area with
a second stone. Through more trial printings with cut-out and inked pieces of cardboard,
Munch arrived at his final solution for the combination of lithographic stones and jigsawed
woodblocks. Munch varied the sequence of the printing of these surfaces, thereby altering the
emphasis given to the drawing and to the flat, grained shapes produced by the woodblocks. (If
the lithographic parts are printed over one or more of the blocks, they have more strength than
they would if the blocks are printed over them.) As Elizabeth Prelinger notes in her lengthy
disentangling of Munch's creative process in *Vampire,* the print's "experimental nature consists
. . . in its development in printing, rather than in reworking of the drawn image."[32] This
approach, also taken by Gauguin, was full of implications for future printmaking.

 Munch pursued the subject of death relentlessly.[33] *The Sick Child* (1894; fig. 10.15), in the
traditional technique of drypoint, is one of many works, among them an important early
painting, reflecting his bitter experience of the death of his sister Sophie from tuberculosis

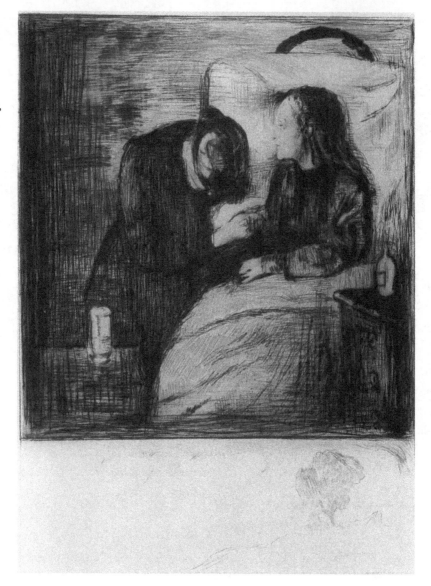

when he was fourteen. This disease was common in late nineteenth-century Norway; Munch himself was afflicted, but his life was spared. Perhaps he felt the guilt familiar to the survivors of a lost loved one. He was unable to find comfort in the Christianity that assuaged the grief of the rest of his family, particularly the severe and conservative Dr. Christian Munch, whose relationship with his son was predictably tumultuous. Munch envisioned the emaciated child looking beyond the confines of the sickroom, her face radiant against a large pillow. At the bottom, an open landscape suggests the freedom from suffering that death will afford her. It is a haunting, ephemeral image, in which all the delicacy drypoint has to offer is exploited. One is reminded of the fragility of Rembrandt's studies of his sick wife, Saskia (see fig. 4.39). Both artists used light to suggest transcendence of death.

In another drypoint, *Death and the Maiden* (1894; fig. 10.16), Munch resuscitated an old Germanic theme in which the fullness of life, represented by the ripe female form, succumbs erotically to the corruption of death. Here, he worked with aggressive scratches that correspond to the violence of Death's approach. But even this is not entirely negative, for in Munch's monistic thought all things are interconnected. The dissolution of death contributes to new life (note the border of spermatozoa and fetuses), just as the loss of self in sexual ecstasy may

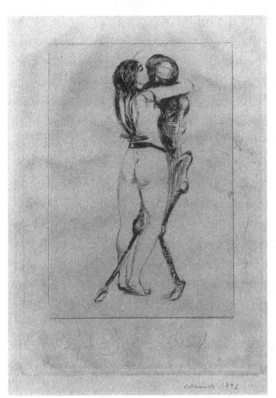

FIGURE 10.16

Edvard Munch. Death and the Maiden. *1894. Drypoint. 304 × 216 mm. Art Institute of Chicago.*

result in the perpetuation of life. From this point of view, sex and death are similar: both oppose the preservation of the self but are necessary. Art alone provided a way of coping with the conflicting forces in Munch's world. By portraying them symbolically, he was able to insulate himself against their destructive power. But even more important, the making of art had, for him, a quasi-religious function. Undertaken just as fanatically as his father had embraced Christianity, it offered the artist a different kind of redemption. This redemptive function of art is a central tenet running through most varieties of Expressionism.

DIE BRÜCKE

The four young architecture students (Fritz Bleyl, Erich Heckel, Ernst Ludwig Kirchner, and Karl Schmidt-Rottluff) who founded *Die Brücke* (The Bridge) in 1905 synthesized this quasi-religious understanding of art, the technical implications of Gauguin's and Munch's woodcuts, the painter's intense involvement in printmaking as established by Klinger, and the various thematic concerns we have been discussing. The artists of *Die Brücke*, ultimately to include Otto Mueller, Emil Nolde, and Max Pechstein, professed that their art was no less than the instrument for the renewal of modern humanity. Their group name suggested bonds between people, the linking of past, present, and future, and human transcendence of mundane existence. It may be significant that Friedrich Nietzsche, in his influential *Thus Spake Zarathustra* (1883), used "bridge" and "rope over an abyss" as metaphors for the ambivalent, constantly striving position of humanity, caught "between animal and Superman" (*Übermensch*). Nietzsche celebrated this ambivalence: "What is great in man is that he is a bridge and not a goal." [34]

For the artists of *Die Brücke,* the metaphor of the bridge expressed their sense of the progressive evolution of art, of which they were the culmination, and captured the essential paradox of the human condition. Finite and earthbound, the human being nevertheless yearns for something more; part animal and part Superman, the human being is fulfilled only in risking everything to attain this transcendent self. To pursue this goal of human renewal, the *Brücke* artists repudiated the "art for art's sake" attitude that they perceived as underlying much avant-garde art. Sons of the middle class, and cultivators of its patronage, they nevertheless rejected what they saw as its materialism and spiritual stagnation: youth, understood ideologically rather than chronologically, was polarized against age and the status quo. Self-teaching and self-promotion, in forms such as traveling exhibitions and the enlistment of "passive" members, who supported the group's efforts by subscribing to prints, replaced academic training and official shows.[35] The young *Brücke* artists settled in the working-class neighborhood of Dresden in order to express separation from their own middle-class origins and solidarity with working people. They visited the countryside in order to establish a close communion with nature and with each other. As an antidote for the impersonality of an industrialized society, they wanted their art to bear the imprint of the artist's emotions and hands.

All of the *Brücke* artists were devoted to printmaking, which represented for them the most direct, hands-on involvement with one's work. Their enthusiasm for printmaking was best described by Kirchner:

> Perhaps what makes an artist a printmaker is, in part, the desire to define clearly and conclusively the singularly loose forms of drawing. On the other hand, the technical challenge of printmaking certainly releases powers in the artist which do not come into play in the much more easily managed techniques of drawing and painting. The mechanical process of printing unifies all the separate phases of the work of art. Yet creative work can be prolonged as long as one wishes without danger. It is extremely exciting to rework a picture again and again over a period of weeks or even months in order to achieve the ultimate in expression and form without any loss of freshness. The mysterious excitement which surrounded the invention of printing during the Middle Ages is still felt by anyone who seriously studies printmaking down to the last detail of craftsmanship. There is no greater joy than to watch the printing press roll over a completely cut woodblock or to etch a lithographic plate with nitric acid and gum arabic and observe whether the desired effect occurs or to test on trial proofs the maturing of the detail, page after page, without noticing the passing hours. Nowhere can one get to know an artist better than in his prints.[36]

Kirchner was the most dedicated printmaker of the group, and, as is evident in the passage above, its most articulate spokesman. In the studio in Dresden, it was he who took the lead in establishing *Die Brücke*'s bohemian lifestyle.[37]

Die Brücke's innovative vision of the print encompassed all the major media, but it was in woodcut that these artists made their most impressive statements. Behind Kirchner's *Kämpfe* (*Battles,* 1915; fig. 10.17), an illustration for Adalbert von Chamisso's novel, *The Amazing Story of Peter Schlemihl* (1813), stands Munch's interest in richly layered textures and his feeling for the grains of woodblocks. Three blocks in black and saturated red and blue were employed in this work. While the color sometimes helps to define areas on the woman's body and Schlemihl's lips, it is fundamentally independent of the forms: it works expressively rather than

descriptively. The "hero" of Chamisso's work sells his shadow, a metaphor for personal and social alienation that greatly appealed to Kirchner, who in this year was inducted into military service and discharged after suffering a nervous collapse, exacerbated by drugs taken to cure his insomnia. *Kämpfe* concerns Schlemihl's ill-fated relationship with a lover, whose psychic pain is incorporated in a seemingly wounded body behind his staring, strained face. Her "bloody" hand seems to grasp a heart, difficult to see because it is printed in red ink over black, on the man's chest. Although we can see reformulation of Munch's obsession here, Kirchner's conception of the tragedy caused by "the ecstasy of the blood" is complicated by his own identification of himself as a woman in his letters (i.e., he was, like a woman, ineligible for military service); the artist's psyche may be split into the male and female protagonists of *Kämpfe*.[38]

From the formal standpoint, Kirchner's print has lost all traces of the curvilinear refinement and seductive color of much late nineteenth-century Symbolist and Post-Impressionist art. The lines and shapes produced by the gouge and knife are brutal, and no vestige of the European tradition of the female nude can be perceived in the formal treatment of the woman's figure, as it still can in Gauguin's Tahitian women. We are treading on new aesthetic ground. Carol Duncan has also argued that the brutal formal means of Expressionist art are one of many signs of a new sense of male domination in the early twentieth century, which manifested itself in art in a movement from the controlling, alluring women of Symbolism to the abjectly submissive and/or animalistic nudes produced by various early twentieth-century avant-garde artists. With her heart-grasping hand recalling Munch's predatory females, and her apparently wounded body defined by slashes and gouges, the female figure in *Kämpfe* seems to embody this transition.[39]

Although woodcuts like *Kämpfe* are the most strikingly original graphic products of *Brücke* artists, they also took lithography in a radically new direction. Schmidt-Rottluff seems to have been the first group member to experiment with lithography, but it was Kirchner and Heckel, working closely together in 1907 and 1908, who developed new processes that flew in the face of the technical accomplishments of nineteenth-century master printers. Indeed, a keynote of *Die Brücke's* approach to the lithograph was the assertion that only the artist should print the stones. Despite the woodcut's importance for *Die Brücke,* the lithograph provided a spontaneity that the woodcut could not. Even Munch expressed shock when shown Schmidt-Rottluff's technically simple but visually raw lithographs by the collector Gustav Schiefler in 1907: "God protect us, we're heading for bad times."[40]

Munch's remark was certainly an overstatement, but subsequent experiments by Kirchner and Heckel, in turn transmitted to Schmidt-Rottluff and others, did represent a total rethinking of lithography as an artist's medium. The "turpentine etch," for example, in which the stone was washed with water with a small amount of turpentine, caused the particles of lithographic pigment to reorganize on the stone—blurring lines, filling in empty areas, and lightening dark tones. The initial formal qualities of the image could thus be completely altered. Similarly, over-etching the stone with nitric acid and gum arabic would break down the lines into globules; under-etching would cause the stone to pick up a heavy layer of ink. Inking their stones to the edges produced an irregular border that proclaimed rather than disguised the materials and processes inherent in lithography. Kirchner's *Street in Dresden* (1908; fig. 10.18) recalls Munch's *The Scream* (fig. 10.11) in its rapid recession of space and its emphasis on isolation and alienation in an urban context (note the skull-like male head at the far left), but the barely defined forms and blotchy surface of the lithograph make Munch's print look re-

FIGURE 10.17

Ernst Ludwig Kirchner.
Kämpfe (Battles), *illus-
tration for* The Amazing
Story of Peter Schlemihl
*by Adelbert Chamisso.
1915. Color woodcut.
334 × 214 mm.
Städelsches Kunstinstitut
und Städtische Galerie,
Frankfurt.*

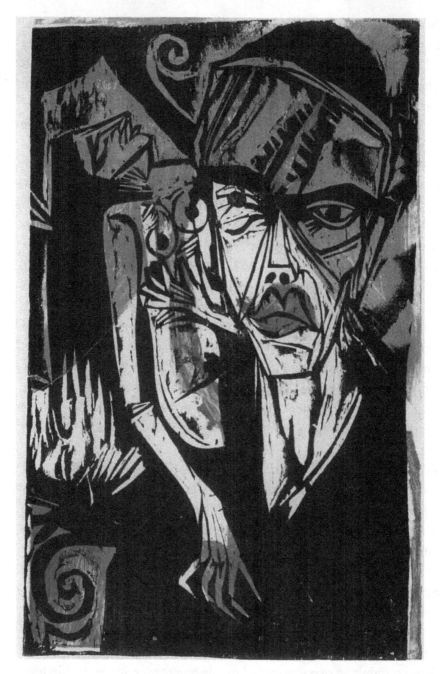

fined, almost precious, by comparison. Kirchner's urban crowd seems to press down upon the viewer like so many ghouls upon their living prey.[41]

Such disturbing urban scenes are opposed to the vision of landscape among the *Brücke* artists, which reveals an ecstatic approach to nature strongly influenced by German Romanticism of the nineteenth century,[42] particularly as expressed in Caspar David Friedrich's works, and even by the Danube school of the sixteenth century. A similar rapturous response to the growth, energy, and complexity of the forest can be seen in both Altdorfer's *Landscape with a Large Pine* (fig. 2.45) and Kirchner's vigorous *Mountain Track with Firs* (fig. 10.19) etched at the beginning of the twenties. The use of line in both etchings makes palpable the upward growth of trees, the drooping of branches, and the tangle of underbrush.

FIGURE 10.18

Ernst Ludwig Kirchner.
Street in Dresden. *1908.*
Lithograph. 270 ×
383 mm. Museum of
Modern Art, New York.

Just as they emphasized the stony character of the lithographic stone and the "woodiness" of the woodblock, the *Brücke* artists reveled in the scratchiness of the etched line, the corrosiveness of the acid, the metallic character of the plate. They used virtually any means to achieve textures: old or rusted plates were employed, as were the backs of plates, aquatint resin was laid on irregularly, and acid would be brushed directly on the plate in open biting. Of all the *Brücke* artists, Emil Nolde, part of the group between 1906 and 1907, was the most innovative intaglio printmaker. His exact procedures are difficult to determine. Schiefler described Nolde's uneven brushing on of an asphaltum etching ground so that the plate would be differently bitten depending on the thickness of the ground. Repeated work with the brushed-on ground and immersions in the acid yielded the highly textured, painterly effects of Nolde's etchings, such as the voluptuous *Kneeling Girl* (fig. 10.20) of 1907.[43]

In discussing *Die Brücke*'s graphic techniques, we have also introduced their thematic concerns. The artist's exploration of the self, the use of the female nude, and a focus on the urban scene and its opposite, the rural landscape, remained, along with the religious themes we shall encounter shortly, the fundamental subject matter of the majority of *Brücke* prints. Kirchner's magnificent *Winter Moonlight* (1919; fig. 10.21, color plate, p. 474), done after *Die Brücke* had disbanded and while he was recovering in the Swiss Alps from his emotional collapse, is one of his most spectacular color woodcuts. Numerous and partly overlapping colors are carefully controlled, despite the Expressionist emphasis on spontaneous response. The jagged cuts of the gouge are well suited to convey the wild iciness of the environment, which remains frozen in spite of Kirchner's use of hot reds and pinks. Utterly convinced of his status

FIGURE 10.19

Ernst Ludwig Kirchner.
Mountain Track with
Firs. *Ca. 1921. Etching.*
282 × 250 mm. Museum
Folkwang, Essen.

as the greatest living German artist, Kirchner committed suicide in 1938, unable to cope with the Nazi deprecation of his works.

The perception of a mystical identification of humanity and nature affected Nolde more than any of the other *Brücke* artists. His emphasis on *Blut und Boden* ("Blood and Soil") eventually led him to Nazism's ardor for the Fatherland and *das Volk* ("the People"), and it was much to his amazement that the Nazis condemned his art along with the rest of the German avant-garde as degenerate. Nolde's lithographic landscapes are some of the most intense Expressionist visions of nature; they reflect the somber, harsh environment of his home in northern Germany. The heavy black forms and rose color, unfolding into more saturated shades, of *Autumn Landscape* (1926; fig. 10.22, color plate, p. 475) give a sense of a cold, sodden earth with life lurking just beneath the surface. The condensed power of Nolde's forms and his freedom of execution look forward to American Abstract Expressionism and the lithographs of Franz Kline.

The treatment of the figure by the *Brücke* artists often shows the influence of African and Oceanic sculpture, which was concurrently being studied by Picasso and other artists.[44] Erich Heckel's *Franzi Reclining* (1910; fig. 10.23) exhibits this influence not so much in the body but in the mask-like face. Heckel's woodcut technique here echoes Munch's. He cut one block into four pieces, which he then printed in strident red and black. With its resultant separation of color areas, the print is startlingly flat and aggressive, and makes the passive eroticism of Nolde's

FIGURE 10.20

Emil Nolde. Kneeling Girl. *1907. Etching and drypoint. 303 × 225 mm. Portland Art Museum.*

Kneeling Girl (fig. 10.20), with her soft, full body and hidden face, look old-fashioned by comparison. Heckel's nude draws on the stereotype of female sexuality as "savage" and "animalistic"—conceptions that often distinguish German Expressionist female nudes from their seemingly more compliant counterparts in French Fauvism. The proliferation of the female nude in both Fauvist and Expressionist art, Duncan has argued, gave form to the triumphant creative will of the male avant-garde artist by equating it with a conquering virility.[45]

Nolde collected tribal art, and in 1913 and 1914 he went, like Gauguin, to the South Seas. His *Dancers* (woodcut, 1917; fig. 10.24) evokes a generalized primitivism in the raw, simplified faces and bodies, but this is combined with sinuous curves reminiscent of German Art Nouveau, or *Jugendstil*. The dancers move ecstatically, bending backward with an impulsiveness that expresses the ancient analogy between woman and irrational instinct. One figure holds her breasts, explicitly linking her movements and her sexuality. The image attempts a literal rendering of the primacy of feeling over matter and form. The design is largely defined by empty, or "blind-stamped," areas, and the paper itself was strongly embossed by the pressure of print-

FIGURE 10.23

Erich Heckel. Franzi
Reclining. *1910. Color
woodcut. 227 × 420 mm.
Museum of Modern Art,
New York.*

FIGURE 10.24

Emil Nolde. Dancers.
*1917. Woodcut. 238 ×
312 mm. Cleveland
Museum of Art.*

ing. The inking of the block (done, along with the printing, by Nolde and his wife, Ada
Vilstrup) is carefully varied so as to reveal the horizontal lines of the wood-grain between the
skirts, visually and emotionally tying the two dancers together, while printing opaquely
elsewhere.[46]

The implication of uninhibited sexuality in images such as Heckel's *Franzi Reclining* or
Nolde's *Dancers* is, of course, redoubled by the placement of the nude in an idyllic natural
setting. Multiple nudes, often bathing, in a forest or beach environment are a staple *Brücke*
subject. Otto Mueller's *Bathing Scene with Four Figures, House, and Boat* (fig. 10.25), a color
lithograph of about 1914, is typical in its evocation of a symbiotic relationship between the
human and the natural, and in its suggestion of innocent sexual play in one figure chasing

another through the water. In Max Pechstein's *Dialog* (color woodcut, 1920; fig. 10.26), however, as Heller points out, the figures overwhelm the setting, which has lost its specificity as well as its capacity to encompass the figures to create an idyllic bond between humanity and nature.[47] What results is a determinedly abstract image, dominated by a harsh angularity and unified by repeated jagged patterns and the simple blue, ocher, and black color scheme. The figures are impressive for their compressed energy, again reminiscent of African sculpture.

The artists of *Die Brücke* looked not only toward African art, but also back to the German origins of the print and to the devotional themes of the earliest woodcuts. There is Nolde's famous woodcut *The Prophet* (1912; fig. 10.27), in which he fully exploited the raw power of the cutting and the grain of the block. The immediacy of the final image belies the careful way in which Nolde created it, for several probable preparatory studies in brush and black ink are extant.[48] The wood itself seems to embody the courage and enduring faith of Old Testament prophets, so closely are image and material wedded. Schmidt-Rottluff's *Road to Emmaus* (woodcut, 1918; fig. 10.28), part of a portfolio of nine religious prints, evokes a medieval otherworldliness and the direct expressiveness of early prints on biblical themes. The risen Christ walks with his broken, sorrowful disciples, his raised hand comforting the viewer, his face transfigured by an awareness that escapes his companions (note his uncanny "hollow" eye). Behind them, a black "comet" bursts ominously across the landscape. As Donald Gordon points out, Schmidt-Rottluff's depiction of Christ as simultaneously terrifying and attractive (we are riveted both by his unearthly eyes and by his enlarged, blessing hand) may be influenced by Rudolf Otto's contemporary, epoch-making study of religious psychology, *The Holy* (1917).[49] Once again, however, the world war must be taken into account in our understanding of this remarkable image. Schmidt-Rottluff has served since 1915 on the Russian front. Whatever else this print encompasses, it may reflect his experiences with death, his gratitude for being alive, and, surely, his awareness of the suffering caused by the war, embodied in this moving image of Christ and his weary followers.

THE BLUE RIDER AND THE BAUHAUS

The second major Expressionist group was *Der Blaue Reiter* (The Blue Rider), formed in Munich in 1912. Its artists (the Russian-born Wassily Kandinsky, August Macke, Franz Marc, Gabrielle Münter, and Alexei von Jawlensky) were never as closely knit as those of *Die Brücke*, but they had a common heritage in *Jugendstil*, with its stylized curvilinear patterns and flattened color areas. This, along with their varied interests in many kinds of folk, tribal, and children's art and French modernism (Robert Delaunay's works for example), lent their works a lyricism very different from the assertive rawness of *Die Brücke*. The outlook of *Der Blaue Reiter* was more cosmic than self-directed, emphasizing the mystical and spiritual, rather than the emotional or psychological. Like *Die Brücke*, however, it conceived of art-making as existential necessity, not as aesthetic exercise. Kandinsky, the major theorist, insisted on the "inner necessity" of form—its total subservience to spirit ("Matter here is simply a kind of pantry from which the Spirit, like a cook, takes necessary ingredients."[50]) Yet, despite this emphasis on spirit, *Der Blaue Reiter*, like *Die Brücke*, cannot be understood apart from political change. Mystical and occultist movements such as Theosophy were bound up with political stances such as socialism and anarchism in that all were understood as ways of defying the materialism

FIGURE 10.25

Otto Mueller. Bathing
Scene with Four Fig-
ures, House, and Boat.
Ca. 1914. Lithograph
with watercolor. 326 ×
433 mm. Galerie
Nierendorf, Berlin.

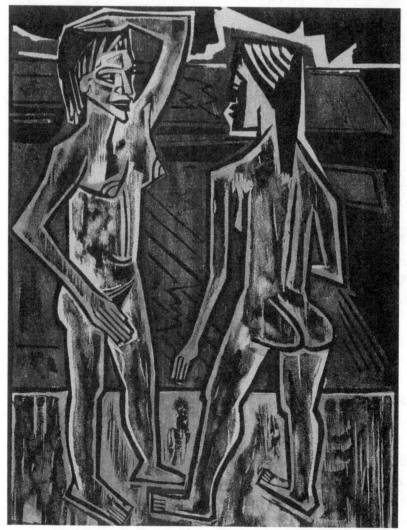

FIGURE 10.26

Max Pechstein. Dialog.
1920. Color woodcut.
400 × 320 mm. Museum
of Modern Art, New
York.

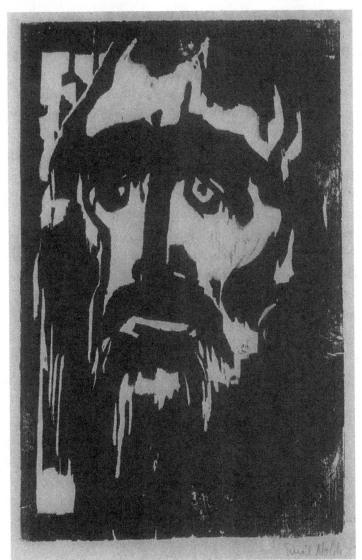

FIGURE 10.27
Emil Nolde. The
Prophet. *1912. Woodcut.
320 × 212 mm. Los
Angeles County Museum
of Art.*

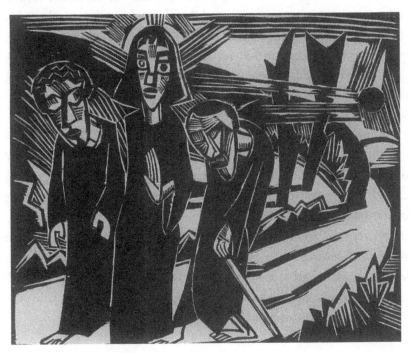

FIGURE 10.28
Karl Schmidt-Rottluff.
The Road to Emmaus
from the portfolio
Schmidt-Rottluff: Neun
Holzschnitte. *1918.
Woodcut. 397 × 499 mm.
Philadelphia Museum
of Art.*

and authoritarianism of the status quo.[51] As suggested at the beginning of this chapter, political revolution was tied to this revolution of culture, which called for the emergence of a new kind of human being. Art carried this transforming and redemptive charge.

Printmaking was as important to *Blaue Reiter* artists as it was to artists of *Die Brücke*. The critic, collector, and publisher Herwath Walden championed their cause (along with others) by fostering exhibitions and by publishing prints in his periodical for avant-garde art. *Der Sturm* (*The Storm*) began publication in 1910, a year before Franz Pfemfert's more overtly political *Die Aktion* (*Action*), which also featured original graphic art.[52] Kandinsky, however, was already an established printmaker before *Der Sturm* was founded. He was the most gifted graphic artist of his group, as Kirchner was in *Die Brücke*.

For most of his early color woodcuts (1902–9), Kandinsky, emulating the Japanese, employed one block for lines and another for colors. He also used water-soluble rather than oil-based pigments to achieve translucency. *Moonlit Night* (1907; fig. 10.29) is his most complicated early print, produced from three half-blocks, three full-sized blocks, and individual stamps (the triangles in the sky and the "K" at the lower left).[53] The mottled blue of the sky, light green of the ocean, and dark green and ocher of its waves were printed from the half-blocks, whereas the sea-serpent and mountain were printed from the full blocks, inked in blues and pinks. The bright yellow moon and highlights on the water derive from another full block. The result is a fairy-tale image, in which a fantastic subject is made more mysterious by evocative color.

In 1913 Kandinsky published a book of his poetry, *Klänge* (*Sounds* or *Harmonies*), along with fifty-six woodcuts, twelve in color, some of which apparently dated from 1907.[54] He had been working on the poetry since 1909. Both verbally and visually, *Klänge* broke new ground. The prose poems juxtaposed events, encounters, objects, and perceptions so as to suggest new types of relationships among them, while the woodcuts complemented rather than illustrated the free flow of dream-like experiences offered by the text.[55] *Lyrical* (1911; fig. 10.30, color plate, p. 475), also published independently, is based on one of Kandinsky's favorite motifs—the horse and rider—but the objective image is becoming more abstract. The expansive leap of the horse, reminiscent of prehistoric cave paintings, is established by a black key block. Three other blocks print yellow, blue, and red, and produce a fourth color, a brownish green, where the blue and yellow overlap. *Lyrical* is about movement, but not the frenetic, machine energy of Futurism, which Walden also promoted. Instead, Kandinsky celebrates the energy of nature and creates an emblem for the soaring of the spirit, the transcendence through creativity that was the aim of *Der Blaue Reiter*.

When World War I broke out in 1914, Kandinsky went back to Russia. There he was a driving force in the development of components of the Russian avant-garde, working and teaching at various institutions until 1921. That year, discouraged by the Soviet government's attitude toward abstract and non-objective art, he returned to Germany. He taught at the Bauhaus in Weimar, that remarkable center for art, architecture, crafts, and design, until 1933. In contrast to the Dadaist movement, which, with some justification, viewed Expressionism as retreating from harsh reality into a kind of utopian mysticism, the Bauhaus maintained an idealistic perspective closely related to earlier Expressionism. Walter Gropius' program, with Lyonel Feininger's Cubist- and Futurist-inspired woodcut *Cathedral* (fig. 10.31) as its title page and an emblem of the group's aspirations, urged artists

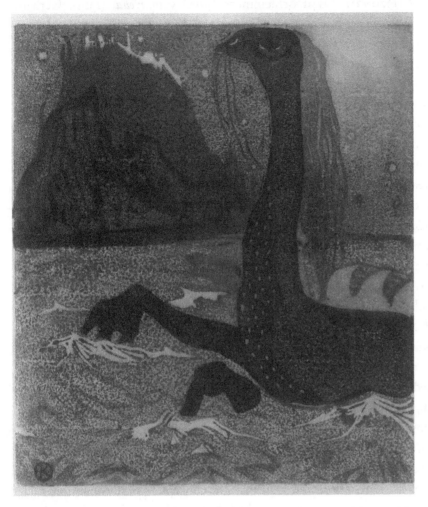

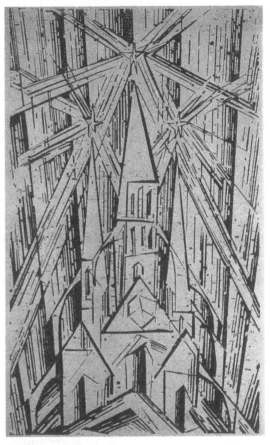

to create a new guild of craftsmen without the class distinctions that raise an arrogant barrier between craftsmen and artist! Together let us desire, conceive and create the new structure of the future which will embrace architecture and sculpture and painting in one unity and which will one day rise toward heaven from the hands of a million workers like the crystal symbol of a new faith.[56]

The importance of craft in printmaking, always present but reiterated by the Expressionists, fitted well into this manifesto, and prints also held out the prospect of monetary reward, important to even the most idealistic institutions. Under Feininger's direction the Bauhaus print studio issued, in 1921, a prospectus for five portfolios entitled *Neue europäische Graphik* (*New European Prints*). These offered the collector a chance to acquire prints by major avant-garde artists, from whom Gropius solicited donations. Only two of these albums were published, and neither was as financially successful as hoped. Other Bauhaus portfolios were Fein-

inger's *Twelve Woodcuts* (1920–21), Oscar Schlemmer's *Game with Heads* (1923), Gerhard Marcks's *The Saga of Wieland of the Edda* (1923), *Masters' Portfolio from the Bauhaus,* and Kandinsky's magical *Kleine Welten (Small Worlds,* 1922), which consisted of four drypoints, two black and white woodcuts, two color lithographs produced from transfers of woodcut impressions to stones, and four color lithographs made in the conventional way.

Kandinsky's employment of these media parallels his theoretical ideas as expressed in *Punkt und Linie zu Fläche (Point and Line to Plane,* 1926), in which different formal and societal functions are attributed to woodcut, intaglio printmaking, and lithography. The essential linearity of intaglio is emphasized in Plate X (fig. 10.32), a drypoint in which straight and curving lines and stippling create dynamic tensions and interrelationships that suggest principles of nature such as gravity, centrifugal force, and even the mutual attraction or repulsion of microscopic organisms. Under the influence of Suprematism and Constructivism, Kandinsky's style had become more geometric. Although still rooted in an Expressionist vision of nature, his forms here are more angular, their motion tempered by a firmer sense of axial and radial structure. In *Orange* (1923; fig. 10.33), a complex color lithograph printed from four stones inked in yellow, red, blue, and black, and dominated by a large orange wedge, these qualities are more pronounced, and flat shapes are more important than lines. For Kandinsky, lithography was a quintessentially modern medium because of its "particular speed in creation, combined with an almost indestructible hardness of the block."[57] It was quite a different vision of the virtues of this medium than that held by early lithographers, who exploited the stone's sensitivity in producing tonal nuances and other qualities associated with traditional drawing.

Although Kandinsky was the most important printmaker associated originally with the *Blaue Reiter* group, other members followed his lead without imitating his style or content. Franz Marc, who died in 1916 at the Battle of Verdun, focused on animals and their surroundings: "Is there a more mysterious idea for the artist than the conception of how nature is really reflected in the eyes of an animal? . . . How wretched, how soulless is our habit of placing animals in a landscape which mirrors our own vision instead of sinking ourselves in the soul of the animal to image its perceptions."[58] *Creation 1* (woodcut, 1914; fig. 10.34) was part of a project to illustrate the books of the Bible with prints by himself, Kandinsky, Klee, Heckel, and Oskar Kokoschka—a plan that was ultimately aborted by the war. Here, the same diagonal and circular movements penetrate the animal bodies and natural environment, welding both into a single statement of the vitality of nature. The theme of an identity between humanity and nature, which ran through Romantic art and was picked up by Gauguin and the Expressionist artists, has evolved here into a projection of the human psyche *into* the animal psyche—an approach very different from Delacroix's use of the tiger as an analog of human passion.

Although earlier associated with *Der Blaue Reiter* and later with its successor group, *Die Blaue Vier* (The Blue Four), and still later with the Bauhaus, Paul Klee is surely one of the most difficult of modern artists to categorize. His mature style is deceptively simple, at once naive and sophisticated, formally refined and expressively engaging. It is related not only to Expressionism but to the exploration of the unconscious mind in Surrealism and to the creation of autonomous, pseudo-geometric structures in Cubism.

Klee's early *Opus 1: Inventions,* produced in Bern between 1903 and 1905, is a puzzling series of eleven etchings whose sequence and iconography have yet to be thoroughly understood. The technique of these prints is traditional—etching, sometimes with aquatint—and

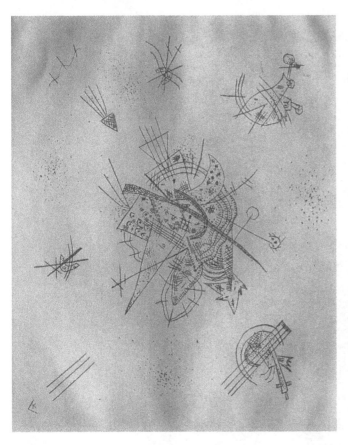

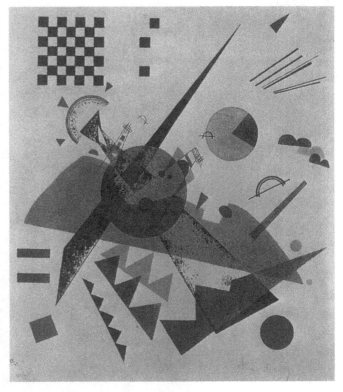

FIGURE 10.32
Wassily Kandinsky.
Plate X of Kleine Welten
(Small Worlds). *1922.*
Drypoint. 239 × 199 mm.
Museum of Modern Art,
New York.

FIGURE 10.33
Wassily Kandinsky.
Orange. 1923. Color
lithograph. 406 ×
384 mm. Museum of
Modern Art, New York.

the style capitalizes on the distortions employed by earlier satirists, such as Goya, Gillray, or Daumier. *Two Men Meet, Each Supposing the Other to Be of Higher Rank* (1903; fig. 10.35) is an exposure of hypocrisy and obsequiousness. The two men out-bow and out-scrape each other as their bodies contort into insect-like forms. The pervasively prickly quality of this and other images in the series reinforces its basic function as social criticism: a small catalog of Klee's observations on human folly.

In *Witch with the Comb* (lithograph, 1922; fig. 10.36), Klee has moved from distortion to a more thorough abstraction. He creates a magical, malevolent being out of line alone. A furrowed brow, piercing eyes, and arrow-hands convey the sense of directed ill-will; the Spanish comb and dangling earring characterize the witch as a seductress. An odd configuration of lines in the center of the body suggests at once her internal body cavity, genital organs, and racy décolleté. Although small, she possesses a concentrated psycho-sexual presence.

A more complex lithograph, perhaps Klee's most evocative, is *Hoffmannesque Scene* (fig. 10.37, color plate, p. 476), published as part of the Bauhaus album of 1921. Perhaps it was named after E.T.A. Hoffmann, author of bizarre short stories, or the comic opera based on

FIGURE 10.34

Franz Marc. Creation 1
from Bauhaus Portfolio
3. *1914. Woodcut. 289* ×
199 mm. British Museum,
London.

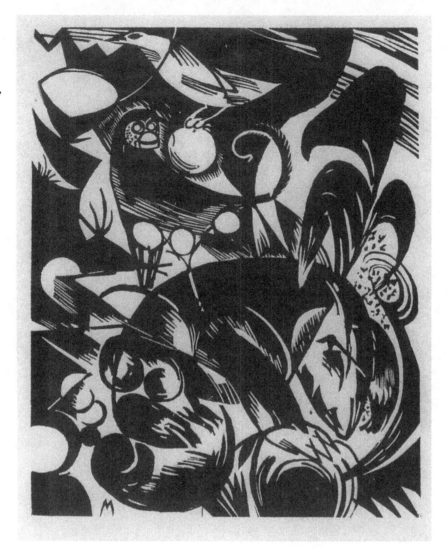

FIGURE 10.35

Paul Klee. Two Men
Meet, Each Supposing
the Other to Be of
Higher Rank *from* Opus
1: Inventions. *1903–5.*
Etching. 118 × *225 mm.*
Museum of Modern Art,
New York.

FIGURE 10.36

Paul Klee. Witch with the Comb. *1922. Lithograph. 311 × 213 mm. Museum of Modern Art, New York.*

them, *The Tales of Hoffmann,* by the nineteenth-century French composer Jacques Offenbach. In this print Klee utilized a technique of oil transfer lithography (borrowed from his painting) that has been discussed by Jim Jordan.[59] Klee worked from a preparatory drawing that he traced onto lithographic transfer paper by means of an intervening "carbon" made by coating the underside of a piece of paper with an oily ink or paint. The image, filtered through three layers of paper (the preparatory drawing, the "carbon," and the lithographic transfer sheet), was then relinquished to the stone, itself a fourth texture and spatial layer. The blurry quality of the lines and the various blotches caused by the pressure of Klee's hand appealed to his sense of the enigmatic and his exploitation of seemingly chance elements that were sometimes not at all accidental. Here, for example, the blotches emphasize the umbrella and the heart stuck with hatpins. The "narrative" image, which calls up undefined and intriguing relationships among the various protagonists, is laid over roughly geometric shapes produced by two additional stones inked in soft violet and yellow. Where these colors overlap, the resulting shapes are tan; where no color appears, the white of the paper forms more shapes. These wedded-together or contiguous planes, not imperviously flat but given an atmospheric character by the stones' grain, create a shifting space that is Klee's adaptation of Cubism.

KOKOSCHKA, CORINTH, LEHMBRUCK, BARLACH, KOLLWITZ

A number of Expressionist artists were not identified with either *Die Brücke* or *Der Blaue Reiter,* although, along with other avant-garde artists of the late nineteenth and early twentieth centuries, they participated in organizations to combat academic art, such as the *Sezession* (Se-

cession) movements in prewar Vienna and Berlin. After the war, Expressionists banded to-gether with others in organizations like the *Novembergruppe* in Berlin, and the Munich and Dresden *Sezessions*.[60]

The artistic and intellectual milieu of prewar Vienna, which included Sigmund Freud and the composers Gustav Mahler and Arnold Schönberg, nourished the nervous, visionary style of Oskar Kokoschka, also known as the author of the violent drama *Murderer, Hope of Women* (1909), which dealt with the perennial Expressionist theme of the male/female conflict as universal and elemental. (He would later construct a life-sized doll as the perfect female companion.) Kokoschka's gruesome illustrations for his play caused a sensation when Walden published them in *Der Sturm*.

The agitated *Self-Portrait with Crayon* (fig. 10.38), a lithograph, gives some sense of his own turbulent life, but goes beyond this to suggest the heightened sensitivity and spirituality that make up the Expressionist vision of human existence. It functioned as a frontispiece for a series of eleven prints (published in 1916 in bound and portfolio form) to accompany the text of Bach's Cantata 60, "O Ewigkeit, du Donnerwort" ("O Eternity, Thou Word of Thunder"). Using this text, itself based on Revelation 14:13, Kokoschka worked out his thoughts about fear and hope, personified respectively by himself and his lover, Alma Mahler, the composer's widow. Here, Kokoschka's huge eyes peer out at the viewer, seeking that vital linking of the artist and viewer through the image. In the urgency of Kokoschka's self-portrayal, we can sense the effort of Expressionism to sustain this link in terms of both profundity and immediacy. The enlarged hands emphasize craft: the manual labor involved in the creation of the Expres-sionist printed image. The grasping movements and undulating contours of the fingers convey the intensity with which the individual stroke of the lithographic crayon (or etching stylus or woodcut gouge) is infused.

Perhaps more effectively than the artists of any other twentieth-century movement, the Expressionists used the self-portrait to assert the penetrating, revelatory, and prophetic nature of artistic vision. It is no accident that Kokoschka's lithograph recalls the self-portraits of Dürer, which asserted the intellectual and spiritual superiority of the artist well before this idea was reflected in social reality. Similarly, Lovis Corinth's *Death and the Artist* (fig. 10.39), from his *Totentanz (Dance of Death)* series of five soft-ground etchings done in the early twenties, recalls Rembrandt's etched *Self-Portrait* of 1648 (figs. 4.42, 4.43). Rembrandt, that explorer of human motives, greatness, and limitation, repeatedly depicted himself, seeking out the hard-to-define relationship between accumulated life experiences and physical appearance. While his own mortality is pervasive in Rembrandt's self-portraits, embodied in his merciless exposure of the flesh by light and his placement of this stubborn fleshiness against an engulfing darkness, Corinth has given a more concrete form to death in the grinning skull behind him. He had suffered a serious stroke in 1911, after which the expressionistic aspects of his basically impres-sionistic style were augmented because he could not control his hand.

Ernst Barlach (like Kokoschka, an Expressionist dramatist) and Wilhelm Lehmbruck were primarily known as sculptors but also produced highly individualistic prints. Both artists exemplify a pronounced medievalism. Lehmbruck's attenuated figures are closely related to Gothic ones, in which bodily distortion is based on the supremacy of spirit over flesh. In *The Vision* (1914; fig. 10.40), really a sketch on the plate composed of tentative drypoint scratches, we meet the theme of troubled sexuality once again. A lovemaking couple is watched by a hovering, ghostly woman. The male is characterized as muscular and aggressive; the female

FIGURE 10.38

Oskar Kokoschka. Self-Portrait with Crayon. *1914. Frontispiece for* "O Ewigkeit, du Donnerwort" ("O Eternity, Thou Word of Thunder"), *eleven prints illustrating the text of Bach's Cantata 60. Berlin: Fritz Gurlitt, 1916 (second edition, 1918). Lithograph. 455 × 305 mm. Museum of Modern Art, New York.*

FIGURE 10.39

Lovis Corinth. Death and the Artist *from* Totentanz (Dance of Death). *1921–22 (published 1923). Soft-ground etching and drypoint. 238 × 178 mm. Museum of Modern Art, New York.*

as supple, passive, and distant. The pervasive lightness of the marks, the graininess of the plate, and the surface tone all combine to give the image a dream-like quality. Lehmbruck's figures, sculpted or graphic, are spiritually incomplete, yearning for something beyond themselves and, like the women in this print, lost in melancholy reveries. Distraught over his experiences in World War I, Lehmbruck committed suicide in 1919.

Ernst Barlach's more ponderous figures were also influenced by medieval art. Although he produced lithographs, his instinct for woodcarving, which informs even his cast sculpture, makes his woodcuts exceptional. *The Cathedrals* (fig. 10.41), from his series of seven woodcuts entitled *The Transformations of God* (1920–21), reveals Barlach's conscious archaism as well as the intense religiosity that we have noted in the artists of *Die Brücke*. The series is one of many

FIGURE 10.40

Wilhelm Lehmbruck.
The Vision. *1914. Dry-
point. 178 × 236 mm.
Museum of Modern Art,
New York.*

adaptations of Christian themes to express the hope of healing and renewal after World War
I—a war which Barlach, like many other artists, had initially supported with his art, contrib-
uting hawkish lithographs to publisher Paul Cassirer's series of jingoistic broadsides.[61] But now,
as if to recreate a devastated world, a dynamic God the Father flies above a town full of Gothic
spires and pointed windows, his presence announced by a rainbow. One is reminded of the
powerful vision of the Son of Man in Dürer's *Apocalypse,* an early masterpiece of woodcut (see
fig. 2.2). In a letter of 1919, Barlach wrote that woodcut "provokes one to confession, to the
unmistakable statement of what one finally means. It . . . enforces a certain general validity of
expression."[62] A more concise statement of the link between printmaking technique and mean-
ing would be difficult to find.

Barlach's close friend was Käthe Kollwitz. Unlike Paula Modersohn-Becker, whose early
death from a heart attack following the birth of her daughter in 1907 cut short her promising
artistic career, Kollwitz lived a long life. Her monumental graphic oeuvre spanned four decades
of German history, from Kaiser Wilhelm through World War I to the rise of Nazism and World
War II. Many artists fled or were driven out of Germany during these turbulent years, but
Kollwitz never left her homeland. She grew up with a deep sense of social commitment, which
informed her prints. She married a doctor who worked in an impoverished section of Berlin,
where she experienced the problems of the poor firsthand, and especially from the woman's
point of view. In World War I, her eighteen-year-old son Peter enlisted in the German army
and was killed within a month (later, World War II was to take her first grandchild). From
then on, the struggle of all mothers to protect their children from war became Kollwitz's leit-
motif. In this sense, her work presents the other side of the mother/child relationship explored
by another great woman printmaker, Mary Cassatt. Certainly, Kollwitz's work and her life
provide an antidote to the contemporary relegation of women to the realm of nature, and the
exclusive association of artistic creativity with virility, as well as to the many negative images of
women that populate late nineteenth- and early twentieth-century art.[63]

FIGURE 10.41

Ernst Barlach. The
Cathedrals *from* The
Transformations of God:
Seven Woodcuts. *1920–
21. Woodcut. 255 ×
360 mm. Los Angeles
County Museum of Art.*

Kollwitz's style moves between naturalism and expressionistic distortion, but her prints reveal a consistent sensitivity to the purely graphic qualities inherent in her media—woodcut, lithography, etching. Her earliest graphic series was *A Weavers' Rebellion* (1893–97), six prints in various techniques based on a play by Gerhart Hauptmann. The subject—a doomed rebellion by Silesian weavers that took place in the 1840s—had great relevance for Kollwitz's contemporaries. She attended the play's private debut in Berlin in 1893; it was considered too inflammatory to be publicly performed. Also influential were the scenes of revolution, *March Days,* from Klinger's *Dramas* (1883), and Zola's novel *Germinal.*[64] In Kollwitz's *Conspiracy* (fig. 10.42), a lithograph, the workers huddle in a dimly lit room. The steep perspective, insistent lines and murky shadows add to the sense of urgency and desperation. The rebellion's failure is interpreted in *The End* (fig. 10.43), in which stippling, aquatint, and line etching are combined, as the dead are brought back into a cottage room dominated by a black loom. (The introduction of textile mills had contributed to the poverty of the weavers, whose hands could not compete with the speed of machines.) The central character, as in most of Kollwitz's works, is a woman, sad but resolute, her clenched fists expressing a quiet defiance. *The Weavers* established its author as a graphic artist of major stature and won a gold medal in the state exhibition of 1898 in Berlin. Kollwitz was, however, denied the prize by Kaiser Wilhelm, who, acting on the advice of the minister of culture, vetoed the jury's decision because of the work's "naturalistic execution, entirely lacking in mitigating or conciliatory elements."[65] This judgment notwithstanding, Kollwitz became the first woman to be admitted to the Berlin Academy of Art in 1919.

The Peasant Uprising of 1525, mounted in the wake of the Reformation but repudiated by Luther, next captured Kollwitz's imagination. In Plate 5 of her series *The Peasants' Revolt* (1902–8), *Breaking Away* (fig. 10.44), the protagonist is "Black Anna," a real woman described in Wilhelm Zimmermann's *History of the Great German Peasants' War* (1841–42). Here, Anna calls her countrymen and women to arms with unforgettable upraised fists. The crowd behind

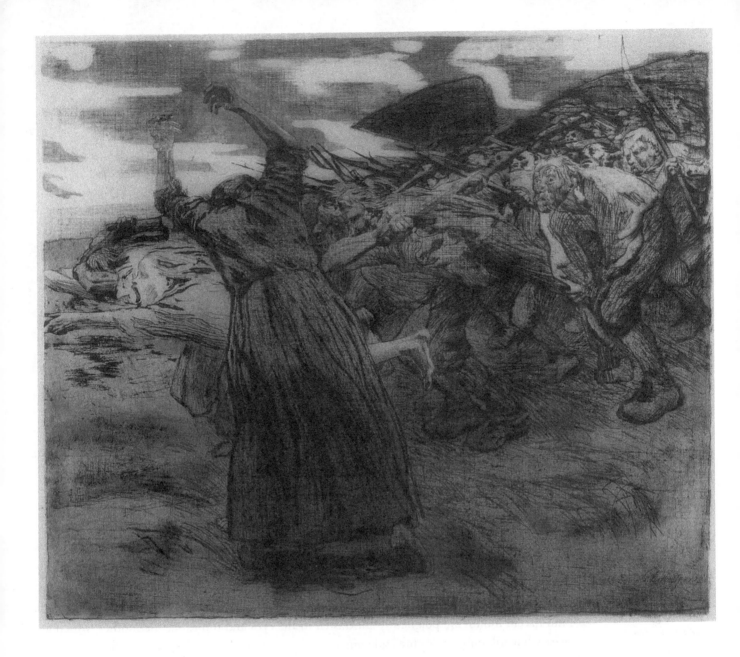

FIGURE 10.44
Käthe Kollwitz. Breaking
Away *(1903): Plate 5 of*
The Peasants' Revolt.
*1902–8. Etching and soft-
ground etching with cloth
texture, aquatint, and
engraving. 507 ×
597 mm. Los Angeles
County Museum of Art.*

her pushes violently toward the left; its shape, along with Anna's silhouette, is a visualization of centuries of anger.

Kollwitz's methods in *The Peasants' Revolt* are bewilderingly complex, focusing on the attainment of layered textures. In *Breaking Away*, for example, a textile texture has been impressed into soft ground and etched into the plate, which has also been worked with lift-ground aquatint and engraving. *The Battlefield* (fig. 10.45) utilizes aquatint, engraving, and a mechanically produced grain, visible in parallel lines of tiny dots, similar to that of photogravure but still of uncertain origin.[66] The composition of *Battlefield* recalls Goya's images of the living standing above piles of bodies in *The Disasters of War* (see figs. 7.44, 7.45). A woman searches for her dead son with a lantern whose light barely penetrates the murky grays but sets off her large, workworn hand.

Her husband's practice sensitized Kollwitz to the desperation of impoverished mothers trying to feed their families and to the high infant mortality rates in Germany during this

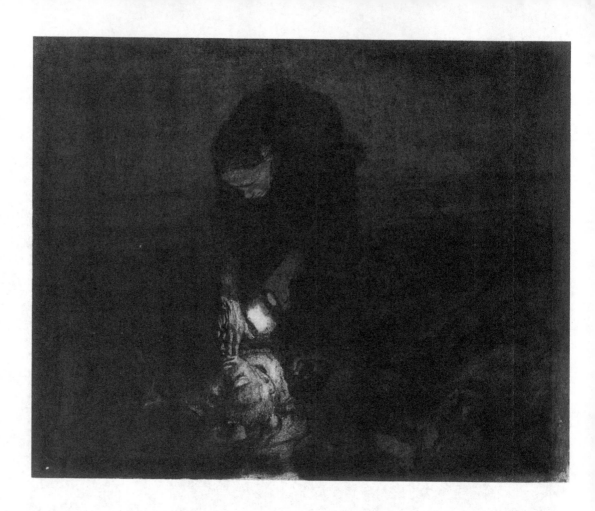

FIGURE 10.45

Käthe Kollwitz. The
Battlefield *(1907): Plate 6
of* The Peasants' Revolt.
*1902–8. Etching and soft-
ground etching, aquatint
and engraving. 412 ×
529 mm. Staatliche
Museen, Berlin.*

period.[67] *Death, Woman, and Child* (etching, 1910; fig. 10.46) exhibits her strong, sensitive drawing and her awareness of the Dance of Death tradition in graphic art, which she interprets with a new power. The mother's arm grasps the child's neck as the bony arm of Death pulls his body away. The heads of mother and child are juxtaposed in a way that suggests images of Mary pressing her face against the face of the dead Christ. The child's darkened eye sockets and flaccid mouth are poignantly contrasted to the eyes and mouth of the mother, which are weary but still quiver with life and pain.

After 1911 Kollwitz turned away from etching, whose technical possibilities she had plumbed, and toward sculpture and lithography, especially transfer lithography. But it was the experience of the war, in which she lost her son, and the subsequent revolution that marked a watershed in Kollwitz's graphic art. Although social criticism had always been important to her—she had contributed many moving drawings documenting the plight of the poor to the periodical *Simplicissimus* from 1908 to 1911, for example—it now became paramount. In her postwar work, she often dealt with simple concepts couched in condensed imagery drawn swiftly without much surface detail. Flexible about the various leftist political ideologies, Koll-witz was driven primarily by compassion, contributing her art to any organization that worked on behalf of the oppressed: the German Good Templars Order, the German Cottage Indus-tries, the Berlin Society for Social Reform. As Ida Rigby points out, Kollwitz's posters sold well because her style—far more naturalistic than that of many Expressionists—appealed broadly to a liberal public. Only the Communists chided her for her pessimism.[68] *Brot!* (lithograph, 1924; fig. 10.47), commissioned as part of a portfolio by the International Workers' Aid, ex-

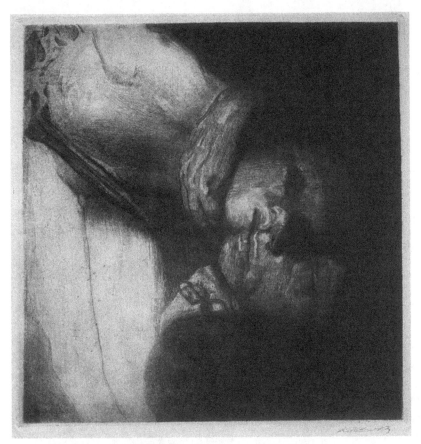

FIGURE 10.46

Käthe Kollwitz. Death, Woman, and Child. *1910. Etching and aquatint. 409 × 411 mm. Museum of Modern Art, New York.*

emplifies the compact graphic power of her postwar work. It is a simple cry for bread that shows a mother emotionally exhausted by her children's hunger. The twisting of the mother's body, conveyed by broad, sure strokes of the lithographic chalk, is an apt physical expression of her desperation.

In 1934 Kollwitz began a lithographic series in which Death dances, but not for the wide range of social classes in Holbein's series—only for the working class, and particularly for its women and children. In the context of contemporary German Fascism, which praised the contributions of mothers to the state and presented itself as a movement of proud German youth, Kollwitz's series is a reminder of hard reality. In *Death Reaches into a Band of Children* (fig. 10.48), the swiftness of the attack is conveyed by the rapidity with which the lithographic medium has been handled. Steinlen and especially Daumier are reprised.[69] In contrast to the earlier etching, in which the pathos of the subject is expressed in the subtlety of the drawing and surface texture, this lithograph is direct and gestural—perhaps without the lasting interest of the etching as a print, but effective as a political statement.

After the Revolution of 1919, Kollwitz also began to work in woodcut. She looked to the example of her friend Ernst Barlach, whose style she echoed. Her *Memorial Sheet for Karl Liebknecht* (1920; fig. 10.49) is her first major effort in this technique. Liebknecht and Rosa Luxemburg were the leaders of the German Communists. Both had been murdered in 1919 with the backing of the Social Democratic government, an act that met with great outrage; Max Beckmann later depicted Luxemburg's death almost as a crucifixion in his lithographic series *Die Hölle* (*Hell*). Kollwitz was invited by Liebknecht's family to make drawings of his

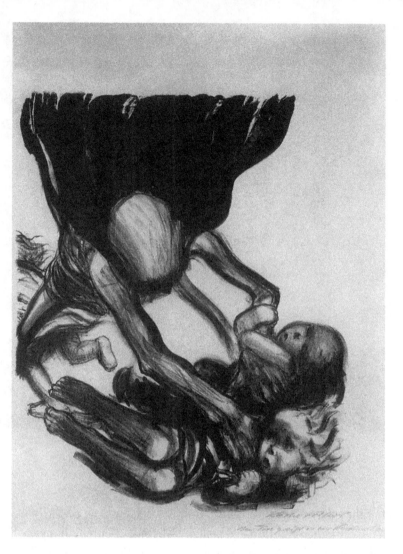

FIGURE 10.47
Käthe Kollwitz. Brot!
(Bread) *from* Hunger.
*1924. Lithograph. 300 ×
280 mm. College of
Wooster Art Museum,
Wooster, Ohio.*

FIGURE 10.48
Käthe Kollwitz. Death
Reaches into a Band of
Children: *Plate 3 of*
Death. *1934–35. Litho-
graph. 500 × 420 mm.
National Gallery of Art,
Washington, D.C.*

corpse; six sketches are extant. The resulting print was issued in an edition of 100 impressions and an unlimited edition whose prints were inexpensively priced. The essence of the image is the workers' love for Liebknecht (the inscription reads, "From the living to the dead"), and Kollwitz called upon the old role of the woodcut as a cheap, widely available art form based on the concerns of ordinary people. The grouping of mourners around the body, now a kind of rigid icon, recalls a Lamentation over the dead body of Christ. Kollwitz questioned whether she needed to be a political follower of Liebknecht to capture the feelings of the workers and dedicate the print to them.[70]

Perhaps Kollwitz's most moving woodcuts are the seven prints of her *War* series (1922–23), in which her personal grief over the death of her son is expressed, yet transformed and transcended, in unforgettable statements of the exploitation of youth in war. And no other conviction is more central to Kollwitz's socialist consciousness than this awareness of lives cut short or wasted in the name of nationalist and imperialist aims. Her last lithograph was captioned, "Seed Corn Must Not Be Ground," a dictum borrowed from Johann Wolfgang Goethe. *The Parents* (fig. 10.50) is one of the simplest and most effective woodcuts of the *War* series, in which Kollwitz developed strident white-on-black effects appropriate to the subject.

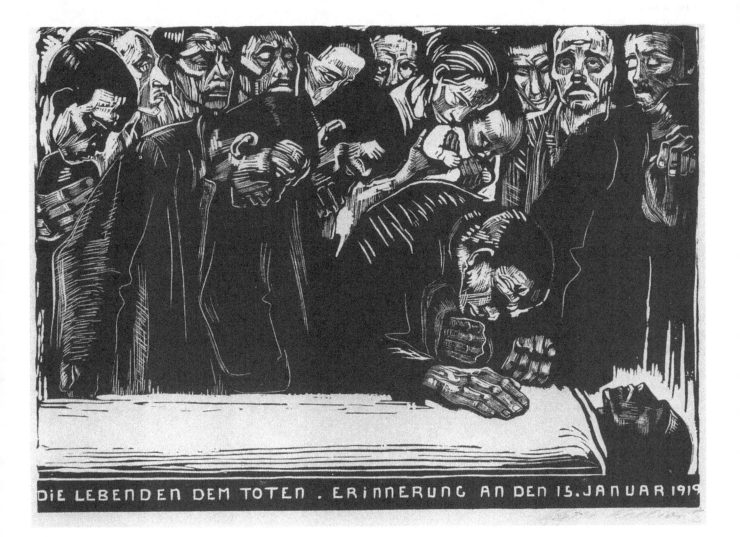

DIE LEBENDEN DEM TOTEN . ERINNERUNG AN DEN 15. JANUAR 1919

A mother and father are bound together into a mountainous form which at once suggests the inexhaustibility of their sorrow and the enduring strength that will survive it. Ultimately, Kollwitz's art was rooted in hope, and a fundamental confidence in human dignity and decency. With the artists of *Die Neue Sächlichkeit* ("The New Objectivity"), hope and confidence seem to evaporate.

FIGURE 10.49

Käthe Kollwitz. Memorial Sheet for Karl Liebknecht. *1920. Woodcut. 376 × 512 mm. Los Angeles County Museum of Art.*

DIE NEUE SÄCHLICHKEIT AND ROUAULT

As we have seen, World War I was a central event in the lives of many Expressionist artists: Marc was killed, Kokoschka was seriously wounded, Kollwitz lost her son, Kirchner suffered a mental breakdown, Lehmbruck committed suicide. But the devastating effect of the first modern war can perhaps best be gauged by the new trend in postwar German art, described by the label *Die Neue Sächlichkeit,* and represented by George Grosz, Otto Dix, and Max Beckmann. In one very important sense, the veristic aspects of the New Objectivity made it anti-Expressionist. Thoroughly moored in the awful reality of wartime and postwar Germany, it denied the transcendent spirituality that Expressionism had so often emphasized. Irony, cynicism, and hopelessness had never been the dominant notes in earlier Expressionist move-

FIGURE 10.50

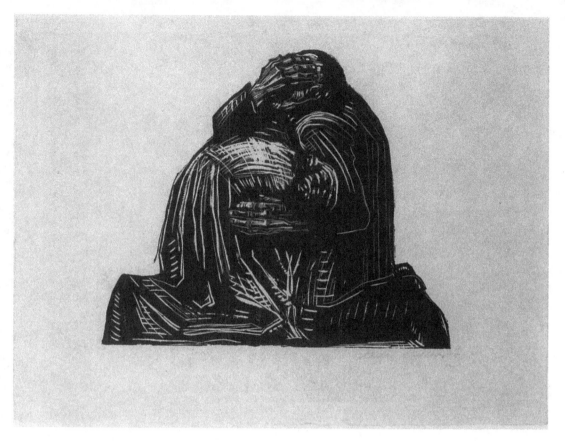

Käthe Kollwitz. The
Parents: *Plate 3 of* War.
*1922–23. Woodcut.
350 × 420 mm. National
Gallery of Art, Wash-
ington, D.C.*

ments. On the other hand, the raw emotionalism and even sensationalism of these artists, their distortion of form, and their exposure of the decadence and emptiness of modern society can be understood only against the background of earlier art, particularly that of Munch and *Die Brücke.*

George Grosz's bitter graphic essays on the corruption of German society emerge from an old print tradition, punctuated by masterpieces like Hogarth's Progresses and Goya's *Caprichos* (see Chapter 7). But Grosz's works express a more profound disillusionment than these earlier artists could have envisioned. Although the nature of the socially critical print implies the existence of a redeemable audience, Grosz's exposure of human decadence is so absolute as to call the didactic function of graphic satire into question. At first, his images seem self-defeating.

Grosz's art was shaped, however, by his Marxism, and its purpose is clarified by under-standing that the public he castigated was primarily bourgeois. His art was dedicated to the service of the proletariat. As one contemporary reviewer noted: "This cynic is a secret moralist. Negation is merely his manner of speaking; what he really . . . loves is the positive."[71] His very style, based on a sparse, nervously active line that traces the edges and insides of buildings and figures as if they were constructed of thin panes of glass that conceal nothing, was shaped by his political beliefs. Most art, Grosz thought, had served the interests of the ruling classes—it was, either consciously or unconsciously, *Tendenzkunst,* "tendentious" or ideological art. He resolved to produce a *Tendenzkunst* of his own, in which artistic preoccupations such as the idea of genius, stylistic innovation, and, most significantly for our purposes, the concept of the fine-art original print, would be abandoned in order to serve the oppressed.[72] Working mostly with transfer lithography and photolithography, Grosz makes even his contemporaries in *Die Neue Sächlichkeit* appear to be overly concerned with the intricacies of printmaking technique.

This anti-art attitude corresponded to the stance of the Dadaist movement, to whose Berlin branch Grosz belonged.

Grosz had enlisted in the German army in the hope that an enlistee would fare better than a conscript. Unlike Dix, whose combat experience remained central to his art, Grosz was more fascinated with the violence and degradation on the homefront. In *People in the Street* (fig. 10.51), a transfer lithograph from his first portfolio, published in 1917, Grosz used the city-view as a means of exposing the seamy underside of Berlin society: a man glances lecherously at a woman as she walks by, the passers-by appear smug, imbecilic, or depraved, and the windows of an apartment house reveal a suicide, a murder, a sexual encounter, and a basement recluse peering fearfully from behind barred glass. As Alexander Dückers suggests, Grosz's simultaneous, fragmented views and active line have much in common with contemporary Cubism and Futurism, although without the Cubist preoccupation with formal issues, and certainly without the Futurist optimistic exaltation of modernity.[73]

Grosz's portfolio of nine photolithographs, *Gott mit uns* (*God Is with Us*, 1920), a devastating indictment of the German army, took its title from the jingoistic motto inscribed on the belt buckles of soldiers. The only image to refer directly to the war, one that Grosz had published earlier in the periodical *Die Pleite* (*Bankruptcy*), showed military doctors pronouncing a rotting corpse fit for active duty (*kriegsverwendungsfähig*). In this image, Grosz echoed Bertolt Brecht's "Legend of the Dead Soldier." Both Brecht and Grosz referred to a story that circulated in the last desperate period of the war about the army digging up corpses to send to the front.[74] Most of the images in *Gott mit uns,* however, deal with the complicity of the military in the suppression of revolutionary forces and in the oppression of the masses. The three multilingual captions of the eighth print, *Ecraser la famine* (*Crush the Famine*), *Die Kommunisten fallen—und die Devisen steigen* (*The Communists Fall—The Currency Rises*), and *Blood Is the Best Sauce* (fig. 10.52), succinctly describe postwar poverty and wild inflation, and condemn the military for its part in the counterrevolutionary slaughter of 1919 (which had included the murders of Liebknecht and Luxemburg). While two fat bourgeois men dine, soldiers murder workers.

The fifty etchings of Otto's Dix's *Der Krieg* (*The War*, 1924) are the acrid heirs of Goya's *Disasters of War*. One of the images, *House Destroyed by Aerial Bombs,* is directly dependent upon Goya's precedent (Plate 30, *Ravages of War;* fig. 7.39). But the differences between the two series are striking. Dix concentrated on new elements of warfare like trench combat, poison gas, and bombing. Along with an exposure of the violation of the body by disfiguring injury and dismemberment that echoes Goya, Dix explored an avenue that Goya had not, at least in the context of the *Disasters:* insanity (*The Madwoman of Sainte-Marie-à-Py* and *Nocturnal Encounter with a Lunatic*). Perhaps the most significant difference is the utter absence of any sense of heroism, courage, or human nobility in Dix's series. Unlike Goya, he seems to have abandoned any hope that humanity will learn from the experience or that anyone can escape the moral degradation that war entails. Dix was not a pacifist: he had enlisted in 1914 in order to immerse himself in the elemental experience of front-line fighting, and some would argue that his approach to his subject is more reportage than antiwar protest.[75] However, as Rigby points out, the horrifying imagery speaks for itself; it is its own indictment.[76] This imagery would haunt Dix through the 1930s, resulting in works that were condemned by National Socialism as undermining the efforts of the German nation to defend itself; his paintings *The Trench* and *The War Cripples* were burned in 1939.

ÉCRASEZ LA FAMINE. DIE KOMMUNISTEN FALLEN - UND DIE DEVISEN STEIGEN. BLOOD IS THE BEST SAUCE.

FIGURE 10.51

George Grosz. People in
the Street *(1915–16):*
Plate 5 of Erste George
Grosz-Mappe. *1917.*
Transfer lithograph.
276 × 217 mm. Los
Angeles County Museum
of Art.

FIGURE 10.52

George Grosz. Blood Is
the Best Sauce *(1919):*
Plate 8 of Gott mit uns
(God Is with Us). *1920.*
Photolithograph. 305 ×
452 mm. Los Angeles
County Museum of Art.

Ration Carriers near Pilkem (etching and aquatint; fig. 10.53) depicts the conditions of
trench and gas warfare that turned men into animals, crouching down into their burrows to
gain the illusion of safety. A radiant sun rises ironically over a ruined earth. But the sheer terror
of war is more brutally conveyed in *Wounded Man—Autumn, 1916, Bapaume* (fig. 10.54), a
horrifying etching in which a skull-like face, a twisted, seemingly severed left arm, and splatters
created by the use of a stop-out varnish on the aquatint background recreate the *experience* of
being wounded. Goya had dwelt primarily on the results, which were a clear indictment of the
alien political power that had invaded Spain. In contrast, Dix's *War* does not indict a specific
government; as in Erich Maria Remarque's *All Quiet on the Western Front* (1929), the narrator
is German, but his nationality scarcely matters.

And, although severely challenged, human dignity is still perceptible in Goya's works,
even in a dismembered corpse. The human beings of Dix's *War,* however, have irretrievably
lost all dignity, even sanity. Here, war has assumed a life of its own apart from the people who
fight it. An exaggerated perspective reminiscent of Munch's *The Scream* (fig. 10.11) causes the
figures and plane in *The Bombing of Lens* (fig. 10.55), a line etching, to careen toward us. Flight
or heroic resistance is made to seem futile; death is imminent. The setting of *Nocturnal En-
counter with a Lunatic* (aquatint, etching, and drypoint; fig. 10.56) is a bombed urban landscape

FIGURE 10.53

Otto Dix. Ration Carriers near Pilkem: *Plate 43 of* The War. *1924. Etching and aquatint. 245 × 298 mm. Los Angeles County Museum of Art.*

FIGURE 10.54

Otto Dix. Wounded Man—Autumn, 1916, Bapaume: *Plate 6 of* The War. *1924. Etching and aquatint. 197 × 290 mm. Los Angeles County Museum of Art.*

FIGURE 10.55

Otto Dix. The Bombing of Lens: *Plate 33 of* The War. *1924. Etching. 298 × 246 mm. Philadelphia Museum of Art.*

(what Lens will become), with ruined buildings rising like bleached ribcages in the desert. The grinning madman, drawn with ragged, angry strokes of the drypoint needle, personifies the insanity of modern war. In all the prints of this series, Dix emphasized the material and the process of making, as earlier Expressionist artists had: the scratchy character of the drypoint or etched line and, even more stridently, the corrosive character of the aquatint process (in this, especially, these prints echo the etchings of the *Brücke* artists, especially Nolde).

Max Beckmann, the most important German painter of the period between the world wars, was also a prolific printmaker.[77] The ten transfer lithographs of *Die Hölle* (*Hell,* 1919), prefaced by a self-portrait, form a powerful allegory of postwar Germany. Beckmann had not

FIGURE 10.56

Otto Dix. Nocturnal Encounter with a Lunatic: *Plate 22 of* The War. *1924. Etching, aquatint and drypoint. 262 × 197 mm. Los Angeles County Museum of Art.*

fought in the war, but as a medical corpsman in various hospitals he had encountered its physical devastation; its emotional devastation must have been ubiquitous. In *The Way Home* (fig. 10.57), a self-portrait is juxtaposed with the disturbing figure of a maimed veteran. In the background a prostitute walks the streets while two more veterans hobble along on crutches. The scene is conceived in terms of angular, splintered forms and harsh light, emitted by street lamps. Even the dog, with jagged teeth and pendulous tongue, contributes to this image of social bankruptcy.

The Night (fig. 10.58), centerpiece for *Die Hölle,* is derived from Beckmann's well-known painting of the same name of 1918–19. Set in a cramped, candlelit room, it is a panorama of brutality that not only reflects the decay of Beckmann's contemporary Germany but also uncannily prophesies the nightmarish realities of the Third Reich. The closed composition and stifling space offer no escape; both tortured and torturer are subject to the determinism that was so much a part of Beckmann's view of the human condition. "My religion," he wrote, "is arrogance before God, defiance of God. Defiance, because he created us so that we cannot love

FIGURE 10.57

Max Beckmann. The
Way Home: *Plate 1 of*
Hell. *1919. Lithograph.*
733 × 488 mm. Museum
of Modern Art, New
York.

ourselves."[78] Like Picasso's *Minotauromachy* (see fig. 11.37), Beckmann's print is a personal
meditation on evils that seemed to be gathering in such force and number that they could best
be expressed symbolically, in the figure of the torturer or the half-man, half-bull minotaur.
Later, in Beckmann's triptych *Departure* (1932), created during the final period of his life in
Germany and the early years of Hitler's reign, he painted a similar scene of torturers and
victims to the left of the gravely serene scene of escape and freedom in the center.

The major French Expressionist artist was Georges Rouault. His name was associated
with the Fauves, although he never belonged to the group, and his work shows quite different
concerns. It echoes the humanitarian compassion and religiosity we have noted in other Ex-

FIGURE 10.58
Max Beckmann. The Night: *Plate 6 of* Hell. *1919. Lithograph. 556 × 703 mm. Museum of Modern Art, New York.*

pressionists. His prints, like the color aquatint *Crucifixion* (1936; fig. 10.59, color plate, p. 477), are extraordinarily painterly. In this sense he stands apart from many Expressionist artists, who sought effects that were inherently graphic, undisguisedly dependent upon the materials and processes with which they worked. To make this print, Rouault worked on the plate in the sugar-lift aquatint technique, establishing the broad brushy areas and the thick black outlines related to his paintings. The medievalism that we have observed in other Expressionists is very evident. Rouault's saturated colors, achieved here with the help of the skilled reproductive printer Roger Lacourière, combine with his thick black outlines to recall the stained glass that had impressed him during his youthful apprenticeship to a glass-painter. Rouault's ardent Catholicism emerges in his style, which is wrought from his French Gothic heritage and modern Expressionism. It is one of the few aesthetically satisfying and emotionally convincing manifestations of traditional religious conviction in twentieth-century art.

Rouault's greatest graphic production and one of the masterpieces of twentieth-century printmaking is *Miserere* (a plea—"Have Mercy"—to God), a set of fifty-eight "etchings," begun in 1922 and completed in 1927, dealing with the disillusionment and devastation of World War I, and, more broadly, with the wretchedness of the human condition.[79] The plates of *Miserere* were intended to be incorporated into a larger series, *Miserere and Guerre (War)*, two volumes of illustrations accompanying a text by Rouault's friend André Suares. The title

of the unpublished work makes clear the intention of its author to produce a successor to Callot's and Goya's series on war.

The complex, unorthodox means used to establish the image on the plate in *Miserere* place Rouault in line with such graphic artists as Seghers and Blake, who pushed the methods of printmaking to extremes in order to achieve painterly, or partly painterly, results. Such an approach differs markedly from the more direct, albeit exacting, means of producing the image in the *Brücke* woodcuts, for example. Even an expert would be hard-pressed to determine Rouault's means from visual inspection alone. He first made studies in gouache (an opaque tempera paint), which the publisher Ambroise Vollard had transferred photographically to copperplates. Rouault then reworked the plates with etching and aquatint, drypoint, roulette, emery paper, and other tools. The results were large and powerful prints that combine the rugged simplicity of Rouault's brushwork with rich graphic effects—juicy blacks, murky grays, varied lines and scratches. The absence of color and the monumentality of Rouault's forms lend these images an awesome gravity that increases as one views the series as a whole.

My Sweet Homeland, What Has Become of You? (fig. 10.60) is a lament couched in the now-familiar language of the bombed cityscape. Above the city and bodies, smoke diffuses into the sky in oddly beautiful, feathery passages that belie the harsh reality below. Other prints from *Miserere* are more terse—condensations of despair into images with a resounding finality, such as *Who Is Not Made Up?* (fig. 10.61). Rouault has asked his question in terms of the simplistic image of the sad clown. But any banality is eclipsed by the ambiguity of the clown's mouth and eyes, which take on, all at once, the expressions of sadness, resignation, and accusation. This print is generally regarded as a spiritual self-portrait. In characteristic Expressionist fashion, the artist is understood as prophet and martyr, driven by a more penetrating vision both to harangue society and to suffer on its behalf.

FIGURE 10.61

Georges Rouault. Who Is Not Made Up? *(1923): Plate 8 of* Miserere. *1922–27 (published 1948). Etching and aquatint over heliogravure. 567 × 429 mm. Grunwald Center for the Graphic Arts, University of California, Los Angeles.*

The importance of Expressionism for the subsequent history of printmaking is fundamental. In the course of the twentieth century, printmaking was to branch out in a variety of directions, many of which were foreshadowed in the works of these artists. Whether we consider Rouault's use of photomechanical means or his combining of the graphic and the painterly, or the wresting of new images from old graphic means simply and powerfully handled (as in the prints of *Die Brücke* or Kandinsky's cosmic abstractions), the prints of the Expressionists indicated new formal and technical directions. But equally important was the Expressionists' reach into the past to reestablish the print as a communicative and socially relevant art form. Though at times despairing and misunderstood by the public it sought to address, the social consciousness of Expressionism was basically unshakable. Despite the print's incorporation into the various predominantly formalist movements of twentieth-century art, this consciousness will remain an important strain within modern printmaking. Perhaps it is inherent in the nature and history of the print.

1. In a fundamental article, Gordon 1966a discussed the origin of the term "expressionism," emphasizing its association with irrationality and personal emotions. Subsequently, Gordon himself modified this emphasis, and now Expressionism is seen to embrace not only personal emotion, but more complex metaphysical and political ideas: see Long 1989, pp. 192–93. Long 1989 also offers a useful critical survey of the scholarship on German Expressionism. Guenther 1989 provides an excellent, concise survey of major Expressionist artists and ideas. There are too many general books on German Expressionism to cite here, but for an especially profound and far-reaching treatment of the movement, as well as subsequent art in an expressionist vein, see Gordon 1987. Its extensive bibliography will direct the reader to other general studies, as well as to the many monographs on Expressionist artists, which I have not routinely cited here. Another comprehensive bibliography is the Robert Gore Rifkind Center for German Expressionist Studies 1990.

2. Carey and Griffiths 1984 provide a good survey of the development of Expressionist printmaking in Germany between 1880 and 1933 and further bibliography on major Expressionist printmakers, including basic standard catalogs that are not cited here. Also see Buchheim [1959] 1960, and Robert Gore Rifkind Center for German Expressionist Studies 1989, for general accounts of Expressionist prints.

3. Heller 1988 especially emphasizes the significance of this idea for *Die Brücke*.

4. Two exemplary recent studies of the interaction of Expressionist art and politics are Rigby 1983; Weinstein 1990.

5. Rigby 1989, pp. 60–61.

6. Quoted ibid., pp. 62–63.

7. See Pollock 1980; Zemel 1980.

8. Quoted in Andersen 1971, p. 205.

9. As suggested earlier in this text, primitivism raises complex problems. See the classic study of modern artists' interest in African, Oceanic, and other art forms, Goldwater 1967. Also see Rubin, ed., 1984, pp. 1–81 and 85–175, for three essays tracing the appearance of African and Oceanic art in the West, and Rubin's introduction to this problem. A further essay in Rubin's book, Varnedoe 1984, deals specifically with Gauguin's primitivism. Recently, these traditional art-historical approaches, focusing on western artists' assimilation of non-western style, have been questioned: see the essays in Karp and Lavine, eds., 1991. Also see Solomon-Godeau 1989 for a revisionist account of Gauguin's primitivism, and Leighten 1990 for a revised approach to Picasso's primitivism, placing it in the context of the French anti-colonial response to the disgraceful exploitation of Africa by Belgium and France.

10. Field 1969 (not paginated).

11. Brettell in Brettell, Cachin, Frèches-Thory, and Stuckey 1988, pp. 297–302, and nos. 167–76, pp. 317–29.

12. Field 1968.

13. Ibid., p. 504. Also see Baas and Field 1984, pp. 108–10.

14. See Field 1970 (not paginated).

15. Brettell in Brettell, Cachin, Frèches-Thory, and Stuckey 1988, nos. 172 a–n, pp. 330–38.

16. Ibid., nos. 185 and 186, pp. 345–47.

17. See Varnedoe 1984, pp. 199–200; Baas and Field 1984, no. 67, pp. 117–18.

18. See Guérin 1927, nos. 36 and 42.

19. See Carey and Griffiths 1984, pp. 11–12.

20. See especially the selection from his *Brahms Fantasies* in Varnedoe and Streicher 1977, nos. 66–70 (not paginated).

21. Ibid., no. 65 (not paginated).

22. On Ensor's prints, see Lebeer 1971; Taevernier 1973.

23. Quoted in Heller 1984, p. 86.

24. Quoted ibid., p. 126. For a study of Munch's interpretations of male/female sexual relationships, see Heller 1978.

25. On the graphic versions of *The Kiss*, see Prelinger 1983, pp. 119–22. This book gives the best account of Munch's technical innovations. Prelinger revises many of the descriptions of Munch's methods by the early connoisseur of his prints, Gustav Schiefler: see Schiefler 1906 and 1927. Schiefler was an important early collector and cataloguer of the German Expressionists as well.

26. A major exhibition of Munch's works in 1978 at the National Gallery of Art in Washington, D.C., was arranged thematically. The excellent catalog essays give a picture of Munch's world-view and are a good source for bibliography on him: National Gallery of Art 1978.

27. Heller 1984, p. 41.

28. Jayne 1989.

29. See Prelinger 1983, pp. 86–90.

30. Quoted in Heller 1984, p. 105.

31. On the techniques used for *Madonna,* see Prelinger 1983, pp. 101–3. It may have occurred to Munch to combine lithography and woodcut as early as 1897, even though the impressions in his print exhibition of that year are hand-colored. See Torjusen 1978, p. 189. On the imagery of women in the nineteenth century in relation to this image, see Slatkin 1980; Heller 1981; Dijkstra 1986.

32. Prelinger 1983, pp. 104–9 (quotation on p. 109).

33. On Munch and the theme of death, see Eggum 1978.

34. Nietzsche [1883] 1961, pp. 43–44. Reinhardt 1977–78, pp. 28–31, first made the connection between Nietzsche's text and the naming of the artists' group. Heller 1988, p. 11, n. 16, argues against any direct connection to Nietzsche's text.

35. Heller 1988, pp. 4–9.

36. From his essay "Concerning Kirchner's Prints," quoted in Miesel, ed., 1970, pp. 24–25.

37. See Gordon 1966b.

38. Gordon 1987, p. 145. Also see pp. 140–52 for a discussion of the split between hero and victim in the Expressionist self-image.

39. Duncan 1982.

40. Munch quoted in Griffiths 1988, p. 193.

41. See Carey and Griffiths 1984, pp. 31–35; Griffiths 1988, pp. 193–201, on *Brücke* lithography.

42. See Rosenblum 1975, especially pp. 10–40.

43. Carey and Griffiths 1984, pp. 35–37.

44. For an account of primitivism and Expressionism, see Gordon 1984.

45. Duncan 1982.

46. Carey and Griffiths 1984, no. 113, pp. 139–40.

47. Heller 1988, no. 83, pp. 224–25.

48. Carey and Griffiths 1984, no. 111, p. 137.

49. Gordon 1987, pp. 57–59.

50. From Kandinsky's "Problem of Form," quoted in Miesel, ed., 1970, p. 46.

51. Two interesting studies on this problem are Long 1987 and Heibel 1989.

52. See Carey and Griffiths 1984, pp. 19–23. For a survey of Expressionist book and periodical illustration, see Raabe 1989.

53. See Roethel 1973, p. 11, for a diagram.

54. Ibid., p. 13, and p. 15, n. 20.

55. For an English translation of and a good introduction to *Klänge,* see Napier 1981. Roethel 1970 includes facsimiles of pages from *Klänge.*

56. Quoted in Carey and Griffiths 1984, p. 24.

57. Ibid., p. 154.

58. From a letter of December 4, 1915, quoted in Myers 1963, p. 177.

59. Jordan 1983.

60. Rigby 1983, pp. 69–91; Weinstein 1990.

61. Rigby 1983, p. 6; Guenther 1989, pp. 9–10.

62. Quoted in Rigby 1989, p. 46.

63. On Kollwitz's life, see Kearns 1976. Comini 1982 contrasts the thematic concerns of female and male Expressionists.

64. Von dem Knesebeck 1989.

65. Paret 1980, p. 21.

66. This grain is noted by Carey and Griffiths 1984, pp. 67–68.

67. Buettner 1986–87, pp. 17–20.

68. Rigby 1983, p. 62.

69. Dittmar 1984 traces Steinlen's influence on both Barlach and Kollwitz.

70. Carey and Griffiths 1984, no. 43, p. 74.

71. Quoted in Dückers 1989, p. 98.

72. See the discussion on *Tendenzkunst* in Lewis 1971, pp. 92–100.

73. Dückers 1989, p. 88.

74. See Lewis 1971, pp. 76–78.

75. See, for example, the interpretation offered in Dückers 1989, pp. 78–85.

76. Rigby 1983, pp. 11–12.

77. See Schulz-Hoffmann and Weiss, eds., 1984, nos. 210–97, pp. 379–439.

78. Quoted in Schulz-Hoffmann 1984, p. 25.

79. See Blunt 1963.

REFERENCES

Andersen, Wayne. 1971. *Gauguin's Paradise Lost.* New York.

Baas, Jacquelynn, and Richard S. Field. 1984. *The Artistic Revival of the Woodcut in France, 1850–1900.* Exhibition catalog. University of Michigan Museum of Art, Ann Arbor.

Bard College. 1983. *The Graphic Legacy of Paul Klee.* Exhibition catalog with essays by Carl Djerassi, Jim Jordan, Christian Geelhaar, and Jürgen Gaesemer. Bard College, Annandale-on-Hudson, N.Y.

Blunt, Anthony. 1963. *Georges Rouault: Miserere* (with a preface by the artist). Boston.

Brettell, Richard, Françoise Cachin, Claire Frèches-Thory, Charles F. Stuckey, with assistance from Peter Zegers. 1988. *The Art of Paul Gauguin.* Exhibition catalog. National Gallery of Art, Washington, D.C., and Art Institute of Chicago, Chicago.

Broude, Norma, and Mary D. Garrard, eds. 1982. *Feminism and Art History: Questioning the Litany.* New York.

Buchheim, Lothar-Günther. [1959] 1960. *The Graphic Art of German Expressionism.* Feldafing, Germany.

Buettner, Stewart. 1986–87. Images of Modern Motherhood in the Art of Morisot, Cassatt, Modersohn-Becker, Kollwitz. *Woman's Art Journal,* vol. 7, no. 2 (Fall 1986/Winter 1987), pp. 14–21.

Carey, Frances, and Antony Griffiths. 1984. *The Print in Germany 1888–1933: The Age of Expressionism.* New York.

Comini, Alessandra. 1982. Gender or Genius? The Women Artists of German Expressionism. In Broude and Garrard, eds., 1982, pp. 271–91.

Dijkstra, Bram. 1986. *Idols of Perversity: Fantasies of Feminine Evil in Fin-de-Siècle Culture.* New York.

Dittmar, Peter. 1984. Das Nachwirken Théophile Alexandre Steinlens am Beispiel von Ernst Barlach und Käthe Kollwitz. *Wallraf-Richartz-Jahrbuch,* vol. 45, pp. 173–201.

Dückers, Alexander. 1989. Portfolios. In Robert Gore Rifkind Center 1989, pp. 67–113.

Duncan, Carol. 1982. Virility and Domination in Early Twentieth Century Vanguard Painting. In Broude and Garrard, eds. 1982, pp. 293–313. (A revision of her article in *Artforum,* vol. 12 [December 1973], pp. 30–39.)

Eggum, Arne. 1978. The Theme of Death. In National Gallery of Art 1978, pp. 143–83.

Field, Richard S. 1968. Gauguin's Noa Noa Suite. *Burlington Magazine,* vol. 110, no. 786 (September), pp. 500–511.

Field, Richard S. 1969. Gauguin's Woodcuts. *Expedition* (Bulletin of the Museum of the University of Pennsylvania), vol. 11, no. 4, pp. 27–29.

Field Richard S. 1970. Gauguin's Woodcuts: Some Sources and Meanings. In *Gauguin and Exotic Art.* Exhibition catalog. University Museum, University of Pennsylvania, Philadelphia.

Gilmour, Pat, ed. 1988. *Lasting Impressions: Lithography as Art.* London.

Goldwater, Robert. 1967. *Primitivism in Modern Art.* New York.

Gordon, Donald E. 1966a. On the Origin of the Word 'Expressionism.' *Journal of the Warburg and Courtauld Institutes,* vol. 29, pp. 368–85.

Gordon, Donald E. 1966b. Kirchner in Dresden. *Art Bulletin,* vol. 48 (September–December), pp. 335–66.

Gordon, Donald E. 1984. German Expressionism. In Rubin, ed., 1984, pp. 369–403.

Gordon, Donald E. 1987. *Expressionism: Art and Idea.* New Haven, Conn.

Griffiths, Antony. 1988. Starting Again from Scratch: Lithography in Germany between the 1890s and 1920s. In Gilmour, ed., 1988, pp. 183–208.

Guenther, Peter. 1989. An Introduction to the Expressionist Movement. In Robert Gore Rifkind Center 1989, pp. 1–37.

Guérin, Marcel. 1927. *L'oeuvre gravé de Gauguin.* Paris.

Heibel, Yule F. 1989. "They Danced on Volcanoes": Kandinsky's Breakthrough to Abstraction, the German Avant-Garde and the Eve of the First World War. *Art History,* vol. 12, no. 3 (September), pp. 342–61.

Heller, Reinhold. 1978. Love as a Series of Paint-

ings and a Matter of Life and Death. In National Gallery of Art 1978, pp. 87–111.

Heller, Reinhold. 1981. *The Earthly Chimera and the Femme Fatale: Fear of Women in Nineteenth-Century Art.* Exhibition catalog. Smart Gallery, University of Chicago.

Heller, Reinhold. 1984. *Munch: His Life and Work.* Chicago.

Heller, Reinhold. 1988. *Brücke: German Expressionist Prints from the Granvil and Marcia Specks Collection.* Exhibition catalog. Mary and Leigh Block Gallery, Northwestern University, Evanston, Ill.

Jayne, Kristie. 1989. The Cultural Roots of Edvard Munch's Images of Women. *Woman's Art Journal,* vol. 10 (Spring/Summer), pp. 28–34.

Jordan, Jim. 1983. Klee's Prints and Oil Transfer Works: Some Further Reflections. In Bard College 1983, pp. 87–105.

Kandinsky, Wassily. [1912] 1970. *Concerning the Spiritual in Art.* Baltimore.

Karp, Ivan, and Steven D. Lavine, eds. 1991. *Exhibiting Cultures: The Poetics and Politics of Museum Display.* With Introduction by Ivan Karp and Steven D. Levine, and essays by Svetlana Alpers, Michael Baxandall, Stephen Greenblatt, and others. Washington, D.C.

Kearns, Martha. 1976. *Käthe Kollwitz: Woman and Artist.* Old Westbury, N.Y.

Lebeer, Louis. 1971. *The Prints of James Ensor.* New York.

Leighten, Patricia. 1990. The White Peril and *L'Art nègre:* Picasso, Primitivism and Anticolonialism. *Art Bulletin,* vol. 72, no. 4 (December), pp. 609–30.

Lewis, Beth Irwin. 1971. *George Grosz: Art and Politics in the Weimar Republic.* Madison, Wis. (Reissued by Princeton University Press in a text edition with enlarged bibliography, 1991.)

Long, Rose-Carol Washton. 1987. Occultism, Anarchism, and Abstraction: Kandinsky's Art of the Future. *Art Journal,* vol. 46, no. 1 (Spring), pp. 38–45.

Long, Rose-Carol Washton. 1989. Scholarship: Past, Present, and Future Directions. In Robert Gore Rifkind Center 1989, pp. 183–205.

Miesel, Victor H., ed. 1970. *Voices of German Expressionism.* Englewood Cliffs, N.J.

Myers, Bernard S. 1963. *Expressionism: A Generation in Revolt.* London.

Napier, Elizabeth R., trans. 1981. *Wassily Kandinsky: Sounds.* With introduction by Elizabeth Napier. New Haven, Conn.

National Gallery of Art. 1978. *Edvard Munch: Symbols and Images.* Exhibition catalog with introduction by Robert Rosenblum and essays by Arne Eggum, Reinhold Heller, Trygve Nergaard, Ragna Stang, Bente Torjusen, and Gerd Woll. National Gallery of Art, Washington, D.C.

Nietzsche, Friedrich. [1883] 1961. *Thus Spake Zarathustra.* Trans. R. J. Hollingdale. Baltimore.

Paret, Peter. 1980. *The Berlin Secession.* Cambridge, Mass.

Pollock, Griselda. 1980. Artists' Mythologies and Media Genius, Madness and Art History. *Screen,* vol. 21, no. 3, pp. 57–96.

Prelinger, Elizabeth. 1983. *Edvard Munch: Master Printmaker.* New York.

Raabe, Paul. 1989. Illustrated Books and Periodicals. In Robert Gore Rifkind Center 1989, pp. 115–29.

Reinhardt, Georg. 1977–78. Die frühe Brücke: Beiträge zur Geschichte und zum Werk der dresdener Kunstlergruppe Brücke der Jahre 1905 bis 1908. *Brücke Archiv,* vols. 9 and 10.

Rigby, Ida Katherine. 1983. *An alle Künstler War—Revolution—Weimar.* Exhibition catalog. University Gallery, San Diego State University.

Rigby, Ida Katherine. 1989. The Revival of Printmaking in Germany. In Robert Gore Rifkind Center 1989, pp. 39–65.

Robert Gore Rifkind Center for German Expressionist Studies, Los Angeles County Museum of Art. 1989. *German Expressionist Prints and Drawings.* 2 vols. With essays by Stephanie Barron, Wolf Dieter-Dube, Alexander Dückers, and others. Catalog by Bruce Davis. Los Angeles.

Robert Gore Rifkind Center for German Expressionist Studies, Los Angeles County Museum of Art. 1990. *Bibliography of German Expressionism.* Los Angeles.

Roethel, Hans Konrad. 1970. *Kandinsky: Das graphische Werk.* Cologne.

Roethel, Hans Konrad. 1973. *The Graphic Work of Kandinsky*. Exhibition catalog. International Exhibitions Foundation, Washington, D.C.

Rosenblum, Robert. 1975. *Modern Painting and the Northern Romantic Tradition: Friedrich to Rothko*. New York.

Rubin, William, ed. 1984. *"Primitivism" in Twentieth Century Art: Affinity of the Tribal and the Modern*. 2 vols. Exhibition catalog with introduction by Rubin, and essays by Rubin, Jack D. Flam, Kirk Varnedoe, Sidney Geist, Donald E. Gordon, and others. Museum of Modern Art, New York.

Schiefler, Gustav. 1907 and 1927. *Verzeichnis des graphischen Werkes Edvard Munchs*. 2 vols. Berlin.

Schulz-Hoffmann, Carla. 1984. Bars, Fetters and Masks: The Problem of Constraint in the Work of Max Beckmann. In Schulz-Hoffman and Weiss, eds., 1984, pp. 15–52.

Schulz-Hoffmann, Carla, and Judith C. Weiss, eds. 1984. *Max Beckmann: Retrospective*. Exhibition catalog with contributions by Walter Barker, Peter Beckmann, James D. Burke, Wolf-Dieter Dube, and others. Saint Louis Art Museum, St. Louis.

Slatkin, Wendy. 1980. Maternity and Sexuality in the 1890s. *Woman's Art Journal*, vol. 1, no. 1 (Spring/Summer), pp. 13–19.

Solomon-Godeau, Abigail. 1989. Going Native. *Art in America*, vol. 77, no. 7, pp. 119–161.

Taevernier, Auguste. 1973. *James Ensor: Catalogue illustré de ses gravures* (text in French, Flemish, and English). Ledeberg, Belgium.

Torjusen, Bente. 1978. The Mirror. In National Gallery of Art 1978, pp. 185–227.

Varnedoe, Kirk. 1984. Gauguin. In Rubin, ed., 1984, pp. 179–209.

Varnedoe, J. Kirk T., with Elizabeth Streicher. 1977. *Graphic Works of Max Klinger*. New York.

Von dem Knesebeck, Alexandra. 1989. Die Bedeutung von Zolas Roman "Germinal" für den Zyklus "Ein Weberaufstand" von Käthe Kollwitz. *Zeitschrift für Kunstgeschichte*, vol. 52, no. 3, pp. 402–22.

Weinstein, Joan. 1990. *The End of Expressionism: Art and the November Revolution in Germany, 1918–19*. Chicago.

Zemel, Carol M. 1980. *The Formation of a Legend: Van Gogh Criticism, 1890–1920*. Ann Arbor, Mich.

11

Picasso and Other European

Printmakers to the 1940s

THE FAUVES

Expressionism was one of many decisive stylistic and thematic approaches that made the early twentieth century one of the most volatile periods in the history of art. Although none of the other modern movements was to prove so important for printmaking, Fauvism, Cubism, and Surrealism each had its graphic component. Partaking of or helping to generate all of these movements, and yet maintaining his independence, was Pablo Picasso. Best known as one of the most inventive modern painters and sculptors, Picasso holds an equally important position in the history of prints.

French Fauvism developed concurrently with German Expressionism. Its name came from *fauve,* meaning "wild beast," a label pinned on these painters by the critic Louis Vauxcelles at the *Salon d'Automne* in 1905. Never a well-organized group, the Fauves lasted as such for only a couple of years. But the painters whose concerns were brought together under the aegis of Fauvism—André Derain, Maurice de Vlaminck, Raoul Dufy, Albert Marquet, Henri Matisse, and, for a time, Georges Rouault—continued to make important contributions even after the label lost its topicality.

Fauvism opposed the static and mechanical (albeit poetic) pointillism or divisionism of Georges Seurat and Paul Signac. Matisse, always an articulate spokesman about his art, employed rhetoric that was very close to the Expressionists' on some points. Art should be dy-

namic, not static, expressing a "nearly religious feeling" about life. "What I am after, above all, is expression. . . . I am unable to distinguish between the feeling I have for life and my way of expressing it. Expression to my way of thinking does not consist of the passion mirrored upon a human face or betrayed by a violent gesture. The whole arrangement of my picture is expressive. The place occupied by figures or objects, the empty spaces around them, the proportions, everything plays a part." But we begin to perceive a sharp distinction between Matisse's approach and that of the German Expressionists when we read, "Composition is the art of arranging in a decorative manner the various elements at the painter's disposal for the expression of his feelings."[1] Whereas the Expressionists claimed that the *act* of making art must be synonymous with inner experience insofar as possible, these were separate steps for Matisse. He defined art as a refinement of feeling tempered with aesthetic choice, enduring and serene.

As Margrit Hahnloser notes, Matisse's artistic sensibility was entirely that of a painter. Whereas he was Picasso's only real rival in painting, he did not replicate the latter's intense interest in printmaking. With the help of many fine printers, Picasso made important innovations in graphic techniques, while Matisse stayed within traditional technical boundaries. However, Matisse's prints, Hahnloser continues, are an extremely important aspect of his oeuvre. Like his paintings, the prints center on the human figure, and the problem of representing the figure in space. The prints provide a record of important changes in Matisse's thinking about that central problem.[2]

Although color was vital to Fauvism—and Vauxcelles' label was based on the violence of the group's color—its emphasis on flatness and decisive shape and contour made the woodcut and linocut appealing. Matisse's woodcut *Nude Study* (also known as *Le Grand Bois*) (1906; fig. 11.1) vibrates with strong patterns. The heavy lines of the background are related, as Jack Flam points out, to Van Gogh's drawings.[3] These lines, so thick that they are almost shapes, actively surround the nude, defined by equally strong contours. Although the body is distorted—Matisse has given us a sense of viewing it from above by diminishing the proportions of the legs and feet—it is still based, more than Heckel's *Franzi Reclining* (fig. 10.23), on the European tradition of the beautiful reclining female figure. Curves, not angles, dominate.

Like most wood-engravings and many of Gauguin's woodcuts, Raoul Dufy's *Fishing* (1912; fig. 11.2) has a white-on-black effect. But rather than vary the working and printing of the wood surface like Gauguin, Dufy aimed for flat black and white areas. A variety of patterns are present. The criss-crossed net, waves, parallel "hatching" in the sky, and oblong, drooping foliage all have different rhythms, which combine into the decorative surface of the whole. The subject is interpreted with Dufy's characteristic ebullience. There are none of the dark or mysterious overtones of Gauguin's images.

Some of the best woodcuts of the Fauvist group were produced by Maurice de Vlaminck. *Martigues Harbor* (ca. 1907; fig. 11.3) reveals the strong influence of Van Gogh, for Vlaminck has imbued his gouge marks with the radiant energy of the former's brushstrokes. This print and Jongkind's *Setting Sun, Port of Antwerp* (fig. 9.27) invest the old Dutch harbor-view and its descendants with new vigor. The same could be said of Dufy's *Marseilles Harbor* (fig. 11.4), a color lithograph published as part of a portfolio, *La Mer* (*The Sea*), in 1925. Bright orange, yellow, green, and violet exemplify the Fauve intensity of color, and the agitated lines again recall the painting of Van Gogh. Whimsically, Dufy placed within the modern seaport a mythological cast: Amphitrite appears in a shell-shaped chariot formed by sea horses, and green dolphins jump alongside.

FIGURE 11.1
Henri Matisse. Nude
Study (Le Grand Bois).
*1906. Woodcut. 475 ×
380 mm. Harvard Uni-
versity Art Museums,
Cambridge.*

FIGURE 11.2
Raoul Dufy. Fishing.
*1912. Woodcut. 321 ×
401 mm. Museum of
Modern Art, New York.*

FIGURE 11.3

Maurice de Vlaminck.
Martigues Harbor.
*Ca. 1918–22. Wood-
cut. 340 × 414 mm.
Kunstmuseum Bern.*

FIGURE 11.4

Raoul Dufy. Marseilles
Harbor *from* La Mer
(The Sea). *1925. Color
lithograph. 330 ×
442 mm. Victoria &
Albert Museum, London.*

In the decade following the First World War, Matisse's style took an interesting turn away from the aggressive experiments with space, form, and color that he and his colleagues in a variety of avant-garde movements had conducted. He aimed for a synthesis of experiment and tradition. Although the artist's interests in the curvaceous sensuality of the female nude and the visual excitement of flat patterns remained the same, a comparison between his *Nude Study*

(fig. 11.1) and his famous lithograph *The Bayadère Trousers*, or *Odalisque in Striped Pantaloons* (fig. 11.5), of 1925 admirably illustrates Matisse's change of style.

In contrast to the early woodcut, *The Bayadère Trousers* shows a realistically depicted nude in a legible space. Matisse's use of lithography, part of an intense effort in the medium undertaken in the twenties, reprised an early nineteenth-century approach by concentrating on subtle tonal values and careful drawing. The harem woman, as well, gave a more modern form to the nineteenth-century European interest in foreign and exotic cultures (recall Delacroix's *Jewess of Algiers*, fig. 9.1), especially as locales whose female occupants were construed as sexually available. Yet Matisse's own description of his aims in his many images of odalisques suppressed this aspect and stressed the "ambience of languid relaxation," but with a "pictorial tension that arises from the interplay and mutual relations of the various elements."[4] Even without the gorgeous colors of Matisse's paintings, the lithograph has that tension in the interaction of the whorl-shaped pattern of the stripes and the arabesque of the chair cover, which, Hahnloser points out, sets off the model, Henriette Darricarrère, as a mandorla accentuates a religious figure in an icon.[5] Despite the tension Matisse established, the plump curves of both the chair and the model and the sensitivity of the drawing lend the image a serene and highly traditional beauty. *The Bayadère Trousers*, as well as Dufy's joyous *Marseilles Harbor*, both done in 1925, are excellent examples of that "call to order," as the writer Jean Cocteau phrased it, that many artists voiced in the second and third decades of the twentieth century, in part as a response to World War I.[6] We shall see a renewed interest in calm, classical order, and sometimes in the subject matter of antiquity, manifest itself in a great variety of ways throughout this chapter.

Like Picasso, Matisse was particularly interested in the thirties in composition with pure line, recalling ancient Greek vase painting. One of the most beautiful books of the twentieth century is his illustrated version of Stephane Mallarmé's *Poésies* (1932). Matisse wanted to "balance each pair of facing pages—the one with the etching white, the other with the typography relatively black. I achieved this by modifying my arabesques in such a way that the spectator's attention would be interested as much by the entire page as by the promise of reading the text."[7] One of the most refined of the twenty-nine etchings is *The Swan* (fig. 11.6), which Matisse distilled from preliminary drawings from nature.[8] The sensitivity to the animal's appearance and movement is equaled here by the superb balance of the design, a hallmark of Matisse's works.

Primavera (*Spring;* fig. 11.7), part of a series of twenty-five linocuts (or linoleum cuts) completed in 1938, also illustrates Matisse's feeling for pure line. Linoleum, made of burlap coated with linseed oil, powdered cork, and rosin, was once an inexpensive, common floor covering. In the 1920s it began to be employed for relief prints. It could be easily carved, unlike the woodblock, and could produce thick areas of ink not unlike those attainable in silkscreen. With its flat, uneventful surface, the linoleum block was ideally suited to the white-line effect that artists had pursued in other graphic media. Without the resistance of the wood surface, the linoleum block responded more readily to the artist's intention. In Matisse's case, it accommodated his love of curves as wood never could, even permitting a swelling and tapering associated with the intaglio line. He commented:

> The linoleum should not be used as a cheap substitute for wood because it gives to a print its own special character, quite different from woodcut, and therefore should be studied. The gouge is controlled directly by the sensibility of the engraver. Indeed, this is so true

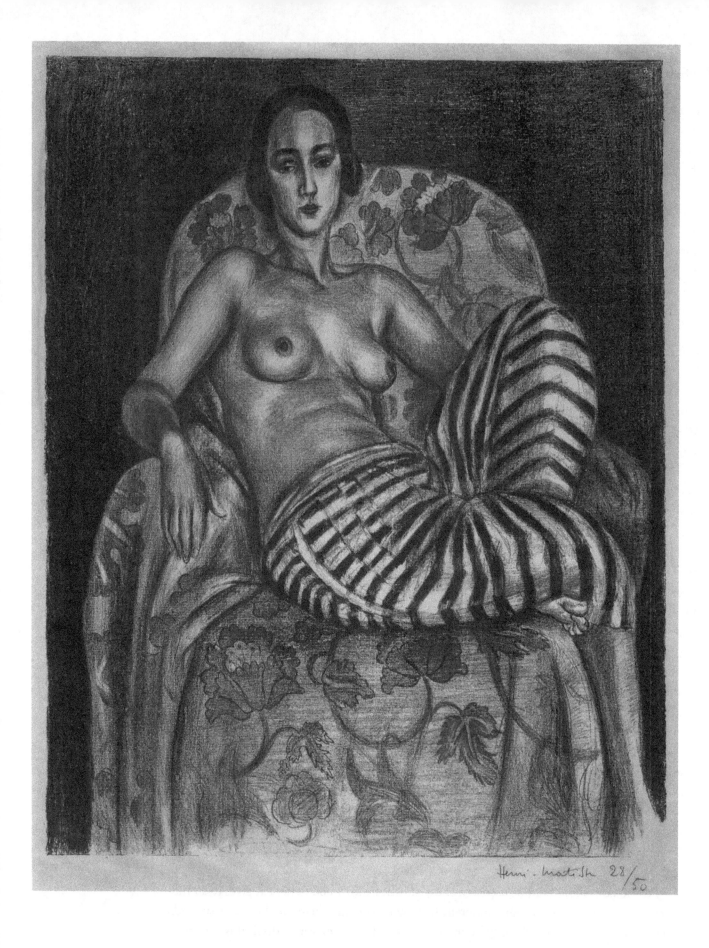

Henri Matisse 28/50

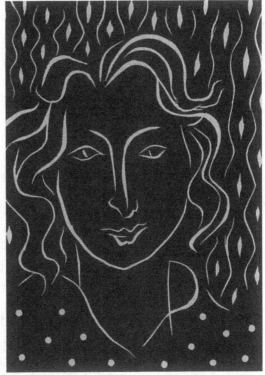

FIGURE 11.6
Henri Matisse. The
Swan: *Page 125 from
Stephane Mallarmé's*
Poésies. *1932. Line
etching. 330 × 254 mm.
Art Institute of Chicago.*

FIGURE 11.7
Henri Matisse. Prima-
vera. *1938. White-line
linocut. 228 × 169 mm.
Bibliothèque Littéraire
Jacques Doucet, Univer-
sités de Paris.*

that the least distraction during the execution of a line causes a slight pressure of the fingers on the gouge and influences the drawing for the worse. Engraving on the linoleum is a true medium for the painter illustrator.[9]

In *Primavera,* as in *The Swan,* Matisse aimed for a design that spreads over the whole page, encompassing the head itself and patterns of dots, serpentine lines, and diamond shapes, while avoiding the concentration in the center suggestive of past art. But as the print's title hints, the beautifully proportioned head, with its elongated nose and flowing locks, evokes the rarified grace of Botticelli's figures.

For his 128 illustrations for Albert Skira's 1943 edition of François Rabelais' *Pantagruel,* a sixteenth-century satirical work, André Derain employed woodblocks inked *à la poupée.* Basing his style on the earliest woodcuts (this example [fig. 11.8] recalls early woodcut playing cards), which had also interested Expressionist artists, Derain established clearly separated color areas with the gouge, so that the overlapping of colors was avoided. The carved-out areas resulted in white lines that replaced the black lines of early woodcuts. With each printing, the single block had to be carefully inked again. Derain chose not to hand-color each impression, which would have more closely approximated early color relief prints, although he achieved a similarly var-ied, mottled quality by his application of ink.

FIGURE 11.5
Henri Matisse. The
Bayadère Trousers
(Odalisque in Striped
Pantaloons). *1925. Litho-
graph. 545 × 440 mm.
National Gallery of Art,
Washington, D.C.*

FIGURE 11.8

*André Derain. Page 24
from* Pantagruel *by
François Rabelais. Paris:
Albert Skira, 1943. Color
woodcut. 125 × 91 mm.
Museum of Modern Art,
New York.*

The emphatic flatness of Derain's print is one of the characteristics pursued by early twentieth-century avant-garde artists, whether they worked in non-objective or representational modes. In printmaking, the stencil technique is most suitable for such effects. In its purest form, this method is very simple: a cut-out screen or stencil is laid against paper, and ink or paint is squeegeed, brushed, or rolled on over it. Later, silkscreen techniques admitted more complexity.

For his illustrated manuscript *Jazz,* published in 1947, in which Matisse condensed all his compositional surety and sensitivity toward line, shape, and color, he began with color paper cut-outs, which he arranged in collages. Cut paper had facilitated his creation of large painted compositions such as *The Dance* (1931–33). He had also used the technique to produce maquettes for cover designs for the art periodical *Verve,* published, as was *Jazz,* by Efstratios Tériade. What began as a preparatory medium, however, now emerged as autonomous, dubbed by Matisse "drawing with scissors."[10] Moreover, the cut-outs helped him create during his convalescence from surgery at the beginning of the 1940s.

The prints that resulted from the cut-paper compositions, although often considered mere reproductions of the original collages, were done under Matisse's supervision. The same paints he had used to color the paper for his collages were now applied to the paper through stencils, a method called *pochoir* in French. Lithography had produced disappointing results, lacking the maximum saturation of color present in the maquettes. Certainly the brightest prints produced up to this time, the *Jazz* plates might visually paraphrase the American-born musical form that had come to epitomize the pace and excitement of the modern era. But the themes of the images are old ones: the voyage, the circus, myth, popular tales. The text, a

summary of Matisse's thoughts on art, love, and joy, was written by the artist himself as an accompaniment to the plates. Handwritten in pencil and reproduced in facsimile, the script is oversized so as to harmonize with the saturated color.

Icarus (fig. 11.9, color plate, p. 478) exemplifies the concentrated power of the color pages. Both the striving and the ill-fated flight of the myth's hero are evoked by the posture of Matisse's dense, black figure, who, with "wings" outspread and head down, challenges the gods, armed only with his ingenuity and audacity. On the left side of his chest, a bright red circle-heart suggests the transcendent human spirit that the myth of Icarus defines. Against the saturated blue sky, hot yellow bursts convey the sun's heat, against which Icarus unsuccessfully pits his wits and courage. But Matisse, with characteristic optimism and grace, did not dwell on the tale's tragic ending.

PICASSO'S EARLY PRINTS, AND THE PRINT IN EARLY TWENTIETH-CENTURY ABSTRACTION

While Matisse's oeuvre centers on joy and sensuality, Picasso's has a very wide expressive range. His works may be cerebral, burlesque, tragic, joyous, passionate, or lyrical, and sometimes two or more of these qualities are audaciously combined. This expressive versatility has its counterpart in stylistic variety. In 1928 the Surrealist writer André Breton remarked that stylistic labels applied to Picasso were "absurdly restrictive,"[11] and Picasso's work, right up until his death in 1973, continued to confirm Breton's observation. Picasso viewed his styles not in terms of an evolution but as a range of expressive choices. His oeuvre moved through such varied manifestations as the early Blue and Rose periods, with their links to Symbolism and Art Nouveau, the analytic and synthetic phases of Cubism, and a linear classicism evoking ancient Greek vases or the engravings after Flaxman (see fig. 6.43). Throughout, his art remained highly personal (indeed, much current scholarship on Picasso emphasizes the autobiographical dimension of his oeuvre), epitomizing the twentieth-century interest in the unconscious as a source for artistic imagery—a strong component of Surrealism. At the same time, Picasso's art affirms the artist's conscious will and intellect.

Along with this expressive and stylistic range, any introduction to Picasso might well emphasize his profound connections to the artists whom he admired—in particular, Rembrandt, Velasquez, and Goya. Despite his importance for twentieth-century modernism, Picasso's respect for past artists surfaces even in his parodies of their work.[12] As we shall see, Picasso's awareness of the past was especially important for his printmaking, even though he often rebelled against printmaking's technical conventions.

Like Rembrandt and Goya in their times, Picasso was unmatched as a printmaker.[13] Because his approach to art was exploratory—based on the evolution of images rather than their resolution—printmaking held a special place for him. He exploited its potential for serial imagery as well as for change within a single image (states). When he worked as a printmaker, Picasso's sensibility emerged from a dialectic between painterly and graphic modes, and between the technical restrictions of whatever graphic medium he was using and his creative will.

In an important study, Pat Gilmour, echoing the foremost scholar of Picasso's prints, Brigitte Baer, establishes the crucial role of printers in Picasso's graphic development. Behind every escalation of complexity, every breakthrough to a new understanding of a medium in his

prints, stood the patience and expertise of a printer and his workshop: Eugène Delâtre, who most likely introduced the painter to etching, for *The Frugal Repast* (fig. 11.10), Roger Lacourière for the last, mixed intaglio prints of *The Vollard Suite,* Fernand Mourlot for the extraordinary lithographs of the late 1940s, and Aldo Crommelynck for the moving etchings of Picasso's late years. Thus, the concept of Picasso as an autonomous fountainhead of free-flowing imagery must be tempered. The artist himself, Gilmour argues, was happy to learn from a gifted artisan.[14]

Picasso's most famous early print is *The Frugal Repast* (1904), part of a series of plates of *Saltimbanques* acquired, then steel-faced and published, by Vollard in 1913. (A saltimbanque was a low-class acrobat or street player, descended from the medieval *jongleur* or *sauteur.*[15]) For economy's sake, Picasso etched the image on a zinc plate that already contained a landscape by another artist. In the early impressions printed in Delâtre's shop, this landscape is better concealed than in those from Vollard's steel-faced edition. The 250 impressions from fourteen plates in the series differ greatly in quality.[16]

Exhibiting the emaciated, elongated forms of Picasso's so-called Blue Period, the image ostensibly deals with poverty and physical blindness. Is it, then, a social comment, the kind we have come to expect within the history of prints? The suffering, emaciated male figure, although not a literal portrait, recalls Picasso's friend Carlos Casagemas, a writer and painter who had tried to kill a woman, then committed suicide in 1900, haunted by the failed love affair and his own impotence.[17] But the hat and neck scarf, found in a portrait of the artist by Sebastián Junyent (1904), also suggest Picasso himself.[18] Theodore Reff and others have explored Picasso's identification with saltimbanques, harlequins, and other circus and street performers in the Blue and Rose periods (1904 and 1905). Alienated from society and impoverished, these were skilled performers, balancing their bodies as an artist balances form, living in half-worlds where illusion and reality combine. "What is the saltimbanque," wrote the poet Théodore de Banville in 1853, "if not an independent and free artist who works wonders to gain his daily bread, who sings in the sun and dances under the stars without hope of entering an academy?"[19] Thus, *The Frugal Repast* might also be a projection of the artist's bohemian existence, his sense of being sacrificed by society, while his own sensitivity is conveyed by the delicate caress of the woman by the man's spidery, enlarged hands. With the woman's hands, these form a rhythmic circular movement and assert the couple's close relationship: his left points to her right and vice versa.[20]

In his efforts to interpret Picasso as a bourgeois artist, Max Raphael suggests that his "sentimental" early images, far from being social criticism, heroize poverty: "One must not see here . . . any sort of accusation against the bourgeois order. Very much like [the writer Rainer Maria] Rilke, Picasso looks upon poverty as a heroic thing and raises it to the power of myth. . . . Far from regarding it as a social phenomenon which it is up to those afflicted to abolish, he makes of it a Franciscan virtue heralding the approach of God. . . . This passive, mystical and religious conception of poverty is grounded in the Christian notion of brotherly love and in bourgeois ideology."[21]

Does Picasso, then, merge his own identity with that of the couple of *The Frugal Repast,* making the image a statement, not about the unfortunate aspects of poverty, but about the virtue and heroism of the artist? Whether or not Raphael's entire analysis is valid, it seems undeniable that *The Frugal Repast* interprets the artist in terms of martyrdom analogous to old religious concepts. The artist's inner greatness is suggested by the shrinkage of bodily form and

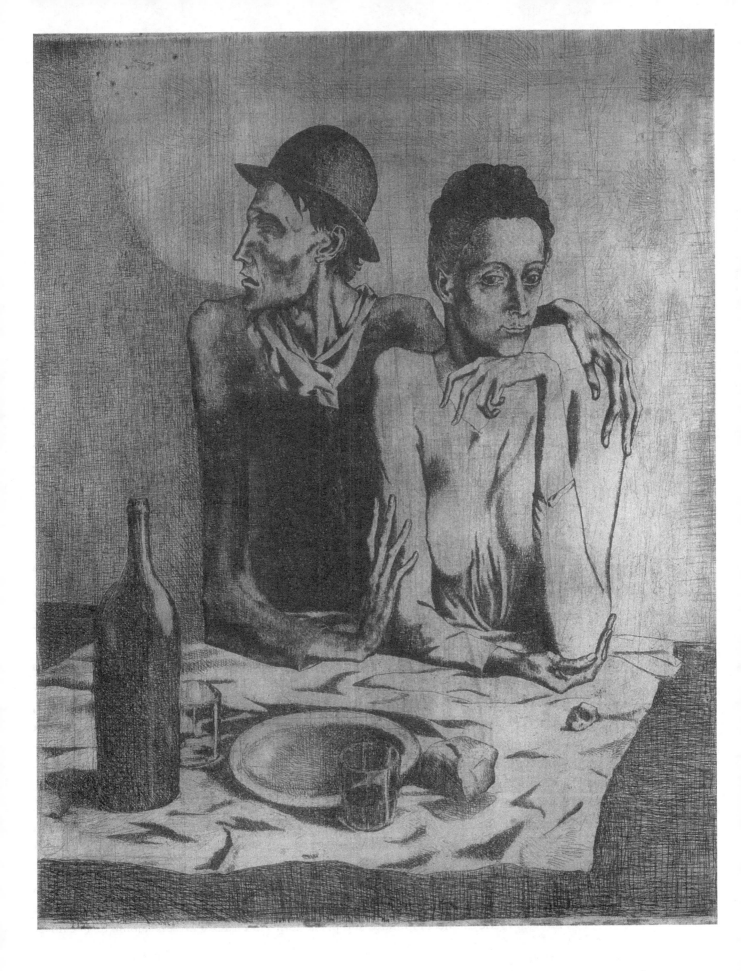

by physical blindness—often a correlative of spiritual insight (as in Rembrandt's works). The still-life is laid out as quietly and carefully as in a painting by the Spanish Baroque artist Francisco de Zurbaran in which the transcendent character of objects is conveyed by lighting and ceremonial placement. Here, the bread and wine unmistakably refer to religious tradition but become the ingredients of a sacrament in which the artist was thought to transcend everyday, profane existence.

Picasso did not cling exclusively to this conception of the artist as martyr, although, despite success and wealth, he remained bohemian in the sense that his acceptance by middle-class culture was uneasy and he never stopped challenging his audience's assumptions. His vision of the artist's role was to be more assertive. It appeared most blatantly in the *Desmoiselles d'Avignon* of 1907, that unresolved painting that launched Cubism via an unrelenting assault on the traditional European understanding of the female nude. As a stylistic term, "Cubism" is one of the most inadequate of art-historical labels. It suggests geometric and methodical qualities that are largely, if not wholly, absent from works done by Picasso and Georges Braque under its aegis. And yet the interpretation of Cubism as intuitive, poetic, and evocative—fostered by Picasso's own likening of it to the undefinable and ephemeral scent of a perfume[22]—denies the intellectual inquiry about the relativity of space, time, and perception that may have been at the heart of this style. Although much of the scholarship on Cubism after World War II fostered a formalist interpretation, the early critics of Cubism as well as more recent scholars have stressed its subject matter and historical context: the ephemera of the Parisian cafe and the painter's studio (especially as found in Cubist collages), dismissed as incidental by some scholars, are now read as evidence placing Cubism within a particular avant-garde social and political milieu.[23]

The considerable importance of the print within Cubism has only recently been brought to light.[24] The absence of color in traditional intaglio methods corresponded to the monochrome basis of Analytic Cubist painting. (The term "analytic" refers to Cubism's early phase, in which the icy, angular deformations of Picasso's *Desmoiselles d'Avignon* were modified into a more rarified, crystalline style and objects seem to be fragmented and reassembled in shifting relationships on the canvas.) Drypoint, especially, lent itself to Analytic Cubism's essential ambiguity. In *Mademoiselle Léonie Seated on a Chaise Lounge* (fig. 11.11), one of the prints accompanying Max Jacob's *San Matorel,* published by Daniel-Henry Kahnweiler in 1911, drypoint is combined with etching. Although the figure crystallizes in the center of the sheet, as in traditional portraiture, it has lost its integrity. The osseous architecture of the human body remains intact in the vertical and horizontal lines hinting at shoulders, backbone, pelvic bones, and so on, while fleshy parts—in curving contours or ambivalent, shaded planes—do not quite congeal around this stable if tentatively stated frame. Picasso evoked the human presence without directly stating visual fact. Foul-biting of the plate and the deliberately crude scratches add to the sense of indefiniteness and mystery. Characterized by Abraham Horodisch as one of the "landmarks of the history of modern book illustration," the images of *San Matorel,* "instead of actually illustrating the text, are visual equivalents inspired by the artistic tenor of the words: not graphic representations of single episodes, but interpretations of the book's spirit."[25]

Georges Braque's *Fox* (1911; fig. 11.12), a still-life combining etching and drypoint, reveals his very different sensibility immediately, despite its stylistic closeness to Picasso's print.[26] The more energetic conflict of rounded and planar forms in Picasso's work is stabilized. The image

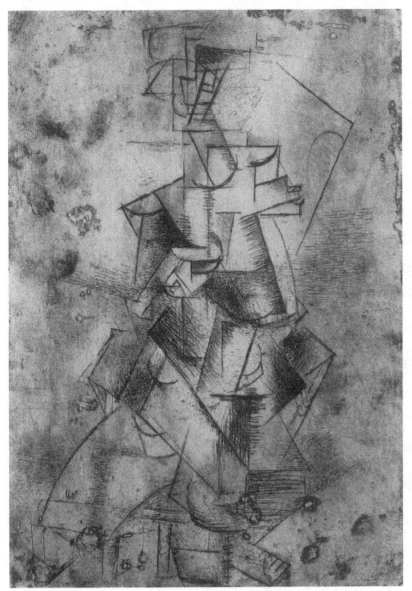

FIGURE 11.11

Pablo Picasso. Made-
moiselle Léonie Seated
on a Chaise Lounge:
Plate 3 of San Ma-
torel *by Max Jacob.*
Paris: Daniel-Henry
Kahnweiler, 1911. Etching
and drypoint. 198 ×
140 mm. Harvard Uni-
versity Art Museums,
Cambridge.

rests more clearly on a vertical/horizontal grid, or at least the implication of one. The lettering, a frequent component of Cubist compositions, spells out the name of a bar and draws attention to the picture plane as flat surface, thereby emphasizing the ambiguous implications of depth in the shaded, fluctuating planes. As Robert Rosenblum has argued, it also alludes to the world of the Paris cafes—the main ambiance of Cubism and other forms of avant-garde art—as well as making puns or statements of the Cubist aesthetic.[27] The incorporation into the images of the lettering of bottle labels, cigarette boxes, and the like, advertisements, newspapers (or, in collage, the actual things) not only obfuscates the boundary between artistic illusion and reality but also speaks of the contemporary urban environment and political conditions in which the art was created.[28] Both of these motives were to prove significant for subsequent movements, most notably Pop Art.

Braque's and Picasso's crucial role in the development of Cubism was not well known at first. In the 1911 exhibition at the *Salon des Indépendants,* their works were missing. Instead the movement was represented by Robert Delaunay, Albert Gleizes, Fernand Léger, Henri le Fau-connier, and Jean Metzinger. In the following year, which also saw the publication of *Du*

FIGURE 11.12

Georges Braque. Fox.
1911. Etching and dry-
point. 545 × 381 mm.
Saint Louis Art Museum.

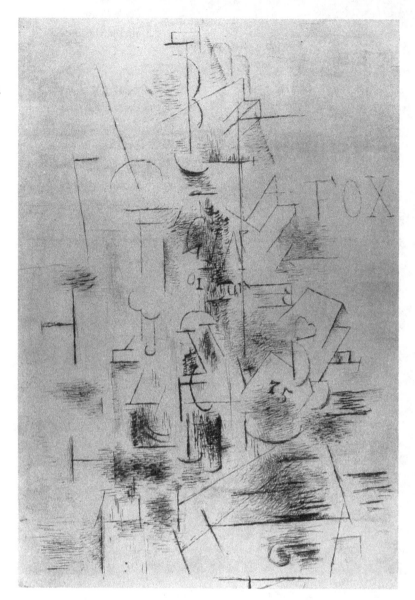

Cubisme by Gleizes and Metzinger, an exhibition labeled the *Section d'Or* (*Golden Section*) included Jacques Villon (Gaston Duchamp) and his brothers Raymond Duchamp-Villon and Marcel Duchamp, Alexander Archipenko, André Dunoyer de Segonzac, Juan Gris, Louis Marcoussis, Francis Picabia, and others. The Cubist aesthetic was manifested in a variety of personal styles.

Jacques Villon, working entirely in drypoint and etching, was one of the most prolific Cubist printmakers. Like Kirchner of the German Expressionists, but unlike a majority of French avant-garde artists, he lent great significance to printmaking with his oeuvre: "There is only one art that propounds signs which are the equivalents of objects, combining abstraction and reality—is anything more abstract than a line, a stroke, a drawing made of lines, of crisscrossed strokes?—and that art is engraving . . . the art found in caves [i.e., the animals and signs incised on prehistoric rock walls] and on copperplates."[29] Thus, Villon associated the traditional syntax of intaglio printmaking—the individual and hatched line—with the modern abstraction.

His *Dinner Table* (1912–13; fig. 11.13) incorporates rhythmic curves and a sense of dynamic movement into the structure of Analytic Cubism. The highlights, contours, and shadows of the objects on the table are interwoven by a sense of continuous curving line. In early impressions of the plate, before steel-facing, the drypoint line is particularly black and velvety. Along with the various angular areas of parallel hatching, these blacks give the image a scintillation reminiscent of Impressionism and Cézanne, who was so important for Cubism.

One of the most famous Cubist prints is Louis Marcoussis' portrait of the poet Guillaume Apollinaire (fig. 11.14), the movement's most perceptive early critic. Executed in etching and drypoint, the print was begun in 1912 and finished posthumously in 1920. Apollinaire's war injury of 1916 is covered with bandages, and his heavy head is rendered comparatively naturalistically (for Cubism). Again lettering is an important formal and iconographic component of the picture: it alludes to a selection of the poet's works—the novel *L'Enchanteur Pourrissant* (*The Rotting Magician*, 1909), and *Alcools* (*Liquors*, 1913), a book of poetry—and gives Apollinaire's original name, Kostrowitsky, at the top. Rosenblum has noted the contrast between Marcoussis' "tremulous style," emerging partly from the drypoint medium itself, and the "severe arcs and angles" of the Cubist vocabulary of form.[30]

In the Russian artist Marc Chagall's twenty etchings and drypoints illustrating his autobiographical *Mein Leben* (*My Life*, written in 1922), the Analytic Cubist style, absorbed during his early years in Paris between 1900 and 1913, is given a highly personal interpretation informed with the sense of a warmly recalled folk culture. These works represent Chagall's rather late involvement in printmaking—he was thirty-five and had just left an increasingly repressive Soviet Union for Berlin—but signal the beginning of a prolific production in various print media (we shall encounter his color lithographs later). In *The Grandfathers* (1923; fig. 11.15), the drypoint stylus is employed with delicacy. The old men, bent and slow-moving and preoccupied with their conversation, are characters from Chagall's Russian Jewish past, affectionately conjured up and kept in the realm of the dream by the abstract and ephemeral nature of the style. Although affirmed by Leon Trotsky, the ethnicity of the various components of Soviet society was suppressed as the Russian Revolution followed its course into Leninism and Stalinism. The prints for Chagall's book, gathered in a portfolio, preceded the text because the Berlin publisher, Paul Cassirer, had difficulty with the translation from Russian into German.[31]

Although Chagall used it to evoke the village culture of the past, Analytic Cubism, with its shifting planes and fragmented masses, was also an ideal purveyor of the multifaceted, rapid sensory impressions of the twentieth-century urban experience. *The Eiffel Tower* (fig. 11.16), symbol of the modern age, was portrayed by Robert Delaunay in a transfer lithograph done in 1926 after paintings dating to about 1910–11, the heyday of Analytic Cubism. Delaunay treated it as a kind of aspiring, contemporary cathedral (compare Feininger's *Cathedral*, fig. 10.31). Designed by Gustave Eiffel for the Paris Exposition of 1889, it was a monumental example of exposed metal construction. The tower and the remainder of the city, even the atmosphere itself, interpenetrate so that the whole is one dynamically integrated experience. Similarly, Kasimir Malevich's *Simultaneous Death in an Airplane and at a Railway* (fig. 11.17), a lithographic illustration for Alexei Kruchenyckh's poem *Vzorval* (*Explodity*, 1913), envisions modernity as a kaleidoscope of sensations and events. Here, under the influence of Italian Futurism, Malevich emphasized the power of technology, in the context of which the deaths of individuals are made to seem insignificant. Despite this dehumanization, the exaltation of the machine age,

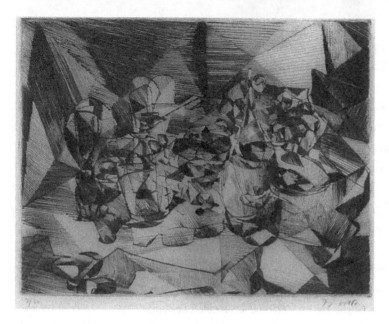

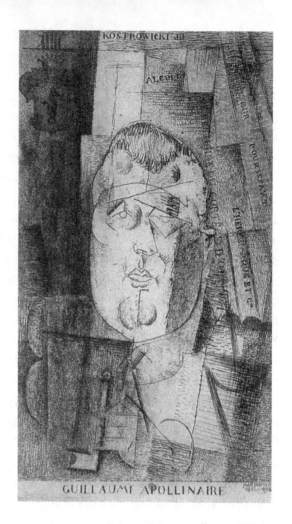

FIGURE 11.13
Jacques Villon. The
Dinner Table. *1912–13.*
Drypoint. 286 × 389 mm.
Saint Louis Art Museum.

FIGURE 11.14
Louis Marcoussis.
Portrait of Guillaume
Apollinaire. 1912–20.
Etching and drypoint.
495 × 276 mm. Mu-
seum of Modern Art,
New York.

even with its random violence, is so intense as to constitute a faith. Humanity is not lost here but has thrown itself romantically into an orgy of speed and progress.

If Analytic Cubism was based, however unsystematically or unscientifically, on a breaking-down and rearranging of form that served to critique traditional modes of representation, then Synthetic Cubism was grounded in a building up of visual information from components—sometimes geometric or quasi-geometric shapes—that drew attention to how objects are signified. The work of Juan Gris, the Spanish artist-theorist of Cubism who clarified the distinction between its two phases, is cerebral and ascetic when compared with the lyricism of Braque or the impetuosity of Picasso. In his lithographs illustrating Max Jacob's *Ne Coupez-Pas, Mademoiselle, ou Les Erreurs de P.T.T. (Don't Hang Up, Miss, or the Errors of P.T.T.,* 1921; see fig. 11.18), a clarified pictorial order reigns over the fluctuations of light or space. Picasso's analogy between the image and perfume no longer seems applicable. Rectangles, trapezoids, ellipses, cylindrical and spherical volumes, while never absolute, are uninterrupted enough to be identified as shapes and objects. The graduated shading and the passage of one plane into another, or into the picture plane itself, are eschewed in favor of the separateness of objects and geometric form. Still, Gris's print also exemplifies the subtlety and wit associated with Cubism: a curving chair back loops under the seat whose edge is contiguous with a paper draped across the table. The ovoid curves of the chair back and seat are repeated in the goblet and, on a smaller scale, the opening of the bottle. Relief from the strictness of the composition is also

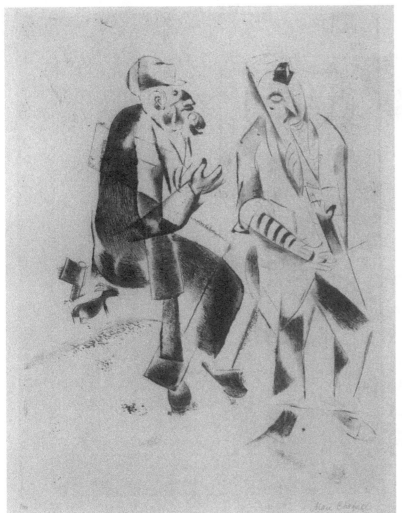

FIGURE 11.15
Marc Chagall. The Grandfathers: *Plate 3 from* My Life. *Berlin: Paul Cassirer, 1923. Etching and drypoint. 276 × 216 mm. Museum of Modern Art, New York.*

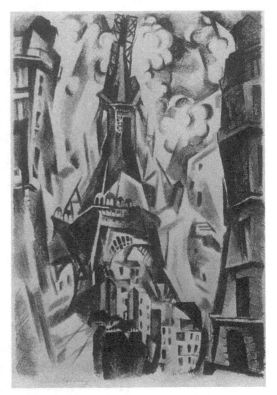

FIGURE 11.16
Robert Delaunay. The Eiffel Tower. *1926. Lithograph. 616 × 451 mm. Museum of Modern Art, New York.*

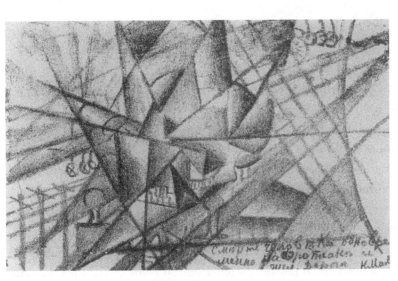

FIGURE 11.17
Kasimir Malevich. Simultaneous Death in an Airplane and at a Railway *from* Vzorval (Explodity) *by Alexei Kruchenyckh. St. Petersburg, 1913. Lithograph. 90 × 140 mm. Museum of Modern Art, New York.*

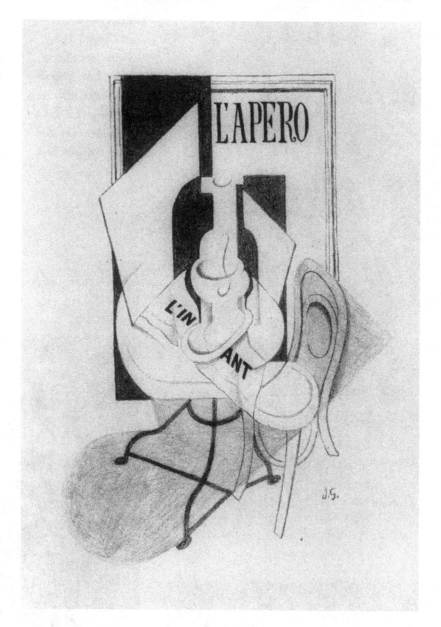

provided by the nuances of gray in the shadow underneath the table and small flourishes such as the curlicue tail of the "R."

Along with Matisse's *Jazz*, Léger's illustrations for *La Fin du Monde, filmé par l'ange N.D.* (*The End of the World, Filmed by the Angel N.D.*, 1919; fig. 11.19) by Blaise Cendrars are impor-tant examples of the stencil technique, foreshadowing the American developments of the 1960s. These plates were reproductions of drawings with color added by brush through stencils (*pochoir*). Léger's use of letters as major components of the design derives from Cubist collage, but is carried much further. Here, their identity as letters can almost be disregarded. They function less as references to something outside themselves than as flat rectangular, curving, or circular shapes arranged in a lively spiral radiating from a central white circle. Like the Dutch artist Piet Mondrian, Léger accompanied his geometric reductiveness with the restriction of his palette to white, black, and the primary colors.

For the deluxe edition of the first major monograph on his work, written by Tériade (1928), Léger produced a transfer lithograph, *Woman Holding a Vase* (fig. 11.20).[32] It typifies the

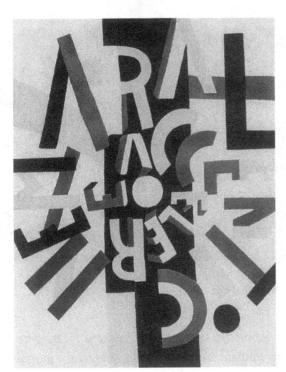

Fernand Léger. Plate 41 from Le Fin du Monde, filmé par l'ange N.D. (The End of the World, Filmed by the Angel N.D.) *by Blaise Cendrars. Paris: Editions de la Sirène, 1919. Color pochoir. 314 × 248 mm. Museum of Modern Art, New York.*

Fernand Léger. Woman Holding a Vase. *1928. Lithograph. 241 × 173 mm. Collection of Lawrence Saphire.*

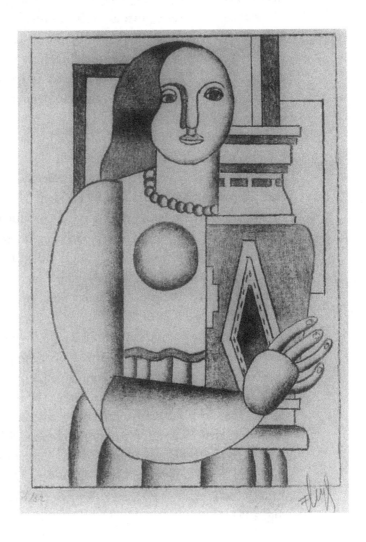

FIGURE 11.21

Rolf Nesch. The Herring
Catch. *1938. Color mixed
intaglio with added relief
elements. 6 plates, each
measuring 600 ×
420 mm. Museum of
Modern Art, New York.*

radical simplification of the human figure into geometric components, inspired by modern machines, for which he is best known. But Léger's woman also has something classically monumental about her, and the "flutings" of her skirt as well as the horizontal "moldings" of the neck of her vase suggest the ancient Greek analogy between the column and the human figure. Once again, Cocteau's postwar "call to order" seems to be at work. Léger's strikingly static, broadly scaled forms are tempered by the understated modeling (note the waves of the hair) and by organic qualities such as the differently positioned pupils and eyelids and the strangely animated hand. Léger's version of Cubism remained one of the most original, and his contributions to the revival of color lithography after World War II were to be some of the most dynamic.

Although they both led to different forms of non-objectivity, Cubism and Expressionism did not relinquish the visual world. Rolf Nesch, one of the most technically innovative printmakers of the early twentieth century, emerged from the Expressionist tradition, having been especially inspired by Kirchner. By accident Nesch discovered a technique of printing a plate that was completely bitten through, thus producing embossed areas in the paper. From this, he reasoned that the opposite approach might also be fruitful, and he began attaching wire to his plates, first by "sewing" it through drilled holes or by soldering. He also used scraps of perforated or stamped metal plates, which he reworked by etching or soldering wire to them. In Nesch's hands, the paper became a relief surface, and graphic and sculptural qualities were combined.[33]

Nesch's most impressive print is *The Herring Catch* (fig. 11.21) of 1938. In that year the artist traveled to the western coast of Norway to participate in the annual event. Nesch and the two Norwegian painters who accompanied him were dazzled by the great fleet of fishing boats with searchlights that probed the surface of the water, illuminating the herring swimming below. *The Herring Catch* is a little over eight feet wide and is divided into six parts. As we shall see, prints that rival mural paintings in size will become increasingly important after World War II, as postwar abstraction sought to distinguish itself from earlier abstract movements by sheer size or the scale of its forms. However, *The Herring Catch* also harks back to prints like Titian's *Submersion of Pharaoh's Army in the Red Sea* (fig. 3.43) and Dürer's *Triumphal Arch* (fig. 2.22).

Like the earlier German Expressionists, Nesch emphasized the ties between humanity and nature. In *The Herring Catch,* the sea is a great continuum that supports both the fish, depicted as abundant, fluid groups of lozenge shapes, and the human elements: the triangular sails of the boats and the struggling figure-groups in two pyramids in the center and right-hand "panels." Although the mottled, etched surface encompasses and unites all forms, the sense of a horizon and a spatial disposition of the figures and boats from foreground to background remain.

Several avant-garde Russian artists, on the other hand, produced radical geometric abstractions in the years following the Russian Revolution of 1917: abstractions that constituted a new visual language for an era of sweeping social, political, and technological innovation. Their country would ultimately reject what they had to offer, and the emigration of some of these artists was important for the future of European art. Malevich, whose early, Futurist-inspired work we have encountered, came to espouse the pure sensation of color as the only truly meaningful aspect of the experience of art. To this end he produced compositions that consisted solely of colored or black and white shapes. The aesthetic purism of Malevich's Suprematist movement distinguished itself from the Constructive Art of Naum Gabo and Antoine Pevsner, brothers who had experienced the growth of avant-garde art in Germany and France respectively, and who returned to Russia in 1917. Constructive Art, as defined by Gabo and Pevsner in the Realist Manifesto of 1920, was more aesthetically open, and focused on the exploration of volume, form, and space, while affirming the function of art in any society—capitalist, socialist, or communist—as a basic expression of the human spirit. With this affirmation, Gabo and Pevsner broke with the more functionalist concerns of Vladimir Tatlin and Alexander Rodchenko, who saw "Art" as an outworn appendage of capitalism, and who attempted, after 1917, to transform the artist into an engineer-producer who adapted creativity to the utilitarian needs of a revolutionary society.[34]

Although its greatest importance is for modern sculpture, the Constructivism associated with Gabo and Pevsner did have an outlet in printmaking. Gabo's wood-engraving *Opus 3* (fig. 11.22), though produced in 1950, is a graphic equivalent of his early plastic and wire constructions, which altered the conception of sculpture as solid mass. In contrast to the emphasis on flatness of much twentieth-century geometric abstraction, Gabo's image is really about the

FIGURE 11.22

Naum Gabo. Opus 3.
1950. Wood-engraving.
270 × 200 mm. Museum
of Fine Arts, Boston.

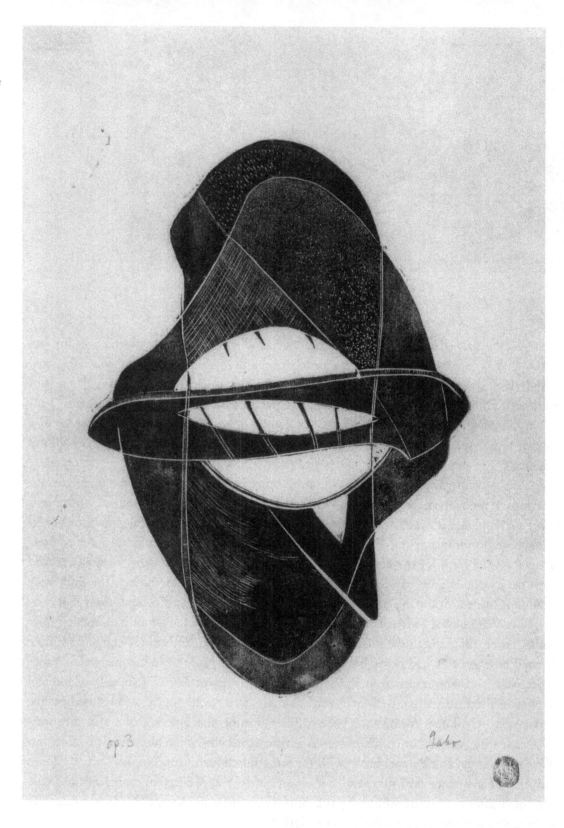

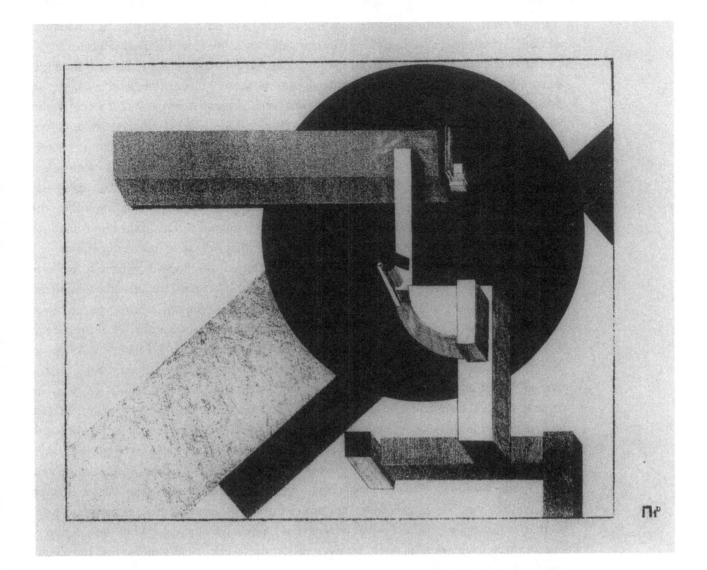

FIGURE 11.23
El Lissitzky. Proun 1-D.
Ca. 1920. Lithograph.
215 × 268 mm. Stedelijk
Museum, Amsterdam.

space traced by intersecting, roughly elliptical planes. At the same time we are made aware of this volume, our eyes are also kept moving on the picture plane by virtue of the continuous, delicate line and the textures created by Gabo's varied treatment of the wood surface.

El Lissitsky was Malevich's student and an active member of the new state art schools established after the Revolution. In his lithographic *Prouns,* basic geometric shapes and volumes are balanced in dynamic stasis. His title was an acronym from the Russian for "Project for the Affirmation of the New." In contrast to Malevich's planar compositions, which retained traditional easel painting's sense of up and down, and of a vertical axis, Lissitsky's *Prouns* are volumetric and architectonic: they exist halfway between painting and architecture.[35] In this example from about 1920 (fig. 11.23), the black circle is stable, but the mechanically shaded volumes offer various compositions and spatial sensations as the image is rotated. Because of their geometric simplicity and an impersonal technique, such prints, Riva Castleman notes, "occupied a strange no-man's-land in relation to fine printmaking of the time."[36] Both the reductive geometry and the absence of any sign of the artist's manipulation of the plate or stone took their meaning from the radical transformation of society envisioned by revolutionary

forces in Russia: a new utopian order in which all vestiges of the past, including the production of fine prints that appealed to connoisseurs and collectors, would be assertively replaced.

The versatile artist, designer, and photographer Lázló Moholy-Nagy absorbed the ideas of the Russian avant-garde when they filtered into his native Hungary. He left his country in 1919, when the Counter-Revolution toppled Bela Kun's Hungarian Soviet, and it was in Berlin that he became closely associated with Lissitsky. Moholy-Nagy's *Untitled* (linocut, ca. 1921–22; fig. 11.24) is typical of the refined spatial and formal tensions of his small graphic oeuvre, confined to the early 1920s. The two groups of squares and rectangles exist in an ambivalent spatial relationship; within the groups, the differently patterned squares and rectangles also exist in ambivalent relationships to each other. Similarly, the spatial recession implied by the converging lines is obliterated by the doubled lines. The smooth surface of the linoleum block was well suited to this almost excruciatingly subtle interplay of shapes, lines, and patterns.

In 1923 Moholy-Nagy was appointed to the faculty of the Bauhaus, which, as we have seen, valued printmaking highly. Also associated with the Bauhaus as a teacher and administrator was Josef Albers, an artist crucial for the development of geometric abstraction and color theory, as well as the history of the print. When the Bauhaus closed under Nazi pressure in 1933, Albers and his wife Anni accepted an invitation to teach at Black Mountain College in North Carolina. Thus Albers, among many others who found refuge in the United States, carried European avant-garde ideas into a new context. In *Above the Water* (1944; fig. 11.25), he expresses the old Germanic love for the grain of wood, playing on its analogy to waves. At once above and within this surface is a geometric figure, ambivalently flat and volumetric. Although this work is traditional in technique, some of Albers' prints of the forties parallel the path taken by Lissitsky in his *Prouns*. His *Graphic Tectonic Series* (1942), a group of nine lithographs, asserts that, in the words of Jo Miller, "mechanical construction (the use of drafting pens and graph papers in this instance) controlled by the artist can arouse the same aesthetic response as a print with conventional media."[37] *Co-ordinal* (fig. 11.26), not originally included in the series, presents a precisely drawn but labyrinthine geometric construction, superimposed on the regular grid of the graph paper.

Geometric abstraction carried different meanings in different contexts, and artists absorbed its impact in varying degrees. A prolific printmaker like André Dunoyer de Segonzac, for example, often departed from twentieth-century avant-garde concerns, harking back to Post-Impressionist or even Barbizon school sensibilities, as in figure 11.27, an etched illustration for Virgil's *Georgics* (1929), an edition in French and Latin published by Vollard. The artist etched the plate *en plein air* in a vineyard close to St. Tropez.[38] He portrayed a halted ox, a distant view of water and mountains, and a flourishing grapevine, all suffused in light, to express a sense of rural prosperity and peace that corresponds to that of the Roman poet.

The interest in antiquity fostered by publishers like Vollard and Skira and revealed in figure 11.27 was echoed, perhaps surprisingly, by a great many early twentieth-century artists. Picasso, for example, did superb illustrations for Ovid's *Metamorphoses* and Aristophanes' *Lysistrata*.[39] The overt depiction of classical subject matter (recall Matisse's *Icarus,* from *Jazz;* fig. 11.9, color plate, p. 478) was only the most obvious manifestation of Cocteau's "call to order." As Elizabeth Cowling and Jennifer Mundy have suggested, the postwar penchant of some artists, especially of those of Mediterranean descent, for the basic stylistic principles of classicism—clarity, harmony, and serenity—manifested itself in a variety of styles, and had a history that actually dated back to before the war.[40] The classicism exhibited by avant-garde

artists was to be sharply distinguished, in these artists' minds, from the classicism of the academic tradition. Like the art of tribal societies, the art of antiquity came to be embraced by modern western artists as part of a new agenda. In trying to separate themselves from the academic art of the immediate past, artists discovered an antiquity that was so distant as to seem exotic, and whose thematic and visual vocabulary could comment on the modern age.

Braque also felt this impulse. Although his close working relationship with Picasso was severed in World War I, he often took up parallel themes and styles in subsequent work. In the 1930s, for example, he departed from earlier Cubism (which neither artist had ever espoused in any doctrinaire way) to explore a style based predominantly on line. Early in the decade Vollard commissioned Braque to etch sixteen plates illustrating Hesiod's *Theogony*. The trial proofs were often exhibited and well-received, but the actual edition, with added cover, frontispiece, and two ornamental pages, did not appear until 1955, when it was published by Aimé Maeght in Paris.[41] The movement of figure and chariot in this plate (fig. 11.28) is conveyed by the continuously moving line as well as the sensitively conceived poses and gestures—the back leg and buttocks of the figure are thrust out as if being left behind the rest of the body, while a flurry of horse's legs and the arched chests and faces of both animal and human forms mark the forward motion. The Cubist interconnectedness of objects and their interpenetration with surrounding space is evident here, but even the shaded planes are linear in their composition,

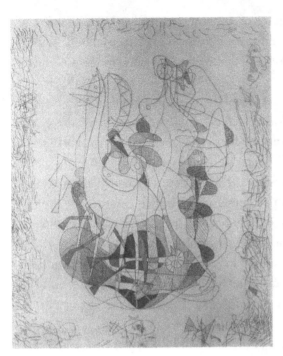

FIGURE 11.28

Georges Braque. Plate 3 from Theogony *by Hesiod. 1932. Paris: Maeght Editeur. 1955 (project begun by Vollard). Etching. 365 × 298 mm. National Gallery of Art, Washington, D.C.*

with cross and parallel hatching echoing, not contradicting, the sparse linearity of the rest of the image. Braque ingeniously developed the nineteenth-century remarque with his border of scratches and sinous lines in which faces occasionally appear. This border and the continuousness of the lines within the image itself are related to the Surrealist technique of automatic drawing.

PICASSO REVISITED: *THE VOLLARD SUITE, MINOTAUROMACHY,* AND OTHER PRINTS

One of the best-known artists' books of the twentieth century is Vollard's edition of Honoré de Balzac's *Le Chef-d'oeuvre Inconnu* (*The Unknown Masterpiece*), published in 1931 with etchings and wood-engravings by Picasso. As Una Johnson has noted, Vollard's choice of illustrator was inspired.[42] Balzac's story held great meaning for the artist, although that meaning was not necessarily the author's. The tale's hero is a great painter who, in his obsession to paint the perfect picture, both naturalistic and ideal, produces an incomprehensible melee of forms from which emerges a single, magnificently realized, foot. In analyzing the appeal of the story for Picasso, Michel Leiris has observed, "All these engravings [*sic*], supposedly based on the story, are of great classical purity—as if Picasso had adopted Balzac's aesthetic point of view but retained, as far as the subject matter is concerned, only the almost complete illegibility of the 'masterpiece', which to Balzac was the fruit of an aberration and the sign of failure."[43]

In *The Painter and Knitting Model* (one of Picasso's many versions of the artist and model theme; fig. 11.29), the canvas is a jumble of lines, but the model is portrayed realistically. As if to emphasize the difference between the imitation of real appearances and the creative act, Picasso has her knitting, a repetitious action that is purely a matter of skill and careful attention to detail. Furthermore, it has a kind of middle-class respectability about it, Leiris notes, from

which the artist distinguishes himself by his choice of vocation (remember our discussion of *The Frugal Repast,* fig. 11.10). The same writer reinforces his assertion of the symbolic import of the artist and model theme for Picasso by observing that he rarely worked in the way shown in the image.[44]

A more extensive exploration of the artist and model theme is found in the context of *The Vollard Suite,* a hundred prints culled from Picasso's large graphic oeuvre between 1930 and 1936 as a payment to Vollard for several paintings he had given the artist. The ninety-seven etchings were combined with three portraits of Vollard, done in 1937, to form a suite.

This series is crucial to any thematic understanding of Picasso. Despite its apparent lack of unity, its imagery adds up to the artist's attempt to understand himself and the nature of his vocation. *The Vollard Suite* is impossible to separate into distinct sections. But basic themes can be discerned: the model or beautiful female nude; the sculptor and model in the studio (Picasso was then sculpting in a studio in the stables of his eighteenth-century chateau at Bois-geloup); the mythical and autobiographical character of the Minotaur, in the studio and in a variety of other situations; violent sexual scenes; images of Rembrandt; and portraits of Vollard.[45]

The sculptor's studio prints, like the images of the artist and model for *Le Chef-d'oeuvre Inconnu,* concern the artist's life conceived in symbolic, idealized terms, although personal references are also present. The nude, bearded artist, his head wreathed in laurel, symbol of poetry, appears repeatedly with a nude model—a voluptuous, almond-eyed woman with whom the artist is also romantically involved. Her face reflects the appearance of Marie-Thérèse Walter, Picasso's current mistress. Indeed, his troubled relationships with Marie-Thérèse and his wife, the dancer Olga Koklova, whom he had married in 1918, constituted the intense personal drama some scholars have perceived in *The Vollard Suite* and other contemporary works.[46] The model and sculptor contemplate various sculptures: the model's head or body; a centaur embracing a woman; a woman, bull, and horse; a figure-group; or totally non-representational works in an organic Surrealist vein.

Although a serene intimacy prevails between the artist and the model, there is also a sense that his real mistress is the work of art. In figure 11.30, he cradles her head and embraces her waist with great tenderness, but gazes, intensely preoccupied, at her abstracted, monumental-ized head (reflecting actual works by Picasso during this period) on the pedestal. In another, ostensibly similar image, he cradles her head again, but is it her head or a sculpted portrait? Her body is gone, seemingly dissolved into the myriad of lines that link life at the left to art at the right: the vine-covered pedestal holding its abstract sculpture. In another image the sculptor, posed with chin on hand—traditionally indicating artists' melancholy—is dreamily gaz-ing, but at the model herself or her artistic facsimile? Her upper face and body are cast in shadow; her lower body is completely illuminated. At the bottom, a mask-like self-portrait has been cast aside.

Perhaps Picasso's relationships and his sexuality not only fed his art but also functioned as its rivals. One senses, in the sculptor's studio prints, that life with the voluptuous model pulls the sculptor away from his contemplation of his works. And yet this is not a clear di-chotomy between mind and body, for Picasso seems to have understood artistic vision itself in highly eroticized terms: his subjects are "embraced" with the eye, and apprehended in an almost tactile manner. And Picasso conceived artistic vision, it should be pointed out, as exclu-sively male, with the female body as its primary object. Indeed, it is important to keep in mind

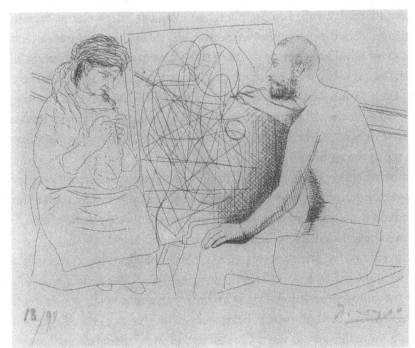

FIGURE 11.29

Pablo Picasso. The
Painter and Knitting
Model *(1927): Plate 4
from* Le Chef-d'oeuvre
Inconnu *by Honoré de
Balzac. Paris: Ambroise
Vollard, 1931. Etching. 194
× 280 mm. Phila-
delphia Museum of Art.*

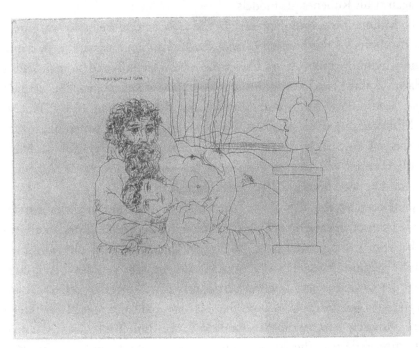

FIGURE 11.30

Pablo Picasso. Sculptor
and His Model with the
Sculpted Head of the
Model *(April 2, 1933)
from* The Vollard Suite.
*1930–37; printed 1939.
Etching. 193 × 267 mm.
Museum of Modern Art,
New York.*

modern artists' persistent association of maleness with creativity and femaleness with passive
sexuality or with allegorical meanings—peace, love, sacrifice, even art.[47]

The deformations of the body, particularly the female body, for which Picasso is so well
known have been related to his basic confusion between art and life. In the terms of this
interpretation, carnal "possession" and visual "possession" go hand in hand, as in *Dancer with
Tambourine* (fig. 11.31), an etching/aquatint done shortly after *The Vollard Suite* (1938). Based
partly on the maenad figures of antiquity, the figure dances wildly and, in her movement, her
various aspects are combined: profile, frontal, and back views. But her movement is not the
key, for Picasso would also pull stationary figures into such complex, hybrid views, as if they

were made of clay he could knead at will. Leo Steinberg, an eloquent interpreter of Picasso's eroticized vision, understood from the masculine perspective, describes these features in terms of the artist's need to "convey a real presence—the thing to be known as a sculptor knows his creation before he withdraws his hand, or as an orbiting, all-seeing eye might apprehend it; or as the thing knows itself from within—or is known to an embrace gifted with sight. The quest was for the form that would be at the same time a diagram and an embrace."[48] The embrace is simple, instinctive; what is difficult is the "diagram" (Steinberg's deliberately oversimplified term) that retains the sense of the embrace.

In this light we can better appreciate Picasso's use of the pure contour line in the sculptor's studio prints. Of necessity diagrammatic and two-dimensional, it is also highly sensual and translates one fully rounded form into another. Like the classical Greek vase paintings that the etchings evoke, it confirms the artist's dialectic between sense and intellect.

In the images of the studio, the artist appears as a thinking, gentle being, "in a state of doubt and melancholy detachment," as Roland Penrose describes him.[49] But he is joined by an alter ego, an aspect of the human condition that is at once humorous, pathetic, and brutal—the Minotaur. In figure 11.32, the bull-headed beast reclines and hoists a glass of wine with the sculptor, now looking more like an old satyr. One almost expects him to sprout horns as he sprawls drunkenly against his Rubenesque models.

Picasso's use of the Minotaur was multifaceted.[50] In the artist's mind the beast was surely related to the bull, hero/victim of the Spanish *corrida* (bullfight), and, as such, a personal symbol for the foremost living Spanish artist. The combination of bull and human had a particularly Spanish flavor, as if the two forces of brute strength and clever courage that clashed in Goya's *Tauromaquia* (see figs. 7.36, 7.37) were uneasily united in one being.[51] But Picasso was also aware of the Minotaur's mythical origin as the monstrous offspring of Pasiphae, wife of King Minos, after she was stricken by Venus with an unnatural passion for a bull. Half-human, half-animal, the monster was kept in the Cretan labyrinth to devour the Athenian youths sent in tribute, until he was vanquished by brave Theseus.

Like the semi-equine centaur, the Minotaur of the Greek myth represented that part of humanity which is brute instinct, unenlightened passion, the sensual appetite. In the twentieth century this conflict between instinct and reason, so basic to ancient Greek culture and to western philosophical and religious thought, was reformulated in terms of Freudian psychology as the conflict between the conscious and unconscious selves. (The Surrealist periodical appearing between 1933 and 1939 was titled *Minotaure;* that between 1944 and 1946, *Labyrinthe.*) The duality of Picasso's Minotaur was certainly inspired by Surrealism, but it also had a profound personal significance, reflecting the relationship between creativity and sexuality that had become problematic for him. As Mary Mathews Gedo points out, Picasso's frustration over his entanglement with wife and mistress must have made him regret, for the first time in his life, the sexual impulse that, in his mind at any rate, had pushed him into his liaison with Marie-Thérèse.[52]

Abruptly, the studio revelry changes into brutality as the monster attacks what may be either a female centaur or a woman on a horse (fig. 11.33). The serene linear style of the sculptor's studio prints has been abandoned for a vigorous, scratchy approach. The female, glassy-eyed, almost catatonic, is now the object of violent lust instead of the pampered and beloved, if sometimes ignored, pet she had been for the sculptor. The huge head with flaring nostrils and the muscular hairy body bear down upon her with such strength that her resistance would

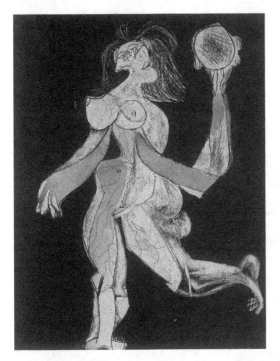

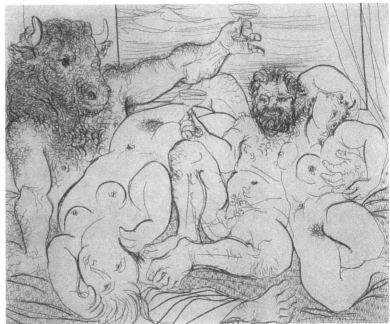

FIGURE 11.31
Pablo Picasso. Dancer
with Tambourine. *1938.*
Etching and aquatint.
665 × 514 mm. Phila-
delphia Museum of Art.

FIGURE 11.32
Pablo Picasso. Drinking
Minotaur and Sculptor
with Two Models *(May*
18, 1933) from The Vol-
lard Suite. *1930–37;*
printed 1939. Etching.
297 × 366 mm. Phila-
delphia Museum of Art.

be futile. Picasso's print offers a disturbingly animalistic interpretation of male lust that is made even more troubling by the passiveness of its object. Gedo suggests that Picasso's violent sexual images represent, in part, his wish to satisfy his lust free of "problematic entanglements."[53] But of course the Minotaur cannot remain an animal; he is part human and, therefore, responsible and guilty.

He is sometimes, like many examples of guilt carefully considered, pathetic. In a beautiful drypoint image (fig. 11.34), he bends over a sleeping girl, his huge head a hair's breadth from her face, so that it seems as if the heat and moisture from his nostrils must wake her. But her sleep makes her self-sufficient in spite of the vulnerability that we would expect it to bring. There is a rare poignancy in the contrast between this idealized, peaceful visage and the massive, bewildered face of the Minotaur. In this and other images of sleeping and watching, Steinberg believes, Picasso departed from the traditional interpretation of sleep as an opportunity for voyeurism by asserting "the superior energy" of the sleeper. As the artist himself explained to his later mistress Françoise Gilot, "[The minotaur] is studying her, trying to read her thoughts, trying to decide whether she loves him *because* he is a monster."[54] In further images, the brute reverts back to the bullring and is sacrificed, slaughtered by a heroic youth as almond-eyed maidens look on. As he dies in one etching, one of them reaches out tenderly to touch his powerful back.

FIGURE 11.33

Pablo Picasso. Amorous Minotaur with a Female Centaur, *third state (May 23, 1933) from* The Vollard Suite. *1930–37; printed 1939. Etching. 194 × 268 mm. Museum of Modern Art, New York.*

FIGURE 11.34

Pablo Picasso. Minotaur Caresses with His Muzzle the Hand of a Sleeper, *second state (June 18, 1933; probably finished 1934) from* The Vollard Suite. *1930–37; printed 1939. Drypoint. 300 × 370 mm. Museum of Modern Art, New York.*

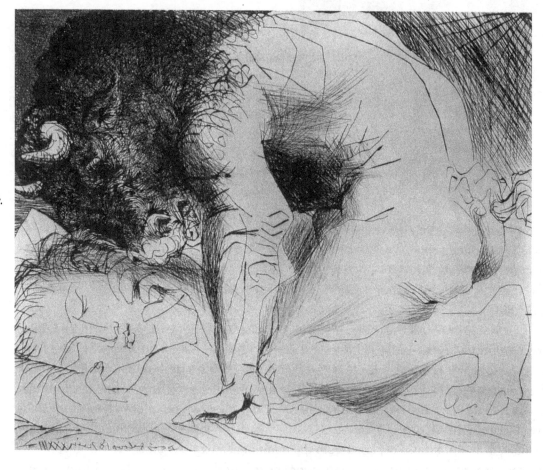

In a stunning nocturnal image (fig. 11.35), the Minotaur, now clearly blinded, bellows up toward the sky and fumbles along his path, guided by a wide-eyed little girl (Marie-Thérèse?) holding a dove; together, these form an emblem of innocence and peace. The scene is watched by fishermen. Two are bearded, look much alike, and also resemble the sculptor of the studio prints. They seem to be taking up their net to depart, perhaps disturbed by the appearance of the Minotaur. The plate was aquatinted and scraped to achieve the mezzotint-like subtlety of the shadows, and linear accents were added in etching.

In one of the last and most impressive of the *Vollard Suite* prints, a superb example of the sugar-lift aquatint process, a "family specialty" of the Lacourières,[55] a faun, another half-human, half-animal creature, although here without his usual hooves, removes a veil from a sleeping woman (fig. 11.36). This image is directly based on an early etching of *Jupiter and Antiope* by Rembrandt, in which the perennially lecherous god, disguised as a faun, approaches the sleeping Antiope, who would be driven into misery by her subsequent pregnancy.[56] Unlike the importunate Minotaur of figure 11.34, or Rembrandt's leering Jupiter in masquerade, this handsome faun approaches the woman more quietly, yet she remains, it seems, just beyond his ardent grasp. His deferential unveiling (with neither the lustfulness of a voyeur nor the lascivious glee of Cupid unveiling Venus) and the dazzling light coming from the balcony give the scene an aura of sacrality, as if the faun were revealing a religious mystery in the female body. Picasso used the sugar-lift solution dryly so as to suggest, with its dewy beading, the scintillation of light on surfaces. It is this light, above all, that lends the image the quality of a magical moment. Indeed, Baer notes that the potted basil in the foreground had the capacity, according to medieval superstition, to transform an ugly animal into a handsome prince. In terms of Picasso's life, she argues, the Minotaur had departed, along with Picasso's passion for Marie-Thérèse.[57]

In considering this print, one thinks immediately of the age-old analogy that identified woman with the fertility of the earth, and was embodied in prehistoric fertility goddesses. But here Picasso's point does not seem to be fertility or even eroticism. His usual explicitness about genitalia is avoided here, even with the front-on view of the sleeper's buttocks and under-thighs. The breasts are modest in size. The sleeping woman, although she is a kind of archetype of cliches about the female sex—eternally youthful, ripe yet innocent—suggests something more rarified, viewed by the faun but elusive. Perhaps it is not too much to say that for Picasso in her perfect beauty, unselfconsciousness, and peace, she represented art—a state of being that the artist-faun-watcher strives to capture. She "knows herself from within"; he can only know her from without, whether through love, vision, or art, all inextricably connected in Picasso's view.

The imagery of *The Vollard Suite* contributed to Picasso's most important print, *The Minotauromachy* (1935; fig. 11.37), which Gedo, Baer, and Gloria Fiero interpret largely in psychoanalytic terms. At the time Picasso was dealing with Marie-Thérèse's pregnancy and the understandable anger of his wife, Olga, with whom he had produced a son, fourteen-year-old Paulo. Baer remarks upon the artist's division of himself into human and Minotaur forms, and points out that the image of Marie-Thérèse appears five times: "doubled, a spectator, unconscious of the passions unleashed by her condition; a little girl hardly younger than when Picasso met her . . . ; the wounded Marie Thérèse, symbolized by the mare; and the torera about to transfix herself with her own sword." Baer also notes that the wound in the mare yields a baby.[58] Fiero emphasizes that the mock or figurative "blindness of the Minotaur objectifies and pro-

Pablo Picasso. Blind
Minotaur Guided
through a Starry Night
by Marie-Thérèse with a
Pigeon, *fourth state
(between December 3,
1934 and January 1, 1935)
from* The Vollard Suite.
*1930–37; printed 1939.
Scraped aquatint with
etching. 247 × 347 mm.
Museum of Modern Art,
New York.*

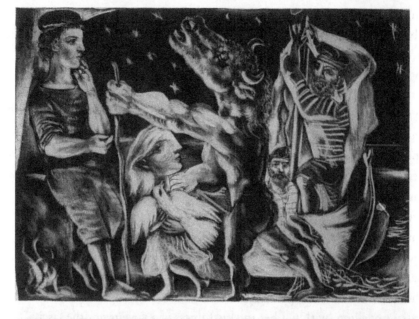

Pablo Picasso. Faun
Unveiling a Sleeping
Woman *(June 12, 1936)
from* The Vollard Suite.
*1930–37; printed 1939.
Sugar-lift aquatint and
etching. 317 × 417 mm.
Philadelphia Museum
of Art.*

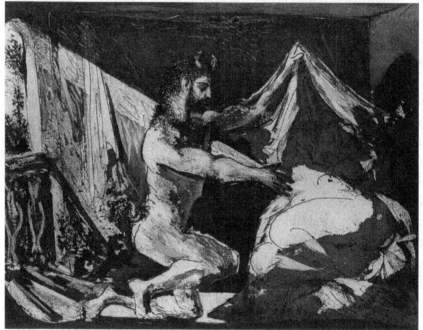

jects the condition of despair experienced by Picasso in 1935."⁵⁹ With his divorce delayed and Marie-Thérèse pregnant, Picasso was, as if blind, unable to paint. On the other hand, the Minotaur could be interpreted as sighted, and Gedo indeed sees his recovery of vision as a sign that Picasso had finally decided to break from Olga and take control of his own destiny.⁶⁰

The autobiographical aspect of this print, and indeed of all of Picasso's art, is fascinating, but *The Minotauromachy* might also have a political dimension having to do with the impending Civil War in Spain and the ominous growth of Fascism in Europe. This imagery of this print and *The Dream and Lie of Franco* (1937; fig. 11.38) culminated in *Guernica* (1937), a protest against the German Fascist bombing, backed by Generalissimo Francisco Franco, of the Basque capital. *Guernica* is the twentieth-century heir to Goya's *Third of May* painting and his *Disasters of War* etchings (see figs. 7.39–7.48). Picasso may also have been thinking of printed

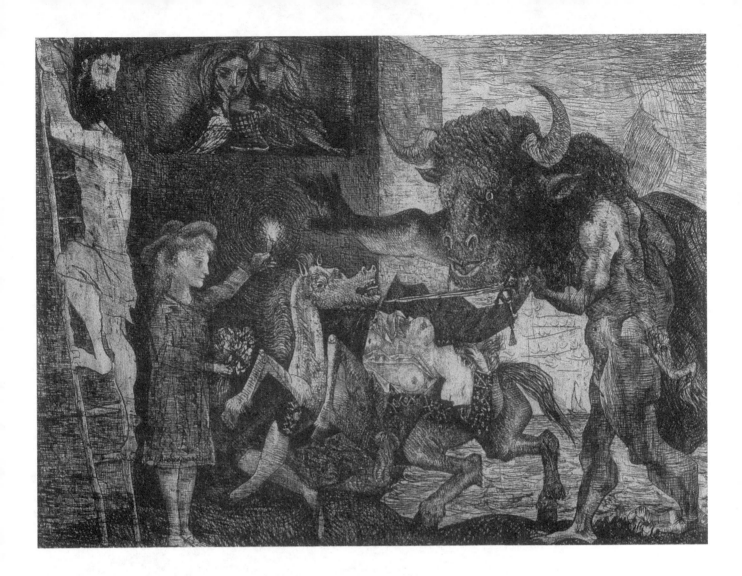

images that dealt with the devastation of World War I, such as Rouault's magisterial *Miserere* prints (see figs. 10.60, 10.61). As if the direct references to Goya could be missed and in an ascetic spirit in keeping with the somber nature of his statement, Picasso painted *Guernica* in grays, blacks, and whites that reinforce its connection to a graphic tradition.[61]

FIGURE 11.37
Pablo Picasso. The Minotauromachy. *1935. Etching with engraving. 495 × 697 mm. Philadelphia Museum of Art.*

The Minotauromachy is a large, heavily worked plate with numerous *pentimenti* (see the area of the sky and the Minotaur's back, for example), although its major elements were there from the beginning.[62] At the center of the composition is an image of sacrifice—a female bullfighter (note the toreador costume), dead and draped across a horse, which looks back at the monster in fear and accusation.[63] To the left is a little girl, holding flowers and a lighted taper. While advancing toward her, the Minotaur shields himself against the light; the little girl stands firm, as if knowing her invulnerability. Thus brutality confronts truth and innocence, with the Minotaur's slaughtered victim exposed in the center for all to see. In the context of the growth of Fascism in the 1930s and the war that it engendered, Picasso's print acquires topical meaning, while retaining its timelessness as a statement of the confrontation of good and evil. The child's candle becomes, in a sense, a new version of the illumination that Goya hoped would dispel ignorance in the *Caprichos,* now pitted against a new and more destructive, collective superstition.

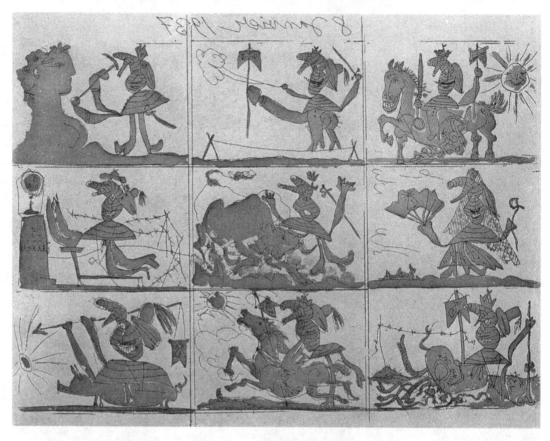

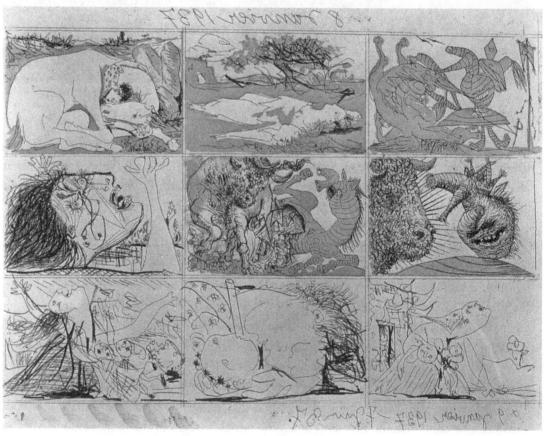

Three characters overlook this drama: a bearded male (judging from *The Vollard Suite*, the artist) and the almond-eyed women in the window, accompanied by doves. All watch with deep concern. The bearded figure climbs a ladder as if to escape the Minotaur, while the women are safe within their fortress. Thus, the well-meaning world looks on, unable to do anything but watch. In the case of the artist, however, this watching must be doubly significant; his head cranes around, his large, intelligent eyes are riveted to the scene, distracting him from his getaway. The more one views this figure, the more one is aware of the ambiguous position in which Picasso envisioned himself. Halfway up the ladder (ladders generally implying ascent to higher realms), he stops to train his gaze back on where he has been. Should he continue upward or step back down? Clearly, the right course of action is not so obvious as that of the pilot(s) of the escaping boat on the horizon. The artist is bound to remain embedded in the world while using his vision to make sense of it for others or to provoke others into responding. His is a position of involvement with a necessary component of detachment.

The moving imagery gathered together in *Guernica* is more dispersed in narrative fashion in the two plates entitled *The Dream and Lie of Franco*, etched rapidly on January 8 and 9, 1937. Originally intended to be cut into tiny plates and separately printed as postcards (the profits of which were supposed to go to Spaniards ruined by Franco),[64] the two plates were printed instead on two larger sheets accompanied by a poem by Picasso. The story is "read" from right to left, top to bottom, like a backward comic strip. Phyllis Tuchman notes the relationship of the motifs in *The Dream and Lie* to the cartoons of René Dubosc for the French Communist journal, *L'Humanité*.[65]

Franco is conceived as an evil "polyp," a hybrid, Surrealist form, externally grotesque and internally rotten. Whenever he is opened up, as when he is gored by the bull in the second register of the second plate, vermin spill from him. He is clever, capable of taking on a number of disguises. In the first scene, he rides out like a knight; he is an antitype to Cervantes' Don Quixote. He balances precariously on a tightrope in an image that comes directly from Goya's *Disasters of War* (see fig. 7.46), his banner balanced on a huge phallus. He takes a pick-ax to a noble female profile that seems to be sculpted from living rock—he offends both human truth and nature. His preposterous disguises as a *maja* and as a pious worshiper in the second sequence of frames are exposed by an encounter with the bull: in this context certainly a symbol of Spain. His prayer at the altar, protected by barbed wire (to keep him in or others out?), ends with his disembowelment at the lower right.

Miraculously recovered, he sits astride a winged horse and rides against the sun (another symbol of illumination?). In the next frame, his mount has changed into a pig. The winged horse and the noble woman (the reference here must be to Goya's *Will She Rise Again?* [fig. 7.47]) become his victims in the next two images of the upper sequence, and, finally, the bearded figure that we have come to associate with the artist embraces and is embraced by the victim-horse. The monster shows his true self: grinning horribly and sprouting hair, he faces the noble bull. Gored again, as he attempts to disguise himself as the sacrificed horse, his belly releases its foul contents. Images of pain and sacrifice drawn from Goya's *Disasters* and incorporated into *Guernica* follow: the head of a weeping woman, mothers and children.

The weeping woman is one of a number of horrifying motifs with which Picasso was preoccupied during this period. An etching of 1937 (fig. 11.39) has been interpreted, in part, as a portrait of the photographer Dora Maar, who became another woman in Picasso's life after Marie-Thérèse gave birth to their daughter, Maya.[66] The brutal distortion of the face evident

in the left central frame of the second *Dream and Lie* sheet is carried further in this etching. The inner parts of the head are externalized, so that the head is, in effect, turned inside out with grief. The inner nostrils, teeth and tongue, and eyeballs are exposed with a kind of artistic surgery closely related to both Expressionism and Surrealism but uniquely Picasso's in its convincing savagery. Looking much like the nails that punctured Christ's hands and feet and functioned, like other instruments of the Passion, as stark emblems of sacrifice, the tears hang on the cheeks and threaten the eyes. Deliberately child-like, aggressively angry marks are scribbled across the face.

The tragic often coexists in Picasso's art with humor. In 1936, three years before Vollard died, the publisher commissioned him to illustrate selections from the Comte de Buffon's *Histoire Naturelle* (*Natural History*), an eighteenth-century encyclopedia of the natural world. As with Balzac's *Le Chef-d'oeuvre Inconnu,* the artist did not feel bound by the text; instead, Vollard selected passages from it that corresponded to the images. The publication, states Una Johnson, might be described as a "wholly engaging suite of etchings coupled with excerpts from a classic French text."[67] It was finally published, in 1942, by Martin Fabiani.

The sugar-lift technique that Picasso learned from the Lacourières and utilized in the last prints of *The Vollard Suite* is also employed here, enabling him to work in a rapid, painterly way that exhibits his gifts of observation and summation. Each animal, like the blustery, arrogant *Rooster* (fig. 11.40), is precisely characterized according to its stance, contour, and texture. A comparison of this work with Bracquemond's *Cock* (fig. 9.25) will reveal the sensitivity to natural appearances that never left Picasso despite the formal liberties he took.

DADA, SURREALISM, AND THE PRINT

Surrealism was crucial to the imagery of *The Vollard Suite,* the deformations and irrational juxtapositions of objects, and the interest in myth and symbol, sleep and dreaming, often found in Picasso's art.[68] It was an international movement that had roots in the irreverent iconoclasm of Dadaism, inspired by the disillusionment of World War I. Although Dadaism was not conducive to printmaking—or any traditional art form, for that matter—its basic challenge to conventional definitions of art and to European culture as a whole (the culture that had produced the war) had ramifications for all forms of modern art. Hans Arp's works—he was a sculptor, painter, printmaker, and poet—were largely based on irrational or chance combinations of highly abstract organic forms with each other or with other objects, as in *Navel Bottle* (lithograph; fig. 11.41), part of the *Arpaden* portfolio of 1923. Despite their organic suggestiveness, Arp's forms are so boldly reduced that they anticipate the Minimalist art of four decades later. In his *Merz* portfolio of the same year, Kurt Schwitters combined geometric abstraction with collage elements taken from the commercial waste of modern culture (see fig. 11.42): *Merz* was short for *Kommerz* (commerce) in German. The portfolio's title thus underlines both Schwitters' use of the detritus of modern consumer culture and his challenge to "Art" as a commodity that is bought and sold. The photomechanical reproduction of these collages removes the sense of the artist's conscious, direct manipulation of his compositional elements for aesthetic and expressive purposes.

When Max Ernst returned from the war to Cologne, he was exposed to the Dadaist ideas emerging from Zurich, the movement's headquarters. Ernst was destined to be one of the most

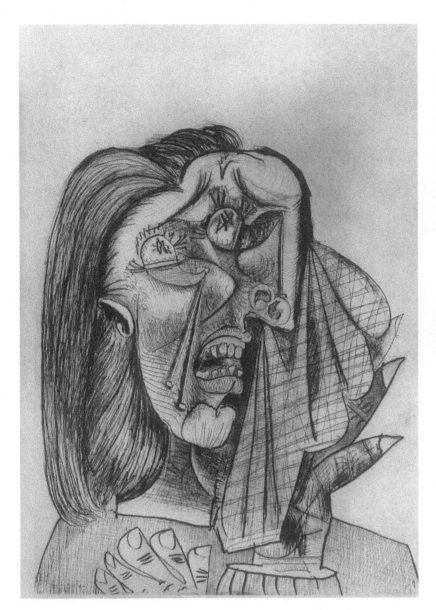

innovative of the Surrealist painters, and certainly the finest Surrealist printmaker. His early
lithographic series, *Fiat Modes, Pereat Ars* (Up with Fashion, Down with Art; 1919), was created
as a homage to de Chirico, the Italian artist whose paintings were so crucial for the develop-
ment of Surrealism. The series' title reflects the Dadaist hostility toward "high" art (the word
"dada" appears in some of the prints; see the center bottom of our example, fig. 11.43) by
suggesting that Europe changes its ideas about fine art as readily as its notions of the proper
hemline. The two main "characters" of *Fiat Modes,* a dressmaker's dummy and a mannequin-
like tailor, parody the artist and his model or creation. Irrationally combining the sense of the

FIGURE 11.41
Jean (Hans) Arp.
Navel Bottle from 7
Arpaden von Hans Arp.
1923. Lithograph. 416 ×
247 mm. Museum of
Modern Art, New York.

FIGURE 11.42
Kurt Schwitters. Plate 4
from Merz Mappe III.
1923. Photo-lithograph
with color collage. 536 ×
438 mm. Museum of
Modern Art, New York.

mechanical diagram, linear perspective, the lettering of advertising, mathematical equations, and mechanistic figures, Ernst reworked diverse visual elements into new, mysterious wholes: an extension of his collages into lithography. Evan Maurer points out that although Ernst's prints generally follow his paintings and collages, the compositions of *Fiat Modes* had enormous impact on his subsequent paintings.[69]

Plate 6 of *Fiat Modes* (fig. 11.43) suggests the hauntingly empty piazzas of de Chirico's paintings, as well as a diagram for constructing something unspecified and nonsensical. It asks us to muster an absurd combination of analytical skills and an irrational dream-like consciousness. The two figures, apparently male and female, descend from the tailor and his dummy in the series' first image, but their relationship is ambiguous, to say the least. In the first lithograph, he had been measuring her, or applying measurements *to* her, in a parody of artistic creation. Now, he is as armless and occasionally upside-down as she is, and he ends up, as she does, in a boxy, stage-like space, delineated with perspective lines that recall the hallowed Renaissance tradition of spatial construction. The artist and his model/creation are thus confused. Both lose their individual identity. As Werner Spies states, the images of *Fiat Modes* are in part "allegories of the facelessness of the manipulated individual."[70] Certainly they reflect the dehumanizing experience of the war through which Ernst and many of his colleagues had lived.

FIGURE 11.43

Max Ernst. Plate 6 from
Fiat Modes, Pereat Ars
(Up with Fashion, Down
with Art). *1919.*
Lithograph. 400 ×
263 mm. Galerie
Brusberg, Berlin.

But rather than reprise the Expressionist veneration of the individual touch and creative spontaneity, Ernst's *Fiat Modes* lithographs critiqued Expressionism by questioning the assumptions it, and indeed all other historical art, had made about artistic creation. Most significantly, the idea that art could somehow redeem society is cast aside.

Ernst's technique in *Fiat Modes,* as Robert Rainwater points out, is crucial to his meaning. Although transfer lithography had traditionally been used for its autographic qualities, Ernst's line here is even and mechanical. Like Grosz, another artist emerging from the Dadaist context, or like Lissitsky in his *Proun* lithographs (see fig. 11.23), Ernst avoided anything that might suggest "fine-art" lithography, especially the idiosyncratic techniques employed by the *Brücke* artists. Printed on machine-made, yellowish paper, the *Fiat Modes* prints lack any sense of the manipulated surface or the character of the stone. Although originally intended to appear in

an edition of sixty, *Fiat Modes, Pereat Ars* found only a minuscule audience (in contrast to the healthy audience for Expressionist prints), and Ernst destroyed most of the edition, making complete sets rare today. As Rainwater puts it, the anti-bourgeois character of *Fiat Modes* and of Dadaism in general alienated the middle-class print collector.[71] Nevertheless, the series established the central concerns of Ernst's extensive graphic oeuvre. His witty, cerebral reversal of assumptions about the fine print became a thread running through his graphic art.

A split within the Dadaist group of the 1920s resulted in the leadership of André Breton, who became the primary theorist of the Surrealist movement and wrote its first manifesto in 1924, and a second in 1929. *Surréalité* was heightened reality derived from the exploration and expression of the unconscious that had been fostered by the psychological theories of Freud. It demanded a "pure psychic automatism" from the poet or visual artist—the "real process of thought . . . free from any control by the reason, independent of any esthetic or moral preoccupation."[72] The interest in the irrational and the dream was not new. In fact, it had been foreshadowed by Symbolist artists, especially Redon, Gauguin, and Klinger, all of whom, as we have seen, were major printmakers. From the standpoint of any artistic medium, but especially printmaking, the Surrealists' more determined emphasis on the unconscious created a dilemma. For art had always been, largely or entirely, a question of conscious intellectual, expressive, and aesthetic choices, and printmaking generally invoked lengthy processes, stages, much technical knowledge, and, historically, a commitment to communicable meaning. Breton himself modified his stance, distinguishing an early, theoretical phase of Surrealism from a later one that could encompass social and political issues. Surrealist artists did not generally produce prints until relatively late in the history of the movement.

In the early years of the Surrealist movement, Ernst greatly expanded his range of printmaking techniques.[73] He incorporated his method of *frottage*—that is, rubbing chalk or pencil on a piece of paper placed on various textured surfaces or collages so that an image would emerge—into a kind of hybrid of printmaking and photography with a close kinship to the *cliché-verre*. Sometimes these prints are called "photograms," although the technique differs from the works normally labeled as such: the cameraless photos made by the American Surrealist artist-photographer Man Ray. For his photograms, Man Ray would place objects or cutouts on photosensitive paper and expose the whole to light, so that the shadows produced an image. But for the series of nineteen illustrations accompanying a section of René Crevel's novel *Babylone* (1927), collectively entitled *Mr. Knife and Miss Fork* (1931), Ernst created pencil frottages on thin, translucent paper, which were then placed face down on pieces of light-sensitive paper. Wherever the rubbed markings of the frottages allowed, the underlying photosensitive paper was exposed, thus creating negative images of Ernst's original frottages. He printed the series with Man Ray's help.

In . . . *it is two little birds she has closed up in her dress* (Plate 8; fig. 11.44), Ernst made two frottages from the same commercial image of a bird, but rotated that image 180 degrees to make the two "breasts." In this section of Crevel's novel, a little girl daydreams at the table about a woman named Cynthia who has seduced her father. The runaway couple become, in the little girl's mind, "Mr. Knife and Miss Fork." The girl is a stand-in for the Surrealist poet (or artist, in Ernst's interpretation), who juxtaposes imagery with the freedom of a child's imagination.[74] Here, the birds are suspended in flight, and encased in the globes of Cynthia's breasts, which seem to hang like two ornaments from her shoulders. The photographic process adds to the bizarre quality of the images, in which ghostly forms emerge from darkness, and,

FIGURE 11.44

Max Ernst with Man Ray.
. . . it is two little birds
she has closed up in her
dress: Plate 8 from René
Crevel's Mr. Knife and
Miss Fork. *1931.*
Photograph from frot-
tages. 177 × 116 mm
(sheet). New York Public
Library.

significantly, interposes one more distancing step between the artwork and the artist's physical manipulation of a surface.[75]

Another example of this approach is Ernst's utilization of the soft-ground etching technique, traditionally the most autographic intaglio medium. In the five etchings that accompanied a special edition of his five-volume work *Une Semaine de Bonté, ou Les Sept Eléments Capitaux (One Week of Kindness, or the Seven Capital Elements,* 1934), Ernst used the soft wax as a recorder of textures of ordinary objects such as pieces of cardboard or, in figure 11.45, crumpled tissue paper. His intervention in the print's appearance consisted primarily of the discovery of delicate birds' heads among the hairline folds. The result is an evocation of a tiny, self-sufficient animal and vegetable world similar to those created by Paul Klee, and the pa-

FIGURE 11.45

Max Ernst. Interior of Sight. *Print accompanying an edition of* Une Semaine de Bonté, ou Les Sept Eléments Capitaux (One Week of Kindness, or the Seven Capital Elements), *vol. 5. 1934. Soft-ground etching. 180 × 129 mm. New York Public Library.*

limpsest-like texture of the image also looks forward to the extraordinary prints of Jean Dubuffet's *Phenomena* series, which we shall encounter in Chapter 13. In another plate Ernst used a comb drawn over the wax to produce a series of wave-like lines that overlap diagonals. Although he worked the plate with his hands, it was not drawn upon in the conventional sense. Rather, the image was produced by an instrument antithetical to drawing, taken from another sphere of reality.[76]

The soft-ground etchings of the special edition of *Une Semaine de Bonté* are quite different from the prints of the collage novel itself. These consist of photo-collages made up of nineteenth-century wood-engravings, especially from scientific journals and lurid pulp novels. Such prints were the stuff of commerce, everywhere apparent, and illustrative rather than artistic. The process of photomechanical reproduction obliterated the "seams" of the original collages, so that new, strikingly beautiful and frequently disturbing images were born. In 1925 the Surrealist poet Pierre Naville had argued that there could never be a true Surrealist visual art; art would always require too much conscious control over form by the artist, and thus could never attain the conceptual freedom of Surrealist poetry. Ernst's collage novels, of which *Une Semaine de Bonté* is arguably the most brilliant, vigorously disputed that claim; indeed, the novel's "text" is restricted to quotations introducing each section.[77] The bizarre imagery of Ernst's collage novels evoked the world of the dream and exploited the Freudian psychoanalytic principles beloved by Surrealists. Most significantly, Ernst's techniques of frottage and collage allowed him to evade the manipulation of formal elements that traditionally defined the activity of the artist.

Ernst was, of course, a highly intellectual artist, and *Une Semaine de Bonté* depends on more than unconscious associations. Political meaning, for example, is embodied in the main

character of the first volume of the novel, the Lion of Belfort. This lion referred to a sculpture by Frédéric-Auguste Bartholdi: a colossal heroic lion lying on its side, carved from a rock face in eastern France. The statue was a symbol of the French defenders of Belfort in the Franco-Prussian War. In 1933 and 1934, the growing Nazi menace gave new meaning to this symbol of French resistance against German aggression, especially for an exiled German living in France. The violent power struggle between the lion and his enemies in the first section of *Une Semaine de Bonté* provokes an unease that had topical significance.[78] Throughout the novel, Ernst sustained this unease in repeated explorations of dominance and submission, of cruelty and violence.

The overall structure and specific symbols of *Une Semaine de Bonté*, moreover, as argued in detail by M. E. Warlick, call up the medieval occult Christian practice of alchemy.[79] Surrealist artists took great interest in mysticism and occultism in their various manifestations, and alchemy, with its arcane, often sexual language and bizarre symbolic imagery, was especially fascinating. *Une Semaine de Bonté* drew upon the alchemical significance of birds, dragons, and lions, and the four basic alchemical elements of earth, air, fire, and water. As the alchemist sought to cleanse the body and the world by mating, killing, cleansing, and resuscitating these substances in the process of distillation, so the Surrealist artist brought together disparate elements in a transformative process. Perhaps the ultimate purpose of alchemy—physical and moral healing through destruction and rebirth—also appealed to Ernst.

Plate 9 from the second volume (Monday) of *Une Semaine de Bonté* (fig. 11.46), like the other images in this section, deals with the alchemical element of water, and also with the meaning of water in Freudian psychoanalysis as a dream-symbol of our experience of the womb and birth canal, and of sex in both its pleasurable and its anxiety-ridden aspects. The water rushing around the bed of a voluptuous sleeping nude and the observing man may even refer symbolically to Freud's analysis of a young female patient ("Dora"), whose dreams, Freud concluded, expressed her childhood anxieties about bedwetting as well as her adult anxieties about sex. Artistically, Maurer points out, this image reminds us of nothing so much as *Anxieties* from Klinger's series, *A Glove* (fig. 10.3), in which water rushes in upon a fitful sleeper, carrying with it, among other things, the now monstrously oversized woman's glove that he has fetishized.[80]

The images devoted to Friday ("The Interior of Sight," illustrated by sequences of images called *Trois Poèmes Visibles—Three Visible Poems*), part of the fifth and last volume of *Une Semaine de Bonté,* are formulated differently from those of the rest of the novel. Even though figure 11.46 depends on an impossible combination of elements, it still retains its character as a dramatic event, with protagonists in a specific setting. It also retains a mood of lurid sexuality that directly relates it to the pulp novels that were the primary source of the images which Ernst put together. But Plate 5 of Friday's series, part of the first "poème visible" (fig. 11.47), depends on scientific illustrations, and the image takes on the character of a rebus, or, to use Renée-Riese Hubert's term, a "constellation" rather than a dramatic scene.[81] A headless woman dominates the image. She is Ernst's "woman of one hundred heads" or "woman without a head" (in French, *femme cent têtes* sounds similar to *femme sans tête*), and she is also a highly classicizing form, the stuff of high art, that is surrounded here by wood-engraved botanical illustrations. The sexual suggestiveness of this image, and the eerie affinity between the botanical and the human created by Ernst's obliteration of the boundaries between the image's component parts, are taken so far as to allow a plant part to penetrate the woman's vagina. The quotation intro-

FIGURE 11.46

*Max Ernst. Plate 9
from "L'Eau" ("Water"),*
Une Semaine de Bonté,
ou Les Sept Eléments
Capitaux (One Week of
Kindness, or the Seven
Capital Elements), *vol. 2.
1934. Line block from
collage of wood-
engravings. 272 ×
206 mm (page). New York
Public Library.*

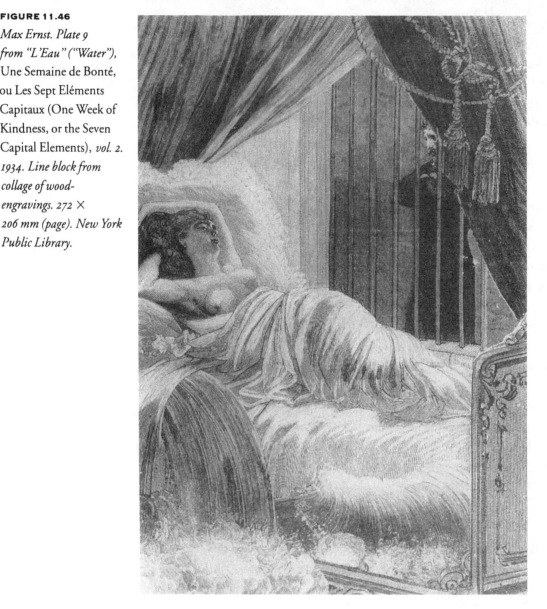

ducing the "First Visible Poem," from the Surrealist poet Paul Eluard, highlights the nature of the collage as an art made from ready-made images: "And I object to the love of ready-made images in place of images to be made."[82] But perhaps Breton best described Ernst's collage novels, especially *Une Semaine de Bonté,* when he likened them to a "herbarium in which every plant consents to flower a second time."[83] This phrase aptly conveys the uncanny way in which the wood-engraved images take on new identities. Although Ernst utilized ready-made images and photomechanical reproduction, one still feels surprise at the transformations shaped by the artist. Ernst's later graphic works sustained the intellectual depth and visual surprise of *Fiat Modes* and *Une Semaine de Bonté.* Most notable are his stunning color etchings for *Maximiliana* (1964), a homage to the nineteenth-century German astronomer Wilhelm Tempel in which Ernst collaborated with the Russian writer and printer Iliazd. The latter's typographic designs were carefully integrated with Ernst's delicate illustrations, and the final result, printed by Georges Visat, is a masterpiece of modern book design.[84]

The sense of predation and cruelty that recurs in *Une Semaine de Bonté,* often focused in Ernst's works on the female nude, also dominates Joan Miró's *Barcelona Series* (1944), a set of

FIGURE 11.47

Max Ernst. Plate 5 from "Premier Poème Visible" ("The First Visible Poem"), Une Semaine de Bonté, ou Les Sept Eléments Capitaux *(One Week of Kindness, or the Seven Capital Elements), vol. 5. 1934. Line block from collage of wood-engravings. 272 × 206 mm (page). New York Public Library.*

fifty transfer lithographs made in 1939.[85] For Miró, sharp, tooth-like forms, and bird- and insect-like creatures, seemed to serve as metaphors for the political and military aggression that erupted that year into World War II. Like his fellow Spaniard Picasso, Miró responded to the Fascism that had devastated his native country by recalling Goya's war imagery with ominous black and white images. In Plate 34 of the series (fig. 11.48), Miró placed the transfer paper over a number of surfaces, including sandpaper and corrugated cardboard, in order to achieve granular or striped textures with the lithographic crayon; here these are emphatic, but in other prints they are subtle. Within this atmosphere, studded with little stars, small creatures flutter about a huge black form anticipating the powerful ovoid shapes and strokes of Robert Motherwell's *Spanish Elegies.*

Miró continued to express his abstract, organic Surrealism in printmaking after he arrived in the United States in 1947. One of the crucial links in the transmission of Surrealism to its postwar American environment, where it would become one of the primary forces behind Abstract Expressionism, was the print workshop of Stanley William Hayter, a British geologist-turned-artist, in New York. It was here that Miró deepened the interest in printmaking that the *Barcelona Series* had sparked, and other transplanted European artists furthered their graphic endeavors. It was also where Americans were introduced to European avant-garde approaches to printmaking.[86]

FIGURE 11.48

*Joan Miró. Plate 34 from
the* Barcelona Series.
*1944. Lithograph. 513 ×
489 mm. Museum of
Modern Art, New York.*

Hayter's way of working was based on the principle of automatism—the artist's relin-
quishing, insofar as possible, conscious control of his or her medium—as prescribed in Breton's
1924 manifesto (the 1929 manifesto modified the emphasis on automatism). André Masson's
Abduction (ca. 1946; fig. 11.49), produced in his workshop in Connecticut, where he had emi-
grated to escape the turmoil of Europe, admirably illustrates automatist procedures. The image
has been defined principally by the apparently random movement of the arm and hand holding
the drypoint stylus (Hayter would rotate his plates under his burin). Significantly, drypoint is
one of the most direct of printmaking methods. This way of working could very seldom remain
"pure" (note that the print's title reprises the theme of sexual violence—a preoccupation of the
Surrealists) but the theory behind it would have an impact on subsequent American painting
and prints, as we shall see in Chapter 13.

THE EUROPEAN LITHOGRAPH IN THE 1940S

The 1940s saw the beginning of a revival of color lithography rivaled only by that of the
1890s. During the first half of the twentieth century, the demand for color prints waned; the
old lithographic shops that had made the earlier flowering possible had long been closed. After
the war, a more affluent middle class created a market for color lithographs that spawned a
regeneration of lithographic artisans (as we have noted, this medium had always involved a
close collaboration between artist and printer). Fernand Mourlot in Paris holds the central
position in the lithographic boom.[87]

Braque met him in 1945, the year in which Picasso also became newly interested in the
medium.[88] *Helios V* (1948; fig. 11.50), depicting the sun god within but transcending the shad-

FIGURE 11.49

André Masson. Abduction. *Ca. 1946; printed 1958. Drypoint. 308 ×
406 mm. Museum of
Modern Art, New York.*

ows of night, is one of Braque's most coveted prints. In its basic composition it recalls the
etched illustrations for Hesiod's *Theogony* (see fig. 11.28) that he had done for Vollard in 1931.
Indeed, the fact that two of the *Theogony* plates were missing and had to be replaced led Braque
to another exploration of mythological themes. But the continuous line that expressed the
vigorous movement of god and chariot in 1931 is now overlaid with many colors. Brilliant blues
are made even more vibrant by their juxtaposition to dull grays and violets. The earlier image
is delicately drawn, but the lithograph, with its bold, brushed-on borders replacing the ephem-
eral remarque-like sketches, is painterly. Braque experimented with a number of different
printings—some with white lines and some with black on variously colored grounds—that
exemplify the potential for change in the artist's conception offered by lithography.

The *Gray Teapot* (1947; fig. 11.51) is just as painterly. White highlights and cool gray shad-
ows give the pot a vivid three-dimensionality against the black and violet ground, which seems
to sink into the paper. Although the contours and swelling mass of the lemon are echoed in
the spout, handle, and body of the teapot, the lemon's bright yellow—the sole non-neutral
color of the print—distinguishes its vegetal nature from the man-made objects surrounding it.
Restricted in color and details and classically composed, Braque's print recalls the nearly mono-
chromatic Dutch still-lifes of the seventeenth century. Like those, however, its restraint belies
an underlying *joie de vivre.*

Chagall did not become involved in color lithography until he came to the United States
in the forties. The master printer Albert Carman translated gouache paintings illustrating four
stories from the *Arabian Nights* (1948). Plate XII (fig. 11.52, color plate, p. 479), conceived in
an intense blue with accents of green and bright yellow, illustrates both the luxuriant visual
qualities and the fairy-tale moods that made Chagall's paintings so accessible and appealing.
Incorporate these qualities into lithography, and one has a highly salable commodity. When

FIGURE 11.50
Georges Braque. Helios
V. *1948. Color lithograph.*
508 × 420 mm. Harvard
University Art Museums,
Cambridge.

FIGURE 11.51
Georges Braque. Gray
Teapot. *1947. Color litho-*
graph. 365 × 540 mm.
Galerie Adrien Maeght,
Paris.

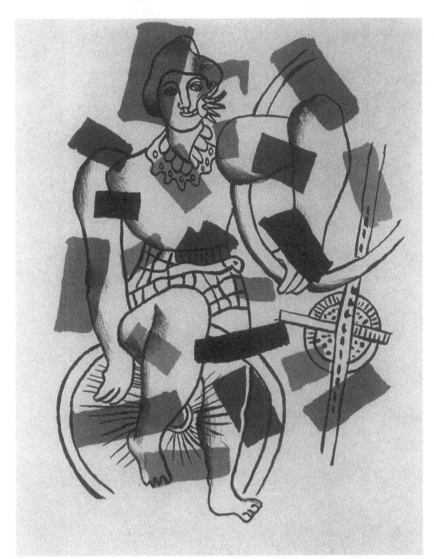

FIGURE 11.53

Fernand Léger. Page 7 of Cirque (Circus). *1947–50. Color lithograph. 363 × 265 mm. New York Public Library.*

Chagall went back to Paris in 1948, he began working in Mourlot's shop to produce color lithographs that were so numerous as to become, over two decades, perhaps too commonplace. Overexposure to the lithographs, some might argue, hinders our appreciation of both prints and paintings.

Léger's greatest graphic work, constituting nearly half of his printed oeuvre, was *Cirque* (Circus, 1947–50), a series of thirty-four color and twenty-nine black and white lithographs that accompanied a text by the artist. The obvious comparison is to Matisse's contemporary *Jazz* (fig. 11.9, color plate, p. 478), and, indeed, both texts were published by Tériade. Like Matisse's stencil-printed images, the lithographs of *Cirque* express an optimistic energy. They strike one, in part, as sighs of relief breathed at the end of World War II. For Léger's part, he rejected his earlier mechanization of the figure for a vibrant vitalism in which his recollections of the American Barnum and Bailey circus take the form of free-wheeling bodies and areas of bright color, sometimes, as in the unicyclist of figure 11.53, dissociated from form. Plants and tropical birds with lurid plumage have replaced the Cubist-derived geometry of his earlier style. "Nothing is as round as the circus," Léger proclaims in the text. "Go to the circus, quit your rectangles, your geometric windows, and you go to the land of circles in action."[89]

FIGURE 11.54

Pablo Picasso. Face.
*1928. Lithograph. 206 ×
141 mm. Museum of
Modern Art, New York.*

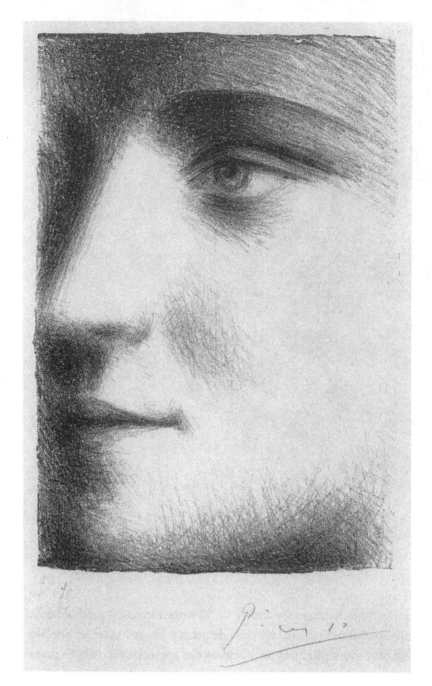

Picasso's work in lithography constituted the most innovative efforts in the medium since Lautrec's in the 1890s and we will reserve our discussion of his lithographs of the late 1940s until Chapter 13. But at first, as in *Face* (1928; fig. 11.54), he drew with the lithographic crayon in a conventional fashion, relying on the nuances of tone that had interested the earliest lithographers, yet with the condensed, draughtsmanly verve of Daumier. *Face* is an excellent example of that monumental classicism with which Picasso so often conceived the whole female form or its parts. A close-up of the beautiful features of Marie-Thérèse Walter, it is also a study of the abstract volumes of the human face and the soft texture of his model's skin. The strong component of tactility in Picasso's art is still evident.

Picasso would apply his ingenuity to the graphic arts (most notably to lithography and linocut) many times before his death in 1973. We shall encounter him again in our final chap-

ter. Now, however, some catching up is in order. It was New York, not Paris, that was to take the lead in avant-garde artistic developments from the 1950s on, and the print would play an important role. Before this could happen, however, American printmaking went through many growing pains. With a vital commercial and illustrative tradition, it was opened to the European concept of the fine print only in the late nineteenth century, when the French and English etching revivals exported their conceptions to the "new world." Despite rocky beginnings, American printmaking eventually learned to utilize the tensions between the commercial and the fine, between the avant-garde and the native, to great advantage.

NOTES

1. Matisse quoted in Barr 1951, pp. 119, 122.

2. Hahnloser 1988, pp. 5–7. Matisse's graphic works are cataloged by Duthuit-Matisse and Duthuit 1983.

3. Flam 1986, p. 151.

4. From an interview with André Verdet, quoted in Flam, ed., 1988, pp. 229–41. For a critique that raises some important issues surrounding Matisse's odalisques, see Silver 1987.

5. Hahnloser 1988, no. 42, p. 90.

6. Cowling and Mundy 1990, especially p. 14. Also see Silver 1991, who points out the gendered implications of the modern "classical" images discussed in this exhibition catalog.

7. Quoted in Castleman [1976] 1988, p. 88.

8. See Breeskin 1935.

9. Quoted in Lieberman 1956, pp. 13–14.

10. Bibliothèque Nationale 1970, pp. 117–18.

11. Quoted in Schiff 1976, p. 13.

12. Ibid., pp. 17–25.

13. For overviews of Picasso's graphic work, see the catalogues raisonnés by Geiser [1933] 1955 and 1968; Mourlot 1949–64; Bloch 1968–79; and Baer 1986, 1988, and 1989 (Baer's catalogs follow Geiser's work, which ceased in 1968 when he died). Also see Geiser 1965; Los Angeles County Museum of Art 1966; Baer 1983.

14. Gilmour 1987, especially p. 89.

15. See Reff 1971.

16. See Passeron 1970, p. 90; Johnson 1977, p. 23, and no. 85, p. 138.

17. See Reff 1973 for a study of the impact of Casagemas on Picasso's early work.

18. For illustration, see ibid., p. 28.

19. Quoted in Reff 1971, p. 37.

20. Passeron 1970, p. 90.

21. Raphael 1976, pp. 106–7.

22. See Schiff 1976, pp. 8–10 and his notes below, for a discussion and further bibliography on the "rationality" of Analytic Cubism. The quotation from Picasso likening Cubism to a perfume is on p. 9, n. 25. For a more recent assessment of issues in the interpretation of Cubism, see Leighten 1988.

23. Leighten 1988, especially pp. 272–73; Leighten 1989, pp. 111–42.

24. See Wallen and Stein 1981; Stein 1983.

25. Horodisch [1957] 1962, pp. 24–25.

26. Rubin 1989 offers an in-depth analysis of the different sensibilities of Braque and Picasso within the development of Cubism.

27. Rosenblum 1973. Also see Varnedoe 1990, pp. 23–49, for a discussion of the Cubist use of words and typography.

28. Exemplary studies in this vein are Leighten 1985 and Leighten 1989, pp. 11–42.

29. Quoted in Passeron 1970, p. 74.

30. Rosenblum [1960] 1966, p. 177.

31. Passeron 1970, p. 120.

32. Saphire 1978, no. 13, p. 48, notes the texture of German transfer paper.

33. For a survey of Nesch's prints and a discussion of his techniques, see Detroit Institute of Arts 1969.

34. For a lucid account of such differences, see Lodder 1983.

35. On Lissitsky's *Prouns,* see Rudenstine, ed., 1981, p. 244, and nos. 453–55, 457–64, and 466–67, pp. 244–48.

36. Castleman [1976] 1988, p. 66.

37. On Albers' prints, see Miller 1973, especially p. 8 for quotation.

38. See Johnson 1977, pp. 37–38, and no. 204, p. 166.

39. See Horodisch [1957] 1962, pp. 42–52.

40. Cowling and Mundy 1990, p. 17.

41. On Braque's illustrations for Hesiod's *Theogony,* see Johnson 1977, p. 38, and no. 171, p. 157; Hofmann 1961, pp. xv–xviii.

42. Johnson 1977, p. 26.

43. Leiris 1973, p. 245.

44. Ibid., pp. 245–49.

45. See Johnson 1977, no. 95, pp. 139–43. On the division of *The Vollard Suite,* see Bolliger 1956; Riedemeister 1956. A good iconographic study of the whole suite is Costello 1979.

46. On the sculptor's studio prints, see Lieberman [1952] 1967. Also see Gedo 1980, pp. 151–61; Baer 1983, pp. 72–100, for accounts of the autobiographical content of Picasso's art during and shortly after the period of *The Vollard Suite.*

47. See Duncan 1982.

48. Steinberg 1972a, p. 201.

49. Penrose 1973, p. 172.

50. Ibid., pp. 171–79; Ries 1972–73; Fiero 1983.

51. Fiero 1983 especially emphasizes the importance of the *corrida.*

52. Gedo 1980, p. 153.

53. Ibid.

54. Steinberg 1972b, p. 98. Gilot is quoted on p. 101.

55. Gilmour 1987, p. 83.

56. Baer 1983, no. 55, pp. 98–99.

57. Ibid., p. 98.

58. Ibid., no. 54, pp. 94–96, especially pp. 95–96 for quotation.

59. Fiero 1983, p. 26.

60. Gedo 1980, p. 161.

61. On Picasso's *Guernica,* see Arnheim 1962; Blunt 1969; Granell 1981; Chipp 1988; Fisch 1988.

62. Baer 1983, no. 54, p. 94.

63. On Picasso's iconographic use of the horse, see Omer 1971.

64. Baer 1983, pp. 104–5, and nos. 58–60, p. 110.

65. Tuchman 1983, p. 47. On modern artists and comics in general, see Gopnik 1990.

66. Baer 1983, p. 102, and nos. 61–64, p. 111.

67. Johnson 1977, p. 39.

68. On Picasso and Surrealism, see Golding 1973.

69. Maurer 1986, pp. 41–45.

70. Spies, ed., 1991, p. 31.

71. Rainwater 1986, p. 8.

72. Breton quoted in Read [1959] 1969, p. 132.

73. Spies and Leppien 1975, pp. ix–xi; Rainwater 1986, p. 16.

74. Greet 1986, p. 100.

75. See Spies and Leppien 1975, no. 13, pp. 12–17, for complete illustrations.

76. Rainwater 1986, pp. 23–24, and fig. 14.

77. Maurer 1986, pp. 58, 79–80. Hubert 1988, pp. 269–86, also discusses the problematic relationship of *Une Semaine de Bonté* to textuality and to the textual sources from which the woodengravings were culled.

78. Maurer 1986, pp. 80–81.

79. Warlick 1987.

80. Maurer 1986, pp. 82–84.

81. Hubert 1988, p. 285.

82. Maurer 1986, p. 87.

83. Quoted ibid., p. 91.

84. On *Maximiliana,* see Greet 1986, pp. 127–56.

85. On Miró's graphic oeuvre, see Dupin 1989.

86. On Hayter, see Moser 1977; Kainen 1986.

87. Gilmour 1988, pp. 329–35.

88. For an overview of Braque's lithographic oeuvre, see Mourlot 1963.

89. Quoted in Saphire 1978, p. 98. For *Cirque* illustrations, see nos. 44–106, pp. 98–167.

REFERENCES

Arnheim, Rudolf. 1962. *Picasso's Guernica: The Genesis of a Painting.* Berkeley, Calif.

Baer, Brigitte. 1983. *Picasso the Printmaker: Graphics from the Marina Picasso Collection.* Exhibition catalog. Museum of Fine Arts, Dallas.

Baer, Brigitte. 1986. *Picasso peintre-graveur, tome III: Catalogue raisonné de l'oeuvre gravé et des monotypes, 1935–1945.* Berne.

Baer, Brigitte. 1988. *Picasso Peintre-graveur, tome IV: Catalogue raisonné de l'oeuvre gravé et des monotypes, 1946–1958.* Berne.

Baer, Brigitte. 1989. *Picasso peintre-graveur, tome*

V: *Catalogue raisonné de l'oeuvre gravé et des monotypes, 1959–1965.* Berne.

Barr, Alfred H., Jr. 1951. *Matisse: His Art and His Public.* New York.

Bibliothèque Nationale. 1970. *Matisse: L'oeuvre gravé.* Exhibition catalog with contributions from Jean Guichard-Meili and Françoise Woimant. Bibliothèque Nationale, Paris.

Bloch, Georges. 1968–79. *Pablo Picasso: Catalogue de l'oeuvre gravé et lithographié.* 3 vols. Berne.

Blunt, Anthony. 1969. *Picasso's Guernica.* New York.

Bolliger, Hans. 1956. *Picasso: Vollard Suite.* London.

Bowie, Theodore, ed., 1970. *Studies in Erotic Art.* New York.

Breeskin, Adelyn. 1935. Swans by Matisse. *American Magazine of Art,* vol. 28 (October), pp. 622–29.

Broude, Norma, and Mary D. Garrard, eds. 1982. *Feminism and Art History: Questioning the Litany.* New York.

Castleman, Riva. [1976] 1988. *Prints of the Twentieth Century.* Rev. ed. New York.

Chipp, Herschel B. 1988. *Picasso's Guernica: History, Transformations, Meanings.* Berkeley, Calif.

Costello, Anita. 1979. *Picasso's Vollard Suite.* New York.

Cowling, Elizabeth, and Jennifer Mundy. 1990. *On Classic Ground: Picasso, Léger, de Chirico and the New Classicism 1910–1930.* Exhibition catalog with introduction by Elizabeth Cowling and Jennifer Munday and essays by Christopher Green, Patrick Elliott, Alexandra Parigoris, et al. Tate Gallery, London.

Detroit Institute of Arts. 1969. *The Graphic Art of Rolf Nesch.* Exhibition catalog with introduction by Jan Askeland and catalog notes by Ernst Scheyer and Ellen Sharp. Institute of Arts, Detroit.

Duncan, Carol. 1982. Virility and Domination in Early Twentieth Century Vanguard Painting. In Broude and Garrard, eds., 1982, pp. 30–39. (A revision of her article in *Artforum,* vol. 12 [December 1973], pp. 30–39.)

Dupin, Jacques. 1989. *Miró, Engraver.* 2 vols. New York.

Duthuit-Matisse, Marguerite, and Claude Duthuit. 1983. *Henri Matisse: Catalogue raisonné de l'oeuvre gravé avec la collaboration de Françoise Garnaud.* With preface by Jean Guichard-Meili. 2 vols. Paris.

Fiero, Gloria K. 1983. Picasso's Minotaur. *Art International,* vol. 26, no. 5 (November–December), pp. 20–30.

Fisch, Eberhard. 1988. *Guernica by Picasso: A Study of the Picture and Its Context.* Lewisburg, Pa., and London.

Flam, Jack. 1986. *Matisse: The Man and His Art, 1869–1918.* Ithaca, N.Y.

Flam, Jack, ed. 1988. *Matisse: A Retrospective.* New York.

Gedo, Mary Mathews. 1980. *Picasso: Art as Autobiography.* Chicago.

Geiser, Bernhard. [1933] 1955. *Picasso peintre-graveur: Catalogue illustré de l'oeuvre gravé et lithographié, tome I, 1899–1931.* Berne.

Geiser, Bernhard. 1965. *Picasso: Fifty-Five Years of His Graphic Work.* New York.

Geiser, Bernhard. 1968. *Picasso peintre-graveur: Catalogue raisonné de l'oeuvre gravé et des monotypes, tome II, 1932–1934.* Berne.

Gilmour, Pat. 1987. Picasso and His Printers. *Print Collector's Newsletter,* vol. 18, no. 3 (July–August), pp. 81–90.

Gilmour, Pat. 1988. Lithographic Collaboration: The Hand, the Head, the Heart. In Gilmour, ed., 1988, pp. 308–59.

Gilmour, Pat, ed. 1988. *Lasting Impressions: Lithography as Art.* London.

Golding, John. 1973. Picasso and Surrealism. In Penrose and Golding, eds., 1973, pp. 77–121.

Gopnik, Adam. 1990. Comics. In Varnedoe and Gopnik 1990, pp. 153–229.

Granell, Eugenio F. 1981. *Picasso's Guernica: The End of a Spanish Era.* Ann Arbor, Mich.

Greet, Anne Hyde. 1986. Max Ernst and the Artist's Book: From *Fiat Modes* to *Maximiliana.* In Rainwater, ed., 1986, pp. 94–156.

Hahnloser, Margrit. 1988. *Matisse: The Graphic Work.* New York.

Hofmann, Werner. 1961. *Georges Braque: His Graphic Work.* New York.

Horodisch, Abraham. [1957] 1962. *Picasso as a Book Artist.* New York and London.

Hubert, Renée Riese. 1988. *Surrealism and the Book.* Berkeley, Calif.

Johnson, Una E. 1977. *Ambroise Vollard, Editeur: Prints, Books, Bronzes.* New York.

Kainen, Jacob. 1986. An interview with Stanley William Hayter. *Arts Magazine,* vol. 60 (January), pp. 64–67.

Leighten, Patricia. 1985. Picasso's Collages and the Threat of War, 1912–13. *Art Bulletin,* vol. 67, no. 4 (December), pp. 653–72.

Leighten, Patricia. 1988. Editor's Statement: Revising Cubism. *Art Journal,* vol. 47, no. 4 (Winter), pp. 269–76.

Leighten, Patricia. 1989. *Re-ordering the Universe: Picasso and Anarchism, 1897–1914.* Princeton, N.J.

Leiris, Michel. 1973. The Artist and His Model. In Penrose and Golding, eds., 1973, pp. 243–63.

Lieberman, William S. 1956. *Matisse: Fifty Years of His Graphic Art.* New York.

Lieberman, William S. [1952] 1967. *The Sculptor's Studio: Etchings by Picasso.* New York.

Lodder, Christina. 1983. *Russian Constructivism.* New Haven, Conn.

Los Angeles County Museum of Art. 1966. *Picasso: Sixty Years of Graphic Works.* Exhibition catalog. Los Angeles County Museum of Art, Los Angeles.

Maurer, Evan M. 1986. Images of Dream and Desire: The Prints and Collage Novels of Max Ernst. In Rainwater, ed., 1986, pp. 37–93.

Melot, Michel, Antony Griffiths, and Richard S. Field. 1981. *Prints: History of an Art.* New York.

Miller, Jo. 1973. *Josef Albers: Prints 1915–1970.* Exhibition catalog. Brooklyn Museum, New York.

Moser, Joann. 1977. *Atelier 17: A 50th Anniversary Retrospective Exhibition.* Exhibition catalog. Elvehjem Art Center, University of Wisconsin, Madison.

Mourlot, Fernand. 1949–64. *Picasso lithographe.* 4 vols. Monte Carlo.

Mourlot, Fernand. 1963. *Braque lithographe, catalogue complet.* Monte Carlo.

Omer, Mordechai. 1971. Picasso's Horse: Its Iconography. *Print Collector's Newsletter,* vol. 2, pp. 73–77.

Passeron, Roger. 1970. *French Prints of the Twentieth Century.* New York.

Penrose, Roland. 1973. Beauty and the Monster. In Penrose and Golding, eds., 1973, 157–96.

Penrose, Roland, and John Golding, eds. 1973. *Picasso in Retrospect.* New York.

Rainwater, Robert. 1986. Max Ernst, Printmaker. In Rainwater, ed., 1986, pp. 3–36.

Rainwater, Robert, ed. 1986. *Max Ernst: Beyond Surrealism.* Exhibition catalog with essays by Anne Hyde Greet, Evan M. Maurer, and Robert Rainwater. New York Public Library.

Raphael, Max. 1976. Picasso in the Light of a Marxist Sociology of Art. In Schiff, ed., 1976, pp. 106–16.

Read, Herbert. [1959] 1969. *A Concise History of Modern Painting.* Revised ed. New York.

Reff, Theodore. 1971. Harlequins, Saltimbanques, Clowns, and Fools. *Artforum,* vol. 10 (October), pp. 30–43.

Reff, Theodore. 1973. Themes of Love and Death in Picasso's Early Work. In Penrose and Golding, eds., 1973, pp. 11–47.

Riedemeister, Leopold. 1956. *Pablo Picasso Suite Vollard: 100 Radierungen.* Hamburg.

Ries, Martin. 1972–73. Picasso and the Myth of the Minotaur. *Art Journal,* vol. 32, no. 2 (Winter), pp. 142–45.

Rosenblum, Robert. [1960] 1966. *Cubism and Twentieth Century Art.* Revised ed. New York.

Rosenblum, Robert. 1970. Picasso and the Anatomy of Eroticism. In Bowie, ed., 1970, pp. 337–50.

Rosenblum, Robert. 1973. Picasso and the Typography of Cubism. In Penrose and Golding, eds., 1973, pp. 49–75.

Rubin, William. 1989. *Picasso and Braque: Pioneering Cubism.* Exhibition catalog. Museum of Modern Art, New York.

Rudenstine, Angelica Zander, ed. 1981. *Russian Avant-Garde Art: The George Costakis Collection.* Exhibition catalog. Museum of Modern Art, New York.

Saphire, Lawrence. 1978. *Fernand Léger: The Complete Graphic Works.* New York.

Schiff, Gert. 1976. Introduction. In Schiff, ed., 1976, pp. 1–25.

Schiff, Gert, ed. 1976. *Picasso in Perspective.* Englewood Cliffs, N.J.

Silver, Kenneth E. 1987. Matisse's retour à l'ordre. *Art in America,* vol. 75, no. 6 (June), pp. 111–23, 167.

Silver, Kenneth E. 1991. Report from London: The Body Politic. *Art in America,* vol. 79, no. 3 (March), pp. 45–53.

Spies, Werner, ed. 1991. *Max Ernst: A Retrospective.* With introduction by Werner Spies and essays by Karin von Maur, Sigrid Metken, Uwe M. Schneede, and Sarah Wilson. New York.

Spies, Werner, and Helmut R. Leppien. 1975. *Max Ernst: Das graphische Werk.* vol. 1 of *Max Ernst: Oeuvre Katalog.* Houston and Cologne.

Stein, Donna. 1983. Cubism in Prints. *Print Review,* vol. 18, pp. 37–53.

Steinberg, Leo. 1972a. The Algerian Women and Picasso at Large. In *Other Criteria: Confrontations with Twentieth-Century Art,* pp. 125–234. New York.

Steinberg, Leo. 1972b. Picasso's Sleepwatchers. In *Other Criteria: Confrontations with Twentieth Century Art,* pp. 93–114. New York.

Tuchman, Phyllis. 1983. Guernica and "Guernica." *Artforum,* vol. 21, no. 8 (April), pp. 44–51.

Varnedoe, Kirk. 1990. Words. In Varnedoe and Gopnik 1990, pp. 23–67.

Varnedoe, Kirk, and Adam Gopnik. 1990. *High and Low: Modern Art, Popular Culture.* Published in conjunction with an exhibition of the same name. Museum of Modern Art, New York.

Wallen, Burr, and Donna Stein. 1981. *The Cubist Print.* Exhibition catalog. University Art Museum, University of California, Santa Barbara.

Warlick, M. E. 1987. Max Ernst's Alchemical Novel: "Une Semaine de Bonté." *Art Journal,* vol. 46, no. 1 (Spring), pp. 61–73.

12

American and Mexican Printmaking

to the Mid-1940s

America today is a society fascinated by images—printed and televised, moving and still, fine-art and commercial, good, bad, and indifferent. This sheer banality, quantity, and variety of imagery in contemporary American culture has roots in the history of its prints. American printmaking has been dominated by a dichotomy between commercial and informational functions and the tradition of the fine-art print. Many of the most original American printmakers have exploited this dichotomy, reconciling the irreconcilable by combining what is commercial or illustrative from their own graphic heritage with the European concept of the original print.

The earliest printers filled the colonists' needs for portraits, broadsides, maps, trade cards, bookplates, and the like. No reproductive printmaking could flourish, because trained artisans and equipment were equally scarce. By the mid-eighteenth century, the colonies could boast only several copperplate presses.[1] Most important, any would-be reproductive printmaker lacked models to copy, particularly the history paintings so valued within the academic tradition. Similarly, there was nothing to compare with the European industry of book illustration, which had flourished since the fifteenth century.[2]

The earliest extant print in America represents a favored American art form, the portrait. With its sparse, uncomplicated forms and concomitant expressive power, John Foster's wood-

698

cut of the Reverend Richard Mather (1670; fig. 12.1) is reminiscent of the very first woodcuts of saints that appeared in Europe in the fifteenth century. The most rudimentary parallel hatching defines the beard and models the minister's face and hands, while his coat and hat are, except for some vagaries of printing, undifferentiated areas of black, and the pages of the book are oddly and uniformly cross-hatched. Nevertheless, the portrait effectively conveys a keen intelligence and stern Puritan moralism. The son of a brewer, Foster was a Harvard graduate who taught Latin and English and was a friend of the Mather family. It was unusual for a person with this background to take up a mechanical trade like printing. Why and how he acquired his skills are unknown.[3]

In contrast to Foster, Peter Pelham was English-trained in portrait painting and engraving. In 1727 he settled in Boston and tried, mostly unsuccessfully, to import to the colonies the English taste for mezzotinted portraits. His impressions of his portrait of Cotton Mather (fig. 12.2), however, sold out after Mather's death in 1728. It is a less powerful image than Foster's, despite Pelham's professional training. There is something supercilious about the aristocratic wig and facial expression when applied to the famous New England Puritan. As Judith Goldman remarks, the portrait "reveals less about Mather than about the taste for mezzotints in Restoration England."[4]

Paul Revere, a talented silversmith, was also an engraver and printer. His most famous engraving, *The Bloody Massacre* (1770; fig. 12.3, color plate, p. 480), brightly hand-colored, was apparently stolen from a drawing by Henry Pelham, the son of Peter. Henry may have lent his design for a Boston Massacre print to Revere to obtain the latter's opinion, not expecting his colleague to pilfer the design and put his own engraving on the market. In the second state of the print, Revere corrected some spelling errors and altered the hands of the clock from eight o'clock to twenty after ten, when the Massacre really occurred. The "eight o'clock state" is apparently unique. The Pelham engraving appeared a week later, undercut by Revere's. In an angry letter, Pelham wrote, "When I heard you was cutting a plate of the late Murder, I thought it impossible, since I knew you was not capable of doing it unless you coppied it from mine." Spelling and grammar aside, Pelham's point was clear—evidently, one of America's great patriots was not above a less than ethical business maneuver.[5] Despite the importance of Pelham's design as a protest against the "Fruits of Arbitrary Power," as his inscription reads, it is interesting to note that he left the colonies as a Loyalist in 1776 to join his half-brother, the painter John Singleton Copley, in London.[6]

Revere's engraving technique is simple—he saved his exquisite design sense and craftsmanship for his metalwork—and aimed purely at effective political communication. Haughty redcoats ("fierce Barbarians grinning o'er their Prey," as the vehement inscription tells us) fire upon the Bostonians, whose innocence is conveyed by their disorder, contrasted with the deliberate organization of the British troops. Amid the chaos and fallen bodies, a woman wrings her hands in despair. Revere was no Goya, but his message was conveyed well enough. At the trial of the British soldiers, John Quincy felt it necessary to warn the jury against being prejudiced by their exposure to such images (with Revere's as the foremost): "The prints exhibited in our houses have added wings to fancy; and in the fervor of our zeal, reason is in hazard of being lost."[7]

In an attempt to echo the success of William Woollett's engraving after Benjamin West's *Death of General Wolfe,* the first American history painter in the grand European tradition, John Trumbull, offered engravings after two of his own paintings: *The Death of General Warren*

Mr. Richard Mather.

at the Battle of Bunker's Hill (fig. 12.4) and *The Death of General Montgomery in the Attack on Quebec* (both 1786; Yale University Art Gallery).[8] These scenes of American martyrdom (the British won both battles) were part of his series on the Revolutionary War. Through these paintings, Trumbull, who had served in the war as an aide-de-camp for General Washington, hoped to glorify his country, popularize history painting, and establish himself financially with federal commissions and the sale of reproductive engravings.[9]

Whereas Revere's print is much like folk art, Trumbull's compositions are sophisticated essays in the European late baroque style. In the absence of adequately trained American printmakers, Trumbull engaged publisher Antonio di Poggi's assistance in securing engravers. Beginning in 1792, the prints were sold by subscription, along with keys that identified the participants in the battles, but interest in the project waned.[10] The events had lost their topicality, and the market for prints of this type was nonexistent. Similarly, Charles Willson Peale's efforts to establish himself as an engraver, even of portraits of national heroes, found little reward.[11] Basically a rural, poor society, America had to recover from the Revolutionary War before it would have much time for "Art," either painted or printed.

By 1817, when President Madison was considering Trumbull's proposal for a series of history paintings to decorate the Capitol Rotunda, tactfully omitting the two American defeats, the public was slightly more receptive, both to Trumbull's ideas of art and to printmaking. Disturbed by the high fee of the English engraver he had hoped to hire to reproduce his Capitol compositions, Trumbull turned to a young American engraver of banknotes, book illustrations, and reproductive prints, Asher B. Durand. Durand and a few others had developed a technical sophistication that marked a considerable upgrading of American printmaking standards. The engravings of Trumbull's *Declaration of Independence* were not as lucrative as he and Durand had hoped, but they made the latter's reputation as an engraver.[12]

FIGURE 12.4
After John Trumbull.
The Death of General
Warren at the Battle of
Bunker's Hill. *1798. En-*
graving. 250 × 290 mm.
Yale University Art
Gallery, New Haven.

Durand abandoned printmaking to become one of the country's foremost landscape painters, a major artist of the Hudson River school. His swan-song as an engraver was his print (1835; fig. 12.5) after John Vanderlyn's *Ariadne* (1811–12; Pennsylvania Academy of the Fine Arts, Philadelphia). As Trumbull had hoped to promote history painting, Vanderlyn wanted the American public to warm up to the European tradition of the nude. His sensuous figure depended upon several venerable artistic prototypes, from ancient statues to Titian's Venuses; nevertheless, his prudish audience shunned it. Durand bought the canvas in 1834, determined to engrave it as a testimony to his ability. In keeping with American mores, Durand kept the painting covered in his studio. The engraving he produced from it, predictably, did not make money. But, among artists, the print made an important impression. Printmaking had at last gained a foothold in the new world.[13]

THE ''CHROMO''

It was the economic growth of the country in the early nineteenth century that made a print boom possible. The staple product of this boom was the ubiquitous chromolithograph, distinguishable from the color lithograph primarily in that it was a commercial as opposed to a fine-art venture.[14] This distinction is basically the result of the narrow concept of the original print that developed along with the etching revival of the later nineteenth century; it would have made little sense to the populace of antebellum America. "Chromos" were often, but not necessarily, reproductive (sometimes spectacularly so, as we shall witness when we consider Prang's skillful likenesses of American landscapes). The men who produced such prints followed the lead of the early European experimenters in the processes of color lithogra-

FIGURE 12.5

*Asher Brown Durand
after John Vanderlyn.*
Ariadne. *1835. Engrav-
ing. 375 × 451 mm. New
York Public Library.*

phy—Charles Hullmandel of London, for example—and they were often from Europe them-
selves. Peter Marzio describes the American chromolithographers: "Theirs was a flexible
philosophy: not bound to a single code of aesthetics, their aim was to make a profit. Insofar as
that goal was consistent with the promotion of a democratic art, they served as art crusaders."[15]

Witness the democratic flavor of these words, spoken in 1893 (when the chromo had fallen
out of favor) on behalf of the National Lithographers' Association:

> Within a few decades, public taste has been lifted out of the sluggish disregard for the
> beautiful . . . and now seeks to adopt the decorative accessories, which beneficent enter-
> prise has so cheapened [this word has no derogatory connotation] as to place them within
> the reach of all, to the ornamentation of its homes. . . . The depressing monotony of plain
> walls are [*sic*] now relieved by bright touches of color . . . awakening in some degree,
> however faint, the innate love of beauty which marks the scale of aspiration in the human
> soul. There is no place, high or low, where pictures are not now seen, for the campaign
> of popular education in art has been carried to the very utmost boundaries of ignorance,
> and the cost of reaping its advantages is next to nothing.[16]

These remarks make clear the profound connection between the rise of chromolithogra-
phy and the American ideal of an educated public that would make democracy work. Despite
its obvious commercialism, the chromolithograph sprang from the same root as the land-grant
universities and Chautauqua societies. Did it work? Did chromos in fact elevate the artistic
taste of the American populace? With characteristic satirical acumen, Mark Twain, in *A Con-*

necticut Yankee in King Arthur's Court (1889), likened the American love of the chromolitho-graph to a native need to fill up one's surroundings. Within his cold tower, the Yankee longs for home:

> There was no soap, no matches, no looking-glass—except a metal one, about as powerful as a pail of water. And not a chromo. I had been used to chromos for years and I saw now that without my suspecting it, a passion for art had got worked into the fabric of my being, and was become a part of me. It made me homesick to look around over this proud and gaudy but heartless barrenness and remember that in our home in East Hartford, all unpretending as it was, you couldn't go into a room but you would find an insurance chromo, or at least a three-color God-Bless-Our-Home over the door—and in the parlor we had nine.[17]

Twain's emphasis on quantity (three colors, nine chromos in the parlor) and his simulta-neous mention of God, love of home, insurance, and a passion for art in this little passage succinctly and affectionately satirize his country. Less lightheartedly, Edwin Lawrence Godkin of *The Nation* coined the phrase "chromo-civilization" to describe the degradation of the aes-thetic, intellectual, and moral senses that he feared in his country. For him, the exposure to chromolithographs and other smatterings of watered-down culture led not to an appreciation of greatness and truth, but to the thirst for more of the second-rate and an affectation of understanding: to a society of dangerously smug ignoramuses.[18] One does not wonder what Godkin's response to television would be! His elitism, Twain's humor, and the National Litho-graphers' Association's populism (to recur later in the contexts of 1930s lithography and screen-printing, and in the Pop Art prints of the 1960s) could be responses to contemporary American society.

It is instructive to compare John H. Bufford's chromolithographic version of the Boston Massacre (1856; fig. 12.6), drawn by William L. Champney, with Revere's prototype, lifted in turn from Henry Pelham. Whereas Revere's print (fig. 12.3, color plate, p. 480) is an incitement to riot in the present, the nineteenth-century print is a reflection upon a mythologized past event. As Goldman describes it, "Redcoats remain aggressive, but the British captain crawls and cowers. The Bostonians do not flee as they did in Revere's print. One lone, brave colonist, embodying ideal attributes of the American character, holds off the British, while a Redcoat kills a black Bostonian, the print's central figure. A black [Crispus Attucks] was indeed killed at Boston, but Bufford's massacre is a Northerner's view of pre–Civil War America."[19]

One of chromolithography's most important functions was the reproduction of paintings, for a native artistic tradition beyond portraiture did develop from the shaky beginnings de-scribed above. William Dreser's skillful recreation of Jasper Cropsey's now destroyed eight-by-fourteen-foot painting, *Starucca Vale—Erie Railroad* (known from other painted versions as well as the print; fig. 12.7) demanded a large number of stones, which were superimposed to achieve the wide range of autumnal hues for which Cropsey, one of the major artists of the Hudson River school, was known. Printed by Thomas Sinclair of Philadelphia in 1865, the chromo was commissioned by Uranus H. Crosby of Chicago for a lottery. Having gone into debt constructing an opera house as a gift to the city, Crosby conceived the lottery as a way of recovering financially. The grand prize was the opera house itself; a third prize was Cropsey's original painting, which ultimately burned along with the opera house; and the chromos were given away to anyone who purchased four tickets.[20]

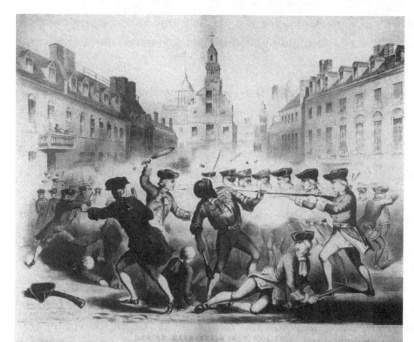

FIGURE 12.6

John H. Bufford and
William L. Champney.
Boston Massacre, March
5th 1770. *1856. Chro-*
molithograph. 445 ×
610 mm. American
Antiquarian Society,
Worcester, Massachusetts.

FIGURE 12.7

William Dreser after
Jasper Cropsey. American
Autumn: Starucca
Valley, Erie Railroad.
1865. Chromolithograph.
396 × 677 mm. Amon
Carter Museum, Fort
Worth, Texas.

Landscapes such as Cropsey's were perhaps the country's most original contributions to nineteenth-century art, and, as Barbara Novak and others have observed, reflections of profound and often contradictory religious and patriotic attitudes toward a land that seemed to stretch endlessly westward.[21] The subject of Cropsey's Starucca images was not only the magnificent natural scenery, but also the viaduct, an engineering marvel with seventeen gray sandstone arches, built for the New York and Erie Railroad in 1848 to complete the line between Deposit and Binghamton, New York. Cropsey's train chugs happily through the panorama, expressing an idyllic symbiosis of technology and nature typical of mid-century American

thought, and apparently still meaningful in 1865, despite the Civil War. As celebrations of railroad engineering, Cropsey's images of Starucca Valley were related to a wood-engraving from *Harper's New York and Erie Rail Road Guide* (1851), demonstrating once again the close links between the fine art and illustration in America.[22]

The spectacular views of the eastern woodlands created by Durand, Cropsey, Thomas Cole, and other Hudson River painters represented an early phase of American's fascination with their natural environment. As exploration pushed west, the more spectacular scenery of the Rocky Mountains, the canyon country of the Colorado and its tributaries, and many other sites presented a wilderness that was both uniquely American and the ultimate expression of the European aesthetic concept of the "sublime," a response to the terrifying, awesome power of nature. Sheer size as well as scale was important to the painters of western scenery: the painting had to overwhelm the viewer as nature itself did. Even the Alps, the sublime haunt of artists like Turner and Friedrich, seemed domesticated in comparison with America's western mountains.

Thomas Moran, whom we will encounter again as one of the champions of the American etching revival, was one of the artist-explorers of the West. Small and hardy, he accompanied the geologist Ferdinand V. Hayden, the photographer William Henry Jackson, and the explorer John Wesley Powell into the wild, recording what he saw in carefully annotated watercolor sketches. He was particularly associated with Yellowstone, whose glorious color, spaciousness, and geological character (scientific accuracy was important to Moran and most other American landscape painters of the nineteenth century) he had explored with Hayden in 1871 and interpreted in *The Grand Canyon of the Yellowstone* (1872), a large canvas purchased by the Department of the Interior. A superb watercolorist in the tradition of Turner, Moran also made numerous smaller paintings of his favorite wilderness site, including "twelve or more" commissioned in 1873 by Louis Prang, the master of chromolithographic technology, as models for prints to be sold in a portfolio published in 1876.[23]

Moran was no stranger to reproductive printmaking. He had worked as a wood-engraver and lithographer of others' compositions and was thoroughly familiar with Turner's numerous reproductive ventures in intaglio techniques, such as the *Liber Studiorum* (see Chapter 9). As Marzio points out, he was sensitive to what the chromolithographer had to do. His watercolor designs show isolated areas of reds, blues, and greens so that the painting could be "easily taken apart and reassembled to resemble the original."[24] Despite variations in quality among the issued portfolios, Prang's venture with Moran has rarely been equaled as an example of pure technical expertise in color printing. *The Lower Yellowstone Range* (1875; fig. 12.8, color plate, p. 480) suspends the viewer in space above a luminous blue, lavender, and gold distance. The depth of the chasm is unrevealed, and we cannot get a foothold on the forbidding rocky outcropping, with its inevitable blasted trees, that is the area of terra firma closest to us. Missing are the reassuring figures in the foreground of Cropsey's images of the Starucca Valley.

Of course, the awesomeness of the West was best conveyed by the oils of Moran, Albert Bierstadt, and others, but those were stationary and expensive. It was through prints like *The Lower Yellowstone Range* and wood-engraved illustrations in popular journals that the average American became acquainted with the West's natural wonders. Paradoxically, paintings and prints encouraged tourism, western migration, the displacement of Native Americans, and the exploitation of the land as well as the preservation of wilderness. Art participated in American culture's double-edged relationship to its natural resources.[25]

Another superb example of chromolithographic technology is Frank Tuchfarber's 1887 print (fig. 12.9) after William Harnett's famous painting of 1886, *The Old Violin* (in a private collection in Cincinnati). Harnett's meticulous *trompe-l'oeil* treatment of valuable objects, and the masculine ambiance of many of his paintings (for example, the four variations on *After the Hunt*), appealed to well-to-do businessmen-collectors, who were inspired by the burgeoning American taste for old-master paintings, including seventeenth-century Dutch still-lifes.[26] Another reason for Harnett's appeal, however, was the perennial American interest in literal appearance. This manifested itself on both the popular and the philosophical level: Novak has stressed the Emersonian dimension of American still-life painting. ("Every object rightly seen," wrote Ralph Waldo Emerson, "unlocks a new faculty of the soul.")[27] The chromolithographs of *The Old Violin*, which have hung in countless American homes, barber shops, and taverns, allowed ordinary Americans to participate in these tastes and concerns.

Despite some discrepancies, such as wrong musical notes, between the painting and its reproductions, the chromolithographs conveyed Harnett's crumpled, perfectly shaded papers, the cracked door with its *trompe-l'oeil* nails, and one of the artist's favorite props, the three-dimensional violin. The image was printed on glass, possibly on metal, and on paper glued to canvas, a third cousin to the oil painting.[28]

Godkin disliked above all the chromos that tried to imitate the texture of oils; for him these were the most deceptive and debased examples of the genre.[29] A general name in Europe for such images was "oleograph." Not only might the print be glued to canvas, but it might be varnished and given striations as well, and framed just like an oil painting. In their book, *The American Woman's Home*, first published in 1869, Catherine Esther Beecher and Harriet Beecher Stowe, better known as the author of *Uncle Tom's Cabin*, gave the housewife advice on how to frame varnished chromos to serve as inexpensive "oils."[30]

One of Prang's biggest successes (fig. 12.10), recommended by *The American Woman's Home* for purchase by its readers, reproduced Eastman Johnson's *The Barefoot Boy* (1860; now in a private collection), which in turn was based on John Greenleaf Whittier's famous poem:

> Blessings on thee, little man,
> Barefoot boy, with cheek of tan!
> With thy turned-up pantaloons,
> And thy merry whistled tunes;
> With thy red lip, redder still
> Kissed by strawberries on the hill;
> With the sunshine on thy face,
> Through thy torn brim's jaunty grace.
> From my heart I give thee joy.—I was once a barefoot boy![31]

In Prang's advertisement for the chromo of *The Barefoot Boy*, published in 1867, the lad was touted as the "homespun" and "self-reliant" personification of the American character.[32] Wholesome, rugged, poor—but not uncomfortably so—the boy exudes health and optimism to the point of being a saccharine cliché. Johnson's was a precursor of various paintings of rural youths that captivated the American imagination in the post–Civil War era. A similarly sentimental conception was John George Brown's *The Berry Boy* (1875; George Walker Vincent Smith Art Museum, Springfield, Massachusetts), and Winslow Homer depicted homespun rural youths in stunning, understated paintings like *Snap the Whip* (1875; Butler Museum of

FIGURE 12.9

Frank Tuchfarber and Company after William Harnett. The Old Violin. *1887. Chromolithograph. 877 × 582 mm. Amon Carter Museum, Fort Worth, Texas.*

American Art, Youngstown, Ohio). Sarah Burns has elaborated on the ideological force of such images, as purveyed in popular literature and art, in which the uncorrupted country boy stood for the country's lost innocence, now nostalgically evoked. Just as the "Barefoot Boy" in Whittier's poem eventually had to put on his shoes and, metaphorically, take on an adult role, so America was all too rapidly being transformed from a largely rural society to an industrialized urban nation. Burns points out that this sanguine image of childhood was sharply contradicted by the appalling conditions under which slum children lived, and the escalation of child labor as industrialization increased. Unlike the "Berry Boys" or "Barefoot Boys" of popular art and literature, impoverished urban children were feared as unruly "street rats" who threatened American complacency about the status quo.[33]

The ideological implications of these paintings were, of course, redoubled when the canvases were reproduced in cheap, widely available chromos. A number of prints of rural youths, including one by Prang after Johnson's well-known *Boyhood of Lincoln* (1868), followed the

FIGURE 12.10

*Louis Prang and Company after Eastman
Johnson.* The Barefoot
Boy. *1867. Chromo-
lithograph. 327 ×
251 mm. Boston Public
Library.*

success of *The Barefoot Boy*. Johnson's image of a young Lincoln studying by firelight was one
of many prints that helped construct a mythology of this singular politician.[34]

The chromolithograph also made significant contributions to nineteenth-century scien-
tific and anthropological knowledge: William Sharp's botanical prints, for example, or the
illustrations for Henry Rowe Schoolcraft's studies on the American Indian, or the reproduc-
tions of naturalist John James Audubon's watercolors. The 1838 edition of *The Birds of America*,
Audubon's watercolor masterpiece, was produced by the English printmaker Robert Havell,
Jr., using the old technique of hand-colored engraving and aquatint. In 1858 the New York
printer Julius Bien undertook a new, much less expensive chromolithographic edition. In order
to approximate the linear and tonal qualities of the original intaglio prints, Bien inked the
plates and printed them on transfer paper so that the image could be established on the litho-
graphic stone. After that, the problem was the reproduction of the transparent water-
colors—normally a preserve of aquatint. *American Flamingo, Old Male* (fig. 12.11, color plate,
p. 481), exhibiting Audubon's striking compositional power and delicacy of color, also shows
the subtlety of Bien's craftsmanship. Although his chromos successfully preserved the qualities
of the original watercolors, the ambitious project was cut short by financial difficulties and the
onset of the Civil War.[35]

Although occasionally issuing plain black and white lithographs and printing colors, the large New York lithographic firm of Currier and Ives usually produced black and white lithographs that were then hand-colored: an archaic procedure in the face of the sophistication of Prang, Bien, and other nineteenth-century American chromolithographic printers. Currier and Ives also lacked modern, steam-driven presses. The two partners themselves and artist-lithographers on their staff produced designs or copied designs by outside artists onto stones, and then the black and white prints were hand-colored, assembly-line fashion, in accordance with a fully painted model. One of Currier and Ives's best-known employees was the English immigrant Fanny Palmer (Frances Flora Bond Palmer), who supported her family with her varied work for the firm: producing sketches, drawing on the stones, and coloring models. The assembly-line colorists employed by Currier and Ives were usually immigrant women, paid a dollar for twelve large lithographs like Palmer's *Champions of the Mississippi: A Race for the Buckthorns* (1866; fig. 12.12, color plate, p. 482), which would then sell for a dollar and a half to three dollars each, as compared with the ten- to twelve-dollar price of Prang's elaborate chromos. Small Currier and Ives prints sold for under a dollar. Like the earliest hand-colored woodcuts, these prints were widely accessible and dealt with a lowest common denominator of cultural expression. Nathaniel Currier and James Merritt Ives held no elitist pretensions, frankly calling their prints the "cheapest and most popular pictures in the world."[36]

Currier and Ives's vast, varied output reminds us that the United States, while struggling to develop a "high" artistic tradition as strong as Europe's, always had vernacular art. No matter how banal these works may be, their inescapable abundance is important. It remains as a foil or a source for American fine-artists even today, when the electronic media have replaced the cheap chromo and wood-engravings of the past. Currier and Ives prints also evoke a nostalgia for a lost America, more optimistic and naive. *The American Fireman, Prompt to the Rescue* (1858; fig. 12.13) is typical. The hero is presented as a kind of saint (compare the Buxheim *St. Christopher,* fig. 1.5) who risks life and limb for the public good. The flames seem to part before his manly stride, as the Red Sea did for Moses, as he carries out a limp female victim of uncertain age. The sublimated sexual implications of the image may have appealed to the print's audience at the same time that its obvious didactic moralism affirmed commonly held American values. Actual fires were a staple of Currier and Ives, who recorded them as faithfully do our local news broadcasts today. Amid news events, animals, patriotic historical scenes, ladies' heads, steamboats and trains, and innumerable fruit and flower pieces, intended, as were the more expensive chromolithographed still-lifes, for Victorian dining rooms, there was also a negative side to Currier and Ives's oeuvre, such as the racism of the *Darktown* series, which featured the stereotype of the shuffling, witless black. Images produced by Currier and Ives reflected America passively—unlike great political prints, which seek to change the status quo. We shall find both the passive reflection of American society and aggressive social commentary in twentieth-century prints as well.

Along with the chromolithograph, the wood-engraving was the staple of American vernacular imagery. By the late nineteenth century, it was the chief kind of image in a vast array of popular books and periodicals. Wood-engraving had become a tedious, specialized craft. Members of a shop often worked on separate blocks, which were then bolted together, touched

FIGURE 12.13

Currier and Ives. The American Fireman, Prompt to the Rescue. *1858. Hand-colored lithograph, designed by Louis Maurer. 441 × 343 mm. Library of Congress, Washington, D.C.*

THE AMERICAN FIREMAN,
Prompt to the Rescue.

up, and printed. Artisans who engraved sky and foliage were dubbed "pruners," the engravers of drapery were "tailors," and those of machinery, "mechanics." The especially skilled who engraved flesh were called "butchers." [37]

A number of American painters designed wood-engravings. Winslow Homer's *The Army of the Potomac—A Sharp-Shooter on Picket Duty* (1862, based on the artist's first oil painting) was designed for *Harper's Weekly,* one of the most popular nineteenth-century American periodicals. Homer's compositional skill and sensitivity for gesture provided the tension in the image of a young soldier of the Army of the Potomac taking aim from his precarious position in a tree, but the technique of wood-engraving supplied the detail suitable for reportage and illustration (fig. 12.14). Many of the images Homer designed for *Harper's* were fairly complex genre scenes or, in the case of his Civil War works, battle, camp, or hospital scenes involving many figures in extensive settings. [38] As we shall see, his involvement in illustration carried over into his large intaglio prints.

Although simple in composition, Homer's wood-engraved image carried a wealth of topical meaning, as Christopher Kent Wilson has demonstrated. *Harper's* strongly supported the war effort, and Homer's many illustrations of the activities of the Army of the Potomac were replete with reassurances to the magazine's northern audience, although these reassurances frequently revealed Homer's characteristic sense of irony and ambiguity. [39] Hidden snipers were important in the war: they provided cover for troops, and took a toll on Confederate artillery crews and officers. The skills of sharpshooters contrasted strongly with the embarrassingly poor marksmanship of the average soldier. And so the wood-engraving—which, Wilson remarks, channels the viewer's gaze in a way that echoes the aiming of the sharpshooter—was a statement of Union confidence and pride. At the same time, the coolness of Homer's representation problematizes the sharpshooter's actions, for he was, in a sense, a hunter, only he took aim,

FIGURE 12.14

Winslow Homer. The Army of the Potomac— A Sharp-Shooter on Picket Duty (*for* Harper's Weekly). *1862. Wood-engraving. 233 × 350 mm. New York Public Library.*

calmly and anonymously, at human prey. The title of the print and painting, Wilson argues, adds even more irony, because picket duty was basically defensive and passive: not adjectives that could be used to describe the sharpshooter's actions. Thus, Homer asks some subtle questions about the nature of war, and how new military strategies might change the individuals who use them.[40]

The viability of wood-engraving for illustration and reproduction in the late nineteenth century was challenged by the progress of photomechanical processes. How were wood-engravers to respond, other than by abandoning the technique altogether? They could bring it out of illustration and into the realm of original printmaking, or improve the quality of their medium so that it could compete effectively with the new technology (at that time the half-tone photomechanical image left much to be desired). The so-called New School of wood-engravers did a little of both, but it mostly adhered to the latter path, using the term "originality" confusingly to refer to innovative ways of carving the wood *and* to stylistic variations among carvers in replicating paintings or photographs. Photographic transparencies could be transferred to wooden blocks, allowing for even closer duplication of a photographed painting or actual scene. Sometimes, however, "original" referred to images drawn on the block "from nature." In these instances wood-engravers were clearly borrowing from the etching revival, which stressed working from nature and autographic expression.[41]

William B. Closson's *The Heart of the Woods* (fig. 12.15), published as part of *The Art of the American Wood-Engraver* (1893), was inscribed "engraved from nature," and exhibits the conservatism of style and subject matter typical of the New School. Such woodland views echoed those of the Hudson River painters much earlier in the century; now, they carried the same implications of repose, solitude, and escape from urbanization and industrialization as forest scenes by contemporary American etchers and painters. Closson used the graver to produce

FIGURE 12.15

William B. Closson. The Heart of the Woods. 1893. Wood-engraving. 193 × 129 mm. Los Angeles County Museum of Art.

thousands of dewy dots that convey light and shade with an impressive subtlety. His means are essentially non-graphic, destroying the line in favor of a pictorial approach. As we have seen, this strategy is not uncommon in the history of prints.

THE ETCHING REVIVAL IN THE UNITED STATES

Just as this kind of virtuoso wood-engraving must be understood against a background of less accomplished examples in the medium, as well as chromolithography and photography, so must the American tradition of the fine-art print. The first etching in America was Charles Willson Peale's *Accident in Lombard Street,* an awkwardly drawn genre scene of 1787.[42] But nothing came of this medium in the United States until Alfred Cadart, leader of the French etching movement, came to New York in 1866, armed with etching supplies and examples of prints by a variety of European "revivalist" etchers. Although this produced no startling change in American printmaking, and he was not able to establish the hoped-for American etching clubs, Cadart's visit was important as a first exposure. Slowly in the following years, American artists became more familiar with contemporary European prints through various exhibitions, and in 1874 James L. Claghorn, president of the Pennsylvania Academy of the Fine Arts, showed his collection comprising old-master prints as well as contemporary works.[43]

In 1877, prompted by the European example, twenty American artists banded together into the New York Etching Club, and the vigorous growth of the American original print began. During the 1880s, etching was a craze among variously talented amateurs as well as professional artists.[44] Francis Seymour Haden, Whistler's brother-in-law, recruited American

works for exhibitions of his Society of Painter-Etchers (later the Royal Society of Painter Etchers and Engravers) and included American members in the organization itself. But of more consequence was his lecture of 1882, in which he championed original etching in New York, Chicago, Boston, Philadelphia, Cincinnati, Detroit, Baltimore, and St. Louis. Haden's taste was thoroughly characteristic of the European etching revival. He revered Rembrandt, preferred landscape as a subject, reveled in the spontaneity and suggestiveness of the etched line and the variable wiping of the plate. Moreover, Haden was an amateur, a fact that must have encouraged American artists unfamiliar with traditional, non-commercial printmaking techniques. Whistler, the expatriate American, was held up as the ultimate talent in modern etching, the heir of Rembrandt, the venerated paradigm of the etcher.

Two figures stand out as crucial promoters of etching in America: Sylvester Rosa Koehler and Philip Gilbert Hamerton. The latter, an English critic and painter-etcher who studied and worked in Paris, wrote *Etching and Etchers* (1868), a book that was, for American etchers, indispensable. It went through a number of editions and was geared toward teaching etching to neophytes. It offered technical instruction, including how to improvise supplies and instruments, as well as the critical tools, determined by the aesthetics of the European revival, to appreciate etching. Hamerton stressed working from nature and rapid spontaneity of execution—an etching was, above all, "rapid autographic rendering of artistic thought," and "sketching carried forward."[45] Of equal importance was the illustration of the text with restrikes of plates by Palmer, Haden, Jongkind, and old masters such as Ostade, Paulus Potter, and, of course, Rembrandt.

Hamerton's *Portfolio* (1870–93) served as a prototype for Koehler's *American Art Review*, a short-lived journal (1879–81) that included original etchings "executed either directly from nature, or under the immediate impulse of inspiration."[46] (Printmakers were seldom if ever quite so spontaneous as this pervasive ideal suggests.) Koehler was a German immigrant who had worked for a decade as Prang's technical manager. Hence, his fostering of original etching emerged from a background in commercial lithography. Not only was he an important early curator of print collections at the Boston Museum of Fine Arts and the Smithsonian, but he also lectured on etching and, perhaps most significantly, translated Maxime Lalanne's *Treatise on Etching* (1880) into English. Koehler, like Auguste Delâtre, was a strong advocate of retroussage and variable wiping of plates, whereas Hamerton eventually came to see these techniques as overused cover-ups for faulty drawing.[47]

Patricia Mandel has noted the "suppressed ache" that pervades the oeuvres of the "quietly elitist" American painter-etchers. "Even the storm-tossed scenes of Thomas Moran . . . do not add up to the national image of Peace and Plenty that characterized the official American consciousness of the pre–Civil War period. Instead, they suggest deeply troubled times, and the appeal of the painter-etcher movement was its very subjectiveness."[48] Francine Tyler has also succinctly characterized the subject matter beloved by these etchers. They shied away from the "real conditions of American life: the constant movement and change, the loss of community, the alienation in the cities, the misgovernment, the factory, cutthroat competition, exploitation of labor, strikes, racism, poverty, the development and exploitation of natural resources." Instead they focused almost entirely on nature as an escape from industrial civilization and probably also from the disillusionment of the Civil War, seeking out the exotic American scenery of Florida or California, or charming rural and woodland views closely related to Barbizon prototypes. The quaint village of East Hampton, Long Island, and its envi-

rons was a favorite haunt because it offered a great variety of picturesque scenery: pastoral views, aged domestic architecture, beach and sea panoramas.[49]

East Hampton provided the most important impetus for the etching careers of both Thomas and Mary Nimmo Moran, who spent the summer there in 1878. Although trained as a painter, Mary Nimmo Moran became better known as painter-etcher, one of many British and American women involved in the etching revival.[50] As Gladys Engel Lang and Kurt Lang have concluded in their sociological study of the etching revival in America and Britain, these women etchers were often as skilled as their male counterparts, but because of their other responsibilities, like caring for families, and the self-effacement valued as a feminine trait, they did not develop the marketing and record-keeping skills and the professional associations needed to become famous etchers.[51]

Although Mary Nimmo Moran was lavishly praised by Koehler and others for the vigorous freshness and "masculinity" of her prints, she deferred modestly to her husband's influence ("I may say I have always been my Husband's pupil," she claimed).[52] Her prints, however, clearly departed from Thomas's in their closer relationship to the unstudied approach of the Dutch and Barbizon schools.[53] In 'Tween the Gloamin' and the Mirk (1883; fig. 12.16), she combined ragged etched lines with roulette to achieve a dusky chiaroscuro that does not hide the textural details of road, fence, water, and grass projecting toward the viewer. As light shrinks toward the horizon, the eye gravitates toward the area to the right of the silhouetted mill, a Rembrandtesque touch, where the road, with cows slowly returning home, also leads.

Perhaps her husband's greatest East Hampton print, An Apple Orchard (1883; fig. 12.17), bears more than a passing resemblance to Crome's Road Scene, Trowse Hall (fig. 9.8). Both artists exploited the crisp brittleness of the etched line in the expanding branches of the sheltering old trees. Here, inspired by the picturesque flavor of his subject, Thomas Moran came close to the intimacy more typical of Mary Nimmo Moran's work. However, the ideal of sublimity and the precedent in graphic art established by Turner proved more significant for him. His prints, carefully worked out from preliminary drawings and watercolor studies, seem less immediate than his wife's warm and vivid images.

The Bridge in the Pass at Glencoe (etching and roulette, begun in 1882; fig. 12.18), a scene from the Scottish Highlands, exemplifies the mountainous sublime that Turner himself had explored so often in paintings and prints, such as those of the Liber Studiorum (see fig. 9.6), a publication that had enormous importance for Moran.[54] Whereas Turner utilized mezzotint for the plates of the Liber, Moran, perhaps influenced by the etching revival's antagonism toward the reproductive techniques of which mezzotint was the prime English example, confined himself to roulette.

Moran's print is an interesting instance of the nineteenth-century use of the remarque. Generally, these marks were supposed to indicate earlier and better impressions. In the case of Glencoe, first issued in 1882, however, the thistle remarque, visible at the lower right, was added in 1888 to make the print more salable. Since there was scarcely any room between the platemark and the image, Moran was forced to clear the plate in that area and awkwardly insert the remarque into the image itself.[55]

It is difficult to overestimate the importance of mountains for the Romantic imagination; Ruskin (an acquaintance of Moran) regarded the depiction of mountains as no less than a moral imperative for the greatest painters. The emphasis on liberty and wildness in the following passage would naturally appeal to the artists of the mountainous American West:

FIGURE 12.16

Mary Nimmo Moran. 'Tween the Gloamin' and the Mirk. 1883. Etching with roulette. 189 × 389 mm. Minneapolis Institute of Arts.

FIGURE 12.17

Thomas Moran. An Apple Orchard (Mulford's Orchard, Easthampton, Long Island). 1883. Etching. 305 × 457 mm. Collection of Henry Behrnd.

Connected with this love of liberty we find a singular manifestation of love of mountains, and see our painters traversing the wildest places of the globe in order to obtain subjects with craggy foregrounds and purple distances. Some few of them remain content with pollards and flat land; but these are always men of third-rate order; and the leading masters, while they do not reject the beauty of the low grounds, reserve their highest powers to paint Alpine peaks or Italian promontories.[56]

In Moran's *Glencoe,* as in Turner's *Ben Arthur, Scotland* from the *Liber,* the viewer is placed low, looking up toward the peaks, whose true extension is concealed by mists. The foreground contains forbidding, jagged boulders and blasted trees. It is an environment hostile to the human interloper, despite the presence of a bridge. But the awesome spaces and formidable ruggedness were intended to provoke an awareness of the infinite. When Moran came to apply to the western wilderness the ideals of sublimity he developed partly from Turner and partly from his American milieu, he apparently found etching a less than perfect medium. In his comparatively few etched wilderness scenes, he attempted to make up for small size—large plates were generally frowned upon by the etching revival—and the absence of color with an effective linear vigor.[57] For the most part, however, he left the West to his numerous wood-engraved illustrations and chromolithographs and, most important, his oils. The American sublime exemplified in Yellowstone, the Rockies, or Yosemite was perhaps beyond the capacity of etching as the late nineteenth century defined it.[58]

Robert Swain Gifford, another original member of the New York Etching Club, had experimented with the medium as a young teenager and published his own prints, the *Naushon*

Island set of etchings, at the age of twenty-five, more than ten years before the club's formation.[59] *Old Trees at Naushon Island* (1865; fig. 12.19) typifies the moody treatment of the New England coast that lies at the heart of Gifford's work. A single tree dominates the composition, but its ghostly, pointed shape is repeated in secondary examples. Gifford's strokes are short and relatively uniform. The eeriness of the image not only reaches back to Danube school prototypes but foreshadows Stow Wengenroth's lithographs of the 1940s (see fig. 12.61). In its composition, tight handling, and pronounced moodiness, *Old Trees* is a highly artificial conception of nature, far from the *plein-air* approach taken by the Barbizon and other nineteenth-century landscapists. A comparison of his early etching to *The Path to the Shore* (1879; fig. 12.20), commissioned by Koehler as a frontispiece for the first issue of his *American Art Review*, sheds considerable light on the consolidation of the specific approach to etching taken by the club and fostered throughout the 1880s. In contrast to the studied arrangement of *Old Trees*, *The Path* seems casual, "artless." The lines are loose and vigorous, unabashedly proclaiming their etched character. The gnarled tree so beloved by the club's various etchers makes its appearance. The presence of the diminutive, walking figure only reinforces the isolation of the site, something the print has in common with *Old Trees*. Later it was renamed *Solitude*—a title that reappears in the works of a number of American painter-etchers of the period.[60] Despite the marked difference between these two prints, both are based on the landscape of the northeast coast, Gifford's home.

Another club member, James David Smillie, was trained by his father as a banknote and reproductive engraver. He helped with the preliminary drawing after Bierstadt's *Rocky Mountains, Lander's Peak* (1863; Metropolitan Museum of Art), which his father etched and engraved in the mid-1860s.[61] During this period the younger Smillie struggled, in his own words, "to rid himself of the restraint of the engraver's methods, and to attain to the breadth and freedom which are valued in the productions of painter-etchers."[62] This he accomplished in *A Fallow Field* (1883; fig. 12.21), which is steeped in the Barbizon mood although it depicts the rural setting of Susquehanna County, Pennsylvania. Simply conceived, straightforwardly yet sensitively etched, this print has the pastoral freshness especially sought by collectors of the period. So thoroughly did it embody the aesthetics of the etching revival that Koehler later used *A Fallow Field* to illustrate his historical and technical book, *Etching* (1885).

Samuel Colman's *Cypress Trees of Point Lobos, California* (1887; fig. 12.22), takes the relatively tame, gnarled tree of Gifford's *Path to the Shore* and transplants it into the more rugged landscape of the California coast, which he had visited in 1886. (Colman traveled to the West first in 1870, a year before Thomas Moran took part in Hayden's historic expedition to the Yellowstone Valley.) Thomas Bruhn notes that the work was probably not etched from nature but created in the studio.[63] As is appropriate for the West, Colman gave his motif greater scale and monumentality. The deeply etched cypress trees are set against a lightly bitten, mountainous distance. Like Moran, Colman admired the mountain landscapes of Turner. But the asymmetry of Colman's composition and the pronounced linearity of the trees against the hazy space also reveal his interest in oriental art.[64]

Unlike Gifford but like the Morans, Colman defined his printmaking in broader terms than line-etching. He augmented the varied texture and tonality of this print with the addition of drypoint and roulette, and with the *sand manner*, in which sandpaper was impressed into the etching ground to give the plate areas of granular appearance (this is different from aquatint, in which the area *around* the resin grains is bitten). The emotional response such land-

scapes evoked in contemporary viewers is recorded in the remarks of a *New York Times* critic: "The tragic element in the writhen trunks and limbs of these cypress trees has not been lost in the rendering, for which Mr. Colman has had the proper feeling."[65] Unfortunately, the response to Colman's etchings was not what he desired, and he was discouraged from a more prolific output.[66]

FIGURE 12.21
*James David Smillie.
A Fallow Field. 1883.
Etching. 152 × 302 mm.
Kohler Art Library, Uni-
versity of Wisconsin—
Madison.*

FIGURE 12.22
Samuel Colman. Cypress
Trees of Point Lobos,
California. *1887. Etch-
ing, roulette, sandpaper,
and drypoint. 270 ×
369 mm. New York
Public Library.*

HOMER: AN ALTERNATIVE APPROACH TO ETCHING

The intaglio prints of Winslow Homer, already encountered as a designer of wood-
engraved illustrations, departed entirely from the works of the etching revival. Homer worked
frequently in a large format (as opposed to the small plates favored by revivalists), and in a
highly finished style related to wood-engraving and traditional reproductive prints, whereas the
painter-etchers of the revival often made reproductive prints after their own paintings in the
same loose, vigorous style as their original etchings. Homer dealt almost exclusively with nar-
rative subjects. While living in the isolated town of Prout's Neck, Maine, Homer had no way
to print his plates, but had to send them to his printer, George Ritchie, in New York. Working

from proofs, Homer altered his plates and sent them back to Ritchie. This slow process seems to suit the meticulous severity of these prints.[67]

The Life Line (1884; fig. 12.23) was Homer's first important etching. It reproduces a successful painting, also of 1884, now in the Philadelphia Museum of Art. The painted *Life Line,* as Nicolai Cikovsky, Jr., points out, was the first in a series of large, conspicuously heroic and ideal canvases painted from 1884 to 1887, in which Homer eschewed incidental detail for the qualities of timelessness and monumentality. Homer, who reached fifty in 1886, was tired of being called a "promising young artist."[68] The print of *The Life Line* and subsequent etchings after his paintings were part of his attempt to publicize himself as an artist of maturity and depth.

Like other painter-etchers, Homer felt free to alter the composition of the model painting to better suit the new medium: the figures are larger in relation to the surrounding space, and the tonal contrasts are enhanced. Later, in 1889, just before he abandoned printmaking for financial reasons, he etched *Saved,* yet another variation on the same dramatic theme of a rescue at sea by the newly developed means of the breeches buoy. This chair-like conveyance was attached to a cable, fired by rocket from shore to foundering ship, so that victims of a shipwreck could be carried to safety. Here, an unconscious buxom female passenger is carried by a heroic rescuer. The suspense of the moment is enhanced by the absence of either ship or shore; the figures are literally suspended against the raging waves in an elemental struggle of humanity and nature.

In its subject, *The Life Line* is not unlike *The American Fireman, Prompt to the Rescue* (fig. 12.13). Both derive from the contemporary predilection for such stories in the popular press. But Homer's compositional skill and his refusal to succumb to sentimentality transformed the banal theme into an arresting and disturbing image. In her thorough discussion of this print, Charlene Engel points out that Homer knew his audience well enough to temper the charged eroticism of the clinging wet drapery by covering the rescuer's face. However, the viewer *is* privy to the victim's indecorous situation.[69] Homer played upon paradox: *The Life Line* is at once erotic, melodramatic, deeply tragic. Indeed, even Homer's wood-engraved illustrations, as Roger Stein has shown, had long complicated and/or contradicted the sentimental and conventionally moralistic texts they were supposed to illustrate.[70]

The Atlantic storms of the late 1870s and early 1880s spawned the United States Lifesaving Service, later to become the Coast Guard. However, in *The Life Line* Homer may have had in mind a particular disaster, not in the Atlantic but in the North Sea: the 1881 wreck of the *Iron Crown,* which he had recorded during his stay in Cullercoats, a fishing village at the mouth of the Tyne in England. The breeches buoy had been used at this wreck. Homer's enduring fascination with the sea and the heroism and ingenuity it elicits from human beings was reinforced by his stay in Cullercoats. He was especially taken with the quiet strength of the fishermen's wives as they waited for their men to return from the dangerous waters or knitted their famous sweaters.[71]

Perils of the Sea (1888; fig. 12.24), one of Homer's most beautiful prints, is based on a painting (1881) of two Cullercoats fisherwomen awaiting news of their husbands' boats. They stand at the top of a cliff, in front of the watchhouse and the backs of the men of the Life Brigade. The men are staring out to the sea and a menacing sky. In contrast, the women seem reluctant to face their enemy but turn away, preoccupied with their hopes and fears. Homer titled his work from the refrain—"O hear us when we cry to Thee/For those in peril on the

FIGURE 12.23

Winslow Homer. The Life Line. *1884 (published 1887). Etching. 331 × 457 mm. Metropolitan Museum of Art, New York.*

sea"—of a mariner's hymn, which implores God to "bind the restless wave" and bid the "mighty ocean deep/Its own appointed limits keep."[72]

The etching is made up of rectangles, triangles, and horizontal and vertical lines tightly knit together, so that the dangerous storm at sea is not so much literally depicted as suggested by the striking tension and rigidity of the composition. We know this is a matter of life and death, and that the women wait on a knife's edge, by the way Homer organized his picture. At the same time, there are feathery passages of etched lines (the clouds, and the reflections of the women and watchhouse on the wet surface of the cliff).

THE "FINE-ART" LITHOGRAPH

It was primarily through etching that the concept of the fine print was strengthened in the United States. Thanks to its stronger ties to reproduction and illustration, and especially the affinity of American society for chromos, lithography found its way to fine-art printmaking more slowly, despite an early burst of enthusiasm about its potential as an artistic medium. In 1828 the critic John Neal visited William S. Pendleton's lithography shop in Boston and proclaimed that "the day is not far off when the best of them [lithographers] will be astonished—whatever they may believe now—at the vigor and beauty of lithographic prints, and amazed at the hidden capacities of the art." Earlier in 1825, Anthony Imbert had included notes on the technique in his *Memoirs of the Celebration of the Completion of the New York Canals.* In a groundbreaking article, Janet Flint has traced the early development of original lithography in nineteenth-century America, discussing examples by Thomas Cole, William Rimmer, William Morris Hunt, and Thomas Moran.[73]

Cole, the dean of Hudson River artists, collaborated with Imbert on an extremely rare or unique print: *Distant View of the Slides That Destroyed the Whilley Family, White Mountains* (1828; Albany Institute of History and Art; fig. 12.25). Mountain disasters—slides, avalanches, storms—were part of the repertory of the Romantic landscape artist. In Cole's own words, such events provoked a sense of humanity's smallness: "We looked up at the pinnacles above us and measured ourselves and found ourselves as nothing." In this particular case, a flood and mudslide had destroyed an entire family who made the mistake of going outside, while their house, "as though it had been a sacred place," as the artist wrote, was saved.[74] The rarity of his lithographs is regrettable, for Cole drew sensitively on the stone, using its potential for tonal nuances to create a richly atmospheric image. Light breaks optimistically through the rain and clouds over the side of the mountain, but the foreground is dark and littered with uprooted and blasted trees as a reminder of the tragedy.

One of the most beautiful early lithographs to be produced in America is Thomas Moran's *Solitude* (1869; fig. 12.26), an extremely rare print. The traditional assumption, deriving from an early writer on American graphic art, Frank Weitenkampf, has been that an accident ruined the stone for *Solitude* early in the printing process. However, a crack visible in impressions of a related print, *In the Forest of the Wissahickon* (1868), indicate that this latter lithograph might be the one whose stone was ruined. Both *Solitude* and *Wissahickon* reflect an interest in interior woodland views cultivated especially during Moran's 1860 visit to the Lake Superior region, recently celebrated in Henry Wadsworth Longfellow's *Song of Hiawatha* (1855). The results of the trip were concentrated drawings of the landscape, including close-up views of the water, rocks, and forests. Although *Wissahickon* contributed to the lithographic series printed expertly by James McGuigan of Philadelphia, *Studies and Pictures by Thomas Moran*, Bruhn has argued persuasively that the much larger *Solitude* could not have been intended for McGuigan's

FIGURE 12.25

Thomas Cole. Distant View of the Slides That Destroyed the Whilley Family, White Mountains. *1828. Lithograph. 216 × 280 mm. Albany Institute of History and Art.*

series. Rather, it stands alone or with the equally large and moody *Desolation* (ca. 1869) as an impressive, Romantic image of a wild forest interior.[75]

That *Solitude* was the artist's personal favorite among his lithographs is not surprising, for it epitomizes the grandiloquent approach to nature for which he was later to become famous in his paintings of the West. A dark, forbidding tonality and sharp, jagged shapes appear throughout. The trees are reminiscent of those in Danube school etchings. But the rich chiaroscuro and rugged terrain of *Solitude* suggest that the most important inspiration for Moran may have been Isabey's lithographic seascapes (see Chapter 8). Moran's drawing is so vigorous and dense that we are made uncomfortable by this hostile wilderness: human beings are made to seem intruders in nature.

Even more unusual than these lithographic landscapes is William Rimmer's *Reclining Nude* (1855–60; fig. 12.27), known in what may be a unique impression in the Boston Museum. Rimmer's persistent interest in the nude, a subject for which American society had little tolerance, as we have already seen, often caused him problems.[76] In considering this print, the word that comes to mind is "Mannerist." The reclining Venus (if that is indeed the subject) descends from the elongated, small-headed creatures of the Fontainebleau school, and the iridescent character of the lighting and misty modeling are reminiscent of Beccafumi or Spranger. Sensitively drawn, this lithograph promises a future for the medium in America that was long in coming, eclipsed by the growth of the chromolithographic industry and the etching revival.

FIGURE 12.27
William Rimmer.
Reclining Nude. *1855–*
60. Lithograph. 265 ×
287 mm. Museum of Fine
Arts, Boston.

THE EARLY TWENTIETH CENTURY: PENNELL

Although late nineteenth-century American printmaking is often unfavorably compared with its justifiably lauded European counterpart, we might want to modify Goldman's remark that, by 1900, "America barely had a fine art print tradition at all."[77] To be sure, there was no Degas, no Lautrec in America, and Whistler, Cassatt, and Prendergast were expatriates (they have been considered in this book with their European colleagues). There was, as well, a strong element of amateurism in the products of the American etching societies; in this they were not different from European ones. And the subject matter of these prints sometimes seems like an endless parade of "twilights" and "solitudes." It is also clear that wood-engraved illustration and chromolithography played a more important role within the broad spectrum of American printmaking. At the same time, it cannot be denied that the American etching revival, like its European counterpart, incorporated some remarkable talents—no mere Sunday "scratchers." Moreover, these prints bear further examination as cultural documents in the light of industrialization, urbanization, and the aftermath of a bloody and divisive war. Further research on the still largely unsung pioneers of American fine printmaking will undoubtedly redress the interpretation of these artists as poor cousins to great Europeans.

By the turn of the century, the momentum that original printmaking had developed in the 1880s slowed. The last exhibition of the New York Etching Club was held in 1893, and Koehler died in 1900. Of second-generation American etchers, it was the Philadelphia Quaker Joseph Pennell who carried the ideals of the etching revival into the new century. Despite the conservatism that generally marks his choice of subject and his technique, more adventurous younger printmakers like John Sloan and George Bellows might have made less progress with-

FIGURE 12.26
Thomas Moran. Soli-
tude. *1869. Lithograph.*
521 × 408 mm. Museum
of Fine Arts, Boston.

out the precedents Pennell set in etching and lithography. Along with producing a large graphic oeuvre, he was a tireless champion of printmaking, writing and speaking about it whenever possible.[78]

In *New York from Brooklyn Bridge* (1908; fig. 12.28), Pennell imposed a Whistlerian mood and a sense of age reminiscent of Meryon's view of Paris on the twentieth-century image of the New York skyline. Despite the new subject, the print was conceived in terms that would have appealed to the etching revivalists, and Pennell, as Timothy Rub points out, must be credited with discovering the picturesque qualities of New York architecture.[79] Plate tone was judiciously employed, and the lines are scratchily autographic. Pennell made the skyscrapers more palatable as subjects for fine prints by clothing them in a nineteenth-century atmosphere. While the smaller apartment and office buildings in the foreground and middleground are part of picturesque "Old New York," the skyscrapers in the distance, dominated by the Singer Building, seem part of another reality. They hover in mists, just like the sublime mountains we have seen in a number of landscapes. Pennell's view of the city and modern industry was essentially Romantic, optimistic, and aesthetic, ignoring the social implications of modern urban industrial capitalism. He was not alone. Until the Depression deflated the bubble of optimism, artists were often taken by the powerful visual forms of the new buildings and the sense of technological accomplishment they embodied.[80]

Pennell was one of the first American artists to recognize and pursue wholeheartedly the artistic potential of lithography. He and his wife, Elizabeth Robins Pennell, researched and wrote an important treatise on the medium, *Lithography and Lithographers*, published in both London and New York in 1898. Pennell lacked comprehensive technical expertise in lithography, and many assertions in this text—for example, claims that the transfer lithograph could not be distinguished from the stone lithograph—were challenged by the professional lithographer Bolton Brown.[81] Nevertheless, the book raised American awareness of the lithographic fine print.

In *The Grain Elevator, Hamburg Harbor* (1914; fig. 12.29), Pennell employed the scraper liberally and the lithographic crayon with a painterly, Goya-esque touch. The turbulence of flashing light, billowing smoke, and restless waves lends the grain elevator, looming and lurching as it were some living giant, a powerful and ambiguous presence. The image relates to Turner's "industrial sublime" in paintings and prints,[82] but there is also something vaguely disturbing in the print's black griminess, in the monstrousness of the elevator. James Watrous points out this basic conflict in Pennell, who, as he grew older, was to lament the passing of old Europe more and more bitterly.[83]

THE HERITAGE OF HENRI: EARLY TWENTIETH-CENTURY REALISTS

The modern urban scene could be aestheticized, viewed through Romantic glasses that made it seem continuous with the old world, or adapted, as we shall see, to avant-garde styles such as Expressionism, Futurism, and Cubism. For John Sloan and other American social realists working in the tradition of the important painter and teacher Robert Henri—George Bellows, Martin Lewis, Edward Hopper, and Reginald Marsh—the most interesting aspect of city life was human, and far from sublime. The excitement and glitter of the urban environ-

FIGURE 12.28

Joseph Pennell. New York
from Brooklyn Bridge.
*1908. Etching. 279 ×
213 mm. Cleveland Museum of Art.*

ment disguised its harshness: the city could seduce and destroy, as in Theodore Dreiser's novel
Sister Carrie (1900).[84] Not unexpectedly, given the traditional importance of prints in dealing
with social conditions and issues, each of these artists was an important printmaker (although
Hopper, regrettably, did not produce very many etchings). Richard Field has elaborated on the
great importance of illustration in the training and development of these artists, as well as on
the empirical tradition of Philadelphia, the city that most nurtured American realism.[85] Although Henri did not make prints, it was his approach to subject matter and style that pointed
the prints of these artists in a direction that departed sharply from that of Whistler and the
ideals of nineteenth-century revivalist etchers:

> *But language can be of no value for its own sake,* it is so only as it expresses the infinite
> moods and growth of humanity. An artist must first of all respond to his subject, he must
> be filled with emotion toward that subject and then he must make his technique so sincere, so translucent that it may be forgotten, the value of the subject shining through it.
> To my mind a fanciful, eccentric technique only hides the matter to be presented, and for
> that reason is not only out of place, but dangerous, wrong.[86]

American and Mexican Printmaking **727**

Henri was speaking about painting, but his words had implications for printmaking as well. Although, as we have seen, the quiet landscapes that dominated the etching revival were reflections of the mood of the country after the Civil War, subject matter was too easily lost in the revivalists' preoccupation with selective inking and wiping, retroussage and remarques. Their concept of the fine print developed in direct opposition to the prosaic world of illustration and chromolithography. They were elitists, insisting on the print as an autographic creation to be sold in limited numbers to an appreciative audience. The landscapes they favored were safe, escapist reveries of individual artists. On the other hand, this dichotomy between the etching revival and the ideals of the younger printmakers of urban genre scenes is less than absolute. Many late nineteenth-century American etchers were also deeply involved in illustration as well. Thomas Moran, for example, worked unceasingly for magazines such as *Scribner's*, and was trained as a designer and carver of wood-engravings. Moreover, the concern to preserve the sense of immediate, intense recognition of what is seen is also apparent in the etchings of the revival. Even when plates were obviously worked in the studio, it appears to have been very important that the etched image be fresh and immediate.

It is subject matter itself that primarily distinguishes the great early twentieth-century American etchers and lithographers from their predecessors who preferred landscape. When the ten etchings of Sloan's *New York City Life* set (1905–6) were hung at the request of Charles Mielatz, then secretary of the moribund New York Etching Club, along with an exhibition of watercolors at the National Academy of Design, a small furor resulted because of Sloan's "vulgar" subject matter. In 1913, as art editor of *The Masses,* Sloan offered the etchings plus three other prints—"you can have any or all of them at $2.00 each"—if the buyer would also include one dollar for a year's subscription to the journal.[87] Considering the groundbreaking character of these etchings, this was indeed a small price to pay.

The Masses, first published between 1911 and 1917, when five of its editors were arrested under the Espionage Act, was an extremely important periodical for artists interested in depicting American social realities. Under the editorship of Max Eastman, it espoused an optimistic, broadly socialist point of view and offered a forum for political opinions, social reform, art, and poetry. Chalk, crayon, or wash drawings, ideally suited for social observation or satire, were reproduced by the gillotage, a method of printing from zinc plates in relief perfected in 1850. Not only Henri, Sloan, and Bellows, but Stuart Davis, Boardman Robinson, Glenn Coleman, and other observers of the American urban scene, could be encountered in the pages of *The Masses.*[88]

Turning Out the Light (1905; fig. 12.30) was one of the most "offensive" images of Sloan's New York City set, for it showed an ordinary couple, working-class apartment-dwellers, in bed and unmistakably alluded to their physical relationship by means of the woman's smile and her action. Sloan's intimate glimpses of affection between couples provided the context of many of his most endearing prints—for example, *Man, Wife and Child* from the same set and *Love on the Roof* of 1914. In the context of early twentieth-century America, his frankness alone was remarkable, but it is his sympathetic yet unmanipulative approach to his subject that makes the print so appealing. This sense of humanity warmly but objectively observed is reminiscent of Rembrandt's sketches of Amsterdam street life, as is the ragged, quick line that belies a skilled draughtsman. Daumier is also recalled in the simplicity and vigor of the woman's pose and gesture. Despite the apparent spontaneity of Sloan's line, he worked from preliminary studies and went back to his etched plates many times, producing numerous states.

It was apparent from some of the *New York City Life* prints that Sloan was also a gifted satirist.[89] *Copyist at the Metropolitan Museum* (1908; fig. 12.31) not only reveals his sensitivity to gesture and his sense of humor, but tells us much about his views on art, which, he felt, should not be based on other art but on the observation of life. In the left foreground are portraits of the artist himself and his wife, Dolly, strolling through the museum and casting bemused glances at a crowd surrounding a woman copyist, who peers intently at her model. Like Hogarth, who included editorial comments in the guise of works of art in his satirical prints, Sloan made a pointed comparison between the copyist and her audience and the shepherd with his animals in the painting on the wall. The children, who stare curiously or gesture excitedly, exhibit an inquisitiveness and candor that the adults have lost.

Along with Pennell, it was the rival printers Bolton Brown and George Miller and the painter George Bellows who raised American consciousness of the artistic potential of lithography.[90] In this medium, collaboration between artists and first-rate printers who understood its difficult technical aspects had always been important. In 1917 Bellows wrote to a friend, "I have been doing what I can to rehabilitate the medium from the stigma of commercialism which has attached to it so strongly." Unlike Sloan, Bellows experienced a favorable response to his prints, and lithography remained a vital part of his oeuvre.[91]

Bellows was as astute in his observation of the society around him as Sloan, and, like the older artist, he combined objectivity with an awareness of the graphic satire of the past. Although Bellows worked entirely in lithography, his artistic and spiritual mentor, as Eleanor Tufts has pointed out, was a great satirical etcher—Goya.[92] *Dance in a Madhouse* (1917; fig. 12.32) clearly depends on Goya's paintings of madhouses, not to mention the Spaniard's chiaroscuro in both etching and lithography and his free, painterly use of the lithographic crayon. But the subject was also close to home, for Bellows was a friend of the family of the superinten-

dent of the Ohio state hospital for the insane near Columbus, Bellows' home town. The artist
described the particular occurrence the print depicts:

> For years the amusement hall was a gloomy old brown vault where on Thursday nights
> the patients indulged in "Round Dances" interspersed with two-steps and waltzes by the
> visitors. Each of the characters in this print represents a definite individual. Happy Jack
> boasted of being able to crack hickory nuts with his gums. Joe Peachmyer was a constant
> borrower of a nickel or a chew. The gentleman in the center had succeeded with a number
> of perpetual motion machines. The lady in the middle center assured the artist by looking

FIGURE 12.32

George Bellows. Dance in a Madhouse. *1917. Lithograph. 468 × 620 mm. Library of Congress, Washington, D.C.*

at his palm that he was a direct descendant of Christ. This is the happier side of a vast world which a more considerate and wiser society could reduce to a not inconsiderable degree.[93]

Despite Bellows' humor, he also suggested hopelessness by the lurid lighting and the seated figures, one with head in hands, at the right. As humor accompanies compassion, so his interest in specific characters combined with a more general social concern—the "vast world" of those unable to cope with an "inconsiderate" society—much as in Hogarth's *The Rake in Bedlam* (fig. 7.6).

The less-than-perfect wisdom of American society to which Bellows alluded laconically in the comment above is nowhere more apparent than in the excesses of popular evangelism, an issue in Bellows' time as it is in our own. In 1915 he was sent to Philadelphia by New York's *Metropolitan Magazine,* with the radical reporter John Reed, to observe the fiery Billy Sunday preach at a revival. The artist described the evangelist as "the worst thing that ever happened to America . . . such a reactionary that he makes me an anarchist."[94] In a lithograph of 1923 (fig. 12.33), Bellows shows Sunday leaping athletically forward upon the tables that had been constructed for the press, haranguing a huge crowd like some monk from Goya's etchings (*Swallow It, Dog* [fig. 7.31] from the *Caprichos* and *Evident Folly* from the *Disparates* come to mind). Sunday's bird-like, pointed features, reminiscent of Daumier's characterizations of priests, reinforce his vitriolic intensity. The lights and ceiling supports in the vast assembly hall combine to suggest the space of a cathedral, although the horizontal format and the particularity of details keep the event firmly in the secular world. Observable in the first two rows of

FIGURE 12.33

George Bellows. Billy
Sunday. *1923. Litho-
graph. 226 × 411 mm.
Cleveland Museum of
Art.*

the audience are a number of Sunday's victims: a plump man with clasped hands raised in adoration (see Goya's *What a Golden Beak!* [fig. 7.30] from the *Caprichos*), a swooning female listener, an old man straining to hear, a man with his head in his hands, apparently seized with remorse, and an innocent girl. Sinclair Lewis' novel *Elmer Gantry* (1927) would also focus on a charismatic evangelist's quest for power.

Bellows' most moving lithographs are those of *Tragedies of the War in Belgium* (1918). Large, glisteningly black, impressively composed and drawn, they are America's finest contribution to the antiwar imagery that we have traced throughout our study. Although he later called them "hallucinations," these images were inspired by the factual report of a committee (led by James Bryce, a British viscount and former ambassador who had tried to avert war with Germany) on the German invasion of neutral Belgium. The Bryce Committee Report, published in the *New York Times* in 1915, raised American awareness of European events and was instrumental in working up the furor against the "Hun" that would inspire America's entrance into World War I in 1917.[95]

Goya's *Disasters of War* underlie Bellows' excruciating depictions of the German atrocities. Unlike the abstract, allegorical interpretations of World War I in Rouault's *Miserere* series (see figs. 10.60, 10.61), these images are painfully realistic. *The Cigarette* (fig. 12.34) visualizes the Bryce Committee Report's statement that "women were attacked and bayoneted, and in a number of cases, their breasts were cut off."[96] Like Goya, Bellows used the psychological impact of mutilation combined with the cavalier indifference of a figure or figures in the print to express the horror and dehumanization of war. The dead woman's hand, impaled on a door, takes on an expressive life, as if raised in fear and pain. Her limp body is brightly lighted and isolated against the grays of the setting, a ransacked home, augmenting her position as martyr.

Bellows must be reckoned as the best American lithographer in the early years of the twentieth century. Martin Lewis and Edward Hopper, also heirs to the artistic ideas of Henri and Sloan, worked in intaglio techniques. Hopper found a particular loneliness and stark, monumental formal constructions in etched urban and rural views. Lewis' varied intaglio

prints focused on the city and its workers, discovering in this environment striking qualities of geometry and light, more intricate and delicate than Hopper's.[97]

Lewis' *Shadow Dance* (1930; fig. 12.35) reveals his impeccable use of traditional intaglio techniques—in this case, drypoint—and the precise rendering of space, geometry, and light that characterizes his interpretation of the city. As the light breaks over the tops of buildings and into the street and sidewalks, people hurry to their jobs or errands, casting long shadows as they go. Although the sense of bustling movement in the street is not lost, Lewis drew out the scene's geometry. This highly structured image offers a hospitable view of the city, perceived as a place full of human activity, moments of pure formal beauty, and strong sensations of light and space.

Despite the perfection of Lewis' technique, Hopper's images of the city are more profound.[98] An admirer of Meryon, who also understood the sense of isolation evoked by the cityscape, Hopper learned etching with his friend Lewis' help. Although Hopper made only about fifty prints, mostly limited to the years between 1919 and 1923, they are perhaps the most impressive produced in America during this period. He worked with very dense black ink, heavily laid on the plate, on stark white paper so that his reduced, geometric composi-

FIGURE 12.34
George Bellows. The Cigarette *from* Tragedies of the War in Belgium. *1918. Lithograph. 374 × 489 mm. Library of Congress, Washington, D.C.*

FIGURE 12.35

Martin Lewis. Shadow
Dance. *1930. Drypoint
with sandpaper ground.
238 × 276 mm. New
York Public Library.*

tions—quite surprising in the context of his time and subject matter—became even more
concentrated.

The Evening Wind (1921; fig. 12.36) has the haunting mood typical of Hopper's works,
conveyed by an isolated figure looking out the window. Her motion of getting into bed is
arrested suddenly by a breeze that stirs the hot city air as it blows the curtains inward. The
swatch of white against the heavy black of the wall effectively pulls the figure's gaze into the
empty sky beyond her room; she looks out wistfully as nineteenth-century figures standing on
the shore look out to sea—in expectation of or hope for some freedom or fulfillment. Hopper
surely had Sloan's *Turning Out the Light* (fig. 12.30) in mind,[99] but *The Evening Wind* seems as
different from this down-to-earth and affectionate image as Jan Vermeer's understated genre
scenes are from the tumultuous interiors of Jan Steen.

Melancholy figures looking out of or seen through windows recur in Hopper's works. In
American Landscape (1920; fig. 12.37), he explored another favorite motif: the boxy volumes of
a house set against the sky and an emphatic horizon. What is remarkable about this etching is
its complete naturalness in the context of a relentless geometry and artistic simplification. The
train tracks slice abruptly through the composition, dividing its lower third from the dark band
of trees and the empty sky. Stillness pervades the print, except for the lumbering cattle who cut
a diagonal path into space. Hopper has portrayed the moment when one of the animals hauls

FIGURE 12.36
Edward Hopper. The
Evening Wind. *1921.*
Etching. 197 × 223 mm.
Museum of Fine Arts,
Boston.

itself up onto the track, its hooves awkwardly balancing its heavy body on the rail. The pastoral meets the machine age in the form of the train, as it so often does in American landscapes. The combination of the momentary and the timeless is characteristic of Hopper.

SOME RESPONSES TO EUROPEAN MODERNISM

Although the prints of Hopper and Lewis exhibit a strong interest in abstraction and geometry, these artists did not distort visual reality in any fundamental way, as contemporary European Cubists and Expressionists did. For the most part, American artists of the early twentieth century were stylistically conservative. Since 1908 the artist-photographer Alfred Stieglitz had been exposing Americans to European modernism in his Photo-Secession Gallery in New York City. Stieglitz also organized exhibitions on Picasso, Cézanne, African art, Henri Rousseau, and Matisse, and his periodical, *Camera Work,* dealt with important critical issues for modernist art. But America's major introduction to the avant-garde came in the form of the 1913 Armory Show in New York and Chicago, in which both American and European artists exhibited.[100] The confrontation with Braque, Picasso, Matisse, the Dadaist Marcel Duchamp, and the sculptor Constantin Brancusi was jolting; it forced American artists to choose

FIGURE 12.37

Edward Hopper.
American Landscape.
*1920. Etching. 190 ×
308 mm. Museum of Fine
Arts, Boston.*

between their own traditions of social realism and landscape and the challenge offered by Cubism, Expressionism, and other contemporary movements. Prints were not a major aspect of the Armory Show, but, as Field suggests, the concentration of recent European prints there could not have failed to interest American artists, for whom printmaking had not, for the most part, been very important.[101] Redon's lithographs and Munch's woodcuts were exhibited. Both were strong challenges to the type of original printmaking America had known: realistic subjects, etched, lithographed, or wood-engraved in some conventional, if virtuoso, manner.

The enormous changes that took place in the period surrounding the Armory Show may be illustrated with examples by John Marin. He began his etching career under the influence of Whistler and Pennell. His critically acclaimed *Chartres Cathedral* (1910; fig. 12.38) is a masterpiece of etching, understood in late nineteenth-century terms. The aged surface of the building is sensitively rendered by scratchy lines and marks; there is a fine balance between detail and overall mood and atmosphere. The image epitomizes the picturesqueness of old Europe. In 1913, however, Marin etched Cass Gilbert's architectural masterpiece in *Woolworth Building (The Dance)*, an equally acclaimed print (etching with drypoint; fig. 12.39), but one that is praised for different reasons. Marin retained the emphasis, drawn from the late nineteenth-century etching revival, on retroussage and individualized inking and wiping (he printed most of his own plates),[102] but the essential approach to the architectural subject has been transformed. The departure from stable structure at which some of his earlier prints (e.g., *Cathedral, Rouen* of 1909) had hinted has come to pass. The skyscraper now reels with a dynamic life of its own. How different from Pennell's image of the Singer Building, done only five years earlier, or his 1915 *Woolworth Building*—essentially treated as a twentieth-century Chartres Cathedral—which answered Marin's challenge by reasserting the older etching aesthetic, preferred among American collectors.[103] The fluctuating planar forms of Marin's print verge on Cubism, or Delaunay's version of Cubism as presented in his images of the Eiffel Tower (fig. 11.16), but without its pervasive ambiguity. The energy of this modern view of the

city is also similar to Italian Futurism, but more lyrical, less aggressive. Whatever its European counterpart may be, Marin's etching has a particularly American optimism and ebullience. As Rub describes it, Marin's prints of the Woolworth Building and other New York monuments are "emblematic of the expansive impulse in American building as well as the union of architecture and engineering that has shaped the best of it." [104] Marin's subjective, joyous response to the city would recur in other etchings in subsequent years—*Brooklyn Bridge from Brooklyn (The Sun)* (1915) and *Downtown, the El* (1921). [105]

Arthur B. Davies, one of the organizers of the Armory Show, absorbed the influence of Cubism and Duchamp's notorious *Nude Descending a Staircase* (1912; Philadelphia Museum of Art) in his drypoint *Bathing Woman and Servant* (1917; fig. 12.40). This lush, velvety print shows ink-loaded lines of varying thickness that function as juxtaposed Cubist planes or as modeling lines for the central figure, whose bent torso and overlapped legs recall the contour drawings and etchings of Matisse and Picasso. The choice of the drypoint medium also reflects Davies' acquaintance with the early Analytic Cubist prints of Braque and Picasso. Davies' predilection for the nude and for allegorical or idealized subjects, as well as his familiarity with a wide variety of printmaking media, made him unusual among American artists. [106] In *Maenads* (1920; fig. 12.41), some impressions of which were printed on seventeenth-century "Venetian" blue paper, Davies evokes Greek antiquity, much as Picasso would in his *Vollard Suite* etchings. [107] Through a complex use of aquatint and stopping-out, he achieved a variety of granular tones that result in a dappled light worthy of Pissarro. This and the graceful movements of the figures give this print its idyllic charm.

Some of the most stylistically and technically adventurous American prints of the early twentieth century are the diminutive woodcuts by Max Weber. These are especially surprising given the American tradition of technically elaborate wood-engravings. [108] Their size belies their formal and expressive power, which rivals the best German Expressionist examples. Weber seems to have been influenced by Schmidt-Rottluff's 1918 portfolio of nine religious prints (see fig. 10.28) and, in his color prints, by Munch's subtle, often wash-like printing of color areas. Weber's means were idiosyncratic and, like Gauguin's, "primitive": he placed the inked block face down on paper laid on the floor and pressed a book placed on the back of the block with his foot. Sometimes he printed all the colors from one block, sometimes from multiple blocks superimposed. In all cases, his color lies in mottled shapes with the effect of a monotype. One of his favorite surfaces for making relief prints was the thin, soft basswood that made up the frames for honeycombs and could be carved with an ordinary penknife. In some cases, such as *Mother and Child* (1919–20; fig. 12.42, color plate, p. 482), a color woodcut, the shape of the comb-honey frame is apparent. In this example, the recessed sides further compress the already compact image. The mother and child theme, suggestive of the Christian Madonna but couched, as here, in the angular or simplified forms derived from African or Oceanic art, was not uncommon as an Expressionist subject. Weber made the image more poignant by the contrast of the closed eyes of the mother and the wide, adoring eyes of the child, held close by the large hands.

On the same generation as Weber, Rockwell Kent rejected forms of European modernism in favor of a highly condensed and simplified style. His wood-engravings and lithographs were generally narrative, symbolic, or political; like Davies, he showed little interest in urban genre, at least as it was naturalistically interpreted. Imbued with a Promethean concept of human aspiration and poetic creativity reminiscent of William Blake, Kent nevertheless created images

FIGURE 12.38
John Marin. Chartres
Cathedral. *1910. Etching.*
287 × 228 mm. Elvehjem
Museum of Art, Uni-
versity of Wisconsin–
Madison.

FIGURE 12.39
John Marin. Woolworth
Building (The Dance).
1913. Etching and dry-
point. 327 × 265 mm.
Minneapolis Institute of
Arts.

that were commercially successful. While other artists struggled during the Depression, Kent had more than enough commissions. He was a perfect example of the artist-illustrator whose role we have noted throughout this account of American printmaking. His preference for wood-engraving, the medium most closely associated with illustration, suited both his style, which lent itself to strong black and white contrast and crisp lines, and his democratic concept of the print.[109]

Starlight (1930; fig. 12.43), for example, was one of twelve prints by Kent used in an advertising campaign for the American Car and Foundry Company. Like the others in the series, it appeared in a number of national magazines. The lone figure underneath the starlit sky with arms uplifted is typical of Kent's works: it suggests human greatness by the isolation and monumentalization of the figure and its gestures. Although it remains as crisp as the line in Homer's *Sharp-Shooter* (fig. 12.14), Kent's wood-engraved line is bolder and does not create any sense of texture or detail. In this sense, Kent's wood-engravings reflect Blake's initial experiments, focusing on the line's abstract power as opposed to its mimetic capacity.

Unlike Marin, Kent, and Weber, many American artists were inspired by the confrontation with European modernism to seek new life in traditional artistic forms. As Field remarks, the print media helped to focus on the central issues faced by American artists:

> Prints, with their underlying commitment to communication and readability, represented a closely connected series of statements of this American dilemma. . . . [Modernist styles were often] grafted onto American subjects. Whenever that occurs, especially in the prints of the late Twenties and Thirties, there results a particular American compromise. The elements of a given style are flattened, simplified, deprived of ambiguity, stylized, and sometimes caricatured. They are bent to the needs of the illustrator to tell something about life. What we formerly regarded as provincial efforts, may now be read, quite simply, as evidence of a very important American struggle for independence and identity. The American scene was and is the most central vehicle for the encoding of our self-understanding.[110]

FIGURE 12.43

Rockwell Kent. Starlight.
*1930. Illustration for the
American Car and
Foundry Company.
Wood-engraving. 135 ×
175 mm. Museum of Fine
Arts, Boston.*

Charles Sheeler's *Delmonico Building* (1926; fig. 12.44), a subtle lithograph printed by Miller, exemplifies this American compromise. The architectural subject naturally yields rectangular volumes and flat surfaces, but Sheeler, the most prominent of the so-called Precisionists, accentuated this geometry by the uncluttered simplicity of his approach. The point is not the poetic ambiguity of Cubist geometry but a clarity and power that quietly celebrate the urban environment, industry, and technology. The low point of view augments the impressiveness of the high-rise building. The smooth, depersonalized handling of the lithographic crayon (contrast Bellows) is very far from the emphatically personal quality of Marin's etching of the Woolworth Building (fig. 12.39). It is a holding back that we will observe again in American art, where a basic predilection for the artist-as-observer, as opposed to the intense, self-absorbed poet, had much appeal.

One of the great monuments of modern architecture and engineering was the Brooklyn Bridge, memorialized by many artists, including John Taylor Arms, a consummate technician who had been trained as an architectural draughtsman. *The Gates of the City* (1922; fig. 12.45), an etching with aquatint depicting the upper section of the bridge, exhibits more attention to surface detail than Sheeler's lithograph—this virtuoso refinement was Arms's trademark— but strikes a similar compromise between abstraction and observation. Again, the subject lends itself to the compromise. The cables form a network of verticals and projecting diagonals; the pointed arches, buttresses, and individual bricks are unavoidably geometric. Yet Arms avoided the picturesque treatment of the surface and the atmosphere that we would expect from Whistler and Pennell. The modern structure is sleek, pristine, devoid of the signs of age and past civilizations. One small figure hardly suffices to alter the cool impersonality of the subject.

FIGURE 12.44
Charles Sheeler. Del-
monico Building. *1926.*
Lithograph. 248 ×
183 mm. Library of
Congress, Washington,
D.C.

FIGURE 12.45
John Taylor Arms. The
Gates of the City. *1922.*
Color etching and aqua-
tint. 229 × 219 mm.
Elvehjem Museum of Art,
University of Wisconsin–
Madison.

PRINTS AND THE DEPRESSION:
SOCIAL REALISM, REGIONALISM, THE DEVELOPMENT
OF SILKSCREEN

The Depression affected artists just as it did the populace at large. In an effort to amelio-
rate unemployment among painters, sculptors, and printmakers, the government founded the
Federal Arts Project of the Works Progress Administration. The FAP was a mixed blessing.
One of the artists active in the Graphic Arts Division of the FAP, Jacob Kainen, has recalled
the difficulties of working for a government bureaucracy ill-suited to artistic creation:

> While work on the Project was exciting and stimulating, the hard facts of day-to-day
> relationships with the administration were generally unhappy. . . . In their zeal to obtain
> what they thought was full value for money received, they brought about regulations that

were eminently in opposition to creative work. Most important among these were unrealistic supervisory methods, periodic firing of artists, and uncomprehending attitudes towards artistic creation.[111]

The firing of Project members every eighteen months led to a feeling of transience shared by many sectors of the public in the thirties, when economic and agricultural conditions drove the unemployed from city to city seeking work, and the farmers from their exhausted land.

Despite these harsh conditions and the clash of art and bureaucracy lamented by Kainen, the era of the Depression boosted American printmaking. The artists' awareness of the suffering of farmers and workers strengthened the already apparent proclivity for social realism in American prints, and the Graphic Arts Division of the WPA/FAP provided materials and places in New York and other cities where artists could make prints, thus introducing many to a new set of media. The range of American printmaking was greatly expanded. Woodcut, lithography, and color printing of a different sort than the chromolithography of the nineteenth century gained more practitioners, and silkscreen or serigraphy (see below) was developed. In addition to the greater technical scope of American printmaking, which would gain momentum in the forties, the thirties saw an increased public interest in the collecting of original prints, and a consciousness among artists of prints' affordability, both due largely to the success of the WPA printmaking programs.[112]

Thomas Hart Benton was the leading painter of the so-called Regionalists, who focused chiefly on rural midwestern subjects. As a term describing a broad approach, however, Regionalism might be applied to any number of American artists of this period who sought their subjects in the environment they knew best—Alexandre Hogue in the Southwest, John Steuart Curry in Kansas; Grant Wood in Iowa; Reginald Marsh in New York City; and so on. Like many other artists of the Regionalist bent, Benton made technically conservative black and white lithographs that were often after or closely related to paintings.[113] Swelling forms and exaggerated gestures characterized his style. *The Departure of the Joads* (fig. 12.46) was part of a commission from Twentieth-Century Fox for lithographs based on John Steinbeck's classic novel of the Depression, *The Grapes of Wrath*, a film of which was released to critical acclamation in 1939. The story of the Joad family, who fled to California from the Oklahoma dust bowl, dramatized the plight of the thousands of homeless farmers and, more broadly, all those enduring hard times in a normally prosperous country. Benton's melancholy nocturnal scene expresses the end of a way of life for this family. No longer bound to the land they had always known, they would try to survive as migrant workers.

The Depression in the cities was also recorded and interpreted by printmakers like Raphael Soyer and Reginald Marsh.[114] Soyer's images of the indigent, such as *The Mission* (1933; fig. 12.47), a lithograph depicting men eating a meager meal of bread and coffee at a Bowery mission, are haunting because of their understatement. Soyer had just begun drawing directly on the stone; previously, he had used transfer paper. His soft technique tempers the anger of the grim-faced man looking out at the viewer. The others eat with a hopeless resignation. For *Breadline—No One Has Starved* (etching, 1932; fig. 12.48), Marsh employed a horizontal format that emphasizes the endlessness of the line of unemployed men, many looking much the same, from their tired faces to their caps to their hands jammed in coat pockets for warmth.

Both Soyer's and Marsh's images, while moving, are reticent and realistic compared with some contemporary political prints, such as William Gropper's satirical transfer lithographs for

FIGURE 12.46

Thomas Hart Benton. The Departure of the Joads *from the* Grapes of Wrath *series. 1939. Lithograph. 314 × 464 mm. Art Institute of Chicago.*

the *New Masses,* Kollwitz's prints of the impoverished in Germany, or the powerful imagery of Mexican artists like José Clemente Orozco, José Guadalupe Posada, David Alfaro Siqueiros, and Diego Rivera. Marsh in particular excelled at the more subtle political or social statements that might be made by the urban genre scene. He loved odd places like Coney Island and the burlesque theaters of New York, the city that was the nearly exclusive source of his imagery. For him, these crowded, gaudy haunts held the same fascination that Montmartre brothels and cafes held for Lautrec: they were part of a bizarre world with its own code of behavior and peculiar visual appeal. In his witty, seedy etchings, masses of humanity whirl on amusement park rides or crowd onto beaches; rows of heavy-jowled, cigar-chomping men leer at fleshy strippers reminiscent of Rubens' nudes. In *Gaiety Burlesque* (1930; fig. 12.49), the audience leans forward over the edges of two breast-shaped theater boxes—a play on the breasts that the dancer half-conceals.

Isabel Bishop, too, focused on New York City in etchings that resemble Marsh's in style. Both artists took much from Sloan's approach to the medium.[115] *Noon Hour* (1935; fig. 12.50), based on a painting in the St. Louis Art Museum, reveals the strength of Bishop's drawing and the vitality of her etched line. The two women, like Marsh's, have an amplitude reminiscent of Baroque figures, but instead of exuding a robust sexuality that appeals to the male viewer as well as to male characters in the print, they are captured by themselves in a casual moment of

conversation. They are viewed less decoratively than the working women who appear in Lewis' prints. Bishop brought to her observations of urban life a female point of view.

In contrast to the great majority of American prints in the thirties, which dealt with contemporary life, Curry's best-known lithograph, *John Brown* (1939; fig. 12.51), is historical. It was taken from his full-length figure of the fiery abolitionist, who had settled in Kansas territory in 1855 in order to work for free (non-slavery) statehood, in the mural *The Tragic Prelude* in the state capitol building in Topeka, Kansas, and also in an oil in the Metropolitan Museum. The lithograph's initial selling price of five dollars reflected the populist consciousness of many American printmakers of the period.[116] Here, Curry approaches the strident expressiveness of Rivera's *Zapata* (see fig. 12.56). The lithographic crayon was the best instrument for the subject. The swirling strokes of the beard and coat and especially of the prairie fire and tornado—well-chosen midwestern metaphors for Brown's fury—give the simultaneous sense of massiveness

FIGURE 12.49

Reginald Marsh. Gaiety
Burlesque. *1930. Etching.
305 × 254 mm. Library
of Congress, Washington,
D.C.*

and energy, augmented by the print's smaller, more concentrated format. Arms akimbo, Brown towers like an American Moses above the prairie, the wagons of the westward-moving settlers, and even above the black man in the lower left, whose freedom he championed. Indeed, the reference to Moses as interpreted by Michelangelo is inescapable, even though it is superimposed on a likeness of Brown derived from a photograph, and this biblical reference is combined with others. Brown's pose echoes the Crucifixion of Christ, and the whirlwind embodies the wrath of Jehovah (recall our discussion of Blake's *Job* in Chapter 6).[117] This print is an unforgettable image expressing Curry's sympathy with the plight of African Americans. However, it is the white abolitionist, to whom the blacks remain pictorially subordinate, who is heroized.

Although African American painters, alongside poets and writers, had flourished in the Harlem Renaissance movement of the twenties, it was in the thirties, under the auspices of the WPA/FAP, that African American artists took up printmaking in a concentrated fashion. Black artists made many contributions to the technical experimentation and the new awareness of the artistic potential of the print that emerged from this period. For example, Dox Thrash, working with the Philadelphia graphics workshop sponsored by the FAP, developed the carborundum print, or "carbograph," in which the granular mixture of carbon and silicone used

for grinding down and polishing lithographic stones is applied to a plate to produce a grained surface that is worked from dark to light like a mezzotint.[118] Wilmer Angier Jennings, who worked for the WPA in his native Atlanta, reprised the medium of wood-engraving in works such as *Still Life* (1937; fig. 12.52), an interior view centering on an African sculpture, indicative of African Americans' growing awareness of and pride in their past. Jennings' handling of his medium is exceptionally delicate, with fine white lines creating an iridescent light that adds to the central object's mystery and power. And William Henry Johnson, employed by the WPA in New York City as a muralist, and a teacher at the Harlem Community Art Center, produced some of the most spirited early silkscreens.

Serigraphy (from the Greek words for "silk" and "to write") was a word coined in 1941 by the print connoisseur Carl Zigrosser to describe (and lend a non-commercial gloss to) the silkscreen or screenprinting process,[119] which is ultimately derived from the simple idea of the stencil. Using a squeegee, the artist or printer passes viscous ink through a screen of silk or other material to the paper underneath. The "stencil" on the screen may be made of a brushed-

FIGURE 12.52

*Wilmer Angier Jennings.
Still Life. 1937. Wood-
engraving. 251 ×
203 mm. Newark
Museum.*

on coating or an adhesive film, cut or prepared photographically (photo-silkscreen or photo-serigraphy). In 1932 Guy MacCoy, who produced some of the first artistic silkscreens, discussed the adaptation of the process from commercial printing. He had in mind the stencil prints or *pochoirs* by contemporary French artists (recall Matisse, fig. 11.9, color plate, p. 478), then being exhibited at the Weyhe Gallery in New York: "The prints were very good and they thrilled us very much, but the stencil had certain limitations which caused the artist to do a certain amount of handwork which varied in each print slightly. The silkscreen method seemed a better way to make a colored print."[120] When silkscreen was incorporated into the WPA-sponsored graphic workshops in the mid-thirties, its future as an artistic medium was insured. It would become particularly important in the sixties, as we shall discuss in Chapter 13.

Johnson explored silkscreen intensively, and his vibrant style, based on brightly colored, energetically juxtaposed shapes reminiscent of Synthetic Cubism, was ideally suited to this medium. His subject matter—rural as well as urban African American life—is treated with both humor and dignity. *Going to Church* (fig. 12.53), produced in the early forties, is one of many of his works evoking the piety of the black culture of rural South Carolina, where Johnson was born in the small town of Florence. Seated demurely in a wagon pulled by a mule, and dressed in their Sunday best, a family makes its way to church through a landscape animated with the bright, flat colors for which serigraphy was so well suited.

FIGURE 12.53

William Henry Johnson. Going to Church. Ca. 1940–41. Color silkscreen. 333 × 445 mm. National Museum of American Art, Smithsonian Institution, Washington, D.C.

POSADA'S HERITAGE: MEXICO AND THE PRINT

A strong influence on American Regionalism and the WPA prints of the Depression era was the development in Mexico of an art "for the masses" and for the celebration of national heritage. In 1911 a coup had ousted the longtime dictator, President Porfirio Díaz, and modern Mexican democracy began its difficult growth. Art, especially in the highly public forms of murals and prints, promoted the national pride that had been building since Benito Juarez triumphed over the French-supported Hapsburg emperor of Mexico, Maximilian. (It was Maximilian whose execution Manet had depicted as an indictment of the French government in paintings and a lithograph done between 1867 and 1869.) [121]

The father of this movement in Mexican art, José Guadalupe Posada, died only three years after the Revolution of 1911, but his graphic art provided inspiration to the Mexican Muralists of the 1920s and 1930s: Diego Rivera, José Clemente Orozco, and David Alfaro Siqueiros.[122] Posada, in turn, epitomized a long tradition of Mexican popular graphics—for example, the lithographs of Constantine Escalante, which criticized Juarez as well as the French. A man of humble origins (he was a baker's son) and ambitions, Posada produced a wide variety of broadsides, popular images combined with texts: topical comments on the Díaz regime, social satire, and depictions of oddities, atrocities, and miracles recalling vignettes from the *Nuremberg Chronicle* (see Chapter 1). While helping Diego Rivera paint a mural in Mexico City in 1920, a young French painter, Jean Charlot, was impressed by Posada's prints, which were being sold by a street vendor. It was Charlot who brought Posada to the attention of the muralists, and, indeed, of a worldwide audience.

Posada was trained as a lithographer, but because of the incompatibility of lithography with letterpress that we have noted, especially in connection with Daumier, he took up wood-engraving, engraving on lead plates (or "type-metal engraving"), and, finally, relief etching on

zinc. Blake, we remember, had developed relief etching, and partly for reasons that would have appealed to a "man of the people" like Posada: in readily combining type with image, it saved money and made his publications more accessible. However, Posada's work could not be more unlike Blake's philosophically erudite prints with their populous cast of allegorical characters. Posada's images are simple and unambiguous. His employer in Mexico City, Antonio Vanegas Arroyo, specialized in all kinds of inexpensive printed materials, from recipe books to children's stories, from songs to political speeches.

Posada made famous the motif of the *calavera* (literally, "skull") or comic skeleton, and used it brilliantly to caricature individuals and groups in Mexican society. The *calaveras,* which probably date back to the eighteenth century, were an effective tool for contemporary satire because they drew upon the Mexican fascination with the image of death in various forms—from the Pre-Columbian gods and goddesses to the gruesome Hispanic Catholic image of the crucified Christ. Sold especially on the "Day of the Dead" or All Souls' Day (November 2), when offerings are made to deceased relatives, the *calavera* prints functioned as souvenirs of the holiday, along with masks, puppets, and toys in the form of the mocking skeleton, and skulls made of sugar.[123]

Individual *calavera* images could be recombined with different texts to serve different purposes. For example, *La Calavera Revuelta* (*The Disorderly Calavera,* zinc etching, 1913; fig. 12.54) could illustrate many kinds of political and military strife, from civil war to foreign meddling in Mexican affairs. Like Bruegel's oddly similar engraving, *Fight of the Money Bags and Strong Boxes* (ca. 1567?),[124] Posada's print expresses a universal point about the self-perpetuating nature of social conflict. In Posada's print, the soldier-skeletons and civilian-skeletons (at the left) engage in a furious skirmish while a torrent of *calaveras,* with amusing, stick-like bodies that bristle with the energy of conflict, flows from the upper left to the lower right. War generates death endlessly, and even the dead, it seems, cannot refrain from war.

One of the best-known and most arresting of Mexican *calavera* prints, *Huerta as a Spider* (type-metal engraving, ca. 1914; fig. 12.55) is probably not by Posada but by an immediate follower, sometimes called the "Master of the Worm-Eaten Skull."[125] The image attacks General Victoriano Huerta, who had betrayed the liberal President Francisco Madero, executed him, and proclaimed himself president. In the tradition of Posada's satire, it effectively conflates the skull, the vampire (note the elongated teeth), the bird of prey (note the taloned "hands"), the spider, and the scorpion into an unforgettable hybrid creature that flattens itself across the page to form a radial pattern around the grinning death's head.

Very different in style is Diego Rivera's *Zapata* (fig. 12.56), a lithograph of 1932, based on one of Rivera's murals in the Palacio de Cortés in Cuernavaca, Morelos (1929).[126] Rivera had been trained in Europe—he produced one of the most impressive bodies of Cubist works—but turned away from modernist abstraction toward a powerful realist style with simplified, monumental forms distantly echoing Pre-Columbian sculpture. Like its U.S. counterpart, this style had strong nationalistic associations. In part an "autographic reproduction" of a painted work, Rivera's lithograph also takes part in the traditional role of lithography as political statement by paying tribute to the heroic leader of the Mexican Revolution from the state of Morelos, Emiliano Zapata, who had been tragically assassinated in 1919. Rivera used the magnificent horse, inclining its head toward his master, as a way of reinforcing the strength of the man. As Zapata, machete in hand, strides forward, the peasants whose cause he championed march behind him.

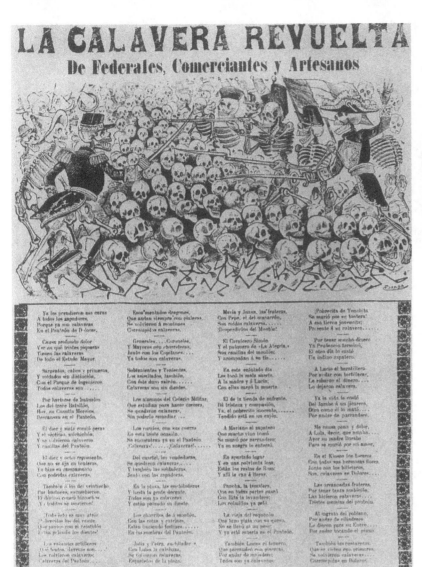

FIGURE 12.54

José Guadalupe Posada. La Calavera Revuelta (The Disorderly Calavera). *1913. Zinc etching. 400 × 302 mm. Denver Art Museum.*

Despite a small oeuvre of lithographs and etchings, Orozco was one of the most important of the Mexican muralists for graphic art.[127] His lithographs, such as *The Franciscan and the Indian* (1926; fig. 12.57), which is based on a fresco in the National Preparatory School in Mexico City, often reprise figures or scenes in his mural compositions. The straightforward simplicity of Orozco's lithographic technique belies the subtlety and ambivalence of this image, which, like Curry's *John Brown* (fig. 12.51), calls up the complexity of race relations. The image heroizes the Franciscan monk, who embraces a starving Indian with compassion, as Brown championed the cause of American slaves. Yet, at the same time, Orozco's image suggests the

FIGURE 12.56

Diego Rivera. Zapata. *1932. Lithograph. 411 × 333 mm. Philadelphia Museum of Art.*

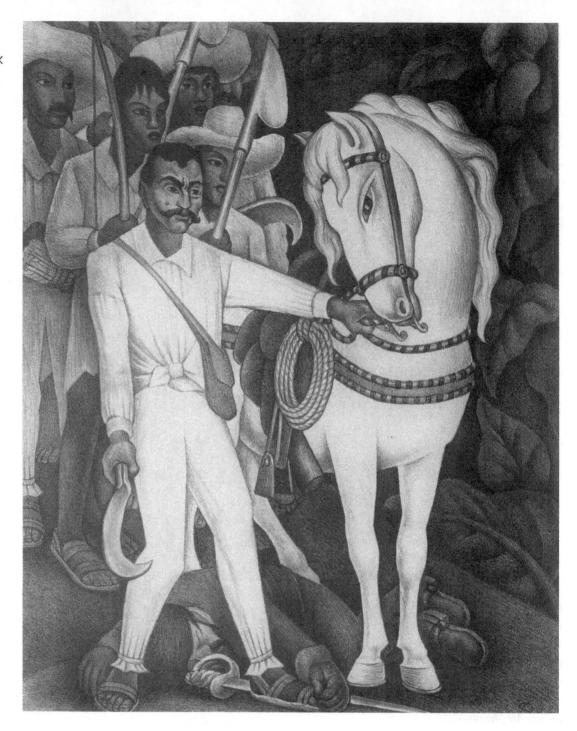

absorption and transformation of Indian culture by white, Spanish colonialization. The monk towers above his Indian charge as Brown does above the African Americans he defends.

Lithographs like Rivera's and Orozco's made the style and content of contemporary Mexican art accessible to a European and American audience. Very important for the appreciation of the Mexican mural and graphic tradition of the 1920s and 1930s was the French painter mentioned above, Jean Charlot. His *Picture Book* (1933), comprising thirty-two color lithographs accompanied by inscriptions by Paul Claudel, was conceived partly as a pictorial source-book in the vein of Turner's *Liber Studiorum*.[128] And, like Turner, who employed the best reproductive techniques of the early nineteenth century (a combination of line etching with

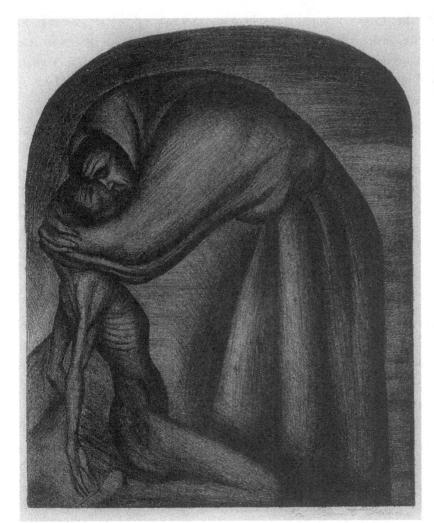

FIGURE 12.57
José Clemente Orozco.
The Franciscan and the
Indian. *1926. Lithograph.*
315 × 265. Cleveland
Museum of Art.

mezzotint and aquatint), Charlot turned to offset lithography, which was normally used for such commercial purposes as the photomechanical reproduction of paintings. In offset lithography, the image on the plate or stone is transferred or *offset* onto a rubber roller; the image is thus reversed, and then righted again in printing, which can be greatly accelerated because of the use of rollers and rotary presses, rather than the traditional presses of fine-art lithography. Charlot's choice of such a process for *original* prints was unusual. To achieve the colors, he worked from multiple zinc plates on which the key or outline image had been impressed. The printing was supervised by the artist and the printers of the Will A. and Lynton R. Kistler firm (run by a father and son) in Los Angeles.

Since *The Picture Book* was to be a representative compendium of Charlot's imagery, the Mexican scenes for which he was famous predominate. These pictures *of* the common people, conceived in plastically simplified forms derived from Pre-Columbian sculpture, were directed *to* the people as well, as Charlot himself explained:

> I also had the term "oleograph" in my head. It was a nineteenth-century word for color litho facsimiles of oil paintings. They even varnished them to fool people further. One of the things that guided me through life is that I don't like "art." That is, I don't like "art for art." What I am trying to do—tried even before I went to Mexico—is art for *people.*

That's why I like the Images d'Epinal [French vernacular political prints] so much, the Guadalupe Posadas, penny-sheets, pilgrimage sheets, and what-not. I meant to react against the "art" lithographs, such as those done by the Nabis: Bonnard, Vuillard, Maurice Denis. Granted that they are beautiful, they are such obvious works of art. All those ideas resulted in the *Picture Book*.[129]

Cargador (Stevedore), Plate 7 from *The Picture Book* (fig. 12.58), is a moving image of hard physical labor and the oppression of those who subsist on it. It reminds us of images of the peasant or urban worker as victim and martyr that we have discussed: Goya's *You Who Cannot* from the *Caprichos* (fig. 7.34), and Daumier's *Rue Transnonain* (fig. 8.22). The analogy drawn in the latter between the slain worker and the dead Christ is also present in Charlot's print, as the stevedore, arms outstretched, is bound to his burden. Claudel's crisp caption reinforces this analogy: "Crucified to the stone."[130]

THE CONTINUING TRADITION OF THE LANDSCAPE PRINT

Throughout the thirties and the forties, landscape maintained its perennial appeal for American printmakers. Like the calm before the storm, Thomas Nason's *Lyme Farm, Connecticut* (fig. 12.59), produced in 1929, presents an idealized image of rural America whose timelessness and stability are emphasized by the simplicity of Nason's style and the meticulousness of his wood-engraving technique.[131] Grant Wood's *March* (fig. 12.60), a lithograph of 1941, is not very different in its expression, despite the difference in date. An essential faith in the land and its apparently unfailing bounty prevails. Instead of the baroque dynamics of Benton and Curry, Wood developed a static style and flawlessly smooth surfaces reminiscent of early Renaissance painting, and his use of the lithographic crayon reflects his approach to painting. Despite Wood's satirical approach to midwesterners in prints and paintings, particularly the notorious *American Gothic* (1930; Art Institute of Chicago),[132] he depicted the rolling hills of his native Iowa with utter affection.

Wood's fields are plowed and inhabited, but the equally timeless north woods of Stow Wengenroth's *Untamed* (1947; fig. 12.61) are savage.[133] The primeval nature that fascinated nineteenth-century Americans will perhaps always be part of the American consciousness, no matter how urbanized and populous we become. Compare Gifford's *Old Trees* (fig. 12.19) or especially Moran's *Solitude* (fig. 12.26), where the same blasted trees and rugged undergrowth also create a simultaneously forbidding and appealing world. Wengenroth's masterly lithographic technique, accompanied by Miller's printing, is especially effective in the rendering of the misty distance with its overlapping conifers, and in the scraped streaks of rain that run diagonally across the image.

In contrast to Wengenroth's largely tonal images of the northwest woods and coasts, Harry Wickey's deeply bitten landscape etchings have a more purely linear energy. *Storm Sweeping the Hudson* (etching, 1933; fig. 12.62) reprises the primary subject of America's greatest nineteenth-century school of landscape painting: the Hudson River Valley. In Wickey's print, the valley is animated by a rapidly moving rainstorm, reminiscent of the storm in Rembrandt's *Three Trees* (fig. 4.45). The natural drama is augmented by Wickey's vigorous line and bold composition. Like Cropsey's images of Starucca Valley (see fig. 12.7), this landscape comfortably accommodates the railroad. Damage to his sight by overexposure to nitric acid fumes in 1935 caused Wickey to abandon the medium, and America lost one of its most original etchers.

FIGURE 12.58

Jean Charlot. Cargador:
Plate 7 of The Picture
Book. *1933. Offset color
lithograph. 206 ×
160 mm. Museum of
Fine Arts, Boston.*

WORLD WAR II AND ATELIER 17

With the Japanese bombing of Pearl Harbor in December 1941, the United States was launched into the Second World War. The Artists for Victory Exhibition, held a year later in the Metropolitan Museum of Art (which normally did not show the works of living American artists), was a huge display of the vitality of American art.[134] A. Hyatt Mayor interpreted the exhibition as a demonstration of patriotism and solidarity:

> This vast exhibition comes aptly at a time that stirs our country more deeply than it has been stirred since the Civil War. Then, as during the Revolution, Americans knew that what they were doing was history, and this knowledge gave force to our art. Today, in another such hour that seems to show the shape of victory to come, the vitality of this exhibition gives us one more affirmation of the strength that we are throwing into man's far-flung struggle.[135]

FIGURE 12.59

Thomas Nason. Lyme Farm, Connecticut. *1929. Wood engraving. 121 × 230 mm. Boston Public Library.*

FIGURE 12.60

Grant Wood. March. *1941. Lithograph. 226 × 301 mm. Library of Congress, Washington, D.C.*

The positive, patriotic spirit of the times was also embodied in the strident simplicity of polemical prints like Rockwell Kent's *Eternal Vigilance Is the Price of Liberty* (1945), a lithograph printed by Miller. World War II would be the last war that swept most Americans up in a tide of patriotism and solidarity. The Artists for Victory Exhibition featured 585 prints that, in general, expressed their nationalism by affirming the traditional American concern with the indigenous landscape and cityscape. First prize, for example, went to Sloan's *Fifth Avenue* (1941), an etching related to a painting of 1909.

But the early forties also saw the initiation of a more adventurous path in the foundation in New York in 1944 of Atelier 17, a printmaking studio run by Stanley William Hayter. Hayter had left its Paris counterpart, populated by European printmakers like Miró and Ernst, when war was declared in 1939. After a brief stay in his native England, Hayter came to New York in

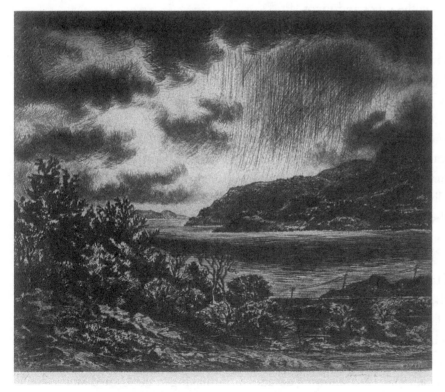

1940, and from that point on, the character of American printmaking would be changed by his impetus. Atelier 17 was not only a place where Americans could be inspired by exiled European artists, it was a place where ideas about all kinds of art were exchanged and new techniques were explored. Not the least of Hayter's gifts were his skill as a teacher and his passionate convictions about prints.[136]

Hayter's own prints often incorporated or were based solely on engraving—an unusual choice that allowed him to lend an old-master linear beauty to his abstract-Surrealist forms. Moreover, he insisted that artists learn the techniques of printmaking thoroughly, a practice that went against the usual dependence of Parisian painter-printmakers on master printers.[137] *Amazon* (etching with engraving, 1945; fig. 12.63) reveals the influence of Picasso, especially the figures in *Guernica* and closely related works such as *The Dream and Lie of Franco* (note the figure's uplifted head and open mouth), but also the sinuous contours and the antiquizing subjects of the *Vollard Suite* etchings (see Chapter 11). The continuous movement of the burin visible in *Amazon* is analogous to the contemporary emphasis on the hand and the brush in Abstract Expressionism: both, in turn, emerged from automatism and abstract Surrealism. The major figures in the Abstract Expressionist movement, however, were chiefly painters for whom prints were largely incidental aspects of their oeuvres. Field states:

> Hayter's prints were bogged down in technical sophistication. By contrast, painters like Rothko, Newman, Pollock, de Kooning, Tomlin and Gottlieb sought new images and techniques that would lead away from the fluent draftsmanly styles of the School of Paris (think of Picasso, Matisse, and Dali). Together the Americans created a new frontal, explosive force in painting that would be regarded as quintessentially American. Fussing around with copper plates or massive limestones did not attract their attention, which was focussed on large-scale gesture and mural-like canvases. An upsurge in American printmaking had indeed come from Hayter, but it did not then attract the major painters as it would during the 1960s and 1970s.[138]

But many superb printmakers, for whom prints were a central means of artistic expression, did emerge from the Atelier 17 experience. Mauricio Lasansky and Gabor Peterdi, artists we shall encounter again in Chapter 13, are two prominent examples.[139] Peterdi taught at Yale and Lasansky at the University of Iowa in Iowa City. Both institutions would prove very important for the development of American printmaking.

The 1940s were important years for American printmaking. Modernist prints gained force, while American landscape and social subjects in the hands of artists like Marsh or Wengenroth retained their vitality. Lack of space precludes an adequate survey of the proliferation of technical possibilities in American prints: the early silkscreens by artists such as Ben Shahn, the color lithographs of Stuart Davis and others, the plaster prints of Hayter, the experiments in textured soft-ground etching by Sue Fuller, the "cellocuts" of Boris Margo, which used plastic and acetone as raw materials, the use of photoengraving by Fred Becker—all of these were harbingers of the decades to come, in which complexity of technique ("cuisine") would become increasingly important to many printmakers.[140] This preoccupation is not the most interesting aspect of American prints of the fifties, sixties, and seventies, however. Rather, it is the struggle to combine the American concern for the natural and social environment with a modernism that was not merely and uneasily borrowed from Europe, but was truly American in appearance and meaning. In the following decades, printmaking in the United States would

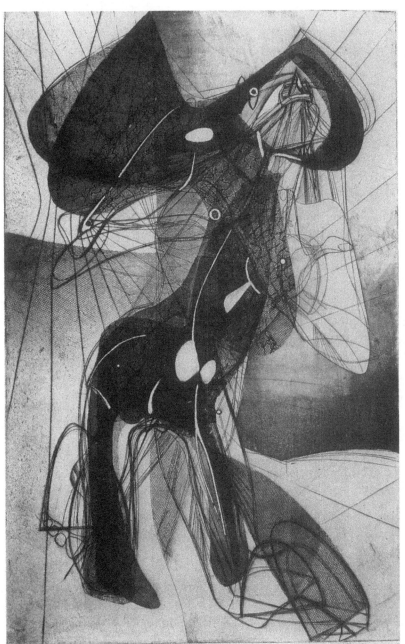

FIGURE 12.63
*Stanley William Hayter.
Amazon. 1945. En-
graving, etching and
embossing. 622 ×
403 mm. Museum of
Modern Art, New York.*

work its way through Abstract Expressionism—a uniquely American but largely abstract paint-
erly movement—to Pop Art, where a formalistic abstraction and American reality, still reti-
cently if astutely observed, finally came together.

For now, however, we return to the touchstone of early twentieth-century printmak-
ing—Picasso. The reader will not be surprised to find him still producing prints that are
technically, expressively, and intellectually provocative.

1. See Hitchings 1970, p. 97.

2. See Goldman 1981, p. 12.

3. On Foster, see Holman 1970.

4. Goldman 1981, p. 17.

5. Pelham's letter quoted in Shadwell 1969, p. 28.

6. Ibid., no. 33, p. 27.

7. Quoted in Goldman 1981, p. 20.

8. On Trumbull's paintings, see Cooper 1982, pp. 48–55. Also see Thistlethwaite 1988, esp. pp. 19–20.

9. On Trumbull's aspirations as a history painter, see Prown 1982.

10. Ibid., p. 38.

11. See Richardson 1964.

12. On Trumbull's *Declaration* and Durand, see Craven 1971; Hendricks 1971.

13. Craven 1971, pp. 55–57.

14. On the chromolithographic industry, see Marzio 1979.

15. Ibid., p. 5.

16. Quoted ibid.

17. Twain 1889, pp. 48–49, quoted in Marzio 1979, p. 119.

18. Marzio 1979, pp. 1–6.

19. Goldman 1981, pp. 22–23.

20. Marzio 1979, p. 33.

21. See Novak 1980 for a thorough study of the cultural and ideological aspects of nineteenth-century American landscapes.

22. Metropolitan Museum of Art 1988, pp. 210–13. On the railroad in American landscape art, see Novak 1980, pp. 157–84. On the railroad in American landscape prints, see Pierce 1988.

23. These lithographs illustrated Ferdinand V. Hayden's *The Yellowstone National Park and the Mountain Regions of Portions of Idaho, Nevada, Colorado and Utah,* published by Prang in Boston in 1876. Marzio 1979 discusses Prang in chap. 6. For a general study of Prang and the chromolithographic industry, see McClinton 1973.

24. Marzio 1979, pp. 108–9.

25. Truettner, ed., 1991 offers particularly controversial interpretations of the imagery of the West.

26. On *The Old Violin* and its reproduction, see Frankenstein 1953, pp. 73–78; Gerdts 1981, pp. 153–78. In an article on Harnett's *vanitas* still-lifes, Groseclose 1987 suggests that the artist may have been more ambivalent toward material wealth and success than most Americans.

27. Novak [1969] 1971, pp. 221–34, especially p. 223 for Emerson quotation. Also see Chirico 1985 for a refutation of Novak's Emersonian interpretation.

28. Marzio 1979, pp. 147–48.

29. Ibid., p. 105.

30. Ibid., pp. 10, 116–18.

31. Quoted ibid., p. 124.

32. Ibid.

33. Burns 1988, especially p. 40.

34. See Holzer 1980.

35. Marzio 1979, pp. 54–58; Morgan 1987.

36. Goldman 1981, p. 26. On Fanny Palmer, see Cowdrey 1962.

37. See Watrous 1984, p. 20.

38. On Homer's periodical illustrations, see Beam 1979.

39. Wilson 1988. Also see Stein 1990 for an analysis of Homer's pictorial undermining or questioning of the texts he illustrated.

40. Wilson 1988, especially pp. 35–41.

41. On the New School of wood-engraving, see Watrous 1984, pp. 20–27.

42. Richardson 1964, pp. 179–80.

43. On the importance of the French in the American etching revival, see Schneider 1982.

44. Other studies of the foundations of American late nineteenth-century etching are O'Brien and Mandel 1984; F. Tyler 1984; Bruhn 1985.

45. Quoted in Schneider 1982, p. 53.

46. Quoted in F. Tyler 1984, p. xii. Also on Koehler, see Ackley 1978; Clark 1980, pp. 85–86.

47. On Koehler's advocacy of retroussage, see Ackley 1978, p. 147.

48. O'Brien and Mandel 1984, pp. 15–17.

49. See F. Tyler 1984, especially p. xiii for quotation.

50. On Mary Nimmo Moran, see Friese 1984; O'Brien and Mandel 1984, pp. 35–36. On women in the etching revival in general, and Mary Nimmo Moran in particular, see Peet 1988, especially pp. 30–34; Lang and Lang, 1990, pp. 269–315

51. Lang and Lang, 1990, pp. 269–315.

52. Peet 1988, pp. 32–34, especially p. 32 for quotation.

53. For differences between Mary Nimmo Moran's and Thomas Moran's etchings, see Bruhn 1985, p. 28; Peet 1988, pp. 33–34.

54. On *Bridge at Glencoe,* see Morand and Friese 1986, no. 39, pp. 112–13. On Turner's influence, see Hults 1986, pp. 27–28.

55. Bruhn 1985, no. 17, pp. 48–50.

56. Ruskin [1843–60] 1888, vol. 3, part 4, pp. 256–57.

57. On plate size, see O'Brien and Mandel 1984, p. 8.

58. See Hults 1986, pp. 34–36.

59. On Gifford, see Hall 1974a, 1974b, 1986; Bruhn 1985, nos. 41–59, pp. 73–92.

60. Published as such in *Nature and Art* (1882), a compilation of poems and illustrations pillaged from the *American Art Review* by Estes and Lauriat, Boston. See Bruhn 1985, p. 18, and no. 47, p. 81.

61. See Witthoft 1987, p. 42.

62. Quoted in F. Tyler 1984, p. xxi.

63. Bruhn 1985, no. 73, p. 109.

64. O'Brien and Mandel 1984, no. 8, pp. 22–23.

65. Quoted in Bruhn 1985, no. 73, p. 109.

66. Ibid., pp. 93–94.

67. The most complete book on Homer's prints is Goodrich 1968. Also see Engel 1985.

68. Cikovsky 1990, pp. 81–89.

69. See Engel 1985, pp. 29–31, on *The Life Line.*

70. Stein 1990.

71. Engel 1985, pp. 29–30, on *The Iron Crown.* On Homer in Cullercoats, see Gerdts 1977.

72. Tatham 1983, p. 22; Engel 1985, pp. 34–35.

73. Flint 1978, especially p. 127 for quotation.

74. Quoted ibid., p. 129.

75. On *Solitude,* see ibid., p. 139; Morand and Friese 1986, no. 14, p. 73 and pp. 31, 43. In Bruhn 1990, a fundamental recent article analyzing and cataloguing Moran's lithographic production, questions about the cracking of *Solitude*'s stone and its inclusion in *Studies and Pictures* are plausibly answered. See especially pp. 13–14 and nos. 27, 30, and 31, p. 17.

76. Flint 1978, p. 134.

77. Goldman 1981, p. 39.

78. Pennell's etchings are catalogued in Wuerth 1928.

79. Rub 1984, p. 13.

80. See Baughman 1983 for an interesting essay on images of the urban complex.

81. On the antagonism between Brown and Pennell, see Adams 1988. Also see Gilmour 1988, pp. 324–26.

82. See Wilton 1980, nos. 85 and 86, pp. 168–69.

83. Watrous 1984, pp. 41–42.

84. On Dreiser and his connections to graphic artists, see Kwiat 1951.

85. Field 1983, pp. 7–29.

86. Quoted ibid., p. 11. Emphasis in original.

87. Watrous 1984, pp. 46–47.

88. On *The Masses,* see O'Neill 1966; Fitzgerald 1973; Field 1983, pp. 17–18; Zurier 1988.

89. See P. Morse 1969, nos. 127–38, pp. 134–49.

90. On Miller, see Flint 1976a; on Brown, see Adams 1986. Also see Gilmour, ed., 1988, pp. 324–26.

91. On Bellows' lithographs, see Mason 1977; Myers and Ayres 1988.

92. On Bellows' use of Goya's images, see Tufts 1971, 1983.

93. Quoted in Mason 1977, no. 49, p. 92.

94. Quoted ibid., no. 143, p. 184–85.

95. Ibid., nos. 51–66, pp. 95–110.

96. Quoted ibid., no. 57, p. 102.

97. On Lewis' prints, see Bruhn 1978; on Hopper's, see Levin 1979.

98. Field, Mancoff, and Urbanelli 1983, pp. 58–59.

99. Engel 1990, p. 211.

100. The classic study of the Armory Show is Brown 1963.

101. Field 1983, p. 16.

102. See Zigrosser 1969, pp. 4–5.

103. See Goldman 1981, pp. 46–49.

104. Rub 1984, pp. 14–15.

105. Zigrosser 1969, nos. 122 and 132.

106. On Davies' printed oeuvre, see Price 1929; Czestochowski 1976, 1987.

107. See Watrous 1984, pp. 66–67.

108. On Weber's prints, see Johnson 1948; Rubenstein 1980.

109. On the prints of Rockwell Kent, see Jones 1975.

110. Field 1983, pp. 20–21.

111. Quoted in O'Connor, ed. 1972, pp. 162–64. On Kainen's prints, see Flint 1976b.

112. See Adams 1983, pp. 136–49; Kiehl 1984, p. 108. On the early history of the silkscreen, see Williams and Williams 1986.

113. On Benton's prints, see Fath [1969] 1979; on Curry's, see Cole 1976.

114. On Marsh's prints, see Sasowsky 1976; on Soyer's, Cole 1967.

115. On Isabel Bishop's prints, see Johnson 1964.

116. Adams 1983, p. 141.

117. Jaffe 1987, pp. 38–45.

118. On black printmakers and the WPA, see King-Hammond 1989 (see p. 6 on Dox Thrash and the carborundum print).

119. Zigrosser 1941.

120. Quoted in Williams and Williams 1986, p. 288.

121. Cachin and Moffett 1983, nos. 104 and 105, pp. 272–80.

122. For overviews of Posada's prints, see Berdecio and Appelbaum 1972; R. Tyler, ed., 1979. R. Tyler 1979 provides a historical background for Posada's prints; Charlot 1979 discusses their influence.

123. On the *calaveras*, see Reuter 1979, pp. 73–75.

124. Klein 1963, no. 31, pp. 80–81.

125. R. Tyler 1979, ed., no. 228, p. 293; Charlot 1979, p. 46.

126. On the fresco cycle as a whole, see Detroit Institute of Arts, Founders Society 1986, pp. 269–73. Rivera also produced a movable fresco panel (in the Museum of Modern Art, New York) based on the image of Zapata in the Palacio de Cortés: see p. 186, fig. 334.

127. On Orozco's prints, see Hopkins 1967.

128. P. Morse 1976, nos. 116–52, pp. 80–113, especially pp. 84–89.

129. Quoted ibid., pp. 88–89.

130. Ibid., no. 127, p. 98.

131. On Nason's prints, see Comstock 1977.

132. On *American Gothic*, see Corn 1983, pp. 129–42.

133. On Wengenroth's prints, see Stuckey and Stuckey 1974.

134. On the Artists for Victory Exhibition, see Landau 1983.

135. Quoted in Watrous 1984, p. 127.

136. On Atelier 17, see Moser 1977, a fundamental study; Kainen 1986.

137. See Field 1981, p. 191.

138. Ibid.

139. On Lasansky's prints, see Fern 1975; on Peterdi's, see Johnson 1959.

140. These developments are covered extensively in Watrous 1984, chap. 5, pp. 126–71.

REFERENCES

Ackley, Clifford S. 1978. Sylvester Rosa Koehler and the American Etching Revival. In *Art and Commerce: American Prints of the Nineteenth Century*, pp. 143–50.

Adams, Clinton. 1983. *American Lithographers 1900–1960: The Artists and Their Printers*. Albuquerque.

Adams, Clinton. 1986. Bolton Brown: Artist-Lithographer. In Tatham, ed., 1986, pp. 213–41.

Adams, Clinton. 1988. The Imperious Mr. Pennell and the Implacable Mr. Brown. In O'Gorman, ed., 1988, pp. 159–76.

Art and Commerce: American Prints of the Nineteenth Century. 1978. Proceedings of a conference at the Boston Museum of Fine Arts, 1975. Charlottesville, Va.

Baughman, Sara D. 1983. Images of the Urban Complex. In Field et al. 1983, pp. 31–43.

Beam, Phillip C. 1979. *Winslow Homer's Magazine Engravings*. New York.

Berdecio, Roberto, and Stanley Appelbaum. 1972. *Posada's Popular Mexican Prints*. New York.

Brown, Milton W. 1963. *The Story of the Armory Show*. New York.

Bruhn, Thomas P. 1978. *The Graphic Work of Martin Lewis*. Exhibition catalog. William

Benton Museum of Art, University of Connecticut, Storrs.

Bruhn, Thomas P. 1985. *American Etching: The 1880s.* Exhibition catalog. William Benton Museum of Art, University of Connecticut, Storrs.

Bruhn, Thomas P. 1990. Thomas Moran's Painter-Lithographs. *Imprint,* vol. 15, no. 1 (Spring), pp. 2–19.

Burns, Sarah. 1988. Barefoot Boys and Other Country Children: Sentiment and Ideology in Nineteenth-Century American Art. *American Art Journal,* vol. 20, no. 1, pp. 25–50.

Cachin, Françoise, and Charles S. Moffett. 1983. *Manet 1832–1883,* Exhibition catalog with contributions by Anne Coffin Hanson and Michel Melot, and print entries by Juliet Wilson Bareau. Galeries Nationales du Grand Palais, Paris, and Metropolitan Museum of Art, New York.

Charlot, Jean. 1979. José Guadalupe Posada and His Successors. In R. Tyler, ed., 1979, pp. 29–57.

Chirico, Robert F. 1985. Language and Imagery in Late Nineteenth-Century Trompe l'Oeil. *Arts Magazine,* vol. 59 (March), pp. 110–14.

Cikovsky, Nicolai, Jr. 1990. *Winslow Homer.* New York.

Cikovsky, Nicolai, Jr., ed. 1990. *Winslow Homer: A Symposium. Studies in the History of Art,* vol. 26. Washington, D.C.

Clark, Cynthia. 1980. Five American Print Curators. *Print Collector's Newsletter,* vol. 11, no. 3, pp. 85–88.

Cole, Sylvan, Jr. 1967. *Raphael Soyer: 50 Years of Printmaking, 1917–1967.* New York.

Cole, Sylvan, Jr. 1976. *The Lithographs of John Steuart Curry: A Catalogue Raisonné.* New York.

Comstock, Francis Adams, and William G. Fletcher. 1977. *The Works of Thomas W. Nason.* Boston.

Cooper, Helen A. 1982. *John Trumbull: The Hand and Spirit of a Painter.* Exhibition catalog with essays by Patricia Mullan Burnham, Martin Price, Jules David Prown, Oswaldo Rodriguez Roque, Egon Verheyen, and Bryan Wolf. Yale University Art Gallery, New Haven, Conn.

Corn, Wanda. 1983. *Grant Wood: The Regionalist Vision.* New Haven, Conn.

Cowdrey, Mary Bartlett. 1962. Fanny Palmer, An American Lithographer. In Zigrosser, ed., 1962, pp. 217–34.

Craven, Wayne. 1971. Asher B. Durand's Career as an Engraver. *American Art Journal,* vol. 3, no. 1 (Spring), pp. 39–57.

Czestochowski, Joseph S. 1976. The Graphic Work of Arthur B. Davies. *American Art Review,* vol. 3 (July–August), pp. 102–13.

Czestochowski, Joseph S. 1987. *Arthur B. Davies: A Catalogue Raisonné of His Prints.* Newark, Del.

Detroit Institute of Arts, Founders Society. 1986. *Diego Rivera: A Retrospective.* Exhibition catalog with essays by Linda Downs, Jorge Hernández Campos, Alicia Azuela, et al. Detroit and New York.

Engel, Charlene S. 1985. For Those in Peril on the Sea: The Intaglio Prints of Winslow Homer. *Print Review,* vol. 20, pp. 23–39.

Engel, Charlene S. 1990. On the Art of Seeing Feelingly: Intaglio Prints by Edward Hopper. *Print Collector's Newsletter,* vol. 20, no. 6 (January–February), pp. 209–11.

Fath, Creekmore. [1969] 1979. *The Lithographs of Thomas Hart Benton.* New ed. Austin, Tex.

Fern, Alan. 1975. *Lasansky: Printmaker.* Iowa City.

Field, Richard S. 1981. Contemporary Trends. In Melot, Griffiths, and Field 1981, pp. 188–233.

Field, Richard S. 1983. Introduction to A Study of American Prints 1900–1950. In Field et al. 1983, pp. 7–29.

Field, Richard S., et al. 1983. *American Prints 1900–1950.* Exhibition catalog. Yale University Art Gallery, New Haven, Conn.

Field, Richard S., Debra N. Mancoff, and Lora S. Urbanelli. 1983. City Life. In Field et al. 1983, pp. 53–64.

Fitzgerald, Richard. 1973. *Art and Politics: Cartoonists of the Masses and Liberator.* Westport, Conn.

Flint, Janet. 1976a. *George C. Miller and American Lithography.* Exhibition catalog. National Collection of Fine Arts, Washington, D.C.

Flint, Janet. 1976b. *Jacob Kainen: Prints, a Retro-*

spective. Exhibition catalog. National Collection of Fine Arts, Washington, D.C.

Flint, Janet. 1978. The American Painter-Lithographer. In *Art and Commerce* 1978, pp. 127–42.

Frankenstein, Alfred. 1953. *After the Hunt: William Harnett and Other American Still Life Painters, 1870–1900*. Berkeley, Calif.

Friese, Nancy. 1984. *Prints of Nature: Poetic Etchings of Mary Nimmo Moran*. Exhibition catalog. Gilcrease Institute of American History and Art, Tulsa, Okla.

Gerdts, William H. 1977. Winslow Homer in Cullercoats. *Yale University Art Gallery Bulletin,* vol. 36, no. 2 (Spring), pp. 18–35.

Gerdts, William H. 1981. *Painters of the Humble Truth: Masterpieces of American Still-Life 1801–1939*. Columbia, Mo.

Gerdts, William H., and Mark Thistlethwaite. 1988. *Grand Illusions: History Painting in America*. Fort Worth, Tex.

Gilmour, Pat. 1988. Lithographic Collaboration: The Hand, the Head, the Heart. In Gilmour, ed., 1988, pp. 308–59.

Gilmour, Pat, ed., 1988. *Lasting Impressions: Lithography as Art*. London.

Goldman, Judith. 1981. *American Prints: Process and Proofs*. Exhibition catalog. Whitney Museum of American Art, New York.

Goodrich, Lloyd. 1968. *The Graphic Art of Winslow Homer*. Exhibition catalog. Museum of Graphic Art, New York, in association with Smithsonian Institution Press, Washington, D.C.

Groseclose, Barbara S. 1987. Vanity and the Artist: Some Still-Life Paintings by William Michael Harnett. *American Art Journal,* vol. 19, no. 1, pp. 51–59.

Hall, Elton. 1974a. *R. Swain Gifford*. New Bedford, Mass.

Hall, Elton. 1974b. R. Swain Gifford. *American Art Review,* vol. 1, no. 4, pp. 51–67.

Hall, Elton. 1986. R. Swain Gifford and the New York Etching Club. In Tatham, ed., 1986, pp. 183–212.

Hansen, T. Victoria. 1986. Thomas Moran and Nineteenth-Century Printmaking. In Morand and Friese 1986, pp. 13–20.

Hendricks, Gordon. 1971. Durand, Maverick and the *Declaration. American Art Journal,* vol. 3, no. 1 (Spring), pp. 58–71.

Hitchings, Sinclair. 1970. The Graphic Arts in Colonial New England. In J. Morse, ed., 1970, pp. 75–109.

Holman, Richard. 1970. Seventeenth-Century American Prints. In J. Morse, ed., 1970, pp. 23–52.

Holzer, Harold. 1980. The Making of a President? Engravings and Lithographs of Abraham Lincoln. *Connoisseur,* vol. 203, no. 816 (February), pp. 77–91.

Hopkins, Jon H. 1967. *Orozco: A Catalogue Raisonné of His Graphic Work*. Flagstaff, Ariz.

Hults, Linda C. 1986. Thomas Moran and the Landscape Print. In Morand and Friese 1986, pp. 21–38.

Jaffe, Irma B. 1987. Religious Content in the Painting of John Steuart Curry. *Winterthur Portfolio,* vol. 22, no. 1 (Spring), pp. 23–45.

Johnson, Una E. 1948. The Woodcuts and Lithographs of Max Weber. *Brooklyn Museum Bulletin,* vol. 9, no. 4, pp. 7–12.

Johnson, Una E. 1959. *Gabor Peterdi: Twenty-Five Years of His Prints, 1934–1959*. Exhibition catalog. Brooklyn Museum of Art, New York.

Johnson, Una E. 1964. *Isabel Bishop: Prints and Drawings, 1925–1964*. Exhibition catalog. Brooklyn Museum of Art, New York.

Jones, Dan Burne. 1975. *The Prints of Rockwell Kent: A Catalogue Raisonné*. Chicago.

Kainen, Jacob. 1972. The Graphic Arts Division of the WPA Federal Arts Project. In O'Connor, ed., 1972, pp. 155–75.

Kainen, Jacob. 1986. An Interview with Stanley William Hayter. *Arts Magazine,* vol. 60 (January), pp. 64–67.

Kiehl, David W. 1984. American Printmaking in the 1930s: Some Observations. *Print Quarterly,* vol. 1, no. 1, pp. 96–111.

King-Hammond, Leslie. 1989. *Black Printmakers and the W.P.A.* Exhibition catalog. Lehman College Art Gallery, City University of New York, Bronx.

Klein, H. Arthur. 1963. *Graphic Worlds of Peter Bruegel the Elder*. New York.

Kwiat, Joseph J. 1951. Dreiser and the Graphic

Artist. *American Quarterly,* vol. 3, no. 2, pp. 127–41.

Landau, Ellen G. 1983. *Artists for Victory: An Exhibition Catalogue.* Library of Congress, Washington, D.C.

Lang, Gladys Engel, and Kurt Lang. 1990. *Etched in Memory: The Building and Survival of Artistic Reputation.* Chapel Hill, N.C.

Levin, Gail. 1979. *Edward Hopper: The Complete Prints.* New York.

McClinton, Katherine M. 1973. *The Chromolithographs of Louis Prang.* New York.

Marzio, Peter C. 1979. *The Democratic Art: Chromolithography 1840–1900—Pictures for a Nineteenth-Century America.* Boston.

Mason, Lauris. 1977. *The Lithographs of George Bellows: A Catalogue Raisonné.* Millwood, N.Y.

Melot, Michel, Antony Griffiths, and Richard S. Field. 1981. *Prints: History of an Art.* New York.

Metropolitan Museum of Art. 1988. *American Paradise: The World of the Hudson River School.* Exhibition catalog with essays by Kevin J. Avery, Oswaldo Rodriguez Roque, John K. Howat, Doreen Bolder Burke, and Catherine Hoover Voorsanger. New York.

Morand, Anne, and Nancy Friese. 1986. *The Prints of Thomas Moran in the Thomas Gilcrease Institute of American History and Art.* Exhibition catalog. Tulsa, Okla.

Morgan, Ann Lee. 1987. The American Audubons: Julius Bien's Lithographed Edition. *Print Quarterly,* vol. 4, no. 4 (December), pp. 362–79.

Morse, John D., ed. 1970. *Prints in and of America to 1850.* Winterthur Conference Report. Charlottesville, Va.

Morse, Peter. 1969. *John Sloan's Prints: A Catalogue Raisonné of the Etchings, Lithographs and Posters.* New Haven, Conn.

Morse, Peter. 1976. *Jean Charlot's Prints: A Catalogue Raisonné.* Honolulu.

Moser, Joann. 1977. *Atelier 17: A 50th Anniversary Retrospective Exhibition.* Exhibition catalog. Elvehjem Museum of Art, University of Wisconsin, Madison.

Myers, Jane, and Linda Ayres. 1988. *George Bellows: The Artist and His Lithographs 1916–1924.* Exhibition catalog. Amon Carter Museum, Fort Worth, Tex.

Novak, Barbara. [1969] 1971. *American Painting of the Nineteenth Century.* Reprint ed. New York.

Novak, Barbara. 1980. *Nature and Culture: American Landscape Painting 1825–1875.* New York.

O'Brien, Maureen, and Patricia C. F. Mandel. 1984. *The American Painter-Etcher Movement.* Exhibition catalog. Parrish Art Museum, Southampton, N.Y.

O'Connor, Francis V., ed. 1972. *The New Deal Art Projects: An Anthology of Memoirs.* Washington, D.C.

O'Gorman, James F., ed. 1988. *Aspects of American Printmaking, 1800–1950.* Syracuse, N.Y.

O'Neill, William. 1966. *Echoes of Revolt: The Masses.* Chicago.

Peet, Phyllis. 1988. *American Women of the Etching Revival.* Exhibition catalog. High Museum of Art, Atlanta.

Pierce, Sally. 1988. The Railroad in the Pasture. In O'Gorman, ed., 1988, pp. 53–80.

Price, Frederic Newlin. 1929. *The Etchings and Lithographs of Arthur B. Davies.* New York.

Prown, Jules David. 1982. John Trumbull as History Painter. In Cooper 1982, pp. 22–41.

Reuter, Jas. 1979. The Popular Traditions. In R. Tyler, ed., 1979, pp. 59–84.

Richardson, E. P. 1964. Charles Willson Peale's Engravings in the Year of National Crisis, 1787. *Winterthur Portfolio,* vol. 1, pp. 166–81.

Rub, Timothy F. 1984. American Architectural Prints. *Print Review,* vol. 18, pp. 6–19.

Rubenstein, Daryl R. 1980. *Max Weber: Prints and Color Variations.* Exhibition catalog. National Collection of Fine Arts, Washington, D.C.

Ruskin, John. [1843–60] 1888. *Modern Painters.* 5 vols. Sunnyside, Orpington, Kent, England.

Sasowsky, Norman. 1976. *The Prints of Reginald Marsh.* New York.

Schneider, Rona. 1982. The American Etching Revival: Its French Sources and Early Years. *American Art Journal,* vol. 14, no. 4, pp. 40–65.

Shadwell, Wendy J. 1969. *American Printmaking: The First 150 Years.* Exhibition catalog. Museum of Graphic Art, New York, in associa-

tion with Smithsonian Institution Press, Washington, D.C.

Simpson, Marc. 1988. *Winslow Homer: Paintings of the Civil War*. Exhibition catalog with contributions by Nicolai Cikovsky, Jr., Lucretia Hoover Giese, Kristin Hoermann, Sally Mills, and Christopher Kent Wilson. Fine Arts Museums of San Francisco.

Stein, Roger B. 1990. Picture and Text: The Literary World of Winslow Homer. In Cikovsky, ed., 1988, pp. 33–59.

Stuckey, Ronald, and Joan Stuckey. 1974. *The Lithographs of Stow Wengenroth, 1931–1972*. With essays by Albert Reese, Sinclair Hitchings, and Paul Swenson. Boston.

Tatham, David. 1983. *Winslow Homer in the 1880s: Watercolors, Drawings and Etchings*. Syracuse, N.Y.

Tatham, David, ed. 1986. *Prints and Printmakers of New York State*. Syracuse, N.Y.

Thistlethwaite, Mark. 1988. The Most Important Themes: History Painting and Its Place in American Art. In Gerdts and Thistlethwaite 1988, pp. 7–58.

Truettner, William H., ed. 1991. *The West as America: Reinterpreting Images of the Frontier, 1820–1920*. Exhibition catalog with essays by William H. Truettner, Nancy Alexander, and Alex Nemerov. National Museum of American Art, Washington, D.C.

Tufts, Eleanor. 1971. Bellows and Goya. *Art Journal*, vol. 30 (Summer), pp. 362–68.

Tufts, Eleanor. 1983. Realism Revisited: Goya's Impact on George Bellows and Other American Responses to the Spanish Presence in Art. *Arts Magazine*, vol. 57 (February), pp. 105–13.

Twain, Mark [Samuel Langhorne Clemens]. 1889. *A Connecticut Yankee in King Arthur's Court*. New York.

Tyler, Francine. 1984. *American Etchings of the Nineteenth Century*. New York.

Tyler, Ron. 1979. Posada's Mexico. In R. Tyler, ed., 1979, pp. 3–27.

Tyler, Ron, ed. 1979. *Posada's Mexico*. Exhibition catalog with contributions by Jean Charlot, Jas Reuter, Joyce Waddell Baily, and Jacques LaFaye. Library of Congress, Washington, D.C.

Watrous, James. 1984. *A Century of American Printmaking, 1880–1980*. Madison, Wis.

Williams, Reba, and Dave Williams. 1986. The Early History of the Screenprint. *Print Quarterly*, vol. 3, no. 4 (December), pp. 286–321.

Wilson, Christopher Kent. 1988. Marks of Honor and Death: *Sharpshooter* and the Peninsular Campaign of 1862. In Simpson 1988, pp. 25–45.

Wilton, Andrew. 1980. *Turner and the Sublime*. Exhibition catalog. Art Gallery of Ontario, Toronto.

Witthoft, Brucia. 1987. The History of James Smillie's Engraving after Albert Bierstadt's *The Rocky Mountains. American Art Journal*, vol. 19, no. 2, pp. 40–49.

Wuerth, Louis A. 1928. *Catalogue of the Etchings of Joseph Pennell*. Boston.

Zigrosser, Carl. 1941. The Serigraph, a New Medium. *Print Collector's Quarterly*, vol. 28, no. 4 (December), pp. 443–77.

Zigrosser, Carl, ed. 1962. *Prints: Thirteen Illustrated Essays on the Art of the Print, Selected for the Print Council of America by Carl Zigrosser*. New York.

Zigrosser, Carl. 1969. *The Complete Etchings of John Marin*. Exhibition catalog. Philadelphia Museum of Art.

Zurier, Rebecca. 1988. *Art for the Masses: A Radical Magazine and Its Graphics, 1911–1917*. Philadelphia.

13

Printmaking in Europe and

America after World War II

PICASSO

So far, we have been concerned primarily with Picasso's intaglio prints and have noted his gifts for technical experiment and trenchant imagery. As we shall see in this chapter, Picasso did not cease to be fascinated by the intaglio processes. But his work in lithography and linoleum cut, two techniques that he took up in earnest after the Second World War, is no less compelling and original.

During the bitter winter of 1945, Picasso's sojourn in the studio of the printer Fernand Mourlot in Paris signaled a new foray into lithography that proved crucial for the future of the medium. Although a colorful legend claims that the fact that Mourlot's shop was heated moved Picasso to work there, a more plausible impetus may have been Braque's recommendation of the printer.[1] By 1945 Picasso had produced twenty-seven lithographs, including the technically conventional *Face* (fig. 11.54). But his lithographs of the late forties took on a new character. Under the supervision of Mourlot and his assistants, Picasso brought new life to this medium, which, despite the strides of the 1890s, was still constrained by its commercial and reproductive function. He utilized any tools he thought appropriate: assorted brushes, knives, emery boards, even glue (for reserving the whites). The master printer's response to the artist's unorthodox procedures contains a mixture of bewilderment and admiration: "He listened carefully, then did the opposite of what he had been taught, and it worked. He always proceeded like this

whatever he did; the way in which he worked the lithographic stone was not merely contrary to custom, but contrary to the most basic rules of the craft."[2]

The numerous versions and states within versions of *Woman in an Armchair* (1949), a portrait of his mistress, the painter Françoise Gilot, in a Polish coat with big, embroidered sleeves, best illustrate Picasso's fruitful volatility in printmaking. He had initially intended to make a color lithograph from five zinc plates. However, liking the black and white image, he abandoned this idea and worked on the plates separately. When the zinc began to wear out, Mourlot transferred the images to new plates so the process could continue.

Figures 13.1 and 13.2 are the two out of the total of ten states that Picasso produced from the plate originally intended for the red printing. In the fifth state (fig. 13.1), Synthetic Cubist in style, the breasts are target-like whorls. Active patterns in the chair back and garments vie with each other, and the enlarged right hand, companion to the restless glance, projects toward the viewer. The whole surface of the print, like a checkerboard, is activated by staccato contrasts of black and white, forward and back.

The calm, majestic image of the final state (fig. 13.2) is very different. Here, Picasso seems to have been inspired in part by Velásquez's portraits of Spanish princesses, with their commanding but vulnerable glances and their overblown costumes with broadly arching curves and flat, glittering surfaces. Picasso made Gilot into a modern *Infanta* while keeping her as his beloved mistress. Between the full sleeves, her softly modeled torso and breast are bared. The stable, central vertical of the spine—a constant throughout the ten variations—serves as an anchor for the ballooning sleeves and hair and as a pedestal for the egg-shaped head with its hypnotic, Byzantine eyes.

Not all of Picasso's lithographs were this complicated. One of his simplest and most beautiful conceptions is *The Dove* (1949; fig. 13.3), a black and white lithograph actually modeled, as Gilot recounts, after one of Matisse's pigeons with feathered feet. Working at home on a zinc plate, Picasso thinned lithographic tusche with petrol to achieve very transparent grays.[3] Just as important as the technical verve is Picasso's rendering of the stance of the animal and the softness of its body: the head tilts inquisitively toward us as the pigeon surveys us with one bright eye. Perhaps some of the poignancy of this work derives from Picasso's memory of his father, whose specialty was painting pigeons; the young Pablo was sometimes entrusted with details such as the feet.[4] But *The Dove* took on a meaning that superseded this autobiographical dimension. Shortly after Picasso created the lithograph, the novelist and poet Louis Aragon, a leader in the French Communist Party, came to his studio to remind him of an unfulfilled pledge. Picasso had promised a sketch for a poster advertising the upcoming World Peace Conference, sponsored by the Party. It was Aragon who promoted Matisse's humble pigeon to a dove, universal symbol of peace.

When the seventy-seven-year-old Picasso moved with Jacqueline Roque (who would become his second wife) to the Chateau de Vauvenargues near Aix-en-Provence in 1958, the process of producing lithographs and waiting for proofs to come back from Mourlot's Paris shop became cumbersome and time-consuming. For Picasso, the work of art was not some slowly calculated game played out to a perfect conclusion, but a record of changing and changeable insights.

In the small village of Vallauris near Cannes was a pottery shop where Picasso had worked occasionally since 1947. He contributed to the civic life of the town by making posters to advertise its bullfights and ceramic industry. The local printer, Hidalgo Arnéra, suggested the

FIGURE 13.1
Pablo Picasso. Woman in
an Armchair, No. 1, *fifth
state. 1949. Lithograph.
700 × 550 mm. Musée
Picasso, Paris.*

relief method of linoleum cut (or linocut) to the painter, who began to explore this unassuming
and inexpensive technique. As Pat Gilmour stresses, Arnéra's willingness to supply the artist
with proofs day or night contributed much to Picasso's enthusiasm.[5] He had made about a
dozen relief prints in wood, but had remained uninspired by the process, much preferring the
greater flexibility of etching and even lithography.

FIGURE 13.2

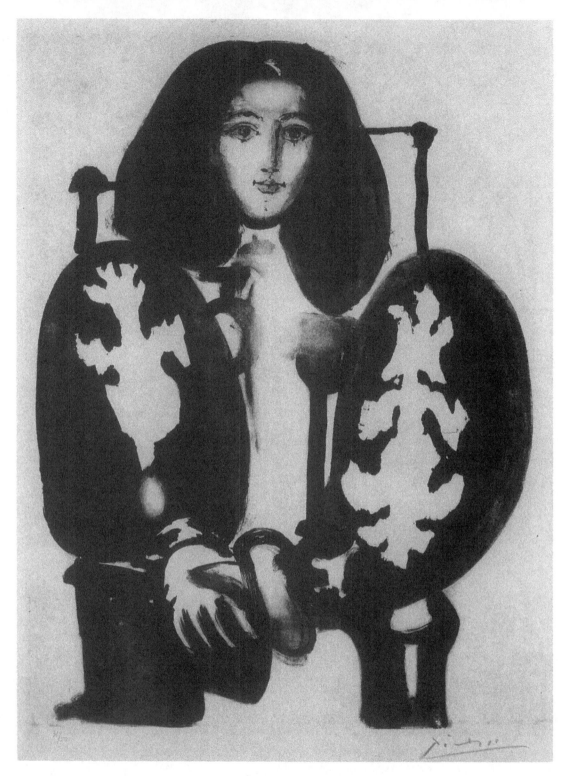

Pablo Picasso. Woman
in an Armchair, No. 1,
*final state. 1949.
Lithograph. 700 ×
550 mm. Museum of
Modern Art,
New York.*

We have seen linocut used earlier by Moholy-Nagy and Matisse, but the linocut began to
be taken more seriously as a graphic medium when Picasso transformed it. *Bust of a Woman*
(1958; fig. 13.4) was done after a portrait by Lucas Cranach the Younger in Vienna (1564), a
postcard of which had been sent to Picasso by his friend, the art dealer Daniel-Henry Kahn-
weiler.[6] Characteristically, the face is adapted from that of his current wife or lover (in this case,
Jacqueline Roque), but the rest of the figure is a bemused tribute to the Cranach family style,

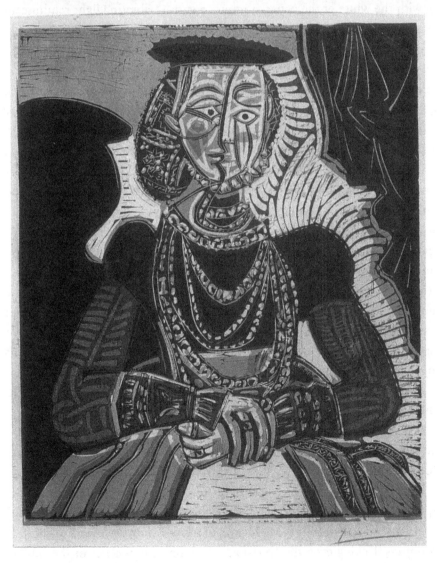

with its obsessive repetition of patterns and ostentatious clothing. It is a very complex print because of the number of blocks requiring registration. Although it crackles with energy, Picasso was unhappy with it.

In the following year, he developed a method that obviated the need to register the blocks and wait for the ink to dry, which Picasso hated.[7] It also perfectly embodied his famous description of the picture as a "sum of destructions."[8] Employing only one block, Picasso carved and reprinted it repeatedly, removing entire sections as he worked. The block would first be printed in a single color. Areas of white could be reserved at this point, not only by carving away, but also by the placement of cut-out paper on the inked block. Then an image in a second color would be painted on, and the parts of the block around this image carved away. Within the forms defined by the second color, a third-stage image would be created with another color. The parts of the block defined by the second color would next be carved away. At any point, Picasso could make incised lines through the ink, reminiscent of the interior modeling lines incised through the slip in ancient Greek black-figure pottery. This process could continue until only thin strips of the block remained: essentially, the artist worked from the exterior to the interior of his forms.[9] The aggressive, vaguely sinister *Still Life with Glass under the Lamp* (1962; fig. 13.5, color plate, p. 483) was produced with the new technique. The yellow ink was printed first. Along with the white of the paper, it creates a garish, vibrating light reminiscent of Van Gogh. The red ink was applied next, then the olive-green, then the black. The thin lines created by incision along the sides or through the color areas reveal hints of the yellow and white that were part of the initial step.

Despite his exploration of lithography and linocut, intaglio printmaking remained Picasso's mainstay. In 1968 he illustrated Fernand Crommelynck's play, *Le Cocu Magnifique* (*The Magnificent Cuckold*), a farce about a jealous husband published in 1966. In Plate 12 (fig. 13.6), Picasso suggested the myth of Apollo and Daphne. As the bearded male figure, reminiscent of the sculptor from the *Vollard Suite* etchings (see figs. 11.30, 11.32), reaches for the voluptuous female, she eludes him, her head thrown back and her left arm raised and metamorphosing into some foliate appendage. Picasso employed scraping and burnishing to give her body a swift, ephemeral intangibility, set off against a deep black background. The male, equally composed of scratches and scrapes, is far more solid, but his sensitively modeled face with its yearning expression makes it clear that he cannot possess the woman.

In *Suite 347* (1968), a series of 347 etchings, an eighty-seven-year-old Picasso, with the help of master printer Aldo Crommelynck, Fernand's son, recombined various characters from his prolific oeuvre and the history of art into amusing, poignant, or outrageously frank, even pornographic, images.[10] Harlequins, clowns, equestriennes, prostitutes and their *dueñas* (this motif recalling Goya's *Caprichos*), musketeers, Rembrandt, Velásquez, Raphael, and Picasso himself (as a hoary satyr or dwarfish, infantile old man) populate these rambling narratives. In *347*, Picasso's art, life, and fantasies, past and current, expand in front of him like a bizarre circus, while he must stand and watch, wanting to participate but prevented by age.

Like much of Picasso's late work, the *347* prints have been variously evaluated. Mary Mathews Gedo, for example, scathingly describes them as "empty virtuoso performances which demonstrate Picasso's mastery of all the tricks of the trade, here presented as a goal rather than a means to expression." Like all his late oeuvre, she claims, *Suite 347* is "an unending, self-indulgent rumination," and she points out the reduction of women in these images to complacent, posturing sex objects, lacking even the appealing, affectionate innocence of the women

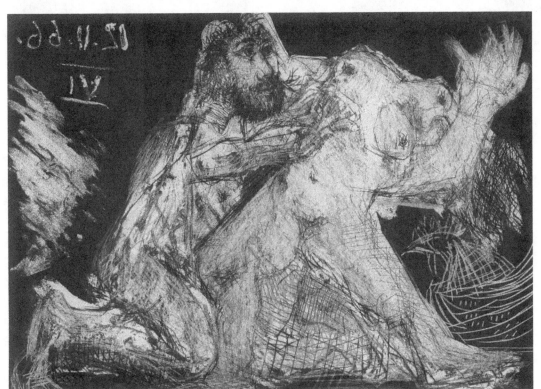

FIGURE 13.6

Pablo Picasso. Plate 12 of Le Cocu Magnifique (The Magnificent Cuckold) *by Fernand Crommelynck. Paris: Editions de l'Atelier Crommelyck, 1968. Etching, aquatint and drypoint. 222 × 320 mm. Museum of Modern Art, New York.*

of *The Vollard Suite*.[11] Certainly, *Suite 347* as a whole may be justifiably critiqued on these grounds. The individual prints, however, often contain moments of technical and formal brilliance. Like *The Vollard Suite* created some thirty years before, many of the *347* images reveal the power and malleability of pure etched line. And most impressive is the way in which Picasso handled the sugar-lift method, even introducing globules of grease onto the plates in defiance of proper technique. Wherever the grease droplets occurred, the grainy aquatint areas were interrupted. With this unconventional method, Picasso, in Gilmour's words, "tickled kittens, lace mantillas, and musketeers' whiskers magically into existence."[12]

Scholars have been most fascinated, however, with the reflection of the aged artist's psychology in the *347* prints, for the series is part of the theater of self-revelation staged in the prints of Picasso's last years.[13] One major theme he explored—and this comes as no surprise by now—is the male artist's desire for the women he paints, and his confusion of creativity and sexual desire. The protagonist of the twenty-two best-known *347* prints (see fig. 13.7) is Raphael. In these compositions based on Ingres's *Raphael and the Fornarina*—known in various versions, one of which (1814) is in the Fogg Art Museum—Picasso once again takes up the problematic relationships of artist and model and of the conflicting but closely linked aspirations for life (collapsed into one of its aspects—sexuality) and for art. In Ingres's painting, a beautiful girl ("la fornarina" means "the baker's daughter") is poised as curvingly and passively as a warm cat on the artist's lap, while he looks away from her to his canvas. Behind him is *The Transfiguration of Christ*. For French artists, this was Raphael's greatest masterpiece, which he was able to conceive despite the pesky distraction of the woman.

Leo Steinberg asserts that it is too easy to attribute Picasso's etched essays on Ingres's painting to the lust of the aged artist.[14] Picasso himself said that the "Raphael and La Fornarina" prints were about more than sex: they also had to do, he said cryptically, with "historical

FIGURE 13.7

Pablo Picasso. Raphael
and the Fornarina: *No.
317 from* Suite 347. *1968.
Etching. 150 × 205 mm.
Galerie Louise Leiris,
Paris.*

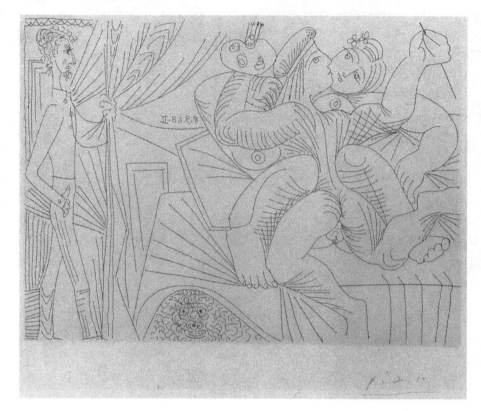

facts."[15] We might speculate that these historical facts concern the position of the artist within society and with respect to the visual reality he confronts. Like many other avant-garde artists, Picasso was fully aware of the tradition he assaulted. He created with a mixture of struggle, defiance, reverence, and humor, with figures like Michelangelo, Rembrandt, and Velásquez, whom art history had made into sacred cows, spying on him "from behind draperies and under the bed." In Gert Schiff's analysis, the prints of Raphael and the Fornarina merge the acts of love (creation in life) and painting (creation in art) into one vital life-statement.[16] The artist is drawn from his easel by the model on the couch and repeatedly makes love to her, palette still in hand and brush sometimes applied directly to her body. The woman is perceived as the object of both the erotic and the artistic gaze of the male, precluding her assumption of the active, creative role of the artist. The images work sequentially as a struggle between and gradual balancing of coitus and painting, so that in the final image, as Steinberg describes it, the painter is a "lovemaker in action, gratifying his love, but upright and seen from behind against an extended plane, like one making a fresco."[17] Appropriately, the circular painting (tondo) of the nude the artist was painting at the beginning of the sequence, which grew smaller throughout, has now disappeared.

Raphael's legendary amorousness, promulgated by Vasari in his *Lives,* was an "affliction" commonly ascribed to artists. Like melancholy, it was an occupational hazard. Perhaps Picasso, currently married to the young Jacqueline and with a lifetime of relationships with women behind him, identified more with this "disease" than that of Dürer's *Melencolia I.* The distracting woman with the wide Grecian eyes, spherical breasts, and aquiline nose is not one character but a conflation of many. Along with the lovemaking couple, other intriguing personages appear: a seated Pope-voyeur who can only sit by and peer lustfully at the couple, and a scraggly

"dogsbody" or "underbed phantasm" (Steinberg's words), who is described by Picasso as Michelangelo, but whose hairy, bulbous features also resemble Rembrandt's in early etched self-portraits. As Janie Cohen has discussed in detail, Rembrandt's prints preoccupied Picasso during his last years.[18] In part, the youthful lovemaking artist spied upon by father-figures like Rembrandt plays upon the Oedipus complex, with the son making love to the mother under the jealous gaze of the father. At the same time, Raphael is also the "Father" of painting, as Baer puts it, and the various Peeping Toms are fascinated not so much with Raphael's sexual antics as with his artistic creation.[19]

Like so many of the characters in Picasso's self-mythologizing imagery, these figures are difficult to pin down. Something in Norman Bryson's recent assessment rings true, however: "Above all, Picasso understands the fate of artistic latecoming, understands it perhaps even more urgently than Ingres, as a struggle which in the end (for Picasso) can only be resolved by radical violence—art as an act of defiant procreation conducted under the gaze of history and authority."[20] The spying characters of the Raphael and the Fornarina sequence of *347* are the authorities of history and art by whom Picasso's art will be watched and judged, but who cannot, in the last analysis, contribute to the artist's performance.

OTHER EUROPEAN MODERNISTS

Picasso's deep involvement in the graphic processes was an exception among modern European "old masters" in the decade or so after the war. Braque, Chagall, Miró, and others continued to produce prints, but largely as an extension and advertisement of their painting. In the postwar atmosphere of Europe as well as America, a newly interpreted Expressionism and Surrealism grew more important in both painting and printmaking.[21] On both sides of the Atlantic, however, there was frustration with the incapacity of past styles, even avant-garde ones, to express the ravaged psyche of twentieth-century humanity. The poetic fragmentation of Cubism had hardened into an academic style, and Surrealism had become too literary and theatrical. This was the era of Jean-Paul Sartre's existentialism and the more skeptical, post-existential stance of Albert Camus. Western civilization was felt to be empty: neither its metaphysical philosophies nor its intellectualizing art could apprehend the present absurdity of the world. Ultimately, this apprehension was left to the individual, essentially alone, defined solely by free will and whatever choices he or she might make in confronting uncontrollable or non-sensical events. The younger generation of artists wanted a complete reformulation of the basis of art.

As Dore Ashton has pointed out, this desire took the form of an abandonment or an ironic treatment of the human figure—*the* great subject in western art.[22] Both approaches are found in the art of Jean Dubuffet. After abandoning art in disgust to become a wine merchant, he came back to his chosen profession in 1942 determined to shed all its art-historical and intellectual baggage. In 1923 Dubuffet had been deeply influenced by Hans Prinzhorn's book on the art of the mentally ill. This imagery, as well as the art of tribal peoples and children, even the angry or scatological graffiti scribbled on urban walls,[23] became the basis for Dubuffet's rejection of western civilization's analytical, logical perspective: there was no separation between humanity and nature, no distinction between Art and expression, and no inherent value in traditional artistic methods or materials. Dubuffet's interests, summarized by the

epithet *l'art brut,* constitute a more radical version of the primitivism that we have already observed.[24] But like the prints of Gauguin, Munch, and the German Expressionists, Dubuffet's graphic work belies its primitivistic ideology with technical and conceptual complexity. The artist himself evaded the label of *l'art brut:* "I don't merit it, I'm not worthy. . . . I have never managed to rid myself completely of the influence of cultural art."[25]

It was in lithography, the traditional realm of the painter-printmaker working with a master artisan, that Dubuffet made the greatest impact on the history of prints. Despite the radical nature of his methods, he worked with no fewer than five lithographic workshops, each of which adapted traditional knowledge to the artist's goals. Dubuffet's experiments in lithography included not only the imprinting of manufactured or natural materials (bark, orange peel, straw, dirt) and various liquids on stones or plates, but also burning or blotting them. His *Phenomena* series included several hundred prints, in twenty-two albums, produced between 1958 and 1962. It is one of the most ambitious printmaking projects of the postwar era, explained in depth by Dubuffet himself. The basic plates of *Phenomena* were to be capable of

> being superimposed on every other. . . . I wished to use equally unorganized, flat surfaces, leaving full play to disorder and chance . . . because such images seemed more suitable to the careful study I was planning. . . . There was this reason, too, that such undefined images, not centered at all, contrary to all concepts of balanced composition and geometric principles, of such form that they appear as fragments drawn from vast open surfaces, belonging to the order of forms and textures where natural forces alone are manifest, where there is no sign of human intervention, these forms aroused my curiosity and interest and held for me an appeal I could not help succumbing to.[26]

Thus, the chance textures of a black and white print like *Rock Foam* (1959; fig. 13.8), included in the *Water, Stone, Sand* album, were part of a textural repertory that Dubuffet could use in many combinations in color lithographs. He remarked, however, that the black and white prints, with titles like *Hair, Dancing Gas, Mud and Ravines,* or *Wounds,* had their own appeal and suggestiveness. Sometimes they were named by a worker in the print shop, sometimes by the artist. ("It is enlightening to see," said Dubuffet, "to what extent the artist's function consists of *naming* things as much as creating pictures.")[27]

The color prints, such as *Scintillation* (1960; fig. 13.9), made of the initially black and white stones or plates inked in color, are fascinating palimpsests of textures. In their uncomposed, "overall" quality and layered complexity, these bear comparison to Jackson Pollock's more famous labyrinthine drip paintings. In a further permutation within *Phenomena* that he dubbed "transfers of assemblages," Dubuffet also used cut-out color proofs in collages that then served as maquettes for new lithographs. Here, he combined chance, the technology of lithography, and the modern medium of collage. The parts of the stones or plates (reflected in the cut-out collage components) to be used in the final lithograph had to be transferred to a new stone or plate—a process complicated by the multicolored nature of the collage-parts, for as many transfers were required as colors.

One such "transfer of assemblage" is *Sleepwalker* (1961; fig. 13.10). In this print, a crude, big-footed figure is suspended in a celestial-terrestrial "landscape" that blends earth and sky with the suggestion of stellar nebulae. There is something poignant in both the crudity and the aimlessness of this figure. Margit Rowell observes that beneath the disintegration of categorical thought represented by Dubuffet's art lies an "undercurrent of tragic humanism, a tragic vision

FIGURE 13.8

Jean Dubuffet. Rock Foam. *February 1959. Plate 10 from the* Water, Stones, Sand *album of* Phenomena. *1958– 62. Lithograph. 540 × 420 mm. Museum of Modern Art, New York.*

of the helpless anonymity of modern man."[28] In that sense, his coarse and ironic treatment of the human figure is related to the half-eaten-away figures of the British painter Francis Bacon or the eviscerated manikins that the Swiss sculptor Alberto Giacometti has stripped of everything but a bony, defiant existence. In America, more variations on this theme were created: for example, the disturbing woodcut figures of Leonard Baskin and the vaguely figurative masses of traumatized flesh in Rico Lebrun's lithographic studies after Grünewald (1961). Everywhere in the postwar period, the deformed, brutalized, disoriented, floating figure became an emblem of the human condition.

Paul Wunderlich's *Rendez-Vous Technic II* (1962; fig. 13.11), a haunting color lithograph in brown, black, and ghostly white, has been called a "travesty of Vesalius's ideal man," a reference to the famous figure whose extended limbs could be inscribed within a perfect circle.[29] The circle appears here as a black doughnut-shape with two headless bodies floating in front of and above it. These figures are skeletons with exposed backbones and ribs put together in interlocking segments. The inverted white figure in particular brings to mind Robert Rauschenberg's radiological self-portrait in *Booster* (see fig. 13.46). Wunderlich's figures still have some flesh, however; they are something like the animated corpses of medieval and Renaissance art, but maimed and decapitated, unable to propel themselves.

FIGURE 13.9
Jean Dubuffet.
Scintillation. *August*
1960. Plate 1 from the
Geography *album of*
Phenomena. *1958–62.*
Color lithograph. 470 ×
370 mm. Museum of
Modern Art, New York.

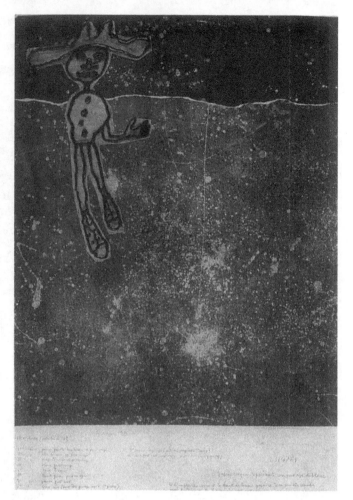

FIGURE 13.10
Jean Dubuffet. Sleep-
walker. *1961. Color*
lithograph (transfer of
assemblage or lithographic
collage). 470 × 380 mm.
Museum of Modern Art,
New York.

Postwar European art also offered examples of non-figurative abstraction. Nicolas de Staël's lithographs and woodcuts, done late in his life, were few in number. In *The Wall (Study in Color, No. 1)*, a color lithograph of 1951 (fig. 13.12), vaguely rectangular shapes of varying sizes and textures are disposed in groups with different rhythms and with slightly shifting spatial locations. The marks move horizontally across the picture plane—with the exception of the blue ones placed diagonally, like a log-jam in a current. Unlike the all-over compositions favored by American Abstract Expressionists, de Staël suggested a center and a "frame" by his darkening and enlarging of the marks. The fascination of his images lies in a subtle tension between order and freedom expressed in a number of ways.

Similar observations could be made about Pierre Soulages' painted compositions, which combine stable structure with "tachistic" marks that reveal the artist's hand. (*Tachisme* is the

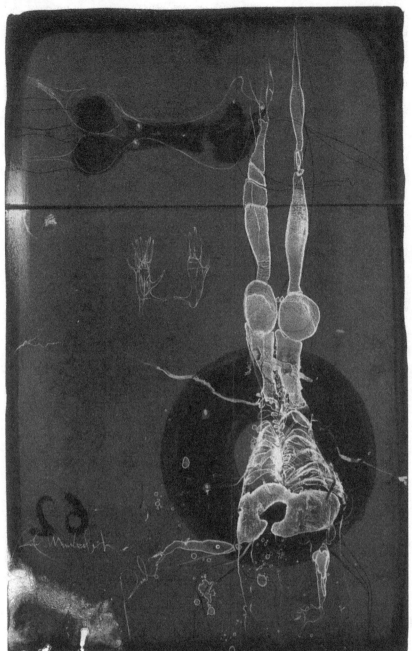

FIGURE 13.11
Paul Wunderlich.
Rendez-Vous Technic II.
1962. Color lithograph.
610 × 395 mm. Museum
of Modern Art, New York.

French word for "stain" or "spot" that came to designate European Abstract Expressionism.) As a printmaker, Soulages pressed the logic of etching to extremes. He bit his plates so deeply that they disappeared in part, and the edges of his powerful, calligraphic emblems—heavy black strokes lying over glimmers of intense color—became the irregular edges of the plate itself. *Untitled* (1957; fig. 13.13) is such a rough-textured image supported by a thick scaffolding of dark bands. The effect is both architectonic and painterly, and, because of the intaglio process, the image is in the paper while appearing to be aggressively on the surface like impasto paint. Soulages's blocky etched compositions have much in common with the engravings of Pierre Courtin, who also pursued the logic of his medium to its limits. He sculpted his plates with jewelers' tools in order to create a deeply embossed relief on the paper. In *Composition* (1956; fig. 13.14), the slightly irregular, powerful shapes are tightly compressed, suggesting the

FIGURE 13.12

Nicolas de Staël. The
Wall (Study in Color,
No. 1). *1951. Color litho-
graph. 505 × 654 mm
(sheet). Museum of
Modern Art, New York.*

process by which the print was made. Because the plates were so deeply worked and were
printed using great pressure, Courtin produced only small editions.

The prints of Wols (Alfred Otto Wolfgang Schulze) and Hans Hartung are, on the other
hand, essentially linear. Wols's work is closely related to the concept of automatic drawing
revealed in the prints of André Masson and his American heir, Jackson Pollock. Three drypoint
"illustrations" by Wols accompanied Sartre's short story "Nourritures" (1949; fig. 13.15). The
raw scratches are an elemental expression of postwar anxiety. They barely begin to coalesce
around a central vertical axis. Like Pollock's dense webs of flung paint, they produce an intrigu-
ing depth. Hartung's fluid, calligraphic lines are more carefully controlled, grouping together
into masses and planes. In *Number 73* (lithograph, 1958; fig. 13.16), the lines undulate; they are
linked not only by their proximity and the rhythm of their placement, broken toward the left,
but also by the soft tone that underlies them and affirms the flatness of the lithographic surface.

Some of the best European prints in an Abstract Expressionist vein were produced by the
German artist Kurt Sonderborg (K. R. H. Hofmann), who exploited the rapid, painterly exe-
cution possible with the lift-ground technique. Not since Kandinsky had such whirling ener-

FIGURE 13.13
Pierre Soulages. Untitled.
*1957. Color etching and
aquatint. 543 × 387 mm.
Museum of Modern Art,
New York.*

FIGURE 13.14
Pierre Courtin. Compo-
sition. *1956. Engraving
and etching, and built-up
plate, printed in brown.
224 × 250 mm. Museum
of Modern Art, New York.*

gies, at once the expression of an individual psyche and of cosmic forces, been concentrated in single images. Despite its apparent spontaneity, Sonderborg's *Composition* (1958; fig. 13.17) is far from loose: it is like a bomb's explosion frozen in its early stages. The slashing marks try to escape from the center but cannot; splashes and drips often stop short of the edge; curves have the compression of tightly coiled springs. Willem de Kooning's *Untitled* (see fig. 13.34) seems relaxed by comparison.

European abstract artists, like many Americans of the period, also experimented with the printing surface in order to obtain more sculptural effects. Antoni Tàpies' subtly balanced compositions of lyrical lines and organic shapes owe much to his fellow Catalan artist, Joan Miró. In 1959 Tàpies began to make lithographs, obtaining textured effects illusionistically in ink, or by using sand or embossing and folding his papers. The textures suggested to him surfaces worn by human presence, such as walls or doors marked with graffiti. In *Untitled* (color lithograph, 1962; fig. 13.18), a grainy gray pillar, criss-crossed with lines suggesting a primitive script or offhand doodle, abuts a brushy black shape. Both appear against a deeply embossed background.

Earlier in the century, Rolf Nesch had given his intaglio plates a relief surface by using bits of metal and wires and bitten plate-holes that deeply embossed the paper's surface (see fig. 11.21). In the 1960s, the Italian painter Lucio Fontana began making prints that, by deep

FIGURE 13.15

Wols (Alfred Otto Wolf-gang Schulze). Large Spot I: *Plate 3 from "Nourritures" by Jean-Paul Sartre. Paris: Jacques Damase, 1949. Drypoint. 190 × 140 mm (page). Museum of Modern Art, New York.*

FIGURE 13.16

Hans Hartung. Number 73. *1958. Lithograph. 476 × 618 mm (irregular). Museum of Modern Art, New York.*

etching that ruptured the paper during printing, echoed the tearing and slashing he had employed in his canvases since 1948. The fifth plate from a series of etchings (1964; fig. 13.19) shows wavering columns of holes, like distant lights in pitch-darkness, contained in an irregular oval. As Riva Castleman observes, Fontana thereby incorporated something that was traditionally regarded as taboo or as a mark of incompetence.[30]

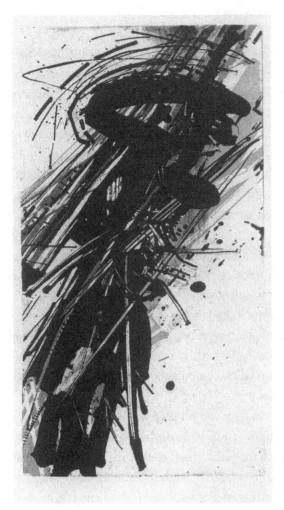

The most important impetus for printmaking in America after the war was the New York studio of the British printmaker Stanley William Hayter. Atelier 17 provided a workplace for Europeans who came to America during the war, fostered contact between these important figures (Masson, Miró, Léger, Ernst, and others) and American artists, and generally increased the interest in printmaking in the United States. As Joann Moser points out, the Museum of Modern Art's exhibition of Atelier 17 prints had an impact on American printmaking similar to that of the Armory Show in 1913.[31] Karl Schrag, who took over Atelier 17 upon Hayter's return to Paris in 1950, emphasized that it provided a place for "immediate and intense communication" among talented artists who wanted to make prints, thereby giving a boost to modern printmaking in general.[32]

As noted in Chapter 12, Hayter went against "School of Paris" traditions by encouraging the artists' hands-on involvement in the techniques of printmaking. Under his aegis particularly fruitful experiments were made at Atelier 17 in soft-ground etching; in multicolor printing from one surface by offsetting successive colors onto a single roller, or by rolling onto one plate inks that would repel each other; and in the relief printing of intaglio plates (as in Blake's relief etchings). This technical emphasis went hand-in-hand with Hayter's preference for graphic rather than painterly qualities (hence for the intaglio techniques over lithography) and his interest in surrealistic and expressionistic abstraction.

One criticism leveled at Atelier 17 has been that its complicated methods tended to draw virtuoso artists more interested in the means than the ends, widening the split between American printmaking and painting of the fifties. Richard Field observes that the major American printmakers who emerged from Hayter's studio—Schrag, Gabor Peterdi, and Mauricio Lasansky—"functioned at some remove" from Abstract Expressionism, the new, big, frontal, gestural style that would shift the center of avant-garde art decisively from Paris to New York.[33] It would take developments in the printmaking workshops of the 1960s to unite the best of American painting with its counterpart in printmaking.

Nevertheless, the founder of American Abstract Expressionism, Jackson Pollock, did pull proofs at Atelier 17 in 1944 and 1945. (Hayter mandated that artists pull their own proofs, a fact that, Castleman notes, probably explains why there were no editions of Pollock's intaglio prints during his lifetime.)[34] These prints were closely related to Masson's automatist creations. In *Untitled 4* (engraving and drypoint, 1944–45; fig. 13.20), Pollock took the relatively free movement of the hand across the plate as his point of departure, working the lines and shapes into a dense, indivisible network. In this print, we can begin to see the overall or uncomposed field he would establish in his famous drip paintings. There are still, however, suggestions of figures, particularly at the far left, and reminiscences of Picasso's Surrealist-Cubist style (*Guernica* was hanging in the Museum of Modern Art) as well as the figurative abstractions of Hayter and Miró.

Peterdi and Lasansky, perhaps the two most important "disciples" of Atelier 17, not only produced imposing graphic oeuvres but established what have become centers of printmaking in the United States: Lasansky at the University of Iowa and Peterdi at Yale. Lasansky's *España* (1956; fig. 13.21) continued the theme of violence and dehumanization that he had expressed in prints of the forties inspired by Picasso's *Guernica,* such as *Dachau* (1946) and the series *For an Eye an Eye* (1946–48).[35] Now, however, he employed monumental symbolic figures that recall

FIGURE 13.20

Jackson Pollock. Untitled 4. 1944–45. *Engraving and drypoint.* 375 × 454 mm. *Museum of Modern Art, New York.*

the imagery of Goya's *Disparates* or the *caprichos enfáticos* from *The Disasters of War*. The dominant figure of this large print—as of its counterpart, *The Vision*—is a spectral rider with hollow eyes who towers above a weeping woman and her dead child. The image is Lasansky's lament for Spain under the Franco dictatorship, but it is also, like Goya's images of the senselessness of war and the abuse of power, timeless. *España* exemplifies Lasansky's preference for large plates and large-scale figures, as well as the concern for technical complexity that he shared with many other American printmakers of the fifties.[36] It was produced from one plate, which was printed first in yellow ocher, then in black. The blacks and grays were produced by a variety of intaglio techniques: conventional and soft-ground etching, engraving, and much scraping and burnishing.

Quetzalcoatl (1972; fig. 13.22) is even larger and more complicated. Over seventy-five inches high, it was produced from fifty-four intaglio plates: one galvanized color master plate, forty-five shaped plates of copper, zinc, and galvanized steel, and eight copper master plates.[37] The plates were worked with a mixture of intaglio methods: engraving, etching, drypoint, soft-ground, electric stippler, aquatint, lift-ground, and scraping and burnishing. In a print of such size and complexity, the image must be able to hold its own against the variety of shapes, colors, and textures if it is not to degenerate into a mere catalog of techniques. This Lasansky accomplished: his image of the feathered serpent-god of Mexico, or a dancer masked and costumed as such, is brightly colored and compelling as it seems to move forward and upward. In contrast to *España*, to many of Lasansky's earlier prints, and especially to the trenchant *Nazi Drawings*,

FIGURE 13.21

*Mauricio Lasansky.
España. 1956. Mixed
intaglio. 809 × 527 mm.
University of Iowa Mu-
seum of Art, Iowa City.*

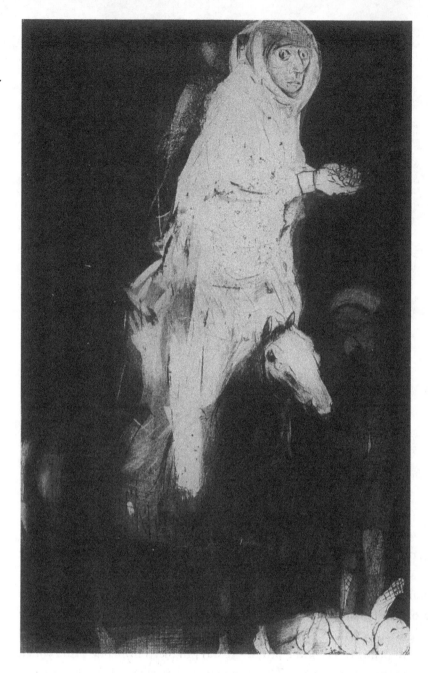

which occupied the artist during the sixties, the color here is not just an accent within a pre-
dominantly black and gray composition. Instead, the staccato rhythms of bright shapes and
patterns are the chief means of evoking the rituals and beliefs of an ancient culture, as well as
the sun-drenched climate and colorful folk art of Mexico, where Lasansky and his family had
a second home.

Peterdi too combined primal imagery and technical virtuosity in his prints. *Apocalypse*
(1952; fig. 13.23) and *Germination I* (1951; fig. 13.24) express the counterpoint of violent death
and stubborn life, a contrast characteristic of Peterdi's oeuvre. *Apocalypse,* a combination of
engraving with conventional and soft-ground etching, relates closely to Hayter's engraving
style, with its tense curves tracing spatial volumes and web-like intersections of lines. *Germi-*

FIGURE 13.22
Mauricio Lasansky.
Quetzalcoatl. *1972. Color
mixed intaglio. 1923 ×
852 mm. University of
Iowa Museum of Art,
Iowa City.*

nation I, on the other hand, is reminiscent of Klee's magical landscapes, and looks forward to those of Friedensreich Hundertwasser. A mixture of etching, aquatint, engraving, and stenciled colors, this print suggests earth-strata and seeds pushing shoots toward the light and rain. Its structure is a stable order based on horizontals and verticals, in contrast to the explosive diagonals of *Apocalypse.*

Although an impressive number of artists were drawn into Atelier 17 by Hayter's enthusiasm, American printmakers did not have to have direct contact with the workshop in order to fall under its influence. Moser describes Rudi Pozzatti's printmaking workshop at Indiana University, for example, as an "indirect descendent" of Atelier 17. What was transmitted was not so much an "Atelier 17 style" as, in Moser's words,

FIGURE 13.23

Gabor Peterdi. Apoca-
lypse. 1952. Engraving,
etching and soft-ground
etching. 587 × 890 mm.
Art Institute of Chicago.

FIGURE 13.24

Gabor Peterdi. Germi-
nation I. 1951. Mixed
intaglio and stencil. 500 ×
605 mm. Associated Amer-
ican Artists, New York.

an approach to printmaking, based on experimentation and a deep love for the metal
plate as a means for original, creative expression. This approach tended to encourage the
use of complex intaglio techniques and mixed media prints which combined intaglio with
planographic processes. The advantages of working in a group atmosphere were recog-
nized and painters and sculptors became more willing to try their hand at printmaking.[38]

Pozzatti's *Venetian Domes* (1955; fig. 13.25) betrays the sheer love of the metal (zinc) plate, worked with the earliest intaglio method, engraving. Crisp arcs establish the volumes of space encompassed by the domes, which appear as transparent skins through which parts of the church interior are visible. The linear activity of this print gives some sense of the scintillation of Venice, whose great church of San Marco, with its copper-sheathed domes and glittering mosaic decorations, is celebrated here. As evidence of his Italian heritage, Pozzatti's oeuvre contains a number of tributes to the dome—in particular that of the cathedral of Florence, designed by Filippo Brunelleschi—as well as to the medallion.[39]

One of the artists whose plates were printed at Atelier 17 was Milton Avery, whose flat, colorful style and buoyant love of nature and the human form had much in common with the works of Matisse. In painting, Avery's sophisticated and sensitive yet reductive approach to form and color held much resonance for the younger generation of American abstract artists whom we shall soon encounter. In the graphic arts, his drypoints and monotypes are among the most refreshing American prints of the late forties and fifties. Avery had made drypoints in the 1930s that were not printed until 1948, when his friend Chris Ritter, organizer of the Laurel Gallery, wanted to include him in the Laurel print portfolios. Hayter directly supervised the printing of these drypoints, preserving their simple elegance and the beautiful burr of the lines.[40]

But Hayter's emphatically graphic approach could not accommodate every sensibility: for example, the painterly élan possible in monotype. Avery's monotypes, many of which were exhibited at the Laurel Gallery in 1950, foreshadowed the contemporary revival of interest in this technique. The most important American examples of the monotype technique had been works in an Impressionist style by Maurice Prendergast. Avery was introduced to the process during convalescence from a heart attack: a friend suggested it as a substitute for the more strenuous medium of oil painting. Rather than use a press, Avery printed his glass plates with the back of a spoon. He worked them with brushes or brush handles, rags, or his fingers and coated them with turpentine to keep his oil washes from drying too quickly. A mottled quality often resulted. In *The Edge of the Forest* (1951; fig. 13.26), however, the pigment is carefully controlled and wiped vertically across the plate, yielding an effect similar to wood-grain in a woodcut.[41] The bold simplicity of Avery's art is revealed in this evocation of a stand of birch trees: the barest marks in a warm white stand for the slender, graceful trunks, ornamented here and there with black patches. They sway against a bright green background that brings to mind the Italian word for spring itself—*primavera,* "first green."

THE POSTWAR AMERICAN PRINT: TECHNIQUE, SIZE, THE FURTHER DEVELOPMENT OF THE SILKSCREEN

Avery's monotypes were part of the bewildering array of technical approaches and styles, many of them developed in the forties at Atelier 17, that characterized American printmaking of the fifties. As Judith Goldman asserts, Hayter had inadvertently pointed the way toward an excessive concern for technique through his emphasis on complex, mixed methods and on craft: the artist's hands-on involvement with the plate. He had said that "if a plate develops beauty in itself, the print will probably be satisfying." This attitude constituted an "equating of the plate with the image it carried," in Goldman's view.[42] Dore Ashton as early as 1952,[43] and

Richard Field more recently, have also found fault with the preoccupation with technique among American printmakers. Field contrasts it qualitatively to the approaches of the *painters* who took up printmaking, noting that "the significant prints of our times have come almost exclusively from the best painters and sculptors, for they are the most sensitive to the visual languages of our technological civilization."[44]

It is true that the Hayter-derived approach to printmaking was firmly graphic and highly technical, and did not allow for much interface between printmaking and painting. But without the technical explorations of printmakers of the forties and fifties, the graphic achievements of the artists of the sixties and seventies (when the American painter-printmaker came into his or her own) would have lacked a firm foundation. Before Atelier 17, American artists had paid comparatively little attention to printmaking. The monotypes of Maurice Prendergast, the etchings of Arthur B. Davies, and the woodcuts of Max Weber were exceptional. Moreover, as Moser has remarked, the idea that technical expertise in printmaking is an impediment rather than an aid to creativity contrasts with conceptions about painting and sculpture, in which the influence of technique on the artist's expressive ability is rarely questioned.[45] The attitude of the best Atelier 17 artists and their heirs was, as Peterdi put it, "to learn to make things in order to forget about the making and concentrate on the content."[46]

The decade of the fifties saw an increasing concern for the size of prints, in a sense reconciling them to the basic direction of American painting. Another hallmark of this decade was the revival of woodcut and wood-engraving by American printmakers such as Leonard Baskin, Worden Day, Antonio Frasconi, Misch Kohn, Seong Moy, and Carol Summers. The intaglio processes that were important in Hayter's studio were explored by such artists as Rudi Pozzatti and John Paul Jones. And color serigraphy, which would prove crucial for the decades to come, was pursued by Dean Meeker, Sylvia Wald, Sister Mary Corita (Frances Elizabeth Kent), and others.

FIGURE 13.26
Milton Avery. The Edge
of the Forest. *1951. Mono-
type. 432 × 559 mm
(sheet). Metropolitan
Museum of Art, New York.*

Some prints done from blocks during this period stressed large size and technical com-
plexity: Adja Yunker's *Magnificat* (1953), for example, was a woodcut printed in fifty-six colors
from eight blocks and was part of a polyptych measuring fourteen feet in length. On the other
hand, Misch Kohn's *Death Rides a Dark Horse* (1949; fig. 13.27), a wood-engraving, was rela-
tively traditional, reviving an old symbol of disease, war, and death similar to the horses of
Dürer's *Apocalypse* (fig. 2.3). But Kohn's apocalyptic horse with headless rider assumed new
connotations in view of humanity's destructive capacity as revealed by the Holocaust and
World War II. Kohn's print is not large, but monumentality is established through the scale of
the figures and the contrasts of black and white. He printed his blocks with a lithography press
under great pressure, so that the brilliant whites would also stand in relief.

Carol Summers arrived at a unique method of printing from wood in the late fifties.
Instead of inking the block, he rolled ink lightly onto a piece of paper laid *over* the dry block.
After this, the paper was sprayed with mineral spirits, thus causing a dissolution and bleeding
of the ink. Many of Summers' works, like *Mezzogiorno* (*Mid-Day* or *South,* 1960; fig. 13.28),
are Mediterranean landscapes. Here, the sun appears four times in the sky above deep blue
mountains, one of which harbors buildings. The powerful shapes and large, subtly nuanced

FIGURE 13.27
Misch Kohn. Death
Rides a Dark Horse.
1949. Wood-engraving.
555 × 400 mm. Fine
Arts Museums of San
Francisco.

FIGURE 13.28
Carol Summers. Mezzo-
giorno. 1960. Color wood-
cut. 915 × 901 mm.
Collection of the artist.

color areas bring to mind Helen Frankenthaler's woodcuts of the seventies, such as *Savage Breeze* (see fig. 13.68, color plate, p. 490)—more grainy, like Munch's, and produced, as we shall see, by his jigsaw method.

Perhaps the period's most impressive prints from blocks were not the complicated color prints of Yunkers, Summers, Kohn, and others, but the black and white figures of Leonard Baskin, carved from sheets of plywood and printed on the large sheets of *shoji* screen-paper that Americans had discovered during the occupation of Japan. *Man of Peace* (1952; fig. 13.29) measured about sixty inches tall. Standing behind barbed wire that brings to mind the Nazi concentration camps, the figure holds up a dead dove, probably a reference to Picasso's famous lithograph for the Communist Party's World Peace Conference in 1949 (fig. 13.3). The figure even bears a facial resemblance to the aging artist. Picasso's involvement with the Communists, dating from the thirties, was the source of heated debate in the late forties and fifties, when red-baiting was current in America.[47] In the very year Baskin created *Man of Peace*, Picasso issued another poster with the dove for the Congress of the People for Peace in Vienna.

A related but even more effective image, *Hydrogen Man* (1954; fig. 13.30), over seventy inches high, could stand as a symbol for the nuclear age. Baskin's ultimate sources for this conception were the anatomical diagrams of the past, such as Nicolas Beatrizet's illustrations for Juan de Valverda's *Anatomia del Corpo Humano* (Rome, 1559), which showed the human figure grotesquely flayed but in active poses.[48] Like Giacometti's figures, Baskin's is eviscerated, its insides supplanted by root-like lines. His head is skull-like; his genitals atrophied. The left leg ends ominously in claws, traditionally suggestive of the devil or demonic possession. The print is an unforgettable image of the death, maiming, and destruction of the species as a whole that nuclear war promises. As photographs of the piled corpses and skeletal victims of Auschwitz, Buchenwald, and Dachau made an indelible impression on twentieth-century artists, so did the evidence of the power of atomic weapons presented by Hiroshima's destruction.

One of the most important media of the 1960s would be silkscreen (also referred to as screenprinting or serigraphy).[49] Despite the enthusiasm of those who were early experimenters with the process, such as Guy Maccoy and William Henry Johnson, silkscreen failed to gain widespread recognition until Pop Art adopted it in the sixties. As Castleman notes, its difference from traditional printmaking methods was part of the reason: "Silkscreen shared with the classic printing media very few of their production methods, and this dearth of clues to the process of manufacture led to widespread distrust of the 'originality' of the art itself."[50] Since one of the major aspects of Pop Art was a questioning of autographic expression (as found in the Abstract Expressionist brushstroke) through the use of commercial processes and mass-media imagery, the silkscreen was an ideal Pop medium. It also neatly fitted the goals of contemporary Op Art. In the meantime, however, some artists of the forties and fifties persisted with silkscreen, producing some interesting results. *The Beginning of Miracles* (1953; fig. 13.31) by Sister Mary Corita is a witty twentieth-century version of the Wedding at Cana (John 2:1–11), when Christ turned water into wine, foretelling the sacrifice of his own blood embodied in the Eucharist. The big-eyed figures of Christ and Mary dominate the composition, which is like a cross-section of a modern apartment house, each boxy space occupied by some episode of the wedding banquet. At the right, the disciples gather around the table on Charles Eames chairs, and a television antenna tops the roof at the left. Despite Sister Mary Corita's humor, the print succeeds in its communication of the miraculous. The scintillating, impressionistic application of serigraphic ink—very different from the flatness one might

FIGURE 13.29
Leonard Baskin. Man of Peace. *1952. Woodcut. 1510 × 777 mm. Brooklyn Museum.*

FIGURE 13.30
Leonard Baskin. Hydrogen Man. *1954. Woodcut. 1816 × 1042 mm. Elvehjem Museum of Art, University of Wisconsin–Madison.*

associate with silkscreen, and dominated by rosy wine-pinks and purples—gives the effect of a mosaic.

Ben Shahn's art has centered on social and political issues. *The Passion of Sacco and Vanzetti* (1958; fig. 13.32), from a drawing originally conceived in 1931–32 and redrawn in 1952, is one of his best-known silkscreens. The execution of the two Italian-born immigrants, a fish-peddler and a shoemaker, took place in 1927, but for Shahn it became a recurring example of human courage. Nicola Sacco and Bartolomeo Vanzetti had been accused and convicted of murder, despite witnesses' testimony that they were far away from the scene of the crime.

FIGURE 13.31

*Sister Mary Corita
(Frances Elizabeth Kent).*
The Beginning of
Miracles. *1953. Color
silkscreen. 393 × 495 mm.
New York Public Library.*

Because of their flight from the draft in 1917 and their labor activities, Sacco and Vanzetti became the targets of political repression. Their execution touched off international demonstrations. Appropriately, Shahn depicted them simply: the portraits are linear and frontal, with the two hollow-eyed men chained together. A famous quotation from their trial, written with an immigrant's misspellings and shaky grammar, is a moving acceptance of their fate and of the good that they found in their own ill-treatment. Shahn would use this statement again, detached from the portraits but just as recognizable, in a 1962 poster for one of his exhibitions.[51]

More technically and formally adventurous were the silkscreens of Dean Meeker and Sylvia Wald. Ashton characterized the latter's *Dark Wings* (1953–54; fig. 13.33) as "an atmospheric print with delicate textures suggesting wings, and life beneath damp forest leaves."[52] Like Sister Mary Corita, Wald exploited the effects of overprinting to give translucent, evocative qualities to the surface. The mottling of the ink throughout, reminiscent of Blake's color prints, creates organic reticulations suggesting veins or roots. To produce these reticulations, Wald squeegeed thick ink through the screen, then lifted it suddenly so that the remaining ink formed a network of tacky lines.

THE TURN OF THE DECADE:
DEFINING THE PRINT, LATE ABSTRACT EXPRESSIONISM

The increasing interest in prints on the part of the American public during this period is reflected by the Print Council of America's attempt in 1961 to define an original print. Founded in 1956 by the prominent collector Lessing Rosenwald and print curators, the Council wanted to provide a forum in which prints could be discussed and to protect print buyers against misrepresentation of works by artists or dealers. (In the same year, the Pratt Graphic Workshop

FIGURE 13.32

Ben Shahn. The Passion
of Sacco and Vanzetti.
1958. Color silkscreen.
654 × 444 mm.
Library of Congress,
Washington, D.C.

in New York City was set up to encourage original printmaking, conservatively defined.) Such abuses as recarving worn plates or printing numerous impressions outside an edition were scarcely new, but printmakers and critics in the fifties had become alarmed by artists' signing reproductions in "limited editions" and selling these at much higher prices than warranted. The Print Council's stipulations for originality were strict: an original print was to be created on the plate, stone, or block by the artist alone and for the explicit purpose of making a print; the impression was to be printed from these surfaces by the artist or pursuant to his directions; and the finished print was to be approved by the artist. But the best prints of the sixties, seventies, and eighties would not always conform to these restrictions, and Castleman detects a fundamental strain of American Puritanism and skepticism beneath the Print Council's intentions.[53]

FIGURE 13.33
Sylvia Wald. Dark
Wings. *1953–54. Color
silkscreen. 469 × 598 mm.
Brooklyn Museum.*

In a 1966 issue of *Artist's Proof,* Fritz Eichenberg and Luis Camnitzer called for a new definition of the print that could incorporate new graphic forms. Camnitzer advocated the acceptance of any kind of material or technology into printmaking, as long as the concept of the edition was maintained.[54] Ultimately, as William Ivins had stated in *Prints and Visual Communication* (1953), the quality of the image and the ideas revealed therein are what matters:

> As we look back from the middle of the twentieth century all that kind of talk and opinion seems very silly, for it has become obvious that what makes a medium artistically important is not any quality of the medium itself but the qualities of mind and hand that its users bring to it. . . . I have sometimes wondered whether there is any field of art collecting which is more hidebound and hamstrung by arbitrary definitions than that of prints.[55]

Ivins' remarks were to be borne out in the adventurous prints of American artists working in the wake of Abstract Expressionism. Although this movement would seem compatible with lithographic tusche or the free-flowing lines of the drypoint stylus, very few prints emerged from the first generation of the New York school. The drypoints Pollock made at Hayter's studio were exceptional. The overwhelming direction of this school was painterly-gestural, emotional and big-scaled. It did not lend itself to prints, especially to the intaglio and woodcut processes emphasized in the fifties. A more important hindrance, however, was the dearth of lithographic facilities in America before 1960.

FIGURE 13.34

Willem de Kooning.
Untitled. 1960. Litho-
graph. 1086 × 780 mm
(irregular). Museum of
Modern Art, New York.

In that year Willem de Kooning was persuaded by friends at the University of California at Berkeley to try lithography. One of the results, *Untitled* (fig. 13.34), done with a floor mop, exploits the capacity of tusche for painterly and chance effects, such as the delicate splatters and drips that modify the aggressiveness of the main brushstrokes. These strokes will be absorbed and altered within the artistic vocabularies of Jasper Johns, Robert Rauschenberg, and other post–Abstract Expressionist artists. Castleman notes the significance of this important American painter's decision to make prints: within a couple of years, de Kooning's lithographs were fetching prices twice as high as those demanded by even the most famous American printmakers.[56]

Also in 1960, the younger painter Sam Francis, working with the Swiss painter Emil Matthieu, produced *The White Line* (fig. 13.35, color plate, p. 484), one of the most beautiful prints to emerge from Abstract Expressionism. Francis' ebullient painting, devoid of the anxiety characteristic of Abstract Expressionism, was influenced by the "flung ink" techniques of the Japanese, as well as by oriental philosophy. The work's "process of becoming" interested him much more than its final state of being. Like Dubuffet, Francis became fascinated with the capacity of printmaking to incorporate chance and change into artistic creation, and developed a manner of working in which several plates or stones could be put together in various ways. One of the first painters to be introduced to the magical properties of the stone by Tatyana Grosman of Universal Limited Art Editions (U.L.A.E.) in 1959, Francis made lithography his primary graphic medium.[57] He is highly sensitive to the manipulation of lithographic tusche, so that his prints contain remarkable nuances: the play of transparency and opacity, of luminosity and the light-absorbing qualities of colors, of minutiae and bold, striking forms. *The White Line* was made with five stones. Although, as the title implies, the image is characterized by a central, largely vacant axis, it is far less "composed" than the Abstract Expressionist compositions of Soulages or Hartung. Like de Kooning's *Untitled,* it divests itself of the principles of composition—primary and secondary centers of interest, symmetrical and occult balance, and the like—that had always dominated western art. It is an image created by the hand, by chance, and by the emotions as much as by the mind, evoking Harold Rosenberg's epithet of "action painting."[58] Although not large physically, its *scale* is big. The separate forms create an active field over the entire pictorial surface—the shape of the stone itself.

Francis made good use of the print workshops of the sixties and seventies, building his own litho shop in 1970.[59] Robert Motherwell had been exposed to printmaking at Atelier 17. It was not only the fragmented character of printmaking processes themselves that at first lacked appeal for him, but the atmosphere of Hayter's studio. Motherwell stated, "Though Hayter did tell me several times I was a born printmaker, I, from my acute shyness made more so by working alongside professional artists, quit making prints there and only resumed years later."[60] In the mid-sixties, however, depressed after his retrospective exhibition at the Museum of Modern Art, Motherwell began to work with the lithographer Irwin Hollander and the intaglio printmaker Emilio Sorini, and he was seduced by printmaking. Although collaboration presented special problems for an art so dependent upon self-revelation in the moment, Motherwell's work with a variety of sensitive printers who knew how to interpret his wishes on the plate or stone became an important aspect of his career.[61] In many ways Motherwell bridged the gap between painterly Abstract Expressionism and the later print-oriented movements.

Motherwell poured his love for the beauty of paint and the brushstroke into the aquatints of *A la Pintura* (*Homage to Painting*), one of the greatest of artists' books, produced over a four-year period (1968–72) at U.L.A.E. Twenty-one aquatints are combined with a poem in Spanish by Rafael Alberti and its English translation. Working with the printer Donn Steward, Motherwell carefully determined the placement of the type and its visual relationship to the image on the page. Equal care was taken to obtain the richest colors. In *Red 8-11* (fig. 13.36, color plate, p. 485), the black shape was printed from one plate, using sugar-lift aquatint. The field against which it soars is a subtly modulated, saturated red obtained from several aqua-tinted plates. Before the particles of aquatint were heated, Motherwell worked them with a brush, at times removing them entirely so that the plate was open-bitten and would hold less ink.[62]

The expansive, delicately nuanced areas of saturated color in the paintings of Barnett Newman would provide inspiration for later color-field and hard-edge painters. Newman emerged out of Abstract Expressionism. Perhaps more than any of his contemporaries, he challenged traditional composition, creating holistic fields that could not be subdivided into individual components. The fields were marked only by stripes—"zips"—that bled into the surrounding color and that sometimes revealed a rugged brushstroke. In Newman's thought-system, more closely allied to the mythic content of Abstract Expressionism than to geometric formalism, the zips were fundamental, isolated, and heroic gestures of creativity. He took his ideas and his titles largely from mythology, the Bible, and Jewish mysticism.[63]

Lithography and etching formed a small part of Newman's oeuvre. His *Cantos* series of lithographs (1963), printed at U.L.A.E., marked a return to color in his work as a whole, and the title, adopted from the divisions in Dante's *Divine Comedy,* suggests a spiritual journey. Within the eighteen prints are interior series of similar images in which the colors and margins are altered. Margins presented special problems for Newman, whose paintings fill the entire field. At first he considered cutting down the paper to achieve a similar effect, but when his publisher Tatyana Grosman pointed out to him that he was not reproducing paintings but creating lithographs, he decided to use the margins to play against the images and achieve different expressive effects. Some images rest calmly within broad margins, while others, like *Canto VI* (fig. 13.37), move to the edges of the paper. As in his paintings, the zip is bound to the surrounding color by bleeding, irregular edges, and both are bound to the paper by the bleed and by the absorbed ink, analogous to the paint that stains Newman's canvases. The result is oneness and big scale, even within a print medium. Newman insisted that the *Cantos* be viewed as prints in a portfolio, not hung on the wall like paintings.[64]

AFTER ABSTRACT EXPRESSIONISM: THE GROWTH OF WORKSHOPS AND THE PRINT BOOM OF THE SIXTIES

The sixties saw the beginning of the so-called print boom in America. An affluent society that had developed a taste for contemporary art, in part because of the success of Abstract Expressionism as a truly American, abstract art, fostered a market for prints. Although, as we saw in Chapter 12, the fine-art print had had to struggle to gain a foothold in America, American attitudes toward printmaking changed decisively in the sixties. Escalating prices for unique

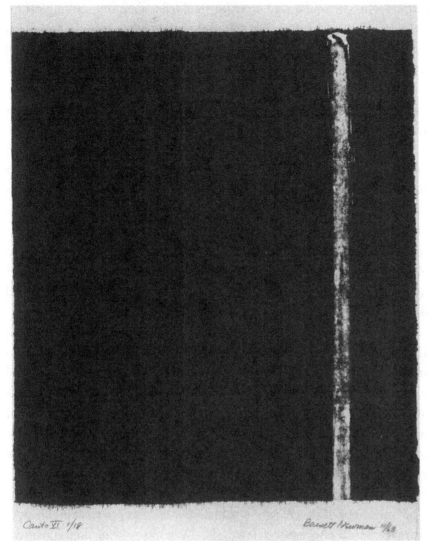

FIGURE 13.37

Barnett Newman. Canto VI (1963) from 18 Cantos. 1963–64. Lithograph. 375 × 320 mm. Museum of Modern Art, New York.

painted or sculpted works of art promoted the growth of a market for more affordable prints, and the visual excitement and scale of many prints of the sixties made them excellent stand-ins for paintings, capable of being hung on walls and carrying an equivalent visual force. At the same time, qualities traditionally associated with printmaking—its capacity for serial imagery and for technical subtlety, for example—were not forgotten in the works of many printmakers of this decade. To keep up with the expanding print market, of course, the number of print publishers increased.[65]

Artists were able to keep up with the demand for prints because of the establishment of graphic workshops, upon which we have already touched. Lithography—whose American history had been extremely sparse—was boosted first,[66] then silkscreen, a medium that had never gained acceptance as an art form. The workshops cut across all American graphic media, however, because they broke with Hayter's approach and introduced American artists to the idea of collaboration with master printers. As Castleman points out, the proliferation of such well-equipped and staffed workshops "affected the amount of time an artist would put into making prints rather than unique works."[67] In a sense, we are brought back to Dürer's assertion to

Jacob Heller that, had he spent the time it took to paint the Heller altarpiece making prints, he would have been a richer man by far. But, like Dürer in the sixteenth century, American artists of the sixties and seventies found an appeal in printmaking that went beyond its financial reward. The character of American art was changing, and the print (especially the silkscreen and the lithograph) was its new vehicle.

Tatyana Grosman, wife of the painter Maurice Grosman, began U.L.A.E. in her garage at West Islip on Long Island in 1957, and the artist June Wayne initiated the Tamarind Lithography Workshop in Los Angeles in 1960.[68] Grosman particularly recruited the second generation of the New York school—Larry Rivers, Francis, Helen Frankenthaler, Jasper Johns, Robert Rauschenberg, and Jim Dine, but the "senior" New York artists Motherwell and Newman also made lithographs at U.L.A.E. as we have seen. Primarily a print publisher, and, as Ambroise Vollard had been, very much interested in artists' books, Grosman was known for her generous tolerance of artistic individuality, her emphasis on quality, and her "low-keyed approach to production."[69] U.L.A.E. editions might be only as large as could be produced in one day. Her encouragement induced the most reluctant painters to learn lithography. (Rauschenberg had said that "the second half of the 20th century was no time to start writing on rocks.")[70]

Tamarind, on the other hand, was a large operation—a school for lithography that actively promulgated technical research and public awareness of the medium. Wayne's own experience as a painter-printmaker had convinced her that the United States needed several facilities like Mourlot's in Paris for the production of lithographs. Indeed, some Tamarind-trained printers branched out to fill this need, including Hollander and Kenneth Tyler of Gemini G.E.L., an important graphic workshop founded in 1966 that greatly expanded the technical possibilities of printmaking.[71] *The Tamarind Book of Lithography: Art and Techniques* (1971) was a landmark in the history of lithography in America.[72]

Even as Abstract Expressionism reached its peak, the artistic climate began to alter. Coupled with the growth of workshops, these changes would be favorable to printmaking. In 1953 in an outrageous gesture, Robert Rauschenberg erased a de Kooning drawing and signed the blank sheet of paper. And Rauschenberg's younger, softer-spoken friend Jasper Johns, largely unknown until his first exhibition in 1958, was quietly building an artistic revolution.

JOHNS AND RAUSCHENBERG

Ever since he began to make prints at U.L.A.E. in 1960, Johns has remained one of the most challenging and skilled American printmakers. The knowledge of master printer Robert Blackburn enabled Johns to begin working with the complexities of lithography right from the first.[73] *Ale Cans* (1964; fig. 13.38) serves as a first glimpse of how the very nature of printmaking could be used toward a Johnsian complexity: the ale can is a common object which Johns sculpted; then he reproduced it or its sculpture as a print. Throughout this process the can is treated with an ambiguous combination of the impersonal and the autographic. As the most eloquent champion of Johns's prints, Richard Field, has asserted, the issues that Johns pursues in his paintings are further complicated in his prints, in which the artist utilizes the property of reproducibility, the plate's or stone's explicit incorporation of process, and the illusionism of the printed surface to great advantage.[74] A virtuoso graphic technician, Johns never allows us to be comfortable with the seductiveness of his technique. Instead, his work constitutes both

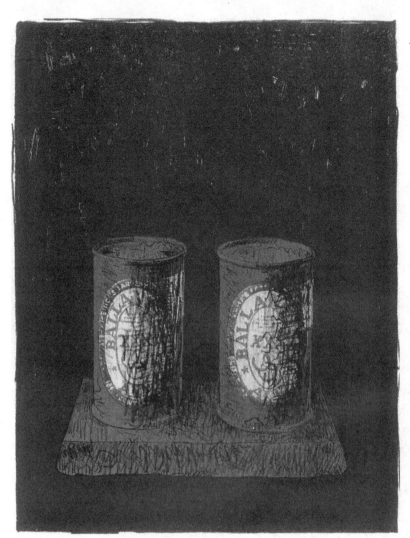

FIGURE 13.38

Jasper Johns. Ale Cans.
*1964. Color lithograph.
362 × 284 mm. Art
Institute of Chicago.*

an insistent questioning of our ability to perceive or to know anything absolutely—including an artist's intentions— and an assertion of the impossibility of permanence.

In his earliest lithographic series for Grosman, *0–9,* begun in 1960 but not printed until 1963 because she was searching for the right paper, Johns dramatically demonstrated this last idea (see fig. 13.39). At the top of the stone, he depicted numerals in sequence from zero to nine. At the bottom, he first drew a large zero. Then, he conceived the idea of reworking the stone so that the zero would be partly erased and altered to a one, then the one to a two, and so on. Grosman described her response:

> I left the stones with Jasper, and after a time he said I could come to collect them. There were two: a target and a zero. The target was all right, but the other one! He explained that the zero had to be printed, and then the drawing partially erased, and a numeral one printed, and then that would be erased. . . . I didn't know if it was even possible to make these changes, but I said we would try.[75]

Finally, the stone was printed in three series of ten—one on eggshell paper in gray ink, another in black ink on off-white paper, and another in color on white paper. As a further

FIGURE 13.39

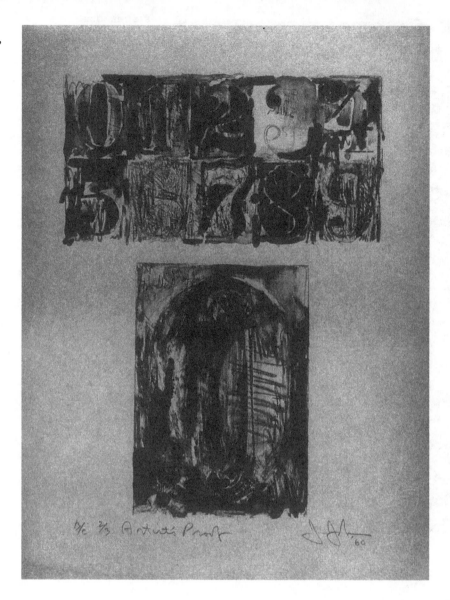

complication, each edition had an extra stone printed over the numeral corresponding to the edition number: three is overprinted in the third edition, and so on. For each edition, there is one series in which all the prints were done with two stones.[76] And this was one of Johns's earliest graphic productions.

Later, in 1968 and 1969 at Gemini, he worked again with numerals, first in black and white and then in colors. For the ten prints of the *Color Numerals* series, Johns wanted to apply the colors to the stone in bands with a single roller moving once across the stone horizontally— "spectrum rolling." This roller, much larger than usual, had to be developed by the printers and was very difficult to charge with ink. The colors were primary (red, yellow, and blue) and secondary (violet, orange, and green), distributed over the prints so as to produce an "opposite" arrangement for each numeral. For example, number 1 has two primary and one secondary colors; number 8 has two secondary and one primary colors. When the color distribution is diagramed, its logical progression emerges; the artist does not apply color out of emotional or even aesthetic considerations, but according to an impersonal system.[77]

Numbers, like flags and targets, were well suited to Johns's purposes. All these are things that the "mind already knows,"[78] or, more accurately, *thinks* it knows. A number is not a thing but an abstract concept, treated here as if it were a thing to be painted or drawn. Johns's numbers and letters are stenciled or stencil-like, confusing their "thingness" (the stencil, after all, really is an object that mechanically makes a sign of an abstract concept). To paint or draw the number makes it into a thing—the context of the work of art superimposes a new meaning on something we thought we knew.

In *Number 7* (fig. 13.40, color plate, p. 485), one of the most interesting of the color numerals, there is another thing we thought we knew—the *Mona Lisa*. Johns greatly admired Leonardo, as well as the aged Marcel Duchamp, father of Dada and Surrealism, who had painted a beard and moustache on a reproduction of the renowned portrait in 1919. But Johns's Mona Lisa is not really an art reproduction, as he explains:

> Just before I came to work at Gemini someone gave me some iron-on decal "Mona Lisas" which you would get from sending in something like bubble gum wrappers and a quarter. . . . and I thought I would use the Mona Lisa decal because I like introducing things which have their own quality and are not influenced by one's handling of them. It was a great problem getting it on to the stone. We tried solvents and everything. I finally ironed it to the stone, and it came out very nicely.[79]

In *Number 7*, Johns referred to Leonardo's masterpiece but the work is three (or more) times removed from it: from the painting to art reproductions such as the one "defaced" by Duchamp, to the iron-on decal, to the print. How then can we know this painting; is it less or more real as an iron-on decal? And how are we to evaluate its juxtaposition, in another work of art, with the ambiguous concept-thing of a number and a handprint, reminiscent of those in prehistoric caves? The pathos of Johns's works resides in its persistent elusiveness. Far from being a determinate statement of a particular culture or psyche at a particular time, the work of art is a set of poignant absences, broached only by accepting the infinity of things it is not. Its existence at any time may properly dissolve into further and future meanings. If Johns's questioning seems cerebral, it is relieved by the interest of the surprise-filled game he plays with the spectator and by the beauty of his surfaces.

No lithograph by Johns illustrates that beauty better than *Voice* (1966–67; fig. 13.41), a stunning abstraction of lithographic ink, rich in its blacks and delicate in its ripples and tonal nuances. It is also about absence—the absence of any form to define the experience of sound, and the absence of his late friend, the poet Frank O'Hara. Barbara Knowles Debs eloquently describes this print:

> Johns has chosen a nearly totally abstract means of expression (grounded though it is by the letters and spoon and fork quite tangibly there), but one that in its upward flow, mysterious blackness, and resonant hollow form irresistibly calls up anthropomorphic associations. It is at once a great bellowing gullet . . . , an evocation or record of sound itself, and a startlingly beautiful painterly abstraction of a very particular type. That it may also be a cry of mourning is suggested both by the fork and spoon so movingly associated elsewhere with Frank O'Hara and by the overt reference to the beautiful Barnett Newman lithograph of 1961 (made as a kind of cathartic piece after the death of his brother).[80]

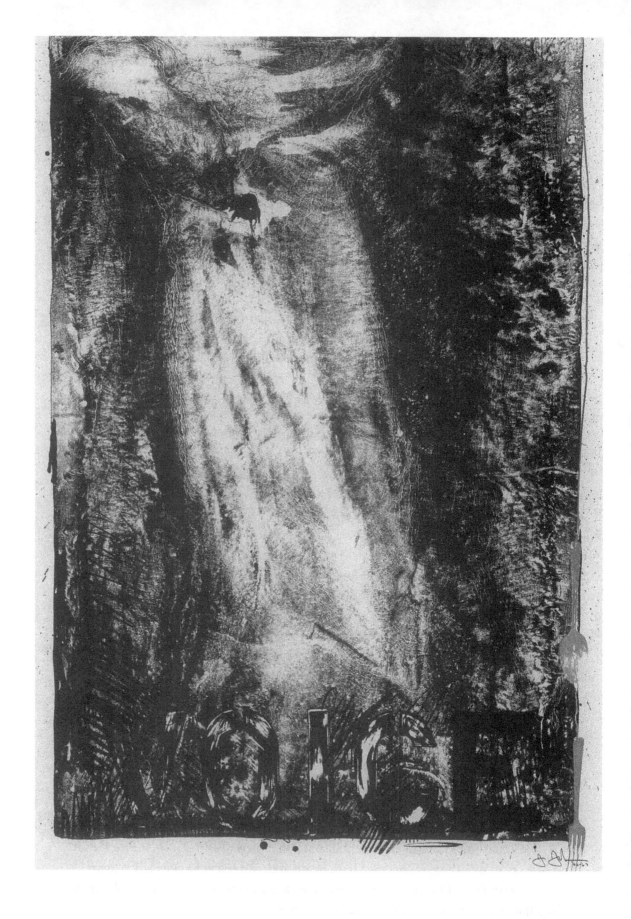

A large part of Johns's art has to do with the assumptions of Abstract Expressionism that the canvas was an arena in which the artist's soul was bared, and that the individual brushstroke was a psychic signature. It also has to do with the elite formalism of much modern abstraction, which would ascribe to the viewer only the small role of picking apart, in order to appreciate, the complicated aesthetic choices the artist has made. In his American flag prints and paintings (in the latter Johns often uses the ancient, translucent medium of encaustic, which allows him to retain the process better than oil), Johns took a cultural icon whose political symbolism was neutralized or compromised by his soft, subtle, brushy handling and fluid drawn lines that define no object (Clement Greenberg's term "homeless representation" is apt here).[81] Conversely, the drawing and brushiness were divested of personality by their relative control as well as by the image they depicted. "Depicted," however, is not the word to describe what Johns did with the flag, for it is not an object represented against a background, but the artistic field itself. Yet it is emphatically not a composition in the tradition of early twentieth-century abstraction, for the artist did not think about setting this stripe here, that star there. He did not create the image; he took it. What did he mean by this artistic appropriation? Although he allowed part of one of his flag-compositions to be reproduced for a Vietnam War Moratorium poster, we might take this as confirmation of Johns's belief that an image's meaning is never the same over time and with different observers.[82] In the fifties, when the flag provided a key image for Johns's early development, it would have reflected an optimistic, naive, and fairly bland postwar America, albeit disrupted by the Korean War (1950–53). But in the turbulent Vietnam era, the flag was a symbol of polarization. On the one hand, it was an object of veneration—including patriotic care and display—by those in favor of the war. On the other hand, it was an object of desecration—including burning, hanging upside-down, even employment as clothing—by protesters. As a symbol, it carried completely divergent implications.

Two Flags (Gray), an offset lithograph of 1970–72 (fig. 13.42), is a particularly complicated example of Johns's graphic decisions. He began with two stones drawn in tusche, printing one flag from each in gray graphite ink. Over these, he printed three plates, already utilized for *Flags II* (1970) and drawn with crayon. Each of the three plates was printed twice, once for the left flag and once for the right, but before the right printing Johns made erasures on the plates. There are slight disjunctions, then, between the upper layers of the left and right flags, but the viewer is hard-pressed to find them because of the complexity of the print's surface. The images seem identical at first, but are not, and comparison (which depends on memory) fails us. There is more: because the flags were drawn in reverse to produce "correct" orientation, they were backward when printed by the commercial offset process, in which a lithographic image is transferred to a rubber roller. When the paper was rotated, the flags appeared vertical. Johns continued with the first two stones for another *Two Flags* in black (1970–72), reworking them with tusche and scratches, and printing them on a regular lithographic press so that their horizontal orientation was normal.

From the point of view of printmaking, the hatching pattern that forms the basis for many of Johns's prints and paintings is particularly interesting. Hatching gave information about volume or mass; its steadily growing complexity from the fifteenth to the eighteenth century gave us more and more information. In Johns's works, it is detached from anything about which we could be informed. It assumes a neutrality, like the stripes of the flag or the flagstones (note the verbal play between the two Johnsian motifs) with which it often appears. In *Four Panels from Untitled 1972* (lithograph, 1973–74; fig. 13.43), based on an oil and encaus-

FIGURE 13.41

Jasper Johns. Voice. *1966–67. Lithograph printed in black and metallic silver from stone, aluminum, and photographic plates. 1048 × 698 mm. Museum of Modern Art, New York.*

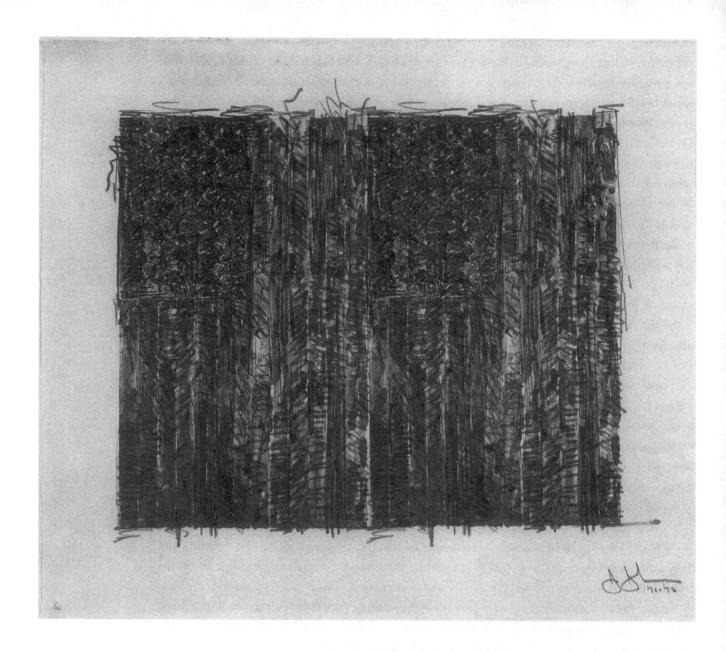

FIGURE 13.42

Jasper Johns. Two Flags
(Gray). *1970–72. Offset
lithograph printed in
graphite. 559 × 699 mm.
Museum of Modern Art,
New York.*

tic polyptych and with mounted boards and wax casts of body parts on the right panel, the
multicolored hatching appears at the left and is embossed in the flagstone print to its right. In
turn, the pattern from these flagstones is embossed into the third print, another set of flagstones
whose pattern is embossed again into the print at the far right. This last image depicts the
boards with attached casts (these from photoplates)—*its* "after-image" is embossed into the
first hatching print at the left.

The motifs of this set of prints have a personal resonance, although one not readily acces-
sible. The artist's psyche is not really available to us through the work of art. The hatching was
suggested to Johns by a decorative pattern on a passing car during a Long Island summer; the
flagstones were derived from a painted wall in Harlem that he noticed while taking a cab to
the airport. As hatching formed the traditional basis of modeling in drawing and printmaking,
casts formed the core of traditional, academic training in drawing. It is hard to avoid a certain
poignancy in the presence of pulled-apart hatchings and dissociated casts of body parts affixed

to boards: where is Art going? But this interpretation, if one may call it that, is purely a function of the observer's mind and emotions. Easier to pin down is what Johns has to say here about the fallibility of knowing. If we "read" the prints from left to right, our memory, embodied in the ghost-embossings, is telling us something different from what we are viewing at the moment. We view flagstones over hatchings, one pattern of flagstones over another, "flat" (but embossed) patterns under illusionistic photoplates of body parts—or, rather, *casts* of body parts—and so on. Comparison here becomes a tricky play between sense and intellect, present perception and past knowledge. Despite the abstract philosophical aspect of all this, Debs points out that Johns is also familiar with nature's cyclical processes, and that the avant-garde composer John Cage described Johns's art as an engagement with "the endlessly changing ancient task: the imitation of nature in her manner of operation."[83] Printmaking, as a process that incorporates time and change more obviously and unavoidably than painting, gave Johns the opportunity to explore this idea more fully.

The hatching pattern of *Four Panels* reappears frequently in Johns's prints—in the beautiful cream and gray silkscreen *Dutch Wives* (1977), for example, and in the virtuoso *Scent* (1975–76; fig. 13.44, color plate, p. 486), whose title is taken from a painting by Jackson Pollock. *Scent* is a field of similar purple, red, and green hatchings, but just as the viewer seems to have found a thematic pattern and rhythm, it becomes apparent that the hatchings are produced with different printmaking techniques—lithography, linocut, and woodcut. Each method yields its peculiar surface texture: the grain of the wood at the right, the painterly liquidity of the lithographic ink at the left, and, in the center, the characteristic stroke of the gouge through the linoleum. The seams between these different surfaces are like the edges of a mirror. One searches for a mirror image beyond the seam but does not find it, for neither the configuration nor the texture of the hatchings is the same. "Scent," like "Voice," is a term that, when applied to a visual phenomenon, suggests elusiveness and absence. One is reminded of Picasso's analogy between Cubism and perfume.

Johns's questioning of Abstract Expressionist ideology was paralleled by his friend Rauschenberg. Like Johns, Rauschenberg compromised the signature quality of the brushstroke by its form and context, and appropriated rather than created imagery, which he enveloped in an painterly atmosphere suggesting a unity that remains, finally, elusive. Both artists are fundamental for the Pop movement; both artists are consistently committed, technically brilliant, and inventive printmakers.

One of Rauschenberg's most famous prints is *Accident* (lithograph, 1963; fig. 13.45), which Castleman describes as "typical of the transition that marked the end of purely action art."[84] Beneath the brushstrokes, comparable to those of de Kooning's *Untitled,* lie photographs that had been transferred to the stone, thus throwing the personal character of the artist's marks into question. Disparate photographs, which epitomized the modern media barrage of information and among which the viewer had to make his or her own associations, were to become increasingly important to Rauschenberg. During the proofing of *Accident* the stone broke, forming a diagonal fissure. The image was redrawn on a second stone, which also broke after a few impressions had been taken. Although the U.L.A.E. printers were upset, Rauschenberg decided to take advantage of the chance mark and even the broken stone chips. Despite an appealing myth reinforced by Calvin Tomkins in the *New Yorker,* Rauschenberg did not print the fragments together with the cracked stone, but made another stone with their image on it and printed it along with the cracked stone, whose fissure widened with each impression.[85]

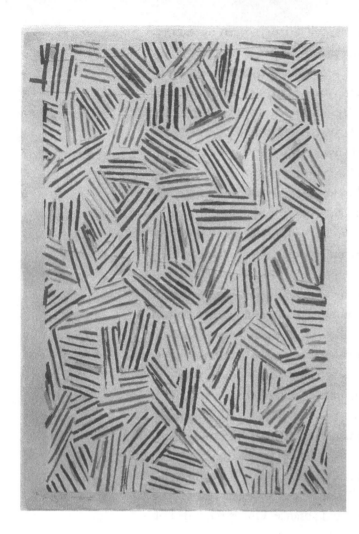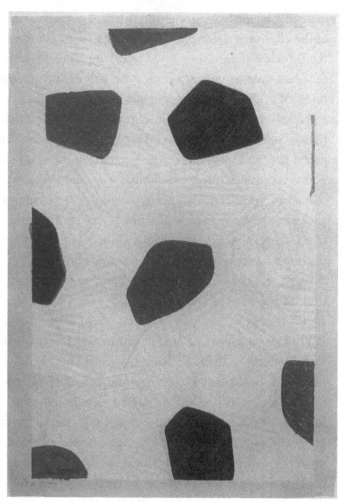

Booster (1967; fig. 13.46), a landmark for its size and combination of techniques (litho-graph and silkscreen), was printed at Gemini. The photographic imagery or pre-printed ma-terial that was offset onto the stone by rubbing dominates, and the references are both personal and topical.[86] Its central image is a full-scale X-ray of Rauschenberg at the age of forty-two, naked except for the hobnail boots—an odd form of self-portrait, but not without precedent. Ensor, for example, had portrayed himself with a skull for his head (see fig. 10.7). Rauschen-berg's X-ray is broken into stages—something like the rockets that were making contemporary history—in such a way as to suggest upward movement, with the lowest "stages" beginning to break away from the whole. The body is surrounded by a casket-like black structure. Across it is screenprinted in red an astronomical chart for the year 1967. The allusion to the passage of time and oncoming death (the old idea of *vanitas*), reinforced by the vehicles and the running and jumping figures that appear here and there, seems clear. Printed in various views is a photograph of an empty chair, an image that Van Gogh had given a powerful presence in a well-known painting, which, significantly, vibrated with the artist's distinctive brushstrokes. But in the Rauschenberg print, the artist's presence, his mark, and his role are elusive, divided among the unused chair, the choice of photographs, the hand drawing, the X-ray of the body, the personal, and the technological. He is there and not there.

Rauschenberg's adoption of technological imagery and processes into his work is part of

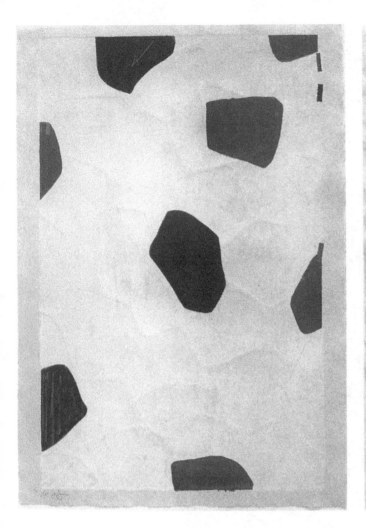

the breaking down of the barriers between art and life characteristic of art after Abstract Expressionism. Rauschenberg's prints are true reflections of their environment, with the artist's selection of imagery serving to focus the viewer's attention on previously unnoticed relationships and meanings. *Booster* seems to call into question the relationship of individuals to the high technology of the space age. What is the connection between the rocket and the human being, between movement into outer space and an athlete jumping into the air? A picture of a power drill in both forward and reverse motion in the center right might indicate technology's potential reversal of nature.[87] In another reading, it might also suggest humanity's potential reversal of technology itself. Humanly created, the space-age technology celebrated in *Booster* must also be responsibly employed.

Too big for one stone, *Booster* was the largest lithograph ever printed on a hand-operated press. The main image of the skeleton was distributed over two stones printed on a single piece of paper. For the prints of the *Stoned Moon* series, also done at Gemini, stones were laminated together. In 1969 the National Aeronautics and Space Administration invited Rauschenberg to view the launching of Apollo 11 and provided photographs of the Kennedy Space Center, which the artist put together on the stones. As Lawrence Alloway described it, the *Stoned Moon* series is "a technological equivalent of Rubens' Medici cycle . . . in its pomp, wit, and fidelity. Just as Rubens' allegories are closely and aptly phased to events in Marie de Medici's court, so

FIGURE 13.45

Rauschenberg's images stay close to the facts of the occasion." Thematically, then, Alloway concluded, this series involves a tighter unity among images than is often the case with Rauschenberg.[88]

 The human-machine interaction that is so important in Rauschenberg's art as a whole is crucial here. In his notes on the series, Rauschenberg wrote, "Launching control aware of 2 ideologies man and technology responsive responsible control and counter-control."[89] The symbiosis of the human and the technological was also apparent in the Gemini shop itself: *Stoned Moon* involved an intensive two-month period of printing, often utilizing all the presses and collaborators at once.[90] *Sky Garden* (lithograph and silkscreen; fig. 13.47) is dominated by a red photograph of the rocket leaving the ground with its fireball beneath. On top of this powerfully spatial image lies a flat, white, labeled diagram of the rocket. At the top of the print, the red turns to blue, and earthbound images of palm trees and a Florida bird are interwoven with the rocket's nosecone and another photograph of the launch from a distance. The bird is not only a play on the jargon for rocket (Rauschenberg had spoken of the take-off as a "bird's nest" that "bloomed with fire and clouds"),[91] but a creature uniting earth and sky.

FIGURE 13.46

Robert Rauschenberg.
Booster *from* Booster
and Seven Studies. *1967.*
Color lithograph and
silkscreen. 1817 × *893 mm.*
Henry Art Gallery, Uni-
versity of Washington,
Seattle.

Rauschenberg is one of the artists most responsible for the recent branching of printmaking into various sculptural forms and molded or shaped paper. Johns also did intaglio prints on lead in the sixties, and the sculptor Louise Nevelson's mysterious lead-intaglio series, including *Tropical Leaves* (fig. 13.48), were made between 1970 and 1973.[92] Such works follow logically from the deep embossing of paper, but substitute malleable lead for the paper and require a hydraulic embossing press. Rauschenberg's printed sculptures, however, are more fully sculptural. In *Shades* (1964), he assembled six Plexiglas sheets, containing lithographic marks and photomechanical half-tone newspaper engravings, into a printed object. Although the title "page" remained fixed, its appearance could be altered by placing a flashing lightbulb behind it, and the other sheets could be interchanged. In his *Cardbird* series (1970–71), Rauschenberg's assemblages of cardboard boxes were duplicated by Gemini printers in offset lithography on a variety of materials: every label, smudge, and piece of tape on the original found objects was replicated. The results, like *Cardbird Door* (fig. 13.49) were elegant sculptures formally related to Picasso's Cubist collages and reliefs, which also contained lettering and found objects.[93]

FIGURE 13.48

Louise Nevelson. Tropical
Leaves *from the* Lead
Intaglio Series. *1970–73.
Intaglio on lead. 765 ×
641 mm. Pace Editions,
Inc., New York.*

FIGURE 13.49

Robert Rauschenberg.
Cardbird Door *from the*
Cardbirds. *1970–71.
Color lithograph and
silkscreen. 2032 × 762 ×
279 mm. National Gal-
lery of Art, Washing-
ton, D.C.*

In *Pages and Fuses* (1973–74), paper pulp was poured into molds made according to the artist's specifications by a French plumber at an old papermill in Ambert, France. The *Pages* are basically monochromatic shapes of molded or sculpted paper, made of bleached and unbleached rag and water melted from mountain snow. Rauschenberg "couched" the pulp himself; that is, he turned it out onto felts where more water could be pressed from it. In some of the *Pages,* he added the same kind of rags used to make the pulp; for *Page 1,* the rag hangs from a freeform shape that Rauschenberg made with his hands instead of a mold. These works are paper sculptures with an anonymous "object" quality. For *Fuses,* described by Joseph Young as "sculptural prints,"[94] Rauschenberg incorporated photographic imagery screened onto Japanese tissue and laminated onto wet pieces of hand-made paper, molded and dyed with intense colors spooned into the pulp. The tissue, in effect, disintegrated, leaving the images softly impressed on the backgrounds. The general title of these prints referred to this fusing of tissue-image and paper background as well as to the bleeding of colors throughout.

Link (fig. 13.50, color plate, p. 487) is one of the most delicate, evocative prints of the *Pages and Fuses* series. It gives an exhilarating sense of upward movement and spatial freedom: the central image is a telephone pole seen from below, while, at the lower right, a white bird hovers on a blue background. The paper shapes and the saturation of the colors give *Link* and other *Fuses* the quality of organic objects, like flower petals or sea shells. To stress their anonymity, Rauschenberg signed the *Fuses* prints on their versos.[95]

In his *Hoarfrost* series of 1974, Rauschenberg employed such fabrics as cheesecloth, satin, silk chiffon, and silk taffeta to create diaphanous, layered, moving "collages" of newspaper and magazine images. Some were greatly enlarged and printed on cloth by the offset lithography process, sometimes with silkscreen additions. Others were transferred to the cloth, using solvents and the pressure of the lithography press, and printed to scale. To guide the Gemini printers in producing these prints, Rauschenberg made master proofs, assembling the flat and crumpled newspaper or magazine excerpts on top of the offset material on the press bed. The *Hoarfrost* prints combine small images, requiring close viewing, with billboard-scale images, but muted and altered by the soft cloth surface. Like the images and information stored in the mind, the various components are singled out or related to each other depending on the viewer's memory-associations. The function of memory is emphasized by the whitish haze that encompasses all, like the blurring of the screen in a movie flashback.[96]

In *Preview* (fig. 13.51), Rauschenberg juxtaposed an ancient Greek *kouros* with two classic cars to suggest surprising relationships. In both the cars and the statue, there is an imposing frontality, symmetry, and perfection of design. Although the cars lack drivers, they seem to move by an uncanny mental comparison we make between them and the literally motionless striding statue. A confusion arises between the anthropomorphizing of the cars and the mechanization of the human form, which is also here a finely crafted object. Once again, Rauschenberg forces us to consider the ambiguous relationship between man and machine. Where does the human stop and the machine, the extension of the human, begin?

AMERICAN POP

Pop Art would have been unthinkable without the destruction of boundaries and the questioning of the nature of art that Johns and Rauschenberg supplied, and these two artists

FIGURE 13.51
Robert Rauschenberg.
Preview *from* Hoarfrost
Editions. *1974. Color
offset, newsprint, silk-
screen transfers and
collage on fabrics. 1753 ×
2045 mm. Museum of
Modern Art, New York.*

are inseparable from full-blown American Pop as represented by Roy Lichtenstein, the sculptor Claes Oldenburg, James Rosenquist, Andy Warhol, and others. Moreover, English artists of the fifties and sixties, such as Richard Hamilton and Eduardo Paolozzi, were questioning the dominant understanding of art in many of the same ways as Rauschenberg and Johns, and appropriating the images and products of American popular culture into their works. Hamilton's 1956 collage, *Just What Is It That Makes Today's Homes So Different, So Appealing?* (Kunsthalle, Tübingen), takes its cue from Schwitters' *Merz* collages (see fig. 11.42) and foreshadows many qualities of American Pop, including its humor. But before we look at the British artists, let us pursue the American developments emerging out of the assumptions of Johns and Rauschenberg.

In place of the signature-brushstroke of Abstract Expressionism, Pop artists substituted flat, depersonalized imagery appropriated from the affluent banality of American culture. Here was a realm not only banned from Art but understood as its antithesis. Here, the dollar was king and everything—even the great, the individual, and the tragic—was brought to a homogeneous level of slick mediocrity. Pop techniques as well were borrowed from the mass media or advertising: silkscreen found its most brilliant expression, especially in Warhol's works, and Roy Lichtenstein audaciously chose and modified the Benday dots of comic strips to mock the brushstroke. ("Benday dots" were named after their inventor, Benjamin Day, an illustrator working in the period after the Civil War.) It is no surprise that the print, or the application to canvas of printmaking techniques, was Pop Art's most important vehicle, for,

more than other media, printmaking had an affinity for the technology that was now so much a part of the American experience.

But the print was not only an inherently democratic art form with close ties to commerce and technology, but also an art form historically associated with social critique. Without separating itself from American mass culture, Pop Art functioned in part as a teacher and eye-opener. It was a critique from within—hence its mixture of bland objectivity, affection, and satire. It taught us to think differently about the barrage of products and printed or broadcasted material that daily assaults our eyes and brains, and warned that simple recognition or consumption can exist without feeling or understanding. As Warhol put it, "Buying is more American than thinking and I'm as American as they come."[97]

Pop Art began contentiously, and it continues to be controversial among scholars and critics.[98] The traditional, objective reticence of American artists—their function as reporters of the society that surrounds them—is certainly applicable to the American Pop movement. It is possible to see Pop artists as neutral or even affectionate commentators on their environment. Writing in 1969, John Russell described Pop as not satirical but affirmative, "a healing art . . . a dis-alienatory, non-discriminatory art: one that binds people together instead of setting them one against the other."[99] In its imagery and techniques, the Pop Art print, like the nineteenth-century chromo, was anti-elite, even while it cultivated an audience among well-to-do collectors. On the face of it, Pop artists were cheerful participants in mass culture: passive mirrors of what was there.

On the other hand, selection is a kind of comment. Viewed from this perspective, Pop artists may be understood as having appropriated their images from mass culture carefully, with an eye for irony, pathos, and humor. Warhol is a particularly interesting example of the problem of interpreting Pop. He cultivated a movie-star persona for himself and orchestrated an interpretation of his art that many think obscured his critical engagement with American culture. Thomas Crow notes that we might think twice about Warhol's disavowal of intention and meaning, since "the authority for the supposed effacement of the author's voice . . . is none other than the author's voice itself." Warhol's subjectivity (for example, his preoccupation with death, which Crow and others have elucidated) emerges in the images chosen and their subtle manipulation by the artist.[100] Perhaps Warhol's denial of subjectivity and depth of meaning was necessary to signal the final death of Abstract Expressionism in the sixties. In this decade, as Michèle Cone states, "seeing was becoming a substitute for acting not only in art, with the demise of action painting, but in life, with the popularization of T.V. viewing."[101] Marshall McLuhan's dictum, "The medium is the message," applied to a culture in which people were rapidly confronted with images among which they could not choose, implied the death of artistic choice, or at least its drastic reformulation.[102]

Moreover, Robert Rosenblum has pointed out that beneath the shock of its subject matter vis-à-vis the tradition of fine art, Pop Art bears much in common with other forms of modern abstraction that responded to Abstract Expressionism: "The most inventive Pop artists share with their abstract contemporaries a sensibility to bold magnifications of simple, regularized forms—rows of dots, stripes, chevrons, concentric circles; to taut, brushless surfaces that often reject traditional oil techniques in favor of new industrial media of metallic, plastic, enamel quality; to expansive areas of flat, unmodulated color. In this light, the boundaries between Pop and abstract art keep fading."[103] Far from being a naive appropriation of readily available images, Pop Art may be read as a sophisticated iconographic and formal phenomenon.

The subject matter of Warhol's work was perhaps the most shocking of any Pop artist's, and debate continues, since his death in 1987, on his merits as an artist and thinker.[104] Having worked as a commercial artist in the fifties, Warhol brought his familiarity with the techniques and imagery of advertising to his first major painting, *Campbell's Soup Cans* of 1962, a Pop Art manifesto. Through subsequent works, *Coca-Cola Bottles* (1962) and *Brillo Boxes* (1964), Warhol gained notoriety with his "Capitalist Realism."

In two silkscreen portfolios of *Campbell's Soup I* and *II* (1968 and 1969), Warhol perverted the graphic tradition of states within the same image that we have discussed so frequently in this book. The red and white can remains the basic subject. Changes occurring between *I* and *II* do not destroy its recognizability but are market-motivated alterations of labels, flavor combinations, names: "Cream of Mushroom Soup" of 1968 (fig. 13.52) is supplanted by "Golden Mushroom Soup—Rich in Sliced Mushrooms" of 1969; the humble "Tomato Soup" pales beside the more recent "Tomato-Beef Noodle-O's"; and so on. Employing as art the stuff of the American Dream—unlimited consumerism and planned obsolescence—defied dominant Abstract Expressionist assumptions. While the challenge to Abstract Expressionism is clear, the nature of Warhol's commentary on consumerism is not: is it a pointed critique or an uncritical embrace? Perhaps it might also be described as an embrace marked by poignancy, for the American Dream was not unproblematic for Andrew Warhola, who grew up as the son of impoverished Czech immigrants in Pittsburgh.[105]

Warhol often worked on canvas with silkscreen, subverting the mystique of the artist's touch and the idea of the uniqueness of the work of art. At the same time, he might also seek unique, "painterly," or unpredictable effects in screenprinting, raising questions about reproducibility and uniqueness. None of this gives us direct access to Warhol's personality, however. Whereas printmaking had long adapted itself to painting, either reproducing paintings or seeking painterly effects, Warhol replaced easel painting with printmaking, but printmaking of a very particular, deliberately self-effacing kind.[106] If Johns had questioned the accessibility of the artist's psyche through the work of art, Warhol attempted, successfully or not, to put this question aside. Compared with the mechanical impersonality of the *Campbell's Soup Cans*, Johns's prints are like the works of the old masters in their formal ambiguity, virtuoso subtlety, and idiosyncracy.

Some of Warhol's most interesting works are about the commodification of individuals through the proliferation of their celebrity images in films, newspapers, and television: "Liz," "Elvis," and, above all, "Marilyn." Warhol began depicting Marilyn Monroe immediately after her apparent suicide in 1962, an event that illustrated the tragic dehumanization accompanying her stardom. Monroe was a subject taken up by a number of artists, including de Kooning.[107] Warhol's *Marilyns*, such as his 1967 screenprint portfolio (see fig. 13.53, color plate, p. 488), employ a repeated photograph, differently and garishly colored, to emphasize her value as a cultural commodity and the disjunction between this and her individuality.

Crow offers an especially intriguing discussion of Warhol's *Marilyns* as memorials playing poignantly with suggestions of presence and absence, and as a subtle critique of her "cult." The Abstract Expressionists had participated in the adulation of Monroe, whose marriage to the playwright Arthur Miller and involvement with the Actors' Studio, run by Lee Strasberg, had brought her into New York bohemian circles. Crow suggests that although Monroe's sexual mystique contributed to Warhol's conception, the artist dealt with her image with "a certain distance and reserve" that undercut the antifeminist aspects of her sex-goddess cult. Warhol

FIGURE 13.52

Andy Warhol. Cream
of Mushroom Soup
from Campbell's Soup I.
*1968. Color silkscreen. 810
× 479 mm. Whitney
Museum of American
Art, New York.

combined photographs of the star to suppress her characteristic seductive playing to the camera. The image Warhol created, Crow suggests, "exhibits a self-containment at odds with the smile."[108]

As Marilyn Monroe the person is lost in her media image, so monumental political figures like Mao Tse-tung could be trivialized and made marketable. Warhol's screenprint portfolio *Mao Tse-tung* (1972) was done during the year of Richard Nixon's trip to China, when Mao captured American popular interest. The *Maos* were also a response to Communist nations' frank use of banners and billboards to reinforce the legendary status of their great leaders. With Warhol's cheerful *Maos,* however, brightly colored and augmented by hand scribbles, an opposing ideology is "rendered impotent" as it is absorbed into American commercial culture.[109]

Equally provocative are Warhol's prints and paintings of the violent aspects of American society, ubiquitously represented in the mass media. The assassination of President Kennedy and the subsequent shooting of Lee Harvey Oswald by Jack Ruby became a bizarre, wrenching media event through extensive television coverage. For the first time in history, television made it possible for an entire society to witness, as it happened and then repeatedly, a political tragedy that would forever alter their nation. Warhol documented this event movingly in his *Jackie* paintings and prints, which employed photographs of the young First Lady and widow, herself a national icon, though in a different sense from Marilyn Monroe. In *Jackie I* (silkscreen; fig. 13.54), a sense of tragedy depends upon our knowledge of the events leading up to the assassination—our memory of Jacqueline Kennedy smiling in her pink suit and fashionable pillbox hat. Warhol incorporated this image into his screenprint portfolio *Flash—November 22, 1963* (1968), where it is combined with photographs of the president, the presidential seal, the gun, and the building from which the shots were fired.

FIGURE 13.54

Andy Warhol. Jackie I.
*1966. Color silkscreen.
610 × 508 mm. Ronald
Feldman Fine Arts,
New York.*

Assassination, a fact of modern political life (Warhol himself survived an assassination attempt in 1968), is only the top layer of a pervasive American violence that many Pop artists subtly probed. Warhol's many images of car crashes (daily events recurring with such frequency that we scarcely take notice of them unless we are directly involved), race riots, and electric chairs (culturally sanctioned killing) are but some examples. The *Electric Chair* portfolio of ten silkscreens (1971) is one of Warhol's grimmest works. The slick treatment of the central photographic image with seductive pastel colors and even (in the eighth print; fig. 13.55) textural richness does not disguise the reality of the chair—and this perhaps is Warhol's point.

If Warhol's adaptation of mass media and commercial design made his works difficult for some to accept, Roy Lichtenstein's use of not only the imagery but even the style and techniques of the comic strip also outraged some critics.[110] *POW! Sweet Dreams, Baby!* (1965; fig. 13.56, color plate, p. 489) is one of his early silkscreens appropriating the lettering, schematic drawing, Benday dots, and even the glamorous, oversimplified violence of the comic strip. Adam Gopnik has recently characterized Lichtenstein's interest in this source material as selective, primarily restricted to the romance imagery of Tony Abruzzo and the World War II adventure comics by Irv Novak. Lichtenstein's adjustments to the work of these artists signaled his own purposes. The Benday dots were enlarged and exaggerated, and the original artists' efforts to provide ambiance were ignored. As Gopnik puts it, Lichtenstein "had to work hard

FIGURE 13.55

Andy Warhol. Electric
Chair *from a portfolio
of ten color silkscreens.
1971. Color silkscreen.
902 × 1219 mm. Ronald
Feldman Fine Arts,
New York.*

to make them look more like comics." In turn, the comic book industry, which had been in a slump, was boosted by Lichtenstein's appropriations, and adopted his stylistic changes.[111]

Taken out of narrative context, the punch of *Sweet Dreams, Baby!* loses its specific purpose—it is just another manifestation of the aggressive power with which our society is obsessed and which is here made banal. The explosive "POW" is belied by the peaceful, unconscious man and even by the ironic use of an affectionate epithet in "sweet dreams, baby." As violence is made banal in Lichtenstein's works, so too is emotion. Tearful scenes of love and love lost receive the same deadpan, schematized formal treatment.

The comic book subject matter of Lichtenstein's early Pop works obscured his formal concerns, rooted in the work of abstract artists like Léger and Picasso and gradually finding more and more in common with contemporary abstractionists. Many of Lichtenstein's works are about art, and his formal means for quoting other images recall the visual syntaxes developed in reproductive printmaking.[112] In *Brushstrokes* (1967), he neutralized the Abstract Expressionist mark by silkscreening it flatly on a background of Benday dots. And in his series of lithographic *Cathedrals* (1969; see fig. 13.57, color plate, p. 489), he parodied Monet's famous studies of the facade of Rouen Cathedral in different lights. Whereas Monet had depended on direct study of the building to arrive at the subtle combinations of colored dabs that evoke a particular time of day, Lichtenstein mechanized the process: yellow dots on white were for noon; black on blue for midnight; red on yellow, the full light of day; blue on red, evening. The dots might be regular or overlapping, but in any case they are depersonalized echoes of Monet's dabs of paint.

One important source for Pop imagery was the common language of road signs and billboard advertisements.[113] Robert Indiana's *LOVE* (fig. 13.58), for example, first appearing in painted form in 1965, reflects his affection for the road signs that broke up the monotony of the flat midwestern landscape from which he came. It also reflects the simple messages (EAT, GAS, REST STOP) of what might be called the language of the American highway. Indiana's LOVE-image had wide distribution as a silkscreen print in different versions. It was an emblem of the sixties, conjuring up with one stark word a more complex American counterculture of

FIGURE 13.58

Robert Indiana. LOVE. *1967. Color silkscreen. 863 × 863 mm. Museum of Modern Art, New York.*

hippies, love-ins, rock music, long hair, and protests against the Vietnam War and the American economic and social establishment in general.

Another midwestern artist, James Rosenquist of North Dakota, actually worked as a billboard painter, traveling across Iowa via commissions for Phillips 66 signs, and later contributing to the advertising landscape of New York City. When blown up to the giant scale of the billboard, naturalistically rendered forms such as the canned pasta and lawn of *Spaghetti and Grass* (color lithograph, 1965; fig. 13.59) acquire an abstract dimension. The print offers a lush contrast of color and texture. The two juxtaposed areas bear a resemblance to the color-field paintings of recent American abstract art, and the twisted pasta strands and wisps of grass parody drip and gestural painting. The two motifs also evoke two very different sensual responses—warm wetness and cool softness. Although both motifs are rendered with the slick, gargantuan, close-up illusionism of the billboard, both express intensely organic, sensual, and oddly intimate experiences. Indeed, the spaghetti is visceral, frankly alluding to the human bowel that will digest it, and also uncomfortably suggestive of blood and death.

Donna Gustafson has noted the recurring focus on food in Pop Art and its relationship to the old concept of *vanitas,* in which the transitory pleasures of the senses were invoked to remind us of our mortality and thereby strengthen our religious faith. But Pop food, she argues, differs from the half-peeled lemons or half-eaten bread of seventeenth-century Dutch still-life. Canned and processed food, like Rosenquist's spaghetti, is not subject to decay in the same way; rather, the transitoriness evoked is that of the even more fleeting realm of advertising labels and media imagery. The rows of canned soup in Warhol's works mimic our own replaceability, and no religious faith waits to redeem us.[114] Carter Ratcliff has remarked about Warhol that he "dedicates his art to the only beauty specific to our times—the allure of the transient,

FIGURE 13.59

James Rosenquist. Spa-
ghetti and Grass. 1965.
Color lithograph. 708 ×
440 mm. Museum of
Modern Art, New York.

the disposable, the 'merely' glamourous."[115] Such a comment might also apply to the glossy visual beauty and sensuality of *Spaghetti and Grass*. The two motifs of the lithograph also appear in Rosenquist's epic painting of the same year, *F-III* (Collection of Richard E. Jacobs). In this work the canned spaghetti and billboard-style grass—a sort of prepackaged slice of pastoral nature—are combined with other slickly rendered products of American industry and

technology, including the atom bomb and the fighter-bomber that threads its way through the eighty-six-foot-long painting.

The obliqueness of Pop Art's critique of American culture, or its passive if not cheerful participation in that culture, leaves it open to accusations of lacking a political conscience. In her skeptical assessment of Warhol, Ashton remarks that he seems to have remained unmoved by the Vietnam War, whereas other American artists—and most emphatically printmakers—were producing vigorous images that overtly and angrily protested against American involvement in Southeast Asia and social injustice in many forms. In the sixties, when Pop Art came to fruition, African Americans were struggling for civil rights and economic opportunity, as they always had, but now with a greater fervor. Elizabeth Catlett's four-color linocut, *Malcolm X Speaks for Us* (1969; fig. 13.60), part of a series of works about black leaders, focuses explicitly on the portrait of Malcolm X, but more subtly conveys a sense of the anger and determination among African Americans that his philosophy tapped (note particularly the repeated face at the top of the print, whose glance echoes that of Malcolm X). Although not a Pop artist, Catlett drew selectively on the Pop vocabulary here with her Warhol-like repetition of the heads, so that the result is not a neutralization but a strengthening of the print's message. The faces to the left and at the bottom of the linocut lead inexorably toward and at the same time radiate from Malcolm X's portrait. In her own words: "I had the idea of a lot of women . . . of different ages around the head of Malcolm—as though they were absorbing from him." Moreover, the impact of each head is augmented by a powerful plasticity reminiscent of Catlett's own sculpture. Catlett herself had long been involved in the civil rights movement, and she worked with the Popular Graphics Workshop in Mexico, her adopted home, which drew upon the heritage of Posada to produce populist prints. Her graphic works clearly reveal her belief that printmaking is a medium that can be both accessible and political, a belief with a long history and, as Ashton's remarks suggest, many contemporary adherents.[116] By contrast, the selection of motifs in the Pop Art print constitutes a comment on America and its relationship to the world, but some would argue that the comment is not strong or clear enough.

Because of his re-presentation of banal objects like a bathrobe or tools in his works, Jim Dine is sometimes associated with the Pop movement. When Dine presents objects like tools, however, they are invested with an almost anthropomorphic presence, rich in the artist's personal memories and associations. Dine's grandfather had owned a hardware store in Cincinnati, and C-clamps, wrenches, pliers, and the like were part of the artist's personal history. His bathrobes are disembodied self-portraits; his Valentine-hearts emblems of human emotion, stand-ins for his wife, Nancy.[117]

Given Abstract Expressionism, Dine's choice of subject for his *Five Paint Brushes* (fig. 13.61), an intaglio print begun in 1972, was ironic. Employed not as part of a medium but as a subject, the paintbrush refuses its role as carrier of the artist's psyche and assumes a life and, more uncannily, an eros of its own. At heart a deeply sensual artist, Dine was attracted to the curving, phallic shapes of the handles and the long-flowing hairs—both were beautiful as pure line but replete with allusions to the human body as well. As he worked on the plate further, the brush hairs grew and, as if to affirm the sexual allusion, the brushes themselves multiplied.

Among printmakers of his generation, Dine offers the most outstanding example of old-master virtuosity. A turning point in Dine's approach came in 1974 when he worked with Mitchell Friedman at Dartmouth. Earlier prints like the witty, erotic *Four Kinds of Pubic Hair*

FIGURE 13.60

Elizabeth Catlett.
Malcolm X Speaks for
Us. *1969. Color lino-
cut. 950 × 700 mm.
Schomburg Center for
Research in Black
Culture, New York
Public Library.*

(1971) and *Five Paint Brushes*—related by their celebration of the etched line—had convinced Dine that etching was his favorite medium. He needed to get "away from the printers," as he put it, and the high-tech look of contemporary lithography and uniform-edition etching. He wanted to explore the etching process more intimately. In the course of this exploration, Dine discovered the usefulness of electric tools for altering plates, and of hand-inking and mono-printing. One of the best graphic series of the twentieth century is *Nancy Outside in July,* thirty-nine portraits of his wife done in collaboration with the famous Parisian printer Aldo Crom-melynck between 1977 and 1981.[118] Crommelynck had worked for twenty years with Picasso as well as with the best contemporary printmakers such as Johns and Hamilton. Dine found his impeccable professionalism a challenge and a foil.[119]

By the third state of *Nancy,* flowers begin to appear somewhat tentatively against the portrait; by the eighth state (1980; fig. 13.62), done from one plate worked with regular and soft-ground etching, drypoint, engraving, and electric tools, beautifully drawn blooms sur-round the face. Not only do the flowers express Nancy Dine's botanical interests, but their finely wrought contours establish a space in front of the sitter, adding psychological distance

FIGURE 13.61

Jim Dine. Five Paint
Brushes, *first state. 1972.
Etching and drypoint.
356 × 692 mm. Brooklyn
Museum.*

and mystery to the portrait. In a fascinating sequence of permutations, many involving non-print techniques, Nancy's image changes dramatically throughout the series. Some of the portraits, in contrast to the romantic eighth state, recall German Expressionist portraits in their taut intensity.

BRITISH POP

As we have mentioned, British artists were already incorporating aspects of American mass culture into their works in the fifties. In the sixties, there was a concurrent version of full-blown Pop in England, in which printmaking also played a major role.[120] Like Rauschenberg and Johns in the United States, Eduardo Paolozzi and R. B. Kitaj, an American working in Britain, were founders of British Pop. Paolozzi's *As Is When* series (1964–65), based on the philosophy of Ludwig Wittgenstein, is a remarkable example of silkscreen technique. Essential to its production and to contemporary British printmaking as a whole was the commercial silkscreener Chris Prater. For the *As Is When* prints, such as *Reality* (fig. 13.63), Paolozzi produced collage maquettes from a great variety of printed materials: patterns for embroidery and electronics, schematized textures for graphic artists, advertisements for toys, among other things. Prater then transformed these maquettes into screens for printing. Like many works by Rauschenberg, Paolozzi's *Reality* is concerned with the relationship between people and technology. The patterns, which express some predetermined way of doing something, are wittily and arbitrarily combined into a new machine that seems to have rotating wheels and complicated interlocking parts. Technology is humanized as it becomes fair game for art.

FIGURE 13.62

Jim Dine. Nancy
Outside in July VIII.
*1980. Etching, drypoint
and engraving. 594 ×
491 mm. Whitney Mu-
seum of American Art,
New York.*

David Hockney commented humorously on his introduction to American society in a
modern version of Hogarth's *Rake's Progress* (etching and aquatint, 1961–63). Andrew Brighton
describes the attitudes toward America that inspired this series:

> For many of us who grew up in Britain between World War Two and the Vietnam
> War . . . America was a dream of liberation. American advertising, literature, films, music,
> and art spoke to our emotional lives in a way little British culture did. This America of
> the imagination stood in contrast to the dull fog of Britain's ruling culture. Britain aspires
> to the social order of a village and its "natural" social hierarchy; to admit that all that
> surrounds you is not familiar is to betray yourself as an *arriviste,* an intruder, it is to be
> naive—like an American. The vision of the "new Britain" of the sixties was partially a
> vision of an Americanised Britain. It was the vision of America as an energetic and glam-
> orous meritocracy.[121]

The Start of the Spending Spree and the Door Opening for a Blonde (fig. 13.64) records Hockney's
self-transformation, effected with money earned from selling his works in New York, into an
eternally youthful, blond American ideal. The rake-artist, drawn in Hockney's deliberately
child-like style and balancing a bottle of Lady Clairol on his head ("Doors open for a blonde"

FIGURE 13.63

Eduardo Paolozzi. Reality *from* As Is When. *1964–65. Color silkscreen. 735 × 513 mm (irregular). Museum of Modern Art, New York.*

FIGURE 13.64

David Hockney. The Start of the Spending Spree and the Door Opening for a Blonde: *Plate 3 of* A Rake's Progress. *London: Editions Alecto in Association with the Royal College of Art, 1963. Color etching and aquatint. 300 × 400 mm. Museum of Modern Art, New York.*

was Clairol's advertising slogan), walks toward a door opening onto sunny beaches and palm trees. Unlike Hogarth's rake, who inherited his money, Hockney's new-found wealth had come from the art market, in which the work of art is just another commodity. Like Hogarth's character, Hockney's is exiled from his paradise for lack of money. He also ends up in Bedlam, depicted as a room with a group of robotic, T-shirt-clad figures listening to transistor radios.

Hockney's affectionately ironic attitude toward America is characteristic of British Pop, which viewed industrialized American culture from the outside, and used it as an antidote to the English status quo. In Hockney's series, the trappings of American consumer culture function as the English artist-rake's temptations.[122] The deadpan naivete and literalism of American Pop artists were therefore qualified in England, if not exactly by nostalgia, at least by the British artists' recognition of the alien nature of what they depicted. In contrast, American Pop artists inhabited the world they appropriated.

Richard Hamilton, the most outstanding printmaker among contemporary British artists, draws his work from American mass culture. As Field has suggested, American resistance to Hamilton's art might be due to the aptness of his critique of this culture, as well as to his apparent "stylelessness," which does not satisfy American expectations for the readily identifiable. Although they took their imagery from what was around them, American Pop artists did so in ways that were, nevertheless, instantaneously recognizable. More indirect and subtle, Hamilton's work probes the aesthetic, emotional, and philosophical questions raised by reproductive media.[123]

I'm Dreaming of a Black Christmas (1971; fig. 13.65) is one of three prints based on a movie-frame image of Bing Crosby that Hamilton also explored in oil paintings. The variety of methods employed to produce these three prints attests to Hamilton's technical expertise.[124] For *Black Christmas,* Hamilton augmented screenprinting and collage with collotype, a process in which a zinc or glass plate is coated with a photosensitive gelatine that hardens wherever it is exposed to light. Ink is retained in inverse proportion to the amount of moisture retained by the gelatine, and the plate is printed lithographically. Like Hamilton's other versions (White

FIGURE 13.65
Richard Hamilton. I'm
Dreaming of a Black
Christmas. *1971. Color
collotype, silkscreen, and
collage. 508 × 761 mm
(irregular). Museum of
Modern Art, New York.*

Christmases) of this image, *Black Christmas* is mysterious and evocative. When taken from its narrative context, the movie-frame is meaningless, and yet Crosby's expression suggests a re- signed melancholy, his pose a transition from one state to another. Hamilton seamlessly blended the private and public aspects of the man. Just as seamlessly, he combined the drawn and the reproduced, so that the photographic quality of the image is assimilated to its painterly handling, and vice versa.

OP ART, COLOR FIELD, AND MINIMALIST TRENDS

Contemporary with Pop Art was Op, distinguished by its interest in active, spatial optical effects created by the geometric combination of bright colors. Because it could produce smooth, flat surfaces, silkscreen was a natural technique for Op Art. With silkscreen, the Hungarian-born Victor Vasarely hoped to produce an art form that was democratic and sig- naled the death of easel painting. In the second print from his album *Planetary Folklore* (1964; fig. 13.66, color plate, p. 490), brightly colored round disks, set in gray or black squares, seem to rotate around horizontal or vertical axes to form ellipses. As the eye follows the labyrinthine path set out by the squares, it experiences abrupt changes between flatness and spatiality, static form and movement, as well as the staccato rhythm set up by the color variations.

Very important for Op Art were the color experiments of Josef Albers, whose prints car- ried the same optical resonance as his paintings, and the notions of non-elite art forms and design excellence deriving from the Bauhaus, where Albers had worked (see Chapter 11). Vasarely had studied with a Bauhaus disciple in Hungary; Richard Anuszkiewicz, Albers' stu- dent, also used silkscreen to provide agitated optical experiences for his viewers. In Anuszkie-

FIGURE 13.67

Richard Anuszkiewicz.
The Eye Sees More:
Plate 3 from The Inward
Eye *by William Blake.*
1970. Color silkscreen.
648 × 497 mm. El-
vehjem Museum of Art,
University of Wisconsin–
Madison.

wicz's illustrations for William Blake's *The Inward Eye* (1970; fig. 13.67), brilliantly contrasting colors trace spiral paths reminiscent of mandalas (the meditative cosmic diagrams of oriental religions) into triangles or trapezoids. At the same time, the lines suggest volumes moving into or out of the picture plane. The absolute tension between the flat, linear surface and its volumetric implications is maintained by the maximum optical activity of the contrasting colors.

Pop and Op, both of which utilized the silkscreen to obtain impersonal, hard-edge effects, challenged the Abstract Expressionist sense of the work of art as psychic revelation and the individual brushstroke as psychic signature. Another challenge came in the form of the radiant, large-scale color field, formed either by the flat application of paint or by staining it into the canvas. The color field emerged first in the work of Abstract Expressionists such as Barnett Newman, Mark Rothko, and Ad Reinhardt. Their nearly minimalizing approach to form was an important influence on younger artists.

In the lyrical, sensuous paintings of Helen Frankenthaler, the color, stained into raw canvas, is not flat and mechanical, but mysterious, even romantic, in its intensity. And Frankenthaler's graphic work is unabashedly painterly. She began working at U.L.A.E. in 1961 in lithography and produced aquatint etchings, but her most important prints are woodcuts

like *Savage Breeze* (1974) and *Essence Mulberry* (1977). Given her painterly orientation, this might seem surprising. But, as Field remarks, the achievement of Frankenthaler's woodcuts is the "total amalgamation of color with surface and space."[125]

Frankenthaler admitted that obtaining fluid shapes in woodcut was a difficult process, "work and no fun every minute."[126] Thomas Krens notes that the difficulty itself may have contributed to the outstanding quality of these prints. With lithography, and even aquatint etching, the means could be adapted to her reliance on "painterly gesture and spontaneity," the very things that "kept her outside the [printmaking] process." Her usual way of proceeding (based on the Abstract Expressionist aesthetic) was to make marks on the plate or stone, proof them, cut up the proofs and rework them into collages, and see if a composition would emerge. But in the subtractive woodcut process, this was impossible. She had to begin with the whole surface and its texture and constantly keep them in mind.[127]

In *Savage Breeze* (fig. 13.68, color plate, p. 490), Frankenthaler cut a mahogany plywood plank with a jigsaw—a procedure adapted from Munch. Like Munch, she also exploited the grain of the wood, which acts here like the canvas in her stained paintings. Bothered by the flatness of the print when the block was divided into green and rosy areas, she forced us into greater awareness of the grainy texture by introducing a surface-breaking band of yellow-orange and a wedge of dark green at the lower left. In the course of composing, she also discovered that subdividing the magenta shape into dark and light areas gave an interesting sense of the shape's projection toward the viewer. Eight pieces eventually formed the image. The woodcut's surface was considerably enlivened by an underprinting in white, which gave the delicate white lines a more definite presence and sharpened the overlying colors. Proofs taken from the block when it was cut into only four pieces later became the print *Vineyard Storm* (1974–76).

In contrast to Frankenthaler's color fields, those of the geometric artist Ellsworth Kelly are impersonal and unmodulated. Kelly's art is about the literal impact of color and shape, both reduced to their most concise, minimal form and both understood carefully in relation to each other. *Yellow* (1973–75; fig. 13.69, color plate, p. 491), for example, is one of a series of twelve lithographs from aluminum plates. The highly saturated color of the truncated square has an extraordinary weight and density, and pulsates against the pale gray field. Although this sort of work might seem an easy printing job, the Gemini printers had difficulty achieving the absolute flatness and uniformity of the yellow field—completely free of dust or modulation of any sort—and maintaining the precision of its edges.[128]

Although silkscreen would seem an obvious choice for an artist like Kelly, in fact he and many other post-painterly abstractionists of Minimalist inclinations (e.g., Kenneth Noland, Jules Olitsky, Frank Stella) favored more traditional methods like lithography and etching. Field suggests that these artists, in contrast to their Pop and Op colleagues, did not want the association with popular or commercial imagery carried by silkscreening: "Their color fields and structures were regarded as totally given and self-determined."[129] The autonomous and self-referential character of post-painterly works is perhaps best exemplified by the oeuvre of Frank Stella, the most interesting printmaker among post-painterly abstractionists. His prints follow his painted series but show concern for the special visual qualities of graphic media, their smaller scale, and their potential for serial expression.[130]

Like many other modern painters, Stella had to be persuaded to make prints; he was seduced by Ken Tyler and the other Gemini printers with a felt marker filled with tusche.[131] Stella's earliest prints were the *Star of Persia* lithographs of 1967, distinguished by the precision

of their registration and the use of metallic inks. In these prints, Stella worked with notched V shapes placed together in a star-shaped arrangement over a graph-paper grid. The star is not a composition, but an "object" whose inner markings are determined by the character of its outer shape. Earlier, he had planned to produce a series of paintings of these stars from drawings but was hampered by the unavailability of bolts of canvas big enough to accommodate his desired dimension of thirteen feet. *Star of Persia I* (fig. 13.70) was made from seven plates, six of which (gray-violet, magenta-violet, orange, yellow-ocher, gold-tan, and gray—all metallic) were printed over the base plate of metallic silver, which glimmers through the lines between the colors. The alignment and registration of these inks along the grid of the graph is one example of the technical excellence of Gemini printing.

Stella's titles are often exotic or romantic; the *Star of Persia*, for example, was a nineteenth-century clipper ship. His works often function as commemorations of something lost (the ancient Near Eastern city of *Sinjerli Variations* or the race-car driver Ronnie Peterson, memorialized in *Polar Coordinates*). In his *Exotic Bird* series of 1977, based on the metal-relief paintings of the same name (or, more accurately, on the drawings for those paintings), Stella achieved a lush, tropical expression and a new freedom of drawing and color, including glitterflex inks for metallic sparkle. The individual prints, such as *Puerto Rican Blue Pigeon* (fig. 13.71, color plate, p. 491), were named after extinct or endangered birds discussed in James Greenway's *Extinct and Vanishing Birds of the World* (1967). One wonders if Stella might also have been thinking of the gorgeously colored, printed birds of another American artist: John James Audubon.

Stella's graphic medium in *Exotic Birds* was a richly textured combination of offset lithography and silkscreen. He had used the latter sparingly, sometimes only to lessen the absorbency of the paper so that lithographic inks would retain their density; sometimes the linear passages had to be more precise than could be produced easily with lithography. But now both tonal and linear silkscreened areas were combined with subtle areas of lithographic washes. *Blue Pigeon* required no fewer than twenty-eight plates and twenty-one screens, printed in fifty-one press runs. Stella's painterly treatment is played against the graph-markings of the background. Moreover, Stella's curves are not freehand, but were produced mechanically from drafting devices such as protractors and French curves.

Stella's sensitive use of lithography and silkscreen is paralleled by the use of etching and aquatint by other Minimalist artists such as Mel Bochner, Sol LeWitt, Vincent Longo, Robert Mangold, Brice Marden, and Dorothea Rockburne.[132] Such artists play a severe restrictiveness of form against an excruciatingly subtle sense of change, randomness, and freedom. Changes might be intensely cerebral and complex, as in Rockburne's *Locus* series (1972–76; see fig. 13.72), which combined an interest in paperworks and sculptural printmaking with a conceptual approach based on intricate foldings and reprintings of the paper.[133] A grid of etched lines forms the basis for Longo's *Screen* (1967), shown here in its second state (fig. 13.73). Whereas the rationality of the grid, altered by random diagonal markings within the individual squares, still dominates the second state, the third (final) state shows the encroachment of the interior markings over the whole grid—it is a totally different image, despite its basis in the earlier state. In both images a mottled light is laid over the rigidity of horizontal and vertical, and the linear variations from manual pressure in holding the etching needle are also perceptible. Variable wiping and plate tone can also augment such subtleties. Anna C. Chave's provocative analysis of the Minimalist movement in terms of authoritarian and technocratic power is less

compelling in the face of the contemplative qualities, delicate surfaces, and small scale of many Minimalist prints.[134]

A PLURALITY OF POSSIBILITIES AND THE RETURN OF TRADITION

The seventies and early eighties were characterized not only by the continuing production of prints by artists associated with Pop Art and Minimalist abstraction, but by a turning toward older techniques and subjects, reformulated for the contemporary world. Partly in reaction to the emphasis on abstraction in much recent art, for example, American artists reprised the old subject of the urban genre scene, and the American taste for literal realism resurfaced.

In their effort to record the native urban and technological environment and, frequently, their sense of the loneliness of this environment, recent American realists such as Richard Estes and Robert Cottingham harked back to earlier artists like Edward Hopper and Charles Sheeler. The playing of art against photography, and the frequent incorporation of the latter into the creative process in Photo-Realist art, also finds a base in Pop-related art: in particular the disarmingly illusionistic silkscreens of Edward Ruscha, who had done experiments in printing

FIGURE 13.72

Dorothea Rockburne.
Locus No. 4. *1972. Soft-*
ground etching and
aquatint on folded paper.
1016 × 762 mm (sheet).
Yale University Art
Gallery, New Haven.

FIGURE 13.73

Vincent Longo. Screen,
second state. *1967. Etch-*
ing. 454 × 378 mm.
Condeso/Lawler Gallery,
New York.

with fugitive "inks" made from substances such as caviar, Dutch Chocolate Metrecal (a diet drink), and Pepto-Bismol.[135] His silkscreened portfolio *Insects* (1972), here illustrated with *Flys* (fig. 13.74), is a humorous essay on the trompe-l'oeil art of the past. The lizard of the Dutch still-life, the crumpled paper of a William Harnett illusion, or the nail in the Picasso collage here find their modern counterparts, depicted to scale and crawling about with no particular composition in mind. In *Flys,* the illusion is unabashedly reinforced by printing on wood veneer. It will come as no surprise that Ruscha, like Rosenquist and Warhol, was trained in advertising art.

With the minutely detailed silkscreens of Estes, which evolve through numerous printing screens, we arrive full circle at another of printmaking's initial driving forces: the creation of pictorial illusion. In its own way, *Grant's* (fig. 13.75, color plate, p. 492) from *Urban Landscapes I* (1972) is as magical as Dürer's *St. Jerome in His Study* (fig. 2.15) for the technical finesse with which it achieves the illusion of space. In Renaissance fashion, the pictorial field is understood as a window through which the viewer looks. Estes' picture-plane windows are ambiguous, since the observer often finds other windows or reflective surfaces insistently looking back. Whereas Dürer was anxious to proclaim the skill of his hand, Estes sought anonymity and used the vastly expanded technical resources at his disposal, as is appropriate for an artist in a highly technological age. His medium is commercial; his surfaces are smooth; his spaces are empty. *Grant's* is partly about the fragmented way in which the city is perceived, its rapid and often confusing juxtapositions, and the extraordinary amount of visual and verbal content that the average city block contains (look at the verbal information in the three windows). But *Grant's* is also about the nature of illusion in art. A color may be silkscreened flatly on the surface of the paper to depict the reflection, in a glass window *in front of* the spectator, of a building *behind* the spectator.[136]

Whereas *Grant's* is devoid of the literal human presence, Jane Dickson's *Stairwell* (fig. 13.76), a large color aquatint of 1984, is insistently and uncomfortably focused on a single female figure. She is anonymous, but the dark atmosphere, raking light, and dizzying spatial view of this print lend her a vulnerability that engages us in her undefined, vaguely threatened situation. The expressive power of this image cannot be detached from the pervasive violence against women in contemporary American cities. Like Estes', Dickson's work recalls the American urban genre scene of the thirties and forties, but more directly, with an eye for the psychological alienation and the physical grittiness suggested by those scenes. In contrast to Estes' slick silkscreened surfaces, Dickson's aquatint grain functions as a metaphor for urban grime. Echoes of Hopper's lonely urban vistas, Lewis' spatial geometry, and Marsh's seedy street corners appear in her prints, but updated to reflect, in her words, "the ominous underside of contemporary culture."[137]

In the paintings of Philip Pearlstein, the old subject of the human body is treated with a cool detachment and rendered with a precision that also reflects the artist's participation in a technological age. Pearlstein's use of color aquatint in *Model in Green Kimono* (1979; fig. 13.77) captures the objectivity and smooth surfaces of his paintings. The superimposition of the aquatinted colors gives the nude a glossy polish that might just as well be that of an automobile or apple: the potential narrative implications of figures in an interior setting are thus neutralized. Similarly, Pearlstein attempts to diffuse eroticism by the scale, the absence of intimate details, and the modernism of composition and surface.[138]

Technically as superb as Pearlstein's etchings, yet drastically different in their expressive impact, are Peter Milton's works, which draw on the tradition of American realism as well as on Surrealism's irrational and evocative juxtapositions of objects, figures, and elusive meanings. *Daylilies* (1975; fig. 13.78) is a palimpsest of memory images.[139] It began with a drawing called *The Theft,* whose central character is the boy looking outward with a crowd behind him—all taken from old photographs. Milton photographed *The Theft* and enlarged it onto high-contrast film. Then he began to draw over and around the original image as he did in his combination of photographic collages and drawings on transparent Mylar to be made into etchings.

To etch his collage-drawings, Milton coated a plate with a photo-resistant substance that hardens wherever it is exposed to ultraviolet light. Then, the Mylar bearing the image was placed against the plate for exposure. Immersing the plate in a chemical bath softens the ground wherever it is protected by a mark made on the Mylar, so that these marks are exposed to acid when the plate is bitten. For *Daylilies,* Milton incorporated photographs around the drawing of the boy and the crowd. To the right on the mantel is a man in an oval frame; to the left is a picture of Milton's children. On the wall at the right is a photograph of an unidentified girl that Milton liked because of its "feeling of delicacy and remoteness."[140] At the bottom right is Eadweard Muybridge's moving picture of a paralytic child crawling, and in the foreground are images conflated from two photographs by the great American painter Thomas Eakins: a portrait of his friend Frank Hamilton Cushing, and a picture of Eakins' cat.

Other references are present as well: lilies from Milton's garden, the magic square from Dürer's *Melencolia I* (fig. 2.16), a pendant with the Egyptian hieroglyph for life, and imagery

FIGURE 13.76
Jane Dickson. Stairwell.
1984. Color aquatint.
908 × 578 mm. Brooke
Alexander Editions,
New York.

FIGURE 13.77
Philip Pearlstein. Model
in Green Kimono. *1979.*
Color etching with aqua-
tint. 1025 × 692 mm.
Hirschl and Adler Gal-
lery, New York.

from the photographs of André Kertesz. Milton did not intend us to construct a narrative, however irrational, from these discrepant parts. Rather, *Daylilies* conveys memories clung to and a poignant nostalgia for a lost world. We know these people from the past only from images, shadows of their real selves (note the shadowy presences on the mirror). Perhaps *Daylilies* also reflects Milton's own affection for the historicism of his art, which put him out of step with many other recent printmakers. The inverted and reversed clock punctuates the meaning of *Daylilies* as a magical superimposition of past moments, images, and lives.

In contrast to the extraordinary technical elaboration of Milton's *Daylilies,* Vija Celmins' *Drypoint—Ocean Surface* (1983; fig. 13.79) is characterized by the exquisite simplicity of direct, meticulous work on the plate. Celmins' bird's-eye view of the watery surface plays its changeability against its uninterrupted wholeness, and while the artist's prolonged, keen observation is obvious in the intricate drawing, her carefully controlled light and the unbroken restraint

and consistency of the image convey timelessness and stillness. In this small print, as well as in her other graphic work in lithography, etching, and mezzotint, Celmins reprises the old American interest in nature and exploration. She also deals with large ideas, despite her modest format: the dialectic between the human and the natural, the sensual and the cognitive, the microcosmic and the cosmic.[141]

Chuck Close produces his portraits on a large scale from photographs. Expressionless and unidealized, often unpleasant, these portraits remind one of photos on passports or drivers' licenses, and they are just as uninformative about personality.[142] Unlike the smooth, "cool" surfaces of contemporary portraits by Alex Katz, however, Close's are technically "hot." His unassuming subjects, completely lacking the jet-set glamour of Warhol's, are rendered with painstaking detail that, along with his large-scale presentation, overwhelms the viewer with visual information. Sometimes this information coheres into a whole; sometimes it dissolves into minutiae. Close's faces lose their inorganic and psychological legibility to a technical syntax.

Close's first print was *Keith* (1972; fig. 13.80), a mezzotint, and its fascination in part derives from the combination of the intentions of an artist new to printmaking with the exigencies of the technique. Close worked at a small etching shop, Crown Point Press, headed by the printer Kathan Brown. Not only did Close want to print on a large scale, which differed from Crown Point's normal practice, but he wanted to work in mezzotint because it was a technique, he said, with "no immediate history." Despite Brown's reservations—mezzotint had been used rarely in the past century, and then only on a modest scale—she took a flexible approach and adapted the shop to Close's needs.[143]

The medium of mezzotint is archaic (especially when we consider the incorporation of so much high technology into contemporary printmaking) but ideally suited to Close's meticulous approach. The large plate precluded hand-rocking, but once it was mechanically pitted, Close worked it as an eighteenth-century mezzotinter would have: scraping and burnishing from absolute black to white. The process took so long that the grids by which the artist worked appear different within the whole: as the plate was printed for proofing, the sections done earlier wore down more than ones done later. Close thus made a print that commented upon his method of painting by dividing the information from photographs into a grid. In one sense the mezzotint *Keith* is like a reproductive print of the painting. But in another sense the print comments upon the very process of printmaking and makes explicit the time and manual labor that some contemporary art denies or ignores. At the same time, the insistent presence of the grid relates to minimalist abstraction, in which all evidence of the artist's hand is expunged.

Scarcely any material, technical, formal, or expressive barriers confront the contemporary printmaker. If the restrictions laid down by the Print Council in 1961 seemed overly narrow then, they are doubly so now. And yet the traditional idea of the original print as championed by the Print Council—a finely conceived and crafted, hand-held, multiple image on paper— is also alive and well. Celmins' or Close's employment of an old medium requiring considerable manual dexterity is no less valid today than approaches that incorporate high-tech, commercial reproductive processes. Now, the printmaker's realm overlaps not just that of the painter (with which it had always been confused), but that of the sculptor as well. Whatever changes the future holds for printmaking, one may be sure that Ivins' observations on the overriding importance of the "quality of mind and hand" will remain true.

1. Gilmour 1987, p. 85, p. 90, n. 36.

2. Mourlot cited in Melot, Griffiths, and Field 1981, p. 184. On Picasso and Mourlot, see Gilmour 1987, pp. 85–87; Gilmour 1988, pp. 330–31.

3. Gilot and Lake 1964, p. 273; Gilmour 1987, p. 86.

4. Gedo 1980, p. 17.

5. Gilmour 1987, p. 88.

6. Lieberman 1985, p. 13.

7. Gilmour 1987, p. 88.

8. Picasso quoted in Goldwater and Treves, eds., 1945, p. 419.

9. Karshan 1968, pp. x–xii, and figs. 6–12.

10. Gilmour 1987, pp. 88–89.

11. Gedo 1980, pp. 247–48.

12. Gilmour 1987, p. 89. Also see Baer 1983, pp. 174–75, on the technique.

13. See Baer 1988 for an appreciative account of Picasso's very late prints and a discussion of their theatrical aspects.

14. Steinberg 1973.

15. Schiff 1983, p. 49.

16. See ibid; Schiff 1972.

17. Steinberg 1973, p. 104.

18. J. Cohen 1983.

19. Baer 1988, p. 122.

20. Bryson, 1984, p. 147.

21. Castleman [1976] 1988, chap. 9, emphasizes these two ideas. My discussion in this section owes much to her text and to her choice of images.

22. Ashton 1962, pp. 143–57.

23. Varnedoe 1990b, pp. 85–89, discusses Dubuffet's interest in graffiti.

24. On Dubuffet and *l'art brut,* see Fisher 1989.

25. Quoted ibid., p. 32.

26. Dubuffet 1964, not paginated.

27. Ibid.

28. Rowell 1973, p. 34.

29. E. Johnson 1966, p. 36.

30. Castleman [1976] 1988, p. 146.

31. Moser 1977, p. 8. Also see Kainen 1986 for an interview with Hayter.

32. Quoted in Moser 1977, p. 13.

33. Field 1981, p. 191.

34. Castleman 1985, p. 12. For a survey of Pollock's prints, see Williams and Williams 1988.

35. See Rhodes 1975.

36. See Fern 1975, p. 17.

37. See Lasansky 1975, no. 139, p. 140.

38. Moser 1977, p. 18.

39. See Geske 1971, passim.

40. U. Johnson 1966, pp. 11–13.

41. Metropolitan Museum of Art 1980, p. 220, and no. 92, p. 225.

42. Goldman 1981, p. 53 (includes Hayter quotation).

43. Ashton 1952.

44. Field 1981, p. 190.

45. Moser 1977, p. 41.

46. Quoted ibid., p. 42.

47. See the discussion in Watrous 1984, pp. 185–86.

48. Roylance in Far Gallery 1970, not paginated. Also see Hughes 1984 for a discussion of Baskin's contemporary *Hanged Man* in similar iconographic terms.

49. The last term, as noted in Chapter 12, was coined by Zigrosser 1941.

50. Castleman 1980, pp. 11–12, especially p. 11 for quotation.

51. Prescott 1973, fig. 176, p. 144.

52. Ashton quoted in Watrous 1984, p. 221.

53. Print Council of America 1961; Castleman 1985, pp. 51–52.

54. Camnitzer 1966.

55. Ivins [1953] 1969, pp. 114–15.

56. Castleman 1985, p. 73.

57. Sparks 1989, pp. 70–73.

58. Rosenberg [1959] 1965.

59. Einstein 1975; Francis and Page 1979.

60. Quoted in Terenzio and Belknap 1984, p. 28.

61. Gilmour 1988, p. 350.

62. Terenzio and Belknap 1984, no. 95, pp. 189, 192. On *A la Pintura,* also see McKendry 1972; Colsman-Freyburger 1974; Sparks 1989, pp. 171–93.

63. On the philosophical and mythological content of Newman's art, see Hess 1971.

64. Ibid., pp. 126–32; Sparks 1989, pp. 194–210.

FIGURE 13.80
Chuck Close. Keith. *1972. Mezzotint and roulette. 1160 × 900 mm. Museum of Modern Art, New York.*

65. Armstrong and McGuire 1989, pp. 11–13.

66. See Fine 1988 for a discussion of the growth of American lithography after World War II.

67. Castleman 1980, p. 15. On the silkscreen "boom" of the sixties and its connection to silkscreens of the thirties, see Field 1971.

68. On U.L.A.E., see Zerner 1964; Bloch 1978; Sparks 1989. On Tamarind, see Bloch 1971.

69. Krens 1980, p. 38.

70. Quoted in Foster 1970, introduction (not paginated).

71. On Gemini G.E.L., see Castleman 1971; Fine 1984.

72. Antreasian and Adams 1971.

73. Armstrong and McGuire 1989, p. 26.

74. For basic studies of Johns's prints, see Field 1970; Field 1978a; Rose 1970; and, most recently, Castleman 1986.

75. Grosman quoted in Crichton 1977, p. 44.

76. Field 1970, nos. 17–46, not paginated.

77. Young 1969, p. 53.

78. Rosenberg 1964, p. 74.

79. Johns quoted in Young 1969, p. 53.

80. Debs 1986, p. 120.

81. Greenberg 1962.

82. Field 1976, pp. 73–74.

83. Quoted in Debs 1986, p. 118.

84. Castleman [1976] 1988, p. 168.

85. See Tomkins 1976, p. 68; Adams 1986a; Adams 1986b. Also see Gilmour 1986 for replies to Adams.

86. On *Booster* and its significance for combination prints, see R. Cohen 1985a. On *Booster*'s meaning, see Lippard 1967.

87. Fine 1984, no. 4, p. 48.

88. Alloway 1970, in Alloway 1975, p. 134.

89. Rauschenberg 1969.

90. Fine 1984, no. 36, p. 106.

91. Rauschenberg 1969.

92. On Johns's lead relief prints, see Solomon 1969. On Nevelson's lead-intaglio series, see Baro 1974, nos. 109–114.

93. On *Shades,* see Foster 1970, no. 22; on the *Cardbirds,* see Gemini G.E.L. 1971.

94. On this series, see Young 1974.

95. See the artist's explanation, ibid., p. 29.

96. See Gemini G.E.L. 1974.

97. Warhol 1975, p. 229.

98. For example, see the contrasting views set out in Varnedoe 1990a, p. 335.

99. Russell 1969, p. 22.

100. Crow 1987, pp. 130–31, especially p. 130 for quotation.

101. Cone 1989, p. 54.

102. Castleman 1985, p. 17.

103. Rosenblum 1964, p. 56.

104. The vast material on Warhol includes many primary as well as secondary sources (and interpretations): see the bibliography in McShine, ed., 1989. In his excellent monograph on Warhol, Carter Ratcliff 1983 constantly asks how Warhol's intentions might be interpreted. For a grand assessment of Warhol's importance, equating him with Manet in the scope of his subject matter and his revolutionary approach to art, see Rosenblum 1989. For a far more skeptical view, see Ashton 1989.

105. In an intriguing analysis, Collins 1988 describes Warhol's art as a means of banishing or masking the artist's personal fears and disappointments.

106. For a catalogue raisonné of Warhol's prints, see Feldman and Schellmann, eds., 1985.

107. See Alloway 1967; Hess 1972.

108. Crow 1987, pp. 132–33. Also see Collins 1988, pp. 52–53, for a discussion of the connection between Warhol's movie-star images and his obsession with his own imperfect looks.

109. Feldman and Schellmann, eds., 1985, p. 17.

110. On Lichtenstein's early prints, see Waldman 1972.

111. Gopnik 1990, pp. 199–209, especially p. 199 for quotation.

112. R. Cohen 1985b, p. 164.

113. Varnedoe 1990a treats the relationship between advertising and modern art.

114. Gustafson 1986.

115. Ratcliff 1983, p. 103.

116. Ashton 1989, p. 69. On Catlett, see Lewis 1984 (the artist is quoted on p. 91). For a survey of political prints of the Pop era and beyond, see Wye 1988.

117. On Dine's prints, see D'Oench and Feinberg 1986.

118. Ibid., pp. 3–4, especially p. 3 for quotation from Dine. For *Nancy Outside in July,* see Ackley 1983.

119. D'Oench and Feinberg 1986, p. 9. Also see Gilmour 1985 on Dine and Crommelynck.

120. See Alloway 1966.

121. Brighton 1979, not paginated.

122. Martin 1987, p. 31.

123. On Hamilton's oeuvre in general, see Morphet 1970. On Hamilton as a printmaker, see Field 1973.

124. Field 1973, nos. 19, 27, and 34, pp. 35, 44, 52.

125. Field, in Field and Fine 1987, p. 33.

126. Quoted in Krens 1980, pp. 30–31.

127. Ibid., p. 46.

128. Fine 1984, pp. 132–34.

129. Field 1981, p. 204.

130. See Axsom 1983 on Stella's prints.

131. Armstrong and McGuire 1989, pp. 60–61.

132. For a survey of these prints, see Tousley 1975.

133. See Field's discussion of this series in Field and Fine 1987, p. 23.

134. Chave 1990. Also see R. Cohen 1990 for a consideration of Minimalist prints.

135. On Ruscha, see Cathcart 1976.

136. On Estes' printed urban landscapes, see Arthur 1979. Also see Field 1981, p. 218.

137. Quoted in Gould 1987, p. 204. Also see Field and Fine 1987, pp. 73–75.

138. On the revival of traditional etching and aquatint in American printmaking of the late sixties and early seventies, see Field 1975. On Pearlstein's prints, see Field 1978b. Goldman 1981 includes reproductions of the states of *Model in Green Kimono,* pp. 138–43.

139. Milton's discussion of *Daylilies* is included in McNulty 1977, pp. 112–17.

140. Ibid., p. 117.

141. On Celmins' prints, see Ratcliff 1984; Field and Fine 1987, pp. 19, 59–61.

142. Steiner 1987, p. 175.

143. On Close's prints, see Shapiro 1978. For extensive illustration of *Keith,* see Goldman 1981, pp. 64–69. Also see Armstrong and McGuire 1989, p. 82, on Close and Kathan Brown.

REFERENCES

Ackley, Clifford S. 1983. *Nancy Outside in July: Etchings by Jim Dine.* Exhibition catalog. Art Institute of Chicago.

Adams, Clinton. 1986a. Review of Pat Gilmour's *Ken Tyler: Master Printer. Print Collector's Newsletter,* vol. 17, no. 3 (July–August), p. 107.

Adams, Clinton. 1986b. Letter to the Editor. *Print Collector's Newsletter,* vol. 17, no. 4 (September–October), p. 139.

Alloway, Lawrence. 1966. The Development of British Pop. In Lippard 1966, pp. 27–67.

Alloway, Lawrence. 1967. Marilyn as Subject Matter. Reprinted in Alloway 1975, pp. 140–44.

Alloway, Lawrence. 1970. Rauschenberg's Graphics. Reprinted in Alloway 1975, pp. 125–35.

Alloway, Lawrence. 1975. *Topics in American Art since 1945.* New York.

Antreasian, Garo, and Clinton Adams. 1971. *The Tamarind Book of Lithography: Art and Techniques.* New York.

Armstrong, Elizabeth, and Sheila McGuire. 1989. *First Impressions: Early Prints by Forty-Six Contemporary Artists.* Exhibition catalog. Walker Art Center, Minneapolis.

Arthur, John. 1979. Richard Estes: The Urban Landscape in Print. *Print Collector's Newsletter,* vol. 10, no. 1 (March–April), pp. 12–15.

Ashton, Dore. 1952. Brooklyn Reviews Today's American Print Techniques. *Art Digest,* vol. 26, no. 20 (September), pp. 6–8.

Ashton, Dore. 1962. *The Unknown Shore: A View of Contemporary Art.* Boston.

Ashton, Dore. 1989. Blinding with Gold Dust. *Art International,* no. 7 (Summer), pp. 67–73.

Axsom, Richard H. 1983. *The Prints of Frank Stella: A Catalogue Raisonné, 1967–1982.* Exhibition catalog. Museum of Art, University of Michigan. Ann Arbor and New York.

Baer, Brigitte. 1983. *Picasso the Printmaker: Graphics from the Marina Picasso Collection.* Exhibition catalog. Dallas Museum of Art.

Baer, Brigitte. 1988. Seven Years of Printmaking:

The Theatre and Its Limits. In Tate Gallery 1988, pp. 95–135.

Baro, Gene. 1974. *Nevelson: The Prints*. New York.

Bloch, Maurice E. 1971. *Tamarind: A Renaissance in Lithography*. Exhibition catalog. International Exhibitions Foundation, Washington, D.C.

Bloch, Maurice E. 1978. *Words and Images: Universal Limited Art Editions*. Exhibition catalog. Frederick S. Wight Gallery, University of California, Los Angeles.

Brighton, Andrew. 1979. *David Hockney Prints, 1954–1977*. Exhibition catalog. Midland Group and Scottish Arts Council. Nottingham, England.

Bryson, Norman. 1984. *Tradition and Desire: From David to Delacroix*. Cambridge and New York.

Camnitzer, Luis. 1966. A Redefinition of the Print. *Artist's Proof*, vol. 6, p. 103.

Castleman, Riva. 1971. *Technics and Creativity: Gemini G.E.L.* Exhibition catalog. Museum of Modern Art, New York.

Castleman, Riva. 1980. *Printed Art: A View of Two Decades*. Exhibition catalog. Museum of Modern Art, New York.

Castleman, Riva. 1985. *American Impressions: Prints since Pollock*. New York.

Castleman, Riva. 1986. *Jasper Johns: A Print Retrospective*. Exhibition catalog. Museum of Modern Art, New York.

Castleman, Riva [1976] 1988. *Prints of the Twentieth Century: A History*. Rev. ed. New York.

Cathcart, Linda L. 1976. *Edward Ruscha*. Exhibition catalog. Albright-Knox Gallery, Buffalo, N.Y.

Chave, Anna C. 1990. Minimalism and the Rhetoric of Power. *Arts Magazine*, vol. 64, no. 5 (January), pp. 44–63.

Cohen, Janie L. 1983. Picasso's Exploration of Rembrandt's Art, 1967–1972. *Arts Magazine*, vol. 58 (October), pp. 119–26.

Cohen, Ronny H. 1985a. The Medium Isn't the Message. *Art News*, vol. 84, no. 8 (October), pp. 74–81.

Cohen, Ronny H. 1985b. Prints about Art. *Print Collector's Newsletter*, vol. 16, no. 5 (November–December), pp. 164–68.

Cohen, Ronny H. 1990. Minimal Prints. *Print Collector's Newsletter*, vol. 21, no. 2 (May–June), pp. 42–46.

Collins, Bradford R. 1988. The Metaphysical Nosejob: The Remaking of Warhola, 1960–1968. *Arts Magazine*, vol. 62, no. 6 (February), pp. 47–55.

Colsman-Freyberger, Heidi. 1974. Robert Motherwell: Words and Images. *Print Collector's Newsletter*, vol. 4, no. 6 (January–February), pp. 125–29.

Cone, Michèle. 1989. Warhol's Risk: Voyeurism or Exposure? *Arts Magazine*, vol. 63, no. 10 (Summer), pp. 51–55.

Crichton, Michael. 1977. *Jasper Johns*. Exhibition catalog. Whitney Museum of American Art, New York.

Crow, Thomas. 1987. Saturday Disasters: Trace and Reference in Early Warhol. *Art in America*, vol. 75, no. 5 (May), pp. 128–36.

Debs, Barbara Knowles. 1985. On the Permanence of Change: Jasper Johns at the Modern. *Print Collector's Newsletter*, vol. 17, no. 4 (September–October), pp. 117–23.

D'Oench, Ellen G., and Jean E. Feinberg. 1986. *Jim Dine Prints: 1977–1985*. Published in conjunction with an exhibition, Davison Art Center, Wesleyan University, Middletown, Conn.

Dubuffet, Jean. 1964. Notes on Lithographs by Transfers of Assemblages, and on the "Phenomena" Series. In Philadelphia Museum of Art 1964, not paginated.

Einstein, Susan. 1975. The Prints of Sam Francis. In Selz 1975, pp. 225–46.

Far Gallery. 1970. *Leonard Baskin: The Graphic Work 1950–1970*. Exhibition catalog with Introduction by Dale Roylance. Far Gallery, New York.

Feldman, Frayda, and Jorg Schellmann, eds. 1985. *Andy Warhol Prints: A Catalogue Raisonné*. New York.

Fern, Alan. 1975. The Prints of Mauricio Lasansky. In Lasansky 1975, pp. 12–18.

Fern, Alan, and Judith O'Sullivan. 1984. *The Complete Prints of Leonard Baskin*. With introduction by Ted Hughes. Boston.

Field, Richard S. 1970. *Jasper Johns: Prints*

1960–1970. Exhibition catalog. Philadelphia Museum of Art.

Field, Richard S. 1971. *Silkscreen: History of a Medium.* Exhibition catalog. Philadelphia Museum of Art.

Field, Richard S. 1973. *The Prints of Richard Hamilton.* Exhibition catalog. Davison Art Center, Wesleyan University, Middletown, Conn.

Field Richard S. 1975. *Recent American Etching.* Exhibition catalog. Davison Art Center, Wesleyan University, Middletown, Conn.

Field, Richard S. 1976. Jasper Johns' Flags. *Print Collector's Newsletter,* vol. 7, no. 3 (July–August), pp. 69–77.

Field, Richard S. 1978a. *Jasper Johns: Prints 1970–1977.* Exhibition catalog. Davison Art Center, Wesleyan University, Middletown, Conn.

Field, Richard S. 1978b. *The Lithographs and Etchings of Philip Pearlstein.* Exhibition catalog. Exhibition assembled by William C. Landwehr. Springfield Art Museum, Springfield, Mo.

Field, Richard S. 1981. Contemporary Trends. In Melot, Griffiths, and Field 1981, pp. 188–233.

Field, Richard S., and Ruth E. Fine. 1987. *A Graphic Muse: Prints by Contemporary American Women.* Exhibition catalog. Mount Holyoke College Art Museum, South Hadley, Mass.

Fine, Ruth E. 1984. *Gemini G.E.L.: Art and Collaboration.* Exhibition catalog. National Gallery of Art, Washington, D.C.

Fine, Ruth E. 1988. Bigger, Brighter, Bolder: American Lithography since the Second World War. In Gilmour, ed., 1988, pp. 257–82.

Fisher, James L. 1989. Jean Dubuffet and l'Art Brut. In Museum of Modern Art 1989, pp. 23–34.

Foster, Edward A. 1970. *Robert Rauschenberg: Prints, 1948/1970.* Exhibition catalog. Minneapolis Institute of Arts, Minneapolis.

Francis, Sam, and George Page. 1979. *Sam Francis: The Litho Shop, 1970–1979.* Exhibition catalog. Brooke Alexander Gallery, New York.

Gablik, Suzi, and John Russell, eds. 1969. *Pop Art Redefined.* London.

Gedo, Mary Mathews. 1980. *Picasso: Art as Autobiography.* Chicago.

Gemini G.E.L. 1971. *Robert Rauschenberg: Cardbirds.* Gemini G.E.L. brochure. Los Angeles.

Gemini G.E.L. 1974. *Robert Rauschenberg: Hoarfrost Editions.* Gemini G.E.L. brochure. Los Angeles.

Geske, Norman A. 1971. *Rudy Pozzatti: American Printmaker.* Lawrence, Kans.

Gilmour, Pat. 1985. Symbiotic Exploitation or Collaboration: Dine and Hamilton with Crommelynck. *Print Collector's Newsletter,* vol. 15, no. 6 (January–February), pp. 194–98.

Gilmour, Pat. 1986. Letters to the Editor. *Print Collector's Newsletter,* vol. 17, no. 4 (September–October), pp. 138–39.

Gilmour, Pat. 1987. Picasso and His Printers. *Print Collector's Newsletter,* vol. 18, no. 3 (July–August), pp. 81–90.

Gilmour, Pat. 1988. Lithographic Collaboration: The Hand, the Head, the Heart. In Gilmour, ed., 1988, pp. 308–59.

Gilmour, Pat, ed., 1988. *Lasting Impressions: Lithography as Art.* London.

Gilot, Françoise, and Carlton Lake. 1964. *Life with Picasso.* New York.

Goldman, Judith. 1981. *American Prints: Process and Proofs.* Exhibition catalog. Whitney Museum of American Art, New York.

Goldwater, Robert, and Marco Treves, eds. 1945. *Artists on Art.* New York.

Gopnik, Adam. 1990. Comics. In Varnedoe and Gopnik 1990, pp. 153–229.

Gould, Claudia. 1987. Jane Dickson: An Interview. *Print Collector's Newsletter,* vol. 17 (January–February), p. 204.

Greenberg, Clement. 1962. After Abstract Expressionism. *Art International,* vol. 6, no. 8, pp. 24–32.

Guggenheim Museum. 1973. *Jean Dubuffet: A Retrospective.* Exhibition catalog with essay by Margit Rowell. Solomon R. Guggenheim Museum, New York.

Gustafson, Donna. 1986. Food and Death: *Vanitas* in Pop Art. *Arts Magazine,* vol. 60, no. 6 (February), pp. 90–93.

Hess, Thomas B. 1971. *Barnett Newman.* New York.

Hess, Thomas B. 1972. Pinup and Icon. In Hess and Nochlin, eds., 1972, pp. 223–37.

Hess, Thomas B., and Linda Nochlin, eds. 1972. *Woman as Sex Object: Studies in Erotic Art 1730–1970.* New York.

Hughes, Ted. 1984. The Hanged Man and the Dragonfly. In Fern and O'Sullivan 1984, pp. 11–23.

Ivins, William M. [1953] 1969. *Prints and Visual Communication.* Reprint. Cambridge, Mass.

Johnson, Elaine L. 1966. *Contemporary Painters and Sculptors as Printmakers.* Exhibition catalog. Museum of Modern Art, New York.

Johnson, Una E. 1966. *Milton Avery: Prints and Drawings.* With a commemorative essay by Mark Rothko. New York.

Kainen, Jacob. 1986. An Interview with Stanley William Hayter. *Arts Magazine,* vol. 60 (January), pp. 64–67.

Karshan, Donald. 1968. *Picasso Linocuts, 1958–1963.* New York.

Kozloff, Max. 1974. *Jasper Johns.* New York.

Krens, Thomas. 1980. *Helen Frankenthaler Prints: 1961–1979.* Exhibition catalog. Sterling and Francine Clark Institute, Williamstown, Mass.

Lasansky, Mauricio. 1975. *Lasansky: Printmaker.* Iowa City.

Lewis, Samella. 1984. *The Art of Elizabeth Catlett.* Claremont, Calif.

Lieberman, William S. 1985. Introduction. In McVinney 1985, pp. 9–14

Lippard, Lucy. 1966. *Pop Art.* With contributions by Lawrence Alloway, Nancy Marmer, and Nicolas Calas. New York.

Lippard, Lucy. 1967. *Robert Rauschenberg: Booster and 7 Studies.* Gemini G.E.L. brochure. Los Angeles.

McKendry, John J. 1972. *Robert Motherwell's "A La Pintura": The Genesis of a Book.* Exhibition catalog. Metropolitan Museum of Art, New York.

McNulty, Kneeland. 1977. *Peter Milton: Complete Etchings 1960–1976.* With essays by the artist. Boston.

McShine, Kynaston, ed. 1989. *Andy Warhol: A Retrospective.* Exhibition catalog with essays by Kynaston McShine, Robert Rosenblum, Benjamin H. D. Buchloh, and Marco Livingstone. Museum of Modern Art, New York.

McVinney, L. Donald. 1985. *Picasso Linoleum Cuts.* Exhibition catalog. Metropolitan Museum of Art, New York.

Martin, Richard. 1987. David Hockney and William Hogarth: The Rake Redivivus (Twice) in the Twentieth Century. *Arts Magazine,* vol. 62, no. 4 (December), pp. 28–33.

Melot, Michel, Antony Griffiths, and Richard S. Field. 1981. *Prints: History of an Art.* New York.

Metropolitan Museum of Art. 1980. *The Painterly Print: Monotypes from the Seventeenth to the Twentieth Century.* With essays by Sue Welsh Reed, Eugenia Parry Janis, Barbara Stern Shapiro, et al. Published in connection with an exhibition. Metropolitan Museum of Art, New York.

Morphet, Richard. 1970. *Richard Hamilton.* Exhibition catalog. Tate Gallery, London.

Moser, Joann. 1977. *Atelier 17: A 50th Anniversary Retrospective Exhibition.* Exhibition catalog. Elvehjem Art Center, University of Wisconsin, Madison.

Museum of Modern Art. 1989. *Dubuffet Prints from the Museum of Modern Art.* Exhibition catalog with essays by Audrey Isselbacher, Susan J. Cooke, and James L. Fisher. Museum of Modern Art, New York.

Philadelphia Museum of Art. 1964. *The Lithographs of Jean Dubuffet.* Exhibition catalog with an Introduction by Kneeland McNulty and Notes on Lithographs by Transfers of Assemblages, and on the "Phenomena" Series by Jean Dubuffet.

Prescott, Kenneth W. 1973. *The Complete Graphic Works of Ben Shahn.* New York.

Print Council of America. 1961. *What Is an Original Print?* Edited by Joshua Binion Cahn. New York.

Ratcliff, Carter. 1983. *Andy Warhol.* New York.

Ratcliff, Carter. 1984. Vija Celmins: An Art of Reclamation. *Print Collector's Newsletter,* vol. 14 (January–February), pp. 193–96.

Rauschenberg, Robert. 1969. Notes on Stoned Moon. *Studio International,* vol. 178, no. 917 (December), pp. 246–47.

Rhodes, Stephen. 1975. Themes and Images in Mauricio Lasansky's Prints. In Lasansky 1975, pp. 47–50.

Rose, Barbara. 1970. The Graphic Work of Jasper Johns. Parts 1 and 2. *Artforum,* vol. 8, no. 7, pp. 39–45; vol. 9, no. 1, pp. 65–74.

Rosenberg, Harold. 1964. Jasper Johns: Things the Mind Already Knows. *Vogue,* vol. 143, no. 3 (February), pp. 175–77, 201–3.

Rosenberg, Harold. [1959] 1965. The American Action Painters. In *The Tradition of the New,* pp. 23–39. New York.

Rosenblum, Robert. 1964. Pop Art and Non-Pop Art. In Gablik and Russell, eds., 1969, pp. 53–56.

Rosenblum, Robert. 1989. Warhol as Art History. In McShine, ed., 1989, pp. 25–37.

Rowell, Margit. 1973. *Jean Dubuffet: An Art on the Margins of Culture.* In Guggenheim Museum 1973, pp. 15–34.

Russell, John. 1969. Introduction. In Russell and Gablik, eds., 1969, pp. 21–40.

Russell, John, and Suzi Gablik, eds. 1969. *Pop Art Redefined.* New York.

Schiff, Gert. 1972. Picasso's *Suite 347,* or Painting as an Act of Love. In Hess and Nochlin, eds., 1972, pp. 239–53.

Schiff, Gert. 1983. *Picasso: The Last Years, 1963–1973.* Exhibition catalog. Grey Art Gallery and Study Center, New York University, New York City.

Selz, Peter. 1975. *Sam Francis.* With an essay on his prints by Susan Einstein. New York.

Shapiro, Michael. 1978. Changing Variables: Chuck Close and His Prints. *Print Collector's Newsletter,* vol. 9, no. 3 (July–August), pp. 69–72.

Solomon, Alan R. 1969. *Jasper Johns: Lead Reliefs.* Gemini G.E.L. brochure. Los Angeles.

Sparks, Esther. 1989. *Universal Limited Art Editions, a History and Catalogue: The First Twenty-Five Years.* Chicago.

Steinberg, Leo. 1973. A Working Equation, or— Picasso in the Home Stretch. *Print Collector's Newsletter,* vol. 3, pp. 102–5.

Steiner, Wendy. 1987. Postmodernist Portraits. *Art Journal,* vol. 46, no. 3 (Fall), pp. 173–77.

Tate Gallery. 1988. *Late Picasso: Paintings, Sculpture, Drawings, Prints 1953–1972.* Exhibition catalog with essays by Michel Leiris, John Richardson, Marie-Laure Bernadac, Brigitte Baer, and David Sylvester. London.

Terenzio, Stephanie, and Dorothy C. Belknap. 1984. *The Prints of Robert Motherwell: A Catalogue Raisonné, 1943–1984.* New York.

Tomkins, Calvin. 1976. Profiles: The Moods of a Stone, Tatyana Grosman. *New Yorker,* vol. 52, no. 16 (June 7), pp. 42–76.

Tousley, Nancy. 1975. *Prints: Bochner, LeWitt, Mangold, Marden, Martin, Renouf, Rockburne, Ryman.* Exhibition catalog. Art Gallery of Ontario, Toronto.

Varnedoe, Kirk. 1990a. Advertising. In Varnedoe and Gopnik 1990, pp. 231–367.

Varnedoe, Kirk. 1990b. Graffiti. In Varnedoe and Gopnik 1990, pp. 69–99.

Varnedoe, Kirk, and Adam Gopnik. 1990. *High and Low: Modern Art, Popular Culture.* Exhibition catalog. Museum of Modern Art, New York.

Waldman, Diane. 1972. *Roy Lichtenstein: Drawings and Prints.* New York.

Warhol, Andy. 1975. *The Philosophy of Andy Warhol (from A to B and Back Again).* New York.

Watrous, James. 1984. *A Century of American Printmaking 1880–1980.* Madison, Wis.

Williams, Reba, and Dave Williams. 1986. The Early History of the Screenprint. *Print Quarterly,* vol. 3, no. 4 (December), pp. 286–321.

Williams, Reba, and Dave Williams. 1988. The Prints of Jackson Pollock. *Print Quarterly,* vol. 5, no. 4 (December), pp. 346–73.

Wye, Deborah. 1988. *Committed to Print: Social and Political Themes in Recent American Printed Art.* Exhibition catalog. Museum of Modern Art, New York.

Young, Joseph E. 1969. Jasper Johns: An Appraisal. *Art International,* vol. 13, no. 7, pp. 50–56.

Young, Joseph E. 1974. "Pages" and "Fuses": An Extended View of Robert Rauschenberg. *Print Collector's Newsletter,* vol. 5, no. 2 (May–June), pp. 25–30.

Zerner, Henri. 1964. Universal Limited Art Editions. *L'Oeil,* no. 120 (December), pp. 36–43, 82.

Zigrosser, Carl. 1941. The Serigraph, A New Medium. *Print Collector's Quarterly,* vol. 28, no. 4 (December), pp. 443–77.

Glossary

This glossary contains general printmaking terms that are relevant to this text. The reader should be aware that many books on prints, especially studio manuals, contain more specialized glossaries. Also see the excellent general glossaries in Antony Griffiths, *Prints and Printmaking: An Introduction to the History and Techniques* (London, 1980), and Michel Melot, Antony Griffiths, and Richard S. Field, *Prints: History of an Art* (New York, 1981).

Address: Lettering beneath a printed image that provides information about the publisher and the production of the print. Terms that might typically be found in the address are "invenit" or "pinxit" (for the primary designer or painter); "sculpsit" or "fecit" (for the reproductive printmaker); and "excudit" (for the publisher). In addition, information about copyright or privilege may be found in the address: for example, "Cum Privilegio Regis" (published "with permission of the king"). *See* Copyright; Reproductive print.

A la poupée: A method of inking in which various colors are all dabbed on *one* plate or block by hand, using a cloth applicator known as a *poupée* ("doll" in French). *A la poupée* inking may be contrasted with inking separate plates or blocks that are then registered on one sheet of paper. *See* Registration.

Aquatint: A tonal method of etching in which a plate is coated with an acid-resistant, powdery resin and heated, so that the grains of resin adhere to the plate. Aquatint produces a grainy surface which, when etched, will print non-linear areas of tone. *See* Etching; Lift-ground; Sugarlift; Tonal processes.

Artist's proof: An impression that is set aside specifically for the artist. Such impressions are usually indicated by numbering or by being marked "proof" or "A.P." *See* Proof.

Autographic: Made by the artist's hand, or retaining the quality of being made by the artist's hand, as in transfer lithography or a rapid, sketchy approach to drypoint or etching.

Avant la lettre: French term referring to an impression pulled before the lettering, or address, has been added. Proofs made *avant la lettre* are often considered more valuable than lettered impressions. *See* Address; Proof.

Biting: In etching, immersing the plate in the acid solution or mordant. *See* Etching; Foul-biting; Mordant.

Black print: A print that achieves nocturnal effects through engraving and etching. Such prints were much in demand by seventeenth-century collectors, a taste that culminated in the invention of mezzotint at mid-century. *See* Engraving; Etching; Mezzotint.

Blind-stamping: Impressing a design (or publisher's or collector's mark) on paper by the pressure of the stamp alone, without the use of ink. *See* Embossing.

Blockbook: A fifteenth-century method of printing books, primarily used in the Netherlands and Germany, in which individual pages were printed from single blocks of wood into which both image and text were cut. Although from the technological point of view blockbooks were less advanced than books printed with movable type, they may not have served as direct precursors to Johann Gutenberg's invention. Their labor-intensive

production meant that blockbooks would only be texts that were extremely popular, such as the *Ars Moriendi* or the *Biblia Pauperum. See* Letterpress; Woodcut.

Broadsheet: A large sheet of paper, printed on one side, and often illustrated with woodcuts. Broadsheets form an important category of popular prints in the Renaissance. They often dealt with contemporary events, social satire, or religious beliefs. Also called "broadsides." *See* Woodcut.

Burin: The primary instrument used in engraving. Its wedge-shaped tip produces a sharp, clean-edged line. *See* Engraving.

Burnishing: Smoothing out an intaglio plate with a tool called a burnisher. Generally, burnishing is used to correct a mistake or to lighten an area by reducing the amount of ink that the plate will hold. *See* Intaglio.

Burr: The ridge of displaced metal at the end of or along an engraved or drypoint line. In engraving, the burr is generally removed with the scraper. The burr in the drypoint process absorbs ink and produces a characteristic soft, velvety line when the plate is printed. Drypoint burr wears down quickly in the printing process. *See* Drypoint; Engraving.

Cancellation: The destruction or damaging of the printing surface at the end of an edition, insuring that no additional impressions will be pulled from it. *See* Edition.

Chiaroscuro woodcut: *Chiaroscuro* is an Italian term, synonymous with the French *clair-obscur,* describing a kind of woodcut produced from one or more tonal blocks, often combined with a line or key block. The blocks are registered and printed on the same sheet of paper. Originally intended to echo monochrome drawings on tinted paper, highlighted with white ink or chalk and called chiaroscuro drawings, chiaroscuro woodcuts are distinguished from color woodcuts primarily by their monochromatic appearance. *See* Registration; Woodcut.

Chromolithograph ("Chromo"): Another name for color lithograph, but especially a color lithograph made more for commercial purposes (such as reproduction) than as an original print. Particularly applied to commercial color lithographs of the Victorian era. *See* Lithography; Reproductive print.

Cliché-verre: French for "glass print," a print made by combining photographic and printmaking methods. A design is created on a glass plate that has an opaque coating of collodion (a syrupy solution normally used for coating photographic plates), printer's ink, or oily pigment. The plate is printed by placing it against light-sensitive paper, which receives the image as from a photographic negative. With the coated side down on the paper, a sharper picture is created. Placing the clean side down creates a softer, shimmering image.

Copyright: Protection of an artist's design from copyists, sometimes for a limited amount of time or within a limited territory. Also called "privilege."

Counterproof: An impression taken from another impression. Since they are in the same direction as the artist's original design, counterproofs can help the artist see where a plate, stone, or block needs to be corrected.

Crachis: From the French *cracher,* "to spit." A technique in which lithographic tusche is spattered onto the stone to create a tonal effect. *See* Tusche.

Crayon manner: A tonal (non-linear) intaglio process that imitates the effect of chalk lines. The plate is covered with an etching ground and then worked with various tools that penetrate the ground

with irregular points. The plate is etched as usual and can be touched up with various intaglio tools. *See* Etching; Mattoir; Roulette; Tonal processes.

Dot and lozenge: A system of engraving that superimposed stippling and curved cross-hatching regularly, so that within each roughly trapezoidal lozenge was a single dot or very short burin stroke. *See* Hatching; Stipple engraving.

Drypoint: A primary intaglio technique in which an image is scratched manually into a plate using a sharp tool, such as a stylus. The burr builds up along the sides of the line and absorbs the ink, producing a softer, velvety line when printed. *See* Burr; Intaglio.

Echoppe: A kind of etching needle invented by Jacques Callot, which had a sharp edge along the circumference of its flat, oval end. By twisting it, lines of varying thickness could be created, thus enabling the etched line to swell and taper like an engraved line. *See* Engraving; Etching.

Edition: A predetermined number of impressions taken from any printing surface. The number of impressions included in an edition is recorded in the denominator of a fractional notation at the bottom of a print; the numerator of this fractional notation refers to the position of the print within the edition. At the end of an edition, the printing surface is cancelled. *See* Cancellation.

Electrolysis: Broadly speaking, the use of electricity to cause chemical change in a conductive substance. In the context of printmaking, electrolysis is used in the steel-facing of intaglio plates, or to produce an electrotype. *See* Electrotype; Intaglio; Steel-facing.

Electrotype: A metal duplicate of a block or plate produced by using electrolysis to coat a mold of the original. Invented in 1839, the process of electrotyping super-seded stereotyping. *See* Electrolysis; Stereotype.

Embossing: Printing a design on paper without the use of ink. *See* Blind-stamping.

Engraving: A primary, and the earliest, intaglio technique in which the image is manually incised on a metal plate, usually copper, using a burin, which produces a crisp, V-shaped line. The burr curls up at the end and along the sides of the line and is normally scraped away. Width and depth of the line are dependent on the pressure of the artist's hand and arm on the burin; typically, engraved lines swell in the middle and taper toward the ends. *See* Burin; Burr; Intaglio.

Etching: A primary intaglio technique in which lines (or, in aquatint and lavis, tones) are chemically established on a metal plate by means of acid solution or mordant. An image is drawn through an acid-resistant coating or "ground" to expose the metal underneath. The plate is immersed in the acid bath, in which the lines or tones are "bitten." The width and depth of the lines are controlled by the length of time the plate is in the acid; the plate may also be rebitten in some areas, while other areas are protected by "stopping-out" with an acid-resistant varnish. *See* Aquatint; Biting; Ground; Intaglio; Lavis; Mordant; Stopping-out.

Formschneider: German for "form-cutter." In relief printmaking, the artisan responsible for cutting an artist's design into the wooden block. The intervention of this artisan in the printmaking process is one of the many factors distinguishing early woodcutting from early intaglio printmaking. *See* Relief; Woodcut.

Foul-biting: Any accidental etching of the plate caused by a misapplication or breaking down of the etching ground. *See* Biting; Etching; Ground.

Gillotage: A process invented in 1850 by

Firmin Gillot, by which a lithographic plate was made into a relief plate. A lithographic image on zinc was dusted with an acid-resistant resin and etched. The gillotage could be printed with text by a relief process, which gave it a certain advantage over the lithograph proper. *See* Lithography; Relief.

Glyphography: A nineteenth-century process that produced a durable relief-printing surface. A drawing was made through a waxy coating on a plate, and then the undrawn areas of wax were carefully built up. This surface was then electrotyped, with the electrotype functioning as a mold to cast a relief surface for printing. *See* Electrotype; Relief.

Goldsmith: A highly skilled artisan who created intricate gold objects, such as liturgical chalices and censers. Goldsmithing is intimately related to the development of engraving in the fifteenth century. *See* Engraving.

Ground: The acid-resistant coating of a plate that is to be etched. The waxy mixture is applied to the plate by dabbing, rolling, melting (when the plate is heated), or pouring (when the coating is dissolved in chloroform). Also called "resist." *See* Biting; Etching; Mordant.

Half-tone: A method of transforming a tonal image into a regular pattern of small dots by photographing it through a screen. The negative, containing dots of various size depending on tonal intensity, can be used to produce a printing surface. An important aspect of many photomechanical printing techniques. *See* Photomechanical.

Hatching: Parallel lines drawn, cut, or etched close together to give the overall effect of a tone. When the lines are placed at angles to each other, it is described as "cross-hatching."

Heliogravure: A process, developed in the mid-1850s, by which photography and intaglio printmaking were combined. It was primarily used for commercial purposes like reproduction. A bichromated gelatine sheet hardened to varying degrees when exposed to light through a photographic negative. This sheet, its hardened parts acting as an acid-resist, was transferred to a clean or aquatinted plate which was then bitten after the softened gelatine was washed away. The plate was hand-inked, wiped, and printed as usual, and could be retouched with various intaglio tools, as in Rouault's *Miserere* (*see* Chapter 10). Like any intaglio plate, it leaves a platemark. Also called "hand-photogravure." *See* Aquatint; Intaglio; Photogravure; Photomechanical.

Impression: Any individual print taken from a plate, block, stone, screen, or other printing surface. *See* Proof.

Intaglio: One of the four basic categories of printmaking, including the individual graphic media of etching and engraving. The key trait of intaglio printmaking is that the ink rests in linear incisions or areas beneath the upper surface of the plate, which must be wiped off before printing. Intaglio prints are printed in roller presses under great pressure, which forces the paper into the incisions and produces an indented border or platemark around the image. *See* Drypoint; Engraving; Etching; Mezzotint.

Kleinmeister: German for "Little Masters." Engravers working in Nuremberg in the wake of Dürer, known for their small, finely crafted engravings.

Laid paper: A type of hand-made paper cast from a mold with prominent vertical wire marks and horizontal "chains." *See* Wove paper.

Lavis: An acid wash invented in 1750 by Johann-Adam Schweikard and used in etching. The acid is allowed to etch the plate directly, usually by brushing onto

the surface. For this reason the technique is sometimes called "brush etching." It has no grain, like aquatint, but a brush-stroke is often evident, and the bubbles in the acid produce small dots surrounded by dark rings. The French term *manière de lavis* refers to any kind of etching that achieves a washlike effect and incorporates both lavis and aquatint. *See* Aquatint; Etching.

Letterpress: Book printing by a relief process utilizing movable metal letters for the text and woodcut blocks for the illustrations, if any. *See* Blockbook; Relief.

Lift-ground: Another name for the sugar-lift aquatint technique. *See* Aquatint; Ground; Sugar-lift.

Line block: A process that developed out of the gillotage, but was photomechanically based. A zinc plate with a photomechanically established image was etched in stages, using an acid-resistant resin, to produce a relief plate that printed only line, in contrast to half-tone processes. *See* Gillotage; Photomechanical; Relief.

Linocut or linoleum cut: A relief process similar to woodcut, using a linoleum block instead of wood. *See* Relief; Woodcut.

Lithography: The chief planographic technique, invented by Alois Senefelder in the late eighteenth century. An image is drawn or painted with a greasy medium on a flat surface, usually fine-grained limestone, but also on zinc or aluminum plates. The medium may range from chalk-like to liquid (tusche). The stone is treated with nitric acid and gum arabic to set the image, dampened, inked, and printed, traditionally using a press with a bar that scrapes across the back of the paper laid face down on the stone. *See* Lithotint; Planographic; Transfer lithography; Tusche; Zincography.

Lithotint: Another name for wash lithograph. Thinned lithographic tusche is used to produce delicate areas of wash, difficult to print because of their low grease content. *See* Lithography; Tusche.

Maculature: An impression taken from an intaglio plate that has already been printed. A maculature will help clean the ink out of the incised or etched lines, and it will also help the artist analyze the plate in order to do additional work. *See* Intaglio.

Mattoir: Also called a "mace-head," this blunt-ended, irregularly spiked tool produces tonal areas when used to work a grounded plate in the crayon or pastel manners. *See* Crayon manner; Pastel manner; Roulette; Tonal processes.

Metalcut: A relief print made from a metal plate rather than a wooden block. *See* Relief; Woodcut.

Mezzotint: One of the primary tonal processes in intaglio printmaking. The plate is worked with a mezzotint rocker, scoring it all over. If printed at this stage, the mezzotinted plate would print totally black. It is then worked by scraping and burnishing to produce lighter areas. Also called "the English manner" or *la manière anglaise. See* Intaglio; Tonal processes.

Monotype: A hybrid of printmaking and painting (or, less typically, drawing) in which the artist produces a unique impression from a painted or drawn surface. Impressions taken subsequently from this surface are called "cognates."

Mordant: In the context of printmaking, the corrosive substance used to etch or bite the plate. Etching mordants can contain various kinds of acids (e.g., nitric, sulphuric, hydrochloric), depending on the type of metal involved. *Also see* Biting; Etching; Ground.

Niello: An Italian Renaissance technique of applying a metallic black alloy (*nigellum*) to an engraved silver or gold plate. Before the application of *nigellum,* these plates

could be inked and printed by normal intaglio means, thus producing niello prints. *See* Intaglio.

Offset: The transferring of the lithographic image from the stone or plate to a rubber roller, a double reversal of the image that preserves the original direction of the design. Offset lithography permits the use of multiple rollers, a much faster process than dampening, inking, and printing the single stone or block. Also called "offset lithography." *See* Lithography.

Original print: Generally implies that a print has been made by the artist's hand, as opposed to a reproductive printmaker or a photomechanical process. Ambiguity arises because this term was at first used to distinguish non-reproductive prints from the far more common reproductive prints made by artisans after drawings, paintings, or sculptures by artists. When the development of photomechanical reproduction usurped the function of the reproductive print, the latter came to look more "original." Moreover, modern "original" printmakers may sometimes incorporate photomechanical processes into their works, and attempts to restrict the definition of the original print have failed to accommodate those kinds of prints— quite obviously "original" if we measure their intellectual and aesthetic content. *See* Photomechanical; *Peintre-graveur;* Reproductive print.

Pastel manner: one of the tonal intaglio processes; an offshoot of the crayon manner that imitates colored pastel drawings. *See* Crayon manner; *Mattoir;* Roulette; Tonal processes.

Peintre-graveur: French for "painter-engraver," a term distinguishing an original printmaker from a reproductive printmaker. *See* Original print; Reproductive print.

Photogravure: The combination of intaglio printmaking and photography for commercial printing. There are two basic types: hand-photogravure or heliogravure, and machine photogravure, in which a fine screen printed onto the gelatine supplants the aquatint of heliogravure. This regular grid allows for mechanical inking and printing using low pressure. Unlike heliogravures, machine photogravures have no platemark. When printed from a plate bent into a cylinder, the machine photogravure is called a rotogravure. Rotogravures could be printed very rapidly. *See* Heliogravure; Intaglio; Photomechanical.

Photolithography: The use of photography in lithography and offset lithography. *See* Lithography; Offset.

Photomechanical: Any of various techniques to transfer an image by means of a photographic negative to printing surface, whether that surface is relief, intaglio, or planographic. Many photomechanical techniques utilize bichromated gelatine, which hardens upon exposure to light and whose soft parts can be washed away. *See* Heliogravure; Line block; Photogravure.

Photo-silkscreen: The use of photography in silkscreen printing. *See* Screenprint; Serigraphy; Silkscreen.

Planographic: Chiefly refers to lithography, although could apply in principle to silkscreen and even monotype: a printmaking technique in which the image is produced on a flat surface rather than by incision or cutting of any kind. *See* Lithography; Monotype; Screenprint; Serigraphy; Silkscreen.

Platemark: The indentation left by the beveled edge of the plate in intaglio prints. *See* Intaglio.

Plate tone: A film of ink left on an intaglio plate after wiping to produce tonal nuances. *See* Intaglio; Tarlatan.

Pochoir: A French term for a print produced with a brush and stencil. *See* Stencil.

Polyautography: An early name for lithography, expressing the idea of lithography as a means of reproducing drawings. *See* Autographic; Lithography.

Proof: Broadly, this term can refer to any impression taken from the printing surface, but it especially refers to those impressions pulled in order to check the progress of an image (also called "working proofs" or "trial proofs"), or pulled before the image, or image and its accompanying lettering, are complete (as in a "proof before letters" or "*avant la lettre*"). In the nineteenth century, the concept of the "artist's proof" developed to designate an impression pulled outside the edition proper, although it might be identical to impressions within the edition. *See* Edition; Impression; State.

Registration: The aligning of multiple printing surfaces (plates, blocks, stones, screens, etc.) on the same sheet of paper to produce the final image. Frequently an aspect of color printing.

Relief: The earliest major category of printmaking. The printing surface, usually a wooden block, but sometimes a lineoleum block or even a metal plate, is carved so that the top surface holds the ink and the lower surface remains clean. Unlike intaglio prints, relief prints do not require high pressure in printing. Relief prints are compatible with letterpress printing and are therefore frequently used in book illustrations. *See* Letterpress; Linocut; Metalcut; Woodcut; Woodengraving.

Remarque: A small sketch made by an artist outside the main design, and not necessarily related to the design. Generally associated with etchings and originally (in the eighteenth century) intended to test acid strength, remarques were usually burnished away before the edition. But nineteenth-century practices fostered their retention, and even the production of "remarque proofs" in which the remarque served primarily as a marketing device. *See* Burnishing; Edition; Etching; Proof.

Reproductive print: Any print whose main purpose is to reproduce, although sometimes with significant changes, a work in another medium, usually painting. This differs from a printmaker's appropriation of motifs or whole compositions, as well as from a collaboration between painter and printmaker to produce an independent print. Generally, the reproductive print is made by a professional printmaker other than the artist who produced the original design, although what might be called "autographic reproductions"— that is, graphic reproductions of works in other media by the same artist—are not uncommon. Reproductive printmaking is normally distinguished from "original printmaking," although the boundaries between the two enterprises, like those between reproductive printmaking, appropriation, and collaboration, are far from absolute. *See* Autographic; Original print; *Peintre-graveur.*

Restrike: An impression (usually inferior) made after the edition, often after the artist's death. *See* Edition.

Retroussage: A technique to soften lines in intaglio printmaking, especially associated with Rembrandt and with the etching revival of the nineteenth century. While wiping the plate, the artist uses the tarlatan to pull ink up and out of the incised or etched lines. *See* Intaglio; Tarlatan.

Roulette: An intaglio tool with a rotating, spiked wheel, producing the effect of a chalk line when used as part of the crayon

or pastel manners. *See* Crayon manner; Pastel manner; Tonal processes.

Screenprint: A printmaking medium based on the simple idea of the stencil. Using a variety of substances, the artist blocks out a design on a screen of silk, cotton, nylon, or other material. Ink is forced through the screen with a squeegee. "Screenprint" is synonymous with "serigraph" and "silkscreen." *See* Serigraphy; Silkscreen; Stencil.

Serigraphy: Another word for screenprinting, coined by the print connoisseur Carl Zigrosser in 1941 to distinguish the process used in original printmaking from commercial screenprinting processes. *See* Screenprint; Silkscreen; Stencil.

Silkscreen: Another word for screenprinting and serigraphy—somewhat misleading in that the material used in this process is not always silk. "Silkscreen" is generally preferred in American usage, however. *See* Screenprint; Serigraphy; Stencil.

Soft-ground: A form of etching in which the plate is covered with a soft, waxy ground. The design is established on the plate by drawing on a sheet of paper placed over it, and the plate is then etched. Various textures like cloth can also be impressed in soft-ground and etched. *See* Etching; Ground.

State: An impression that shows changes on the printing surface itself. A more specific term than "proof" (*see above*).

Steel-facing: A nineteenth-century process in which intaglio plates are coated with a thin layer of steel. Steel-facing, patented in 1857, vastly increased the life of the intaglio plate, although experts disagree about whether this entails a subtle lapse in the quality of impression. *See* Electrolysis; Intaglio.

Stencil: Any form that is cut, shaped, or blocked out to allow ink or paint to be brushed or squeegeed through parts of it, thus producing a print. The screen in silkscreen (or screenprinting or serigraphy) is a kind of stencil. Stencil printmaking is one of the four basic approaches to producing a print. *See Pochoir;* Screenprint; Serigraphy; Silkscreen.

Stereotype: A nineteenth-century cast metal duplicate of a printing surface, especially a wood-engraving block, made by the creation of a plaster mold that is then used to cast the stereotype. Patented in 1829, the stereotype was made obsolete by the later process of electrotyping. *See* Electrotype.

Stipple engraving: The use of dots, flicks, or short strokes, produced by burins and other instruments, to produce stippled (dotted) tonal effects. *See* Burin; Engraving.

Stopping-out: The use of acid resistant varnish in any form of etching to prevent the mordant from further biting of the plate in selected areas. *See* Biting; Etching; Mordant.

Sugar-lift: A form of etching (usually aquatint etching) in which the artist uses a sugary substance to make an image on the plate, which is then grounded or covered with stop-out varnish. When the plate is immersed in water, the sugar swells and lifts off, thus exposing the plate in marked areas. The plate can then be etched or aquatinted as usual. An alternative method is to lay aquatint on the plate before applying the sugar-lift solution. *See* Aquatint; Etching; Ground; Lift-ground; Stopping-out.

Sulphur tint: The use of sulphur powder dusted over a layer of oil on an intaglio plate. Generally used in the seventeenth and eighteenth centuries to produce an effect similar to aquatint. *See Aquatint.*

Tampon: The rag stump used for various purposes such as softening lines in chalk

drawing or working the surface of a monotype or *cliché-verre* plate. *See Cliché-verre;* Monotype.

Tarlatan: The loosely woven muslin cloth used to wipe intaglio plates. *See* Intaglio.

Tonal processes: Intaglio processes relying on tone rather than line: aquatint, mezzotint, and the crayon and pastel manners are characteristic tonal processes. Tonal processes are particularly associated with the height of reproductive printmaking in the late eighteenth century. *See* Aquatint; Crayon manner; Intaglio; Pastel manner; Tonal Processes.

Transfer lithography: A technique utilizing transfer paper coated with a soluble layer that, when moistened, releases the artist's drawing (done in a greasy medium) onto the lithographic stone or plate. Two of the advantages of transfer lithography are its portability and the opportunity it affords to work in the same direction as the final image. The primary disadvantages are the loss of the subtlety of drawing that can be obtained by working directly on the stone and the fact that some of the drawing is lost in transfer. *See* Lithography.

Tusche: Liquid lithographic medium. *See Crachis;* Lithography.

Veduta: Italian for "view." The term refers to topographical prints or paintings, especially popular in the eighteenth century, but can encompass imaginary views as well.

Vignettes: Small prints without borders employed in book illustration.

Watermark: A mark identifying the paper manufacturer, generally produced by placing a shaped wire into the paper mold. Visible when the paper is held up to the light, watermarks are frequently useful for establishing the date or origins of prints.

White-line woodcut and wood-engraving: Relief processes from wooden blocks that are cut and inked to produce the effect of white lines on a black background. More rarely, intaglio plates can also produce white-line effects, either by being printed in relief or by using white ink in an intaglio manner. *See* Intaglio; Relief; Woodcut; Wood-engraving.

Woodcut: The oldest printmaking technique and the primary relief technique, in which the design is carved into a fairly soft wooden block with gouges, chisels, and knives. Woodcut differs from wood-engraving (*see below*) in that the carving is generally with the grain rather than against it. *See* Relief; Wood-engraving.

Wood-engraving: A relief technique utilizing hard wooden blocks, but carved on the end-grain rather than on the plank-grain, as in woodcut (*see above*). Wood-engravings can look very much like woodcuts, or they can be much finer and more detailed, because of the difference in the wooden surface. *See* Relief; Woodcut.

Wove paper: A type of hand-made paper cast from a mold with such a tightly woven mesh that no visible pattern remains in the paper. The invention of wove paper in the eighteenth century permitted the widespread use of wood-engraving as a means of book illustration, since only such a smooth paper surface could pick up the intricate detail of the wood-engraved image. *See* Laid paper.

Zincography: A term for lithography done from the more portable zinc plates rather than from stones. *See* Lithography.

Selected Bibliography of Print Reference Catalogs

This bibliography contains some of the basic print reference catalogs available as of 1991, listed by geographic area rather than by period. For more complete multiartist listings, and for bibliographies of catalogs on individual artists, consult the following works:

Mason, Lauris, and Joan Ludman, comps. 1979. *Print Reference Sources: A Selected Bibliography, 18th–20th Centuries.* Millwood, N.Y.

Mason, Lauris, and Joan Ludman, comps. 1986. *Old Master Print References: A Selected Bibliography.* White Plains, N.Y.

Riggs, Timothy A., comp. 1983. *The Print Council Index to Oeuvre-Catalogues of Prints by European and American Artists.* Millwood, N.Y.

MULTINATIONAL CATALOGS

Bartsch, Adam. 1803–21. *Le peintre-graveur.* 21 vols. Vienna. Prints by German, Dutch, Flemish, and Italian printmakers, almost all before 1700; the only French prints included by Bartsch were from the School of Fontainebleau.

The Illustrated Bartsch. 1978–. New York. A continuing series, founded by Walter L. Strauss, who acted as general editor until his death in 1988. *The Illustrated Bartsch* was intended to illustrate, revise, and expand upon Adam Bartsch's original *Le peintre-graveur.* Volumes in *The Illustrated Bartsch* are published in a non-systematic manner and consist of picture atlases of prints cataloged by Bartsch, supplementary picture atlases of prints not cataloged by Bartsch,

commentary volumes with detailed analyses of individual prints, and index volumes.

Lehrs, Max. 1908–34. *Geschichte und kritische Katalog des deutschen, niederländischen und französischen Kupferstichs im XV Jahrhundert.* 9 vols. Vienna. German, Netherlandish, and French engravings of the fifteenth century.

Passavant, Johann David. 1860–64. *Le peintre-graveur.* 6 vols. Leipzig. Supplements Bartsch with additional fifteenth- and sixteenth-century works.

Schreiber, Wilhelm Ludwig. 1891–1911. 5 vols. *Manuel de l'amateur de la gravure sur bois et sur métal au XVe siècle.* Berlin and Leipzig. Fifteenth-century woodcuts and metalcuts. Volumes 1–3 treat single-sheet prints; volumes 4 and 5 treat blockbooks and woodcut illustrations in early printed books.

Schreiber, Wilhelm Ludwig. 1926–30. *Handbuch der Holz- und Metallschnitte des XV Jahrhunderts.* 8 vols. Leipzig. Woodcuts and metalcuts of the fifteenth century. A revision of the first three volumes of Schreiber's *Manuel de l'amateur de la gravure (see above)* on single-sheet prints.

AMERICAN

Beall, Karen F., et al. 1970. *American Prints in the Library of Congress.* Baltimore. Primarily modern American prints.

Peters, Harry Twyford. 1929. *Currier and Ives.* New York.

Peters, Harry Twyford. 1931. *America on Stone.* New York. American lithographs other than those by Currier and Ives.

Reilly, Bernard F., Jr. 1991. *American Political Prints, 1766–1876: A Catalog of the Collections in the Library of Congress.* Washington, D.C.

Stauffer, David McNeely. 1907. *American Engravers Upon Copper and Steel.* 2 vols. New York.

BRITISH

George, M. Dorothy. 1935–54. *Catalogue of Political and Personal Satires in the Department of Prints and Drawings in the British Museum.* Vols. 5–11. London. Satirical works in the British Museum from 1761 to 1832.

O'Donoghue, Freeman Marius, comp. 1908–25. *Catalogue of Engraved British Portraits in the Department of Prints and Drawings in the British Museum.* 6 vols. London.

Smith, J. Chaloner. 1883. *British Mezzotinto Portraits, from the Introduction of the Art to the Early Part of the Present Century.* 4 vols. London.

Stephens, Frederic George. 1870–83. *Catalogue of Political and Personal Satires in the Department of Prints and Drawings in the British Museum.* Vol. 1–4. London. Satirical works in the British Museum from 1320 to 1770.

FRENCH

Baudicour, Prosper de. 1859–61. *Le peintre-graveur français continué.* 2 vols. Paris. Continues Robert-Dumesnil (*see below*), covering artists born in the eighteenth century.

Beraldi, Henri. 1885–92. *Les graveurs du dix-neuvième siècle.* 12 vols. Paris. Nineteenth-century French prints.

Bibliothèque Nationale, Paris. 1930–. *Inventaire du fonds français.* Continuing effort to catalog the vast holdings of French prints in the National Library in Paris alphabetically by artist. The *Inventaire* is separated into four basic parts: prints of the sixteenth, seventeenth, and eighteenth centuries, and prints after 1800. For many artists, the Bibliothèque Nationale holdings are complete or nearly so.

Delteil, Loys. 1902–26. *Le peintre-graveur illustré.* 31 vols. Paris. Late nineteenth- and early twentieth-century French artists.

Portalis, Le Baron Roger, and Henri Beraldi. 1880–82. *Les graveurs du dix-huitième siècle.* 3 vols. Paris. Reproductive engravers of the eighteenth century.

Robert-Dumesnil, Alexandre Pierre François. 1835–71. *Le peintre-graveur français.* 11 vols. Prints by French artists born in the seventeenth century; vol. 11 was completed after the author's death by Georges Duplessis.

GERMAN AND NETHERLANDISH

Dodgson, Campbell. 1903–11. *Catalogue of Early German and Flemish Woodcuts in the British Museum.* London. Fifteenth- and sixteenth-century prints.

GERMAN

Andresen, Andreas. 1864–78. *Der deutsche Peintre-graveur; oder: Die deutschen Maler als Kupferstecher nach ihrem Leben und ihren Werken, von dem letzten Drittel des 16. Jahrhunderts bis zum Schluss des 18. Jahrhunderts, und in Anschluss an Bartsch's Peintre-graveur, an Robert-Dumesnil's und Prosper de Baudicour's französischen Peintre-graveur.* 5 vols. Leipzig. German painter-engravers from the last third of the sixteenth century to the close of the eighteenth century.

Andresen, Andreas. 1878. *Die deutschen Maler-Radierer des 19. Jahrhunderts.* 5 vols. Leipzig. German painter-etchers of the nineteenth century.

Geisberg, Max. 1923–31. *Der deutsche Einblatt-Holzschnitt in der ersten Hälfte des 16. Jahrhunderts.* 43 portfolios, plus index volume. Munich. German single-sheet woodcuts in the first half of the sixteenth century.

Hollstein, F. W. H., et al. 1954–. *German Engravings, Etchings and Woodcuts, ca. 1400–1700.* Amsterdam. Continuing series.

ITALIAN

Hind, Arthur M. 1938–48. *Early Italian Engravings: A Critical Catalogue with Complete Reproduction of All Prints Described.* 7 vols. London.

Vesme, Alexandre de. 1906. *Le peintre-graveur italien.* Milan. Eighteenth-century Italian etchers and engravers.

NETHERLANDISH

Dutuit, Eugène. 1881–85. *Manuel de l'amateur d'estampes.* Vols. 4–6. Paris. Revises Bartsch (*see above*). Vol. 1 of Dutuit deals with early printed art such as blockbooks, nielli, and playing cards. Vols. 2 and 3 were not published.

Hippert, Théodore, and Jean-Théodore Joseph Linnig. 1874–79. *Le peintre-graveur hollandais et belge du dix-neuvième siècle.* 3 vols. Brussels. Dutch and Flemish painter-engravers of the nineteenth century.

Hollstein, F. W. H., et al. 1949–. *Dutch and Flemish Etchings, Engravings and Woodcuts, ca. 1450–1700.* Amsterdam. Continuing series.

Van der Kellen, Johann Philip. 1866. *Le peintre-graveur hollandais et flamand.* Utrecht. Continuation of Bartsch for seventeenth-century artists.

Bibliographical Note

Among the significant publications on prints that have appeared while the text of this book was in press are a number that merit special mention. As with the references cited in conjunction with the chapters of the text, this essay makes no pretense of being a comprehensive view of recent bibliography of the history of prints. Rather, it is a sampling of sources that have come to my attention, with an emphasis on publications in English. Moreover, this essay addresses only books and articles specifically treating prints or major printmakers. In most cases, I have personally examined these, although several mentioned below have not been accessible to me. A more thorough account of recent books on prints may be gleaned from reviews in the *Print Collector's Newsletter* and *Print Quarterly*.

EARLY PRINTS

The five hundredth anniversary of Schongauer's death was marked in 1991 by major exhibitions with substantial catalogs—none, however, in English.[1] Although there is little new information on Schongauer, familiar evidence is reassessed and old questions such as the artist's postulated trip to Spain or his apprenticeship with Caspar Isenmann are reexamined skeptically. Schongauer emerges as the fulfillment of the late Gothic, a superlative graphic artist working for the urban educated class, who was no iconographic innovator but who introduced into German printmaking themes and pictorial motifs from the great age of Flemish painting.

The 1992 exhibition catalog of Mantegna's prints, drawings, and paintings, and David Landau and Peter Parshall's *The Renaissance Print*, published in 1994, are both scholarly milestones.[2] The essays by David Landau and Suzanne Boorsch for the 1992 catalog do not solve the knotty problems that Mantegna's prints present but rather raise new questions or judge old ones in the light of new observations. The problematic nature of Mantegna's printmaking activity is exemplified by the entirely different assessments of it that these two scholars offer. Landau extends the number of prints by the master himself from seven to eleven, while Boorsch resuscitates the old theory that Mantegna did not make prints—instead, the finest engravings associated with Mantegna are by someone dubbed the "Premier engraver." She also identifies "Z.A." (formerly taken to be Zoan Andrea) as Giovanni Antonio da Brescia (the "Z" reflecting the soft pronunciation of "G" in northern Italy), a sensible suggestion that will condition further evaluations of prints related to Mantegna. Needless to say, the chronology of the prints is revised differently by each scholar. A number of thoughtful reviews by other scholars of Italian prints should be read in conjunction with the essays and entries on prints in this catalog.[3] The importance of engraving for Mantegna is reconfirmed by Evelyn Lincoln in her article, "Mantegna's Culture of Line." Engravings were a means by which Mantegna cultivated a patronage outside the Gonzaga court and exhibited, through their linear system, the orderly rationality of his drawing style.[4]

Landau and Parshall's book covers both northern and Italian Renaissance prints. Among the new insights it provides are Landau's reassessment of Marcantonio's prints and the engrav-

er's relationship to Raphael (long overdue since Innis H. Shoemaker and Elizabeth Broun's 1982 catalog, *The Engravings of Marcantonio Raimondi*) and of the use of the problematic term "reproductive"; Parshall's reevaluation of the northern Renaissance woodcut, which no longer appears as a "second cousin" to engraving, and his discussion of the early development of etching. Scholars of prints will find a rich resource in this text as well as in its notes and bibliography.

In her 1991 article on Raphael's *Suicide of Lucretia,* engraved by Marcantonio (fig. 3.32 in this text), Patricia Emison continues to ask how the medium of the print allowed artists to assert their creative autonomy. She argues that by presenting Lucretia not as a moral heroine and didactic example but as a passionate and tragic figure the engraving reveals the inventive and expressive skill of the artist.[5]

The importance of Goltzius in the northern tradition continues to be confirmed. Nancy Bialler's catalogue of the 1992 exhibition of his chiaroscuro woodcuts in the Rijksmuseum and the Cleveland Museum of Art sets new standards in the scholarship on these beautiful and technically innovative prints.[6] And Walter Melion's work on Goltzius and the importance of his practice of engraving within Netherlandish art theory is furthered in his *Shaping the Netherlandish Canon: Karel van Mander's "Schilder-boeck"* of 1991.[7]

Building on the scholarship of Henri Zerner and others, the Grunwald Center for the Graphic Arts and the Bibliothèque Nationale in Paris have recently mounted an exhibition of French Renaissance prints. Its weighty catalog revisits episodes in French printmaking from the fifteenth and sixteenth centuries, dealing with the Fontainebleau School and the work of such figures as Jean Duvet and Jacques Bellange, while essays explore the social, political, and religious contexts of these printmakers.[8]

NORTHERN BAROQUE PRINTS

In 1994, two books appeared on Bohemian etcher Wenceslaus Hollar: an exhibition catalog on the prints from the Museum Boymans–van Beuningen in Rotterdam, and Richard Godfrey's book, published in conjunction with an exhibition at the Yale Center for British Art, encompassing Hollar's drawings, prints, and paintings.[9] But it was perhaps Dutch Baroque landscape etching that received the most attention in the early 1990s. In 1992, the new *Harvard University Art Museums Bulletin* devoted its first issue by Kristina Hartzer Nguyen to the context of Dutch landscape prints, supplementing earlier work by Clifford S. Ackley, David Freedberg, and others.[10] Linda Stone-Ferrier's recent article on Rembrandt's landscape etchings is an important contribution to Rembrandt literature, confirming the artist's hostility to contemporary changes in the Dutch countryside.[11] A particularly rich resource is Catherine Levesque's study of Haarlem landscape print series.[12] Beginning with Bruegel's series of *Large Landscapes* as a foil for the seventeenth-century Dutch examples, Levesque argues convincingly for the connection between Dutch landscape print series and humanist writings on the educational and moral values of travel and landscape viewing, as well as for the patriotic and historical associations of Haarlem landscape prints, paralleled in texts on Dutch history, such as accounts of the siege of Haarlem.

THE REPRODUCTIVE TRADITION

Interest in reproductive printmaking, both in terms of individual printmakers and its theory and practice, is witnessed by recent exhibitions on Cort and on prints after Michelangelo's Sistine ceiling frescoes or after the paintings of Poussin.[13] It may be that we will develop a more precise and varied terminology to describe the subtle interchange between paintings, drawings, or sculptures and prints "after" them. For example, Michael Bury raises the issue of how we have used the term "reproductive" with respect to Ghisi's engravings. He argues that the engraving "after" the *School of Athens* (fig. 5.2 in this text) was never intended to be read as a duplication of that painting, but rather as an echo of Raphael's pictorial invention.[14]

PIRANESI, STUBBS, AND BLAKE

Piranesi scholarship was enriched in 1994 by a new catalogue raisonné of his prints by John Wilton-Ely.[15] This book, which has the advantage of being fully illustrated, contains Wilton-Ely's general introduction along with informative discussions of each major group of prints, a concordance of the different Piranesi catalogs, and extensive bibliography and indexes. The catalog follows Wilton-Ely's *Piranesi as Architect and Designer* (1993), published from a lecture series and useful as an introduction to this architectural etcher.[16]

In the field of original printmaking in eighteenth-century England, Stubbs's prints were newly cataloged in 1989 by Christopher Lennox-Boyd, Rob Dixon, and Tim Clayton, and Blake's working methods continue to be explored, with scrupulous attention to the methods and equipment of his time, by scholar-printmaker Joseph Viscomi in *Blake and the Idea of the Book*.[17] Viscomi's approach parallels Robert N. Essick's in positing a profound relationship between Blake's printmaking *techniques* and his thought itself. Viscomi asserts that Blake did work backwards on his relief etching plates, and his unraveling of Blake's production of small editions (as opposed to individual printings) will have many implications for the chronology of Blake's prints.

BROAD STUDIES: LATE EIGHTEENTH- AND EARLY NINETEENTH-CENTURY PRINTS

Antony Griffiths and Frances Carey of the British Museum have produced an exhibition catalog exploring the little-known field of printmaking and collecting in German-speaking territories in the age of Goethe (1749–1832).[18] The book is particularly interesting as an example of scholarship on the social and economic aspects of the history of prints. The authors consider reproductive and original printmaking, book illustration, the early history of lithography and wood-engraving, the impact of foreign artistic influences as well as German nationalism—including the awareness of the accomplishments in graphic art in the German past—the roles of publishers and dealers, and changes in popular tastes.

Patricia Anderson's *The Printed Image and the Transformation of Popular Culture* is a close

study of the evolution of inexpensive illustrated materials, such as *The Penny Magazine* or *Cassell's Illustrated Family Paper,* and their impact on the working classes in England between 1790 and 1860.[19] Wood-engraved illustrations, portraits of exemplary individuals, and reproductions of works of art, often stereotyped for mass distribution, appear in Anderson's study as potent tools for social reform and control, as well as reflections of the interests and concerns of working-class readers.

POLITICAL PRINTS: GILLRAY, CRUIKSHANK, AND GOYA

A small exhibition catalog from the Hood Museum at Dartmouth College, written by Katherine Hart with the assistance of Laura Hacker, has informative entries and an introductory essay on Gillray's prints.[20] Robert L. Patten's biographical study of the early part of George Cruikshank's career (1792–1835) appeared in 1992, providing fascinating glimpses of the life and context of this major British caricaturist, and, by extension, other artists working in this mode.[21]

But in the realm of eighteenth- and early nineteenth-century political prints, it is Goya who continues to excite the most controversy. The title of Janis A. Tomlinson's *Goya in the Twilight of Enlightenment* suggests that it is a rejoinder to the massive 1989 publication, *Goya in the Spirit of Enlightenment.*[22] Among the many significant ideas explored by Tomlinson are that the castigation of the vices of the nobility in the *Caprichos* reflected royal goals, and that Manuel Godoy, so long maligned in Goya scholarship, has been unfairly represented, as has the artist's relationship with this major patron. Tomlinson's book is one of a number of Goya publications in the early 1990s that will add to our knowledge—among them, a two-volume exhibition catalog on Goya's work of the 1790s (etchings and portraits) published by the Academia de Bellas Artes de San Fernando.[23]

LATE NINETEENTH-CENTURY EUROPEAN PRINTS

At the time that I was working on the small section of Chapter 8 dealing with Odilon Redon, Ted Gott's *The Enchanted Stone* was an exception to the general dearth of recent scholarship on Redon's lithographs. But a new interest in Redon has awakened: in 1992, another major Redon scholar, Stephen F. Eisenman, published *The Temptation of Saint Redon: Biography, Ideology and Style in the "Noirs" of Odilon Redon,* addressing, among other issues, the connections between Redon's imagery in drawings and lithographs and earlier French caricatures, such as those by Daumier. Redon's imagery, Eisenman argues, also reflects the turbulent politics after the Franco-Prussian War.[24] *Odilon Redon: Prince of Dreams,* a vast exhibition catalog written by multiple authors, including Douglas Druick and Peter Zegers, accompanied an exhibition at the Art Institute of Chicago in 1994.[25] The exhibition disproportionately represented Redon's paintings, pastels, and charcoals to the detriment of his etchings and lithographs. Nevertheless, the catalog raises so many psychological and contextual issues about Redon's works that it constitutes an escalation of scholarly inquiry that will certainly affect the study of his prints.

Far less well known than their French counterparts, late nineteenth-century Belgian artists produced a large body of graphic art, explored in *Les XX and the Belgian Avant-Garde: Prints, Drawings, and Books, ca. 1890,* an exhibition catalog edited by Stephen H. Goddard, who is also a contributor to the essays.[26] Among other concerns, these essays explore the connection between Belgian avant-garde art in the late nineteenth century and progressive social and political issues, and the artistic expression of Belgian national identity. The preeminence of Ensor as an original printmaker and satirist whose roots lay in Bosch and Bruegel is confirmed.

From Pissarro to Picasso: Color Etching in France is the most recent contribution of Phillip Dennis Cate and the Jane Voorhees Zimmerli Museum to a series on French printmaking, which includes two earlier publications on color lithography and woodcut, both cited in my text. Like these, *From Pissarro to Picasso* constitutes an important reference book for the media and printmakers discussed. Cate and co-author Marianne Grivel review the origins of color printing and bring to light new documentation on the support structure of publishers, dealers, and collectors for innovations in this field.[27]

GERMAN EXPRESSIONIST PRINTS

A 1992 exhibition of German print portfolios between 1890 and 1930 at the Detroit Institute of Arts focused attention on this important format for prints. Reinhold Heller's introductory essay in the catalog establishes the historical background of serial imagery as utilized by such German graphic artists as Dürer, Chodowiecki, Phillipp Otto Runge, Rethel, and Menzel. Robin Riesenfeld's essay addresses the social and historical context of the German print cycle from Klinger through the Expressionists, emphasizing how it was promoted by artists and dealers to constitute a semi-private viewing experience for a liberal middle-class audience. Lengthy entries on individual cycles, such as Dix's *War,* are highly informative.[28] In 1993, a second publication on German Expressionist prints, with text by Reinhold Heller, was produced to accompany an exhibition at the Mary and Leigh Block Gallery at Northwestern University. As in the Block Gallery's first German Expressionist catalog, cited in Chapter 10 of my text, Heller's introductory essay and the individual entries establish the broad social context and the goals of German printmakers between 1918 and 1933.[29] In 1995, the Museum of Fine Arts, Boston, mounted an exhibition of Emil Nolde's prints. The beautifully illustrated catalog, with essays on Nolde's etchings, woodcuts, and lithographs, by Clifford S. Ackley, Timothy O. Benson, and Victor Carlson respectively, confirms once again the central importance of printmaking for German Expressionist artists.[30]

Elizabeth Prelinger, who has examined the labyrinthine paths of Munch's printmaking, has addressed the experimentation evident in Käthe Kollwitz's prints (as well as drawings and sculptures) in a 1992 exhibition catalog for the National Gallery of Art.[31] Kollwitz emerges more clearly as not only a socially and politically committed artist but also as a graphic artist who, like Rembrandt, lavished much attention on each printmaking medium's distinctly different formal beauty and capacity for change. The exquisite illustrations of Prelinger's text (for example, the plates showing the evolution of *Woman with Dead Child*) demonstrate once again that technical complexity in printmaking is not incompatible with significant content.

Jennifer Mundy's *George Braque: Printmaker* offers a lucid and informative introductory essay on Braque's techniques, his relationships with printers, and the overall function of print-making within his oeuvre.[32] And publications on Braque's colleague Picasso, of course, continue to be produced in great numbers. For his prints, volumes 1 and 2 of Brigitte Baer's catalogues raisonnés were published in the early 1990s.[33] Karen Kleinfelder's study of the artist-and-model theme in Picasso's works focuses on his prints and drawings between 1954 and 1970. She expands upon and critiques earlier biographical interpretations of Picasso's artist-and-model imagery, interweaving such interpretations with recent theories of textuality, signification, and the gaze.[34] Picasso's participation in the production of books as a modern art form is, of course, part of Riva Castleman's survey of the modern "artist's book" that accompanied a 1994–1995 exhibition at the Museum of Modern Art.[35] In addition to Picasso, Castleman discusses a number of early twentieth-century printmakers as well as more recent artists. Images are reproduced along with text so readers are able to get a sense of how artists and book designers collaborated. In addition, Castleman describes the various roles of authors, publishers, and printers.

AMERICAN PRINTS TO THE MID-TWENTIETH CENTURY

Thomas P. Bruhn's *The American Print: Originality and Experimentation, 1790–1890* explores the work of some little-known American printmakers and challenges the description of American printmaking before the etching revival as a wasteland. The catalog highlights such works as the landscape engravings of Connecticut printmaker Abner Reed, Rembrandt Peale's lithograph of George Washington (1827), and early lithographs by Cole and Moran.[36]

In the text, I was able to address Homer's substantial body of designs for illustrative wood-engravings only very briefly. David Tatham's *Winslow Homer and the Illustrated Book* of 1992 is an important addition to the scholarship on Homer as well as that on the history of wood-engraved illustration in America. Tatham sheds light on the relationship between the painter's commercial work and his painting career, the cultural history that contributed to Homer's works, and the practice of commercial wood-engraving. Like Roger Stein, Tatham also shows how Homer sometimes rose above prosaic material, or contradicted the content of the texts he was illustrating.[37]

Ron Tyler's *Prints of the West* explores the contribution of popular prints such as wood-engravings and chromolithographs to the mythic image of the American West.[38] Although Tyler adopts an objective rather than a politicized approach, his book augments our understanding of the role of graphic imagery within the ideology of Manifest Destiny, a topic heretofore explored primarily with paintings. The ambivalent position of women artists within the WPA/FAP Graphic Arts Project is illuminated by Helen Langa's essay, "Egalitarian Vision, Gendered Experience."[39] Despite the ostensible freedom and equality offered women artists by the WPA/FAP, social factors—for example, the concern for economic recovery in combination with the concept of the heroic male worker—conditioned the images women produced.

A survey of color printmaking in America from the late nineteenth century to about 1960 (when the large printmaking workshops began to arise) is provided by a catalog, by David

Acton, Karen F. Beall, and Clinton Adams, of the collection of color prints in the Worcester Art Museum.⁴⁰ This book not only deals with familiar names such as Cassatt, Weber, and Lasansky but also includes a wide range of little-known yet technically innovative printmakers.

LATE MODERN PRINTS

The latest prints treated in the text come from the early 1980s: a good introduction to printmakers' concerns in this decade is Riva Castleman's *Seven Master Printmakers*.⁴¹ As noted above, Castleman's *A Century of Artists' Books* also includes discussions of a number of late modern printmakers. In the last decade of the twentieth century, it is not surprising to find many recent catalogues raisonnés of major late twentieth-century printmakers such as Hayter, Dubuffet, Francis, De Kooning, Lichtenstein, and Johns.⁴² For an assessment of some of these publications and others, as well as a discussion of the role of the catalogue raisonné—evidence of the persistence of connoisseurship and the concept of "originality" as the primary basis for print scholarship—see Richard S. Field's essay in the *Print Collector's Newsletter*.⁴³ Field, himself author of the recent catalogue raisonné of Johns's prints, urges that print connoisseurship be combined with issues of "meaning, context, use, and reception." Judging from this sampling of publications on prints in the early 1990s, this mixture of approaches is indeed developing.

NOTES

1. Sophie Renouard de Bussierre, *Martin Schongauer: Maître de la gravure rhénane*, exhibition catalog, Musée du Petit Palais, 1991; Tilman Falk and Thomas Hirte, *Martin Schongauer: Das Kupferstichwerk*, exhibition catalog, Staatliche Graphische Sammlung, Munich, 1991; Musée d'Unterlinden, *Le Beau Martin: Gravures et dessins de Martin Schongauer*, exhibition catalog with contributions by Georges Bischoff, Albert Chatelet, Helmut Reichwald, Tilman Falk, Fritz Koreny, Fedja Anzelewsky, Maxime Préaud, and others, Colmar, 1991; Staatliche Museen Preussischer Kulturbesitz, Berlin, *Martin Schongauer: Druckgraphik im Berliner Kupferstichkabinett*, exhibition catalog edited by Hartmut Krohm and Jan Nicolaisen, 1991.

2. Jane Martineau, ed., *Andrea Mantegna*, exhibition catalog with essays by Suzanne Boorsch, Keith Christiansen, David Ekserdjian, Charles Hope, David Landau, and others, Royal Academy of Art, London, and Metropolitan Museum of Art, New York, 1992; David Landau and Peter Parshall, *The Renaissance Print, 1470–1550* (New Haven, Conn., and London, 1994).

3. Patricia Emison, "Andrea Mantegna, A Printmaker?! A Controversy," *Print Collector's Newsletter*, vol. 23, no. 2 (May–June 1992), pp. 41–46; Keith Christiansen, "The Case for Mantegna as a Printmaker," *Burlington Magazine*, vol. 135 (September 1993), pp. 604–12.

4. Evelyn Lincoln, "Mantegna's Culture of Line," *Art History*, vol. 16, no. 1 (March 1993), pp. 33–59.

5. Patricia Emison, "The Singularity of Raphael's *Lucretia*," *Art History*, vol. 14, no. 3 (September 1991): 372–96.

6. Nancy Bialler, *Chiaroscuro Woodcuts: Henrick Goltzius and his Time*, exhibition catalog, Rijksmuseum, Amsterdam, 1992.

7. Walter Melion, *Shaping the Netherlandish Canon: Karel van Mander's "Schilder-boeck"* (Chicago and London, 1991).

8. Grunwald Center for the Graphic Arts, *The French Renaissance in Prints from the Bibliothèque Nationale*, exhibition catalog with essays by Suzanne Boorsch, Nancy J. Vickers, Philip Benedict, Cynthia Burlingham, and Peter Fuhring, Bibliothèque Nationale, Paris, and Grunwald

Center for Graphic Arts, University of California, Los Angeles, 1994.

9. Jacqueline Burgess, *Wenceslaus Hollar: Seventeenth-Century Prints from the Museum Boymans–van Beuningen, Rotterdam* (Alexandria, Va., 1994); Richard T. Godfrey, *Wenceslaus Hollar: A Bohemian Artist in England* (New Haven, Conn., 1994).

10. Kristina Hartzer Nguyen, *The Made Landscape: City and Country in Seventeenth-Century Dutch Prints, Harvard University Art Museums Bulletin,* vol. 1, no. 1 (1992).

11. Linda Stone-Ferrier, "Rembrandt's Landscape Etchings: Defying Modernity's Encroachment," *Art History,* vol. 15, no. 4 (December 1992), pp. 403–33.

12. Catherine Levesque, *Journey Through Landscape in Seventeenth-Century Holland: The Haarlem Print Series and Dutch Identity* (University Park, Penn., 1994).

13. Calcographia Nazionale, Rome, *La Sistina riprodotta: Gli affreschi di Michelangelo dalle stampe del cinquecento alle campagne fotografiche Anderson,* exhibition catalog in Italian edited by Alida Moltedo with contributions by Evelina Borea, Maria Antonella Fusco, and Marina Miraglia, 1991; Courtauld Institute, London, *Prints Representing Poussin,* exhibition catalog, 1994; Museum Boymans–van Beuningen, Rotterdam, *Cornelis Cort: Accomplished Plate-Cutter from Hoorn in Holland,* exhibition catalog in Dutch and English, 1994.

14. Michael Bury, "On Some Engravings by Giorgio Ghisi Commonly Called 'Reproductive,'" *Print Quarterly,* vol. 10, no. 1 (March 1993), pp. 4–19.

15. John Wilton-Ely, *Giovanni Battista Piranesi: The Complete Etchings* (London, 1994).

16. John Wilton-Ely, *Piranesi as Architect and Designer* (New York and New Haven, Conn., 1993).

17. Christopher Lennox-Boyd, Rob Dixon, and Tim Clayton, *George Stubbs: The Complete Engraved Works* (London, 1989); Joseph Viscomi, *Blake and the Idea of the Book* (Princeton, N.J., 1993).

18. Antony Griffiths and Frances Carey, *German Printmaking in the Age of Goethe,* exhibition catalog, British Museum, London, 1994.

19. Patricia Anderson, *The Printed Image and the Transformation of Popular Culture, 1790–1860* (Oxford, 1991).

20. Hood Museum of Art, Dartmouth College, *James Gillray: Prints by the Eighteenth-Century Master of Caricature,* exhibition catalog with essay and entries by Katherine Hart, assisted by Laura Hacker, Hanover, N.H., 1994.

21. Robert L. Patten, *George Cruikshank's Life, Times and Art,* vol. 1, 1792–1835 (London, 1992).

22. Janis A. Tomlinson, *Goya in the Twilight of Enlightenment* (New Haven, Conn., 1992).

23. Juliet Wilson-Bareau, *Dibuyos y Aguafuertes,* vol. 1 of *La Década de los Caprichos,* 2 vols., exhibition catalog by Wilson Bareau and Nigel Glendinning, Academia de Bellas Artes de San Fernando, Madrid, 1992. For a discussion of this and other publications on Goya's prints from the early 1990s, see Janis A. Tomlinson, "Goya's *Caprichos,*" *Print Quarterly,* vol. 10, no. 2 (June 1993), pp. 187–89.

24. Stephen F. Eisenman, *The Temptation of Saint Redon: Biography, Ideology and Style in the "Noirs" of Odilon Redon* (Chicago, 1992).

25. Art Institute of Chicago, *Odilon Redon: Prince of Dreams,* exhibition catalog with essays by Douglas Druick, Peter Zegers, and others, 1994.

26. Stephen H. Goddard, ed., *Les XX and the Belgian Avant-Garde: Prints, Drawings, and Books ca. 1890,* exhibition catalog with essays by Jane Block, Susan M. Canning, Donald Friedman, Stephen H. Goddard, Sura Levine, Alexander Murphy, and Carl Strikwerda, Spencer Museum of Art, University of Kansas, Lawrence, 1992.

27. Phillip Dennis Cate and Marianne Grivel, *From Pissarro to Picasso: Color Etching in France,* exhibition catalog, Jane Voorhees Zimmerli Museum, Rutgers University, New Brunswick, N.J., 1992.

28. Robin Riesenfeld, *The German Print Portfolio: Serials for a Private Sphere,* exhibition catalog with introduction by Reinhold Heller, Detroit Institute of Arts, 1992.

29. Reinhold Heller, *Stark Impressions: Graphic Production in Germany, 1918–1933,* exhibition catalog, Mary and Leigh Block Gallery, Northwestern University, Evanston, Ill., 1993.

30. Clifford S. Ackley, Timothy O. Benson, and Victor Carlson, *Nolde: The Painter's Prints,* exhibition catalog, Museum of Fine Arts, Boston, in association with the Los Angeles County Museum of Art, 1995.

31. Elizabeth Prelinger, *Käthe Kollwitz,* exhibition catalog, National Gallery of Art, Washington, D.C., 1992.

32. Jennifer Mundy, *Georges Braque: Printmaker,* exhibition catalog, Tate Gallery, London, 1993.

33. Brigitte Baer, *Picasso peintre-graveur: Catalogue raisonné de l'oeuvre gravé et lithographié et des monotypes,* vol. 1, *1899–1931* (Bern, 1990); vol. 2, *1932–1934* (Bern, 1992).

34. Karen Kleinfelder, *The Artist, His Model, Her Image, His Gaze: Picasso's Pursuit of the Model* (Chicago, 1993).

35. Riva Castleman, *A Century of Artists' Books,* exhibition catalog, Museum of Modern Art, New York, 1994.

36. Thomas P. Bruhn, *The American Print: Originality and Experimentation, 1790–1890,* exhibition catalog with additional essay by Kate Steinway, William Benton Museum of Art, University of Connecticut, Storrs, 1992.

37. David Tatham, *Winslow Homer and the Illustrated Book* (Syracuse, N.Y., 1992).

38. Ron Tyler, *Prints of the West* (Golden, Colo., 1994).

39. Helen Langa, "Egalitarian Vision, Gendered Experience: Women Printmakers and the WPA/FAP Graphic Arts Project," in *The Expanding Discourse: Feminism and Art History,* ed. Norma Broude and Mary Garrand, pp. 409–23 (New York, 1992).

40. David Acton, *A Spectrum of Innovation: Color in American Printmaking, 1890–1960,* exhibition catalog with contributions by Clinton Adams and Karen F. Beall, Worcester Art Museum, Worcester, Mass., 1990.

41. Riva Castleman, *Seven Master Printmakers,* exhibition catalog, Museum of Modern Art, New York, 1991.

42. Lanier Graham, ed., *The Prints of Willem de Kooning: A Catalogue Raisonné* (Paris, 1991); Sophie Webel, ed., *L'oeuvre gravé et des livres illustrés par Jean Dubuffet: Catalogue raisonné* (Paris, 1991); Peter Black and Desirée Moorhead, eds., with an essay by Jacob Kainen, *The Prints of Stanley William Hayter* (Mount Kisco, N.Y., 1992); Connie Lembark, ed., with an introduction by Ruth E. Fine, *The Prints of Sam Francis: A Catalogue Raisonné* (New York, 1992); Mary Lee Corlett, *The Prints of Roy Lichtenstein: A Catalogue Raisonné 1948–1993,* with introductory essay by Ruth E. Fine (New York, 1994); Richard S. Field, *The Prints of Jasper Johns: A Catalogue Raisonné* (West Islip, N.Y., 1994).

43. Richard S. Field, "Some Reflections Apropos Recent Catalogues Raisonnés," *Print Collector's Newsletter,* vol. 23, no. 4 (November–December 1992), pp. 182–90.

Illustration Credits

ALBANY INSTITUTE OF HISTORY AND ART, Albany, New York. Collection of the Albany Institute of History and Art *12.25* (1965.68.4).

AMERICAN ANTIQUARIAN SOCIETY, Worcester, Massachusetts. Courtesy, American Antiquarian Society *12.1, 12.6.*

AMON CARTER MUSEUM, Forth Worth, Texas. *12.7* (1969.187); *12.9* (1972.170).

THE ART INSTITUTE OF CHICAGO, Chicago. Photos © 1984, The Art Institute of Chicago, All Rights Reserved: Gift of Dr. Harold Joachim *13.25* (1960.202); Gift of Emily Crane Chadbourne *12.40* (1927.474); Gift of Mr. and Mrs. Henry C. Woods *13.23* (1966.179). Photos © 1990, The Art Institute of Chicago, All Rights Reserved: Mr. and Mrs. Carter H. Harrison Collection *8.47(c)* (1954.1193). Photos © 1993, The Art Institute of Chicago, All Rights Reserved: Clarence Buckingham Collection *10.2* (1948.256), *10.13* (1963.299); Clarence Buckingham Fund *10.16* (1963.274); Gift of the Print and Drawing Club *13.3* (1950.27); Given in Memory of A. Peter Dewey *11.6* (1946.1043); John H. Wrenn Memorial Collection *3.29* (1947.690); Mr. and Mrs. Carter H. Harrison Collection *8.48* (1949.1004), *8.50* (1948.450); Potter Palmer Collection *3.35* (1919.2553); Prints and Drawings Purchase Fund *11.40* (1946.439); Restricted gift of Mrs. H. S. Perkins *12.46* (1972.782); Stickney Collection *1.31* (1938.1124); U.L.A.E. Collection, challenge grant of Mr. and Mrs. Thomas Dittmer; restricted gift of supporters of the Department of Prints and Drawings, Centennial Endowment *13.38* (1982.947), *13.39* (1982.945II[o]), *13.44(c)* (1983.564); William McCallin McKee Memorial Collection *8.41* (1943.1024). Photos © 1994, The Art Institute of Chicago, All Rights Reserved: The Singer Collection; Wallace L. DeWolf and Joseph Brooks Fair funds *2.53* (1920.2199); Through prior acquisitions of Mr. and Mrs. Potter Palmer, Jr., Honoré Palmer and an anonymous donor *5.13* (1993.263). Reproduction rights: © 1996 The Munch Museum / The Munch Ellingsen Group / ARS, New York *10.13, 10.16;* © 1996 Succession H. Matisse, Paris / Artists Rights Society (ARS), New York *11.6;* © 1996 Artists Rights Society (ARS), New York / SPADEM, Paris *11.40, 13.3.*

THE BALTIMORE MUSEUM OF ART. Adler Purchase Fund *8.35* (BMA 1949.3); Joseph Katz Collection *8.21* (BMA 1963.98); The Cone Collection, formed by Dr. Claribel Cone and Miss Etta Cone of Baltimore, Maryland *8.36* (BMA 1950.12.344); The George A. Lucas Collection of the Maryland Institute, College of Art, on indefinite loan to The Baltimore Museum of Art *8.30* (L.33.53.13694).

BAUHAUS-ARCHIV MUSEUM FÜR GESTALTUNG, Berlin. Reproduction rights: © 1996 Artists Rights Society (ARS), New York / VG Bild-Kunst, Bonn *11.24.*

BIBLIOTHÈQUE LITTÉRAIRE JACQUES DOUCET, Universités de Paris, France. Photo: Jean-Loup Charmet *11.7.* Reproduction rights: © 1996 Succession H. Matisse, Paris / Artists Rights Society (ARS), New York.

BIBLIOTHÈQUE NATIONALE, Paris. © Cliché Bibliothèque Nationale de France. *3.2, 5.1, 5.12, 5.14, 5.24, 5.25, 5.27, 5.28, 5.29, 5.30, 5.37, 5.38, 6.23, 6.24, 7.15, 8.10, 8.27, 9.3, 9.11, 9.16, 9.27, 9.31, 9.32, 9.38.*

BIBLIOTHÈQUE ROYALE ALBERT Ier, Cabinet des Estampes, Brussels. Photos © Bibliothèque royale Albert Ier, Bruxelles *2.50, 6.25, 10.7, 10.8.*

BOSTON PUBLIC LIBRARY, Print Department, Boston. *12.10;* By permission of the Estate of Thomas Nason *12.59;* By permission of the Estate of Stow Wengenroth *12.61.*

THE BRITISH LIBRARY, London. By permission of The British Library *1.15* (IB 18 Ills. no. 5 8870018); *4.20* (G 11960); *9.48* (3226.f.24); *9.49* (C.43.h.19); *9.50* (C.99.24).

THE BRITISH MUSEUM, London. Courtesy of the Trustees of The British Museum. *1.25, 1.35, 2.44, 3.5, 3.6, 3.19, 3.36, 3.37, 3.38, 3.48, 3.51, 4.7, 4.8, 4.21, 4.35, 4.37, 4.42, 4.49, 4.53, 4.54, 5.11,*

5.15, 5.18, 5.19, 6.37, 6.40(c), 6.42, 6.43, 6.45, 6.46, 7.11, 7.12, 7.13(c), 7.17, 7.18, 8.2, 8.12, 9.8, 9.10, 10.34.

BROOKE ALEXANDER EDITIONS, New York. Courtesy Brooke Alexander, New York 13.76. Photo: D. James Dee, New York.

THE BROOKLYN MUSEUM, Brooklyn, New York. Print Department Auction Fund 13.61 (73.115); The Brooklyn Museum Purchase 13.29 (53.38), 13.33 (59.14).

CINCINNATI ART MUSEUM, Cincinnati. Bequest of Herbert Greer French 2.25, 5.51.

CLEVELAND MUSEUM OF ART, Cleveland. Photos © 1994 The Cleveland Museum of Art: Bequest of James Parmelee 4.41 (40.879), 12.28 (40.910); Bequest of John L. Severance 4.50 (42.757), 5.49(c) (42.732); Bequest of Ralph King and Purchase from the J. H. Wade Fund 4.55 (59.241); Delia E. Holden Fund 10.24 (60.158); Dudley P. Allen Fund 1.37 (23.227), 1.39 (41.389), 2.8 (44.473), 2.13 (59.103), 2.33 (74.19), 2.34 (80.93), 2.36 (80.48), 2.40 (29.147), 2.41 (29.159), 3.13 (26.260), 4.44 (61.80), 6.19 (41.30), 8.38 (45.352); Elizabeth Severance Prentiss Collection 4.45 (66.334); Elizabeth Severance Prentiss and Leonard C. Hanna, Jr. Collections by exchange 2.14 (65.231); Fiftieth Anniversary Gift of The Print Club of Cleveland 10.22(c) (70.353); Gift of Leonard C. Hanna, Jr. 2.43 (35.20), 5.53 (35.11), 9.39 (47.402), 12.33 (35.268); Gift of Leonard C. Hanna, Jr. in memory of Ralph King 2.16 (26.211); Gift of Mr. and Mrs. A. Dean Perry in memory of Julia Raymond, and Gift of Miss Helen B. Falter 5.31 (77.50); Gift of Mr. and Mrs. Albrecht Saalfield 13.70 (72.92); Gift of Mr. and Mrs. Paul Ehrenfest in memory of William J. Collins 2.12 (61.274); Gift of Mrs. Ralph King 2.9 (43.178), 2.18 (41.40), 8.45 (26.298); Gift of P. & D. Colnaghi Co. 6.26 (25.1217); Gift of Ralph King 2.6 (25.73), 3.11 (24.219), 3.12 (24.217), 3.14 (24.223), 3.15 (24.221, 24.222), 4.3 (25.59), 4.47 (41.148), 9.28 (22.182); Gift of the Hanna Fund 2.57 (53.213); Gift of The Print Club of Cleveland 2.2 (22.96), 2.3 (32.313), 2.4 (22.104), 2.10 (21.1170), 2.32 (63.230), 2.35 (26.106), 2.39 (29.161), 2.42 (29.168), 3.33 (64.23), 3.40 (31.205), 6.3 (25.1248),

8.44 (53.346), 9.29 (61.151), 9.60(c) (54.377); Gift of The Print Club of Cleveland in honor of William Mathewson Milliken 4.51 (58.306); Gift of The Print Club of Cleveland in memory of Ralph King 2.11 (26.117); John L. Severance Fund 1.41 (51.429), 1.46 (52.79); L. E. Holden Fund 4.11 (62.20); Leonard C. Hanna, Jr., Fund 2.15 (72.29); Mr. and Mrs. Charles G. Prasse Collection 2.20 (66.172), 3.30 (72.309); Mr. and Mrs. Lewis B. Williams Collection 8.3 (42.1003), 8.4 (50.490), 12.57 (41.506); Purchase from the J. H. Wade Fund 3.7 (67.127); The Charles W. Harkness Endowment Fund 3.49(c) (23.1052); The Fanny Tewksbury King Collection 1.38 (56.744), 3.17 (56.741). Reproduction rights: © 1967 Frank Stella and Gemini G.E.L. By permission of Artists Rights Society (ARS), New York 13.70.

COLLEGE OF WOOSTER ART MUSEUM, Wooster, Ohio. The John Taylor Arms Collection, Gift of Ward M. and Mariam C. Canaday (1967) 2.23, 4.26, 9.12, 9.13, 9.14, 9.17, 9.18, 9.19, 9.20, 9.25, 9.26, 9.40, 10.47, 12.50. Reproduction rights: © 1996 Artists Rights Society (ARS), New York / VG Bild-Kunst, Bonn 10.47.

CONDESO / LAWLER GALLERY, New York. Photo © 1992 Ellen Page Wilson 13.73.

ELVEHJEM MUSEUM OF ART, University of Wisconsin–Madison. Photos © Elvehjem Museum of Art, University of Wisconsin–Madison. Anonymous Funds purchase 13.57(c) (1974.39); F. J. Sensenbrenner Trust Fund purchase 10.15 (1979.1124); Gift of David C. Ruttenberg 13.67 (1981.20C); Gift of John H. Van Vleck 9.34 (1980.3240); Humanistic Foundation Funds purchase 4.15 (63.4.10), 4.16 (63.4.16), 4.17 (63.4.23), 13.30 (60.3.2); Mark H. and Katherine E. Ingraham Fund purchase 12.38 (1976.8), 12.45 (1975.3); Oscar Rennebohm Foundation Fund purchase 12.30 (64.1.2); Plaenert Endowment Fund purchase 9.2 (1988.62); Robert Gale Doyon Fund and Harold F. Bishop Fund purchase 13.53(c) (1978.252); Thomas E. Brittingham Fund purchase 7.20 (70.7.19), 7.21 (70.7.21), 7.22 (70.7.23), 7.23 (70.7.25), 7.24 (70.7.14), 7.25 (70.7.75), 7.26 (70.7.12), 7.28

(70.7.68), *7.29* (70.7.69), *7.30* (70.7.53), *7.31*
(70.7.58), *7.32* (70.7.50), *7.33* (70.7.39),
7.34 (70.7.42), *7.35* (70.7.71); Transfer from the
State Historical Society of Wisconsin *6.15*
(05.1.32), *6.16* (05.1.24); University purchase *7.1*
(66.8.2), *7.2* (66.8.4), *7.3* (66.8.6), *7.4* (66.8.9),
7.5 (66.8.10), *7.6* (66.8.15), *7.7* (66.8.17), *7.8*
(66.8.75), *7.9* (66.8.79). Reproduction rights: ©
1996 The Munch Museum / The Munch
Ellingsen Group / ARS, New York *10.15*; ©
1967 Andy Warhol Foundation for the Visual
Arts / ARS, New York *13.53(c)*.

FINE ARTS MUSEUMS OF SAN FRANCISCO.
Achenbach Foundation for Graphic Arts
purchase *13.27* (1965.68.16).

FOLGER SHAKESPEARE LIBRARY, Washington,
D.C. Art Collection. By permission of the
Folger Shakespeare Library *4.19*.

GALERIE BRUSBERG, Berlin. Reproduction
rights: © 1996 Artists Rights Society (ARS),
New York / SPADEM / ADAGP, Paris *11.43*.

GALERIE LOUISE LEIRIS, Paris. Cliché et
photographie Galerie Louise Leiris, Paris *13.7*.
Reproduction rights: © 1996 Artists Rights
Society (ARS), New York / SPADEM, Paris.

GALERIE ADRIEN MAEGHT, Paris. Reproduction
rights: © 1996 Artists Rights Society (ARS),
New York / ADAGP, Paris *11.51*.

GALERIE NIERENDORF, Berlin. Reproduction
rights: © 1996 Artists Rights Society (ARS),
New York / VG Bild-Kunst, Bonn *10.25*.

GEMINI G.E.L., Los Angeles. © 1983 Vija
Celmins and Gemini G.E.L. *13.79*.

GRUNWALD CENTER FOR THE GRAPHIC
ARTS, University of California, Los Angeles.
Gift of Mr. and Mrs. Stanley Talpis *10.61*.
Reproduction rights: © 1996 Artists Rights
Society (ARS), New York / ADAGP, Paris.

HARVARD UNIVERSITY ART MUSEUMS,
Cambridge, Massachusetts. Louise Haskell Daly
Fund *10.60* (M 14,138). Courtesy of The Fogg
Art Museum: Francis Burr and Alpheus Hyatt
Funds *11.1* (M 13,022); Francis H. Burr Fund
11.9(c) (M 12,164); Friends of the Fogg Fund
10.59(c) (M 12,046); Gift of Meta and Paul J.
Sachs *11.11* (M 12,908); Gray Collection of
Engravings Fund *11.50* (G 8828); Hyatt,

Prichard and Anonymous Funds *4.39*
(M 13,972); Program for Harvard College Fund
8.28 (M 13,710). Reproduction rights: © 1996
Artists Rights Society (ARS), New York /
ADAGP, Paris *10.59(c)*, *10.60*, *11.50*; © 1996
Succession H. Matisse, Paris / Artists Rights
Society (ARS), New York *11.1*, *11.9(c)*.

HENRY ART GALLERY, University of Washington,
Seattle. Gift of Anne Gerber *13.46* (64.24.6).
Reproduction rights: © 1967 Robert
Rauschenberg and Gemini G.E.L.

HENRY BEHRND, Madison, Wisconsin.
Collection of Henry Behrnd *12.17*.

HIGH MUSEUM OF ART, Atlanta, Georgia.
Purchase for the Ralph K. Uhry Collection *8.42*
(73.23).

HOUGHTON LIBRARY, Harvard University,
Department of Printing and Graphic Arts,
Cambridge, Massachusetts. Reproduction rights:
© 1996 Artists Rights Society (ARS), New York /
SPADEM, Paris *11.27*.

HUNTERIAN ART GALLERY, University of
Glasgow. Photo: © Hunterian Art Gallery, Uni-
versity of Glasgow, Birnie Philip Bequest *9.54*.

THE JANE VOORHEES ZIMMERLI ART
MUSEUM, Rutgers, The State University of
New Jersey. Friends Purchase Fund *8.37*.

THE JOHN RYLANDS UNIVERSITY LIBRARY,
Manchester, England. Reproduced by courtesy
of the Director and University Librarian,
the John Rylands University Library of
Manchester *1.5*.

THE JOSEF ALBERS FOUNDATION, INC.,
Orange, Connecticut. Reproduction rights:
© 1996 Artists Rights Society (ARS), New York /
VG Bild-Kunst, Bonn *11.25*, *11.26*.

KRESGE ART MUSEUM, Michigan State
University, East Lansing. *9.24* (50.1.8).

KUNSTMUSEUM BERN (Musée des Beaux-Arts de
Berne). Hermann und Margit Rupf-Stiftung
11.3. Reproduction rights: © 1996 Artists Rights
Society (ARS), New York / ADAGP, Paris.

LAWRENCE SAPHIRE COLLECTION, New York.
Photo: Ali Elai, New York *11.20*. Reproduction
rights: © 1996 Artists Rights Society (ARS), New
York / SPADEM / ADAGP, Paris.

LOS ANGELES COUNTY MUSEUM OF ART,

Los Angeles. Collection of Mary Stansbury Ruiz *2.55* (M.88.91.71); Gift of Mary Stansbury Ruiz *3.41* (M.88.91.15); Howard De Forest Bequest *12.15* (47.31.113); The Robert Gore Rifkind Center for German Expressionist Studies *10.27* (M.82.288.239); *10.44* (M.82.288.187), *10.49* (M.82.287.35), *10.51* (M.82.288.71e), *10.52* (M.82.288.73g), *10.53* (M.82.288.55c), *10.54* (M.82.288.51f), *10.56* (M.82.288.53b); The Robert Gore Rifkind Center for German Expressionist Studies, purchased with funds provided by Anna Bing Arnold, Museum Acquisition Fund and Deaccession Funds *10.30(c)* (M.83.1.102.5), *10.31* (83.1.3a), *10.41* (83.1.7b). Reproduction rights: © 1996 Artists Rights Society (ARS), New York / ADAGP, Paris *10.30(c)*; © 1996 Artists Rights Society (ARS), New York / VG Bild-Kunst, Bonn *10.31, 10.44, 10.49.*

MADISON ART CENTER, Madison, Wisconsin. Bequest of Rudolph and Louise Langer *12.41, 12.51.* Photo: John M. Robinson *12.41.*

THE METROPOLITAN MUSEUM OF ART, New York. All rights reserved, The Metropolitan Museum of Art: Anonymous Gift *3.18* (29.44.19); Bequest of James Clark McGuire *1.14* (31.54.189), *1.17* (31.54.169); By Exchange *3.31* (31.31.2); Elisha Whittelsey Fund *3.52* (53.530.2); Gift of Émile Protat *1.1* (54.613); Gift of Felix Warburg *2.28* (20.64.21); Gift of Felix M. Warburg and his family *4.52* (41.1.34); Gift of Mr. and Mrs. Charles Kramer *13.4* (1985.1079.1); Gift of Mrs. Bessie Potter Vonnoh *8.53* (41.12.14); Harris Brisbane Dick Fund *1.30* (34.38.1), *2.24* (Ref Book 881), *2.48* (25.2.11), *2.56* (33.52.2), *3.47* (67.770), *3.55* (27.82.2), *4.14* (42.41.11), *5.20* (30.53.17a-b), *5.40* (53.600.217), *5.41* (28.22.6), *5.43* (53.600.568), *5.46* (40.9.11), *7.44* (32.62.12), *12.23* (41.20.5); Harris Brisbane Dick Fund, Elisha Whittelsey Collection, Elisha Whittelsey Fund, Douglas Dillon Gift *9.58* (68.670); Jacob Schiff Fund *7.40* (22.60.25[33]); Purchase, by Exchange *13.26* (1981.1081); Purchase, Jacob H. Schiff Bequest *9.1* (22.60.14); Purchase, Rogers Fund and Jacob H. Schiff Bequest *7.39* (22.60.25[30]), *7.41* (22.60.25[36]), *7.42* (22.60.25[39]), *7.43* (22.60.25[15]); Rogers Fund *3.44* (08.277.38), *3.50* (22.73.345), *5.21* (22.67.3), *7.45* (22.60.25[62]), *8.6* (22.63.19), *8.7* (17.12); The Elisha Whittelsey Collection, The Elisha Whittelsey Fund *3.54* (51.501.4087), *5.33* (28.100[2]), *6.27* (55.503.31), *6.34* (1982.1100.6). Photo © 1994, by The Metropolitan Museum of Art: Bequest of Adele S. Colgate (1963) *12.12(c)* (63.550.42). Photo © 1978 by The Metropolitan Museum of Art, The Elisha Wittelsey Collection, The Elisha Whittelsey Fund (1961) *6.36(c)* (61.531). Reproduction rights: © 1996 Artists Rights Society (ARS), New York / ADAGP / SPADEM, Paris *8.53;* © 1996 Artists Rights Society (ARS), New York / SPADEM, Paris *13.4;* © 1996 Milton Avery Trust / Artists Rights Society (ARS), New York *13.26.*

MILWAUKEE ART MUSEUM, Milwaukee, Wisconsin. Purchase, Gertrude Nunnemacher Schuchardt Fund *13.74.*

THE MINNEAPOLIS INSTITUTE OF ARTS, Minneapolis. Dunwoody Fund (1941) *12.39;* Goddard (1919) *12.16;* The Ladd Collection, Gift of Hershel V. Jones (1916) *5.47.*

MUNCH-MUSEET, Oslo. Photo © Oslo kommunes kunstsamlinger, Munch Museet, Oslo *10.9, 10.14(c).* Reproduction rights: © 1996 The Munch Museum / The Munch-Ellingsen Group / ARS, New York.

MUSÉE DU LOUVRE, Département des Arts Graphiques, Paris. Cliché des Musées Nationaux, Paris *5.34, 5.35.* Photos © R.M.N.-SPADEM.

MUSÉE PICASSO, Paris. Cliché des Musées Nationaux, Paris *13.1.* Photo © R.M.N. Reproduction rights: © 1996 Artists Rights Society (ARS), New York / SPADEM, Paris.

MUSEO CORRER, Gabinetto Stampe e Disegni, Venice. Photos: Osvaldo Böhm *3.22, 3.43, 6.1;* Photo: Fotografia Giacomelli *3.28.*

MUSEO NACIONALE DEL PRADO, Madrid. Photos: Museo del Prado, Madrid. All Rights Reserved *7.52.* Reproduction rights: © 1996 Artists Rights Society (ARS), New York / SPADEM, Paris *11.39.*

MUSEO NAZIONALE DEL BARGELLO, Florence. Photo: Alinari / Art Resource, New York *3.1.*

MUSEUM OF ART, RHODE ISLAND SCHOOL OF DESIGN, Providence. Museum Works of Art

Fund *4.5, 8.14.* Photo: Cathy Carver; National
Endowment Fund *13.75(c);* Purchased with the
aid of funds from the National Endowment for
the Arts *13.56(c).*

MUSEUM OF FINE ARTS, Boston. Bequest of
W. G. Russell Allen *2.19, 8.32;* Bequest of
William B. Babcock *7.27;* Davidson Collection.
Stephen Bullard Memorial Fund *3.8;* From the
Collection of Lois and Michael Torf, Photo:
Courtesy, Museum of Fine Arts, Boston *11.22;*
Gift of Caroline Hunt Rimmer *12.27;* Gift of
George P. Gardener *12.37;* Gift of Mrs. C.
Gaston Smith Group *12.43;* Gift of Mrs. Lydia
Evans Tunnard, in memory of W. G. Russell
Allen *4.33, 6.31;* Gift of the Children of
Dr. James B. Ayer *3.46;* Gift of W. G. Russell
Allen *12.58;* Gift of Watson Grant Cutter *12.3(c);*
Gift of William Emerson *12.36;* Harvey D.
Parker Collection *3.32, 4.38, 5.9, 8.8;* Horatio
Curtis Fund *2.38;* Katherine Bullard Fund *2.7;*
Katherine Elliot Bullard Fund *4.24, 5.16, 9.59;*
Maria Antoinette Evans Fund *3.4;* 1951 Purchase
Fund *7.48;* Sylvester Rosa Koehler Collection
12.26.

MUSEUM FOLKWANG, Essen, Germany.
Reproduction rights: © Dr. Wolfgang and
Ingeborg Henze-Ketterer, Wichtrach / Bern
10.19; © 1996 Artists Rights Society (ARS), New
York / ADAGP, Paris *10.29.*

THE MUSEUM OF MODERN ART, New York.
Abby Aldrich Rockefeller Fund *10.10, 10.18,
10.21(c), 10.33, 10.38, 10.57, 10.58, 11.30, 11.33, 11.34,
11.35, 13.19;* Anonymous loan *11.49;* Gift of Abby
Aldrich Rockefeller *8.39, 11.54, 13.12;* Curt
Valentin Bequest *13.2;* Gift of Celeste Bartos
11.17, 13.42, 13.36(c), 13.68(c); Gift of E. W.
Kornfeld *13.35(c);* Gift of J. B. Neumann *10.39,
11.41;* Gift of Lee Krasner Pollock *13.20;* Gift of
Madame Paul Klee *10.35;* Gift of Mr. and Mrs.
Alfred Jaretzki, Jr. *11.21;* Gift of Mr. and Mrs.
Armand P. Bartos *13.13, 13.16;* Gift of Mr. and
Mrs. Otto Gerson *10.23;* Gift of Mr. and Mrs.
Peter A. Rübel *13.11;* Gift of Mr. and Mrs. Ralph
F. Colin *13.8, 13.9;* Gift of Mr. and Mrs. Ralph F.
Colin in honor of René d'Harnoncourt *13.10;*
Gift of Mrs. Bertha M. Slattery *13.15;* Gift of
Mrs. Bliss Parkinson *8.56, 13.34;* Gift of Mrs.
Donald B. Straus *13.5(c);* Gift of Mrs. Theodore

Boettger *10.46;* Gift of Paul J. Sachs *10.26;* Gift of
Samuel A. Berger *10.40;* Gift of the Celeste and
Armand Bartos Foundation *13.37, 13.41, 13.45,
13.59;* Gift of Theodore Schempp *13.14;* Gift of
Victor S. Riesenfeld *11.2;* Given anonymously
11.14; Jeanne C. Thayer Fund and Purchase
13.43; John B. Turner Fund *13.80;* Larry Aldrich
Fund *13.66(c);* Leo Castelli Fund *13.65;* Monroe
Wheeler Fund *13.6;* Mr. and Mrs. Ralph F.
Colin, Leon A. Mnuchin and Mrs. Alfred R.
Stern Funds *13.64;* Philip Johnson Fund *12.63;*
Purchase *10.36, 10.37(c), 13.51;* Purchase Fund
10.5, 10.32, 11.16, 11.42, 11.48; Riva Castleman
Fund *13.58;* The Joseph G. Mayer Foundation
Fund *13.63;* The Louis E. Stern Collection *8.54,
11.8, 11.15, 11.19, 11.38, 11.52(c);* The William B.
Jaffe and Evelyn A. J. Hall Collection *10.12.*
Photos © 1993 The Museum of Modern Art.
*10.21(c), 10.37(c), 11.52(c), 13.5(c), 13.35(c), 13.66(c),
13.68(c).* Photos © 1994 The Museum of Modern
Art *13.36(c), 13.51.* Reproduction rights: © 1996
Artists Rights Society (ARS), New York /
ADAGP / SPADEM, Paris *8.54, 8.56;* © 1996
The Munch Museum / The Munch-Ellingsen
Group / ARS, New York *10.10, 10.12;* © Dr.
Wolfgang and Ingeborg Henz-Ketterer,
Wichtrach / Bern *10.18, 10.21;* © 1996 Artists
Rights Society (ARS), New York / VG Bild-
Kunst, Bonn *10.23, 10.26, 10.46, 10.57, 10.58, 11.41,
11.42;* © 1996 Artists Rights Society (ARS), New
York / ADAGP, Paris *10.32, 10.33, 11.8, 11.15, 11.16,
11.48, 11.49, 11.52(c), 13.8, 13.9, 13.10, 13.12, 13.13,
13.15, 13.16, 13.66(c);* © 1996 Artists Rights
Society, (ARS) New York / Pro Litteris, Zurich
10.38; © 1996 Artists Rights Society (ARS),
New York / SPADEM, Paris *11.2, 11.30, 11.33,
11.34, 11.35, 11.38, 11.54, 13.2, 13.5(c), 13.6;* © 1996
Artists Rights Society (ARS), New York /
SPADEM / ADAGP, Paris *11.19;* © 1996
Pollock-Krasner Foundation / Artists Rights
Society (ARS), New York *13.20;* © 1996 Willem
de Kooning Revocable Trust / Artists Rights
Society (ARS), New York *13.34;* © 1996 The
Estate of Sam Francis / Artists Rights Society
(ARS), New York *13.35 (c);* © 1974 Robert
Rauschenberg and Gemini G.E.L. *13.51.*

NATIONAL GALLERY OF ART, Washington, D.C.
Photos © 1993, Board of Trustees, National

Gallery of Art, Washington, D.C.: Ailsa Mellon Bruce Fund *3.9, 3.10, 5.22, 9.15;* Andrew W. Mellon Fund *4.18, 5.17, 6.12, 9.57;* Gift of Lloyd Cutler and Polly Kraft, in Honor of the Fiftieth Anniversary of the National Gallery of Art *8.20;* Gift of Mr. and Mrs. Earl H. Look *6.17;* Gift of R. Horace Gallatin *4.46;* Gift of W. G. Russell Allen *3.20, 6.2, 8.5;* Mark J. Millard Architectural Collection *6.14;* Mark J. Millard Architectural Collection, acquired with assistance from The Morris and Gwendolyn Cafritz Foundation *6.21;* Print Purchase Fund (Rosenwald Collection) *3.53;* Rosenwald Collection *1.2, 1.6, 1.7, 1.8, 1.9, 1.10, 1.11, 1.12, 1.13, 1.18, 1.20, 1.27, 1.33, 1.34, 1.40, 1.42, 1.43, 1.44, 1.45, 1.47, 1.52, 2.46, 2.47, 2.49, 3.3, 3.21, 3.23, 4.10, 4.12, 5.23, 5.26, 6.5, 6.6, 6.7, 6.8, 6.9, 6.10, 6.11, 6.32, 6.33, 6.41, 7.46, 7.47, 7.50, 7.51, 7.53, 8.17, 8.22, 8.23, 8.26, 8.33, 9.30, 9.55, 10.1, 10.11, 10.42, 10.43, 10.48, 11.5, 11.10, 11.28;* Samuel H. Kress Collection *1.16;* Widener Collection *6.29, 6.30.* Photos © 1994, Board of Trustees, National Gallery of Art, Washington, D.C.: Gift of David Gensburg *13.69(c);* Gift of Gemini G.E.L. *13.40(c), 13.50(c);* Rosenwald Collection *2.37(c), 5.50(c), 7.37, 8.43(c), 8.52(c)* Photo: Dean Beasom, *9.51, 9.62, 10.50.* Photos © 1995 Gift of Gemini G.E.L. *13.47, 13.49.* Reproduction rights: © 1996 The Munch Museum / The Munch–Ellingsen Group / ARS, New York *10.11;* © 1996 Artists Rights Society (ARS), New York / VG Bild-Kunst, Bonn *10.42, 10.43, 10.48, 10.50;* © 1996 Succession H. Matisse, Paris / Artists Rights Society (ARS), New York *11.5;* © 1996 Artists Rights Society (ARS), New York / SPADEM, Paris *11.10;* © 1996 Artists Rights Society (ARS), New York / ADAGP, Paris *11.28;* © 1969 Jasper Johns and Gemini G.E.L. *13.40(c);* © 1969 Robert Rauschenberg and Gemini G.E.L. *13.47;* © 1971 Robert Rauschenberg and Gemini G.E.L. *13.49;* © 1974 Robert Rauschenberg and Gemini G.E.L. *13.50(c);* © 1975 Ellsworth Kelly and Gemini G.E.L. *13.69(c).*

NATIONAL MUSEUM OF AMERICAN ART, Smithsonian Institution, Washington, D.C. Gift of the Harmon Foundation *12.53.*

NATIONAL MUSEUM OF AMERICAN HISTORY, Smithsonian Institution, Washington, D.C.

Division of Graphic Arts *12.8(c)* (9310687); *12.11(c)* (94-6763).

NEW BEDFORD WHALING MUSEUM, Old Dartmouth Historical Society, New Bedford, Massachusetts. *12.19.*

THE NEW YORK PUBLIC LIBRARY, New York. S. P. Avery Collection, Miriam and Ira D. Wallach Division of Art, Prints and Photographs, The New York Public Library, Astor, Lenox and Tilden Foundations *8.15, 9.4, 9.5, 9.33, 9.35(c), 9.36;* Print Collection, Miriam and Ira D. Wallach Division of Art, Prints and Photographs, The New York Public Library, Astor, Lenox and Tilden Foundations *2.30, 2.51, 2.52, 3.42, 4.1, 4.27, 5.8, 5.39, 6.4, 7.14(c), 7.16, 8.16, 8.18, 8.19, 8.24, 8.25, 9.46, 11.53, 12.5, 12.14, 12.22, 12.35, 12.48, 13.31;* S. P. Avery Collection *9.23;* Spencer Collection, The New York Public Library, Astor, Lenox and Tilden Foundations *11.44, 11.45, 11.46, 11.47.* Reproduction rights: © 1996 Artists Rights Society (ARS), New York / ADAGP / SPADEM, Man Ray Trust, Paris *11.44;* © 1996 Artists Rights Society (ARS), New York / SPADEM / ADAGP, Paris *11.45, 11.46, 11.47, 11.53.*

THE NEWARK MUSEUM, Newark, New Jersey. Gift of the W.P.A. Federal Art Project (1943) *12.52.*

ÖSTERREICHISCHE NATIONALBIBLIOTHEK, Vienna, Bild-Archiv. *2.22.*

PHILADELPHIA MUSEUM OF ART, Philadelphia. Given by an anonymous donor *10.55;* Given by Dr. George J. Roth *10.28;* Given by Henry P. McIlhenny *8.31, 12.56;* Given by Lessing J. Rosenwald *5.32;* Given by Mrs. Robert M. Hogue *8.9;* Given by P. H. and A. S. W. Rosenbach *6.35;* Given by Staunton B. Peck *6.54;* Purchased: McIlhenny Fund from E. Weyhe *8.29;* William S. Pilling Collection *9.21;* Purchased: Lisa Norris Elkins Fund *11.32;* The Charles M. Lea Collection *4.4.* Reproduction rights: © 1996 Artists Rights Society (ARS), New York / VG Bild-Kunst, Bonn *10.28;* © 1996 Artists Rights Society (ARS), New York / SPADEM, Paris *11.29, 11.31, 11.32, 11.36, 11.37.*

THE PIERPONT MORGAN LIBRARY, New York. *4.43* (B.22ii); *6.52* (PML 30214); *9.52* (B.86i); *9.53* (B.86iv).

PINACOTECA NAZIONALE, Gabinetto dei Disegni e delle Stampe, Bologna. 4.6 (inv. P.N. 23870).

PORTLAND ART MUSEUM, Portland, Oregon. Vivian and Gordon Gilkey Graphic Arts Collection 10.20.

ROBERT N. ESSICK, Altadena, California. Collection of Robert N. Essick 6.44.

RONALD FELDMAN FINE ARTS, INC., New York. Courtesy Ronald Feldman Fine Arts, New York, 13.54, 13.55. Photo © 1987 D. James Dee 13.54. Reproduction rights: © 1966 Andy Warhol Foundation for the Visual Arts / ARS, New York 13.54; © 1971 Andy Warhol Foundation for the Visual Arts / ARS, New York 13.55.

THE SAINT LOUIS ART MUSEUM, Saint Louis, Missouri. Bequest of Daniel R. Fitzpatrick 8.55(c); Purchase: Friends of The Saint Louis Art Museum Fund, Mr. and Mrs. Joseph Tucker 11.13; Purchase: The Sidney and Sadie Cohen Foundation, Inc., Print Purchase Fund 11.12. Reproduction rights: © 1996 Artists Rights Society (ARS), New York / ADAGP, Paris 11.12, 11.13.

SCHOMBURG CENTER FOR RESEARCH IN BLACK CULTURE, New York. Art and Artifacts Division, Schomburg Center for Research in Black Culture, The New York Public Library, Astor, Lenox and Tilden Foundations 13.60. Photo: Manu Sassonian.

SCHWEIZERISCHES INSTITUT FÜR KUNSTWISSENSCHAFT ZÜRICH, Zurich. Courtesy of Dr. Stephan Schmidheiny 9.61.

STAATLICHE KUNSTSAMMLUNGEN, Dresden, Kupferstich-Kabinett. 5.6.

STAATLICHE MUSEEN, Berlin, Kupferstichkabinett, Preussicher Kulturbesitz. Photos: Jörg P. Anders 1.28 (B.2; L.2; 188-1881), 1.29 (Lehrs 58; Inv.561-1), 1.32 (B.35; L.81; 339-1), 1.36 (B.97; L.289; 457-1), 2.29 (Holl.18), 4.40 (B.99-I; 315-1893), 7.10 (E.279-II), 10.4, 10.6, 10.45 (K1.96-VI, 499-1909); Photo: Karin Marz 3.45. Reproduction rights: © 1996 Artists Rights Society (ARS), New York / VG Bild-Kunst, Bonn 10.45.

STÄDELSCHES KUNSTINSTITUT UND STÄDTISCHE GALERIE, Frankfurt a.M. Reproduction rights: © Dr. Wolfgang and Ingeborg Henze-Ketterer, Wichtrach / Bern 10.17.

STEDELIJK MUSEUM, Amsterdam. Reproduction rights: © 1996 Artists Rights Society (ARS), New York / VG Bild-Kunst, Bonn 11.23.

TYLER GRAPHICS LTD., Mount Kisco, New York. Printed and published by Tyler Graphics Ltd. 13.71(c). Photo: Steven Sloman. Reproduction rights: © 1977 Frank Stella / Tyler Graphics Ltd. By permission of Artists Rights Society (ARS), New York.

THE UNIVERSITY OF IOWA MUSEUM OF ART, Iowa City. Gift of Dr. and Mrs. Webster B. Gelman 13.21; Gift of Frederick E. and Stephanie Lagormarcino Bishop 13.22. Reproduction rights: By permission of the Lasansky Corporation, Iowa City.

UNIVERSITY OF MICHIGAN MUSEUM OF ART, Ann Arbor. Gift of Helmut Stern (1986 / 1.155.7) 10.3.

VICTORIA & ALBERT MUSEUM, London. Photos © The Board of Trustees of the Victoria & Albert Museum, London 5.52, 8.46(c), 8.49, 8.51, 11.4. Reproduction rights: © 1996 Artists Rights Society (ARS), New York / SPADEM, Paris 11.4.

VILLE DE GENÉVE, Musée d'art et d'histoire, Cabinet des Estampes, Geneva. 2.21.

WHITNEY MUSEUM OF AMERICAN ART, New York. Purchase, with funds from the Friends of the Whitney Museum of American Art 13.52 (69.13.5); Purchase, with funds from the Wilfred P. and Rose J. Chrysler Garbisch Purchase Fund and the Print Committee 13.62 (86.48.8). Reproduction rights: © 1996 Andy Warhol Foundation for the Visual Arts / ARS, New York. 13.52.

THE WHITWORTH ART GALLERY, University of Manchester, England. 6.50.

YALE CENTER FOR BRITISH ART, New Haven, Connecticut. Paul Mellon Collection 5.42 (B1977.14.1336); 5.44 (B1985.36.1078); 5.45 (B1977.14.11938); 5.48 (B1977.14.21234[d]); 6.38 (B1985.36.1443); 6.39 (B1977.14.11061); 6.47 (B1992.8.13[23]); 6.48 (B1978.43.1570); 6.49 (B1992.8.14[42]); 7.19 (L 272.8[f°]); 8.13(c) (N14 [f°B]); 9.6 (B1977.14.13983); 9.7 (B1977.14.8355); 9.9 (S 271.56[f°]); 9.43 (NJ18 B47 A15 Qu3); 9.44 (B1978.1720); 9.45 (B1977.14.10895).

YALE UNIVERSITY ART GALLERY, New Haven,
 Connecticut. Arthur Fleischer Fund (B.A. 1953),
 (LL.B. 1958), Purchase Fund *13.72;* Gift of Mr.
 and Mrs. Walter Bareiss (B.S. 1940s) *13.18;* Gift
 of Robert V. Krikorian (B.A. *1950*) 12.4; The
 Ernest Steefel Collection of Graphic Art *13.17.*
 Reproduction rights: © 1996 Artists Rights

Society (ARS), New York / ADAGP, Paris *13.18;*
 © 1996 Dorothea Rockburne / Artists Rights
 Society (ARS), New York *13.72.*
ZENTRALBIBLIOTHEK ZÜRICH, Zurich.
 Graphische Sammlung *2.26, 2.27;*
 Handschriftenabteilung (Ms. C101, f. 13
 verso) *1.19.*

Index

Bacon, Francis (b. 1909), 777

Baer, Brigitte, 649, 775

Baillie, Captain William, 246

Balaam and the Angel (Dirk Volkertsz. Coornhert after Marten van Heemskerck), 259–60; fig. 5.3, 262

Balaam and the Angel (Rembrandt van Rijn), 259

Balcony, The (James Abbott McNeill Whistler), 557, 559; fig. 9.42, 559

Baldassare Castiglione (Raphael), 229

Baldini, Baccio (1436–1487?), 138–39

 The Judgment Hall of Pilate, 139; fig. 3.4, 140

 The Libyan Sibyl, 138–39; fig. 3.3, 138

 The Nativity, 138–39

Baldung, Hans (1484/85–1545), 96–99; and Dürer, 97, 99; and Expressionism, 582; and Tiepolo, 327, 328; woodcut technique of, 109

 The Bewitched Groom, 85, 98–99, 327, 328, 398; fig. 2.20, 98

 Christ Carried to Heaven by Angels, 109; fig. 2.34, 110

 Luther with Halo and Dove (from *Actae et Res Gestae*, by Martin Luther), 103; fig. 2.27, 105

 Witches' Sabbath (Witches Preparing for the Sabbath Flight), 96–97; fig. 2.19, 97

Baldwin, Robert W., 238, 239, 244

Balli de Sfessania (Jacques Callot), 207, 208, 404; fig. 4.12, 208

Balloon, The (Edouard Manet), 456; fig. 8.28, 457

Bandinelli, Baccio (1493–1560), 170, 171

 Martyrdom of St. Lawrence (engraved by Marcantonio Raimondi), 170–71; fig. 3.36, 170

Barbari, Jacopo de' (ca. 1460/70–1516), 155–58, 161–62, 172; and Dürer, 84, 155–57; and Lucas van Leyden, 157; and Pollaiuolo, 156; and Schongauer, 156; and Titian, 161

 Apollo and Diana, 156; fig. 3.20, 157

 St. Sebastian, 157; fig. 3.23, 158

 Triumph of Men over Satyrs, 161

 Victory and Fame, 84, 156–57; fig. 3.22, 158

 View of Venice, 161; fig. 3.28, 162

Barbarians! (Francisco Goya), 414

Barbiere, Domenico del (ca. 1506–65/75), 120, 257

 Group of Saints (after Michelangelo), 257–58; fig. 5.1, 258

Barbizon School: and American etchers, 717; and Dunoyer de Segonzac, 664; etchings of,

529–35; and Huet, 522; lithographs of, 442–43; and Pissarro, 497, 555; and Whistler, 557

Barcelona Series (Joan Miró), 686–87; fig. 11.48, 688

Barefoot Boy, The (Louis Prang after Eastman Johnson), 706–8; fig. 12.10, 708

Barlach, Ernst (1870–1938), 616, 617–18, 623

 The Transformations of God: Seven Woodcuts, 617–18

 The Cathedrals, 617; fig. 10.41, 619

Barocci, Federico (1535–1612), 184, 186; and Baroque style, 195, 197, 282; and Carracci, 195–96; and Cort, 184, 186, 271, 273; and etching, 184, 186, 194, 195, 255, 271–72; and Parmigianino, 271, 272; and Rembrandt, 224, 273; and reproductive printmaking, 271–73

 The Annunciation, 272–73; fig. 5.15, 273

 The Madonna with the Cat (engraved by Cort), 184

 The Rest on the Return from Egypt (engraved by Cort), 184, 271

 St. Francis Receiving the Stigmata, 184, 186, 195; fig. 3.55, 187

Baroque art, 12, 179–80; and Barocci, 195, 197, 282; Dutch, 215–47; French, 287–90; Italian, 195–204; and Mannerism, 195, 196, 197; and Rubens, 274–82; and Venetian Renaissance style, 171

Barricade, The (Edouard Manet), 456, 459; fig. 8.30, 459

Barry, James (1741–1806), 358–59

 Job Reproved by His Friends, 358–59; fig. 6.39, 361

Bartholdi, Frédéric-Auguste (1834–1904), 685

Bartholomew, Saint, 257

Bartolozzi, Francesco (ca. 1725/27–1815), *Portrait of Lady Smyth and Her Children* (after Sir Joshua Reynolds), 313; fig. 5.49 (color plate), 465

Bartsch, Adam, 143, 323

Basire, James, 360

Baskin, Leonard (b. 1922), 777, 790, 793

 Hydrogen Man, 793; fig. 13.30, 794

 Man of Peace, 793; fig. 13.29, 794

Basse, Jan, the Elder (1571–1636), 195

Bastille Day (Maurice Prendergast), 571; fig. 9.60 (color plate), 473

Hunt, William Morris (1824–1879), 721

Hunters in a Mountain Landscape (Nicolas de Bruyn after Gillis van Coninxloo), 215; fig. 4.22, 217

Hunting for Teeth (Francisco Goya), 401; fig. 7.26, 404

Hutton, James, 309

Hutton, John, 498

Huxley, Aldous (1894–1963), 342–44

Hydrogen Man (Leonard Baskin), 793; fig. 13.30, 794

Hypnerotomachia Poliphili (Francesco Colonna), 160–61, 563; fig. 3.26, 161; fig. 3.27, 161

Icarus (Henri Matisse), 649, 664; fig. 11.19 (color plate), 478

Iconoclasm, 109

Iconography, The (Anthony van Dyck), 205, 275; fig. 4.10, 206

Idea, 256

"Idea of a Fine Library of Prints" (Florent Le Comte), 257

Idée de la Perfection de la Peinture (Roland Fréart de Chambray), 287–88

If Day Breaks, We Will Go (Francisco Goya), 403, 409; fig. 7.35, 409

Illustration. *See* Book and journal illustration

Illustration Nouvelle, L', 542, 545

Illustrations for the Book of Job (William Blake), 360, 364, 372–75; fig. 6.52, 373; fig. 6.53, 374; fig. 6.54, 375

Iliazd (writer and printer), 686

Imbert, Anthony, 721

I'm Dreaming of a Black Christmas (Richard Hamilton), 830–31; fig. 13.65, 831

Imitations of Modern Drawings (Thomas Rowlandson), 312–13; fig. 5.48, 313

Impressionism, 13, 494; Expressionism compared with, 582; and lithography, 496–99, 505, 513

Incurables, Les (Denis-Auguste Raffet), 446; fig. 8.16, 447

Indiana, Robert (b. 1928), 822–23
LOVE, 822–23; fig. 13.58, 823

Indiana University, 787–88

Indulgences, 26, 109

Industrialization: eighteenth-century image of, 306; and nineteenth-century art, 526, 534, 536

Inferno (Dante): Blake's illustrations for, 360, 414; Doré's illustrations for, 562; fig. 9.47, 564

In Front of M. Manet's Canvas (Honoré Daumier), 451

Ingouf, Pierre-Charles (1746–1800), 303, 304
The Happy Household (with Jean-Michel Moreau le jeune after Jean-Baptiste Greuze), 303; fig. 5.40, 303

Ingres, Jean Auguste Dominique (1780–1867), 773
Raphael and the Fornarina, 773

Ink, 5–6, 7

Inking: spectrum rolling, 804; variable, 565, 567–68. *See also A la poupée*

Innocent Amusement (Daniel Chodowiecki), 387; fig. 7.10, 389

Inquisition, 398, 401, 402, 403

Insanity (as theme): for Bellows, 729–31; for Dix, 627, 628, 630; Dubuffet's interest in, 775; for Goya, 729; for Hogarth, 384

Insects (Edward Ruscha), 837; fig. 13.74, 838

Institoris, Heinrich, and Jakob Sprenger: *Malleus Maleficarum (Hammer of Witches)*, 85

Intaglio printmaking: at Atelier 17, 758, 784–90; origins of, 43–44; steel facing in, 315–16, 542, 650; techniques, 3–4, 6, 7, 45. *See also* Drypoint; Engraving; Etching

In the Forest of the Wissahickon (Thomas Moran), 722

Introduction to the High School of Painting (Samuel van Hoogstraeten), 220

Invenzioni Capric di Carceri (Giovanni Battista Piranesi), 339; fig. 6.19, 342

Inward Eye, The (William Blake, illus. by Richard Anuszkiewicz), 832; fig. 13.67, 832

Iowa, University of, 784

Isabey, Eugène (1803–1886), 723
Six Marines, 434, 723
Near Dieppe, 435, 493; fig. 8.4, 437

Isenheim Altarpiece, The (Matthias Grünewald), 53

Isenmann, Caspar, 53

Isocephalism, 288

Is There No One to Untie Us? (Francisco Goya), 385, 401; fig. 7.25, 403

Italian Landscape (Jean-Baptiste-Camille Corot), 532; fig. 9.15, 533

. . . It is two little birds she has closed up in her dress (Max Ernst), 682–83; fig. 11.44, 683

Ives, James. *See* Currier and Ives

Night, 588, 594; fig. 10.4, 589

 The Plague, 588; fig. 10.5, 590

Kneeling Girl (Emil Nolde), 603, 605; fig. 10.20, 605

Knight and Lady (Israhel van Meckenem), 62

Knight, Death, and the Devil (Albrecht Dürer), 53, 59, 89–92, 576; fig. 2.14, 91

Koberger, Anton (ca. 1445–1513), 38, 40, 75, 76, 77, 83, 85

Koch, Robert, 33

Koehler, Sylvester Rosa, 713–14, 717, 725; *American Art Review,* 713, 717; *Etching,* 717

Kohn, Misch (b. 1916), 790, 791

 Death Rides a Dark Horse, 791; fig. 13.27, 792

Koklova, Olga, 668, 674

Kokoschka, Oskar (1886–1980), 612, 616

 Murderer, Hope of Women, 616

 "*O Ewigkeit, Du Donnerwort,*"

 Self-Portrait with Crayon, 616; fig. 10.38, 617

Kolb, Anton, 161, 179

Kölderer, Jorg (d. 1540), 100

Kollwitz, Käthe (1867–1945), 14, 582, 618–25; and Callot, 212; and Goya, 414, 582; and Klinger, 589, 590; and Munch, 589; Soyer and Marsh compared with, 743; and Steinlen, 498, 623; techniques of, 619, 621, 622

 Brot!, 622–23; fig. 10.47, 624

 Death, 623

 Death Reaches into a Band of Children, 623; fig. 10.48, 624

 Death, Woman, and Child, 622; fig. 10.46, 623

 Memorial Sheet for Karl Liebknecht, 623–24; fig. 10.49, 625

 The Peasants' Revolt, 619, 621

 The Battlefield, 621; fig. 10.45, 622

 Breaking Away, 619, 621; fig. 10.44, 621

 War, 624–25

 The Parents, 624–25; fig. 10.50, 626

 A Weavers' Rebellion, 619

 Conspiracy, 619; fig. 10.42, 620

 The End, 619; fig. 10.43, 620

Koninck, Philips de (1619–1688), 216

Korean War, 807

Koreny, Fritz, 47

Körner, Hans, 21, 22

Krens, Thomas, 833

Krieg, Der (Otto Dix), 627–30; fig. 10.53, 629; fig. 10.54, 629; fig. 10.55, 630; fig. 10.56, 631

Kristeller, Paul, 138, 143, 153, 173

Krohg, Christian (1852–1925), 594

Krohg, Oda, 594

Kromm, Jane E., 384

Kruchenyckh, Alexei: *Vzorval* (illus. by Kasimir Malevich), 655; fig. 11.17, 657

Kun, Bela, 664

Kunstkammern, 100, 121, 122

Kunzle, David, 388, 395

La Belle, Jenijoy, 372

Lacourière, Roger, 633, 650

Lacourières, The, 673, 678

Laetitia (John Raphael Smith after George Morland), 387–88; fig. 7.11, 389

Lafrenson, Nicolas (Lavreince) (1737–1807), 300, 314

 The Happy Moment (engraved by Nicolas De Launay), 300; fig. 5.37, 301

Lafréry, Antonio (1512–1577), 171, 254; *Speculum Romanae Magnificentiae,* 171

Lagerlöf, Margaretha Rossholm, 289

Lalanne, Maxime (1827–1886): *Treatise on Etching,* 543, 713

Lambeth Books (William Blake), 370

Lamentation over the Body of Abel (Lucas van Leyden), 165

Lampsonius, Domenicus (1532–1599), 264, 286

Lancret, Nicolas (1690–1743), 301

Landau, David, 137, 177

Landscape: in American lithographs, 703–5, 713–18, 722–23, 754; Barbizon school and its influence on, 442–43, 529–35, 664, 713–14, 717; classical, 198, 202, 217–18, 289; Danube school, 117–18; in early prints, 58, 85, 116–20; eighteenth-century, 311, 313; in etching revival, 544–45, 713–18; Expressionist, 602, 604; and Hopper, 734–35; Hudson River school, 703–5, 754; and Huet, 522; in lithography, 434–35, 493–96, 703–5, 722–23; Mannerist, 215, 220; mezzotint, 307, 309–10, 522, 524–26; nineteenth-century English, 307, 309–10, 494–96, 522, 524–28, 536; nineteenth-century French, 434–35, 493–94, 529–35, 544–45, 554–55, 571; Norwich school, 526; in Rembrandt's prints, 218–19, 232–36; and Romanticism, 526,

Pierre Milan (d. 1473), 270, 271
 Nymph and Ornament for Fontainebleau (with
 René Boyvin after Rosso Fiorentino), 270;
 fig. 5.13, 272
Pier with Chains, The (Giovanni Battista Piranesi),
 339, 346; fig. 6.21, 344
Pietà (as theme), 126, 127–128, 196
Pietà (Annibale Carracci), 126, 196; fig. 4.2, 197
Pietà (Hendrik Goltzius), 126; fig. 2.54, 126
Pietà (Jacques Bellange), 127–28; fig. 2.56, 128
Pietà (Michelangelo), 126, 246
Pietro da Cortona. *See* Cortona, Pietro da
Pillage, The (Jacques Callot), 210; fig. 4.15, 210
Pillsbury, Edmund P., 271
Pinned Hat, The (Auguste Renoir), 505; fig. 8.43
 (color plate), 469
Piranesi, Giovanni Battista (1720–1778), 13, 323–
 24, 333–46; and antiquity, 334–35, 337,
 346; architectural training of, 333–34;
 Heemskerck's anticipation of, 260; and stage
 design, 334, 344; vigor of etchings of, 318
 Le Antichità Romane, 338–39
 *The Foundations of Hadrian's Mausoleum
 (Castel Sant' Angelo)*, 339; fig. 6.18, 341
 Frontispiece for the second volume, 338–39;
 fig. 6.17, 340
 Carceri d'Invenzione (Prisons), 339, 341–46
 The Drawbridge, 339; fig. 6.20, 343
 The Lion Bas-Reliefs, 346
 The Man on the Rack, 339, 346; fig. 6.22, 345
 The Pier with Chains, 339, 346; fig. 6.21, 344
 Della Magnificenza ed Architettura de' Romani,
 337
 Invenzioni Capric di Carceri, 339
 The Drawbridge, 339; fig. 6.19, 342
 Opere Varie, 334
 Prima Parte di Architetture e Prospettive, 334–35, 344
 The Ancient Mausoleum, 335; fig. 6.12, 336
 Varie Vedute di Roma Antica e Moderna, 337
 The Pyramid of Cestius, 337; fig. 6.14, 338
 Vedute di Roma, 337–38
 The Basilica of Constantine, 337; fig. 6.15, 339
 The Colosseum (Bird's Eye View), 337;
 fig. 6.16, 340
Pirckheimer, Caritas, 80, 89
Pirckheimer, Willibald, 80, 84, 100
Pisanello, Antonio (ca. 1395–1455), 244
Pissarro, Camille (1830–1903), 496–98, 554–55;

and Cassatt, 553; Davies compared with,
 737; etchings of, 554–55; lithographs of,
 496–98; political comment of, 497–98
 Twilight with Haystacks, 554–55; fig. 9.37 (color
 plate), 473
 The Vagabonds, 497–98; fig. 8.36, 498
 Women Bathing in the Shade of Wooded Banks,
 496–97; fig. 8.35, 497
 Woman in a Kitchen Garden, 555; fig. 9.38, 556
Pissarro, Lucien (1863–1944), 563–64
 Ophelia, 564; fig. 9.50, 567
Pit of Disease (John Flaxman), 414
Pitt, William, 360
Pius II, 36
Plagiarism: of Claude in *Liber Veritatis*, 524; of
 Dürer by Marcantonio, 89, 162–63; and
 Hogarth, 382; and Mantegna, 155. *See also*
 Copyright
Plague, The (Max Klinger), 588; fig. 10.5, 590
Planetary Folklore (Victor Vasarely), 831; fig. 13.66
 (color plate), 490
Planets (as theme in blockbooks), 37, 92, 93
Plantin Press, 274
Platemark, 4, 45
Playing cards, 45
Pleasant Spots (Claes Jansz. Visscher), 215
Plein-air, 10, 289, 530, 664, 717
Pleite, Die, 627
Plexiglas, 814
Pleydenwurff, Hans (ca. 1420–1472), 58
*Ploughman, The—The Christian Ploughing the Last
 Furrow of Life*, (Edward Calvert), 561;
 fig. 9.45, 562
Plutarch, 288
Pochoir, 648–49
Poesies (Stephane Mallarmé; illus. by Matisse),
 645–47; fig. 11.6, 647
Poggi, Antonio di, 700
Poire (pear), satirical meaning of, 446–47
Polar Coordinates (Frank Stella), 834
Polichinelle (Edouard Manet), 440
Poliphilus and Polia Wandering Among Ruins (Un-
 known Venetian artist; from *Hypnerotoma-
 chia Poliphili*, by Francesco Colonna), 160,
 563; fig. 3.27, 161
Poliphilus in a Wood (Unknown Venetian artist;
 from *Hypnerotomachia Poliphili*, by Fran-
 cesco Colonna), 160, 563; fig. 3.26, 161